RENAISSANCE LIVES

from the **African American National Biography**

GENERAL EDITORS

Henry Louis Gates Jr.

*W. E. B. DuBois Institute for African and African American Research,
Harvard University*

Evelyn Brooks Higginbotham

Harvard University

In association with the

AMERICAN COUNCIL OF LEARNED SOCIETIES

OXFORD
UNIVERSITY PRESS

2009

OXFORD
UNIVERSITY PRESS

Oxford University Press, Inc., publishes works
that further Oxford University's objective of excellence
in research, scholarship, and education.

Oxford New York
Auckland Cape Town Dar es Salaam Hong Kong Karachi
Kuala Lumpur Madrid Melbourne Mexico City Nairobi
New Delhi Shanghai Taipei Toronto

With offices in
Argentina Austria Brazil Chile Czech Republic France Greece
Guatemala Hungary Italy Japan Poland Portugal Singapore
South Korea Switzerland Thailand Turkey Ukraine Vietnam

Copyright © 2009 by Oxford University Press, Inc.

Published by Oxford University Press, Inc.
198 Madison Avenue, New York, New York 10016
www.oup.com

Oxford is a registered trademark of Oxford University Press

Library of Congress Cataloging-in-Publication Data

Harlem Renaissance lives / edited by Henry Louis Gates Jr. and Evelyn Brooks
Higginbotham.
 p. cm.
 Includes bibliographical references and index.
 ISBN 978-0-19-538795-7
 1. African Americans—Intellectual life—20th century. 2. African American
authors—Biography. 3. African American artists—Biography. 4. African
American intellectuals—Biography. 5. Harlem Renaissance. 6. Harlem
(New York, N.Y.)—Intellectual life—20th century. 7. New York (N.Y.)—
Intellectual life—20th century. I. Gates, Henry Louis. II. Higginbotham,
Evelyn Brooks, 1945–
E185.6.H265 2009
305.896'073074710904—dc22

 2008051794

9 8 7 6 5 4 3 2 1

Printed in the United States of America
on acid-free paper

CONTENTS

Introduction vii

HARLEM RENAISSANCE LIVES 1

Directory of Contributors 557

Index 563

INTRODUCTION

he Harlem Renaissance was the most important period in twentieth-century African American intellectual and cultural life. Most commonly known as a literary movement that occurred in the 1920s and early 1930s, it was much more than that. It also encompassed critical writing, music, theater, musical theater, and the visual arts, and it affected politics, social development, and almost every aspect of the African American experience from the early 1920s through the mid-1930s. The Harlem Renaissance was part of and deeply influenced by (as well as an influence on) two other sociopolitical developments in the African American community in the early twentieth century: the Great Migration, which altered the demographics of black America, and the concept of the "new Negro," which was sometimes considered synonymous with the Harlem Renaissance but also stood alone as a reflection of new political awareness and racial pride that emerged in the early years of the century and became a dominant factor during and following World War I.

THE EMERGENCE OF THE HARLEM RENAISSANCE

A number of events signaled the beginnings of the Harlem Renaissance. The first took place in music, as the blues and jazz made their way from cities such as New Orleans, Memphis, St. Louis, and Chicago to New York City—particularly Harlem. Pioneered by W. C. Handy and other musicians, the blues emerged at the end of the nineteenth century and became popular during the second decade of the new century in Harlem clubs and through sales of phonograph records by blues singers Mamie Smith and Bessie Smith. Jazz moved north from New Orleans to Harlem, with James Reese Europe in 1905 one of the first to play jazz in the city. During World War I, Europe enlisted in the famed black Fifteenth Infantry Regiment, known as the Harlem Hellfighters, and served as a machine gun officer and bandleader. While overseas, he introduced jazz to the French and to Europeans in general; the new music took the continent by storm. Tragically he was killed in 1919 by a deranged member of his own

band while on tour in Boston after returning to the United States. Though he did not live to realize his full potential as a composer and bandleader, Europe was given a public funeral in New York City, the first ever for a black person, and buried with full honors at Arlington National Cemetery. In 1921 Eubie Blake and Nobel Sissle carried the soul of this new music to standing-room-only audiences on Broadway in an all-black musical revue, *Shuffle Along*. Both the poet Langston Hughes and the influential poet and diplomat James Weldon Johnson saw the incredibly popular *Shuffle Along* as a sign of the emerging Harlem Renaissance.

Another major event that marked the beginnings of the Renaissance was the 1924 Civic Club dinner, held to acknowledge the upsurge in black literary activities. In the early 1920s a series of unconnected literary events—including Claude McKay's volume of poetry, *Harlem Shadows* (1922), Jean Toomer's novel *Cane* (1923), and the initial published works of other young black writers—contributed to Harlem's emerging cultural life. The Civic Club dinner, in addition to formally acknowledging the literary activity that was already underway, furthered the movement by bringing together the three major players in the literary Renaissance: the black literary-political intelligentsia, white publishers and critics, and young black writers. Charles S. Johnson of the Urban League conceived the dinner to recognize Jessie Fauset on the occasion of the publication of her first novel, *There Is Confusion*. By the time the diners convened on 21 March 1924, however, the event had expanded to include recognition of the broad array of new literary talent in the black community and to present this talent to New York's white literary establishment. The impact was significant. At this dinner Alain Locke was offered the opportunity to guest-edit an issue of the *Survey Graphic*, a liberal journal of social issues. Locke devoted the resulting "Harlem issue," published in March 1925, to defining the aesthetic of black literature and art. Other black writers made contacts at the dinner that resulted in published books in the coming months.

However, the most important sign of the Harlem Renaissance was the increase in the artistic accomplishments of the young African Americans whose

literary and artistic talent was the basis of the Renaissance. In both quantity and quality, and in terms of public awareness and acceptance, the black creative artists of this period achieved far more than their predecessors. In the three years after *Shuffle Along* had taken black musical theater to Broadway, nine more musicals written by blacks and featuring black performers played on Broadway. In addition, by the late 1920s and early 1930s white writers and producers turned to black themes and black performers for several significant productions. Jerome Kern and Oscar Hammerstein did so in 1927 for their hit *Showboat*; Irving Berlin cast blues singer Ethel Waters in *As Thousands Cheer* (1933); and George and Ira Gershwin brought their great opera *Porgy and Bess* to Broadway in 1935. Black writers achieved similar success in literature. Although no single work had the impact on literature that *Shuffle Along* had on musical theater, during the fifteen years beginning in 1922 the sixteen best-known black authors of the Harlem Renaissance published more than fifty books with mainstream commercial publishers. As with musical theater, their work stimulated white authors to produce works focusing on the African American experience. Du Bose Heyward's best-selling 1925 novel, *Porgy*; Carl Van Vechten's controversial *Nigger Heaven* (1926); Julia Peterkin's Pulitzer Prize–winning 1928 novel, *Scarlet Sister Mary*; and Fannie Hurst's very successful *Imitation of Life* (1933) represent the most significant examples of this development.

THE LITERATURE AND ART OF THE RENAISSANCE

Efforts to define precisely the nature of the literary and artistic creativity of the Harlem Renaissance meet with frustration. There was no common literary style or political ideology associated with the movement; it was a reflection of identity far more than an ideology or a literary or artistic school. What united participants was their sense of taking part in a common endeavor and their commitment to giving artist expression to the African American experience. This identity is much stronger among writers and poets than among musicians and performers. Perhaps the best statement defining perception of the movement among its practitioners was Hughes's essay "The Negro Artist and the Racial Mountain"; published in *The Nation* in 1926 the

essay was an artistic declaration of independence—from the stereotypes that whites held of African Americans and the expectations they had for their creative works, as well as independence from the expectations that black leaders and black critics had of black writers and the expectations black writers had for their own work. As Hughes concluded:

> We younger Negro artists who create now intend to express our individual dark-skinned selves without fear or shame. If white people are pleased we are glad. If they are not, it doesn't matter. We know we are beautiful. And ugly too. The tom-tom cries and the tom-tom laughs. If colored people are pleased we are glad. If they are not, their displeasure doesn't matter either. We build our temples for tomorrow, strong as we know how, and we stand on top of the mountain, free within ourselves.

The determination of black writers to follow their own artistic vision, and the diversity that this created, was the principal characteristic of the Harlem Renaissance. This diversity ranged from Hughes's weaving of the stylistic forms of African American music into his experimental poems of ghetto life, as in "The Weary Blues," to McKay's adopting the sonnet as the vehicle for his militant attack on racial violence, "If We Must Die," and for his glimpses of Harlem life in "The Harlem Dancer." Countee Cullen in turn employed classical literary allusions as he explored the African roots of black life in "Heritage"; Nella Larsen presented a psychological study of an African American woman's loss of identity in her novel *Quicksand*; and Zora Neale Hurston drew on the folk life of the black rural south in her highly acclaimed *Their Eyes Were Watching God*. Diversity and experimentation were also demonstrated by the blues of Bessie Smith, the range of jazz from the early rhythms of Jelly Roll Morton to the playing and singing styles of Louis Armstrong and the sophisticated orchestration of Duke Ellington, and the primitivism and African images used by Aaron Douglas in his paintings and illustrations.

Within this diversity, several themes emerged that more clearly defined the nature of the Harlem Renaissance. No single black artist expressed all these themes, but each addressed one or more in his or her work. A primary concern for most artists

was the effort to recapture the African American past both its African heritage and its rural southern roots. The poets Cullen and Hughes examined African heritage in their works, and Douglas used African motifs in his art. A number of musicians, from the classical composer William Grant Still to jazz great Armstrong, introduced African-inspired rhythms and themes in their compositions. In *Cane* Toomer provided a notable example of the use of southern black culture to convey the African American experience. Hurston used her background as a folklorist to create a rich depiction of rural southern black life in *Their Eyes Were Watching God*. Jacob Lawrence's series of paintings, especially *The Life of Harriet Tubman* and *The Migration Series*, portrayed southern experiences from black history.

Harlem Renaissance writers were also very much engaged with exploring life in Harlem and other urban centers. Both Hughes and McKay drew on Harlem images for their poetry, and McKay used the ghetto as the setting for his first novel, *Home to Harlem*. W. E. B. Du Bois and several other black critics accused some black writers, including McKay and Hughes as well as Rudolph Fisher and Wallace Thurman, of exploiting black urban life by overemphasizing crime, sexuality, and other less savory aspects of ghetto life. Other black writers, such as Fauset, wrote about the black urban experience but focused their work on the middle class. The artists Jacob Lawrence and Archibald J. Motley Jr. used vivid colors in their depiction of urban scenes and urban life.

Virtually every novel and play, and most of the poetry of the Harlem Renaissance explored race in America, especially the impact of race and racism on African Americans. In their simplest form these works protested racial injustice. McKay's poem "If We Must Die" was one the best of this genre. Most Harlem Renaissance writers avoided overt protest or propaganda, focusing instead on the psychological and social impact of race. Among the finest of these studies were Larsen's two novels, *Quicksand* (1928) and *Passing* (1929); both explored characters of mixed racial heritage who struggled to define their racial identity in a world of prejudice and racism. Hughes used a similar theme in his poem "Cross" and then expanded it in his 1931 play, *Mulatto*. The theme arises again in Fauset's 1929 novel *Plum Bun*. In that same year Thurman made color discrimination within the urban black community the focus of his novel *The Blacker the Berry*.

Harlem Renaissance writers blended various aspects of African American culture in their work, for example, by using black music as an inspiration for poetry or drawing on black folklore for novels and short stories. Best known for this were Hughes, who used the rhythms and styles of jazz and the blues in much of his early poetry; James Weldon Johnson, who published two collections of black spirituals in 1927 and 1928; and Sterling Brown, who used the blues and southern work songs in many of the poems in his 1932 collection, *Southern Road*. Other writers looked to black religion as a literary source. Johnson made the black preacher and his sermons the basis for the poems in *God's Trombones*, and Hurston and Larsen used black religion and black preachers in their novels. Hurston's first novel, *Jonah's Gourd Vine*, describes the exploits of a southern black preacher, and in the last portion of *Quicksand* Larsen's heroine is ensnared by religion and a southern black preacher.

Through all these themes Harlem Renaissance writers were determined to express the African American experience in all its variety and complexity as realistically as possible. This commitment to realism ranged from the ghetto realism that created such controversy when writers exposed negative aspects of African American life to Hughes's beautifully crafted and detailed portrait of small-town black life in *Not Without Laughter* and the witty and biting satire of Harlem's black literati in Thurman's *Infants of the Spring*.

THE DECLINE OF THE HARLEM RENAISSANCE

A number of factors contributed to the decline of the Harlem Renaissance in the mid-1930s. Because the Great Depression increased the economic pressure on both writers and publishers, organizations such as the NAACP and the Urban League, which had actively promoted the Renaissance in the early 1920s, shifted their interests to economic and social issues in the late 1920s and 1930s. This process was accelerated by Fauset's departure as literary editor of *Crisis* in 1926 and Charles S. Johnson's resignation in 1927 from the Urban League—along with the editorship of its journal, *Opportunity*—ending that organization's focus on the arts and literature.

A second factor in the decline was the departure from Harlem of many key figures in the late

1920s and the early 1930s. Charles S. Johnson moved south in 1931, as did James Weldon Johnson, and Du Bois followed in 1934. Hughes left Harlem in 1931 and did not return permanently until World War II. Brown, Douglas, and the poet and author Arna Bontemps shifted their bases of operations to black universities in the 1930s. The writers Fisher and Thurman died in 1934, and James Weldon Johnson died four years later. Many of the rest stopped writing. Cullen took a full-time job teaching school in 1934; most of his writing after that time consisted of children's stories. Larsen dropped out of sight and never published her projected third novel. McKay, returning to Harlem in 1934 after an absence of about twelve years, noted the lack of literary activity. After his return he published only an autobiography and a history of Harlem. Hurston, in contrast, actually enjoyed her greatest period of literary output in the 1930s but fell silent and largely dropped out of sight after the 1940s. Only Hughes continued to support himself through writing after the 1930s, but he no longer considered himself part of a literary movement.

Any doubt that the era of the Harlem Renaissance had ended was put to rest by the Harlem Riot of 1935. This event shattered the illusion of Harlem as the "Mecca of the New Negro" that had figured so prominently in the folklore of the Renaissance. Harlem was a ghetto, with all the problems associated with American urban ghettos: high rates of poverty and crime; poor and overcrowded housing; inadequate city services; job discrimination; and control of government, the police force, and employment by the dominant white power structure.

In spite of all these problems creative production did not cease overnight. Almost one-third of the major works published during the Renaissance appeared after 1929, and Hurston's *Their Eyes Were Watching God*, arguably the best novel of the Renaissance, came out in 1937. Black music continued in popularity through the 1930s and beyond, especially the increasingly sophisticated sounds of Armstrong and Ellington, and Lawrence produced his best paintings in the 1930s. In the final analysis the Harlem Renaissance ended when most of those associated with it left Harlem or stopped writing and the new young artists who emerged in the 1930s and 1940s chose not to associate with the movement.

This volume contains all these stories and more, as told through the lives of the people who lived them.

CARY D. WINTZ

ABBOTT, Robert Sengstacke

(28 Nov. 1868–29 Feb. 1940), newspaper publisher, was born Robert Abbott in Fort Frederica, St. Simons Island, off the coast of Savannah, Georgia, the son of Thomas Abbott and Flora Butler, former slaves who operated a grocery store on St. Thomas Island. Thomas Abbott died the year after Robert was born, and Robert's mother moved to Savannah, where in 1874 she married John Herman Henry Sengstacke. Sengstacke was the son of a German father and a black American mother and, although born in the United States, was reared in Germany. He returned to the United States in 1869 and pursued careers in education, the clergy, and journalism. In the latter role Sengstacke became editor of the *Woodville Times*, a black community weekly newspaper that served Savannah-area residents. Abbott's admiration for his stepfather inspired him to add the name Sengstacke to his own and to attempt to become a publisher in his own right.

Abbott's first newspaper job was as a printer with the white-owned *Savannah Echo*. He soon decided to obtain a college education; after attending several other institutions, Abbott enrolled at Hampton Institute in Virginia in 1889 at the age of twenty-one. Hampton, founded by the Congregationalists and supported by northern philanthropists, was both a trade school and an academic institution for African Americans. Abbott completed training as a printer in 1893, then culminated his undergraduate career with a bachelor's degree in 1896, after nearly seven years at Hampton. His experience there included opportunities to hear two charismatic black speakers, Frederick Douglass and IDA B. WELLS-BARNETT, who influenced him to seek a leadership role in the development of civil rights for black Americans. After graduating from Hampton, Abbott moved to Chicago, where in 1899 he earned a law degree from Kent College of Law, the only black in his class of seventy students. Abbott, however, was never admitted to the bar. For the next few years he tried to establish a career as a lawyer in several midwestern cities without success; eventually he returned to Woodville to teach in a local school.

In 1905, at the age of thirty-seven, Abbott returned to Chicago and began publication of his own newspaper, the *Chicago Defender*. He chose Chicago as the base for his paper because of its large black population (more than thirty thousand), though at the time the black newspaper field in Chicago was extremely crowded, with three established local weeklies and the availability of two other well-respected journals, the *Indiana Freeman* and the *New York Age*. The title "Defender" represented his pledge that the paper would defend his race against the ills of racism.

Abbott's first number of the *Defender* was virtually a one-man production operated from rented desk space in a real estate and insurance office with furnishings that included a folding card table and a borrowed kitchen chair. But with an initial investment of twenty-five cents (for paper and pencils) and the help of his landlady's teenage daughter, he was able to launch a publishing enterprise that became one of the most influential newspapers in the United States. Within ten years the *Defender* was the nation's leading black newspaper, with an estimated circulation of 230,000.

Despite his early exposure to the printing trade and newspaper publishing, Abbott was seen by many of his contemporaries as an unlikely candidate for success as a newspaperman. He was not an articulate speaker, but he had a strong talent for gathering rumor, hearsay, and other information and turning them into human-interest stories. Abbott also proved a master at upstaging his competitors. Proclaiming his paper to be "the only two-cent weekly in the city" and focusing front-page coverage on sensational and crime news, Abbott steadily increased his paper's readership. The *Defender*'s most significant contribution, however, was perhaps its crusade to encourage black migration from the former slave states of the South to Chicago and other midwestern cities.

The campaign, launched during World War I, was instrumental in bringing thousands of blacks to the North in search of better jobs, housing, and educational opportunities. For Abbott the migration was part of a plan to increase the *Defender*'s circulation and give him an opportunity to penetrate the black readership markets in the South. Several southern cities so resented the effectiveness of the *Defender*'s campaign that they banned its distribution. The *Atlanta Constitution* wrote that the migration cost the South "her best labor" force

and that the region's economy suffered greatly. It has been estimated that nearly thirty-five thousand blacks moved to Chicago from the founding of the *Defender* in 1905 to 1920, more than doubling the city's African American population.

An indirect result of the heavy influx of black migrants to Chicago was a race riot in 1919 that highlighted the tensions between whites and blacks in the city. Abbott was appointed to the Commission on Race Relations, charged with determining the causes of the riot. Although the commission's report implicated the *Defender*'s strong stance for black civil rights as a contributing factor in the riots, Abbott signed the document.

The *Defender* was a fearless champion for the cause of racial equality for African Americans. Abbott enumerated his policies as the elimination of racial prejudice in the United States, the opening of trade union membership to blacks, black representation in the president's cabinet, equal employment opportunities for blacks in the public and private sectors, and black employment in all police forces nationally. He also sought the elimination of all school segregation and the passage of federal civil rights legislation to protect against breakdowns in desegregation laws at the state level as well as to extend full voting rights to all Americans. These policies found a ready market, and the *Defender*'s growth during World War I allowed it to open and maintain branch offices in several major U.S. cities as well as one in London. During the war Abbott publicly asked why blacks should fight for the United States on foreign battlefields while being denied basic rights at home, a stance that provoked investigations by the federal government. In 1918, just two months short of his fiftieth birthday, Abbott married Helen Thornton Morrison; they had no children.

In the decade following World War I, the *Defender*'s circulation began to fall with the arrival of a new competitor, the *Chicago Whip*, and the onset of the Depression years. The *Defender* generally supported Republican politics, although in 1928 Abbott opposed Herbert Hoover in favor of the Democratic candidate Alfred E. Smith. During the 1930s, perhaps because of the 1919 riots and the impact of the Depression, the *Defender* took a more moderate stance regarding racial matters. The period also took a personal toll on Abbott, and he suffered several financial reversals. By 1935 circulation had declined to seventy-three thousand.

After his mother died in 1932, Abbott began to travel extensively and attempted during the mid-1930s an ill-fated venture into magazine publishing with *Abbott's Monthly*.

Following a costly divorce from his first wife in 1932, Abbott married Edna Brown Dennison in 1934 but soon fell into ill health. In 1939 he gave control of the *Defender* to his nephew John H. Sengstacke, son of his half brother Alexander. Abbott died at his home in Chicago the following year. He left behind a newspaper that had pioneered new territory for the black press, becoming the first national paper to have an integrated staff and to be unionized. In 1956, under John Sengstacke's leadership, the *Defender* became a daily newspaper, soon to become the flagship publication of the nation's largest black newspaper chain.

FURTHER READING
Abbott's papers are in the *Chicago Defender* Archives in Chicago.
Ottley, Roi. *The Lonely Warrior* (1955).
Wolseley, Roland E. *The Black Press U.S.A.* (1971; 2d ed., 1990).

CLINT C. WILSON

ALLEN, James Latimer

(7 Feb. 1907–1977), photographer, was born in New York City to Virginia Allen, a dressmaker who migrated from the British Virgin Islands in 1900, and an unidentified father. James attended Dewitt Clinton High School, where he discovered photography through the school's camera club, the Amateur Cinema League. The school was fertile ground for several members of the upcoming Harlem Renaissance, including the poet COUNTEE CULLEN, whose first published piece appeared in the school magazine, the *Magpie*. The artist CHARLES ALSTON also developed his talents as the art editor for the *Magpie* and leader of the art club. In 1923 Allen began a four-year apprenticeship at Stone, Van Dresser and Company, a white-owned illustration firm, where he received additional instruction in photography. Louis Collins Stone, the firm's owner and a portrait painter, and his wife seem to have taken a personal interest in Allen and in nurturing black talent. The writer and artist Richard Bruce Nugent also spent part of his adolescence in New York City, attended Dewitt Clinton, and was employed by this firm.

Following graduation from high school in 1925 Allen embarked on a career as an artist-photographer. With the support of patrons like ALAIN LEROY LOCKE and Carl Van Vechten, Allen opened a portrait studio at 213 West 121st Street in 1927 and quickly became the photographer of choice for the luminaries of the Harlem Renaissance. With subjects including Alston, Cullen, AARON DOUGLAS, W. E. B. DU BOIS, LANGSTON HUGHES, NELLA LARSEN, Locke, HAROLD JACKMAN, CHARLES SPURGEON JOHNSON, HALL JOHNSON, JAMES WELDON JOHNSON, JACOB LAWRENCE, Norman Lewis, ROSE MCCLENDON, CLAUDE MCKAY, LOUISE THOMPSON PATTERSON, PAUL ROBESON, JOEL AUGUSTUS ROGERS, ARTHUR ALFONSO SCHOMBURG, EDNA LEWIS THOMAS, Van Vechten, and A'LELIA WALKER, Allen's roster of clients makes up the most comprehensive visual record of Harlem's cultural elite by an African American photographer. Carl Van Vechten, who was white, began his extensive body of photographs in 1932.

Allen created a visual image of the New Negro—the modern, urban, sophisticated, well-educated African American who exemplified the best that the race had to offer and refuted the claims of black inferiority that sustained white supremacist beliefs and Jim Crow policy. In his images well-groomed, well-dressed African American men and women posed in front of a simple gray backdrop are elegantly displayed as testaments to African American talent and achievement. Inscriptions on many of the photographic prints indicate that these portraits not only were meant for private display but also were exchanged between members of Harlem's social circles. The photographs seemed to have functioned as mutually reaffirming talismans of shared ideals and purpose in a world hostile to African American equality. This compelling vision was also deployed to promote the New Negro ideal among a national audience. Allen's portraits and his commercial images were consistently published in the leading Negro periodicals of the day, such as the *Crisis*, *Opportunity*, and the *Messenger*. *Opportunity*, the magazine of the National Urban League, featured Allen's photographs on their cover sixteen times between 1934 and 1942. His images provided a model of the New Negro that black leaders encouraged all African Americans to emulate.

Allen also enjoyed considerable recognition as a fine artist. He was one of four photographers who competed for the William E. Harmon Foundation Awards for Distinguished Achievement among Negroes established in 1926. The annual exhibition (1927–1931, 1933, and 1935) of submissions in the fine arts category was the chief venue open to African American artists. In 1930 Allen was awarded the Commission on Race Relations Prize for Photographic Work from the Harmon Foundation. This was a special award established that year specifically to honor photography. Allen won this prize again in 1931 and 1933. He was the only photographer included in the film *A Study of Negro Artists* produced by the foundation in 1934. Allen was featured in other key exhibitions, including the Exhibition of Young Negro Artists in 1927, An Exhibition of Negro Art in 1935 at the Harlem YMCA, and the Exhibition of Fine Arts Productions by American Negroes, Hall of Negro Life, Texas Centennial in 1936 in Dallas. In 1930 he received a solo show, An Exhibition of Portraits by James L. Allen (A Group of New Portraits) at the Hobby Horse, a Harlem bookstore and café located at 113 West 136th Street.

With the onset of the Great Depression, Allen supplemented his income by taking photographs for the Harmon Foundation and the Harlem Art Workshop, thus producing an important archive of artworks and portraits of artists at work in their studios. He was employed as an instructor at the WPA-funded Harlem Community Art Center founded by the sculptor AUGUSTA SAVAGE in 1937. His documentation of activities there allowed Allen to work exclusively as a photographer and to maintain a studio, which he relocated to 2138 Seventh Avenue and then to 1858 Seventh Avenue until 1944.

Allen appears to have enlisted in World War II and was assigned to the Office of Strategic Services in Washington, D.C., where because of his prior experience he was tasked with processing film taken for intelligence purposes. Allen married around this time and never resumed his career as a photographer. He remained in Washington, working as a civil servant. When he died his personal archive was destroyed by his wife, who did not approve of his early profession. Surviving photographs by Allen can be found in the Moorland-Spingarn Research Center at Howard University, the Beinecke Rare Book and Manuscript Library at Yale University, the Schomburg Center for Research in Black Culture in New York, and the Harmon Foundation Collection at the National Archives and the Library of Congress. Allen, along with other photographers of

his generation, reinvented the iconography of blackness and established a modern black aesthetic that symbolized the racial pride that African Americans felt during the interwar period.

FURTHER READING

Holloway, Camara Dia. *Portraiture and the Harlem Renaissance: The Photographs of James L. Allen* (1999).

Willis, Deborah. *Reflections in Black: A History of Black Photographers 1840 to the Present* (2000).

Wright, Beryl, and Gary Reynolds. *Against the Odds: African-American Artists and the Harmon Foundation* (1989).

CAMARA DIA HOLLOWAY

ALSTON, Charles Henry

(26 or 28 Nov. 1907–27 Apr. 1977), artist and teacher, was born in Charlotte, North Carolina, the youngest of five children of the prominent Episcopalian minister Primus Priss Alston and his second wife, Anna (Miller) Alston. Nicknamed "Spinky" by his father, Charles showed his artistic bent as a child by sculpting animals out of the red clay around his home. His father died suddenly when Charles was just three. In 1913 his mother married a former classmate, Harry Pierce Bearden (uncle of ROMARE BEARDEN), and the family moved to New York City. Charles's stepfather worked at the Bretton Hotel as the supervisor of elevator operators and newsstand personnel, and over the years the family lived in comfortable brownstones in better neighborhoods.

Alston attended DeWitt Clinton High School, where he was art editor of the student newspaper the *Magpie* during the week, and he studied at the National Academy of Art on Saturdays. He turned down a scholarship to the Yale School of Fine Arts, choosing instead to work as a bellhop at Pennsylvania Station and attend Columbia University in New York. At Columbia he became a member of Phi Alpha Phi, the prestigious black fraternity whose members included at various times ADAM CLAYTON POWELL JR. and PAUL ROBESON. He also worked on the student newspaper the *Spectator* and drew cartoons for the *Jester*, the students' humor magazine. Alston also frequented nightclubs like Pod's and Jerry's or Mike's, turning his artistic eye on the energy of the jazz clubbers. *Opportunity* used his portrait of the popular dancer Lenore Cox for its cover. After he completed his undergraduate studies at Columbia, Alston became director of

the boys' program at Utopian House, a community center that provided care for the children of working mothers, where one of his pupils was the young JACOB LAWRENCE.

In 1929 when he received a Dow Fellowship to pursue his graduate studies, Alston left Utopian House and its children's program to the management of George Gregory. After earning his MA at Columbia in 1930, he became director of the library school at the Carnegie Art Workshop located at the 135th Street branch of the New York Public Library, which is now the Schomburg Center for Research in Black Culture. There Alston worked with the program supervisor and sculptor AUGUSTA SAVAGE, as well as with the author GWENDOLYN BENNETT and the artist AARON DOUGLAS. When the school lost its Carnegie funding, the New Deal's Works Progress Administration (WPA) sponsored its new quarters in part of an old stable that Alston had found for his own studio at 306 West 141st Street. Known simply as "306," it became a center for creative minds, black and white. The success of that center led to the formation of the Harlem Artists Guild in 1935, after 306 closed.

In the mid-1930s not only did Alston become the first African American supervisor of the WPA Federal Art Project Commission but he also established his reputation as an artist. His 1934 *Girl in a Red Dress* demonstrated his engagement with the cutting edge of art. As the art historian Richard J. Powell noted, the woman is "defiantly black, beautiful and feminine, yet also unsettled, mysterious and utterly modern" (Powell, 19). The two murals that Alston executed in 1936—*Magic and Medicine* and *Modern Medicine*—were exhibited at the Museum of Modern Art before they were moved, after a controversy quelled only by community support, to their permanent location in Harlem Hospital. The controversy stemmed from white reaction to Alston's portrayal of African magic alongside modern medicine. As Nathan Irvin Huggins noted in *Harlem Renaissance*, the panel *Magic and Medicine*

depicted the artist's conception of African magic. It has strong elemental and natural emphasis: animals, lightening, and the sun share the scene with dancing and conjuring Africans. Alston employed these obvious symbols—dancing, drums, fetishes, etc—to embody the mural's message: modern medicine is better than primitive medicine. Nevertheless,

the African panel was more effective—more romantic and magical—than those that depicted modern doctors in white smocks.

(Huggins, 169)

Two Rosenwald Fellowships (1938–1939 and 1940–1941) enabled Alston to travel and work extensively in the southern United States, spending studio time at Atlanta University with HALE WOODRUFF. Alston's return to New York brought him back to commercial art as an illustrator for magazines such as *Mademoiselle*, *Fortune*, *Scribner's*, *Red Book*, and *Collier's*. The draft in World War II kept him stateside, and in 1942 Alston began working for the U.S. Office of War Information as an illustrator for a weekly series, "Negro Achievement," carried by 225 black newspapers. He married Myra Adala Logan in New York on 8 April 1944. He decided to pursue his prospering commercial art career and produced magazine covers and book jackets. While attending Pratt Institute under the GI Bill, Alston studied fine arts under the artist Charles Martin, who introduced Alston to the postimpressionist sculptor Alexander Kostellow, who introduced him to abstract expressionism. Alston continued his graduate studies at New York University.

In 1950 Alston became the first African American instructor to teach at New York's Art Students League. The 1950s brought Alston commissions for several murals: in Los Angeles, the Golden State Mutual Life Insurance Company, with Hale Woodruff; in New York, the Abraham Lincoln High School (Brooklyn) and the Museum of Natural History (Manhattan). He painted his abstract *Configuration* (1952) and the racially ambiguous couple of *Adam and Eve* (1954). During this period his work was exhibited in galleries throughout New York. Alston also taught at the Museum of Modern Art (1956–1957) and participated in the MOMA art educator Victor D'Amico's teaching project at the World's Fair in Brussels. Alston's painting *The Family* was purchased and presented to the Whitney Museum of American Art.

In the 1960s Alston continued to produce signature work on African American families: figurative, colorful, and heavily sculptural in form. But as Beryl Wright pointed out in *African-American Art: 20th-Century Masterworks*, the catalog produced for a 1994 exhibit at New York's Michael Rosenfeld Gallery, Alston's oeuvre encompassed much more: his work "ranges from caricatures of Harlem

nightclubbers, absorbing abstractions like *Untitled* (1952), paintings of protest and large public murals" (Wright, 63). Indeed, the turmoil of the early 1960s led Alston and other artists in 1963 to form the Spiral Group in New York, an attempt by African American artists to define their relationship to the civil rights struggles of students in the South. That group dissolved, but not before it produced the Spiral Black and White Exhibit on 5 June 1965 of work done only in black and white.

Alston's career continued to prosper throughout the 1960s and 1970s, from murals for several New York buildings to a bronze bust of Martin Luther King Jr. now in the permanent collection of the National Portrait Gallery of the Smithsonian. Alston was appointed full professor at the City College of New York in 1973, and in 1975 he received the first Distinguished Alumni Award from Columbia University. His final years were difficult: Alston's wife, Myra, battled cancer for several years, succumbing in January 1977. Three months later, on 27 April 1977, Alston himself died of the disease. His lifelong friend George Gregory eulogized Alston as a "man for all seasons: genteel and friendly, wise and with the power of perception—to see and feel things, people, his surroundings. Added to perspective and understanding, he lived his life by that Arista motto of character, service, and excellence" (Henderson, 26).

FURTHER READING
Henderson, Harry. "Remembering Charles Alston," in *Charles Alston: Artist and Teacher* (1990).
Huggins, Nathan Irvin. *Harlem Renaissance* (1973).
Michael Rosenfeld Gallery. *African-American Art: 20th-Century Masterworks*, essay by Beryl Wright (1993).
Powell, Richard J. "Re/Birth of a Nation," in *Rhapsodies in Black: Art of the Harlem Renaissance* (1997).

MARY ANNE BOELCSKEVY

ANDERSON, Charles Alfred "Chief"

(9 Feb. 1907–13 Apr. 1996), aviator and instructor of the Tuskegee Airmen, was born in Bryn Mawr, Pennsylvania, to Janie and Iverson Anderson, of whom little else is known. During his early childhood, he lived with his grandmother in Staunton, Virginia. There Anderson longed for an airplane so he could fly to see what was on the other side of the mountains that surrounded

Staunton and the Shenandoah Valley. He frequently left home in search of airplanes that were rumored to have crashed in the valley. His constant disappearances frustrated his grandmother, and she sent him back to his parents. Once back in Pennsylvania, however, he continued leaving home in search of airplanes.

At the age of thirteen Anderson applied to aviation school, but was denied admission because he was African American. In 1926, at the age of nineteen, he used his savings and borrowed money from friends and relatives to purchase a used Velie Monocoupe, one of the first airplanes manufactured for private pilots. He appealed to white flight instructors and flight schools to teach him to fly, but no program would accept an African American student, but, persevering, he eventually found a school that would teach him basic ground school subjects and elementary aircraft maintenance. Anderson learned about aviation at the airport by listening to the pilots talk and watching airplanes take off and land. He spent six weeks practicing in his airplane learning on his own until he developed the courage to take off. On one of his early flights, Anderson hit a tree but remained undaunted and was successful in teaching himself to fly. In August of 1929 he earned his private pilot's license, and in 1932 he earned his air transport license—becoming the first African American to do so.

Earning the coveted air transport license, however, was not the means to productive employment in aviation that Anderson had anticipated. No airline or aviation company would hire him. Instead of using his piloting skills, he had to take a series of menial jobs, including caretaker for a boarding school and ditch digger.

It was while Anderson was employed as a ditch digger that he met Dr. Albert E. Forsythe, a prominent African American doctor who practiced in Newark and Atlantic City, New Jersey, and a pilot in his own right. Forsythe approached Anderson with the idea of using their mutual expertise in aviation to showcase African American potential in the burgeoning field of aviation. In July 1933 Anderson and Forsythe flew from Atlantic City, New Jersey, to Los Angeles, California, and back, making them the first African Americans to complete a round trip, transcontinental flight across the United States. This flight was accomplished without the aid of landing lights, parachutes, air-to-ground radios, or other modern instrumentation. In fact the only instruments they had were a compass and an altimeter, and they navigated the route using a road map.

The aviation duo also flew to Montreal, Canada, making them the first African Americans to fly internationally. In 1934 they promoted their "Pan American Goodwill Tour" of the Caribbean and South America in Forsythe's Fairchild 24, "The Spirit of BOOKER T. WASHINGTON" which he had purchased earlier that year. They first flew from Miami to the Bahamas, making them the first pilots to land an airplane in Nassau, which had no airport. Later in the tour, the plane crashed in Trinidad. Even with the unfortunate end of the airplane, the tour received worldwide attention and upon their return to the United States, the pair was honored in Newark, New Jersey, with a parade with more than 15,000 onlookers. Anderson would later recreate this historic flight on his eighty-sixth birthday.

Anderson married his childhood sweetheart, Gertrude Elizabeth Nelson, in 1933. The couple would have two sons, Alfred and Charles.

In the late 1930s Anderson offered flight instruction to African American youth and adults in Pennsylvania, and in 1939 he initiated the Civilian Pilot Training Program at Howard University in Washington, D.C. In 1940 he became an instructor in the Civilian Pilot Training Program at Tuskegee Institute (later Tuskegee University) in Alabama. He was the first pilot to fly an airplane into Tuskegee.

On 19 April 1941 First Lady Eleanor Roosevelt, wife of President Franklin Delano Roosevelt, visited Tuskegee Institute to learn more about infantile paralysis on behalf of her husband, who suffered with the disease. A Tuskegee Institute physician told her about the aviation program, and she requested a tour. She was introduced to Anderson and asked if he would give her a ride in his airplane. Against the adamant advice of her Secret Service staff, Anderson gave Eleanor Roosevelt a successful, forty-minute ride in his two-seater airplane.

In 1941 the first class of aviation cadets arrived at Tuskegee Institute to begin flight training. "Chief" Anderson was the key flight instructor for the primary phase of flight training for the Tuskegee Airmen, who became the first African Americans to serve as pilots in the U.S. military. His students included General Benjamin O. Davis, General Daniel "Chappie" James, and the over 1,000 African American men who received flight instruction at Tuskegee Institute's Moton Field.

Anderson was a founding member of Tuskegee Airmen, Inc., an organization dedicated to remembering and honoring those first pilots, and Negro Airmen International. In 1988 he was awarded an honorary doctor of science degree from Tuskegee University. Known as the father of black aviation Charles Alfred "Chief" Anderson is noted for his persevering spirit in the field of aviation and his innumerable contributions to the legacy of the Tuskegee Airmen. Anderson died of cancer at his home in Tuskegee.

FURTHER READING
Cooper, Charlie. *Tuskegee Heroes* (1996).
Dryden, Charles. *A-Train: Memoirs of a Tuskegee Airman* (1997).

Obituary: New York Times, 17 Apr. 1996.

LISA M. BRATTON

ANDERSON, Eddie "Rochester"

(18 Sept. 1905–28 Feb. 1977), radio and movie actor, was born Edward Lincoln Anderson in Oakland, California. Anderson was from a show business family. His father, "Big Ed" Anderson, was a vaudevillian, and his mother, Ella Mae (maiden name unknown), was a circus tightrope walker. As a youngster Eddie sold newspapers on the streets of Oakland, a job that, according to his own account, injured his voice and gave it the rasping quality that was long his trademark on radio.

Between 1923 and 1933 Anderson's older brother Cornelius had a career in vaudeville as a song and dance man, and Eddie, who had little formal education, joined him occasionally. With vaudeville dying, however, Eddie drifted toward Hollywood. In the depths of the Depression, pickings were slim. His first movie appearance was in 1932 in *What Price Hollywood?* For a few years he had only bit parts, but then he secured a major role in the movie *Green Pastures* (1936), playing the part of Noah, an old southern preacher. *Green Pastures* was a movie adaptation of a Marc Connelly play from stories by Roark Bradford. A rather lavish version of a simple Negro interpretation of the Bible, with heaven a giant "fish fry," the movie was considered to be the first since *Hallelujah* (1929) to treat with sympathy issues of concern to blacks.

After his performance in *Green Pastures*, Anderson was continually employed in Hollywood and made a great many movies. Very often he played

minor roles, usually black stereotypes, but there were enough of them to provide a handsome living. For example, he had minor roles in *Show Boat* (1936) and *Gone with the Wind* (1939), in which he was so elaborately made up that few people recognized him. His talent for both comic and serious roles was readily apparent to the movie industry. In the year 1937 alone he appeared in six movies.

Anderson's rise to fame came through the role of Rochester on the *Jack Benny Show*. This radio program had been on the air since 1932 and Jack Benny had tried numerous comic personae—always purporting to be himself and not a fictional character—before settling on "the thirty-nine-year-old skinflint." Anderson joined the show in 1937. According to numerous scripts of later years, Benny "found" Rochester working as a Pullman porter and hired him as his personal valet. The truth was slightly different. Anderson was engaged for one show in which he played a train porter, and the sketch was so successful that five weeks later Benny decided to put in another porter scene featuring Rochester. These two shows worked so well that Benny decided to make Rochester a permanent part of his radio team. Rochester became his butler, valet, and general factotum.

By the early 1940s Anderson was earning more than $100,000 a year, making him the highest-paid African American in show business until Sidney Poitier began acting in the 1950s. A superb comic actor with exquisite timing, Anderson owed much of his success to his highly distinctive voice, often described as rasping or wheezing. Whatever the description, it was one of the classic voices of radio, instantly recognizable after two words—perhaps even after one syllable. Someone once suggested to Anderson that he have an operation to remove the "frog" in his throat, to which Anderson responded that if he had a frog in his throat he had no intention of having it operated on since it was a "gold-plated frog."

Because all the characters played themselves on the Benny show, many listeners came to believe that Rochester (as he was now called by everyone, even members of his own family) really was Benny's much-harried servant. Several listeners wrote in to complain about the low wages that Rochester was receiving and about the other intolerable burdens that he had to endure. Benny was forced to write back to many of these people and tell them that Rochester was really a well-paid actor named Eddie

Anderson. During these years Anderson and his family lived in a mansion with a ballroom and were waited on by servants of their own. (He had married Mamie Sophie Wiggins in 1932; they had three children.) Anderson collected custom-built sports cars and raised thoroughbred horses. One of these ran in the Kentucky Derby in 1945.

Benny was, in fact, sensitive to the problem of using a "stock colored butler character," and to its racial implications. In the early 1940s he made an effort to eliminate any of Rochester's traits or habits that might appear to be racial stereotypes. For example, he removed all references to Rochester's eating watermelon or drinking gin. The racial issue was seldom raised in these years, least of all by Eddie Anderson, probably in part because it was always Benny, and not Rochester, who was the butt of the jokes.

Anderson stayed with the Benny radio program until it ended in 1955. He also appeared on Benny's television show until it ended in 1965; but in Benny's later television specials he was not a regular. By this time, feelings were running high against black stereotypes. When asked in a 1970 television appearance to re-create his old role as butler, he said, "Massa Benny, we don' do dat no mo'" (Leslie Halliwell, *The Filmgoer's Companion* [4th ed., 1974], 22).

Throughout the radio years and beyond, Anderson continued his film appearances. In 1943 he had the lead in the successful movie version of the Harold Arlen and E. Y. Harburg stage musical *Cabin in the Sky*, which also featured ETHEL WATERS and LOUIS ARMSTRONG. Directed by Vincente Minnelli, this film was considered notable for its humanized version of black American life. Anderson continued to have movie roles in the 1960s and had a splendid part as a taxi driver in Stanley Kramer's visual farce *It's a Mad, Mad, Mad, Mad World* (1963). On television he had a role in *Bachelor Father* (1962) and *Love, American Style* (1969). He also did a cartoon voice for the Harlem Globetrotters' television program.

Anderson's first wife died in 1954; his second marriage was to Eva Simon, but it ended in divorce. He died in Los Angeles.

FURTHER READING

Bogle, Donald. *Blacks in American Films and Television* (1988).
Harmon, Jim. *The Great Radio Comedians* (1970).
Landy, Eileen. *Black Film Stars* (1973).
Watkins, Mel. *On the Real Side: Laughing, Lying, and Signifying* (1994).

Obituary: *New York Times*, 1 Mar. 1977.

GEORGE H. DOUGLAS

ANDERSON, Garland

(1886–31 May 1939), playwright and minister, was born in Wichita, Kansas. Little is known about his parents, although his mother is said to have been an active reformer and a poet. Anderson completed four years of school (the only formal education that he ever received) before his father moved the family to California to take a job as a janitor in the post office. The following year Anderson's mother died, and at age twelve he left home to become a newsboy, selling the *Telegraph Press* on the corner of Third and Market streets in San Francisco.

After working as a porter on the railroad, Anderson worked for the next fifteen years as a bellhop in various San Francisco hotels. During this period he also became a temporary convert to Christian Science. One afternoon in 1924 he saw a performance of Channing Pollack's moralistic drama *The Fool* and knew immediately that he had found the medium for his message to the world: He would write a play. He later said,

> At first the idea seemed absurd. . . . No one realized more than myself that though I wanted to write this play, I had no training in the technique of dramatic construction; but I also realized that to shirk what I wanted to do could be likened to the outer shell of the acorn after it was planted in the ground saying to the inner stir of life for expression, "What are you stirring for? Surely you don't expect to become a great oak tree?" With this firm conviction I determined to write a play.

In three weeks of writing, between phone calls summoning him at the hotel where he worked, he completed *Don't Judge by Appearances* (later shortened to *Appearances*), the story of a black bellhop falsely accused of rape by a white woman—a bold topic in 1924 for a black author. At the play's denouement, however, the woman is revealed to be a mulatto who has been passing as white; this denouement was the only possible one in a year in which riots had threatened the Provincetown Playhouse in New York City because the black actor

PAUL ROBESON had kissed onstage the hand of a white actress playing his wife in Eugene O'Neill's drama *All God's Chillun Got Wings*.

With the encouragement of the residents at the hotel where he worked, Anderson sent his play to the popular performer Al Jolson, who provided Anderson with the means to travel to New York City to seek his fortune. At a backers' audition at the Waldorf-Astoria Hotel, six hundred guests applauded the reading of the play by actor Richard B. Harrison, but they donated only $140 toward the production of *Appearances*.

Believing that "you can have what you want if you want it hard enough," Anderson wrote President Calvin Coolidge and persuaded Coolidge's secretary to grant him a meeting at the White House. Possibly as a result of the publicity surrounding that meeting, producer Lester W. Sagar took over Anderson's script in June 1925 and put the play into rehearsal with three African Americans in the cast of seventeen. Immediately, the white actress Nedda Harrigan resigned, refusing to perform on the same stage with a black actor (in previous Broadway shows, the black characters had been played by whites in blackface). Nevertheless, on 13 October 1925 at the Frolic Theater, *Appearances* opened. It was the first full-length play by a black playwright to be presented on the Broadway stage and the first Broadway play to incorporate both black and white cast members. Although it received tepid notices, the reviewers praised Anderson's entrepreneurial spirit. The drama ran for twenty-three performances, then toured major American cities until, on 1 April 1929, it returned to the Hudson Theatre in New York City to prepare for its opening at the Royale Theatre in London the following March.

In London the play became a *succès de curiosité*. Apparently Anderson's impeccable manners coupled with his unrelenting optimism attracted the British press, and he became somewhat of a celebrity. He was introduced to Queen Mary and was invited by the author John Galsworthy to speak at a meeting of PEN, the most prestigious literary club in London. Anderson also undertook a business venture, with the backing of a British industrialist, by establishing a chain of milk bars called Andy's Nu-Snack, thus introducing to Londoners cold malted milk. During his stay in England, Anderson met a white Englishwoman named Doris (maiden name unknown), whom he married in 1935 in Vancouver, Washington, one of the few states at that time to allow racially mixed marriages. She later published, under the name Doris Garland Anderson, her own account of the interracial marriage, the provocatively titled *Nigger Lover* (1938).

Although Anderson is said to have written two or three other plays, none was produced, and in his middle years he turned his energies to religion. In 1933 he published *Uncommon Sense: The Law of Life in Action*, a text extolling the virtues of religious faith. In 1935 he became a minister in the New Thought movement at the Seattle Center of Constructive Thinking. During the last five years of his life he toured the United States, Canada, and England, lecturing on the topic, "You Can Do What You Want to Do If You Believe You Can Do It." Following his free lecture he offered—in the optimistic tradition of Elbert Hubbard, and later Dale Carnegie—a series of eight lessons (for fifteen dollars) on how faith in self and God can lead to good fortune. In 1936 a newspaper in Regina, Canada, observed: "He is the first Negro since BOOKER T. WASHINGTON to tour the country speaking to white people only. Seldom, he admitted, does a Negro ever appear to hear him. 'They are not interested,' he said rather sadly." He died in New York City.

Anderson sold a second script entitled *Extortion* to David Belasco in 1929, but it was never produced. Nor was his first play ever produced again. According to JAMES WELDON JOHNSON, *Appearances* "may not be an altogether convincing argument for the theories it advances, but the author himself is." Nonetheless, Anderson left his stamp on the Broadway stage. Because no New York critic complained about black and white actors appearing together on stage, within four months of the opening of Anderson's most notable play, Belasco produced *Lulu Belle* (1926), with ninety-seven black actors and seventeen white actors. Hence the production of *Appearances* marked the beginning of an integrated Broadway stage.

FURTHER READING

Anderson, Garland. *From Newsboy and Bellhop to Playwright* (1929).
Abramson, Doris. *Negro Playwrights in the American Theatre, 1925–1959* (1969).
Hatch, James V., and Omanii Abdullah. *Black Playwrights, 1823–1977: An Annotated Bibliography of Plays* (1977).
Hatch, James V., and Ted Shine, eds. *Black Theatre USA* (1974).

Peterson, Bernard L., Jr. *Early Black American Playwrights and Dramatic Writers* (1990).

<div align="right">JAMES V. HATCH</div>

ANDERSON, Marian

(17 Feb. 1897–8 Apr. 1993), contralto, was born in Philadelphia, Pennsylvania, the daughter of John Berkeley Anderson, a refrigerator room employee at the Reading Terminal Market, an ice and coal dealer, and a barber, and Anne (also seen as "Annie" and "Anna," maiden name unknown), a former schoolteacher. John Anderson's various jobs provided only a meager income, and after his death, before Marian was a teenager, her mother's income as a laundress and laborer at Wanamaker's Department Store was even less. Still, as Anderson later recalled, neither she nor her two younger sisters thought of themselves as poor. When Marian was about eight, her father purchased a piano from his brother; she proceeded to teach herself how to play it and became good enough to accompany herself. Also as a youngster, having seen a violin in a pawnshop window, she became determined to purchase it and earned the requisite four dollars by scrubbing her neighbors' steps. When she attempted to teach herself this instrument as well, she discovered that she had little aptitude for it.

Anderson joined the children's choir of Union Baptist Church at age six. Noticing her beautiful voice and her ability to sing all the parts, the choir director selected her to sing a duet for Sunday school and later at the regular morning service; this was her first public appearance. Later she joined the senior choir and her high school chorus, where occasionally she was given a solo.

While she was still in high school, Anderson attempted to enroll at a local music school but was rejected with the curt statement, "We don't take Colored." She applied and was accepted to the Yale University School of Music, but a lack of finances prevented her from enrolling. Although she was not the product of a conservatory, Anderson was vocally prepared by Mary Saunders Patterson, Agnes Reifsnyder, Giuseppe Boghetti, and Frank La Forge. Over the years she was coached by Michael Raucheisen and Raimond von zur Mühlen, and she also worked briefly (in London) with Amanda Aldridge, daughter of the famous black Shakespearean actor Ira Aldridge. Boghetti, however, had the greatest pedagogical influence.

Anderson's accompanists (with whom she enjoyed excellent relationships) were the African Americans Marie Holland and William "Billy" King (who, for a period, doubled as her agent), the Finnish pianist Kosti Vehanen, and the German pianist Franz Rupp. Between 1932 and 1935 she was represented by the Arthur Judson Agency and from 1935 through the remainder of her professional life by the great impresario Sol Hurok.

One of the happiest days of Anderson's life was when she called Wanamaker's to notify her mother's supervisor that Anne Anderson would not be returning to work. On another very happy occasion, in the late 1920s, she was able to assist in purchasing a little house for her mother in Philadelphia. Her sister Alyce shared the house; her other sister, Ethel, lived next door with her son James Depreist, who became a distinguished conductor.

For many, including critics, an accurate description of Anderson's singing voice presented challenges. Because it was nontraditional, many simply resorted to the narrowly descriptive "Negroid sound." Others, however, tried to be more precise. Rosalyn Story, for example, has described Anderson's voice as "earthy darkness at the bottom . . . clarinet-like purity in the middle, and . . . piercing vibrancy at the top. Her range was expansive—from a full-bodied D in the bass clef to a brilliant high C" (Story, 38). Kosti Vehanen, recalling the first time he heard Anderson's "mysterious" voice, wrote, "It was as though the room had begun to vibrate, as though the sound came from under the earth. . . . The sound I heard swelled to majestic power, the flower opened its petals to full brilliance; and I was enthralled by one of nature's rare wonders" (Vehanen, 22). Reacting to his first encounter with Anderson's voice, Sol Hurok wrote, "Chills danced up my spine. . . . I was shaken to my very shoes" (Story, 47).

In 1921 Anderson, who was by then a well-known singer at church-related events, won the National Association of Negro Musicians competition. Believing that she was ready for greater public exposure, she made her Town Hall (New York City) debut in 1924. Disappointed by the poor attendance and by her own performance, she considered giving up her aspirations for a professional career. The following year, however, she bested three hundred other singers to win the National Music League competition, earning a solo appearance with the New York Philharmonic at Lewisohn Stadium.

In 1926, with financial assistance from the Julius Rosenwald Fund, Anderson departed for Europe for further musical study. After returning to the United States, she gave her first concert at New York City's Carnegie Hall in 1930. That same year she gave her first European concert, in Berlin, and toured Scandinavia. In 1931 alone she gave twenty-six concerts in fifteen states. Between 1933 and 1935 she toured Europe; one of her appearances was at the Mozarteum in Salzburg, where the renowned conductor Arturo Toscanini uttered the memorable line "Yours is a voice such as one hears once in a hundred years" (Anderson, 158). Another exciting experience took place in the home of the noted composer Jean Sibelius in Finland. After hearing Anderson sing, he uttered, "My roof is too low for you" and then canceled the previously ordered coffee and requested champagne. Sibelius also honored Anderson by dedicating his composition *Solitude* to her.

Anderson's second Town Hall concert, arranged by Hurok and performed on 30 December 1935, was a huge success. A one-month tour of the Soviet Union was planned for the following year but ended up lasting three months. Anderson was a box-office sensation as well in Europe, Africa, and South America. Her seventy U.S. concerts in 1938 still stand as the longest and most extensive tour for a singer in concert history. Between November 1939 and June 1940 she appeared in more than seventy cities, giving ninety-two concerts. Her native Philadelphia presented her with the Bok Award in 1941, accompanied by ten thousand dollars. She used the funds to establish the Marian Anderson Award, which sponsors "young talented men and women in pursuit of their musical and educational goals."

During 1943 Anderson made her eighth transcontinental tour and married the architect Orpheus H. Fisher of Wilmington, Delaware. The marriage was childless. In 1944 she appeared at the Hollywood Bowl, where she broke a ten-year attendance record. In 1946, six hundred editors in the United States and Canada, polled by *Musical America*, named Anderson radio's foremost woman singer for the sixth consecutive year. Anderson completed a South American tour in 1951 and made her television debut on the *Ed Sullivan Show* the following year. Her first tour of Japan was completed in 1953, the same year that she also toured the Caribbean, Central America, Israel, Morocco, Tunisia, France, and Spain.

Anderson sang the national anthem at the inauguration of President Dwight D. Eisenhower in 1957, and between 14 September and 2 December of that year she traveled thirty-nine thousand miles in Asia, performing twenty-four concerts under the auspices of the American National Theater and Academy and the U.S. State Department. Accompanying Anderson was the journalist Edward R. Murrow, who filmed the trip for his *See It Now* television series. The program, which aired on 30 December, was released by RCA Records under the title *The Lady from Philadelphia*. In 1958 Anderson served as a member of the U S. delegation to the General Assembly of the United Nations. Three years later she sang the national anthem at the inauguration of President John F. Kennedy, appeared in the new State Department auditorium, and gave another concert tour of Europe. Her first tour of Australia was a highlight of 1962.

In early 1964 Hurok announced Marian Anderson's Farewell Tour, beginning at Constitution Hall on 24 October 1964 and ending on Easter Sunday 1965 at Carnegie Hall. The momentousness of the event was reflected in Hurok's publicity: "In any century only a handful of extraordinary men and women are known to countless millions around the globe as great artists and great persons. . . . In our time there is Marian Anderson." After the tour she made several appearances as narrator of Aaron Copland's *Lincoln Portrait*, often with her nephew James DePreist at the podium.

Although in her own lifetime Anderson was described as one of the world's greatest living contraltos, her career nonetheless was hindered by the limitations placed on it because of racial prejudice. Two events, in particular, that illustrate the pervasiveness of white exclusiveness and African American exclusion—even when it came to someone of Anderson's renown—serve as historical markers not only of her vocal contributions but also of the magnificence of her bearing, which in both instances turned two potential negatives into resounding positives.

In 1938, following Anderson's numerous international and national successes, Hurok believed that it was time for her to appear in the nation's capital at a major hall. She previously had appeared in Washington, D.C., at churches, schools, and civic organization meetings and at Howard University, but she had not performed at the district's premier auditorium, Constitution Hall. At that time, when negotiations began for a Marian Anderson concert to be given in 1939 at the hall owned by

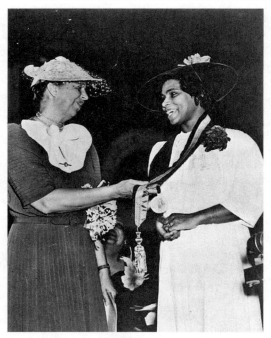

Marian Anderson with Eleanor Roosevelt. In a famous episode in 1939, the Daughters of the American Revolution denied Anderson permission to sing in Constitution Hall in Washington, D.C.—whereupon Mrs. Roosevelt arranged for Anderson to perform at the Lincoln Memorial. (National Archives/Joe McCary, Photo Response Studio)

the Daughters of the American Revolution, a clause appeared in all contracts that restricted the hall to "a concert by white artists only, and for no other purpose." Thus, in February 1939 the American who had represented her country with honor across the globe was denied the right to sing at Constitution Hall simply because she was not white.

A great furor ensued, and thanks to the efforts of First Lady Eleanor Roosevelt and Secretary of the Interior Harold Ickes, the great contralto appeared the following Easter Sunday (9 April 1939) on the steps of the Lincoln Memorial before an appreciative audience of seventy-five thousand. She began the concert by singing "America" and then proceeded to sing an Italian aria, Franz Schubert's "Ave Maria," and three Negro spirituals—"Gospel Train," "Trampin'," and "My Soul Is Anchored in the Lord." Notably, she also sang "Nobody Knows the Trouble I've Seen." Commemorating the 1939 Lincoln Memorial concert is a mural at the Interior Department; it was formally presented in 1943, the year

that Anderson made her first appearance in Constitution Hall, by invitation of the Daughters of the American Revolution and benefiting United China Relief.

The second history-making event came on 7 January 1955, when Anderson made her debut at the Metropolitan Opera House in New York, becoming the first black American to appear there. Opera had always interested Anderson, who tells the story in her autobiography of a visit with the noted African American baritone Harry Burleigh, during which she was introduced to and sang for an Italian gentleman. When she climbed the scale to high C, the man said to Burleigh, "Why sure she can do Aida," a traditionally black role. On her first trip to England, Anderson had visited a teacher who suggested that Anderson study with her, guaranteeing that she would have her singing Aida within six months. "But I was not interested in singing Aida," Anderson wrote. "I knew perfectly well that I was a contralto, not a soprano. Why Aida?"

The international press announced Anderson's pending debut at the Met in October 1954. As the educator and composer Wallace Cheatham later noted, the occasion called for the most excellent pioneer, "an artist with impeccable international credentials, someone highly respected and admired by all segments of the music community" (Cheatham, 6). At the time there was only one such person, Marian Anderson. About Anderson's debut, as Ulrica in Giuseppe Verdi's *Un Ballo in Maschera*, *Time* magazine (17 Jan. 1955) reported that there were eight curtain calls. "She acted with the dignity and reserve that she has always presented to the public. . . . Her unique voice—black velvet that can be at once soft and dramatic, menacing and mourning—stirring the heart as always."

Anderson was a recipient of the Spingarn Medal (from the NAACP), the Handel Medallion (from New York City), the Page One Award (from the Philadelphia Newspaper Guild), and the Brotherhood Award (from the National Conference of Christians and Jews). She was awarded twenty-four honorary doctorates and was cited by the governments of France, Finland, Japan, Liberia, Haiti, Sweden, and the Philippines. She was a member of the National Council on the Arts and a recipient of the National Medal of Arts; in 1978 she was among the first five performers to receive the Kennedy Center Honors for lifetime achievement.

Several tributes were held in the last years of Anderson's life. In February 1977 the musical world turned out to recognize Anderson's seventy-fifth (actually her eightieth) birthday at Carnegie Hall. On 13 August 1989 a gala celebration concert took place in Danbury, Connecticut, to benefit the Marian Anderson Award. The concert featured the recitalist and Metropolitan Opera star Jessye Norman, the violinist Isaac Stern, and the maestro Julius Rudel, conducting the Ives Symphony Orchestra. Because Anderson's residence, Marianna, was just two miles from the Charles Ives Center, where the concert was held, the ninety-two-year-old grand "lady from Philadelphia" was in attendance. The Public Broadcasting Service (PBS) television station affiliate WETA prepared a one-hour documentary, *Marian Anderson*, which aired nationally on PBS on 8 May 1991. Anderson died two years later in Portland, Oregon, where she had moved to live with her nephew, her only living relative.

Many actions were taken posthumously to keep Anderson's memory alive and to memorialize her many accomplishments. The 750-seat theater in the Aaron Davis Arts Complex at City College of New York was named in her honor on 3 February 1994. The University of Pennsylvania, as the recipient of her papers and memorabilia, created the Marian Anderson Music Study Center at the Van Pelt–Dietrich Library. Of course, her greatest legacy is the singers who followed her. As the concert and opera soprano Leontyne Price, one of the many beneficiaries of Anderson's efforts, said after her death, "Her example of professionalism, uncompromising standards, overcoming obstacles, persistence, resiliency and undaunted spirit inspired me to believe that I could achieve goals that otherwise would have been unthought of" (*New York Times*, 9 Apr. 1993).

FURTHER READING

Anderson's papers and memorabilia are housed at the Van Pelt–Dietrich Library at the University of Pennsylvania.

Anderson, Marian. *My Lord, What a Morning* (1956).

Bogle, Donald. *Brown Sugar: Eighty Years of America's Black Female Superstars* (1980).

Cheatham, Wallace. "Black Male Singers at the Metropolitan Opera," *Black Perspective in Music* 16, no. 1 (Spring 1988): 3–19.

Sims, Janet. *Marian Anderson: An Annotated Bibliography and Discography* (1981).

Southern, Eileen, ed. *Biographical Dictionary of Afro-American and African Musicians* (1982).

Southern, Eileen, ed. *The Music of Black Americans: A History*. 2d ed. (1983).

Story, Rosalyn. *And So I Sing* (1990).

Vehanen, Kosti. *Marian Anderson: A Portrait* (1941; repr. 1970).

Obituaries: New York Times and *Washington Post*, 9 Apr. 1993.

ANTOINETTE HANDY

ANDERSON, Regina

(21 May 1901–5 Feb. 1993), librarian, Harlem Renaissance cultural worker, and playwright, was born Regina Anderson in Chicago, the daughter of Margaret (Simons) Anderson, an artist, and William Grant Anderson, a prominent criminal attorney. She was reared in a black Victorian household in Chicago's Hyde Park district, amply provided for by a father who counted W. E. B. DU BOIS, Theodore Roosevelt, and Adlai Stevenson among his friends and clients. Regina attended normal school and high school in Hyde Park, studying later at Wilberforce University and the University of Chicago, and eventually receiving a degree in Library Science from Columbia University's School of Library Science.

The Chicago of her youth and early adulthood struck her as provincial, yet it was flavored by migrants from the deep South and enlivened by the voice of IDA B. WELLS, whose writings on lynching gave Anderson an understanding of the link between race and violence, a subject of one of her Harlem Renaissance plays, *Climbing Jacobs Ladder* (1931). While the young woman scorned her parents' adherence to the genteel tradition, she inherited from their household a firm sense of self and a *savoir-vivre* that enabled her to move through different levels of society with ease and confidence. Following her parents' divorce, Anderson lived for a short time with her grandmother, then moved to New York in 1923, joining other "new women" and "new Negro women," who, empowered by their new voting rights, flocked to New York in search of personal emancipation. Anderson first settled in downtown Manhattan, living at a YWCA, and applied for a library position in the vast New York Public Library system. At the time without a degree,

but with some experience working in libraries in Chicago, Anderson was placed in Harlem, at the 135th Street branch as assistant to the enlightened Ernestine Rose, a white woman who would make the branch an intellectual center for Renaissance Harlem.

Realizing that she herself was a victim of an educational system that had disregarded black contributions to America, and having never taken even a single course in black history, Anderson began to study African American history and culture in order to accommodate the interests of the library's black patrons. She perfectly understood the historical significance of her appointment and with inexhaustible energy set about building the collection of books, organizing groups for literary discussions featuring the younger generation of writers and artists, and the likes of LANGSTON HUGHES and COUNTEE CULLEN, who were hosted by an impressive volunteer corps that included ETHEL RAY NANCE, Regina's roommate. Nance later recalled her roommate's late-night reading activity, which produced notes on new and promising books, and her roommate's vigilant lookout for new and promising authors to bring to the library. Within a year of her residency in Harlem, she was instrumental in convincing CHARLES S. JOHNSON to organize the now-famous March 1924 Civic Club dinner which launched the Harlem Renaissance, a turning point in African American history and culture. If, as Nathan Huggins suggested, Anderson had taken on the mission of getting to know herself through her race, it can also be said that she shared ARTHUR SCHOMBURG's mission of educating African Americans about themselves.

Recognizing the value of drama as a pedagogical tool, Anderson opened the basement of the library in 1924 for community theater, joining Du Bois in establishing the Crigwa (later Krigwa) Players, which would employ the theater as an extension of the aims of the *Crisis* Magazine. The Crigwa Players offered more serious fare than that provided by Harlem's Lafayette Theatre and, influenced by Thomas Montgomery Gregory's Howard University Players and the revolutionary design of new Irish drama, it created additional outlets for writers and performers and attracted a loyal Harlem audience. With the demise of Krigwa, in 1928 Anderson herself spearheaded the founding of the Harlem Experimental Theatre, which opened the way for the founding of the American Negro

Theatre (ANT). Relocated to St. Philip's Episcopal Church Parish House, the ANT established a tradition of theater-going that continued even into the early twenty-first century in the form of the community-based H.A.D.L.E.Y players, led by the octogenarian Gertrude Jeannette, a former member of the now-defunct American Negro Theatre, which also included Sydney Poitier and Harry Belafonte as members. Working full time at the library, raising funds, and helping run the Harlem Experimental Theatre, under her pen name Ursula Trelling, Anderson composed a number of plays which saw production by the company, beginning with *Climbing Jacob's Ladder* in 1931.

The apartment that Anderson shared with Ethel Ray Nance and Luella Tucker at 580 St. Nicholas Avenue became an important salon, its significance captured in its alternate name, "Dream Haven." Firm believers in the importance of dialogue, the residents of Dream Haven brought together members of the younger generation, JEAN TOOMER, ERIC WALROND, AARON DOUGLAS, ZORA NEALE HURSTON and the older custodians of culture, CHARLES S. JOHNSON, ALAIN LOCKE, and W. E. B. Du Bois. Located in a newly integrated building, 580, where ETHEL WATERS also lived, faced the beautiful St. Nicholas Park and its roof, affording a splendid view of Harlem, the Mecca of the black world that all had come to love so much. "Dream Haven" embodied the wonderful friendship between Anderson and Nance that was to last many years after 1926, when Nance left New York and Anderson married William T. Andrews, an attorney and New York state assemblyman. They would have one daughter, Regina Ann.

A letter from W. E. B. Du Bois proved instrumental in helping Anderson secure a permanent position in the library after graduating from library school. Career advancement propelled the move from the 135th Street to downtown branches until 1936, when she began work at the Columbia branch, located on 115th Street near the university. In 1947 Anderson became supervisor of the Washington Heights branch and instituted discussion groups and a "Family Night" program that brought international and national notables to the neighborhood's mostly East European immigrant population. As responsive to the Washington Heights neighborhood as she had been to her Harlem clientele, Anderson established English as a second language

classes in order to help immigrants make the transition to American life.

A cosmopolitan who enjoyed travel Anderson visited many countries in Europe, Asia, and Africa on behalf of women and human rights, while serving as vice president of the National Council of Women and the Urban League's representative to the United Nations Educational, Scientific, and Cultural Organization (UNESCO). In 1967 Anderson retired to her country home in Mahopac, New York, an area she and her family integrated, bringing large numbers of guests of color who received a warm welcome in the area. From their penthouse apartment atop 409 Edgecombe Avenue, home base over the years to WALTER WHITE, W. E. B. Du Bois, Thurgood Marshall, and Aaron Douglas, she and Andrews remained important figures in Harlem's social and political life. With long memory, she was mindful of the radical thrust of her own aims for black theater and welcomed the revolutionary Black Arts Movement of the 1960s and 1970s. She was a consultant to New York Metropolitan Museum's controversial 1968 retrospective exhibition, *Harlem on My Mind*, a project that brought back vivid memories of "Dream Haven" and the Harlem of her earlier days The rediscovery of the Harlem Renaissance in the 1970s provided additional opportunities for Anderson to share her own memories of the period. She was a source for Nathan Huggins's important study, *Harlem Renaissance* (1971), which initiated the modern reappraisal of the period.

In 1971 Anderson and her former Dream Haven mate, Ethel Ray Nance, completed a manuscript, *A Chronology of African-Americans in New York, 1621–1966*, a reflection of the "power of pride" in heritage that had energized 580 St. Nicholas Ave. Unpublished at the time of her death in 1993 the manuscript was foundational to the millennium exhibition and book, *The Black New Yorkers: The Schomburg Illustrated Chronology*, produced by the New York Public Library's Schomburg Center for Research in Black Culture, the successor to the 135th Street branch which Regina Anderson had nurtured.

FURTHER READING
The Schomburg Center in New York has a
 five-videocassette interview with Anderson
 conducted by Jean Blackwell Hutson in 1986 and a
 large photo collection covering the subject's

personal, professional, and civic activities. It also holds committee reports she compiled for the Human Relations Committee of the National Council of Women of the United States.

Huggins, Nathan. *Harlem Renaissance* (1971).
Hull, Gloria. *Color, Sex, and Poetry: Three Women Writers of the Harlem Renaissance* (1987).
Levering Lewis, David. *When Harlem was in Vogue* (1979).
Marks, Carol, and Diana Edkins. *The Power of Pride* (1999).
Roses, Lorraine Elena, and Ruth Elizabeth Randolph. *Harlem's Glory: Black Women Writing, 1900–1950* (1997).

ONITA ESTES-HICKS

ARMSTRONG, Lil

(3 Feb. 1898–27 Aug. 1971), jazz pianist, composer, and singer, was born Lillian Hardin in Memphis, Tennessee, the daughter of Dempsey Hardin, a strict, churchgoing woman who disapproved of blues music. Nothing is known of her father. At age six Lil began playing organ at home, and at eight she started studying piano. In 1914 she enrolled in the music school of Fisk University in Nashville, taking academic courses and studying piano and music theory. After earning her diploma, around 1917 she joined her mother in Chicago, where she found work demonstrating songs in Jones' Music Store. Prompted by her employer, in 1918 Hardin became house pianist for the clarinetist Lawrence Duhé's band at Bill Bottoms's Dreamland Ballroom, where she played with the cornetists "Sugar Johnny" Smith, Freddie Keppard, and KING OLIVER; the trombonist Roy Palmer; and other New Orleans musicians. Because she was still a minor, her mother picked her up every night after work.

In January 1920 Hardin joined a second Oliver-led band, and in May 1921 she went to San Francisco with Oliver's Creole Jazz Band for a six-month job at the Pergola Dance Pavilion. Hardin then went back to Chicago and a job at the Dreamland, resuming her former position with Oliver in the summer of 1922. In late August, LOUIS ARMSTRONG joined Oliver's group as second cornetist. Shortly thereafter Armstrong and Hardin began courting. However, while working at the Dreamland, she had married a singer named Jimmie Johnson, whose infidelities soon proved grounds for divorce. Eager to help free

Armstrong from his own ill-advised first marriage, Hardin arranged divorces for both of them in 1923, and they were married in February 1924. They had no children. In 1923 King Oliver's Creole Jazz Band recorded thirty-seven performances, on which the pianist was limited to a strictly subordinate role in the rhythm section.

Even before they were married, Lil had begun trying to make Louis more sophisticated in his manners and dress, as well as urging him to leave Oliver. Louis, however, remained adamantly loyal to Oliver until mid-1924, when the band broke up following a long midwestern tour. Months of Lil's prodding had taken their toll, and, finally convinced that he should seek better avenues to showcase his own talent and reap its reward, Louis gave Oliver notice. In September he was offered a featured position in FLETCHER HENDERSON's orchestra at the Roseland Ballroom in New York. In October, Lil followed her husband east but soon returned to Chicago to lead her own band at the Dreamland. During this period, Louis Armstrong's reputation grew far beyond what it had been in Chicago, but by early November 1925 he was ready to leave New York, primarily because Lil wanted him to come home. By this time she was enjoying a successful run with her Dreamland Syncopators and encouraged the owners to pay a higher salary than usual to bring in Louis as a featured attraction.

Between November 1925 and December 1927 Lil Armstrong appeared on all of the Louis Armstrong Hot Five and Hot Seven recordings, forty-four titles in all. She also led one Hot Five date under her own name (as Lil's Hot Shots) in May 1926 and participated, along with Louis, on sessions with Butterbeans (JODIE EDWARDS) and Susie, ALBERTA HUNTER, and the Red Onion Jazz Babies. In July 1926 she also recorded with the New Orleans Bootblacks and the New Orleans Wanderers. In early 1929 she recorded with Johnny Dodds in both trio and sextet settings.

Although her command of the piano was marred by limited technique, swift, unswinging time, and a paucity of melodic ideas, Lil Armstrong was nevertheless a highly productive composer of jazz songs. It is difficult to ascertain exactly which songs she wrote independently of Louis Armstrong, but it can be assumed that she played an important role in transcribing and arranging certain melodic themes that he invented. Among the Hot Five and Hot Seven numbers for which she is given full or partial

credit are "I'm Gonna Gitcha," "Droppin' Shucks," "King of the Zulus," "Jazz Lips," "Struttin' with Some Barbecue," "Hotter than That," and "Knee Drops." She also contributed "Gate Mouth," "Too Tight Blues," "I Can't Say," "Perdido Street Blues," "Papa Dip," and "Mixed Salad" to the 1926 Bootblacks and Wanderers sessions as well as "Pencil Papa," "Heah Me Talkin'," and "Goober Dance" to Dodds's 1929 dates. However, it must be said that her own contributions on piano, whether as soloist or accompanist, are invariably the least interesting elements of these recordings.

During the late 1920s Lil bought an eleven-room home in Chicago and real estate on Lake Michigan's Idlewild resort, properties she retained throughout her life. When Lil's job at the Dreamland ended in the spring of 1926, Louis joined Carroll Dickerson's orchestra at the Sunset Café while Lil worked in Hugh Swift's band and later toured with Freddie Keppard. During this time Lil also studied at the Chicago Musical College, and, after earning a degree in teaching, she studied at the New York College of Music, where she received her postgraduate degree in 1929.

Louis, who had started philandering while he was in New York, was beginning to tire of Lil's constant jealousy and pressure for him to better himself commercially. He began a serious relationship with another woman, Alpha Smith, around 1928. After numerous arguments with her husband, who had at last become successful, Lil finally sued for legal separation in August 1931, retaining her properties and receiving a considerable cash allowance. She eventually granted him a divorce and also won a suit against him for the rights to the songs they had co-composed. Lil never remarried, and she kept all relevant Louis Armstrong memorabilia, including letters, photos, and his old cornet, until her death.

Through the mid-1930s Lil Armstrong led both all-female and all-male bands of varying sizes in the Midwest, sometimes under the billing of Mrs. Louis Armstrong and Her Orchestra. She also broadcast regularly and appeared as a soloist in the *Hot Chocolates* and *Shuffle Along* revues. From 1936 Lil Armstrong lived in New York and worked as a house pianist for Decca Records, between 1936 and 1940 leading small jazz groups with such featured sidemen as Joe Thomas, J. C. Higginbotham, Buster Bailey, and Chu Berry. She also provided the accompaniments for the singers Blue Lu Barker,

Rosetta Howard, Alberta Hunter, Frankie "Half Pint" Jaxon, Peetie Wheatstraw, and others and participated in jazz dates under the leadership of Red Allen, Johnny Dodds, and Zutty Singleton. She emerges as a vivacious and entertaining singer on her own Decca recordings of 1936–1940. Among her compositions from this period are "My Hi-De-Ho Man," "Brown Gal," "Just for a Thrill," "Born to Swing," "Let's Get Happy Together," and "Everything's Wrong, Ain't Nothing Right." In late 1940 Armstrong returned to Chicago, where she worked throughout the next decade as a soloist in many local venues.

In early 1952 Armstrong went to Paris, where she recorded in a trio with SIDNEY BECHET and Zutty Singleton and also under her own name in 1953 and 1954. She worked primarily as a soloist in Paris but also spent some time in London before returning in the late 1950s to Chicago. In December 1960 she recorded with Franz Jackson's band and in September 1961 led her own group for an album in the Riverside label's *Chicago: The Living Legends* series. In late October 1961 she participated in the telecast of *Chicago and All That Jazz*, an all-star jazz concert segment of NBC's *Dupont Show of the Week*. Little is known of Armstrong's activities after this point, but she probably continued appearing in clubs in Chicago and environs. Following Louis Armstrong's death in July 1971, a memorial concert was staged in his honor on 27 August at Chicago's Civic Center, and it was during her performance at this event that Lil Armstrong suffered a fatal coronary.

FURTHER READING

In 1960 or 1961 an oral interview with Lil Armstrong titled *Satchmo and Me* was released as Riverside RLP12–120.

Dahl, Linda. *Stormy Weather* (1984).

Giddins, Gary. *Satchmo* (1988).

Jones, Max, and John Chilton. *Louis: The Louis Armstrong Story 1900–1971* (1971; rev. ed., 1988).

Placksin, Sally. *American Women in Jazz* (1982).

Unterbrink, Mary. *Jazz Women at the Keyboard* (1983).

Obituary: New York Times, 28 Aug. 1971.

DISCOGRAPHY

Bruyninckx, Walter. *Swing Discography, 1920–1988* (12 vols., 1985–1989).

Rust, Brian. *Jazz Records, 1897–1942* (1982).

JACK SOHMER

ARMSTRONG, Louis

(4 Aug. 1901–6 Jul. 1971), jazz trumpeter and singer, known universally as "Satchmo" and later as "Pops," was born in New Orleans, Louisiana, the son of William Armstrong, a boiler stoker in a turpentine plant, and Mary Est "Mayann" Albert, a laundress. Abandoned by his father shortly after birth, Armstrong was raised by his paternal grandmother, Josephine, until he was returned to his mother's care at age five. Mother and son moved from Jane Alley, in a violence-torn slum, to an only slightly better area, Franklyn and Perdido streets, where nearby cheap cabarets gave the boy his first introduction to the new kind of music, jazz, that was developing in New Orleans. Although Armstrong claims to have heard the early jazz cornetist Buddy Bolden when he was about age five, this incident may be apocryphal. As a child, he worked odd jobs, sang in a vocal quartet, and around 1911 bought a used cornet with his savings. He dropped out of school and got into trouble; in 1913 he was placed in the New Orleans Colored Waifs' Home for Boys, where Peter Davis, the music instructor, gave Armstrong his first formal music instruction. He left the home in June 1914. Although he was remanded to the custody of his father, he soon went to live with his mother and younger sister, Beatrice, whom Armstrong affectionately called "Mama Lucy."

As a teenager, Armstrong played street parades, associated with the older musicians, and held various jobs, including delivering coal with a mule-drawn coal wagon. In his second autobiography, *My Life in New Orleans*, he relates the importance of these years in his development, particularly the influence of KING OLIVER:

> At that time I did not know the other great musicians such as JELLY ROLL MORTON, Freddy Keppard, . . . and Eddy Atkins. All of them had left New Orleans long before the red-light district was closed by the Navy and the law [1917]. Of course I met most of them in later years, but Papa Joe Oliver, God bless him, was my man. I often did errands for Stella Oliver, his wife, and Joe would give me lessons for my pay. I could not have asked for anything I wanted more. It was my ambition to play as he did. I still think that if it had not been for Joe Oliver jazz would not be what it is today.

(99)

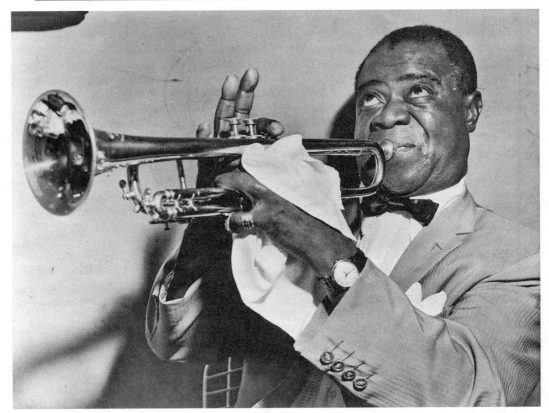

Louis Armstrong, 1953, one of the earliest jazz trumpet virtuosos, who also revolutionized singing styles, late in his career. (Library of Congress.)

In 1918 Armstrong married Daisy Parker and began his life as a professional musician. Between November 1918 and August 1922 he played cornet at Tom Anderson's club as well as in the Tuxedo Brass Band, in Fate Marable's band on Mississippi River excursion paddle-wheel steamers, and incidentally in several New Orleans cabarets. His musical associates during these years were Oliver, Warren "Baby" Dodds, Johnny Dodds, Johnny St. Cyr, Honore Dutrey, George "Pops" Foster, and EDWARD "KID" ORY.

Armstrong's rise to prominence began with his move to Chicago in August 1922, when Oliver invited him to come to the Lincoln Garden's Cafe as second cornet in Oliver's Creole Jazz Band. This group defined jazz for the local Chicago musicians and stimulated the development of this music in profound ways. Armstrong's first recordings were made with Oliver in 1923 and 1924; "Riverside

Blues," "Snake Rag," "Mabel's Dream," "Chattanooga Stomp," and "Dipper Mouth Blues" are some of the performances that preserve and display his early mature work.

In 1924 Armstrong divorced his first wife and that same year married the pianist in Oliver's band, Lillian Hardin (LIL ARMSTRONG). She encouraged him to accept an invitation to play with the FLETCHER HENDERSON orchestra at the Roseland Ballroom in New York City. Armstrong's impact on this prominent name band was phenomenal. His solo style brought to the East a tonal power, creative virtuosity, and rhythmic drive that had not been a regular aspect of the Henderson band's performance practice. Armstrong's influence on Henderson, himself an arranger and pianist, and two of his fellow band members, in particular, the arranger and saxophonist DON REDMAN and the saxophone virtuoso COLEMAN HAWKINS, was partially responsible for

the development of a new jazz idiom or style—swing. During his fourteen months with Henderson, Armstrong participated in more than twenty recording sessions and left memorable solos on "One of These Days," "Copenhagen," and "Everybody Loves My Baby," on which he cut his first, brief, vocal chorus. While in New York, Armstrong also recorded with CLARENCE WILLIAMS's Blue Five, a small combo that included the already famous saxophonist SIDNEY BECHET, and with the star blues singers MA RAINEY and BESSIE SMITH. With Henderson, Armstrong played trumpet, but in these small-group sessions he returned to cornet. For another two years he continued to use both instruments but finally retired his cornet for the brighter, more-focused sound of the trumpet.

Despite his growing stature among the jazz community, Armstrong was still but a sideman when he returned to Chicago in 1925. He immediately became the star of his wife's band at the Dreamland Cafe and soon joined Erskine Tate's orchestra at the Vendome Theater. In November 1925 he made his first recordings as a leader with a pickup group of old associates he called the "Hot Five"—his wife, Lil, on piano; Kid Ory on trombone; Johnny Dodds on clarinet; and St. Cyr on banjo. These recordings of the Hot Five and the Hot Seven (with the addition of bass and drums) are towering monuments of traditional jazz. "Cornet Chop," "Gut Bucket Blues," "Heebie Jeebies," "Skid-Dat-De-Dat," "Big Butter and Egg Man," "Struttin' with Some Barbecue," "Hotter Than That," and several others are numbered among the classics of this style, have entered the standard repertoire, and continue to be studied and performed regularly. In these recordings Armstrong established his eminence as a cornet and trumpet virtuoso and an unparalleled improviser, composer, and jazz vocalist. Melrose Brothers published notated transcriptions of some of his solos in 1927 immediately after the appearance of these recordings; these may be the first transcriptions from recorded performances ever published. The significance of this series of recordings is summarized by Gunther Schuller in his study *Early Jazz*:

The smooth rhythms of the earlier improvisations give way to stronger, contrasting, harder swinging rhythms. Double-time breaks abound. Melodic line and rhythm combine to produce more striking

contours. This was, of course, the result not only of Armstrong's increasing technical skill, but also of his maturing musicality, which saw the jazz solo in terms not of a pop-tune more or less embellished, but of a chord progression generating a maximum of creative originality. . . . His later solos all but ignored the original tune and started with only the chord changes given.

(Schuller, 102–103)

Armstrong's association with Earl "Fatha" Hines in 1927 led to another series of pathbreaking recordings in 1928, most notably "West End Blues," with a reconstituted Hot Five, and "Weather Bird," a trumpet and piano duet. In "West End Blues," Armstrong not only achieves an unprecedented level of virtuosity but also displays the beginnings of motivic development in jazz solos. In "Weather Bird," Hines and Armstrong partake in a rapid exchange of antecedent-consequent improvised phrases that set a pattern for future jazz improvisers who "trade fours and twos."

In 1929 Armstrong moved with his band from Chicago to New York for an engagement at Connie's Inn in Harlem. The floor show used a score by FATS WALLER that became a Broadway success as *Hot Chocolates* and featured an onstage Armstrong trumpet solo on "Ain't Misbehavin'." He also pursued many other endeavors, going into the recording studio to front his own band with Jack Teagarden and playing and singing in Luis Russell's group, which also featured the Chicago banjoist and guitar player Eddie Condon. Armstrong's singing style was unique in American popular music, especially when it was first presented to listeners on a broad scale through recordings of the 1920s.

One of his first vocal accomplishments was to introduce an improvisatory vocal-instrumental mode of singing called "scat singing" in his recordings of "Heebie Jeebies" and "Gully Low Blues" of 1926 and 1927, respectively. Although this method of singing nonsense syllables was common in New Orleans and had been used by others, it was Armstrong's recordings that were credited with the invention of this new device and that influenced hosts of later jazz singers. Contrasting with the classically oriented popular-song vocalists of the day, with the shouting-and-dancing stage singers of ragtime and minstrelsy, and with the loud and lusty belters of the classic blues, Armstrong's natural

technique brought a relaxed but exuberant jazz style and a gravelly personal tone to popular singing. His 1929 recordings of "I Can't Give You Anything but Love" and "Ain't Misbehavin'" achieved great popular success. Armstrong continued to sing throughout his career and reached a pinnacle of popular success in 1964 when his recording of "Hello Dolly" became the best-selling record in America, moving to number one on the popular music charts.

From 1930 to the mid-1940s Armstrong was usually featured with a big band. In 1935 he joined forces with Joe Glaser, a tough-minded businessman who guided his career until 1969. Armstrong divorced Lil Hardin, marrying Alpha Smith in 1938. He later divorced her and was married a fourth and final time in 1942 to Lucille Wilson. He had no children with any of his wives. After World War II, Armstrong returned to performing with a small ensemble and played a concert in New York's Town Hall, with "Peanuts" Hucko (clarinet), Bobby Hackett (trumpet), Jack Teagarden (trombone), Dick Cary (piano), Bob Haggart (bass), and Big Sid Catlett (drums), that inaugurated a new phase in his career. After the success of this "formal concert," Armstrong began to tour with a band labeled his "All Stars," ensembles of approximately the same size but with varying personnel selected from the ranks of established, well-known jazz musicians. Through Glaser's efforts, Armstrong and his All Stars became the highest-paid jazz band in the world. They toured successfully, sparking a renewed interest in Armstrong's recordings and earning him a place on the cover of *Time* magazine on 21 February 1949.

Throughout his long career Armstrong, as trumpeter, remained the leading figure among classic jazz musicians and rode many waves of public and financial success, but his historical impact as a jazz instrumentalist lessened as new styles developed and younger musicians looked elsewhere for leadership. Still, his solo trumpet playing remained superlative while other phases of his career, such as singing, acting, writing, and enjoying the fruits of his celebrity, gained prominence as time passed. Between 1932 and 1965 he appeared in almost fifty motion pictures, including *Rhapsody in Black and Blue* (1932), *Pennies from Heaven* (1936), *Every Day's a Holiday* (1937), *Doctor Rhythm* (1938), *Jam Session* (1944), *New Orleans* (1946), *The Strip* (1951), *High Society* (1956), *Satchmo the Great* (1957), *The Beat Generation* (1959), *When the Boys Meet the Girls* (1965), and *Hello, Dolly!* (1969). Beginning with

broadcasts in April 1937, he was the first black performer to be featured in a network radio series, and he appeared as a guest on dozens of television shows starting in the 1950s.

Often unjustly criticized for pandering to the racist attitudes that prevailed in the venues where he performed, Armstrong was, in fact, a significant leader in the struggle for racial equality in America. He was a black artist whose work blossomed contemporaneously with the other artistic and intellectual achievements of the Harlem Renaissance and an important personage who spoke publicly in protest and canceled a U.S. State Department tour in 1957 when Governor Orval Faubus of Arkansas refused to let black children attend a public school. Armstrong firmly believed in equal opportunity as a right and in personal merit as the only measure of worth, and he was one of the first black jazz musicians to perform and record with white musicians (Hoagy Carmichael, Tommy Dorsey, Jack Teagarden, Bud Freeman, and Bing Crosby, among others). His artistry was such that he became a role model not only for black musicians but also for numerous aspiring young white musicians, most notably Bix Beiderbecke, Jimmy McPartland, Bobby Hackett, and Gil Evans.

Informally he became known as an "Ambassador of Goodwill," and Ambassador "Satch" toured Europe and Africa under the sponsorship of the Department of State during the 1950s. Armstrong amassed many honors in his lifetime—medals, stamps in his honor from foreign countries, invitations from royalty and heads of state, and critical awards such as the annual *Down Beat* Musicians Poll—but none seemed to hold greater significance for him than returning to his birthplace, New Orleans, in 1949 as King of the Zulus for the annual Mardi Gras celebration. Even though ill health plagued him in his last few years, Armstrong continued to work, appearing on television and playing an engagement at the Waldorf-Astoria Hotel in New York City during the last year of his life. He died in his home in Corona, Queens, New York.

Louis Armstrong and but three or four others are preeminent in the history of jazz. His importance in the development of this art form has gained greater, almost universal recognition in the years since his death as scholars and musicians reevaluate his contributions as a soloist, composer, bandleader, and role model. The measure of his impact on the social

history of twentieth-century America also seems to be greater now as he gains recognition for his contributions to the Harlem Renaissance, for his actions as a thoughtful spokesperson for black Americans, as a significant writer of autobiography, as an entertainer of stature, and as a singer responsible for the development of major trends in American popular and jazz singing. His most accomplished biographer, Gary Giddins, wrote in *Satchmo*: Genius is the transforming agent. Nothing else can explain Louis Armstrong's ascendancy. He had no formal training, yet he alchemized the cabaret music of an outcast minority into an art that has expanded in ever-widening orbits, with no sign of collapse (26).

FURTHER READING

The papers of Louis Armstrong are preserved in the Louis Armstrong Archive at Queens College of the City University of New York, and virtually all of his recordings, some oral history material, and other related documents are at the Institute of Jazz Studies at Rutgers University in Newark, New Jersey.

Armstrong, Louis. *Satchmo: My Life in New Orleans* (1954).

Armstrong, Louis. *Swing That Music* (1936).

Collier, James Lincoln. *Louis Armstrong: An American Genius* (1983).

Friedwald, Will. *Jazz Singing: America's Great Voices from Bessie Smith to Bebop and Beyond* (1990).

Giddins, Gary. *Satchmo* (1988).

Gourse, Leslie. *Louis' Children: American Jazz Singers* (1984).

Jones, Max, and John Chilton. *Louis: The Louis Armstrong Story 1900–1971* (1971; rev. ed., 1988).

Schuller, Gunther. *Early Jazz: Its Roots and Musical Development* (1968).

Schuller, Gunther. *The Swing Era: The Development of Jazz 1930–1945* (1989).

Obituary: New York Times, 7 July 1971.

DISCOGRAPHY

Westerberg, Hans. *Boy from New Orleans: A Discography of Louis "Satchmo" Armstrong* (1981)

FRANK TIRRO

ARTIS, William Ellisworth

(2 Feb.1914–1977), sculptor, ceramicist, and educator, was one of America's most prolific and respected three-dimensional artists in the mid-twentieth century. Born in Washington, North Carolina, to Elizabeth Davis and Thomas Miggett, he lived primarily with his father until the fall of 1926 when he relocated to Harlem and began living with his mother and her husband, George Artis. In New York he assumed the surname of his stepfather. He attended Haaren High School and went on to study sculpture and pottery at the AUGUSTA SAVAGE Studio of Arts and Crafts in the early 1930s, joining the ranks of JACOB ARMSTEAD LAWRENCE, Gwendolyn Knight, ROMARE BEARDEN, Norman Lewis, and other notable artists whose initial studies included instruction under Savage. Artis was also a contemporary of his fellow sculptors SELMA HORTENSE BURKE and RICHMOND BARTHÉ, the latter the most exhibited and honored three-dimensional artist associated with the Harmon Foundation.

Artis won the JOHN HOPE Prize affiliated with the Harmon Foundation exhibition of 1933 for the terra-cotta *Head of a Girl,* which contributed to his receiving the Metropolitan Scholarship Award for Creative Sculpture to attend the Art Students League of New York in 1933–1934. At the league he studied with the French-born cubist sculptor Robert Laurent, a close colleague of the famed sculptor William Zorach, who also taught there. In 1935 Artis received a second John Hope Prize and went on to study at the Crafts Students League with Roberta Laber and at the Greenwich House Ceramic Center under Maude Robinson between 1936 and 1938. He was among the artists featured at the 1936 Texas Centennial exhibitions. Artis entered the New York State College of Ceramics in Alfred, New York, in 1940 for a year of instruction under Charles M. Harder and Marion L. Fosdick, after whom the Alfred University School of Art and Design Gallery was later renamed. Audrey McMahon of the College Art Association, who also served as regional director of the New York Works Project Administration/Federal Art Project, subsequently hired Artis to teach modeling and ceramics at the 135th Street branch of the YMCA in Harlem. He was later appointed director of the Boys' Work Department and instructed arts and crafts classes between 1937 and 1941; he also participated in a citywide mural project that targeted community centers and churches.

During World War II Artis served as a technical sergeant in the army, winning first prize in sculpture at the 1944 Atlanta University Annual Exhibition of Paintings, Sculpture, and Prints by Negro Artists

of America while still enlisted. The prizewinning piece, *Woman with a Kerchief,* embodied the characteristics of the style for which he became well known—an elegantly executed head or bust of an unidentified subject with smooth, clean lines and serene expression. He received the prestigious Purchase Award from the International Print Society for his sculpture titled *African Youth* in 1945. Upon the completion of his military commitment, Artis received a Harmon Foundation Fellowship that subsidized brief residencies at six of the member institutions of the Historically Black Colleges and Universities (Spelman, Tuskegee, Talladega, Hampton, Fisk, and North Carolina Central) in the early months of 1946 to hold workshops demonstrating his ceramics techniques. That fall he reentered the ceramics program at New York State College for another year of study under Fosdick and Harder.

In 1947 Artis was awarded a Julius Rosenwald Fellowship to work at Tuskegee Institute and explore the use of Alabama clays in his ceramic work and to hold periodic open-studio sessions for student observation. He declined the opportunity, opting to briefly attend classes at Alfred University before enrolling at Syracuse University on the GI Bill. At Syracuse he came under the tutelage of the acclaimed Yugoslavian-born sculptor Ivan Meštrović and began to more vigorously explore abstract forms and functional adaptations in his work. Meštrović exposed him to Modernist techniques and composition and challenged him to investigate a range of visual stimuli, most notably contemporary documentary films. Artis moved away from production of busts and began creating works that referenced the entire human form, though not in an upright pose. He earned a BFA in 1950 and an MFA in Sculpture from Syracuse in 1951.

In the spring of 1947 he had received a second Atlanta University Art Annual Purchase Prize for a terra-cotta piece done in his signature style titled *Head.* Professional recognition continued in 1951 with his receipt of the National Sculpture Society Award and the Atlanta University Purchase Prize in Sculpture for a dramatic marble work of a crouched boy titled *Quiet One.* He spent a summer teaching on a South Dakota Native American reservation followed by one semester at Tuskegee Institute before matriculating at Nebraska State Teachers College, earning a second BA in art education in 1955. He did graduate study at Pennsylvania State University between 1956 and 1959, working concurrently

during a portion of that time as associate professor of ceramics at Nebraska State Teachers College at Chadron from 1956 to 1965. His reputation continued to mount, and Artis won four additional Purchase prizes at Atlanta University over this period of time for *Head of Boy* in 1952, *Head of Young Lady* in 1959, *Young Mother* in 1962, and *Young Mother's Love* in 1963. In 1965 he received second prize in sculpture for *We Have Seen His Face.* Additionally, he won the annual Purchase Prize for a piece that was included in a group exhibition held at the Joslyn Museum of Art in Omaha, Nebraska, in 1962.

In the summer of 1965 Artis was hired by the metals specialist Alvin Pine to work at California State University, Long Beach, as assistant to the sculptor and Modernist jeweler Claire Falkenstein and the French sculptor of Polish origin Piotr Kowalski, two of the eight artists-in-residence awardees whose work was featured at that year's International Sculpture Symposium. Artis remained through the fall, continuing to assist both artists. The next fall he took a position as professor of art at Mankato State College in Minnesota, working there from 1966 until 1975. For his dedication and effectiveness as an instructor, he was named Outstanding Educator of America by the University of Minnesota in 1970, adding to the National Conference of Artists' Outstanding Afro-American Artist Award earned the same year. He was also presented with the Smith-Mason Gallery Award in 1971.

Over the course of his career, Artis received more than one hundred distinguished awards, commissions, and honors and had his work reviewed in *Time, Sculpture Review,* and the *Christian Science Monitor.* He was a member of several national professional organizations, including the American Ceramic Society, National Sculpture Society, National Art Educators Association, New York Society of Arts and Crafts, and College Art Association. His work appeared in more than thirty exhibitions including at the Museum of Modern Art, Whitney Museum of American Art, and High Museum of Art in Atlanta. Artis's work is in the permanent collections of many of the major art museums and galleries in the United States.

Artis was described by the artist Mary Parks Washington, a Spelman College student during the time Artis visited the campus and who was the subject of a bust he created around 1945, as hardworking, reclusive, quiet, and devoted to a male

friend living in Paris. Artis died in 1977 of unknown causes.

FURTHER READING

Driskell, David Clyde. *Paintings by Ellis Wilson, Ceramics and Sculpture by William E. Artis* (1971).

Pendergraft, Norman E. *Heralds of Life: Artis, Bearden and Burke* (1977).

Reynolds, Gary A., and Beryl J. Wright. *Against the Odds: African-American Artists and the Harmon Foundation* (1989).

AMALIA K. AMAKI

ATTAWAY, William Alexander

(19 Nov. 1911–17 June 1986), writer, was born in Greenville, Mississippi, the son of William S. Attaway, a medical doctor, and Florence Parry, a teacher. His family moved to Chicago when Attaway was six years old, following the arc of the Great Migration, that thirty-year period beginning in the last decade of the nineteenth century during which more than 2 million African Americans left the South for the burgeoning industrial centers of the North. Unlike many of these emigrants, who traded the field for the factory and the sharecropper's shack for the ghetto, the Attaways were professionals at the outset, with high ambitions for themselves and their children in their new homeland.

Attaway attended public schools in Chicago, showing no great interest in his studies until, as a high school student, he encountered the work of LANGSTON HUGHES. He became, from that point on, a more serious student and even tried his hand at writing, composing scripts for his older sister's amateur drama club. After completing high school he enrolled at the University of Illinois, where he initially flourished not only academically but also athletically, becoming a collegiate tennis player.

His father's death while Attaway was still at college, however, derailed his academic career. As the Great Depression descended over America, Attaway dropped out of the university to wander the country, working as a seaman, à la Langston Hughes and CLAUDE MCKAY, a salesman, and a labor organizer, as well as in a variety of other odd jobs. He writes that "in Chicago I had all the advantages that a self-made man imagines are good for an only son. But after my father's death I rebelled and spent my time hoboing" (Bone, 132). After two years away from the university, he returned to finish his degree. During this period he experimented with one-act plays and short stories, publishing some of this work in newspapers and literary magazines. His first published short story, "Tale of the Blackamoor," appeared in 1936 in the little magazine *Challenge*, formed in 1934 to give another literary outlet for the new generation of African American writers. A drama, *Carnival*, was written and produced about the same time.

In the mid-1930s Attaway became involved in the Federal Writers' Project (FWP), a government initiative that provided work opportunities for unemployed writers during the Depression that was administered through the Works Projects Administration. Attaway helped write the Illinois section of the FWP's chief project, an American Guide Series, profiling the then forty-eight states. His work brought him into contact with some of the luminaries of contemporary African American literature also employed by the FWP, including RICHARD WRIGHT, Claude McKay, ARNA WENDELL BONTEMPS, MARGARET WALKER, RALPH WALDO ELLISON, and Frank Yerby.

Moving to New York, Attaway entered the theater world with the assistance of his sister Ruth, who by now had achieved something of a reputation as a stage actress. He performed in several productions, including a 1939 traveling production of George S. Kaufman's *You Can't Take It with You*. In that year, he learned that his first novel, *Let Me Breathe Thunder*, had been accepted for publication by Doubleday. The novel, heavily influenced by John Steinbeck's *Of Mice and Men*, focuses on the adventures of two white hoboes during the Depression. It received limited critical attention and that mainly negative. It was generally thought to be too derivative and too heavily dependent upon mere reportage drawn from Attaway's own wanderings to be a successful work of literature.

His efforts did earn Attaway a two-year grant from the Julius Rosenwald Fund, which enabled him to work on a second novel. He completed and published in 1941 *Blood on the Forge*. This is a novel of an altogether different scope than his first, incisively portraying the collapse of traditional black folk culture in the relentlessly dehumanizing ghettos of the industrial, urbanized North. *Blood on the Forge* was well received critically but did not sell profitably, perhaps owing to the publication at about the same time of Richard Wright's *Native Son*, a novel that garnered immense critical and popular attention. The lack of commercial success of his second novel led Attaway to find new directions for his

creative energy, most notably in writing songs and books about music and, eventually, scriptwriting for stage, screen, and television.

Attaway's songwriting was heavily influenced by calypso rhythms, and in 1957 he published the *Calypso Song Book,* containing many of the songs from which he drew inspiration. In the 1950s he made the acquaintance of Harry Belafonte and collaborated with him and others in writing songs, authoring or coauthoring more than five hundred in his lifetime. Perhaps his most famous collaboration led to one of Belafonte's most popular hits, the "Banana Boat Song." Then, in 1967, Attaway published for children a compilation of representative popular music in America, including historical commentary, *Hear America Singing.*

Also, beginning in the 1950s, Attaway turned to writing for radio, film, and television, one of the first African American writers to do so. His work was featured in such television series as *Wide Wide World* and the *Colgate Comedy Hour.* He was one of the writers for an hour-long television special, airing in 1964, *One Hundred Years of Laughter,* showcasing, among the others, the African American comedians Redd Foxx, MOMS MABLEY, and Flip Wilson in their first appearances on the small screen.

In 1962, at the age of fifty-one, Attaway married Frances Settele, from New York, at a ceremony held in his friend Belafonte's home. The couple had two children—a son, Bill, born in 1964, and a daughter Noelle, born in 1966. In the year of his daughter's birth, Attaway took his family to Barbados for a vacation and wound up staying eleven years among the people and the music he loved. Upon their return to America, the family settled in California, where Attaway spent the remaining years of his life writing screenplays.

FURTHER READING

Bone, Robert A. *The Negro Novel in America* (1965).

Gayle, Addison, JR. *The Way of the New World: The Black Novel in America* (1975).

Gloster, Hugh Morris *Negro Voices in American Fiction* (1948).

Hughes, Carl M. *The Negro Novelist* (1953).

Margolies, Edward. "Migration: William Attaway and *Blood on the Forge,*" in *Native Sons: A Critical Study of Twentieth-century Negro American Authors* (1968).

Redding, J. Saunders. "The Negro Writer and American Literature," in *Anger and Beyond: The Negro Writer in the United States* (1966).

GEORGE P. WEICK

BAKER, Ella

(13 Dec. 1903–13 Dec. 1986), civil rights organizer, was born Ella Josephine Baker in Norfolk, Virginia, the daughter of Blake Baker, a waiter on the ferry between Norfolk and Washington, D.C., and Georgianna Ross. In rural North Carolina where Ella Baker grew up, she experienced a strong sense of black community. Her grandfather, who had been a slave, acquired the land in Littleton on which he had slaved. He raised fruit, vegetables, and cattle, which he shared with the community. He also served as the local Baptist minister. Baker's mother took care of the sick and needy.

After graduating in 1927 from Shaw University in Raleigh, North Carolina, Baker moved to New York City. She had dreamed of doing graduate work in sociology at the University of Chicago, but it was 1929, and times were hard. Few jobs were open to black women except teaching, which Baker refused to do because "this was the thing that everybody figures you could do" (Cantarow and O'Malley, 62). To survive, Baker waitressed and worked in a factory. During 1929–1930 she was an editorial staff member of the *American West Indian News* and in 1932 became an editorial assistant for GEORGE SCHUYLER's *Negro National News*, for which she also worked as office manager. In 1930 she was on the board of directors of Harlem's Own Cooperative and worked with the Dunbar Housewives' League on tenant and consumer rights. In 1930 she helped organize and in 1931 became the national executive director of the Young Negroes' Cooperative League, a consumer cooperative. Baker also taught consumer education for the Works Progress Administration in the 1930s and, according to a letter written in 1936, divided her time between consumer education and working at the public library at 135th Street. She married Thomas J. Roberts in 1940 or 1941; they had no children.

Beginning in 1938 Baker worked with the National Association for the Advancement of Colored People (NAACP), and from 1941 to 1946 she traveled throughout the country but especially in the South for the NAACP, first as field secretary and then as a highly successful director of branches

to recruit members, raise money, and organize local campaigns. Among the issues in which she was involved were the antilynching campaign, the equal-pay-for-black-teachers movement, and job training for black workers. Baker's strength was the ability to evoke in people a feeling of common need and the belief that people together can change the conditions under which they live. Her philosophy of organizing was "you start where the people are" and "strong people don't need strong leaders." In her years with the NAACP, Baker formed a network of people involved with civil rights throughout the South that proved invaluable in the struggles of the 1950s and 1960s. Among the more significant of her protégés was the Alabama seamstress Rosa Parks. Baker resigned from her leadership role in the national NAACP in 1946 because she felt it was too bureaucratic. She also had agreed to take responsibility for raising her niece. Back in New York City, she worked with the NAACP on school desegregation, sat on the Commission on Integration for the New York City Board of Education, and in 1952 became president of the New York City NAACP chapter. In 1953 she resigned from the NAACP presidency to run unsuccessfully for the New York City Council on the Liberal Party ticket. To support herself, she worked as director of the Harlem Division of the New York City Committee of the American Cancer Society.

In January 1958 Bayard Rustin and Stanley Levison persuaded Baker to go to Atlanta to set up the office of the Southern Christian Leadership Conference (SCLC) to organize the Crusade for Citizenship, a voter registration program in the South. Baker agreed to go for six weeks and stayed for two and a half years. She was named acting director of the SCLC and set about organizing the crusade to open simultaneously in twenty-one cities. She was concerned, however, that the SCLC board of preachers did not sufficiently support voter registration. Baker had increasing difficulty working with Martin Luther King Jr., whom she described as "too self-centered and cautious" (Weisbrot, 33). Because she thought that she would never be appointed executive director, Baker persuaded her friend the Reverend John L. Tilley to assume the post in April, and she became associate director. After King fired Tilley in January 1959, he asked Baker once again to be executive director, but his board insisted that her position must be in an acting capacity. Baker, however, functioned as executive director and signed

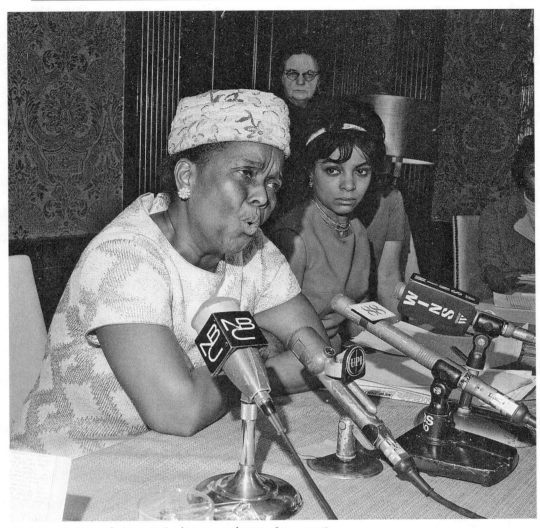

Ella Baker, speaking at the Jeannette Rankin news conference, 3 January 1968.

her name accordingly. In April 1960 the executive director post of SCLC was accepted by the Reverend Wyatt Tee Walker.

After hundreds of students sat in at segregated lunch counters in early 1960, Baker persuaded the SCLC to invite them to the Southwide Youth Leadership Conference at Shaw University on Easter weekend. From this meeting the Student Nonviolent Coordinating Committee (SNCC) was eventually formed. Although the SCLC leadership pressured Baker to influence the students to become a youth chapter of the SCLC, she refused and

encouraged the students to beware of the SCLC's "leader-centered orientation." She felt that the students had a right to decide their own structure. Baker's speech "More than a hamburger," which followed King's and James Lawson's speeches, urged the students to broaden their social vision of discrimination to include more than integrating lunch counters. Julian Bond described the speech as "an eye opener" and probably the best of the three. "She didn't say, 'Don't let Martin Luther King tell you what to do,'" Bond remembers, "but you got the real feeling that that's what she meant" (Hampton and

Fayer, 63). James Forman, who became director of SNCC a few months later, said Baker felt the SCLC "was depending too much on the press and on the promotion of Martin King, and was not developing enough indigenous leadership across the South" (Forman, 216).

After the Easter conference weekend, Baker resigned from the SCLC, and after having helped Walker learn his job she went to work for SNCC in August. To support herself she worked as a human relations consultant for the Young Women's Christian Association in Atlanta. Baker continued as a mentor to SNCC civil rights workers, most notably Robert P. Moses. At a rancorous SNCC meeting at Highlander Folk School in Tennessee in August 1961, Baker mediated between one faction advocating political action through voter registration and another faction advocating nonviolent direct action. She suggested that voter registration would necessitate confrontation that would involve them in direct action. Baker believed that voting was necessary but did not believe that the franchise would cure all problems. She also understood the appeal of nonviolence as a tactic, but she did not believe in it personally: "I have not seen anything in the nonviolent technique that can dissuade me from challenging somebody who wants to step on my neck. If necessary, if they hit me, I might hit them back" (Cantarow and O'Malley, 82).

After the 1964 Mississippi summer in which northern students went south to work in voter registration, SNCC decided to organize the Mississippi Freedom Democratic Party (MFDP) as an alternative to the regular Democratic Party in Mississippi. Thousands of people registered to vote in beauty parlors and barbershops, churches, or wherever a registration booth could be set up. Baker set up the Washington, D.C., office of the MFDP and delivered the keynote speech at its Jackson, Mississippi, state convention. The MFDP delegates were not seated at the Democratic National Convention in Washington, D.C., but their influence helped to elect many local black leaders in Mississippi in the following years and forced a rules change in the Democratic Party to include more women and minorities as delegates to the national convention.

From 1962 to 1967 Baker worked on the staff of the Southern Conference Education Fund (SCEF), dedicated to helping black and white people work together. During that time she organized a civil liberties conference in Washington, D.C., and worked with Carl Braden on a mock civil rights commission hearing in Chapel Hill, North Carolina. In her later years in New York City she served on the board of the Puerto Rican Solidarity Committee, founded and was president of the Fund for Education and Legal Defense, which raised money primarily for scholarships for civil rights activists to return to college, and was vice chair of the Mass Party Organizing Committee. She was also a sponsor of the National United Committee to Free Angela Davis and All Political Prisoners, a consultant to both the Executive Council and the Commission for Social and Racial Justice of the Episcopal Church, and a member of the Charter Group for a Pledge of Conscience and the Coalition of Concerned Black Americans. Until her death in New York City she continued to inspire, nurture, scold, and advise the many young people who had worked with her during her career of political activism.

Ella Baker's ideas and careful organizing helped to shape the civil rights movement from the 1930s through the 1960s. She had the ability to listen to people and to inspire them to organize around issues that would empower their lives. At a time when there were no women in leadership in the SCLC, Baker served as its executive director. Hundreds of young people became politically active because of her respect and concern for them.

FURTHER READING
Ella Baker's papers are in the Schomburg Center for Research in Black Culture of the New York Public Library.
Cantarow, Ellen, and Susan Gushee O'Malley. *Moving the Mountain* (1980).
Forman, James. *The Making of Black Revolutionaries* (1972).
Hampton, Henry, and Steve Fayer. *Voices of Freedom* (1991).
Ransby, Barbara. *Ella Baker and the Black Freedom Movement* (2003).
Weisbrot, Robert. *Freedom Bound* (1990).
Obituary: *New York Times*, 17 Dec. 1986.

SUSAN GUSHEE O'MALLEY

BAKER, Josephine

(3 Jun. 1906–10 Apr. 1975), dancer, singer, and entertainer, was born in the slums of East St. Louis, Missouri, the daughter of Eddie Carson, a drummer, who abandoned Baker and her mother after

Josephine Baker at the Winter Garden Theater in New York, 11 February 1936.

the birth of a second child, and of Carrie McDonald, a onetime entertainer who supported what became a family of four by doing laundry. Poverty, dislocation, and mistreatment permeated Baker's childhood. By the age of eight she was earning her keep and contributing to the family's support by doing domestic labor. By the time Baker was fourteen, she had left home and its discord and drudgery; mastered such popular dances as the Mess Around and the Itch, which sprang up in the black urban centers of the day; briefly married Willie Wells and then divorced him; and begun her career in the theater. She left East St. Louis behind and traveled with the Dixie Steppers on the black vaudeville circuit, already dreaming of performing on Broadway.

Baker's dream coincided with the creation of one of the greatest musical comedies in American theater, *Shuffle Along*, with music by EUBIE BLAKE and lyrics by NOBLE SISSLE. A constant crowd-pleaser with her crazy antics and frantic dancing as a comic, eye-crossing chorus girl, Baker auditioned for a role in the musical in Philadelphia in April of 1921, only to be rejected as "too young, too thin, too small, and too dark." With characteristic determination, she bought a one-way ticket to New York, auditioned

again, and was rejected again, but she secured a job as a dresser in the touring company. On the road she learned the routines, and, when a member of the chorus line fell ill, she stepped in and became an immediate sensation. More than five hundred performances later, in the fall of 1923, the *Shuffle Along* tour ended, and Baker was cast in Sissle and Blake's new show, *Bamville*, later retitled and better known as *The Chocolate Dandies*. When the musical opened in New York in March of 1924, Baker not only played Topsy Anna, a comic role straight out of the racist minstrel tradition, but also appeared as an elegantly dressed "deserted female" in the show's "Wedding Finale," foreshadowing the poised and polished performer of world renown she would become.

In the summer of 1925 Baker's dancing at the Plantation Club at Fiftieth Street and Broadway caught the eye of Caroline Dudley Reagan, a young socialite planning to stage a black revue in Paris in the vein of *Shuffle Along* or *Runnin' Wild*, the revue that introduced the Charleston in 1924. The company that came to be known as La Revue Nègre was long on talent, with such now legendary figures as the composer Spencer Williams, the bandleader and pianist CLAUDE HOPKINS, and the clarinetist SIDNEY BECHET, the dancer and choreographer Louis Douglas, and the set designer Miguel Covarrubias. Baker joined the troupe as lead dancer, singer, and comic. When the performers arrived in Paris in late September 1925, opening night at the Théâtre des Champs Elysées was ten days away. During that brief time the revue was transformed from a vaudeville show, replete with the stereotypes expected by a white American public, into a music-hall spectacle filled with colonialist fantasies that appealed to the largely male, voyeuristic Parisian audience.

When La Revue Nègre opened to a packed house on 2 October 1925, it was an instantaneous *succès de scandale*. First, Baker stunned the rapt onlookers with her blackface comic routine, in which, seemingly part animal, part human, she shimmied, contorted her torso, writhed like a snake, and vibrated her behind with astonishing speed. Then she provoked boos and hisses as well as wild applause when, in the closing "Dance sauvage," wearing only feathers about her hips, she entered the stage upside down in a full split on the shoulders of Joe Alex. Janet Flanner recorded the moment in the *New Yorker*: "Midstage, he paused, and with his long

fingers holding her basket-wise around the waist, swung her in a slow cartwheel to the stage floor, where she stood like his magnificent discarded burden, in an instant of complete silence. She was an unforgettable female ebony statue." Called the "black Venus" and likened to African sculpture in motion, Baker was seen both as a threat to "civilization" and, like *le jazz hot*, as a new life force capable of energizing a weary France mired down in tradition and in need of renewal.

Paris made "la Baker" a celebrity, embracing both her erotic yet comic stage persona and her embodiment of Parisian chic as she strolled the city's boulevards beautifully dressed in Paul Poiret's creations. Beginning in 1926 Baker starred at the oldest and most venerated of French music halls, the Folies-Bergère. Once again, she was a shocking sensation. Instead of the customary bare-breasted, light-skinned women standing in frozen poses onstage at the Folies, Baker presented the Parisian audience with a dark-skinned, athletic form clad in a snicker-producing girdle of drooping bananas, dancing the wildest, most electrifying Charleston anyone had ever witnessed. As the young African savage Fatou, she captured the sexual imagination of Paris.

In 1928, sensing that her public was beginning to tire of her frenetic antics, Baker left Paris. During an extended tour of European and South American cities with her manager and lover, Giuseppe "Pepito" Abatino, she studied voice, disciplined her dancing, and learned to speak French. However, Baker's reception in such cities as Vienna, Budapest, Prague, and Munich was not what it had been in Paris. Protests broke out in hostile reaction to her nudity, to jazz music, and to her foreignness. Baker also encountered for the first time the racism she thought she had left behind in America, the racism against which she would campaign onstage and off for the rest of her life. By the time she made her triumphal return to Paris two and a half years later, she had transformed herself into a sophisticated, elegantly attired French star.

In the 1930s Baker's career branched out in new directions. Singing took on new importance in her performances, and in her 1930–1931 revue at the Casino de Paris she perfected her signature song, "J'ai deux amours," proclaiming that her two loves were her country and Paris. She began recording for Columbia Records in 1930. She starred in two films, *Zou-Zou* (1934) and *Princesse Tam-Tam* (1935),

whose story lines paralleled her rags-to-riches life. In the first film she is transformed from a poor laundress to a glamorous music-hall star and in the second from a Tunisian goat girl to an exotic princess. In the fall of 1934 she successfully tackled light opera in the starring role of Offenbach's operetta *La Créole*.

One year later, hoping to enjoy the success at home she had earned abroad, Baker sailed with Pepito to New York and began four months of preparation for the Ziegfeld Follies of 1936. The reviews of the New York opening in January took hateful aim at Baker's performance. Belittling her success abroad with the explanation that in France "a Negro wench always has a head start," the reporter remarked that "to Manhattan theatergoers last week she was just a slightly buck-toothed Negro woman whose figure might be matched in any night-club show, and whose dancing and singing might be topped practically anywhere outside of Paris." Critics, black and white, resented her performing only French cabaret material rather than "Harlem songs." Newspapers also reported that Baker personally was snubbed, refused entrance to hotels and nightclubs. Reactions to this discrimination varied, with some condemning her for "trying to be white." The columnist ROI OTTLEY of the *Amsterdam News*, on the other hand, praised her efforts to overcome Jim Crowism, saying that "she was just trying to live ignoring color." He recommended that "Harlem . . . should rally to the side of this courageous Negro woman. We should make her insults our insults."

Disappointed by her reception in her homeland and saddened by the death from cancer of Pepito, Baker returned to Paris and to the nude revues at the Folies-Bergère. By then thirty years old, she wanted to marry and have children. She realized the first desire on 30 November 1937, when she wed Jean Lion, a rich and handsome Jewish playboy and sugar broker. After fourteen months of marriage, during which Baker did not become pregnant and Lion continued his wild ways, she filed for divorce, which was granted in 1942.

In June of 1940 German troops invaded Paris. Baker, who refused to perform either for racist Nazis or for their French sympathizers, fled to Les Milandes, her fifteenth-century château in the Dordogne, with her maid, a Belgian refugee couple, and her beloved dogs. Since September 1939 Baker had served as an "honorable correspondent,"

gathering information about German troop locations for French military intelligence at embassy and ministry parties in Paris. Once Charles de Gaulle had declared himself leader of Free France in a radio broadcast from London and called for the French to resist their German occupiers, Baker joined "*résistance*" and was active in it throughout World War II, working mostly in North Africa. For her heroic work she was awarded the Croix de Guerre, and de Gaulle himself gave her a gold cross of Lorraine, the symbol of the Fighting French, when he established headquarters in Algiers in the spring of 1943. Baker was a tireless ambassador for the Free France movement and for de Gaulle, performing for British, American, and French soldiers in North Africa and touring the Middle East to raise money for the cause. In recognition of the propaganda services she performed during this tour, she was made a sublieutenant of the Women's Auxiliary of the French Air Force. After the war de Gaulle awarded Baker the coveted Medal of Resistance.

Moving into the 1950s Baker harnessed her formidable energies behind two causes. The first was her own pursuit of racial harmony and human tolerance in the form of her "Rainbow Tribe." To demonstrate the viability of world brotherhood, with the orchestra leader Jo Bouillon, whom she had married in 1947, Baker adopted children of many nationalities, races, and religions and installed them at Les Milandes. In order to support the family that eventually numbered thirteen and to finance the massive renovation of the château and related construction projects, Baker returned to the stage. A quick trip to the United States in 1948 was as unsuccessful as the one twelve years earlier and left her convinced that, if possible, race relations there were even worse than before. This realization prompted Baker's second cause, the pursuit of civil rights for black Americans through the desegregation of hotels, restaurants, and nightclubs.

Traveling with a $250,000 Parisian wardrobe; singing in French, Spanish, English, Italian, and Portuguese; and performing with masterly showmanship, in 1951 Baker began an American tour in Cuba. When word of her success in Havana reached Miami, Copa City moved to book the star for a splashy engagement. Contract negotiations were long and difficult. Initiating what would become her standard demand with nightclubs, Baker insisted on a nondiscrimination clause. If management would not admit black patrons, she would not perform.

The integrated audience for Baker's show at Copa City was the first in the city's history. Baker took her tour and her campaign against color lines from city to city—New York, Boston, Atlanta, Las Vegas, and Hollywood. And audiences loved her. *Variety* wrote, "The showmanship that is Josephine Baker's . . . is something that doesn't happen synthetically or overnight. It's of the same tradition that accounts for the durability of almost every show biz standard still on top after many years."

The pinnacle of Baker's civil rights efforts was reached in August 1963 when she was invited to the great March on Washington. Dressed in her World War II uniform, Baker stood on the platform in front of the Lincoln Memorial and spoke to the crowd of thousands, blacks and whites, demonstrating for justice and equality: "You are on the eve of victory. You can't go wrong. The world is behind you." Baker was among those arrayed around Martin Luther King Jr. as he delivered his "I have a dream" speech. Certainly, for Josephine Baker, that day was a dream come true.

The remaining years of Baker's life were not tranquil. Given her extravagant spending and generosity, financial problems continued to plague her. Jo Bouillon finally despaired of trying to raise so many children or to impose any fiscal responsibility and left Baker. In 1968 Les Milandes was sold, and Baker, who barricaded herself in the house with her children, was evicted. Such setbacks notwithstanding, she continued to give comeback performances, astonishing crowds with her ability to rejuvenate herself the moment she stepped on stage, the consummate star. Her final performance in Paris to a sold-out house on 9 April 1975 was no exception. The following day, just two months shy of her sixtyninth birthday, Baker died of a cerebral hemorrhage brought on by a stroke. All of France mourned the passing of "la Joséphine." National television broadcast the procession of her flag-draped coffin through the streets of Paris and the funeral service at the Church of the Madeleine, where twenty thousand Parisians gathered to pay their respects.

In *Jazz Cleopatra: Josephine Baker in Her Time*, Phyllis Rose writes of Baker's "cabaret internationalism" as her "way of expressing a political position." A performer of consummate skill, Baker enthralled audiences for more than a half century. But personal adulation was not enough. Like PAUL ROBESON, Harry Belafonte, Lena Horne, Bill Cosby, and others, Baker put her prestige and popularity

in the service of civil rights, racial harmony, and equality for all humanity.

FURTHER READING

Baker, Josephine, and Marcel Sauvage. *Les mémoires de Joséphine Baker* (1927).

Baker, Josephine, and Marcel Sauvage. *Les mémoires de Joséphine Baker* (1949).

Baker, Josephine, and Jo Bouillon. *Joséphine* (1976).

Colin, Paul. *Le tumulte noir* (1927).

Hammond, Bryan, and Patrick O'Connor. *Josephine Baker* (1988).

Rose, Phyllis. *Jazz Cleopatra: Josephine Baker in Her Time* (1989).

Obituary: New York Times, 13 April 1975.

KAREN C. C. DALTON

BARNETT, Claude Albert

(16 Sept. 1889–2 Aug. 1967), entrepreneur, journalist, and government adviser, was born in Sanford, Florida, the son of William Barnett, a hotel worker, and Celena Anderson. His father worked part of the year in Chicago and the rest of the time in Florida. Barnett's parents separated when he was young, and he lived with his mother's family in Oak Park, Illinois, where he attended school. His maternal ancestors were free blacks who migrated from Wake County, North Carolina, to the black settlement of Lost Creek, near Terre Haute, Indiana, during the 1830s. They then moved to Mattoon, Illinois, where Barnett's maternal grandfather was a teacher and later a barbershop owner, and finally to Oak Park. While attending high school in Oak Park, Barnett worked as a houseboy for Richard W. Sears, cofounder of Sears, Roebuck and Company. Sears offered him a job with the company after he graduated from high school, but Barnett's mother insisted that he receive a college education. He graduated from Tuskegee Institute with a degree in Engineering in 1906. His maternal grandfather and BOOKER T. WASHINGTON, founder and head of Tuskegee Institute, were the major influences on Barnett's life and values. He cherished the principles of hard work, self-help, thrift, economic development, and service to his race.

Following graduation from Tuskegee, Barnett worked as a postal clerk in Chicago. While still employed by the post office, in 1913 he started his own advertising agency, the Douglas Specialty Company, through which he sold mail-order portraits of famous black men and women. He left the post office in 1915 and in 1918, with several other entrepreneurs, founded the Kashmir Chemical Company, which manufactured Nile Queen hair-care products and cosmetics. Barnett became Kashmir's advertising manager and he toured the country to market its products and his portraits. He helped to develop a national market for Kashmir and also pioneered the use of positive advertisements. Traditional advertisements featured an unattractive black woman with a message that others should use the company's products to avoid looking like her. In contrast, Barnett used good-looking black models and celebrities with positive messages about the beauty of black women. He visited local black newspapers to negotiate advertising space and discovered that they were desperate for national news but did not have the resources to subscribe to the established newswire services. Barnett recommended that the *Chicago Defender*, founded by ROBERT ABBOTT in 1905 and the most widely circulated black newspaper during the early twentieth century, establish a black news service. The newspaper rejected his proposal since it had enough sources for its own publication and feared harming its circulation by providing competitors with material.

In March 1919, with backing from Kashmir's board of directors, Barnett started the Associated Negro Press (ANP) in the company's office. In 1926 the Kashmir Chemical Company dissolved under legal pressure from Procter and Gamble, which made a similar line of products called Cashmere. Barnett was now free to devote his attention fully to ANP. During this era black newspapers published weekly, so ANP evolved as a mail service rather than as a wire service, thereby making it affordable to subscribers. Moreover, the major wire services did not offer much information about African Americans. Barnett began ANP with eighty subscribers, including almost all the black newspapers and several white papers. He charged $25 to join ANP and a monthly fee of $16 to $24, depending on whether newspapers received dispatches once or twice a week. Subscribers agreed to credit ANP for articles featured in their newspapers, to provide ANP with news about their communities, and to forfeit membership if they failed to pay for the service within sixty days.

The staff produced about seventy pages of copy a week, including news stories, opinion pieces, essays,

poetry, books reviews, cartoons, and occasionally photographs; the copy was then mimeographed and sent to subscribers. It did not cost much to operate ANP. The service mined news stories from various sources, such as black newspapers, the white press, special correspondents, and news releases from government agencies, foundations, organizations, and businesses, creating one of the most comprehensive files of news stories about African Americans. Barnett wrote some of the stories himself under the pen name Albert Anderson, a combination of his middle name and his mother's maiden name. Because subscribers usually were late in paying their fees, Barnett struggled to keep ANP afloat. Sometimes he took advertising space in the newspapers in lieu of news service fees. His companies, first Associated Publishers Representatives and later the National Feature Service, then sold the space to advertisers, offering advertisers lower rates than they would get if they placed advertisements directly with the newspapers.

In 1932 Barnett became one of the first graduates to serve on Tuskegee Institute's board of trustees. He also served as president of the board of trustees of Provident Hospital in Chicago, director of the Supreme Liberty Life Insurance Company, member of the Red Cross's national board of governors, and trustee of the Phelps-Stokes Fund. During the late 1920s and early 1930s he headed the Republican Party's publicity campaign for the black vote. Some of his ANP subscribers became upset by his stories that favored the Republicans. After Franklin D. Roosevelt's election to the presidency in 1932 and First Lady Eleanor Roosevelt's growing popularity among African Americans, Barnett ended his relationship with the Republican Party.

Barnett married the popular concert singer and actress ETTA MOTEN (BARNETT) in 1934. She had three daughters from a previous marriage. Barnett managed her career until 1942, when she assumed the lead role in the Broadway show *Porgy and Bess* and began to require the attention of a full-time agent. Also in 1942, Barnett became special assistant to the secretary of agriculture, Claude R. Wickard, a position that he held with successive secretaries until 1952, when the Republicans regained the White House with the election of Dwight D. Eisenhower. During his tenure with the Department of Agriculture, Barnett was a strong advocate for black tenant farmers and sharecroppers and sought to make it possible for them to own land. He also tried to improve the condition of black farmers through federal aid for health, education, and insurance programs. He was particularly interested in strengthening black agricultural colleges.

During World War II, ANP employed eight people at its Chicago headquarters and had almost two hundred subscribers. The news service opened an office in Washington, D.C., and later one at the United Nations in New York City. Barnett penned many articles about segregation in the military and pressed the federal government to accredit black journalists as war correspondents. His advocacy of racial equality played an important role in President Harry S. Truman's decision in 1948 to desegregate the military.

With an expanding African independence movement after World War II, Barnett secured more than one hundred African newspapers as subscribers to ANP. In 1959 he organized the World News Service to provide copy to subscribers in Africa. Barnett traveled to Africa more than fifteen times to solicit subscribers and to collect material for articles on black progress. He and his wife became avid collectors of African art and were much-sought-after speakers on Africa to African American civic, fraternal, and religious organizations. Although he had no formal training as a newsman, Barnett helped to develop a generation of black journalists. Most of his featured columnists wrote for the benefit of a large black audience rather than for pay.

With the rise of the civil rights movement during the late 1950s, many white newspapers began to cover the black community in the United States. News organizations started hiring black correspondents, most of whom had broken into the industry with ANP. Barnett had established a means for the black press to secure national and later international news about black people. ANP, with its motto "Progress, Loyalty, Truth," set professional standards for the black press and nurtured black journalists who were well prepared to move into mainstream media with the success of the civil rights movement. Increased competition, persistent financial problems, and failing health forced Barnett to close ANP and to retire in 1963. He made several more trips to Africa and began writing an autobiography. He died of a cerebral hemorrhage at his Chicago home.

FURTHER READING

The Archives and Manuscript Department of the Chicago Historical Society house Barnett's papers and ANP files. Most of this material is available on microfilm.

Evans, Linda J. "Claude A. Barnett and the Associated Negro Press." *Chicago History* 12, no. 1 (Spring 1983): 44–56.

Hogan, Lawrence D. *A Black National News Service: The Associated Negro Press and Claude Barnett, 1919–1945* (1984).

Silverman, Robert Mark. "The Effects of Racism and Racial Discrimination on Minority Business Development: The Case of Black Manufacturers in Chicago's Ethnic Beauty Aids Industry." *Journal of Social History* 31, no. 3 (Spring 1998): 571–597.

Obituary: New York Times, 3 Aug. 1967.

ROBERT L. HARRIS JR.

BARNETT, Etta Moten

(5 Nov. 1901–2 Jan. 2004), actor, singer, and philanthropist, was born Etta Moten in Weimar, Texas, the only daughter of Reverend Freeman F. Moten and Ida Norman Moten. The ten-year-old Etta took an active part in church, singing in the choral group and instructing Sunday-school lessons. Standing on a makeshift step stool, in order to be at the same height level as the rest of the choir, she shared her voice with the congregation.

After high school Barnett wedded Lieutenant Curtis Brooks. During their seven-year marriage, she had four children, one of whom died at birth. Following in the footsteps of her college-educated parents, she attended the University of Kansas in the 1920s; however, in order to receive her education, Barnett had to sacrifice her conventional family life. She divorced her husband and left her three daughters under her parents' supervision while she attended school. On weekends she cared for her children at her parents' house, but during the week Barnett was a full-time student, earning a degree in voice and drama in 1931. Once an unhappy wife but dedicated mother of three, Barnett changed her fate at a time when many people thought change for women, especially black women, was impossible.

Barnett sang with the EVA JESSYE Choir of New York after she finished her education. On the way to New York she met her future second husband, CLAUDE BARNETT, father of the Associated Negro Press Claude, dazzled by Etta's ambition, wrote introductory letters to his New York acquaintances to smooth her entrance into the theater scene. Soon after she arrived in New York Etta joined the Broadway cast of *Fast and Furious* (1931). Her performance earned her a place in the touring cast of *Zombie* (1932), which coincidentally played in Chicago, where Etta became reacquainted with her future husband, Claude. Due to his affiliation with national newspapers, he also had connections in Hollywood; Etta headed to the West Coast.

Entering the ranks of the film industry, Barnett dubbed songs for actresses, including Barbara Stanwyck and Ginger Rogers, without getting recognition in the credits. However, she became famous for her on-screen portrayal of a widow in *Gold Diggers* (1933), singing "My Forgotten Man." Because her role was not that of the stereotypical housekeeper or nursemaid, Barnett's performance gave credence to the idea that black actors could portray realistic characters, something many Americans at the time considered impossible. Her role in the film sparked interest and pride among African Americans around the nation, and the black press anointed her "The New Negro Woman." In addition, *Gold Diggers* won Barnett national acclaim for her musical talent: she was the first black woman to perform at the White House, reprising her song from the film at Franklin D. Roosevelt's birthday party in 1934.

In her next film, *Flying Down to Rio* (1933), with Fred Astaire and Ginger Rogers, Barnett appeared with large fruit placed strategically in her hair, a style that many people mistakenly believed originated with Carmen Miranda, as she sang "The Carioca." Her performance of the musical number increased her fame when the Academy Awards panel nominated the piece for best song. A dynamic duo, Etta and Claude Barnett married in 1934, and Etta's three daughters moved to their mother's new Chicago residence.

Barnett returned to New York to play the role of Bess in *Porgy and Bess* in 1942. According to Barnett, Gershwin sought her to fill the role in 1935, when he initially produced the show. However Barnett, a lush contralto, politely declined the role since Gershwin had composed the part for a soprano voice. Yet Barnett did play Bess in the production's longest stint, starting in New York in 1942 and traveling throughout the United States and Canada until 1945. Among Barnett's other Broadway credits are *Sugar Hill* (1931) and *Lysistrata* (1946). Sidney

Poitier charmingly described her as "the most incredible, amazing, voluptuous, dignified, and sensual actress to grace the Broadway stage in my lifetime" (Kinnon, "Etta at 100," 62).

Though she enjoyed a successful career in film and theater, Barnett's influence reached beyond the artistic sphere and into the world of activism and philanthropy. Beginning in 1947 African governance and culture became a part of Etta and Claude life as they traveled to the continent several times on behalf of three United States presidents during the movement for African independence. In March of 1957 Etta interviewed Martin Luther King Jr. about Ghana's independence celebration. Though her husband died in 1967, she carried on their support of African progress for the next thirty-seven years. In the 1950s she broadcast her own radio show, *I Remember When*, to listeners in thirty-eight states. Various organizations, such as the African American Institute, the National Council for Negro Women, the DuSable Museum of African American History, and the Chicago Lyric Opera, received her support and membership. In 1979 her legendary work earned her a place in the Black Filmmakers Hall of Fame.

At the age of ninety-six, Barnett remarked, "I've always said that the only difference between a rut and a grave is the depth, and I'm not ready for either one" (Kinnon, "Etta Moten Barnett," 52–54). Having lived a long, fulfilling life Etta Moten Barnett died of pancreatic cancer in Chicago's Mercy Hospital at the age of 102. Barnett's diverse acting roles, her portrayal of Bess, and her philanthropy have left a lasting impression on American culture.

FURTHER READING

Kinnon, Joy Bennett. "A Diva for All Times," *Ebony* (2004).

Kinnon, Joy Bennett. "Etta at 100: Etta Moten Barnett, Pioneer Actress, Singer, and Activist, Celebrates Centennial," *Ebony* 57 (2001).

Kinnon, Joy Bennett. "Etta Moten Barnett: Still on the Case at 96," *Ebony* (1997).

Laskas, Jeanne Marie. "Her Heart Keeps on Singing," *Good Housekeeping* 226, issue 2 (1998).

"Pioneer Actress-Singer Etta Moten Barnett Celebrates 100th Birthday in Chicago." *Jet* 100 (Dec. 2001).

Obituaries: (London) *Independent*, 7 Jan. 2004; *Variety*, 12 Jan. 2004; *Jet*, 26 Jan. 2004.

ALLISON KELLAR

BARNETT, Ida B. Wells

(16 July 1862–25 Mar. 1931), antilynching reformer and journalist, was born Ida Bell Wells, the first of eight children born to James Wells, a carpenter, and Elizabeth Arrington, a cook, in Holly Springs, Mississippi. Her parents worked for Spires Boling, a contractor and architect, as slaves and then as free blacks until 1867, when James Wells, against the wishes of his employer, exercised his new right to vote. After returning from the polls to find his carpentry shop locked, Wells moved the family to a house nearby and went into business for himself. In Holly Springs, Ida Wells attended a freedmen's school, of which her father was a trustee, and Shaw University (later Rust College), founded by the Freedmen's Aid Society of the Methodist Episcopal Church and incorporated in 1870.

Ida Wells's early life as a "happy, light-hearted schoolgirl" (Duster, 16) was upended in 1878, when both of her parents and her infant brother died in a yellow fever epidemic that swept the Mississippi Valley that year. Wells, who was then sixteen years of age and the oldest of the five surviving siblings, dropped out of Shaw to support her family by teaching at a rural school in Mississippi. In 1880 or 1881, her two brothers went to live with members of her extended family. Around that time, one of her sisters died of a disease of the spine from which she had been suffering for several years. Subsequently, Wells's widowed aunt, Fanny Wells, invited Ida and her two younger sisters to join her in Memphis. Upon her arrival in the "Bluff City," as Memphis was called, Wells took classes at LeMoyne College and taught school in Woodstock, Tennessee, ten miles outside the city; subsequently she taught in the Memphis public school system.

Wells's activist career began in earnest on 15 September 1883, when she refused to leave a first-class ladies car on the Chesapeake, Ohio, and Southwestern Railway. After the U.S. Supreme Court overturned the 1875 Civil Rights Acts in October of 1883, Wells again attempted to ride a first-class car, so that her subsequent suit against the railway could challenge the Supreme Court's decision. Although Wells won her case in the lower courts in 1884, the Tennessee Supreme Court overturned the decision in 1887.

Soon after the first court decision, Wells was asked to write about her protest for the *Living Way*,

a Baptist weekly in Memphis. Her successful debut as a journalist came at a time when urbanization and the increase in black literacy rates helped propel the growth and independence of the black press. Taking the pen name of "Iola," she was soon invited to write about practical matters, black womanhood, and politics in black weeklies across the country and, occasionally, for the white dailies in Memphis. In 1887 Wells became the first woman elected as an officer of the Negro Press Association, which had been established in 1884. By 1889 she was anointed "The Princess of the Press" by her colleagues and became a co-owner of the *Free Speech and Headlight*, a militant weekly.

In 1891 a *Free Speech* editorial praising black men who set fire to buildings in Georgetown, Kentucky, in response to a lynching drew calls for the paper's extinction. In the same year, Wells was fired from her teaching position when she wrote an editorial criticizing the inadequacy of the segregated schools and the sexual exploitation of black woman teachers by white board members. With the opportunity to devote all her time to newspaper work, Wells continued writing and traveling throughout the Mississippi Valley to secure subscriptions for the paper.

When a mob murdered a close friend of Wells's and two of his associates in March 1892, Wells embarked on what became a lifelong crusade against the horrors of lynching. The victims— associated with the People's Grocery, a black-owned cooperative—were not killed for any criminal act, she editorialized, but because they took business away from a white competitor. The circumstances surrounding their deaths propelled Wells to call for a boycott of the Memphis trolleys, encourage thousands of blacks to leave Memphis for the newly opened Oklahoma Territory, and expose, as she put it, the "truth about lynching." Lynching had long been a common practice in rural America, especially in the South and West, but, beginning in the late 1880s, it began to take on a particularly racial character in the South. In 1892 alone, there were more than two hundred lynchings, most often of African Americans by whites. Southern white leaders routinely justified the practice by claiming that since emancipation black men had retrogressed to a savage state, and were raping white women. Lynching was primarily a problem in the South, but it was northern academics, at Harvard University, the University of Pennsylvania, and elsewhere, who were most responsible for promulgating theories of black retrogression.

Using the methods of investigative journalism (before there was such a category), Wells documented the fact that less than a third of black victims were even accused of rape, much less found guilty of it. Instead, she averred, it was black women who were the real victims of interracial rape and coercion. Blacks, she thought, were really being punished for their increasing militancy; for their ability to compete economically with whites; and, in particular, for the growing number of consensual relationships between black men and white women. Such assertions undermined the "scientific" racism of the period, the moral authority of white women and men, and the justification for the disenfranchisement of blacks. Her writings, replete with statistics and firsthand observation and interviews, provided the sociological framework that underpinned subsequent studies and antilynching strategies for the remainder of the twentieth century.

In 1892 Wells's campaign urged that blacks boycott the city streetcars and leave Memphis for the new territories opening in the West. Soon after, on 27 May 1892, the offices of *Free Speech* were destroyed, and Wells was exiled from the city upon the threat of death. She found refuge in Brooklyn, New York, where she wrote antilynching editorials for T. Thomas Fortune's *New York Age*, widely considered the country's best black newspaper. Subsequently, her writings were compiled into a pamphlet, *Southern Horrors: Lynch Law in All Its Phases*, which was subsidized by a testimonial given to Wells by black women activists from New York, Boston, and Philadelphia, Pennsylvania. The gathering held on 5 October 1892 was the "real beginning of the club movement among colored women in this country," Wells wrote in her autobiography, *Crusade for Justice* (Wells, 81). In 1896 the movement coalesced into the National Association of Colored Women, the first secular, nationwide organization of African American women.

In 1893 Wells was invited to take her campaign to the British Isles by two editors of *Anti-Caste*, an anti-racist journal published in England. She returned to the United States to protest the exclusion of blacks from the 1893 World's Columbian Exposition in Chicago and to publish a pamphlet, *The Reason Why the Colored American Is Not in the World's Columbian Exposition*, with, among others, Frederick Douglass, an

ardent supporter of her campaigns. Wells's return to the British Isles in 1894 resulted in the formation of the British Anti-lynching Committee, made up of influential journalists, members of Parliament, and such prominent figures as the Duke of Argyll and the Archbishop of Canterbury. Such attention pressed important liberal figures in the United States, including the labor leader Samuel Gompers and the Women's Christian Temperance Union president Frances Willard (who had earlier opposed Wells), to lend their names to the antilynching cause. Upon her return, Wells continued her campaign across the United States and in 1895 published the anti-lynching pamphlet *The Red Record*.

In June of 1895 Ida Wells married Ferdinand L. Barnett, a Chicago widower who had founded the *Conservator*, the city's first black newspaper, and who, in 1896, became the first black appointed as an assistant state's attorney for Cook County. Soon after their marriage, Wells-Barnett purchased the *Conservator* from stockholders and presided over the Ida B. Wells Club, founded in 1893, which helped establish one of the first black kindergartens in the city. While remaining active in many endeavors, Wells-Barnett and her husband had four children: Charles in 1896, Herman in 1897, Ida in 1901, and Alfreda in 1904. During this period, she campaigned for Republican candidates throughout the state, cofounded the interracial Frederick Douglass Club, worked with the settlement-house founder Jane Addams to thwart calls for segregation in the Chicago public schools, enjoined an interracial delegation to the White House to protest the lynching of a South Carolina postmaster, and mobilized protests against lynchings in her adopted state of Illinois.

In August of 1908, a riot in Springfield, Illinois—in which two blacks were lynched and businesses and homes destroyed—so alarmed a group of northern reformers that they called for the establishment of a new organization later known as the National Association for the Advancement of Colored People (NAACP). Although Wells-Barnett was one of its "Founding Forty" members, she later criticized the organization for its moderation. In response to the riot, Wells-Barnett established the Negro Fellowship League, a settlement house that provided employment and legal protection for the burgeoning number of blacks who migrated to Chicago from the South. In 1913, when women gained limited suffrage in Illinois, Wells-Barnett cofounded the first black women's suffrage club in Chicago, the Alpha Suffrage Club, which was instrumental in the election two years later of the first black city alderman, OSCAR DE PRIEST.

During World War I, both Barnetts were associated with militant protest and, like others viewed by the federal government as "radicals," were the subjects of dossiers compiled by military intelligence. In 1917, despite warnings by government authorities that she was committing treason, Wells-Barnett protested the hanging of twelve black soldiers who were court-martialed for their alleged role in a riot in Houston, Texas, where the men were stationed. Although she was not arrested, Wells-Barnett was refused a passport to attend the Versailles Peace Conference in 1919 as a delegate of the National Equal Rights League, an organization headed by the Boston editor WILLIAM MONROE TROTTER. MARCUS GARVEY's Universal Negro Improvement Association had also selected Wells-Barnett as a delegate to the Versailles Conference.

The ending of the war in Europe coincided with an upsurge in racial violence in the United States, and Wells-Barnett again played a vital role in publicizing these events. She published on-site investigations of the 1918 East St. Louis Massacre, where at least forty black people lost their lives, and also covered the even bloodier Elaine, Arkansas, race riot the following year. The Arkansas riot was precipitated by local authorities when they attempted to break up a union meeting of black sharecroppers. Several of the farmers and a white deputy sheriff were killed in the melee, but the response by white planters and farmers was unprecedented in its barbarity. Over the course of seven days, local whites, aided and abetted by U.S. infantry troops, systematically chased down and killed more than two hundred African Americans in what historian David Levering Lewis has described as an American pogrom. More than a thousand black sharecroppers were rounded up and packed in a stockade. Wells-Barnett, the NAACP, and other organizations engaged in a multi-year effort to defend the sharecroppers, twelve of whom were sentenced to death. Sixty-seven others were given lengthy prison terms.

But the racial violence of the era was not restricted to the South. In her hometown of Chicago in 1919, an attack and subsequent drowning of a black youth, swimming in the "white side" of a beach area, escalated into urban warfare

that resulted in the death of thirty-eight people, including fifteen whites and twenty-three blacks. The Chicago riot was distinguished by the militant response of blacks who fought back and, in some cases, took the offensive. In its aftermath, Wells-Barnett urged blacks to testify against white assailants. She also became active in civic organizations formed to ameliorate race relations and, with her lawyer husband, helped defend African Americans indicted for violent crimes and murder during the uprising.

Despite her declining health in the 1920s, Wells-Barnett continued to fight discrimination and racial violence through the Ida B. Wells Club. She also remained active in politics with the Cook County League of Women's Clubs and helped to establish an early Chicago branch of A. PHILIP RANDOLPH's Brotherhood of Sleeping Car Porters and Maids. In 1930, a year before her death of uremia in Chicago, she ran unsuccessfully as an independent for a state senate seat in Illinois.

Wells-Barnett left a rich legacy of activism. She helped to establish community institutions and organizations that aided poor blacks, empowered women, and defended those unjustly accused by the legal and extra-legal systems of law. Wells-Barnett's strategies, developed through her campaign against lynching, also anticipated future political movements. Her militant activism drew upon a long tradition of African American civil disobedience and self-defense, and her political journalism challenged the prevailing racial and sexual stereotypes of her times. Her essential radicalism, which focused on the interconnections of race, class, and gender discrimination, prefigured that of later black feminist activists and writers such as Angela Davis, Alice Walker, and Bell Hooks.

FURTHER READING

The Ida B. Wells Papers, including her diary, are in Special Collections, Reggenstein Library, University of Chicago.

Duster, Alfreda M. *Crusade for Justice: The Autobiography of Ida B. Wells* (1970).

McMurry, Linda O. *To Keep the Waters Troubled: The Life of Ida B. Wells* (1998).

Obituaries: Chicago Tribune, 25 March 1931; *Chicago Defender*, 4 April 1931; *National Notes*, May 1931: 17; *Crisis*, June 1931: 207.

PAULA J. GIDDINGS

BARTHÉ, Richmond

(28 Jan. 1901–6 Mar. 1989), sculptor, was born in Bay St. Louis, Mississippi, the son of Richmond Barthé and Marie Clementine Roboteau, a seamstress. His father died when Barthé was one month old. Barthé began drawing as a child and first exhibited his work at the county fair in Mississippi at age twelve. He did not attend high school, but he learned about his African heritage from books borrowed from a local grocer and publications given to him by a wealthy white family that vacationed in Bay St. Louis. This family, which had connections to Africa through ambassadorships, hired Barthé as a butler when he was in his teens; he moved with them to New Orleans. At age eighteen Barthé won first prize for a drawing he sent to the Mississippi County Fair. Lyle Saxon, the literary critic for the *New Orleans Times Picayune*, then attempted to register Barthé in a New Orleans art school, but Barthé was denied admission because of his race.

In 1924 Barthé began classes at the School of the Art Institute of Chicago, his tuition paid by a Catholic priest, Harry Kane. Living with an aunt, Barthé paid for his board and art supplies by working as a porter and busboy. During his senior year Barthé began modeling in clay at the suggestion of his anatomy teacher, Charles Schroeder. His busts of two classmates were shown in the Negro History Week exhibition. These works, along with busts of the Haitian general Toussaint-Louverture and the painter HENRY OSSAWA TANNER (first exhibited at a children's home in Gary, Indiana), were included in the Chicago Art League annual exhibition in 1928, the year of Barthé's graduation.

Barthé achieved wide recognition for his bronze busts and figures in the 1930s and 1940s. Within a year after his move to New York City in February 1929, he completed thirty-five sculptures. He continued his education at the Art Students League with fellowships from the Rosenwald Foundation (1929–1930). Barthé's first solo exhibitions (favorably reviewed by the *New York Times*) were in 1934 at the Caz-Delbo Gallery in New York, the Grand Rapids Art Gallery in Michigan, and the Women's City Art Club in Chicago, followed by exhibitions in New York at Delphic Studios (1935), Arden Galleries (1939), DePorres Interracial Center (1945), International Print Society (1945), and Grand Central Art Galleries (1947). He also exhibited in numerous group shows at various institutions, including the Harmon Foundation (1929, 1931, and 1933), the New

York World's Fair (1939), the Whitney Museum annual exhibitions (1933, 1940, 1944, and 1945), the Metropolitan Museum of Art's *Artists for Victory* (1942), and the Pennsylvania Academy of Fine Arts' annual exhibitions (1938, 1940, 1943, 1944, and 1948).

Many of Barthé's early works, such as *Masaai* (1933), *African Woman* (c. 1934), and *Wetta* (c. 1934), depict Africans. Barthé dreamed of visiting Africa, stating, "I'd really like to devote all my time to Negro subjects, and I plan shortly to spend a year and a half in Africa studying types, making sketches and models which I hope to finish off in Paris for a show there, and later in London and New York" (Lewis, 11), but he never traveled to the continent. Other works by Barthé, such as *Feral Benga, Stevedore,* and *African Man Dancing* (all 1937), were among the first sculptures of black male nudes by an African American artist.

In the mid-1930s Barthé moved from Harlem to midtown Manhattan for a larger studio and to be closer to major theaters, as many of his clients were theatrical celebrities. Among his portrait busts are *Cyrina* (from *Porgy and Bess,* c. 1934), *Sir John Gielgud as Hamlet* (commissioned for the Haymarket Theatre in London, 1937), *Maurice Evans as Richard II* (1938, in the Shakespeare Theatre in Stratford, Connecticut), and *Katherine Cornell as Juliet* (1942). Barthé later produced busts of other entertainers, such as JOSEPHINE BAKER (1950) and PAUL ROBESON as Othello (1975).

Barthé's largest work was an eight-by-eighty-foot frieze, *Green Pastures: The Walls of Jericho* (1937–1938), which he completed under the U.S. Treasury Art Project at the Harlem River Housing Project. His other public works of art include portraits of Abraham Lincoln, in New York (1940) and India (1942); Arthur Brisbane, in Central Park; GEORGE WASHINGTON CARVER, in Nashville (1945), and BOOKER T. WASHINGTON, at New York University (1946).

Many of Barthé's busts, such as *Birth of the Spirituals* (1941) and *The Negro Looks Ahead* (1944), are imbued with a calm spirituality. Barthé described his representational work as an attempt to "capture the beauty that I've seen in people, and abstraction wouldn't satisfy me. . . . My work is all wrapped up with my search for God. I am looking for God inside of people. I wouldn't find it in squares, triangles and circles" (Reynolds and Wright, 154). A strong believer in reincarnation, the artist often called himself an "Old Soul" who had been an artist in Egypt in an earlier life.

In the 1940s Barthé received numerous awards, beginning with Guggenheim fellowships in 1941 and 1942. In 1945 he was elected to the National Sculpture Society (sponsored by the sculptor Malvina Hoffman) and the American Academy of Arts and Letters. He also received the Audubon Artists Gold Medal of Honor and the James J. Hoey Award for interracial justice. The sculptor was also active in several artists' organizations: the Liturgical Arts Society, the International Print Society, the New York Clay Club, and the Sculptors Guild. He also had solo exhibitions at the South Side Art Center in Chicago (1942); the Sayville Playhouse on Long Island (1945); the Margaret Brown Gallery in Boston (1947); and Montclair Art Museum in New Jersey (1949).

In 1950 Barthé received a commission from the Haitian government to sculpt a large monument to Toussaint-Louverture; it now stands in front of the Palace in the Haitian capital, Port-au-Prince. In 1947 Barthé had moved to Jamaica, where he remained through the late 1960s. His most notable works from this time are the General Dessalines monument in Port-au-Prince (1952) and a portrait of Norman Manley, the prime minister of Jamaica (1956). The Institute of Jamaica hosted Barthé's solo show in 1959. In 1964 the artist received the Key to the City from Bay St. Louis. He then sculpted contemplative black male nudes, such as *Meditation* (1964), *Inner Music* (1965), and *Seeker* (1965).

Barthé left the West Indies in 1969 because of increasing violence there and spent five years traveling in Switzerland, Spain, and Italy. He then settled in Pasadena, California, and worked on his memoirs. In 1978 he had a solo exhibition at the William Grant Still Center in Los Angeles and was subsequently honored by the League of Allied Arts there in 1981. He died in Pasadena. Following his death, a retrospective was held at the Museum of African American Art (1990). Barthé's work toured the United States with that of Richard Hunt in the Landau/Traveling Exhibition *Two Sculptors, Two Eras* in 1992. His work, which was eventually collected by the Metropolitan and Whitney museums in New York City, the Smithsonian Institution in Washington, D.C., and the Art Institute of Chicago, among many others, continues to be featured in exhibitions and survey texts on African American art.

FURTHER READING

Lewis, Samella. *Two Sculptors, Two Eras* (1992).

Reynolds, Gary A., and Beryl J. Wright. *Against the Odds: African American Artists and the Harmon Foundation* (1989).

THERESA LEININGER-MILLER

BATES, Peg Leg

(11 Oct. 1907–8 Dec. 1998), tap dancer and entrepreneur, was born Clayton Bates in Fountain Inn, South Carolina, the son of Rufus Bates, a laborer, and Emma Stewart, a sharecropper and housecleaner. He began dancing when he was five. At age twelve, while working in a cotton-seed gin mill, he caught and mangled his left leg in a conveyor belt. The leg was amputated on the kitchen table at his home. Although he was left with only one leg and a wooden peg leg that his uncle carved for him, Bates resolved to continue dancing. "It somehow grew in my mind that I wanted to be as good a dancer as any two-legged dancer," he recalled. "It hurt me that the boys pitied me. I was pretty popular before, and I still wanted to be popular. I told them not to feel sorry for me." He meant it. He began imitating the latest rhythm steps of metal tap-shoe dancers, adding his own novelty and acrobatic steps. He worked his way from minstrel shows and carnivals to the vaudeville circuits. At fifteen, after becoming the undisputed king of one-legged dancers, able to execute acrobatic, graceful soft-shoe dancing and powerful rhythm-tapping all with one leg and a peg, Bates established a professional career as a tap dancer.

In 1930, after dancing in the Paris version of Lew Leslie's *Blackbirds of 1928*, Bates returned to New York to perform as a featured tap dancer at such famous Harlem nightclubs as the Cotton Club, Connie's Inn, and Club Zanzibar. On Broadway in the 1930s he reinvented such popular tap steps as the Shim Sham Shimmy, Susie-Q, and Truckin' by enhancing them with the rhythmic combination of his deep-toned left-leg peg and the high-pitched metallic right-foot tap. As one of the black tap dancers able to cross the color barrier, Bates joined performers on the white vaudeville circuit of Keith & Loew and performed on the same bill as BILL "BOJANGLES" ROBINSON, Fred Astaire, and Gene Kelly. In 1949 Bates sang and danced the role of the swashbuckling pirate Long John Silver in the musical review *Blackouts*. "Don't give up the ship, although you seem to lose the fight; life means do the best with all you got, give it all your might," he sang in the Ken Murray musical that played for three years at the Hollywood and Vine Theatre in Hollywood, California. Wearing a white suit and looking as debonair as Astaire, Bates made his first television appearance in 1948 on *This Is Show Business*, a show hosted by Clifton Fadiman and Arlene Francis, performing high-speed paddle-and-roll tapping and balancing on his rubber-tipped peg as though it were a ballet pointe shoe. On the *Ed Sullivan Show* in 1955, Bates strutted his stuff as he competed in a tap challenge dance, countering Hal LeRoy's wiggly steps with airy wing steps. "You're not making it easy," Bates chided as he tossed off heel clicks and soared into a flash finish with trenches (in which the body leans forward on the diagonal and the legs kick high to the back). Bates made more than twenty appearances on the *Ed Sullivan Show*, last appearing in a tap challenge dance with "Little Buck" on 22 August 1965.

While television gave him greater fame than ever before, Bates continued to pursue a variety of performance venues. In 1951 he invested his earnings and, with his wife, Alice, purchased a large turkey farm in New York's Catskill Mountains and converted it into a resort. The date of his marriage to Alice is not known, but the marriage lasted until her death in 1987. They had one child. The Peg Leg Country Club, in Kerhonkson, New York, flourished as the largest resort in the country that was owned and operated by a black person, and it catered to a largely black clientele and featured hundreds of jazz musicians and tap dancers. "During the prejudice years, country clubs were not integrated," said Bates, "and I started thinking how blacks might like to have a country resort just like any other race of people." After selling the property in 1989, Bates continued to perform and teach. He appeared before youth groups, senior citizens, and handicapped groups, spreading his philosophy of being involved in spite of life's adversities and encouraging youngsters to be drug-free and pursue an education. "Life means, do the best you can with what you've got, with all your mind and heart. You can do anything in this world if you want to do it bad enough," he often said.

Bates's tap dancing was melodically and rhythmically enhanced by the combination of his deep-toned peg, made of leather and tipped with rubber, with the higher-pitched metallic tap shoe.

He was also accomplished in acrobatics, flash dancing (that is, executing spectacularly difficult steps involving virtuosic aerial maneuvers), and novelty dancing. He consistently proved himself beyond his peg-legged specialty, surpassing many two-legged dancers to become one of the finest rhythm dancers in the history of tap dancing.

In 1992 Bates was master of ceremonies at the National Tap Dance Day celebration in Albany, New York, where he received a Distinguished Leadership in the Arts award. In 1991 Bates was honored with the Flo-Bert Award by the New York Committee to Celebrate National Tap Dance Day. Bates died in Fountain Inn, South Carolina, just a mile and a half from the place where he lost his leg.

FURTHER READING
Hill, Constance Valis. "Tap Day to Receive a Peg Leg Flourish." *Albany Times Union*, 22 May 1992.
Frank, Rusty. *Tap! The Greatest Tap Dance Stars and Their Stories, 1900–1955* (1990, 1994).

Obituary: New York Times, 8 Dec. 1998.

CONSTANCE VALIS HILL

BEARDEN, Romare

(2 Sept. 1911–11 Mar. 1988), artist, was born Romare Howard Bearden in Charlotte, North Carolina, the son of R. Howard Bearden, a grocer, and Bessye Johnson. When Bearden was about four years old, the family moved to New York, settling in Harlem, where he went to public school and his parents developed a wide network of acquaintances among the Harlem jazz musicians and intellectuals of the day. His father later became an inspector for the New York Board of Health; his mother, a civic leader. Bearden finished high school in Pittsburgh, however, having lived there for a time with his grandmother. In 1932, after two years at Boston University, he transferred to New York University, where he created illustrations for the undergraduate humor magazine and earned a BS degree in Education in 1935. For the next two years he contributed political cartoons to the *Baltimore Afro-American*. Unable to find steady work, he enrolled at the Art Students League and studied drawing with the German emigré artist George Grosz in 1936–1937.

At about this time, Bearden joined the 306 Group, an informal association of black artists and writers—among them JACOB LAWRENCE and RALPH ELLISON—who met in the studio of his cousin, the painter CHARLES ALSTON, at 306 West 141st Street. From 1938 to 1942, now beginning to paint, Bearden supported himself as a full-time caseworker with the New York City Department of Social Services, a job to which he returned after World War II. In 1940, at the Harlem studio of a friend, Ad Bates, Bearden exhibited some of the work he had completed over the past four years, including paintings in oil and gouache, watercolors, and drawings. Taking his own studio on 125th Street, located over the Apollo Theater, he began work on a series of paintings that evoked the rural South of his childhood. Typical of the series is *Folk Musicians* (1941–1942), painted in a bold and dramatic style with flat planes and simplified, colorful figures.

While serving with an all-black regiment in 1944, Bearden mounted a solo exhibition at the "G" Place Gallery in Washington, D.C., which brought him to the attention of the influential New York dealer Samuel Kootz. Bearden's first exhibition at the Kootz Gallery, in 1945, was devoted to the *Passion of Christ* series, a group of semiabstract, cubist-inspired watercolors on paper. The exhibition was highly successful in terms of reviews and sales; *He Is Arisen*, purchased by the Museum of Modern Art in New York, was the first of Bearden's works to enter a museum collection. The following year, Kootz exhibited Bearden's painting *Lament for a Bullfighter*, inspired by García Lorca's poem "Lament for the Death of a Bullfighter." Inclusion of Bearden's works in the 1945 and 1946 annuals at the Whitney Museum of American Art in New York and in the Abstract and Surrealist American Art show held at the Art Institute of Chicago in 1948 further boosted his growing reputation.

In 1951 Bearden went to Paris on the GI Bill to study philosophy at the Sorbonne. In addition to meeting the Cubist masters Pablo Picasso and Georges Braque, Bearden joined the circle of black artists and writers inspired by the concept of negritude. As he later admitted, however, the most significant thing he learned during his year in France was how to relate the black experience to universal experience. Between 1952, when he returned to New York, and 1954, the year he married the West Indian dancer Nanette Rohan, Bearden devoted himself mainly to music; some twenty of the songs he wrote in this period were published and recorded. Bearden then returned to painting and set up a new studio in lower Manhattan, on Canal Street, where he and his wife lived for the rest of his life. (They had no

children.) In 1961 he showed some of his now wholly abstract oil paintings in the first of several solo exhibitions at the Cordier & Ekstrom Gallery, his dealers from that year on.

Bearden, who had described art in the journal he began keeping in 1947 as "a kind of divine play" (Schwartzman, 217), was increasingly drawn to collage, a way of "playing" with assortments of materials to create a whole and a medium much employed by the Cubists. He created his first signed collage, *Circus*, in 1961; three years later collage became his chief method of expression. The beginning of the civil rights movement and his participation in the discussions of the Spiral Group (which he cofounded in 1963) on the role of black artists in a time of new challenges coincided with this profound change in Bearden's art. In 1964 he created a series of small montages composed of fragments of reproductions cut from newspapers, magazines, or postcards and pasted onto a paper backing; these assemblages were then photographed and enlarged. The resulting *Projections*, as Bearden titled them, were exhibited that year at Cordier & Ekstrom. Later, arranged in series by subject matter, they were developed into true collages. One such sequence, titled *The Prevalence of Ritual*, includes individual panels representing "The Funeral," "The Baptism," and "The Conjur Woman." Another collage series evokes Harlem street life, as in *The Dove*, a crowded assemblage of cutout figures set against a suggestion of city buildings. The bizarrely composite figures, the abrupt shifts in scale between heads and bodies, and the arbitrary spatial relationships convey the rich, kaleidoscopic variety of the scene. Other series recall the Harlem jazz world of the 1930s (*The Savoy*, for example) and southern life (the nostalgic *Train Whistle Blues*).

As Bearden developed his collage techniques into the 1970s, he began to incorporate more of his own painted touches, in acrylics or watercolors, as well as torn pieces of paper in various hand-painted colors and bits of fabric. Spaces were opened up and thus were easier to perceive. Coinciding with the start of annual visits to his wife's family home on Saint Martin, the artist's palette took on the lush colors of the Caribbean and the collage figures became overtly sensuous. One of these later collages, *The Block* (1971), a large six-panel composition, approached mixed-media work; with the accompaniment of taped gospel and blues music, children's voices, and actual street noises, it re-created the look, sounds, and "feel" of an urban street.

Besides working in collage, Bearden designed tapestries and posters; in 1968 he was represented in an international poster exhibition in Warsaw, Poland. He designed sets for the Alvin Ailey Dance Company in 1977 and continued to make prints, including the colored lithographs that illustrate a 1983 edition of the work of the Caribbean poet Derek Walcott. He also created murals, such as *Quilting Time*, commissioned by the Detroit Institute of Arts and installed there in 1986. In it, the quilter and six onlookers form a frieze against a brilliantly hued tropical setting. The whole is a mosaic of glass tesserae, so combined and colored as to suggest the molding of bodies and the textures and folds of fabrics.

A large traveling retrospective of Bearden's work, organized by the Mint Museum in Charlotte, North Carolina, in 1980 and concluding its tour at the Brooklyn Museum in 1981, capped Bearden's career. Also in 1980 he taught at Yale University, one of several temporary teaching posts he held during the course of his career. Represented in every major museum in New York City and in others throughout the country, he is considered to have transformed collage, generally regarded as a minor art form, into a forceful means of expression with universal appeal. His biographer called him "An artist for all seasons and for all humankind" (Schwartzman, 305).

In addition to *The Painter's Mind: A Study of Structure and Space in Painting*, written with his longtime friend, the artist Carl Holty (1969), Bearden wrote (with Harry Henderson) *A History of Afro-American Artists from 1792 to the Present*, which was posthumously published in 1993. He and Henderson also wrote a book for young readers, *Six Black Masters of American Art* (1972).

Part of Bearden's legacy consists of his multiple roles as teacher; as art director of the Harlem Cultural Council, to which he was appointed in 1964; as organizer of the landmark exhibition, the Evolution of Afro-American Artists: 1800–1950, held at City College of New York in 1967; and as cofounder, in 1969, of the Cinque Gallery in New York, a showcase for younger artists from various minority groups. For these contributions, Bearden was inducted into the National Institute of Arts and Letters in 1966; he was honored by his home state in 1976 as recipient of the Governor's Medal of the State of North Carolina,

and he also was awarded the National Medal of Arts in 1987. The Pratt Institute (1973) and Carnegie-Mellon University (1975) awarded him honorary doctorates. He died in New York City.

FURTHER READING

The Schomburg Center for Research in Black Culture of the New York Public Library is the primary source of archival material relating to Bearden: photographs, his sketchbook and notebooks, and correspondence. The center also maintains a collection of his posters as well as examples of his other work. The Archives of American Art in New York houses the Romare Bearden Papers.

Campbell, Mary Schmidt, and Sharon F. Patton. *Memory and Metaphor: The Art of Romare Bearden, 1940–1987* (1991).

Igoe, Lynn M., with James Igoe. *250 Years of Afro-American Art: An Annotated Bibliography* (1981).

Schwartzman, Marvin. *Romare Bearden: His Life and Art* (1990).

Obituary: *New York Times*, 13 Mar. 1988.

ELEANOR F. WEDGE

BEAVERS, Louise

(8 Mar. 1902–26 Oct. 1962), actress, was born in Cincinnati, Ohio, the daughter of William Beavers. Her mother's identity is not known. As a child Louise moved with her musically inclined family to California, where in 1918 she graduated from Pasadena High School. She then joined the Ladies' Minstrel Troupe for a year before being recognized by talent scouts.

Beavers, who would appear in more than one hundred motion pictures, began her Hollywood career by playing a maid to leading lady Lilyan Tashman in *Gold Diggers* (1923). Early on, maid was a role that Beavers had to play offscreen as well as on. From 1920 to 1926 she worked first as a dressing room attendant and then as the personal maid of the actress Leatrice Joy. In 1927 Beavers landed a major role in *Uncle Tom's Cabin*, followed in 1929 by roles in *Coquette* and *Nix on Dames*. In the early 1930s she earned critical notices for her handling of subservient roles in *Ladies of the Big House* (1932), *What Price Hollywood?* (1932), *Bombshell* (1933), and *She Done Him Wrong* (1933). Big-boned, dark-skinned, and usually smiling on the screen, Beavers was best known for playing the good-natured maid or

Louise Beavers, appearing as the star in the motion picture *Prison Bait, c. 1939. (Library of Congress.)*

housekeeper for such stars as Mae West, Claudette Colbert, and Jean Harlow.

Typecast as a maid for her entire career, Beavers was seen serving a cavalcade of other motion picture greats, including Clara Bow, Boris Karloff, Hedda Hopper, James Stewart, Joan Crawford, Spencer Tracy, Ralph Bellamy, Ginger Rogers, Joan Blondell, Jimmy Durante, Edward G. Robinson, Humphrey Bogart, Ronald Reagan, Jane Wyman, Rosalind Russell, Henry Fonda, Bing Crosby, John Wayne, Zero Mostel, Orson Welles, Marlene Dietrich, W. C. Fields, Sidney Poitier, June Allyson, Jack Lemmon, Debbie Reynolds, Lloyd Bridges, Natalie Wood, and Pearl Bailey, among many others. As the film historian Donald Bogle has pointed out, Beavers came to epitomize the lovable, loyal, overweight "Mammy" figure seemingly capable of taking on all the troubles of the world. "She perfected the optimistic, sentimental black woman

whose sweet, sunny disposition and kindheartedness almost always saved the day, the Depression era's embodiment of Christian stoicism and goodness, lending a friendly ear and hand to down-on-their-luck heroines, who knew that when the rest of the world failed them, Louise would always be there" (Bogle, 73).

Beavers's professional breakthrough came in her powerful portrayal of the businesslike, pancake-flapping Aunt Delilah to Claudette Colbert's Bea in *Imitation of Life* (1934), a sensitive performance acclaimed by both the white and black press; many critics felt that Beavers deserved an Oscar nomination. Yet what Beavers mostly won from that performance was the "Aunt Jemima" label that would stick to her forever. Despite her screen persona as a domestic, Beavers never cooked, though she did maintain a high-calorie diet to keep her weight up, and she took elocution lessons to cultivate a southern drawl. She married LeRoy Moore in the late 1950s.

Beavers was proud to be featured in two pioneering black-cast films produced by Million Dollar Productions, *Life Goes On* (1938) and *Reform School* (1939), even though in *Reform School* her role as a probation officer was a Mammy-type character. Of note is that, whereas in these films her respective characters were named "Star" and "Mother Barton," in other movies her names were usually associated with black servitude, such as "Lulu" in *The Expert* (1932), "Ivory" in *Ladies of the Big House* (1932) and *Women without Names* (1940), "Pearl" in *She Done Him Wrong* (1933), "Loretta" in *Bombshell* (1933), "Magnolia" in *Pick Up* (1933), "Imogene" in *Hat, Coat, and Gloves* (1934), "Florabelle" in *Wives Never Know* (1936), "Ophelia" in *Virginia* (1941), "Ruby" in *The Big Street* (1942), "Maum Maria" in *Reap the Wild Wind* (1942), "Mammy Jenny" in *Jack London* (1943), "Bedelia" in *Barbary Coast Gent* (1944), "Petunia" in *Seven Sweethearts* (1942), "Gussie" in *Mr. Blandings Builds His Dream House* (1948), and "Mammy Lou" in *Belle Starr* (1941). More typically, however, Louise Beavers was listed in movie credits—if at all—simply as "maid" (*Night World, Street of Women,* and *Young America,* all 1932), "cook" (*Made for Each Other,* 1939), "Mammy" (*Too Busy to Work,* 1932), "Aunt [so-and-so]" (Tina in *The Lady's from Kentucky,* 1939), or "Mamie" (*Make Way for Tomorrow,* 1937).

Ending the 1940s with *Tell It to the Judge* (1949), Beavers then starred in *Girls' School, The JACKIE ROBINSON Story,* and *My Blue Heaven* in 1950; *Colorado Sundown, I Dream of Jeannie,* and *Never Wave at a WAC* in 1953; *Goodbye, My Lady, Teenage Rebel,* and *You Can't Run Away from It* in 1956; *Tammy and the Bachelor* in 1957; *The Goddess* in 1958; and *All the Fine Young Cannibals* in 1960.

Beavers also played roles on television. Following on the heels of two other prominent black actresses who had starred on the popular television series *Beulah* (ETHEL WATERS and Hattie McDaniel), Beavers decided to play the Henderson household's good-natured domestic. Her brief tenure, begun in 1952, lasted until the next year, when the show went off the air because she decided to leave the role. Her other television credits include *Star Stage* (1956), "The Hostess with the Mostest" on *Playhouse 90* (1957), and "Swamp Fox" on *Walt Disney Presents* (1959). Perhaps it was appropriate that, after nearly three decades and more than 116 films, Beavers's final role was the "Gilbert maid," serving Bob Hope and Lucille Ball in the 1961 madcap comedy *The Facts of Life*. She died the following year in Los Angeles.

The career of Louise Beavers serves as a critical reminder of how, in the early days of Hollywood, the stock roles available to black actresses progressed from merely inhabiting the background to representing a servile and gratuitous stereotype. Just as Aunt Delilah in *Imitation of Life* selflessly shares her pancake recipe with Bea rather than cash in on it herself, Louise Beavers exemplifies the legions of other early black actresses whose talents were subordinated to the self-serving biases of the dominant society.

FURTHER READING

Bogle, Donald. *Brown Sugar: Eighty Years of America's Black Female Superstars* (1980).

Loukides, Paul, and Linda K. Fuller, eds. *Beyond the Stars: Stock Characters in American Popular Film* (1990).

Nesteby, James R. *Black Images in American Films, 1896–1954: The Interplay between Civil Rights and Film Culture* (1982).

LINDA K. FULLER

BECHET, Sidney

(14 May 1897–14 May 1959), clarinetist, soprano saxophonist, and composer, was born Sidney Joseph Bechet, the youngest of five sons and two daughters (three other children died in infancy) born to Omar

Bechet, a shoemaker, and Josephine Michel in New Orleans, Louisiana. Bechet was raised as a middle-class Creole at the time when state law reclassified Creoles of color as Negro. The adoption of the black codes and de jure segregation had profound repercussions for the first generations of ragtime and jazz musicians in the Crescent City. Although Sidney spoke French in his childhood household and his grandfather, Jean Becher, was free and had owned property since 1817, Sidney Bechet identified himself as African American.

The Bechet family was decidedly musical. Sidney's father played the flute and trumpet for relaxation, and Sidney's brothers all played music as a hobby and developed skills in various trades for their vocations. Homer was a janitor and string bassist, Leonard a dentist and trombonist, Albert Eugene a butcher and violinist, Joseph a plasterer and guitarist. When he was only seven or eight years old, Sidney began playing a toy fife and soon began practicing on his brother's clarinet morning, noon, and night. He played in a band with his older brothers, but his family and other adult musicians quickly realized that Sidney was a prodigy whose technique outstripped that of some professionals.

Sidney's mother organized parties and hired professional bands to play in her home. When Sidney was just ten years old, she hired the great band of Manuel Perez (who sent the equally legendary Freddie Keppard as a substitute) to play for her oldest son's twenty-first birthday. George Baquet, the band's clarinetist, was late for the engagement, and Sidney, sequestered in another room, began playing his brother's clarinet as Baquet arrived. Sidney played well enough to cause Keppard to believe that it was Baquet warming up. As a result, Baquet began giving Sidney clarinet lessons. Bechet learned from him certain rudiments of clarinet playing, but he had already developed an unorthodox set of fingerings and refused to learn to read music. Bechet also studied with Paul Chaligny and Alphonse Picou. His most important influence, however, came from "Big Eye" Louis Nelson. Nelson did not play in the academic style and specialized in the rougher "uptown" styles of the black players. Another lasting influence was the opera, which his mother took him to listen to. He especially liked the tenors (his favorite was Enrico Caruso), and the heavy vibrato that characterized his playing was in part modeled after them.

As Bechet began to play with professional organizations in parades, picnics, dance halls, and parties, he did not attend school regularly, despite his family's admonitions, and he reportedly ignored their advice about learning a trade other than music. At age fourteen he joined the Young Olympians, and soon he was playing with all the notable bands of New Orleans, including those led by Buddy Petit and Bunk Johnson. Bechet's family worried about the boy's exposure to the seamier aspects of musicians' nightlife. Yet, in this setting, Bechet developed into a soft-spoken and charming fellow who was very attractive to women. He also became a heavy drinker with a very short fuse and sometimes displayed a violent temper. As a teenager he was jailed for a violent incident. This odd mixture of musical virtuosity, charm, and violence would follow Bechet throughout his adult life.

Bechet went to Chicago in 1918, where he quickly found work within the various New Orleans cliques that dominated the scene. There he met and played for NOBLE SISSLE, JAMES REESE EUROPE, and WILL MARION COOK. Bechet's virtuosity and his ear for melodies and harmony were such that he amazed all three of these bandleaders, despite his not being able to read music, a skill normally required for these orchestras. In 1919 Bechet joined Cook's Southern Syncopated Orchestra, which brought him to New York, where his talents were much in demand. He then went to the British Isles with Cook's orchestra. British audiences received the orchestra warmly, and many critics singled out Bechet's playing as noteworthy. The most important review came from the Swiss conductor Ernst Ansermet, who wrote, in what was the first truly insightful critical article on jazz, that Bechet was an "extraordinary clarinet virtuoso" and an "artist of genius."

While in England, Bechet bought a soprano saxophone. The soprano saxophone was used very little in jazz, in part because of the severe intonation problems it presents, especially in the early models. But Bechet had a strong embouchure and a highly developed vibrato that allowed him to express himself with the instrument, and his supremacy as the greatest soprano saxophonist in jazz was not challenged until John Coltrane took up the instrument years after Bechet's death. The saxophone was perfect for Bechet, as its brassier and louder projection facilitated his natural inclination

to take the melodic lead, usually the prerogative of trumpeters in the jazz ensembles of the 1910s and 1920s.

Bechet's stay in London ended when he was charged with assaulting a woman. Bechet pleaded not guilty, as did his codefendant, George Clapham. The stories of the two defendants and the two women involved conflicted, and Bechet hinted that his troubles with the police in England had racial overtones. He was sentenced to fourteen days of hard labor and was then deported on 3 November 1922.

Upon his arrival in New York, Bechet began to work in the theater circuit. He joined Donald Heywood's show *How Come*, in which Bechet played the role of How Come, a Chinese laundryman who was also a jazz musician. He was later billed as the "Wizard of the Clarinet" in theater bookings under Will Marion Cook's leadership. Bechet also began his recording career in New York, through CLARENCE WILLIAMS, a shrewd talent scout who helped supply black talent to record companies eager to cash in on the blues craze that followed MAMIE SMITH's hit record "Crazy Blues." In 1923 Bechet recorded his soprano saxophone on "Wild Cat Blues" and "Kansas City Man Blues" on Okeh Records. These records were listened to by thousands and served as models of jazz phrasing and improvisation for young musicians, including the likes of JOHNNY HODGES, Harry Carney, and Lionel Hampton. Bechet's success led to other recordings, where he accompanied singers such as Sara Martin, Mamie Smith, Rosetta Crawford, Margaret Johnson, EVA TAYLOR, and Sippie Wallace. Bechet also began composing and made a big impression with his "Ghost of the Blues." He also wrote significant portions of *Negro Nuances*, a musical cowritten with Will Marion Cook and his wife, ABBIE MITCHELL. While the musical was not successful, Cook praised Bechet's compositions lavishly in the *Chicago Defender*.

In 1925 Bechet joined the *Black Revue*, featuring JOSEPHINE BAKER. The show took them to France, where they both became expatriates. Bechet continued working under the leadership of Noble Sissle and others. He also worked extensively in Germany, where he met Elisabeth Ziegler in 1926. He would eventually marry her in 1951, after both of them had married and divorced others. His original plans to marry Ziegler, after bringing her back to Paris in 1928, were spoiled. An argument between Bechet

and the banjoist Gilbert "Little Mike" McKendrick began over a dispute about the correct harmonies to a song they had just played. By the end of the night the two were shooting at each other. Neither Bechet nor McKendrick was hit, but the pianist Glover Compton was shot in the leg, the dancer Dolores Giblins was shot in the lung, and an innocent bystander was shot in the neck. Bechet was sentenced to fifteen months in jail and was then deported.

He moved to Berlin and later returned to the United States after rejoining Noble Sissle's orchestra. In New York he led the New Orleans Feetwarmers with the trumpeter Tommy Ladnier. The group was short-lived, and Bechet briefly went into retirement from music and opened the Southern Tailor Shop in Harlem. In addition to tailoring, Bechet held jam sessions in the back room and cooked and served Creole cuisine. In 1934 Bechet returned to music once again at the behest of Noble Sissle. By the end of the 1930s the market for Bechet's style of jazz had lessened, but his cachet increased by the 1940s during the crest of the jazz revival. He played as either a bandleader or a star soloist throughout the United States. In 1949 he returned to Europe, eventually settling in France again, where he was the acknowledged patron saint of the European jazz revival. In 1951 he married Ziegler, with whom he lived for the rest of his life. He also had another home with a woman named Jacqueline, with whom he had a son, Daniel, in 1954. Bechet penned his most famous composition, "Petite fleur," in 1952, and in 1953 the Paris Conservatory Orchestra debuted his *La Nuit est une Sorcière*, a ballet in seven movements. With the help of two amanuenses, Joan Reid and Desmond Flower, Bechet also wrote *Treat It Gentle*, one of the most literarily ambitious jazz autobiographies.

Bechet, along with LOUIS ARMSTRONG, was among the first great jazz improvisers to liberate their solos from the rhythms and contours of the melody. Bechet's fame might have been even more widespread had the clarinet not fallen out of favor and the soprano saxophone been less obscure. He was the first to fashion legato melodies on the instrument and influenced such saxophone giants as Johnny Hodges and COLEMAN HAWKINS. He died before two of his disciples on the instrument, Steve Lacy and John Coltrane, popularized the instrument in the 1960s.

FURTHER READING

Bechet, Sidney. *Treat It Gentle* (1960).

Chilton, John. *Sidney Bechet: The Wizard of Jazz* (1987).

Obituary: *New York Times*, 15 May 1959.

SALIM WASHINGTON

BENNETT, Gwendolyn

(8 July 1902–30 May 1981), writer and artist, was born in Giddings, Texas, the daughter of Joshua Robin Bennett and Mayme F. Abernathy, teachers on an Indian reservation. In 1906 the family moved to Washington, D.C., where Gwendolyn's father studied law and her mother worked as a manicurist and hairdresser. When her parents divorced, her mother won custody, but her father kidnapped the seven-year-old Gwendolyn. The two, with Gwendolyn's stepmother, lived in hiding in various towns along the East Coast and in Pennsylvania before finally settling in New York.

At Brooklyn's Girls' High (1918–1921) Bennett participated in the drama and literary societies—the first African American to do so—and won first place in an art contest. She attended fine arts classes at Columbia University (1921) and the Pratt Institute, from which she graduated in 1924. While she was still an undergraduate, her poems "Nocturne" and "Heritage" were published in *Crisis* (Nov. 1923) and *Opportunity* (Dec. 1923), respectively.

Bennett's poetry generally dealt with racial uplift and pride in her African heritage. "To Usward," published in both *Opportunity* and *Crisis* in May 1924, was a tribute to the new generation and a call to those who have "a song to sing." She also produced symbolist-inspired and romantic lyrics, such as "Quatrains" (1927). It expressed the tension Bennett experienced, torn between art and literature:

> Brushes and paints are all I have
> To speak the music in my soul
> While silently there laughs at me
> A copper jar beside a pale green bowl.

Over the next nine years, twenty-two of Bennett's poems appeared in *Opportunity*, *Crisis*, *Palms*, and *Gypsy*. Additional poems were published in WILLIAM STANLEY BEAUMONT BRAITHWAITE's *Anthology of Magazine Verse for 1927 and Yearbook of American Poetry* (1927), COUNTÉE CULLEN's *Caroling Dusk* (1927), and JAMES WELDON JOHNSON's *The Book of American Negro Poetry* (1931).

Bennett also created cover illustrations for *Crisis* in December 1923 and March 1924; the latter, *Pipes of Pan*, was a line drawing of a young African American man listening to music produced by nymphs and satyrs. Her covers for *Opportunity* appeared in January and July 1926 and December 1930. She also produced oil landscapes, but she rarely exhibited her work publicly.

In 1924 Bennett began teaching design, watercolor, and crafts at Howard University in Washington, D.C., and was reunited with her mother. The following year, on a $1,000 Delta Sigma Theta sorority fellowship, she studied art in Paris at the Académies de la Grande Chaumière, Julian, and Colarossi and at the École du Panthéon. She published two short stories, "Wedding Day," published in *Fire!!* (1926), and "Tokens," published in CHARLES SPURGEON JOHNSON's *Ebony and Topaz: A Collectanea* (1927). Both express the isolation and loneliness she experienced in Paris and feature African American expatriates who remained in France after serving in World War I.

After Bennett returned to Washington, D.C., in 1926, her father died, and she lost most of the paintings and batiks she had produced abroad in a fire in her stepmother's home. She then spent two years (1927–1928) writing "The Ebony Flute," a "literary and social chit-chat" column for *Opportunity*, for which she had also written book reviews. During the summer of 1927 she taught art classes at Nashville's Tennessee Agricultural and Industrial State College. The same year she served as editor for the magazine *Black Opals*.

In 1928 Bennett received a scholarship to study art at the Barnes Foundation in Merion, Pennsylvania. That year she married Alfred Jackson and moved to Eustis, Florida, where her husband had a medical practice. Unhappy in the segregated South, Bennett gained sixty pounds in four years and wrote little. The couple moved to Hempstead, Long Island, in 1932, and Bennett took a job with the Department of Information and Education of the Welfare Council of New York writing feature articles that appeared in the *Amsterdam News*, the *New York Age*, the *Baltimore Afro-American*, and *Better Times*.

After Jackson died in 1936, Bennett lived alternately with her stepmother and with the sculptor AUGUSTA SAVAGE in New York. She worked as a teacher, then as a project supervisor in the Federal Art Teaching Project. When Savage resigned as director of the Harlem Community Art Center, a

Federal Art Project endeavor, in 1939, Bennett took that position. She was also active in the Harlem Artists Guild, the National Negro Congress, the Artists Union, the Negro People's Theater, and the Negro Playwright's Company, serving on the board of directors of the last.

In 1941 Bennett gave a series of lectures on African American arts at the School for Democracy; she also married a white Harvard graduate and fellow teacher, Richard Crosscup. Three years later Bennett was suspended from the Harlem Community Art Center by the House Un-American Activities Committee (HUAC) for her leftist sympathies. She then cofounded and directed the George Carver Community School, an adult education center for African Americans in Harlem. HUAC investigated the school, and it closed in 1947. From the end of the 1940s until the late 1960s, Bennett worked for the Consumers Union as a correspondent.

Upon their retirement in 1968, Bennett and her husband moved to Kutztown, Pennsylvania, and opened an antique store. Bennett died of congestive heart failure in Reading, Pennsylvania. Although she was a minor writer and artist, Bennett contributed significantly to the New Negro movement with her editing, teaching, and leadership, aiding the careers of such better-known colleagues as AARON DOUGLAS, LANGSTON HUGHES, and Cullen.

FURTHER READING

Bennett's papers are in the Schomburg Center for Research in Black Culture and History at the New York Public Library.

Govan, Sandra. "After the Renaissance: Gwendolyn Bennett and the WPA Years," *MidAtlantic Writers Association* 3 (Dec. 1988).

Primeau, Ronald. "Frank Horne and the Second Echelon Poets of the Harlem Renaissance," in *The Harlem Renaissance Remembered*, ed. Arna Bontemps (1972).

THERESA LEININGER-MILLER

BENTLEY, Gladys

(12 Aug. 1907–18 Jan. 1960), blues singer and pianist, was born Gladys Alberta Bentley in Philadelphia, Pennsylvania, the eldest of four children of George L. Bentley and Mary C. Mote, a native of Trinidad. The Bentley family was very poor. Later a lesbian, Bentley acknowledged that even as a child she felt more comfortable in boys' clothing than in girls'

clothing; however, it was when Bentley developed a long-term crush on one of her female schoolteachers that her classmates began to ridicule her and her parents began to take Bentley from doctor to doctor in an effort to "fix" her. Finally at age sixteen Bentley left Philadelphia and traveled to Harlem, New York, where she quickly became immersed in the Harlem Renaissance and its "don't ask, don't tell" attitude about sexuality. Bentley became just one of many homosexual or bisexual celebrities, joining the likes of LANGSTON HUGHES, ETHEL WATERS, BESSIE SMITH, and MA RAINEY. Though Bessie Smith may have been the "Queen of the Blues," Bentley was known as the "Brown Bomber of Sophisticated Songs."

In Harlem, Bentley found acceptance among the participants in the "sporting life," which favored gambling, rent parties, female impersonators, sex shows, drugs, and alcohol. She began performing at the sporting life events, quickly becoming extremely popular. It was not uncommon to find Bentley, a talented pianist, playing and singing all night long at a piano. Writing to COUNTÉE CULLEN, a friend said of Bentley, "When Gladys sings 'St. James Infirmary,' it makes you weep your heart out" (Duberman, 324).

Bentley's first major job was at the Mad House, which later became Barbara's Exclusive Club. Starting at thirty-five dollars a week, Bentley soon received a hundred dollars a week when Carl Van Vechten and others began crowding into the clubs to see her perform. As Bentley's popularity increased, she moved on to clubs such as the Cotton Club, Connie's Inn, and the Clam House. Weighing anywhere from two hundred and fifty to three hundred pounds she dressed in a tuxedo with tails and top hat, and her manly style of dress quickly became a feature of her shows. She was even more famous for her raunchy lyrics, full of sexual innuendos that she interpolated into the popular songs of the day. Bentley was so convincing as a man that the artist ROMARE BEARDEN thought that she was a female impersonator. In fact, she did sometimes perform under the name "Bobby Minton." Bentley was one of the few openly lesbian performers, flirting outrageously with the women in her audiences.

In 1928 Bentley began recording for Okeh Records, eventually making a total of eight records. Some of her more famous songs include "How Long, How Long Blues," "Worried Blues," "How Much Can I Stand?" and "Moanful Wailin' Blues."

Bentley was at the height of her popularity during the 1920s and 1930s. In 1931 she was celebrated in Blair Nile's novel *Strange Brother*, being the basis of the character Sybil. Carl Van Vechten's book *Parties* and Clement Woods's book *Deep River* were reported to have characters based on the larger-than-life Gladys Bentley (Faderman, 1991). It was also in the early 1930s that Bentley married her white female lover in a much-publicized civil ceremony in New Jersey.

Advantages of the show business lifestyle for lesbians was the ability to earn a decent living, limit contact with men, and work within a predominantly female social world. During the early 1930s Bentley moved on to the New York jazz scene, performing primarily at the Ubangi Club on Fifty-second Street. By the late 1930s the Depression and Harlem's loss of fashionable status became contributing factors in her decision to move to California. There she lived with and cared for her elderly mother and sang at such gay clubs as Hollywood's Rose Room, Mona's in San Francisco, and Joaquin's El Rancho in Los Angeles. She began experiencing problems with the police while at Joaquin's El Rancho and at Mona's in early 1940. The clubs were required to obtain special permits that allowed Bentley to perform her act in men's clothing instead of women's clothing (*Gay and Lesbian Biography*, 1997). By the 1950s and the McCarthy era, Bentley was forced to perform in women's clothing and came under the scrutiny of the U.S. House Committee on Un-American Activities because of her same-sex marriage in New Jersey.

In 1945 Bentley made five recordings for the Excelsior label, including *Thrill Me till I Get My Fill*, *Find Out What He Likes*, and *Notoriety Papa*. She also worked with the Washboard Serenaders on the Victor label. In a 1952 interview with *Ebony* magazine, Bentley claimed to have overcome her lesbianism through the ingestion of female hormones and announced that she was happily married to a male newspaper columnist named J.T. Gibson. When interviewed, Gibson denied that a wedding had taken place. Bentley was married for a brief time to a cook named Charles Roberts. Bentley was forty-five and Roberts twenty-nine; on the marriage certificate she stated that she was thirty-five.

During the 1950s Bentley performed twice on Groucho Marx's live television show *You Bet Your Life*. Bentley also recorded a record for the Flame label. It was at this time that she became an active member in a Hollywood church called the Temple of Love in Christ. In the late 1950s Bentley began to study to become a minister, but she died during an influenza epidemic before she was able to become ordained. In 1992 Rosetta Records, a small feminist label, reissued five of Bentley's songs on a disc titled *Mean Mothers: Independent Women Blues, Volume 1*. In 2004 Sony Music released a DVD set titled *You Bet Your Life: The Best Episodes*, which includes a 1958 performance of Bentley singing "Them There Eyes."

FURTHER READING
Duberman, Martin Bauml. *Hidden from the History: Reclaiming the Gay and Lesbian Past* (1989).
Faderman, Lillian. *Odd Girls and Twilight Lovers: A History of Lesbian Life in Twentieth-century America* (1991).
Rodger, Gillian. *GLBTQ: An Encyclopedia of Gay, Lesbian, Bisexual, Transgender & Queer Culture* (2002), also available online at http://www.glbtq.com.
Tyrkus, Michael, ed. "Gladys Bentley (1907–1960): Classic Blues Singer," *St. James Press Gay and Lesbian Biography* (1997).

ANNE K. DRISCOLL

BERNHARDT, Clyde

(11 July 1905–20 May 1986), jazz trombonist and singer, was born Clyde Edric Barnhardt in Gold Hill, North Carolina, the son of Washington Michael Barnhardt, a miner, and Elizabeth Mauney. When Clyde was a child, he added Barron to his name because his grandmother in slavery had been lent to a family named Barron who treated her kindly. He changed the spelling of his surname in 1930 on the advice of a psychic. Thus his full name became Clyde Edric Barron Bernhardt or Clyde E. B. Bernhardt.

In 1912, after his father suffered a heart attack and left mining, Bernhardt helped to peddle goods from a wagon. The family moved to New Hope (later absorbed into Badin), North Carolina, and in 1915 his father died. Bernhardt attended school for three months each year while holding various jobs, including work at Alcoa Aluminum in 1918. The following year his mother took the family to Harrisburg, Pennsylvania, and then to Steeltown, Pennsylvania. Bernhardt returned to Badin in November 1919 with the intent of resuming

work at Alcoa, but instead he secured a better job, becoming a messenger boy for Western Union. After rejoining his mother and siblings in Steeltown in April 1921, he quit school, having reached eighth grade. He held various jobs over the next several years.

Although Bernhardt had been attracted to music in his preschool years, only in 1922 did he purchase a trombone and begin serious studies with teachers in Pennsylvania and Ohio, when his mother relocated the family and he moved out on his own. By 1925 he was working professionally, and in 1928, after affiliations with several little-known bandleaders, Bernhardt joined the Whitman Sisters—Alice Whitman and her sisters Essie, Mable, and Alberta—in their show in Harlem and toured with them until June 1929. In March 1931 he joined the cornetist KING OLIVER's band, touring for eight months. With Oliver's encouragement Bernhardt began doubling as a blues singer. In 1931 he thought that he had married a woman named Barbara, known as "Bobby" (maiden name unknown), only to discover a few months later that she was already married. He never attempted marriage again.

Bernhardt joined Marion Hardy's Alabamians in New York City in November 1931. He worked with Billy Fowler's band from September 1932 to April 1933, a gig that included jobs accompanying the pianist and singer FATS WALLER. Bernhardt was a member of Vernon Andrade's dance orchestra from 1934 to 1937, and in September 1934 he made his first recordings, "Ain't It Nice?" and "Functionizin'," with Alex Hill's band. As a member of the pianist Edgar Hayes's big band from February 1937, Bernhardt performed in Europe in 1938 and made annual tours accompanying the dancer BILL ROBINSON; he also worked with the pianist Horace Henderson's big band in 1941.

After leaving Hayes, Bernhardt toured briefly with Waller's big band, but he was bored by the lack of challenging parts or solos. In September 1942 he joined the pianist Jay Mcshann's big band, touring until July 1943. He played in the tenor saxophonist Cecil Scott's band at the Ubangi Club in New York City for five months. In 1944 he joined the orchestra of the pianist Luis Russell, who featured Bernhardt as a singer, most notably in well-received performances at the Apollo Theater in Harlem. Bernhardt suffered from bronchitis and was obliged to quit Russell's band in October. For the remainder of 1944 he worked in the pianist CLAUDE HOPKINS's band at the Club Zanzibar in New York. He joined the Bascomb Brothers' orchestra in 1945, and he spent the first four months of 1946 with Scott again.

From 1946 to 1948 Bernhardt for the first time led his own group, the Blue Blazers. He rejoined Russell from 1948 to 1951 while also working with other bands. In 1952 he began recording under the pseudonym Ed Barron, and he had a hit rhythm and blues song with his own "Cracklin' Bread," but he was cheated out of royalties by the record company. From 1952 to 1970 he played in Joe Garland's dance orchestra. During the course of this lengthy affiliation he resumed day work and general studies. He passed the high school equivalency examination in 1963 and then took a job as a custodian in Newark, New Jersey.

Interest in Bernhardt's musical activities was rekindled by a series of articles published by Derrick Stewart-Baxter in 1967 and 1968 and by a recording that Stewart-Baxter produced in the latter year and issued in 1971. Bernhardt retired as a custodian in February 1972 and vacationed for a few weeks in England, where he was treated as a musical celebrity. He worked with the bassist Hayes Alvis's band later that year, shortly before Alvis died. Bernhardt recorded his own albums *Blues and Jazz from Harlem* (1972) and *More Blues and Jazz from Harlem* (1973), the latter with the Harlem Blues and Jazz Band of which he eventually became the sole leader. A heart attack interrupted his new career in 1974, but he recovered and resumed playing and singing, touring Europe annually from 1976 to 1979 with his band. He spent his final years from 1979 onward as a member of drummer Barry Martyn's Legends of Jazz. Bernhardt died in Newark.

Though Bernhardt was not an important jazz or rhythm and blues performer, he is important for his detailed, levelheaded reminiscences of dozens of African American entertainers, including valuable essays on less well-known performers such as the Whitman Sisters, Hardy and his Alabamians, Andrade, Scott, and the Bascomb Brothers, among others, as well as important jazz musicians such as McShann and Russell. Bernhardt's several published recollections of a forceful, responsible, talented, shrewd King Oliver in late career provide an especially welcome antidote to the romantic but pathetic portrait of Oliver popularized in the famous early jazz book *Jazzmen* (1939).

FURTHER READING

Bernhardt, Clyde E. B. "Talking about King Oliver: An Oral History Excerpt," *Annual Review of Jazz Studies* 1 (1982).

Bernhardt, Clyde E. B., with Sheldon Harris. *I Remember: Eighty Years of Black Entertainment, Big Bands, and the Blues* (1986).

Gaster, Gilbert. "Clyde Bernhardt," *Storyville*, no. 44 (1 Dec. 1972).

Stewart-Baxter, Derricks, with Clyde E. B. Bernhardt. "The Clyde Bernhardt Story," *Jazz Journal* 20 (Sept. and Oct. 1967) and 21 (Jan. and Feb. 1968).

Obituary: New York Times, 31 May 1986.

BARRY KERNFELD

BETHUNE, Mary McLeod

(10 July 1875–18 May 1955), organizer of black women and advocate for social justice, was born Mary Jane McLeod in Mayesville, South Carolina, the child of the former slaves Samuel McLeod and Patsy McIntosh, farmers. After attending a school operated by the Presbyterian Board of Missions for Freedmen, she entered Scotia Seminary (later Barber-Scotia College) in Concord, North Carolina, in 1888 and graduated in May 1894. She spent the next year at Dwight Moody's evangelical Institute for Home and Foreign Missions in Chicago, Illinois. In 1898 she married Albertus Bethune. They both taught briefly at Kindell Institute in Sumter, South Carolina. The marriage was not happy. They had one child and separated late in 1907. After teaching in a number of schools, Bethune founded the Daytona Normal and Industrial Institute for Training Negro Girls in Daytona, Florida, in 1904. Twenty years later the school merged with a boys' school, the Cookman Institute, and was renamed Bethune-Cookman College in 1929. Explaining why she founded the training school, Bethune remarked, "Many homeless girls have been sheltered there and trained physically, mentally and spiritually. They have been helped and sent out to serve, to pass their blessings on to other needy children."

In addition to her career as an educator, Bethune helped found some of the most significant organizations in black America. In 1920 Bethune became vice president of the National Urban League and helped create the women's section of its Commission on Interracial Cooperation. From 1924 to 1928 she also served as the president of the National

Mary McLeod Bethune, organizer of black women and advocate for social justice, 6 April 1949. (Library of Congress/Carl Van Vechten.)

Association of Colored Women. In 1935, as founder and president of the National Council of Negro Women, Bethune forged a coalition of hundreds of black women's organizations across the country. She served from 1936 to 1950 as president of the Association for the Study of Negro Life and History, later known as the Association for the Study of Afro-American Life and History. In 1935 the National Association for the Advancement of Colored People awarded Bethune its highest honor, the Spingarn Medal. She received honorary degrees from ten universities, the Medal of Honor and Merit from Haiti (1949), and the Star of Africa Award from Liberia (1952). In 1938 she participated along with liberal white southerners in the annual meetings of the Southern Conference for Human Welfare.

Bethune's involvement in national government began in the 1920s during the Calvin Coolidge and Herbert Hoover presidential administrations, when she participated in child welfare conferences. In June 1936 Bethune became administrative assistant and, in January 1939, director in charge of Negro Affairs in the New Deal National Youth

Administration (NYA). This made her the first black woman in U.S. history to occupy such a high-level federal position. Bethune was responsible for helping vast numbers of unemployed sixteen- to twenty-four-year-old black youths find jobs in private industry and in vocational training projects. The agency created work-relief programs that opened opportunities for thousands of black youths, which enabled countless black communities to survive the Depression. She served in this office until the NYA was closed in 1944.

During her service in the Franklin D. Roosevelt administration, Bethune organized a small but influential group of black officials who became known as the Black Cabinet. Prominent among them were William Henry Hastie of the Department of the Interior and the War Department and Robert Weaver, who served in the Department of the Interior and several manpower agencies. The Black Cabinet did more than advise the president; it articulated a black agenda for social change, beginning with demands for greater benefit from New Deal programs and equal employment opportunities.

In 1937 in Washington, D.C., Bethune orchestrated the National Conference on the Problems of the Negro and Negro Youth, which focused on concerns ranging from better housing and health care for African Americans to equal protection under the law. As an outspoken advocate for black civil rights, she fought for federal anti–poll tax and antilynching legislation. Bethune's influence during the New Deal was further strengthened by her friendship with First Lady Eleanor Roosevelt.

During World War II, Bethune was special assistant to the secretary of war and assistant director of the Women's Army Corps. In this post she set up the first officer candidate schools for the corps. Throughout the war she pressed President Roosevelt and other governmental and military officials to make use of the many black women eager to serve in the national defense program; she also lobbied for increased appointments of black women to federal bureaus. After the war she continued to lecture and to write newspaper and magazine columns and articles until her death in Daytona Beach, Florida.

Urged by the National Council of Negro Women, the federal government dedicated the Mary McLeod Bethune Memorial Statue at Lincoln Park in southeastern Washington, D.C., on 10 July 1974. Bethune's life and work provide one of the major links between the social reform efforts of post-Reconstruction black women and the political protest activities of the generation emerging after World War II. The many strands of black women's struggle for education, political rights, racial pride, sexual autonomy, and liberation are united in the writings, speeches, and organization work of Bethune.

FURTHER READING

Holt, Rackman. *Mary McLeod Bethune: A Biography* (1964).

Ross, B. Joyce. "Mary McLeod Bethune and the National Youth Administration: A Case Study of Power Relationships in the Black Cabinet of Franklin D. Roosevelt," *Journal of Negro History* 60 (Jan. 1975): 1–28.

Smith, Elaine M. "Mary McLeod Bethune and the National Youth Administration," in *Clio Was a Woman: Studies in the History of American Women* (1980).

Obituary: New York Times, 19 May 1955.

DARLENE CLARK HINE

BIBB, Joseph Dandridge

(21 Sept. 1895–Dec. 1966), editor, writer, publisher, lawyer, and government official, was born in Montgomery, Alabama, the son of Viola (Lovett) Bibb and Joseph D. Bibb, an African Methodist Episcopal (AME) minister and a prominent teacher and advocate for the employment of black teachers. Bibb used his earnings from working in the railroad industry and southern factories to pay for his college education; he attended Atlanta University, Livingstone College, and Howard University, and completed his legal training at Yale and Harvard Universities.

After the completion of his formal education, Bibb moved to Chicago, the destination of thousands of job-seeking African Americans from the South. This mass exodus from the South—the Great Migration—saw blacks pour into urban areas between 1915 and 1925. Chicago and other cities such as Detroit and New York saw their black populations double and triple; these cities offered relative freedom from the violence and lack of opportunity in the South, but it was still hard for blacks to find work. Consequently, African Americans created their own newspapers to address issues such as racial discrimination, violence, and poor living

conditions. Black newspapers, however, continued to urge southern blacks to migrate to the North.

Realizing the growing need to empower black citizens and to address black issues, Bibb, along with William Linton, started the *Chicago Whip* in 1919 with a mere twenty-five cents. The *Whip* appeared on the scene when black newspapers were experiencing a renaissance in Chicago, one of the nation's most racially polarized cities. Such newspapers included the *Chicago Conservator* (1878–1914), the *Chicago Defender* (1905–present), and the *Chicago Bee* (1925–1947). Published weekly, the *Whip* reached a circulation of 65,000 within its first year, second only to the *Chicago Defender*. Throughout its twenty-year existence, the paper campaigned for black rights and often featured the civil rights leader MARCUS GARVEY. In his editorials Bibb urged complete integration and the hiring of black workers. Because of this, the paper was considered to be militant by politicians and members of the mainstream press; Bibb later recalled how he was labeled "Red, radical, revolutionary" (*Ebony*, Jan. 1956). While writing for the *Whip*, Bibb also practiced law, and in 1922 he married Goldie Thompson. In 1929 the *Whip* promoted the successful "Don't Buy Where You Can't Work" campaign to combat the practices of white-owned businesses that wouldn't hire blacks. Other black newspapers throughout the country publicized similar boycotts. The *Whip* was liquidated during the Depression in 1939, and Bibb began working as managing editor of the Chicago edition of the *Pittsburgh Courier*, a popular black newspaper that published local and national editions. As an editor, he continued the spirit of the *Whip* in his columns on black civil rights.

Known for his biting editorials on behalf of civil rights, Bibb was also a staunch and loyal Republican, and this made him something of an anomaly at a time when most African Americans were gradually shifting their loyalty from the Republican to the Democratic party, seen as more committed to racial equality. For more than twenty-five years, Bibb served as a writer and speaker for the National Republican Committee. In 1952 Bibb was vocal about what he perceived as a smear campaign against then-vice presidential candidate Richard Nixon by Democratic campaigners to deter blacks from voting for Nixon and Dwight Eisenhower for president. Bibb urged the Republican Party to reach out to black voters.

During his campaign for governor of Illinois in 1952, the Republican candidate William G. Stratton had promised to appoint the first African American to state cabinet. Upon his 1953 inauguration Stratton named Bibb director of public safety. This made the fifty-seven-year-old Bibb the first African American to hold a cabinet post in Illinois and in any state since Reconstruction. Many saw this as a cynical move to court black voters. Nonetheless, Bibb described his new role as overseeing the "well-being and protection of the citizens of Illinois and visitors within its borders" (*Ebony*, Jan. 1956).

Bibb had to give up his law career and newspaper column for the state job, which paid $12,000 a year. From 1953 to 1961 Bibb served as director of public safety, overseeing four state penitentiaries, the state police, all state parole agents, and the Division of Criminal Investigation and Identification. Bibb reduced the prison population and pushed for prison reform and the efficiency of crime labs. He answered letters from inmates and investigated their complaints. When Bibb took office, Illinois had one of the largest populations in the United States, and traffic problems were becoming more of an issue. Bibb researched new techniques to control safety and noise on the Illinois expressways and pushed for a sixty-five-mile-per-hour speed limit in the state.

As the first black department director in the state of Illinois, Bibb restructured the Department of Public Safety to make it more efficient. But his major contributions are embodied in the written word—in his editorials and columns in the *Chicago Whip* and *Pittsburgh Courier*. Bibb remains an important figure in the history of the black newspapers that exhaustively fought for the rights and safety of black citizens.

FURTHER READING

"'Mr. Public Safety' Joseph Bibb is Guardian of Illinois Life and Property," *Ebony* (Jan. 1956)
Jet (Sept. 1967)

MARTHA PITTS

BLACKBURN, Robert Hamilton

(12 Dec. 1920–21 Apr. 2003), master printer, artist, educator, and founder of the Printmaking Workshop, was born in Summit, New Jersey, the son of Jeannette Chambers Blackburn and Archibald Blackburn of Jamaica, West Indies. Robert, also known as Bob, had a younger sister, Gertrude, and

a half brother. His father, although trained as a minister, found employment with the Lackawanna Railroad in Summit. When Blackburn was two, the family moved to rural Elmira, New York. Blackburn fondly recalled his early childhood in the rural town, where he listened to the train whistle from his bedroom window, attended church every Sunday, and won a toy car as a prize for a drawing he had done. During the Depression, when Blackburn was seven, his family moved to Harlem, where he attended public schools from 1932 to 1936.

At Frederick Douglass Junior High School, Blackburn was influenced by his teacher, the poet COUNTÉE CULLEN, who sparked his interest in literature and the history of art. Blackburn served as the art editor of the *Pilot*, the school paper, and was awarded the Frederick Douglass Guidance and Art medals in 1936. Three years earlier he had met CHARLES HENRY ALSTON, a painter and sculptor, and enrolled in his Harlem Arts Workshop, a Public Works Art Project-sponsored program at the New York Public Library. Alston proved to be a major influence on Blackburn as a mentor and teacher, as were Ronald Joseph, another teacher at the Harlem Arts Workshop who introduced him to Chinese art, and Henry W. Bannarn, a sculptor. While Blackburn was initially too young to qualify for the $23.80 weekly project pay, he met and was influenced by a number of emerging artists and thinkers, including JACOB ARMSTEAD LAWRENCE, Sara Murrell, Norman Lewis, Ad Bates, ROMARE BEARDEN, and RICHARD WRIGHT. In the 1930s Blackburn was a member of the Harlem Artists Guild, founded by AUGUSTA SAVAGE, and he took classes at her Uptown Art Laboratory along with Lawrence and Gwendolyn Knight. Blackburn also attended after-school classes at the Harlem YMCA's Arts and Crafts Department (1934–1935), working with painters Richard W. Lindsey and Rex Gorleigh, as well as the sculptor WILLIAM ELLISWORTH ARTIS. He assisted Artis on a mural for the boys' recreation hall and received the YMCA's John Wanamaker Medal, the Spingarn Award, the Robert Pious Award, the Poussant Award, and the G. J. Pinckney Award.

In 1936 Blackburn entered DeWitt Clinton High School, where he was the art editor for the school's literary magazine, the *Magpie*, in which he published his poetry, stories, and prints. Among his fellow contributors to the *Magpie* were Richard Avedon, James Baldwin, and Sidney "Paddy"

Chayefsky. While in high school Blackburn also attended the Harlem Community Art Center (HCAC). Directed by AUGUSTA SAVAGE, and later GWENDOLYN BENNETT, HCAC grew to be the largest WPA program in the country. At HCAC, Blackburn recalled hearing a lecture by the abstract painter Vaclav Vytlacil, one of several white artists who worked in this predominantly black circle (who would later become an important influence at the Art Students League). Another was Riva Helfond, a WPA artist, who first introduced Blackburn to lithography, etching, woodblock, and silk screening in 1938. Blackburn subsequently published twelve editions of lithographs, some in the *Magpie*, and entered into juried exhibits with the assistance of the Harmon Foundation. ALAIN LEROY LOCKE, his Howard University colleague, and JAMES AMOS PORTER, were among the many critics who praised Blackburn's drawings and lithographs from this period.

Knowing that his family could not fund a college education during the Depression, Blackburn was determined to find ways to make his livelihood in art. He was a scholarship student at the Art Students League from 1940 to 1943, where he was instructed by Vytlacil and printmaker Will Barnet. In 1943 Blackburn graduated from the league, and for four years he worked as a freelance graphic artist for the Harmon Foundation, the China Institute of America, and Associated American Artists. In 1945 Blackburn moved from Harlem to downtown Manhattan, where he shared a loft with the painter Ernest Crichlow. Two years later Blackburn purchased a lithographic press and began printing for other artists and taught three classes a week. In 1948 he officially opened the Creative Graphic Workshop. Although this workshop did not turn a profit, it provided Blackburn with studio space and enabled him to collaborate with a range of artists, including John Von Wicht, Ronald Joseph, Larry Potter, Tom Laidman, Stella Wright, Peter Bradley, and Eldzier Cortor.

In 1949 he also began printing for Cooper Union School of Art students. He did this job for twenty years before being offered a teaching position in the mid-1960s. Blackburn also taught printmaking at Brooklyn College, Maryland Institute College of Art, New York University, Pratt Institute, Rutgers University School of Visual Arts, and Columbia University (where he was a faculty member from 1970 to 1990). In the early 1950s, Blackburn studied

drawing with Wallace Harrison and made plein air ink sketches with Ronald Joseph. In April 1952 *ART-news* magazine highlighted his technical achievements and collaboration with Will Barnet on a suite of color lithographs created from 1951 to 1952.

The following year Blackburn left the workshop in charge of a group of artist-friends and traveled to Europe on a John Hay Whitney Traveling Fellowship. He spent six months in Paris, working with André Lhote, an important Cubist painter, and spent a year touring Europe. From 1957 to 1963 Blackburn was employed as the first master printer at ULAE (Universal Limited Art Editions), Long Island, New York, founded by Tatyana and Maurice Grosman. Blackburn printed the first seventy-nine editions of lithographs for major American artists, including Helen Frankenthaler, Grace Hartigan, Jasper Johns, Robert Rauschenberg, and Larry Rivers. After six years with ULAE, Blackburn returned as director to the Printmaking Workshop. In 1971 the PMW was incorporated as a nonprofit institution, eventually offering scholarships, international fellowships, and community programs to students of all ages in support of its mission to encourage and support creativity and training in the field of printmaking. Blackburn served as director, teacher, master printer, and friend to generations of artists working there.

Blackburn's most productive and mature period as a lithographer was the late 1950s through 1971, when his work was influenced by Cubism, as well as abstract expressionism and color field painting with the focus on abstraction, gesture, and color. Blackburn's experimentation and technical achievements in color lithography greatly affected the work of well-known ULAE artists and contributed to the popularity of the medium and print boom of the 1960s in the United States. Blackburn was unique among African American artists in terms of his artistic development from representation to abstraction and emphasis on the flat, two-dimensional surface of the printmaking stone. In 1971, the year PMW was incorporated as a nonprofit, Blackburn also created a board of trustees. While at ULAE he kept PMW running and eventually returned to full-time director. During the 1970s and 1980s, after ULAE, Blackburn, after twenty-five years of producing lithography, made the woodcut his primary medium. In both small- and large-scale woodcuts, Blackburn continued to maintain "his command of color, his sense of improvisation, and

his control of compelling abstract balances" (Cullen, "A Life in Print").

The Printmaking Workshop has been described as " . . . the oldest continuously operating nonprofit, artist-run printmaking studio in the country" (Cullen, "A Life in Print"). As an educational and artistic cooperative, it helped to produce the work of thousands of culturally diverse artists, promoting cultural exchange and advancement in the fields of art and education. Blackburn's passion for collaboration and cooperative learning was ignited by his experiences growing up in the artistic milieu of the late Harlem Renaissance and the WPA-sponsored art centers. He recreated the benefits of those experiences through his own workshop, which came to mentor artists in the same process. As director of the Printmaking Workshop, his interest in fostering the careers of young artists and creating a center for creative expression took precedence over his own artistic career. In spite of this, Blackburn created an outstanding body of work exhibited internationally and in the collections of the Library of Congress, the Brooklyn Museum, the Bronx Museum, the United Negro College Fund, the Baltimore Museum of Art, Asilah Museum (Morocco), and the Tel Aviv Museum. In 1997 more than 2,500 artworks from the Printmaking Workshop Print Collection, formed by donations from participating artists, were transferred to the Library of Congress, in Washington, D.C.

Blackburn received numerous awards, including the Skowhegan Governor's Award for Lifetime Service (1987), the New York Governor's Award (1988), the Mayor of New York City's Award of Honor for Arts and Culture (1992), the John T. and Catherine D. MacArthur Foundation Fellowship (1992), Lifetime Achievement Awards from the College Art Association and the National Fine Print Association (2002); and six honorary doctoral degrees.

FURTHER READING

Billops, Camille, and James V. Hatch. "Bob Blackburn (1920–2003)," *Artist and Influence*, V, XXII (2003).

Cullen, Deborah. "Appreciation: Robert Blackburn (1920–2003): A Printmaker's Printmaker," *American Art*, vol. 17, no. 3 (2003).

Cummings, Paul. "Interview with Bob Blackburn in the Printmaking Workshop," Archives of American Art, 4 December 1970.

Gaither, Edmund. "Millennium Portrait: Robert Blackburn," *American Visions* (Feb. 2000).

Parris, Nina. *Through a Master Printer: Robert Blackburn and the Printmaking Workshop*, Columbia Museum Exhibition Catalog (March–May, 1985).

York, Hildreth. "Bob Blackburn and the Printmaking Workshop," *Black American Literature Forum*, vol. 20, no. 1/2 (Spring–Summer 1986).

Obituaries: New York Times, 25 Apr. 2003 and *Art in America* (June 2003).

LENA HYUN

BLAKE, Eubie

(7 Feb. 1883–12 Feb. 1983), composer and pianist, was born James Hubert Blake in Baltimore, Maryland, the son of John Sumner Blake, a stevedore, and Emily Johnston, a launderer. His father was a Civil War veteran, and both parents were former slaves. While the young Blake was a mediocre student during several years of public schooling, he showed early signs of musical interest and talent, picking out tunes on an organ in a department store at about age six. As a result, his parents rented an organ for twenty-five cents a week, and he soon began basic keyboard lessons with Margaret Marshall, a neighbor and church organist. At about age twelve he learned cornet and buck dancing and was earning pocket change singing with friends on the street. When he was thirteen, he received encouragement from the ragtime pianist Jesse Pickett, whom he had watched through the window of a bawdy house in order to learn his fingering. By 1898 he had steady work as a piano player in Aggie Shelton's sporting house, a job that necessitated the lad's sneaking out of his home at night, after his parents went to bed. The objections of his deeply religious mother when she learned of his new career were overcome only by the pragmatism of his sporadically employed father, once he discovered how much his son was making in tips.

In 1899 (the year SCOTT JOPLIN's famous "Maple Leaf Rag" appeared), Blake wrote his first rag, "Charleston Rag" (although he would not be able to notate it until some years later). In 1902 he performed as a buck dancer in the traveling minstrel show *In Old Kentucky*, playing briefly in New York City. In 1907, after playing in several clubs in Baltimore, he became a pianist at the Goldfield Hotel, built by his friend and the new world lightweight boxing champion Joe Gans. The elegant Goldfield was one of the first establishments in Baltimore where blacks and whites mixed, and there Blake acquired a personal grace and polish that would impress his admirers for the rest of his life. Already an excellent player, he learned from watching the conservatory-trained "One-Leg Willie" Joseph, whom he often cited as the best piano player he had ever heard. While at the Goldfield, Blake studied composition with the Baltimore musician Llewellyn Wilson, and at about the same time he began playing summers in Atlantic City, where he met such keyboard luminaries as WILLIE "THE LION" SMITH, Luckey Roberts, and JAMES P. JOHNSON. In July 1910 he married Avis Lee, the daughter of a black society family in Baltimore and a classically trained pianist.

In 1915 Blake met the singer and lyricist NOBLE SISSLE, and they quickly began a songwriting collaboration that would last for decades. One of their songs of that year, "It's All Your Fault," achieved success when it was introduced by Sophie Tucker. Sissle and Blake also performed in New York with JAMES REESE EUROPE's Society Orchestra. While Sissle and Europe were in the service during World War I, Blake performed in vaudeville with Henry "Broadway" Jones. After the war Sissle and Blake formed a vaudeville act called the Dixie Duo, which became quite successful. In an era when blacks were expected to shuffle and speak in dialect, they dressed elegantly in tuxedos, and they were one of the first black acts to perform before white audiences without burnt cork. By 1917 Blake also had begun recording on both disks and piano rolls.

In 1920 Sissle and Blake met the successful comedy and dance team of Flournoy Miller and Aubrey Lyles, who suggested combining forces to produce a show. The result was the all-black *Shuffle Along*, which opened on Broadway in 1921 and for which Blake was composer and conductor. The score included what would become one of his best-known songs, "I'm Just Wild about Harry." Mounted on a shoestring budget, the musical met with critical acclaim and popular success, running for 504 performances in New York, followed by an extensive three-company tour of the United States. The show had a tremendous effect on musical theater, stirring interest in jazz dance, fostering faster paced shows with more syncopated rhythms, and paving the way in general for more black musicals and black performers. *Shuffle Along* was a springboard for the careers of several of its cast members, including

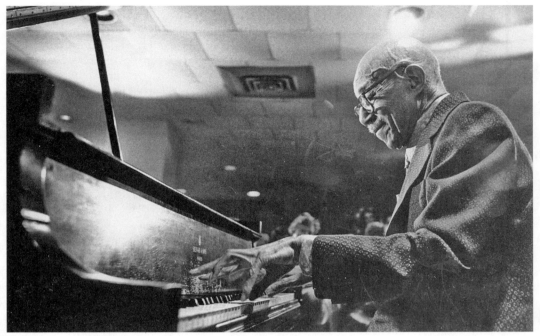

Eubie Blake, the veteran jazz, pianist, performs during his surprise birthday party, New York's Waldorf-Astoria Hotel, 7 February 1976. (AP Images.)

JOSEPHINE BAKER, ADELAIDE HALL, FLORENCE MILLS, and PAUL ROBESON.

Sissle and Blake worked for ten years as songwriters for the prestigious Witmark publishing firm. In 1922, through Julius Witmark, they were able to join ASCAP (American Society of Composers, Authors, and Publishers), which did not at that time include many blacks. They also appeared in an early sound film in 1923, *Sissle and Blake's Snappy Songs*, produced by the electronics pioneer Lee De Forest. In 1924 they created an ambitious new show, *The Chocolate Dandies*. Unable to match the success of *Shuffle Along*, the lavish production lost money, but Blake was proud of its score and considered it his best.

The team returned to vaudeville, ending their long collaboration with a successful eight-month tour of Great Britain in 1925–1926. The two broke up when Sissle, attracted by opportunities in Europe, returned to work there; Blake, delighted to be back home in New York, refused to accompany him. Over the next few years Blake collaborated with Harry Creamer to produce a few songs and shows; reunited with "Broadway" Jones to perform the shortened "tab show" *Shuffle Along Jr.* in vaudeville (1928–1929); and teamed with the lyricist ANDY RAZAF to write songs for *Lew Leslie's Blackbirds of 1930*, including "Memories of You," later popularized by Benny Goodman. After Lyles's death in 1932, Sissle and Blake reunited with Miller to create *Shuffle Along of 1933*, but the show failed, in part because of the Depression. The remainder of the decade saw Blake collaborating with the lyricist Milton Reddie on a series of shows, including the Works Progress Administration–produced *Swing It* in 1937, and with Razaf on several floor shows and "industrials" (promotional shows). Blake's wife died of tuberculosis in 1939, but despite his grief he managed to complete, with Razaf, the show *Tan Manhattan*.

During World War II, Blake toured with United Service Organizations shows and worked with other collaborators. In 1945 he married Marion Gant Tyler, a business executive and former showgirl in several black musicals. She took over management of his financial affairs and saw to the raising of his ASCAP rating to an appropriate level, enhancing their financial security considerably.

After the war, at the age of sixty-three, Blake took the opportunity to attend New York University, where he studied the Schillinger system of composition. He graduated with a degree in music in 1950. Meanwhile, the presidential race of 1948 stirred renewed interest in "I'm Just Wild about Harry" when Harry Truman adopted it as a campaign song. This resulted in a reuniting of Sissle and Blake and in a revival in 1952 of *Shuffle Along.* Unfortunately, the producers' attempts to completely rewrite the show had the effect of eviscerating it, and the restaging closed after only four performances.

Following a few years of relative retirement, during which Blake wrote out some of his earlier pieces, a resurgence of popular interest in ragtime in the 1950s and again in the 1970s thrust him back into the spotlight for the last decades of his life. Several commemorative recordings appeared, most notably, *The Eighty-six Years of Eubie Blake,* a two-record retrospective with Noble Sissle for Columbia in 1969. In 1972 he started Eubie Blake Music, a record company featuring his own music. He was much in demand as a speaker and performer, impressing audiences with his still considerable pianistic technique as well as his energy, audience rapport, and charm as a raconteur. Appearances included the St. Louis Ragfest, the Newport Jazz Festival, the *Tonight Show,* a solo concert at Town Hall in New York City, and a concert in his honor by Arthur Fiedler and the Boston Pops in 1973, with Blake as soloist. In 1974 Jean-Cristophe Averty produced a four-hour documentary film on Blake's life and music for French television. The musical revue *Eubie!,* featuring twenty-three of his numbers, opened on Broadway in 1978 and ran for a year. Blake was awarded the Presidential Medal of Freedom at the White House in 1981.

Blake's wife, Marion, died in June 1982; he left no children by either of his marriages. A few months after his wife's death, his hundredth birthday was feted with performances of his music, but he was ill with pneumonia and unable to attend. He died five days later in New York City.

Over a long career as pianist, composer, and conductor, Blake left a legacy of more than two thousand compositions in various styles. His earliest pieces were piano rags, often of such extreme difficulty that they were simplified for publication. As a ragtime composer and player, he, along with such figures as Luckey Roberts and James P. Johnson, was

a key influence on the Harlem stride-piano school of the 1930s. In the field of show music, Blake moved beyond the confines of ragtime, producing songs that combined rhythmic energy with an appealing lyricism. Particularly notable was his involvement with the successful *Shuffle Along,* which put blacks back on the Broadway stage after an absence of more than ten years. Over his lifetime he displayed a marked openness to musical growth, learning from "all music, particularly the music of Mozart, Chopin, Tchaikovsky, Victor Herbert, Gershwin, Debussy, and Strauss," and, indeed, some of his less well known pieces show these influences. Finally, his role in later years as an energetic "elder statesman of ragtime" provided a historical link to a time long gone as well as inspiration to many younger fans.

FURTHER READING
Blake's papers are at the Maryland Historical Society in Baltimore.
Jasen, David A., and Trebor Jay Tichenor. *Rags and Ragtime: A Musical History* (1978).
Kimball, Robert, and William Bolcom. *Reminiscing with Sissle and Blake* (1973).
Rose, Al. *Eubie Blake* (1979).
Southern, Eileen. *The Music of Black Americans: A History* (1971; 2d ed., 1983).

WILLIAM G. ELLIOTT

BLANKS, Birleanna

(18 Feb. 1889–12 Aug. 1968), vaudeville entertainer and singer, was born in Iowa but grew up in East St. Louis, Illinois. Her mother, Amanda Billups, was a Native American, and her father, Addison Blanks, was an African American.

After her studies were complete, Blanks first taught school in her hometown; however, she soon spread her wings as a professional entertainer, performing around the country and appearing in shows in Chicago and New York City. She began her career in a touring vaudeville act, dancing and singing with her sister, Arsceola Blanks, in the late 1910s. Her sister married Leonard Harper and formed Harper & Blanks, another vaudeville act; Birleanna married the baseball player Chesley Cunningham (the date of the marriage is unknown).

In 1919 Blanks made her debut in Harlem at the Lafayette Theatre, where she sang in *Over the Top.* This musical comedy was the first Billy King show in which she performed for the Harlem theater. That

same year she appeared in a few more of the company's shows, including *They're Off* and *Exploits in Africa*. In 1921 she appeared in King's *New Americans: A Trip Round the World* and *Derby Day in Dixie*.

The Lafayette Theatre was a landmark in its time for being one of the first theaters to allow integrated seating. In addition it was known for its acting troupe, the Lafayette Players, which presented dramatic plays to black audiences. These dramatic plays starred black actors, an uncommon choice in casting at a time when blacks were known primarily for their singing and dancing in comedies. Anita Bush, the founder of the Lafayette Players, wanted to prove that black people were capable of acting in serious as well as in comedic roles. The Lafayette Theatre also catered to new playwrights in the 1910s and 1920s by producing new plays. One of the playwrights that benefited from this opportunity was Billy King, the playwright whose shows Birleanna Blanks performed in at the Lafayette.

In her mid-thirties, having made a name for herself with the Billy King Stock Company, Blanks went on to sing in other production companies such as the Panama Amusement Company in Chicago, Illinois, and the Harlem Producing Company. Around 1923 she became a member of the Three Dixie Songbirds, singing with AMANDA RANDOLPH and Hilda Perlina in Chicago nightclubs. She then performed with this group in the 1925–1926 run of *Lucky Sambo* with Mae Barnes. During this time Blanks recorded "Mason Dixon Blues" and other songs with Paramount, singing with the FLETCHER HENDERSON Orchestra.

For unknown reasons Blanks left the music industry to seek other job opportunities and did not perform in any shows or record any songs after 1928. As in the experiences of many actors and singers, the Depression possibly was a factor in her absence from the theater and music scene. At the age of seventy-nine Birleanna Blanks died of cancer in New York City at the Florence Nightingale Nursing Home. She was buried at the Woodlawn Cemetery in the Bronx.

Half Native American and half African American, Blanks was a singer who led the way for mixed-race women in the entertainment business. With her vaudeville acts, musical comedy roles, and Paramount recordings, she served as a model of success for women of future generations.

FURTHER READING

Harris, Sheldon. "Birleanna Blanks," in *Blues Who's Who: A Biographical Dictionary of Blues Singers* (1979).

Kellner, Bruce. "Birleanna Blanks," in *The Harlem Renaissance: A Historical Dictionary* (1984).

Peterson, Bernard L., Jr. *The African American Theatre Directory, 1816-1960: A Comprehensive Guide to Early Black Theatre Organizations, Companies, Theatres, and Performing Groups* (1997).

Southern, Eileen. *The Music of Black Americans: A History* (1997).

ALLISON KELLAR

BLEDSOE, Jules

(29 Dec. 1897–14 July 1943), baritone, was born Julius Lorenzo Cobb Bledsoe in Waco, Texas, the son of Henry L. Bledsoe and Jessie Cobb, occupations unknown. Following his parents' separation in 1899, Jules lived with his maternal grandmother, a midwife and nurse, who encouraged him to appreciate music. After graduating magna cum laude in 1918 from Bishop College in Marshall, Texas, Bledsoe began graduate medical studies at Columbia University, withdrawing after the death of his mother in 1920 to dedicate himself to singing. In 1924 he presented his debut recital at Aeolian Hall in New York.

Bledsoe's first major stage role was as Tizan in the racially mixed opera *Deep River* by Frank Harling and Laurence Stalling in 1926. That same year he performed in the premiere of Louis Gruenberg's *The Creation* (conducted by Serge Koussevitzky in New York) and worked as an actor at the Provincetown Playhouse. Bledsoe is best known for creating the role of Joe in 1927 in Jerome Kern's *Show Boat*, which ran for two years at the Ziegfeld Theater. (Bledsoe later estimated that he had sung "Old Man River" twenty thousand times.) In 1929 Bledsoe recorded "Lonesome Road" and "Old Man River" to be added to the soundtrack of the 1929 silent film of *Show Boat*. On screen he was represented by the black actor and comedian STEPIN FETCHIT. In 1925 he appeared at the Gallo Theater in New York as Amonasro in the third act of Verdi's *Aida*, performing with members of the New York Philharmonic. In that year he also began a two-year tour of *Show Boat*, followed by a Carnegie Hall recital and concerts in Europe.

In 1932 Bledsoe sang in the Cleveland performance of *Tom-Tom*, an opera by SHIRLEY GRAHAM

[DU BOIS], later the wife of W. E. B. DU BOIS. He then returned to the role of Amonasro in Cleveland and New York, with occasional vaudeville and radio engagements. He performed the *Aida* role in Amsterdam the next season and toured Europe in *The Emperor Jones*. Beginning in 1934, Bledsoe performed in New York, adding to his repertoire the major baritone roles of *Carmen*, *Faust*, and *Boris Godunov*. His recitals and radio broadcasts, however, included spirituals and even blues.

In 1935 Bledsoe participated in charity events in New York, helping to raise money for the Metropolitan Opera—though because of his race he was not even considered for employment by that company—for out-of-work actors, and for pacifist causes. He also returned to Europe to work in musicals. By 1936 he composed and performed his own song cycle, *African Suite*, with Amsterdam's Concertgebouw Orchestra, conducted by Willem Mengelberg.

Bledsoe's plans to leave his home in Roxbury, New York, to return to Europe were thwarted by the outbreak of war in 1939. He spent the remainder of his career largely in recitals to benefit patriotic or humanitarian causes, although he did appear in several films: *Safari* (1940), *Santa Fe Trail* (1940), *Western Union* (1941), and *Drums of the Congo* (1942). He died of a cerebral hemorrhage in Hollywood, where he had been promoting the sale of war bonds. His funeral was held the next week at his boyhood church, New Hope Baptist, in Waco, Texas. He never married.

Although cast in opera for several "race" roles in the United States, Bledsoe was also successful in European productions in roles that were not race-based. Reviews indicate that he was a major vocal talent with an outstanding ability to communicate. One New York critic observed in 1926, "He has a baritone voice of truly exceptional quality. He is a singer who can pick the heart right out of your body—if you don't look out. And in the second act [of *Deep River*] he showed last night that he is a very fine actor as well." A Parisian critic, praising Bledsoe in 1931, said, "If he remained absolutely what he is, he would be unique in the history of song."

Among Bledsoe's compositions, in addition to the *African Suite*, are arrangements of spirituals for voice and piano, *Ode to America* for baritone and chorus—dedicated to Franklin Roosevelt and first performed in a 1941 broadcast hosted by Eleanor Roosevelt—and the opera *Bondage*, after

Harriet Beecher Stowe's *Uncle Tom's Cabin* (never produced).

Bledsoe's career was distinguished by his opera performances, particularly in Europe. American performance opportunities sometimes allied him with figures of the Harlem Renaissance and of vaudeville. Few other black concert artists during this period were able to sustain careers, the major exceptions being ROLAND HAYES, MARIAN ANDERSON, and PAUL ROBESON (who followed Bledsoe as Joe in *Show Boat*).

In 1939 Bledsoe wrote to a former classmate, "I have to be very careful not to injure my prestige. I have had to refuse lesser offers already this year. Most people don't understand that an artist is like a piece of merchandise, which has to be maintained and kept around a certain value, or else . . . the downward grade is begun."

FURTHER READING
The Jules Bledsoe Papers are in the Texas Collection of Baylor University Library, Waco, Texas. The vertical file of the Schomburg Research Center at the New York Public Library contains newspaper clippings.
Geary, Lynnette G. "Jules Bledsoe: The Original 'Ol' Man River,'" *Black Perspective in Music* 17, no. 1/2 (1989): 27–54.

Obituary: Waco Tribune, 21 July 1943.

DOMINIQUE-RENÉ DE LERMA

BONNER, Marita Odette

(16 June 1898–6 Dec. 1971), educator and author, was born in Boston, Massachusetts, the daughter of Joseph Bonner, a machinist and laborer, and Mary A. Nowell. Educated in the Brookline, Massachusetts, public schools, Bonner applied to Radcliffe College at the urging of her high school adviser and was one of the few African American students accepted for admission. She majored in English and comparative literature and founded the Radcliffe chapter of Delta Sigma Theta, a black sorority. A gifted pianist and student of musical composition, Bonner won the Radcliffe song competition in 1918 and 1922. Bonner also studied German, a language in which she became fluent. During her last year in college she taught English at a Cambridge high school. After graduating with a BA in 1922, she taught at the Bluefield Colored Institute in Bluefield, Virginia, until 1924 and at Armstrong High School

in Washington, D.C., from 1924 to 1930, when she married William Almy Occomy, a Brown graduate. The couple moved to Chicago, where they raised three children.

Bonner began writing in high school, contributing pieces to the student magazine, the *Sagamore*. At Radcliffe she was selected to study writing under Charles Townsend Copeland. Copeland, who encouraged her to write fiction, advised Bonner not to be "bitter"—advice that she thought clichéd and consequently ignored. During her literary career she published short stories, essays, and plays, most of which examined the debilitating effects of economic, racial, and sexual prejudice on black Americans. Bonner's first publication, a short story called "The Hands," was published in *Opportunity* in August 1925, and her award-winning essay "On Being Young—A Woman—and Colored" was published in December of that year in *Crisis*; these two magazines continued to publish her work. In the essay, Bonner examines the triple jeopardy facing black women writers and answers Copeland when she addresses "white friends who have never had to draw breath in a Jim-Crow train. Who never had petty putrid insult[s] dragged over them."

She continues these themes in her other writings. In her 1928 essay "The Young Blood Hungers," a haunting refrain captures the anger and despair of a generation facing economic slavery and brutal racism. In her short story "Nothing New" she introduces Frye Street, a fictional neighborhood in Chicago that she describes as running "from freckled-face tow heads to yellow Orientals; from broad Italy to broad Georgia; from hooked noses to square black noses. . . . Like muddy water in a brook" (*Crisis*, 1926). She later returned to this neighborhood for many of her stories. Although multiethnic, black Frye Street does not have the same opportunities as white Frye Street.

While living in Washington, D.C., Bonner wrote and published several works that won awards from *Crisis*, including "Drab Rambles" (1927) and "The Young Blood Hungers" (1928). She was also an active member of the S Street literary salon of black writers established by the poet and playwright GEORGIA DOUGLAS JOHNSON. During this time Bonner wrote and published three plays: *The Pot-Maker: A Play to Be Read* (1927), *The Purple Flower* (1928), and *Exit an Illusion* (1929); the latter two also won *Crisis* awards. In her introduction to *Nine Plays by Black Women* (1986), Margaret Wilkerson calls

Bonner's *The Purple Flower* a black quest for freedom and happiness in a racist society and "perhaps the most provocative play" of the first half of the twentieth century.

After her marriage and subsequent move to Chicago, Bonner took a three-year break from publishing, and when she returned she devoted herself exclusively to fiction, publishing her stories under her married name. These stories offer a vivid portrait of black Chicago and its strained interactions with other minorities and with a racist white society. Her first work was a three-part narrative titled "A Possible Triad on Black Notes," published in the July, August, and September 1933 issues of *Opportunity*. "Tin Can," a two-part narrative, won the 1933 *Opportunity* literary prize for fiction and was published in the July and August 1934 issues of that magazine. These stories and the eight that followed all show the destructiveness of the urban environment on a people suffering from economic slavery and enforced poverty. All set on Frye Street in Chicago, these stories work together, as critics have noted, much the same way that James Joyce's *Dubliners* stories work; Bonner may have intended this, as shown by the heading to her story "Corner Store": "Three Tales of Living: From 'The Black Map' (A book Entirely Unwritten)" (*Opportunity*, 1933).

Bonner's literary career ended in 1941, the year in which she and her husband joined the First Church of Christ, Scientist. Although the church tenets did not conflict with her writing, Bonner nonetheless devoted her intellectual energy to the church rather than to a literary career. After her children were all in school, Bonner resumed teaching. The Chicago Board of Education, dismissing both her Radcliffe degree and her prior teaching experience, required that she take education classes that she passed easily. She taught at Phillips High School from 1944 to 1949 and at the Dolittle School from 1950 to 1963, where she taught mentally and educationally disadvantaged students. Bonner's daughter, Joyce Occomy Stricklin, remembers her mother—a woman who approached everything she did "with every fiber of her being"—frequently spending her evenings calling students' parents to offer encouragement and advice: "She believed in her students and was convinced that lack of love and attention were the most serious handicaps they faced" (Flynn and Stricklin, ix).

Bonner died of complications after a fire in her Chicago apartment. She left behind a notebook

containing six completed but unpublished stories. All her works have since been collected in one volume, *Frye Street and Environs: The Collected Works of Marita Bonner* (1987), by Joyce Flynn and Joyce Occomy Stricklin. In her introduction Flynn writes, "Bonner's works offer the perspective of an educated black female consciousness on a rapidly changing America between the world wars." Bonner was a thematic associate of JESSIE FAUSET, NELLA LARSEN, and ZORA NEALE HURSTON and the literary foremother of many black writers, including RICHARD WRIGHT, Alice Walker, and Toni Morrison.

FURTHER READING

A notebook of previously unpublished stories and Bonner's letters are in the Arthur and Elizabeth Schlesinger Library at Radcliffe College.

Flynn, Joyce, and Joyce Occomy Stricklin, eds. *Frye Street and Environs: The Collected Works of Marita Bonner* (1987).

Peterson, Bernard L., Jr. *Early Black American Playwrights and Dramatic Writers* (1990).

Roses, Lorraine Elena, and Ruth Elizabeth Randolph. "Marita Bonner: In Search of Other Mothers' Gardens," *Black American Literature Forum* 21 (Spring–Summer 1987): 165–183.

ALTHEA E. RHODES

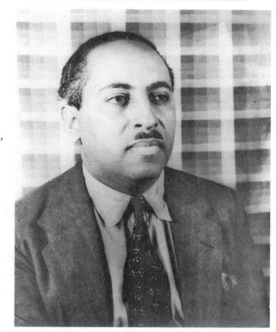

Arna Bontemps, poet, novelist, historian, and librarian who played a major role in shaping modern African American literature, 15 August 1939. (Library of Congress/Carl Van Vechten.)

BONTEMPS, Arna Wendell

(13 Oct. 1902–4 June 1973), writer, was born in Alexandria, Louisiana, the son of Paul Bismark Bontemps, a bricklayer, and Maria Carolina Pembroke, a schoolteacher. He was reared in Los Angeles, where his family moved when he was three. He graduated from Pacific Union College in Angwin, California, in 1923.

Bontemps then moved to Harlem, New York, where the Harlem Renaissance had already attracted the attention of West Coast intellectuals. He found a teaching job at the Harlem Academy in 1924 and began to publish poetry. He won the Alexander Pushkin Prize from *Opportunity*, a journal published by the National Urban League, in 1926 and 1927 and *The Crisis* (official journal of the NAACP) Poetry Prize in 1926. His career soon intersected that of the poet LANGSTON HUGHES, with whom he became a close friend and sometime collaborator. In Harlem, Bontemps also came to know COUNTÉE CULLEN, W. E. B. DU BOIS, ZORA NEALE HURSTON, JAMES WELDON JOHNSON, CLAUDE MCKAY, and JEAN TOOMER.

In 1926 Bontemps married Alberta Johnson; they had six children. In 1931, as the Depression deepened, Bontemps left the Harlem Academy and moved to Huntsville, Alabama, where he taught for three years at Oakwood Junior College. By the early 1930s Bontemps had begun to publish fiction as well as poetry. His first novel, *God Sends Sunday*, was published in 1931, and an early short story, "A Summer Tragedy," won the *Opportunity* Short Story Prize in 1932. *God Sends Sunday* is typical of the Harlem Renaissance. Little Augie, a black jockey, earns money easily and spends it recklessly. When his luck as a jockey runs out, he drifts through the black sporting world. Slight in plot, the novel is most appreciated for its poetic style, its re-creation of the black idiom, and the depth of its characterization. While most reviewers praised it, Du Bois found it "sordid" and compared it with other "decadent" books of the Harlem Renaissance, such as Carl Van Vechten's *Nigger Heaven* (1926) and McKay's *Home to Harlem* (1928). But Bontemps thought enough of the basic story to collaborate with Cullen on

St. Louis Woman (1946), a dramatic adaptation of the book.

Bontemps's next novel would be on a much more serious theme, but he first attempted another genre. In collaboration with Hughes, he wrote *Popo and Fifina* (1932), the first of his many children's books. A travel book for children, it introduced readers to Haitian life by describing the lives of a boy named Popo and his sister Fifina. Bontemps followed his initial success in the new field with *You Can't Pet a Possum* (1934), a story of a boy and his dog in rural Alabama.

Northern Alabama in the early 1930s proved inhospitable to an African American writer and intellectual. The SCOTTSBORO BOYS were being tried in Decatur, just thirty miles from Huntsville. Friends visited Bontemps on their way to protest the trial, and the combination of his out-of-state visitors and the fact that he was ordering books by mail worried the administration of the school. Bontemps claimed in later years that he was ordered to demonstrate his break with the world of radical politics by burning a number of books from his private library—works by Johnson, Du Bois, and Frederick Douglass. Bontemps refused. Instead, he resigned and moved back to California, where he and his family moved in with his parents.

In 1936 Bontemps published *Black Thunder*, his finest work in any genre. Based on historical research, *Black Thunder* tells the story of Gabriel Prosser's rebellion near Richmond, Virginia, in 1800. Prosser, an uneducated fieldworker and coachman, planned to lead a slave army equipped with makeshift weapons on a raid against the armory in Richmond. Once armed with real muskets, the rebels would defend themselves against all attackers. Betrayed by another slave and hampered by a freak storm, the rebels were crushed, and Prosser was hanged. But in Bontemps's version of the affair, whites won a Pyrrhic victory; they were forced to recognize the human potential of slaves.

Although *Black Thunder* was well reviewed by both black and mainstream journals, such as the *Saturday Review of Literature*, the royalties were not sufficient to support Bontemps's family in Chicago, where they had moved just before publication. Bontemps taught briefly in Chicago at the Shiloh Academy and then accepted a job with the WPA Illinois Writers' Project. In 1938, after publishing another children's book, *Sad-Faced Boy* (1937), he received a Rosenwald Fellowship to work on

what became his last novel, *Drums at Dusk* (1939), based on the Haitian rebellion led by Toussaint-Louverture. Although the book was more widely reviewed than his previous novels, the critics were divided, some seeing it as suffering from a sensational and melodramatic plot, others praising its characterizations.

The disappointing reception of the book and the poor royalties it earned convinced Bontemps that "it was fruitless for a Negro in the United States to address serious writing to my generation, and . . . to consider the alternative of trying to reach young readers not yet hardened or grown insensitive to man's inhumanity to man" ("Introduction," x). Henceforth Bontemps addressed most of his books to youthful audiences. He wrote *The Fast Sooner Hound* (1942) in collaboration with Jack Conroy, whom he had met through the Illinois Writers' Project.

In 1943 Bontemps earned his master's degree in Library Science from the University of Chicago. The necessity of earning a living then took him to Fisk University, where he became head librarian, a post he held until 1964. Thereafter he returned to Fisk from time to time. He also accepted positions at the Chicago Circle campus of the University of Illinois and at Yale University, where he served as curator of the James Weldon Johnson Collection of Negro Arts and Letters.

During these years Bontemps produced an astonishing variety and number of books. His children's books include *Slappy Hooper* (1946) and *Sam Patch* (1951), which he wrote in collaboration with Conroy, *Lonesome Boy* (1955), and *Mr. Kelso's Lion* (1970). At the same time he wrote biographies of Douglass, GEORGE WASHINGTON CARVER, and BOOKER T. WASHINGTON for teenage readers; *Golden Slippers* (1941), an anthology of poetry for young readers; *Famous Negro Athletes* (1964); *Chariot in the Sky* (1951), the story of the Fisk Jubilee Singers; and *The Story of the Negro* (1948).

For adults Bontemps and Hughes edited *The Poetry of the Negro* (1949) and *The Book of Negro Folklore* (1958). With Conroy, Bontemps wrote *They Seek a City* (1945), a history of African American migration in the United States, which they revised and published in 1966 as *Anyplace but Here*. Bontemps's historical interests also led him to write *One Hundred Years of Negro Freedom* (1961) and to edit *Great Slave Narratives* (1969) and *The Harlem Renaissance Remembered* (1972). He also edited a

popular anthology, *American Negro Poetry* (1963), just in time for the black reawakening of the 1960s.

Bontemps had been forced by the reception of his work to put his more creative writing on hold after 1939, but the 1960s encouraged him to return to it. He collected his poetry in a slim volume, *Personals* (1963), and wrote an introduction for *Black Thunder* when it was republished in 1968 in a paperback edition. At the time of his death, he was completing the collection of his short fiction in *The Old South* (1973). Bontemps died at his home in Nashville.

Bontemps excelled in no single literary genre. A noteworthy poet, he published only one volume of his verse. As a writer of fiction, he is best known for a single novel, written in midcareer and rediscovered in his old age. Yet the impact of his work as poet, novelist, historian, children's writer, editor, and librarian is far greater than the sum of its parts. He played a major role in shaping modern African American literature and had a wide-ranging influence on African American culture of the latter half of the twentieth century.

FURTHER READING

The major collections of Bontemps's papers are at Fisk University; the George Arents Research Library, Syracuse University; and the James Weldon Johnson Collection, Beinecke Rare Book Room and Manuscript Library, Yale University.
Bontemps, Arna. "Introduction," in *Black Thunder* (1968).
Bontemps, Arna. "Preface," in *Personals* (1963).
Bontemps, Arna. "Why I Returned," in *The Old South* (1973).
Fleming, Robert E. *James Weldon Johnson and Arna Wendell Bontemps: A Reference Guide* (1978).
Gwin, Minrose C. "Arna Bontemps," in *American Poets, 1880–1945*, ed. Peter Quartermain (1986).
Jones, Kirkland C. "Arna Bontemps," in *Afro-American Writers from the Harlem Renaissance to 1940*, ed. Trudier Harris (1987).
O'Brien, John. *Interviews with Black Writers* (1973).

ROBERT E. FLEMING

BOWMAN, Laura

(3 Oct. 1881–29 Mar. 1957), actor and singer, was born Laura Bradford in Quincy, Illinois, the daughter of a Dutch mother and a father with mixed black and white parentage. She grew up in Cincinnati, where she sang in church choirs. Her early family life was difficult, and her father arranged her marriage at sixteen to Henry Ward Bowman, a railroad porter. The unhappy marriage lasted only two years. In 1902 Bowman's dream of a singing career began with her professional debut as a member of the chorus in the Midwest tour of the Williams and Walker Company's production of *In Dahomey*. The show went on to New York and in 1903 toured England, where it also played at Buckingham Palace for the ninth birthday of the Prince of Wales, Edward VIII.

During the tour of *In Dahomey* Bowman fell in love with Pete Hampton, another performer in the show. Soon after arriving in England the original company broke up, and Bowman and Hampton decided not to join the new one. Instead, they formed the Darktown Entertainers quartet with singers Will Garland and Fred Douglas. Performing everything from grand opera to lullabies, the Darktown Entertainers appeared on stage in Germany, Hungary, Austria, France, Switzerland, and Russia. When increasing political unrest forced the group to leave Russia, they returned to London and disbanded. Bowman and Hampton, now in a common-law marriage, returned to the United States, where Bowman appeared in the chorus of *The Southerns* during its thirty-two-week run in New York. Then the couple returned to London to join the second company of *In Dahomey*, this time with Bowman as one of the show's principal actors. After the show closed, Bowman and Hampton worked as a duet throughout Europe and purchased a house in England in 1910. But with war approaching, the British government ordered all foreigners to leave the country. Extremely ill on the voyage home, Hampton died shortly after their arrival.

In 1916, just weeks after Hampton's death, Bowman joined the Lafayette Players, the well-known stock acting troupe from Harlem, New York. She appeared in numerous dramatic and musical productions, often receiving positive reviews from critics. There she also met and fell in love with actor Sidney Kirkpatrick. Because the Lafayette Players management did not want married couples in the company, Bowman and Kirkpatrick eventually left. They married and formed a duo that performed in Boston, Philadelphia, and Washington, D.C. Settling for a time in Indianapolis, Kirkpatrick's hometown, the light-skinned couple circumvented racial prejudice that prohibited African Americans from performing in many of the town's venues by

billing themselves as the Hawaiian Duet. During this time Bowman also made her screen debut in the African American independent filmmaker OSCAR MICHEAUX's *The Brute* (1920), an association that would continue into the early 1940s.

In 1923 Bowman and Kirkpatrick moved to New York, where they became involved with the Ethiopian Art Players. Bowman took on the role of Aunt Nancy in the Broadway production of *The Chip Woman's Fortune* by the black playwright WILLIS RICHARDSON. She also played Herodias to Kirkpatrick's Herod in Oscar Wilde's *Salome*, as well as the role of Aemilia in a jazz version of Shakespeare's *Comedy of Errors*. After the company disbanded, Bowman and Kirkpatrick performed in Indianapolis shortly before rejoining the Lafayette Players. By this time, the couple's popularity convinced the troupe's management to put aside the stipulation against married actors. Bowman's role, in 1928, was as the wife of the lead character in thirty-two performances of *Meek Mose*, written by actor and playwright FRANK H. WILSON. Although the production received fairly negative reviews, Bowman was uniformly praised for her part.

While in New York, Bowman established the National Art School, which taught drama to aspiring African American actors and staged performances at churches, schools, and social events. When the Lafayette Players moved to Los Angeles in August 1928, Bowman and Kirkpatrick followed. The company, after good attendance and reviews at the outset, soon struggled to fill seats and in January 1932 disbanded. Joining the JUANITA HALL Singers, Bowman and Kirkpatrick sang in several films, including *Dixie Anna* and *Check and Double Check*.

The couple moved back to New York City, where Bowman appeared in *Sentinels* in 1931 and *The Tree* in 1932 on Broadway. As had happened earlier in her career, the shows received bad reviews, but Bowman's performances were applauded. Although her roles were based on the black mammy stereotype, by the early thirties she had established herself as a legitimate actor on the stage.

Bowman and Kirkpatrick traveled to Los Angeles briefly to join the revived Lafayette Players in 1932. The troupe lasted only three weeks, but she remained in Los Angeles for several months. There she made *Ten Minutes to Live* (1932), with Micheaux, and had a role in the film *Drums of Voodoo* (released 1934). By the end of 1932 Bowman and Kirkpatrick

were back in New York performing their duo act. Soon after their return Kirkpatrick died suddenly from a heart attack, leaving Bowman widowed for the second time.

Despite her personal tragedy Bowman continued to work, and just weeks after her husband's death played Auntie Hagar in the all-black cast of *Louisiana*. She also began to drink heavily, and while at a Harlem bar frequented by black performers, she met her next husband, LeRoi Antoine, a Haitian immigrant twenty-three years younger than Bowman, with aspirations to become an opera singer. Bowman and Antoine married soon after they met in 1933.

During the remainder of the 1930s Bowman appeared in stage, screen, and radio productions. After *Drums of Voodoo* was released, the original Broadway cast restaged a production of *Louisiana*, with Bowman once again as Auntie Hagar. She also appeared in the short-lived *Yesterday's Orchid* (1934). She played Edgar Allan Poe's housekeeper in *Plumes in the Dust*, which opened in Washington, D.C., in 1936 before moving to New York's Forty-sixth Street Theatre. Critics singled out Bowman for her well-executed role as Parthenia, the Conjur woman in 1938's *Conjur*, which featured an all-black cast. The following year she once again played the stereotypical role of domestic servant, this time in a short-lived production of *Please, Mrs. Garibaldi*.

As a radio actor, Bowman could be heard on numerous shows, including *Southernaires, Personal Column on the Air*, and *Pores and Drums* as well as radio soap operas such as *Stella Dallas* and *Pretty Kitty Kelly*. Indeed, her radio performances became a steady source of income during the 1930s. In 1938 she had a role in Micheaux's film *God's Stepchildren*. Bowman and Antoine decided to move to Los Angeles to help his career as an actor, and in 1940 Bowman played the leading role of Dr. Helen Jackson in the movie *Son of Ingagi*, notable as the first all-black horror film. In the same year she also appeared in *The Notorious Elinor Lee*, another independent film by Micheaux.

An amateur theater group Bowman created during the early 1940s landed her work on radio, and the group's show—often featuring biblical stories—became widely popular. The venture paid little but kept Bowman busy until the mid-1940s, when she began acting again. Her role in the Hollywood production of *Decision* led to a role in a new postwar drama, *Jeb*, in New York. She played the mother of

a black World War II hero who struggles with racial prejudice after returning to the South at the end of the war. Opening on 7 February 1946 at the Locust Street Theatre in Philadelphia, it enjoyed a short run on Broadway. Afterward Bowman was invited to perform with a company touring with *Anna Lucasta*. With more than nine hundred performances, the play was an overwhelming success, and the company took it to Europe. Bowman remained in the United States and continued with the play on the "subway circuit"—the Bronx, Brooklyn, Atlantic City, and other nearby locations. After four years as Theresa in *Anna Lucasta*, she returned to Los Angeles when the show finally closed. The role of Theresa was her last.

In 1951, shortly after arriving in Los Angeles, Bowman, by then weighing more than two hundred pounds, suffered a stroke that confined her to a wheelchair for the rest of her life. Although she had made a significant amount of money during her career, she had no savings during her last years. For the next six years Antoine attended dutifully to his bedridden wife. Bowman died at her home in Los Angeles at the age of seventy-six. In her obituary the *New York Times* noted, "It was said of Miss Bowman that she played in about every country that had a theatre." In 1961 Antoine published her biography, *Achievement: The Life of Laura Bowman*, "as told by Laura Bowman to her husband."

FURTHER READING

Sampson, Henry T. *Blacks in Black and White: A Source Book on Black Films* (1977).

Tanner, Jo A. *Dusky Maidens: The Odyssey of the Early Black Dramatic Actress* (1992).

MARY ANNE BOELCSKEVY

BRADFORD, Perry

(14 Feb. 1895–20 Apr. 1970), blues and vaudeville songwriter, publisher, and musical director, was born John Henry Perry Bradford in Montgomery, Alabama, the son of Adam Bradford, a bricklayer and tile setter, and Bella (maiden name unknown), a cook. Standard reference books give his year of birth as 1893, but Bradford's autobiography gives 1895. Early in his youth Bradford learned to play piano by ear. In 1901 his family moved to Atlanta, where his mother cooked meals for prisoners in the adjacent Fulton Street jail. There he was exposed to the inmates' blues and folk singing. Bradford attended Molly Pope School through the sixth grade

and claimed to have attended Atlanta University for three years, there being no local high school. This is chronologically inconsistent, however, with his claim to have joined Allen's New Orleans Minstrels in the fall of 1907, traveling to New Orleans for Mardi Gras performances in February 1908 and then moving on to Oklahoma.

After working as a pianist in Chicago, Bradford toured widely from about 1909 to 1918 with Jeanette Taylor in a song-and-dance act billed as Bradford and Jeanette. His nickname "Mule" came from his being featured in a piano and vocal vaudeville song titled "Whoa, Mule," although the jazz dance historians Marshall and Jean Stearns point out that the name also fit Bradford's personality. Bradford learned countless dances from local performers as he toured. When appropriate he memorialized the best dances in lyrics to songs such as "The Bullfrog Hop" (c. 1909) and "Rules and Regulations" (printed in 1911). A shrewd entrepreneur, he initially published his songs as sheet music to be sold after performances. This informal method of distribution was caused in part by the racist structure of the publishing industry, which put roadblocks in the paths of aspiring African American songwriters. (Compare the experiences of the lyricist and composer ANDY RAZAF.) Bradford's financial situation improved slightly with the commercial publication of "Scratchin' the Gravel" (1917) and "The Original Black Bottom Dance" (1919). During these final years of the decade he produced and performed in the musical revues *Sergeant Ham of the 13th District* (1917 and 1919), *Made in Harlem* (at the Lincoln Theatre in New York, 1918)—for which he wrote "Harlem Blues"—and *Darktown after Dark* (1919). Around 1918 Bradford married his first wife, Marion Dickerson, who took Taylor's place in the revues; details of his subsequent marriage or marriages are unknown.

In 1920 Bradford initiated a revolution in popular music. After several companies had turned him down, Bradford convinced Fred Hager of Okeh records to take a chance in spite of racist warnings "not to have any truck with colored girls in the recording field" (Bradford, 118). In February the African American singer MAMIE SMITH recorded for Okeh Bradford's songs "That Thing Called Love" and "You Can't Keep a Good Man Down," accompanied by a white band; these were not immediately released, owing to an industry-wide patent dispute that was still half a year from settlement. In August,

with an African American band, the Jazz Hounds, that was put together hastily, Smith recorded "It's Right Here for You" and "Crazy Blues." "Crazy Blues" became a huge hit, selling perhaps more than a million copies. It initiated the 1920s craze for female blues singers and more broadly opened up the field of recording to African Americans, not only in general markets but also in a newly created market: race records.

In 1921 Bradford organized tours for Smith, directed further recording sessions, and established his own publishing company. He quickly made five-figure sums in royalties, and when a Columbia Records lawyer, unaware of the immediate success of "Crazy Blues," offered to make the song a big hit if Bradford would waive his rights to royalties, Bradford made the classic reply, "The only thing Perry Bradford waives is the American flag" (Bradford, 155). Also in 1921 the singer ETHEL WATERS featured Bradford's song "Messin' Around" on the Theater Owners' Booking Association circuit, and Bradford himself performed in the show *Put and Take* (1921). But all did not go smoothly in this year. Bradford reached an out-of-court settlement for having previously sold "Crazy Blues" (a retitled version of "Harlem Blues") to other publishers under the alternative titles "The Broken Hearted Blues" and "Wicked Blues." Also, a series of financial and touring disputes with Smith's husband and her boyfriend led Bradford to switch from Okeh to Columbia to promote the singer EDITH WILSON, who recorded Bradford's "Evil Blues" in 1922. The same year he was sued for publishing a song owned by another publisher, was convicted of this charge and also of having witnesses commit perjury while testifying on his behalf, and was sentenced to four months in prison.

Among his achievements in the 1920s Bradford claimed to have taught the Black Bottom dance to Ethel Ridley, who introduced it in Irvin C. Miller's show *Dinah* (1923). From this point on his star descended quickly. He assembled great musicians such as LOUIS ARMSTRONG, JAMES P. JOHNSON, and Buster Bailey for undistinguished recordings made from 1923 to 1927 under the name of Perry Bradford's Jazz Phools, and in 1927 he introduced his song "All I Had Is Gone." He also wrote lyrics to the musical revue *Messin' Around* (1929). He seems to have made no further impact, however, apart from a hit song recorded by Louis Jordan's new band in 1939, "Keep a Knockin'

(But You Can't Come In)." The singer and songwriter NOBLE SISSLE asserts: "The industry, especially some of the publishers, finally had Perry's terrific catalog of 1,400 songs blackballed from being recorded because he would not sell out to them. They practically broke him. His only brother Negro publisher, CLARENCE WILLIAMS, offered him the same fate. He had to sell out to a white publisher" (Bradford, 10). Bradford lived on relief and worked in New York as a mailman at Queens General Hospital, where he died after having spent his last years in ill health and confined to a nursing home.

As a musician Bradford was no match for the pianist and composer JELLY ROLL MORTON, but they resembled one another in crucial ways. Both were aggressive, perceptive self-promoters who backed up brash claims with documented achievements. Touring the country during the developmental years of blues and jazz, they absorbed and disseminated what they heard, thus helping to create an international music from scattered rural and urban folkways. Both were inflexibly hardheaded and after a period of great success—Bradford's financial and sociocultural, Morton's artistic—found themselves left behind as they stuck doggedly to musical styles that had fallen out of fashion.

Bradford's autobiography is a sustained outburst against his having been left out of early histories of blues and jazz and also against what was in his (probably incorrect) opinion an overestimation of the significance of New Orleans jazzmen in comparison to African American jazz musicians in other places. Although he distorts history as much as he repairs it, his essential arguments have been taken into account in most subsequent studies, and the great significance of his personal contribution to the music's flowering is now widely acknowledged.

FURTHER READING

Bradford, Perry. *Born with the Blues: Perry Bradford's Own Story, The True Story of the Pioneering Blues Singers and Musicians in the Early Days of Jazz* (1965).

Charters, Samuel B., and Leonard Kunstadt. *Jazz: A History of the New York Scene* (1962; rpt. 1981, 1984).

Stearns, Marshall, and Jean Stearns. *Jazz Dance: The Story of American Vernacular Dance* (1968).

BARRY KERNFELD

BRAITHWAITE, William Stanley Beaumont

(6 Dec. 1878–8 June 1962), poet, critic, and anthologist, was born in Boston, Massachusetts, the son of William Smith Braithwaite and Emma DeWolfe. Of his two avocations—American poetry and the status of the American Negro—the second clearly had its origins in an unusual cultural heritage. The Braithwaite family, of mixed black and white descent, was wealthy and held prominent positions in British Guiana. Braithwaite's father studied medicine in London but quit because of apparent mental strain and moved to Boston, where he married DeWolfe, whose family had been in slavery. His father remained aloof from neighbors, educating his children at home. Braithwaite's autobiography mentions no employment held by his father, whose death, when his son was eight years old, left the family destitute.

Braithwaite's mother was forced into menial employment, and at the age of twelve, so was Braithwaite. After showing interest in reading, he

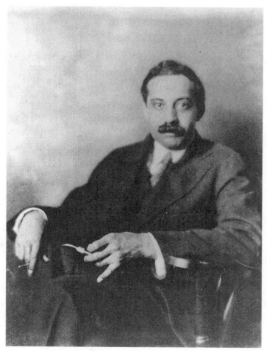

William Stanley Braithwaite, poet, critic, and anthologist, c. 1915. (Library of Congress, National Association for the Advancement of Colored People Records.)

was given a job as a typesetter, where exposure to the poetry of John Keats fixed the course of his life: "Keats had created in me an aspiration that became the most passionate urgency in my life, and Wordsworth and Burns nourished it into an ambition that developed into a fanatical determination" (Butcher, 174). Braithwaite read widely and completed a volume of poetry before he was twenty-one, but a series of disappointments made him aware of the tremendous racial barriers he would have to overcome as an African American in order to make a living in the literary field. He became determined to prove that a black poet could be successful despite the fact that he was black—without being forced into a special category as a Negro writer. With this resolve he developed a Keatsian theory of poetry: "It is not the feeling of contemplative anxiety aroused by the philosophic or moral imagination that gives to poetry its highest value, but the agitated wonder awakened in the spirit of the reader by the sudden evocation of magic" (Butcher, 29–30). Braithwaite's attempted evocations of sheer beauty show virtually no awareness of his racial heritage or of the social problems confronting black Americans, and as a result he has often been criticized or dismissed by those concerned with black literature. It should be remembered, however, that Braithwaite frequently championed black writers, offered his guidance to writers of the Harlem Renaissance, and analyzed the position of black writers in essays such as "The Negro in American Literature."

In "The Negro in American Literature" he traces the treatment of black people in American literature by both black and white writers from *Uncle Tom's Cabin* through the mid-1920s. He does not praise authors whose work shows no signs of race but whose work transcends the racial. Of JAMES WELDON JOHNSON he says, "Mr. Johnson's work is based upon a broader contemplation of life, life that is not wholly confined within any racial experience, but through the racial he made articulate that universality of the emotions felt by all mankind" (Butcher, 77). Of JEAN TOOMER's *Cane* he writes: "So objective is it, that we feel that it is a mere accident that birth or association has thrown him into contact with the life he has written about. He would write just as well . . . about the peasants of Russia, or the peasants of Ireland" (83). Although Braithwaite's poetry is not a reflection of his black heritage, he admired writers whose work went beyond their black heritage to universal human experience.

In 1903, with his career still before him, he married Emma Kelly; the couple had seven children. A few months after his marriage, he dedicated himself full time to literature. His first volume, *Lyrics of Life and Love* (1904), was published by subscription. In 1906 he began writing reviews and criticism for the staid but influential *Boston Evening Transcript*. The collections of the year's best poetry that he published there developed into an annual anthology of magazine verse that appeared from 1913 until 1929.

Braithwaite was an important guiding force during the emergence of modern poetry in the United States. He recognized the genius of Edwin Arlington Robinson before the turn of the century and became a close friend. Among the others whose careers he advanced was Robert Frost, whom he first praised in 1915. He was receptive to imagism, although he did not share the American poet and editor Harriet Monroe's enthusiasm for Ezra Pound.

In spite of his influence, Braithwaite was hampered by financial difficulties. He published his yearbooks at his own expense, and he was unable to publish a projected anthology of Negro poetry. His *Poetry Journal*, begun only months after Monroe's *Poetry*, failed after a few issues. It was not until 1935, when he accepted a professorship at Atlanta University, that he enjoyed financial security. He taught ten years before retiring to Harlem, where he produced *Selected Poems* (1948) and *The Bewitched Parsonage: The Story of the Brontës* (1950). He died at his home in New York City.

It is doubtful that Braithwaite will be remembered as a poet. His *Selected Poems* is a very slim volume, and the poetry is fragile and overly delicate. Between this volume and his first appeared only one other, *The House of Falling Leaves* (1908). His work rarely appears in anthologies. Philip Butcher, editor of *The William Stanley Braithwaite Reader*, predicts that "William Stanley Braithwaite's stature is sure to grow as scholars give attention to the records of his life and work" (7). If Braithwaite is remembered, it will be as an important critical voice of the early twentieth century.

FURTHER READING

Forty libraries have papers relating to Braithwaite. The major collections are at Harvard University and Syracuse University.

Bardolph, Richard. *The Negro Vanguard* (1971).

Butcher, Philip, ed. *The William Stanley Braithwaite Reader* (1972).

Redding, J. Saunders. *To Make a Poet Black* (1939).

Obituary: *New York Times*, 9 June 1962.

DALTON GROSS
MARYJEAN GROSS

BRAWLEY, Benjamin

(22 Apr. 1882–1 Feb. 1939), educator and author, was born Benjamin Griffith Brawley in Columbia, South Carolina, the son of Margaret Saphronia Dickerson and Edward McKnight Brawley, a prosperous Baptist minister and president of a small Alabama college. Brawley was an exceptionally bright boy, and the family's frequent moves never interfered with his learning. Up until the third grade he was tutored at home by his mother, but he also attended schools in Nashville, Tennessee, and Petersburg, Virginia. During summers, when he was not studying the classics, Latin, and Greek at home, he earned money by doing odd jobs, working on a tobacco farm in Connecticut or in a printing office. One summer he drove a buggy for a white doctor—and studied Greek while the doctor was out. At age twelve he was sent to Virginia to be tutored in Greek and he also studied the language with his father.

By age thirteen Brawley had excelled so much in his studies that he was sent to the preparatory program at Atlanta Baptist College (later Morehouse College). He was surprised and disappointed on his arrival to note that most of the older students there knew nothing of classical literature, much less Greek or Latin. His classmates were equally surprised to find such a young man in their midst, but they soon discovered just how valuable an asset he was. Aware of his intellectual and grammatical prowess, they brought their compositions to him before passing them on to their instructors. Brawley excelled outside the classroom as well. He played football, managed the baseball team, and cofounded the school newspaper, the *Athenaeum* (later the *Maroon Tiger*), for which he wrote numerous articles and poems. Brawley is also said to have initiated the first debate among African American colleges when his Morehouse team challenged another group from Talladega College.

In 1901 Brawley graduated with honors from Atlanta Baptist College and immediately took a teaching position, for five months at thirty-five dollars a month, in a one-room school in Georgetown, Florida, but then, in 1902, he took a teaching job at

his alma mater, where he stayed until 1910. During his years at Atlanta Baptist College, he also earned his BA (1906) from the University of Chicago and his MA (1908) from Harvard by taking mostly summer courses. Then he accepted a professorship at Howard University and while teaching there met Hilda Damaris Prowd, who became his wife in 1912. They had no children. After only two years at Howard, he returned to Atlanta Baptist, where, in addition to teaching, he became the college's first dean and where his teaching techniques became legendary.

Brawley considered teaching to be a divine profession that should be used to bring students "into the knowledge of truth," the success of which depended as much upon the efforts of the teacher as on those of the student. He expected of his students the same high academic and moral standards that he had learned as a child, and he stressed that teaching should take into account the whole student—his or her physical, emotional, economic, and moral background. Brawley would commonly make students memorize long passages from classical literature, and he returned any compositions with even the slightest degree of sloppiness or imprecision, marking them with terse comments like "Too carelessly written to be carefully read" (Parker, *Phylon* [1949], 18). A traditionalist first, last, and always, Brawley was also dissatisfied with the state of education in the country, which emphasized materialism and innovation rather than rote learning.

Although Brawley still earned his primary living as a teacher, he also began to turn seriously toward another profession. He had written articles for his school paper and other publications for several years, but from 1921 on he produced at least ten books and about one hundred newspaper and magazine articles, book reviews, editorials, and other efforts. Whether he was writing about African American life and culture, as in *A Social History of the American Negro* (1921), or more literary topics, as in *A New Survey of English Literature* (1925), Brawley stressed two major themes: first, that literature must rest on a sound artistic and moral basis, and second, that it should present not just the struggles of individuals and races, but "a mirror of our hopes and dreams" as well (*The Negro Genius* [1937], 196). He was particularly saddened that most novels and short stories about African Americans that came out of Harlem and other places in the 1920s depicted characters as comic or appealed to readers'

lower natures. "We are simply asking," he wrote in *The Negro Genius*, "that those writers of fiction who deal with the Negro shall be thoroughly honest with themselves" (206). Only by strict adherence to these high ideals, Brawley believed, could the lot of his own race be improved and race relations be dealt with honestly.

In 1920, after many years at Morehouse, Brawley went to the African Republic of Liberia to conduct an educational survey. Shortly after his return in early 1921, he followed in his father's footsteps and became an ordained Baptist minister at the Messiah Congregation in Brockton, Massachusetts. After only a year, however, he found the congregation's type of Christianity not to his liking and resigned. Brawley returned to teaching, first at Shaw University in North Carolina, where his father, by then in failing health, taught theology, and then, in 1931, at Howard, where he stayed until the end of his life. In 1936 he published PAUL LAURENCE DUNBAR: *Poet of His People*. He died at his home in Washington, D.C., from complications following a stroke.

Brawley's impeccable academic credentials and high standards earned him the respect of almost all his students, although that respect was shown in unusual ways. One story goes that a student came to class carrying under his arm a bundle wrapped in newspaper, which everyone assumed was laundry. Instead, the student had carefully wrapped his essay in the bundle to be sure that it met Brawley's exacting standards. Brawley's techniques, coupled with his difficulty in abiding by any standards other than his own, earned him his share of criticism, but far more often than not they achieved desirable results.

FURTHER READING
The Brawley papers are at the Moorland-Spingarn Research Center at Howard University. A complete bibliography of Brawley's published works appears in *North Carolina Historical Review* 34 (Apr. 1957): 165–175.
Parker, John W. "Benjamin Brawley and the American Cultural Tradition." *Phylon* 16 (1955): 183–194.
Phylon Profile XIX. "Benjamin Brawley—Teacher and Scholar." *Phylon* 10 (1949): 15–24.
Price, Charlotte S. *Richard Le Gallienne as Collected by Benjamin Griffith Brawley* (1973).

Obituaries: New York Times, 7 Feb. 1939; *The Crisis* 46 (1939).

ROGER A. SCHUPPERT

BRICKTOP

(14 Aug. 1894–31 Jan. 1984), entertainer and night-club operator, was born in Alderson, West Virginia, the daughter of Thomas Smith, a barber, and Hattie E. (maiden name unknown), a domestic worker. Christened Ada Beatrice Queen Victoria Louise Virginia, because her parents did not wish to disappoint the various neighbors and friends who offered suggestions for naming her, Bricktop received her nickname because of her red hair when she was in her late twenties from Barron Wilkins, owner of a nightclub called Barron's Exclusive Club in Prohibition-era Harlem.

Bricktop's father died when she was four, and her mother moved with the children to Chicago to be near relatives. Hattie Smith worked as a domestic in Chicago, and her children attended school. Bricktop showed early musical talent and interest in performing. She made her stage debut as a preschooler, playing the part of Eliza's son Harry in a production of *Uncle Tom's Cabin* at the Haymarket Theatre. As an adolescent, she had the opportunity to perform onstage again when she was hired as part of the chorus for a show at the Pekin Theatre. She quit school at age sixteen to pursue a career as an entertainer, first touring with (Flournoy) Miller and (Aubrey) Lyles, a well-known black comedy team.

After the Miller and Lyles show folded, Bricktop toured with a variety of black vaudeville acts across the northern half of the United States. In the early 1920s she returned to Chicago and worked

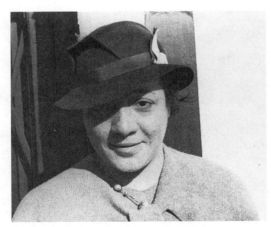

Bricktop, expatriate who ran nightclubs in Paris and Rome frequented by American celebrities, June 1934. (Library of Congress/Carl Van Vechten.)

as a saloon performer at Roy Jones's and the Cafe Champ, owned by heavyweight champion JACK JOHNSON. In 1922 she went to Harlem, where she worked in Connie's Inn, among other nightclubs, and received her nickname. In 1924 she was invited to work in Paris at Le Grand Duc, a tiny club in Montmartre managed by Eugène Bullard, an African American pilot who had distinguished himself during World War I in the French Foreign Legion and the Lafayette Escadrille.

Never a great song stylist, Bricktop attracted the attention of white Americans in Paris because of her charming personality and her ability to make them feel at home. T. S. Eliot wrote a poem for her. F. Scott Fitzgerald liked to say, "My greatest claim to fame is that I discovered Bricktop before Cole Porter." But it was her discovery by Porter, who later wrote the song "Miss Otis Regrets" for her, that put the imprimatur of acceptance upon her. Under Porter's aegis, Bricktop became a darling of the American celebrity set in Paris. By the fall of 1926, Bricktop had opened the first Bricktop's nightclub in Paris, catering to such American luminaries as Fitzgerald, Elsa Maxwell, Tallulah Bankhead, Ernest Hemingway, and Barbara Hutton, and to international celebrities like the Aga Khan. "Everybody belonged, or else they didn't bother coming to Bricktop's more than once," she wrote in her autobiography.

A succession of Bricktop's nightclubs followed, both in Paris and, in the summertime, at Biarritz, where Bricktop claimed to have cradled the romance of the Duke of Windsor and the American divorcée Wallis Simpson. Among the careers she nurtured was that of the British-born black singer Mabel Mercer.

The stock market crash in the United States in October 1929 had no effect, at first, on the "gay" life in Paris. In December 1929 Bricktop married Peter Duconsé, an African American saxophonist from New Orleans, and the two purchased a country home in Bougival, outside Paris. Childless, each led an independent life, as well as sharing a life together. Some years after their marriage, however, Peter had an affair with a young African American singer whom Bricktop had taken under her wing in Paris. On learning of her husband's infidelity, Bricktop refused to sleep with him again, although she never divorced him. He died in 1967.

In 1939, as war in Europe and the invasion of France seemed imminent, the Duchess of Windsor

(the former Wallis Simpson) and Lady Mendl (Elsie de Wolfe) helped Bricktop escape from Paris to New York, where her friend Mabel Mercer had already relocated. Mercer managed to find a niche as a singer in New York cabarets, but Bricktop's special talents as a self-described "saloonkeeper par excellence" went unappreciated. Bankrolled by the tobacco heiress Doris Duke, she relocated to Mexico City, where she successfully ran clubs until the war in Europe was over. In 1943 she converted to Catholicism and remained a devout Catholic for the rest of her life.

Returning to Paris in 1950, she found her old stomping grounds much changed, as was the clientele. After trying and failing to revive the prewar atmosphere, Bricktop removed to Rome, where on the Via Veneto from 1951 to 1965 she re-created the feeling of the old Bricktop's for a new celebrity crowd, primarily American film stars. The romance of Richard Burton and Elizabeth Taylor first made the gossip columns when they were seen together at the Rome Bricktop's during the filming of *Cleopatra*. To Bricktop, her career in Rome was secondary to the golden years in Paris, and she never fully accepted the Hollywood film stars as the nouveau royalty.

When Bricktop's older sister Blonzetta became ill in 1965, Bricktop returned to Chicago to nurse her and, after her death, went back to straighten out her affairs. Blonzetta left Bricktop a substantial inheritance. In her early seventies, Bricktop moved to Los Angeles, returned briefly to Europe, and then in 1970 settled in New York City. She made a recording of "So Long, Baby" with Cy Coleman, briefly ran a club owned by Huntington Hartford and then one called Soerabaja, and appeared from time to time at clubs in Chicago, at the Playboy Club in London, and at "21" in New York. Ill health caused her to cease working in 1979.

In August 1983 Bricktop published her autobiography, *Bricktop*, written with Jim Haskins. Five months later she died in New York City. To the end she was a lady of the dawn who drank only champagne and expected a rose from every male visitor.

FURTHER READING

Bricktop's papers are in the collection of the Schomburg Center for Research in Black Culture of the New York Public Library.

Boyle, Kay, and Robert Altman. *Being Geniuses Together, 1920–1930* (1968).

Haskins, Jim. *Mabel Mercer: A Life* (1968).

Obituary: Rolling Stone, 29 Mar. 1984.

JIM HASKINS

BRIGGS, Cyril Valentine

(28 May 1888–18 Oct. 1966), journalist and activist, was born on the Caribbean island of Nevis, the son of Marian M. Huggins, a woman of color, a plantation worker and Louis E. Briggs, a white native of Trinidad and plantation overseer. From childhood Briggs had a stutter that made verbal communication difficult, but he more than compensated through the power of his pen. Butting heads with colonial school administrators, he was dismissed from two primary schools before settling at Ebenezer Wesleyan on the island of St. Kitts; he graduated from this school in 1904. In his autobiographical writings Briggs indicated that despite its challenges, colonial education shaped his later career by introducing him to radical thinkers like the freethinking agnostic Robert Green Ingersoll. After his graduation Briggs embarked on his lifelong career in journalism by becoming a reporter for the *St. Kitts Daily Express* and the *St. Christopher Advertiser*.

Briggs immigrated to the United States on 4 July 1905 and joined a growing West Indian activist community in Harlem. Little is known about his first years in the United States except that he became engaged to Bertha Florence Johnson in Norfolk, Virginia. Johnson moved to New York in 1912, and the couple married on 7 January 1914. In 1912 Briggs became a society reporter for the *New York Amsterdam News*, an African American newspaper founded in 1909. He rose through the ranks at the *Amsterdam News* as sporting editor and editorial writer for three years before he resigned to join the staff of the *Colored American Review*, a black business magazine. He returned to the *Amsterdam News* almost immediately, but his work with the *Colored American Review* launched his career as a radical nationalist journalist. From 1915 to 1919 Briggs published hard-hitting editorials urging African Americans to have race pride and to seek self-determination, notably through the creation of a separate black state. When President Woodrow Wilson argued that post–World War I peace in Europe should rest not on governments but on the

rights of European peoples, Briggs published an editorial calling for a separate state within the geographical borders of the United States where the rights of African Americans would be respected.

When the United States entered World War I, Briggs registered for military service, joining the many African Americans who believed that wartime service could counteract white racism. His hopes were dashed with the 2 July 1917 antiblack race riot in East St. Louis, and he became an outspoken opponent of U.S. participation in the war. Southern mobs lynched at least sixteen African American World War I veterans between 1918 and 1920, and summertime race riots were so violent in 1919 that JAMES WELDON JOHNSON, writer and later executive secretary of the NAACP, termed it "Red Summer." Briggs is perhaps best known for organizing the African Blood Brotherhood for African Liberation and Redemption (ABB) in response to this turmoil. The nationalist fraternity recruited men willing to arm themselves against racial violence, fostered pride in African ancestry, and promoted African American participation in a global anticapitalist struggle.

Briggs launched his own paper, the *Crusader*, in September 1918. The mission of the *Crusader* was to advance a movement to "help make the world safe for the Negro" (*Crusader*, Sept. 1918). In choosing these words, Briggs noted the irony of President Wilson calling World War I a war to make the world "safe for democracy" while African Americans still faced oppression on the home front. In early issues Briggs advocated self-pride and armed resistance, and after Red Summer he expressed increasingly anticapitalist and anti-imperialist opinions. His radical views led to a break with the *Amsterdam News* in 1919. From 1919 until the Tulsa race riot of 1921 the *Crusader* acted as the official organ of the Hamitic League of the World, a nationalist organization of which Briggs was a member. In the June 1921 issue he praised black residents who fought back against the white mobs, declared the *Crusader* the official organ of the ABB, and introduced the latter as an above-ground organization.

Dissatisfied with the platforms of mainstream politics, Briggs allied with the Communist Party. He saw communism as a means of ending racial oppression and in an October 1919 editorial wrote, "If to fight for one's rights is to be Bolshevist, then we are Bolshevists and let them make the most of it!" ("Bolshevist!!!" *Crusader*, Oct. 1919). Briggs's allegiance to racial nationalism and class-based communist revolution put him at odds with both African American and Communist Party leaders. His relationship with MARCUS GARVEY, founder of the United Negro Improvement Association, was particularly problematic. Briggs originally sought an alliance with Garvey as a fellow West Indian immigrant in favor of racial self-determination, but a conflict over Garvey's strict anticommunism and a feud over adherents left the men estranged.

The *Crusader* folded due to decreased funding and government anticommunist pressure in 1922, and the ABB disbanded in 1925. Undeterred, Briggs was at the forefront of African American and communist cooperation in the 1920s and helped spur increasing black membership in the Communist Party into the late 1930s. Nevertheless, he maintained his black nationalist views and in 1942 was expelled from the party for holding this line. Briggs is also significant as one of a cadre of West Indian immigrants who took leading roles in an era of post–World War I radicalism and were sometimes referred to as the New Negro movement. Perhaps due to his own international experience, he was a global thinker who garnered inspiration from such disparate sources as his Caribbean upbringing, African history, the Irish independence movement, and Soviet Communism.

Briggs migrated to California and worked as editor of the *California Eagle* from 1945 to 1949. He remained an outspoken radical and in 1958 was called before the House Un-American Activities Committee, where he angered representatives by refusing to offer any information about communism. Instead, he took the opportunity to criticize the slow pace of school desegregation efforts in the South. Briggs died in Los Angeles.

FURTHER READING

Blake, Gene. "Integration Issue Raised by Witness at Red Quiz," *Los Angeles Times*, 4 Sept. 1958.

Hill, Robert A., and Cyril V. Briggs. *The Crusader* (1987).

James, Winston. *Holding Aloft the Banner of Ethiopia: Caribbean Radicalism in Early Twentieth-Century America* (1998).

Kornweibel, Theodore, Jr. *"Seeing Red": Federal Campaigns against Black Militancy, 1919–1925* (1998).

Makalani, Minkah. "For the Liberation of Black People Everywhere: The African Blood Brotherhood, Black Radicalism, and Pan-African

Liberation in the New Negro Movement, 1917–1936," PhD diss., University of Illinois at Urbana-Champaign (2004).

Solomon, Mark. *The Cry Was Unity: Communists and African Americans, 1919–1936* (1998).

AMBER MOULTON-WISEMAN

BROOKS, Shelton

(4 May 1886–6 Sept. 1975), songwriter, was born Shelton Leroy Brooks in Amesburg, Ontario, near Detroit, to Potter, a Methodist minister, and Laura Brooks. Both of his parents sang and played the organ, and they kept a harmonium (pump organ) in the home. Shelton began experimenting on this while still a small child. Because Shelton was too small to reach the foot pedals, however, an older brother operated them while he played the keyboard. The family moved to the United States while Shelton was a boy, and he began his career in Detroit and Cleveland, honing the performing skills that would later make him a popular entertainer. He migrated to Chicago, the unrivaled hub of African American entertainment in the Midwest, sometime before 1909.

Brooks's first known song, "You Ain't Talking to Me," was published in 1909 by Will Rossiter of Chicago, and Brooks stuck with this firm for most of his publications. The second of these, "Some of These Days," became an enormous hit. Brooks personally persuaded the vaudeville star Sophie Tucker to feature the song in her act at Chicago's Orpheum Theatre; it became a sensation and became Tucker's theme song for the remainder of her long career. Each of her four varying recordings of the song (1911, 1926, 1927, and 1929) became a hit, and a short feature film named for the song was released with Tucker as its star. Brooks followed this song with a number of lesser efforts, including "The Cosey Rag" and "Jean" (1911), "All Night Long" (1912), "At an Old-Time Ball" (1913), and "Rufe Johnson's Harmony Band" (1914). His best and most successful song during these years was "I Wonder Where My Easy Rider's Gone" (1913), which cleverly combined horse racing and romantic subject matter with blues touches. It in turn helped inspire W. C. HANDY's 1914 hit "Yellow Dog Blues," which serves as an answer to Brooks's song and even readapts the chorus of the Brooks song for the verse of Handy's.

Brooks was reputed to be a gifted improviser, and like many vaudevillians, he chose not to write down much of his material. Thus he may well have created numerous songs that did not survive his stage acts. He almost always composed alone, writing both music and lyrics, but occasionally he collaborated with others. For the 1912 "Oh You Georgia Rose," his co-authors were the little-known Johnnie Watters and W. R. Williams. Most of Brooks's songs were published by the major white firms of the day, initially all by Rossiter of Chicago and after 1913 also by some of the New York firms. His "You Ain't No Place but Down South" (1912) was published in Dallas by his African American songwriting peer Chris Smith. Sometime around 1912 Brooks married a woman named Lina; they had one son.

Brooks had his second hit in 1916 with the dance song "Walking the Dog," which lived on as a title and as a concept beyond Brooks's actual piece. GERTRUDE "MA" RAINEY probably used Brooks's music in a dog-walking number that she performed in vaudeville around 1920. Brooks's piece may also have given George Gershwin the idea for an instrumental number of the same name that he wrote some years later. Another Brooks dance hit of the World War I years was "I Want to Shimmie" (1919), which capitalized on a shoulder-shaking dance featured by Gilda Gray and other leading vaudevillians of the period.

It was in 1917 that Brooks had his second universally popular smash hit with "The Darktown Strutters' Ball." Whereas most of Brooks's songs, even the best of them, feature rather weak verses leading to a payoff in the chorus, this one is strong throughout. In both its overall structural integrity and its theme, "The Darktown Strutters' Ball" may have owed something to Irving Berlin's 1911 hit "Alexander's Ragtime Band." An invitation is issued to a potential dancer or audience member to join one or more persons at a musical event, whether as passive listeners or (preferably, in the dance-mad era in which these songs were issued) as dancers, participants. The verse slides smoothly into the infectious chorus, which supplies the rhythmic and harmonic payoff for what preceded it. Among the innumerable jazz and vaudeville artists who recorded "The Darktown Strutters' Ball" were LOUIS ARMSTRONG, CAB CALLOWAY, COLEMAN HAWKINS, FLETCHER HENDERSON, Benny Goodman, ETHEL WATERS, Benny Carter, Artie Shaw, the Quintet of the Hot Club of Paris (featuring Django Reinhardt), the Original Dixieland Jazz Band, Red Nichols, VALAIDA SNOW, and the Original Indiana Five.

Brooks himself recorded some duets with the blues singer Sara Martin in 1923 and served in 1926 as an accompanist on some Ethel Waters sides featuring his songs.

By 1920 Brooks's best years as a songwriter were behind him. In 1920 he contributed songs to two shows, *Canary Cottage* and *Miss Nobody from Starland* (neither was a notable success). In 1922 his career got a second wind when he was hired by the producer Lew Leslie to appear in *Plantation Revue*, one of many shows mounted to cash in on the runaway success of the 1921 EUBIE BLAKE–NOBLE SISSLE show *Shuffle Along*. Leslie's shows, which ran at his own Plantation Club, became a major success after he discovered a scintillating young singer-dancer named FLORENCE MILLS. Mills was teamed up with Brooks in the show *From Dover Street to Dixie*, which combined British and African American material. This became a sensation in London, and Mills and Brooks gave a highly successful command performance before King George V, Queen Mary, and the royal family of England.

Although his inspiration was winding down, Brooks remained active through the 1930s. He appeared in a short film for Vitaphone in 1929 and was on radio regularly in the period around 1930. He made cameo appearances in stage productions, including *Brown Buddies* in 1930. His friend W. C. Handy, ever willing to take a chance on African American talent, published Brooks's "Swing That Thing" in 1933 and "After All These Years" in 1936. Neither song was particularly successful. Brooks appeared in a film entitled *Double Deal* in 1939, and he continued to make stage appearances, including one at the Apollo Theater in 1942. In the same year he was recognized as one of the grand old men of American music at an ASCAP tribute, alongside Irving Berlin, W. C. Handy, and Harold Arlen. By this time he had moved to Los Angeles, where he died at the age of eighty-nine, largely forgotten despite his importance as the creator of popular music standards. The musical style he pioneered had receded several generations into the past.

FURTHER READING

Jasen, David A., and Gene Jones. *Spreadin' Rhythm Around* (1998).

Morgan, Thomas L., and William Barlow. *From Cakewalks to Concert Halls* (1992).

ELLIOTT S. HURWITT

BROWN, Ada

(1 May 1890–31 Mar. 1950), singer and actor, was born Ada Scott in Kansas City, Kansas, the daughter of H. W. and Anna Morris Scott. (Some scholars list her as being born on 1 May 1889 in Junction City, Kansas.) Nothing is known about her education, except that she began piano lessons at an early age. She also started singing in the local church choir, developing the voice that the historian Bruce Kellner calls "full, rich, and mellow" (Kellner, 55). Indeed, musical ability ran in Brown's family: Her cousin was renowned ragtime pianist and composer James Sylvester Scott.

Brown's professional life began in 1910, when she became a performer at Bob Mott's Pekin Theater in Chicago. Barely out of her teens, Brown also performed in clubs in Paris, France, and Berlin, Germany. In the early 1920s Brown joined BENNIE MOTEN's band, which was considered the Midwest's preeminent band. During the 1920s and 1930s Brown sang the blues on both the West Coast and the East Coast, as well as in recording studios in Chicago and St. Louis. She recorded "Evil Mama Blues," "Ill Natured Blues," and "Break o' Day Blues" with Moten's band in September 1923 for the Okeh label. By the end of the 1920s, however, Brown had left the band for the East Coast's vaudeville theater circuit. There she became a popular attraction. She toured with the shows *Step on It* (1922) and *Struttin' Time* (1924), both musical revues written by the African American team of Flournoy Miller and Aubrey Lyle. By 1928, when Brown made her second record, including "Panama Limited Blues" and "Tia Juana Man," critics and audiences alike applauded her sweet voice. Such popularity not only earned her the title the "Queen of the Blues" but also brought her to the stage. Brown's stage appearances at Harlem's Lafayette Theatre included *Plantation Days* (1927), *Bandannaland* (1928), and *Tan Town Tamales* (1930). She also played at the Liberty Theater with BILL "BOJANGLES" ROBINSON in *Brown Buddies* (1930), a musical comedy about African American soldiers in France during World War I. The show had a thin plotline but featured plenty of song and dance.

In 1936 Brown moved to Chicago, where she sang with the FLETCHER HENDERSON Orchestra at the Grand Terrace Café. That same year, along with actor Leigh Whipper and actress FREDI WASHINGTON, Brown helped found the Negro Actors Guild of America in New York City, a benevolent welfare

organization for African American performers composed of six committees: finance, administrative, membership, entertainment, sickness, and welfare. Brown's first and only film appearance came in 1943, when she played herself in *Stormy Weather*, the thinly disguised life of Bill "Bojangles" Robinson ("Bill Williamson"). Critics now consider this film, a cinematic survey of African American entertainment from 1918 to 1943, an unusual opportunity for audiences to see African American entertainers prominent in the 1940s. Even into the twenty-first century, Brown's performance in the film was still winning critical accolades. In his 2001 book *Toms, Coons, Mulattoes, Mammies, and Bucks*, Donald Bogle writes: "FATS WALLER and Ada Brown provided spicy renditions of 'Ain't Misbehavin' and 'That Ain't Right'" (131).

Before her sudden and unexplained retirement from music in 1945, Brown teamed up with Robinson once again, this time at the Broadway Theater in New York City in *Memphis Bound*. After the show closed, she returned to Kansas City, Kansas (some sources give Kansas City, Missouri, as the location). Brown died at home of kidney disease on 31 March 1950. She is buried in the Westlawn Cemetery in Kansas City, Kansas. Ada Brown belonged to the first generation of African American blues singers. Along with MA RAINEY, BESSIE SMITH, and many others, she helped to make the female blues singer an icon in American culture.

FURTHER READING

Bogle, Donald. *Toms, Coons, Mulattoes, Mammies, and Bucks: An Interpretive History of Blacks in American Films* (2001).

Kellner, Bruce. *The Harlem Renaissance: A Historical Dictionary for the Era* (1987).

Stewart-Baxter, Derrick. *Ma Rainey and the Classic Blues Singers* (1970).

MARY ANNE BOELCSKEVY

BROWN, E.C. (Edward Cooper)

(1877–28 Jan. 1928), businessman and banker, was born in Philadelphia, Pennsylvania, to Robert Brown, a turnkey in the local jail, and Anne Brown, a homemaker. E. C. Brown was the eldest of three children. He attended the public schools in Philadelphia and after his high school graduation worked for three years as a mail clerk at the financial firm of Bradstreet Mercantile. He took stenography and typewriting classes at the Spencerian Business College in Philadelphia and subsequently worked as a stenographer for the National Railway Company but was soon laid off. Brown then became secretary to a Frank Thompson, who ran a catering business in Florida in the late 1890s. Around 1901 Brown left Thompson and started a real estate business in Newport News, Virginia. By 1908 he was renting more than 300 houses and had more than 800 tenants. On 27 June 1908 he opened the Crown Savings Bank, a private bank catering to African Americans in Newport News, while still holding onto his real estate business. In 1909 Brown founded another private bank for African Americans, the Brown Savings Bank in Norfolk, Virginia. The success of both banks made Brown nationally known within African American business circles. Later it would be discovered that both banks were financially unsound and that Brown was using depositors' funds to finance his real estate deals.

Brown was active in BOOKER T. WASHINGTON's National Negro Business League, which was founded in 1900 and provided a forum for black businesspeople to discuss their successes and problems in business operations. At the league's 1908 meeting Brown described his career in real estate, endorsing Washington's philosophy of black self-help. At that time Brown was treasurer of the Colored Bankers Association, and a member of the National Negro Bankers' Association, which was dissolved around 1916. At the 1919 National Negro Business League meeting Brown cited his success in Virginia as an example of why southern blacks should support black businesses. He also said that he was still the president and a stockholder in the Brown Savings Bank of Norfolk. Despite his popularity among black businessmen and -women, Brown lost a bid to become president of the National Negro Business League in 1921

Brown's lasting accomplishments, however, were made in the North. In 1913, for reasons that are unclear, he returned to Philadelphia to open a real estate office. About this time Brown formed a business partnership with the Philadelphia politician Andrew Steven Jr. In January 1916 they opened a private bank in Philadelphia known as Brown and Stevens. Its advertisements in the *Philadelphia Tribune* beckoned African Americans recently arrived in Philadelphia during the Great Migration. Migrants found the Brown and Stevens Bank attractive because it welcomed small savings accounts

and encouraged clients to invest in real estate and black business. In 1917 Brown and other black entrepreneurs established the Payton Apartments Corporation to manage the Payton Apartments—considered a desirable address for members of the black middle class—in Harlem. Around this time Brown married Estelle Smith, although the exact year of the marriage is unclear. The Browns raised Estelle's daughter Suzie.

In July 1918 Brown and Stevens founded the Dunbar Amusement Company to finance a new theater in Philadelphia and in 1919 bought the Quality Amusement Company from Robert Levey of New York City. That company controlled the Lafayette Players Stock Company and the Lafayette Theatre in Harlem. Under Brown the company later acquired the Howard Theatre in Washington, D.C., the Avenue Theatre in Chicago, and the Douglass Theatre in Baltimore. As head of the Quality Amusement Company, Brown featured weekly performances by the Lafayette Players in Philadelphia. They starred in the show *Within the Law*, a comedy-drama, at the grand opening of the Dunbar Theatre in Philadelphia on 29 December 1919. The Dunbar Theatre also featured motion pictures for black audiences such as OSCAR MICHEAUX's *The Symbol of the Unconquered*, released in 1920, vaudeville acts such as the blues singer MAMIE SMITH, and musicals like EUBIE BLAKE and NOBLE SISSLE's *Shuffle Along*.

In 1920 Brown lost his bid to become president of the National Negro Business League. Meanwhile yet more serious setbacks loomed in his financial matters. In July of that year Brown sold his stock in the Quality Amusement Company, which controlled the Lafayette Theatre in New York. Then, citing a two-thousand-dollar weekly deficit, in August 1921 Brown persuaded stockholders in the Dunbar Amusement Company to sell the Dunbar Theatre in Philadelphia to JOHN TRUSTY GIBSON. This was the first time the public became aware of Brown's financial problems. In 1925 there was a run on the Brown and Stevens Bank, forcing it to file for involuntary bankruptcy. As a private bank Brown and Stevens was not subject to oversight by the state banking department that could have identified problems early on. An auditing of the bank's books revealed evidence of inadequate record keeping and fraud. The state auditor alleged that Brown and Stevens used their companies for their own financial gain. Because of the bankruptcy, hundreds of African Americans lost their savings. Brown moved to New York City and set up a real estate business. He remained in the city until his death. An ambitious man with questionable business practices, his business empire collapsed as rapidly as it had risen. Yet Brown's lasting legacy was his promotion of the Lafayette Players and black theaters during the Harlem Renaissance.

FURTHER READING

Hamilton, Kenneth M., ed. *Records of the National Negro Business League* (c. 1994).

Harris, Abram Lincoln, JR. *The Negro as Capitalist: A Study of Banking and Business among American Negroes* (1969).

Kellner, Bruce. "E.C. Brown," in *The Harlem Renaissance: A Historical Dictionary for the Era*, ed. Bruce Kellner (1987).

Richardson, Clement, ed. *The National Cyclopedia of the Colored Race*, vol. 1 (1919).

Sampson, Henry T. *Blacks in Blackface: A Source Book on Early Black Musical Shows* (1980).

Obituary: New York Age, 28 Jan. 1928.

ERIC LEDELL SMITH

BROWN, Hallie Quinn

(10 Mar. 1845?–16 Sept. 1949), elocutionist, educator, women's and civil rights leader, and writer, was born in Pittsburgh, Pennsylvania, the daughter of Thomas Arthur Brown, a riverboat steward and express agent, and Frances Jane Scroggins, an educated woman who served as an unofficial adviser to the students of Wilberforce University. Thomas Brown was born into slavery in Frederick County, Maryland, the son of a Scottish woman plantation owner and her black overseer. Brown purchased his freedom and that of his sister, brother, and father. By the time of the Civil War, he had amassed a sizable amount of real estate. Hallie's mother, Frances, was also born a slave, the child of her white owner. She was eventually freed by her white grandfather, a former officer in the American Revolution.

Both of Hallie's parents became active in the Underground Railroad. Around 1864, the Browns and their six children moved to Chatham, Ontario, where Thomas worked as a farmer and Hallie began to show a talent for public speaking and performance. The Browns returned to the United States around 1870, settling in Wilberforce, Ohio, where Hallie and her youngest brother enrolled

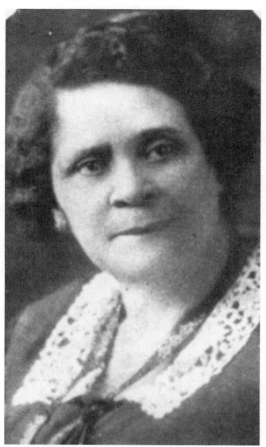

Hallie Quinn Brown, elocutionist and educator. (Duke University.)

in Wilberforce University, an African Methodist Episcopal (AME) liberal arts school and the first four-year college owned and operated by African Americans in the United States. Wilberforce was at that time under the direction of the AME bishop Daniel Alexander Payne, America's first black college president and a Brown family friend.

Brown graduated with a BS from Wilberforce University in 1873. (The university later gave Brown two honorary degrees, an MS in 1890 and a doctorate in Law in 1936.) Shortly after graduation Brown moved to the South, beginning what would become a lifelong commitment to education and to the advancement of disenfranchised women and African Americans. For more than a decade, in plantations and public schools from Yazoo,

Mississippi, to Columbia, South Carolina, Brown taught literacy skills to black children and adults denied education during slavery.

Attracted to its combination of education with entertainment, Brown had joined the Lyceum movement in 1874. The Lyceum, a nineteenth-century movement that fostered adult education in the arts, sciences, history, and public affairs through traveling programs of lectures and concerts, brought Brown's eloquent lectures to a wide audience in the South and Midwest. By the early 1880s Brown was touring with the Lyceum full time. She continued her elocution training at the Chautauqua Lecture School from which, in 1886, she graduated at the top of her class, having completed several summer sessions.

As Brown's eminence and reputation grew, so did her job prospects. From 1885 to 1887 she served as dean of Allen University in Columbia, South Carolina, the first black college in South Carolina, founded in 1870. In 1887 Brown returned to Ohio, where for the next five years she taught in the Dayton public schools and at a night school she founded for migrant African American adults recently relocated from the South. The Tuskegee Normal and Industrial Institute brought Brown to Alabama from 1892 to 1893 to serve as lady principal, or dean of women, under the direction of BOOKER T. WASHINGTON.

Brown's lasting dedication to Wilberforce University began in 1893, when she was hired by her alma mater as professor of elocution. Brown would remain a part of the Wilberforce community, as an English and elocution teacher, trustee, and fundraiser, until her death. Shortly after her appointment, however, Brown suspended her classroom teaching duties in favor of a series of extensive lecture tours of Europe.

Brown left for Europe in 1894 and remained on tour for much of the next five years. She quickly became an internationally lauded lecturer and performer, speaking on the themes of African American culture, temperance, and women's suffrage. Enamored audiences flocked to experience Brown's lectures on topics like "Negro Folklore and Folksong" and her recitations of the works of PAUL LAURENCE DUNBAR and other African American authors. Brown was a featured speaker in London at the Third Biennial Convention of the World's Woman's Christian Temperance Union in 1895 and a representative to the International Congress of

Women held in London in 1899. Having been introduced to the royal family via letter by FREDERICK DOUGLASS in 1894, Brown performed for Queen Victoria on several occasions, even joining the monarch for tea at Windsor Castle and as a guest during the Jubilee Celebration in 1899. Brown was made a member of the exclusive Royal Geographical Society in Edinburgh, and in 1895 she helped form the first British Chautauqua, a Lyceum-style touring educational program, in North Wales.

Brown returned to teaching full time at Wilberforce around the turn of the century but visited Europe once again in 1910 as a representative to the Woman's Missionary Society of the AME Conference held in Edinburgh. For Brown, this trip marked the culmination of over ten years of work with the AME Church and validated her role in the church outside of her association with Wilberforce University. In 1900 Brown had campaigned for the job of AME secretary of education. Although she failed to get the appointment, she remained committed to expanding the role of women in the church. Brown remained in Britain for seven months, raising enough money for Wilberforce to build a new dormitory. Still popular as a lecturer, Brown gave a command performance for King George and Queen Mary and was a dinner guest of the Princess of Wales.

While Brown is remembered for her achievements as an elocutionist, it is her vision of a nationally organized African American women's community that has secured her place in history. Brown was a pioneering force in the formation of the black women's club movement, the development of which saw the establishment of schools, scholarships, museums, elder-care facilities, and political institutions.

Concerned that the achievements of African Americans would be omitted from the exhibitions at the 1893 World's Fair and Columbian Exposition in Chicago, Brown petitioned for a seat on the Board of Lady Managers, the planning committee presiding over the U.S. exhibits. "For two hundred and fifty years the Negro woman of America was bought and sold as chattel," Brown argued. "Twenty-five years of progress find the Afro-American woman advanced beyond the most sanguine expectations. Her development from the darkest slavery and grossest ignorance into light and liberty is one of the marvels of the age. . . . What more is needed? Time and equal chance in the race of life" (*The World's Congress*

of Representative Women, May Wright Sewall, ed., 1894). The Board denied Brown's request, explaining that only individuals representing organizations could participate. Provoked by her exclusion and motivated to set up a national organization devoted to and run by black women, Brown cofounded the Colored Women's League of Washington, D.C. Two years later Brown's organization merged with Josephine St. Pierre Ruffin's Boston Women's Era Club, becoming the National Federation of Afro-American Women, which was later renamed the National Association of Colored Women (NACW).

Brown served as national president of the NACW from 1920 to 1924 and as honorary president until her death. During her tenure at the NACW, Brown took a leadership role in two projects: the creation and maintenance of a memorial at the former home of Frederick Douglass in Washington, D.C., and the establishment of the Hallie Q. Brown Scholarship Loan Fund for the education of black women, a national program open to college students and postgraduate women, that allots generous loans to be repaid with no interest.

In addition to her work with the NACW, Brown played major roles in several other African American and women's organizations. She served as president of the Ohio State Federation of Colored Women's Clubs from 1905 to 1912 and worked as an organizer for the Women's Christian Temperance Union. Brown lent her support and oratorical skill to a variety of issues. In 1922 she lobbied President Warren Harding and several key U.S. senators in support of a federal antilynching law and worked with the NAACP in its efforts to defeat a national bill outlawing interracial marriages. On another occasion, in an incident reported in the *New York Times*, Brown arrived in Washington, D.C., for the 1925 All-American Musical Festival of the International Council of Women and found the auditorium segregated. In a biting speech condemning the council's racist policy, Brown threatened a boycott by the festival's black performers if segregation continued. When her demands were not met, many of the audience members joined the two hundred black performers in a boycott of the program.

Brown was also engaged in mainstream political organizations. An ardent Republican, she spoke in support of local, state, and national candidates in Ohio, Pennsylvania, Illinois, and Missouri. Brown's Republican activities increased in the 1920s and

1930s, during which time she labored on behalf of the National League of Women Voters and as vice president of the Ohio Council of Republican Women. In 1924 Brown emerged on the national stage, addressing the Republican National Convention in Cleveland. Speaking in support of Warren Harding's nomination, Brown took the opportunity to discuss issues of significance to African Americans. After the convention, Brown directed the Colored Women's Activities at the Republican national campaign headquarters in Chicago and the new National League of Republican Colored Women, which adopted the slogan "We are in politics to stay and we shall be a stay in politics."

Concurrent with her teaching, lecturing, and organizing, Brown worked as a writer, essayist, and anthologist. She published several collections of speeches and prose, including *Bits and Odds: A Choice Selection of Recitations* (1880), *Elocution and Physical Culture* (1910), *First Lessons in Public Speaking* (1920), *The Beautiful: A True Story of Slavery* (1924), *Our Women: Past, Present and Future* (1925), and *Tales My Father Told* (1925). She often wrote of the power and complexity of black America's relationship to language, frequently using black vernacular speech in her writing, and of the importance of African American heritage, family history, and culture. In 1926, when Brown was in her seventies, she published her best-known book, *Homespun Heroines and Other Women of Distinction*, a collection of sixty biographies of black women born in North America between 1740 and 1900.

"Miss Hallie," as Brown was known at Wilberforce, remained active until her death in 1949, near age one hundred. Her legacy continues through the scholarship fund that bears her name; the good works of the Hallie Quinn Brown Community House in St. Paul, Minnesota; and the Hallie Q. Brown Memorial Library at Wilberforce University, a facility that includes a collection of books by and about African Americans.

FURTHER READING

Brown's unpublished papers are held at the Hallie Q. Brown Memorial Library at Wilberforce University in Wilberforce, Ohio.

Davis, Elizabeth Lindsay, ed. *Lifting as They Climb* (1933, 1996).

Majors, M. A. *Noted Negro Women: Their Triumphs and Activities* (1893).

LISA E. RIVO

BROWN, Lawrence Benjamin

(29 Aug. 1893–25 Dec. 1972), pianist and composer, was born in Jacksonville, Florida, the son of Clark Benjamin Brown, himself the son of a former slave. Little is known of Brown's natural mother, who died when Lawrence was three; from then on, he was raised by his stepmother Cenia Brown.

During his youth Brown took music instruction from the well-respected William Riddick. Exhibiting incredible promise, Brown was sent to Boston to receive further instruction in his primary instrument, piano. In addition to scholarships, Brown financed his education in Boston by working as an elevator operator. In 1916 he made his professional music debut as accompanist for the tenor Sydney Woodward. With this exposure Brown caught the eye of other musicians, including the famed tenor ROLAND HAYES. Brown and Hayes toured abroad from 1918 to 1923 and received great popular acclaim. They had many important engagements, including a performance for the king and queen of England at Buckingham Palace in 1921.

While in England, Brown also took advantage of advanced training at Trinity College in London. There he had composition instruction from Amanda Aldridge, daughter of the great African American actor Ira Aldridge. Brown's interest and talent in composition went beyond piano and vocal arrangements. In 1923 he performed some string arrangements with the famed cellist Beatrice Harrison at Wigmore Hall in England. Brown's profound talent at musical composition and arrangement as well as at singing and piano playing quickly proved him to be one of the most important new figures in the musical world.

Brown used his educational instruction to pursue research into folk songs, paying particular attention to the music of African Americans. His work took him to the southern United States, where he began to absorb the traditional work songs of field workers and laborers. From this research he developed his popular arrangements of hundreds of Negro spirituals, more than thirty of which were published during his lifetime in collections such as JAMES WELDON JOHNSON's *Book of American Negro Spirituals* (1925) and Brown's own *Negro Folk Songs* (1930). Brown is distinguished among arrangers of the spirituals for his attention to detail and investment in preserving the original elements of the songs. Arrangements authored by Brown include "Swing Low, Sweet Chariot," "Joshua Fit

de Battle of Jericho," "Ezekiel Saw de Wheel," and "Steal Away." Many of his compositions went on to become very popular.

In 1925 the baritone PAUL ROBESON became the first major singer to perform Brown's spiritual arrangements in concert. Robeson was also the first solo singer to offer an entire concert of spirituals. This practice was continued by other African American singers such as the contralto MARIAN ANDERSON. Robeson's performance of Brown's arrangements at the Greenwich Village Theatre was the spark that generated a forty-year relationship between the two men, professionally and personally. During the 1930s they toured Europe together while Robeson reprised his role as Joe in the Jerome Kern and Oscar Hammerstein II musical *Show Boat*. Their camaraderie on and off the stage was legendary: Robeson's bass-baritone vocal lines were often harmonized by Brown's tenor, and their political work for issues ranging from worker rights to antiapartheid organizing solidified their standing as a powerful artistic force. They performed internationally, including in New York, Paris, London, and Ireland. The pair appeared before European royalty on numerous occasions, including before the Prince of Wales and the king of Spain.

Part of the pair's popularity stemmed from their many recordings. They recorded classics such as "Nobody Knows de Trouble I've Seen," "Sometimes I Feel Like a Motherless Child," and "Joe Hill" for RCA Victor records. In 1939 Brown led the orchestra and chorus for Robeson's CBS recording of "Ballad for Americans," which garnered them international attention. The two men often offered their support and art in service of armed struggles around the globe, including a United Service Organizations (USO) camp tour during World War II. Beyond Negro spirituals and work songs Brown was also a champion of world folk music. In addition to Robeson's detailed and incisive study of the music, it was Brown who investigated this music for inclusion in their repertoire. Brown was often contacted by musicians and conductors for music of obscure folk songs.

Brown had many important relationships with artists and leaders during the course of his lifetime, including with the scholar and writer Lloyd Louis Brown and with the poet and writer LANGSTON HUGHES. Brown was also a confidant for Robeson's wife Eslanda Cardoza Goode Robeson, who often traveled with the pair. His close relationship with the Robeson family was put to the test after World War II when Robeson came under intense scrutiny for his ties to the Soviet Union. Opportunities to perform abroad were denied after the United States government revoked Robeson's passport in 1950. Despite the passport's later reinstatement, the careers and reputations of both men suffered. Brown retired in 1963 after illness ended Robeson's career. Brown never married and lived the last forty-seven years of his life as a resident of Harlem. In February 1973 he was honored by friends and family with a concert of his works at Saint Martin's Episcopal Church in Harlem.

FURTHER READING

The Lawrence Benjamin Brown Papers are in New York City at the Schomburg Center for Research in Black Culture.
Green, Jeffrey P. "Roland Hayes in London, 1921," *Black Perspective in Music* (1982).

SHANA L. REDMOND

BROWN, Sterling Allen

(1 May 1901–13 Jan. 1989), professor of English, poet, and essayist, was born in Washington, D.C., the son of Sterling Nelson Brown, a minister and divinity school professor, and Adelaide Allen. After graduating as valedictorian from Dunbar High School in 1918, Brown matriculated at Williams College, where he studied French and English literature and won the Graves Prize for an essay on Molière and Shakespeare. He graduated from Williams in 1922 with Phi Beta Kappa honors and a Clark fellowship for graduate studies in English at Harvard University. Once at Harvard, Brown studied with Bliss Perry and, most notably, with George Lyman Kittredge, the distinguished scholar of Shakespeare and the ballad. Kittredge's example as a scholar of both formal and vernacular forms of literature doubtlessly encouraged Brown to contemplate a similar professorial career, though for Brown the focus would be less on the British Isles than on the United States and on African American culture, in particular. Brown received his MA in English from Harvard in 1923 and went south to his first teaching job at Virginia Seminary and College at Lynchburg.

Brown's three years at Virginia Seminary represent much more than the beginning of his teaching career, for it was there that he began to immerse himself in the folkways of rural black people, absorbing their stories, music, and idioms. In this

regard, Brown is usefully likened to two of his most famous contemporaries, ZORA NEALE HURSTON and JEAN TOOMER (with whom Brown attended high school). Like Hurston, Brown conducted a kind of iconoclastic ethnographic fieldwork among southern black people in the 1920s (she in Florida, he in Virginia) and subsequently produced a series of important essays on black folkways. Like Hurston and Toomer, Brown drew on his observations to produce a written vernacular literature that venerated black people of the rural South instead of championing the new order of black life being created in cities in the North. And like Toomer, in particular, Brown's wanderings in the South represented not just a quest for literary material but also an odyssey in search of roots more meaningful than what seemed to be provided by college in the North and black bourgeois culture in Washington. After Virginia Seminary, Brown taught briefly at Lincoln University in Missouri and Fisk University before beginning his forty-year career at Howard University in 1929.

Brown's first published poems, many of them "portraitures" of Virginia rural black folk, such as Sister Lou and Big Boy Davis, appeared in the 1920s in *Opportunity* magazine and in celebrated anthologies, including COUNTÉE CULLEN's *Caroling Dusk* (1927) and JAMES WELDON JOHNSON's *Book of American Negro Poetry* (1922; 2d ed., 1931). When Brown's first book of poems, *Southern Road*, was published in 1932, Johnson's introduction praised Brown for having, in effect, discovered how to write a black vernacular poetry that was not fraught with the limitations of the "dialect verse" of the PAUL LAURENCE DUNBAR era thirty years earlier. Johnson wrote that Brown "has made more than mere transcriptions of folk poetry, and he has done more than bring to it mere artistry; he has deepened its meanings and multiplied its implications." Johnson also showed his respect for Brown by inviting him to write the *Outline for the Study of the Poetry of American Negroes* (1931), a teacher's guide to accompany Johnson's poetry anthology.

The 1930s were productive and exciting years for Brown. In addition to settling into teaching at Howard and publishing *Southern Road*, he wrote a regular column for *Opportunity* ("The Literary Scene: Chronicle and Comment"), reviewing plays and films as well as novels, biographies, and scholarship by black and white Americans alike. From 1936 to 1939 Brown was the Editor on Negro Affairs

for the Federal Writers' Project. In that capacity he oversaw virtually everything written about African Americans and wrote large sections of *The Negro in Virginia* (1940). The latter work led to his being named a researcher on the Carnegie-Myrdal Study of the Negro, which generated the data for Gunnar Myrdal's classic study, *An American Dilemma: The Negro Problem and Modern Democracy* (1944). In 1937 Brown was awarded a Guggenheim Fellowship, which afforded him the opportunity to complete *The Negro in American Fiction* and *Negro Poetry and Drama*, both published in 1937. *The Negro Caravan: Writings by American Negroes* (1941), a massive anthology of African American writing, edited by Brown with Ulysses Grant Lee and ARTHUR P. DAVIS, continues to be the model for bringing song, folktale, mother wit, and written literature together in a comprehensive collection.

From the 1940s into the 1960s Brown was no longer an active poet, in part because his second collection, "No Hidin' Place," was rejected by his publisher. Even though many of his poems were published in *The Crisis*, the *New Republic*, and the *Nation*, Brown found little solace and turned instead to teaching and writing essays. In the 1950s Brown published such major essays as "Negro Folk Expression," "The Blues," and "Negro Folk Expression: Spirituals, Seculars, Ballads and Work Songs," all in the Atlanta journal *Phylon*. Also in this period Brown wrote "The New Negro in Literature (1925–1955)" (1955). In this essay he argued that the Harlem Renaissance was, in fact, a New Negro Renaissance, not a Harlem Renaissance, because few of the significant participants, including him, lived in Harlem or wrote about it. He concluded that the Harlem Renaissance was the publishing industry's hype, an idea that gained renewed attention when publishers once again hyped the Harlem Renaissance in the 1970s.

The 1970s and 1980s were a period of recognition and perhaps of subtle vindication for Sterling Brown. While enduring what was for him the melancholy of retirement from Howard in 1969, he found himself suddenly in the limelight as a rediscovered poet and as a pioneering teacher and founder of the new field of African American studies. Numerous invitations followed for poetry readings, lectures, and tributes, and fourteen honorary degrees were bestowed on him. In 1974 *Southern Road* was reissued. In 1975 Brown's ballad poems were collected and published under the title *The*

Last Ride of Wild Bill and Eleven Narrative Poems. In 1980 Brown's *Collected Poems,* a volume edited by Michael S. Harper, was published in the National Poetry Series. Brown was named poet laureate of the District of Columbia in 1984.

Brown had married Daisy Turnbull in 1927, possibly in Lynchburg, where they had met. They had one child. Brown was very close to his two sisters, who lived next door in Washington. They cared for him after his wife's death in 1979 until Brown entered a health center in Takoma Park, Maryland, where he died.

Brown returned to Williams College for the first time in fifty-one years on 22 September 1973 to give an autobiographical address and again in June 1974 to receive an honorary degree. The address, "A Son's Return: 'Oh Didn't He Ramble'" (*Berkshire Review* 10 [Summer 1974], 9–30; reprinted in Harper and Stepto, eds., *Chant of Saints* [1979]), offers much of Brown's philosophy for living a productive American life. At one point he declares, "I am an integrationist . . . because I know what segregation really was. And by integration, I do not mean assimilation. I believe what the word means—an integer is a whole number. I want to be in the best American traditions. I want to be accepted as a whole man. My standards are not white. My standards are not black. My standards are human." Brown largely achieved these goals and standards. His poetry, for example, along with that of LANGSTON HUGHES, forever put to rest the question of whether a written art based on black vernacular could be resilient and substantial and read through the generations. Despite his various careers, Brown saw himself primarily as a teacher, and it was as a professor at Howard that he felt he had made his mark, training hundreds of students and pioneering those changes in the curriculum that would lead to increasing appreciation and scrutiny of vernacular American and African American art forms. In short, Brown was one of the scholar-teachers whose work before 1950 enabled the creation and development of American studies and African American studies programs in colleges and universities in the decades to follow.

FURTHER READING
Brown's papers are housed at Howard University, chiefly in the Moorland-Spingarn Collection.
Gates, Henry Louis, Jr. *Figures in Black: Words, Signs, and the "Racial" Self* (1987).

Gabbin, Joanne. *Sterling A. Brown: Building the Black Aesthetic Tradition* (1985).
Jones, Gayl. *Liberating Voices: Oral Tradition in African American Literature* (1991).
Stepto, Robert. "'When de Saints go Ma'chin' Home': Sterling Brown's Blueprint for a New Negro Poetry." *Kunapipi* 4, no. 1 (1982): 94–105.
Stepto, Robert. "Sterling Brown: Outsider in the Renaissance," in *Harlem Renaissance Revaluations* (1989).

Obituary: New York Times, 17 Jan. 1989.

ROBERT STEPTO

BRUCE, John Edward

(22 Feb. 1856–7 Aug. 1924), journalist and historian, was born in Piscataway, Maryland, the son of Martha Allen Clark and Robert Bruce, who were both enslaved Africans. In 1859 Major Harvey Griffin, Robert Bruce's owner, sold Robert to a Georgia slaveholder. Raised by his mother, John lived in Maryland until 1861, when Union troops marching through Maryland freed him and his mother, taking them to Washington, D.C., where John lived until 1892. In 1865 John's mother worked as a domestic in Stratford, Connecticut, where her son received his early education in an integrated school. One year later they returned to Washington, D.C., where John continued his education. Although he did not complete high school, he enrolled in a course at Howard University in 1872. John married Lucy Pinkwood, an opera singer from Washington, D.C. In 1895 he married Florence Adelaide Bishop, with whom he had one child.

Bruce began his journalistic career at eighteen as a general helper to the Washington correspondent of the *New York Times.* He was also employed as a correspondent in New York for John Freeman's *Progressive American,* which published Bruce's first article, "The Distillation of Coal Tar." Between 1879 and 1884 Bruce, under the pen name "Rising Sun," started three newspapers: the *Argus* (1879), the *Sunday Item* (1880), which was the first African American daily, and the *Washington Grit* (1884). Following the publication of the *Grit,* which was known for its frank style, T. Thomas Fortune, editor of the *New York Freeman,* referred to Bruce as "Bruce Grit." In order to maintain financial stability as a journalist, Bruce worked the majority of his life as a messenger in the federal customhouse in Westchester, New York, retiring in 1922.

Throughout his life Bruce was an active proponent of African American civil rights. In 1890 Fortune founded the Afro American League (AAL), a pioneer civil rights organization that supported African American suffrage. Recognized as a talented speaker, Bruce addressed delegates at the AAL inaugural convention in Washington, D.C. Citing the Constitution, he examined the legal justification of African American citizenship. He contended that the federal government had failed to protect African American civil rights, and as long as white violence and African American disfranchisement continued, "a blot will remain on the escutcheon."

Between 1896 and 1901 Bruce served as an associate editor of *Howard's American Magazine*, for which he published an influential pamphlet, *The Blood Red Record*. The pamphlet, which was advertised in a number of African American newspapers, was a condemnation of lynching and racism in the American justice system. Bruce listed the names and "alleged" crimes of more than a hundred African American men who were killed by white mobs. According to Bruce, whites denied African Americans an opportunity to receive a fair trial. Whites, he argued, receive a trial by jury even if they "assassinate the President of the United States." Bruce's scathing remarks on American justice revealed its historical legacy of racism.

Leaving *Howard's American Magazine*, Bruce moved to Albany, New York, and worked as a journalist for the *Albany Evening Journal* and the *Times Union*. He also contributed articles to the *New York Age*, the *Cleveland Gazette*, and the *Washington Colored American*, three prominent African American newspapers. In Albany, Bruce continued to work for African American civil rights. In 1898 he joined the Afro American Council, founded by Bishop Alexander Walters of the African Methodist Episcopal Church. In "Concentration of Energy," Bruce insisted that the only way for African Americans to obtain political and economic power is "with intelligent organization." He urged African Americans to invest in banks owned by blacks, and he encouraged African American cooperative economics. In July 1905 W. E. B. DU BOIS organized the Niagara Conference to protest BOOKER T. WASHINGTON's accommodationist philosophy and segregation in the South. Bruce, a proponent of African American civil rights, was invited by Du Bois to attend the conference, but he did not have the money to travel to the historic meeting.

Bruce was an active member in a number of African American literary societies, such as the American Negro Academy founded by Alexander Crummell, an intellectual and scholar. Bruce believed that African Americans must engage in the realm of ideas because, as he said on the occasion of becoming president of the literary Phalanx Club, "The battle of this race is an intellectual one" and "anybody of earnest and clear-thinking, clear headed men is a potent and powerful force." Moreover he said that the "secret of power is knowledge," and whites aspire to "repress black men who are seeking this power."

Another major interest for Bruce was history. On 18 April 1911 Bruce, along with ARTHUR SCHOMBURG, a renowned bibliophile, founded the Negro Society for Historical Research (NSHR), which was a precursor of CARTER G. WOODSON's Association for the Study of African American Life and History. The NSHR sought to "teach, enlighten, and instruct our people in Negro history and achievement." Bruce viewed history as a medium to combat intellectual racism and promote racial pride. Before the founding of the NSHR, Bruce published *Short Biographical Sketches of Eminent Negro Men and Women in Europe and the United States* (1910). Designed for children, the text contained short biographies of prominent African American leaders in order to "awaken race pride."

In addition to his historical and political tracts, Bruce wrote short stories, poems, plays, and one novel, *The Awakening of Hezekiah Jones* (1916). The novel describes the life of Jones, an African American official elected in a southern city. At the end of the novel Jones experiences an "awakening" and recognizes the political necessity of racial unity. Because Bruce's literary activities mirrored his ideology, his art served a political function.

After World War I, Bruce became increasingly disenchanted with the pace of African American progress. Following the war, race riots, lynchings, and racial inequality intensified throughout the nation, and in 1919 Bruce became a major figure in the largest black nationalist organization for people of African descent, MARCUS GARVEY's Universal Negro Improvement Association (UNIA). Between 1921 and 1923 Bruce served as a contributing editor of Garvey's *Negro World*, his opinions appearing as "Bruce Grit's Column." Five years after joining UNIA in 1919, Bruce died in Bellevue Hospital in New York City.

Unlike Washington, Du Bois, and Garvey, Bruce has not received a great deal of scholarly attention despite the fact that he was so well known that five thousand people attended his funeral. As a distinguished African American journalist, Bruce's articles were read not only in the United States but also throughout the African diaspora. His tenacity and political participation became a model for African American journalists, historians, and political activists.

FURTHER READING

Bruce's papers are in the Schomburg Center for Research and Black Culture, New York Public Library.

Crowder, Ralph L. *John Edward Bruce: Politician, Journalist, and Self-Trained Historian of the African Diaspora* (2004).

Gilbert, Peter, comp. and ed. *The Selected Writings of John Edward Bruce: Militant Black Journalist* (1971).

Seraile, William. *Bruce Grit: The Black Nationalist Writings of John Edward Bruce* (2003).

Obituary: New York Times, 11 Aug. 1924.

DAVID ALVIN CANTON

BRUCE, Roscoe Conkling, Sr.

(21 Apr. 1879–16 Aug. 1950), educator, journalist, and lecturer, was born in Washington, D.C., the only child of Josephine Beall Willson Bruce and the U.S. senator Blanche Kelso Bruce, a Republican of Mississippi. When Senator Bruce was to take his oath of office, Mississippi's senior senator James Alcorn refused to escort him to the front of the Senate chamber. An embarrassing silence fell over the chamber until Senator Roscoe Conkling of New York extended his arm to Senator Bruce and escorted him forward. Senator Bruce was so grateful for the courtesy that he named his son for the gentleman from the Empire State.

Roscoe Conkling Bruce Sr. attended the M Street High School in Washington, D.C., and subsequently spent two years (1896–1898) at the prestigious Phillips Exeter Academy in Exeter, New Hampshire. He won distinction in scholarship and journalism, was a member of the Golden Branch, the oldest debating society in country, and was also one of the editors of the academy's *Exonian*, Phillips Exeter's student newspaper and supposedly the oldest continuously running secondary school

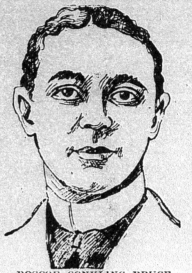

ROSCOE CONKLING BRUCE

Takes the Stand at Tuskegee's Twelfth Annual Negro Conference—Booker T. Washington Presides Over the Sessions.

Tuskegee, Ala.—The twelfth annual Tuskegee Negro conference began its sessions at Tuskegee N. and I. school February 14. It was organized by Principal Booker T. Washington for the purpose of bringing together the Negro farmers and their wives who live in the vicinity of Tuskegee once a year for the purpose of counsel and advice with each other. Mr. Wash-

ROSCOE CONKLING BRUCE.

ington presided at all the sessions and delivered the opening address, in part saying: "We shall get more out of struggle than out of contentment, etc., etc." Following this address was a general discussion by the farmers and their wives of their conditions. Those owning land and homes told how they acquired it, what difficulties they had met; etc. A careful census was made by Roscoe Conkling Bruce to show how many owned land, homes, live stock, etc., how many mortgaged their crops, how many come out ahead each year, how many individuals in a family, the nature and length of the schools, nature of the homes, etc. There was a large attendance at the workers' conference February 18, made up of prominent educators of both races, and people interested in Negro education.

Roscoe Conkling Bruce Sr., pictured in an undated newspaper article describing his participation in the Twelfth Annual Negro Conference at the Tuskegee Institute. (Library of Congress.)

newspaper in the country. Bruce entered Harvard College in 1898 and graduated with an AB degree in 1902, magna cum laude. He won a reputation by winning the Pasteur Medal for debating in 1898, offered by Baron Pierre de Coubertin of Paris, to stimulate interest in the problems of French politics. Out of a field of fifty men Bruce was one of the three men chosen to represent Harvard in a debate against Princeton in 1899. In 1900 Bruce was selected to represent Harvard in the Harvard-Yale oratorical contest, and he was awarded the Coolidge Debating Prize. According to the *Washington Post*, on 17 December 1901 Bruce was elected class orator by the Harvard senior class, defeating his white opponent by a vote of 2 to 1. Upon graduation from Harvard he became a member of the Phi Beta Kappa Society.

The Tuskegee Normal and Industrial Institute offered Bruce the position of academic director, and for the next four years (1902–1906) he not only directed the academic department but also taught various subjects. During his tenure at Tuskegee he married Clara Washington Burrill of Washington, D.C., on 3 June 1903. The Reverend Francis James Grimké of the Fifteenth Street Presbyterian Church in Washington, D.C., performed the ceremony.

In the fall of 1906 Bruce accepted a position with the District of Columbia Public Schools as a supervising principal in the Tenth Division. In 1907 Superintendent William E. Chancellor appointed him as assistant superintendent of the African American schools, a position Bruce held for fourteen years. The influence and experience at Tuskegee Institute helped to shape the characteristic of Bruce's progressive educational policy in Washington, D.C. Bruce emphasized industrial and business instruction and sought to convert the Armstrong Manual Training School into a technical high school. He was insistent that at least one industrial course be required of every student at the distinguished Dunbar High School, the first African American high school in the United States. Two vocational schools, one for boys and another for girls, were established on the basis of his recommendation with the approval of the superintendent of schools and the board of education.

Perhaps his most notable contribution to Washington, D.C.'s public schools was to allow the school system to be reorganized under the Congressional Organic Act of 1906. This act vested control of the public schools in a board of education consisting of nine members, all of whom had five years'

residence in Washington, D.C., immediately preceding their appointments, and three of whom had to be women. The members of the board, who served without compensation, were appointed by the District of Columbia Supreme Court judges for three-year terms of office.

In July 1921 Bruce resigned from the district's public school system and accepted a position in Kimball, West Virginia, to organize modern high school facilities for African American youth living in more than a dozen communities. In the fall of 1921 Bruce was appointed principal of the Browns Creek District High School in Kimball, West Virginia.

In 1927 Bruce became the resident manager of the recently opened Dunbar Apartments located on Seventh Avenue in Harlem. The Dunbar Apartments were created to provide decent housing and services for low-income African American residents. Initiated and financed by John D. Rockefeller Jr., the Dunbar complex, designed by the architect Andrew J. Thomas, was the first cooperative housing enterprise for African Americans.

In the early 1930s Bruce became the editor in chief of the Harriet Tubman Publishing Company. Associate editors of the publishing house included not only his wife, Clara, but also other notables, GEORGIA DOUGLAS JOHNSON, KELLY MILLER, ARTHUR ALFONSO SCHOMBURG, and Mary Eliza Church Terrell among them. In addition to his work as editor, Bruce prepared the manuscript for a supplementary reader for use by eighth- and ninth-graders in public school titled *Just Women*, a history of notable African American women.

At the age of seventy-one Roscoe Conkling Bruce Sr. died in New York City and was interred in the historic Woodlawn Cemetery in Washington, D.C. He was survived by his three children, Clara Josephine, Roscoe Conkling Jr., and Burrill Kelso Bruce. His wife, Clara W. Burrill Bruce, died on 22 January 1947 at the age of sixty-five.

FURTHER READING

Bruce's papers are housed in the Moorland-Spingarn Research Center, Manuscript Division, Howard University, Washington, D.C., and in the District of Columbia Public Schools, Charles Sumner School Museum and Archives, Washington, D.C.

Lewis, David Levering. *W.E.B. Du Bois: Biography of a Race* (1993).

Sollars, Werner, Titcomb Caldwell, and Thomas A. Underwood, eds. *African Americans at Harvard* (1993).

E. RENÉE INGRAM

BRYMN, Tim

(5 Oct. 1881–3 Oct. 1946), dance-orchestra leader, military bandleader, and songwriter, was born James Timothy Brymn in Kinston, North Carolina, to Peter and Eliza. He attended Shaw University in his home state and continued his education at the National Conservatory of Music in New York, which had once boasted Antonin Dvorák among its teachers and WILL MARION COOK among its pupils. In New York, Brymn teamed up with the lyricist CECIL MACK (Richard McPherson), and together they wrote some songs for the publishing firm of Joseph Stern. In 1901 they had their first song hit, "Josephine, My Jo," which was interpolated into the Williams and Walker show *Sons of Ham*. Brymn and Mack followed up the next year with "Please Go 'Way and Let Me Sleep." By this time Brymn was also writing with others besides Mack. His "My Little Zulu Babe" was recorded by Williams and Walker near the end of 1901; in this case Brymn's co-composer was the now-forgotten W. S. Estren.

In 1904 Brymn accompanied the Williams and Walker company to England, where he served as music director for the successful London run of their musical *In Dahomey*. In 1906, once more in the United States, Brymn became music director for the Smart Set traveling shows, which enjoyed a long and prominent run on the African American touring circuit. Brymn interrupted his Smart Set work at least once, settling in as bandleader at the Pekin Theater in Chicago during 1907–1908. However, with the Smart Set he wrote the scores for a number of shows featuring their star SHERMAN H. DUDLEY; among these productions were *The Black Politician* (1908) and *His Honor, the Barber* (1909). In the latter Brymn worked with many of the greatest black talents in the theater of the day, including Mack, CHRIS SMITH, FORD DABNEY, and Jim Burris. Among Brymn's contributions (again with Mack) was "Porto Rico," which capitalized on a new craze for Latin American themes. Brymn continued his associations with some of these men and showed a quick eye for new trends throughout the era before World War I. In 1912 he and Smith penned the remarkable "I've Got the Blues but I'm Too Blamed

Mean to Cry," one of the earliest known blues songs. Brymn was helping set new musical trends during this period. It was also around this time that he moved permanently to New York.

Early in 1914 Brymn became the conductor of New York's Clef Club Orchestra, following the schism that climaxed with the departure of its founding director, JAMES REESE EUROPE. Brymn was soon a leading New York bandleader, his ascendancy confirmed by conducting duties at some of the Times Square roof garden theatrical "midnight frolics." He also provided ragtime and other syncopated dance music for the fast crowd that frequented New York's after-hours nightspots. At the first of these, the Shelburne Hotel and Restaurant, his band included the young New Orleans clarinet virtuoso SIDNEY BECHET, who had not yet switched to soprano saxophone, the instrument with which he later became associated. By the time Brymn ended this run of engagements at the fashionable Times Square roof gardens and enlisted in the American Expeditionary Forces, he was fronting an orchestra of twenty men.

Brymn's career reached its climax in World War I. He organized and led the band of the 350th Field Artillery Regiment, the most prominent African American marching band in France aside from Jim Europe's. This band, known as the Black Devils, was featured in the parades commemorating the end of the war. Reportedly Brymn's band played with such vigor in a victory parade on their return that President Woodrow Wilson was moved to step out of his car in the procession, telling his aides "I simply *must* march to this music!" Brymn's Black Devils band toured the United States successfully following demobilization in 1919 and also made recordings. At this time they were sponsored by the renowned opera singer Ernestine Schumann-Heink. Their recordings for the Okeh label were all issued in the spring of 1921 and included both the standard pop fare of the day and more blues- or ragtime-oriented songs by African American songwriters. Among the latter were "Arkansas Blues" (Spencer Williams and Anton Lada), "It's Right Here for You" (PERRY BRADFORD), "The Jazz Me Blues" (Tom Delaney), and "The Memphis Blues" (W. C. HANDY).

This choice of repertoire reflects Brymn's connections with the leading African American songwriters in Tin Pan Alley during this period, especially those also active as publishers in the Gaiety

Theater Building in Times Square. The association with Handy seems to have been the closest. Brymn penned the lyrics for Handy's instrumental "Aunt Hagar's Children Blues" in 1921, words that went on to be as famous as the music itself. This is probably Brymn's best-known song, and he himself directed an early vocal ensemble recording of it in 1923, leading a group known as Tim Brymn's Black Devil Four (a vocal quartet with piano and bells) for the Okeh label. Brymn also worked with white Tin Pan Alley songwriters. The song "Stop! Rest a While" was used in the 1921 black show *Put and Take*; in this case both music and lyrics were jointly attributed to Brymn and L. Wolfe Gilbert. By this time Brymn's best songwriting years were coming to an end. In 1921 he became manager of the New York office of the publishing house run by CLARENCE WILLIAMS and Armand Piron, then in the process of relocating from Chicago.

Brymn passed the last half-century his life in relative obscurity, mostly working as a coach to other entertainers. His connection with W. C. Handy remained strong, and through the connection Brymn was occasionally able to issue a new song; as late as 1930 Handy Brothers Music Company published his "Toot Toot, Dixie Bound in the Morning." Again Brymn penned the lyrics, working with the composer Chris Smith; by this time their connection went back at least two decades. However, the prominence they had enjoyed in the first decade of the twentieth century was behind them, and it was only their friendships with more-current show business figures such as Handy that kept them on the fringes of show business.

Though Brymn was not responsible for the creation of many blues or jazz standards, he was an important talent in black Broadway shows and in the early years of the blues craze. In addition to the songs noted above, his known works include "La Rumba," "Shout, Sister, Shout," "Moonlight," "Camel Walk," "I Take Things Easy," "Those Tantalizing Eyes," "Look into Your Baby's Face and Say Goo Goo," "Valse Angelique," "Cocoanut Grove Jazz," "After Tea," "This Is the Judgment Day," "'Round My Heart," "If You Don't I Know Who Will," and "My Pillow and Me." A complete catalog of his works has not yet been assembled. Brymn was probably of more importance as a bandleader than as a creative artist, both as a Clef Club colleague of James Reese Europe and as Europe's only real rival among military bandleaders with the American Expeditionary Forces in France during 1918–1919.

FURTHER READING

ASCAP Biographical Dictionary of Composers, Authors, and Publishers (1952).

Peterson, Bernard L. *Profiles of African American Stage Performers and Theatre People, 1816–1960* (2001).

Obituaries: New York Times, 4 Oct. 1946; *Variety*, 9 Oct. 1946.

ELLIOTT S. HURWITT

BUBBLES, John

(19 Feb. 1902–18 May 1986), dancer, singer, entertainer, and actor, was born John William Sublett in Louisville, Kentucky. His parents' names are not known. His early childhood was spent in Indianapolis, Indiana, where his family was part of a touring carnival; by the age of seven, John was performing on the stage, participating in amateur contests as a singer. Accounts differ as to when he returned to Louisville and when he met his vaudeville team partner, Ford Lee "Buck" Washington. Some sources list their ages as ten and six, respectively, while others list them as thirteen and nine. The team began working professionally by 1915 as "Buck and Bubbles," an act combining music and comedy.

They would remain together for nearly forty years, originally combining Washington's talents as a pianist with Sublett's as a singer; when his voice changed, Sublett turned to tap dancing as his primary talent. As they developed their act, the two took odd jobs to help support themselves and their families. While employed as ushers in the gallery at the Mary Anderson Theater in Louisville, they worked on their act after hours and were seen by the theater's manager. When an opening in the program arose, Buck and Bubbles were hired to perform, but they had to appear in blackface, posing as white minstrels, since the theater did not allow African American acts on the stage. An audition for a touring show, *The Kiss Me Company*, ensued and Sublett became Washington's legal guardian so that Buck would be allowed to tour at such a young age.

In September 1919 the duo reached New York and played without blackface at the Columbia Theater on Forty-seventh Street, across from the mecca of vaudeville, the Palace. The act was an immediate

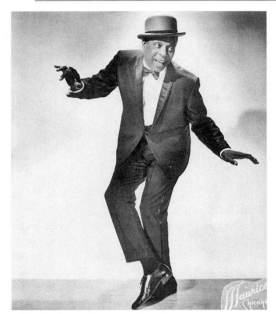

John Bubbles (c. 1964), often described as "the father of rhythm tap," changed the face of tap dance. (Library of Congress, New York World-Telegram and the Sun Newspaper Photograph Collection.)

success, becoming one of the few black acts to tour on the Keith, Orpheum, and other white vaudeville circuits. African American acts were primarily relegated to the Theater Owners' Booking Association (TOBA or "Toby"), which circulated acts to theaters in African American communities. According to Bubbles, "We were easy to book because we didn't conflict with most acts. Nobody wrote for us or gave us lines. We thought funny and that's the way it came out onstage" (Smith, 59). Buck and Bubbles became the first African American act to be held over at the Palace, the first to play Radio City Music Hall, and only the second to be featured in the Ziegfeld Follies in 1931, after headlining in Lew Leslie's *Blackbirds of 1930*.

In 1927 RCA Victor made test recordings of Buck and Bubbles that were not released. From nine sides recorded for Columbia between 1930 and 1934, only two were released: "He's Long Gone from Bowling Green" and "Lady Be Good." The duo made recordings in London in 1936, and there is reportedly a solo album released by Bubbles, *From Rags to Riches*. In 1935 George Gershwin cast Bubbles as the original Sportin' Life in *Porgy and Bess*. Washington

was also in the cast, as "neither took a job without the other being hired" (*Variety* Obituary, 110). Later, Buck and Bubbles became the first African Americans to perform on television, in New York in 1939. The team became popular in Europe as well, touring extensively.

Buck and Bubbles' performances on film began in 1929 with a series of Pathé comedy shorts: *Black Narcissus, Fowl Play, In and Out, Darktown Follies, High Toned*, and *Honest Crooks*. These were followed by *Night in a Niteclub* (1934), *Calling All Stars* (1937), *Varsity Show* (1937), and *Atlantic City* (1944). In 1943, billed as John W. Sublett, rather than John Bubbles, as he was more popularly known, he performed the featured role of Domino Johnson in MGM's *Cabin in the Sky*, the all-black cast musical starring ETHEL WATERS, LENA HORNE, and EDDIE "ROCHESTER" ANDERSON. Sublett won critical acclaim for his solo number, "Shine," a song written by DUKE ELLINGTON, which some critics perceive as a subtle, incisive protest against racism. Other film appearances include *I Dood It* (also known as *By Hook or by Crook*, 1943), *Laff Jamboree* (1945), *Mantan Messes Up* (1946), and *A Song Is Born* (1948).

After Washington's death in 1955, Bubbles continued as a solo performer until 1967, when a stroke left him partially paralyzed and sent him into semiretirement. In 1955 he appeared in the German film *Solang' es hübsche Mädchen gibt*, released in the United States as *Beautiful Girls* (1958). Bubbles is among the legendary tap dancers featured in the film documentary *No Maps on My Taps* (1979). He was also the first African American entertainer to appear on *The Tonight Show Starring Johnny Carson*. Some of his other major television appearances include *The DuPont Show of the Week* (1961), *The Lucille Ball Show* (1962), and *The Belle of 14th Street* (1967), a vaudeville re-creation conceived for Barbra Streisand. As a solo act, he appeared regularly with Danny Kaye, Judy Garland, and Anna Maria Alberghetti. During the 1960s he toured Vietnam with Bob Hope and earned the Award of Merit from the U.S. government. There was little work after 1967, but in 1979 George Wein called upon Bubbles to sing at the Newport Jazz Festival. In 1980 Bubbles returned to the New York stage in *Black Broadway*, a musical revue, and was honored by the American Guild of Variety Artists (AGVA) with a lifetime achievement award. That same year a recording of excerpts from *Porgy and Bess*, by Leontyne

Price and William Warfield, featuring Bubbles as Sportin' Life, was released by RCA Victor.

Bubbles, often described as "the father of rhythm tap," which was also known as "jazz tap," changed the face of tap dance. When he was eighteen years old, he was laughed out of the Hoofers Club, a Harlem gathering place where the foremost tap dancers in the nation openly challenged and competed against each other. This event served to heighten his drive to be acknowledged as a dancer and sent him into intensive practice. At that time, tap dancers stayed on their toes and included a great deal of "flash," or gymnastic virtuosity, in their acts. Bubbles pared down his body movement and added his heels to his tap combinations, creating more syncopated rhythms while exhibiting mastery in the speed and complexity of the steps he improvised.

Soon, dancers came to his shows to try to copy his style. Bubbles frustrated them by changing his steps with each performance. "Double over-the-tops," a difficult figure-eight pattern, and "cramp rolls," a complex sequence of heel-toe combinations, were among his signature innovations. His style is said to have prepared the way for the rhythms of bebop jazz. Hollywood called upon Bubbles to tutor Fred Astaire, Eleanor Powell, and Ann Miller, among other renowned dancers. In the words of FAYARD NICHOLAS, of the famed Nicholas Brothers dance team, "What you used to see Fred Astaire do in the movies, Bubbles had done long before." Bubbles's last appearance as a performer occurred in 1980 at a tribute to George and Ira Gershwin at the Kennedy Center Library. A cerebral hemorrhage took his life at his home in Baldwin Hills, near Los Angeles, California.

FURTHER READING
Goldberg, Jane. "John Bubbles: A Hoofer's Homage," *Village Voice*, 4 Dec. 1978.
Smith, Bill. *The Vaudevillians* (1976).

Obituaries: New York Times, 20 May 1986; *Variety*, 21 May 1986; *The Annual Obituary: 1986*.

FREDA SCOTT GILES

BURCH, Charles Eaton

(14 July 1891–23 Mar. 1948), educator, literary scholar, and biographer of the English novelist Daniel Defoe, was one of five sons born to Helena Burch in Saint George's, Bermuda. Nothing is known of his father. Charles Burch was educated in the elementary and secondary schools of Bermuda. Burch met and married Willa Carter Mayer, who at one time served as a professor of education at Miner Teacher's College in Washington, D.C. She also served as a supervisory official of the public schools of the District of Columbia and authored *Clinical Practices in Public School Education* (1944). Whether or not they had children is not known.

Burch attended Wilberforce University in Wilberforce, Ohio, from which he was awarded a BA in 1914. Four years later, he earned a MA from Columbia University. Fifteen years later in 1933 he was awarded a PhD in English from Ohio State University. He taught at several institutes of higher education, one of which was Tuskegee Institute during 1916–1917. From 1918 to 1921 he served as an instructor of English at Wilberforce University in Ohio. He also served on the faculty of Howard University in Washington, D.C., from 1921 to 1948 as a professor of English, eventually becoming head of the English department.

Burch made many scholarly contributions to Howard University, one of which was the development of an African American literature course titled "Poetry and Prose of Negro Life." As head of the English department during his fifteen-year tenure at Howard University, Burch recruited scholars and teachers who helped strengthen the department and the African American literature course that he had previously developed. Burch wrote essays on the lives of a variety of subjects, including PAUL LAWRENCE DUNBAR. "A Survey of the Life and Poetry of Paul Lawrence Dunbar" was the subject of Burch's master's thesis at Columbia University.

Burch published numerous scholarly articles and became well known as he developed into an influential expert in eighteenth-century English literature. He emerged as an authority on the life and works of the English novelist and journalist Daniel Defoe. Burch wrote essays on Defoe's life and writings of the era of 1706–1731 and journeyed to Scotland, where Defoe had been politically active in the eighteenth century, several times to do extensive research. His intense study produced many publications on various related topics. The *Howard University Record* published Burch's essay "Daniel Defoe's Views on Education" in 1922. The essay was revised for the *London Quarterly Review* in 1930, and remained in progress for a more intense study, which led Burch to spend time at Edinburgh

University in Scotland, researching Defoe's life and studying with H. J. C. Grierson during 1927–1928.

Burch's research at the National Library of Scotland from 1927–1928 produced a series of articles concerning Defoe's life and activities connected to the political union of Scotland and England in 1707. Burch established Defoe's authorship of pamphlets and writings that were not previously attributed to Defoe. Burch wrote four essays during this time: "An Equivalent of Daniel Defoe" (*Modern Language Notes* 37844 [June 1929], 378), an article in which Burch addressed an excerpt from *Equivalent*, a poem written anonymously in 1706 about Defoe (Burch stated that the poem is a "Scotch satire" of Defoe and his views in favor of the union of England and Scotland, and suspected the author to be Dugald Campbell, who had expressed similar attitudes against both the union and Defoe); "Defoe's Connections with the *Edinburgh Courant*" (*Review of English Studies* 5 [Oct. 1929], 437–440); "Attacks on Defoe in Union Pamphlets," (*Review of English Studies* 6 [July 1930], 318–319); and "Wodrow's List of Defoe's Pamphlets on the Union" (*Modern Philology* 28 [Aug. 1930], 99–100), an article in which Burch described his examination of a collection of pamphlets ascribed to Defoe. Burch stated how likely it is that five pro-union pamphlets included in the librarian Robert Wodrow's list are accepted as genuine pamphlets written by Defoe. Burch said they were written by Defoe because it is likely that Defoe assisted Wodrow in compiling union notes and documents and that the style of writing is that of Defoe's. (Wodrow was a Scottish clergyman who served as a librarian at Glasgow University after he received his MA degree.) Two of Burch's essays on Defoe's literary relationship contributed to Burch's doctoral dissertation while he studied at Ohio State University. Those essays were "The English Reputation of Daniel Defoe: British Criticism of Defoe as a Novelist 1719–1860" and "Defoe's British Reputation 1869–1894" (*Englische Studien* 67 [1932], 18–98 and 68 [1934], 410–423).

In April 1937 an article by Burch was published in *Philological Quarterly* titled "Notes on the Contemporary Popularity of Defoe's Review." This article produced support of Defoe's reputation with the people of London concerning Defoe's periodical. In April of that same year the *London Quarterly and Holborn Review* published Burch's essay "The Moral Elements in Defoe's Fiction." This article focused

on Defoe's character and personality and greatly influenced Defoe's biographical writers.

Burch again traveled to Scotland to do further research at the National Library and the archives of Edinburgh University in 1938. He spent six months during this visit doing more biographical research that produced more articles over the next ten years. Burch's research on the life of Defoe during this study abroad produced "Defoe and the Edinburgh Society for the Reformation of Manners" (*Review of English Studies* 16 [July 1940], 306–312), an article in which Burch explained his notes pertaining to the minutes of an organization called the Edinburgh Society for the Reformation of Manners, of which Defoe was a member. Defoe desired to be a member of a different branch, called the Societies in London for Reformation. Defoe was admitted on 3 April 1707 and later agreed to correspond with the former branch and requested reformation manuals for the branch that he had recently joined. Burch explained in his footnotes that the manuscript, dated 7 March 1707, was brought to his attention by Dr. H. L. Sharp of the Edinburgh University Library. Burch also produced "Benjamin Defoe at Edinburgh University, 1710–1711," (*Philological Quarterly* 19 [Oct. 1940], 343–348); and "Defoe and his Northern Printers" (*Publications of the Modern Language Association of America* 60 [Mar. 1945]: 121–128), this latter being an article in which Burch described a controversy that Defoe encountered between his Scottish printer, Mrs. Agnes Campbell Anderson, and a rival of hers named James Watson. Watson wanted to discredit Defoe and Mrs. Anderson because she printed Defoe's controversial articles about the union of England and Scotland. Mrs. Anderson owned the largest printing shop in Scotland and continued to print Defoe's articles, and on 12 May 1712, as her printing license was about to expire, she called on Defoe for his influence and help.

Burch contributed other writings pertaining to Defoe, including "The Authorship of a Scots Poem (1707)" (*Philological Quarterly* 22 [Jan. 1943], 51–57); "An Unassigned Defoe Pamphlet in the Defoe-Clark Controversy" and "A Discourse Concerning the Union: An unrecorded Defoe Pamphlet?" (*Notes and Queries* 188 [5 May, 16 June 1945], 185–187, 244–246); and "Defoe's First *Seasonable Warning or the Pope and the King of France Unmasked* (1706)" (*Review of English Studies* 21 [Oct. 1945], 322–326), an article in which Defoe attempted to persuade "the inhabitants of

Edinburgh . . . to wish for a union"; and "Defoe's 'Some Reply to Mr. Hodges and Some Other Authors'" and "The Authorship of 'A Letter Concerning Trade from Several Scots Gentlemen that are Merchants in London,' etc. (1706)" (*Notes and Queries* 193 [21 Feb., 6 Mar. 1948], 72–74, 101–103). In 1948 the *American Peoples Encyclopedia* published articles by Burch about Defoe and the Scottish novelist Tobias Smollett.

Burch suffered and died of a heart attack in Stamford, Connecticut. At the time of his death, several writing projects were in progress. One was an essay first published in 1922 in which Burch intended to do an expanded study. In progress also were two unfinished book-length projects. One was about the life of Defoe and the other was about Defoe's pamphlets on the union. Mordecai W. Johnson, then president of Howard University, delivered the eulogy at Burch's funeral, which was held in Andrew Rankin Memorial Chapel, located on the main campus of Howard University.

As a literary authority on the life and writings of Daniel Defoe, Charles Eaton Burch ranks high as a scholar and a specialist of eighteenth-century English literature. One year after his death the English department at Howard University established the Charles Eaton Burch Memorial Lectures, an annual series of lectures that features outstanding scholars.

FURTHER READING

Burch's essays and other writings are in the Moorland-Spingarn Research Center of Howard University. His writings are also listed in the *Cambridge Bibliography of English Literature* and the *New Cambridge Bibliography of English Literature*, and in Velma McLin Mitchell's "Charles Eaton Burch: A Scholar and His Library" (*College Language Association Journal*, 16 [1973]: 369–376). A portion of Mitchell's work titled "The Charles Eaton Burch Collection in Founder's Library" was catalogued at Howard University before the writings were dispersed.

Arvey, Verna. "Charles Eaton Burch, Who Treads an Unbeaten Path," *Opportunity* (1942).

Mitchell, Velma McLin. "Charles Eaton Burch: A Scholar and His Library," *College Language Association Journal* (1973).

Obituaries: Washington Star, 25 Mar. 1948; *Washington Post*, 27 Mar. 1948.

FLORENCE M. COLEMAN

BURKE, Selma Hortense

(31 Dec. 1900–29 Aug. 1995), sculptor, art educator, and mentor, was born in Mooresville, North Carolina, one of eight children of Mary L. Elizabeth Jackson Cofield Burke, a homemaker and a teacher, and Neal Burke, a Methodist minister. Burke's artistic experiences began in childhood, when she played in the pliable soil around her North Carolina home: "I shaped my destiny early with the clay of North Carolina rivers. I loved to make the whitewash for my mother, and was excited at the imprints of the clay and the malleability of the material" (Krantz and Koslow). She was further inspired by the art objects that her father and uncles brought back with them from their travels in Africa the Caribbean, and Europe. As a chef aboard ships, her father had the chance to both preach and explore in other countries, bringing back artwork. Her uncles were missionaries who traveled extensively, returning with mementos that inspired Burke.

Despite her family's support of her art, Burke pursued a more practical career as well, and she became a registered nurse in 1924. She was briefly married in 1928 to Durant Woodward, who died a year after their wedding. She continued her medical education at the Woman's Medical College in Philadelphia, acquiring a nursing post with a wealthy woman. During the next four years she was introduced to a range of people and experiences. After the death of her patient, she decided to quit nursing and pursue her art career

She moved to New York in 1935 and became an artist's model and student at Sarah Lawrence College in Bronxville, New York. Though she did not get a degree, she received a Boehler Foundation Fellowship in 1938, with which she was able to spend a year in Europe, studying with the sculptor Aristide Maillol, the painter Henri Matisse, and the ceramist Michael Povolney. Returning to the United States in 1939, she attended Columbia University and taught sculpture at the Harlem Community Art Center, then directed by AUGUSTA SAVAGE, a New York artist. The HCAC was part of the Works Progress Administration started during the Depression to keep Americans working. Savage's artistic contemporaries included Horace Pippin, William Scott, JACOB ARMSTEAD LAWRENCE, and ROMARE BEARDEN. Burke bravely accepted the challenges of sculpture, a medium with substantial material costs and considered too physically demanding for women to undertake. Inspired by the Modernism

of the Harlem Renaissance and the School of Paris, Burke worked with a variety of sculptural mediums and methods, including marble, brass, directly carved wood, and lost-wax, bronze casts.

During the 1930s Burke met the writer CLAUDE MCKAY. They married, divorced, married a second time, and divorced finally in 1940. This same year, she started the Selma Burke School of Sculpture in New York City. Burke continued her studies and graduated from Columbia University with a master's degree in Fine Art in 1941, assisted by a Rosenwald Fellowship. At the beginning of World War II, she briefly worked as a navy truck driver, but an injury forced her to stop.

In 1943 Burke entered a competition to create a portrait of President Franklin Delano Roosevelt and won the Fine Arts Commission prize to sculpt the president in a relief plaque. Upon seeing the finished work, Eleanor Roosevelt reportedly told Burke, "It's very well done, but you've made him too young." Burke's reply was quoted in the *New York Times*: "I've not done it for today, but for tomorrow and tomorrow." The bust was said to have influenced John R. Sinnock, chief engraver at the U.S. mint, in designing the Roosevelt dime, in circulation since 1945.

After the war, Burke maintained a studio in Greenwich Village, producing many stone pieces. In 1949 she married the architect Hermann Kobbe. Together they moved to Bucks County, Pennsylvania. Burke sculpted there for the next six years, until Kobbe died. She maintained this home even when she started the Selma Burke Art Center in Pittsburgh in 1968, and it remained in operation until 1981. During this time, she also worked for the Pennsylvania Council on the Arts, serving under three governors. She taught at Haverford, Livingston, and Swarthmore colleges until the 1970s.

She continued to work on her own sculptures, completing *Mother and Child* in 1968 and *Big Mama* in 1972—works that focused on black culture and a woman's experience. In 1979 President Jimmy Carter presented Burke with the Award for Outstanding Achievement in the Visual Arts, and in 1989 she was awarded an *Essence* magazine award in honor of her achievements in the arts. Retiring from her academic and administrative duties in 1981, Burke worked from her Bucks County studio, producing one of her most well-known works, a brass bust of MARY MCLEOD BETHUNE. She continued to work on her art until her death, leaving unfinished

a sculpture of ROSA PARKS. Burke donated her large collection of European and African art, as well as her own work, to Winston-Salem University in North Carolina.

FURTHER READING
Fax, Elton. *Black Artists of the New Generation* (1977).
Gale Research. *Notable Black American Women* (1992).
Hine, Darlene Clark, Elsa Barkley Brown, and Rosalyn Terborg-Penn, eds. *Black Women in America: An Historical Encyclopedia* (1993).
Kranz, Rachel, and Philip J. Koslow. *The Biographical Dictionary of Black Americans* (1999).

ROBIN JONES

BURLEIGH, Henry Thacker

(2 Dec. 1866–12 Sept. 1949), composer and spiritual singer, was born in Erie, Pennsylvania. Little is known about his parentage. When he was a boy, his excellent singing voice made Harry, as he was known, a sought-after performer in churches and synagogues in and around his hometown. In 1892, having decided on a career in music, Burleigh won a scholarship to the National Conservatory of Music in New York City. His matriculation coincided with the arrival of the Czech composer Antonín Dvořák, who taught there for four years. Dvořák, who was intensely interested in indigenous American music, found a valuable resource in the young Burleigh, who sang for him various African American spirituals. From Burleigh, Dvořák first heard "Go Down, Moses," "Roll, Jordan, Roll," "Were You There," "Swing Low," and "Deep River." When Dvořák set an arrangement of Stephen Foster's "Old Folks at Home," he dedicated it to Burleigh.

Buoyed by Dvořák's interest, Burleigh was further encouraged by what he interpreted to be fragments of these spirituals in Dvořák's famous New World Symphony. Some analysts agreed, but others took exception to this interpretation. An aesthetic dispute quickly took on political overtones. "Nothing could be more ridiculous than the attempts that have been made to find anything black . . . in the glorious soulful melody which opens the symphony," opined one New York critic. "Nothing could be more white. . . . Only a genius could have written it." While a few figures in the outwardly refined world of concert music had expressed some appreciation of African American traditions, Burleigh saw how readily this attitude could yield to prejudices that were ultimately

no different from the racism he had encountered throughout his life. Burleigh never forgot the lesson. Indeed, when his own compositions first came before New York critics in the late 1890s, the composer encountered the same perverse efforts to reduce art to racial categories. One critic, admitting Burleigh's quality, proclaimed that "in his excellent songs [Burleigh was] more white than black."

Despite the sincere appreciation he received from such a luminary as Dvořák, Burleigh was wary of the white-dominated music world because of its bigotry and its tendency to place music into racial categories. He was also uncomfortable with the growing popularity of minstrelsy and jazz in the early twentieth century, for he feared that African American musical traditions could too easily be caricatured and mocked. Minstrel songs, he declared, "are gay and attractive. They have a certain rhythm, but they are not really music. The mistake [in capitalizing on their appeal] was partly the fault of the Negroes, partly the result of economic pressure."

Burleigh would never compromise his art, as he was sensitive to how easily it could be miscast and distorted. At the same time, though, he never abandoned the ideal that the cultural store he could bring forth in his singing and songwriting had a universality and hence a potential to transcend identities and labels. The spiritual, he felt, provided "the accent that is needed, a warm personal feeling which goes directly to the heart of the people." It had meaning as an articulation not only of African American culture but of the general human experience, particularly of the great human yearnings for freedom and universality, illustrated by what Burleigh believed to be the two most profound stories in scripture—those of Moses and of the Resurrection. To Burleigh, the spirituals embodied these profound sentiments. Dvořák's response to them revealed how they could resonate in the soul of another musically sensitive person who was as yet unacquainted with any component of American culture. During World War I Burleigh found this point further underscored when a song he wrote called "The Young Warrior" became a popular marching tune among troops in the Italian army.

While working as a notator and editor in a New York publishing house, Burleigh continued to compose, almost exclusively as a songwriter, and

throughout his life he sang. He became a celebrated performer of spirituals in several New York churches and compiled and published the first full anthology of African American religious music. He died in New York City in relative obscurity, but his music has been posthumously rediscovered and appreciated.

FURTHER READING
Simpson, Anne K. *Hard Trials: The Life and Music of Henry T. Burleigh* (1990).
Southern, Eileen. *The Music of Black Americans: A History* (1971).

ALAN LEVY

BUSH-BANKS, Olivia Ward

(27 Feb. 1869–8 Apr. 1944), writer, was born in Sag Harbor, New York, the daughter of Abraham Ward, probably a fisherman, and Eliza Draper. Both were members of the Montauk Indian tribe of Long Island and both were also of African descent. When Olivia was just nine months old her mother's death forced the family to move to Providence, Rhode Island. Shortly after her father's remarriage, Olivia came under the guardianship of her maternal aunt Maria Draper, whom she credited with having given her an education and preparing her for life. Her aunt's determination and endurance, Olivia believed, resulted from her Native American upbringing. Olivia graduated from Providence High School, where she was trained as a nurse and developed strong interests in drama and literature.

In 1889 Olivia married Frank Bush in Providence and soon gave birth to two daughters, but the couple divorced by 1895. From the end of the century to about 1915, Olivia Bush shuttled between Boston and Providence, taking any available job to support her family. She also wrote poetry and in 1899 published her first volume of verse, *Original Poems*, which yielded some small financial rewards. The collection consisted of ten poems, including elegies extolling African American courage and virtue ("Crispus Attucks," "The Hero of San Juan Hill"), imaginative odes to faith and perseverance ("My Dream of the New Year"), and verses celebrating the ecstasies of religion ("Treasured Moments," "The Walk to Emmaus"). Several works from *Original Poems* were reprinted in the *Voice of the Negro*, one of the premier African American periodicals of the first decade of the twentieth century. Bush

shared publication in the *Voice* with other notable African American poets such as James David Corrothers, GEORGIA DOUGLAS JOHNSON, and Daniel Webster Davis.

Caring for her children and for her Aunt Maria made writing as a full-time career difficult. In about 1900 Bush became assistant drama director of the Robert Gould Shaw Community House in Boston. From 1900 to 1904 she also contributed to the *Colored American Magazine*, and thus she had poems published in the two journals that had the largest circulation among African Americans in the decade before 1910.

Bush's second collection, *Driftwood* (1914), expanded the themes set forth in *Original Poems*. *Driftwood* included poems, short prose pieces, and several elegies addressed to Abraham Lincoln, Frederick Douglass, William Lloyd Garrison, Wendell Phillips, and PAUL LAURENCE DUNBAR, who praised the volume in his preface. Bush soon departed from the pious sensibility shown in both volumes of poetry; her only published play, *Memories of Calvary: An Easter Sketch* (c. 1917), was also her last effort at purely religious pastoralism.

After about 1916 Olivia Bush married Anthony Banks, a Pullman porter. They lived in Chicago, where she founded the Bush-Banks School of Expression and became a drama instructor in the public schools. While at the Shaw Community House, she had decided that drama was indeed her creative strength. It was perhaps during this period (around 1920) that Bush-Banks's unpublished play, "Indian Trails; or, Trail of the Montauk," was written. This play, whose characters closely depict the society of the Algonquian, demonstrates Bush-Banks's knowledge of and facility with the nuances of the Algonquian language and material culture. Only small fragments of the play survive, but it was probably written in response to a 1918 New York State Supreme Court case, *Wyandank Pharaoh v. Jane Ann Benson et al.*, which declared that the Montauk tribe had become extinct because of intermarriage, mostly with blacks but also with whites. The play is a romantic idyll with political and cultural undertones; while it mourns a dissolving Montauk unity, it also reaffirms that unity when O-ne-ne (Wild Pigeon) brings word that whites have agreed to return land to the tribe.

The fragmentation of the Montauks as a result of the *Benson* case caused Bush-Banks to redirect her creative energies and pursue the African American experience as a principal form of expression. During the early years of the Depression she furthered her artistic interests and also began her journalistic efforts in African American culture. She championed the artists, musicians, and writers of the Harlem Renaissance and was associated with LANGSTON HUGHES, COUNTÉE CULLEN, A. PHILIP RANDOLPH, PAUL ROBESON, W. E. B. DU BOIS, and many other leading lights of the period. She also participated in the Federal Theater Project of the Works Progress Administration in 1936, coaching drama for three years in Harlem at the Abyssinian Community Center run by the Reverend ADAM CLAYTON POWELL SR. The 1930s seemed also to bring about a change in the tone of Bush-Banks's works. Perhaps the class consciousness that typified the Harlem Renaissance clashed with Bush-Banks's earlier coming to terms with her African Indian heritage. Several unpublished short sketches, including "Greenwich Village Highlights" (c. 1929), "New Year Musings" (1932), and "Black Communism" (1933), as well as an unpublished one-act play, "A Shantytown Scandal" (c. 1935), indicate Bush-Banks's growing disaffection with the Harlem Renaissance, which seemed to suffer a sharp decline in spirit at the onset of the Depression.

Perhaps Bush-Banks's lasting contribution to the literature of the Harlem Renaissance is her "Aunt Viney's Sketches," a cycle of stories that themselves are folk pronouncements on the Depression and on the Harlem scene. (In 1937 Bush-Banks sent six Aunt Viney stories to the Library of Congress, but the copyright application was left unfinished.) She may have intended the title character as a contrast to the young slave woman created by Dunbar in his short story "Viney's Free Papers"; Dunbar's Viney uses her newly found freedom as a weapon against her community. Bush-Banks's Aunt Viney is a mature, lively, sagacious African American woman whose hard-won folk wisdom, conveyed through the richness and power of vernacular speech, renders both racial pride and deft cultural criticism. In this Bush-Banks strongly echoes the efforts of her predecessors, notably Dunbar and CHARLES CHESNUTT, and she precedes Langston Hughes's famous "Simple" tales, which first appeared in 1943.

Although only two volumes of poetry, a play, two poems ("A Picture," 1900, and "On the Long Island Indian," 1916), and three essays in magazines

("Undercurrents of Social Life," 1900, and "Echoes from the Cabin Song" and "Essay on John Greene," both 1932) represent Bush-Banks's published works, her total output reveals a creative life that touched other lives. Not only did she provide documentation and social criticism of the Harlem Renaissance but her literary contributions to that period and the one immediately preceding it are also considerable. Bush-Banks died in New York City.

FURTHER READING

Guillaume, Bernice F., ed. *The Collected Works of Olivia Ward Bush-Banks* (1991).

NATHAN L. GRANT

CALLOWAY, Blanche Dorothea Jones

(9 Feb. 1902–16 Dec. 1978), the first woman to lead an otherwise all-male orchestra, was the older sister of the well-known bandleader CAB CALLOWAY. Born in Rochester, New York, Blanche and her three younger siblings moved to Baltimore when she was a teenager. She grew up in a comfortably middle-class family; her father, Cabell, was a lawyer and her mother, Martha Eulalia Reed, taught music. Calloway's father died in 1910, and her mother married insurance salesman John Nelson Fortune a few years later and had two more children.

Calloway's mother likely instilled a love of music in all of her children; Calloway's brother Elmer also briefly pursued a musical career. Martha made sure that young Calloway took piano and voice lessons as a child, but Martha never imagined music as a career for a proper young woman. She expected that her daughter would pursue a "respectable" career as a nurse or teacher. Inspired by African American women cabaret and blues entertainers like FLORENCE MILLS and IDA COX, Calloway dreamed of a musical career. With the encouragement of her music teacher, Calloway auditioned for a local talent scout. Calloway's talent impressed the scout and he wanted to book her for local events, but she resisted. To her mother's dismay, Calloway dropped out of Morgan College in the early 1920s to embark on a music career, a career that would span fifty years.

She worked in local Baltimore clubs and performed in the musical *Shuffle Along* with EUBIE BLAKE and NOBLE SISSLE in 1921. Her big break came in 1923 when she joined the national tour of the all–African American musical revue *Plantation Days*, which featured her idol Florence Mills. When the show ended in Chicago in 1927, Calloway decided to stay in Chicago, the jazz music capital in the 1920s. She became a popular attraction in local Chicago clubs. She also toured extensively, performing at exclusive venues like the Crio Club in New York and to capacity crowds in Atlantic City, Boston, Kansas City, New York, Pittsburgh, and Saint Louis. In 1925 she capitalized on the public craze for "race records" and recorded two records ("Lazy Woman Blues" and "Lonesome Lovesick Blues") with her new group, Blanche Calloway and Her Joy Boys. The Joy Boys featured some of the hottest young talent in jazz like trumpeter LOUIS ARMSTRONG in some of his earliest recordings, drummer William Randolph "Cozy" Cole, and saxophonist Ben Webster.

In the late 1920s she appeared with Rueben Reeves and recorded on Vocalion Records. In 1931 she appeared at the Pearl Theater in Philadelphia. She caught the attention of Kansas City bandleader Andy Kirk who asked her to tour with him and his band, the Clouds of Joy. Calloway learned a great deal about managing a band and booking performances. She also discovered that she often overshadowed her mentor. Around 1930 or 1931 Calloway made a serious attempt to start her own orchestra. Stories vary as to how this came about. In one version, Calloway convinced several of Kirk's band members to defect. Kirk caught wind of the plot and ended his association with Calloway. In another, Pearl Theater manager Sam Steiffel noted the popularity of Calloway and considered using her to replace Kirk as bandleader. Kirk learned of Steiffel's plans and dropped Calloway from the remaining tour dates. In 1931 Calloway succeeded in forming an orchestra and revived the name Blanche Calloway and Her Joy Boys. She became the first women ever to lead an all-male orchestra, and they recorded for RCA Victor. She later changed the name to Blanche Calloway and Her Orchestra. Calloway and her orchestra were considered one of the best groups in the country. A 1933 article in the *Pittsburgh Courier* ranked Calloway and the Joy Boys among the top ten outstanding African American orchestras. A year earlier, a reviewer praised Calloway's professionalism, management, and talent.

Yet Calloway faced difficulties flourishing in a racially segregated and male-dominated music world. As an African American performer, she often suffered the indignities of racial bigotry. She had to perform for segregated audiences. While on a tour in 1936, she used the ladies' room at a filling station in Yazoo, Mississippi. As a result, police pistol-whipped an orchestra member, jailed him and Calloway for disorderly conduct, and fined them both $7.50. While in jail, another orchestra member stole all of the group's money and abandoned the band in Mississippi. The musicians scattered, and Calloway sold her yellow Cadillac for cash to leave Mississippi. Like fellow female performer trumpeter VALAIDA SNOW, Calloway earned a reputation as an

exceptional musician but few opportunities outside of the roles of singer or dancer existed for women at that time. Also Calloway's flamboyant performance style and provocative lyrics challenged normative assumptions about "respectable" female performers. Though such antics contributed to her brother Cab's success, Blanche found it increasingly difficult to get bookings by the mid-1930s.

Calloway had been a strong influence in her brother Cab's career and iconic performance style. She herself was a lively performer known for her animated style, musical skill, and raucous stage presence. She taught him a great deal about performing, and the two performed together as a brother and sister act. She helped him get his first break with a stage role in the *Plantation Days* revue when a cast member fell ill. She may even have inspired his signature "Hi De Hi" chant in his song "Minnie the Moocher." Cab had said that he came up with the phrase when he forgot the words during a performance. Calloway's "Just a Crazy Song," which she had previously performed and then recorded in early 1931, opens with her wailing "Hi Hi Hi, Ho De Ho De Ho," echoed by a band member in a classic call and response. Calloway's own signature song, "Growlin' Dan," which she co-wrote, recounts the tale of Minnie the Moocher and the King of Sweden and also features the phrase "Ho De Ho De Ho." The two likely collaborated with one another and borrowed frequently from each other's acts.

Calloway found it difficult to make a living in the mid-1930s as the few opportunities for women band leaders dried up. In 1938 she broke up her orchestra. In 1940 she formed a short-lived all-women orchestra since "all-girl" groups were popular during war time. She struggled to get bookings and the group soon disbanded. She worked as a solo act until the mid-1940s, when she moved to a Philadelphia suburb with her husband and became a socialite. She pursued civic causes and served as a Democratic committeewoman. Misfortune dogged Calloway, who discovered that her husband was a bigamist in late 1943.

In the early 1950s she moved to Washington, D.C., and managed a nightclub the Crystal Caverns to support herself. When a bandleader abandoned future R&B star RUTH BROWN at a nearby club, Calloway hired her to perform at the Crystal Caverns. She became Brown's personal manager and took the young performer under her wing. Brown credits Calloway with discovering her and helping her land a deal with Atlantic Records.

Calloway continued to achieve significant firsts in the last decades of her life. In the late 1950s Calloway moved to Miami and resumed her political activism. She became the first African American precinct voting clerk, and she is reputed to be the first African American woman ever to vote in Florida when she cast a ballot for the 1958 election. She became a member of the NAACP and CORE and served on the board of the National Urban League. In 1964 she and about forty other African American women participated in a protest with the NATO Women's Peace Force in The Hague, Netherlands. In the 1960s she worked as a disc jockey and program manager for Miami radio station WMBM. She converted to Christian Science, which she credited with helping her fight a twelve- year battle with cancer. Around 1968 she formed Afram House Inc., a successful mail order company that offered cosmetics designed exclusively for African American women. In the last years of her life, she married her high school sweetheart and moved back to Baltimore. She died of breast cancer.

FURTHER READING

Arwulf, Arwulf. *All Music Guide to Jazz: The Experts' Guide to the Best Jazz Recordings* (1998).

"Blanche Calloway Jones." *The Black Perspective in Music* 7, No. 2 (Autumn 1979).

Foster, Catherine. "In Cab Calloway's Family, One Intrepid Woman Inspires Another; Daughter Portrays Bandleader Aunt," *Boston Globe*, 9 Nov. 2003.

Pfeffer, Murray L. "Blanche Calloway." In Big Bands Database Plus. Available at http://nfo.net/usa/c1.html.

Prozdowski, Ted. "Cab's Clan: Chris Calloway Celebrates her Aunt Blanche," *Boston Phoenix* 21–27 Nov. 2003.

SHENNETTE GARRETT

CALLOWAY, Cab

(25 Dec. 1907–18 Nov. 1994), popular singer and bandleader, was born Cabell Calloway III in Rochester, New York, the third of six children of Cabell Calloway Jr., a lawyer, and Martha Eulalia Reed, a public school teacher. In 1920, two years after the family moved to the Calloways' hometown of Baltimore, Maryland, Cab's father died. Eulalia later remarried and had two children with John Nelson Fortune,

Cab Calloway was propelled to stardom with his exuberant "Minnie the Moocher." (Library of Congress, Photo by Carl Van Vechten, 1933.)

an insurance salesman who became known to the Calloway children as "Papa Jack."

Although he later enjoyed a warm relationship with his stepfather, the teenaged Cab had a rebellious streak that tried the patience of parents attempting to maintain their status as respectable Baltimoreans. He often skipped school to go to the nearby Pimlico racetrack, where he both earned money selling newspapers and shining shoes and began a lifelong passion for horse racing. After his mother caught him playing dice on the steps of the Presbyterian church, however, he was sent in 1921 to Downingtown Industrial and Agricultural School, a reform school run by his mother's uncle in Pennsylvania. When he returned to Baltimore the following year, Calloway recalls that he resumed hustling but also worked as a caterer, and that he studied harder than he had before and excelled at both baseball and basketball at the city's Frederick Douglass High School. Most significantly, he resumed the voice lessons he had begun before reform school, and he began to sing both in the church choir and at several speakeasies, where he performed with Johnny

Jones's Arabian Tent Orchestra, a New Orleans–style Dixieland band. In his senior year in high school, Calloway played for the Baltimore Athenians professional basketball team, and in January 1927 he and Zelma Proctor, a fellow student, had a daughter, whom they named Camay.

In the summer after graduating from high school, Calloway joined his sister Blanche, a star in the popular *Plantation Days* revue, on her company's midwestern tour, and, by his own account, "went as wild as a March hare," chasing "all the broads in the show" (Calloway and Rollins, 54). When the tour ended in Chicago, Illinois, he stayed and attended Crane College (now Malcolm X University). While at Crane he turned down an offer to play for the Harlem Globetrotters, not, as his mother had hoped, to pursue a law career, but instead to become a professional singer. He worked nights and weekends at the Dreamland Café and then won a spot as a drummer and house singer at the Sunset Club, the most popular jazz venue on Chicago's predominantly African American South Side. There he befriended LOUIS ARMSTRONG, then playing with the CARROLL DICKERSON Orchestra, who greatly influenced Calloway's use of "scat," an improvisational singing style that uses nonsense syllables rather than words.

When the Dickerson Orchestra ended its engagement at the Sunset in 1928, Calloway served as the club's master of ceremonies and, one year later, as the leader of the new house band, the Alabamians. His position as the self-described "dashing, handsome, popular, talented M.C. at one of the hippest clubs on the South Side" (Calloway and Rollins, 61) did little to help his already fitful attendance at Crane, but it introduced him to many beautiful, glamorous, and rich women. He married one of the wealthiest of them, Wenonah "Betty" Conacher, in July 1928. Although he later described the marriage as a mistake, at the time he greatly enjoyed the "damned comfortable life" that came with his fame, her money, and the small house that they shared with a South Side madam.

In the fall of 1929 Calloway and the Alabamians embarked on a tour that brought them to the mecca for jazz bands of that era, Harlem in New York City. In November, however, a few weeks after the stock market crash downtown on Wall Street, the Alabamians also crashed uptown in their one chance for a breakout success, a battle of the bands at the famous Savoy Ballroom. The hard-to-please

Savoy regulars found the Alabamians' old-time Dixieland passé and voted overwhelmingly for the stomping, more danceable music of their rivals, the Missourians. The Savoy audience did, however, vote for Calloway as the better bandleader, a tribute to his charismatic stage presence and the dapper style in which he outfitted the Alabamians.

Four months later, following a spell on Broadway and on tour with the pianist FATS WALLER in the successful *Connie's Hot Chocolate* revue, he returned to the Savoy as the new leader of the Missourians, renamed Cab Calloway and His Orchestra. In 1931 the band began alternating with DUKE ELLINGTON's orchestra as the house band at Harlem's Cotton Club, owned by the gangster Owney Madden and infamous for its white-audiences-only policy. Calloway also began a recording career. Several of his first efforts for Brunswick Records, notably "Reefer Man" and "Kicking the Gong Around," the latter about characters in an opium den, helped fuel his reputation as a jive-talking hipster who knew his way around the less salubrious parts of Manhattan. Although he denied firsthand experience of illicit drugs, Calloway did admit to certain vices—fast cars, expensive clothes, "gambling, drinking, partying [and] balling all through the night, all over the country" (Calloway and Rollins, 184).

It was 1931's "Minnie the Moocher," with its scat-driven, call-and-response chorus, that became Calloway's signature tune and propelled him to stardom. The most prosaic version of the chorus had Cab calling out, "Hi-de-hi-de-hi-di-hi, Ho-de-ho-de-ho-de-ho" or, when the mood took him, "Oodlee-odlyee-odlyee-oodle-doo" or "Dwaa-de-dwaa-de-dwaa-de-doo," while his orchestra—and later the audience—responded with the same phrase. Calloway recalled in his autobiography that the song came first and the chorus was later improvised when he forgot the lyrics during a radio broadcast. The song's appeal was broadened in 1932 by its appearance in the movie *The Big Broadcast* and in a Betty Boop cartoon short, *Minnie the Moocher*. Radio broadcasts from the Cotton Club and appearances on radio with Bing Crosby made Calloway one of the wealthiest entertainers during the Depression era. The Calloway Orchestra embarked on several highly successful national tours and in 1935 became one of the first major black jazz bands to tour Europe.

Although the Calloway Orchestra was arguably the most popular jazz band of the 1930s and 1940s, most jazz critics view the bands of Duke Ellington, Louis Armstrong, and COUNT BASIE as more musically sophisticated. Albert Murray's influential *Stomping the Blues* (1976) does not even mention Calloway, although it does list several members of his orchestra, including the tenor saxophonist CHU BERRY and the trumpeter Dizzy Gillespie, who joined the band in 1939 and left two years later, after he stabbed Calloway in the backside during a fight. With the drummer Cozy Cole and the vibraphonist Tyree Glenn, the Calloway Orchestra showcased its rhythmic virtuosity in several instrumentals, including the sprightly "Bye Bye Blues" and the sensual "A Ghost of a Chance," both recorded in 1940.

It was, however, Calloway's exuberant personality, his cutting-edge dress style—he was a pioneer of the zoot suit—and his great rapport with his audiences that packed concert halls for nearly two decades. In the 1940s he was ubiquitous, appearing on recordings, radio broadcasts of his concerts, and in movies such as *Stormy Weather* (1943), in which he starred with Lena Horne, BILL "Bojangles" ROBINSON, Katherine Dunham, and Fats Waller. In 1942, he hosted a satirical network radio quiz show, *The Cab Calloway Quizzicale*. Calloway even changed the way Americans speak, with the publication of *Professor Cab Calloway's Swingformation Bureau* and *The New Cab Calloway's Hepsters Dictionary: Language of Jive* (1944), which became the official jive language reference book of the New York Public Library. The *Oxford English Dictionary* credits Calloway's song "Jitter Bug" as the first published use of that term.

The end of World War II marked dramatic changes in Calloway's professional and personal lives. In 1948 the public preference for small combos and the bebop style of jazz, pioneered by Gillespie, among others, forced Calloway to break up his swing-style big band. One year later Calloway divorced Betty Conacher, with whom he had adopted a daughter, Constance, in the late 1930s, and married Zulme "Nuffie" McNeil, with whom he would have three daughters, Chris, Lael, and Cabella. His career revived, however, in 1950, when he landed the role of Sportin' Life in the revival of George Gershwin's *Porgy and Bess* on Broadway and in London and Paris. The casting was inspired, since Gershwin had modeled the character of Sportin' Life on Calloway in his "Hi-de-hi" heyday. From 1967 to 1970 he starred with Pearl Bailey in an all-black

Broadway production of *Hello, Dolly!*, and in 1980 he endeared himself to a new generation of fans, with his performance of "Minnie the Moocher" in the film *The Blues Brothers*, with John Belushi and Dan Aykroyd. That role led to appearances on the television shows *The Love Boat* and *Sesame Street* and on Janet Jackson's music video "Alright," which won the 1990 Soul Train award for best rhythm and blues/urban contemporary music video.

In June 1994 Calloway suffered a stroke at his home in White Plains, New York, and died five months later at a nursing home in Hockessin, Delaware. President Bill Clinton, who had awarded Calloway the National Medal of the Arts a year earlier, paid tribute to him as a "true legend among the musicians of this century, delighting generations of audiences with his boundless energy and talent" (*New York Times*, 30 Nov. 1994). Calloway, however, probably put it best when he described himself in his autobiography as "the hardest jack with the greatest jive in the joint."

FURTHER READING

Calloway's papers are held at Boston University.

Calloway, Cab, and Bryant Rollins. *Of Minnie the Moocher and Me* (1976).

Schuller, Gunther. *The Swing Era: The Development of Jazz, 1930–1945* (1989).

Obituary: New York Times, 20 Nov. 1994.

STEVEN J. NIVEN

CALVIN, Floyd (Joseph)

(13 July 1902–1 Sept. 1939), journalist, radio broadcaster, and founder of Calvin's News Service, was born in Washington, Arkansas, to Joseph Edward and Hattie Ann (Mitchell). Calvin attended the Rural School in Clow, Arkansas, until the seventh grade. From 1916 to 1920 he attended Shover State Teacher Training College in Arkansas, and from 1920 to 1921 he was enrolled at Townsend Harris Hall, City College in New York City.

In 1922, shortly after leaving City College, Calvin was hired by the labor activist A. PHILIP RANDOLPH as the associate editor of *The Messenger* magazine. *The Messenger*—the third most popular magazine of the Harlem Renaissance, after *The Crisis* and *Opportunity*—had been founded in 1917 by Randolph and the economist CHANDLER OWEN to advance the cause of socialism to the black masses. They believed that a socialist society was the only one that would be free from racism. *The Messenger* contained poetry, stories, and essays from the finest writers of the day, including Calvin himself, PAUL ROBESON, ZORA NEALE HURSTON, WALLACE THURMAN, and DOROTHY WEST. Meanwhile in 1923 Calvin married Willa Lee Johnson, and the couple had three children. Willa Lee was born in Mineral Springs, Arkansas, and graduated from Lane College in Jackson, Tennessee, and immediately embarked on a teaching career. Willa Lee relocated north when she married Floyd Calvin and took over Calvin's News Service at Calvin's death.

While working for *The Messenger* in 1923, Calvin wrote an investigative series about conditions in the Jim Crow South called "Eight Weeks in Dixie." In the final installment of the series, an article titled "The Present South," Calvin examined the reverberations of the lynching of a young black man in Hope, Arkansas—from the immediate consequences of the killing to the ongoing flight of young people like Calvin to the industrial cities of the North to the more pernicious effect: the black community's general unease over threats to their property and their lives. Deeply moved by eyewitness testimonies, Calvin wrote: "On July 27th John West, Negro, was taken from the streets of Hope and lynched. I did not see it. I saw its effects" (Calvin, Floyd J. "The Present South," *Messenger*, 5 Jan. 1923).

In 1924 Calvin began work as the eastern district managing editor for the *Pittsburgh Courier*, based in New York, the most widely circulated African American newspaper of the time. Calvin was known for his progressive stance on social issues, and he openly disagreed with one of the *Pittsburgh Courier*'s most notable and controversial writers, GEORGE SAMUEL SCHUYLER. Whereas Schuyler believed that African Americans should reject "race consciousness" in favor of complete "Americanization," Calvin, while neither for nor against amalgamation, did not see the need and desire of the African American population to assimilate into the larger society as necessarily anathema to race consciousness. Later Calvin became the special features editor for the *Courier*, a position he held until 1935. In that position Calvin chronicled the experiences of successful African American men and women. Calvin traveled more than ten thousand miles, visiting every state in the South and Southwest, gathering information, doing extensive research, and conducting revealing interviews,

material which eventually became the basis of many of his human interest and feature stories. Some of the outstanding articles were those featuring the role of African American individuals in educational institutions, as bankers, educators, social workers, and insurance agents. At a time in American journalism when blacks were largely portrayed negatively in the mainstream press, Calvin's profiles, essays, and editorials served as a balancing, more realistic representation of African American life.

On 2 October 1927 Calvin made history when he debuted as a host of the first radio show to focus on black journalism. Broadcast on New York's WGBS, it was sponsored by the *Pittsburgh Courier*. Calvin's "Some Notable Colored Men" featured Calvin reading the names of one hundred African American men of distinction. On 26 November 1927 Calvin editorialized on the radio about the role of "Negro Journalism" in the American press. He used his platform on the radio to report on the happenings and evolution within the African American arts community. In fact, when the *Pittsburgh Courier Hour* was terminated at WGBS and subsequently picked up by its competition, WCGU, Floyd's first broadcast on the new station was on the subject of "The Negro in Art" in connection with an exhibit of fine arts by black artists at the International House on Riverside Drive.

The year 1935 proved to be another pivotal year in Calvin's career. He started Calvin's News Service, used by African American weeklies, which numbered 150 by the time of Calvin's death. Calvin's News Service offered recipes, features, and opinions, in addition to news of particular interest to the African American community.

Floyd J. Calvin died at the Medical Center in New York City after a brief, undisclosed illness. He was just thirty-seven years old. At the time of his death Calvin was a member of Churches of the Living God Church, an Elk, and a registered Republican.

FURTHER READING

Boris, Joseph J. *Who's Who in Colored America, 1928–1929* (1929).
Sampson, Henry T. *Swin' on the Ether Waves: A Chronological History of African Americans in Radio and Television Programming, 1925–1955* (2005).
Smith, Jessie Carney. *Black Firsts: 4,000 Ground-Breaking and Pioneering Historical Events* (2003).

ROBYN MCGEE

CAMPBELL, Elmer Simms

(2 Jan. 1906–27 Jan. 1971), cartoonist, author, artist, and graphic illustrator, was born in St. Louis, Missouri, to Elmer Cary Campbell, a high school administrator, and Elizabeth Simms, a painter and homemaker. Campbell moved to Chicago to live with an aunt and to take advanced art classes at Elmwood High School. In 1923, while a student there, he won a national contest for an editorial cartoon about Armistice Day. After graduation, Campbell attended the Lewis Institute and the University of Chicago, where he worked at *The Phoenix*, a humor magazine. He also worked as a post office messenger and railroad car waiter. Campbell was accepted to the School of the Art Institute of Chicago and completed three years of study there before returning to St. Louis to work briefly at Triad Studios, a commercial art studio. He then moved to Harlem to live with an aunt and attend the Art Students League, where he studied printmaking with George Grosz. He took classes at the Academy of Design, did freelance gag writing in which he scripted punch lines for cartoons, and sold his own cartoons to make a modest living.

Campbell's work on *The Phoenix* led to interviews with editors associated with his Chicago coworker Ed Graham, who had since become a well-known cartoonist. E. Simms Campbell, as he was then known, entered the commercial art world in his twenties as a cartoonist and artist for *The New Yorker* and the National Association for the Advancement of Colored People's magazine *The Crisis*. He later sold cover art to *Life* and *Judge* magazines and wrote gag strips for the *Saturday Evening Post*.

Campbell rented an apartment at the prestigious Dunbar Building on Seventh Avenue in New York, where bandleader CAB CALLOWAY and musician DUKE ELLINGTON were among his fellow lodgers. Campbell and Calloway frequented the Cotton Club, one of the hot spots in Harlem, and became fast friends. Campbell's frequent socializing did not affect his work life: he worked hard, turning out three hundred to five hundred pieces of art each year at the height of his career. His watercolor

illustrations of jazz musicians and nightlife, including a cultural map of Harlem, were inspired by his late nights out on the town.

Campbell authored art manuals in the 1930s and illustrated a children's book, *Popo and Fifina*, in 1932, featuring text by LANGSTON HUGHES. He illustrated a book of Haitian poetry by Binga Dismond titled *We Who Die & Other Poems* (1943). Campbell was married in 1936 to Constance; when she died in 1940, he married her younger sister Vivian. Vivian and Elmer's child, Elizabeth Ann, married noted photographer and filmmaker Gordon Parks.

The artist Russell Patterson introduced Campbell to Arnold Gingrich, editor of *Esquire* magazine from 1933 to 1946. Patterson encouraged Campbell to incorporate women into his cartoons, and Campbell's *Cuties* cartoon for *Esquire* became his best-known work and the first syndicated feature drawn by a black artist. His work for *Esquire* also made him the first African American artist hired by a national magazine. The harem girl drawings in *Cuties* first appeared in autumn 1933 in the premiere issue of *Esquire*. Gingrich credited Campbell with the success of the publication, since each issue featured as least one piece by Campbell. When he was not submitting full-page original work, Campbell roughed out illustrations for other staff artists and submitted punch lines, or "gag lines," for cartoons for other members of the staff. The scantily clad *Cuties* were so popular that Avon books published the collected cartoons in paperbacks for sale to military troops abroad during World War II. The twenty-five-cent *Cuties* volumes featured the women making comments about men, life, fashion, and clothing. King Features Syndicate represented the *Cuties* cartoons until the late 1960s. Campbell was also credited with the creation of the *Esquire* mascot. Sculptor Sam Berman was given a Campbell sketch of Esky, a pop-eyed, mustachioed character, and Berman constructed a three-dimensional ceramic Esky figure that would be used on every cover of the magazine.

When *Esquire* moved from watercolor illustrations to photography around 1957, Campbell was hired to create original art for the new magazine *Playboy*. *Phantom Island*, a Campbell-drawn cartoon, had a long run for King Features. Campbell's commercial artwork was used in advertisements for Springmaid, Hart Schaffner and Marx, and Barbasol. His distinctive signature appeared in the lower portion of each piece of commercial art.

The irony of Campbell making a successful living drawing white women in lingerie at a time when southern state laws mandated jail terms for blacks whistling at white women was not lost on Campbell. He wrote articles about racism (and also music) for *Esquire*.

Cartoons from the turn of the century through the 1920s typically showed black figures in what was termed "cue ball" style, because the human figures lacked shadowing or detail work. Human heads were drawn as solid-colored circles with the eyes, ears, and lips attached. This unnatural characterization was transformed by the group of cartoonists that included Campbell. Black cartoon characters depicted in illustrations were shown with shading and highlighting that depicted more natural looking facial colorings and features.

Campbell worked for more than forty years as one of the most successful illustrators and cartoonists in the industry. After returning to the United States from Switzerland following an absence of nearly 14 years, he died of cancer in 1971 (his wife, Vivian, had also died of cancer the previous year). Campbell's funeral was held in the White Plains Community Unitarian Church, in the same community where in 1938 he had lost a legal challenge to purchase a home because of segregationist legal restrictions. By 2000, more than one hundred black cartoonists worked in editorial and panel cartooning as a result of the pioneer work of artists such as E. Simms Campbell.

FURTHER READING

Calloway, Cab, with Bryant Rollins. *Of Minnie the Moocher & Me* (1976).

Driskell, David. *Two Centuries of Black American Art* (1976).

Lewis, David Levering. *When Harlem Was in Vogue* (1982).

Stromberg, Fredrik. *Black Images in the Comics: A Visual History* (2003).

PORTER, JAMES A. *Modern Negro Art* (1969).

Powell, Richard J. *Impressions/Expression: Black American Graphics* (1980).

"Country Gentleman," *Ebony* (Aug. 1947).

Obituary: New York Times, 29 Jan. 1971.

PAMELA LEE GRAY

CARTER, Elmer Anderson

(1890–16 Jan. 1973), writer and editor, was born in 1890; his parents' names and his birthplace are now unknown. Little is known of his early life and education. He married Thelma Johnson, with whom he had one daughter. Carter and his wife lived in New York City at the same address, 409 Edgecombe Avenue, from the 1940s until their deaths.

A devoted New Yorker, Carter was a prolific writer and speaker for civil rights, especially concerning jobs, housing, and public office. A committed member of the National Urban League, on 23 July 1928 he delivered a speech on employment and fair housing issues during Negro Week on the Common. In September of that year he took over the editorship of *Opportunity: Journal of Negro Life*, the Urban League's in-house magazine, when CHARLES SPURGEON JOHNSON stepped down as editor. With more than 10,000 subscribers when Carter took over, the magazine published monthly until he left in 1945, when it turned quarterly; it ceased publication in the winter of 1949. Johnson and then Carter made sure the magazine contributed to black literature while also offering insightful articles on social and political issues of importance to all people but especially to African Americans. To this end, many African American artists and writers showcased their talents in the magazine. Carter's editorial influence helped bring more scholarly articles and social information that was not available or was simply overlooked in popular newspapers and magazines of the early 1900s. Carter also wrote for the magazine and other publications.

In June 1932 Carter's article "Eugenics for the Negro," published in *Birth Control Review*, proved to be an important piece on a controversial subject. At the time many writers argued that it might be better for African Americans to refrain from having children in poor communities that did not provide many opportunities for the offspring.

In 1942 his article "Shadows of the Slave Tradition" for *Survey Graphic* explored the legacies of black heritage and what it meant for New York's and the country's future. For Carter, the way to expose prejudice was through sharp writing, and the best path for fighting it lay in political and legal action. Carter's later writings were more overtly political, such as "Fighting Prejudice with Law" in the *Journal of Educational Sociology* (Jan. 1946) and "Practical Considering of Anti-Discrimination Legislation: Experiences under the New York Law

Elmer Anderson Carter, 1941. Elmer Carter (left) presents the Spingarn Award to the author Richard Wright. (Library of Congress.)

against Discrimination" in the *Cornell Law Quarterly* (Fall 1954). He also wrote a book about the National Urban League in New York.

Carter was not just a writer and speaker but also an important political figure in New York from the 1930s to the 1960s. Partway into Carter's career as an editor at *Opportunity*, New York governor Herbert Lehman appointed him to the three-person Unemployment Insurance Appeal Board with a term of six years. This appointment began Carter's public career as a lifelong political ally for African Americans who were unfairly treated at work and were denied proper housing. After leaving the magazine in 1945, Carter became the first director of the New York State Commission against Discrimination. When the group reorganized to become the State Division of Human Rights, he was its first director. He resigned in 1961, leaving the group to other leaders. For the next two years he served as special assistant on race relations for Governor Nelson A. Rockefeller. He died in 1973.

FURTHER READING

Johnson, Abby Arthur, and Ronald Maberry Johnson. *Propaganda and Aesthetics: The Literary Politics of*

Afro-American Magazines in the Twentieth Century (1979).

Johnson, Charles S. "The Rise of the Negro Magazine," *Journal of Negro History* 13 (1928).

Nelson, Cary. *Repression and Recovery: Modern American Poetry and the Politics of Cultural Memory, 1910–1945* (1989).

Obituary: New York Times, 19 Jan. 1973.

CHRISTINE G. BROWN

CARTER, Eunice Hunton

(16 July 1899–25 Jan. 1970), attorney, was born in Atlanta, Georgia, the daughter of the Canadian-born William Alphaeus Hunton, an executive with the Young Men's Christian Association (YMCA), and Addie Waites Hunton, a field worker with the Young Women's Christian Association (YWCA) in Europe. Carter's parents had three other children, but only Carter and her younger brother lived to adulthood. After the race riots of 1906, Carter's family left Atlanta for Brooklyn, New York, where Carter attended public schools. When her mother went to Strasbourg, which was at that time in Germany, to study at Kaiser Wilhelm University from 1909 to 1910, Carter accompanied her.

Carter attended Smith College in 1917, graduating cum laude with a BA and an MA in 1921. Her master's thesis was titled "Reform of State Government with Special Attention to the State of Massachusetts." Following in her parents' footsteps, Carter went into public service. For eleven years she was employed as a social worker with family service agencies in New York and New Jersey. In 1924 she married Lisle Carter, a Barbados native and dentist who practiced in New Jersey. The couple had one child.

Eunice Carter took occasional classes at Columbia University, finally committing herself to night classes at the Fordham University School of Law, where she completed her LLB in 1932. She was admitted to the New York Bar Association in 1934. That same year she made an unsuccessful bid for a seat in the New York state assembly. Between 1935 and 1945 she belonged to the National Association of Women Lawyers, the National Lawyers Guild, the New York Women's Bar Association, and the Harlem Lawyers Association. She served as secretary of the Committee on Conditions in Harlem after the riots there in the spring of 1935.

An Episcopalian and a Republican, Carter began a private practice after law school and also started her active career in social organizations. In August 1940 an *Ebony* article listed Carter as one of seventy known Negro women who had become lawyers since 1869 ("Lady Lawyers," 18). Carter remained in private practice only briefly before William C. Dodge hired her to be a prosecutor for New York City magistrate and criminal courts. As a prosecutor, Carter tried many cases against prostitutes, most of which she did not win. Because the same bail bondsman and lawyer represented these women, Carter suspected that a larger organization was controlling prostitution. She told her boss, who dismissed her suspicions. However, Thomas Dewey, a special prosecutor investigating organized crime, took her suspicions seriously and eventually hired Carter as an assistant district attorney. She became part of a team that Dewey organized to investigate rackets and organized crime, particularly as it involved "Dutch" Schultz (Arthur Flegenheimer). She is also acknowledged for developing valuable evidence in the case against "Lucky" Luciano. Because of Carter's skills, in 1941 Dewey named her head of a Special Sessions Bureau overseeing juvenile justice. Eventually supervising more than 14,000 criminal cases per year, Carter served as a trial prosecutor until 1945.

Carter then returned to private practice and greater involvement in civic and social organizations and the movement for equal rights for women. She was a charter member, chairperson, trustee, and member of the Executive Board of the National Council of Negro Women (NCNW), founded in 1935 by MARY MCLEOD BETHUNE and twenty other women. Carter was also a member of the Roosevelt House League of Hunter College, and was active in the National Board of the YWCA (1949), the YWCA's administrative committee for its Foreign Divisions, the Panel on Women in Occupied Areas under Communism, and the Association of University Women. In 1945, as the chair of the NCNW's committee of laws, Carter, with her close associate Mary McLeod Bethune, attended a San Francisco conference that organized the United Nations. She was also very active in the local YWCAs of Harlem and Manhattan. Carter served as the secretary of the American Section of the Liaison Committee of International Organizations and the Conference on the Group of U.S. National Organizations; as a consultant to the Economic and Social Council

Eunice Hunton Carter who in 1936 became the first black woman to be named a New York district attorney. (Archival Research International/Double Delta Industries Inc. and Pike Military Research.)

for the International Council of Women (1947); as the chairperson of the Friends of the NAACP; as the vice president of the Eastern Division of the Pan-Pacific Women's Association and the National Council of Women of the U.S. (1964); and as the co-chair of the YWCA's Committee on Development of Leadership in Other Countries. In 1954 Carter visited Germany to serve as an adviser to the German government on women in public life. In 1955 she was elected to chair the International Conference of Non-Governmental Organizations of the United Nations. She was also a trustee of the Museum of the City of New York and a member of the Urban League. Carter retired from law in 1952. She died in New York City.

FURTHER READING

The following collections contain information on Carter: a vertical file on Carter in the Woodruff Library of the Atlanta University Center; the National Council of Negro Women papers at the National Archives for Black Women's History in Washington, D.C.; and the Eunice Carter portrait collection in the New York Public Library Research Library.

Berger Morello, Karen. *The Invisible Bar. The Woman Lawyer in America, 1638 to the Present* (1986).

Obituaries: New York Times, 26 Jan. 1970; *New York Amsterdam News*, 31 Jan. 1970; *Jet*, 12 Feb. 1970.

FAYE A. CHADWELL

CARVER, George Washington

(c. 1864–5 Jan. 1943), scientist and educator, was born in Diamond (formerly Diamond Grove), Missouri, the son of Mary Carver, who was the slave of Moses and Susan Carver. His father was said to have been a slave on a neighboring farm who was accidentally killed before Carver's birth. Slave raiders allegedly kidnapped his mother and older

sister while he was very young, and he and his older brother were raised by the Carvers on their small farm.

Barred from the local school because of his color, Carver was sent to nearby Neosho in the mid-1870s to enter school. Having been privately tutored earlier, he soon learned that his teacher knew little more than he did, so he caught a ride with a family moving to Fort Scott, Kansas. Until 1890 Carver roamed around Kansas, Missouri, and Iowa seeking an education while supporting himself doing laundry, cooking, and homesteading.

In 1890 Carver entered Simpson College in Indianola, Iowa, as a preparatory student and art major. Convinced by his teacher that there was little future in art for a black man, he transferred the next year to Iowa State, where he was again the only African American student. By the time he received his master's degree in Agriculture in 1896, Carver had won the respect and love of both faculty and students. He participated in many campus activities while compiling an impressive academic record. He was employed as a botany assistant and put in charge of the greenhouse. He also taught freshmen.

The faculty regarded Carver as outstanding in mycology (the study of fungi) and in cross-fertilization. Had he not felt obligated to share his knowledge with other African Americans, he probably would have remained at Iowa State and made significant contributions in one or both of those fields. Aware of deteriorating race relations in the year of *Plessy v. Ferguson* (1896), he instead accepted BOOKER T. WASHINGTON's offer in 1896 to head the agricultural department at Tuskegee Normal and Industrial Institute in Macon County, Alabama. Carver brought both his knowledge and professional contacts to Tuskegee. Two of his former teachers, James Wilson and Henry C. Wallace, became U.S. secretaries of agriculture, as did Wallace's son, Henry A. Wallace. All three granted Department of Agriculture aid to Tuskegee and provided access to such presidents as Theodore Roosevelt and Franklin D. Roosevelt.

Carver's strong will led to conflicts with the equally strong-willed Washington over Carver's incompetence at administration. His contacts and flair for teaching and research protected Carver from dismissal. In both his teaching and his research, his primary goal was to alleviate the crushing cycle of debt and poverty suffered by many black farmers who were trapped in sharecropping and cotton dependency. As director of the only all-black agricultural experiment station, he practiced what was later called "appropriate technology," seeking to exploit available and renewable resources. In the classroom, in such outreach programs as farmers' institutes, a wagon equipped as a mobile school, and in agricultural bulletins, Carver taught how to improve soil fertility without commercial fertilizer, how to make paints from native clays, and how to grow crops that would replace purchased commodities. He especially advocated peanuts as an inexpensive source of protein and published several bulletins containing peanut recipes.

Carver never married, but he came to regard the Tuskegee students as his "adopted family." He was a mentor to many, providing financial aid and personal guidance. Devoutly religious in his own way, he taught a voluntary Bible class on campus.

At the time of Washington's death in 1915, Carver was respected by agricultural researchers but was largely unknown to the general public. Long in the shadow of Washington, Carver became the heir to the principal's fame after being praised by Theodore Roosevelt at the funeral. In 1916 he was inducted into the Royal Society for the Arts in London. Then the peanut industry recognized his usefulness. In 1921 a growers' association paid his way to Washington, D.C., so that he could testify at congressional tariff hearings, where his showmanship in displaying peanut products garnered national publicity. In 1923 Atlanta businessmen founded the Carver Products Company, and Carver won the Spingarn Medal of the National Association for the Advancement of Colored People. The company failed but obtained one patent and much publicity. In 1933, for example, an Associated Press release overstated Carver's success in helping polio patients with peanut oil massages. Carver became one of the best-known African Americans of his era.

His rise from slavery and some personal eccentricities—such as wearing an old coat with a flower in the lapel and wandering the woods at dawn to commune with his "Creator"—appealed to a wide public. Advocates of racial equality, a religious approach to science, the "American dream," and even segregation appropriated Carver as a symbol of their varied causes. Carver made some quiet, personal stands against segregation, but he never made public statements on any racial or political issues. Thus his name could be used for contradictory goals. He relished the publicity and did little

to correct the exaggerations of his work, aside from humble protestations regarding his "unworthiness" of the honors that came in increasing numbers.

Though some of this mythology was unfortunate, Carver served as a role model to African Americans and as a potent force promoting racial tolerance among young whites. The Commission on Interracial Cooperation and the Young Men's Christian Association sent him on lecture tours of white campuses in the 1920s and 1930s. On these occasions Carver converted many who heard his lectures to the cause of racial justice. To them Carver was no "token black" but a personal friend and confidant. Indeed, many people who met Carver, Henry Ford among them, were made to feel they were "special friends."

Carver never earned more than $1,200 a year and refused compensation from peanut producers. Nevertheless he was able to accumulate almost $60,000 because he lived in a student dormitory and spent very little money. In 1940 he used his savings to establish the George Washington Carver Foundation to support scientific research—a legacy that continues at Tuskegee University. He died three years later in Tuskegee. Although his scientific contributions were meager relative to his fame, Carver did help hundreds of landless farmers improve the quality of their lives. And his magnetic personality and capacity for friendship inspired and enriched countless individuals.

FURTHER READING

Most of Carver's papers are at the Tuskegee University Archives in Alabama.

Holt, Rackham. *George Washington Carver: An American Biography* (1943; rev. ed., 1963).

Kremer, Gary R. *George Washington Carver in His Own Words* (1987).

McMurry, Linda O. *George Washington Carver: Scientist and Symbol* (1981).

LINDA O. MCMURRY

CATLETT, Elizabeth

(15 Apr. 1915–), sculptor, printmaker, and teacher, was born Alice Elizabeth Catlett to Mary Carson, a truant officer, and John Catlett, a math teacher and amateur musician who died shortly before Elizabeth's birth. Elizabeth and her two older siblings were raised by their mother and paternal grandmother in a middle-class neighborhood of Washington, D.C. Encouraged by her mother and her

teachers at Dunbar High School to pursue a career as an artist, she entered Howard University in 1931, where she studied with the African American artists JAMES LESESNE WELLS, LOÏS MAILOU JONES, and JAMES A. PORTER. After graduating cum laude with a BS in Art in 1935, Catlett taught art in the Durham, North Carolina, public schools before beginning graduate training at the University of Iowa in 1938. Under the tutelage of the artist Grant Wood, Catlett switched her concentration from painting to sculpture and undertook the study of African and pre-Columbian art. From Wood, Catlett gained a respect for disciplined technique, and when he encouraged her to depict subjects derived from her own experience, she focused on African American women and the bond between mother and child, themes that would occupy her for a lifetime. Catlett received the University of Iowa's first MFA in 1940, and the following year *Mother and Child* (1940, limestone), a component of her thesis project, won first prize in sculpture at the American Negro Exposition in Chicago.

After a summer teaching at Prairie View College in Texas, Catlett was hired as head of the art department at Dillard University in New Orleans in 1940. The following summer, while in Chicago studying ceramics at the Art Institute of Chicago and lithography at the Southside Community Art Center, Catlett met the artist Charles White. The couple married later that year and eventually settled in Harlem, New York, in 1942, where they thrived as part of the area's African American creative community. Catlett continued her studies at the Art Students League and with sculptor Ossip Zadkine. She taught at the Marxist-based Jefferson School, and sat on the arts committee of one of the largest Popular Front organizations in Harlem. Catlett's job as promotional director of the George Washington Carver School, a community school for working people, brought her into contact with working-class and poor people for the first time. As her politics crystallized, so too did her commitment to depicting the reality and courage of working Americans and to producing work for African American audiences. In 1945 she was awarded a grant from the Rosenwald Fund to produce a series depicting black women. The renewal of the grant for the next year allowed for the completion of the innovative series *The Negro Woman*, fifteen linoleum cuts documenting the epic history of African American women's oppression, resistance, and survival. An integrated

narrative of text and prints, the series depicts the historic figures Sojourner Truth, Harriet Tubman, and Phillis Wheatley along with images of field hands, washerwomen, segregation, and lynching.

Fellowship funds also brought Catlett and White to Mexico in 1946, where in addition to finishing *The Negro Woman* series, Catlett hoped to resuscitate her failing marriage. Although the couple returned to New York and filed for divorce several months later, this first trip to Mexico proved pivotal for Catlett both professionally and personally. In early 1947 she returned to Mexico City, where she had befriended a circle of Mexican artists that included Diego Rivera, Frida Kahlo, and David Alfaro Siqueiros. Soon after, she made Mexico her permanent residence and joined the printmaking collective, Taller de Grafica Popular (TGP), or the People's Graphic Art Workshop, through which she had produced *The Negro Woman* series. The TGP supported progressive and nationalist causes through graphic materials that communicated directly with the primarily illiterate public. Attracted to the workshop's creatively collaborative environment and its engagement with audiences, Catlett made the TGP her artistic home for the next decade and remained a member until 1966. It was in 1947, as well, that Catlett met and married the Mexican artist Francisco Mora. Between 1947 and 1951, the couple had three children, Francisco, Juan, and David.

In Mexico Catlett found a vital environment for politically committed art, which had become less permissible in the United States by the late 1940s, especially after the establishment of the House Un-American Activities Committee in 1947. From her arrival in Mexico until the mid 1950s, Catlett focused on printmaking, primarily lithography and linoleum prints, inexpensive mediums that are easily reproduced. Topical and populated with both Mexican and African American families and workers, Catlett's print work during this period is graphically bold, combining elements of expressionism and Soviet social realism with a visual vocabulary drawn from Mexican and African sources.

When her youngest child entered kindergarten in 1956, Catlett returned to sculpture, although she continued to make prints. Shortly after her arrival in Mexico, Catlett had studied ceramic sculpture and pre-Columbian art with Francisco Zuniga and in the mid-1950s she studied woodcarving with Jose L. Ruiz. In 1958, Catlett became the first woman professor of sculpture at Mexico's National School of Fine Arts, and a year later she became head of the department, a position she held until her retirement in 1976.

Catlett had arrived in Mexico a highly educated and technically sophisticated artist with a developed style. In Mexico, her sculptures continued to feature simple and fluid forms with few embellishments and a reverence for materials. Whether in marble, onyx, bronze, terra cotta, or woods, her sculptures are concerned with volume and space. They convey a sense of monumentality even in small and medium-size pieces. The influence of Henry Moore, Jan Arp, and Constantin Brancusi can be seen in her smooth and highly polished surfaces and organic forms. But while they flirt with abstraction, her sculptures remain figurative. Representations of ethnicity and the female body, specifically images of motherhood and the body of the black woman, Catlett's pieces continually revisit themes and compositions of earlier works.

At the National Conference of Negro Artists in 1961, Catlett delivered a keynote address that called for politically engaged art: "We must search to find our place, as Negro artists, in the advance toward a richer fulfillment of life on a global basis. Neither the Negro artist nor American art can afford to take an isolated position" (*Fifty-Year Retrospective*, 20). The speech raised her profile within the art community but also increased pressure from the U.S. State Department, which identified her as an "undesirable alien." Catlett became a Mexican citizen in 1962 and found herself barred from the United States until 1971, when she was finally granted a visa to attend her first solo exhibition in the United States, held at the Studio Museum in Harlem. Beginning with her initial Mexican exhibition in 1962, there was steady demand for her work in both Mexican and American exhibitions, and after the Studio Museum exhibition, she regularly received solo shows, seventeen in the 1970s alone, mostly in the United States.

Through the Black Arts Movement and the women's movements of the 1960s and 1970s, Catlett renewed her interest in American politics and themes and, in turn, her work drew attention from intellectuals and curators in the United States. Her sculptural and print works from this period comment directly on topical issues, including the imprisonment of Angela Davis in

Freedom for Angela Davis (1969, serigraph) and race riots in *Watts/Detroit/Washington/Harlem/Newark* (1970, hand colored linocut). Catlett's support of black nationalism can be seen in such works as *Homage to My Young Black Sisters* (1968, cedar), *Malcolm X Speaks for Us* (1969, color linocut), *The Torture of Mothers* (1970, color lithograph), *Negro es Bello* (1968, lithograph), which includes renderings of Black Panther buttons, *Homage to Black Women Poets* (1984, mahogany), *Black Unity* (1968, mahogany), represented by a clenched fist on one side and a pair of faces on the other, and *Target* (1970, bronze), a bust of a black man as seen through the cross-hairs of a gun sight. Catlett's commitment to the Black Arts Movement included exhibiting at black institutions where her work would be seen by African American audiences.

Upon her retirement from teaching in 1976, Catlett and Mora, who died in February 2002, moved to Cuernavaca, Mexico. In 1982 she took a second apartment in New York and began spending more time teaching and lecturing in the United States. Catlett continued to produce work through the 1980s, 1990s, and into the new century. Her work has been included in every major exhibition of black artists from the 1960s to the present, and she has received numerous exhibitions, awards, and commissions in Mexico, the United States, and Europe. Called the "dean of black American female artists" by the *New York Times*, Catlett has received six honorary doctorates and honors from a host of institutions, including the cities of Atlanta, Cleveland, Little Rock, Philadelphia, Dallas, and Washington, D.C., the Philadelphia Museum of Art, and the National Council of Negro Women. In September 2002, the Cleveland Museum of Art mounted *Elizabeth Catlett: Prints and Sculpture*, a major exhibition spanning the artist's sixty-year career.

FURTHER READING

Catlett's papers are held at the Amistad Research Center, Tulane University, New Orleans.

Hampton University Museum. *Elizabeth Catlett, Works on Paper, 1944–1992* (1993).

Herzog, Melanie. *Elizabeth Catlett: An American Artist in Mexico* (2000).

Lewis, Samella. *The Art of Elizabeth Catlett* (1984).

Neuberger Museum of Art. *Elizabeth Catlett Sculpture: A Fifty-Year Retrospective* (1998).

LISA E. RIVO

CATO, Minto

(23 Aug. 1900–26 Oct. 1979), mezzo-soprano, was born La Minto Cato in Little Rock, Arkansas. She attributed her unusual first name to a grandmother of French extraction. Her father, Roy Cato, was the son of a Native American father. There appears to be no connection between this Minto Cato and the English actor (1887–1960) who went by the same name. Although her immediate family included no professional musicians, an aunt sang and played piano. Cato attended the Washington Conservatory of Music following her studies at Armstrong High School. While still in her teens, she taught piano in the public schools of Monticello, Arkansas, and Athens, Georgia. In 1919 she established a music studio in Detroit, where her parents settled permanently in 1930.

Cato entered show business at Detroit's Temple Theater in 1922 with the B. F. Keith vaudeville circuit. For most of the 1920s she worked steadily with impresario Joe Sheftell, whom she married around 1923. Their daughter, Minto Cato Sheftell, was born around 1924. In 1922 Sheftell's shows were called the *Creole Bronze Revue* and played primarily in the northeastern United States. Later in the 1920s Sheftell's tours as "Joe Sheftell and His Black Dots," then as the *Southland Revue*, took the couple all over the world. In one tour ending in 1927 Cato and Sheftell were in Hawaii, Samoa, Fiji, Australia, and New Zealand, returning home by way of Alaska, Canada, and Mexico. Their work also took them throughout Europe, and to Palestine. Cato appeared in New York throughout the 1920s, including at the Cotton Club in 1924 and later in the show *Hot Chocolates* at Connie's Inn. When Cato appeared with the Whitman Sisters traveling show in Pittsburgh in October 1927, she and Sheftell had apparently separated. As of late January 1929 she had left the Whitmans and returned to her home in Harlem. In the spring of that year she worked as a solo act at Chicago's Regal Theater, accompanying herself at the piano. Cato was also an impresario in this period, with such shows as the *Frivolities of 1928*. At her peak as a vaudeville producer, she had a sixteen-person "flash act," working the Keith's, Loew's, Fox, and Pantages theater circuits, and also the Tivoli circuit in Australia, New Zealand, and Hawaii.

A trained classical singer, Cato found her greatest success performing show music. The high point of her work in this area came in 1929–1930, with

producer Lew Leslie's *Blackbirds* shows. In the first edition, in the fall of 1929, her costars included LOUIS ARMSTRONG; she would appear with him again in 1931. In *Blackbirds of 1930* she premiered EUBIE BLAKE and ANDY RAZAF's "Memories of You," one of the great ballads of the jazz age. Her roles in such productions (as Mammy Jones and Aunt Jemima) perpetuated stereotypes of African Americans, holdovers from the minstrelsy still typical at the time. Cato's personal life was deeply affected by her work in *Blackbirds*. She took as a lover the show's lyricist, Andy Razaf, one of the great writers of the Harlem Renaissance and a prolific hitmaker. The two cohabited for several years in the early 1930s, although Razaf was married to someone else. A number of Razaf's associates assumed that he and Cato were married.

In 1930 Cato appeared at the San Jose, a Spanish-language club in East Harlem, performing the song "The Peanut Vendor" in a West Indian version. Her career in show business took her to summer resorts as well, including the Paradise in Atlantic City during 1930 and 1931. Among the songs that she used successfully, both in the United States and abroad, were W. C. HANDY's "St. Louis Blues," FATS WALLER's "Honeysuckle Rose," and Jack Yellen and Lew Pollack's "My Yiddishe Momme," which was used by a great many non-Jewish entertainers. Her talents ranged beyond music as well, and in the summer of 1937 she managed a resort kitchen in Saratoga Springs, New York.

Cato's breakthrough in opera came in May 1936, when she sang the role of Azucena in a production of *Il Trovatore* sponsored by the Federal Music Project. Cato also staged and directed this performance, which featured her students from the Harlem Music Center, and the Knickerbocker Little Symphony. The singers, aged sixteen to thirty, included high school and college students, and also laborers, office workers, and domestics. Many of the sixty-one singers could not read music, and Cato taught them their parts by singing them and also wrote their Italian lyrics out on paper. Her conductor for *Trovatore* was Luigi Lovreglio.

Cato sang *Aida* with New York's Hippodrome Opera Company in April 1937 under the baton of Alfredo Salmaggi. The following summer she sang Queenie in *Show Boat* and Liza in *Gentlemen Unafraid*, both with music by Jerome Kern, with the Municipal Opera Society of St. Louis. In 1944 she was featured in a fundraiser for the National Negro

Opera Company at New York's Town Hall. She performed *Aida* again in July 1944, this time in a summer season, put on by the National Negro Opera Company in Washington, D.C., that also included *Faust* and *La Traviata*. In July 1945 she appeared in a Washington fundraiser for the National Council of Negro Women. Among her last major operatic roles was in *La Traviata* with the National Negro Opera Company in 1947.

In the fall of 1944 the African American press announced that Cato was abandoning opera for show business. In the summer of 1945 she again won acclaim as Queenie in *Show Boat*, this time in Detroit. While there she performed for wounded war veterans, thus beginning a new phase in her career. Beginning late in 1945 Cato worked the American Red Cross circuit in Europe with a vocal trio. Following the breakup of this group, Cato continued as a solo act, accompanying herself on the piano. These tours took her to England, Belgium, France, and Germany, and she spent much of her time in Europe into the early 1950s. In England she appeared on BBC radio and early television, on such shows as *Starlight* and the *Variety Band Box Programme*. Her French tours took her to the resort towns of Cherbourg, Nice, and Cannes as well as the major cities. In Paris she appeared on radio, at the world-famous Hot Club, and at such top venues as the Salle Pleyel and the Théâtre du Chatelet. While there she gave the Paris premiere of the new Irving Berlin musical *Annie Get Your Gun* (under the title *Annie du Far West*). She continued to find success in Belgium, the Netherlands, and Germany.

By the late 1940s Cato's American career had fallen dormant. The mainstream opera world remained closed to African Americans, only opening up later to younger singers such as Leontyne Price. And with the numerous changes in show business styles in the mid-twentieth century, Cato was out of fashion at home. There was possibly also a less innocent explanation for her career's decline. In 1953 Cato told the *Chicago Defender* that she was blacklisted for her past connections to left-wing causes. She had performed at such events as a 1938 fundraiser to buy milk for Spanish Civil War refugee children on the Republican side. Although this antifascist cause was aligned with a democratically elected government, participation in such activities would come back to haunt American entertainers during the McCarthy era of the

1950s. Cato was a target of the House Un-American Activities Committee during this period.

Cato was honored with an award by the Manhattan-Bronx Friends of the Symphony of the New World in 1972. In her later years she was primarily active with the National Association of Negro Musicians, and they held a memorial program in Cato's honor after her death in 1979. A Catholic, she was buried at the Gate of Heaven Cemetery in Hawthorne, New York. In addition to her daughter, her survivors included a brother, Marion Cato of Atlanta, Georgia.

FURTHER READING

Mintc Cato's papers are in the Schomburg Center for Research in Black Culture at the New York Public Library.

Singer, Barry. *Black and Blue: the Life of Andy Razaf* (1992).

Southern, Eileen. *Biographical Dictionary of Afro-American and African Musicians* (1981).

ELLIOTT HURWITT

CHESNUTT, Charles Waddell

(20 Jun. 1858–15 Nov. 1932), writer, was born in Cleveland, Ohio, the son of Andrew Jackson Chesnutt, a horse car driver, and Ann Maria Sampson. His parents were free African Americans who had left Fayetteville, North Carolina, in 1856 to escape the oppressiveness of life in a slave state and its sparse opportunity. They were married in Cleveland in 1857. During the Civil War, Chesnutt's father served four years as a teamster in the Union army, but the family returned to Fayetteville in 1866 because A. J. Chesnutt's father, Waddell Cade (a local white farm owner—the name Chesnutt came from A. J.'s mother, Ann), helped his son establish a grocery store there. Young Charles helped in the store and over the years heard many things there about southern life and folkways that he recorded or remembered and that later became part of or informed his writings. Charles attended the Howard School, which existed through the efforts of local black citizens and the Freedmen's Bureau, but after his father lost his store and moved to a nearby farm, Charles was forced at age fourteen to change his role in the school from that of eager pupil to pupil-teacher in order to help with family finances. He continued to read widely in various fields, especially in literature, thereby further educating himself.

Chesnutt began teaching in Charlotte, North Carolina, in 1872 and in the summers in other North and South Carolina communities. In the fall of 1877 he returned to Fayetteville to work in the new state normal school there. The following summer he married one of the school's teachers, Susan U. Perry, and the first of their four children was born the following spring. Though Chesnutt became principal of the normal school at age twenty-two and continued to study various subjects regularly, he felt restricted in opportunities and intellectually isolated in the post–Civil War South. In 1883 he used his self-taught ability to take shorthand at two hundred words per minute to escape, first to New York for a few months and then to Cleveland, where he was joined by his family in April 1884. He lived there the rest of his life.

In Cleveland, Chesnutt worked as an office clerk and court reporter, passed the Ohio bar exam in 1887 (with the highest grade in his group), and established a prosperous legal stenography firm, eventually after several moves acquiring a fourteen-room home. More importantly, he worked at becoming a writer. He had been moving in that direction for

Charles W. Chesnutt published The Colonel's Dream in 1905. (University of North Carolina.)

some time, and in 1872 a local weekly Negro newspaper had published his condemnation of the reading of dime novels. The growth of his interest in literature and his ambition to become a writer are reflected in numerous entries in his journals during the 1870s and 1880s, especially as he became more and more aware of what had been written and was being written about the South and black people, subjects about which he felt confident of his own better knowledge and understanding. His journal entry for 29 May 1880 spoke of a purpose for his intended writing that would improve the South and all of its people. It included the declaration, "I think I must write a book." However, before he would accomplish that goal there were to be years of sketches, tales, and stories, beginning in 1885 published in various periodicals, including eventually such widely known magazines as *Family Fiction, Puck, Overland Monthly, The Crisis, Southern Workman, Century, The Outlook, Youth's Companion*, and various newspapers in some of the nation's larger cities.

Chesnutt's most important breakthrough came with the publication of his tale "The Goophered Grapevine" in the *Atlantic Monthly* for August 1887. Although the editors did not then know the author's race, this was the first piece of short fiction published by an African American in a magazine with such prestige as to easily put the work before the majority of American readers. Chesnutt would publish short fiction and articles (both usually concerning racial matters) for much of the rest of his life, but very much tapering off after the early part of the twentieth century.

"The Goophered Grapevine" was the first of three of his stories in the *Atlantic Monthly* that focused on conjuring as an important aspect of black folklife. This is revealed in post–Civil War tales about earlier times in the Fayetteville area told by Uncle Julius, a shrewd and likable character who uses the stories to his own advantage and along the way also reveals much about what slavery meant in the daily concerns of its victims, of which he had been one. These three tales and four other Uncle Julius tales became Chesnutt's first book, *The Conjure Woman*, published by Houghton Mifflin (1899). In these stories Chesnutt broadened the range of racial realism in American literature, and all of his five volumes of fiction would deal with various facets of racial problems, with strong focusing on the experiences and points of view of his

African American characters, though his concerns were always for both blacks and whites in American society and particularly in the South.

The stories of his second book of fiction, *The Wife of His Youth and Other Stories of the Color Line*, also published by Houghton Mifflin (1899), are in most ways quite different from the conjure stories and illustrate the variety of Chesnutt's skill and art. They are more contemporary and less rural and folk oriented, with more focus (sometimes ironically) on middle-class African Americans, especially those with light skin color. About half of these stories are set in North Carolina, and about half in Ohio. As its title suggests, this book intended to demonstrate the complex difficulties and sensitivities of those who (like Chesnutt himself) were of obvious racially mixed blood in societies both north and south, in which they aspired to rise even in the face of uncertainties about how that would be viewed. Chesnutt had very light skin and few Negroid features. He wrote about respect and injustice from personal concern and experience. These stories are sometimes tragic and sometimes comic, as he tried to write from a balanced and whole view of racial phenomena he had observed at close hand. Various reviews called attention to Chesnutt's presentation of African American characters in other than stereotypes and his making them of real interest and concern as individual human beings. Notable among such reviews was high praise from William Dean Howells in the *Atlantic Monthly* for May 1900, which took note of both of Chesnutt's volumes of fiction and of his biography of Frederick Douglass (1899) in the Beacon Biographies Series. Howells also identified Chesnutt with various well-known contemporary writers of realistic fiction whom Howells championed.

On 30 September 1899 Chesnutt had closed his stenography business in order to pursue writing full time. In the autumn of 1900 Houghton Mifflin brought out *The House behind the Cedars*, the first of three novels Chesnutt would publish. It is a fuller and more straightforward exploration of some of the miscegenation themes that had been found in his second volume of stories. The primary setting of the novel is the Fayetteville area, and it focuses on the emotional and practical (and sometimes tragic) difficulties of relatively white African Americans who chose to pass as white in the post–Civil War South. Although Chesnutt himself chose not to pass even though he could have, he knew

those who had done so and understood and sympathized with their motives. Another novel, *The Marrow of Tradition*, followed from Houghton Mifflin in October 1901. This work, with his largest cast and most complicated plot, also is set in North Carolina. It is based on the riot that occurred in Wilmington in 1898 when white supremacists took over the city government with accompanying violence against blacks. In addition to having concerns with racial justice, as had his first novel, this book also has some focus on the aspirations of African Americans who choose to participate in the more highly respected professions. However, this work is even more interracial, its principal characters are white, and there is more direct criticism of the white population. While Howells praised the straightforwardness of the novel's moral concerns, he was disturbed by its bitterness. It did not sell well enough for Chesnutt to continue his attempt to succeed as a full-time author, and he reopened his stenography business before the year was over.

While disappointment and the need to gain financial stability slowed Chesnutt's literary aspirations, he did publish one more novel. Another North Carolinian, Walter Hines Page, while an editor at Houghton Mifflin had praised Chesnutt's accuracy of local color and had assisted his progress. Now Page persuaded Chesnutt to leave Houghton Mifflin, even though his relations with that firm had been good, and in September 1905 (the year in which Thomas Dixon's racially negative novel *The Clansman* was a best seller) Page's firm (Doubleday, Page & Company) brought out *The Colonel's Dream*. Its protagonist, a former Confederate officer, returns to his southeastern North Carolina hometown and proposes a plan to bring it out of the economic hardships caused by the Civil War and its aftermath. He is willing to invest his own resources, but the plan is rejected because of greed and racial prejudice in the community. Reflecting Chesnutt's continuing loving concern for the area where he had spent his formative years, this book is dedicated to "the great number of those who are seeking, in whatever manner or degree . . . to bring the forces of enlightenment to bear upon the vexed problems which harass the South."

However, the various-faceted message for the South (and the country as a whole) that pervades Chesnutt's fiction and nonfiction, particularly concerning economic and social justice in relation to race, was not being accepted by those for whom it

was most intended. He now turned his efforts more to other aspects of his life, among them his family, his business, and his involvement in several cultural organizations in Cleveland. One of these was the prestigious bibliophilic Rowfant Club, which refused membership to this nationally respected author three times before finally admitting him in 1910. His satiric "Baxter's Procrustes" (*Atlantic Monthly*, June 1904) is based on that club, and many think it is his best-written story. His career as a writer resulted in his publishing between 1885 and 1931 sixty-one pieces of short fiction (including those in the two volumes); one biography; thirty-one speeches, articles, and essays; seven poems; and three novels. Also, he left unpublished a sizable correspondence, one play, six novels, fifty-three essays and speeches, eighteen short stories (most of which have now been published by Render), three journals, and one notebook.

Chesnutt's published fiction, particularly his five books, was his most important accomplishment both artistically and in his attempts to improve social (particularly racial) relations. However, in addition to his fiction, his early work as an educator, his stenographic work in Cleveland, and his other writings, he also was active in various other pursuits that gave him pleasure, visibility, influence, reputation, and opportunity. He put his concerns, his knowledge of the law, and his respected reputation and personality to good use in speaking out on political and legal matters locally and nationally, particularly when they concerned the rights of African Americans. Early in his career as a writer he had made the acquaintance of George Washington Cable and through this association had joined in the efforts of the Open-Letter Club, a project of several persons interested in and knowledgeable about the South to provide accurate information about that region and racial matters. Chesnutt was an active member of the National Association for the Advancement of Colored People (NAACP) in Cleveland and nationally, and there was mutual respect between him and both BOOKER T. WASHINGTON and W. E. B. DU BOIS. Though these two leaders took somewhat different approaches to the problems of African Americans and how best to solve them, Chesnutt saw merit in some aspects of the positions of both men and said so publicly, but also spoke up when he disagreed with them. He was a member of the General Committee of the NAACP and of Washington's Committee of Twelve for the

Advancement of the Interests of the Negro Race. He addressed immediate socioeconomic problems and in various ways tried to promote awareness of and concern over the racial situation in America (particularly in the South—William Andrews has referred to his three novels as a New South trilogy). Chesnutt felt that the racial situation was undermining American democracy and that solutions to it would require sensitive understanding, ethical and moral conscience, and courage. In both his fiction and nonfiction his view of the proper future for African Americans was for gradual assimilation of them into the mainstream of American life through education and hard work. His three daughters and his one son all graduated from well-known colleges, and he lived to see them established in their chosen endeavors and moving into that mainstream, as he had in his way before them.

Though the major part of Chesnutt's literary career ended with the publication of *The Colonel's Dream* in 1905, respect for him as a pioneering writer continued. Among the recognition given him was an invitation to attend Mark Twain's seventieth birthday party at Delmonico's in New York in 1905 and membership in the National Arts Club in 1917. In 1913 Wilberforce University gave him an honorary degree, and in 1928 he was awarded the NAACP's prestigious Spingarn Medal for his "pioneer work as a literary artist depicting the life and struggle of Americans of Negro descent, and for his long and useful career as scholar, worker and freeman of one of America's greatest cities." That same year *The Conjure Woman* was republished by Houghton Mifflin in a special edition with a foreword by the literary critic and leader in racial concerns Joel Spingarn. In 1926 the committee to choose the first recipient of the newly established Harmon Foundation Award for the work of an African American writer during the preceding year recommended that the chronological stipulation be waived and the first award be given to Chesnutt to acknowledge his pioneering work and his continuing example to other African American writers. This was not allowed, and unfortunately Chesnutt never knew of this acknowledgment of high esteem from a distinguished panel of his literary peers both black and white.

Chesnutt was the first important African American writer whose primary genre was fiction and the first African American writer to be published primarily by major publishers and major periodicals.

Writing and publishing during times that were not very socially, politically, or legally favorable to African Americans in general, Chesnutt wrote fiction to provide entertainment and to call attention to racism and social injustice, especially for middle-class light-skinned blacks and working-class blacks in small towns and the rural South. He believed that the sources of as well as the solutions to their problems were in the South, so he wrote about the South and in ways that he intended to be more accurate, realistic, and better than those of others using similar subject matter. He purposefully dealt with topics regarding racial problems, such as miscegenation, which he felt other southern writers were avoiding or mistreating. In doing this he used various literary devices, including accurate dialect and details of local color and black life, satire, humor, irony, pathos, and even first-person point of view for nonblack characters. However, while he wrote with unblinking truth and obvious strong social purpose, he also wrote without rancor and with attention to and faithful portrayal of both sides of problems, creating a variety of memorable characters. He especially hoped to counter the too often derogatory and stereotypical portrayal of black characters and to make readers more aware of the positive and often complex humanity and variety of African Americans, the mistreatment of minorities and their need for greater social justice, and the fallibility of human nature.

Sylvia Render has pointed out that Chesnutt promoted American ideals in popular American forms and in accord with accepted contemporary literary standards, and was published by very reputable firms. However, after his death his works were generally underread and undervalued until attention to them revived in the 1960s. In his Spingarn Medal acceptance Chesnutt said, "I didn't write my stories as Negro propaganda—propaganda is apt to be deadly to art—but I used the better types [of Negroes], confident that the truth would prove the most valuable propaganda." A few months later he wrote to JAMES WELDON JOHNSON, "I wrote the truth as I saw it, with no special catering to anybody's prejudices." He died in Cleveland.

FURTHER READING
The most important sources for unpublished
 Chesnutt writings and related materials are the
 Chesnutt collection of the Cravath Library at Fisk
 University and the Chesnutt papers at the Library

of the Western Reserve Historical Society, Cleveland, Ohio.

Andrews, William L. *The Literary Career of Charles W. Chesnutt* (1980).

Chesnutt, Helen M. *Charles Waddell Chesnutt: Pioneer of the Color Line* (1952).

Ellison, Curtis W., and E. W. Metcalf Jr. *Charles W. Chesnutt: A Reference Guide* (1977).

Heermance, J. Noel. *Charles W. Chesnutt: America's First Great Black Novelist* (1974).

Keller, Frances Richardson. *An American Crusade: The Life of Charles Waddell Chesnutt* (1978).

Render, Sylvia Lyons. *Charles W. Chesnutt* (1980).

JULIAN MASON

CHRISTIAN, Marcus Bruce

(8 Mar. 1900–21 Nov. 1976), poet, historian, civil rights activist, college instructor, and small businessman, was born in Houma (Mechanicsville), Louisiana, to Emanuel Banks Christian and Rebecca Harris. Christian was born into a family of teachers; both his father and grandfather had taught in rural Louisiana. The latter was a former slave who served as a director of the Lafourche Parish public school system during Reconstruction. Christian's mother died when he was three, and his father, who had tutored him, died ten years later. Little else is known of his early education. He moved with his siblings to New Orleans in 1919, where he worked as a chauffeur before opening his own dry cleaners business. During the 1920s he started writing and publishing poetry, and he studied in the evening division of the New Orleans public school system. The publication of more than a dozen of Christian's poems in *Opportunity* during the 1930s brought favorable remarks from W. E. B. DU BOIS, LANGSTON HUGHES, and other literary figures.

Marcus Christian is best remembered for his work as director of the Negro unit of the Federal Writer's Project (FWP) in Louisiana. Through the assistance of Lyle Saxon, a New Orleans author and head of the Louisiana FWP, Christian was appointed to the "Colored Project" of the program in 1936. Three years later Christian was named director, and the work he oversaw created a trove of folklore and history of African Americans in Louisiana. Christian's work informed much of the material about black Louisiana culture described in the *New Orleans City Guide* (1938), *Louisiana: A State Guide* (1941), and *Gumbo Ya-Ya* (1945). After

his death, the Marcus Christian Collection at the University of New Orleans became best known among scholars for the voluminous, unpublished manuscript titled "The Negro in Louisiana" (later re-titled "A Black History of Louisiana"). Created as the culminating work of the "Negro unit," the 1128-page manuscript remains unpublished; however, the work and its accompanying research materials quickly made the Christian material one of the most consulted archival collections in New Orleans.

Christian sought employment with the Writer's Project by approaching Saxon directly. After reading some of his poetry, Saxon hired Christian and later introduced him to many famous African American authors. The "Negro unit" was housed at Dillard College (later Dillard University), and despite the difficulty of conducting research in libraries and archives during the Jim Crow era, the writers amassed a great amount of material. Much of the manuscript consisted of compilations and transcriptions of newspapers and other materials from the nineteenth century. The information about blacks that Saxon used in the state and city guides tended to offer rosier depictions of slavery and its aftermath. Since Christian's Negro unit enjoyed considerable autonomy, its interpretation of the effect of enslavement proved much more sophisticated and probing. World War II ended FWP financial support in 1943 but work remained to be completed on Christian's manuscript. The materials were kept at Dillard and Christian was awarded a Rosenwald fellowship (1943–1944) to complete the book. The work remained incomplete, however, and Christian worked as an assistant librarian at Dillard through the rest of the 1940s.

Christian married Ruth Morand in 1943, but the marriage ended three years later and produced no children.

With the death of Saxon in the mid-1940s, Christian lost a valuable patron. The 1950s found Christian struggling economically, and he delivered newspapers for many years. He balanced this menial labor by mining his research and publishing historical articles and poems in the *Louisiana Weekly*, the state's newspaper of record for the African American community. By the mid-1960s Christian had emerged as an elder among the leaders of Louisiana's modern civil rights movement, for whom Christian's research into the nineteenth-century Afro-Creole protest movement provided inspiration. Christian's greatest effect on

the movement stemmed from his African American history articles published in the *Louisiana Weekly* as well as a few lectures broadcast via radio for black audiences. Christian connected the modern civil rights activists to Louisiana's nineteenth-century Afro-Creole protest tradition.

In the last several years of his life, during the 1970s, Christian entered the teaching profession and enthralled students in classrooms at the University of New Orleans as a special lecturer in English and history. History department members and others successfully advocated hiring Christian as an instructor even though he had never completed high school. Friends remembered these as his happiest years. Christian fell ill during one of his University of New Orleans class lectures and died in Charity Hospital.

Christian's legacy is perhaps best understood in relation to other writers. He was Louisiana's ZORA NEALE HURSTON, researching and writing about the folkways and folk culture of Louisiana's African Americans but above all he served as Louisiana's CARTER G. WOODSON. He labored for decades to amass the first substantial collection of African American historical materials for use by scholars, artists, and lay readers, restoring humanity, complexity, and agency to scholarly interpretations of Louisiana's African American history and culture.

FURTHER READING

A few vital finding aids and excerpts from Christian's work have been placed online. Christian scholar and advocate Rudolph Lewis developed the first online presence for Christian as part of *Chicken Bones: A Journal*. Available at http://www.nathanielturner.com/marcusbrucechristian.htm.

Marcus Christian Collection. Mss 11. Online Inventory. Special Collections, Earl K. Long Library, University of New Orleans. http://library.uno.edu/help/subguide/louis/inventories/011.htm

Dent, Tom. "Marcus B. Christian: A Reminiscence and an Appreciation," *Black American Literature Forum*, 18:1 (1984).

Johnson, Jerah. "Marcus B. Christian and the WPA History of Black People in Louisiana," *Louisiana History* 20:2 (Spring 1979).

Redding, Joan. "The Dillard Project: The Black Unit of the Louisiana Writers' Project," *Louisiana History* 32:1 (Winter 1991).

Obituary: (New Orleans) *Times-Picayune*, 23 Nov. 1976.

MICHAEL MIZELL-NELSON

CLARKE, John Henrik

(1 Jan. 1915–16 July 1998), scholar and activist, was born John Henry Clark in Union Springs, Alabama, the first of five children to John Clark and Willella (Willie) Mays, sharecroppers. Later Clarke changed the spelling of his name, dropping the "y" in Henry and replacing it with "ik" after the Norwegian playwright, Henrik Ibsen. He also added an "e" at the end of Clarke.

Clarke's great grandmother Mary, who lived to be 108, inspired him to study history. The young Clarke sat on her lap, listening to stories, and it was through her, he later said, that he first became aware of the word "Africa." Clarke grew up in the Baptist church and wanted to satisfy his intellectual curiosity regarding the Bible and its relationship to African people. Like a detective he searched the Bible looking for an image of God that looked like him. His dissatisfaction with what he found later helped him to produce one of his most famous short stories, "The Boy Who Painted Christ Black" (1940), which was translated into over a dozen languages.

Following the death of his mother in 1922 Clarke's family moved to Columbus, Georgia. Clarke did not attend school until the third grade because of his family's poverty, and since during the era of Jim Crow African Americans could not use public libraries across the South, Clarke had to develop creative ways to obtain information. He picked up used books and magazines from white schools and took newspapers out of garbage cans. Occasionally, when employed by rich white families, Clarke borrowed books from them.

Like thousands of others Clarke grew tired of the bleakness and repression of the South and joined the Great Migration in search of a better future. Hopping a freight train Clarke and a friend, Roscoe Chester, hoboed to the North, first to Chicago and then in 1933 to New York City. Though the Depression still gripped the world Clarke found greater opportunities to grow in New York than were possible in Georgia. He and Chester lived on Manhattan's Lower Eastside, surviving on a diet of bread and sardines.

When he was eighteen Clarke was introduced to communist literature by a Russian, George Victor, and soon became active in the Young Communist League on the Lower Eastside. Clarke also joined the defense of the SCOTTSBORO BOYS and Angelo Herndon, organizing rallies and lectures throughout the city.

One of the most significant meetings that Clarke experienced during his early years in Harlem occurred at the New York Public Library. Before he left Georgia, Clarke had read and been greatly influenced by ARTHUR A. SCHOMBURG's essay, "The Negro Digs Up His Past," which had appeared in *The New Negro*, an influential anthology edited by ALAIN LOCKE, a prominent figure in the Harlem Renaissance. This essay was Clarke's first exposure to the reality that African people had a history that was older than Europe, and it left him with many questions and a determination to meet its author. "I could not stomach the lies of world history, so I took some strategic steps in order to build a life of scholarship and activism in New York" (Clarke Papers, Funeral Program).

One afternoon Clarke decided to visit Schomburg, then curator of the "Division of Negro Literature" at the 135th Street Branch of the New York Public Library. Following their first meeting— Clarke interrupted Schomburg's lunch with a request to hear the story of African history— Schomburg took the young man under his wing, guiding him in his studies until his death in 1938. Despite the loss of his mentor Clarke found other black scholars to study under, most notably those at the Harlem History Club. Directed by Willis N. Huggins, the Harlem History Club (later the Edward Wilmont Blyden Society) served as Clarke's formal introduction to the study of history. Here he met other scholars like John G. Jackson, JOEL A. ROGERS, Charles Siefort, RICHARD B. MOORE, and William Leo Hansberry, among others, from all corners of the world. In addition to these studies Clarke also took writing classes sponsored by the Works Project Administration (WPA).

In 1941 Clarke was drafted into the U.S. Army Air Corps. At the end of World War II he received an honorable discharge and decided to continue his training as a scholar. His postwar years were productive. In 1948 he published his first volume of poetry, *Rebellion in Rhyme*. Around the same time, he enrolled at New York University on the G.I. Bill but was uninspired and withdrew. Clarke would not earn a degree until he was awarded a PhD from Pacific Western University in 1995 for the completion of a competitive dissertation.

In 1958 he spent several months traveling across Ghana, Nigeria, and Togo. Clarke's African sojourn enabled him to understand the diversity and depth of African cultures, while allowing him to draw some parallels to his childhood in the South. It also provided him with the opportunity to see some of the new states that were emerging out of colonialism and the many challenges that they faced. In Ghana, Clarke freelanced for the *Ghana Evening News*, and it was his time in that country—with its rich land and ancient culture—that transformed his consciousness. Clarke saw both the triumph and the inevitable tragedy of Ghana. "I was frightened because I suspected that the colonial powers would not give up Africa very easily and that the first target of fragmentation would be Ghana. Unfortunately, history has proved me right" (Adams, 106).

On his way home from Africa, Clarke spent time in Britain, France, and Italy. He even attended the Second Congress of Black Writers and Artists in Paris in 1959, where he met African thinkers from around the world.

With the rise of black consciousness in the 1960s the demand for Clarke's expertise increased. For five years he directed the African Heritage program for HARYOU-ACT, the first antipoverty agency in Harlem, and served as a special consultant for the Columbia University–WCBS-TV series, "Black Heritage: The History of Afro-Americans." In 1969 Clarke joined Hunter College's faculty, where he established and chaired the department of black and Puerto Rican studies. There he built a comprehensive department, introducing new courses on African history, literature, and other previously neglected subjects.

He also had an instrumental role in shaping black studies departments around the country, most notably at Cornell University, where he served as distinguished visiting professor of African history. In 1983 Clarke was the recipient of the Thomas Hunter Professorship and in 1985 he retired from Hunter College as Professor Emeritus of African world history. In 1994 Clarke was awarded the Phelps-Stokes Fund's Aggrey Medal for his role "as a public philosopher and relentless critic of injustice and inequality."

Clarke published hundreds of articles and essays, authored approximately ten books, and edited over eighteen volumes. Some of his most popular works included *Notes for an African World Revolution* (1991), *Christopher Columbus and the African Holocaust* (1992), and *Who Betrayed the African Revolution?* (1991). Some of his edited works include *Harlem, A Community in Transition* (1964), *Malcolm X: The Man and His Times*

(1969), *William Styron's Nat Turner: Ten Black Writers Respond* (1970), and *Marcus Garvey and the Vision of Africa* (1973). He also co-founded the Harlem Writers Guild—which nurtured such authors as James Baldwin, Lorraine Hansberry, and Maya Angelou—Freedomways, the African Heritage Studies Association, the National Council of Black Studies, the Association for the Study of Classical African Civilizations, the Black Academy of Arts and Letters, and the African American Scholar's Council.

Following his retirement from Hunter College, Clarke remained a sought-after lecturer. In 1997 the actor Wesley Snipes produced a documentary about Clarke's life, *A Great and Mighty Walk*, and professor Clinton Crawford of Brooklyn's Medgar Evers College offered a course, "The Life and Writings of John Henrik Clarke."

In 1993 Clarke donated approximately 10,000 volumes from his library to Clark Atlanta University and the university dedicated a wing of the Woodruff Library Center in his honor. Clarke's papers and other documents, however, were deposited at the Schomburg Center for Research in Black Culture. His heirs were his wife, Sybil Williams Clarke, whom he married on 21 September 1997, and his two children from a previous marriage (date and name of spouse unknown), Nzinga Marie Clarke and Sonni Kojo Clarke.

Clarke's profound grasp of history was impressive. He routinely delivered detailed lectures, replete with dates and numerous references, without notes. He received honorary degrees from the University of Denver, Colorado, the University of the District of Columbia, and, posthumously, from Medgar Evers College. Clarke maintained, without apology, that he was a black nationalist, a socialist, and a Pan-Africanist. He did not see any contradictions among these goals or ideals and often stated that the choice for African people throughout the world was simple: "Pan-Africanism or perish!"

FURTHER READING

The most extensive collection of primary material related to Clarke's life and work is to be found in the John Henrik Clarke collection at the Schomburg Center for Research in Black Culture of the New York Public Library.

Adams, Barbara Eleanor. *John Henrik Clarke: Master Teacher* (2000).

Harris, Robert L., Jr. *Journal of Negro History* 83 (Fall 1998).

Kelley, Robin D. G. *New York Times Magazine* (3 Jan. 1999).

Painter, Nell. *The Crisis* (Sept./Oct. 1998).

Obituaries: New York Amsterdam News, 23 July 1998; *New York Times*, 20 July 1998.

CHRISTOPHER WILLIAMS

COLEMAN, Bessie

(26 Jan. 1892–30 Apr. 1926), aviator, was born Elizabeth Coleman in Atlanta, Texas, the daughter of George Coleman, a day laborer of predominantly Indian descent, and Susan (maiden name unknown), an African American domestic and farmworker. While Bessie was still very young, the family moved to Waxahachie, Texas, where they built a three-room house on a quarter-acre of land. She was seven when her father left his family to return to the Indian Territory (Oklahoma). The Coleman household was Baptist, and Bessie was an avid reader who became particularly interested in BOOKER T. WASHINGTON, Harriet Tubman, and PAUL LAURENCE DUNBAR. After finishing high school, she studied for one semester at Langston Industrial College, in Langston, Oklahoma.

Between 1912 and 1917 Coleman joined her two brothers in Chicago, where she studied manicuring at Burnham's School of Beauty Culture and worked at the White Sox Barber Shop. She supplemented her income by running a chili parlor on the corner of Twenty-fifth and Indiana avenues. In 1917 she married Claude Glenn. It was during this time that her brother Johnny related World War I stories to her about women flying planes in France. She decided that this would be her ambition.

Coleman was rejected by a number of American aviation schools because of her race and sex. ROBERT ABBOTT, the founder of the *Chicago Defender*, a newspaper dedicated to black interests, suggested that she study aviation in France; she left the United States in November 1920. With Abbott and the banker Jesse Binga's financial assistance, she studied at the School of Aviation run by the Caudron Aircraft Manufacturing Company in Le Crotoy. She later trained in Paris under a French pilot who reportedly shot down thirty-one German planes in World War I. Coleman's plane of choice was the 130-horsepower Nieuport de Chasse.

On 15 June 1921 Coleman received her pilot's license, number 18310, the first awarded to an

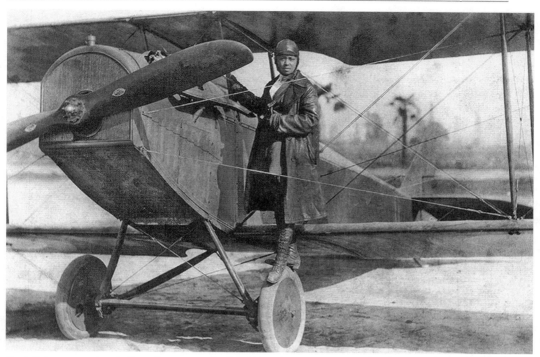

Bessie Coleman, seen here in the early 1920s, was the first African American woman to fly an airplane. After no American school would admit her, she learned to speak French so that she could train at a flight school in Paris. (Google Images.)

American woman by the French Federation Aeronautique Internationale, and she became the only licensed African American woman pilot in the world. She returned to the United States in September 1921 but went back to Europe to study in Germany, where she received the first flying license granted to an American woman. She returned to the United States in August 1922.

With her goal of obtaining a pilot's license fulfilled, Coleman then sought to become an accomplished stunt and exhibition pilot. Barnstorming was the aviation fashion of the day, and Coleman decided to become part of these aerial acrobatics. United States air shows were attended by thousands of people. Sponsored by Abbott and Binga, Coleman made her first air show appearance at Curtiss Field in Garden City, Long Island, New York, during Labor Day weekend 1922 flying a Curtiss aeroplane. She then appeared at an air show at Checkerboard Airdrome in Chicago on 15 October. By this time Coleman had purchased three army surplus Curtiss biplanes.

Coleman's third exhibition was held in Gary, Indiana, where she met David Behncke, the founder and president of the International Airline Pilots Association, who became her manager. The Gary exhibition was supervised by Reynolds McKenzie, an African American real estate dealer. There Coleman made a parachute jump after a white woman changed her mind.

On 4 February 1923, while Coleman was flying from municipal flying field in Santa Monica, California, to Los Angeles on her first exhibition flight on the Pacific Coast, her Curtiss JN-4 "Jenny" biplane engine failed, and she plunged 300 feet to the ground. The airplane was completely demolished, and Coleman had to be cut from the wreckage. During her recuperation she went on the lecture circuit and resumed flying as soon as she was able. Newspapers reported that she planned to establish a commercial passenger flight service.

Using Houston as her base, Coleman performed at air shows in Columbus, Ohio; Waxahachie and Austin, Texas; Memphis, Tennessee; and Wharton

and Cambridge, Massachusetts. She thrilled crowds and became widely known for her flying outfit, which consisted of a pilot's cap, helmet, and goggles, a Sam Browne belt, long jacket and pants, white shirt and tie, and high boots. In 1924 Coast Firestone Rubber Company of California hired Coleman to do aerial advertising.

While recuperating from another airplane accident, which occurred during a race from San Diego to Long Beach, Coleman reflected on her third goal, opening the field to African Americans by establishing an aviation school in Los Angeles. She lectured to church and school groups and attended private dinners, speaking on the opportunities for blacks in aviation. She appeared in a number of documentary news films, and Coleman reportedly was scheduled to appear in *The Flying Ace*, billed as the "greatest airplane mystery thriller ever made"; it was produced in 1926 and featured an all-black cast.

In late April 1926 Coleman was in Florida at the invitation of the Negro Welfare League of Jacksonville to perform in an air show in Orlando for the annual First of May celebration. When the Orlando Chamber of Commerce informed her that African Americans would not be allowed to view her performance, she refused to participate in the show until "the Jim Crow order had been revoked and aviators had been sent up to drop placards letting the members of our race know they could come into the field" (Marjorie Kritz, "Bessie Coleman, Aviator Pioneer," undated leaflet, U.S. Department of Transportation). William D. Wills, Coleman's publicity agent and mechanic, flew her Jenny plane from Texas because local agencies would not rent a plane to a black person. Mechanical problems had occurred during the flight from Texas, and on the morning of Friday, 30 April, at Paxon Field, during a practice run, after the plane had been in the air only twelve minutes and had reached 3,000 feet, Wills, who was at the instruments, attempted to complete a nosedive, but the plane did not right itself. Though safety conscious, Coleman apparently had failed to secure her seat belt or wear a parachute. "Brave Bessie" was catapulted out of the plane and fell to her death. The plane continued in a downward spiral and crashed; Wills was also killed. Members of the Eighth Regiment of the Illinois National Guard served as pallbearers at Coleman's funeral in Chicago.

Coleman's place in aviation history is secure. In 1929 William J. Powell, author of *Black Wings* (1934), organized the Bessie Coleman School in Los Angeles. Bessie Coleman Aero Clubs, which promoted interest in aviation within the African American community, soon sprang up all across the United States, and the *Bessie Coleman Aero News*, a monthly periodical edited by Powell, first appeared in May 1930. On Labor Day 1931 the Bessie Coleman Aero Club sponsored the first all-black air show in the United States. Every Memorial Day African American aviators fly over her gravesite at Lincoln Cemetery in Chicago in single-file nose low to allow women passengers to drop flowers on her grave. The Chicago mayor HAROLD WASHINGTON proclaimed 26 April 1986 Bessie Coleman Day. Also in 1986 the Federal Aviation Administration created the Bessie Intersection, located forty miles west of Chicago's O'Hare Airport, in her honor. She is included in a monument to African American aviators, *Black Americans in Flight*, at Lambert-St. Louis International Airport. On 27 April 1994 a U.S. Postal Service Bessie Coleman commemorative stamp was issued. She continues to be an inspiration to young African American women.

FURTHER READING
Freydberg, Elizabeth. *Bessie Coleman: The Brownskin Lady Bird* (1994).
Patterson, Elois. *Memoirs of the Late Bessie Coleman, Aviatrix: Pioneer of the Negro People in Aviation* (1969).
Rich, Doris L. *Queen Bess: Daredevil Aviator* (1993).

Obituary: Chicago Defender, 8 May 1926.

CONSTANCE PORTER UZELAC

COLEMAN, Bill

(4 Aug. 1904–24 Aug. 1981), jazz musician, was born William Johnson Coleman in Centerville, Kentucky, the son of Robert Henry Coleman, a cook, and Roberta Johnson, a seamstress. Coleman's parents had separated by the time he was five, and he grew up with his mother and aunt in Crawfordsville, Indiana. When he was seven, he moved with his mother to Cincinnati, a popular stop on the Theater Owners' Booking Association circuit and a city that hosted traveling circuses, riverboats, jug bands, and medicine shows. He saw the blues singers MAMIE SMITH, MA RAINEY, and BESSIE SMITH at local vaudeville houses. When he was fourteen, he joined a band organized to teach young boys music, and he began playing alto saxophone. At seventeen he took

piano lessons and did some singing. A year later, he bought a cornet he saw in a pawnshop window. While earning money in a variety of odd jobs, he taught himself the instrument and began to perform at social gatherings. He also started to play with the trombonist J.C. Higginbotham, the pianist Edgar Hayes, and others at area roadhouses. He led his own group (as Professor Johnson Coleman and His Band) for an engagement in Richmond, Indiana, and he played weekends at a vacation camp in Kalamazoo, Michigan.

In 1923 Coleman joined the Clarence Paige orchestra and traveled more widely. He heard players such as LOUIS ARMSTRONG with FLETCHER HENDERSON on a 1925 recording of "Money Blues," and Rex Stewart with the Henderson band in 1926. By this time, Coleman had married his first wife, Madelyn Grant, in 1925. In early 1927 he joined the Lloyd Scott orchestra for six months, first on tour and then playing at New York's Savoy Ballroom. In New York he heard the DUKE ELLINGTON band and Armstrong play in person for the first time. The Scott group toured extensively. Coleman struggled to earn a living over the next five years, playing for theater shows, at black dances in places like the Renaissance Ballroom, and occasionally as an accompanist at dancing schools. But he also played in groups led by Cecil Scott (1929–1930), Horace Henderson (1930), Charlie Johnson (1930), and Luis Russell (1929, 1931–1932). In 1933 he went overseas for the first time with Lucky Millinder's group. When he returned, he joined Benny Carter's orchestra and played at the Apollo, the Harlem Club, and the Empire Ballroom. He joined the Teddy Hill group in January 1934, and he recorded with Hill and with FATS WALLER.

In September 1935 Coleman became one of the first American jazz musicians to seek escape from American racism by moving to Paris, where he found "a mellow, cultural city where you were accepted for what you were!" (Carr et al., 99). He worked with the dancer and bandleader Freddy Taylor in 1935 and 1936, and he recorded with Willie Lewis's band in 1936. In January 1936 he made his first recordings under his own name. He traveled to India with Leon Abbey's band (1936–1937), returning to Paris to record in July 1937 with the guitarist Django Reinhardt and the trombonist Dicky Wells and in November 1937 with the violinist Stéphane Grappelli. He traveled to Egypt with the Harlem Rhythm Makers (1938–1940); in March 1939 he played at the wedding of Muhammed Reza Pahlevi, the future shah of Iran, in Cairo. On jazz standards like "I Got Rhythm," recorded with Reinhardt, Coleman played with "light phrasing and almost translucent tone" (Liam Keating, liner notes to Charly Records' 1993 CD issue of Wells and Coleman, *Swingin' in Paris*); he also exhibited an "irrepressible vivacity" and the elegant sensitivity that made him increasingly popular throughout Europe.

Coleman returned to New York City in March 1940. He continued to tour widely and record often, playing with Carter and Fats Waller (1940), Teddy Wilson (1940–1941), Andy Kirk (1941–1942), Ellis Larkins (1943), Mary Lou Williams (trio and orchestra, 1944), John Kirby (1945), Sy Oliver (1946–1947), and Billy Kyle (1947–1948). He made recordings with most of these groups, highlighted by a series of excellent solos with Carter's group on "Embraceable You," "But Not for Me," and "Lady Be Good," among others. He also recorded with Lester Young for Commodore Records in 1942 and 1944. In March 1945 he recorded in Los Angeles with the Capitol International Jazzmen, a group that included Carter, COLEMAN HAWKINS, Nat "King" Cole, and the drummer Max Roach. He also continued to perform abroad, touring the Philippines and Japan with a USO group during 1945.

Invited to play at the opening of a new club in Paris, Coleman returned to Europe in December 1948. He remained in France for the rest of his life. His lyrical playing, lively singing, and open personality made him enormously popular throughout France and Europe. He played often in Belgium, Germany, and especially Switzerland at festivals, in concerts, and on television programs, and he recorded extensively with both European and American jazz artists. By now he had divorced his first wife, and in Paris in October 1953 he married his second wife, Lily Renee Yersin, who took over the management of his career. He had no children from either marriage. He returned for brief visits to the United States in 1954 and 1958, only to be reminded in several ugly incidents of the pervasive racial prejudice that had driven him away.

Despite mounting health problems, Coleman toured and recorded in the 1960s and 1970s, playing in England in 1966 and 1967 and recording with the tenor saxophonist Ben Webster. In 1968 he was elected to the French Academy of Jazz; in 1969 he realized a lifelong ambition by playing in the band accompanying Duke Ellington during

Ellington's appearance on French television. In 1971 the U.S. Cultural Center's African programming office engaged him to go to West Africa to familiarize the National Orchestra of the Ivory Coast with jazz. In 1972 the French celebrated his jubilee (fifty years of playing the trumpet) with articles in jazz magazines, appearances on TV, and recognition throughout the country, and in 1974 the government made him a knight of the Order of Merit, the second-highest official distinction in France. He lived his last few years in the village of Cadeillan and died in Toulouse.

Like all trumpet players of his generation, Coleman was greatly influenced by Armstrong. But he gradually developed his own style and voice and became noted for his elegant, fluid phrasing, lovely melodic ideas, ease in the upper register, and relaxed approach. Essentially a swing player, he remained musically adventurous, even adopting some bop ideas during the 1940s and 1950s. Perhaps his greatest contribution to jazz, though, lies in his work as "a modern-time troubadour," an ambassador of jazz to the rest of the world.

FURTHER READING

Coleman, Bill. *Trumpet Story* (1981).
Carr, Ian, et al. *Jazz: The Essential Companion* (1987).
Harrison, Max, et al. *The Essential Jazz Recordings*, vol. 1, *Ragtime to Swing* (1984).

Obituary: Jazz Journal International, Nov. 1981.

DISCOGRAPHY

The Complete Commodore Jazz Recordings, vol. 2 (1988).

RONALD P. DUFOUR

COOK, Will Marion

(27 Jan. 1869–20 July 1944), composer and librettist, was born in Washington, D.C., the son of John Hartwell Cook, a professor of law at Howard University, and Marion Isabel Lewis, a sewing instructor. He received classical violin training at the Oberlin Conservatory of Music (1884–1887). For approximately the next decade he presumably studied violin and composition with the German violinist Joseph Joachim at the Hochschule für Musik in Berlin (1888–1889?), and he continued harmony and counterpoint training under Antonín Dvořák and John White at the National Conservatory of Music in New York City (1893–1895?).

Cook was a prolific composer whose instrumentals and songs were closely related to the craze for cakewalking and two-stepping. His first musical success began with the show *Clorindy, the Origin of the Cakewalk* (1898), which he originally wrote for the vaudevillian comedians BERT WILLIAMS AND GEORGE WILLIAM WALKER, although it was first performed with Ernest Hogan in the lead. This landmark production departed from the minstrel tradition in two ways: first, by employing syncopated ragtime music; and second, by introducing the cakewalk to Broadway audiences. The show, which opened at the Casino Roof Garden Theatre in New York, emerged along with Bob Cole's *A Trip to Coontown* as one of the first all-black shows to play in a major Broadway theater, and Cook became the first black conductor of a white theater orchestra. The author JAMES WELDON JOHNSON noted that Cook "was the first competent composer to take what was then known as rag-time and work it out in a musicianly way" (Johnson, 103). The show's star, ABBIE MITCHELL, became Cook's wife in 1899. They were divorced in 1906, but continued to work together in show business; they had two children.

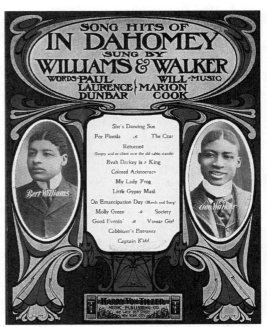

Will Marion Cook wrote the music for In Dahomey, a hit musical performed in 1902 by the comedy team Bert Williams and George Walker. (Duke Univesity.)

Clorindy presented songs that countered minstrel stereotypes. Whereas many of the tunes, notably "Hottes' Coon in Dixie" and "Who Dat Say Chicken in Dis Crowd?," continued in the minstrel tradition, others, such as the choral "On Emancipation Day" and the hauntingly lyrical "Ghost Ship" (unpublished), were stirring tunes that reflected black pride and the pain of the Middle Passage. The production played throughout the summer of 1898 at the Casino in New York. After a brief but successful tour the show was incorporated into the Williams and Walker Company as part of their vaudeville routine.

In the first decade of the twentieth century Cook emerged as an original, if sometimes erratic, genius of musical comedy. He teamed with PAUL LAURENCE DUNBAR, Alex Rogers, Joe Jordan, Williams and Walker, Jesse Shipp, CECIL MACK, James Rosamond Johnson, and James Weldon Johnson to produce some of the most popular musical shows, vaudeville, and hit tunes. Cook's next three productions, *The Casino Girl* (1900), *The Policy Players* (1900), and *Jes Lak White Fo'ks* (1900), failed to duplicate his *Clorindy* success, but his fortunes turned upward when he created the music for Williams and Walker's *In Dahomey* (1902–1905), *Abyssinia* (1906–1907), and *Bandana Land* (1907–1909). *In Dahomey* opened successfully in New York, establishing the Williams and Walker Company as the premier black musical comedy troupe for the remainder of the decade. In addition, the show toured throughout Great Britain during the 1903–1904 season.

In 1910 Cook formed the New York Syncopated Orchestra, which toured the United States that same year. He also formed the orchestra known as the Clef Club in 1912, a group of black musicians and entertainers. Both the Syncopated Orchestra and the Clef Club performed a mixture of Cook's music, as well as popular and classical music. His most popular songs, along with those from *Clorindy*, were "Swing Along," a satiric choral piece on relations between blacks and whites, "Mandy Lou," "Red, Red Rose," "Exhortation: A Negro Sermon," "Brown Skin Baby Mine," "Darktown Is Out Tonight," "Nobody Knows the Trouble I See," and "The Rain Song." In 1918 Cook moved his Syncopated Orchestra to Europe, and he was largely instrumental in creating the vogue for black musicians there and in England.

Cook's classical musical education proved a mixed blessing. Endowed with tremendous talent, his refusal to tolerate racism in the white world and show business egos in his own circles alienated him from many friends and colleagues. During the last two decades of his life Cook's productivity declined, but he did compose *In Darkydom* (1914) and fragments of a Negro folk opera called *St. Louis Woman* (1929). He also wrote spirituals, such as "Troubled in Mind" (1929), and during World War II he and his son Will Mercer Cook composed patriotic songs.

Abbie Mitchell referred to him as "a giant in experience, a sincere student of music in spite of all statements to the contrary, notwithstanding his eccentricities, his erratic temperament, which in later years caused him many disappointments, much poverty, loss of influence, contacts and friends and a deep sorrow" (Mercer Cook Papers). He died in New York City's Harlem Hospital.

FURTHER READING
Valuable sources of information on Cook include the Mercer Cook Papers, Moorland-Spingarn Research Center, Howard University; the Theatre Museum, London; the Music Division, Library of Congress; and the Billy Rose Theatre Collection at the New York Public Library for the Performing Arts, Lincoln Center.
Johnson, James Weldon. *Black Manhattan* (1930).
Peterson, Bernard L. *A Century of Musicals in Black and White* (1993).
Riis, Thomas L. *Just before Jazz* (1989).
Riis, Thomas L. *More than Just Minstrel Shows* (1992).
Sampson, Henry T. *Blacks in Blackface* (1980).
Obituary: New York Times, 21 July 1944.

DAVID KRASNER

COOKE, Charles "Doc"

(3 Sept. 1891–25 Dec. 1958), arranger, composer, and bandleader, was born Charles Leonidas Cooke in Louisville, Kentucky. Little is known of Cooke's early years. He attended Louisville and Detroit public schools and was active as a composer and arranger in Detroit before 1910. Cooke scored an early hit in 1918, when his song "I've Got the Blue Ridge Blues" (words by Charles Mason; cocomposed by Richard Mason) was included in *Sinbad*, a successful show featuring a young Al Jolson.

By 1920 Cooke was based in Chicago, where he quickly became a leading theatrical and cabaret bandleader and worked as musical director at Riverside Park. He was in residence at Paddy Harmon's

Dreamland Ballroom from 1922 to 1927 before moving to ChicagoMunicipal Pier in the summers and the Casino at White City during the colder months. His orchestra was broadcasting live from White City over station WBCN by May 1927. Cooke continued his education during these years and earned a doctor of musical arts degree from the Chicago Musical College in 1926.

Like many of the most highly regarded bandleaders of the era, Cooke was recruited to make jazz recordings in the 1920s. His twenty-one released sides were recorded for three leading labels and under four different ensemble names. First came six sides for the Gennett Company of Richmond, Indiana, recorded in January 1924 by Cook's Dreamland Orchestra, a twelve-piece ensemble. Cookie's Gingersnaps, a smaller version of the same band, made another four sides in June 1926 for Okeh. Cook and his Dreamland Orchestra (named for the popular ballroom), now back to full strength, recorded five sides for Columbia in July and December 1926. A final six pieces were recorded for Columbia in June 1927 and March 1928 as "Doc" Cook and his fourteen Doctors of Syncopation. Why his last name was given in truncated form is not known; it may have originated as an error and become too troublesome to correct.

Most of the material Cooke's bands covered on their recordings was somewhat undistinguished novelty and other pop material of the period that nonetheless left room for "hot" solo breaks by the better jazz soloists in the band. A few of the pieces were by some of the best songwriters of the era, such as JELLY ROLL MORTON and FATS WALLER, but were generally not their choicest material. Among the popular successes for the band was "Here Comes the Hot Tamale Man," which they recorded in both vocal and instrumental versions. Their best jazz record was "Willie the Weeper," which is sometimes included in anthologies of jazz records from its era. The song has an infectious Latin beat, a memorable tuba line, and a wailing clarinet line by Jimmie Noone.

Cooke's ensembles were renowned for their technical expertise, and the section players were required to be fully trained reading musicians. Cooke may have compromised slightly in the interest of featuring hot soloists, although the two most famous of these, the clarinetist Noone and the cornetist Freddie Keppard, both from New Orleans,

probably would not have been hired if they could play only by ear.

Cooke moved to New York in 1930 and was soon among the busiest music arrangers in the city. At first he was involved primarily in theatrical music, initially in African American shows such as *Brown Buddies* (1930) and *Yeah Man* (May 1932). His orchestral work *Sketches of the Deep South* was performed at an American Society of Composers, Authors, and Publishers (ASCAP) Silver Jubilee concert in 1939. He became perhaps the most sought-after arranger for shows with African American themes and stars, including *The Hot Mikado* (1939) and *Cabin in the Sky* (1942). He found success in the white show world as well, writing arrangements for the comedy team Olsen and Johnson in their *Sons o' Fun* (1941), for Eddie Cantor's *Banjo Eyes* (1941), and for younger performers, such as Jackie Gleason in his *Follow the Girls* (1944). He was a staff arranger for a number of years for both the RKO theater chain and for New York's Radio City Music Hall. Cooke also did a great deal of work for the impresario Billy Rose between about 1930 and 1950. Some of his arrangements for Rose survived in the Performing Arts Library at Lincoln Center (in the New York Public Library). They showed him to have been an assured, sophisticated craftsman. During the 1940s Cooke became less active and moved to New Jersey for a prolonged semiretirement.

Cooke's relationship with the songwriter and publisher W. C. HANDY was particularly close and lasted for decades. The two made their last recordings together for the Audio Archives label in 1952, which included Handy's daughter, the singer Katherine Handy Lewis, and a small choir. Handy played cornet and sang on these sessions and also recounted anecdotes from his long life. Cooke acted as pianist for the sessions and may have done some arranging work as well. By this time Handy had been completely blind for a number of years, so his ability to continue such work was understandably limited to dictating or playing ideas. Cooke and Handy also co-composed some of their last songs together, including "Big Stick Blues March" in 1951 and "Newspaperman's Blues" in 1954. When the latter was published, Handy predicted that it would be his company's biggest hit; but this was standard show business puffery. Upon his death Cooke left a wife, a sister, and other relations, none of whom were named in his obituaries.

As a composer, Cooke was versatile if not notably inspired. Few of his songs were hits, although "Blame It on the Blues," "Messin' Around," and "Lovin' You the Way I Do" all enjoyed some measure of success. Unfortunately, he seems not to have found much opportunity to work in the larger compositional forms or to take full advantage of his classical training. Although Cooke was never the subject of a recorded anthology in modern times, his recordings could be heard on the French-produced compact disc *Jimmie Noone, 1923–1928* (Classics CD, 1991).

FURTHER READING

Chilton, John. *Who's Who of Jazz: Storyville to Swing Street* (1972).

Southern, Eileen. *Biographical Dictionary of Afro-American and African Musicians* (1982).

ELLIOTT HURWITT

COOKE, Marvel Jackson

(4 Apr. 1903–29 Nov. 2000), was born in Mankato, Minnesota. Although her father, Madison Jackson, was an attorney—the first black member of the South Dakota bar—he could not build a practice in the overwhelmingly white community in which they lived, so he instead became a Pullman porter. Her mother, Amy Wood, was a former cook and teacher. Her father was a socialist, and her mother was a close friend of W. E. B. DU BOIS, circumstances that helped Cooke acquire an early commitment to political activism. Her political consciousness was also raised by personal experiences of overt racism. When the family moved into an all-white neighborhood, their new neighbors demonstrated outside the house. As a student Cooke qualified for a War Department job as a translator but was demoted to file clerk when her race was discovered; she wrote to her state senator, however, and was reassigned to her original position.

At the University of Minnesota, Cooke helped found a chapter of Alpha Kappa Alpha, studied literature, wrote poetry, and committed herself to writing and civil rights activism. After her graduation in 1925, she moved to Harlem and began working as an editorial assistant for the *Crisis*. She rented an apartment at Harlem's most prestigious address, 409 Edgecombe Avenue, and soon became part of the intellectual and cultural ferment of the Harlem Renaissance. Her friends included the poet LANGSTON HUGHES, the novelist and *Crisis* literary editor JESSIE REDMON FAUSET, the actor PAUL ROBESON, the future executive director of the NAACP ROY WILKINS (to whom she was briefly engaged), and the star athlete Cecil Cooke, whom she married in 1929.

A year before her marriage, Cooke took a job with New York's leading black newspaper, the *Amsterdam News*, as secretary to the women's editor. After their marriage, however, the Cookes moved to Greensboro, North Carolina, where Marvel Cooke taught history, English, and Latin at North Carolina Agricultural and Technical College. The couple had no children. Two years later they moved back to New York, and Cooke returned to the *Amsterdam News*, first as editor of a short-lived feature, then as the paper's first female news reporter. At the *News*, Cooke countered the paper's tendency to print sensational stories by conducting serious investigations of poor working conditions, euthanasia, and crime. She helped organize a writer's group to encourage literary creation and a local branch of the American Newspaper Guild. When the paper's owner challenged this action, the guild members picketed, the first black workers in the United States to picket a black-owned business. In 1936 Cooke joined the Communist Party. In 1939 she covered MARIAN ANDERSON's historic concert at the Lincoln Memorial and the opening of *Gone with the Wind*, which she criticized for its portrayal of black characters.

In 1940 Cooke left the *Amsterdam News*, and in 1942 she became assistant managing editor of the *People's Voice*, a militant new paper created by ADAM CLAYTON POWELL JR. The *Voice*'s editorial policy treated race relations "within the larger context of a [class-and-ideology-based] people's movement composed of labor and the political left, both white and Negro" (Robbins, 132). When the managing editor resigned, Cooke assumed his responsibilities without any increase in pay or official recognition of her new function. She also worked closely with the paper's theatrical editor, FREDI WASHINGTON, whose regular columns included some of the era's most penetrating critiques of theatrical representations of race. According to Cooke, she recruited Washington into the Communist Party, and they were both fired in 1947, shortly before the paper folded, for political as well as economic reasons.

In 1950 Cooke became a reporter for the *Daily Compass*, a leftist paper based in New York, making history by becoming the first African American woman to join the staff of a white newspaper. Here Cooke wrote her famous series of stories on the "Bronx Slave Market," which investigated working conditions for black women who stood on street corners in the Bronx waiting to be hired by "local housewives looking for bargains in human labor" (quoted in Shapiro, 245). Cooke next published reports on prostitution and teenage drug use. Her investigations of labor exploitation and drug addiction prompted reform initiatives by the Domestic Workers Union and the city of New York. In 1952 the *Daily Compass* folded, and Cooke's career as a journalist came to an end.

A year later Cooke was called to testify before the Permanent Subcommittee on Investigations. The subcommittee was interested in information regarding one of Cooke's *People's Voice* colleagues, but Cooke refused to cooperate, pleading the Fifth Amendment. Also that year Cooke became New York director of the Council of Arts, Sciences, and Professions. Presumably blacklisted, Cooke was unemployed from 1955 until 1960, at which time she was hired by the New York surgeon Samuel Rosen to work in his office. Cooke left this position in 1968, becoming, as she later reported, "a nice little housewife" (Currie interview). Cooke entered public life, however, in 1969, as national legal defense secretary for the Angela Davis Defense Committee. In 1971 Cooke became associated with the National Council for American-Soviet Friendship, serving as national vice chair in the 1980s. Cecil Cooke died in 1978, and Marvel Cooke lived alone in their Harlem apartment until her own death from leukemia. Ten years before her death, however, the journalist Kathleen Currie conducted seven in-depth interviews with Cooke concerning her life and career, available on the Washington Press Club Foundation Web site.

FURTHER READING

The *People's Voice* 1942–1948 is available on microfilm at the Schomburg Center for Research in Black Culture, New York Public Library.

Mills, Kay. *A Place in the News: From the Women's Pages to the Front Page* (1988).

Robbins, Richard. "Counter-Assertion in the New York Negro Press," *Phylon* 10.2 (1949): 126–136.

Shapiro, Bruce, ed. *Shaking the Foundations: 200 Years of Investigative Journalism in America* (2003).

Streitmatter, Rodger. *Raising Her Voice: African-American Women Journalists Who Changed History* (1994).

Obituary: *New York Times*, 10 Dec. 2000.

CHERYL BLACK

COOPER, Jack Leroy

(18 Sept. 1888–12 Jan. 1970), radio personality and advertising executive, was most likely the first black announcer in the history of broadcasting, on the air as early as 1924. His successful radio career would span four decades and make him a wealthy man. Cooper did not come from an entertainment background. Born in Memphis, Tennessee, he was one of ten children of William and Lavina Cooper. Jack Cooper quit school after the fifth grade to help support his impoverished family. He held a number of low-paying jobs and for a time got interested in boxing, winning more than a hundred bouts as a welterweight fighter. But he found his calling on the vaudeville stage, where he became a singer and dancer, beginning in 1905 and continuing well into the 1920s. He was more than just a performer, writing and producing skits and entire shows, often in collaboration with his first wife Estelle (sometimes called Estella), who was also a performer. He parlayed that talent into a job as a columnist and theater critic for the *Chicago Defender* newspaper, but his heart was in performing, and he hoped to find a job in the new medium of radio. In the days before audiotape was in use, radio stations eagerly sought live talent. Although there were a handful of black performers in early radio, the vast majority were white, as were all the announcers. Cooper was determined to change that. He persuaded station WCAP (later known as WRC) in Washington, D.C., to hire him as an entertainer, doing the comedy skits, dialects, and impersonations that had made him popular in vaudeville. The station did not pay him much, and he quickly grew tired of being a comedian, but he realized that radio was what he wanted to do with his life. When he returned to Chicago, he decided to plan for a career in broadcasting.

That plan came to fruition on 3 November 1929 when Jack Cooper debuted with his own show, *The All Negro Hour*, on station WSBC (World Storage Battery Company), having convinced the station's owner Joseph Silverstein that there was a large black audience in Chicago not being served

by any of the other stations. Silverstein leased time to people who wanted to do a radio show, and Cooper made use of that arrangement. *The All Negro Hour* was a one-hour variety show, and this time Cooper was not restricted to performing comedy sketches. He booked his own guests, wrote much of the material, directed the skits, and above all, he did the announcing. Later his show would include some of the first newscasts aimed at black listeners, using content from the *Chicago Defender*. What was unique about Cooper's new show was the respect it showed for black performers and listeners. At a time when the radio programs that featured blacks tended to place them in stereotyped roles, Cooper refused to perform any skits that demeaned people of color (Newman, 55). He also tried to combat the myth that white listeners would have no interest in a show with an all-black cast. While black listeners were his primary target audience, he made his show appealing to the white audience, too.

By this time Cooper was divorced from Estelle, and had married Billie, who worked with him at WSBC. Nothing else is known of his second wife, and the marriage did not last long, as he married Gertrude (Roberts), also a performer, in 1938.

By the mid-1930s Cooper had gone from doing only one hour a week to being on WSBC three days a week. By 1937 he was on the air Monday through Friday. In addition to doing his variety show with its comedy routines, he became known for his disc jockey show. Having an announcer playing phonograph records was still a relatively new concept; most stations still relied on orchestras and live vocalists. Stations solely devoted to black audiences would not go on the air until 1948, but Cooper was ahead of his time, and his listeners loved the music he played, an eclectic blend of music by black performers—blues, dance music, even some gospel. When he was not on the air, he wrote and produced commercials for his sponsors, and his work was so much in demand that he was able to open his own production company and advertising agency.

Jack Cooper was a role model for many young African Americans who wanted to go into broadcasting, and he mentored a number of them over the years. By the late 1940s he had become so popular as a broadcaster that the media reported that his annual salary was $185,000 (Newman, 56). Cooper prided himself on speaking in a style that reflected an educated person, but he did so with such warmth that he was known as "the voice with the smile" (Jackson, 11).

While he made a lot of money in broadcasting, he always had time for community service; he raised money for black charities and volunteered his time on various committees that were involved with interracial understanding, earning awards for doing so. Starting in 1938 he began broadcasting a program called *Search for Missing Persons*, which helped to reunite listeners with those people they had lost touch with over the years. In the late 1940s Cooper began producing an educational program called *Listen Chicago*, a current events forum for the black audience, featuring the day's top news makers. At a time when there still were no entirely black-owned and -staffed radio stations, he was able to employ a number of local black performers to appear on his shows. One of his favorite performers was his third wife, Gertrude (Trudy), who was a talented musician in her own right. She also helped him to run his advertising agency.

By the 1950s his health began to decline, and he developed vision problems that led to blindness. He retired from radio in 1959 and died from a heart condition in January of 1970 at the age of 81. In the twenty-first century, when all-black radio stations are common and black music is loved by both white and black audiences, few people remember Cooper. Yet it was largely as a result of his success in Chicago that stations in other cities began to offer programming with more appeal to blacks. Jack L. Cooper was a pioneering voice for African Americans, a respected businessman, entertainer, and disc jockey who paved the way for acceptance of blacks in broadcasting.

FURTHER READING

Jackson, Jay. "The Voice with a Smile," *Negro Digest* (Feb. 1945).

Newman, Mark. *Entrepreneurs of Profit and Pride—From Black Appeal Radio to Radio Soul* (1988).

Ottley, Roi. "From Poverty to 90 Suits—Saga of a Negro in Radio," *Chicago Tribune*, 10 Jan. 1954.

Williams, Gilbert A. *Legendary Pioneers of Black Radio* (1998).

Obituary: "Last Rites Held for City's First Black DJ," *South Side (IL) Bulletin*, 21 Jan. 1970.

DONNA L. HALPER

COOPER, Tarzan

(30 Aug. 1907–19 Dec. 1980), professional basketball player, was born Charles Theodore Cooper in Newark, Delaware, the son of Theodore Cooper and Evelyn (whose maiden name is unknown). He was a standout for the Central High School basketball team in Philadelphia, Pennsylvania, where he graduated in 1925. Cooper immediately began a twenty-year career in professional basketball, playing initially with the Philadelphia Panther Pros in 1925, then going on to star for the all-black Philadelphia Giants from 1926 to 1929. Robert Douglas, owner of the famed all-black professional team the New York Renaissance, spotted Cooper in a game at Philadelphia and signed him the next day to play for his team. Cooper then began an eleven-year stint with the Rens, named for their home court, the Renaissance Ballroom in Harlem. Over these eleven years the Rens earned a record of 1,303 wins and 203 losses.

At six feet, four inches, Cooper was considered a giant for his era. Howie Evans, sports editor of the *New York Amsterdam News*, noted in 1977 that "his hands were like giant shovels, and held more than their share of his 215 pounds." Cooper's large size earned him the nickname "Tarzan." He played center and was often considered the Rens's most valuable player. Joe Lapchick, center of the Original Celtics of New York City, considered Cooper both the best center in professional basketball and the best center he had ever played against.

In the 1932–1933 season, the Renaissance team earned a record of 127–7, including a winning streak of 88 consecutive games. From 1932 to 1936 just seven players constituted the Renaissance team: Cooper, Eyre "Bruiser" Saitch, James "Pappy" Ricks, William "Wee Willie" Smith, John "Casey" Holt, Bill Yancey, and Clarence "Fats" Jenkins. The "Magnificent Seven," as the Rens were called, consistently defeated the Original Celtics, the top white team of the day. For example, in 1933 the Rens topped the Original Celtics in seven out of eight meetings.

The teamwork and style of play exhibited by the Rens became their trademark. Known for their passing ability, the Rens rarely dribbled the ball down the court. Instead, their fast breaks consisted of quick passes from player to player, resulting in a scored basket. The Rens were also known for their endurance on the court, rarely calling a time-out in a game. This forced the opposing team to play to exhaustion and use up their own time-outs. The Rens's playing ability attracted crowds of up to fifteen thousand, both black and white. Nonetheless, they faced many forms of prejudice and discrimination while on the road.

During the Great Depression the Rens became a barnstorming team, traveling to the Midwest and the South to play amateur and professional teams, both black and white. Douglas purchased a custom-made bus for his players to travel in. The bus often served as a restaurant and a hotel for the team, as discrimination prevented the players from being served or housed in many places. In addition the team would set up headquarters in a large city such as Indianapolis, travel up to two hundred miles to a game, and then return to the city afterward. The Rens regularly played and defeated white teams that belonged to the National Basketball League (NBL), such as Oshkosh, Sheboygan, and Fort Wayne. During Cooper's era professional basketball remained segregated by team, although black and white teams played each other.

Cooper served as the leader of the Rens squad that won the World Professional Championship in 1939. In the 1938–1939 season the Rens had accumulated 112 wins and only 7 losses. Having defeated both the New York Yankees basketball team and the Harlem Globetrotters in preliminary games, the Rens became the first World Professional titleholders by defeating the Oshkosh All-Stars, the 1939 NBL Champions, by a score of 34–25.

Gas rationing and travel restrictions during World War II forced Douglas to cut back on the number of away games. Many of the Rens traveled the relatively short distance from New York City to Washington, D.C., on the weekends to play as Washington Bears during the war. In 1943, with Cooper serving as player-coach, the Bears went 66–0 and entered the World Professional Championship in Chicago. With a 38–30 win over the Dayton Bombers behind them, they defeated the Oshkosh All-Stars 43–31 to win the 1943 title.

In 1963 the famed 1932–1933 Renaissance team, of which Cooper was a member, was inducted into the Naismith Memorial Basketball Hall of Fame in Springfield, Massachusetts. Through the efforts of Eddie Younger, a former Ren, Cooper was the first Renaissance player to be inducted into the Hall of Fame in May 1977. Cooper was nearly seventy years old at his induction ceremony. As witness to his popularity and playing ability forty years earlier, hundreds of supporters traveled to Springfield to

witness his induction, including the former Rens owner and coach Douglas.

As Evans stated in the *New York Amsterdam News* in May 1977, "It is because of Tarz, there was a Baylor, a Wilt, a Doctor J, and all the others still to come." Following his professional basketball career, Cooper worked in the Philadelphia Navy Yard. He also volunteered his time as a basketball instructor at the Philadelphia YMCA. Cooper died at home in Philadelphia. He was divorced and had no children, and the name of his wife and the dates of their marriage and divorce are unknown.

FURTHER READING

Cooper's file is at the Naismith Memorial Basketball Hall of Fame, Springfield, Massachusetts. Important primary sources on Cooper and the Renaissance team include hundreds of articles in the *New York Amsterdam News*, the *Pittsburgh Courier*, the *Chicago Defender*, and other black newspapers.

Ashe, Arthur R., Jr., with Kip Branch, Ocania Chalk, and Francis Harris. *A Hard Road to Glory: A History of the African-American Athlete*, vol. 2, 1919–1945 (1988).

Dickey, Glenn. *The History of Professional Basketball since 1896* (1982).

Peterson, Robert W. *Cages to Jump Shots: Pro Basketball's Early Years* (1990).

SUSAN J. RAYL

COTTER, Joseph Seamon, Sr.

(2 Feb. 1861–14 Mar. 1949), author, teacher, and civic leader, was born in Bardstown, Kentucky, the son of Michael (also spelled Micheil) Cotter, a boardinghouse owner who was known as an avid reader, and Martha Vaughn. Cotter was raised largely by his mother, a freeborn woman of mixed English, Cherokee, and African heritage. It was from her naturally dramatic manner—she orally composed poems and plays as she worked at chores—that he acquired his love of language and stories. Having taught herself, she also taught her son to read and enrolled him in school. When he was eight, however, economic necessity forced him to drop out of school to begin work at various jobs, first in a brickyard, then in a distillery, and finally as a ragpicker and a teamster. Until age twenty-two, manual labor consumed much of Cotter's life.

The friendship of the prominent black Louisville educator William T. Peyton, who sensed Cotter's natural intelligence, inspired Cotter's enrollment in night school in 1883. His talent and discipline are indicated by the fact that after less than a year of studies he was teaching. He began his career as an educator in Cloverport, Kentucky, staying there until 1887. He then conducted a private school for two years. After teaching at the Western Colored School in Louisville, Kentucky, from 1889 to 1893, Cotter founded and served as principal of the Paul Laurence Dunbar School in Louisville. He remained there until 1911—during his most fruitful years as a poet—and then became principal of the Samuel Coleridge-Taylor School, where he remained until his retirement in 1942.

Cotter would be remembered in Louisville primarily as an educator, but his life held much more, both privately and professionally. In 1891 he married Maria Cox of Louisville. Despite the demands of his teaching and administrative duties, he began to work more diligently at the poetry that would be the source of his national reputation. His first published work, *A Rhyming* (1895), showed the strong influence of early English lyrics, including the ballad and the sonnet, but by the time this volume saw print, Cotter was moving in a different direction. On Thanksgiving Day 1894, having already acquired a burgeoning reputation as a local poet, Cotter hosted his fellow poet PAUL LAURENCE DUNBAR on his first visit to the South and discovered not only an enduring friendship but also a new style that would both distinguish him individually and link him to a larger tradition. Excited by Dunbar's incorporation of African American dialect into poetry, Cotter, sensing the appropriateness of this language to the oral storytelling tradition into which he had been born, often followed the same practice in his own career, beginning with his second collection, *Links of Friendship* (1898). He also adopted Dunbar's practice of writing poems in praise of African American leaders, as in "Frederick Douglass," "Dr. BOOKER T. WASHINGTON to the National Negro Business League," and "The Race Welcomes Dr. W. E. B. DU BOIS as Its Leader." Cotter never entirely gave up experimenting with more established English forms and language, however. If in his era African American poetry fell into three schools—the dialect poetry of Dunbar, the protest tradition of Du Bois, and "literary" work that was couched in European forms and expressed noble sentiments—Cotter ultimately participated in all three.

Cotter experimented with other genres as well. *Caleb, the Degenerate* (1903), his only play, was written in blank verse and was practically unperformable. It attempted to express dramatically many of the views endorsed by Washington in his conservative 1895 Atlanta Exposition speech, which encouraged African Americans to be content with their current lot as laborers and to concentrate on vocational education. Cotter's *Negro Tales* (1912), a mixture of prose genres that constituted his only fiction outside of newspapers, came immediately after his prolific period at the Dunbar School. It was one of only four collections of fiction by African American writers to appear nationally between 1906 and 1922. Then, while moving in new political directions in the second half of his life, Cotter embraced Du Bois's call for African American intellectual achievement. Cotter published his *Collected Poems* (1938) and *Sequel to "The Pied Piper of Hamelin," and Other Poems* (1939)—on the whole, his best work—near the end of his teaching career.

Cotter was without family in his last years. His firstborn son, who bore his name, had been a promising poet before his death from tuberculosis at age twenty-three. Cotter's other two children also predeceased him, as did his wife. But he lost himself in his community. Aside from his teaching and writing, he was also active in the NAACP, the Kentucky Negro Educational Association, the Story-Tellers League, and the Authors League of America, and he served as director of the Louisville Colored Orphans Home Society. He helped organize African American neighborhoods in Louisville, and his initiation of storytelling contests for local children grew into a national movement and earned him a place in *Who's Who in America* in 1919, during an era when African Americans were rare in those ranks. The teacher-poet was remembered in Louisville as a humanitarian who devoted himself to the younger generation, as when in writing a community creed he advised his fellow citizens: us lose ourselves in the welfare of our children." Even more characteristically, in "The Negro Child and the Story Book" (*Collected Poems*) he praised the power of the imagination in the lives of the young.

Cotter died at his home in Louisville, a pillar of his community and a minor but essential figure in his field. Although the aesthetic quality of his work is inconsistent, he combined wide-ranging formal and stylistic approaches with a thematic concern for both the universal human condition and the particular needs of his race. During the seemingly fallow period between the turn-of-the-century eclipse of figures such as Dunbar and CHARLES CHESNUTT and the beginnings of the Harlem Renaissance, he held the small but already significant ground that had been gained in the field of African American letters.

FURTHER READING
Cotter's papers are in the Western Branch of the Louisville Free Public Library.
Cotter, Joseph S. *Negroes and Others at Work and Play* (1947).
Cotter, Joseph S. *A White Song and a Black One* (1909).
Shockley, Ann Allen. "Joseph S. Cotter, Sr.: Biographical Sketch of a Black Louisville Bard," *College Language Association Journal* 18 (Mar. 1975).

W. FARRELL O'GORMAN

COX, Ida

(25 Feb. 1896–10 Nov. 1967), blues singer, was born Ida Prather in Toccoa, Stephens County, Georgia, of parents whose names have not been recorded. In Cedartown, Georgia, where she spent her childhood, Prather sang in the African Methodist church choir. At age fourteen she left home to tour with the White and Clark Black & Tan Minstrels, playing "Topsy" roles. She subsequently joined other companies, including the Rabbit Foot Minstrels and Pete Werley's Florida Cotton Blossom Minstrels. She married three times. Her first husband, Adler Cox, whom she married about 1916, was a trumpeter with the Florida Blossoms Minstrel Show; he died in World War I. The date of her second marriage, to Eugene Williams, is unknown; the couple had a daughter. Her third husband was Texan Jesse "Tiny" Crump, a pianist and organist who may be heard performing on some of her recordings and who also shared management responsibilities with her.

By 1922 Cox was solidly established as a star performer. With Crump, she led her own touring tent show throughout the South from 1929 into the 1930s. That revue, *Raisin' Cain*, was chosen to be the first show from the Theatre Owners' Booking Circuit to open at New York's Apollo Theater. Difficult times after the stock market crash forced Cox and Crump to reorganize and seek bookings as far away as the West Coast before bringing the show, under the title *Darktown Scandals*, to the Midwest. Still, Cox never

ceased barnstorming through the South in the late 1930s and into the 1940s.

Her performances maintained a high-class tone. They were constructed on a simple formula: three letters in each name (i.e., Cox, Ida), three jokes between songs, and three songs. With regal bearing, dignity, and a beauty that combined glamour and sophistication, she came across as a blues queen in every way. Audiences saw her as "always a lady," ever though her often salty lyrics were laced with sexual allusions and sly humor directed at men. The most distinctive aspect of her work was the frequent use of macabre formulas; her work has been characterized as death-focused blues. Though she could be imperious and demanding, she was known as a fair employer and a good manager.

Working the clubs and theaters over the course of a quarter century, mostly in the Southeast, she performed with headliners such as JELLY ROLL MORTON, in Atlanta around 1920; KING OLIVER, in Chicago; and BESSIE SMITH, in the 1934 revue *Fan Waves*. At the invitation of John Hammond, she took part in the 1939 Carnegie Hall concert *From Spirituals to Swing*.

From 1923 to 1929 she recorded extensively for Paramount with the pianist LOVIE AUSTIN ("Any Woman's Blues") but not exclusively, as the company claimed. Under an assortment of aliases—Julia/Julius Powers, Jane Smith, Velma Bradley, Kate Lewis—she also cut sides for Harmograph and Silvertone. Her output included more than seventy titles. These early recordings suffer from inferior sound, but backed up by Austin and her Blues Serenaders, as well as other outstanding musicians such as Tommy Ladnier and Jim Bryant—and later COLEMAN HAWKINS and FLETCHER HENDERSON—they reveal a high level of artistry.

In her phrasing she had an expressive habit of displacing the normal word stress in a way that intensified the rhythmic pulse and held the listener's attention. Outstanding titles from the 1923 and 1924 sessions include "Death Letter Blues," "Chicago Monkey Man Blues," "Wild Women Don't Have the Blues," and "Kentucky Man Blues." By 1925 and 1926, at her artistic peak, she recorded "Mississippi River Blues," "Coffin Blues," and "Rambling Blues." Following a ten-year hiatus, she recorded for Vocalion-Okeh with Lionel Hampton, HOT LIPS PAGE, J. C. Higginbotham, JAMES P. JOHNSON, and Charlie Christian ("Four Day Creep").

Following a stroke in 1945 she retired in 1949 to Knoxville, Tennessee, where she lived with her daughter until her death. Between 1940 and 1960 Cox performed only intermittently and reluctantly, as she became increasingly active in church work. After a hiatus of more than twenty years, she returned to the recording studio in 1961 for a final album, *Blues for Rampart Street*, with an all-star band including Coleman Hawkins and Roy Eldridge. The album featured a persuasive new version of "Death Letter Blues." Even though her voice had faded, the *New York Times* reviewer John Wilson praised the greater "artfulness of her phrasing" (10 Sept. 1961). Sammy Price, the blues pianist who took the place of Crump on that final recording, commented on her "flowing blues sound," the "good melodic lines, words that make sense, decent diction" (Harrison, 238). The brief revival of her career ended when she suffered another stroke in 1965 in Knoxville.

A classic blues singer known in the 1920s and 1930s for the ability to communicate feeling and bring out her own personality in performance, Cox was sometimes billed as the Uncrowned Queen of the Blues and the Sepia Mae West. Possessed of a regal stage presence and a strong, resonant voice with a touch of nasal quality, coupled with a "salty cynicism all her own," she was most effective in traditional-form blues songs, notably her own blues compositions and those of Austin, with whom she regularly performed and recorded in the early 1920s.

FURTHER READING

Carr, Ian, et al. *Jazz, the Essential Companion* (1987).
Harrison, Daphne D. *Black Pearls: Blues Queens of the 1920s* (1988).
Oliver, Paul. *Conversation with the Blues* (1965).
Stewart-Baxter, Derrick. *Ma Rainey and the Classic Blues Singers* (1970).

Obituary: New York Times, 12 Nov. 1967.

LOUIS E. AULD

CROTHERS, Scatman

(23 May 1910–23 Nov. 1986), actor, singer, musician, and composer, was born Benjamin Sherman Crothers in Terre Haute, Indiana, the youngest of five children of Benjamin Crothers, a clothing store owner and odd jobber from Jonesboro, Arkansas, and Fredonia Lewis Crothers. Crothers's

mother bought him his first drum, which, along with the guitar, he taught himself to play. Although unable to read music, he began street performing for small change at age seven. Crothers encountered discrimination in largely segregated Terre Haute when black players were barred from the high school football team. Responding with what would soon become his characteristic blend of superficial accommodation and subversive disregard of racist standards, he tolerated such discrimination as a temporary situation and became the "yell leader" for school pep rallies. At the same time, he flouted segregation by using his winning personality to frequent "whites only" restaurants. As he later recalled, "I did a lot of things that blacks didn't do in my hometown" (Haskins, 31–32).

Influenced by vaudeville shows, Crothers became an entertainer at a local roadhouse, dropped out of high school in the tenth grade, and continued to transgress racial barriers through interracial dating. He soon became the band director of Montague's Kentucky Serenaders, a traveling band, worked with blues musician T-Bone Walker, and met LOUIS ARMSTRONG, who impressed Crothers with his powerful voice and vocal "scat" style. Already scatting, Crothers developed his style further and left the band in 1931. He soon became a fixture on Dayton, Ohio's WFMK radio station, where he was first called "Scat Man" after the program director asked him to provide a snappier name than Sherman, as he was then known. "Call me 'Scat Man,' because I do quite a bit of scattin'," Crothers reportedly responded, and the name stuck.

For the next several years Crothers played with different bands throughout the Midwest, including JIMMIE LUNCEFORD's group. In between gigs he worked in hotels to support himself. At this time Crothers became the first black performer to appear at the Moonlight Gardens club in Springfield, Ohio, and the first black guest to stay at the Jefferson Hotel in Peoria, Illinois. Drawing on his own experience and abilities, Crothers formed his own group, Scat Man and His Band, in 1936, which played mostly for white audiences but also frequented black-and-tan clubs for mixed clienteles. In April 1936 he met Helen Sullivan, a white waitress at one of the clubs, and on 15 July 1937 they were married in Cleveland, Ohio, after being rebuffed by a judge in Canton, Ohio. The interracial marriage created controversy within their families. Although Crothers's parents died without meeting Helen, the couple established a lifelong commitment.

Now billed as "The Original Scat Man and His Band," Crothers and his musicians traveled together throughout the Midwest and East for the next few years, while Helen stayed at home rather than fuel racial tension by traveling with the band. Audiences soon became familiar with Crothers's theme song, "I Am the Scat Man," penned by Sulky Davis, and his incorporation of bebop into the band's largely swing repertoire. He frequently played the Chicago Loop along with jazz luminaries like DIZZY GILLESPIE. Upon a suggestion from his manager Bert Gervis, Crothers reformed his band into a trio and headed for Hollywood in 1944. He played at Hollywood clubs and performed in his first play, *Insults of 1944*, at the Playtime Theater in Los Angeles. He also performed for soldiers at the Hollywood Canteen in 1944 before once again expanding his band and resuming a national tour. This time Helen accompanied him despite the discrimination the interracial couple encountered on a regular basis. At this time Crothers began to write his own songs. His first, titled "Truly I Do," was completed in 1945 and reflected his love for Helen. In 1948 he recorded his first single, Phil Harris's "Chattanooga Shoe Shine Boy," for RCA-Victor. The recording brought him increased attention, and he followed it with Riff Charles's "Dead Man's Blues" for Capitol Records, which offered him a contract in 1948.

Returning to Los Angeles, Crothers and his wife had a daughter, Donna, in 1949. Crothers worked as a traveling musician while Helen and Donna settled in a small house in a black Los Angeles neighborhood. In 1949 Crothers took a stand against segregation in Las Vegas when he refused to enter a club through the kitchen. He broke another racial barrier that year when he became the first black man to secure a regular spot on a Los Angeles television show, Paramount's *Dixie Showboat*. This led to more television, particularly *The Colgate Comedy Hour*, and to radio work, where his distinctive voice was soon in demand. His first significant film appearance was in *Meet Me at the Fair* (1952) with Dan Dailey. The role of Enoch was remarkable in its substance at a time when most roles for blacks in Hollywood were limited and often demeaning. The movie also included some of Crothers's original songs. He then composed for and performed songs in *The Return of Gilbert and Sullivan* (1950) and *East of Sumatra* (1953).

Crothers's work ethic was relentless, and he continued to travel and perform, including appearances in the Los Angeles Valley area, Las Vegas, and at Harlem's famous Apollo Theater. He also recorded several singles for Capitol Records during this period, including "On the Sunny Side of the Street," his own compositions "Blue Eyed Sally" and "I'd Rather Be a Hummingbird," and the timely tunes "Television Blues" and "The Atom Bomb Blues." However, Crothers finally refused to play Las Vegas after again encountering segregation there in the early 1950s. In the late 1950s, he continued to make several television appearances and released an album titled *Rock and Roll with Scatman* for High Fidelity Records. In 1957 he began traveling overseas with the USO, where he met Bob Hope and developed a strong interest in golf.

Throughout the 1960s, Crothers traveled and performed in television and film. Though he did not participate directly in the civil rights movement, he continued to break down barriers, and in 1967 he was the first black entertainer to appear at the Forge in Glendale, California. He appeared in the films *Hello Dolly!* (1969) and *The Great White Hope* (1970), and in 1970 he was featured as the swinging Scat Cat in Walt Disney's *The Aristocats*. This role led to more vocal work, including the voice of Meadowlark Lemon in various children's television movies featuring the animated Harlem Globetrotters (1970–1972) and the title character of *Hong Kong Phooey* (1974–1976).

In the 1970s, when black actors began to gain more opportunities, he appeared as Big Ben in *Lady Sings the Blues* (1972), the gangster Lewis in *The King of Marvin Gardens* (1972), and Turkle in *One Flew Over the Cuckoo's Nest* (1975). He finally achieved fame in his role as Louie on NBC's television series *Chico and the Man* (1974–1977), which showcased his optimism and genial humor. His participation in the controversial animated feature *Coonskin* (1975) and his turn as a Pullman porter in *Silver Streak* (1976) raised accusations of "Uncle Tomism" during a time of elevated racial consciousness, but his life-long refusal to bow to racism and his role as Mingo in the miniseries *Roots* (1976) belied this.

Crothers's appearances in increasingly complex roles suggested that he was becoming as skilled an actor as he was a musician, and he welcomed parts of many different kinds. He merged his talents in 1978 in his touring revue, *The Scatman Crothers Show*, and continued to appear on television variety shows and in celebrity golf tournaments. His reputation as a strong character actor with a charismatic screen presence was established further in 1980 in his role in Stanley Kubrick's *The Shining* (1980), for which he won Best Supporting Actor from the Academy of Science Fiction, Fantasy and Horror Films and an NAACP Image Award, and as the MC Doc Lynch in Clint Eastwood's *Bronco Billy* (1980). In 1981 he was honored with a star on the Hollywood Walk of Fame, and he continued to perform on television and in film for the next few years, most notably in Steven Spielberg's segment in *Twilight Zone: The Movie* (1983). Scatman Crothers died of cancer in Van Nuys, California, after a lifetime of musical performances, appearances in forty-six films and more than eighty-four television programs, and as the voice of many popular cartoon characters. For many, his life exemplified faith, optimism, and the courage to ignore or overcome racial barriers. He was posthumously inducted into the Black Filmmakers Hall of Fame in 1987.

FURTHER READING

Haskins, Jim. *Scatman: An Authorized Biography of Scatman Crothers* (1991).

"Scatman Crothers: After 50 Years in Show Biz, an 'Overnight' Success," *Ebony* (July 1978).

Obituary: "Scatman Crothers Dies at 76; Actor Got Start in Speakeasies," *New York Times*, 23 Nov. 1986.

JILL SILOS

CULLEN, Countée

(30 May 1903?–9 Jan. 1946), poet and playwright, was the son of Elizabeth Thomas Lucas. The name of his father is not known. The place of his birth has been variously cited as Louisville, Kentucky, New York City, and Baltimore, Maryland. Although in later years Cullen claimed to have been born in New York City, it probably was Louisville, which he consistently named as his birthplace in his youth and which he wrote on his registration form for New York University. His mother died in Louisville in 1940.

In 1916 Cullen was enrolled in Public School Number 27 in the Bronx, New York, under the name of Countee L. Porter, with no accent on the first "e." At that time he was living with Amanda Porter, who generally is assumed to have been his grandmother. Shortly after she died in October 1917, Countee went to live with the Reverend FREDERICK

ASHBURY CULLEN, pastor of Salem Methodist Episcopal Church in Harlem, and his wife, the former Carolyn Belle Mitchell. Countee was never formally adopted by the Cullens, but he later claimed them as his natural parents and in 1918 assumed the name Countée P. (Porter) Cullen. In 1925 he dropped the middle initial.

Cullen was an outstanding student in every school he attended. He entered the respected, almost exclusively white, Dewitt Clinton High School for boys in Manhattan in 1918. He became a member of the Arista honor society, and in his senior year he received the Magpie Cup in recognition of his achievements. He served as vice president of the senior class and was associate editor of the 1921 *Magpie*, the school's literary magazine, and editor of the *Clinton News*. He won an oratorical contest sponsored by the film actor Douglas Fairbanks and served as treasurer of the Inter-High School Poetry Society and as chairperson of the Senior Publications Committee. His poetry appeared regularly in school publications and he received wider public recognition in 1921 when his poem, "I Have a Rendezvous with Life," won first prize in a citywide contest sponsored by the Empire Federation of Women's Clubs. At New York University, which Cullen attended on a New York State Regents scholarship, he was elected to Phi Beta Kappa in his junior year and received a bachelor's degree in 1925. His poems were published frequently in the school magazine, *The Arch*, of which he eventually became poetry editor. In 1926 he received a master's degree from Harvard University and won the *Crisis* magazine award in poetry.

When Cullen's first collection of poetry, *Color*, was published in 1925 during his senior year at New York University, he had already achieved national fame. His poems had been published in *Bookman*, *American Mercury*, *Harper's*, *Century*, the *Nation*, *Poetry*, the *Crisis*, the *Messenger*, *Palms*, and *Opportunity*. He had won second prize in 1923 in the Witter Bynner Undergraduate Poetry Contest sponsored by the Poetry Society of America. He placed second in that contest again in 1924 but won first prize in 1925, when he also won the John Reed Memorial Prize awarded by *Poetry* magazine.

Color received universal critical acclaim. ALAIN LOCKE wrote in *Opportunity*: "Ladies and Gentlemen! A genius! Posterity will laugh at us if we do not proclaim him now. COLOR transcends all of the limiting qualifications that might be brought

forward if it were merely a work of talent" (Jan. 1926). The volume contains epitaphs, only two of which could be considered racial; love poems; and poems on other traditional subjects. But the significant theme—as the title implies—was race, and it was the poems dealing with racial subjects that captured the attention of the critics. Cullen was praised for portraying the experience of African Americans in the vocabulary and poetic forms of the classical tradition but with a personal intimacy. His second volume of poetry, *Copper Sun*, published in 1927 also by Harper and Brothers (the publisher of all his books), won first prize in literature from the Harmon Foundation. There are fewer racial poems in this collection than in *Color*; however, they express an anger that was not so pronounced in the earlier volume. The majority of the poems in *Copper Sun* deal with life and love and other traditional themes of nineteenth-century poetry.

Cullen edited the October 1926 special issue of *Palms* devoted to African American poets, and he collected and edited *Caroling Dusk* in 1927, an anthology of poetry by African Americans. Cullen was by this time generally recognized by critics and the public as the leading literary figure of the Harlem Renaissance. Gerald Early in *My Soul's High Song* (1991) said, "He was, indeed, a boy wonder, a young handsome black Ariel ascending, a boyish, brown-skinned titan who, in the early and mid-twenties, embodied many of the hopes, aspirations, and maturing expressive possibilities of his people."

Cullen said that he wanted to be known as a poet, not a "Negro poet." This did not affect his popularity, although some Harlem Renaissance writers, including LANGSTON HUGHES, interpreted this to mean that he wanted to deny his race, an interpretation endorsed by some later scholars. A reading of his poetry reveals this view to be unfounded. In fact his major poems, and most of those still being printed in anthologies, have racial themes. Cullen expounded his view in the *Brooklyn Eagle* (10 Feb. 1924):

If I am going to be a poet at all, I am going to be POET and not NEGRO POET. This is what has hindered the development of artists among us. Their one note has been the concern with their race. That is all very well, none of us can get away from it. I cannot at times. You will see it in my verse. The consciousness of this is too poignant at times. I cannot escape it. But what I

mean is this: I shall not write of negro subjects for the purpose of propaganda. That is not what a poet is concerned with. Of course, when the emotion rising out of the fact that I am a negro is strong, I express it. But that is another matter.

From 1926 to 1928 Cullen was assistant editor to CHARLES S. JOHNSON of *Opportunity* (subtitled "A Journal of Negro Life"), for which he also wrote a feature column, "The Dark Tower." On the one hand, in his reviews and commentaries, he called upon African American writers to create a representative and respectable race literature, and on the other insisted that the African American artist should not be bound by race or restricted to racial themes.

The year 1928 was a watershed for Cullen. He received a Guggenheim Fellowship to study in Paris, the third volume of his poetry, *The Ballad of a Brown Girl*, was published, and, after a long courtship, he married Nina Yolande Du Bois. Her father, W. E. B. DU BOIS, the exponent of the "Talented Tenth" concept, rejoiced at bringing the young genius into his family. The wedding, performed by Cullen's foster father, was the social event of the decade in Harlem. After a brief honeymoon in Philadelphia, Cullen left for Paris and was soon joined by his bride. The couple experienced difficulties from the beginning. Finally, after informing her father that Cullen had confessed that he was sexually attracted to men, Nina Yolande sued for divorce, which was obtained in Paris in 1930.

Cullen continued to write and publish after 1928, but his works were no longer universally acclaimed. *The Black Christ and Other Poems*, completed under the Guggenheim Fellowship, was published in 1929 while he was abroad. His only novel, *One Way to Heaven*, was published in 1932, and *The Medea and Some Poems* in 1935. He wrote two books for juveniles, *The Lost Zoo* (1940) and *My Lives and How I Lost Them* (1942). His stage adaptation of *One Way to Heaven* was produced by several amateur and professional theater groups but remained one of his several unpublished plays. Critics gave these works mixed reviews at best.

Cullen's reputation as a writer rests on his poetry. His novel is not an important work, and it received little attention from the critics. He rejected so-called jazz and free-style as inappropriate forms of poetic expression. He was a romantic lyric poet and a great admirer of John Keats and Edna St. Vincent Millay.

While his arch traditionalism and lack of originality in style had been seen in *Color* as minor flaws, they came to be viewed as major deficiencies in his later works.

Cullen's fall from grace with the critics had little effect on his popularity. He remained much in demand for lectures and readings by both white and black groups. In 1931 alone he read his poetry and lectured in various institutions in seventeen states and Canada. Some of his poems were set to music by Charles Marsh, Virgil Thomson, William Schuman, William Lawrence, Margaret Bonds, and others. However, even though he continued to live with his foster father, royalties and lecture fees were insufficient income for subsistence. He searched for academic positions and was offered professorships at Sam Huston College (named for an Iowa farmer, not the Texas senator), Dillard University, Fisk University, Tougaloo College, and West Virginia State College. There is no clear explanation of why he did

Countée Cullen in Central Park, 1941. (Library of Congress.)

not accept any of the positions. In 1932 he became a substitute teacher in New York public schools and became a full-time teacher of English and French at Frederick Douglass Junior High School in 1934, a position he held until his death (caused by complications of high blood pressure) in New York City, and where he taught and inspired the future novelist and essayist JAMES BALDWIN.

Cullen married Ida Mae Roberson in 1940, and they apparently enjoyed a happy married life. Cullen's chief creative interest during the last year of his life was in writing the script for *St. Louis Woman*, a musical based on ARNA BONTEMPS's novel *God Sends Sunday*. With music by Harold Arlen and lyrics by Johnny Mercer, *St. Louis Woman* opened on Broadway on 30 March 1946. Although the production was opposed by WALTER WHITE of the National Association for the Advancement of Colored People and some other civil rights activists as an unfavorable representation of African Americans, it ran for four months and was revived several times by amateurs and one professional group between 1959 and 1980.

On These I Stand, a collection of poems that Cullen had selected as his best, was published posthumously in 1947. The 135th Street Branch of the New York Public Library was named for Cullen in 1951, and a public school in New York City and one in Chicago also bear his name. For a few brief years Cullen was the most celebrated African American writer in the nation and by many accounts is considered one of the major voices of the Harlem Renaissance.

FURTHER READING

Countée Cullen's personal papers are in the Amistad Research Center at Tulane University and the James Weldon Johnson Collection in Beinecke Library at Yale University.

Early, Gerald, ed. *My Soul's High Song: The Collected Writings of Countee Cullen, Voice of the Harlem Renaissance* (1991).

Ferguson, Blanche E. *Countee Cullen and the Negro Renaissance* (1966).

Perry, Margaret. *A Bio-Bibliography of Countée P. Cullen, 1903–1946* (1971).

Shucard, Alan R. *Countee Cullen* (1984).

Obituaries: *New York Herald Tribune*, 10 Jan. 1946; *New York Times*, 10 and 12 Jan. 1946; *Negro History Bulletin* 14 (Feb. 1946): 98.

CLIFTON H. JOHNSON

CULLEN, Frederick Ashbury

(1868–25 May 1946), minister and Harlem civil rights leader, was born in Fairmount (Somerset County), Maryland, the son of Isaac and Emmeline Williams Cullen, who had been slaves. The youngest of eleven children, Cullen grew up in poverty, his father having passed away two months after his birth. He moved to Baltimore with his mother at age twelve and worked for a physician while attending Maryland State Normal School (later Towson University). He then taught public school in Fairmount for two years before entering Morgan College (later Morgan State University), an Episcopalian seminary in Baltimore; between his first and second year of studies, he also worked as a waiter in Atlantic City, New Jersey. He had received a preacher's license while in Fairmount and was ordained in 1900.

Cullen's religious awakening had taken place in September 1894, at Sharp Street Methodist Episcopal Church in Baltimore, and he had preached his first sermon at Fairmount Centennial Methodist Church. His first assignment consisted of a two-church circuit, Boyer's Chapel and Willis's Chapel, in Catlin, Maryland. Although the Catlin church board initially objected to his appointment, deeming him too young for the job, he ultimately earned its approval, successfully leading the parish from 1900 to 1902. His achievements included improving the parish finances, initiating a music program, and effecting a degree of reconciliation between his two congregations (the two chapels represented factions that had formed during a trustees' dispute prior to Cullen's hiring). The superintendent of his district then intended to transfer him to a church in Pennsylvania, but the bishop reassigned him to St. Mark's Church, a predominantly black congregation in New York City. The last-minute reassignment brought Cullen to the city where he would work and reside for the rest of his life.

As an assistant to senior pastor William H. Brooks, Cullen was asked to tend to "Salem Chapel," St. Mark's storefront mission in Harlem, New York. On his first day as its pastor, 20 April 1902, he preached to an audience of three women, and the collection netted a total of nineteen cents. Aided by the New York City Church Extension and Missionary Society, Cullen expanded his congregation by focusing on Sunday-school recruitment, befriending local children by participating in their games

and favoring them with sweets. As the children became involved with his church, so, too, did their parents.

In August 1902 the mission moved to a house on 124th Street. Despite hostile neighbors and a February 1904 fire, the Salem church flourished, and it was promoted to independent status in 1908. The congregation then relocated to a property at Lenox Avenue and 133d Street, where it resided until 1924. Later Salem took possession of a West Harlem edifice formerly occupied by predominantly white Calvary Methodist Episcopal Church. During the early 1920s Salem Methodist Episcopal Church counted over twenty-five hundred names on its rolls (with a youth group of over two hundred members) and was solidly established as one of Harlem's largest and most influential institutions.

During a vacation in 1906 or 1907, Cullen was introduced to Carolyn Belle Mitchell, a soprano and pianist based in Baltimore. After a short engagement they were married at Salem, and she assisted him with his duties there until her death in 1932. The Cullens were childless until they unofficially adopted a teenager named Countée Porter sometime prior to 1919. As COUNTÉE CULLEN, the boy became a prominent lyric poet and a star of the Harlem Renaissance.

Frederick Cullen enjoyed a close relationship with his son, who composed at least two poems in his honor ("Fruit of the Flower" and "Lines for My Father, Dad"); an enthusiastic traveler, the elder Cullen relished their annual joint visits to Europe and the Middle East between 1926 and 1939. Their family became ranked among Harlem's cultural elite, and Countée Cullen's 1928 wedding (to Yolande Du Bois, daughter of W. E. B. DU BOIS) was a social extravaganza with a guest list of twelve hundred.

At the height of his career, Frederick Cullen was regarded as a major force in the black community. His ministries paired evangelistic fervor with initiatives for social justice and extracurricular programs for Harlem children. By the time of Cullen's retirement, the church offered more than three dozen activities and clubs for young people; the most prominent of these was the Salem Crescent Athletic Club, whose alumni included champion boxer Sugar Ray Robinson. The church also raised tuition funds for a number of its youths, sending them to schools such as Atlanta's Gammon Theological Seminary, which awarded Cullen an honorary doctorate. In addition, Cullen battled crime through strategies such as visiting brothels incognito, subsequently badgering their proprietors with the observations he had collected in order to pressure them toward more seemly business practices. Cullen also supported the development of the National Urban League, a merger of three smaller social service agencies into a single, substantially more effective organization.

Cullen also provided counsel to the founders of churches such as Epworth Methodist Episcopal, and his church hosted the "World Gospel Feast" parties led by the charismatic and controversial George W. Becton. A fierce believer in interdenominational cooperation, Cullen worked closely with other powerful religious leaders such as ADAM CLAYTON POWELL SR. (head of Abyssinian Baptist) and Hutchens C. Bishop (rector of St. Philip's Protestant Episcopal) during his tenure as president of the Harlem branch of the NAACP, this branch having been established in 1910. Under his watch, the chapter grew to more than one thousand members; its accomplishments included successfully petitioning the New York City government to appoint its first African American policeman, Samuel J. Battle (later New York's first African American sergeant, lieutenant, and parole commissioner) in 1911. With other NAACP leaders, he organized protest demonstrations and raised legal aid funds for cases such as that of the SCOTTSBORO BOYS.

Cullen led his church for four decades, until ill health forced him to step down. According to his autobiography, he retired on 14 April 1942, but other records cite 1943 or 1944 as the year in question. Cullen outlived both his wife and son, dying at home in New York City at the age of seventy-eight.

FURTHER READING

Cullen, Frederick Ashbury. *From Barefoot Town to Jerusalem* (n.d.).

Early, Gerald. Introduction to *My Soul's High Song: The Collected Writings of Countée Cullen, Voice of the Harlem Renaissance* (1991).

Faturoti, Ambrose Olumuyiwa. "Church Leadership in Harlem: Responsibility and Discernment," in *Renaissance Collage* (2004), available online at http://xroads.virginia.edu/~MA03/faturoti/harlem/.

Powers, Peter. "'The Singing Man Who Must Be Reckoned With': Private Desire and Public

Responsibility in the Poetry of Countée Cullen," *African American Review* 34.4 (Winter, 2000).

Obituary: New York Times, 27 May 1946.

PEG DUTHIE

CUMBO, Marion

(1 Mar. 1899–17 Sept. 1990), cellist, was born in New York City. Cumbo was inspired to pursue music by the careers of the great cellist Pablo Casals and the violinist and black musical comedy composer WILL MARION COOK. He was educated in the city's public schools as well as at the Martin-Smith School of Music, where he became a protégé of Minnie Brown, and at the Institute of Musical Art (later the Juilliard School of Music), where he studied with Willem Willeke. He also studied with Leonard Jeter and Bruno Steindl in Chicago, Illinois. In 1920 Cumbo received special recognition as a featured soloist at the annual convention of the National Association of Negro Musicians in New York.

During the 1920s Cumbo became a part of the Negro String Quartet, with Felix Weir as first violinist, Arthur Boyd as second violinist, HALL JOHNSON as violist, and Cumbo as cellist. They originally played informally in homes two or three times a week, rehearsing Mozart, Haydn, and Beethoven quartets. Later they performed concerts in New York, Washington, D.C., and Philadelphia, where they appeared with singer MARIAN ANDERSON. The quartet also accompanied singer ROLAND HAYES in a Carnegie Hall recital rendering of Negro spirituals arranged by Johnson. Cumbo expressed the desire to show that blacks could be identified with high art instead of high crime as usually portrayed in the media.

Cumbo worked in both concert and theatrical venues. He was a soloist with the Philadelphia Concert Orchestra, a black symphonic group founded in 1905 with Gilbert Anderson as its conductor. In the late 1940s he performed with the African American musical director Everett Astor Lee's Cosmopolitan Little Symphony, and in the 1970s he played with the Senior Musicians' Orchestra of AFM Local 802. During the interims he performed in the pit orchestras for the Midnight Frolics revue at the Amsterdam Theatre (1919) and in the 1922–1924 touring company of NOBLE SISSLE and EUBIE BLAKE's Broadway musical *Shuffle Along*.

Other Broadway productions in which he performed were the *Chocolate Dandies* of 1924, *Brown Buddies* of 1930, *Blackbirds* of 1938, and *Hot Mikado* of 1939. He also played in various vaudeville shows and appeared with both the Johnson and the EVA ALBERTA JESSYE choral ensembles.

Cumbo came of age as a "New Negro" striving for equal access to the symphonic stage. To address this dilemma he became a part of a racially inclusive ensemble known as the Symphony of the New World (1964–1978). Lee led his nearly half-black orchestra into performances of the European works of Brahms, Mendelssohn, and Saint-Saëns, as well as the African American works of WILLIAM GRANT STILL, Howard Swanson, and Ulysses Simpson Kay. To provide more performing opportunities for black symphonic players, Cumbo and his impresario wife, Clarissa Burton Cumbo, established Triad Presentations in 1970, which presented annual concerts at Alice Tully Hall. Cumbo represented a pioneering artist who bridged the concert and theatrical worlds while enhancing the performing status and opportunities for blacks in America.

MARVA GRIFFIN CARTER

CUNEY-HARE, Maud

(16 Feb. 1874–14 Feb. 1936), musician, author, and educator, was born Maud Cuney in Galveston, Texas, to NORRIS WRIGHT CUNEY, a prominent Republican politician and entrepreneur, and Adelina Dowdie Cuney, a public school teacher, soprano vocalist, and community activist. Both of Cuney's parents were born slaves of mixed racial parentage, and both gained freedom, education, social clout, and considerable financial advantage as the acknowledged offspring of their fathers. This, in addition to Norris Wright Cuney's political success with the Texas Republican Party, situated the Cuney family solidly among the Texan black elite. Cuney describes her early home life as one that was comfortable and markedly pleasant, and she praises both of her parents for instilling in her and in her younger brother, Lloyd Garrison Cuney, the values of education, racial pride, and social obligation.

Following her graduation from Central High School in 1890, Cuney moved to Boston, Massachusetts, where she enrolled in the New England Conservatory of Music. Her major was the pianoforte, though she was an eclectic musician whose talents included voice and violin. At the conservatory, Cuney studied under such renowned instructors as Edwin Klahre, Martin Roeder, and Edwin

Ludwig. In addition to music, Cuney showed great promise and interest in the literary and dramatic arts. After completing her musical studies at the conservatory, Cuney enrolled at the Lowell Institute of Harvard University, where she studied English literature.

In Boston, Cuney met the city's intellectual and social black elite. She was a regular member of a prestigious social group known as the Charles Street Circle (or the West End Set), whose members included Josephine St. Pierre Ruffin and W. E. B. DU BOIS. For a brief time, Cuney and DuBois were engaged to be married. Although the engagement dissolved, the two remained lifelong friends and collaborators in intellectual, artistic, and activist pursuits.

In 1898 Cuney married J. Frank McKinley, a physician more than twenty years her senior. The two relocated to Chicago, where McKinley, who was biracial, hoped for them to "pass" as a Spanish American couple. In 1900 Cuney gave birth to a daughter, Vera, who indeed was identified as a Spanish American on her birth certificate. Disputes over the ethics of passing caused strife in the McKinley marriage. Despite her temporary compliance, Cuney was staunchly opposed to passing. In 1902, McKinley filed for divorce and won custody of Vera.

After the divorce, Cuney returned to Boston, where in 1904 she married William Parker Hare, a descendant of a moneyed family of Boston's black elite. At this point, she changed her surname to Cuney-Hare, and it was under this name that the majority of her professional work would be acknowledged.

In Boston, Cuney-Hare resumed her musical career, performing publicly as a pianist and delivering lectures on literature and music of the African diaspora. Cuney-Hare regularly collaborated with William Howard Richardson, a Canadian-born baritone vocalist who shared her interest in the origins and trajectories of the music of the African diaspora. They performed together for more than twenty years, touring domestically and abroad.

Cuney-Hare's flourishing musical career did not coincide with an abatement of her social or political initiatives. In 1907 she was among the first women to join the antisegregationist Niagara Movement, the forerunner to the National Association for the Advancement of Colored People (NAACP).

In 1910, when W. E. B. Du Bois launched the NAACP's charter publication, the *Crisis: A Record of the Darker Races*, Cuney-Hare became its musical editor. In later years, when her eclectic career and exhausting performance schedule prevented her from continuing in this full-time position, Cuney-Hare contributed to the publication by submitting articles and reviews.

In 1913, the Crisis Publishing Company published Cuney-Hare's first full-length text, a biography of her father called *Norris Wright Cuney: A Tribune of the Black People*. Though sentimental, Cuney-Hare's work was thoroughly researched and provided both personal insight to and a documented account of an important if often overlooked historical figure. In 1918, Cuney-Hare edited an anthology of poems titled *The Message of the Trees: An Anthology of Leaves and Branches*. The compilation celebrated the place of nature and beauty in the human world. It included a broad range of poets, both men and women, canonical and obscure, and of both British and American nationality. Uncharacteristically for Cuney-Hare, only one black poet's work (PAUL LAURENCE DUNBAR's "The Haunted Oak") was included in the extensive survey. She dedicated the book to her daughter, Vera, who had died after a long illness in 1908.

Cuney-Hare saw the arts as integral to the project of racial uplift, and in 1926 she used private funds to found the Allied Arts Centre, a nonprofit, community-based organization in Boston. The center facilitated a number of art, music, and drama groups and housed a small theater (aptly named the Little Theatre) as well. While predominantly African American in its constituency, the Allied Arts Centre was explicitly an inclusive interracial organization, founded on the principle of combating racial prejudice through conscientious artistic work. Cuney-Hare's contributions to the center were practical as well as financial and conceptual. She served as managing director of the center, in addition to which she lectured, gave recitals, and produced plays.

With the Little Theatre of the Allied Arts Centre in mind, Cuney-Hare wrote the script for her play, *Antar of Araby*, in 1929. The play told a romantic tale of the historical Arab/Abyssinian slave poet Antar, whose valor outshines and disproves presuppositions ascribed to his color. According to Cuney-Hare's stage directions, Antar "must be of dark complexion, but [give] an impression of

wealth and magnificence" (34). In 1930, a year after its publication and first performance, *Antar* was anthologized in WILLIS RICHARDSON's *Plays and Pageants from the Life of the Negro*.

Cuney-Hare's lifetime of scholarly and artistic work culminated in 1936 with her final publication, a comprehensive musical anthropology called *Negro Musicians and Their Music*. Identifying such elements as ritual, dance, mysticism, and entertainment as valid and integral components of musical production, Cuney-Hare validated Afrocentric trends and influences in the musical arts and reclaimed a legitimate space for people of African descent within discourses of "high art." The book drew upon Cuney-Hare's extensive primary research from a number of countries and territories, including Mexico, the Virgin Islands, Puerto Rico, and Cuba. Musical scores, photographs, and artistic reproductions were included at length alongside her narrative analyses. Unfortunately, Cuney-Hare died on 14 February 1936, of a cancerous tumor, just before the final proofs for *Negro Musicians* were sent to the publisher. Despite the general approval and critical acclaim given *Negro Musicians*, sales were low, and the book soon became obscure. Later critics attributed this failure to a number of causes, including posthumous publication and the continuing economic effects of the Depression (Hales, 137).

Though most remembered as a musician, Cuney-Hare excelled in a number of careers and was an influential and visionary figure in African American history. Various themes from Cuney-Hare's life and writing—from the idea of diasporic continuity (as in *Negro Musicians*) to the celebration of the black body as beautiful (as in *Antar*) to the empowering potential of a community art forum—foreshadowed social, academic, and artistic movements that would more fully flourish in the latter half of the twentieth century. In the late 1990s, both *Norris Wright Cuney* and *Negro Musicians* were "rediscovered" and republished as part of Henry Louis Gates Jr.'s series devoted to African American women writers from 1910 to 1940.

FURTHER READING

A noteworthy collection of Maud Cuney-Hare's original sheet music is available at Clark Atlanta University Special Collections, and a series of her "Music and Art" columns appear in the *Crisis: A Record of the Darker Races*, in issues dating between 1910 and 1935.

Du Bois, W. E. B. *The Autobiography of W. E. B. Du Bois: A Soliloquy on Viewing My Life from the Last Decade of Its First Century* (1968).

Gatewood, Willard B. *Aristocrats of Color: The Black Elite, 1880–1920* (1993).

Hales, Douglas. *A Southern Family in White and Black: The Cuneys of Texas* (2003).

Hunter, Tera W. "Introduction," in *Norris Wright Cuney: A Tribune of the Black People*, by Maud Cuney-Hare, 2d ed. (1995).

Love, Josephine Harreld. "Introduction," in *Negro Musicians and Their Music*, by Maud Cuney-Hare, 2d ed. (1996).

Woodson, Carter G. "The Cuney Family," in *The Negro History Bulletin* 11, no. 6 (Mar. 1948).

AIDA AHMED HUSSEN

DABNEY, Ford

(15 Mar. 1883–21 June 1958), songwriter and bandleader, was born Ford Thompson Dabney in Washington, D.C., to a musical family. Both his father and an uncle, the renowned WENDELL P. DABNEY, were professional musicians. Dabney studied first with his father, then with Charles Donch, William Waldecker, and Samuel Fabian. In 1904 he traveled to Haiti where he was retained as court pianist to President Noro Alexis, remaining in that post until 1907. On his return to the United States he resettled in Washington where he became the proprietor of a vaudeville and motion picture theater. He also organized touring companies, including Ford Dabney's Ginger Girls, which toured in African American vaudeville. Two members of this troupe, Lottie Gee and Effie King, became well-known entertainers in their own right.

The precise beginnings of Dabney's work as a composer are difficult to pin down with any precision. His catalog of original works is small, and he generally worked as half of a team with another composer. Dabney co-wrote "That Minor Strain" in 1910 with CECIL MACK. His other works included "Oh You Devil" and "Porto Rico" (both instrumentals). However, his major composition during these years was "(That's Why They Call Me) Shine" (1910, with lyrics by Cecil Mack and Lew Brown), a remarkable comic song that became a standard. Among the many fine performances of the song in later years was one by the vaudevillian JOHN BUBBLES (real name John Sublett) in the film *Cabin in the Sky*.

Dabney's original material is probably what first brought him to the attention of JAMES REESE EUROPE, and he was featured in Clef Club concerts from the outset of that illustrious organization's history in 1910. In 1913 Dabney moved permanently to New York City, where he soon became associated with the Tempo Club, the rival to the Clef Club. In this venture Dabney worked very closely with Europe, who had resigned from the Clef Club in a schism at the end of 1913. Together Europe and Dabney soon dominated dance music in New York through their close association with

Vernon and Irene Castle, who revolutionized social dance in New York, the United States at large, and even London and Paris. Europe and Dabney wrote much of their dance repertoire, at least eight numbers of which were published. These included "The Castle Walk," "Castle Maxixe," "Castle Perfect Trot," "Castles' Half and Half," "The Castle Combination," "Castle Innovation Tango," "Castle Lame Duck Waltz," and "Enticement: An Argentine Idyll." As a joke, and to provide a bit of variety, the sheet music for this last number named the composers as "Eporue and Yenbad." All of these pieces appeared in the spring of 1914, published by the New York firm of Joseph Stern. Dabney, Europe, and the Castles were now at the very pinnacle of the entertainment world.

World War I broke up this highly productive aggregation. Vernon Castle enlisted in order to aid his British homeland in the war effort and was killed on a training flight in 1917. Europe led a highly acclaimed military band in France and returned to America in triumph in 1919, but he was murdered shortly thereafter. Dabney played a featured role among the musicians in Europe's funeral procession. During the Tempo Club years he had found a niche as a bandleader in Times Square. He organized a dance band to play the "midnight frolics" at the roof garden of Florenz Ziegfeld's New Amsterdam Theater, a job he held for eight years, ending only in the 1920s. The personnel of this band was highly stable, and it included some of the finest talent of the period in which ragtime gradually gave way to the new strains of jazz. Among these performers were the renowned cornetist "Cricket" Smith and a number of the other musicians featured in the bands of James Reese Europe. For several summers this ensemble played at the Palais Royale in Atlantic City during the hot summer months.

Ford Dabney recorded all of his known sides from 1917 to 1922, most of them for the Aeolion Vocalion label. In addition to the dance band recordings (in a prejazz ragtime style) Dabney recorded a number of sides with a standard military band, and with that aggregation his work was further still from the incipient jazz ideal. However, there are interesting modern touches in the dance band recordings, which feature some of the leading African American soloists of the World War I era, such as the cornetist Smith. The best of these players were veterans of Dabney's long-term residency as the New Amsterdam Theater roof garden. Apart

from Smith and Dabney himself (on piano), the capable personnel included Allie Ross, an important Harlem player in both classical and popular music for several decades, on violin. Dabney claimed in an interview some years later that the band personnel consisted of cornet, trombone, clarinet, saxophone, piano, bass (doubling tuba), and drums. However, on listening to these recordings it is evident that there are additional brass players on many tracks and also one or more flutes (doubling piccolo), multiple violins, banjo(s), and possibly sometimes mandolin.

The repertoire on the Dabney recordings closely follows the records of his better-known contemporaries, such as James Reese Europe and the white vaudeville bands of the period. Pieces like SHELTON BROOKS's "Darktown Strutters' Ball" are featured. Among the medleys is "How You Gonna' Keep 'Em Down on the Farm" (also recorded by Europe), in which the title tune is merely the opening and closing strain on a recording that diverges in the middle to include a diverse range of alternate material including "My Bonnie Lies over the Ocean." This mix-and-match format was facilitated by Vocalion's innovative "close groove" technology for cutting 78-rpm records, which made for longer playing time.

In the latter part of his career, after 1923, Dabney was less active as a composer than as a performer and entrepreneur. He ran an entertainment bureau, booking the acts of other performers, and also continued to perform himself, usually in resorts beyond the confines of New York City: Newport, Rhode Island, in summer, and Palm Beach and Miami, Florida, in winter. In 1927 the F. E. Miller and Aubrey Lyles show *Rang Tang* featured a number of songs by Dabney (music) and Jo Trent (words). In addition to the title song, these included "Brown," "Harlem," "Jungle Rose," "Monkey Land," "Sambo's Banjo," "Sammy and Topsy," "Summer Nights," and "Zulu Fifth Avenue." None of these songs became standards of the jazz age. However, Ford Dabney had played a crucial role in African American music in the first two decades of the twentieth century, as both a composer and a bandleader. He was a resident of Harlem at the time of his death in 1958 at the age of seventy-five.

FURTHER READING

ASCAP *Biographical Dictionary of Composers, Authors, and Publishers* (1952).

Badger, Reid. *A Life in Ragtime* (1995).

Brooks, Tim. *Lost Sounds: Blacks and the Birth of the Recording Industry, 1890–1919* (2004).

Obituary: New York Times, 23 June 1958.

ELLIOTT S. HURWITT

DAFORA, Asadata

(4 Aug. 1890–4 Mar. 1965), singer, dancer, and choreographer, was born John Warner Dafora Horton in Freetown, Sierra Leone. Little is known of his parents, but both were part of the prominent black elite in colonial society. Dafora's great-great-grandfather was the first black man to be knighted by Queen Victoria and the first black mayor of Sierra Leone. Dafora's parents, moreover, met in England, while his father was studying at Oxford and his mother studying the piano. Dafora received a British education at the local Wesleyan School in Freetown and went on to study music and dance in Italy and Germany.

Dafora's career took off after he moved to New York City in 1929, traveling with a troupe of African dancers. His first years in New York were rather unremarkable, however, and there is little evidence of Dafora's influence on the theatrical scene during this period. But that soon changed with Dafora's production of *Kykunkor* (Witch Woman) in 1934, the theatrical event of the season. The show had languished until it received critical notice in the *New York Times* from John Martin, the dance critic, on 9 May 1934. After Martin's glowing account, 425 people appeared at the theater that evening, 200 of whom had to be turned away. The large crowds continued, forcing the show to move to a bigger theater at City College and eventually reopen in other venues around town as the show sold out from May to August, almost all of its unplanned run.

Kykunkor told the story of a wedding ritual in West Africa in which a jealous rival of the groom employs Kykunkor to cast a death spell on the groom, who is eventually saved by a witch doctor. Full of drama and celebration, the conventional story of love and jealousy gained its allure from witches, spells, and elaborate ceremonies. The story also served as a showpiece for vibrant group dances and pantomime solos, all accompanied by vigorous drumming and singing. Eighteen men and women, some African, some African American, in colorful costumes, dancing to live music, created quite a visual feast.

Many audience members viewed the production as a concert direct from the jungle. Leading artists and intellectuals of the time, including George Gershwin, Sherwood Anderson, Theodore Dreiser, and Carl Van Vechten, populated the audience, seeking an authentic experience of "primitive" Africa. The souvenir program following the production went so far as to claim that *Kykunkor* impressed even scientists and explorers as a rare, truthful vision of Africa. James Chapin, curator of the American Museum of Natural History, declared, "Never outside of Africa have I ever seen or heard anything so typically Ethiopian. . . . The drum rhythms and most of the singing rang so true as to carry me back to the dark continent."

Leading African Americans also praised the authenticity of *Kykunkor*. Premiering during the final years of the Harlem Renaissance, the production received the praise of the stringent critic ALAIN LOCKE. An influential promoter of the Harlem Renaissance, Locke saw in Dafora's *Kykunkor* true African art transplanted to America. He extolled its stylistic purity and its artistry, devoid of the baseness and vulgarity that he often criticized in the cultural forms of African Americans. According to Locke, this was "primitive" art at its best, undiluted and inspirational.

Much of the stamp of authenticity came from the prominence of African dancing in the production. Vastly different from the linear and tightly held backbones of ballet and even modern dance at this time, African dance featured flat-footed stomping, isolated actions of the hips, torso, and shoulders in rhythmic patterns, and bodies bent forward from the waist on deeply bowed legs with protruding buttocks. Since many observers considered the barefoot dancing and pounding drums to be innately racial, *Kykunkor* in some sense reinforced common stereotypes of dark-skinned peoples as being close to nature, animals, and the basic functions of living, including sex.

Dafora worked within these conceptions and excelled partly because of them. *Kykunkor* established him as the prime exponent of authentic African dance. He went on to work on the Negro Theatre Unit of the Works Progress Administration's Federal Theatre Project, choreographing Orson Welles's direction of a Haitian version of *Macbeth* in 1936. He then left the Federal Theatre Project to work on his next production, *Zunguru* (1938). *Zunguru* was similar to *Kykunkor* in its use of African ritual, music, and dance, but it never achieved the success of its predecessor. In 1939 Dafora choreographed dances for PAUL ROBESON's revival of *Emperor Jones*.

Much of Dafora's reputation rested on the spectacular success of *Kykunkor*, and he was never able to recreate that achievement on stage. In the early 1940s, however, he became a noted spokesperson for the African Academy of Arts and Research, founded in 1943. The academy's purpose was to foster interest in and support of African culture, and Dafora was one of its stars. He and his troupe played a prominent role in the successful African festivals sponsored by the academy beginning in 1943. The first two festivals, in 1943 and 1945, even attracted the attendance of the First Lady Eleanor Roosevelt, who was eager to show her support of cultural events promoting racial understanding.

Dafora went on tour around the United States with his troupe in 1946–1947. Appearing at all the leading African American colleges, he carried through with his lifelong attempt to promote African culture. He had less and less opportunity to do so as he grew older, facing competition from younger dancers and choreographers such as Pearl Primus and Katherine Dunham, who creatively combined African and Caribbean rituals with American theatrics. Dafora's African "authenticity" eventually led him to make an appearance at the Great Apes House at the New York Zoological Society in June 1949, an outward indication that his trademark authenticity had become a kind of cage, restricting his creativity and narrowly marking his talents.

In 1947 Dafora created *Batanga*, another dance-drama in the tradition of *Kykunkor*, but it received little praise. He languished in the 1950s, retreating from public view. Fed up with the United States, he went back to Sierra Leone in May 1960, returning only briefly to the United States in 1962 for health reasons. The following year he returned again to Sierra Leone. He died in Harlem, New York.

FURTHER READING

Dafora's papers are at the New York Public Library's Schomburg Center for Research in Black Culture.

Emery, Lynne Fauley. *Black Dance from 1619 to Today*, rev. ed. (1988).

Long, Richard. *The Black Tradition in American Dance* (1989).

Thorpe, Edward. *Black Dance* (1989).

JULIA L. FOULKES

DAVENPORT, Charles Edward "Cow Cow"

(23 Apr. 1894–3 Dec. 1955), pianist, singer, and composer, was born Charles Edward Davenport in Anniston, Alabama, one of eight children of Queen Victoria Jacobs, a church organist, and Clement Davenport, a minister. He showed an interest in music early in childhood, teaching himself organ and briefly taking piano lessons at age twelve. At his father's urging he attended Alabama Theological Seminary (1910–1911) to train as a minister, but was later expelled for playing a march in ragtime style at a social event. Moving to Birmingham, he worked as a pianist at various venues including a club on Eighteenth Street. He then toured widely in towns in Alabama and Georgia. In 1917 he was discovered by the pianist Bob Davies and was invited to join his touring company, the "Barkroot Carnival." Working for the carnival gave Davenport a valuable range of musical and theatrical experience, including solo singing and playing, accompanying singers, and working as a comedian. Under Davies's mentorship Davenport considerably broadened his piano skills. For several years thereafter he worked as a solo act and an accompanist in vaudeville and other types of entertainment including Haeg's Circus in Macon, Georgia, where he worked for an extended period as a blackface minstrel. Around 1917 he found a job as a brothel pianist in the Storyville section of New Orleans.

Davenport married Helen Rivers in 1921, but the union was short-lived. By 1922 he had teamed with the singer Dora Carr, and the pair toured extensively on the so-called Theater Owners' Booking Association (TOBA) and other vaudeville circuits. Initially playing in the South, by 1924 they were performing at major venues in the North such as the Lincoln Theater in New York. The same year Davenport made his first recordings, two sides for Okeh of vocal duets with Carr accompanied by CLARENCE WILLIAMS on piano. These were successful, and in the following two years Okeh released eight more sides featuring the duo, most of them blues-based vaudeville-style duets in the manner of other black comedy teams of the period such as Butterbeans and Susie. Between 1925 and 1927 Davenport recorded a series of piano rolls for Vocalstyle, US Music, and QRS. Although less well known than his disc recordings, his piano rolls are an integral part of his legacy and widely admired by connoisseurs.

Davenport's partnership with Carr ended probably in 1926 when she left him for another man. By the end of the year he had formed a new partnership with the singer Ivy (or Iva) Smith, with whom he toured on the TOBA as "Davenport & Smith's Chicago Steppers." The duo recorded for the Paramount, Vocalion, and Gennett labels between 1927 and 1930. Over the same period Davenport recorded important solo sides for these labels as well as accompanying a number of singers, including the vaudevillian Hound Head Henry and the minstrel Jim Towel. A major discovery was the singer Sam Theard, whom Davenport found in Chicago and with whom he made an important series of recordings, mainly for Brunswick, during 1929–1930.

Nearly all Davenport's most important recordings were made between 1925 and 1930. Although he has often been characterized as a boogie-woogie pianist, his basic style is a potent brew of folk blues and ragtime best described as "barrelhouse." Despite its earthy origins his playing never sounds crude, but instead his style combines technical sophistication with creativity and a depth of blues feeling matched by few other pianists. An example is "Texas Shout" (Vocalion, 1929) an up-tempo, strident blues combining twelve-bar and sixteen-bar sections and featuring lightning-fast split octaves in the bass. No less impressive is Davenport's ability to sustain a slow blues. An outstanding instance is "My Own Man Blues" (Paramount, 1927) with Ivy Smith on vocal and Leroy Pickett on violin. Taken at an extremely slow, almost static, tempo, the track achieves an astonishing emotional intensity with a great economy of musical material.

A fine composer with a gift of adapting folk-based materials in a most creative manner, Davenport composed most of his important recordings. Perhaps his best known composition is "Cow Cow Blues," a rollicking barrelhouse number recorded by Davenport no less than eight times, including three times on piano roll. Originally titled "Railroad Blues," the song was later recycled as "Cow Cow Boogie," in which form it became, in 1942, a major swing-era hit (as Davenport was not credited for its composition, he sued for copyright infringement but was persuaded to settle out of court for just $500). No less important is "Mama Don't Allow," which became a jazz standard. Davenport also claimed authorship of the well-known "(I'll Be Glad When You're Dead) You Rascal You."

During the Depression Davenport organized a new act with Ivy Smith. The show toured extensively in the South; but after a promising start the show ran into trouble in Mobile. Unable to meet his costs by legitimate means, Davenport ended up in prison for six months. After his release Davenport, now broke and without work, rejoined Haeg's Circus as a minstrel and then, dispirited, went to Cleveland to live with his sister Martha. Cleveland was to become his permanent base. It was there he met his third wife, the dancer and singer Peggy Taylor. Their marriage was to last the rest of his life (his second marriage was to Iva France in the 1930s).

Davenport's career never regained its momentum after the Depression. His piano playing was compromised first by an illness in the 1930s, which Davenport described as pneumonia, then by a severe stroke in 1938, and finally by arthritis. He recorded little: just five sides for Decca in 1938 as a vocalist. For the rest of his life he performed only intermittently at New York nightspots like the Onyx Club (c. 1942) and the Stuyvesant Casino (1948), along with venues in Cleveland and elsewhere. He was for a time an editor of the magazine *Jazz Record*. He became an ASCAP member in 1946, which provided him with a small but steady income. He recorded sixteen piano sides made in 1945–1946 for the Comet, Circle, and Jazz Record labels, only eight of which were released. Around 1947 Davenport, semiretired from music, worked for the rest of his life at a Cleveland defense plant called Thomson Products. He died at his home from hardening of the arteries. Davenport's recordings from the 1920s show him as one of the finest early blues pianists, combining originality and depth of expression. It is regrettable that ill health compromised his playing at such a relatively early age.

FURTHER READING

Davenport, Cow Cow. "Mama Don't Low No Music," in *Selections from the Gutter: Jazz Portraits from The Jazz Record*, ed. Art Hodes (1977).

Evans, David. *Cow Cow Davenport Vol. 3: The Unissued 1940s Acetate Recordings,* Document DOCD-5586.

Harris, Sheldon. "Cow Cow Davenport," in *Blues Who's Who: A Biographical Dictionary of Blues Singers* (1979).

Silvester, Peter. *A Left Hand Like God: The Story of Boogie-Woogie* (1988).

PETER MUIR

DAVIS, Arthur Paul

(21 Nov. 1904–21 Apr. 1996), scholar, professor, and cultural critic, was born in Hampton, Virginia, the youngest of nine siblings in one of Hampton's most socially prominent black families. His father, Andrew Davis, born a slave, was an 1872 graduate of Hampton Institute and was the "leading plasterer and plastering contractor in Hampton" (*Negro History Bulletin*, Jan. 1950). He and his wife, Frances S. Nash, were strict disciplinarians who taught their children to refuse any form of charity during the difficult Depression era and to refuse menial job offers from whites. Davis's parents also taught him high standards of decorum, including not eating watermelon, not shelling peas on the front porch, and avoiding "emotional excesses" (for example, "shouting" in church and talking loudly), he recalled in a 1944 essay called "When I Was in Knee Pants" (47).

Davis's parents sent him to the privately funded Whittier Elementary School, which employed the stern educational traditions of New England and had a well-stocked library funded by the town of Norwich, Connecticut. In the South of 1912 a grammar school library was rare. The well-known philanthropists Francis Greenwood Peabody, George Foster Peabody, Andrew Carnegie, and BOOKER T. WASHINGTON visited Whittier on yearly tours of black schools. Other notables, including former president William Howard Taft, spoke at the school and during their visits interacted with students, events Davis recounted in his essay "I Go to Whittier School." Davis graduated from Hampton Institute in 1922. He attended Howard University for the 1922–1923 academic year in order to meet language requirements for Columbia University, which had awarded him a scholarship. From Columbia University he received a BA degree in Philosophy and election to Phi Beta Kappa in 1927, an MA in 1929, and a PhD in 1942.

Davis was the second black student to be elected to Phi Beta Kappa at Columbia University, and he attributed his high academic achievements to his concern that any "failure" meant disappointing his entire race (*Obsidian*, Winter 1978, quoted in *New Directions*, July 1980, 9). The photographer for the *New York Times* front-page article erroneously proclaimed him to be the first black Phi Beta Kappa and declined to photograph Davis upon seeing that he was too light-skinned to look like an African American in a photograph. In spite of his academic accomplishments, Davis was not

offered an assistantship or teaching position during his graduate studies at Columbia University, a slight he attributed to racism. He supported himself by working outside the university as waiter, elevator operator, settlement house worker, and summer manager of a "Negro" motel, a position from which Davis often remarked that his "real" education came. As a resident of Harlem during the flourishing of the New Negro Renaissance, he met "Negroes of all kinds and classes" and socialized with celebrated writers, artists, and intellectuals, including LANGSTON HUGHES, COUNTÉE CULLEN, WALLACE THURMAN, and ALAIN LOCKE, editor of the ground-breaking anthology *The New Negro: An Interpretation* (1925).

Davis began his teaching career as an instructor of English from 1927 to 1928 at North Carolina College in Durham. He was a professor of English at Virginia Union University in Richmond from 1929 to 1944 and a professor of graduate English for Hampton Institute Summer School from 1943 to 1949. At Howard University he was a professor of English from 1944 to 1969 and a university professor from 1969 to 1980. From 1964 until his retirement in 1980, Davis taught the nation's first graduate course in black literature at Howard University. Teachers, graduate students, and postdoctoral scholars from across the nation took the two-semester survey course, which was offered during the regular academic year and in summer sessions to meet the needs of public school teachers.

A prolific writer of essays, scholarly articles, and newspaper columns, Davis's writing career began when his valedictorian address, "The Contribution of the Individual," was published in the *Southern Workman*'s August 1922 issue. He wrote for the *Norfolk Journal and Guide* a weekly newspaper column titled "Cross Currents," later named "With a Grain of Salt," from 1933 through 1950. Davis's first major academic publication, *Isaac Watts: His Life and Works* (1943), was self-published as a requirement of earning a PhD from Columbia. However, in 1948 the biography was published in London in recognition of Watts's bicentenary and received high critical acclaim there from the *Times*' Literary Supplement, which praised its "careful scholarship" and its unprecedented achievement of placing Watts "so well in historical perspective" (*London Times*, 27 Nov. 1948).

Davis's *The Negro Caravan* (1941), coedited with STERLING A. BROWN and Ulysses Lee, received wide critical acclaim as a landmark anthology of black literature. Davis coedited *Cavalcade: Negro American Writing from 1760 to the Present* (1971) with J. SAUNDERS REDDING. This became a leading textbook in African American literature. He coedited with Joyce Ann Joyce *The New Cavalcade: African American Writing from 1760 to the Present*, Vols. I (1991) and II (1992). The second volume included an unprecedented number of black women poets. He also coedited with Michael Peplow *The New Negro Renaissance: An Anthology* and created *Ebony Harvest*, a series of twenty-six forty-five-minute radio lectures broadcast from American University radio station WAMU-FM in 1972 and 1973 and aired by approximately one-hundred public radio stations. Between 1922 and 1979 he published at least twenty-two cultural commentaries and essays for *The Crisis, Journal of Negro Education, Negro Digest, Common Ground*, and others; twenty-seven book reviews for *Opportunity, CLA Journal, Midwest Journal*, the *Washington Post*, and the *Journal of Negro History*; and thirty-five scholarly articles and essays in *Phylon*, the *CLA Journal*, and the few other venues interested in articles on black literature. His only published short story, "How John Boscoe Outsung the Devil," was published in several anthologies. While a university professor he also wrote speeches for John Cheek, at the time the president of Howard University. The recipient of numerous national and local awards, recognitions, and tributes, Davis died in Washington, D.C.

FURTHER READING
At Howard University, Washington, D.C., the Moorland-Spingarn Research Center's Reading Room contains a vertical file and card catalog entries for Davis, and the Moorland-Spingarn Manuscript Collection has several cataloged boxes of correspondence, manuscripts, and other materials by Davis.

Davis, Arthur Paul. "I Go to Whittier School," *Phylon* 21 (Summer 1960).

Davis, Arthur Paul. *Selected Black American, African, and Caribbean Authors: A Bio-Bibliography*, comps. James A. Page and Jae Min Roh (1985).

Davis, Arthur Paul. "When I Was in Knee Pants," *Common Ground* (Winter 1944).

Obituary: Washington Post, 23 Apr. 1996.

BEVERLY LANIER SKINNER

DAWSON, William Levi

(26 Sept. 1899–2 May 1990), composer, conductor, and educator, was born in Anniston, Alabama, the oldest of the seven children of George W. Dawson, an illiterate day laborer and former slave, and Eliza Starkey. A precocious and self-determined child William Dawson developed an affinity for music at an early age, delighting in the band concerts and traveling musical shows that passed through his hometown. Encouraged by his mother, who had come from an educated family, he began taking music lessons from S. W. Gresham, a former bandmaster at the Tuskegee Institute. Dawson aspired to attend the institute headed by BOOKER T. WASHINGTON. His parents had no money for his education but Dawson, determined to play in the Tuskegee Band, boarded a train at the age of thirteen and headed for Tuskegee, Alabama. Paying his tuition by working in the fields surrounding Tuskegee, Dawson participated in every musical activity he could, joining the choir, playing trombone in the band, and traveling with the famous Tuskegee Singers before graduating in 1921.

Following graduation Dawson moved to Kansas, where he taught band at Kansas Vocational College for a year. He then moved to Kansas City, Missouri, where he joined the Blackman's Concert Band. Hopeful of attending Ithaca Conservatory the next year, Dawson sold his first composition, "Forever Thine," door-to-door to earn tuition money. Financial problems, however, ended that dream, and he accepted a job with Lincoln High School in Kansas City, Missouri, in 1922. His choir became well known for its performances of African American spirituals, which Dawson arranged, leading to the publication of "King Jesus Is A-Listening" in 1925 by H. T. FitzSimmons of Chicago. By year's end Dawson was also supervising the instrumental music program for all the African American schools in the city.

Although Dawson was now teaching full-time he did not abandon his dreams of higher education. He enrolled in the bachelor of music program at the Horner Institute of Fine Arts in Kansas City, privately studying with professors at night because of segregationist policies at the school. At his graduation ceremonies in 1925 the Kansas City Orchestra played his trio for violin, cello, and piano, but Dawson was unable to acknowledge the audience's applause because he sat not with his classmates but in the balcony reserved for African Americans.

In 1927 Dawson left Kansas City for the thriving musical scene in Chicago, where he soon became the first chair trombonist and the only black member of the Civic Orchestra of Chicago. He also played in Charlie "Doc" Cook's dance band, Doctors of Syncopation. Dawson continued his musical studies at the Chicago Musical College and the American Conservatory of Music, earning his master of music in composition in 1927 under the guidance of Adolph Weidig. He also worked at Gamble-Hinged Music and H. T. FitzSimmons, arranging and editing music for both publishing houses. That same year he married Cornella Lampton, daughter of an African Methodist Episcopal (AME) bishop and a musician in her own right. Sadly, she died less than a year later.

While Dawson was living in Chicago he began work on a symphony. Inspired by Antonin Dvorak's *New World Symphony*, he wanted to produce a piece that reflected his heritage. "It is an attempt to develop Negro music," Dawson explained in an interview in the *New York Times* in 1933, "something they have said again and again couldn't be developed. I never doubted the possibilities of our music, for I feel that buried in the South is a music that somebody, someday, will discover." To ensure there would be no doubt that the symphony was based in African American folk idioms, he titled his work the *Negro Folk Symphony*. On 20 November 1934 Leopold Stokowski led the Philadelphia Orchestra in its first performance of the *Negro Folk Symphony* in Carnegie Hall in New York City.

Although Dawson continued to compose he remained committed to education. In 1930 Dawson returned to his alma mater to organize and conduct its school of music. By 1925 Tuskegee Institute had transformed from a secondary to a collegiate level institution, and Dawson established a program that reflected both Tuskegee's heritage as a vocational school and its future as a center for higher learning, hiring faculty members with impressive credentials, yet remaining committed to a strong music education program. Shortly thereafter, on 21 September 1935, he married Cecile Demae Nicholson in Atlanta, Georgia, in the home of the artist HALE WOODRUFF.

Under Dawson's masterful direction the Tuskegee Institute Choir became one of the most popular of its generation. The one hundred voice choir appeared at the opening of Radio City Music Hall in New York in 1932, sang for presidents Herbert

Hoover and Franklin D. Roosevelt, and was the first African American performing organization to appear at Constitution Hall in Washington, D.C., in 1946, breaking a long-standing race barrier. During his tenure as the director of the Tuskegee Choir Dawson also composed a number of arrangements of African American spirituals such as "There Is a Balm in Gilead" and "Ezekiel Saw de Wheel." These beloved arrangements have become permanent fixtures in the choral repertoire and remain perennial favorites of audiences and choirs around the world.

Despite the busy touring schedule of the Tuskegee Institute Choir, Dawson frequently traveled internationally. In 1952 he took a yearlong sabbatical to West Africa, visiting Sierra Leone, Liberia, the Gold Coast (later Ghana), Nigeria, Senegal, and Dahomey (later Benin). He carried one of the first battery-operated reel-to-reel tape recorders and recorded African performing groups and tribal dances. In 1956 the United States State Department invited Dawson to tour Spain to train local choirs in the African American spiritual tradition. That same year he retired from the Tuskegee Institute, after twenty-five years of leadership in the music department.

Despite his official retirement William Levi Dawson continued to publish and conduct. Committed to educating audiences and students about African American music he led seminars and guest conducted high school and college choirs. He also established his own music publishing business, printing his arrangements under the imprint Music Press. William Levi Dawson died in Montgomery, Alabama, at the age of ninety.

FURTHER READING

Dawson's papers are housed in the Manuscript, Archives, and Rare Book Library, Emory University, Atlanta, Georgia.

Dawson, William L. "Interpretation of the Religious Folk Song of the American Negro," *Etude Magazine* (Mar. 1955).

Haberlen, John B. "William Dawson and the Copyright Act," *Choral Journal* 23.7 (Mar. 1983).

Spady, James G., ed. *William Dawson: A Umum Tribute and a Marvelous Journey* (1981).

ELIZABETH A. RUSSEY

De PRIEST, Oscar Stanton

(9 Mar. 1871–12 May 1951), politician, was born in Florence, Alabama, the son of Martha Karsner, a part-time laundress, and Neander R. De Priest, a teamster and farmer. His father, a former slave, joined the Republican Party. After a neighbor's lynching, the family moved to Salina, Kansas, in 1878. Young Oscar had sandy hair, blue eyes, and a light complexion and often fought over racial slurs made in his presence. After two years at Salina Normal School, he left home at seventeen, settling in Chicago. He apprenticed as a house painter and by 1905 had a successful contracting and real estate business. In 1898 he married Jessie L. Williams; they had one child.

De Priest was elected Cook County commissioner in 1904 and 1906 because he delivered a bloc of African American voters from the city's Second and Third wards for the Republican Party. He educated his constituency about city and county relief resources but lost the 1908 nomination over a dispute with the First District congressman Martin B. Madden. For the next few years he maneuvered among various factions, sometimes supporting Democrats over Republicans. He reconciled with Madden and backed white Republican candidates for alderman against African Americans running as independents in 1912 and 1914.

In 1915 the growing African American community united to elect De Priest to the city council. Significant support came from women, who had won the municipal ballot in 1913. As alderman, he introduced a civil rights ordinance and fought against job discrimination. Indicted in 1917 on charges of taking a bribe from a gambling establishment, De Priest claimed the money as a campaign contribution. He was successfully defended by Clarence Darrow but was persuaded not to run again. He campaigned as an independent in 1918 and 1919 but lost to black Republican nominees. In the 1919 race riots, his reputation was revived when, armed with pistols, he drove twice a day to the stockyards to supply his community with meat.

The riots helped De Priest renew ties to the Republican mayor, William Hale Thompson, and he was a delegate to the 1920 Republican National Convention. In 1924 he was elected Third Ward committeeman. His help in Thompson's 1927 election won De Priest an appointment as assistant Illinois commerce commissioner. In the 1928 election he again ran successfully for Republican delegate and Third Ward committeeman. That same year he supported the renomination of Congressman Madden, who died shortly after the primary, and used his

influence with the Thompson faction of the Republican party to win the nomination for Madden's seat. After he was nominated, he was indicted for alleged gambling connections and vote fraud, charges that his supporters maintained were politically motivated. De Priest refused to withdraw and won the election to represent the predominantly black First District. The case against him was subsequently dismissed for insufficient evidence.

De Priest became the first African American to serve in the U.S. Congress in twenty-eight years and the first from a northern state. He considered himself "congressman-at-large" for the nation's 12 million black Americans and promised to place a black cadet in West Point, fight for enforcement of the Fourteenth and Fifteenth amendments, and secure work relief for the unemployed. But he vowed to "represent all people, both black and white."

While denying that he sought "social equality," De Priest used his position to secure the rights of citizenship for African Americans. When his wife's attendance at First Lady Lou Hoover's traditional tea for congressional wives in 1929 created controversy, De Priest used the publicity to promote a fund-raiser for the National Association for the Advancement of Colored People (NAACP). He was much in demand as a speaker, urging audiences to organize and to vote, even in the South, where threats were made against his life. Although the Great Depression, which began shortly after his arrival in Congress, lured his constituents toward the Democrats, he won reelection in 1930 and 1932. He opposed federal relief, preferring state and local measures.

De Priest sponsored a number of bills to benefit his constituents, including pensions for surviving former slaves and appropriations for African American schools in the District of Columbia. His most important legislative victory was an amendment to the 1933 bill creating the Civilian Conservation Corps barring discrimination based on race, color, or creed. After the infamous 1931 SCOTTSBORO BOYS case in which nine young African American men were sentenced to death after being convicted on questionable evidence by an all-white jury of raping two white women, De Priest called for a law to enable a trial to be transferred to another jurisdiction if the defendant was deemed not likely to get a fair trial. Warning that the country would suffer if one-tenth of its population were denied justice, he said, "If we had a right to exercise our franchise . . . as the constitution provides, I would not be the only Negro on this floor." The bill died in the Judiciary Committee, as did his proposal for an antilynching bill. He also fought unsuccessfully to integrate the House of Representatives restaurant, where he was served, but his staff was not.

By 1934 De Priest faced charges that his party was doing little to help African Americans hard hit by the depression, and he lost to Arthur W. Mitchell, the first African American Democrat elected to Congress. De Priest was vice chairman of the Cook County Republican Central Committee from 1932 to 1934, a delegate to the Republican National Convention in 1936, and alderman from the Third Ward in 1943–1947. He lost the 1947 election for alderman, partly because of charges of cooperating with the Democratic mayor. He continued in the real estate business with his son Oscar De Priest Jr. and died at his home in Chicago.

Skillful at organizing a coalition of black voters and using this bloc to pressure the dominant white political machine, De Priest was the forerunner of many local African American politicians in the latter part of the twentieth century. His six years in Congress enabled him to raise black political consciousness. Kenneth Eugene Mann, writing in the *Negro History Bulletin* in October 1972, noted that De Priest "took advantage of his opportunities and frequently created them."

FURTHER READING

The Arthur W. Mitchell Papers at the Chicago Historical Society have material on De Priest. For De Priest's speeches and resolutions in Congress, see the *Congressional Record*, 71st to 73rd Congresses.

Christopher, Maurine. *Black Americans in Congress* (1971; repr. 1976).

Grossman, James R. *Land of Hope: Chicago, Black Southerners, and the Great Migration* (1989).

Ragsdale, Bruce A., and Joel D. Treese. *Black Americans in Congress 1870–1989* (1990).

Obituaries: New York Times and *Chicago Tribune*, 13 May 1951; *Chicago Defender*, 19 May 1951.

KRISTIE MILLER

DEAN, Lillian Harris "Pig Foot Mary"

(1870–1929), entrepreneur in the food service and real estate arenas, was born Lillian Harris in the

Mississippi Delta. She made a small fortune selling pigs' feet and other Southern culinary delicacies on the streets of Harlem, first out of an old baby carriage, later out of a steam table attached to a newsstand owned by John Dean, who became her husband. She multiplied this small fortune through shrewd real estate investments and retired comfortably in California, where she died in 1929. According to the journalist ROI OTTLEY, she arrived in New York in 1901 and first worked as a domestic. She soon began selling pigs' feet in the San Juan Hill section of Manhattan, which was then a large African American neighborhood (before Harlem gained prominence) and later became the site of the Lincoln Center for the Performing Arts. DUKE ELLINGTON immortalized the rough and tumble San Juan Hill neighborhood in a lively, blues-inflected composition of the same name.

Ottley claims Harris moved her business to Harlem around 1917, setting up shop on the corner of Lenox Avenue (later Malcolm X Boulevard, though commonly known by both names) and West 135th Street, where Dean had his newsstand. This corner was important for cultural and civic reasons, as it was the home to both Harlem Hospital and the Schomburg Center for Research in Black Culture. The historic Harlem YMCA was nearby on 135th Street. (The corner also had an important culinary history, from Dean's pigs' feet cart up through Pan Pan's, a long-established and famous soul food lunch counter that burned down in 2004.) The New York City Department of City Planning devoted a Web page on its "Virtual Tour of Malcolm X Boulevard" to "Pig Foot Mary's," the "tiny feed stand where she sold her famous boiled pigs' feet." The virtual tour goes on to call her "one of Harlem's shrewdest entrepreneurs."

A traditional southern dish thought by some African American traditions to be good luck when eaten on New Years' Day, pigs' feet was not the only dish Dean sold. According to JAMES WELDON JOHNSON in his 1925 article "The Making of Harlem," Mary Dean, whom "everybody who knows the corner . . . knows," later also sold fried chicken and hot corn at her stand, and many pedestrians were "tempted by the smell" (637). Johnson, the great poet, memoirist, novelist, journalist, and activist, also wrote about Dean in *Black Manhattan* (1930), where he described the rush of post–World War I Harlem real estate transactions, which effectively amounted to the ethnic transfer of most of Harlem from white to black: "All classes bought. It was not an unknown thing for a colored washerwoman to walk into a real-estate office and lay down several thousand dollars on a house. There was Mrs. Mary Dean, known as 'Pig Foot Mary'. . . . She paid $42,000 for a five-story apartment house . . . which was sold later to a colored undertaker for $72,000" (154). The purchase and sale took place in 1917 and 1923, respectively. Presumably there were a few similar deals.

According to Ottley, Dean retired with a fortune of $375,000 (worth approximately $4 million in 2005, adjusted for inflation). Though Dean was apparently a great cook who was also shrewd and charismatic, the role of her husband in her success has not been commented on in most of the anecdotes about her, which tend to emphasize her skill in business. John Dean, who already owned a newsstand on the important Harlem corner when she arrived, certainly must have played some role, and Ottley notes that John Dean encouraged his wife's investments. Lillian Dean, described by Ottley as being physically large with a deep voice, was perhaps an inspiration for the formidable character of Mary Rambo, a strong and independent African American woman who rescues the narrator in RALPH ELLISON's *Invisible Man* (1952). The character as originally written in a section published a few years after the novel seems to have more in common with Pig Foot Mary (more fire and gusto) than does the somewhat milder sketch of the character published in the novel. Pig Foot Mary also was a minor character in the 1997 historical gangster film *Hoodlum*, a major Hollywood production and respectable box office success (starring Laurence Fishburne and Tim Roth). Pig Foot Mary was played by Loretta Devine, a highly regarded actress of the late twentieth century.

FURTHER READING
Johnson, James Weldon. *Black Manhattan* (1930).
Johnson, James Weldon. "The Making of Harlem," *The Survey Graphic* (Mar 1925).
New York City Department of City Planning. "Malcolm X. Boulevard: Virtual Tour of Living Landmarks and Lenox Shadows." Available at www.nyc.gov/html/dcp/html/mxb/mxsite47.shtml.
Ottley, Roi. *New World A-Coming* (1943).

PAUL DEVLIN

DELANEY, Beauford

(30 Dec. 1901–26 Mar. 1979), painter, was born in Knoxville, Tennessee, the eighth of ten children, to Delia Johnson, a domestic worker, and John Samuel Delaney, a Methodist minister. Beauford attended the segregated Knoxville Colored High School, from which he graduated with honors. As a teenager, he met a local artist, Lloyd Branson, who painted impressionist-style landscapes and portraits. For several years Beauford worked for Branson as a porter in exchange for art lessons and began creating representational landscapes and portraits of local Knoxville blacks. Recognizing the young artist's talent, Branson pushed him to pursue formal art studies in Boston and helped finance his education.

In September 1923 Delaney left Knoxville for Boston, where he attended the Massachusetts Normal Art School (now Massachusetts College of Art), studying portraiture and academic traditions. He took classes at the Copley Society, the South Boston School of Art, and the Lowell Institute, and he copied original works of art at the Museum of Fine Arts, the Isabella Stewart Gardner Museum, and the Fogg Art Museum in Cambridge, refining his skills as a draftsman. Gradually, Delaney became fascinated by more modern work, especially that of the impressionist painter Claude Monet, which he saw in a retrospective mounted just after the artist's death in 1926. Monet's late water lily paintings provided an important example of abstract brushwork, light, and color that would prove critical to Delaney's later expressionistic painting.

Delaney arrived in New York City in November 1929 during the height of the Harlem Renaissance and settled in Greenwich Village, where he lived in several different apartments during his twenty-three-year stay. During the early 1930s Delaney supported himself doing traditional pastel and charcoal portraits of dancers and society. He also began producing more experimental works, sketching and painting people in the streets of Greenwich Village and Harlem, using erratic line and bright color. Delaney credited this stylistic shift to his New York environment. "I never drew a decent thing until I felt the rhythm of New York," he explained. "New York has a rhythm as distinct as the beating of a human heart. And I'm trying to put it on canvas. . . . I paint people. People—and in their faces I hope to discover that odd, mysterious rhythm" (*New York Telegraph*, 27 Mar. 1930).

Newspaper critics increasingly recognized Delaney's work, and in February 1930 the Whitney Studio Gallery included three of his oil portraits and nine pastel drawings in a group exhibition. The Whitney offered him work as a caretaker, gallery guard, and doorman, and in return he received a studio in the basement for two years. Delaney continued his studies with the Ashcan school artist John Sloan and the American regionalist artist Thomas Hart Benton at the Art Students' League in New York. In late 1930 he began a series of pastel and charcoal drawings of famous African American jazz musicians, including DUKE ELLINGTON, ETHEL WATERS, and LOUIS ARMSTRONG.

During the Works Progress Administration era, Delaney worked as an assistant to CHARLES ALSTON on his Harlem Hospital mural project but found himself drawn to European modernists, such as Cézanne, Gauguin, Van Gogh, and the fauves. He also loved the American modernists, including John Marin, Alfred Stieglitz, Arthur Dove, Georgia O'Keeffe, and Stuart Davis, and saw their work often at Stieglitz's gallery, An American Place. As art sales were slow during the Depression, Delaney earned money teaching art classes at various Greenwich Village schools and at an adult education project in Brooklyn.

In addition to experiencing the racial injustices of the time, Delaney also struggled with his homosexuality. Moreover, he began to suffer long bouts of depression and paranoia aggravated by alcoholism, and these illnesses plagued him throughout the remainder of his life.

In 1934 Delaney began exhibiting in the Washington Square Outdoor Exhibit, and his work became increasingly expressionistic, using distortion, heightened color, and manipulated perspective to create psychologically and spiritually charged paintings. During 1938 Delaney had two solo exhibitions of portraits, at the Eighth Street Playhouse in New York and Gallery C in Washington, D.C., and in October 1938 *Life* magazine featured him as "one of the most talented Negro painters." Delaney became a close friend of the writer James Baldwin in the early 1940s, and this pivotal friendship lasted throughout Delaney's life, providing companionship and intellectual camaraderie. Over the years Delaney painted roughly twelve portraits of Baldwin, including *Dark Rapture* (1941) and *James Baldwin* (1965).

During the 1940s Delaney's psychological problems and economic circumstances worsened, and, according to many of his notes, his paintings became a kind of salvation, a means of escaping the difficult realities of his daily life. Delaney's commitment to modernism and abstraction intensified, and the influence of European artists, particularly the postimpressionists and the fauves, can be seen in many works of this period, including *Can Fire in the Park* (1946), *Green Street* (1946), and *Washington Square* (1949). By the late 1940s Delaney had become an established expressionist painter in the New York art scene. He received positive reviews when he showed in two group exhibitions at Roko Gallery in 1949, and the following year he was given a solo exhibition there.

In 1950 Delaney won a two-month fall fellowship at the Yaddo writers and artists' community in Saratoga Springs, New York. While there, he read extensively and began thinking seriously about traveling to Paris, where many African American artists were working and living in exile. He returned to Yaddo in November 1951 and, after dispersing his paintings, sailed for Paris on 28 August 1953. Delaney settled in the Montparnasse section of Paris, going to many galleries, and frequenting the Musée d'Art Moderne, the Orangérie, and the city's many galleries. In Paris he found a circle of expatriate artists that included his dear friend James Baldwin, the painters Larry Calcagno, Larry Potter, and Bob Thompson, and the photographer Ed Clark.

While some of his paintings during this time were purely abstract, such as *Abstraction* (1954), others reflect Delaney's travels in Europe. In 1954 he exhibited at the Salon des Réalités Nouvelles in the Musée d'Art Moderne and the Ninth Salon at the Musée des Beaux Arts. By the fall of 1955 he had left Montparnasse for the suburb of Clamart. Still supporting himself through sporadic painting sales and generous contributions from friends, Delaney could not afford psychiatric treatment and suffered ongoing bouts of depression and paranoia that affected his ability to work. When he could concentrate, he vacillated between large-scale abstraction and figuration. In *Composition 16* (1954), Delaney's canvas glows with thick, swirling, intensely colored green, red, and yellow impasto surrounding a central glowing yellow light. *Self-Portrait* (1961) demonstrates the same fascination with light and gestural brushwork, integrated with an expressive likeness of the artist. The most important works to come out of his

Paris years, however, were the allover abstractions, both the oil-on-canvas paintings and a series of gouache works on paper, which he showed in three important solo exhibitions at Galerie Paul Facchetti in 1960, the Galerie Lambert in 1964, and the Galerie Darthea Speyer in 1973.

In the summer of 1961 Delaney traveled to Greece. During the trip he was plagued by taunting, threatening voices that eventually led to his hospitalization, a subsequent suicide attempt, and then temporary institutionalization. His patron, Darthea Speyer, the cultural attaché at the American Embassy in Paris, arranged for his return to Paris. Eventually, Delaney's friends began to urge him to get professional psychological help, and he briefly rested at La Maison du Santé de Nogent sur Marne outside Paris. Afterward he stayed with Madame du Closel, a French art collector, and her husband. Delaney soon came under the care of a psychiatrist, Dr. Ferdiere, who specialized in depression and who diagnosed Delaney with acute paranoia. During this period Delaney created a series of quickly executed gouache works on paper that he called Rorschach tests, some done at his doctor's request. Delaney's final years in Paris were spent in a studio at rue Vercingetorix, where he was supported mainly by the du Closels. Despite his doctor's warnings, he drank sporadically, nullifying the effects of his antipsychotic medication. Delaney spent his final years institutionalized in St. Anne's Hospital for the Insane in Montparnasse, where he died in 1979.

FURTHER READING
Leeming, David. *Amazing Grace: A Life of Beauford Delaney* (1998).
Leeming, David, and Robert Rosenfeld Gallery. *Beauford Delaney Liquid Light: Paris Abstractions, 1954–1970* (1999).
Long, Richard, and Studio Museum of Harlem. *Beauford Delaney: A Retrospective* (1978).

Obituaries: New York Times, 1 Apr. 1979; *Le Monde*, 5 Apr. 1979; *International Herald Tribune*, 6 Apr. 1979.

LISA D. FREIMAN

DELANY, Bessie, and Sadie Delany

(3 Sept. 1891–25 Sept. 1995) and (19 Sept. 1889–25 Jan. 1999), were born Annie Elizabeth Delany and Sarah Louise Delany in Raleigh, North Carolina, the

daughters of Henry Beard Delany, an educator and Episcopal bishop, and Nanny James Logan. Bessie was to become a dentist, and Sadie a schoolteacher; late in life, they gained fame for their published reminiscences. Descended from a mix of black, American Indian, and white lineages, the sisters grew up in a family of ten children in Raleigh on the campus of St. Augustine's, the African American school where their father, a former slave, served as priest and vice principal. The sisters graduated from St. Augustine's (Sadie in 1910 and Bessie in 1911) at a time when few Americans, black or white, were educated beyond grammar school. "We had everything you could want except money," recalled Bessie. "We had a good home, wonderful parents, plenty of love, faith in the Lord, educational opportunities—oh, we had a privileged childhood for colored children of the time" (*Smithsonian*, Oct. 1993, 150).

After completing their studies at St. Augustine's, both Sadie and Bessie went on to teaching jobs in North Carolina. Their father had strongly urged his daughters to teach, since he was unable to finance further education at a four-year college. He also advised them to make their own way, warning them against accepting scholarships that would obligate them to benefactors. Bessie took a job in the mill town of Boardman, while Sadie became the domestic science supervisor for all of the black schools in Wake County. Although she received no extra salary, Sadie also assumed the duties of supervisor of black schools in the county. Both sisters were shocked by the conditions their students lived in. Bessie later said in the sisters' joint memoir, *Having Our Say: The Delany Sisters' First 100 Years* (1993), that she found the families in Boardman "poor and ignorant" (89). Sadie remarked that her students' families in Wake County were "in bad shape" and that they "needed help with the basics" and "didn't know how to cook, clean, eat properly, or anything" (81). She therefore concentrated her efforts on teaching sanitation, hygiene, and food preparation. She also convinced many of her charges to continue their education.

In 1916 Sadie moved to Harlem in New York City and enrolled at Pratt Institute, then a two-year college. After graduating in 1918 she enrolled at Columbia University, where she earned a BS in 1920. She returned to North Carolina briefly with the intention of helping her people but, discouraged by the pervasive Jim Crow system, soon returned to Harlem. She encountered racism in New York but concluded that the North "was an improvement over the South" (107). She began teaching in an elementary school in Harlem in 1920, and for several years she also ran a candy business. In 1925 she received her master's degree in education from Columbia. Beginning in 1930, she taught at Theodore Roosevelt High School, a white school in the Bronx. Having skipped the interview because she feared her color would cost her the job, Sadie stunned school officials on the first day of school; but as she later observed, "Once I was in, they couldn't figure out how to get rid of me" (120). With her appointment, Sadie became the first African American in New York City to teach domestic science at the high school level.

In 1918, after teaching for a short time in Brunswick, Georgia, and taking science courses at Shaw University in Raleigh, Bessie joined her sister in New York, where she enrolled the following year in the dentistry program at Columbia University. She completed her DDS in 1923 and became only the second black female dentist licensed in the state of New York, with a practice in Harlem. She was well known there as "Dr. Bessie" and her office was a meeting place for black leaders, including JAMES WELDON JOHNSON and E. FRANKLIN FRAZIER. During the Depression of the 1930s she found herself twice evicted from her office, but she persisted in her work.

During their childhood the Delany sisters had encountered the segregation and the discrimination of the Jim Crow South and the threat of violence that underlay the system. Bessie remembered the first time she faced segregation when, as a child in the mid-1890s, she found she could no longer go to the park that she had previously played in, and she also recalled experimenting with drinking the water from a "whites only" fountain and discerning no difference in its taste. Yet, like her sister, she found that in the North, too, restrictions and dangers hemmed her in. Bessie's closest brush with the Ku Klux Klan came not in the South, however, but on Long Island.

Neither Bessie nor Sadie ever married. Nanny Delany had urged her daughters to decide whether they were going to marry and raise families or have careers. As Bessie said years later, it never occurred to anyone that a woman could have both a family and a profession, and the sisters decided on careers. Bessie and Sadie lived together for nearly eight decades in New York City and then in nearby

Mount Vernon, and they were surrounded by family members. All but one of their siblings settled in Harlem, and after their father's death in 1928 their mother lived with them. The sisters were devoted to their mother, and it was largely to please her that after World War II they left Harlem and moved to a cottage in the north Bronx. In 1950 Bessie gave up her dental practice to care for their mother full time. After their mother's death in 1956, the sisters moved to Mount Vernon, where they purchased a house in an all-white neighborhood. Sadie retired in 1960. Sadie was amiable by nature, having broken the color barrier in the New York City public schools through craft instead of confrontation. By contrast, Bessie was feisty and contentious, accustomed to speaking her mind. "We loved our country," she observed, "even though it didn't love us back" (60). Asked her impression of the Statue of Liberty when she first entered New York harbor, she replied that it was important as a symbol to white immigrants but meant nothing to her. Regarding her experience at Columbia University, she noted: "I suppose I should be grateful to Columbia, that at that time they let in colored people. Well, I'm not. They let me in but they beat me down for being there! I don't know how I got through that place, except when I was young nothing could hold me back" (115).

The Delany sisters might have escaped notice by the wider world had they not in 1993 coauthored a best-selling memoir with the assistance of Amy Hill Hearth. *Having Our Say: The Delany Sisters' First 100 Years* had its origins in an essay that Hearth had written for the *New York Times* on the occasion of Bessie's one-hundredth birthday. So enthusiastic were readers' responses to the article that Hearth continued her interviews and produced the book. Published when Bessie was 102 and Sadie was 104, *Having Our Say* offered a perceptive, witty review of the sisters' lives through the previous century. As Hearth observed in her introduction to the book, it was meant less as a study of black history or of women's history than of American history, but the sisters' age, race, and gender combined to provide a tart perspective on the past. These two black women spoke of their strong family, the racism and sexism that could have thwarted them, and their triumphs. They spoke of their experiences as teachers in the segregated South, their participation in the mass migration of African Americans from the South to the urban North, and—although more briefly—their recollections of the Harlem Renaissance in the 1920s and the Great Depression of the 1930s. *Having Our Say* remained on the *New York Times* best-seller list—first in hardback and then as a paperback—for seventy-seven weeks.

By the time Bessie Delany died at age 104 at her Mount Vernon home in 1995, *Having Our Say* had sold nearly a million copies in hardback or paper and had been translated into four foreign languages. Reviewers were generally enthusiastic about the book, but an unsigned commentary in the *Women's Review of Books* in January 1994 questioned the role of Amy Hill Hearth as a white woman selectively pulling together the recollections of two elderly black women. Such criticism did not, however, diminish the popular appeal of the sisters' story, which was adapted as a Broadway play in 1995 and as a television movie in 1999, starring Diahann Carroll as Sadie and Ruby Dee as Bessie. That same year Sadie Delany died in Mount Vernon, at age 109.

FURTHER READING
The Delany family papers are at St. Augustine's College, Raleigh, North Carolina.
Delany, Sarah L., and A. Elizabeth Delany, with Amy Hill Hearth. *The Delany Sisters' Book of Everyday Wisdom* (1994).
Delany, Sarah L., and A. Elizabeth Delany, with Amy Hill Hearth. *Having Our Say: The Delany Sisters' First 100 Years* (1993).
Delany, Sarah L., with Amy Hill Hearth. *On My Own at 107: Reflections on Life without Bessie* (1997).
Obituaries: Bessie Delany: *New York Times* and *Washington Post*, 26 Sept. 1995; Sadie Delany: *New York Times*, 26 Jan. 1999.

RICHARD HARMOND
PETER WALLENSTEIN

DELANY, Clarissa Scott

(1901–1927), poet, essayist, educator, and social worker, was born Clarissa Mae Scott in Tuskegee, Alabama, the third of five children born to EMMETT JAY SCOTT and Elenor Baker Scott. Her father served as secretary to BOOKER T. WASHINGTON, the founder of Tuskegee Institute; secretary-treasurer at Howard University; and special adviser on African American Affairs to President Woodrow Wilson. Scott spent her early years in Tuskegee, where she had access to intellectual, social, and cultural activities available to students, faculty, and staff

at Tuskegee Institute; she was educated in New England, entering Bradford Academy in 1916, then Wellesley College in 1919.

At Wellesley Scott was an active, competitive student, who earned scholarship honors, participated on the debate team, and earned a letter in field hockey. She was also a talented singer and pianist, and held memberships in various social groups and religious organizations. Delany attended meetings of Boston's Literary Guild and is identified as one who contributed to the writing of poetry by African American Bostonians, an activity that provided her entry into the cultural activities of the Harlem Renaissance. The era was characterized by the production of copious amounts of literature, increased racial consciousness; there were outpourings of music, painting, and dancing as well as social and political involvement. Scott graduated from Wellesley with Phi Beta Kappa honors in 1923, which led to an article about her in the June 1923 issue of The Crisis with her photograph on the cover.

Scott traveled to France and Germany and after returning to the United States, she accepted a teaching position at Dunbar High School in Washington, D.C., where she chose to remain only three years. During this period, she started her brief writing and publishing career. Scott was further immersed in the atmosphere of the Harlem Renaissance through her participation in the Saturday Nighters Club in Washington, D.C., where GEORGIA DOUGLAS JOHNSON hosted the literary gatherings in her home. In this setting, the younger and the more established writers discussed their works, exchanged ideas, and received encouragement and inspiration from each other. Guests included such well-known figures of the period as William Waring Cuney, STERLING BROWN, ANGELINA WELD GRIMKÉ, Richard Bruce Nugent, LANGSTON HUGHES, JEAN TOOMER, ALICE DUNBAR-NELSON, JAMES WELDON JOHNSON, W. E. B. DU BOIS, JESSIE FAUSET, ALAIN LOCKE, and GWENDOLYN BENNETT.

After her marriage to Hubert T. Delany in the fall of 1926, the couple moved to New York City, where she was employed as a social worker. She became director of the Joint Committee on the Negro Child Study. In a venture with the National Urban League and the Women's City Club of New York, Delany gathered information and published a study regarding delinquency and neglect of New York City black children. Hubert Delany,

a successful attorney, earned prestigious positions, including that of a court justice.

Because of patterns of exclusion, it was customary for many women writers of the early twentieth century to have their works published in anthologies and literary periodicals. Lyric poetry was widely considered a proper genre for women. Delany's four published poems illustrated her talents. "Solace" tied for fourth place in a 1925 poetry contest sponsored by Opportunity: A Journal of Negro Life. In 1926, "Joy" appeared in Opportunity and "The Mask" in Palms. In 1927 COUNTÉE CULLEN published these three poems and "Interim" in Caroling Dusk: An Anthology of Verse by Negro Poets. "The Mask" makes use of a common theme in African American literature, reflecting the practice of African Americans to hide their thoughts and feelings as a form of protection. The narrator states, "I turned aside until the mask was slipped once more in place." Both "Joy," and "Interim," make use of figurative language and present descriptions of nature with references to "roistering wind," "stalwart pines," sun, and rain. The tone of these poems is solemn and introspective.

In an essay entitled "A Golden Afternoon in Germany," published in Opportunity, Delany described her experiences touring Europe. She also wrote several reviews, which were also published in Opportunity. Her contemporaries, W. E. B. Du Bois among them, praised her poetry. Angelina Weld Grimké eulogized her in a poem, "To Clarissa Scott Delany," which was published in CHARLES S. JOHNSON'S Ebony and Topaz in 1927. Illustrating the strength, relevance, and timelessness of her lyrics, Johnnetta Cole selected Delany's "Interim" for inclusion in her inaugural address as president of Spelman College in 1988. The actor Danny Glover included lines from "Interim" in his address celebrating Spelman's 121st commencement. He charged the graduates to not be afraid to venture out, quoting the closing lines of Delany's poem, 'Another day will find me brave/ And not afraid to dare."

In 1927 Delany returned to her parents' home in Washington, D.C., where she died. Her death, as noted on her death certificate, was caused by kidney disease, possibly a reaction to streptococcal infection that she had endured over a six-month period. It was also speculated that she died of a lung infection, probably tuberculosis. In 1931 her family established YWCA Camp Clarissa Scott on land they donated on Chesapeake Bay.

FURTHER READING

Hatch, Shari, and Michael R. Strickland, eds. "Delany, Clarissa (nee Scott)," *African-American Writers: A Dictionary* (2000).

Roses, Lorraine, and Ruth Randolph. "Delany, Clarissa M. Scott (1901–1927)," *Harlem Renaissance and Beyond: Literary Biographies of 100 Black Women Writers 1900–1945* (1990).

Smith, Jessie Carney. "Clarissa Scott Delany," *Notable Black American Women* (1992).

GWENDOLYN S. JONES

DELANY, Hubert T.

(11 May 1901–28 Dec. 1990), lawyer, judge, politician, and civil rights advocate, was born Hubert Thomas Delaney in Raleigh, North Carolina, the eighth of ten children of Nanny Logan Delany and the Episcopal Suffragan Bishop Henry Beard Delany.

Until he was fourteen years old Delany assumed that he would follow his father into the priesthood of the Episcopal Church. But in 1915 Delany visited Christ Church on Capitol Square in Raleigh to hear a choir that accompanied a prominent bishop from New York. Much to his surprise he was guided into the gallery by an usher who asked the young man why he didn't attend Saint Ambrose, the colored Episcopal church.

Having grown up on the campus of historically black Saint Augustine's College where his parents taught, Hubert Delany had, until that moment, been protected from the rigid system of racial segregation that gripped North Carolina in the early twentieth century. Disappointed in his church, Delany turned his future toward the law.

Completing the high school program at Saint Augustine's in 1919 Delany soon followed his older siblings to Harlem. Working his way through college as a Red Cap at Penn Station, Delany graduated from City College in 1923, and taught at P.S. 80 in Harlem while studying law at night at New York University, graduating in 1926. That same year Delany married Clarissa Scott, a Phi Beta Kappa graduate of Wellesley and a promising poet who taught at Washington's elite black Dunbar High School. Born in Tuskegee, Alabama, Clarissa was the daughter of EMMETT JAY SCOTT, the former personal secretary to BOOKER T. WASHINGTON and secretary-treasurer at Howard University. Within the year, CLARISSA SCOTT DELANY died of kidney disease.

Delany set up his law practice in an office shared with James S. Watson at 240 Broadway. An active Democratic politician Watson was patriarch of a prominent Harlem family of Jamaican origins. Through his wife Delany became acquainted with the luminaries of the Harlem Renaissance and many of them remained his friends and clients throughout his life, including LANGSTON HUGHES and PAUL ROBESON. In 1927 Delany was appointed assistant U.S. attorney for the southern district of New York. Two years later he received the Republican nomination to fill Greater Harlem's 21st District congressional seat. Delany was advised not to campaign in Washington Heights in hopes that Irish Americans would assume, based on his name, that he was one of them. He campaigned there and lost the election. Fellow Republican Fiorello LaGuardia was running for reelection in a nearby district and the two men became friends. When LaGuardia was elected mayor of New York in 1933, he appointed Delany to the City Tax Commission.

In that same year, 1933, Delany became the only black partner in a law firm made up of former assistants in the U.S. Attorney's office, the second black member of the Bar Association of New York City, and was admitted to practice before the U.S. Supreme Court.

After the Harlem Riot of 1935 Mayor LaGuardia appointed Delany and others, including E. FRANKLIN FRAZIER, COUNTÉE CULLEN, and A. PHILIP RANDOLPH, to the investigatory commission that found that the riot was caused not by communist agitators but by economic deprivation, racial discrimination, and an unresponsive city government.

Hubert Delany was an early member of the Council on African Affairs, founded in 1937 by Paul Robeson and Max Yergan. In 1947 the attorney general of the United States included the council on his list of subversive "communist-front" organizations. The next year Delany and several other members of the council, including the educator MARY MCLEOD BETHUNE and the Harlem pastor and politician ADAM CLAYTON POWELL JR., resigned, possibly in response to cold war pressures and a growing schism between Robeson and Yergan.

By the late 1930s Delany was serving on the executive boards of the National Lawyers Guild and the National Association for the Advancement of Colored People. At the NAACP he was initially among the strongest supporters of the *Crisis* editor W. E. B. DU BOIS, whose political philosophy was

becoming increasingly separatist. However, in 1948, Delany supported Du Bois's termination. Ten years later, however, when Du Bois celebrated his ninetieth birthday, Delany was one of the principal speakers.

Among Delany's many clients was the classical contralto MARIAN ANDERSON. After the Daughters of the American Revolution refused to allow Anderson to perform in Constitution Hall in Washington, D.C., in 1939 Delany introduced the resolution to the executive board of the NAACP that led to her performing instead on the steps of the Lincoln Memorial.

Delany married the former Willetta Smith in the 1940s. A native of Yonkers, New York, and an alumna of Howard University, she had served as Delany's secretary at the Tax Commission. This second marriage made Hubert Delany the father of a daughter, Madelon, who became a professor at City College, and a son, Harry, who became one of New York's leading surgeons.

Mayor Fiorello LaGuardia appointed Delany to the Domestic Relations Court in New York in 1942, where he served until 1955 when Mayor Robert F. Wagner refused to reappoint him because of his "left-wing views." Wagner refused to elaborate on his objections to Delany's politics and his action prompted a storm of protest from black organizations and individuals. Writing in the *New York Post*, TED POSTON described Wagner's action as a victory for the Democratic Manhattan borough president Hulan Jack. In late 1959, as Martin Luther King Jr. left Montgomery's Dexter Avenue Baptist to return to his father's church, Ebenezer Baptist in Atlanta, Alabama, authorities charged King with failure to pay income tax. At the historic moment when lunch counter sit-ins were spreading across the South, Hubert Delany, leading King's legal team, won a "not guilty" verdict from an all-white Alabama jury.

Hubert Delany died of heart disease in New York City.

FURTHER READING
Almost nothing has been written about Hubert Delany, although he is mentioned in passing in a number of books about the Harlem Renaissance, New York politics, and the civil rights movement. He corresponded with most of the leading figures of African American culture and politics in the twentieth century and his letters can be found in several collections in the Beinecke Library at Yale, the Library of Congress, and the Moorland-Spingarn Collection at Howard University.

ROBERT HINTON

DETT, R. Nathaniel

(11 Oct. 1882–2 Oct. 1943), composer and educator, was born Robert Nathaniel Dett in Drummondsville (later Niagara Falls), Ontario, Canada, the son of Robert Tue Dett, a musician and music teacher, and Charlotte Johnson, a musician. The Detts were a highly literate and musically active family, especially interested in European concert traditions. For young Dett, the classical traditions formed his musical roots, and he would never lose touch with them.

Dett initially pursued formal musical study at Oberlin College in Ohio, where he graduated in 1908. Thereafter Dett intermittently studied on the graduate level at Columbia University in New York City, the University of Pennsylvania, the American Conservatory of Music in Chicago and at Harvard University in Massachusetts, where he won prizes for both literature and music. He also studied advanced composition in Paris in 1929 with the renowned teacher Nadia Boulanger. For much of his professional life, from 1913 to 1931, Dett served as director of music at the Hampton Institute in Virginia. Throughout these years he also devoted himself to musical composition. In 1916 he married Helen Elise Smith, with whom he had two children.

Both in his compositions and in his teaching at Hampton, Dett displayed ambivalence toward the issue of racial identification in art. During the early and mid-twentieth century, artists and critics discussed at length the roles and obligations of African American artists. As was the case with writers and painters, a key issue for composers was whether one should strive to be a consciously African American composer or else a composer who happened to be African American. Historians, journalists, and other commentators have tended to sympathize with the former position and, if only by implication, have criticized those who have chosen the latter course as having somehow sidestepped the center of cultural ferment. While the strengths and weaknesses of this perspective continue to be debated, Dett's career brings context to this question.

Dett undoubtedly saw himself as a composer who happened to be African American. At Hampton he insisted that his music students engross themselves in the classical traditions of Europe. When he took the Hampton Choir on tour he rarely performed spirituals or gospel music, though audiences in America and Europe eagerly hoped he would. Instead, Dett preferred the mainstream choral literature. To Dett the question of a recognizable racial identity was best regarded as a kind of final layer, a cultural epidermis, which if given excessive attention could easily become distracting, obscuring the rest of the cultural body. In this regard he felt that many of the popular music forms such as ragtime, blues, and jazz had lost their artistic integrity, falling into titillation and pandering. In a letter Dett wrote:

> We have this wonderful folk music, . . . but this store will be of no value unless we treat it in such a manner that it can be presented in choral form, in lyric and operatic works, in concertos and suites and salon music, unless our musical architects take the loose timbre of Negro themes and fashion from it music which will prove that we too have national feelings and characteristics.

As with the contemporary novelist William Faulkner, the ideal for Dett was to create art that was rooted in history and geography but that would resonate among those unacquainted with that history and locale. The quotable hymn or folk fragment was not nearly enough; artful interpretations and settings were critical.

In 1926 Carl Engel, chief of the music division at the Library of Congress, asked Dett to write a quartet for piano, violin, saxophone, and banjo. Engel was seeking a piece that would merge African American traditions with those of Western Europe. Dett politely declined the offer, stating that "any effort from the outside to lay down rather strict lines along which art should develop can only result in self-consciousness and consequently in inartistic and insincere results."

Dett's compositions generally employed the harmonies and forms of traditional nineteenth-century symphonic and choral writing. But unlike many of the romantics, Dett rarely sought to incorporate identifiable idioms into his music. Like the writers of his day who led the Harlem Renaissance, Dett chose to define himself in relation to established classical traditions; but, unlike them, he preferred no identification with any cultural movement. He wrote some well-regarded grand oratorios and several suites for solo piano. His most famous work is one of his piano pieces, *In the Bottoms Suite* (1913). It contains thematic, geographic, and dance references. Here Dett revealed his convictions about how the soul can be properly displayed. The work shows his brilliant command of setting and form, with head and heart in gentle harmony.

Dett's compositions remain known in the world of American concert music, particularly among lovers of choral and piano music, but his refinement may have limited his music's broader appeal. Artists like Dett, who considered their race to be incidental, seem destined to be ignored as long as most enthusiasts of African American arts seek racial consciousness from the artists they wish to promote. Ironically, this political priority limits the visibility of many great African Americans of the past. R. Nathaniel Dett deserves the attention he sought—as a mainstream American composer. Dett died in Battle Creek, Michigan.

FURTHER READING
Dett's papers are at the library of Hampton University in Virginia.
Gray, Arlene. *Listen to the Lambs* (1984).
McBrier, Vivian Flagg. *R. Nathaniel Dett, His Life and Works* (1977).

ALAN LEVY

DILL, Augustus Granville

(1882–9 Mar. 1956), sociologist, business manager of *The Crisis*, curator, and musician, was born Augustus Granville Dill in Portsmouth, Ohio, to John Jackson and Elizabeth Stratton Dill. Having finished his secondary schooling at the age of seventeen, Dill briefly taught in Portsmouth before attending Atlanta University, where he earned his BA in 1906. Dill's extracurricular interests included playing the piano for the university choir and serving on the debating team. He earned a second BA at Harvard University in 1908 and an MA from Atlanta University on his return to Atlanta in the same year. There he was mentored by W. E. B. DU BOIS, whose post as associate professor of sociology Dill assumed when Du Bois left Atlanta in 1910.

In 1913 Du Bois persuaded Dill to move to New York and assume the responsibilities of business manager and editorial assistant of *The Crisis*. Although Dill had no professional training for

such a position, he diligently contributed to the magazine's success. In his autobiographical *Dusk of Dawn*, Du Bois acknowledges that Dill "gave to the work his utmost devotion and to him was due much of its phenomenal business success" (226). By 1919 the circulation of *The Crisis* had reached 104,000.

In 1920 Dill, Du Bois, and JESSIE FAUSET published *Brownies' Book*, a culturally- affirming magazine for African American children, intended in part as a reaction to the negative portrayal of black people in D. W. Griffith's popular film, *Birth of a Nation* (1915). Although well produced *Brownies' Book* was financially unsuccessful and closed after two years of publication.

Du Bois and Dill collaborated on other projects, including four books: *The College-Bred Negro* (1911), *The Common School and the Negro American* (1912), *The Negro American Artisan* (1912), and *Morals and Manners among Negro Americans* (1915). While working on *The Crisis* and *Brownies' Book*, Dill joined the Intercollegiate Liberal League, a group that fostered debate of contemporary political issues among college students. He urged the members of the league to consider how racial discrimination and intimidation at the polls were contributing to the ongoing disenfranchisement of African Americans. At the league's meeting at Harvard in 1921, Dill is quoted in the *New York Times* as dismissing as "foolish" any "talk about industrial or political democracy so long as you ignore the 12,000,000 Negroes in the United States."

While living in New York, Dill enthusiastically immersed himself in the arts. His talent as a pianist and organist enabled him to accompany noteworthy performers in concert. Dill also participated in cultural events at the 135th Street Library, a well-known meeting place for the artists, writers, and intellectuals of the Harlem Renaissance. In August 1921 Dill organized an important exhibition of art works by black artists at this venue. There Dill was sometimes seen as an eccentric figure. After a lecture by Carl Van Doren, for example, Dill curled up on the speaker's table to ask questions. Such outrageous behavior, along with his taste for fine clothing and his ever-present chrysanthemum buttonhole, was excused as dandyism. In 1928, however, Dill was arrested for engaging in homosexual sex in a subway bathroom, a venue commonly used by closeted men. The public exposure from the incident led Du Bois to fire Dill from *The Crisis* and brought an end to the pair's longtime collaboration.

Subsequently Dill was unable to secure steady employment. He supported himself in New York by playing piano and organ (he once accompanied the singer ROLAND HAYS in performance) and by running a bookstore. In 1952 he went to live with his sister, Mary Dill Broadus, in Louisville, Kentucky, with whom he was living when he died. Dill contributed most significantly to African American intellectual culture through his academic collaborations with Du Bois and through his editorial work on *The Crisis*. His obituary in the *New York Times* acknowledged his important input to the NAACP through his management of its journal. In addition, he encouraged and enabled a celebration of African American identity and artistic expression and has become a symbol of gay culture during the Harlem Renaissance.

FURTHER READING
Chauncey, George. *Gay New York: Gender, Urban Culture, and the Making of the Gay Male World, 1890–1940* (1994).
Logan, Rayford W., and Michael R. Winston, eds. *Dictionary of American Negro Biography* (1982).
Schwarz, A. B. Christa. *Gay Voices of the Harlem Renaissance* (2003).
Wright, Earl. "The Atlanta Sociological Laboratory 1896–1924: A Historical Account of the First American School of Sociology," *Western Journal of Black Studies* (Fall 2002).

DENNIS GOUWS

DOMINGO, Wilfred Adolphus

(26 Nov. 1889–14 Feb. 1968), socialist, journalist, and Jamaican nationalist, was born in Kingston, Jamaica. He was orphaned at an early age and raised by his uncle, Adolphus Grant, and was trained as a tailor. In Jamaica, he joined Sandy Cox's National Club, a pioneering nationalist organization, and became a leader along with MARCUS GARVEY. In 1910 Domingo moved to Boston, where he attended night school in preparation for medical school. In 1912 he instead moved to New York, where he became a successful importer of Caribbean food. When Garvey settled in New York in 1916, Domingo introduced him to local black political leaders. He became the first editor of the *Negro World* in 1917, the paper associated with Garvey's Universal Negro Improvement Association, a Pan-African nationalist organization. At the same time, Domingo—along with other "New Negro"

radicals, including CHANDLER OWEN, A. PHILIP RANDOLPH, and RICHARD BENJAMIN MOORE— became increasingly active in the Harlem Socialist Party (SP). In general the American SP ignored the oppression of black people, at worst supporting segregation and at best arguing that blacks were subject to only class, and not race, oppression. However, the Harlem branch uniquely attempted to work out a socialist program to deal with black oppression, thanks in part to the work of the pioneer black socialist HUBERT HENRY HARRISON (who had left the SP by the time Domingo joined).

Domingo, like many radicals from the British Caribbean, opposed the World War both as a socialist internationalist and as an opponent of British imperialism. Domingo's socialist politics increasingly put him at odds with Garvey, and in 1919, Garvey fired him. He quickly became associated with Owen and Randolph's *Messenger*, and in 1920 he also helped Moore edit the short-lived, anti-Garvey *Emancipator*. At the same time he was a leading member of the radical black nationalist African Blood Brotherhood (ABB), organized by Moore, Grace Campbell, and CYRIL VALENTINE BRIGGS. Unlike other members of the New York ABB, however, Domingo did not join the Communist Party. In fact, in 1919 he criticized the precursor to the Communist Party for not paying enough attention to racial oppression.

In the mid-1920s Domingo withdrew from active political life, focusing instead on his business. He did, however, contribute a chapter to ALAIN LEROY LOCKE's anthology *The New Negro* (1925) on West Indians in the United States in which he articulated his perspective on the role of black immigrants on black politics, arguing: "The outstanding contribution of West Indians to American Negro life is the insistent assertion of their manhood in an environment that demands too much servility and unprotesting acquiescence from men of African blood." In 1923, when the *Messenger* attacked Garvey for his Caribbean background, Domingo broke with the *Messenger*, not out of sympathy with Garvey but to protest the paper's increasingly anti–West Indian bias, among other disagreements.

In the 1930s Domingo became active in Caribbean politics. He helped form the Jamaica Progressive League in New York in 1936, which advocated self-rule; it soon merged with Norman Manley's Jamaican nationalist People's Nationalist Party. In 1937–1938 he toured Jamaica, and in the late 1930s he contributed to the *Jamaican Labour Weekly*, Jamaica's first labor paper. With Moore he helped organize the West Indian National Committee in 1941, which, while supporting the British in World War II, sought Caribbean self-determination. In 1941 Manley invited Domingo to visit Jamaica for six months to help organize there. Even before touching shore Domingo was arrested by British authorities under the auspices of wartime emergency powers. Despite the fact that, unlike during World War I, Domingo clearly supported the British, he was held for twenty months in a Jamaican detention center without being charged. Liberals—including the American Civil Liberties Union—radicals, and nationalists took up his case, and in February 1943 the British released him. However, it was not until 1947 that the U.S. government would allow Domingo—who had never become a U.S. citizen—to again enter the country. In the 1950s he broke with his comrades in both the United States and in Jamaica and opposed the short-lived West Indian Federation. In the late 1950s he wrote two pamphlets on this subject, *The British West Indian Federation: A Critique* (1956) and *Federation: Jamaica's Folly* (1958). Some sources report that he was married to a classical pianist, but all details of this alleged relationship, including the woman's name, are a mystery. In 1964 Domingo suffered a stroke and four years later died in New York City.

FURTHER READING

Allen, Ernest, Jr. "The New Negro: Explorations in Identity and Social Consciousness, 1910–1922," in *1915: The Cultural Moment*, eds. Adele Heller and Lois Rudnick (1991).

Hart, Richard. *Towards Decolonisation: Political, Labour and Economic Development in Jamaica, 1938–1945* (1999).

James, Winston. *Holding Aloft the Banner of Ethiopia: Caribbean Radicalism in Early Twentieth-Century America* (1998).

Samuels, Wilfred D. *Five Afro-Caribbean Voices in American Culture, 1917–1929* (1977).

Turner, Joyce Moore. "Richard B. Moore and His Works," in *Richard B. Moore, Caribbean Militant in Harlem: Collected Writings 1920–1972*, eds. W. Burghardt Turner and Joyce Moore Turner (1988).

J. A. ZUMOFF

DOUGLAS, Aaron

(26 May 1899–2 Feb. 1979), artist and educator, was born in Topeka, Kansas, the son of Aaron Douglas Sr., a baker from Tennessee, and Elizabeth (maiden name unknown), an amateur artist from Alabama. Aaron had several brothers and sisters, but he was unique in his family in his singular drive to pursue higher education. He attended segregated elementary schools and then an integrated high school. Topeka had a strong and progressive black community, and Aaron was fortunate to grow up in a city where education and social uplift were stressed through organizations such as the Black Topeka Foundation. He was an avid reader and immersed himself in the great writers, including Dumas, Shakespeare, and Emerson. His parents were able to feed and clothe him but could offer him no other help with higher education. When he needed money to pursue a college degree, he traveled via rail to Detroit, where he worked as a laborer in several jobs, including building automobiles. It was hard work, but it increased his desire to attend college.

Upon his return to Topeka, Douglas decided to attend the University of Nebraska and arrived ten days into the term with no transcripts in hand. This was the first in a series of steps he made to educate himself and improve his artistic skills. The chairman of Nebraska's art department realized Douglas's potential and agreed to accept him on the condition that his transcripts would follow. At Nebraska, Douglas discovered the writings of W. E. B. DU BOIS and found inspiration in them. By 1921 he was a constant reader of *Crisis* magazine, and later, *Opportunity*, and he began to seriously consider the nation's racial situation. Douglas graduated from Nebraska with a BFA in 1922 and accepted a teaching position at Lincoln High School in Kansas City, Missouri, where he was one of only two black faculty members. In 1925, after seeing a special issue of *Survey Graphic* magazine, which focused on Harlem and featured a portrait of the black actor ROLAND HAYES on its cover, Douglas decided to quit his job and pursue his dream of working as a full-time artist. Hoping for wider artistic opportunities and contact with a larger black community, Douglas moved to Harlem in 1925. While he was full of dreams, Douglas had very few connections in New York.

Only days after his arrival, the *Crisis* editor W. E. B. Du Bois hired him to work in the magazine's mail room and to help illustrate the magazine.

Du Bois, who had been editing *Crisis* for fourteen years, was struggling against the competition, *Opportunity* magazine, published by the National Urban League. Needing a stronger visual message, Du Bois turned to Douglas, commissioning bold covers, prints, and drawings to accompany essays, stories, and editorials expressing Du Bois's vision of what African Americans should know about the world around them, and what causes they should support. In 1927 Douglas was made art director at *Crisis*. When Douglas had started work at *Crisis*, he had also been hired by JAMES WELDON JOHNSON to illustrate for *Opportunity* magazine. Douglas soon found himself in the unique, and pleasant, position of having two major publications vying for his talents. Through his *Crisis* connections, Douglas met the Bavarian artist Winold Reiss, who offered him a scholarship to study with him in his New York atelier, where Douglas immersed himself in the study of black life. Douglas was soon noticed by other patrons, and he quickly became one of the most sought-after illustrators of the Harlem Renaissance, receiving commissions to illustrate magazines and book covers as well as to execute a number of private commissions and public murals.

From his earliest Harlem paintings and prints, Douglas developed a strong commitment to establishing an African American identity tied to an African past, a history and identification encouraged by both Du Bois and ALAIN LOCKE. Douglas was drawn to African art even while he knew very little about it. As one of the key visual spokesmen for what became known as the Harlem Renaissance, Douglas used the art of the Ivory Coast, Ethiopia, and Egypt to establish a firm connection between African Americans and African culture. As he wrote to his future wife, Alta Sawyer, in 1925:

> We are possessed, you know, with the idea that it is necessary to be white, to be beautiful. Nine times out of ten it is just the reverse. It takes lots of training or a tremendous effort to down the idea that thin lips and a straight nose is the apogee of beauty. But once free you can look back with a sigh of relief and wonder how anyone could be so deluded.
>
> (Kirschke, 61)

Douglas married Alta in 1926. Over the years the couple's Harlem home became a central meeting place for the artists and writers of the Harlem Renaissance. Meanwhile, Douglas's illustrations, full

of race pride and African heritage, had wide distribution and were seen across the country, in libraries, schools, social clubs, beauty parlors, and homes. He also provided artwork for other magazines, including *Theatre Arts Monthly*, as well as for numerous books. Douglas produced covers and interior illustrations for some of the Harlem Renaissance's most significant literary achievements, including Alain Locke's *New Negro*, WALLACE THURMAN's *The Blacker the Berry*, Paul Morand's *Black Magic*, James Weldon Johnson's *God's Trombones*, COUNTÉE CULLEN's *Caroling Dusk*, and CLAUDE MCKAY's *Banjo*, and several works by LANGSTON HUGHES. Douglas was moved by the artistic milieu in which he worked, especially the literature of the time, written by his friends, which, along with his own work, described black life. Douglas's work articulated the black experience in Harlem in the 1920s and 1930s, including the tremendous output of visual arts and music, and the effects of discrimination and the Depression. Douglas offered a unique visual style, which combined elements of American and European modernism, including cubism, orphism, precisionism, and art deco patterning, with a strong Pan-Africanist vision. His linoleum cuts, pen and ink drawings, oils, gouaches, and frescos forged a distinct combination of modernist elements.

In 1928 Douglas and GWENDOLYN BENNETT became the first African American artists to receive a fellowship to study at the Barnes Foundation in Merion, Pennsylvania. Douglas's one-year fellowship was followed, in 1931, by a year of study in Paris at the Academie Scandinave, where he met the African American painters HENRY OSSAWA TANNER and PALMER HAYDEN.

In addition to his work as an illustrator, Douglas was a painter, particularly of portraits. He was interested in murals and received several mural commissions, including a mural at the Harlem branch of the YMCA, the College Inn in Chicago, and Bennett College in South Carolina. His most innovative project—created for Cravath Hall Library at Fisk University in Nashville, Tennessee, in 1930—was a massive cycle of murals celebrating philosophy, drama, music, poetry, and science, as well as African and African American culture. Restoration of these murals in 2003 revealed orphist-like geometric circles and abstract papyrus-topped columns, as well as four murals that had been covered for decades. One mural depicts Africans left behind as their

family members and friends are taken away, never to be seen again. The mural cycle chronicles the history of blacks from Africa and slavery, to their triumphant release from servitude through education. Ambitious in its Pan-Africanist vision the mural includes elements drawn from Egypt, West Africa, and the Congo. In the 1960s Douglas entirely repainted the Fisk murals with a much brighter, bolder palette. In 1934 Douglas completed *Aspects of Negro Life*, four large mural panels sponsored by the WPA for the Countée Cullen Library at 135th Street (now the Schomburg Center for Research in Black Culture). Like the Fisk murals, these panels illustrate life in Africa before enslavement, through the years of slavery, emancipation, and into the African American present. Douglas offered hope even in the Depression, through creativity, music, and culture.

The Fisk mural commission led to Douglas's return to the university in 1937, where he established the university's first art department, remaining as chair of the department for over thirty years, until his retirement in 1966. In 1944, after years of part-time graduate work, he earned his MA from Columbia University Teacher's College. He taught and worked as an artist well into his seventies and considered his work as an educator at Fisk to be his greatest accomplishment. Douglas, whose work influenced countless artists with its unique vision of African American identity linked to a Pan-Africanist vision, died in Nashville in 1979.

FURTHER READING
Douglas's papers are held in the Fisk University Special Collections, Nashville, Tennessee, and at the Schomburg Center for Research in Black Culture of the New York Public Library.
Kirschke, Amy Helene. *Aaron Douglas: Art, Race and the Harlem Renaissance* (1995).

Obituary: New York Times, 22 Feb. 1979.

AMY HELENE KIRSCHKE

DU BOIS, Shirley Lola Graham

(11 Nov. 1896–27 Mar. 1977), author, composer, playwright, and activist, was born Shirley Lola Graham in Evansville, Indiana, the daughter of David A. Graham, a minister in the African Methodist Episcopal Church, and Etta Bell Graham, a homemaker. Graham's father had read many novels to his daughter, including *Uncle Tom's Cabin*, *Les Miserables*, *Ben Hur*, and *Quo Vadis?*, influencing her to become

a voracious reader. His storytelling and commitment to intellectual pursuits strongly influenced Graham's literary development.

Young Graham's early education began in New Orleans, where her exposure to classic literature put her at an advantage over many of her classmates. When she was eight or nine years old, her family moved to Nashville, Tennessee, where she earned her first income writing for the local newspaper. In 1912 she attended Tenth Street High School in Clarksville, Tennessee, where she distinguished herself as the class poet, and won an essay contest with a paper entitled "BOOKER T. WASHINGTON." Her father's constant relocations resulted in the family's move to Spokane, Washington, where she graduated with honors from Lewis and Clark High School in 1915. In 1921 she married her first husband, Shadrach McCants, who worked for a newspaper and was also a tailor who owned a clothing store.

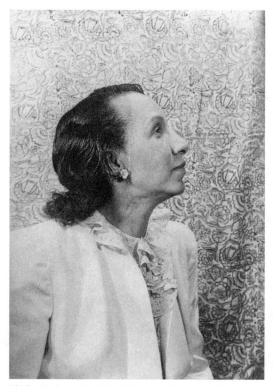

Shirley Graham Du Bois, 18 July 1946. In 1932, she became the first African American woman to write and produce an all-black opera, Tom-Toms: An Epic of Music and the Negro. (Library of Congress/Carl Van Vechten, photographer.)

They had two sons, Robert and David Graham, born in 1923 and 1925, respectively. However, the couple later divorced with the decree rendered in Portland, Oregon, in 1927.

Graham began to compose songs, musical plays, and operas while at the Sorbonne in Paris, France, in 1929 where she studied music composition. In 1930, Graham returned to the United States and taught music at Morgan College in Baltimore, Maryland, for two years. She then entered Oberlin College in Ohio to complete her bachelor's degree. In 1932 she composed *Tom-Tom* for a school production at Oberlin College, which later developed into a highly acclaimed opera dramatizing the history of African Americans, set in Africa in the beginning, and ending in Harlem. In 1934, Graham earned a bachelor's degree in music from Oberlin and a MA in Music History in 1935. From 1935 to 1936, Graham taught music and arts at Agricultural and Industrial State College in Nashville. She won a Julius Rosenwald Fellowship in 1938 for creative writing and spent two years at the Yale School of Drama, where she wrote a three-act play, *Dust to Earth*. She also wrote other short plays that were produced by the Gilpin Players in Cleveland, Ohio, including *Coal Dust* (1938) and *I Gotta Home* (1939). During the same period she wrote a radio play, *Track Thirteen*, that was produced in 1940.

In addition to her teaching and writing, she served as supervisor of the Negro Unit of the Chicago Federal Theater from 1936 to 1938. During World War II, she was USO Director at Fort Huachuca in Arizona, and later became the NAACP's national field secretary and founding editor of *Freedomways* magazine, where she remained until 1963. Graham is also remembered for her marriage to W. E. B. DU BOIS. She met him when she was only thirteen years old after her father invited him to Colorado Springs, Colorado, to deliver a lecture; he was in his early fifties. As a young woman, she had admired his writings and faithfully tracked his career through the NAACP's magazine *The Crisis*, which he edited. While at Oberlin, Graham sent a draft of her thesis, "Survival of Africanisms in Modern Music," to W. E. B. for suggestions and comments and he returned it with favorable remarks. Through this medium, W. E. B. became Graham's literary mentor for various writing projects and their professional relationship blossomed into love. Shortly after the death of his first wife, the fifty-four-year-old Graham and eighty-four-year-old Du

Bois were married without publicity on 14 February 1951. The union was immediately complicated by her husband's indictment on 9 February 1951, from charges related to his peace activism and support for Communism. The federal government branded him as an agent of an unnamed foreign power—presumably the Soviet Union—and had him arrested. Upon his release, the two began traveling extensively and raising funds to support her husband's cause.

Du Bois and her husband received considerable criticism for their involvement with the Communist Party during the 1950s, spurring their travel to Western and Eastern Europe, the Soviet Union, and China. The experience dramatically changed Shirley Du Bois's political consciousness, and in 1962 she and her husband joined the Communist Party and moved to Accra, Ghana, on invitation from President Kwame Nkrumah. Du Bois resigned her position as editor of *Freedomways* to accompany her husband and assist him in completing his epic writing project, the *Encyclopedia Africana*.

After her husband's death in 1963 at the age of ninety-five, Du Bois wrote two books about her husband. She remained in Ghana, writing and sorting out details for many of his unfinished projects. In 1967, when Nkrumah was ousted from the presidency, Du Bois was forced to leave Ghana and took up residence in Cairo for a few years. In 1971 she attempted to move to New York, but the Justice Department denied her a visa, claiming that she had been associated with more than thirty organizations on the U.S. attorney general's list of subversive groups. The government eventually relented and allowed her to visit the United States for two months. Stateless, she ended up in Beijing, China, where after several years she lost her battle with breast cancer and died in 1977 at the age of sixty-nine. Her influence was great even in China, where officials held a memorial service on 2 April 1977 at the Papaoshan Cemetery for Revolutionaries. Du Bois was a controversial figure, yet she represented an important advocate for civil rights and employed her skills as an author, playwright, and composer to fight racial discrimination. Du Bois was a prolific writer as well. She not only composed numerous plays and songs but also a number of popularized biographies including: *Dr. George Washington Carver Scientist* with George D. Lipscomb and Elton C. Fax (1944); *Paul Robeson Citizen of the World* [juvenile literature] (1946); *There Was Once a Slave:*

The Heroic Story of Frederick Douglass (1947); *Your Most Humble Servant: The Story of Benjamin Banneker* (1949); *The Story of Phillis Wheatley* [juvenile literature] (1949); *The Story of Pocahontas* (1953); *Jean Baptiste Pointe Du Sable: Founder of Chicago* [juvenile literature] (1953); *Booker T. Washington: Educator of Hand, Head, and Heart* (1955); *His Day is Marching On: A Memoir of W. E. B. Du Bois* (1971); *Gamel Abdul Nasser, Son of Nile* (1974); *Julius K. Nyerere: Teacher of Africa in* (1975); and *The Zulu Heart* (1978).

FURTHER READING

Du Bois, Shirley Graham. *Du Bois: A Pictorial Biography* (1978).

Du Bois, Shirley Graham. *His Day Is Marching On: A Memoir of W. E. B. DuBois* (1971).

Golus, Carrie. "Shirley Graham Du Bois," *Contemporary Black Biography*, vol. 21 (1999).

Horne, Gerald. *Race Woman: The Lives of Shirley Graham Du Bois* (2000).

VERNITTA BROTHERS TUCKER

DU BOIS, W. E. B.

(23 Feb. 1868–27 Aug. 1963), scholar, writer, editor, and civil rights pioneer, was born William Edward Burghardt Du Bois in Great Barrington, Massachusetts, the son of Mary Silvina Burghardt, a domestic worker, and Alfred Du Bois, a barber and itinerant laborer. In later life Du Bois made a close study of his family origins, weaving them rhetorically and conceptually—if not always accurately—into almost everything he wrote. Born in Haiti and descended from mixed race Bahamian slaves, Alfred Du Bois enlisted during the Civil War as a private in a New York regiment of the Union army but appears to have deserted shortly afterward. He also deserted the family less than two years after his son's birth, leaving him to be reared by his mother and the extended Burghardt kin. Long resident in New England, the Burghardts descended from a freedman of Dutch slave origin who had fought briefly in the American Revolution. Under the care of his mother and her relatives, young Will Du Bois spent his entire childhood in that small western Massachusetts town, where probably fewer than two-score of the four thousand inhabitants were African American. He received a classical, college preparatory education in Great Barrington's racially integrated high school, from whence, in June 1884, he became the first African American graduate.

W. E. B. Du Bois, 31 May 1919. Du Bois was the first African American to earn a doctoral degree from Harvard University. Throughout his life he served as one of black America's leading intellectual voices. (Library of Congress/Cornelius M. Battey, photographer.)

A precocious youth, Du Bois not only excelled in his high school studies but also contributed numerous articles to two regional newspapers, the Springfield *Republican* and the black-owned New York *Globe*, then edited by T. Thomas Fortune.

In 1888 Du Bois enrolled at Harvard as a junior. He received a BA cum laude, in 1890, an MA in 1891, and a PhD in 1895. Du Bois was strongly influenced by the new historical work of the German-trained Albert Bushnell Hart and the philosophical lectures of William James, both of whom became friends and professional mentors. Other intellectual influences came with his studies and travels between 1892 and 1894 in Germany, where he was enrolled at the Friedrich-Wilhelm III Universität (then commonly referred to as the University of Berlin but renamed the Humboldt University after World War II). Because of the expiration of the Slater Fund fellowship that supported his stay in Germany, Du Bois could not meet the residency requirements that would have enabled him formally to stand for the degree in economics, despite his completion of the required doctoral thesis (on the history of southern U.S. agriculture) during his tenure. Returning to the United States in the summer of 1894, Du Bois taught classics and modern languages for two years at Wilberforce University in Ohio. While there, he met Nina Gomer, a student at the college, whom he married in 1896 at her home in Cedar Rapids, Iowa. The couple had two children. By the end of his first year at Wilberforce, Du Bois had completed his Harvard doctoral thesis, "The Suppression of the African Slave Trade to the United States of America, 1638–1870," which was published in 1896 as the inaugural volume of the Harvard Historical Studies series.

In high school Du Bois came under the influence of and received mentorship from the principal, Frank Hosmer, who encouraged his extensive reading and solicited scholarship aid from local worthies that enabled Du Bois to enroll at Fisk University in September 1885, six months after his mother's death. One of the best of the southern colleges for newly freed slaves founded after the Civil War, Fisk offered a continuation of his classical education and the strong influence of teachers who were heirs to New England and Western Reserve (Ohio) abolitionism. It also offered the northern-reared Du Bois an introduction to southern American racism and African American culture. His later writings and thought were strongly marked, for example, by his experiences teaching school in the hills of eastern Tennessee during the summers of 1886 and 1887.

Although he had written his Berlin thesis in economic history, received his Harvard doctorate in history, and taught languages and literature at Wilberforce, Du Bois made some of his most important early intellectual contributions to the emerging field of sociology. In 1896 he was invited by the University of Pennsylvania to conduct a study of the Seventh Ward in Philadelphia. There, after an estimated 835 hours of door-to-door interviews in 2,500 households, Du Bois completed the monumental study, *The Philadelphia Negro* (1899). The Philadelphia study was both highly empirical and hortatory, a combination that prefigured much of the politically engaged scholarship that Du Bois pursued in the years that followed and that reflected the two main strands of his intellectual engagement during this formative period: the scientific study of the so-called Negro Problem and the appropriate political responses to it. While completing his fieldwork in Philadelphia, Du Bois delivered

to the Academy of Political and Social Science in November 1896 an address, "The Study of the Negro Problem," a methodological manifesto on the purposes and appropriate methods for scholarly examination of the condition of black people. In March 1897, addressing the newly founded American Negro Academy in Washington, D.C., he outlined for his black intellectual colleagues, in "The Conservation of the Races," both a historical sociology and theory of race as a concept and a call to action in defense of African American culture and identity. During the following July and August he undertook for the U.S. Bureau of Labor the first of several studies of southern African American households, which was published as a bureau bulletin the following year under the title *The Negroes of Farmville, Virginia: A Social Study*. During that same summer, *Atlantic Monthly* published the essay "The Strivings of the Negro People," a slightly revised version of which later opened *The Souls of Black Folk* (1903).

Together these works frame Du Bois's evolving conceptualization of, methodological approach to, and political values and commitments regarding the problem of race in America. His conceptions were historical and global, his methodology empirical and intuitive, his values and commitments involving both mobilization of an elite vanguard to address the issues of racism and the conscious cultivation of the values to be drawn from African American folk culture.

After the completion of the Philadelphia study in December 1897, Du Bois began the first of two long tenures at Atlanta University, where he taught sociology and directed empirical studies—modeled loosely on his Philadelphia and Farmville work—of the social and economic conditions and cultural and institutional lives of southern African Americans. During this first tenure at Atlanta he also wrote two more books, *The Souls of Black Folk*, a collection of poignant essays on race, labor, and culture, and *John Brown* (1909), an impassioned interpretation of the life and martyrdom of the militant abolitionist. He also edited two short-lived magazines, *Moon* (1905–1906) and *Horizon* (1907–1910), which represented his earliest efforts to establish journals of intellectual and political opinion for a black readership.

With the publication of *Souls of Black Folk*, Du Bois emerged as the most prominent spokesperson for the opposition to BOOKER T. WASHINGTON's policy of political conservatism and racial accommodation. Ironically, Du Bois had kept a prudent distance from Washington's opponents and had made few overt statements in opposition to the so-called Wizard of Tuskegee. In fact, his career had involved a number of near-misses whereby he himself might have ended up teaching at Tuskegee. Having applied to Washington for a job shortly after returning from Berlin, he had to decline Tuskegee's superior monetary offer because he had already accepted a position at Wilberforce. On a number of other occasions Washington—sometimes prodded by Albert Bushnell Hart—sought to recruit Du Bois to join him at Tuskegee, a courtship he continued at least until the summer of 1903, when Du Bois taught summer school at Tuskegee. Early in his career, moreover, Du Bois's views bore a superficial similarity to Washington's. In fact, he had praised Washington's 1895 "Atlanta Compromise" speech, which proposed to southern white elites a compromise wherein blacks would forswear political and civil rights in exchange for economic opportunities. Like many elite blacks at the time, Du Bois was not averse to some form of franchise restriction, so long as it was based on educational qualifications and applied equally to white and black. Du Bois had been charged with overseeing the African American Council's efforts to encourage black economic enterprise and worked with Washington's partisans in that effort. By his own account his overt rupture with Washington was sparked by the growing evidence of a conspiracy, emanating from Tuskegee, to dictate speech and opinion in all of black America and to crush any opposition to Washington's leadership. After the collapse of efforts to compromise their differences through a series of meetings in 1904, Du Bois joined WILLIAM MONROE TROTTER and other Washington opponents to form the Niagara Movement, an organization militantly advocating full civil and political rights for African Americans.

Although it enjoyed some success in articulating an alternative vision of how black Americans should respond to the growing segregation and racial violence of the early twentieth century, the Niagara Movement was fatally hampered by lack of funds and the overt and covert opposition of Washington and his allies. Indeed, the vision and program of the movement were fully realized only with the founding of a new biracial organization, the National Association for the Advancement of Colored People (NAACP). The NAACP grew out of

the agitation and a 1909 conference called to protest the deteriorating status of and escalating violence against black Americans. Racial rioting in August 1908 in Springfield, Illinois, the home of Abraham Lincoln, sparked widespread protest among blacks and liberal whites appalled at the apparent spread of southern violence and lynch law into northern cities. Although its officers made some initial efforts to maintain a détente with Booker T. Washington, the NAACP represented a clear opposition to his policy of accommodation and political quietism. It launched legal suits, legislative lobbying, and propaganda campaigns that embodied uncompromising, militant attacks on lynching, Jim Crow, and disfranchisement. In 1910 Du Bois left Atlanta to join the NAACP as an officer, its only black board member, and to edit its monthly magazine, *The Crisis*.

As editor of *The Crisis* Du Bois finally established the journal of opinion that had so long eluded him, one that could serve as a platform from which to reach a larger audience among African Americans and one that united the multiple strands of his life's work. In its monthly issues he rallied black support for NAACP policies and programs and excoriated white opposition to equal rights. But he also opened the journal to discussions of diverse subjects related to race relations and black cultural and social life, from black religion to new poetic works. The journal's cover displayed a rich visual imagery embodying the sheer diversity and breadth of the black presence in America. Thus the journal constituted, simultaneously, a forum for multiple expressions of and the coherent representation and enactment of black intellectual and cultural life. A mirror for and to black America, it inspired a black intelligentsia and its public.

From his vantage as an officer of the NAACP, Du Bois also furthered another compelling intellectual and political interest, Pan-Africanism. He had attended the first conference on the global condition of peoples of African descent in London in 1900. Six other gatherings followed between 1911 and 1945, including the First Universal Races Congress in London in 1911, and Pan-African congresses held in Paris in 1919; London, Brussels, and Paris in 1921; London and Lisbon in 1923; New York City in 1927; and in Manchester, England, in 1945. Each conference focused in some fashion on the fate of African colonies in the postwar world, but the political agendas of the earliest meetings were often compromised by the ideological and political entanglements of the elite delegates chosen to represent the African colonies. The Jamaican black nationalist MARCUS GARVEY enjoyed greater success in mobilizing a mass base for his version of Pan-Africanism and posed a substantial ideological and political challenge to Du Bois. Deeply suspicious of Garvey's extravagance and flamboyance, Du Bois condemned his scheme to collect funds from African Americans to establish a shipping line that would aid their "return" to Africa, his militant advocacy of racial separatism, and his seeming alliance with the Ku Klux Klan. Although he played no role in the efforts to have Garvey jailed and eventually deported for mail fraud, Du Bois was not sorry to see him go. (In 1945, however, Du Bois joined Garvey's widow, Amy Jacques Garvey, and GEORGE PADMORE to sponsor the Manchester Pan-African conference that demanded African independence. Du Bois cochaired the opening session of the conference with Garvey's first wife, Amy Ashwood Garvey.)

The rupture in world history that was World War I and the vast social and political transformations of the decade that followed were reflected in Du Bois's thought and program in other ways as well. During the war he had written "Close Ranks," a controversial editorial in *The Crisis* (July 1918), which urged African Americans to set aside their grievances for the moment and concentrate their energies on the war effort. In fact, Du Bois and the NAACP fought for officer training and equal treatment for black troops throughout the war, led a silent protest march down Fifth Avenue in 1917 against racism, and in 1919 launched an investigation into charges of discrimination against black troops in Europe. Meanwhile, the unprecedented scope and brutality of the war itself stimulated changes in Du Bois's evolving analyses of racial issues and phenomena. *Darkwater: Voices within the Veil* (1920) reflects many of these themes, including the role of African colonization and the fundamental role of the international recruitment and subjugation of labor in causing the war and in shaping its aftermath. His visit to Liberia in 1923 and the Soviet Union in 1926, his subsequent study of Marxism, his growing awareness of Freud, and the challenges posed by the Great Depression all brought him to question the NAACP's largely legalistic and propagandistic approach to fighting racism. In the early 1930s Du Bois opened the pages of *The Crisis* to wide-ranging discussions of the

utility of Marxian thought and of racially based economic cooperatives and other institutions in the fight against race prejudice. This led to increasing antagonism between him and his colleagues at the NAACP, especially the executive director WALTER WHITE, and to his resignation in June 1934.

Du Bois accepted an appointment as chair of the sociology department at Atlanta University, where he had already been teaching as a visiting professor during the winter of 1934. There he founded and edited a new scholarly journal, *Phylon*, from 1940 to 1944. There, too, he published his most important historical work, *Black Reconstruction in America: An Essay toward a History of the Part Which Black Folk Played in the Attempt to Reconstruct Democracy in America, 1860–1880* (1935), and *Dusk of Dawn: An Essay toward an Autobiography of a Race Concept* (1940), his most engaging and poignant autobiographical essay since *Souls of Black Folk*. During this period Du Bois continued to be an active lecturer and an interlocutor with young scholars and activists; he also deepened his studies of Marxism and traveled abroad. He sought unsuccessfully to enlist the aid of the Phelps-Stokes Fund in launching his long-dreamed-of project to prepare an encyclopedia of black peoples in Africa and the diaspora. By 1944, however, Du Bois had lost an invaluable supporter and friend with the death of JOHN HOPE, the president of Atlanta University, leaving him vulnerable to dismissal following sharp disagreements with Hope's successor.

Far from acceding to a peaceful retirement, however, in 1944 Du Bois (now seventy-six years old) accepted an invitation to return to the NAACP to serve in the newly created post of director of special research. Although the organization was still under the staff direction of Du Bois's former antagonist, Walter White, the 1930s Depression and World War II had induced some modifications in the programs and tactics of the NAACP, perhaps in response to challenges raised by Du Bois and other younger critics. It had begun to address the problems of labor as well as legal discrimination, and even the court strategy was becoming much more aggressive and economically targeted. In hiring Du Bois, the board appears to have anticipated that other shifts in its approach would be necessary in the coming postwar era. Clearly it was Du Bois's understanding that his return portended continued study of and agitation around the implications of the coming postwar settlement as it might affect black peoples in Africa and the diaspora, and that claims for the representation of African and African American interests in that settlement were to be pressed. He represented the NAACP in 1945 as a consultant to the U.S. delegation at the founding conference of the United Nations in San Francisco. In 1947 he prepared and presented to that organization *An Appeal to the World*, a ninety-four-page, militant protest against American racism as an international violation of human rights. During this period and in support of these activities he wrote two more books, *Color and Democracy: Colonies and Peace* (1945) and *The World and Africa: An Inquiry into the Part Which Africa Has Played in World History* (1947), each of which addressed some aspect of European and American responsibilities for justice in the colonial world.

As ever, Du Bois learned from and was responsive to the events and developments of his time. Conflicts with the U.S. delegation to the United Nations (which included Eleanor Roosevelt, who was also a member of the NAACP board) and disillusionment with the evolving role of America as a postwar world power reinforced his growing radicalism and refusal to be confined to a safe domestic agenda. He became a supporter of the leftist Southern Negro Youth Congress at a time of rising hysteria about Communism and the onset of the cold war. In 1948 he was an active supporter of the Progressive Party and Henry Wallace's presidential bid. All of this put him at odds with Walter White and the NAACP board, who were drawn increasingly into collusion with the Harry S. Truman administration and into fierce opposition to any leftist associations. In 1948, after an inconclusive argument over assigning responsibility for a leak to the *New York Times* of a Du Bois memorandum critical of the organization and its policies, he was forced out of the NAACP for a second time.

After leaving the NAACP, Du Bois joined the Council on African Affairs, where he chaired the Africa Aid Committee and was active in supporting the early struggle of the African National Congress of South Africa against apartheid. The council had been organized in London in the late 1930s by Max Yergan and PAUL ROBESON to push decolonization and to educate the general public about that issue. In the postwar period it, too, became tainted by charges of Communist domination and lost many former supporters (including Yergan and Ralph Bunche); it dissolved altogether in 1955.

Having linked the causes of decolonialization and antiracism to the fate of peace in a nuclear-armed world, Du Bois helped organize the Cultural and Scientific Conference for World Peace in March 1949, was active in organizing its meetings in Paris and Mexico City later that year, and attended its Moscow conference that August. Subsequently this group founded the Peace Information Center in 1950, and Du Bois was chosen to chair its Advisory Council. The center endorsed and promoted the Stockholm Peace Appeal, which called for banning atomic weapons, declaring their use a crime against humanity and demanding international controls. During this year Du Bois, who actively opposed the Korean War and Truman's foreign policy more generally, accepted the nomination of New York's Progressive Party to run for the U.S. Senate on the platform "Peace and Civil Rights." Although he lost, his vote total ran considerably ahead of the other candidates on the Progressive ticket.

During the campaign, on 25 August 1950, the officers of the Peace Information Center were directed to register as "agents of a foreign principal" under terms of the Foreign Agents Registration Act of 1938. Their distribution of the Stockholm Appeal, alleged to be a Soviet-inspired manifesto, was the grounds for these charges, although the so-called foreign principal was never specifically identified in the subsequent indictment. Although the center disbanded on 12 October 1950, indictments against its officers, including Du Bois, were handed down on 9 February 1951. Du Bois's lawyers won a crucial postponement of the trial until the following 18 November 1951, by which time national and international opposition to the trial had been mobilized. Given the good fortune of a weak case and a fair judge, Du Bois and his colleagues were acquitted. Meanwhile, following the death of his wife, Nina, in July 1950, Du Bois married Shirley Graham, the daughter of an old friend, in 1951. Although the union bore no children, David, Shirley Du Bois's son from an earlier marriage, took Du Bois's surname.

After the trial, Du Bois continued to be active in the American Peace Crusade and received the International Peace Prize from the World Council of Peace in 1953. With Shirley, a militant leftist activist in her own right, he was drawn more deeply into leftist and Communist Party intellectual and social circles during the 1950s. He was an unrepentant supporter of and apologist for Joseph Stalin,

arguing that though Stalin's methods might have been cruel, they were necessitated by unprincipled and implacable opposition from the West and by U.S. efforts to undermine the regime. He was also convinced that American news reports about Stalin and the Soviet bloc were unreliable at best and sheer propaganda or falsehoods at worst. His views do not appear to have been altered by the Soviets' own exposure and condemnation of Stalin after 1956.

From February 1952 to 1958 both W. E. B. and Shirley were denied passports to travel abroad. Thus he could not accept the many invitations to speak abroad or participate in international affairs, including most notably the 1957 independence celebrations of Ghana, the first of the newly independent African nations. When these restrictions were lifted in 1958, the couple traveled to the Soviet Union, Eastern Europe, and China. While in Moscow, Du Bois was warmly received by Nikita Khrushchev, whom he strongly urged to promote the study of African civilization in Russia, a proposal that eventually led to the establishment in 1962 of the Institute for the Study of Africa. While there, he also received the Lenin Peace Prize.

But continued cold war tensions and their potential impact on his ability to travel and remain active in the future led Du Bois to look favorably on an invitation in May 1961 from Kwame Nkrumah and the Ghana Academy of Sciences to move to Ghana and undertake direction of the preparation of an "Encyclopedia Africana," a project much like one he had long contemplated. Indeed, his passport had been rescinded again after his return from China (travel to that country was barred at the time), and it was only restored after intense lobbying by the Ghanaian government. Before leaving the United States for Ghana on 7 October 1961, Du Bois officially joined the American Communist Party, declaring in his 1 October 1961 letter of application that it and socialism were the only viable hope for black liberation and world peace. His desire to travel and work freely also prompted his decision two years later to become a citizen of Ghana.

In some sense these actions brought full circle some of the key issues that had animated Du Bois's life. Having organized his life's work around the comprehensive, empirically grounded study of what had once been called the Negro Problem, he ended his years laboring on an interdisciplinary

and global publication that might have been the culmination and symbol of that ambition: to document the experience and historical contributions of African peoples in the world. Having witnessed the formal détente among European powers by which the African continent was colonized in the late nineteenth century, he lived to taste the fruits of the struggle to decolonize it in the late twentieth century and to become a citizen of the first new African nation. Having posed at the end of the nineteenth century the problem of black identity in the diaspora, he appeared to resolve the question in his own life by returning to Africa. Undoubtedly the most important modern African American intellectual, Du Bois virtually invented modern African American letters and gave form to the consciousness animating the work of practically all other modern African American intellectuals to follow. He authored seventeen books, including five novels; founded and edited four different journals; and pursued two full-time careers: scholar and political organizer. But more than that, he reshaped how the experience of America and African America could be understood; he made us know both the complexity of who black Americans have been and are, and why it matters; and he left Americans—black and white—a legacy of intellectual tools, a language with which they might analyze their present and imagine a future.

From late 1961 to 1963 Du Bois lived a full life in Accra, the Ghanaian capital, working on the encyclopedia, taking long drives in the afternoon, and entertaining its political elite and the small colony of African Americans during the evenings at the comfortable home the government had provided him. Du Bois died the day before his American compatriots assembled for the March on Washington for Jobs and Freedom. It was a conjunction more than rich with historical symbolism. It was the beginning of the end of the era of segregation that had shaped so much of Du Bois's life, but it was also the beginning of a new era when "the Negro Problem" could not be confined to separable terrains of the political, economic, domestic, or international, or to simple solutions such as integration or separatism, rights or consciousness. The life and work of Du Bois had anticipated this necessary synthesis of diverse terrains and solutions. On 29 August 1963 Du Bois was interred in a state funeral outside Castle Osu, formerly a holding pen for the slave cargoes bound for America.

FURTHER READING

Du Bois's papers are at the University of Massachusetts, Amherst, and are also available on microfilm.

Du Bois, W. E. B. *The Complete Published Works of W. E. B. Du Bois*, comp. and ed. Herbert Aptheker (1982).

Horne, Gerald. *Black and Red: W. E. B. Du Bois and the Afro-American Response to the Cold War, 1944–1963* (1986).

Lewis, David Levering. *W. E. B. Du Bois: Biography of a Race, 1868–1919* (1993).

Lewis, David Levering. *W. E. B. Du Bois: The Fight for Equality and the American Century, 1919–1963* (2000).

Marable, Manning. *W. E. B. Du Bois: Black Radical Democrat* (1986).

Rampersad, Arnold. *The Art and Imagination of W. E. B. Du Bois* (1976).

Obituary: *New York Times*, 28 Aug. 1963.

THOMAS C. HOLT

DUDLEY, Sherman Houston

(1873–29 Feb. 1940), vaudeville entertainer and theatrical entrepreneur, was born in Dallas, Texas. The names of his parents are unknown. Though in later interviews Dudley frequently changed the story of how he broke into show business, his earliest stage work was most likely in Texas and Louisiana as part of a medicine show. This job, in which he played music and told jokes to draw a crowd to the pitchman and his wares, was an appropriate beginning for a man who always sought to be the center of attention. Dudley eventually became an artist and businessman who, as demonstrated by both his actions and writings, was passionately concerned with cultivating the rights and strengthening the dignity of African American performers during an era when what it meant to be a black entertainer was greatly in flux.

Dudley's apprenticeship in the professional theatrical world took place during the last decade of the nineteenth century, and as a young man he worked with many of the most influential and recognized black performers of minstrelsy and vaudeville. He formed the Dudley Georgia Minstrels in 1897 to perform around Texas, and his first real touring show was with P. T. Wright's Nashville Students during the 1898 season. Even in this early show, he was described in newspaper articles as not only

one of the top comedians but also as a writer of humorous sketches. Throughout his career Dudley performed only in comedies and always in black-face, an expected practice for vaudevillians of the day. He apparently met his first wife while part of WILL MARION COOK's Clorindy company. Alberta Ormes-Dudley, a talented actress herself, toured with her husband throughout the first decade of the twentieth century and frequently acted opposite him. In 1900 Dudley worked with veteran minstrel Billy Kersands in the ill-fated *King Rastus* and later reteamed with Kersands in 1902 as part of Richards and Pringle's Georgia Minstrels. He stayed with the show for two years, acting, writing, and stage managing. Reviews singled him out for his energetic wit and comic timing.

His break into stardom occurred in 1904, when he signed up with the Smart Set Company to replace the recently deceased Tom McIntosh as the show's headliner. His three shows with the Smart Set became his theatrical legacy and gave him both the industry contacts and financial security to embark on the next phase of his career. He also developed his signature routine at this time, which became synonymous with his name and was demanded of him by audiences around the country. The routine was called "Dudley and His Mule," and it was worked into the narratives of each of his Smart Set shows. Dudley would stroll onstage with a live mule, which, dressed in a pair of overalls, would amble around the stage while his human sidekick commented on his bad behavior. In a June 1932 article for *The Crisis* magazine, Dudley commented, "I had to follow the mule not the mule to follow me. My cues came from him. And I had to answer mighty quick. I talked to the mule about what he did and the audience thought he was doing what I had taught him" (203).

The typical Smart Set show consisted of a thin plot that was little more than an excuse to show-case female dancers, ragtime music, and zany comedy. In *The Black Politician*, Dudley made a hit of the humorous ditty "Come after Breakfast, Bring 'Long Your Lunch, and Leave before Supper." The next production was titled *His Honor the Barber*, in which Dudley played Raspberry Snow, a small-town barber whose ambition in life is to shave the president. When he is about to get his chance, the whole affair is revealed to have been a dream. *Dr. Beans from Boston* debuted in 1912 and ran intermittently for several years. Dudley's character, Gymnasium

Butts, masqueraded as the eponymous doctor in order to scam a southern town's drugstore. Even as *Dr. Beans* was touring, Dudley embarked on the next phase of his lengthy career, that of theater owner and circuit manager.

For black entertainers the first two decades of the twentieth century were marked by a new economic freedom coupled with both increased mobility and visibility, which in turn brought new forms of prejudice. Most U.S. theaters at the time were organized within large white-owned chains called circuits. These immensely powerful and lucrative enterprises dictated which vaudeville and variety acts performed within the chain of theaters, and in exchange the performers were guaranteed regular employment. African Americans were frequently limited to a single act on an evening's bill, and the houses were normally segregated. Dudley—who in 1906 wrote a letter praising Chicago's black-owned Pekin Theatre—saw an opportunity as both a savvy businessman and a conscientious African American to create a separate circuit exclusively presenting black acts and catering to black audiences. He bought his first theater in Washington, D.C., in 1912 and named it after himself. By 1914 the Dudley Circuit had become a conglomeration of nineteen theaters in the East, South, and Midwest. As an owner and promoter, Dudley was known for his fair dealings and his willingness to cultivate young talent. In 1916 he joined with two white promoters to create the Southern Consolidated Circuit (SCC). The SCC's chain of more than twenty-five theaters allowed hundreds of black performers to work steadily for an entire season.

Two major events occurred at the beginning of the 1920s that changed how the African American entertainment business was run, and Dudley was at the center of both. Noting the profitability of the SCC, a group of white theater managers revived the near-defunct Theatre Owners' Booking Association (TOBA) in 1920 to compete with the SCC for the same performers and over similar routes throughout the circuit. The feud between the organizations was short lived, however, because the next year the SCC was absorbed into its rival. Dudley was briefly left off of the board of directors but was reinstated in January 1922. TOBA (which performers said was an acronym for "Tough on Black Asses") quickly began booking the talent into segregated houses and squeezing extra performances out of its acts. The Colored Actors' Union (CAU), the voice

of entertainers in the industry, was founded shortly after this merger. Always the joiner, Dudley was one of the charter members of the organization and was its first treasurer. He noted this contradictory position in several of his frequent letters to the black press and confessed that he was attempting to balance the interests of both owners and performers. He also continued to produce specific shows that toured in TOBA houses, like *Bamville Follies* in 1926 and *Ebony Follies* in 1928.

In 1924 Dudley was married a second time, to Desdemona B. Dudley, a former employee. Her background is a mystery. In 1926 he sought a divorce on the grounds of infidelity, but before the case could go to trial, she was killed by the man named in the suit as her alleged lover.

Dudley also became an early black entrepreneur in the budding movie industry. Much like his advancements in the theatrical world, his ability to work with white businesspeople supported his more altruistic ideas of aiding African American artists. Dudley had always been a vocal advocate of "race pictures," films that featured African American performers and were intended for black audiences. In 1927 he assumed the presidency of the financially struggling Colored Players Film Corporation, which until that time had been run by a group of white Philadelphians. The company produced the silent film *The Scar of Shame,* starring Lucia Lynn Moses and Lawrence Chenault, in 1929 and then quietly folded. At the same time, Dudley's theaters were hit hard by the economic effects of the Depression, and by 1930 he had sold off much of his interest in the chain.

Dudley had lived in the Washington, D.C., area since the early days of the Dudley Circuit, and in the last decade of his life he continued working with the CAU and breeding racehorses on his Oxen Hill farm. Starting in the mid-1930s he co-produced variety shows with his son Sherman H. Dudley Jr. One of Dudley's obituaries noted that his son, following in his father's footsteps, was working on opening a show at the Apollo Theater in Harlem, New York (*Baltimore Afro-American*, 16 Mar. 1940).

FURTHER READING

Hill, Anthony D. *Pages from the Harlem Renaissance: A Chronicle of Performance* (1996).

Sampson, Henry T. *Blacks in Blackface: A Source Book on Early Black Musical Shows* (1980).

KEVIN BYRNE

DUNBAR, Paul Laurence

(27 June 1872–9 Feb. 1906), author, was born in Dayton, Ohio, the son of Joshua Dunbar, a plasterer, and Matilda Burton Murphy, a laundry worker. His literary career began at age twelve, when he wrote an Easter poem and recited it in church. He served as editor in chief of his high school's student newspaper and presided over its debating society. While still in school, he contributed poems and sketches to the *Dayton Herald* and the *West Side News*, a local paper published by Orville Wright of Kitty Hawk fame, and briefly edited the *Tattler*, a newspaper for blacks that Wright published and printed. He graduated from high school in 1891 with the hope of becoming a lawyer, but, lacking the funds to pursue a college education, he went instead to work as an elevator operator.

Dunbar wrote and submitted poetry and short stories in his spare time. His first break came in 1892, when the Western Association of Writers held its annual meeting in Dayton. One of Dunbar's former teachers arranged to have him deliver

Paul Laurence Dunbar, as shown in the frontispiece to his Lyrics of Sunshine and Shadow, 1905. (Library of Congress.)

the welcoming address, and his rhyming greeting pleased the conventioneers so much that they voted him into the association. One of the attendees, poet James Newton Matthews, wrote an article about Dayton's young black poet that received wide publication in the Midwest, and soon Dunbar was receiving invitations from newspaper editors to submit his poems for publication. Encouraged by this success, he published *Oak and Ivy* (1893), a slender volume of fifty-six poems that sold well, particularly after Dunbar, an excellent public speaker, read selections from the book before evening club and church meetings throughout Ohio and Indiana.

In 1893 Dunbar traveled to Chicago, Illinois, to write an article for the *Herald* about the World's Columbian Exposition. He decided to stay in the Windy City and found employment as a latrine attendant. He eventually obtained a position as clerk to Frederick Douglass, who was overseeing the Haitian Pavilion, as well as a temporary assignment from the Chicago *Record* to cover the exposition. After a rousing Douglass speech, the highlight of the exposition's Negro American Day, Dunbar read one of his poems, "The Colored Soldiers," to an appreciative audience of thousands. Sadly, when the exposition closed, Chicago offered Dunbar no better opportunity for full-time employment than his old job as elevator boy, and so he reluctantly returned to Dayton. However, he did so with Douglass's praise ringing in his ears: "One of the sweetest songsters his race has produced and a man of whom I hope great things."

Dunbar's determination to become a great writer was almost derailed by a chance to pursue his old dream of becoming a lawyer. In 1894 a Dayton attorney hired him as a law clerk with the understanding that Dunbar would have the opportunity to study law on the side. However, Dunbar discovered that law no longer enthralled him as it once had; moreover, he found that working and studying left him no time to write, and so he returned to the elevator and his poetry. He soon had enough new poems for a second volume, *Majors and Minors* (1895), which was published privately with the financial backing of H. A. Tobey of Toledo, Ohio. This work contains poems in both standard English ("majors") and black dialect ("minors"), many of which are regarded as among his best. In 1896 William Dean Howells, at the time America's most prominent literary critic, wrote a lengthy and enthusiastic review of *Majors and Minors*'s dialect poems for *Harper's*

Weekly, a highly regarded literary magazine with a wide circulation. The review gave Dunbar's career as a poet a tremendous boost. Sales of *Majors and Minors* skyrocketed, and Dunbar, now under the management of Major James Burton Pond's lecture bureau, embarked on a national reading tour. Pond also arranged for Dodd, Mead and Company to publish *Lyrics of Lowly Life* (1896), a republication of ninety-seven poems from Dunbar's first two volumes and eight new poems. Howells, in the introduction to this volume, described Dunbar as "the only man of pure African blood and of American civilization to feel the negro life aesthetically and express it lyrically." The combination of Howells's endorsement and Dunbar's skill soon led the latter to become one of America's most popular writers.

After the publication of *Lyrics of Lowly Life*, Dunbar went on a reading tour of England. When he returned to the United States in 1897, he accepted a position as a library assistant at the Library of Congress in Washington, D.C. Meanwhile, several national literary magazines were vying for anything he wrote, and in 1898 Dunbar seemed to have developed the golden touch. *Lippincott's Monthly Magazine* published his first novel, *The Uncalled*, which appeared in book form later that year; *Folks from Dixie*, a collection of twelve short stories that had been published individually in various magazines, also came out in book form; and he collaborated with WILL MARION COOK to write a hit Broadway musical, *Clorindy*. At this time he developed a nagging cough, perhaps the result of an abundance of heavy lifting in the dusty, drafty library combined with skimping on sleep while pursuing deadlines. Partly because of his success and partly because of ill health, he resigned from the library at the end of 1898 to devote himself full time to his writing.

In 1899 Dunbar published two collections of poems, *Lyrics of the Hearthside* and *Poems of Cabin and Field*, and embarked on a third reading tour. However, his health deteriorated so rapidly that the tour was cut short. The official diagnosis was pneumonia, but his doctor suspected that Dunbar was in the early stages of tuberculosis. To help ease the pain in his lungs, he turned to strong drink, which did little more than make him a near-alcoholic. He gave up his much-beloved speaking tours but continued to write at the same breakneck pace. While convalescing in Denver, Colorado, he wrote a western novel, *The Love of Landry* (1900), and published *The Strength of Gideon and Other Stories*

(1900), another collection of short stories. He also wrote two plays, neither of which was ever published, as well as some lyrics and sketches. In the last five years of his life, he published two novels, *The Fanatics* (1901) and *The Sport of the Gods* (1901, in *Lippincott's*; 1902, in book form); two short story collections, *In Old Plantation Days* (1903) and *The Heart of Happy Hollow* (1904); eight collections of poetry, *Candle-Lightin' Time* (1901), *Lyrics of Love and Laughter* (1903), *When Malindy Sings* (1903), *Li'l Gal* (1904), *Chris'mus Is A-comin' and Other Poems* (1905), *Howdy, Honey, Howdy* (1905), *Lyrics of Sunshine and Shadow* (1905), and *Joggin' Erlong* (1906); and collaborated with Cook on another musical, *In Dahomey* (1902).

Dunbar had married writer Alice Ruth Moore (ALICE DUNBAR-NELSON) in 1898; they had no children. In 1902 the couple separated, largely because of Dunbar's drinking, and never reconciled. After the breakup Dunbar lived in Chicago for a while, then in 1903 returned to live with his mother in Dayton, where he died of tuberculosis in 1906.

Dunbar's goal was "to interpret my own people through song and story, and to prove to the many that after all we are more human than African." In so doing, he portrayed the lives of blacks as being filled with joy and humor as well as misery and difficulty. Dunbar is best known for his dialect poems that, intended for a predominantly white audience, often depict slaves as dancing, singing, carefree residents of "Happy Hollow." On the other hand, a great deal of his lesser-known prose work speaks out forcefully against racial injustice, both before and after emancipation, as in "The Lynching of Jube Benson," a powerful short story about the guilt that haunts a white man who once participated in the hanging of an innocent black. Perhaps his two most eloquent expressions of the reality of the black experience in America are "We Wear the Mask," in which he declares, "We wear the mask that grins and lies, . . . /We smile, but, O great Christ, our cries /To thee from tortured souls arise," and "Sympathy," wherein he states that "I know why the caged bird sings, . . . /It is not a carol of joy or glee, /But a prayer . . . that upward to Heaven he flings."

Dunbar was the first black American author to be able to support himself solely as a result of his writing. His success inspired the next generation of black writers, including JAMES WELDON JOHNSON, LANGSTON HUGHES, and CLAUDE MCKAY, to dream of and achieve literary success. Dunbar was celebrated and scrutinized by the national media as a representative of his race. His charm and wit, his grace under pressure, and his ability as a speaker and author did much to give the lie to turn-of-the-century misconceptions about the racial inferiority of blacks.

FURTHER READING
Dunbar's papers are in the archives of the Ohio Historical Society.
Gentry, Tony. *Paul Laurence Dunbar* (1989).
Martin, Jay, and Gossie H. Hudson, eds. *The Paul Laurence Dunbar Reader* (1975).
Williams, Kenny J. *They Also Spoke: An Essay on Negro Literature in America, 1787–1930* (1970).

Obituary: New York Times, 10 Feb. 1906.

CHARLES W. CAREY JR.

DUNBAR-NELSON, Alice

(19 July 1875–18 Sept. 1935), writer, educator, and activist, was born Alice Ruth Moore in New Orleans to Joseph Moore, a seaman, and Patricia Wright, a former slave and seamstress. Moore completed a teachers' training program at Straight College (now Dillard University) and taught in New Orleans from 1892 to 1896, then in Brooklyn, New York, from 1897 to 1898. Demonstrating a commitment to the education of African American girls and women that would continue throughout her life, Moore helped found the White Rose Home for Girls in Harlem in 1898.

Moore's primary ambition, however, was literary, and she published her first book at the age of twenty, *Violets and Other Tales* (1895), a collection of poetry in a classical lyric style, essays, and finely observed short stories. The publication of Moore's poetry and photograph in a Boston magazine inspired the famed poet PAUL LAURENCE DUNBAR to begin a correspondence with her that led to their marriage in 1898. Her second book, *The Goodness of St. Rocque and Other Stories* (1899), a collection of short stories rooted in New Orleans Creole culture, was published as a companion volume to Dunbar's *Poems of Cabin and Field*, and their marriage was celebrated as a literary union comparable to that of Robert and Elizabeth Barrett Browning. The couple separated, however, in 1902, after less than four tumultuous and sometimes violent years, due in part to Paul's alcoholism. Paul Laurence Dunbar died of tuberculosis four years

later. Although the couple never reconciled, Alice Dunbar expressed regret and outrage that his family did not inform her of his last illness, or even his death, which she learned of from a newspaper article.

In the fall of 1902 Alice Dunbar resumed her teaching career at Howard High School in Wilmington, Delaware. As an English and drawing instructor, then head of the English department, Dunbar also served as an administrator and directed several of her own plays at the school. Dunbar also pursued scholarly work at various institutions, including Columbia University and the University of Pennsylvania, ultimately completing an MA degree at Cornell University. A portion of her master's thesis on the influence of Milton on Wordsworth was published in the prestigious *Modern Language Notes* in 1909. In 1910 Dunbar secretly married a fellow Howard High School teacher, Henry Arthur Callis, although they soon divorced.

During this busy period of teaching, administration, and study, Dunbar also participated in the burgeoning black women's club movement, through which she delivered lectures on a variety of subjects, most commonly race, women's rights, and education. However, she achieved the most renown when speaking as the widow of Paul Laurence Dunbar. Like her late husband, she struggled with the preference among white audiences for Paul's "dialect" poetry, although she ably performed these works, along with his "pure English poems," which she preferred. Building on her work as a public speaker, Dunbar edited and published *Masterpieces of Negro Eloquence* (1914), a collection of Negro oratory from the pre– and post–Civil War era, designed to celebrate the fiftieth anniversary of the Emancipation Proclamation.

In 1916 Dunbar married Robert J. Nelson, a widower with two children, but maintained her association with her first husband by hyphenating her name. In *The Dunbar Speaker and Entertainer: The Poet and His Song* (1920), Dunbar-Nelson assembled a wider range of African American oratory than in the political speeches of *Masterpieces of Negro Eloquence*, and included a large number of her husband's and her own poetry deemed suitable for performance, along with poetry, fiction, and speeches by JAMES WELDON JOHNSON, CHARLES W. CHESNUTT, and others. Dunbar-Nelson seems to have found her lifelong connection to her first husband both an asset, in furthering her writing

and speaking career, and a burden, evidenced by several unsuccessful attempts to publish under a pseudonym.

Dunbar-Nelson's third marriage was satisfying both personally and professionally; as a journalist Nelson was supportive of Dunbar-Nelson's writing and political activities. Dunbar-Nelson combined her literary and political interests through the production and publication of *Mine Eyes Have Seen the Glory* (1918), a play promoting African American involvement in World War I. She also toured the South for the Women's Committee for National Defense on behalf of the war effort and was active in the campaign for women's suffrage. She continued her political activism despite protests from her employers at Howard High, and in 1920 lost her job following an unsanctioned trip to a social justice conference in Ohio.

Relieved of her teaching duties, Dunbar-Nelson devoted herself more fully to political activism, and from 1920 to 1922 enjoyed a close collaboration with her husband through their publication of the liberal black newspaper, the *Wilmington Advocate*. She joined a delegation of black activists to meet with President Warren G. Harding in 1921, worked for passage of the Dyer Anti-Lynching Bill in 1922, and organized black women voters for the Democratic Party in 1924. As a member of the Federation of Colored Women, she cofounded the Industrial School for Colored Girls in Marshalltown, Delaware, and worked as a teacher and parole officer for the school from 1924 to 1928.

Dunbar-Nelson's journalistic and historical writings date from 1902, when she wrote several articles for the *Chicago Daily News*. In 1916 her lengthy historical work "People of Color in Louisiana" was published in *The Journal of Negro History*, and from 1926 to 1930 she was a newspaper columnist for the Pittsburgh *Courier* and the Washington *Eagle*. Many of her columns were syndicated by the Associated Negro Press, and her subjects ranged beyond the usual material considered suitable for women journalists, taking on political and social issues of the day, which she dealt with in a witty and incisive style. By contrast, many of Dunbar-Nelson's literary efforts, including four novels, went unpublished in her lifetime, although the best of them are now collected in a three-volume set, *The Works of Alice Dunbar-Nelson* (1988). Included are previously published and unpublished works of poetry, fiction, essays, and drama, which give evidence of

Dunbar-Nelson's wide range of interests, both thematically and formally.

Dunbar-Nelson's exquisitely crafted fiction secures her position as a pioneer of the African American short story. Interestingly, her fiction and poetry, which she considered the most "pure" from a literary point of view, deal only tangentially with the racial issues that so occupied her political and journalistic activities. In these works she focuses instead on issues of gender oppression and psychology, and evidences a frustration in her diary at the lack of interest from mainstream white publishers. The African American press was more receptive to her literary work, and between 1917 and 1928 Dunbar-Nelson published poems in *The Crisis, Opportunity, Ebony,* and *Topaz,* and other African American journals, enjoying a small heyday as a poet with the advent of the Harlem Renaissance.

In addition to recording her often frustrated literary ambitions, Dunbar-Nelson's diary, begun in 1921, offers a glimpse of her romantic relationships with both men and women, her lifelong worries about finances, and her struggle with traditional women's roles. Even in her mostly amicable relationship with Robert Nelson, Dunbar-Nelson objects to his insistence on her managing both household and professional duties, and she chafes at the regulation of her dress and makeup by male employers. The extant portions of the diary include the years 1921 and 1926–1931, and were published as *Give Us Each Day: The Diary of Alice Dunbar-Nelson* (1984).

In 1932 Robert Nelson received a political appointment to the Pennsylvania Athletic Commission and the couple moved to Philadelphia. Living in prosperity for the first time in her life, Dunbar-Nelson maintained an active social life among the black elite, including such luminaries as James Weldon Johnson, W. E. B. DU BOIS, LANGSTON HUGHES, GEORGIA DOUGLAS JOHNSON, and Mary Church Terrell. No longer burdened by financial want, Dunbar-Nelson remained active in the last years of her life as a philanthropist and political activist. She died in Philadelphia of a heart condition.

Alice Dunbar-Nelson's life and work are testament to the diverse talents and activities of educated African American women of the late nineteenth and early twentieth centuries. As a light-skinned woman of mixed African, European, and Native American ancestry, Dunbar-Nelson was acutely sensitive to the resentment of both whites and darker-skinned African Americans, but also occasionally passed for white in order to gain access to the racially segregated world of opera, museums, theater, and bathing spas. In much of her literary work, Dunbar-Nelson focused on nonracial themes, often creating white or racially ambiguous characters, but in her work as an educator, journalist, and activist, Dunbar-Nelson placed herself firmly within African American culture, where her contributions remain vital.

FURTHER READING

Dunbar-Nelson, Alice. *Give Us Each Day: The Diary of Alice Dunbar-Nelson,* ed. Gloria T. Hull (1984).

Hull, Gloria T. *Color, Sex, and Poetry: Three Women Writers of the Harlem Renaissance* (1987).

ALICE KNOX EATON

DUSE, Mohammed Ali

(26 November 1866–25 June 1945), actor, journalist, and Pan-African activist, was born in Alexandria, Egypt, to an Egyptian father and a Sudanese mother. In various documents he called his father, who was an army officer, either "Abbas Mohammed Ali" or "Abdul Salem Ali." Early in his life Duse was separated from his family and forgot any knowledge of Arabic. He claimed to have been brought to England at the age of nine by a French officer with whom his father had studied at a military academy. In 1882 his father was killed by a British naval bombardment in a nationalist uprising at Tel-el-Kebir, and his mother returned to the Sudan bringing Duse's sisters with her. He subsequently lost all communication with his family. During his early theatrical career in London he adopted the non-Arabic name "Duse," maintaining that it derived from the surname of the officer who had brought him to England. The name carried a certain cachet on account of the Italian-born actress Eleanora Duse, who was renowned for her leading roles in stage adaptations of novels by Alexandre Dumas. Despite his indistinct family background, speculation that Duse's parents were African American has not been verified.

In 1885 Duse was engaged as an actor by Wilson Barrett, a leading actor-manager, with whose company he toured England and later the United States and Canada. In 1898 he was contracted by the theater company of Sir Herbert Beerbohm Tree and in 1902 staged his own productions of *Othello* and

The Merchant of Venice. Between 1909 and 1911 Duse embarked on a career as a journalist and contributed a number of articles to the influential socialist journal *New Age* on topics relating to Egyptian nationalism and Pan-Islamism. In 1911 Duse also participated in the Universal Races Congress in London and published a history of Egypt entitled *In the Land of the Pharaohs.* Following this publication Duse was elected to honorary membership of the American Negro Academy and the Negro Society of Historical Research in New York. But the history also led to accusations of plagiarism against Duse that brought an end to his connection with the *New Age.* He subsequently founded his own newspaper, *African Times and Orient Review* (*ATOR*), which provided a lively forum for early Pan-African and Pan-Islamic politics in Britain; *ATOR*'s headquarters in London, at 158 Fleet Street, became the hub of a multifaceted group of organizations related to Egyptian, West African, and Indian nationalisms, as well as the All-India Muslim League, Pan-Islamism, the Khilafat Movement, and black nationalisms in the United States.

There is little information available about Duse's wife, Beatrice Mohammed, except that she was white and British and that he permanently separated from her in 1921. In that year Dusé (now accenting the last letter of his name) left Britain on a business trip to the United States. On behalf of the Inter-Colonial Corporation, which he established in partnership with JOHN EDWARD BRUCE, Dusé aimed to negotiate African American contracts for cocoa to be supplied from West African traders. This scheme, along with subsequent Pan-African business ventures, proved largely unsuccessful. Nonetheless Dusé's reputation as a historian allowed him to make a living by lecturing in the United States, and from 1921 to 1931 he led a peripatetic life as a lecturer, journalist, actor, and radio broadcaster, going to New York, Boston, Washington, Tuskegee, Detroit, Chicago, and Saint Louis.

In New York, Dusé renewed his association with MARCUS MOZIAH GARVEY, who had briefly worked as a messenger boy at *ATOR* before establishing himself as a leading international black activist. Between 1922 and 1924 Dusé headed an African Affairs department for Garvey's Universal Negro Improvement Association (UNIA) and contributed articles to UNIA's newspaper, the *Negro World.* Dusé's self-identification as an Egyptian Muslim and his practice of wearing the fez probably appealed to Garvey, who liked to deploy uniforms and other regalia for their popular appeal. More important, the friends and contacts that Dusé had established in London were invaluable to UNIA, and his presence in the organization during this period may account for the distribution of the *Negro World* in Nigeria, Sierra Leone, and the Gold Coast. But by the time that Garvey was imprisoned in February 1925, Dusé had parted ways with him.

For a short period in 1925 Dusé was secretary of the American Asiatic Association in Detroit. If he was not actually involved in founding the Nation of Islam, his lecturing and other Islamicist activities in Detroit probably helped to establish a political climate congenial to the development of that movement there under Wallace Fard Muhammad. After 1926 Dusé returned to New York and renewed his efforts to establish a trading business between the United States and West Africa, first in partnership with the Gold Coast businessman Winfried Tete-Ansa and later alone. But again his business plans were unsuccessful.

In 1931 Dusé traveled to Nigeria in the company of a white American woman, Gertrude La Page. He lived with her in Lagos, where he managed and edited a local newspaper, the *Comet.* His novel *Ere Roosevelt Came,* which depicts racial politics in the United States, was serialized in the *Comet* from February to October 1934. A thinly fictionalized version of the conflict between Garvey (characterized as "Napoleon Hatbry") and W. E. B. DU BOIS ("Reginald Bologne De Woode") showed Dusé's support for Garvey's program of economic enterprise over Du Bois's one of political and cultural advancement. Dusé's autobiography, "Leaves from an Active Life," which was serialized in the *Comet* from 12 June 1937 to 5 March 1938, made no reference to Garvey; this was possibly because of the changing political climate and fear of deportation.

In competition with Nnamdi Azikiwe's *West African Pilot,* sales of the *Comet* gradually declined. Dusé eventually retired as an editor but maintained his role as company director of the newspaper until his death in Lagos on 26 February 1945. Although he had not directly participated in the official Pan-African Congress movement established by Du Bois, Dusé played an important role as an international advocate for Pan-Africanism. Although he clearly preferred the economic model of black commercial unification advanced by Garvey, he

consciously advocated and actively linked Pan-African ideology with other struggles for democratic change among subjugated peoples in the United States, Africa, and Asia.

FURTHER READING

Duffield, Ian. "The Business Activities of Dusé Mohammed Ali: An Example of the Economic Dimension of Pan-Africanism, 1912–1945," *Journal of the Historical Society of Nigeria* 4 (June 1969): 571–600.

Duffield, Ian. "Dusé Mohammed Ali: His Purpose and His Public," in *The Commonwealth Writer Overseas: Themes of Exile and Expatriation*, ed. Alastair Niven (1976).

Duffield, Ian. *Dusé Mohammed Ali and the Development of Pan-Africanism 1866–1945*. PhD dissertation, University of Edinburgh, 1971.

Hill, Robert, and Carol A. Rudisell, eds. "Biographical Supplement: Dusé Mohammed Ali," in *The Marcus Garvey and Universal Negro Improvement Association Papers* (1983).

Mahmud, Khalil. "Introduction to the Second Edition," in *In the Land of the Pharaohs: A Short History of Egypt*, by Duse Mohamed (1968).

Mohamed, Duse. "Leaves from an Active Life," *The Comet*, 12 June 1937–5 March 1938.

ÍDE CORLEY

EDMONDS, S. Randolph

(30 Apr. 1900–28 Mar. 1983), playwright and educator, was born Sheppard Randolph Edmonds in Lawrenceville, Virginia, one of the nine children of George Washington Edmonds and Frances Fisherman, sharecroppers and former slaves. His mother had been moved from New Orleans to a nearby plantation around Petersburg, Virginia, during the Civil War. She died when Randolph was twelve. Like many other black children, Edmonds attended school for only a short part of the year—in his case five months—and worked the rest on nearby plantations. He went on to attend St. Paul's Normal and Industrial School (later St. Paul's College), the local high school in Lawrenceville, and worked during the summers of 1918–1920 as a waiter in New York City, where he first attended the theater. In 1921 he graduated as valedictorian, with prizes in both English and history. The director of academics at St. Paul's, J. Alvin Russell, encouraged him to attend his alma mater, Oberlin College.

At Oberlin on scholarship, Edmonds and other black students organized a literary group called the Dunbar Forum. Interested at first in writing poetry, short stories, and essays, he soon began to write plays. He was impressed with the philosophy of Frederick H. Koch, a drama professor at the University of North Carolina at Chapel Hill, who believed that plays should be based on the experiences of the people who would form their audiences. Edmonds interrupted his studies at Oberlin, taking a year off to earn money by scrubbing floors, waiting tables, cutting hair, and working other odd jobs. He graduated from Oberlin in 1926 with a BA in English, having seen his own first full-length play, *Rocky Roads*, successfully staged by the Dunbar Players. The Dunbar Players staged three of his short plays during 1927, thus inspiring what would be a lifelong interest in college dramatics.

Edmonds became an instructor in English and drama at Morgan State College in Baltimore, Maryland, and studied Shakespearean drama, playwriting, and play production at Columbia University during the summers from 1927 through 1930. At Morgan he not only organized the Morgan Dramatic Club but also formed, in 1930, the Negro Intercollegiate Drama Association. The Morgan Players won critical acclaim from New York critics after their 10 May 1929 performance of Paul Green's *The Man Who Died at Twelve O'Clock*, placing fourth out of a field of twenty in the Seventh Annual Little Theatre Tournament

Edmonds received his MA from Columbia in 1931. That same year he married Irene Colbert, who was the great-granddaughter of the nineteenth-century abolitionist orator Henry Highland Garnet. They had two children, Henriette Highland Garnet and S. Randolph Jr. In 1932 the Morgan Players again took the stage in New York for their presentation of Edmonds' folk *Bad Man* on NBC radio. Folk plays made use of the materials of everyday African American life that the cultural critic ALAIN LOCKE had seen, at the opening of the Harlem Renaissance, as the untapped wealth of the "New Negro" worthy of development. On sabbatical from Morgan in 1934–1935 Edmonds studied drama at Yale University on a fellowship from the Rockefeller Foundation. Upon his return he accepted an invitation from Dillard University to organize and head the speech and theater department there. He left behind at Morgan the first department of drama in any black school. In 1938 his study of theater in Dublin and London on a Rosenwald Fellowship allowed him to complete *Land of Cotton*, a full-length social drama he had begun at Yale. It also renewed his interest in fantasy, a dramatic mode his earliest plays had exhibited.

In the twelve years Edmonds taught at Dillard his plays met with growing success in their performance by the Dillard University Players. In the 1930s the United States saw a burgeoning of educational theater and Edmonds played a key role in that growth. In 1936 he organized black colleges throughout the South and Southwest into the Southern Association of Dramatic and Speech Arts. The interscholastic theater organization he created for Louisiana high school drama groups joined the Louisiana Interscholastic Athletic and Literary Association. But Edmonds was not only a promoter of dramatic organizations at black colleges; he was also a prolific playwright who championed the use of African American materials in his plays. He wrote several essays and articles in the *Messenger*, *Opportunity*, *Phylon*, *Crisis*, and *Arts Quarterly* to argue the significance of educational theater. Edmonds recognized three necessities for the development of

black American theater: playwrights, trained and gifted guidance, and an audience.

Edmonds addressed these needs not only in his own plays but also in two anthologies of his work, *Shades and Shadows* (1930) and *Six Plays for Negro Theatre* (1934). Though he intended the plays in the first collection only to be read, not performed, Edmonds explained in the preface of the second collection that he intended it specifically "for Negro Little Theatres, where there has been for many years a great need for plays of Negro life written by Negroes." The 1934 *Six Plays for Negro Theatre* are so-called folk plays, written in the dialect fashionable at the time and based on subject matter drawn from the lives of common people. *Old Man Pete*, for example, explores the adjustment problems faced by many rural Southerners who came to the urban North during the Great Migration. In another play, NAT TURNER, Edmonds portrays the leader of the 1831 armed slave revolt as a religious visionary motivated by humanitarian concerns. A third collection of Edmonds' work, *The Land of Cotton and Other Plays*, was published in 1943. While most of Edmonds' plays make heavy use of melodrama, they also demonstrate the playwright's interest in teaching black history. As such his plays were performed in black colleges and universities throughout the South.

In 1942 Edmonds and James E. Gayle established in New Orleans the Crescent Concerts Company, considered the first concert company owned and controlled by blacks. Although short-lived due to continual problems gaining the necessary approval of entertainers from city officials, the company brought to the stage such artists as the singer and actor PAUL ROBESON, the concert pianist PHILIPPA DUKE SCHUYLER, the opera singer MARIAN ANDERSON, and the singer Anne Brown, who was the original Bess in Gershwin's *Porgy and Bess*.

S. Randolph Edmonds retired in 1970, recognized as a pioneer in the black theater movement who brought the daily lives of his largely African American audiences to the stage. Among the honors he received before his death perhaps the most significant was the commemoration of the Randolph Edmonds Players Guild at his alma mater.

FURTHER READING

Abramson, Doris. *Negro Playwrights in the American Theatre, 1925–1959* (1969).

Hatch, James V., ed. *Black Theater, U. S. A.: Forty-five Plays by Black Americans, 1847–1974* (1974).

Koch, Frederick N. "Drama in the South," *Carolina Playbook* (June 1940).

MARY ANNE BOELCSKEVY

EDWARDS, Jodie "Butterbeans"

(19 July 1898?–28 Oct. 1967), comedian, was born Jodie Edwards in Marietta, Georgia. Little is known about his early life, including his exact birth date, which has been listed as both 1898 and 1895. It is believed that Edwards began performing professionally in carnivals at age twelve with the Moss Brothers Carnival doing minstrel routines.

In 1915 Edwards met Susie Hawthorne, who later became his wife, while they were both working for the *Smart Set* variety show, which was run by MA RAINEY and performed out of a tent. In 1916 the pair left the show and set off on their own, originally as a dance act. Soon they added comic banter in between their dances. In 1917 they left *Smart Set* for good and went off on their own as a musical comedy team.

In May 1917 Edwards and Hawthorne were married on stage as a publicity stunt in either Philadelphia, Pennsylvania, or Greenville, South Carolina (or perhaps in both places or several places). Though they originally "married" as a show business stunt, they either "really" married at some point or simply counted an onstage marriage as a real one. At any rate, they remained by all accounts a loving couple (despite making their living from sometimes hostile onstage bickering) until Susie's death on 7 December 1963.

Their mock-bickering routine, later expanded and perfected, was originally gleaned from an earlier couple. In 1917 they joined "Stringbeans and Sweetie Mae," a popular husband and wife comedy duo. Mel Watkins claims that Edwards and Hawthorne, now calling themselves "Butterbeans and Susie," appropriated the routine of Stringbeans and Sweetie Mae upon the death of Butler "Stringbeans" May (or Budd "Stringbeans" LeMay) a few months after the two couples started performing together. Many sources report that the mock-married-couple-argument routine, which Butterbeans and Susie made famous, later became the basis of the famous routine of George Burns and Gracie Allen, who became household names through their comic bickering. According to Lynne Abbot, a St. Louis theater manager named Charles

Turpin suggested that Edwards call himself "Butterbeans." Part of usurping Stringbeans's act meant wearing overly tight and somewhat ridiculous-looking suits that contrasted with the more fashionable dresses worn by Susie.

Butterbeans and Susie's act consisted of singing, dancing, and joke telling. They were quite popular from the 1920s through the 1940s, continuing even into the 1960s, when, after Susie's death, their daughter played her role for a time. According to historian Mel Watkins, "They usually began their act with a duet. Then, after she [Susie] sang a blues tune, they might join in a duet or begin the comic patter. . . . Humorous send-ups of marital squabbles were also a part of their act, and they would often punctuate their song and dance routines with snappy quips and lighthearted signifying" (Watkins, 376). Butterbeans would conclude with a dance called "The Heebie Jeebies" or "The Itch," which was a big success with audiences. Watkins cites James Cross (who is known to have played "Stump" in the act of Stump and Stumpy) describing the "Heebie Jeebies/Itch" dance as such: "He [Edwards] kept his hands in his pockets and looked like he was itching to death, and when he took his hands out of his pockets and started to scratch all around the beat, the audience flipped" (Watkins, 377).

During the 1920s the couple had a successful recording career, working for "race record" labels such as Okeh Records. They made many "hokum blues" records, slow tempo recordings in which they would signify at each other, trading insults and banter. These good-natured and mildly entertaining tunes seem to have been thought of as a little corny. Some of these records were full of sexual innuendo. One of their songs, "I Want a Hot Dog for my Roll," with its highly suggestive lyrics, was famously not released by their record label. (It would later be made available, however, on their *Complete Recorded Works*.)

Despite their risqué lyrics and worldly comic routines, Jodie and Susie Edwards were a religious couple who gave generously to Pilgrim Baptist Church in Chicago. Indeed, they were rather comfortable financially, thanks to prudent spending and to long years of hard work on the Theater Owners Booking Association (TOBA) circuit. In later years they lived in a large house at 3322 South Calumet Avenue in Chicago. The doors of the house were open to performers from the old days who may have fallen on hard times or whose shtick had fallen out of fashion, such as Lincoln Perry (STEPIN FETCHIT). Perry, a close friend of the Edwardses, claimed that their door was always open to him when he was down on his luck in later years, and that he knew he could always get a meal at their home. Also, the Edwardses are said to have discovered and promoted the comedian "MOMS" MABLEY.

Jodie "Butterbeans" Edwards died as he walked on stage at the Dorchester Inn in Harvey, Illinois. His funeral was said to have been attended by Mabley, Perry, Redd Foxx, and LOUIS ARMSTRONG.

FURTHER READING

Hoekstra, Dave. " 'Butter and Sue' Set the Stage in Bronzeville: Vaudeville's Couple," *Chicago Sun-Times*, 26 Mar. 2006.

Peterson, Bernard L. *Profiles of African American Stage Performers and Theater People, 1815–1960* (2001).

Watkins, Mel. *On the Real Side: Laughing, Lying, and Signifying—The Underground Tradition of African American Humor That Transformed American Culture, From Slavery to Richard Pryor* (1994).

PAUL DEVLIN

ELLINGTON, Duke

(29 Apr. 1899–24 May 1974), jazz musician and composer, was born Edward Kennedy Ellington in Washington, D.C., the son of James Edward Ellington, a butler, waiter, and later printmaker, and Daisy Kennedy. The Ellingtons were middle-class people who struggled at times to make ends meet. Ellington's mother was particularly attached to him; in her eyes he could do no wrong. They belonged to Washington's black elite, who put much stock in racial pride. Ellington developed a strong sense of his own worth and a belief in his destiny, which at times shaded over into egocentricity. Because of this attitude, and his almost royal bearing, his schoolmates early named him "Duke."

Ellington's interest in music was slow to develop. He was given piano lessons as a boy but soon dropped them. He was finally awakened to music at about fourteen when he heard a pianist named Harvey Brooks, who was not much older than he. Brooks, he later said, "was swinging, and he had a tremendous left hand, and when I got home I had a real yearning to play."

He did not take formal piano lessons, however, but picked the brains of local pianists, some of whom were excellent. He was always looking

Duke Ellington, photographed by Gordon Parks Sr. at the Hurricane Club in New York City, 1943. (Library of Congress.)

for shortcuts, ways of getting effects without much arduous practicing. As a consequence, it was a long time before he became proficient at the stride style basic to popular piano playing of the time.

As he improved, Ellington discovered that playing for his friends at parties was a route to popularity. He began to rehearse with some other youngsters, among them the saxophonist Otto "Toby" Hardwick and the trumpeter Artie Whetsol. Eventually a New Jersey drummer, Sonny Greer, joined the group. By age sixteen or seventeen Ellington was playing occasional professional jobs with these and other young musicians. The music they played was not jazz, which still was not widely known, but rags and ordinary popular songs.

Ellington was not yet committed to music. He was also studying commercial art, for which he showed an aptitude. However, he never graduated from high school, and in 1918 he married Edna Thompson; the following spring their son, Mercer, was born. Although later Ellington lived with several different women, he never divorced his wife.

He now had a family to support and was perforce drawn into the music business, one of the few areas in which blacks could earn good incomes and achieve a species of fame. Increasingly he was working with a group composed of Whetsol, Greer, and Hardwick under the nominal leadership of the Baltimore banjoist ELMER SNOWDEN. This was the nucleus of later Ellington bands. In 1923 the group ventured to New York and landed a job at a well-known Harlem cabaret, Barron's Exclusive Club. The club had a clientele of intellectuals and the social elite, some of them white, and the band was not playing jazz, but "under conversation music." Ellington was handsome and already a commanding figure, and the others were polite, middle-class youths. They were well liked, and in 1923 they were asked to open at the Hollywood, a new club in the Broadway theater district, soon renamed the Kentucky Club.

As blacks, they were expected to play the new hot music, now growing in popularity. Like many other young musicians, they were struggling to catch its elusive rhythms, and they reached out for a jazz specialist, the trumpeter James "BUBBER" MILEY, who had developed a style based on the plunger mute work of a New Orleanian, "KING" OLIVER. Miley not only used the plunger for *wah-wah* effects but also employed throat tones to produce a growl. He was a hot, driving player and set the style for the band. Somewhat later, SIDNEY BECHET, perhaps the finest improviser in jazz at the time, had a brief but influential stay with the band.

Through the next several years the band worked off and on at the Kentucky Club, recording with increasing frequency. Then, early in 1924, the group fired Snowden for withholding money, and Ellington was chosen to take over. Very quickly he began to mold the band to his tastes. He was aided by an association with Irving Mills, a song publisher and show business entrepreneur with gangland connections. Mills needed an orchestra to record his company's songs; Ellington needed both connections and guidance through the show business maze. His contract with Mills gave Ellington control of the orchestra.

As a composer, Ellington showed a penchant for breaking rules: if he were told that a major seventh must rise to the tonic, he would devise a piece in which it descended. His still-developing method of composition was to bring to rehearsal—or even to the recording studio—scraps and pieces of musical ideas, which he would try in various ways until he got an effect he liked. Members of the band would

offer suggestions, add counterlines, and work out harmonies among themselves. It was very much a cooperative effort, and frequently the music was never written down. Although in time Ellington worked more with pencil and paper, this improvisational system remained basic to his composing.

Beginning with a group of records made in November 1926, the group found its voice: the music from this session has the distinctive Ellington sound. The first important record was "East St. Louis Toodle-Oo" (1926), a smoky piece featuring Bubber Miley growling over a minor theme. Most important of all was "Black and Tan Fantasy" (1927), another slow piece featuring Miley in a minor key. It ends with a quotation from Chopin's "Funeral March." In part because of this touch, "Black and Tan Fantasy" was admired by influential critics such as R. D. Darrell, who saw it as a harbinger of a more sophisticated, composed jazz. Increasingly thereafter, Ellington was seen by critics writing in intellectual and music journals as a major American composer.

Then, in December 1927 the group was hired as the house band at the Cotton Club, rapidly becoming the country's best-known cabaret. It was decided, for commercial purposes, to feature a "jungle sound," built around the growling of Miley and the trombonist Joe "Tricky Sam" Nanton. About this time Ellington added musicians who would fundamentally shape the band's sound: the clarinetist Barney Bigard, a well-trained New Orleanian with a liquid tone; the saxophonist JOHNNY HODGES, who possessed a flowing, honeyed sound and quickly became the premier altoist in jazz; and Cootie Williams, who replaced the wayward Miley and soon became a master of the plunger mute. These and other instrumentalists each had a distinctive sound and gave Ellington a rich "tonal palette," which he worked with increasing mastery.

Through the 1920s and 1930s Ellington created a group of masterpieces characterized by short, sparkling melodies, relentless contrasts of color and mood, and much more dissonant harmony than was usual in popular music. Among the best known of these are "Mood Indigo" (1930) and "Creole Love Call" (1927), two simple but very effective mood pieces; "Rockin' in Rhythm" (1930), a driving up-tempo piece made up of sharply contrasting melodies; and "Daybreak Express" (1933), an uncanny imitation of train sounds. These pieces alone won Ellington a major position in jazz history, but they are only examples of scores of brilliant works.

By now he had come into his own as a songwriter. During the 1930s he created many standards, like "Prelude to a Kiss" (1938), "Sophisticated Lady" (1932), and "Solitude" (1934). This songwriting was critically important, for, leaving aside musical considerations, Ellington's ASCAP royalties were in later years crucial in his keeping the band going.

It must be admitted, however, that Ellington borrowed extensively in producing these tunes. "Creole Love Call" and "Mood Indigo," although credited to Ellington, were written by others. Various of his musicians contributed to "Sophisticated Lady," "Black and Tan Fantasy," and many more. Though it is not always easy to know how much others contributed to a given work, it was Ellington's arranging and orchestrating of the melodies that lifted pieces like "Creole Love Call" above the mundane.

By 1931, through broadcasts from the Cotton Club and his recordings, Ellington had become a major figure in popular music. In that year the band left the club and for the remainder of its existence played the usual mix of one-nighters, theater dates, and longer stays in nightclubs and hotel ballrooms. The singer Ivie Anderson, who would work with the organization for more than a decade and remains the vocalist most closely associated with Ellington, joined him at this time.

In 1933 the band made a brief visit to London and the Continent. British critics convinced Ellington that he was more than just a dance-band leader. He had already written one longer, more "symphonic" piece, "Creole Rhapsody" (1931). He now set about writing more. The most important of these was "Black, Brown, and Beige," which was given its premiere at Carnegie Hall in 1943. The opening was a significant event in American music: a black composer writing "serious" music using themes taken from black culture.

Classical critics did not much like the piece. The problem, as always with Ellington's extended work, was that, lacking training, he was unable to unify the smaller themes and musical ideas he produced. Ellington, although temporarily discouraged, continued to write extended pieces, which combined jazz elements with devices meant to reflect classical music.

Additionally, beginning in 1936, Ellington recorded with small groups drawn from the band. These recordings, such as Johnny Hodges's "Jeep's Blues"

(1938) and Rex Stewart's "Subtle Slough," contain a great deal of his finest work. Yet most critics would say that his finest work of the time was a series of concertos featuring various instrumentalists, including "Echoes of Harlem" (1935) for Cootie Williams and "Clarinet Lament" (1936) for Barney Bigard.

In 1939 the character of the band began to change when the bassist Jimmy Blanton, who was enormously influential during a career cut short by death, and the tenor saxophonist Ben Webster were added. Ellington had never had a major tenor soloist at his disposal, and Webster's rich, guttural utterances were a new voice for him to work with. Also arriving in 1939 was Billy Strayhorn, a young composer who had more formal training than Ellington. Until Strayhorn's death in 1967, a substantial part of the Ellington oeuvre was actually written in collaboration with Strayhorn, although it is difficult to tease apart their individual contributions. In 1940 Ellington switched from Columbia to Victor. The so-called Victor band of 1940 to 1942, when a union dispute temporarily ended recording in the United States, is considered by many jazz critics to be one of the great moments in jazz. "Take the 'A' Train," written by Strayhorn, is a simple, indeed basic, piece, which gets its effect from contrapuntal lines and the interplay of the band's voices. "Cotton Tail" (1940) is a reworking of "I've Got Rhythm" that outshines the original melody and is famous for a powerful Webster solo and a sinuous, winding chorus for the saxophones. "Harlem Air Shaft" (1940) is a classic Ellington program piece meant to suggest the life in a Harlem apartment building and is filled with shifts and contrasts that produce a sense of rich disorder. "Main Stem" (1942) is another hard-driving piece, offering incredible musical variety within a tiny space. Perhaps the most highly regarded recording from this period is "Ko-Ko" (1940). Originally written as part of an extended work, it is based on a blues in E-flat minor and is built up of the layering of increasingly dissonant and contrasting lines.

By the late 1940s, it was felt by many jazz writers that the band had deteriorated. The swing band movement, which had swept up the Ellington group in the mid-1930s, had collapsed, and musical tastes were changing. A number of the old hands left, taking with them much of Ellington's tonal palette, and while excellent newcomers replaced them, few equaled the originals. Through the late 1940s and

into the 1950s there were constant changes of personnel, shifts from one record company to the next, and a dwindling demand for the orchestra. Henceforth Ellington would need his song royalties to support what was now a very expensive organization. In 1956 Ellington was asked to play the closing Saturday night concert at the recently established Newport Jazz Festival. At one point in the evening he brought the tenor saxophonist Paul Gonsalves forward to play twenty-seven choruses of the blues over a rhythm section. The crowd was wildly enthusiastic; the event got much media attention, and Ellington's star began to rise again.

Through the late 1950s and 1960s Ellington continued to create memorable pieces, many of them contributed by Strayhorn, particularly the haunting "Blood Count" (1967). Also of value were a series of collaborations with Ellington by major jazz soloists from outside the band, including LOUIS ARMSTRONG, COLEMAN HAWKINS, and John Coltrane. Other fine works were Strayhorn's "UMMG," featuring Dizzy Gillespie; "Paris Blues" (1960), a variation on the blues done for a movie by that name; and an album tribute to Strayhorn issued as . . . *And His Mother Called Him Bill* (1967).

But by this time Ellington's main concerns were his extended works, which eventually totaled some three dozen. Many of these were dashed off to meet deadlines, or even pulled together in rehearsal, and are of slight value. Almost all suffer from the besetting flaw in Ellington's longer works, his inability to make unified wholes of what are often brilliant smaller pieces.

Although some critics insist that much of this work is of value, it was not well reviewed outside the jazz press when it appeared. Among the most successful are "The Deep South Suite" (1946), "Harlem (A Tone Parallel to Harlem)," first recorded in 1951, and "The Far East Suite" in collaboration with Strayhorn and recorded in 1966.

To Ellington, the most important of these works were the three "Sacred Concerts," created in the last years of his life. They consist of collections of vocal and instrumental pieces of various sorts, usually tied loosely together by a religious theme. Although these works contain fine moments and have their admirers, they do not, on the whole, succeed. Duke Ellington's legacy is the short jazz works, most of them written between 1926 and 1942: the jungle pieces, like "Black and Tan Fantasy"; the concertos,

like "Echoes of Harlem"; the mood pieces, such as "Mood Indigo"; the harmonically complex works, like "Ko-Ko"; and the hard swingers, such as "Cotton Tail." This work has a rich tonal palette. It uses carefully chosen sounds by his soloists; endless contrast not only of sound but also of mood, mode, key; the use of forms unusual in popular music, like the four-plus-ten bar segment in "Echoes of Harlem"; and deftly handled dissonance, often built around very close internal harmonies. Although Ellington was not a jazz improviser in a class with Armstrong or Charlie Parker, his body of work is far larger than theirs, more varied and richer, and is second to none in jazz. Ellington died in New York City.

FURTHER READING

Many Ellington papers and artifacts are housed in the Duke Ellington Collection, National Museum of American History, Smithsonian Institution. Additional materials are lodged in the Duke Ellington Oral History Project at Yale, the Schomburg Center for Research in Black Culture of the New York Public Library, and the Institute for Jazz Studies at Rutgers University.

Ellington, Edward Kennedy. *Music Is My Mistress* (1973).

Collier, James Lincoln. *Duke Ellington* (1987).

Dance, Stanley. *The World of Duke Ellington* (1970).

Ellington, Mercer, with Stanley Dance. *Duke Ellington in Person* (1978).

Jewell, Derek. *Duke: A Portrait of Duke Ellington* (1977).

Ulanov, Barry. *Duke Ellington* (1946).

DISCOGRAPHY

Aasland, Benny. *The "Wax Works" of Duke Ellington* (1979–).

Bakker, Dick M. *Duke Ellington on Microgroove* (1972–).

Massagli, Luciano, Liborio Pusateri, and Giovanni M. Volonté. *Duke Ellington's Story on Records* (1967–).

JAMES LINCOLN COLLIER

ELLISON, Ralph Waldo

(1 Mar. 1913?–16 Apr. 1994), novelist and essayist, was born in Oklahoma City, Oklahoma, the oldest of two sons of Lewis Ellison, a former soldier who sold coal and ice to homes and businesses, and Ida Milsaps Ellison. (Starting around 1940 Ellison gave his year of birth as 1914; however, the evidence is strong that he was born in 1913.) His life changed for the worse with his father's untimely death in 1916, an event that left the family poor. In fact, young Ralph would live in two worlds. He experienced poverty at home with his brother, Herbert (who had been just six weeks old when Lewis died), and his mother, who worked mainly as a maid. At the same time, he had an intimate association with the powerful, wealthy black family in one of whose houses he had been born.

At the Frederick Douglass School in Oklahoma City he was a fair student, but he shone as a musician after he learned to play the trumpet. Graduating from Frederick Douglass High School in 1932, he worked as a janitor before entering Tuskegee Institute in Alabama in 1933. There his core academic interest was music, and his major ambition was to be a classical composer—although he was also fond of jazz and the blues. In Oklahoma City, which was second only to Kansas City as a hotbed of jazz west of Chicago, he had heard several fine musicians, including Lester Young, Oran "HOT LIPS" PAGE, Count Basie, and LOUIS ARMSTRONG. The revolutionary jazz guitarist Charlie Christian and the famed blues singer JIMMY RUSHING both grew up in Ellison's Oklahoma City. However, classical music was emphasized at school. At Tuskegee, studying under WILLIAM LEVI DAWSON and other skilled musicians, Ellison became student leader of the school orchestra. Nevertheless, he found himself attracted increasingly to literature, especially after reading modern British novels and, even more influentially, T. S. Eliot's landmark modernist poem, *The Waste Land*.

In 1936, after his junior year, Ellison traveled to New York City hoping to earn enough money as a waiter to pay for his senior year. Ellison never returned to Tuskegee as a student. Settling in Manhattan, he dropped his plan to become a composer and briefly studied sculpture. Working as an office receptionist and then in a paint factory, he also found himself inspired, in the midst of the Great Depression, by radical socialist politics and communism itself. He became a friend of LANGSTON HUGHES, who later introduced him to RICHARD WRIGHT, then relatively unknown. Encouraged by Wright, whose modernist poetry he admired, Ellison continued to read intensively in modern literature, literary and cultural theory, philosophy, and art. His favorite writers were Herman Melville and Fyodor Dostoyevsky from the nineteenth century and, in his own time, Eliot, Ernest Hemingway, and André Malraux (the French radical author

of the novels *Man's Fate* and *Man's Hope*). These men, joined by the philosopher and writer Kenneth Burke as well as Mark Twain and William Faulkner, became Ellison's literary pantheon. (Ellison never expressed deep admiration for any black writer except—for a while—Wright. He liked and was indebted to Langston Hughes personally but soon dismissed his work as shallow.)

In 1937, as editor of the radical magazine *New Challenge*, Wright surprised Ellison with a request for a book review. The result was Ellison's first published essay. Next, Wright asked Ellison to try his hand at a short story. The story, "Hymie's Bull," was not published in Ellison's lifetime, but he was on his way as an author. A trying fall and winter (1937–1938) in Dayton, Ohio, following the death of his mother in nearby Cincinnati, only toughened Ellison's determination to write. In 1938 he secured a coveted place (through Wright) on the Federal Writers' Project in New York, where he conducted research into and wrote about black New York history over the next four years. That year he married the black actress and singer (and communist) Rose Poindexter.

Slowly Ellison became known in radical literary circles with reviews and essays in magazines such as *New Masses*, the main leftist literary outlet. When he became managing editor (1942–1943) of a new radical magazine, *Negro Quarterly*, the lofty intellectual and yet radical tone he helped to set brought him more favorable attention. About this time Ellison came to a fateful decision. He later identified 1942 as the year he turned away from an aesthetic based on radical socialism and the need for political propaganda to one committed to individualism, the tradition of Western literature, and the absolute freedom of the artist to interpret and represent reality.

Facing induction during World War II into the segregated armed forces, Ellison enlisted instead in the merchant marine. This led to wartime visits to Swansea in Wales, to London, and to Rouen, France. During the war he also published several short stories. His most ambitious, "Flying Home" (1944), skillfully combines realism, surrealism, folklore, and implicit political protest. Clearly Ellison was now ready to create fiction on a larger scale. By this time his marriage had fallen apart. He and Rose Poindexter were divorced in 1945. The next year he married Fanny McConnell, a black graduate in drama of the University of Iowa who was then an employee of the National Urban League in Manhattan.

With a Rosenwald Foundation Fellowship (1945–1946) Ellison began work on the novel that would become *Invisible Man*. (One day, on vacation in Vermont, he found himself thinking: "I am an invisible man." Ellison thus had the first line, and the core conceit, of his novel.) In 1947 he published the first chapter—to great praise—in the British magazine *Horizon*. In the following five years Ellison published little more. Instead, he labored to perfect his novel, whose anonymous hero, living bizarrely in an abandoned basement on the edge of Harlem, relates the amazing adventure of his life from his youthful innocence in the South to disillusionment in the North (although his epilogue suggests a growing optimism).

In April 1952 Random House published *Invisible Man*. Many critics hailed it as a remarkable literary debut. However, black communist reviewers excoriated Ellison, mainly because Ellison had obviously modeled the ruthless, totalitarian, and ultimately racist "Brotherhood" of his novel on the Communist Party of the United States. Less angrily, some black reviewers also stressed the caustic depiction of black culture in several places in *Invisible Man*. Selling well for a first novel, the book made the lower rungs of the best-seller list for a few weeks. Then, in January 1953, *Invisible Man* won for Ellison the prestigious National Book Award in fiction. This award transformed Ellison's life and career. Suddenly black colleges and universities, and even a few liberal white institutions, began to invite him to speak and teach. That year he lectured at Harvard and, the following year, taught for a month in Austria at the elite Salzburg Seminar in American Studies.

In 1955 he won the *Prix de Rome* fellowship to the American Academy in Rome. There he and his wife lived for two years (1955–1957) in a community of classicists, archaeologists, architects, painters, musicians, sculptors, and other writers. While in Rome, Ellison worked hard on an ambitious new novel about a light-skinned black boy who eventually passes for white and becomes a notoriously racist U.S. senator, and the black minister who had reared the boy as his beloved son. He worked on this novel for the rest of his life.

Returning home, Ellison taught (1958–1961) as a part-time instructor at Bard College near New York City. This was followed by a term at the University

of Chicago in 1961; two years (1962–1964) as a visiting professor of writing at Rutgers University in New Brunswick, New Jersey; and a year (1964–1965) as a visiting fellow in American Studies at Yale. During this time he published several important essays even as he toiled on his novel. In 1960 he published a short excerpt from his novel in the *Noble Savage*, a magazine that had been cofounded by Saul Bellow, a future Nobel Prize winner and close friend of Ellison's for some time.

Over the years Ellison was involved intellectually and personally with a wide range of major American scholars, critics, and creative writers. These included the philosopher Kenneth Burke, the critic Stanley Edgar Hyman, Bellow himself, the poet and novelist Robert Penn Warren, and the poet Richard Wilbur. Among blacks, his most important friendship for many years was with Albert L. Murray, a fellow student at Tuskegee in Ellison's junior year and later a professor of English there. Murray settled with his family in Harlem and published books about African Americans and the national culture. Starting in the 1960s Ellison was devoted to two institutions that honored achievement in the arts. The first was the American Academy and the National Institute of Arts and Letters. (Initially a member of the institute, he was elected later to the inner circle of excellence, the academy.) The other organization was the Century Association in mid-Manhattan, probably the most prestigious private club in the United States dedicated to the arts and literature.

As the years passed and his second novel failed to appear, Ellison's essays and interviews played a crucial role in furthering his reputation as an American intellectual of uncommon brilliance. His collection *Shadow and Act* (1964) reinforced this reputation. In it, Ellison insisted on the complexity of the American experience and the related complexity of black life. The black writer and artist, he insisted, should not be bound by morbid or negative definitions of the black experience but by a highly positive sense that cultural achievements such as the blues, jazz, and black folklore represent the triumph of African Americans over the harsh circumstances of American history—and a triumph of the human spirit in general. The Declaration of Independence, the U.S. Constitution, and the Bill of Rights were sacred documents authenticating the special promise of American and African American culture.

In 1965 a national poll of critics organized by a respected weekly magazine declared *Invisible Man* to be the most distinguished work of American fiction published since 1945. Other formal honors followed. However, the rise of Black Power and the Black Arts Movement about this time led to a backlash among younger, militant blacks against Ellison's ideas. Shunned at times on certain campuses, he was occasionally heckled or even denounced as an "Uncle Tom." Ellison was hurt by these assaults but remained confident about his values and insights. Moreover, the hostility of some younger blacks was offset by a host of honors. In 1966 he was appointed Honorary Consultant in American Letters at the Library of Congress, and the next year he joined the board of directors of the new Kennedy Center for the Performing Arts in Washington, D.C. At a crucial time in the rise of public television, he became a director of the Educational Broadcasting Corporation. In 1969 France made Ellison a *Chevalier dans l'Ordre des Artes et Lettres*. He also became a trustee of the New School for Social Research (now New School University) in New York and of Bennington College, in Vermont. Also in 1969 he received the highest civilian honor bestowed on a U.S. citizen, the Presidential Medal of Freedom.

From 1970 until 1979, when he reached the age of compulsory retirement, Ellison was Albert Schweitzer Professor of Humanities at New York University. Always interested in art—he and his wife collected African art as well as Western paintings and sculpture—he became a director of the Museum of the City of New York. In addition, he was a trustee of the Rockefeller-inspired Colonial Williamsburg Foundation in Virginia and a member of the Board of Visitors of Wake Forest University in Winston-Salem, North Carolina. He took these two last appointments as proof of important social change in the South, about which Ellison was sentimental because of the South Carolina and Georgia origins of his father and mother, respectively. In 1975 Oklahoma City honored him when he helped open the Ralph Ellison Branch of the city library system. President Ronald Reagan awarded him the National Medal of Arts in 1985.

The following year Ellison published his third book, *Going to the Territory*. Like *Shadow and Act*, this volume collected shorter pieces that reflected his unabated interest in the complex nature of black American and American culture. Vigorous to the

end, Ellison died at his home in Manhattan. By this time he had seen his critics of the late 1960s and early 1970s decline in influence even as *Invisible Man* had become established as an American classic in fiction. After his death a succession of volumes have helped keep his reputation alive. These include his *Collected Essays* (1995), *Flying Home and Other Stories* (1996), and the novel *Juneteenth* (1999), all edited by John F. Callahan, who had been a trusted friend of Ellison's as well as a professor of American literature. Ellison's reputation rests on two remarkable books. As a novel of African American life, *Invisible Man* has no clear superior and very few equals to rival its breadth and artistry. With the exception of *The Souls of Black Folk* by W. E. B. DU BOIS, *Shadow and Act* is probably the most intelligent book-length commentary on the nuances of black American culture ever published.

FURTHER READING

The primary source of information on Ellison is the Ralph Waldo Ellison Papers in the Manuscripts Division of the Library of Congress, Washington, D.C.

Benston, Kimberly. *Speaking for You: The Vision of Ralph Ellison* (1987).

Graham, Maryemma, and Amjitjit Singh, eds. *Conversations with Ralph Ellison* (1995).

Murray, Albert, and John F. Callahan, eds. *Trading Twelves: The Selected Letters of Ralph Ellison and Albert Murray* (2000).

O'Meally, Robert G. *The Craft of Ralph Ellison* (1980).

Rampersad, Arnold. *Ralph Ellison: A Biography* (2007).

Obituary: New York Times, 17 Apr. 1994.

ARNOLD RAMPERSAD

EUROPE, James Reese

(22 Feb. 1880–9 May 1919), music administrator, conductor, and composer, was born in Mobile, Alabama, the son of Henry J. Europe, an Internal Revenue Service employee and Baptist minister, and Lorraine Saxon. Following the loss of his position with the Port of Mobile at the end of the Reconstruction, Europe's father moved his family to Washington, D.C., in 1890 to accept a position with the U.S. Postal Service. Both of Europe's parents were musical, as were some of his siblings. Europe attended the elite M Street High School for blacks and studied violin, piano, and composition with Enrico Hurlei of the U.S. Marine Corps band and

with Joseph Douglass, the grandson of FREDERICK DOUGLASS.

Following the death of his father in 1900, Europe moved to New York City. There he became associated with many of the leading figures in black musical theater, which was then emerging from the tradition of nineteenth-century minstrelsy. Over the next six years, Europe established himself as a composer of popular songs and instrumental pieces and as the musical director for a number of major productions, including Ernest Hogan's "Memphis Students" (1905), John Larkins's *A Trip to Africa* (1904), Bob Cole and JOHN ROSAMOND JOHNSON's *Shoo-Fly Regiment* (1906–1907) and *Red Moon* (1908–1909), S. H. DUDLEY's *Black Politician* (1907–1908), and BERT WILLIAMS's *Mr. Load of Koal* (1909). During *Red Moon*'s run, he was involved with, but did not marry, a dancer in the company, Bessie Simms, with whom he had a child.

In April 1910 Europe became the principal organizer and first president of the Clef Club of

James Reese Europe, the regimental bandleader with the Fifteenth "Hellfighters" Infantry Regiment, brought live ragtime, blues, and jazz to Europe during World War I. (National Archives.)

New York, the first truly effective black musicians' union and booking agency in the city. So effectual was the club during the years before World War I that, as JAMES WELDON JOHNSON recalls in his memoir *Black Manhattan* (1930), club members held a "monopoly of the business of entertaining private parties and furnishing music for the dance craze which was then beginning to sweep the country." Europe was also appointed conductor of the Clef Club's large orchestra, which he envisioned as a vehicle for presenting the full range of African American musical expression, from spirituals to popular music to concert works. On 27 May 1910 he directed the one-hundred-member orchestra in its first concert at the Manhattan Casino in Harlem. Two years later, on 2 May 1912, Europe brought 125 singers and instrumentalists to Carnegie Hall for an historic "Symphony of Negro Music," featuring compositions by WILL MARION COOK, Harry Burleigh, JOHN ROSAMOND JOHNSON, William Tyers, Samuel Coleridge-Taylor, and himself. It was the first performance ever given by a black orchestra at the famous "bastion of white musical establishment," and Europe returned to direct concerts there in 1913 and 1914.

In 1913 Europe married Willie Angrom Starke, a widow of some social standing within New York's black community; they had no children. Later that year, he and his fellow Clef Club member FORD DABNEY became the musical directors for the legendary dance team of Vernon Castle and Irene Castle until the end of 1915 when Vernon Castle left to serve in World War I. Irene Castle recalls in her memoir *Castles in the Air* (1958) that they wanted Europe because his was the "most famous of the colored bands" and because he was a "skilled musician and one of the first to take jazz out of the saloons and make it respectable." With the accompaniment of Europe's Society Orchestra, the Castles toured the country, operated a fashionable dance studio and supper club in New York City, and revolutionized American social dancing by promoting and popularizing the formerly objectionable "ragtime" dances, such as the turkey trot and the one-step. The most famous of the Castle dances, the fox-trot, was conceived by Europe and Vernon Castle after an initial suggestion by the composer W. C. HANDY. As a result of his collaboration with the Castles, in the fall of 1913 Europe and his orchestra were offered a recording contract by Victor Records, the first ever offered to a black orchestra. Between December 1913

and October 1914 Europe and his Society Orchestra cut ten sides of dance music for Victor, eight of which were released.

In 1916 Europe enlisted in the Fifteenth Infantry Regiment of the New York National Guard, the first black regiment organized in the state and one of the first mobilized into federal service when the United States entered World War I in 1917. After encountering severe racial hostility while training in South Carolina, the infantry was sent directly to France and assigned to the French army. Europe, who held two assignments, bandmaster of the regiment's outstanding brass band and commander of a machine gun company, served at the front for four months and was the first black American officer to lead troops in combat in the Great War. The entire Fifteenth Regiment, which was given the nickname "Hellfighters," emerged after the Allied victory in November of 1918 as one of the most highly decorated American units of the war. Europe's band, which performed throughout France during the war, was the most celebrated in the American Expeditionary Force and is credited with introducing European audiences to the live sound of orchestrated American ragtime, blues, and a new genre called "jazz."

On 17 February 1919 the regiment and its band were given a triumphant welcome-home parade up Fifth Avenue, and Lieutenant Europe, hailed as America's "jazz king," was signed to a second recording contract; he and the band subsequently embarked upon an extensive national tour. Europe's career ended abruptly and tragically a few months later, however, when during the intermission of one of the band's concerts in Boston, he was fatally stabbed by an emotionally disturbed band member. Following a public funeral in New York City, the first ever for a black American, Europe was buried with military honors in Arlington National Cemetery.

Europe composed no major concert works, but many of his more than one hundred songs, rags, waltzes, and marches exhibit unusual lyricism and rhythmic sophistication. His major contributions, however, derive from his achievements as an organizer of professional musicians, a skilled and imaginative conductor and arranger, and an early and articulate champion of African American music. Through his influence on NOBLE SISSLE, EUBIE BLAKE, and George Gershwin, among others, Europe helped to shape the future of American

musical theater. As a pioneer in the creation and diffusion of orchestral jazz, he initiated the line of musical development that led from FLETCHER HENDERSON and Paul Whiteman to DUKE ELLINGTON. Without the expanded opportunities for black musicians and for African American music that Europe helped to inaugurate, much of the development of American music in the 1920s, and indeed since then, would be inconceivable.

FURTHER READING
Badger, Reid. *A Life in Ragtime: A Biography of James Reese Europe* (1995).
Charters, Samuel B., and Leonard Kunstadt. *Jazz: A History of the New York Scene* (1962).
Erenberg, Lewis A. *Steppin' Out: New York Nightlife and the Transformation of American Culture, 1890–1930* (1981).
Kimball, Robert, and William Bolcom. *Reminiscing with Sissle and Blake* (1973).
Riis, Thomas. *Just Before Jazz: Black Musical Theater in New York, 1890–1915* (1989).

Obituaries: New York Times, 12 May 1919; *Chicago Defender*, 24 May 1919.

REID BADGER

EVANTI, Lillian Evans

(12 Aug. 1890–7 Dec. 1967), opera and concert vocalist and composer, was born Annie Wilson Lillian Evans in Washington, D.C., the daughter of Dr. William Bruce Evans and Annie D. Brooks. Her antebellum ancestors made their mark in African American history. Evanti's paternal grandfather, Henry Evans, was an abolitionist involved in the 1859 Oberlin-Wellington riot. Her great uncle Lewis Sheridan Leary participated in John Brown's raid at Harpers Ferry, Virginia. Her mother, Annie Evans, was a schoolteacher in Washington D.C. Her father, William Bruce Evans, whose ancestors came to Washington from Oberlin, Ohio, first served as a physician and later became one of the few black school principals in Washington, D.C.

Lillian Evans was a precocious child who sang her first public recital in 1894 at the age of four. The Evans family loved classical music and singing. They purchased a piano and hired a piano teacher to give their daughter lessons. Lillian regularly performed in public at school commencements, church socials, and holiday celebrations. She attended Armstrong Manual Training School, where her father

was principal. With her parents as role models, Lillian decided to become a kindergarten teacher and enrolled in a two-year course at Washington's Miners Teachers College (later part of the University of the District of Columbia).

After graduation she taught kindergarten and gave private music lessons to earn tuition money to attend Howard University, from which she graduated in 1917. At Howard, Lillian met her husband, Roy Tibbs, who was her music professor; they married in 1918. Her stage name was derived from combining her maiden name, Evans, with her married name, Tibbs. Critics and fans dubbed her "Madame Evanti." Their only child, Thurlow Evans Tibbs, was born in 1921, after which Evanti continued teaching. By 1924, however, she had realized that her true ambition was to be an opera singer. She went to Paris that year to study music and acting, despite her husband's protests. One of her teachers urged her to audition at the Nice Opera House in Nice, France, and she was hired. In March 1925 she made her opera debut in the title role in Delibes's *Lakmé*, and at the same time made history as the first black female to sing in a European opera house. In 1927 she reprised the same role at the Trianon-Lyrique opera house in Paris. Her homecoming in Washington, D.C., in October 1925 saw her in concert before a crowd of 1,600 at the Lincoln Theater. Evanti sang in Europe during the remainder of the 1920s and the early 1930s.

In 1932 Evanti took the bold step of auditioning for the Metropolitan Opera in New York. At that time no African American had ever performed in an opera on that stage. Unlike MARIAN ANDERSON, who had never sung an opera role before her Met debut in 1954, Evanti already claimed mastery of twenty-four operas. Despite her repertoire and formidable musical training, she was rejected by the Met, and rejected again in 1933 and 1946. While the Met rejections were a career setback for Evanti, most of her public performances were well received. In 1932 she gave a critically acclaimed concert at Washington's Belasco Theater. In 1934 she became the first African American singer invited to the White House since 1882, when soprano Mathilda Joyner sang for President Benjamin Harrison. A few months after her White House appearance Evanti contacted Eleanor Roosevelt about starting an opera house or performing arts center in Washington, D.C. She also went to Congress to advocate "an American National Theater and Academy."

Evanti's dream came true when the Kennedy Center for the Performing Arts opened in 1971 in Washington, D.C.

Evanti is most remembered for her performance in the role of Violetta in Verdi's *La Traviata* with the National Negro Opera Company (NNOC) at the Watergate in Washington, D.C., on 28 August 1943. Violetta was Evanti's favorite role; she sang it more than fifty times. Evanti is sometimes erroneously credited with founding the NNOC, but Mary Cardwell Dawson was the actual founder. Dawson and Evanti had artistic differences, and Evanti left the company in the summer of 1944.

Evanti also had a career as a songwriter. W. C. HANDY's music publishing company published her setting of the Twenty-third Psalm and her other compositions, including "The Mighty Rapture," "Thank You Again and Again," "Speak to Him Thou," and "High Flight." In the 1940s, when Evanti was a goodwill ambassador to Argentina and Brazil for the U.S. State Department, she composed the song "Himno Pan Americano." For the Republican presidential candidate Thomas E. Dewey in 1948, Evanti composed the tune "There's a Better Day A-coming." In 1949 while campaigning for suffrage for the District of Columbia, Evanti wrote the song "Hail to Fair Washington." She later founded her own music publishing house, Columbia Music Bureau. Evanti organized twenty black women singers in the District of Columbia into the Evanti Chorale. The group debuted in Washington on 18 April 1950 with a program featuring American composers.

Lillian Evanti was a compelling role model for the generation of African American female opera singers such as Leontyne Price, Grace Bumbry, and Mattiwilda Dobbs that emerged in the 1960s. Lillian Evanti died in Washington, D.C.

FURTHER READING

Smith, Eric Ledell. "Lillian Evanti: Washington's African-American Diva," *Washington History* 11.1 (Spring/Summer 1999): 24–43.

Obituary: Washington Post, 8 Dec. 1967.

ERIC LEDELL SMITH

FARROW, William McKnight

(13 Apr. 1885–Dec. 1967), painter, graphic artist, printmaker, curator, and educator, was born in Dayton, Ohio. His family later moved to Indianapolis, where he attended high school in 1903 and 1904. While Farrow was in high school, the noted muralist William Edouard Scott recognized his artistic potential and encouraged him to enroll at the School of the Art Institute of Chicago. In 1908 Farrow moved to Chicago to begin classes at the Institute, Scott's alma mater and one of the first U.S. art schools to admit black students.

Farrow studied intermittently at the School of the Art Institute of Chicago from 1908 to 1918, while working for the U.S. Postal Service. When Farrow arrived at the institute, founded as the Chicago Academy of Fine Arts in 1879, it was not yet a world-class art institution. In the early twentieth century, the institute was actively building its collection with European art and quality exhibitions. Separate from these efforts, the Chicago-founded Harmon Foundation supported several institute-affiliated black artists: annually, it presented the William E. Harmon Award for Distinguished Achievement Among Negroes, established in 1914 by Joel E. Spingarn, chairman of the board of the National Association for the Advancement of Colored People (NAACP), and advertised in the *Crisis*, the NAACP's monthly magazine. The Harmon Foundation also sponsored several exhibitions of African American art in major cities, and from 1928 to 1933 it mounted similar group exhibitions that traveled around the United States. In 1917 Farrow participated in a Harmon Foundation-sponsored show in Chicago, which was cosponsored by the Arts and Letters Society of Chicago. A great deal of Farrow's work was displayed in the Harmon Foundation-sponsored exhibits of 1928 to 1933.

Farrow, along with the Chicago artists Charles Dawson, HALE A. WOODRUFF, and Arthur Diggs, also received support from the Art Institute of Chicago. The Institute mounted the Negro in Art Week, one of the first exhibitions to display works done by living black artists. ALAIN LOCKE, who organized this exhibition along with its cosponsors

the Chicago Woman's Club and the Art Institute, showcased African American art that met prevailing European art standards of quality and portrayed the emergent New Negro movement. Part of the larger cultural movement variously labeled the Negro Renaissance and the Harlem Renaissance, the New Negro movement was borne by ambitious, black intellectuals, musicians, artists, and performers, and the interest in black creativity. The Chicago Art League, cofounded by Farrow in 1923, embodied the spirit of the times, for it offered classes and exhibition opportunities for local artists. The league organized yearly exhibitions held at the YMCA on Wabash Avenue in Bronzeville.

In 1922, Farrow was hired as an assistant curator at the Art Institute of Chicago and was put in charge of writing labels for displayed art and cataloguing. Eventually he was given oversight of print art, and in 1926 he accepted the position of curator of the Egyptian Collection. He continued to work at the institute until 1945. Farrow's regular column "Art in the Home" appeared in the influential black weekly *Chicago Defender*, and he also wrote essays for the *Crisis* and *Homesteader*.

In 1926 Farrow also accepted a position to teach art at Carl Schurz High School in 1926. While teaching at the high school, Farrow wrote commercial art instruction books including *Easy Steps to Commercial Art* (1931), *Practical Use of Color* (1933), and *Figure Drawing and Instruction* (1935). In 1948, after the *Pittsburgh Courier* published a profile of his life and work, Farrow was fired from his teaching post. The school's staff had hired Farrow believing he was white and fired him upon learning that he was not.

Farrow's artistic approach was conservative; he worked in a naturalistic style, founded in the nineteenth-century figural traditions, to render flattering portraits and pleasant landscapes. Farrow, exhibited in New York and Washington, D.C., was well known during his lifetime. His works were on view in the gallery exhibits at Chicago's Southside Community Art Center, part of the Great Depression's Work Progress Administration recovery program that gave work to artists struggling during the Great Depression. The Community Art Center exhibitions influenced a generation of students including William S. Carter, Charles White, and the photographer Gordon Parks, and it was an important gallery space for black artists during the Depression. Farrow's works were featured in exhibitions including the Chicago Art Institute's *The*

American Negro Expo in 1940 and a solo show at the New York Public Library in 1940.

Farrow's commercial graphic artwork, most notably the posters he designed for commercial clients, including Pathé phonographs and Kimball pianos, became popular images in poster reproduction. His art is part of the collections at Clark Atlanta University, New York Public Library, and Fort Huachuca (Arizona). His work may be seen in numerous public places including the Steward Community House, Provident Hospital, and Roosevelt High School (all in Chicago). Farrow's portrait of the author and poet PAUL LAURENCE DUNBAR, painted in 1934, hangs in the National Portrait Gallery of the Smithsonian Institution in Washington, D.C.; both Farrow and Dunbar grew up in Dayton, Ohio, and went on to become part of the Harlem Renaissance and New Negro movement.

FURTHER READING

Driskell, David C. *Two Centuries of Black American Art* (1976).

Fine, Elsa Honig. *The Afro-American Artist* (1973).

Kennedy, Elizabeth, ed. *Chicago Modern, 1893–1945: Pursuit of the New* (2004).

Lewis, Samella S. *African American Art and Artists* (1990).

Meyerowitz, Lisa. "The Negro in Art Week: Defining the 'New Negro' Through Art Exhibition," *African American Review* (Spring 1997).

Reynolds, Gary, and Beryl J. Wright. *Against the Odds: African American Artists and the Harmon Foundation* (1989).

Obituary: Times (London), 30 Dec. 1927.

PAMELA LEE GRAY

FATHER DIVINE

(? May 1879–10 Sept. 1965), religious leader and founder of the Peace Mission movement, was born George Baker in Rockville, Maryland, to George Baker Sr., a farmer, and Nancy Smith, a former slave who worked as a domestic with her three daughters before marrying Baker sometime in the 1870s. Nancy, who had been owned by two Catholic masters, exposed her children to the African American spiritual traditions of the Jerusalem Methodist Church in Rockville until she died in 1897.

Following his mother's death, George Baker gravitated to Baltimore, as did thousands of African American in search of a better life. He appears on the census of 1900 as a gardener, and he also found work on the docks, where he witnessed the crime and poverty of the destitute and was moved by a new message of ecstatic salvation emanating from dozens of storefront churches in the city. Baker, a dark, stout man with a high-pitched voice, impressed people with his earnest demeanor. He quickly rose from Sunday school teacher to evangelist. However, it was Baker's message, rather than oratorical skills or charisma, that ultimately distinguished him from any number of itinerant preachers. His message synthesized the teachings of evangelical churches with the "New Thought" ideology of Charles Fillmore and Robert Collier. Essentially a form of positive thinking, proponents of New Thought asserted that correct thinking, which Baker and others interpreted in a religious sense, could empower the believer to improve his or her circumstances. This notion contrasted sharply with the ritualistic or heaven-focused beliefs of many denominations, regardless of their form of worship. Baker's theology could be applied to solving earthly problems of poverty and racism. Indeed, he later referred to his centers as "heavens on earth."

The most striking element of Baker's message, that of his own divinity, gradually emerged after he attended the Azusa Street Revival, which gave birth to the Pentecostal movement in California during the spring of 1906. Baker returned to Baltimore convinced that he had been transformed to serve a higher purpose. The following year Samuel Morris entered Baker's church and proclaimed, "I am the Father Eternal!" (Weisbrot, 19). Morris was cast out by the congregation, who considered his words blasphemous, but Baker was intrigued by Morris's interpretation of 1 Corinthians 3:16, "Know ye not that ye are the temple of God, and the Spirit of God dwelleth in you?" (AV) as establishing the possibility of human divinity. For the next five years the two enjoyed a relationship in which Morris was "Father Jehovia, God in the Fathership degree" and Baker was "the Messenger, God in the Sonship degree" (Watts, 27). Later, John Hickerson, known as "Reverend St. John Divine Bishop," who claimed to speak fluent Hebrew and taught that all black people were descended from Ethiopian Jews, became the third member of their trinity.

In 1912 this divine partnership ended as Hickerson and Baker both began to question whether their own degree of divinity might equal or surpass that claimed by Father Jehovia. Hickerson went north to

establish the Church of the Living God in New York City, and Baker went south, preaching in various towns until 1914, when he settled briefly in Valdosta, Georgia. There a group of irate husbands and clergy had Baker indicted on lunacy charges, arguing that claiming to be God and encouraging sexual abstinence even for married women was proof of his insanity. One local paper ridiculed him with the headline "Negro Claims to Be God." He was booked as "John Doe, alias God," indicating that he no longer used the name Baker. But neither on the witness stand nor in interviews did Baker appear to be one of the crazed lunatics that he and his followers were made out to be. The jury found Baker guilty but did not have him committed because he was not a threat to himself or others. Chastened by this experience and by an earlier clash with southern ministers that got him sixty days on a Georgia chain gang, Baker moved in late 1914 to New York City, where he established a religious organization that, for a while at least, kept a relatively low profile.

The prototype for the Peace Missions began in a quiet, middle-class neighborhood in Brooklyn in 1917 and then two years later moved to an affluent white suburb in Sayville, New York, where he was known as "Major Jealous Devine" before settling on the appellation "Father Divine." These missions were experiments in communal living. Residents and visitors entered a world in which race was considered not to exist; even the words "white" and "Negro" were barred from use. Gender distinctions were also treated as suspect, and adherents referred to "those who call themselves women" and "so-called men." Nor were distinctions recognized on the basis of class, title, or office; all identities were subordinate to being a follower of God. On 15 November 1931 Father Divine and ninety-three of his followers were arrested at their Long Island mission for disturbing the peace. The interracial composition of the movement drew the ire of Judge Lewis Smith, who considered race mixing ipso facto a disturbance of the peace. Father Divine, believing that he was being persecuted, refused to pay the five-dollar fine. When the fifty-six-year-old judge suddenly dropped dead three days after imposing a one-year sentence, Father Divine remarked, "I hated to do it." The conviction was later overturned, and the coverage in the black press brought Father Divine to national attention.

During the Depression Father Divine moved his base of operation to Harlem and opened an estimated 160 Peace Missions in the United States, Canada, and Europe. The movement even boasted of a postcard from China addressed to "God, Harlem, USA" that was promptly delivered to Father Divine. While the majority of his followers in New York were black migrants from the South and immigrants from the Caribbean, in other areas of the country, such as California, white membership may have risen as high as 70 percent. A number of Father Divine's wealthy followers contributed land, buildings, and large sums of money to the organization. Where other charities opened soup kitchens for the poor, Father Divine served lavish buffets twice daily, consisting of between fifty and two hundred menu items of the finest fare available. These centers operated on an honor system where the poorest dined for free and others paid as little as ten cents for a meal and two dollars a week for lodging. Critics have argued that Father Divine was merely pandering to the poor, simple, and ignorant, but according to one contemporary academic observer, "Eating is hardly ever advanced as a reason for having come into the movement" (Fauset, 63 n. 10). Father Divine referred to these banquets as "Holy Communions," and in the absence of any formal liturgy for the sect, the meals, songs, and testimonials formed the core of their religious activity.

Father Divine advanced bold political positions, calling for a minimum wage, limits on corporate wealth, the abolition of capital punishment, and the passage of antilynching legislation. He ran his organization through a series of secretaries, mostly women; there were no ministers or clergy other than Father Divine himself. Drinking, smoking, and sexual relations were strictly prohibited, while industry and financial independence were strongly encouraged. By the end of the Depression, the Peace Mission operated scores of businesses, several hotels, a large farming cooperative, a number of mansions, and two newspapers, *New Day* and *Spoken Word*. Yet, the Peace Mission did not pass a collection plate at its meetings, nor did it peddle healing merchandise or accept contributions from nonmembers. Those who lived at a mission center might be expected to donate their earnings to the movement, but Father Divine's propensity to share the wealth seems consistent with his philosophy of prosperity, rather than with the unalloyed avarice of a con artist.

During the 1940s membership in the Peace Mission movement declined rapidly from its height of

about 50,000. The end of the Depression diminished Father Divine's appeal and relevance. Moving to his Philadelphia estate in 1942 to avoid a lawsuit, he became separated from his base of support. The death of his first wife, Peninnah, known as "Mother Divine," generated doubt about Father Divine's promise of everlasting life for the faithful. Father Divine's assertion that Peninnah was reincarnated in the form of his second wife, "Sweet Angel," a young, white Canadian whom he married in 1946, cast further suspicion on his omnipotence. He made few public appearances in the 1950s, and rumors of his failing health quickly spread. The man who would be God died of diabetes in 1965, but to a small band of stoic believers, he still exists in spirit.

The acquisition of great wealth and claims of divinity invite comparisons between Father Divine and DADDY GRACE, another flamboyant black minister of the period. However, the breadth of Father Divine's poverty programs, the extent of his political activism, and his use of theology to address social conditions suggest that he had more in common with MARCUS GARVEY as a colorful, complex, and important historical figure.

FURTHER READING
The papers of Father Divine are held by the Peace Mission in Philadelphia, Pennsylvania. Many of the sermons, essays, beliefs, and writings of Father Divine are published in the Peace Mission's two newspapers, *Spoken Word* and *New Day*.
Fauset, Arthur Huff. *Black Gods of the Metropolis* (1971).
Watts, Jill. *God, Harlem U.S.A. The Father Divine Story* (1992).
Weisbrot, Robert. *Father Divine and the Struggle for Racial Equality* (1983).

Obituary: New York Times, 11 Sept. 1965.

SHOLOMO B. LEVY

FAUSET, Arthur Huff

(20 Jan. 1899–2 Sept. 1983), folklorist, educator, was born in Flemington, New Jersey, the middle of three children of the Reverend Redmon Fauset, an African Methodist Episcopal (AME) minister who died when Arthur was four, and Bella Huff, a white woman and widow with three children. He was also a half-brother to the author JESSIE RED-MON FAUSET, whose mother was Annie Seamon, Rev. Fauset's first wife and mother to seven of their

children. Fauset grew up in Philadelphia, Pennsylvania, attending Central High School and then the School of Pedagogy for Men, graduating in 1917. Beginning in 1918 he taught elementary school in the Philadelphia public school system and eventually became principal of the Joseph Singerly School in 1926, a position he held for twenty years. ALAIN LOCKE became Fauset's mentor, encouraging him to pursue higher education and arranging a loan that enabled him to study part time at the University of Pennsylvania while he continued teaching. Fauset also became a protégé of Charlotte Mason, a wealthy and eccentric white patron who contributed financial support to such Harlem Renaissance luminaries as LANGSTON HUGHES, ZORA NEALE HURSTON, AARON DOUGLAS, and Locke. Fauset's essay "American Negro Folk Literature" was included in Locke's groundbreaking 1925 collection, *The New Negro*.

Fauset had discovered anthropology at college and in the summer of 1923 he participated in a six-week field study in Nova Scotia. Fauset's findings were later published as *Folklore from Nova Scotia* (1931). He pursued his study of anthropology when he returned to the University of Pennsylvania for three years. He received all his degrees, BA (1921), MA (1924), and PhD (1942), from that university. His PhD in Anthropology made him one of the first African American anthropologists. Fauset's early career coincided with the years of the Harlem Renaissance, roughly 1919–1935, when African American arts and letters flourished, and the importance of studying African American culture became paramount for black intellectuals. Fauset's reviews, articles, stories, and essays appeared in African American journals such as *Black Opals*, *Opportunity*, and *Crisis*, as well as in the one and only issue of *Fire!!*, the 1926 arts journal edited by Wallace Thurman. His short story "A Tale of the North Carolina Woods" was published in the January 1922 issue of *Crisis*, and another of his short stories won first prize in the 1926 *Opportunity* contest. Fauset took issue with a basic tenet of Harlem Renaissance civil-rights-through-arts-and-letters thinking in a 1933 *Opportunity* essay, in which he argued that the recognition of African Americans as equal to whites in the arts would not necessarily bring social and economic equality.

A member of the Philadelphia Anthropological Society and the American Folklore Society, as well

as a fellow in the American Anthropological Association, Fauset remained primarily interested in folklore, however, and his studies and writings focused on the folklore of Nova Scotia and on African Americans in Philadelphia, the West Indies, and the South. As Nathan Irvin Huggins observed: "He turned his attention to Negro materials not only because of his racial attachments but because of his fear that the rapidly changing and urbanizing South would soon obliterate this very rich source of the Negro's past" (Huggins, 73). His survey of notable African Americans throughout history in *For Freedom* (1935) included lesser-known figures as well. *Sojourner Truth, God's Faithful Pilgrim* (1938) was republished in 1971, and his 1942 PhD dissertation was the basis for his best-known work, *Black Gods of the Metropolis: Negro Religious Cults of the Urban North* (1944). An examination of the religious cults and religious leaders such as FATHER DIVINE and Prophet F. S. Cherry, the book remains an important study of early-twentieth-century African American urban culture.

In 1935 Fauset married Crystal Dreda Bird. In the November 1938 contest for the Pennsylvania House of Representatives, Crystal Bird Fauset became the first African American woman elected to a state legislature. Their marriage ended in 1944, without children. During World War II Fauset enlisted in the U.S. Army but, at the age of forty-two, was too old to serve. He returned to Philadelphia with an honorable discharge. Fauset retired from teaching in the Philadelphia school system in 1946, after over twenty years as a teacher and principal. He continued his research in New York City in the 1950s, eventually making Manhattan his permanent home. In 1969 he collaborated with fellow one-time Philadelphia school principal Nellie Rathbone Bright to write *America: Red, White, Black, Yellow*. Intended for elementary school students, the book surveyed the contributions of minority groups in the making and development of the United States. Fauset remained active until his death, at age eighty-four.

FURTHER READING

Harrison, Ira E., and Faye V. Harrison, eds.
 African-American Pioneers in Anthropology (1999).
Higgins, Nathan Irvin. *Harlem Renaissance* (1973).
Wilson, Sondra Kathryn, ed. *The Crisis Reader* (1999).

MARY ANNE BOELCSKEVY

FAUSET, Jessie Redmon

(27 Apr. 1882–30 Apr. 1961), writer, editor, and teacher, was born outside Philadelphia, Pennsylvania, in Camden County, New Jersey, the daughter of Redmon Fauset, an African Methodist Episcopal minister, and Annie Seamon. Fauset was probably the first black woman at Cornell University, where she graduated Phi Beta Kappa with a degree in Classical and Modern Languages in 1905. She taught briefly in Baltimore before accepting a job teaching French and Latin at the famed all-black M Street (later Dunbar) High School in Washington, D.C. While teaching, Fauset completed an MA in French at the University of Pennsylvania (1919).

From 1912 to 1929 Fauset contributed numerous articles, reviews, poems, short stories, essays, and translations of French West Indian poems to the *Crisis*, the official publication of the National Association for the Advancement of Colored People. At the urging of its editor, W. E. B. DU BOIS, she moved to New York City to become the literary editor of the *Crisis* from 1919 to 1926. She was instrumental in discovering and publishing most of the best-known writers of the Harlem Renaissance, including LANGSTON HUGHES, CLAUDE MCKAY, JEAN TOOMER, and COUNTÉE CULLEN. In 1920–1921 Fauset also edited a monthly magazine for African American children called *Brownies' Book*. During this period Fauset and her sister made the apartment they shared in Harlem a salon where the black intelligentsia and their allies gathered to discuss art and politics.

Although she exercised substantial influence as a literary mentor, Fauset is best known for her writing. Her poetry appeared in the *Crisis* and was published in numerous anthologies. Her essays and articles run the gamut from Montessori education to international politics to travel essays about her experiences as a delegate to the second Pan-African Congress held in London, Brussels, and Paris in 1921. Her best-known essay, "The Gift of Laughter" (1925), is an analysis of the black comic character in American drama. Fauset is primarily known, however, for her four novels—*There Is Confusion* (1924), *Plum Bun* (1929), *The Chinaberry Tree* (1931), and *Comedy: American Style* (1933)—all novels of manners centering on the careers, courtships, and marriages of the black professional classes, Du Bois's so-called talented tenth.

Fauset and her fellow Harlem Renaissance writers WALTER WHITE and NELLA LARSEN, with whom she is frequently compared, were all galvanized into print by the 1922 publication of T. S. Stribling's *Birthright*, a best-selling novel about a mixed race Harvard graduate written by a white man. In a 1932 interview, Fauset remembered how she felt when *Birthright* was published: "Here is an audience waiting to hear the truth about us. Let us who are better qualified to present that truth than any white writer try to do so" (*Southern Workman*, May 1932, 218–219). *There Is Confusion* (1924) was her first attempt to present that truth. Du Bois called it "the novel that the Negro intelligentsia have been clamoring for" (*Crisis*, Feb. 1924, 162). It offered some refreshingly positive images of black characters: Joanna Marshall turns the street dances of African American children into a successful stage career; Peter Bye overcomes his bitterness toward the white branch of his family and becomes a surgeon; and Maggie Ellersley, a poor laundress's daughter, establishes her own lucrative chain of beauty shops.

Fauset traveled in Europe and studied French at the Sorbonne and the Alliance Française in Paris in 1925. She left her job as an editor at the *Crisis* in 1926 in order to find employment that would allow her more time for writing. Discrimination made it impossible for her to work in a New York publishing house, so she returned to teaching. From 1927 to 1944 she taught at a Harlem junior high school and DeWitt Clinton High School in New York City.

In 1929 Fauset published her second and best novel, *Plum Bun*, a story about light-skinned Angela Murray, who abandons her darker-complexioned sister to "pass" for white, initially seeking to marry a white man to gain access to power and wealth. Here Fauset turned nursery rhymes and the traditional romance plot to alternative uses, unveiling the complex ways in which racism and sexism make the happy endings such plots promise impossible for black women to achieve. In 1929 Fauset married Herbert E. Harris, an insurance executive. They had no children.

Fauset's third novel, *The Chinaberry Tree* (1931), explores issues of miscegenation, illegitimacy, and "respectability" as they are played out in a small New Jersey town. Only after the white writer Zona Gale agreed to write an introduction to the novel testifying that blacks such as those Fauset depicted—middle-class, hard-working, "respectable" blacks—really existed did the publisher agree to go ahead with the book. Most white publishers and readers preferred black characters that did not challenge stereotypes—primitive, exotic characters displaying uninhibited sexuality in Harlem's slums—to Fauset's portraits of the black professional classes.

Fauset's final novel, *Comedy: American Style* (1933), explores the damage wreaked on the lives of a middle-class black family by the internalized racism of the mother. Olivia Cary's obsession with whiteness leads to the suicide of her dark-complexioned son, the unhappy marriage of her light-skinned daughter to a racist white man, and the emotional and material ruin that follow alienation from their community.

Fauset continued to travel extensively, lecturing on black writers to audiences of various types. She was visiting professor at Hampton Institute in 1949 and taught French and writing at Tuskegee Institute. She died in Philadelphia.

Fauset's literary reputation has experienced some dramatic turns. Initial reviews in both the black and the white press were generally positive. WILLIAM STANLEY BRAITHWAITE, for example, called Fauset "the potential Jane Austen of Negro Literature" (*Opportunity*, Jan. 1934, 50). During the 1960s and 1970s, however, critics of African American literature preferred accounts of poverty and racial protest to Fauset's portrayals of the black elite. Robert Bone, labeling her novels "uniformly sophomoric, trivial, and dull," placed Fauset in the "Rear Guard" of the Harlem Renaissance, contrasting her conservatism with the more politically confrontational texts of younger writers. Feminist critics of the 1980s and 1990s, however, recuperated much of Fauset's work. Fauset's plots—dismissed by earlier critics as melodramatic, sentimental, and marred by coincidence—have been interpreted anew as sites for investigating how class and race complicate the traditional romance plot. Given the structure of American society in the 1920s and 1930s—institutionalized racism and sexism and white control of publishing houses and patronage—Fauset's achievements as an important actor in Harlem literary culture and a theorist of gender, race, and power are particularly noteworthy.

FURTHER READING

Fauset manuscript materials are at the Moorland-Spingarn Research Center at Howard University.

Christian, Barbara. *Black Women Novelists: The Development of a Tradition, 1892–1976* (1980).

McDowell, Deborah. "The Neglected Dimension of Jessie Redmon Fauset," in *Conjuring: Black Women, Fiction, and Literary Theory*, eds. Marjorie Pryse and Hortense Spillers (1985).

Sylvander, Carolyn Wedin. *Jessie Redmon Fauset, Black American Writer* (1981).

Wall, Cheryl. "Jessie Redmon Fauset, 1882–1961," in *Gender of Modernism*, ed. Bonnie Kime Scott (1990).

Watson, Carole McAlpine. *Prologue: The Novels of Black American Women, 1891–1965* (1985).

Obituary: New York Times, 3 May 1961.

ERIN A. SMITH

Stepin Fetchit as Gummy in the 1929 movie Hearts in Dixie, one of the first all-talkie studio productions to boast a predominantly African American cast. (AP Images.)

FETCHIT, Stepin

(30 May 1892–19 Nov. 1985), actor, was born Lincoln Theodore Monroe Andrew Perry in Key West, Florida, to immigrant parents that arrived in the United States from the Bahamas just prior to his birth in 1892. His family lived in Key West until Perry was six years old, and then moved to Tampa. According to Fox Studio's biographical information on the actor, Perry lost both of his parents when he was quite young. A well-to-do black woman his mother once worked for took care of him for a time, sending him to Catholic school in Alabama. However, Perry did not take to academics. An inveterate class clown, he eventually ran away from the school and found work in traveling vaudeville and minstrel shows.

Although a number of apocryphal stories circulate regarding the origins of Perry's stage name, Stepin Fetchit, the earliest use of this phrase in association with the actor appeared in the early 1920s, when Perry wrote a regular entertainment column for the *Chicago Defender*, a prominent African American newspaper. "Lincoln Perry's Letter" chronicled the activities of the growing black entertainment community in Los Angeles and touted the author's own work as half of a vaudeville act called Step and Fetch It. When his partner left the duo, Perry took the name as his own. As Stepin Fetchit, he appeared in nearly fifty Hollywood films. He continued to write the column into his early

years as Stepin Fetchit as well, offering aspiring actors and actresses advice about entering show business.

Stepin Fetchit first appeared on screen in an independently produced film entitled *The Mysterious Stranger* (1925). The first of his films with a major Hollywood studio was MGM's *In Old Kentucky* (1927), which featured Fetchit in a small role as a stable boy. In the ensuing years, he appeared in other films, including the 1929 version of *Show Boat*, playing Joe, the same role that celebrated actor Paul Robeson would make famous almost seven years later. In 1929, Fetchit got a major break in Fox's all-black-cast musical *Hearts in Dixie*. He appeared as Gummy, a shiftless, tragicomic black character that would set the standard for the Stepin Fetchit image and performance. Fetchit's trademark bald head, shambling gait, laconic expression, and drawling, garbled speech all made their combined debut in *Hearts in Dixie*.

Stepin Fetchit's appearance as Gummy also signified the beginning of his association with Fox. Fetchit was one of the first black actors to sign

a long-term contract with a major film studio; he would ultimately make twenty-four films for Fox. Indeed, part of his myth as an African American screen icon is that in his heyday he was a millionaire once or twice over. This is a myth that Fetchit himself helped to circulate, especially in interviews he granted in the later years of his life. Yet the studio records from his Hollywood days suggest that Fetchit lived his entire film career hand-to-mouth. He had two periods of employment with Fox, one from 1928 until 1929, and a second from 1933 until 1937. The most that Stepin Fetchit was ever paid by Fox was $750 per week. Although this was a handsome sum for a black actor in 1930s America, it would not have made Fetchit a millionaire, and his notorious spendthrift habits kept the actor always waiting for an advance. His patchy work record while not working for Fox eventually landed him in bankruptcy at least twice in his lifetime, once in 1931, and again in 1947. Yet the significance of his relationship with Fox cannot be overlooked.

During this era most black actors could not depend upon steady work with any one production company. They instead had to accept whatever roles they could find, moving from studio to studio. Indeed, this was Fetchit's own experience during his 1929–1933 hiatus from Fox, when he appeared in eight non-Fox films, including *A Tough Winter*, one of the *Our Gang* shorts produced by Hal Roach. The comedian's career is a testament to the mixed blessing that a studio contract could offer. On the one hand, he was at the mercy of the studio, which could drop him at will. On the other, his consistent work and exposure in Fox's films allowed him to develop Stepin Fetchit into an instantly identifiable character that gave him a visibility and notoriety he would enjoy at the height of his career.

Stepin Fetchit was perhaps at his most memorable in the films of John Ford, in which he appeared with the popular actor Will Rogers. The duo appeared in a triad of films for Fox in the mid-1930s, *Judge Priest* (1934), *David Harum* (1934), and *Steamboat Round the Bend* (1935). The films presented a softened and paternalistic vision of American race relations. *Judge Priest*, for instance, opens in a post–Civil War Southern town; Fetchit's character Jeff Poindexter is on trial for chicken-stealing, but is befriended by the town's folksy, lovable Judge Priest (Rogers), who looks after him and takes him fishing. However, Fetchit's idiosyncratic performances in this trio of films also suggest the way his characters could be slyly manipulative of whites.

Nonetheless, Fetchit's glory days were short-lived. During his hiatus from the studio, he had married, fathered a son, and had a highly publicized separation from his wife, who alleged brutality and nonsupport. The actor was bankrupt when he signed with the studio the second time, and he quickly acquired new debts, which included attorneys' fees and judgments against him in various civil court cases for fraud, assault breach of marriage, and disorderly conduct. Once Fetchit had been re-signed, Fox publicly claimed to be putting his money into a "trust fund," yet the studio actually garnished his check in order to repay loans and advances that had been made on his behalf. the *Chicago Defender*, for which he had once written columns offering thoughtful counsel to entertainers "of the race," criticized him regularly now (as did other black newspapers), publicizing his bankruptcy when he was not working and condemning his scandals and excesses when he was. In his memoir *Amateur Night at the Apollo*, Fetchit's friend, actor, and impresario Ralph Cooper, recalled that one of the actor's ostentatious Cadillacs arrived daily on the Fox set ferrying Fetchit's supply of near beer, "which he drank like water all day long" (Cooper, 126).

When Fetchit stopped work on the set of the Shirley Temple vehicle *The Littlest Rebel* in 1935, claiming medical problems, the studio suspended him. Further, in a move that deeply angered and humiliated Fetchit, Fox replaced him with younger actor Willie Best, who was now capitalizing on Fetchit's fame by billing himself as "Sleep 'n' Eat." Although Fox continued to employ Fetchit through 1937, ostensibly so that he could repay his debts to the studio, toward the end, his brief and isolated appearances in Fox films like *On the Avenue* (1937) reflected his declining fortunes in Hollywood. As the 1930s drew to a close, Fetchit made an appearance alongside fellow comedian W. C Fields in Hal Roach's *Zenobia* (1939) as a character named Zero. *Zenobia* marked the beginning of his absence from Hollywood films for the next decade and a half.

In the meantime, he made theater appearances, played nightclubs, and performed in a few all-black cast films. Though he reprised his role as Jeff Poindexter in John Ford's period piece *The Sun Shines Bright* (1953) and appeared sporadically after in offbeat movies like *Amazing Grace* (1974) and *Won Ton Ton, the Dog Who Saved Hollywood*

(1976), by the 1960s, Stepin Fetchit was a character many decades out of step with the time. As the racial tide in the United States turned, Fetchit tried to turn with it, joining the Nation of Islam. He sharpened the racial content of his iconoclastic stage show, and became associated with boxer Muhammad Ali. In interviews, Fetchit drew parallels between his friendship with Ali and his past friendship with another legendary and outspoken African American boxer, Jack Johnson. But such refinements did not shield Fetchit from the harsh criticisms of younger blacks, many of whom were taking part in the civil rights movement and the emerging Black Power movement, and saw him as a racial pariah. He was criticized in a 1968 CBS television documentary hosted by Bill Cosby, *Black History: Lost, Stolen or Strayed*, for perpetuating stereotypical and degrading images of African Americans. Fetchit refuted the charges in media interviews, citing his career as a pioneering effort that made a career the likes of Cosby's possible. Fetchit filed a $3 million lawsuit against CBS for defamation of character, though his case was dismissed in 1974.

A year later, in 1976, Fetchit suffered a severe stroke and was hospitalized with partial paralysis and loss of speech. As a result, he became a resident patient at the Motion Picture Country Home and Hospital in Woodland Hills, California. Fetchit died in 1985 from complications from pneumonia and congestive heart failure.

Fetchit performed with many stars of the classic Hollywood era, including Spencer Tracy, Shirley Temple, Lionel Barrymore, and Alice Faye. His image, though distasteful to most today, was not significantly worse than the roles played by his African American contemporaries in the 1930s. His career and his life provide a sense of the price that African Americans paid to be represented in American popular culture.

FURTHER READING

A partial collection of Stepin Fetchit's papers can be found in the Margaret Herrick Library, Academy of Motion Picture Arts and Sciences, Beverly Hills, California.

Bogle, Donald. *Toms, Coons, Mulattoes, Mammies & Bucks: An Interpretive History of Blacks in American Films* (1996).

Cooper, Ralph. *Amateur Night at the Apollo: Ralph Cooper Presents Five Decades of Great Entertainment* (1990).

Cripps, Thomas. "Stepin Fetchit and the Politics of Performance," in *Beyond the Stars: Stock Characters in American Popular Film*, eds. Paul Loukides and Linda K. Fuller, (1990)

Watkins, Mel. *On The Real Side: A History of African American Comedy* (1999).

Watkins, Mel. *Stepin Fetchit: The Life and Times of Lincoln Perry* (2005).

Obituary: "Stepin Fetchit Dead at 83; Comic Actor in Over 40 Films." *Variety*, 27 Nov. 1985.

MIRIAM J. PETTY

FISHER, Rudolph

(9 May 1897–26 Dec. 1934), author and physician, was born in Washington, D.C., the son of John Wesley Fisher, a clergyman, and Glendora Williamson. Fisher was raised in Providence, Rhode Island, and in 1919 received his BA from Brown University, where he studied both English and biology. Fisher's dual interests, literature and science, were reflected in his achievements at Brown, where he won numerous oratorical contests and was granted departmental honors in biology; the following year he received an MA in Biology. In 1920 Fisher returned to Washington to attend Howard University Medical School. He graduated with highest honors in June 1924 and interned at Washington's Freedman's Hospital. Later that year Fisher married Jane Ryder, a local teacher, with whom he had one son.

When Fisher moved to New York in 1925 he made rapid advances in his careers as a doctor and a writer. A bright young physician Fisher became a fellow of the National Research Council at Columbia University's College of Physicians and Surgeons. There he studied bacteriology, pathology, and roentgenology (the use of X-rays) for two years before opening up his own practice and publishing the results of his independent scientific research. Fisher was also an instant success as a fiction writer, publishing four short stories during his first year at Columbia. His story, "The City of Refuge," is an ironic tale that juxtaposed Harlem's promise with its inevitable shortcomings. The story appeared in the prestigious *Atlantic Monthly* (Feb. 1925), a first for a Harlem Renaissance writer, and was included in Edward J. O'Brien's *Best Short Stories of 1925* later that year. From this point onward, Fisher's career as a writer would be characterized by his ability

to place his stories in traditionally white, mainstream publications such as the *Atlantic Monthly* and *McClure's*, as well as in black publications such as *Crisis* and *Opportunity*. His stories deal with the conflict between the values of Southern black folk and the demands of Northern urban life as well as the effects of interracial and intraracial prejudice on Harlem's inhabitants.

Fisher's first novel, *The Walls of Jericho* (1928), explores America's equation of white skin with economic opportunity, and the resulting class antagonism in Harlem. Warmly received by black critics because the novel lacked the exotic and erotic sensationalism of many insider exposés of Harlem, *The Walls of Jericho* examines the tensions between the black proletarians, or "rats," and the black middle and upper classes, or "dickties." Although his often comic and ironic dissection of Harlem society skewered upper-class pretensions as well as lower-class ignorance, Fisher nevertheless concluded his novel with a utopian resolution: a truck-driving furniture mover, Joshua "Shine" Jones, overcomes his enmity for a wealthy lawyer, Fred Merrit, who in turn provides him with the opportunity to start his own business.

Following the publication of his novel Fisher pursued various positions that confirmed not only his continued commitment to a dual career in medicine and writing but also his willingness to act as public educator within his community. In 1929 he was appointed superintendent of the International Hospital on Seventh Avenue, a position he held through 1932. In addition he worked as a roentgenologist for the New York Health Department from 1930 to 1934, served on the literature committee of the 135th Street Young Men's Christian Association, and lectured at the 135th Street Branch of the New York Public Library.

Fisher's next novel, *The Conjure-Man Dies: A Mystery Tale of Dark Harlem* (1932), generally recognized as the first black detective novel, is an elaborately plotted work that utilizes flashbacks in order to reconstruct the mystery behind the puzzling murder of a conjurer who later appears alive after the disappearance of the corpse. *The Conjure-Man Dies* allowed Fisher to continue his exploration of Harlem's social climate, while also indulging his interest in science and medicine through his fictional creation, Dr. John Archer. Summoned to examine the murdered corpse, Archer becomes the cerebral assistant to a local police detective, Perry

Dart, in the ensuing investigation. Using medical discussions about the properties of blood and scientific debates about determinism, Fisher weaves an eerie tale.

Although he intended *The Conjure-Man Dies* to be the first in a series of Harlem-based detective novels featuring Archer and Dart, Fisher completed only one sequel, *John Archer's Nose*, a novelette published posthumously in January 1935 in *Metropolitan* magazine. Fisher did, however, complete a dramatic treatment of his earlier detective novel, titled *Conjur' Man Dies*, which was staged in 1936 at the Lafayette Theatre in Harlem to mixed reviews.

Rudolph Fisher was killed, ironically, by the intellectual curiosity that fueled his substantial achievements. Exposed to lethal radiation during his work with newly developed X-ray equipment, the multitalented writer known for his acerbic wit was stricken with intestinal cancer and died a tragically early death in New York City. Despite his substantial artistic contributions to the Harlem Renaissance, Rudolph Fisher remained underappreciated by literary scholarship through the end of the twentieth century.

FURTHER READING

Bell, Bernard W. *The Afro-American Novel and Its Tradition* (1987).

Huggins, Nathan Irvin. *Harlem Renaissance* (1971).

Lewis, David Levering. *When Harlem Was in Vogue* (1981).

Obituaries: New York Times, 27 Dec. 1934; *New York Age*, 5 Jan. 1935.

MICHAEL MAIWALD

FITZGERALD, Ella

(25 Apr. 1917–15 June 1996), singer and songwriter, was born Ella Jane Fitzgerald in Newport News, Virginia, the only child of William Fitzgerald, a transfer wagon driver, and Temperance Williams, a laundress and caterer. Fitzgerald never knew her father; her mother married Joseph Da Silva, a Portuguese immigrant, when Fitzgerald was three years old. Following the tide of the Great Migration, the family moved north to Yonkers, New York. Fitzgerald's half-sister, Frances, was born there in 1923.

Fitzgerald's childhood is scantily documented; throughout her life she remained extremely reluctant to grant interviews and to reveal much about her early years in particular. She belonged to

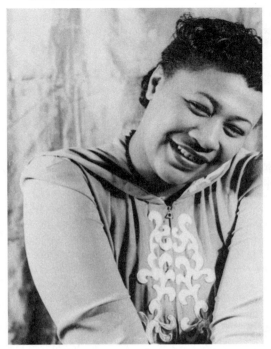

Ella Fitzgerald in a 1940 portrait by Carl Van Vechten.
(Library of Congress.)

Bethany African Methodist Episcopal Church and received her education at various public schools, where she excelled in her studies. At some point she took a few private piano lessons and learned the rudiments of reading music. Singing and dancing were her early loves, and Fitzgerald would show off the latest steps to earn small change on neighborhood street corners and in local clubs. Her mother brought home records by MAMIE SMITH, the Mills Brothers (Harry and Herbert Mills), and the white singing trio the Boswell Sisters. Throughout her career Fitzgerald singled out Connee Boswell, leader of the group and a popular solo artist, as an important early musical influence.

After her mother died in 1932, Fitzgerald was allegedly abused by her stepfather and moved to Harlem to live with her mother's sister, Virginia. Like many other children during the Great Depression, she dropped out of school in the struggle for economic survival. She worked running numbers and as a lookout for a local "sporting house," knocking on the door in warning if the police should be nearby. Unfortunately, she must have been caught.

Through the family court system, Fitzgerald was sent to Public School 49 in Riverdale-on-Hudson, essentially an orphanage. Thus began a harrowing episode in her life that she never publicly acknowledged.

Overwhelmed with children—P.S. 49 was the only facility for blacks—Fitzgerald was transferred to the New York State Training School for Girls at Hudson, euphemistically labeled a reform school. In addition to the overcrowded and dilapidated quarters, the girls routinely endured beatings by male staff members. Punishments included shackles and solitary confinement (*New York Times*, 23 June 1996). After her release Fitzgerald joined Harlem's homeless.

In contrast to the singer BILLIE HOLIDAY, for whom similar childhood traumas came to inform her tragic persona, Fitzgerald apparently sought to excise these experiences from her memory. Instead she cultivated a guileless, happy-go-lucky image through her musical repertoire and interviews, one that she perpetuated throughout her life. These traits had an added benefit; they formed a protective insulation that allowed her to negotiate the male-dominated musical culture she soon entered.

The story of Fitzgerald's victory at Apollo Theater's Amateur Night contest on 21 November 1934 has become the stuff of legend. She intended to compete as a dancer, but the presence of the Edwards Sisters, a well-known and glamorously attired dancing team, unnerved her. Instead she sang "Object of My Affection" and "Judy," songs she learned from Boswell's versions.

As her prize, Fitzgerald should have been given a week's engagement at the theater, but she looked so disheveled from living on the streets that the management would not allow it. A second win the following February, this time at the Harlem Opera House, earned her a week-long spot with the Tiny Bradshaw Band. Her real break, however, came that spring with her gradual addition to the CHICK WEBB Orchestra. Already widely admired as a drummer and bandleader, the twenty-seven-year-old Webb craved popular success. His gamble on the young "girl singer" helped turn the band into a lucrative commercial venture that rivaled any such ensemble across the country.

Fitzgerald's career ushered in a new era for popular singers in which they were no longer ancillary performers in big bands, but rather powerful,

independent artists. During the early swing era, singers were typically limited to one vocal chorus within a band's arrangement of a given song, and to one or two numbers during a live set. Webb however afforded Fitzgerald an unprecedented amount of the spotlight, and within months of joining the band, she dominated its recorded output. By 1937 she was given equal billing with Webb. Some three months after his death in June 1939 (Webb had battled tuberculosis of the spine), the group was rechristened Ella Fitzgerald and Her Famous Orchestra.

Her talents warranted the high profile. Already exhibiting the vocal ease, perfect intonation, and exuberant swing for which she became admired, Fitzgerald scored her first two hits in 1936: "Sing Me a Swing Song (And Let Me Dance)" and "(If You Can't Sing It) You'll Have to Swing It" (also known as "Mr. Paganini"). However, it was her refashioning of a children's nursery rhyme that made her the most popular singer in America, black or white, at a time when "race music" rarely crossed over into the mainstream. Fitzgerald cowrote "A-Tisket, A-Tasket" (1938) with the arranger Al Feldman, later known as Van Alexander. She authored several other songs over the course of her career and was a member of the American Society of Composers, Authors, and Publishers (ASCAP).

Fitzgerald embarked on a solo career in 1942, but her popularity temporarily waned. Her repertoire had been built on commercial dance band arrangements and "novelty" tunes subject to changing fashion. She was thought of as a pop singer rather than a jazz singer, categories she ultimately transcended.

Fitzgerald had always possessed an uncanny ear, and she began to pick up the new harmonic and rhythmic vocabulary of bebop being developed by musicians such as the saxophonist Charlie Parker and the trumpeter Dizzy Gillespie. Scat singing, a kind of wordless vocal improvisation, had been part of Fitzgerald's performances since "You'll Have to Swing It." In that song, scat was considered nothing more than an entertaining gimmick, but Fitzgerald would be among the first singers to emulate the virtuosic bebop solo by "using her voice like a horn," a metaphor common among musicians. In such instances, the song was not a vehicle for storytelling or psychological drama, but rather a springboard that launched her own improvisational flights.

In fact, Fitzgerald counted among the rare musicians who made the stylistic transition from swing to bebop. She toured the South with Gillespie's big band in 1946 and found that jamming nightly with the instrumentalists honed her skills. Around this time, she added three staples to her repertoire that became landmarks of vocal jazz: the wordless "Flying High," "Lady Be Good," and "How High the Moon," the source of the chord changes for Charlie Parker's "Ornithology." Fitzgerald consistently referenced Parker's melody in her performances, making her connection to bebop musically explicit.

Behind the scenes, Fitzgerald had met the bassist Ray Brown, also on the road with Gillespie, and married him the following year. (He was her second husband; her 1941 union with Ben Kornegay was annulled when her manager Moe Gale discovered the groom's criminal past.) The Browns adopted Fitzgerald's nephew, named Ray Jr., but the relationship could not bear their frenetic and often separate touring schedules. They divorced in 1953, yet continued to work together intermittently.

A new phase in Fitzgerald's career began in the 1950s through her association with the impresario Norman Granz, an exceptional promoter of both jazz and racial equality. His *Jazz at the Philharmonic* (JATP) programs brought the music from clubs into concert halls, not only across the United States but also in Europe, Asia, and Australia, creating worldwide recognition for those musicians he presented. Fitzgerald toured with JATP for the first time in 1949, and Granz became her manager in 1953. He liberated her from her longtime recording contract with Decca in 1955 to record for his own new Verve label.

Under Granz's direction she completed a series of groundbreaking "songbooks" dedicated to the work of individual composers and lyricists: Cole Porter (1956), Richard Rodgers and Lorenz Hart (1956), DUKE ELLINGTON (1957), George and Ira Gershwin (1959), and Harold Arlen (1961). With Fitzgerald's performances faithful to the original melodies and with little in the way of embellishment, the songbooks sought to elevate these works from Broadway theater, movie musicals, and dance halls to the status of art song. They further helped Fitzgerald cross over from jazz to general audiences, where she continued to break color barriers in exclusive clubs and other venues.

Granz sold Verve in 1960 but remained Fitzgerald's manager; she moved to the West Coast Capitol

label in 1966. Although she attempted to keep up with the pop music of the day, singing songs by the Beatles, among others, she eventually realized that the time for covering other people's compositions was over, and returned to her tried-and-true repertoire.

In the decades that followed, she continued to perform and record as much as her health allowed. Fitzgerald underwent open-heart surgery in 1986. Diabetes led to eyesight and circulatory problems, including the amputation of a toe in 1987 and both legs below the knees in 1993, shortly after she retired from performing. She died in her Beverly Hills home in 1996, the recipient of some thirteen Grammy Awards, eight honorary PhDs, the National Medal for the Arts, and a Kennedy Center award.

FURTHER READING

Ella Fitzgerald's music and business papers are housed at the Library of Congress.

Gourse, Leslie. *The Ella Fitzgerald Companion* (1998).

Nicholson, Stuart. *Ella Fitzgerald: A Biography of the First Lady of Song* (1993; additions 1996).

Pleasants, Henry. *The Great American Popular Singers* (1974).

Obituary: New York Times, 16 June 1996.

LARA PELLEGRINELLI

FLETCHER, Tom

(16 May 1873–13 October 1954), entertainer, was born in Portsmouth, Ohio, the son of Luther Fletcher, a steamboat fireman, and Mary Eliza Cox, a cook. A stage performance sometime before 1888 of Harriet Beecher Stowe's *Uncle Tom's Cabin* that featured a cadre of African American actors and in which he played a small part initially inspired Tom Fletcher to pursue a career in entertainment. Later Fletcher became the first black actor to play the role of Uncle Tom.

Fletcher spent more than sixty years on the stage or performing in various venues. As a boy soprano he sang in local talent shows and played in the Portsmouth fife corps. His professional theatrical career began at age fifteen when he appeared with such groups as Howard's Novelty Colored Minstrels, the Old Kentucky show, Ed Winn's minstrel company, and Richard and Pringle's Georgia Minstrels. At the turn of the twentieth century Fletcher launched a new career in vaudeville shows

and nightclub performances, frequently performing with Al Bailey in an act known as "Bailey and Fletcher, the Minstrel Boys."

In 1908 Tom Fletcher played a leading role as a singer and dancer in the second edition of the Memphis Students, replacing the ailing founder Ernest Hogan. The Memphis Students was an ensemble consisting of musicians who were neither students nor from Memphis. They featured the soprano ABBIE MITCHELL and three dancers, Edith Harrison, Esmeralda Statum, and Isola Ringold. Their New York act played Proctor's 125th Street Theater and the Orpheum in Brooklyn with so much success that it was booked for the summer season at Hammerstein's Roof Garden on Broadway. This playing-singing-dancing orchestra was the first to perform syncopated music on a public concert stage, radically departing from the previous dance hall settings or theater orchestra pits. They numbered about twenty, performing predominantly on banjos, mandolins, guitars, saxophones, and drums, along with a violin, a few brass instruments, and a double bass. This historic ensemble paved the way for the acceptance of syncopated song and dance music on the concert stage by the likes of Paul Whiteman and DUKE ELLINGTON nearly a generation later.

In 1919 Fletcher joined the New York Syncopated Orchestra's American tour under WILL MARION COOK's baton and performed in such venues as Orchestra Hall in Chicago, Pabst Theatre in Milwaukee, and Carnegie Hall in Pittsburgh. This unique performing group adopted the term "orchestra" as it was used in its earliest and broadest sense: a group of mixed instruments playing together with more than one instrument on a single part. The fifty players and singers consisted of violins, saxophones, trombones, trumpets, mandolins, banjos, guitars, a bass horn, tympani, and drums, in addition to a male quartet and a soprano soloist. Fletcher was a member of the group for four months, serving as assistant manager, stage manager, leading comedian, and sometimes advance agent. Throughout his career he also entertained the who's who of white America in their homes, hotels, restaurants, and yachts.

No doubt Fletcher is best remembered for his autobiography, *100 Years of the Negro in Show Business*, which gives the only eyewitness account from a black insider of the late nineteenth- and early twentieth-century theatrical players, personalities, and pioneers. His career spanned the rise and fall

of minstrelsy, yet he valued its role in the march toward economic equality and social justice.

FURTHER READING

Fletcher, Tom. *100 Years of the Negro in Show Business: The Tom Fletcher Story* (1954).

MARVA GRIFFIN CARTER

FORD, Arnold Josiah

(23 Apr. 1877–16 Sept. 1935), rabbi, black nationalist, and emigrationist, was born in Bridgetown, Barbados, the son of Edward Ford and Elizabeth Augusta Braithwaite. Ford asserted that his father's ancestry could be traced to the Yoruba tribe of Nigeria and his mother's to the Mendi tribe of Sierra Leone. According to his family's oral history, their heritage extended back to one of the priestly families of the ancient Israelites, and in Barbados his family maintained customs and traditions that identified them with Judaism (Kobre, 27). His father was a policeman who also had a reputation as a "fiery preacher" at the Wesleyan Methodist Church where Arnold was baptized; it is not known if Edward's teaching espoused traditional Methodist beliefs or if it urged the embrace of Judaism that his son would later advocate.

Ford's parents intended for him to become a musician. They provided him with private tutors who instructed him in several instruments—particularly the harp, violin, and bass. As a young adult, he studied music theory with Edmestone Barnes and in 1899 joined the musical corps of the British Royal Navy, where he served on HMS *Alert*. According to some reports, Ford was stationed on the island of Bermuda, where he secured a position as a clerk at the Court of Federal Assize, and he claimed that before coming to America he was a minister of public works in the Republic of Liberia, where many former slaves and early black nationalists settled.

When Ford arrived in Harlem, New York City, around 1910, he gravitated to its musical centers rather than to political or religious institutions, although within black culture, all three are often interrelated. He was a member of the Clef Club Orchestra, under the direction of JAMES REESE EUROPE, which first brought jazz to Carnegie Hall in 1912. Other black Jewish musicians, such as WILLIE "THE LION" SMITH, an innovator of stride piano, also congregated at the Clef Club. Shortly after the orchestra's Carnegie Hall engagement, Ford became

the director of the New Amsterdam Musical Association. His interest in mysticism, esoteric knowledge, and secret societies is evidenced by his membership in the Scottish Rite Masons, where he served as Master of the Memmon Lodge. It was during this period of activity in Harlem that he married Olive Nurse, probably around 1916, with whom he had two children before they divorced in 1924.

In 1917 MARCUS GARVEY founded the New York chapter of the Universal Negro Improvement Association (UNIA), and within a few years it had become the largest mass movement in African American history. Ford became the musical director of the UNIA choir, while Samuel Valentine was the president and Nancy Paris its lead singer. These three became the core of an active group of black Jews within the UNIA who studied Hebrew, religion, and history and held services at Liberty Hall, the headquarters of the UNIA. As a paid officer, Rabbi Ford, as he was then called, was responsible for orchestrating much of the pageantry of Garvey's highly attractive ceremonies. Ford and Benjamin E. Burrell composed a song called "Ethiopia," which speaks of a halcyon past before slavery and stresses pride in African heritage—two themes that were becoming immensely popular. Ford was thus prominently situated among those Muslim and Christian clergy, including GEORGE MCGUIRE, chaplain general of the UNIA, who were each trying to influence the religious direction of the organization.

Ford's contributions to the UNIA, however, were not limited to musical and religious matters. He and E. L. Gaines wrote the handbook of rules and regulations for the paramilitary Universal African Legion (which was modeled after the Zionist Jewish Legion) and developed guidelines for the Black Cross Nurses. He served on committees, spoke at rallies, and was elected one of the delegates representing the thirty-five thousand members of the New York chapter at the First International Convention of Negro Peoples of the World, held in 1920 at Madison Square Garden. There the governing body adopted the red, black, and green flag as its ensign, and Ford's song "Ethiopia" became the "Universal Ethiopian Anthem," which the UNIA constitution required be sung at every gathering. During that same year Ford published the *Universal Ethiopian Hymnal*.

Ford was a proponent of replacing the term *Negro* with the term *Ethiopian* as a general reference

to people of African descent. This allowed the biblical verse "Ethiopia shall soon stretch out her hand to God" (Psalms 68:31) to be interpreted as applying to their efforts, and it became a popular slogan of the organization. At the 1922 convention, Ford opened the proceedings for the session devoted to "The Politics and Future of the West Indian Negro," and he represented the advocates of Judaism on a five-person ad hoc committee formed to investigate "the Future Religion of the Negro."

Following Garvey's arrest for mail fraud in 1923, the UNIA lost much of its internal cohesion. Since Ford and his small band of followers were motivated by principles that were independent of Garvey's charismatic appeal, they were repeatedly approached by government agents and asked to testify against Garvey at trial, which they refused to do. However, in 1925 Ford brought separate lawsuits against Garvey and the UNIA for failing to pay him royalties from the sale of recordings and sheet music, and in 1926 the judge ruled in Ford's favor. No longer musical director, and despite his personal and business differences with the organization, Rabbi Ford maintained a connection with the UNIA and was invited to give the invocation at the annual convention in 1926.

Several black religious leaders were experimenting with Judaism in various degrees between the two world wars. Rabbi Ford formed intermittent partnerships with some of these leaders. He and Valentine started a short-lived congregation called Beth B'nai Israel. Ford then worked with Mordecai Herman and the Moorish Zionist Temple, until they had an altercation over theological and financial issues. Finally, he established Beth B'nai Abraham in Harlem in 1924. A Jewish scholar who visited the congregation described their services as "a mixture of Reform and Orthodox Judaism, but when they practice the old customs they are seriously orthodox" (Kobre, 25). The Harlem chronicler JAMES VANDERZEE photographed the congregation with the Star of David and bold Hebrew lettering identifying their presence on 135th Street and showing Rabbi Ford standing in front of the synagogue with his arms around his string bass and with members of his choir at his side, the women wearing the black dresses and long white head coverings that became their distinctive habit and the men in white turbans.

In 1928 Ford created a business adjunct to the congregation, called the B'nai Abraham Progressive Corporation. Reminiscent of many of Garvey's ventures, this corporation issued one hundred shares of stock and purchased two buildings; it operated a religious and vocational school in one and leased apartments in the other. However, resources dwindled as the Depression became more pronounced, and the corporation went bankrupt in 1930. Once again it seemed that Ford's dream of building a black community with cultural integrity, economic viability, and political virility was dashed, but out of the ashes of this disappointment he mustered the resolve to make a final attempt in Ethiopia. The Ethiopian government had been encouraging black people with skills and education to immigrate to Ethiopia for almost a decade, and Ford knew that there were more than forty thousand indigenous black Jews already in Ethiopia (who called themselves Beta Israel but who were commonly referred to as Falasha). The announced coronation of Haile Selassie in 1930 as the first black ruler of an African nation in modern times raised the hopes of black people all over the world and led Ford to believe that the timing of his Ethiopian colony was providential.

Ford arrived in Ethiopia with a small musical contingent in time to perform during the coronation festivities. They then sustained themselves in Addis Ababa by performing at local hotels and relying on assistance from supporters in the United States who were members of the Aurienoth Club, a civic group of black Jews and black nationalists, and members of the Commandment Keepers Congregation, led by Rabbi W. A. Matthew, Ford's most loyal protégé. Mignon Innis arrived with a second delegation in 1931 to work as Ford's private secretary. She soon became Ford's wife, and they had two children in Ethiopia. Mrs. Ford established a school for boys and girls that specialized in English and music. Ford managed to secure eight hundred acres of land on which to begin his colony and approximately one hundred people came to help him develop it. Unbeknown to Ford, the U.S. State Department was monitoring Ford's efforts with irrational alarm, dispatching reports with such headings as "American Negroes in Ethiopia—Inspiration Back of Their Coming Here—'Rabbi' Josiah A. Ford" and instituting discriminatory policies to curtail the travel of black citizens to Ethiopia.

Ford had no intention of leaving Ethiopia, so he drew up a certificate of ordination (*shmecha*) for Rabbi Matthew that was sanctioned by the Ethiopian government, in the hope that this document would give Matthew the necessary credentials

to continue the work that Ford had begun in the United States. By 1935 the black Jewish experiment with Ethiopian Zionism was on the verge of collapse. Those who did not leave because of the hard agricultural work joined the stampede of foreign nationals who sensed that war with Italy was imminent and defeat for Ethiopia certain. Ford died in September, it was said, of exhaustion and heartbreak, a few weeks before the Italian invasion. Ford had been the most important catalyst for the spread of Judaism among African Americans. Through his successors, communities of black Jews emerged and survived in several American cities.

FURTHER READING

The papers of Rabbi Ford are held largely in private collections; however, correspondence between Ford and Matthew is contained in the Rabbi Matthew Collection at the Schomburg Center for Research in Black Culture of the New York Public Library, along with other collections relating to Harlem's black Jews. Detailed records of Ford's efforts in Ethiopia are available at the National Archives, State Department Records for Ethiopia.

King, Kenneth J. "Some Notes on Arnold J. Ford and New World Black Attitudes to Ethiopia," in *Black Apostles: Afro-American Clergy Confront the Twentieth Century*, eds. Randall Burkett and Richard Newman (1978).

Kobre, Sidney. "Rabbi Ford," *The Reflex* 4.1 (1929).

Scott, William R. "Rabbi Arnold Ford's Back-to-Ethiopia Movement: A Study of Black Emigration, 1930–1935," *Pan-African Journal* 8.2 (1975).

SHOLOMO B. LEVY

FORD, James William

(22 Dec. 1893–21 June 1957), labor leader and Communist Party official, was born James William Foursche in Pratt City, Alabama, the son of Lyman Foursche, a steelworker, and Nancy Reynolds, a domestic. Not long after his birth the family began to use a new surname when a white policeman questioning his father insisted that "Foursche" was too difficult to spell and changed the name to Ford. The most traumatic experience of Ford's boyhood was the lynching of his grandfather, a Georgia railroad worker. Ford started work at thirteen, joining his father at the Tennessee Coal, Iron and Railroad Company, where he worked as a water boy,

mechanic's helper, and then steam-hammer operator. Nevertheless, he managed to complete high school.

Entering Fisk University at the age of twenty, Ford excelled in his studies and in athletics, but when America entered World War I in 1917 he withdrew from college to serve in France. He was a radio engineer in the Signal Corps and became a noncommissioned officer. He also organized a protest against the bigotry of a white captain; as a result, the officer lost his command. After his discharge in 1919 Ford returned to Fisk and graduated in 1920.

Moving to Chicago, Ford tried to get a federal job using the skills he had learned in the army, but he was rejected, apparently because of race. He played semiprofessional baseball for a time, and then in 1919 got a job as a parcel dispatcher at the post office. He soon joined the postal workers' union and served as its delegate in the Chicago branch of the American Federation of Labor. He also worked with A. PHILIP RANDOLPH during the early years of the Brotherhood of Sleeping Car Porters. At his job Ford became known as a militant, quick to criticize his bosses and even the leaders of his own union. His aggressive style made enemies, and he was dismissed in 1927.

By this time Ford had abandoned his former conviction that blacks could make their way entirely through education and self-improvement. He had become interested in the left wing of the labor movement when white members of the communist-backed Trade Union Educational League (TUEL) supported his accusations of racial discrimination in the Chicago Federation of Labor. He became a member of TUEL, helped organize the American Negro Labor Congress in 1925, and joined the Communist Party in 1926. The following year, attending the Fourth World Congress of the International Labor Union (ILU) in Moscow as a TUEL delegate, he was elected to the congress's executive committee. In 1928 Ford returned to Moscow for the Sixth World Congress of the Communist International, where he served on the party's Negro Commission. He was one of the first to identify the struggles of black Americans with those of colonized people around the world, and he pressed these views at one international conference after another during the late 1920s and early 1930s.

Moving to New York City Ford threw himself into the activities of the party. He helped organize the Trade Union Unity League (an American

affiliate of the ILU), and he directed the Negro Departments of both the TUUL and the TUEL. He was arrested in 1929 for leading a protest against the U.S. presence in Haiti, and again in 1932 during the Bonus March. In fall 1932 Ford was nominated by the Communist Party for vice president of the United States. With the presidential nominee, William Z. Foster, he toured the nation's larger cities until he was disabled by a heart attack. The two received 100,000 votes. Resuming political activity in 1933 Ford became head of the Harlem section of the Communist Party and also served on the party's political committee, national committee, and New York State committee.

During the early 1930s Ford was bitterly critical of black leaders, supporting his party's claim that they were "shamelessly aiding the white master class." But like many communists, he became more amenable to cooperation once the party leadership called for a "Popular Front" against fascism in the summer of 1935. For the next several years he worked actively with black organizations like the National Association for the Advancement of Colored People (NAACP), the National Negro Congress, and the Urban League. The new approach was evident during Ford's 1936 campaign for vice president. Running this time with Earl Browder, Ford called for coalitions among all progressive forces and advocated social legislation, relief for the unemployed, aid to farmers, and equal rights for blacks.

Though by 1940 Ford had become the best-known black communist in America, the party itself was suffering from the country's anger over the recent pact between Stalin and Hitler—a pact that party members refused to disavow. When Browder and Ford headed the national ticket again that year, they faced investigations, arrests, and a hostile press. They received fewer than 50,000 votes, less than half their 1936 total. A year later the political winds changed again when Hitler invaded Russia. Ford, like most American communists, threw himself into the war effort. He now criticized other black leaders for launching the "Double V" campaign (aimed at a second victory, over racial injustice); he accused them of "aiding the Axis camp" by diverting attention from the main task of destroying Hitler.

Once the war ended and Soviet-American relations cooled again, Earl Browder was expelled from the party. Ford sided with Browder's critics, blaming

his ally of twenty years for leading the party "into the swamp of revisionism." Ford was stripped of his offices but was allowed to stay in the party, and he remained a loyal member for the rest of his life. He was married twice. The name of his first wife, by whom he had three sons, is not known; his second wife was Reva. (Neither her maiden name nor the dates of his two marriages are known.) He died in New York City.

As a loyal communist Ford often changed his political tactics to conform to the dictates of party leadership. But communism also provided Ford with a core of beliefs that allowed him to integrate his commitment to the labor movement, his experience as an African American, and his interest in liberation movements around the world. At his worst, he operated (in the words of one critic) as "the prototype of the pliable Stalinist functionary." At his best he contributed to the country's dialogue on race relations by highlighting the economic and international context of the African American experience.

FURTHER READING
Davis, Benjamin. *Communist Candidate for Vice-President of the United States, James W. Ford* (1936).
Foner, Philip S. *Organized Labor and the Black Worker, 1619–1973* (1974).
Foner, Philips S., and James S. Allen, eds. *American Communism and Black Americans: A Documentary History, 1919–1929* (1987).
Foster, William Z. *History of the Communist Party of the United States* (1952).
Howe, Irving, and Lewis Coser. *The American Communist Party: A Critical History* (1962).
Record, Wilson. *The Negro and the Communist Party* (1951).
Obituaries: New York Times, 22 June 1957; *Daily Worker*, 24 June 1957.

SANDRA OPDYCKE

FRAZIER, E. Franklin

(24 Sept. 1894–17 May 1962), sociologist, was born Edward Franklin Frazier in Baltimore, Maryland, the son of James Edward Frazier, a bank messenger, and Mary E. Clark. Frazier's father had taught himself to read and write and until his death in 1904, stressed the usefulness of a formal education as a means of escaping poverty.

Young Frazier's interest in sociology began at an early age. It can be partly traced to James Frazier's attempt to make his children aware of the volatile atmosphere of race relations in Atlanta, Georgia, and Baltimore with daily discussions of articles and editorials from local newspapers. Despite the death of his father when Frazier was eleven years old, it appears that this process had a profound effect on Frazier's intellectual growth. He attended elementary and secondary school in Baltimore, and after graduating from Baltimore Colored High School in 1912, he attended, on scholarship, Howard University in Washington, D.C., graduating with honors in 1916. At Howard he subscribed to a vague socialist philosophy but, more importantly, demonstrated his mastery in languages, literature, and mathematics. He later taught these subjects at successive institutions: mathematics at Tuskegee Institute (1916–1917), English, French, and history at St. Paul's Normal and Industrial School in Lawrenceville, Virginia (1917–1918), and French and mathematics at Baltimore High School (1918–1919).

In 1919 Frazier entered the graduate program in sociology at Clark University (Worcester, Massachusetts), where, under the tutelage of Frank Hankins, he became skilled in the use of sociological methods and theories as objective tools in the examination of racial problems in American society. After receiving his MA in 1920, Frazier spent a year as a researcher at the New York School of Social Work (1920–1921) followed by a year at the University of Copenhagen in Denmark (1921–1922), where as a research fellow of the American Scandinavian Foundation, he studied that nation's rural folk high schools.

In 1922, back in the United States, Frazier married Marie Brown. Their union was childless. Earlier that same year he became director of the summer school session at Livingstone College in Salisbury, North Carolina. Until 1927 he also held a combined appointment as director of the Atlanta University School of Social Work and as instructor of sociology at Morehouse College in Atlanta. During these years Frazier published often and widely, more than thirty articles on such topics as the African American family, the activities of black business leaders, and the development of the African American middle class, until the appearance of "The Pathology of Race Prejudice" in the June 1927 issue of *Forum*.

Frazier's analysis of racial discrimination as a social pathology manifested in societal norms was highly controversial. Locals discovered the article with the appearance of several editorials in the *Atlanta Constitution* and the *Atlanta Independent* that condemned the findings revealed in the article. Not only did these editorials criticize Frazier's analysis, but they also questioned his intellectual abilities. Soon thereafter, the Fraziers began to receive harassing phone calls, death threats, and threats of being lynched. As a result of this violent atmosphere, and at the urging of friends, the Fraziers soon left the city.

From Atlanta, Frazier went to the University of Chicago as a graduate student and as a research fellow in the department of sociology. In 1929 he accepted a position as a lecturer in the sociology department at Fisk University in Nashville. After earning a PhD in 1931, Frazier remained at Fisk, where he subsequently became a research professor of sociology in the department of social science. In 1934 he became professor and head of the Department of sociology at Howard University. He retired as professor emeritus of sociology in 1959 but continued to teach through both the African Studies Program at Howard and the School of Advanced International Studies Program at Johns Hopkins University until his death.

The black family—which Frazier viewed as a social unit that helped integrate its members into American society—and race relations in the United States, especially their negative impact on the development of the African American family, as well as the effects of urbanization on black family structure were all explored in Frazier's dissertation, published as *The Negro Family in Chicago* (1932). This path-breaking book, which has been compared to W. E. B. DU BOIS's classic study *The Philadelphia Negro* (1899), was followed by his book *The Negro Family in the United States* (1939). This book, which won the Anisfield Award in 1939 for the most significant work in the field of race relations, expanded on Frazier's earlier findings in Chicago and analyzed the various cultural and historical forces that influenced the development of the African American family from the time of slavery until the 1920s.

Frazier's most controversial book was *Black Bourgeoisie* (1957), an examination of the economic, political, and social behavior of the African American middle class as shaped by the experience of

slavery and the forces of racial prejudice and discrimination. Frazier argued that the African American middle class had developed as a hybrid group. Lacking a solid economic base and subject to the same social marginality and isolation suffered by the African American population as a whole, the African American middle class tended to adhere to a set of values that differed from that of middle-class whites. More interested in high levels of consumption and status than in production and savings, the black bourgeoisie, Frazier concluded, tended to share the values and mirror the behavior of the white upper class rather than the white middle class. A Guggenheim Fellowship awarded in 1939 enabled Frazier to extend his study of race relations and black family life to Brazil and the Caribbean. An ancillary interest in European and African relations was the focus of his *Race and Culture Contacts in the Modern World* (1957).

Frazier served as president of the District of Columbia Sociological Society and the Eastern Sociology Society and as vice president of the African Studies Association and the American Sociological Society (now the American Sociological Association). His election in 1948 as president of the American Sociological Society marked the first time that an African American had served as chief presiding officer of a national professional association. In 1955 he became an honorary member of the Gamma chapter of Phi Beta Kappa at Howard University. He died in Washington, D.C.

FURTHER READING

Frazier's papers are in the Moorland-Spingarn Research Center, Howard University.

Blackwell, James E., and Morris Janowitz, eds. "E. Franklin Frazier," in *Black Sociologists*.

Edwards, G. Franklin. "E. Franklin Frazier: Race, Education, and Community," in *Sociological Traditions from Generation to Generation*, eds. Robert K. Merton and Matilda White Riley (1980).

Odum, Howard. *American Sociology* (1951).

Platt, Anthony M. *E. Franklin Frazier Reconsidered* (1991).

Vlasek, Dale R. "E. Franklin Frazier and the Problem of Assimilation," in *Ideas in America's Cultures from Republic to Mass Society*, ed. Hamilton Cravens (1982).

Obituary: New York Times, 22 May 1962.

ERIC R. JACKSON

FREEMAN, Harry Lawrence

(9 Oct. 1869–21 Mar. 1954), composer and conductor, was born in Cleveland, Ohio, the son of Agnes Sims (father's name unknown). Freeman studied piano as a child with Edwin Schonert and later with Carlos Sobrino. He engaged in the study of theory, composition, and orchestration with Johann Beck, founder and first conductor of the Cleveland Symphony Orchestra. By age ten Freeman had organized a boys' quartet, for which he arranged most of the music, was accompanying pianist, and sang soprano. By age twelve he was assistant organist and later became organist for his family church. While in his early twenties Freeman moved to Denver, Colorado, where he began composing salon pieces, dances, and marches.

The motivation behind his attraction to composition on a larger scale was his attendance of a performance of Richard Wagner's opera *Tannhäuser* by the Emma Juch grand opera company. For nearly the next six months an inspired Freeman produced a new composition almost every day. An avid student of "history, the great poets, romances, and the tragic dramas" (Hipsher, p. 190), his first large work was an opera, *The Martyr*, composed in 1893, about Platonus, an Egyptian nobleman who is condemned to death for accepting the faith of Jehovah instead of that of his ancestors. He formed the Freeman Grand Opera Company, which presented *The Martyr* at the Deutsches Theater in Denver and, later, in Chicago, Cleveland, and Wilberforce, Ohio. The performance at Wilberforce is explained by his membership on the Wilberforce University faculty (1902–1904). Under the leadership of Beck the Cleveland Symphony performed scenes from *Zuluki* (1898), Freeman's second opera (originally known as *Nada*), in 1900.

Around Freeman's composing of "serious" larger works he spent several years composing (either individually or collectively) and conducting works in a lighter vein. His most notable activities in this area took place in the first decade of the twentieth century, during which he served for a brief period as music director of Chicago's Pekin Theater and was also music director of the road show John Larkins Musical Comedy. Freeman was music director for the noted entertainer Ernest Hogan's *Rufus Rastus* company (1906), composed the music for *Captain Rufus* (1907), and with James "Tim" Brymn composed the music for *Panama* (1908).

Freeman married the singer and actress Carlotta Thomas from Charleston, South Carolina (year unknown). They had one child, Valdo Lee. Both mother and son starred in several of Freeman's operas, and Valdo produced and directed many of them.

As the second decade of the twentieth century approached, Freeman and his family moved to New York City. There Freeman worked with the Bob Cole/Johnson Brothers' (JOHN ROSAMOND JOHNSON and JAMES WELDON JOHNSON) Red Moon company. When Red Moon closed in 1910 Freeman moved on to other activities. He established the Freeman School of Music and the Freeman School of Grand Opera, served as choral conductor with the Negro Choral Society, organized the Negro Grand Opera Company, engaged in music criticism, and taught at the Salem School of Music.

Freeman received a William E. Harmon Foundation first-place award in 1930, resulting in a gold medal and $400 as "the composer of the first Negro grand opera." (The musicologist Eileen Southern, however, points out that this distinction belongs to John Thomas Douglass for Virginia's Ball in the 1860s.) Also in 1930 excerpts from nine of Freeman's fourteen operas were presented in concert at Steinway Hall in New York City.

Freeman himself was the librettist for most of his operas. Synopses of several of these appeared in the historian Benjamin Brawley's essay "A Composer of Fourteen Operas," published in Southern Workman (July 1933). Brawley wrote, "Anyone who has opportunity to study his work at close range is amazed at his achievement and overwhelmed by the sheer power exhibited. His creative faculty is just now at its height. What he may yet produce in the years to come is beyond all estimate." Although the number of operas remained at fourteen, Freeman did many revisions of earlier ones.

Much of his recognition stemmed from the 1928 production of his opera Voodoo (1923), produced by Freeman himself at the Palm Garden in New York City, though he did not attain financial success from it or any of his other compositions. Performed by an "all-Negro cast of thirty" and an all-black orchestra, the presentation was reviewed by the New York Times (11 Sept. 1928). The reviewer said of the musical character of the work: "The composer utilizes themes from spirituals, Southern melodies

and jazz rhythms which, combined with traditional Italian operatic forms, produces a curiously naive mélange of varied styles." An abridged version of Voodoo was presented on WCBS radio. In her 1936 publication Negro Musicians and Their Music, the music historian Maud Cuney-Hare reported that Paramount Film Company "purchased 'Voodoo,' to be presented on the screen in a condensed version." There is no evidence that filming took place or that a film was released.

Other titles of Freeman's known operas are An African Kraal (1903), The Octoroon (1904), Valdo (1905), The Tryst (1909), The Plantation (1915), Athalia (1916), and Vendetta (1924). Brawley indicated that at the time of his Southern Workman article, Freeman was working on his fourteenth opera, Uzziah. Other works by Freeman include ballet music, a symphonic poem for chorus and orchestra, two cantatas, songs, and instrumental pieces. Freeman was guest conductor and music director of the pageant O Sing a New Song at the Chicago World's Fair in 1934. The Martyr was presented in concert at Carnegie Hall in 1947. Freeman died in his home in New York City.

Not only is Freeman important to the history of African American music but his work also demands recognition in the annals of American music. As the first African American to attain any type of recognition and respectability as a composer of operatic compositions, he was an American pioneer. That he had but little formal instruction makes his accomplishments all the more remarkable. To stage his productions it was necessary to establish his own opera companies and schools to finance the productions it was necessary for him to teach and engage in less demanding theatrical activities. But Freeman never lost faith in himself and his abilities, nor did he lose faith in the eventual eradication of a segregated system.

FURTHER READING
Hipsher, Edward Ellsworth. American Opera and Its Composers (1927).
Sampson, Henry. Blacks in Blackface: A Source Book on Early Black Musical Shows (1980).
Southern, Eileen. The Music of Black Americans: A History (1983).

Obituary: New York Times, 26 Mar. 1954.

ANTOINETTE HANDY

FULLER, Meta Warrick

(9 June 1877–Mar. 1968), sculptor, was born Meta Vaux Warrick in Philadelphia, Pennsylvania, the daughter of William H. Warrick and Emma Jones. Meta's great grandmother, according to family lore, was an Ethiopian princess brought to the American colonies as a slave. Emma owned and operated several hairdressing parlors that catered to a white clientele. William owned a chain of barbershops and dabbled in real estate. Meta was ten years younger than her two siblings, William and Blanche. Through lessons and field trips to museums and concerts, the Warricks introduced their children to art and encouraged their creative endeavors. Meta, who played the guitar, took dancing lessons, and sang in the church choir, exhibited an early talent for drawing.

After graduation from public high school in 1894, Warrick won a three-year scholarship to the Pennsylvania Museum and School for Industrial Arts (now the Philadelphia College of Art). In 1897 her stay was extended when she was awarded a postgraduate scholarship to study sculpture. She graduated in 1899 with honors and took home first prize for best general work in modeling.

In 1899, following a generation of American artists who made pilgrimages to perfect their training and elevate their stature, Warrick left for Paris, which by the late nineteenth century had become the center of fine arts in the Western world. Paris later became the preferred destination for African American artists like WILLIAM H. JOHNSON, HALE WOODRUFF, and LOÏS MAILOU JONES, who were weary of America's racist and segregationist policies. The African American painter HENRY OSSAWA TANNER, a friend of Warrick's uncle, had moved to Paris in 1891 and acted as her guardian during her stay in France. She studied at the École des Beaux-Arts, the epicenter of academic art instruction, and, from 1900 to 1902, at the Academie Colarossi, where she met the American sculptor Augustus Saint-Gaudens.

In the summer of 1900 Warrick met W. E. B. DU BOIS, who was in Paris for the Universal Exposition. Du Bois took the young artist under his wing, escorting her to social events, introducing her to the city's literati, and encouraging her to adopt African American themes in her work. The next summer Warrick arrived at the house of sculptor Auguste Rodin with her sculpture *Secret Sorrow (The Man Eating His Heart)* under her arm. "Mademoiselle,"

Rodin is said to have exclaimed, "you are a sculptor. You have the sense of flow in your fingers." Encouraged by Saint-Gaudens and Rodin, Warrick began holding private exhibitions at her studio. In 1902 S. Bing mounted a one-woman show of her work at his prestigious gallery, L'Art Nouveau. Warrick's Parisian period culminated in 1903 when the Salon d'Automne exhibited *The Wretched*, a sculpture depicting seven figures in varying forms of human anguish. Traditionally trained in the academic style, Warrick was one of only a few women to study in Paris at the turn of the century. Emotional, expressive, and imbued with themes of death and sorrow, her Parisian work owes a great deal to Rodin and to the Romantic realist sculptural style popular in late nineteenth-century France.

Upon her return to the United States in 1902, Warrick enrolled at the Pennsylvania Academy of Fine Arts, where she won the school's top award in ceramics. Encouraged by her success in Paris, she set up a studio in Philadelphia. Local dealers, however, failed to buy her work. Certain that her race was the reason behind their disinterest, Warrick turned to clients in Philadelphia's black community. Her reengagement with the African American community resulted in an increase in black subjects in her work. In 1907 she became the first African American woman to receive a federal art commission when she was selected to produce a sculpture for the Negro Pavilion at the Jamestown Tercentennial Exposition. A depiction of the history of African Americans since settling in Jamestown in 1607, the tableau was composed of fifteen pieces and 150 figures.

In 1909 Warrick married Solomon Fuller, a neuropathologist and psychiatrist from Monrovia, Liberia, whose father was a repatriated former American slave. The newlyweds moved to Framingham, Massachusetts, over the objections of racist neighbors who organized a petition attempting to stop the Fullers from integrating the predominantly white suburb of Boston. A year later most of Fuller's work was destroyed in a fire that razed the Philadelphia warehouse where she was storing the contents of her studio. Devastated by her loss, which included almost all of her Parisian sculptures, Fuller shifted her focus to starting a family. Between 1910 and 1916 she gave birth to three sons: Solomon Jr., Perry James, and William Thomas. Fuller eventually returned to sculpting, and she thrived in the Boston-area art scene. Critics have argued that Fuller's focus

Meta Warrick Fuller's Ethiopia Awakening (bronze, 1914) is one of Fuller's first sculptures embodying the struggles and aspirations of African Americans. (Schomburg Center.)

pieces. Inspired by Du Bois's Pan-African philosophy, Fuller emphasized the commonality of black Americans' heritage by mining African and African American themes and forms.

Fuller's sculpture *Ethiopia Awakening* marks a shift in African American representation. While Fuller's twelve-inch plaster prototype was produced as early as 1914, the final, lifesize bronze sculpture was unveiled in 1922 at the Making of America exhibit in New York City. Drawing from African and especially Egyptian sculptural forms, Fuller's figure, a standing female wearing the headdress of ancient Egyptian royalty, emerges from mummy wrappings. The figure adopts the stillness, formality, and highly symbolic nature of Egyptian sculpture. Fuller departed, however, from traditional Egyptian sculptural imagery in insisting on frontality and by adding movement by turning her figure's head. As a statement of racial pride and anticolonialist protest, Fuller's image differs significantly from the work of contemporaries like Picasso, who appropriated African sculpture for its "primitivist" quality but removed it from its aesthetic and political contexts. Fuller, conversely, uses her image to connect black America to Africa, to the beauty of African women, and to the optimism of a new "awakening."

One of the first African American artists to draw heavily on African sculpture and themes, Fuller predated ALAIN LOCKE's call for artists to fashion a black aesthetic by turning to Africa, an idea codified in his 1925 essay "The Legacy of the Ancestral Arts." An important precursor to the Harlem Renaissance, Fuller led the way in style and content for the next generation of black artists. Although Fuller never lived in Harlem, she exhibited with and served as a juror for the Harmon Foundation. Fuller showed regularly at the Philadelphia Academy of Art and focused on themes relating to war, violence, and the search for peace. She received second prize for *Peace Halting the Ruthlessness of War* in a competition sponsored by the Women's Peace Party in 1915. Fuller's most significant works confronted the political and social climate of her time. Her 1919 sculpture, *Mary Turner (A Silent Protest against Mob Violence)*, memorialized both the 1917 brutal lynching of Mary Turner, who was eight months' pregnant, and the subsequent silent protest march organized by the NAACP in Harlem.

In 1929 Fuller built a studio near her home, which served as a salon where she entertained, taught classes, and mounted annual exhibitions. She

on domestic life, which was encouraged by her husband, kept her from becoming an internationally recognized artist.

It was Du Bois who both reignited Fuller's career and prompted her serious adoption of African American subject matter. In 1913, while editor of the *Crisis*, he commissioned a sculpture commemorating the fiftieth anniversary of the Emancipation Proclamation. In the resulting work, *Spirit of Emancipation*, an eight-foot-tall figural grouping, Fuller eschewed images of victimization and paternalism common to representations of slavery and featured instead a boy and girl with distinctly African features. The work exhibited a quieter, more stoic, and less emotionally wrought quality than her Parisian

celebrated the places and people that were important to her by creating sculptures for a host of local organizations, as well as busts of family, friends, and people she admired, including Charlotte Hawkins Brown and Samuel Coleridge-Taylor. She exhibited extensively in the Boston area, as well as at the 1936 Texas Centennial Exposition in Dallas, the AUGUSTA SAVAGE Studios in New York, the 1940 Exposition of the Art of the American Negro 1851–1940 in Chicago, and the seventy-fifth anniversary of the Emancipation Proclamation exhibition held at the Library of Congress in Washington, D.C., in 1940.

In 1950, when her husband became blind as a result of diabetes, Fuller gave up her studio to care for him. Shortly after his death in 1953, she contracted tuberculosis and remained in a sanatorium for two years. Following her recovery she resumed work, donating the proceeds from her art to the civil rights movement and producing a series of sculptures of ten famous black women for the Afro-American Women's Council in Washington, D.C., in 1957. She continued honoring African American lives with works like *The Crucifixion* (1963), which eulogizes the four girls murdered in the 1963 Birmingham, Alabama, church bombing, and *Good Shepherd* (1965), dedicated to the clergymen who marched with Martin Luther King Jr.

Fuller died in 1968, and her ashes were dispersed off the coast of Martha's Vineyard, Massachusetts. Although she remained artistically active until her death at age ninety, a retrospective of her work was not mounted until 1984. The posthumous exhibition An Independent Woman: The Life and Art of Meta Warrick Fuller was held at the Danforth Museum of Art in her adopted city of Framingham.

FURTHER READING

Fuller's papers and photograph collection are held at the New York Public Library's Schomburg Center for Research in Black Culture.

Brawley, Benjamin Griffith. *The Negro in Literature and Art in the United States* (1929).

Driskell, David, ed. *Harlem Renaissance: Art of Black America* (1987).

LISA E. RIVO

GARVEY, Marcus

(17 Aug. 1887–10 June 1940), black nationalist, was born Marcus Moziah Garvey in St. Ann's Bay, Jamaica, the son of Marcus Moziah Garvey, a stonemason, and Sarah Jane Richards. He attended the local elementary school and read widely on his own. Difficult family finances forced him into employment at age fourteen as a printer's apprentice. Three years later he moved to Kingston, found work as a printer, and became involved in local union activities. In 1907 he took part in an unsuccessful printers' strike. These early experiences honed his journalistic skills and raised his consciousness about the bleak conditions of the black working class in his native land.

After brief stints working in Costa Rica on a banana plantation and in Panama as the editor of several short-lived radical newspapers, Garvey moved to London, England, in 1912 and continued to work as a printer. The next two years there would profoundly mold his thoughts on black advancement and racial solidarity. He probably studied at the University of London's Birkbeck College; absorbed BOOKER T. WASHINGTON's philosophy of black self-advancement in his autobiographical *Up from Slavery*; and, perhaps most important, met MOHAMMED ALI DUSE, a Sudanese-Egyptian who was working for African self-rule and Egyptian independence. Duse Mohammed published a small magazine, *Africa Times and Orient Review*. He allowed Garvey to write for the magazine and introduced him to other Africans. Garvey left London convinced that blacks worldwide would have to fend for themselves if they were ever to break the shackles of white racism and free the African continent from European colonial rule.

Back home in Jamaica in 1914, Garvey founded the Universal Negro Improvement and Conservation Association and African Communities League, usually known as the Universal Negro Improvement Association (UNIA). The UNIA would be the vehicle for Garvey's efforts at racial advancement for the rest of his life. His initial undertaking, a trade school in Jamaica, did not succeed, and in 1916 he took his organization and cause to the burgeoning "black mecca" of Harlem in New York City.

Over the next few years Garvey's movement experienced extraordinary growth for a number of reasons. With its slogan "One Aim, One God, One Destiny," the UNIA appealed to black American soldiers who had served abroad in World War I and were unhappy returning to a nation still steeped in racism. Harlem was a fortuitous location for Garvey's headquarters, with its sizable working-class black population, large number of West Indian immigrants, and the cultural explosion of the Harlem Renaissance in the 1920s. A Pan-African movement was already under way by the early 1920s, emphasizing the liberation of the African continent and black racial pride worldwide, and Garvey successfully tapped into this sentiment. Garvey himself was a gifted writer (using his weekly newspaper the *Negro World* as his mouthpiece) and a spellbinding orator in dazzling paramilitary garb.

Garvey's first marriage in 1919, to his secretary Amy Ashwood Garvey, was an unhappy relationship that ended in divorce three years later. The couple was childless. In 1922 he married Amy Jacques Garvey, his new secretary. They had two sons.

By the early 1920s the UNIA had probably 65,000 to 75,000 dues-paying members with chapters in some thirty American cities, as well as in the West Indies, Latin America, and Africa. On various occasions Garvey claimed anywhere from 2 to 6 million members. Accurate membership figures are impossible to obtain, but unquestionably millions of other blacks were followers in spirit. Auxiliary organizations included the Universal Black Cross Nurses, the Black Eagle Flying Corps, and the Universal African Legion. The *Negro World* had a circulation of some 50,000. In August 1920 the UNIA hosted a huge monthlong international convention in New York City, with several thousand black delegates from all parts of the world, complete with uniforms, mass meetings, and parades. Garvey was named provisional president of a nonexistent but symbolically powerful "Republic of Africa." This latter move reflected Garvey's interest in the regeneration of Africa. He had already been exploring with the government of Liberia a UNIA construction and development project there and the potential for a back-to-Africa colonization movement for American blacks. Unfortunately, this undertaking foundered as his domestic businesses came into increasing difficulty.

Marcus Garvey, dressed in a military uniform as the "Provisional President of Africa" during a parade up Lenox Avenue in Harlem, New York, for the opening day exercises of the annual Convention of the Negro Peoples of the World, August 1922. (AP Images.)

Garvey's business enterprises were his proudest achievements and ultimately the source of his undoing. Inspired by Booker T. Washington's support of black businesses, Garvey founded the Negro Factories Corporation to encourage black entrepreneurship in the United States and abroad. The corporation sponsored a number of small businesses in the United States, including a Harlem hotel and a publishing company.

The crown jewel of Garvey's enterprises was the Black Star Line, a steamship company founded in 1919 to carry passengers and trade among Africa, the Caribbean, and the United States. Garvey launched the line with his usual grandiose promises and a stock sale that raised more than $600,000 (at five dollars a share) the first year. What followed in the next twenty-four months was a tragic series of mishaps and mismanagement. The Black Star Line consisted of three aging, overpriced vessels that were plagued by mechanical breakdowns, accidents, and incompetent crews. The business side of the operation suffered from sloppy record keeping, inflated claims made to investors, and dishonest and possibly criminal practices on the part of company officers. One of the ships sank; another was auctioned off; the third was abandoned in Cuba.

Some of Garvey's critics, including many blacks, had begun to question his ethics, his business practices, and the whole UNIA operation. Notable among his black opponents was W. E. B. DU BOIS of the National Association for the Advancement of Colored People. Garvey's insistence on black nationalism ran counter to the NAACP's goal of full integration into American society. When Garvey associated openly with leaders of the white racist Ku Klux Klan and declared that the Klan was a better friend of his race than the NAACP "for telling us what they are, and what they mean, thereby giving us a chance to stir for ourselves," thousands of blacks were outraged.

In 1922 Garvey and three other Black Star Line officials were indicted by the U.S. government for using the mails fraudulently to solicit stock for the defunct steamship line. Ever the showman, Garvey used his trial for a flamboyant defense of himself and the larger cause of black advancement, striking a chord with at least some of his remaining followers, who saw him as a victim of white persecution. Unimpressed, the jury convicted Garvey (though not his codefendants), and he was sentenced to five years' imprisonment. After a failed appeal to the U.S. Supreme Court, Garvey began his term in February 1925. That he was able to continue running the UNIA from his Atlanta jail cell was a tribute to his influence over his followers.

In 1927 President Calvin Coolidge commuted Garvey's sentence, and he was deported to Jamaica. The remainder of his life was a struggle to rebuild his movement. He attempted to rekindle his cause by getting involved in Jamaican politics but to no avail. He presided over UNIA conventions in Kingston in 1929 and Toronto in the late 1930s, but the grim realities of the Great Depression left most blacks with little interest and fewer resources to support movements such as his. He died of a stroke in London, where he had moved in 1935.

Obituaries of Garvey emphasized his business failures and portrayed him as an irrelevant relic from the past. His real achievement, however, was in creating the first genuine black mass movement in the United States and in extending that influence to millions of blacks abroad. He emphasized racial pride and purity, the proud history of his race, self-respect, and self-reliance. For his millions of poor and working-class American followers, Garvey's message of black pride and solidarity in the early 1920s came at a critical nadir of race relations. Such themes drew on the philosophy of Booker T. Washington as well as Du Bois, his sworn enemy. He was a harbinger of later black nationalist leaders such as Malcolm X, Stokely Carmichael, and Louis Farrakhan. Garvey thus served as an important link between early twentieth-century black leaders and modern spokesmen. Moreover, he inspired modern African nationalist leaders, such as Kwame Nkrumah of Ghana and Jomo Kenyatta of Kenya, in their struggles against European colonialism.

FURTHER READING

Garvey's papers and materials from the UNIA can be found in the multivolume *Marcus Garvey and Universal Negro Improvement Association Papers*, ed. Robert A. Hill (1983–). Amy Jacques Garvey, ed., *Philosophy and Opinions of Marcus Garvey* (1968), is a collection of his early writings up to 1925.

Cronon, E. David. *Black Moses: The Story of Marcus Garvey and the Universal Negro Improvement Association* (1955).

Davis, Daniel S. *Marcus Garvey* (1972).

Garvey, Amy Jacques. *Garvey and Garveyism* (1963).

Martin, Tony. *Race First: The Ideological and Organizational Struggles of Marcus Garvey and the Universal Negro Improvement Association* (1976).

Stein, Judith. *The World of Marcus Garvey: Race and Class in Modern Society* (1986).

Vincent, Theodore. *Black Power and the Garvey Movement* (1971).

Obituary: New York Times, 12 June 1940.

<div style="text-align:right">WILLIAM F. MUGLESTON</div>

GIBSON, John Trusty

(4 Feb. 1878–17 June 1937), theater entrepreneur and prominent Philadelphia businessman, was born in Baltimore, Maryland, the son of George Henry and Elizabeth Gibson. In his biography in the 1929 edition of *Who's Who in Colored America* Gibson claimed to have attended public school in Baltimore but it is unclear whether he graduated from high school. The historian Henry T. Sampson in his book *Blacks in Blackface* reports that Gibson attended Morgan State Preparatory School (later Morgan State University) for two years. In 1928, however, he would receive an honorary doctorate from Morgan State. Sometime around 1899 Gibson moved to Philadelphia, Pennsylvania, where he worked in various jobs, including weaving, upholstering furniture, and peddling meat. In 1910 he became part owner with Samuel Reading of the North Pole Theater in Philadelphia. This small theater in the black Philadelphia community offered silent films and vaudeville acts. Around 1912 Gibson bought out his partner and became sole owner of the North Pole Theater, becoming the first African American to own a theater in Philadelphia. He later changed the name to the Auditorium, but the name change failed to increase business and it soon closed.

In April 1913 Gibson became part owner of the New Standard Theater in Philadelphia, a larger and more successful vaudeville house. He married Ella Lewis of Chester, Pennsylvania, in 1914, and the next year he became sole owner of the Standard, renaming it Gibson's New Standard Theater. That same year he financed Irvin C. Miller's new musical comedy show, *Broadway Rastus*. With a score composed by W.C. HANDY and a cast of popular performers such as Leigh Whipper and Lottie Grady, the show was a hit and established Gibson as a producer. Later in 1925 he produced the musical comedy *Chocolate Box Revue*. Gibson preferred, however, to have others like the vaudevillians Sandy Burns and Sam Russell produce his theater shows. Early vaudeville acts at the Standard included J. ROSAMOND JOHNSON, Aida Overton Walker, Tom Brown, Salem Tutt Whitney, JOSEPHINE BAKER, and BESSIE SMITH. The popular Whitmore Sisters credited Gibson with giving them their first show business break. African Americans compared the New Standard to black theaters like the Lafayette Theater in Harlem, the Pekin Theater in Chicago, and the Howard Theater in Washington, D.C. In 1919 the Dunbar Theater, owned by the African American banker Edward Cooper Brown, opened in Philadelphia and gave Gibson's Standard Theater stiff competition. But in 1921 Gibson bought the Dunbar from Brown for $120,000. Gibson then renamed the house Gibson's Dunbar Theater and once again became the only black theater owner in Philadelphia. Gibson's Dunbar Theater opened on 26 September 1921 as a Theater Owners' and Bookers Association (TOBA) vaudeville circuit house. The TOBA was a theatrical syndicate similar to the Keith and Albee vaudeville circuits but established tours for African American entertainers. Gibson wanted to be part of TOBA because by purchasing stock in the association, he won the right to stage appearances by TOBA artists. In 1921 Gibson was appointed by the TOBA chief, Milton Starr, to be vice president and eastern region representative of TOBA. With acquisition of the Dunbar, however, came unexpected labor and financial problems. In 1921 the National Association of Colored Stage Employees complained that Gibson, unlike Brown, was reluctant to hire black people. Around the same time the musicians in the house orchestra demanded a 50-percent wage increase and walked out on Gibson. These labor difficulties were compounded by the fact that black Philadelphians shunned the Dunbar, which offered the Lafayette Players in black versions of white Broadway shows. They seemed to prefer the older Standard Theater with its silent moving pictures and exciting TOBA vaudeville shows.

Vaudeville performers resented spending all of their salary on travel from town to town on trains. This and other complaints about unfair TOBA routing practices led E. L. Lummings to form a new vaudeville circuit, the Managers and Performers Association (M&P) in March 1922. M&P

competed with TOBA for the business of touring black vaudeville performers. On 24 July 1922 the entertainment newspaper *Billboard* announced that John T. Gibson was now vice president of the Managers and Performers vaudeville circuit. It is not clear whether Gibson had given up his job as vice president of TOBA. By December 1922, however, the two organizations would merge to become one black vaudeville circuit: TOBA. Among the black vaudevillians Gibson brought to the Standard Theater in the late 1920s were LOUIS ARMSTRONG, PAUL ROBESON, Salem Tutt Whitney and J. Homer Tutt, ROSE MCCLENDON, DUKE ELLINGTON, ETHEL WATERS, BESSIE SMITH, FATS WALLER, and the Lafayette Players.

In addition to managing theaters, Gibson was active in the civic life of Philadelphia. He served on the board of Douglass Hospital, the Chamber of Commerce, and the Board of Trade. He belonged to the Citizens Republican Club, which was a black Republican organization, and he was a member of the Masons and the black fraternity Kappa Alpha Psi. Gibson's prosperity and prestige enabled him to purchase an estate in the Philadelphia suburb of Bethayes, Montgomery County, Pennsylvania. He also bought Philadelphia real estate, including an apartment building, row houses, and tenement buildings. For reasons that are unclear, Gibson's closed its doors in 1928. Gibson lost money in the stock market crash of 1929, and this disaster, along with the arrival of talking motion pictures and radio, as well as vaudeville's decline, hurt Gibson's business. He was forced to lease Gibson's Dunbar Theater in November 1929 to a group of Jewish businessmen. They eventually bought it and changed its name to the Lincoln in 1931. In 1932 the comedian and black theater owner SHERMAN H. DUDLEY became part owner of the Standard Theater. As the nation entered the Great Depression, Gibson lost control of his other real estate, plus the Standard Theatre, and he died in Philadelphia. His stunning career as an African American theater owner and promoter of black musicals put Philadelphia on the map during the Harlem Renaissance.

FURTHER READING

"John T. Gibson," in *The Harlem Renaissance: A Historical Dictionary for the Era*, ed. Bruce Kellner (1987).

Richardson, Clement. *The National Cyclopedia of the Colored Race*, vol. 1 (1919).

Sampson, Henry T. *Blacks in Blackface: A Source Book on Early Black Musical Shows* (1980).

Obituary: Philadelphia Tribune, 17 June 1937.

ERIC LEDELL SMITH

GILBERT, Mercedes

(1889–1 Mar. 1952), actress and writer, was born in Jacksonville, Florida, the daughter of Daniel Marshall Gilbert, the owner of a furniture business, and Edna Earl Knott, the owner of a dressmaking business. In an unfinished autobiographical manuscript Gilbert wrote that because of her parents' jobs, she was cared for and educated by a nurse. She enrolled in the Boylan Home, a seminary for girls in Jacksonville, when she was in the fourth grade. After her family moved to Tampa, Florida, Gilbert attended a Catholic school and the Orange Park Normal and Industrial School. She went to Edward Waters College in Jacksonville and after graduation taught school in southern Florida before deciding that she wanted a different profession. She then entered the Brewster Hospital Nurses Training School and graduated three years later, staying on the staff for two more years as the assistant superintendent.

After moving to New York City in 1916, first possibly having spent some time in Chicago, Gilbert searched for a nursing job. She found, however, that her hospital in Florida did not have the appropriate qualifications to make it a Grade One training school, so she would have had to spend three more years in postgraduate training at Lincoln Hospital. Since she had been writing poems and plays with some success for most of her life, in the early 1920s Gilbert began to take seriously the advice of friends who told her to find a songwriter to collaborate with her in setting some of her poetry to music. Though she may have worked as a private nurse for some periods of time in New York City, in 1922 Gilbert began to achieve status as a songwriter. She notes in her autobiographical manuscript, "Strange to say, the first was a song about the 'sport of kings,' horse racing, titled 'The Also Ran Blues.' This song became quite a hit and was recorded by most of the record companies" (Roses and Randolph, 123). Gilbert managed an eight-piece jazz band and a blues singer who recorded the popular "The Decatur Street Blues" and "Got the World in a Jug," both of which she wrote in the early 1920s. In 1922 she married Arthur J. Stevenson.

Her marriage did not interfere with her blossoming career in the arts. Though she had been successfully composing songs and writing for the Associated Negro Press, she got her first significant part as an actress in *The Lace Petticoat*, a Broadway musical comedy in which all the members of the cast were white, "except the singers and myself" (Roses and Randolph, 123). She subsequently appeared in many Broadway shows, including *Lost*; *Bomboola*; *Play Genius*; *Play*; *Malinda*; *How Come Lawd?*; *The Searching Wind*; and *Carib Song*. Of special note is her performance as Zipporah, the wife of Moses, throughout the five-year run of *Green Pastures*, which played in New York City and on tour during the early 1930s. Her obituary in the *New York Times* notes that her portrayal of Zipporah and her performance as Cora Lewis in *Mulatto* were her most notable. The role of Cora Lewis, the wife of Colonel Norwood in LANGSTON HUGHES's *Mulatto*, is especially significant not only because it contains excellent monologues that would highlight any actress's skills but also because she unexpectedly had to take over the role previously played by Rose McClendon, being handed the script on a Saturday evening and set to appear onstage on Tuesday. A reviewer in the *New York World Telegram* notes on 8 May 1936 that "Mercedes Gilbert pinch-hits successfully. . . . Hers is a perilous part and she makes hay with it" (quoted in Roses and Randolph, 122). She played the role on Broadway for a year, the rest of the 1935–1936 season, and on tour for seven months. Another contemporary reviewer notes, "Miss Gilbert, as Cora Lewis . . . is performing so remarkably and being so well received by different audiences that both author Langston Hughes and producer Martin Jones predict a long run at the Ambassador Theatre . . . where 'Mulatto' has now been running more than eleven months" (Stewart, 7).

Gilbert also appeared on radio, television, and in such silent pictures as *The Call of His People*, *Secret Sorrow*, and *Body and Soul*. In *Body and Soul*, which was directed by one of the most famous black filmmakers of the 1920s, OSCAR MICHEAUX, Gilbert worked with the popular black actor PAUL ROBESON. Also of note are her performances in the all-black productions of *Lysistrata* and *Tobacco Road*. In the 1940s she began to tour the United States and Canada in a one-woman show consisting of recitals of her work. During this time she also toured colleges performing and lecturing on black history. A collection of her work, *Selected Gems of Poetry, Comedy, and Drama* (1931), contains comments on the dust jacket stating that Gilbert's monologues were performed on national radio. The publishers note that "the work is mainly in Southern dialect, because the direct appeal of this soft speech is intriguing and amusing to readers both North and South" (Roses and Randolph, p. 123). She was also a member of the Olympic Committee for the 11th Olympiad (1936). Her only novel, *Aunt Sara's Wooden God*, was published in 1938 with a foreword by Langston Hughes. The novel, like much of Gilbert's other work, has fallen into undeserved obscurity. She also wrote three plays, *Environment*, *In Greener Pastures*, and *Ma Johnson's Harlem Rooming House*; this latter was first produced by the Harlem YMCA in 1938.

The last record of Mercedes Gilbert in the Schomburg Collection is an invitation to her and her husband's twenty-fifth wedding anniversary on 19 July 1947. There is no information available that indicates children or further public activity after 1947. Her obituary in the *New York Times* states that she was living in Jamaica, New York, when she died in the Queens General Hospital.

FURTHER READING
An autobiographical manuscript and other information available through the Schomburg Center for Research in Black Culture of the New York Public Library and through Gilbert's publisher, Christopher House.
Gloster, Hugh Morris. *Negro Voices in American Fiction* (1948).
Roses, Lorraine E., and Ruth E. Randolph. *Harlem Renaissance and Beyond: Literary Biographies of 100 Black Women Writers, 1900–1945* (1990).
Obituary: New York Times, 6 Mar. 1952.

SHARON L. BARNES

GILPIN, Charles Sidney

(20 Nov. 1878–7 May 1930), actor, was born in Richmond, Virginia, the youngest of fourteen children of Peter Gilpin, a steel mill laborer, and Caroline (White) Gilpin, a trained nurse who worked at Richmond City Hospital. Gilpin attended St. Francis Catholic School for Colored Children, where, through the encouragement of his teachers, he performed in school theatricals. He left school at age twelve to apprentice himself in the print shop of the

Richmond Planet newspaper, but left Richmond in 1896 to pursue a career on stage. While earning a living in a series of odd jobs, Gilpin appeared in minstrel shows, reviews, and vaudeville. He joined the Big Spectacular Log Cabin Company and, after this troupe went bust, he was picked up by the Perkus & Davis Great Southern Minstrel Barnstorming Aggregation. This company, too, went bankrupt and so Gilpin supported himself with jobs as a barber and trainer of prizefighters.

In 1903 Gilpin joined the Carey and Carter Canadian Jubilee Singers and in 1906 he performed with the BERT WILLIAMS and GEORGE WALKER Abyssinia Company, billed as a "baritone soloist." From 1908 to 1911 he appeared with Robert T. Motts' Pekin Theater, one of the first legitimate black theatre companies in Chicago, where in 1907 he was hailed for his performance in the Irvin C. Miller and Aubrey Lyles play *The Mayor of Dixie* (1907). He toured the United States with the Pan-American Octettes from 1911 to 1913 before joining Rogers and Creamer's Old Man's Boy Company. He made his way from Chicago to New York and in 1915 joined one of the earliest black theatrical stock companies in New York, the Anita Bush Players.

When the troupe moved from the Lincoln Theater in Harlem to the Lafayette Theater they became known as the Lafayette Players. The players mounted a new production each week with Gilpin as the featured performer. In 1916 he appeared in whiteface as the character Jacob McCloskey in the Dion Boucicault play *The Octoroon*. Gilpin left the company in a dispute over salary. In 1919 John Drinkwater's play *Abraham Lincoln* premiered at the Cort Theatre in New York to positive reviews from the local press. Gilpin performed as the character William Custis, a former slave turned minister who travels to Washington, D.C., for a conference with President Lincoln.

It was during this period that the thirty-two-year-old Eugene O'Neill enjoyed some success as a playwright with the production of his work by the Provincetown Players of New York. The company had established a precedent by using black actors to play black parts, for example, in the mounting of O'Neill's one-act play about the Harlem underworld, *The Dreamy Kid* (1918). The Provincetown Players knew that Gilpin would be ideal for the part of the leading-man in O'Neill's latest drama on black life.

The Emperor Jones, featuring Gilpin, debuted in November 1920 at the Provincetown Theatre in Greenwich Village. The play dramatizes the story of Brutus Jones, a Pullman car train porter who, through bluff and brutality, installs himself as the titular head, the emperor, of an island inhabited by black citizens. Jones' rise to power, and his slow, painful descent and death are vividly portrayed on stage. In several scenes, Jones remains alone, delivering lengthy passages of haunting and compelling soliloquy. Gilpin's deep resonant voice, flawless diction, commanding presence, and histrionic acting skills mesmerized audiences. Noted the author Edith J. R. Isaacs, "when the play and the player met they became one." Indeed, as the doomed Emperor Jones, Gilpin took the theatre community of New York by storm.

Critics from the black and mainstream press were effusive in their praise of Gilpin. Alexander Woollcott, drama critic for the *New York Times*, called Gilpin's performance "amazing and unforgettable . . . superb acting." By December, the production had been moved to the Princess Theatre to accommodate the crowds and ran for more than 200 performances before commencing a two-year, national and international road tour. When the play arrived in the District of Columbia, the *Washington Post* called *The Emperor Jones*, "one of the season's greatest successes," and recognized Gilpin as, "one of the greatest of contemporary actors."

In early 1921 the New York Center of the Drama League of America nominated Gilpin as one of the ten individuals who had done the most for American theater during the year 1920. He was the first black actor to receive the honor and storm clouds quickly arose over whether Gilpin should be allowed to attend the annual dinner at a hotel that barred black guests. Some, including local writers and league members, called for the invitation to be withdrawn. But the Drama League stood firm in its resolve. The controversy put Gilpin in a difficult position. He did not wish to offend the black community, nor did he want to alienate himself from the white men upon whom he depended for his living. He chose to attend the dinner, arriving promptly at 7 P.M. He ate the meal while sitting at a table with his theatre colleagues, and accepted his award with grace.

Gilpin later commented on the affair, with his words appearing in the *New Times*: "Against those who do not care to sit in the same dining room with

me I have no complaint.' . . . He then quoted poet Alexander Pope: 'Real people everywhere, without regard to color or estate, realize that Honor and shame from no condition rise. Act well your part: there all the honor lies.'"

In June 1921 the National Association for the Advancement of Colored People (NAACP) awarded Gilpin the Spingarn Medal, an annual prize established in 1914, given to black citizens of high achievement. In September that same year he was invited by President Warren G. Harding to visit the White House, where the two men talked of ways to uplift the black race.

Gilpin's post-*Emperor Jones* years were full of ups and downs. In March 1924 he appeared as the character Cicero Brown in the black-cast production of the Nan Bagby Stephensen play *Roseanne*. A review appearing in the *New York Times* described his performance as, "a disappointing one." That same year, when the Provincetown Players revived *The Emperor Jones*, the *New York Times* announced that the part of Brutus Jones, the role made famous by Gilpin, would be played by another actor, PAUL ROBESON. Some have contended that O'Neill chose Robeson because he tired of Gilpin's appearances on stage in an inebriated state, or of his tendency to exchange O'Neill's dialogue for his own, or because Gilpin refused to speak the racial epithets written into the play. The truth about Gilpin's interpretation of the play and his relationship with O'Neill is still debated by theatre scholars.

In September 1924 Gilpin appeared in a review with FLORENCE MILLS called *Dixie to Broadway*. In 1925, in the Joe Byron-Totten play *So That's That*, Gilpin was "handicapped by an inadequate role" in an "inept play," noted the *New York Times*. Over the next few years he worked odd jobs, made recordings of dramatic readings, performed monologues on the new medium of radio, appeared in a silent all-black independent film called *Ten Nights in a Barroom* (1926), made public appearances, performed at benefits for needy black actors, and supported his family which included a common-law wife, a sister, and college-aged son. For Gilpin, his unheralded success as Brutus Jones became a curse. He was hopelessly typecast, with his every appearance compared to *The Emperor Jones*, so much so that he eventually gave in and initiated his own 1926–1927 revival of *The Emperor Jones*, serving as director as well as lead actor.

In 1927 Gilpin announced his return to vaudeville, but by this time he had begun to succumb to the effects of his drinking. Suffering from fragile health, he lost his most important asset: his voice, forcing him to return to odd jobs, including his old post as an elevator operator at a local department store. In 1929 he was scheduled to appear as lead in the play *The Bottom of the Cup*, but the actor DANIEL HAYNES opened the show for Gilpin, who was afflicted with pneumonia.

Charles S. Gilpin died at the age of fifty-one in Eldridge Park, New Jersey. According to the *New York Times*, he left the sum of $25 to his sister, Lelia Brown, and the bulk of his estate to Alma Bynum, his common-law wife and their son Paul. In August of that year, a woman calling herself Lillian Wood Gilpin claimed to be Gilpin's wife and she sued for a portion of his $2,500 estate.

Though his career as a performer spanned some forty years, Charles Gilpin is most often cited solely for his performance in *The Emperor Jones*. Indeed, noted JAMES WELDON JOHNSON, when Gilpin took on the role of Brutus Jones, "another important page in the history of the Negro in the theatre was written." Gilpin, too, must be recognized as one of the best actors of his times.

FURTHER READING
Gill, Glenda. *No Surrender! No Retreat!: African American Pioneer Performers of the 20th Century American Theater* (2003).
Hill, Errol, and James Hatch. *A History of African American Theatre* (2003).
Isaacs, Edith J. R. *The Negro in the American Theatre* (1968).
Johnson, James Weldon. *Black Manhattan* (1968).
Krasner, David. *A Beautiful Pageant: African American Theatre Drama and Performance in the Harlem Renaissance, 1910–1927* (2002).

PAMALA S. DEANE

GORDON, Emmanuel Taylor

(29 Apr. 1893–5 May 1971), singer, actor, and writer, was born in White Sulphur Springs, Montana, the youngest child of John Francis Gordon and Mary Anna Goodall, who were married in 1879. John Gordon claimed Zulu ancestry, while Mary Anna Goodall was born into slavery in Bourbon County, Kentucky, in 1853. Moving to Montana in 1881, John Gordon traveled by steamboat up the Missouri River to work as cook for a Fort Benton mining

company. Mary joined him a year later with their son Robert, the first of their five children. An expert chef, John Gordon worked as a cook in several Montana mining camps. In 1893 John left to work as a cook for a Canadian railroad, but reportedly died in a train wreck. Mary Gordon, left to raise five children alone, supported her family with wages earned as a cook, laundress, and nurse—working for the cowboys, miners, and prostitutes that dominated the fledgling mining town of White Sulphur Springs.

The Gordon home was filled with music; all members of the family sang and played various instruments. Mary Gordon was renowned for the haunting beauty and power of the spirituals she sang. Taylor, or "Mannie" Gordon, as he was called, attended the local school and worked at whatever employment he could find—carrying messages for the local bawdy houses, serving drinks, setting bowling pins, selling "hop" and cleaning pipes in opium dens, and working as an automobile mechanic. Taking a cue from his mother, Gordon would sing as he worked. Although his was the only black family in White Sulphur Springs, Gordon later claimed to have thought little of race, even as his socially ambiguous position allowed him to move between classes, delivering messages between local prostitutes and their well-heeled clients and selling opium out of a Chinese laundry. Abandoning formal education, Gordon learned to ride and rope, working cattle for a wealthy rancher. He also became an able mechanic, a skill that would later serve him well as a driver for a Montana-based land-development company owned by the circus impresario John Ringling.

In 1910 the St. Paul, Minnesota, opera house manager Louis N. Scott, who had visited Montana as John Ringling's guest, hired Gordon as his personal chauffeur. Here, Gordon was forced to adapt to unfamiliar circumstances, encountering racial segregation for the first time and finding that he could no longer rely on Blue Steel Betty, the trusty revolver his mother had insisted he leave behind, to settle arguments. He was nevertheless enthralled by the prospects of urban life. Also working as a Pullman porter, doorman, and cook, he eventually made his way to New York, where he became Ringling's valet, traveling throughout the country on Ringling's private rail car. In 1915 in St. Louis, Missouri, a passerby overheard Gordon singing along to an Enrique Caruso record and suggested that

he pursue a musical career. With Ringling's support, he moved to New York to study with the composer WILL MARION COOK and, after stints as a dockworker, bricklayer, elevator operator, and immigration agent, began performing with B. F. Keith's vaudeville revue in 1919 Beginning in 1925 he began touring major venues as a concert tenor, accompanied by JOHN ROSAMOND JOHNSON on piano, singing from *The Book of American Negro Spirituals*. He also sang with Johnson's vaudeville act known as the Inimitable Five. Gordon's career peaked in 1927 when he toured France and England, performing for a number of dignitaries, including England's King George V and Queen Mary.

By 1925 Gordon had come to the attention of Carl Van Vechten, the white arts patron, and with Van Vechten's help, published his autobiography, *Born to Be,* in 1929. With a foreword by Van Vechten, an introduction by Muriel Draper, and illustrations by Miguel Covarrubias, *Born to Be* was a remarkable achievement, as Gordon details his rugged upbringing in Montana, recounts many amorous adventures on both sides of the color line, offers blunt commentaries on racial politics, and drops names in copious quantities, paying tribute to "the world's greatest celebrities, artists, musicians, writers, bull-dikers, hoboes, faggots, bankers, sweetbacks, hotpots, and royalty, who have framed my mind so that life goes on for me, one thrill after another" (235). Throughout the book he displayed a marked ambivalence toward African American identity, straightforwardly depicting the demeaning and sometimes violent facts of segregation while insisting that "the Race Question has never been the big ghost in my life" (234). His enthusiasm for further adventures seemed misguided, however, as the publication of *Born to Be* heralded a period of professional and personal decline. In addition to *Born to Be,* Gordon published "Malicious Lies Magnifying the Truth," an essay examining racial prejudice, in Nancy Cunard's *Negro* anthology in 1934. In the essay he identified prejudice as a universal trait among all races, but he detailed how prejudice became exacerbated in contemporary America, using analyses of the ideology of white supremacy, class distinctions among immigrants, and passing by black actresses in Hollywood.

Gordon continued entertaining privately and eventually pursued an acting career, appearing as a cast member on Broadway in *Shoot the Works* (1931), *Ol' Man Satan* (1932), *The Gay Divorcee* (1932), and

After Such Pleasures (1934), and in the film *The Emperor Jones* (1933); yet he never reclaimed his previous level of success. He completed the novel "Daonda" in 1935, but it was never published. In 1947 Gordon suffered a nervous breakdown and was institutionalized several times over the next decade.

In February 1959 Gordon was released to the care of his sister, Rose Beatris Gordon, who still resided in White Sulphur Springs and who by this time had gained her own renown. Taylor Gordon supported himself through rental incomes, an antique business, occasional concerts and talks, and through his writing. His later books include *Born to Be Sequel* (1970) and *The Man Who Built the Stone Castle* (1967), which was about White Sulphur Springs' historic landmark. He died in White Sulphur Springs in 1971.

FURTHER READING
Gordon, Taylor. *Born to Be* (1929, repr. 1995).
Johnson, Michael K. "Migration, Masculinity, and Racial Identity in Taylor Gordon's *Born to Be*," in *Moving Stories: Migration and the American West, 1850–2000* (2001).

HUGH DAVIS
JODIE FOLEY

GORDON, Eugene F.

(23 Nov. 1891–18 Mar. 1974), author and journalist, was born in Oviedo, Florida, to Elijah and Lillian. Some early biographical sketches give his birth year as 1890. He was raised on his grandfather's farm in Hawkinsville, Georgia, and went to the only school in that town for black students. He attended Howard University Academy, a preparatory school run by Howard, but by 1917, when he was in his junior year, he left to join the military. He later explained that he was an idealist who believed his military service would gain him more respect in the still-segregated United States. In 1916 he married Edythe Mae Chapman of Washington, D.C. They would have one son together.

After his military service was completed, Gordon and his wife moved to Boston. He was hired by the *Boston Post* in 1919, becoming one of the few black reporters at a white-owned newspaper. He also edited copy and worked on feature stories. After taking some extra journalism courses at Boston University in the early 1920s, he was promoted to an editorial position at the *Post* in

1923. He not only supervised short fiction for the newspaper (newspapers regularly serialized popular books and offered works of fiction by well-known authors) but wrote editorials and commentary in the Sunday edition of the *Post* and sometimes in the daily edition. In the majority of American cities, even the most talented black journalists were hired only by the local black newspapers, so Gordon's position at the *Post* was unusual for its time.

During the mid-1920s, in addition to his work at the *Post*, Gordon began to freelance for a number of publications, including the National Urban League's *Opportunity* magazine and such mainstream publications as *Scribner's* and *American Mercury*. He also contributed a 1928 essay to the *Annals of the American Academy of Political and Social Science*, in which he evaluated the current state of black journalism. In that essay he praised the *Pittsburgh Courier* as the paper that took the most courageous editorial stands on issues. His magazine articles were usually social commentary about African American life in the United States. He also edited a short-lived literary journal called the *Saturday Evening Quill* from 1928 to 1930. The *Quill* evolved from a black literary club in Boston, whose members wanted to publish their own work independently, mainly for the enjoyment of friends and colleagues. They raised the money and put out three annual issues of the journal, which featured original poetry, short stories, and critical essays. W. E. B. DU BOIS, then editor of *The Crisis*, praised the *Quill*, as did CHARLES JOHNSON of *Opportunity*. In addition to contributions from such writers as Helene Johnson, Waring Cuning, and DOROTHY WEST, Gordon's wife Edythe, who was working on a master's degree at Boston University, contributed short fiction and poetry, and the *Quill* was the first place her work was published.

While definitive information about Gordon is not available, he seems to have become increasingly more frustrated by the limitations placed on him in the racist and segregated world of the 1920s and 1930s. In a 1934 essay he observed that even becoming an officer in the military had not earned him more respect from white society, and although the Harlem Renaissance had provided greater opportunities for black artists and intellectuals, he believed that society at large was still as racist as ever. He gave examples in his essays, describing how despite being both an educator and a journalist, he was still

mistaken for a porter or an elevator operator by white people who did not know him.

At some point in the early 1930s Gordon and Edythe separated, though they were not formally divorced until 1942. But the most dramatic change in Gordon's life was his involvement with the Communist Party. In the 1930 edition of *Who's Who in Colored America*, he listed himself as a member, and he became increasingly more active as the decade progressed. That he joined was not in itself unique. A number of intellectuals, both black and white, identified with socialist or communist ideologies during the Great Depression. But for Gordon as a journalist, the episodes of racial injustice he observed made him more determined to speak out against racism, and he increasingly saw the Communist Party's journals as a good fit for his views. By 1934, when an unarmed black janitor named George Borden was shot and killed when he resisted being arrested for several outstanding (and relatively minor) traffic violations, Gordon published a commentary on the case for a communist publication, entitled "The Borden Case: The Struggle for Negro Rights in Boston" (1935). It was far more outspoken than what he could have printed in the *Boston Post*. He also participated in demonstrations with the League of Struggle for Negro Rights. These activities began to attract the attention of some of the more mainstream media newspapers, which were critical of him and other "Reds" for demanding justice in a way that seemed too forceful.

By 1935 Gordon wrote exclusively for publications identified with the Communist Party. He began praising the Soviet Union as an example of egalitarianism, and in April 1935 he announced that he would go to Russia to study and work. He was hired by the *Moscow Daily News* as a reporter, and when he returned to the United States after three years in Moscow, he told the *New York Age* that "there is no color prejudice whatsoever in the USSR." He also praised the Moscow newspaper for giving him more opportunities to cover major stories than his U.S. paper did ("Eugene Gordon Back from Three Year Stay in Russia," 3). He moved to New York, where he wrote for many years for such publications as the *Daily Worker* and the *National Guardian*. He became known for his investigative reporting. His focus was stories of injustice that had gone unpunished—innocent black men who had been subjected to police brutality or black women who were raped by white men. He felt that while the mainstream white press was quick to report on crimes allegedly committed by blacks, that same white press was usually silent when blacks were the victims of crime. Some of Gordon's columns in the communist press were quoted by black newspapers like the *Chicago Defender*, but more often than not the mainstream press ignored Gordon's reporting.

In the mid-1940s Gordon married June, who had once been the wife of Carl Reeve, a Communist Party leader and the son of the party matriarch Ella "Mother Bloor" Reeve. June Gordon ultimately faced deportation to Russia in 1960 because the U.S. government said she had entered the country illegally in 1928. Her supporters believed she was targeted for being a communist and for demonstrating on behalf of workers' rights. Eugene Gordon died in New York, seldom mentioned by the mainstream media, mourned only by his colleagues and friends in the Communist Party. Scholars have begun to pay more attention to Gordon's tireless efforts to gain respect for journalists of color.

Had Gordon not become an active member of the Communist Party, he may have been remembered as a pioneering journalist, one of the first African Americans to attain the position of editor at a white newspaper, a respected media critic, and editor of a critically acclaimed literary journal. But in a country where communists were reviled by people like Representative Martin Dies, cofounder of the House Committee on Un-American Activities, and Senator Joseph McCarthy, Gordon's career was marginalized by the mainstream press.

FURTHER READING
Daniel, Walter C. *Black Journals of the United States* (1982).
"Eugene Gordon Back from 3 Year Stay in Russia." *New York Age*, 5 Feb. 1938.
Miller, Eben Simmons. "A New Day Is Here: The Shooting of George Borden and 1930s Civil Rights Activism in Boston," *New England Quarterly* 73.1 (Mar. 2000): 3–31.
"To Study in Soviet Russia." *Chicago Defender*, 27 Apr. 1935.
"U.S. Orders Deportation of Known Red." *Gettysburg Pennsylvania Times*, 6 Aug. 1960.

DONNA HALPER

GRANGER, Lester Blackwell

(16 Sept. 1896–9 Jan. 1976), social scientist and former executive secretary of the National Urban

League, was born in Newport News, Virginia, one of six sons of William Randolph Granger, a physician from Barbados, and Mary L. Turpin Granger, a local teacher. Granger earned his BA degree from Dartmouth College in 1918, but his dream of pursuing a law degree was derailed by the outbreak of World War I, during which he served as a lieutenant in the U.S. Army in the Ninety-second Infantry Division.

Following his military service, Granger returned to New Jersey and joined the New Jersey Urban League, where he briefly served as the industrial secretary for the Newark affiliate. In 1920 he moved to North Carolina in order to teach at the Slater Normal School in Winston-Salem and at St. Augustine College in Raleigh. Two years later Granger returned to New Jersey, having accepted a job as an extension worker at the Manual Training and Industrial School for Colored Youth in Bordentown, New Jersey, a position he retained until 1934. It was in Bordentown that he met Harriet Lane, whom he married in August 1923. During the early to mid-1920s Granger also pursued graduate studies at New York University and the New School of Social Work.

Upon his departure from the Manual Training and Industrial School for Colored Youth, Granger began work at the New York office of the National Urban League. There he headed the Workers Bureau and even became the first business manager of the League's magazine *Opportunity*. His vigorous leadership led to the creation of the Workers Councils, which promoted trade unionism among African American workers and challenged the racial discrimination they faced from their employers and the labor organizations that were set up to protect their rights. In 1938 he took a two-year leave of absence to work with the New York City Welfare Council, but he returned to the National Urban League in 1940 to serve as assistant executive secretary in charge of industrial relations. He was promoted to executive secretary in 1941, and he remained at this position for the following twenty years.

The 1940s saw Granger's increasingly active participation in the struggle against racial segregation, especially in military service and defense employment. Even while at the helm of the National Urban League, where the focus of his duties was social service, Granger participated in a number of political movements, including the March on Washington movement, which he joined in 1941. Granger's commitment to equality in military service received broad recognition in 1945, during which year he served as a special adviser on race relations to Secretary of the Navy James Forrestal and was awarded the U.S. Navy's highest civilian award, the Distinguished Civilian Service Medal. Two years later President Truman awarded Granger the Medal of Merit, expressing gratitude to Granger as a man who contributed "more than any other person to the effective utilization of Negro personnel in the service" (Ploski, 293). In 1948 President Truman personally appointed Granger to the Committee on Equality of Treatment and Opportunity in the Armed Services. This five-man committee pressed for the integration of the armed services, which was achieved in 1950.

One of the most noteworthy innovations Granger implemented during his service in the National Urban League was the creation of the Pilot Placement Project. This program was aimed at placing blacks in positions from which they were previously barred. Additionally Granger helped establish a Commerce and Industry Council and Trade Union Advisory Council, which became the nexus of business support for the League, thus ensuring cooperation from various organizations. During his time as executive secretary of the Urban League, the number of local affiliates grew from forty-one to sixty-five and the organization's budget rose from $600,000 to $4.5 million.

Granger's innumerable efforts in the sphere of social service did not go unrecognized. In 1951 he became the first African American to be nominated as president of the National Conference of Social Work, and just ten years later he was elected in Rome as the president of the International Conference of Social Work.

When Granger retired at age sixty-five from the National Urban League in October 1961, President Eisenhower praised him for his character and integrity. In the years following his retirement Granger taught at Dillard University in New Orleans, Louisiana, where he was named an Amistad Scholar in Residence. After a lifetime of public service, Lester Granger died in 1976 in Alexandria, Louisiana.

FURTHER READING

Lester B. Granger's papers are housed in the Amistad Research Center at Tulane University in New Orleans.

Parris, Guichard, and Lester Brooks. *Blacks in the City: A History of the National Urban League* (1971).

Wormley, L. Stanton, and Lewis H. Fenderson. *Many Shades of Black* (1969).

Obituary: New York Times, 10 June 1976.

LATICIA ANN MARIE WILLIS

GRIGGS, Sutton E

(1872–1930), writer and Baptist minister, was born Sutton Elbert Griggs in Chatfield, Texas, the son of Allen R. Griggs, a prominent Baptist minister; his mother's name is not known. Griggs received his elementary education in the Dallas public schools and attended Bishop College in Marshall, Texas. After graduating in 1890, he attended the Richmond Theological Seminary (later a part of Virginia Union University) and graduated after three years. After his ordination as a Baptist minister, he was given his first pastorate at Berkley, Virginia, where he remained for two years. He then moved to Tennessee, where he spent thirty years, first at the First Baptist Church of East Nashville and later at the Tabernacle Baptist Church of Memphis, where he held ministerial office for nineteen years. Griggs married Emma J. Williams of Portsmouth, Virginia, in 1897; they had no children.

After Reconstruction and the subsequent segregation and antiblack violence, Griggs, along with other African American writers such as CHARLES CHESNUTT, PAUL LAURENCE DUNBAR, W. E. B. DU BOIS, and BOOKER T. WASHINGTON, responded by creating works that portrayed black Americans, often emphasizing their demands for civil rights. Griggs not only wrote five novels but also published a number of political and philosophical tracts. He published, promoted, and distributed these works himself, often by selling them door-to-door. One critic, Hugh Morris Gloster, asserts that because of Griggs's strategy of taking his work directly to his audience his books were more widely read and circulated than those of Chesnutt or Dunbar. In spite of Griggs's vigorous promotion of his own work, he maintained that all his novels were financial failures.

The first, the best known, and arguably the finest of Griggs's five novels, *Imperium in Imperio*, appeared in 1899. It is, as are all his novels, a political work. The story is centered on two individuals: Belton Piedmont and the biracial Bernard Belgrave. Starting with their early childhood, Griggs traces the lives of these two characters through their contrasting social positions. Although Belton suffers intense discrimination (he is even hanged by a lynch mob but not killed), he adopts an accommodating and integrationist stance. Bernard, on the other hand, is well treated because of his white father; nevertheless, he becomes the more militant of the two. Perhaps most important, the story contains a description of a secret black government situated within the United States. The story's two protagonists wrestle with the problems of racism and segregation, as well as many of the political and philosophical ideas found in Griggs's other work.

Griggs's four other novels likewise address the themes he examined in *Imperium in Imperio*. His second novel, *Overshadowed* (1901), deals with the harsh conditions imposed on blacks through segregation, painting a gloomy picture. *Unfettered* (1902) is the story of a young biracial woman, Morlene, who falls in love with Dorlan Worthell, a courageous young black man. In this novel Griggs brings all his characteristic melodramatic and sentimental tendencies to bear. In addition he tacks on an appendix, called "Dorlan's Plan." Foreshadowing his own more didactic work, the plan runs more than fifty pages, presenting a program to elevate the black race. In *The Hindered Hand* (1905) Griggs continued his probing inquiry of race relations through themes of lynching, miscegenation, and emigration to Africa. His final novel, *Pointing the Way* (1908), offers legal action as a possible recourse for blacks, a suggestion that also appears in his later writings.

After *Pointing the Way* Griggs abandoned the novel in favor of social and political tracts. He produced nearly three dozen such works. For the most part his themes remained the same, as he discussed problems such as lynching and mob violence, inadequate employment opportunities, miscegenation, and black suffrage. One of the longest of these works, *Wisdom's Call* (1911), is a reworking of two of his earliest tracts, *The Needs of the South* (1909) and *The Race Question in a New Light* (1909). In it Griggs directed his attention toward the intelligence and capability of blacks, concluding that their judgment is sound and reliable. *The Guide to Racial Greatness*, published in 1923 and one of his better-known works, lays out a guide intended to solve many of the racial problems that Griggs detailed in his novels and tracts. As with his novels, he published these tracts himself and sold them door-to-door.

Griggs's work was, for the most part, ignored until the 1940s. Since then there has been a reexamination of his writings, with critics labeling him everything from a radical militant to an accommodationist.

Near the end of his life, Griggs returned to Texas. In Denison he served as pastor of Hopewell Baptist Church, a position his father had held. He left Denison for Houston, intending to found a religious and civic institute. He died there, however, before the realization of his plan.

FURTHER READING

Bigsby, C. W. E., ed. *The Black American Writer* (1969).

Bruce, Dickson D., Jr. *Black American Writing from the Nadir: The Evolution of a Literary Tradition, 1877–1915* (1989).

Davis, Arthur P. *From the Dark Tower: Afro-American Writers (1900 to 1960)* (1974).

Fleming, Robert E. "Sutton E. Griggs: Militant Black Novelist," *Phylon* 34 (Mar. 1973).

Gloster, Hugh M. "Sutton E. Griggs: Novelist of the New Negro," *Phylon* 4 (Fourth Quarter, 1943).

CHRIS RUIZ-VELASCO

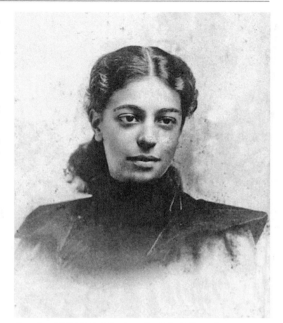

Angelina Weld Grimké, whose Rachel: A Play of Protest was the first play by an African American woman to be publicly staged. (Moorland-Spingarn Center.)

GRIMKÉ, Angelina Weld

(27 Feb. 1880–10 June 1958), poet and teacher, was born in Boston, Massachusetts, the daughter of Archibald Henry Grimké, an attorney and diplomat, and Sarah E. Stanley. Angelina's parents separated when she was very young, and she, an only child, was raised by her father. Her mother's absence undoubtedly contributed to Grimké's reverential treatment of maternal themes in her poetry, short stories, and especially her only published play, *Rachel* (1920). Her father dominated Grimké's life until his death in 1930. His continual insistence on her personal propriety and academic achievement seemed to inhibit his daughter's self-determination as much as it inspired her to make him proud of her.

Growing up in Boston, Grimké enjoyed a comfortable, middle-class life. Her distinguished family name gave her certain advantages, such as an education at better schools and frequent exposure to prominent liberal activists. But as the daughter of a white woman and a man of mixed ancestry, she was no stranger to racial tension. Her sensitivity to racism was further enhanced by her family's history. Grimké was named for her father's aunt, the social reformer Angelina Emily Grimké, who had campaigned for women's suffrage and for the abolition of slavery. Her father, the son of a slave, had dedicated his life to fighting prejudice. This heritage put enormous pressure on Grimké to carry on her family's tradition of embracing social causes. Timid and obedient as a child, she turned to writing as a release for her preoccupations: her need for a mother's attention, her diligence in living up to her father's expectations, and her inability to establish a lasting romantic partnership. Upon reaching adulthood, she remained introverted but began to use her writing as a public platform for denouncing racism.

In 1898 Grimké enrolled in the Boston Normal School of Gymnastics (which eventually became the department of hygiene at Wellesley College), graduating in 1902 with a degree in physical education. She then moved to Washington, D.C., where she taught physical education at the Armstrong Manual Training School, a vocational institution, until 1907. Apparently unhappy with both her duties and her work environment, Grimké left Armstrong to teach English at the M Street High School, having prepared herself by taking summer courses in English at Harvard University from 1904 to 1910. Grimké

remained at M Street until she retired from teaching in 1926.

Although Grimké wrote most prolifically between 1900 and 1920, her first published piece, a poem titled "The Grave in the Corner," appeared in the *Norfolk (Massachusetts) County Gazette* when she was only thirteen (27 May 1893). During her post-secondary studies Grimké published more of her verse in the *Boston Transcript*. However, not all of her work was well received. The editor of the *Transcript*, Charles S. Hunt, rejected Grimké's poem titled "Beware Lest He Awakes" on the grounds that its "implied threat of a bloody rising on the part of the negro" was anachronistic. The poem, eventually published in the *Pilot* (10 May 1902), reflects the battle against racism that more typically characterizes Grimké's short fiction and her play *Rachel*. Another early poem, "El Beso," was published in the *Transcript* (27 Oct. 1909), accompanied by praise for Grimké's poetic talent.

Grimké's best-known poems include "To Keep the Memory of Charlotte Forten Grimké" (1915), about Charlotte L. Forten Grimké, her aunt by marriage, "The Black Finger" (1923), "A Winter Twilight" (1923), "Tenebris" (1924), "For the Candlelight" (1925), "When the Green Lies over the Earth" (1927), and "Your Hands" (1927). These poems express her recurring themes of unfulfilled love and racial injustice or pay tribute to famous people. Other works feature tender depictions of children and mothers. A sense of despair pervades much of Grimké's verse, but only occasionally does her tone become strident or even moderately antagonistic. Her surviving manuscripts suggest that Grimké had, at one time, considered collecting her poetry into a volume tentatively titled *Dusk Dreams*. The project never materialized, and the majority of Grimké's verse remains in holograph form among her personal papers. Much of this unpublished work consists of highly sentimental love poetry addressed to women by obviously female speakers. Some scholars have suggested that these lesbian overtones kept Grimké from publishing verse that might have brought scandal to her family name.

Less varied in theme than her poetry, Grimké's prose and drama focus almost exclusively on lynching and the chagrin of African American motherhood. Her short stories "The Closing Door" (1919) and "Goldie" (1920) combine these two topics in an effort to shock white readers into realizing how prejudice and racially motivated violence contribute to the disintegration of the black family. Both stories appeared in the *Birth Control Review* and were widely perceived as advocating childlessness among African Americans. The heroines of these stories fervently desire to bear children, but they sacrifice their maternal longings in order to avenge and prevent persecution of blacks by whites. The young women make this decision after they lose friends and family members to lynch mobs. Likewise, the title character in Grimké's play *Rachel* breaks off her engagement and forswears motherhood when her "adopted" children come home in tears after having racist taunts hurled at them by white children.

Grimké is primarily regarded as a poet, yet her most celebrated work is her play *Rachel*. Written in three acts, the play depicts the struggle of a young black woman and her family in dealing with the racial prejudice that constricts their lives. Grimké unabashedly uses the story as a vehicle for antiracist propaganda, subtitling it *A Play of Protest*. Even critics who have faulted Grimké's dramatic technique have been unable to deny the impact of her message. When the Drama Committee of the NAACP supported the original production of *Rachel* on 3 March 1916, Grimké became the first African American woman to have written a publicly staged drama. The play underwent at least two other stagings before its publication in 1920. It was not performed again for nearly seventy-five years, until its revival by the Spelman (College) Players in 1991.

Critics suggest that parts of *Rachel* are autobiographical. The title character's physical description matches that of Grimké. More significantly, Rachel's decision to forgo marriage and motherhood parallels a conscious choice made by Grimké. However, these similarities are largely superficial. Rachel abandons her dreams because of her heartbreak and anger over the racial injustice she sees affecting her loved ones. In contrast, Grimké's journals and poetry indicate that her homosexuality relegated her to a lonely and celibate life.

A second play, *Mara*, was discovered among Grimké's personal papers. It was apparently written in the wake of *Rachel*'s popularity, but no record exists of any performances or of Grimké's attempts to have it published.

Throughout her life Grimké never enjoyed good health, which may explain in part why she eventually stopped teaching physical education in favor of English. A train accident led to a serious back

injury in July 1911, and her retirement from teaching may have stemmed from physical incapacity. She nursed her father, who had retired to Washington, D.C., as he declined into death (1928–1930). She then moved to New York, where she spent the rest of her life in virtual seclusion. Her last significant publication was a selection of poems featured in COUNTÉE CULLEN's anthology *Caroling Dusk* (1927). After some thirty years of isolation, both artistic and social, Grimké died in New York in 1958.

For the most part, Grimké's published poems, stories, and her play enjoyed moderate acclaim during her lifetime. Although she lived geographically remote from the hub of the Harlem Renaissance, she earned recognition from her more prominent contemporaries, notably LANGSTON HUGHES and Cullen. She also attended literary gatherings in the Washington, D.C., home of her close friend and fellow poet GEORGIA DOUGLAS JOHNSON. Yet compared with her peers, Grimké published relatively few works. Her renown may have suffered further because of her failure to produce a collection of her poems or any other sizable volume. When she withdrew from the literary world, her works faded into obscurity, where they remained until they regained scholarly interest in the late twentieth century. Grimké's resurgent eminence as a poet stems not only from her skillful imagery and lyricism but also from her unusual perspective as a woman of color who felt compelled to suppress her sexuality.

FURTHER READING

Grimké's papers are held at the Moorland-Spingarn Research Center of Howard University in Washington, D.C.

Hirsch, David A. Hedrick. "Speaking Silences in Angelina Weld Grimké's 'The Closing Door' and 'Blackness,'" *African American Review* 26 (1992), 459–474.

Hull, Gloria T. *Color, Sex, and Poetry: Three Women Writers of the Harlem Renaissance* (1987).

LAINE A. SCOTT

GUMBY, Levi Sandy Alexander

(1 Feb. 1885–16 Mar. 1961), collector, historian, author, and social personality, was born in Maryland, the son of Levi Thomas and Louisa Morris Gumby. In 1901 Gumby and his sister were sent to live with their grandparents, and it was there, at age sixteen, that Gumby began his scrapbook collection, making his first book—a practice that he would continue throughout the rest of his life—out of wallpaper, paste, and clippings of the September 1901 assassination of President McKinley. In 1902 Gumby entered Dover State College (later Delaware State University) in Delaware and began to study law. Before completing his studies Gumby withdrew from school and moved to New York City around 1906, where he would live until his death nearly sixty years later.

Gumby was immediately dazzled by life in the "big city" and sought to integrate himself into the urban community. During his early years in New York, Gumby held a variety of jobs to support his passion for collecting African American memorabilia and creating scrapbooks, including waiting tables at Columbia University and working as the personal butler of a wealthy banker, as a bellhop, and also as a postal worker during World War I. Gumby was also a founding member of the Southern Utopia Fraternity, an organization that provided support for young men who came to New York from the South seeking a wider variety of social, economic, and educational opportunities.

By 1910 Gumby had begun to recognize the importance of chronicling the often-ignored events of African American history and consequently began to take his role as a collector more seriously. In addition to creating scrapbooks composed of clippings, photographs, letters, and playbills, he began to collect rare books and manuscripts with the financial backing of his friend Charles W. Newman, a wealthy white stockbroker, who supported Gumby throughout the 1920s. When his growing collection of scrapbooks, rare books, and manuscripts began to overflow his apartment, with the help of Newman, Gumby rented a large studio at 2144 Fifth Avenue between 131st and 132nd streets in Harlem that became known as "Gumby's Bookstore" because of the shelves of books that lined the studio's walls. Gumby furnished his studio, a converted storefront, with a grand piano and Persian rugs as a means of impressing his guests, as well as the young men whom he liked to entertain. He used the studio to hold gatherings and receptions, sometimes renting it out for exhibitions, performances, and parties. The studio officially opened in 1926 and became a gathering place for the major literary figures of the Harlem Renaissance—a period ranging from roughly 1920 until 1935 that

represented an explosion of black literary, artistic, intellectual, and cultural production—including ALAIN LOCKE, CLAUDE MCKAY, COUNTÉE CULLEN, LANGSTON HUGHES, RICHARD BRUCE NUGENT, WALLACE THURMAN, Helene V. Johnson, and DOROTHY WEST, as well as artists, actors, and musicians such as PAUL ROBESON, all of whom Gumby was personally acquainted with.

At his gatherings Gumby proved a vivacious and spirited host who loved to entertain, often performing his own sexually explicit sonnets. Gumby's reputation as a host, his magnetic personality, and his keen sense of fashion garnered him nicknames such as "The Count," "Mr. Scrapbook," and "Great God Gumby," and established him as one of the most significant personalities of the Harlem Renaissance. Not only did he collect documents and materials relating to and created by Harlem Renaissance figures but his studio also served as a meeting place for those interested in the movement. Gumby's personality, coupled with his studio, helped to create a major creative and social nexus—a place in which the artistic community of Harlem at the time could thrive, as nearly every major literary or artistic figure of the Harlem Renaissance was associated with Gumby and his studio at one time or another. As Richard Bruce Nugent humorously noted in his biographical vignette of Gumby entitled "On Alexander Gumby" from the collection *Gay Rebel of the Harlem Renaissance* (2002), not only did Gumby collect memorabilia, clippings, and books but he also collected artists (224).

Gumby was openly gay and his studio became a gathering place for Harlem's queer community as well as for its literary and artistic elite. The popularity of "Gumby's Bookstore" illustrates that the Harlem Renaissance was in many ways also a queer renaissance.

In 1930, inspired by other literary publications of the time such as *FIRE!!* and *Harlem* (both edited by Wallace Thurman), Gumby set out to produce his own literary journal entitled *The Gumby Book Studio Quarterly*. The journal was short-lived—the first and only issue was printed in 1930–1931 and was never distributed. The stock market crash of 1929 and the Depression of the 1930s affected Gumby greatly, as Charles W. Newman lost millions and "Gumby's Bookstore" lost the support of its regular patrons, forcing Gumby to give up the studio, sell many of his books, and store his scrapbooks in the cellar of a friend's home. In 1931 Gumby was diagnosed with tuberculosis and was forced to spend nearly a year in Riverside Hospital in the Bronx and four years in Randall's Island Hospital. Throughout his hospital stay Gumby continued to work on his scrapbooks, collecting newspaper articles, cards, and photos of friends who came to visit, which he eventually incorporated into his autobiographical scrapbooks. Although Gumby was behind on his scrapbooking because of his illness, when he was released in 1934 he renewed his urge to collect and sought to rebuild and restore his collection by creating new scrapbooks and adding additional clippings and documents.

In 1950 Gumby donated his collection of 300 scrapbooks—which he titled *The L. S. Alexander Gumby Collection of Negroiana*—to Columbia University's libraries, and was subsequently hired in 1951 for a period of eight months to organize the collection. The materials in Gumby's scrapbooks, which chronicle the history of the American Negro from 1850 on, consist mainly of newspaper and magazine clippings, photos, pamphlets, playbills, autographs, letters, slave documents, and materials that Gumby personally gathered from well-known African American personalities such as Langston Hughes, Paul Robeson and JOSEPHINE BAKER. Each scrapbook within Gumby's collection is devoted to one subject, be it an individual, an organization, or a more general topic such as "Jazz" or "Lynchings and Race Riots." Six of the scrapbooks pertain to Gumby himself and are labeled "Gumby's Autobiography." In 1952 Gumby also composed an autobiographical essay about his collection entitled "The Adventures of My Scrapbooks" that was published in the *Columbia Library Columns*. Gumby continued to add materials to the collection until his death from complications due to tuberculosis. He considered his scrapbooks not just a hobby but also as a significant contribution to African American history and culture, a history that in Gumby's mind frequently remained unrecorded within mainstream narratives.

FURTHER READING

"The L. S. Alexander Gumby Collection of Negroiana" is housed in the Butler Rare Book and Manuscript Library of Columbia University in the New York City.

Gumby, L. S. Alexander. "The Adventures of My Scrapbooks," *Columbia Library Columns* 2.1 (Nov. 1952).

Gumby, L. S. Alexander. "Autobiographical Essay," *Columbia Library World* (Jan. 1951).

Kadlecek, Jo. "Black History Remains Alive in Alexander Gumby's Popular Scrapbooks," *Columbia News* (18 Feb. 2002).

Nugent, Richard Bruce. "On Alexander Gumby," in *Gay Rebel of the Harlem Renaissance: Selections from the Work of Richard Bruce Nugent*, ed. Thomas H. Wirth (2002).

Wirth, Thomas H. "Introduction," in *Gay Rebel of the Harlem Renaissance: Selections from the Work of Richard Bruce Nugent*, ed. Thomas H. Wirth (2002).

Obituary: New York Times, 18 Mar. 1961.

J. JAMES IOVANNONE

HALL, Adelaide

(20 Oct. 1901?–7 Nov. 1993), vaudeville, musical theater, and jazz singer and actress, was born in New York City, the daughter of William Hall, a white man of Pennsylvania German roots who worked as a music teacher at the Pratt Institute, and Elizabeth Gerrard, an African American. She made many jokes about her birth year; on her birthday in 1991 she declared that she was ninety years old, hence the conjectural 1901.

Hall and her sister sang at school concerts. After her father's death she began her stage career. From its debut in 1921 and into 1922 she appeared in the pioneering African American musical revue *Shuffle Along* as one of the Jazz Jasmines chorus girls; she also sang a duet with Arthur Porter, "Bandana Days." In the revue *Runnin' Wild* (1923) she introduced the song "Old Fashioned Love." At some point in 1925 she performed at the Club Alabam in New York City. In May of that year she traveled to Europe with the *Chocolate Kiddies* revue. By one account she married in 1924 her manager Bert Hicks, a Trinidadian merchant navy officer who would not allow her to tour with *Chocolate Kiddies* to the Soviet Union; elsewhere the marriage is dated 1936.

Back in New York, Hall was featured in *Tan Town Topics* (1926), and she starred in *Desires of 1927*, which toured from October 1926 to early 1927. In October 1927 she recorded two titles, including "Creole Love Call," as a guest member of DUKE ELLINGTON's orchestra. Following the death of actress FLORENCE MILLS, Hall was chosen to star on Broadway with dancer BILL ROBINSON ("Mr. Bojangles") in *Blackbirds of 1928*, in which she introduced the songs "I Can't Give You Anything but Love" and "Diga Diga Do." The show opened in May 1928 and then traveled the following year to Paris, where Hall remained, starring at the Moulin Rouge and the Lido. Dazzlingly beautiful, a formidable dancer (partnering with her tutor Robinson), and equally comfortable singing jazz melodies and risqué cabaret songs, Hall in those days rivaled JOSEPHINE BAKER as the leading African American female entertainer.

In 1930 Hall starred in *Brown Buddies on Broadway*. She toured widely in the early 1930s as a soloist accompanied by the pianist Joe Turner (not the singer of that name), Benny Payne, Art Tatum, or the guitarist Bernard Addison. In Europe she performed in the *Cotton Club Revue* of 1931, and she recorded with Turner and Francis Carter in London that year. In 1933 she recorded two titles as a leader accompanied by Ellington's orchestra.

Hall was featured in the film short *All Colored Vaudeville Show* (1935). From 1936 she lived in Europe and through her marriage to Hicks became a British citizen (perhaps in 1938), but accounts of those few years are somewhat confused. In Paris she recorded "I'm Shooting High" and "Say You're Mine" with Willie Lewis's orchestra in the spring of 1936, and Hall and Hicks opened their own club, La Grosse Pomme (The Big Apple). She also worked with Ray Ventura's orchestra in France. After touring Europe she settled in London in 1938, when she starred in *The Sun Never Sets* and recorded with FATS WALLER. Hall and Hicks opened the Florida Club, but it was destroyed by a German bomb in the Blitz. She then toured, entertaining the troops in battle zones.

After the war Hall had her own radio series. She performed in London in *Kiss Me, Kate* (1951), *Love from Judy* (1952), and *Someone to Talk To* (1956). She came to New York to work in the show *Jamaica* (1957) and then returned to London, where she and her husband opened the Calypso Club. After Hicks died in 1963, Hall's activities lessened considerably, but she performed in the show *Jamie Jackson* (1968), recorded her first album, *That Wonderful Adelaide Hall* (1970), and sang at St. Paul's Cathedral in a memorial service following Ellington's death in 1974.

In 1977 Hall created a one-woman show with which she toured widely for the remainder of her life, giving concerts in New York in 1988 and 1992. She was the subject of a documentary made for BBC television, *Sophisticated Lady* (1989). Pneumonia and an infection resulting from a fall led to her death in London.

In jazz circles Hall is remembered specifically for her first session with Ellington, in which she set aside her mainstream, smooth-toned, quavering, vaudeville-style singing voice and instead delivered a wordless vocalization imitating the sound of BUBBER MILEY's growling, plunger-muted trumpet playing. More broadly, Hall was a leading actress and singer in African American musical theater

who helped to introduce the genre in the 1920s and to ensure that it would be remembered at the century's end.

FURTHER READING

Chilton, John. *Who's Who of Jazz: Storyville to Swing Street*, 4th ed. (1985).

Sampson, Henry T. *Blacks in Blackface: A Source Book on Early Black Musical Shows* (1980).

Obituaries: (London) *Times* 8 Nov. 1993 *New York Times*, 10 Nov. 1993.

BARRY KERNFELD

HALL, Juanita

(6 Nov. 1901–28 Feb. 1968), singer and stage performer, was born in Keyport, New Jersey, the daughter of Abram Long, a farm laborer, and Mary Richardson. Of African American and Irish parentage, she was raised by her maternal grandparents and received training in classical music at Juilliard School of Music in New York City. Although one

Juanita Hall as Bloody Mary in South Pacific in June 1949. (Library of Congress/Carl Van Vechten.)

source mentions an earlier marriage to Clayton King, most sources state that, while still in her teens, she married the actor Clement Hall, who died in the 1920s. There were no children from the union, and Hall never remarried. Despite severely limited opportunities for African Americans on Broadway in the 1920s, Hall managed to break into the chorus of *Show Boat* in 1928 and joined the HALL JOHNSON Choir in the chorus of *The Green Pastures* in 1930. She remained with the Hall Johnson Choir as soloist and assistant director from 1931 to 1936.

In 1936 Hall served as musical arranger and director for *Sweet River*, a George Abbott adaptation of *Uncle Tom's Cabin* at the 51st Street Theatre. She conducted a Works Progress Administration chorus in New York City from 1936 to 1941 and also organized the Juanita Hall Choir. She directed the latter group in a Brattleboro Theatre production of *Conjur* in Brooklyn, New York, in 1938 and also appeared in radio broadcasts with Kate Smith, Rudy Vallee, and the Theatre Guild of the Air.

Hall began to reestablish her presence on Broadway with a bit part in S. N. Behrman's *The Pirate* in 1942. This was followed by appearances in the musicals *Sing Out, Sweet Land* in 1943, *St. Louis Woman* in 1946, and *Street Scene* in 1947. In 1948 she made her debut as a nightclub singer at New York's Old Knickerbocker Music Hall, singing, among others, songs written for her by LANGSTON HUGHES and Herbert Kingsley.

The break in her career came when Hall appeared in "Talent '48," an annual talent showcase sponsored by the Stage Managers Club. There she was seen by the songwriting team of Richard Rodgers and Oscar Hammerstein II, who were then in the process of writing *South Pacific*. As recalled later by Rodgers in the *New York Times*, "As soon as we heard her, Oscar and I knew that at least one part in 'South Pacific' had been filled. There was our Bloody Mary—high spirited, graceful, mischievous, proud, a gloriously gifted voice projected with all the skills of one who knew exactly how to take over a song and make it hers." When she opened in the original cast of *South Pacific* in the Majestic Theatre on 7 April 1949, Brooks Atkinson commented, "Juanita Hall's bustling, sharp-witted performance is a masterpiece" (*New York Times*, 5 June 1949).

Bloody Mary became Hall's signature role for the remainder of her career. Her rendition of her big number, "Bali Ha'i," in the words of *Variety*, "virtually stole the show from its principals Ezio Pinza

and Mary Martin and gave her name status" (6 Mar. 1968). The short, stocky actress walked away with both the Donaldson and Antoinette Perry (Tony) awards for Best Supporting Actress in a Musical that season. She left the show after nine hundred performances for a year of nightclub singing and then returned at the request of Rodgers. She later recreated the role in summer stock and notably for a revival at the City Center in 1957. She finally committed it to film for the movie version of *South Pacific* in 1958. Her other song from the show, "Happy Talk," eventually became her favorite for its positive outlook. According to Mary Martin, Hall had worked out the number's singular hand movements herself.

Thanks to her multiracial heritage, Hall found herself in demand for a variety of character roles. After the Tonkinese Bloody Mary, she played a West Indian brothel keeper in Harold Arlen's *House of Flowers* in 1954, appearing opposite Pearl Bailey and Diahann Carroll. In 1958 Rodgers and Hammerstein cast her as a Chinese American marriage broker in their *Flower Drum Song*. (Joshua Logan, *South Pacific*'s director, had originally thought Hall was Chinese.) She also appeared in the movie version of *Flower Drum Song* (1961).

Hall made numerous television appearances on *The Ed Sullivan Show, The Coca-Cola Hour, The Perry Como Show,* and *The Dave Garroway Show.* She also sang with her Juanita Hall Choir in the movie *Miracle in Harlem* (1949). Among her other stage appearances were *Sailor, Beware* with the Lafayette Players in 1935, *The Secret Room* in 1945, and *The Ponder Heart* in 1956. She was also the recipient of a citation from Israel in 1952 for her efforts in the Bonds for Israel drive.

Suffering from failing health and eyesight because of diabetes, Hall scored her last triumph in a one-woman show, *A Woman and the Blues,* at the East 74th Street Theatre in 1966. Her program combined the blues and jazz of her nightclub acts with the showstoppers of her Broadway career. A benefit on her behalf was staged the year before her death by the Actors Fund of America. She died in Bay Shore, Long Island, and was buried in her hometown of Keyport.

Hall's interpretation of Bloody Mary set the standard for the perennially popular *South Pacific* for half a century. Hall expanded opportunities for African Americans during the American musical theater's golden age. Her versatility in roles other than as African American characters, while not exactly nontraditional casting, may have helped point the way to that later practice.

FURTHER READING
"After 21 Years," *Time*, 6 June 1949.
Anderson, Doug. "The Show Stopper," *Theatre Arts* 36, no. 10 (1952).
Rodgers, Richard. "Juanita Hall," *New York Times*, 10 Mar. 1968.

Obituary: New York Times, 1 Mar. 1968.

J. E. VACHA

HAMID, Sufi Abdul

(6 Jan. 1903–30 July 1938), religious and labor leader, was born, according to his own statement, in Lowell, Massachusetts. According to the Harlem historian ROI OTTLEY, however, Hamid was born in Philadelphia, Pennsylvania. At various times he also claimed to have been born in different places in the South. Little is known about his early life, including his parents' identities. According to Ottley, his original name was Eugene Brown. In an interview with writers from the Works Progress Administration, Hamid claimed to have been taken to Egypt at the age of nine, then to Athens, Greece, where he received his schooling through the university level. According to the interview, he returned to the United States in 1923 and began to work for the William J. Burns Detective Agency in St. Louis, Missouri, and Memphis, Tennessee. Hamid soon left that job and moved to Chicago, where he joined the Ahmedabad movement, an Islamic organization based in India. Around this time he changed his name to Bishop Conshankin. In 1928 he left the Ahmedabad organization and formed the Illinois Civic Association, which led several boycotts of white-owned businesses that, though operating in black areas of Chicago, refused to hire African Americans. Sponsored by the *Chicago Whip*, a black newspaper, and J. C. Austin, a minister of a black Baptist church, the organization successfully waged boycotts with the slogan "Don't buy where you can't work." The group claimed credit for the hiring of eighteen hundred African Americans in Chicago from 1928 to 1930.

In 1930 Hamid moved to New York City, changed his name to Sufi Abdul Hamid, and began to call for boycotts of white-owned businesses in Harlem that did not employ African Americans.

He founded the International Islamic Industrial Alliance, a boycott organization that later changed its name to the Negro Industrial and Clerical Alliance. Through 1932, however, most of Hamid's political work took place atop stepladders on the streets of Harlem, where he became famous for his orations demanding jobs for African Americans in the stores along the neighborhood's main commercial thoroughfares. Sporting a turban, cape, and riding boots, Hamid was one of Harlem's most colorful characters. Although his soapbox oratory was laced with references to the Koran and various Asian religions, his message was economic organization, and it gained him a significant following in a section of New York that suffered from an unemployment rate that was higher than 50 percent throughout the Depression.

During the summer of 1933 Hamid organized the picketing of small stores in the area of 135th Street. Several of the store owners capitulated and hired African Americans as clerks. Emboldened by this success, Hamid in the spring of 1934 moved his campaign to the large chain and department stores on 125th Street, Harlem's commercial and cultural axis. In May he organized a picket line around Woolworth's after the manager refused to hire members of the Negro Industrial and Clerical Alliance as sales clerks. Hamid's successes spurred other black leaders in Harlem, among them ministers, various black nationalists, and communists, to mount their own boycotts. He was invited to join a coalition of groups in leading a boycott of Blumstein's department store but was soon expelled after insisting that any newly hired black sales clerks should be made members of his organization. After his expulsion he began to appeal to African Americans to "drive Jewish businessmen out of Harlem." Hamid was accused by the Communist Party of being a "black Hitler" and of taking money from merchants who agreed to hire black workers. Similarly, mainstream black ministers and newspapers denounced Hamid for his anti-Semitism, and he was often accused of embezzling dues money from the Negro Industrial and Clerical Alliance.

In the fall of 1934 a group of Jewish businessmen met with Mayor Fiorello LaGuardia to complain that Hamid was conducting a race war against Jews in Harlem. In October he was arrested on charges of "spreading anti-Semitism in Harlem." Following four days of conflicting testimony he was acquitted. A few weeks after his acquittal Hamid changed the name of his organization to the Afro-American Federation of Labor.

In January 1935 Hamid was arrested, reportedly for publishing and selling a pamphlet without a license, and was sentenced to ten days in jail. By this time the Harlem boycott movement had ebbed, and after his release Hamid declared that he would return to studying and teaching black magic and mysticism. He continued to speak atop his stepladder on Harlem streets and to operate a headquarters that housed a grocery store and the remnants of the Afro-American Federation of Labor, and his organization continued to picket stores in an attempt to force them to hire African Americans. But Hamid's rhetoric often veered into a mystical racialism, and his group became increasingly isolated. In July 1935 one of Hamid's targets, the Lerner Company, won a court injunction against the activities of the Afro-American Federation of Labor, effectively disbanding the organization. The company had argued that Hamid's aim was to drive white people—and Jews in particular—out of Harlem. Hamid then dropped out of public view for more than two years, during which time he reputedly studied Asian religions. He was briefly married to Madame STEPHANIE ST. CLAIR, who ran the numbers racket in Harlem in the 1930s. In 1938 she was sentenced to prison for shooting at him.

That same year Hamid formed the Temple of Tranquility, a quasi-religious organization and economic cooperative in Harlem. The organization established a cooperative wholesale fruit and vegetable market as well as a parking garage and an automobile service station. Hamid died later that year in an airplane crash.

Hamid was an important catalyst behind the Harlem boycott movement of the early and mid-1930s, one of the defining events in New York's black community during the Great Depression. He was also one of the first African American leaders to be embroiled in a controversy concerning anti-Semitism, an issue that vexed relations between African Americans and Jews for the rest of the twentieth century.

FURTHER READING

An interview with Hamid and various conflicting biographical accounts are included in the "biographical sketches" section of the Negroes of New York, 1936–1941, project of the Writers' Program of the Works Progress Administration,

on microfilm at the Schomburg Center for
Research in Black Culture, New York City.

McKay, Claude. *Harlem: Negro Metropolis* (1940).
Muraskin, William. "The Harlem Boycott of 1934:
Black Nationalism and the Rise of Labor-Union
Consciousness," *Labor History* 13 (Summer, 1972),
361–373.
Naison, Mark. *Communists in Harlem during the
Depression* (1983).
Ottley, Roi. *"New World A-Coming": Inside Black
America* (1943).

THADDEUS RUSSELL

HANDY, W. C.

(16 Nov. 1873–28 Mar. 1958), blues musician and
composer, was born William Christopher Handy
in Florence, Alabama, the son of Charles Bernard
Handy, a minister, and Elizabeth Brewer. Handy
was raised in an intellectual, middle-class atmo-
sphere, as befitted a minister's son. He studied
music in public school, then attended the all-black
Teachers' Agricultural and Mechanical College in
Huntsville. After graduation he worked as a teacher
and, briefly, in an iron mill. A love of the cornet
led to semiprofessional work as a musician, and by
the early 1890s he was performing with a traveling
minstrel troupe known as Mahara's Minstrels; by
mid-decade, he was promoted to bandleader of the
group. Handy married Elizabeth Virginia Price in
1898. They had five children.

It was on one of the group's tours, according
to Handy, in the backwater Mississippi town of
Clarksdale, that he first heard a traditional blues
musician. His own training was limited to the light
classics, marches, and early ragtime music of the
day, but something about this performance, by gui-
tarist Charley Patton, intrigued him. After a brief
retirement from touring between 1900 and 1902 to
return to teaching at his alma mater, Handy formed
his first of many bands and went on the road once
more. A second incident during an early band tour
cemented Handy's interest in blues-based music. In
1905, while playing at a local club, the Handy band
was asked if they would be willing to take a break
to allow a local string band to perform. This ragged
group's attempts at music making amused the more
professional musicians in Handy's band until they
saw the stage flooded with change thrown sponta-
neously by audience members and realized that the
amateurs would take home more money that night

*W. C. Handy in New York City in November 1949.
(AP Images.)*

than they would. Handy began collecting folk blues
and writing his own orchestrations of them.

By 1905 Handy had settled in Memphis, Ten-
nessee. He was asked in 1907 by mayoral candi-
date E. H. "Boss" Crump to write a campaign song
to mobilize the black electorate. The song, "Mr.
Crump," became a local hit and was published
five years later under a new name, "The Memphis
Blues." It was followed two years later by his biggest
hit, "The St. Louis Blues." Both songs were actually
ragtime-influenced vocal numbers with a number of
sections and related to the traditional folk blues only
in their use of "blue" notes (flatted thirds and sev-
enths) and the themes of their lyrics. Many of his
verses were borrowed directly from the traditional
"floating" verses long associated with folk blues,
such as the opening words of "St. Louis Blues": "I
hate to see that evening sun go down." In the mid-
1920s early jazz vocalist BESSIE SMITH recorded "St.
Louis Blues," making it a national hit.

In 1917 Handy moved to New York, where he
formed a new band, his own music-publishing oper-
ation, and a short-lived record label. He was an
important popularizer of traditional blues songs,
publishing the influential *Blues: An Anthology* in

1926 (which was reprinted and revised in 1949 and again after Handy's death in 1972) and *Collection of Negro Spirituals* in 1939. Besides his work promoting the blues, he also was a champion of "Negro" composers and musicians, writing several books arguing that their musical skills equaled that of their white counterparts. In 1941 he published his autobiography, *Father of the Blues*, a not altogether reliable story of his early years as a musician.

By the late 1940s Handy's eyesight and health were failing. In the 1950s he made one recording performing his blues songs, showing himself to be a rather limited vocalist by this time of his life, and one narrative recording with his daughter performing his songs. His first wife had died in 1937; he was married again in 1954, to Irma Louise Logan. He died in New York City. His autobiography was reissued after his death. In 1979 the W. C. Handy Blues Awards were established, to recognize excellence in blues recordings.

Handy may not have "fathered" the blues, as he claimed, nor did he write true "blues" songs of the type that were performed by country blues musicians. But he did write one of the most popular songs of the twentieth century, which introduced blues tonalities and themes to popular music. His influence on stage music and jazz was profound; "St. Louis Blues" remains one of the most frequently recorded of all jazz pieces.

FURTHER READING
Handy, W. C. *Father of the Blues: An Autobiography* (1941, repr. 1991).
Dickerson, James. *Goin' Back to Memphis: A Century of Blues, Rock 'n' Roll, and Glorious Soul* (1996).
Southern, Eileen. *The Music of Black Americans: A History* (1971, repr. 1983).

RICHARD CARLIN

HARLESTON, Edwin Augustus

(1882–21 Apr. 1931), painter and civil rights activist, was born in Charleston, South Carolina. "Teddy," as he was called, was one of six children of Edwin Gailliard Harleston and Louise Moultre. Harleston's father, born in 1852, was one of eight children of the white plantation owner William Harleston and his slave Kate. Edwin Gailliard Harleston had worked as a rice planter but returned to Charleston and his family's Laurel Street home in search of a better living for his wife and children. There he ran a produce-transporting business for a few years and

then brought his nickname "Captain" along when he left boating in 1896 to set up the Harleston Brothers Funeral Home with his brother Robert Harleston, a former tailor. The segregated funeral business meant they would have no competition from whites. Most of Captain's sons were uninterested in joining the business after their uncle Robert left, however, and it fell to Edwin Augustus Harleston to put aside his own dreams of art for the family business.

For his elementary education Edwin attended the Morris Street School, the first public school for African Americans in Charleston, where he was taught by white teachers. In 1897 Harleston's mother died shortly after the stillbirth of her sixth child; Captain Harleston's sister and her husband moved from Beaufort to Charleston to help care for the Harleston children. Edwin left public school and began to blossom in the college preparatory program at the Avery Institute. With a scholarship in hand, he participated in chorus as well as several clubs, found a lifelong mentor in his English teacher Mattie Marsh, and graduated class valedictorian in 1900. He presented the principal with a portrait of Abraham Lincoln as a farewell gift. At Atlanta University, a black college with a predominantly white faculty, Harleston considered teaching and later medicine as possible careers. He took public speaking and the typical drawing classes, became a starter on the football team, and most likely heard a sociology lecture or two by the faculty member W. E. B. DU BOIS. During his college years, Harleston supported himself by working summers on the Hudson River Day Line. When he graduated in 1904, he won a fellowship for graduate study. In 1905 he pursued graduate studies in sociology and chemistry at Atlanta University. His application for admission to Harvard for 1906 was accepted, and he was scheduled to enter that fall as a junior, with a career in medicine in mind. (It was standard practice at the time for Harvard to demand that white students from less prestigious colleges and African American students in general enter studies at a lower level in order to bring their educations up to Harvard standards.)

When Harleston arrived in Boston in the fall of 1906, however, he found that he was more interested in art, and instead of matriculating at Harvard, he enrolled at the new Boston School of the Museum of Fine Arts, becoming the only African American in a class of 232. To earn money for his art studies,

Harleston, along with his roommate, sold postcards, but short finances caused him to take a year off (1907–1908) to work on a cargo line between Boston and Canada. During this year Harleston's race consciousness was raised by activist black organizations and newspapers in his new surroundings. Here was the budding of what later became his civil rights activism. His savings enabled Harleston to return to the Boston School in 1908, where he studied under William Paxton and Frank Benson and was awarded a scholarship for free tuition in 1911. He had finished most of the required courses by the end of 1912, when he decided to leave school. The reasons for his departure—whether the resignation of a mentor or pressing family matters—remain unclear.

Harleston returned to Charleston and a third-floor apartment over the newly expanded Harleston and Mickey Funeral Home. Harleston's father had a skylight installed to encourage his artist son; however, the family business allowed no free time during his first year and caused many interruptions in the years that followed. In 1913 he began a long-term romance with Elise "Little Liza" Forrest. They married seven years later. Harleston's 1916 self-portrait shows the strain of balancing two lives: a picture in a white shirt with a black bow tie of the thirty-three-year-old frustrated artist who a year later became a certified embalmer and sank even deeper into the work of the funeral home. Nonetheless, Harleston attempted to drum up commissions for portraits. The man who as a teenager had presented his high school principal with a portrait of Lincoln now in 1917 sent the president of a life insurance company, where his college friend Truman Gibson was vice president, a portrait of his mother. The ploy did not work, but Gibson used his contacts to get Harleston a commission for a portrait of one of Atlanta's black leaders.

Harleston's attempt to find work as an artist coincided with his groundbreaking work with the National Association for the Advancement of Colored People. The northern-based NAACP had been unsuccessful in its earlier attempts to expand its statewide organizations into the South, but worsening conditions for African Americans nationwide changed its fortunes. The NAACP protests and picketing throughout the spring and summer of 1915 against the release of D. W. Griffith's racist film *The Birth of a Nation* enhanced the organization's reputation in a year that saw nearly one hundred blacks lynched, which was, according to Du Bois

in the *Crisis*, the highest number of lynchings in more than decade. Under Field Secretary JAMES WELDON JOHNSON, the NAACP made a new push into the South to set up chapters for eventual state organizations, and Harleston helped establish the Charleston chapter. On 27 February 1917 the twenty-nine African American professionals in the new Charleston chapter applied for a charter. Harleston became its first president and soon afterward led the campaign that forced the public school system in Charleston to hire African American teachers.

On 15 September 1920 in Brooklyn, New York, Harleston married his longtime sweetheart Elise Forrest. The previous year Harleston had financed her training as a photographer in New York so they could work together in a studio. Although the couple had no children, they raised as their own child their niece, Gussie Edwina, whose parents had succumbed to tuberculosis in 1921, when she was just four years old. In 1922 the Harlestons opened their joint studio, featuring portraits in oils, charcoal, and photography. Harleston used Charleston as a base from which he traveled to New York and Washington, D.C., to exhibit his work. His work in a realistic style influenced by his wife's photography began to gain recognition. He produced commissioned portraits of a former president of Atlanta University, the philanthropist Pierre S. du Font, and the president of the Atlanta Life Insurance Company as well as his 1924 *The Bible Student*. He was also featured in a 1924 article in *Opportunity*, the new Urban League arts and letters periodical.

Harleston continued his training in art. He spent the summers of 1924 and 1925 studying outdoor painting at the Art Institute of Chicago. These years were part of the creative energy fueled by the Harlem Renaissance, and like other African American artists during this time, Harleston benefited from the new interest and support shown in contests sponsored by the Urban League and the NAACP and exhibitions funded by the Harmon Foundation. His drawing *A Colored Grand Army Man*, based on a photograph by his wife Elise, won the seventy-five-dollar first prize in the Spingarn Competition of the NAACP in 1925, and his oil portrait *Ouida* won the 1931 Joel Spingarn Award in the annual competition sponsored by the NAACP's periodical the *Crisis*. Harleston was chosen to assist the graphic illustrator AARON DOUGLAS in painting the *Black History* murals for the library at Fisk University, completed in October 1930. Shortly

afterward, in February 1931, Harleston's *The Old Servant* was awarded the ALAIN LOCKE Prize for portraiture at the Harmon Foundation Exhibition.

The third decade of the twentieth century not only ushered in new attention to African American art but also groped toward a definition of its unique gifts. Harleston saw little of the fourth decade. In April 1931 his father died of pneumonia, and Harleston, who is said to have kissed his dead father goodbye, succumbed to the same disease on 10 May 1931. Although his work was praised posthumously, Harleston's realistic portraiture style was at odds with the new styles and sensibilities erupting in these Harlem Renaissance years. Nonetheless, critics such as the art historian JAMES AMOS PORTER argued against opinions that dismiss too quickly such art as outside these shifting trends. Porter noted that traditional painters like Harleston, LAURA WHEELER WARING, PALMER C. HAYDEN, and HENRY OSSAWA TANNER were indeed "concerned with the Negro [subject]" in the opening decades of the twentieth century and moreover that Harleston's "unforgettable renderings of *The Old Servant* and *The Negro Soldier* [were] both rich in sensuous and psychological values and done before 1925" (p. 34). The reevaluation of Harleston's art continues. Five of Harleston's paintings, including his portrait of Douglas, are owned by the Gibbes Museum of Art in Charleston.

FURTHER READING

McDaniel, Maurine Aku. *Edwin Augustus Harleston, Portrait Painter, 1882–1931* (1994).

Porter, James A. "Four Problems in the History of Negro Art," *Journal of Negro History* 27, no. 1 (Jan. 1942): 9–36.

Reynolds, Gary A., and Beryl J. Wright. *Against the Odds: African-American Artists and the Harmon Foundation* (1989).

Riggs, Thomas, ed. *The St. James Guide to Black Artists* (1997).

MARY ANNE BOELCSKEVY

HARRINGTON, Oliver W.

(14 Feb. 1912–2 Nov. 1995), cartoonist, was born Oliver Wendell Harrington in New York City, the son of Herbert Harrington, a porter, and Euzenie Turat. His father came to New York from North Carolina in the early 1900s when many African Americans were seeking greater opportunities in the North. His mother had immigrated to America,

arriving from Austria-Hungary in 1907, to join her half sister. Ollie Harrington grew up in a multiethnic neighborhood in the South Bronx and attended public schools. He recalled a home life burdened by the stresses of his parents' interracial marriage and the financial struggles of raising five children. From an early age, he drew cartoons to ease those tensions.

In 1927 Harrington enrolled at Textile High School in Manhattan. He was voted best artist in his class and started a club whose members studied popular newspaper cartoonists. Exposure to the work of Art Young, Denys Wortman, and Daniel Fitzpatrick later influenced his style and technique. About that time, toward the end of the Harlem Renaissance, he began to spend considerable time in Harlem and became active in social groups there. Following his graduation from Textile in 1931, he attended the National Academy of Design school. There he met such renowned artists and teachers as Charles L. Hinton, Leon Kroll, and Gifford Beal. During his years at the academy, Harrington supported himself by drawing cartoons and working as a set designer, actor, and puppeteer.

In 1932 he published political cartoons and *Razzberry Salad*, a comic panel satirizing Harlem society. They appeared in the *National News*, a newspaper established by the Democratic Party organization in Harlem, which folded after only four months. He then joined the Harlem Newspaper Club and was introduced to reporters such as TED POSTON, Henry Lee Moon, and ROI OTTLEY of the *Amsterdam News*, as well as Bessye Bearden of the *Chicago Defender* and her son ROMARE BEARDEN. In 1933 Harrington submitted cartoons to the *Amsterdam News* on a freelance basis. During the next two years he also attended art classes at New York University with his friend Romare Bearden. In May 1935, he joined the staff of the *News* and created *Dark Laughter*, soon renamed *Bootsie* after its main character, a comic panel that he would draw for more than thirty-five years. Harrington remarked that "I simply recorded the almost unbelievable but hilarious chaos around me and came up with a character" (*Freedomways* 3, 519).

When the Newspaper Guild struck the *News* in October 1935, Harrington, while not a guild member, supported the strike and would not publish his cartoons until it was settled. During the strike he became friends with journalists Benjamin Jefferson Davis Jr. (later a New York City

Oliver W. Harrington, artist correspondent, sketching the antiaircraft artillery section chief sergeant Car⸳ K. Hilton, of Pine Bluff, Arkansas, in 1944. (Library of Congress.)

councilman) and MARVEL COOKE, who were members of the Communist Party. While probably not a party member, he maintained active ties to the left from that time. Harrington soon returned to freelance work and taught art in a WPA program. Edward Morrow, a Harlem reporter and graduate of Yale University, and Bessye Bearden encouraged him to apply to the School of the Fine Arts at Yale, which accepted him in 1936. Supporting himself with his *Bootsie* cartoons (which he transferred to the larger-circulation *Pittsburgh Courier* in 1938), scholarship assistance, and waiting on tables at fraternities, Harrington received a bachelor of fine arts degree in 1940. He won several prizes for his paintings, although not a prestigious traveling fellowship at graduation, which he believed was denied him because of his race.

In 1942, after working for the National Youth Administration for a year, Harrington became art editor for a new Harlem newspaper, the *People's Voice*, edited by ADAM CLAYTON POWELL JR. He also created a new comic strip, *Jive Gray*. In 1943 and 1944 he took a leave from the *Voice* to serve as a war correspondent for the *Pittsburgh Courier*. While covering African American troops, including the Tuskegee Airmen, in Italy and France, he witnessed racism in the military to a degree he had not experienced before. In Italy he me⸱ WALTER WHITE, executive secretary of the National Association for the Advancement of Colored People (NAACP).

In 1946 White, who was attemp⸱ing to strengthen the NAACP's public relations de⸱artment following racial violence against returning veterans, hired Harrington as director of public relations. But by late 1947 the two had become estranged and

Harrington resigned to become more active politically. With the *Bootsie* cartoons and book illustration work again his principal source of income, and after ending a brief wartime marriage, he joined a number of political committees in support of the American Labor Party and Communists arrested in violation of the Smith Act. In 1950 he became art editor of *Freedom*, a monthly newspaper founded by Louis Burnham and PAUL ROBESON. He also taught art at the Jefferson School for Social Sciences, a school that appeared on the attorney general's list of subversive organizations. Informed of his ties to the school, the FBI opened a file on Harrington.

By early 1952, with some of his friends under indictment and others facing revocation of their passports, Harrington left the United States for France. Whether he had knowledge of the FBI investigation is unclear, but by the time he reached Paris, the Passport Office there had been instructed to seize his passport if the opportunity arose. Meanwhile, Harrington settled into a life centered around the Café Tournon with a group of expatriate artists and writers that included RICHARD WRIGHT and Chester Himes. Himes called Harrington the "best raconteur I'd ever known." His *Bootsie* cartoons and illustration work continued to provide income, and he traveled throughout Europe. For a short time, following a brief second marriage in 1955, he settled in England, but he returned to Paris in 1956 as the Algerian War was worsening. The war divided the African American community, and Harrington became embroiled in a series of disputes with other expatriates. His visit to the Soviet Union in 1959 as a guest of the humor magazine *Krokodil* again attracted intelligence officials.

Saddened by the death of his close friend Richard Wright, and with his income dwindling due to financial difficulties at the *Courier*, in 1961 Harrington traveled to East Berlin for a book illustration project and settled there for the remainder of his life. He submitted cartoons to *Das Magasin* and *Eulenspiegell* and in 1968 became an editorial cartoonist for the *Daily Worker*, later *People's Weekly World*. His press credentials enabled him to travel to the West, and many of his old friends, including Paul Robeson and LANGSTON HUGHES, visited him in East Germany. In 1972 Harrington returned for a brief visit to the United States; in the 1990s he visited more regularly. In 1994, after the publication of two books of his cartoons and articles raised interest in his work, he was appointed journalist-in-residence

for a semester at Michigan State University. He died in East Berlin. He was survived by his third wife, Helma Richter, and four children: a daughter from his second marriage, a son from his third, and two daughters from relationships with women to whom he was not married. Harrington's complex personal life, as well as his politics, was sometimes a motive for his travels.

Harrington was often referred to as a "self-exile," but he never described himself that way. "I'm fairly well convinced that one is an exile only when one is not allowed to live in reasonable peace and dignity as a human being among other human beings" (*Why I Left America*, 66). Remembered as the premier cartoonist of the African American press for three decades and a central figure in the expatriate community in Paris in the 1950s, he battled racism through his art, his writings, and an alter ego named *Bootsie*.

FURTHER READING
Harrington, Oliver H., and Thomas M. Igne. *Dark Laughter: The Satiric Art of Oliver W. Harrington* (1993).
Harrington, Oliver H., Thomas M. Igne, et al. *Why I Left America and Other Essays* (1993).
Stovall, Tyler. *Paris Noir: African Americans in the City of Light* (1996).

Obituary: New York Times, 7 Nov. 1995.

CHRISTINE G. MCKAY

HARRISON, Hubert Henry

(27 Apr. 1883–17 Dec. 1927), radical political activist and journalist, was born in Concordia, St. Croix, Danish West Indies (now U.S. Virgin Islands), the son of William Adolphus Harrison and Cecilia Elizabeth Haines. Little is known of his father. His mother had at least three other children and, in 1889, married a laborer. Harrison received a primary education in St. Croix. In September 1900, after his mother died, he immigrated to New York City, where he worked low-paying jobs, attended evening high school, did some writing, editing, and lecturing, and read voraciously. In 1907 he obtained postal employment and moved to Harlem. The following year he taught at the White Rose Home, where he was deeply influenced by the social worker Frances Reynolds Keyser, a future founder of the NAACP. In 1909 he married Irene Louise Horton, with whom he had five children.

Between 1901 and 1908 Harrison broke "from orthodox and institutional Christianity" and became an "Agnostic." His new worldview placed humanity at the center and emphasized rationalism and modern science. He also participated in black intellectual circles, particularly church lyceums, where forthright criticism and debate were the norm and where his racial awareness was stimulated by scholars such as the bibliophile ARTHUR SCHOMBURG and the journalist JOHN E. BRUCE. History, free thought, and social and literary criticism appealed to him, as did the protest philosophy of W. E. B. DU BOIS over the more "subservient" one of BOOKER T. WASHINGTON. Readings in economics and single taxism and a favorable view of the Socialist Party's position on women drew him toward socialism. Then in 1911, after writing letters critical of Washington in the *New York Sun*, he lost his postal job through the efforts of Washington's associates and turned to Socialist Party work.

From 1911 to 1914 Harrison was the leading black in the Socialist Party of New York, where he insisted on the centrality of the race question to U.S. socialism; served as a prominent party lecturer, writer, campaigner, organizer, instructor, and theoretician; briefly edited the socialist monthly the *Masses*; and was elected as a delegate to one state and two city conventions. His series on "The Negro and Socialism" (*New York Call*, 1911) and on "Socialism and the Negro" (*International Socialist Review*, 1912) advocated that socialists champion the cause of the African American as a revolutionary doctrine, develop a special appeal to blacks, and affirm their duty to oppose race prejudice. He also initiated the Colored Socialist Club (CSC), a pioneering effort by U.S. socialists at organizing blacks. After the party withdrew support for the CSC, and after racist pronouncements by some Socialist Party leaders during debate on Asian immigration, he concluded that socialist leaders put the white "Race First and class after."

Harrison believed "the crucial test of Socialism's sincerity" was "the Negro," and he was attracted to the egalitarian practices and direct action principles of the Industrial Workers of the World (IWW). He defended the IWW and spoke at the 1913 Paterson Silk Strike with Elizabeth Gurley Flynn and "Big Bill" Haywood. Although he was a renowned socialist orator and was described by author Henry Miller as without peer on a soapbox, Socialist Party leaders moved to restrict his speaking.

Undaunted, Harrison left the Socialist Party in 1914 and over the next few years established the tradition of street-corner oratory in Harlem. He first developed his own Radical Lecture Forum, which included citywide indoor and outdoor talks on free thought, evolution, literature, religion, birth control, and the racial aspects of World War I. Then, after teaching at the Modern School, writing theater reviews, and selling books, he started the Harlem People's Forum, at which he urged blacks to emphasize "Race First."

In 1917, as war raged abroad, along with race riots, lynchings, and discrimination at home, Harrison founded the Liberty League and the *Voice*, the first organization and newspaper of the militant "New Negro" movement. He explained that the league was called into being by "the need for a more radical policy than that of the NAACP" (*Voice*, 7 Nov. 1917) and that the "New Negro" movement represented "a breaking away of the Negro masses from the grip of the old-time leaders" (*Voice*, 4 July 1917). Harrison stressed that the new black leadership would emerge from the masses and would not be chosen by whites (as in the era of Washington's leadership), nor be based in the "Talented Tenth of the Negro race" (as advocated by Du Bois). The league's program was directed to the "common people" and emphasized internationalism, political independence, and class and race consciousness. The *Voice* called for a "race first" approach, full equality, federal antilynching legislation, labor organizing, support of socialist and anti-imperialist causes, and armed self-defense in the face of racist attacks.

Harrison was a major influence on a generation of class and race radicals, from the socialist A. PHILIP RANDOLPH to MARCUS GARVEY. The Liberty League developed the core progressive ideas, basic program, and leaders utilized by Garvey, and Harrison claimed that, from the league, "Garvey appropriated every feature that was worthwhile in his movement." Over the next few years Garvey would build what Harrison described as the largest mass movement of blacks "since slavery was abolished"—a movement that grew, according to Harrison, as it emphasized "racialism, race consciousness, racial solidarity—the ideas first taught by the Liberty League and *The Voice*."

The *Voice* stopped publishing in November 1917, and Harrison next organized hotel and restaurant workers for the American Federation of Labor. He

also rejoined, and then left, the Socialist Party and chaired the Colored National Liberty Congress that petitioned the U.S. Congress for federal antilynching legislation and articulated militant wartime demands for equality. In July 1918 he resurrected the *Voice* with influential editorials critical of Du Bois, who had urged blacks to "Close Ranks" behind the wartime program of President Woodrow Wilson. Harrison's attempts to make the *Voice* a national paper and bring it into the South failed in 1919. Later that year he edited the *New Negro*, "an organ of the international consciousness of the darker races."

In January 1920 Harrison became principal editor of the *Negro World*, the newspaper of Garvey's Universal Negro Improvement Association (UNIA). He reshaped the entire paper and developed it into the preeminent radical, race-conscious, political, and literary publication of the era. As editor, writer, and occasional speaker, Harrison served as a major radical influence on the Garvey movement. By the August 1920 UNIA convention Harrison grew critical of Garvey, who he felt had shifted focus "from Negro Self-Help to Invasion of Africa," evaded the lynching question, put out "false and misleading advertisements," and "lie[d] to the people magniloquently." Though he continued to write columns and book reviews for the *Negro World* into 1922, he was no longer principal editor, and he publicly criticized and worked against Garvey while attempting to build a Liberty Party, to revive the Liberty League, and to challenge the growing Ku Klux Klan.

Harrison obtained U.S. citizenship in 1922 and over the next four years became a featured lecturer for the New York City Board of Education, where the Yale-educated NAACP leader William Pickens described him as "a plain black man who can speak more easily, effectively, and interestingly on a greater variety of subjects than any other man I have ever met in the great universities." In 1924 he founded the International Colored Unity League (ICUL), which stressed that "as long as the outer situation remains what it is," blacks in "sheer self-defense" would have to develop "race-consciousness" so as to "furnish a background for our aspiration" and "proof of our equal human possibilities." The ICUL called for a broad-based unity—a unity of action, not thought, and a separate state in the South for blacks. He also helped develop the Division of Negro Literature, History,

and Prints of the New York Public Library, organized for the American Negro Labor Congress, did publicity work for the Urban League, taught on "Problems of Race" at the Workers School, was involved in the Lafayette Theatre strike, and lectured and wrote widely. His 1927 effort to develop the *Voice of the Negro* as the newspaper of the ICUL lasted several months. Harrison died in New York City after an appendicitis attack. His wife and five young children were left virtually penniless.

Harrison, "the Father of Harlem Radicalism," was a leading black socialist, the founder and leading force of the militant "New Negro" movement, and the man who laid the basis for, and radically influenced, the Garvey movement. During a heyday of black radicalism he was the most class-conscious of the race radicals and the most race-conscious of the class radicals. He critically and candidly challenged the ruling classes, racists, organized religion, politicians, civil rights and race leaders, socialists, and communists. During his life, though well respected by many, Harrison was often slighted. In death his memory was much neglected, not least by "leaders" who had felt the sting of his criticism. He was, however, a political and cultural figure of great influence who contributed seminal work on the interrelation of race and class consciousness and whose book and theater reviews drew praise from leading intellectuals of the day. Historian J. A. Rogers stressed that "No one worked more seriously and indefatigably to enlighten his fellowmen; none of the Aframerican leaders of his time had a saner and more effective program—but others, unquestionably his inferiors, received the recognition that was his due."

FURTHER READING

Hill, Robert A., ed. "Hubert Henry Harrison," in *The Marcus Garvey and Universal Negro Improvement Association Papers*, vol. 1 (1983).

Jackson, John G. *Hubert Henry Harrison: The Black Socrates* (1987).

James, Portia. "Hubert H. Harrison and the New Negro Movement," *Western Journal of Black Studies* 13, no. 2 (1989): 82–91.

Perry, Jeffrey B., ed. *A Hubert Harrison Reader* (2001).

Samuels, Wilford D. "Hubert H. Harrison and 'The New Negro Manhood Movement," *Afro-Americans in New York Life and History* 5 (Jan. 1981): 29–41.

JEFFREY B. PERRY

HARVEY, Georgette Mickey

(1882–17 Feb. 1952), actress and singer, was born Georgette Mickey in St. Louis, Missouri. Her parents' names are not known, but they were reputedly shocked when their daughter, who had learned to sing in the church choir, left home in 1902 to tour with Ernest Hogan's *Rufus Rastus.* Harvey's deep contralto voice, striking looks, and dynamic personality ensured her rapid success. In 1904 she formed her own troupe, the Creole Belles, with whom she toured the United States and Europe, including England, France, Germany, and Belgium. They returned to America and became a sought-after vaudeville act. Tom Fletcher reports that the "Miss Georgette Mickey" became "Harvey" about this time, but no other reference to a marriage or any other cause for the name change has been found (179).

Harvey and her company returned to Europe in 1911, performing in England, Scotland, Ireland, the Scandinavian countries, and Russia. The troupe was especially welcomed in the cabarets and nightclubs of Russia, enjoying tremendous popular and financial success under Harvey's astute management. The troupe eventually broke up, but Harvey remained, enjoying even greater success as a solo act. She was living in a glorious style in St. Petersburg when the Revolution of 1917 forced her to flee. She managed to get on the last train bearing refugees out of the country but was caught and sent to Siberia, where she remained for a year and a half, watching her fortune depreciate. Landing with virtually nothing in Shanghai, Harvey ended up teaching English in China and Japan for two years; she was engaged for a time by a wealthy Japanese family as an interpreter, with whom she traveled throughout Japan and to Egypt and South Africa before earning enough to return to the United States around 1920.

Back in the states, Harvey formed another quartet and quickly reestablished her reputation, first as a recording star for Black Swan records and then in musical and dramatic roles on the New York stage. She made her Broadway debut in NOBLE SISSLE and EUBIE BLAKE's *Runnin' Wild* (1923), and when asked to create the role of Maria in the Theatre Guild's *Porgy* (1927), she insisted that the producers hire the three other members of her troupe as well. Harvey re-created the role of Maria in the 1929 revival of the play as well as in the musical version, *Porgy and Bess,* which premiered in 1935. In 1934 Harvey appeared as Binnie in the Theatre Union's controversial *Stevedore,* a play inspired by labor riots in East St. Louis and Detroit and a dock strike in New Orleans. This drama, in which Harvey uttered the memorable line "I got him! That redheaded son of a bitch!" was attacked by Congress as communist propaganda. The company gave benefit performances for the League of Struggle for Negro Rights, the Actors Fund, and the Scottsboro Defense Fund. Two years earlier Harvey had performed in a benefit to aid the national committee for the defense of the SCOTTSBORO BOYS, nine young black men falsely accused of rape in Alabama.

In 1939 Harvey starred with ETHEL WATERS and FREDI WASHINGTON in the celebrated *Mamba's Daughters,* the first nonmusical Broadway vehicle with a black female star and the first Broadway production designed by a black scenic designer, Perry Watkins. Ethel Waters had met the play's authors, Dorothy and Dubose Heyward, at one of Harvey's famous parties, this one for *Porgy's* director, Reuben Mamoulian. Harvey was one of several notable black actresses to portray the mother in the American Negro Theatre's *Anna Lucasta* (1944). She also performed in an adaptation of Tolstoy's *The Power of Darkness* by ABRAM HILL, who also directed. Other stage credits include *Solid South* (1930), *Savage Rhythm* (1931), *Ol' Man Satan* (1932), *The Party's Over* (1933), *Dance with Your Gods* (1934), *Lady of Letters* (1935), *The Hook-up* (1935), *Pre-Honeymoon* (1936), *Behind Red Lights* (1937), *Brown Sugar* (1937, with a young BUTTERFLY MCQUEEN), *Pastoral* (1939), *Morning Star* (1940, opposite the Yiddish star Molly Picon), the revival of *Porgy and Bess* (1942), and *Lost in the Stars* (1949).

Harvey also performed on Carlton Moss's radio series *Careless Love* (1930–1931), the radio series *A New World A'Comin'* (1944), and in four films: *The Social Register* (1934), *Chloe, Love Is Calling You* (1934), *The Middleton Family at the 1939 New York World's Fair* (1939), and *Back Door to Heaven* (1939). She was also active in the Negro Actors' Guild, serving as an officer of the executive board from 1939 to 1946 and as executive secretary in 1945. Harvey died at Harlem Hospital after a long illness. She had become a legend in the African American theatrical community, remembered by her peers for her sensational life, her adventurous spirit, her dynamic personality, and the remarkable range of her artistic achievements. Harvey once reported that she had written a memoir entitled "Soap Suds to Champagne," but its whereabouts is unknown.

FURTHER READING

A clippings file on Harvey as well as clippings files related to productions in which Harvey appeared may be found in the Billy Rose Theatre Collection, New York Library for the Performing Arts. Additional material (clippings, correspondence) is available in the Carl Van Vechten Papers, Moorland-Spingarn Collection of Howard University, and in the Black Theatre Scrapbook, Leigh Whipper Papers, and Negro Actors Guild files, both at the Schomburg Center for Research in Black Culture, New York Public Library. An audio recording of the *New World A'Comin'* program in which Harvey starred is held by the Schomburg Center.

Fletcher, Tom. *100 Years of the Negro in Show Business: The Tom Fletcher Story* (1954).

Wirth, Thomas H., ed. *Gay Rebel of the Harlem Renaissance: Selections from the Work of Richard Bruce Nugent* (2002).

Obituary: New York Times, 18 Feb. 1952.

CHERYL BLACK

HATHAWAY, Isaac Scott

(4 Apr. 1874–12 Mar. 1967), sculptor, illustrator, ceramicist, and entrepreneur, was born in Lexington, Kentucky, the first of three children born to the Reverend Hathaway and Mrs. Hathaway. Hathaway's mother died when he was only two years old, and his father and grandmother raised him and his two sisters, Fannie and Eva.

A trip with his father to a local museum inspired Hathaway to become an artist. Walking through the museum's galleries, which were filled with busts of famous white American heroes, Isaac noticed the absence of many African Americans, such as Frederick Douglass. He asked his father why they were absent, and the elder Hathaway simply stated that there were no trained African American sculptors to sculpt prominent African American people. The young Hathaway determined to change this by becoming a trained artist.

Hathaway began his career as an artist at Chandler College in Lexington and continued it at Pittsburg Normal College in Pittsburg, Kansas, where he studied ceramics. He studied both art and sculpture in the art department of the New England Conservatory of Music in Boston and the Cincinnati Art Academy in Ohio. He also studied ceramics at the State University of Kansas at Pittsburg and at the College of Ceramics of the State University of New York at Alfred.

In addition to pursuing training in a variety of artistic media, Hathaway taught art to elementary school students in Kentucky. Fellow artists convinced him to start his own business. He meshed his artistic talents and his entrepreneurial skills to establish his first company, called the Afro-Art Company; the name was later changed to the Isaac Hathaway Art Company. Hathaway produced busts of prominent African Americans, including Frederick Douglass, GEORGE WASHINGTON CARVER, BOOKER T. WASHINGTON, and PAUL LAURENCE DUNBAR. He was the first artist to make death masks of famous African Americans. In 1915 he gained even more recognition as an artist and educator when he founded the Department of Ceramics at Tuskegee Institute in Alabama, thereby making ceramics a part of the college curriculum in the United States.

Hathaway broke racial barriers by having his work displayed in academic and government institutions. He contributed molded plaques and masks of both black and white figures that could be displayed on the walls of universities and churches. His busts and sculptures were in the homes of President Franklin D. Roosevelt, Vice President Henry Wallace, and the automotive industry's Ford family, also at Harvard University. Hathaway created bronze metal pieces as well.

In 1946 President Harry S. Truman authorized a commission by the U.S. Mint of a fifty-cent piece; Hathaway was also chosen to design the George Washington Carver commemorative fifty-piece coin in 1951.

Hathaway's wife was Umer G. Hathaway; her maiden name and the years of their marriage are not known. Although he was a forgotten artist at the time of his death in 1967 at age ninety-two, the nonprofit Isaac Scott Hathaway Museum was established in his hometown of Lexington in 2002 to develop a traveling exhibit for schools and civic groups. The museum is also considering the purchase of Hathaway's works and papers and the documenting of other famous African Americans from Lexington.

FURTHER READING

Guelzo, Allen. *Lincoln's Emancipation Proclamation: The End of Slavery in America* (2004).

"Isaac Scott Hathaway," in *African Americans in the Visual Arts: A Historical Perspective*, available online at http://www.cwpost.liunet.edu/cwis/cwp/library/aavaahp.htm.

RENÉE R. HANSON

HAWKINS, Coleman

(21 Nov. 1904–19 May 1969), jazz tenor saxophonist, was born Coleman Randolph Hawkins in St. Joseph, Missouri, the son of William Hawkins, an electrical worker, and Cordelia Coleman, a schoolteacher and organist. He began to study piano at age five and the cello at seven; he then eagerly took up the C-melody saxophone he received for his ninth birthday. Even before entering high school in Chicago, he was playing professionally at school dances. Recognizing his talent, his parents sent him to the all-black Industrial and Educational Institute in Topeka, Kansas. His mother insisted that he take only his cello with him. During vacations, however, Hawkins played both cello and C-melody saxophone in Kansas City theater orchestras, where the blues singer MAMIE SMITH heard him in 1921.

Smith hired Hawkins to tour with her Jazz Hounds, and he traveled and recorded with the group until June 1923, at which time he moved to New York City. There he played with a variety of groups and in numerous jam sessions. In August 1923 he recorded "Dicty Blues" with a FLETCHER HENDERSON group, and in early 1924 Henderson hired him for his new band. Although Hawkins doubled on both clarinet and bass saxophone for Henderson, he increasingly concentrated on the tenor and soon developed a style that revolutionized saxophone playing. At first he employed the technique that was all but universal among saxophonists at the time, slapping his tongue against the reed and producing sharp, staccato notes. Gradually, though, he adopted a more legato style. He was also influenced by the trumpeter LOUIS ARMSTRONG during Armstrong's brief stay with the Henderson band and by the complex harmonic improvisations of the young pianist Art Tatum, whom he heard in 1926.

By 1927 Hawkins was the band's featured soloist and was playing only tenor sax. His solo on "The Stampede" (1926) is a dramatic example of his growth, displaying a full, smooth tone and rhythmic assurance. Hawkins also played with other small groups during the late twenties and early thirties; his solo on "One Hour" (1929) with the Mound

Coleman Hawkins performs at the Newport Jazz Festival in July 1963. (AP Images.)

City Blue Blowers, for instance, showcases his rich tone and powerful emotionalism He made several outstanding recordings with the trumpeter Henry "Red" Allen, including the classic "It's the Talk of the Town" (1933). By now the master of his instrument, Hawkins had fully developed his harmonic approach to improvisation, a marked contrast to the more melodic, scalar approach of the tenor saxophonist Lester Young and others. Hawkins thought about the implications of each chord as it came, adding notes or changing them to create sweeping melodic lines. By then he was a jazz celebrity, but success began to take its toll on his personal life when he and his wife, Gertrude (they had married in 1923), separated.

Hawkins left Henderson in 1933 and arranged a deal with the English impresario Jack Hylton to tour England. He planned to take only a six-month leave but remained overseas until 1939, traveling and performing constantly. Noteworthy recordings include

1935 sessions with a Dutch group known as the Ramblers and a 1937 Paris session with Benny Carter on alto saxophone and trumpet and the Belgian guitarist Django Reinhardt.

When Hawkins returned to New York City in July 1939, his fans greeted him ecstatically. He planned to form his own big band, but musicians of his caliber were more interested in leading their own groups than in joining his. So he put together a small group to play at Kelly's Stable, then on West Fifty-first Street. On 11 October, only six days after opening there, he cut four sides at a recording date for RCA Victor. Almost as an afterthought, and with no rehearsal, he concluded the session with one of the most celebrated and influential performances in jazz history, "Body and Soul."

Hawkins had already experimented a number of times with three- and four-minute ballad improvisations, and he recorded two side-long solos in London accompanied only by the pianist Stanley Black. Although he often spoke of the spur-of-the-moment nature of his choice, it could not have been a complete surprise, since he had been playing an extended late-night version of "Body and Soul" at Kelly's. Now, in one sixty-four-bar improvisation with only minimal rhythm accompaniment, he created a solo that the composer-critic Gunther Schuller described as "a melodic/harmonic journey through a musical landscape without any fault lines." He flirts with the original melody for the first few bars, then quickly moves away, developing his own related harmonic ideas and gradually raising the pitch and intensifying the rhythm and dynamics with each extended group of phrases. By the final bars his initially warm, vibratoless sound becomes almost strident, intensified by a wide, pulsing vibrato. The recorded performance was a best-seller, and it has since become the ultimate touchstone of great tenor playing.

Hawkins toured with his own big band in early 1940, but he lacked the showmanship essential to such a venture, and the group folded. In May 1940 he cut a series of recordings for the Commodore label with a group called the Chocolate Dandies that included three of the best swing players of the era: trumpeter Roy Eldridge, drummer Sid Catlett, and Benny Carter. A few months later he met the young Delores Sheridan in Chicago, and they were married in October 1941. Hawkins moved back to New York in early 1942 to spend more time with his family, which by the end of the decade had grown to include three children. Among his recording highlights during the middle 1940s were three sessions for Signature records and the legendary 1944 Keynote recordings. He also began a long and satisfying relationship with Norman Granz's Jazz at the Philharmonic tours.

Unlike other swing players, Hawkins warmly embraced the modernist bop movement. In February 1944 he led a band that included Dizzy Gillespie on trumpet and Max Roach on drums in the first bop recordings; later that year he included the pianist Thelonious Monk on a recording session. Throughout his life Hawkins offered younger players encouragement and advice, often talking with them on the phone for hours and inviting them to his apartment to examine and listen to his extensive collection of classical records, books, and scores. At the same time he continued to strongly influence swing-oriented contemporaries such as Ben Webster, Don Byas, Herschel Evans, Budd Johnson, and many others.

By 1947 the club scene on Fifty-second Street was dying, and Hawkins left for a series of engagements in Paris, returning to Europe in 1949. The artistic highlight of this period was his recorded solo improvisation "Picasso," a revolutionary venture for the time. He continued to record extensively during the 1950s and to perform continuously in Europe and the United States, and he initiated a performance relationship with Roy Eldridge that was to last, off and on, for the next fifteen years. Two of their best albums together were *The Big Challenge* and a collection of emotionally powerful ballads, *The High and Mighty Hawk*. Once again, though, the demands of his career affected Hawkins's personal life. In 1958 he and his second wife separated, and the sense of order and balance that had come to characterize his life seemed to dissipate.

For a few years his career hardly missed a beat. He appeared on the television programs *The Sound of Jazz* (1957) and *After Hours* (1961), toured South America in 1961, played a series of dates with Eldridge at the Museum of Modern Art, and recorded several landmark albums, including a 1962 session with DUKE ELLINGTON and the classic *Further Definitions* (1961), a small band effort led by Benny Carter and featuring four leading saxophonists. Hawkins also maintained a home base at the Club Metropole, often playing there with Eldridge. Although dismayed by the appearance of free jazz—the first modernist movement he could

not understand or enjoy—he recorded with some of the more traditionally grounded modernists such as SONNY ROLLINS and JOHN COLTRANE, both of whom were profoundly influenced by Hawkins's playing.

A fear of aging had always possessed Hawkins, and it seemed to overcome him in the early 1960s. He steadily withdrew, eating less and drinking more; he was fired from several jobs because he could not get along with other players or because of his drinking. He lost a frightening amount of weight, and by early 1966 his physical appearance, once a source of great personal pride, began to deteriorate. In February 1967 he collapsed while playing in Toronto, but he refused to be hospitalized and returned two nights later to complete the engagement. He embarked on a thirteen-week tour of Canadian and American cities, but he often played poorly. He collapsed again on stage in Oakland, California, on 30 June and was never healthy again. For the most part he remained in his New York apartment, his children and second wife visiting and trying to care for him. When the writer-producer Dan Morgenstern met him at the Chicago airport in April 1969, he was stunned by the saxophonist's emaciated appearance; Hawkins collapsed there while waiting for a car. He performed a moving version of "Yesterdays" for a television show, but it was all he could manage. The pianist at the session, Barry Harris, took Hawkins back to New York, and when Hawkins failed to show up for a rehearsal Harris asked that an apartment-house security guard check on him. Hawkins was found crawling across the floor of his apartment, dragging his horn. He was taken to Wickersham Hospital, where he died.

Hawkins brought the tenor saxophone into the mainstream of jazz and popular music, and he helped pioneer a then-modernist approach to improvisation, based on chords rather than melody. He profoundly influenced tenor saxophonists of his own generation, served as a mentor to the bop movement, and was a model and inspiration to some of the most important later players, particularly Sonny Rollins and John Coltrane. His musical presence could be overwhelming, and listening to his recordings can be a moving experience. More than most of his jazz contemporaries, finally, Hawkins was a man of the world, driven by a deep sense of intellectual curiosity. He listened to music of every kind, and he loved Bach most of all,

especially Bach's mastery of improvising on a theme. "It's just music-adventure," he once noted. "That's what music is, adventure."

FURTHER READING
Chilton, John. *The Song of the Hawk: The Life and Recordings of Coleman Hawkins* (1990).
Harrison, Max, Charles Fox, and Eric Thacker. *The Essential Jazz Records*, vol. 1 (1984).
James, Burnett. *Coleman Hawkins* (1984).
McCarthy, Albert. *Coleman Hawkins* (1963).
Schuller, Gunther. *The Swing Era: The Development of Jazz, 1930–1945* (1989).

Obituary: New York Times, 20 May 1969.

RONALD P. DUFOUR

HAYDEN, Palmer

(15 Jan. 1890–18 Feb. 1973), painter, was born Peyton Cole Hedgeman, the fifth of thirteen children in Widewater, Virginia, to James Hedgeman, an illiterate professional hunter and tour guide for fishermen, and Nancy Hedgeman. Hayden began to draw at the age of four, but he also loved music and longed for a fiddle. He later illustrated these two passions in the painting *Midnight at the Crossroads* (n.d.), a self-portrait as a boy holding a fiddle, wondering which path to take.

As a teenager, Hayden was part of the Great Migration of African Americans moving to the North and arrived in Washington, D.C., in 1906, where he worked in a drugstore, and then was a roustabout and did graphic design for the Ringling Brothers Circus. In 1912 Hayden joined the U.S. Army 24th Infantry Regiment in New York, with a letter of reference from a timekeeper at the Catskill water conduit, where Hayden had worked as a sandhog in a shaft. The timekeeper wrote Hayden's name erroneously, but the artist left it as it was, afraid to tell recruiters about the mistake. While serving in the Philippines, Hayden received a commendation for mapmaking. He wanted to study in Europe in 1915, but because World War I was going on, he reenlisted with a detachment of black cavalrymen (part of the Tenth Cavalry) stationed at West Point, where he was responsible for taking care of horses. While there, he took a correspondence course in drawing.

Honorably discharged from the army in 1920, Hayden worked for the postal service and began taking summer art classes at Columbia University,

which he would continue for four years, receiving average grades. He exhibited landscapes and illustrations of Hiawatha at the Society of Independent Artists in New York on a regular basis, beginning in 1922. In 1924 Hayden got a job as a custodian from Victor Pérard, an art instructor at Cooper Institute (later Cooper Union). He also cleaned homes part-time, including those of the wealthy Alice Miller Dike, and worked for two summers for Asa Randall of the Commonwealth Art Colony in Boothbay Harbor, Maine.

After Hayden's first solo exhibition of fifteen landscapes and marine studies at the Civic Club in 1926, Dike encouraged him to enter a painting—a Maine waterfront scene titled *Boothbay Harbor*—to the Harmon Foundation competition. When it won first prize of a gold medal and $400, Dike gave him $3,000 to go to Europe.

Hayden studied privately in Paris and traveled throughout Brittany while in France from 1927 to 1932. He retained a rather flat, somewhat naive painting style throughout his career, almost exclusively depicting African American folk culture in a celebratory, caricature-like manner, as in *Bal jeunesse* (c. 1927), modeled after the Bal Nègre nightclub in Paris. He painted black families, workers, churchgoers, soldiers, and heroes from memory, inspired by dreams, folktales, and legends.

Hayden exhibited harbor scenes, watercolors of Breton peasants, and images of rural blacks at Galerie Bernheim-Jeune (1927), for which he received a favorable review; the Salon des Tuileries (1930); and two paintings at the American Legion (1931). He enjoyed a lively social life abroad, and *Nous quatre à Paris* (c. 1928–1930) simultaneously invokes the card-playing motif often explored by Paul Cézanne and the leisure activities of African American expatriates, including the painter HALE A. WOODRUFF, and the writers COUNTÉE CULLEN, ERIC WALROND, and CLAUDE MCKAY. Yet *Nous quatre à Paris* is genre portraiture, for the four black male card players are rendered abstractly and are informed by the strong volumes of West African ritual sculpture and modernist modes indebted to it. Another figurally abstract genre painting, *The Janitor Who Paints* (c. 1931) was inspired by Cloyd Boykin, a friend who painted in his Harlem basement apartment; this painting was later published in ALAIN C. LOCKE's *The Negro in Art* (1940). Hayden also produced a series of watercolors depicting African dancers from the Ivory Coast whom he saw perform at the Colonial Exposition of 1931 in Paris. His well-known painting *Fétiche et Fleurs* (c. 1932), with its Fang sculpture head and Kuba textile reinvigorating the still life genre, reflects both the influence of African art on modern European painting and Alain Locke's call for racially representative art. It won the Mrs. John D. Rockefeller Jr. Prize from the Harmon Foundation, but Hayden never produced another still life like it.

Back in New York, Hayden worked for the easel division of the Federal Arts Project of the Works Project Administration from 1934 to 1940, when he was disqualified for marrying an employed white schoolteacher, Miriam Hoffman of Des Moines, Iowa. The couple had no children. Hayden had a solo exhibition at the New Jersey State Museum in 1935. In 1936 he took a second trip to Paris, and Bernheim-Jeune exhibited his work again the following year. At this time his work, such as *Midsummer Night in Harlem* (1936), which featured minstrel-like representations of blacks on a crowded urban street, shared much in common with commercial images of blacks in Europe. Like several of Hayden's compositions, *Midsummer Night in Harlem* was ironic and satirical, but critics like JAMES AMOS PORTER decried its unrealistically colored, dark-skinned figures with exaggerated facial features and deemed the artist's work ludicrous. Others championed these images and found humor in Hayden's representation of African American working-class and folk subjects. Themes throughout Hayden's career concerned old-time religion, the rural South (milking time, hog killing, berry pickers, etc.), rites of friendship and courtship, and music (piano, banjo, and guitar playing and singing). Hayden's work was included in two group exhibitions in 1940, at Rockefeller Center Galleries in New York and Tanner Art Galleries in Chicago. Five years later it appeared at the Albany Institute of Art and History.

In 1944 Hayden traveled to Big Bend Tunnel in the Berkshires of West Virginia to gather material for his *Ballad of John Henry* series, which he had first begun in Paris in the early 1930s. In 1947 Argent Galleries of New York exhibited these twelve paintings of the black steel-driving legend, Hayden's best-known work. The Frick Fine Art Gallery at the University of Pittsburgh would display it more than two decades later, in 1969.

Hayden's New York circle included ELLIS WILSON, Joseph Delaney, BEAUFORD DELANEY,

SELMA HORTENSE BURKE, and ROBERT HAMILTON BLACKBURN, artists who met in 1947 to discuss the problems of African American artists.

Just days before Hayden's death, he received a Creative Artists Public Service Program Foundation commission to paint a black soldier series from World War I until the end of segregated military units. Hayden's work has been exhibited at Atlanta University, Fisk University, the Oakland Museum of Art, the California Museum of African American Art in Los Angeles, and the Smithsonian American Art Museum.

FURTHER READING

Driskell, David Clyde. "The Flowering of the Harlem Renaissance: The Art of Aaron Douglas, Meta Warrick Fuller, Palmer Hayden and William H. Johnson," in *Harlem Renaissance: Art of Black America* (1987).

Gordon, Allan M. *Echoes of Our Past: The Narrative Artistry of Palmer C. Hayden* (1988).

Leininger-Miller, Theresa. "Painting Seascapes and "Negro Characters" : Palmer Hayden in Paris, 1927–1932," in *New Negro Artists in Paris: African American Painters and Sculptors in the City of Light, 1922–1934* (2001).

Sélig, Raymond. "L'oeuvre de Palmer Hayden," *La Revue du Vrai et du Beau* (27 Apr. 1927).

THERESA LEININGER-MILLER

HAYDEN, Robert Earl

(4 Aug. 1913–25 Feb. 1980), poet and teacher, was born Asa Bundy Sheffey in Detroit, Michigan, the son of Asa Sheffey, a steel mill worker, and Gladys Ruth Finn. Early in his childhood, his parents separated, and he was given to neighbors William and Sue Ellen Hayden, who also were black, and who reared and renamed him. Hayden grew up in a poor, racially mixed neighborhood. Extremely near-sighted, unathletic, and introverted, he spent much of his youth indoors reading and writing. When he was eighteen, he published his first poem. Hayden attended Detroit City College from 1932 to 1936; worked for the Federal Writers' Project of the Works Progress Administration (WPA) from 1936 to 1938; published his first volume of poetry, *Heart-Shape in the Dust*, in 1940; and, studying with W. H. Auden, completed an MA in English at the University of Michigan in 1944. In 1946 he began teaching English at Fisk University in Nashville, Tennessee.

During his twenty-three years at Fisk, he published four volumes of poetry: *The Lion and the Archer* (with Myron O'Higgins, 1948), *Figure of Time* (1955), *A Ballad of Remembrance* (1962), and *Selected Poems* (1966). These were years of demanding college teaching and creative isolation, but they were brightened by a Rosenwald Fellowship in 1947; a Ford Foundation grant to write in Mexico in 1954–1955; and the Grand Prize for Poetry in English at the First World Festival of Negro Arts in Dakar, Senegal, in 1966. At a writers' conference at Fisk, also in 1966, Hayden was attacked by younger blacks for a lack of racial militance in his poetry. Hayden's position, however, first articulated in 1948, was that he did not wish to be confined to racial themes or judged by ethnocentric standards. His philosophy of poetry was that it must not be limited by the individual or ethnic identity of the poet. Although inescapably rooted in these elements, poetry must rise to an order of creation that is broadly human and universally effective. He said "I always wanted to be a Negro, or a black, poet . . the same way Yeats is an Irish poet." He was trying, like William Butler Yeats, to join the myths, folk culture, and common humanity of his race with his special, transcendent powers of imagination. Hayden's Baha'i faith, which he adopted in the 1940s, and which emphasized the oneness of all peoples and the spiritual value of art, also helped sustain him as a poet. In the late 1970s he said, "today when so often one gets the feeling that everything is going downhill, that we're really on the brink of the abyss and what good is anything, I find myself sustained in my attempts to be a poet . . . because I have the assurance of my faith that this is of spiritual value and it is a way of performing some kind of service."

In 1969 Hayden joined the department of English of the University of Michigan at Ann Arbor, where he taught until his death. During these years he published *Words in the Mourning Time* (1970), *The Night-blooming Cereus* (1973), *Angle of Ascent: New and Selected Poems* (1975), and *American Journal* (1978, rev. ed., 1982). He was elected to the American Academy of Poets in 1975 and appointed consultant in poetry to the Library of Congress from 1976 to 1978, the first African American to be selected.

Shifting from a romantic and proletarian approach in *Heart-Shape in the Dust* to an interest in rich language and baroque effects in *The Lion and the Archer*, Hayden's mature work did not appear until *A Ballad of Remembrance*. *Ballad* presents

the first well-rounded picture of Hayden's protean subjects and styles as well as his devotion to craft. *Selected Poems* extends this impression and is followed by *Words in the Mourning Time*, which responds to the national experience of war, assassination, and racial militance in the late 1960s. Hayden's next volumes—*The Night-blooming Cereus*, the eight new poems in *Angle of Ascent*, and *American Journal*—reveal an aging poet yielding to his aesthetic nature and his love of art and beauty for their own sake.

An obsessive wordsmith and experimenter in forms, Hayden searched for words and formal patterns that were cleansed of the egocentric and that gave his subjects their most objective aspect. Believing that expert craft was central, he rejected spontaneous expression in favor of precise realism, scrupulous attention to tone, and carefully wrought verbal mosaics. In Hayden's poetry, realism and romanticism interact, the former deriving significantly from his interest in black history and folk experience, the latter from his desire to explore subjective reality and to make poetry yield aesthetic pleasure. As Wilburn Williams Jr. has observed: "Spiritual enlightenment in his poetry is never the reward of evasion of material fact. The realities of the imagination and the actualities of history are bound together in an intimate symbiotic alliance that makes neither thinkable without the other." Some of the major themes of Hayden's poetry are the tension between the tragic nature of life and the richness of the imagination, the past in the present, art as a form of spiritual redemption, and the nurturing power of early life and folk memories. His favorite subjects include the spirit of places, folk characters, his childhood neighborhood, and African American history.

In the debate about the purpose of art, Hayden's stance, closer to the aesthete than the propagandist, has exposed him to criticism. Yet the coalescence in Hayden's poetry of African American material with a sophisticated modernism represents a singular achievement in the history of American poetry. His poetry about black culture and history, moreover, reveals the deepest of commitments to his own racial group as well as to humanity as a whole.

Hayden was married in 1940 to Erma Morris, with whom he had one child. He died in Ann Arbor.

FURTHER READING

Hatcher, John. *From the Auroral Darkness: The Life and Poetry of Robert Hayden* (1984).

Williams, Pontheolla T. *Robert Hayden: A Critical Analysis of His Poetry* (1987).

ROBERT M. GREENBERG

HAYES, Roland

(3 June 1887–31 Dec. 1976), singer, was born in Curryville, Georgia, the son of William Hayes and Fanny (maiden name unknown), tenant farmers and former slaves. Young Roland worked as a field hand from an early age alongside his mother and two brothers. William Hayes had become an invalid following an accident when Roland was an infant, and he died when Roland was twelve. Although neither parent could read or write, Fanny Hayes was determined that her children would get an education. However, Roland was able to attend local country schools, which were inferior and segregated, for only a few months at a time, when he was not needed in the fields. At the age of fifteen, he and his family moved to Chattanooga, Tennessee, as part of his mother's plan to have her sons educated. The three boys were to alternate school and work

Roland Hayes in 1954. (Library of Congress. Photographed by Carl Van Vechten.)

a year at a time, with one brother working to help support the family while the two others studied.

Hayes found employment as a laborer in a machine shop, and despite the harsh working conditions—in one of several accidents, hot iron splashed on his feet and left permanent scars—he rose to foreman. When his turn came to take a year off and attend school, he decided against it because he was making more than his brothers could earn. He therefore stayed at the machine shop and was tutored in the evenings by a local black teacher.

Like many of his fellow workers, Hayes often sang as he labored. At his church, his distinctive tenor voice attracted the attention of the choir director, W. Arthur Calhoun, an African American who was taking a year off from his studies at Oberlin College Conservatory in Ohio. Calhoun persuaded Hayes to sing in the choir and offered to help him develop his voice. Fanny Hayes refused to let Calhoun give her son singing lessons, however, believing that black musicians were trashy riffraff. Calhoun persisted, and one day he took Hayes to the home of a prosperous white man who owned a phonograph. When the man played operatic recordings, including performances by the Italian tenor Enrico Caruso, Hayes was overwhelmed—he later described it as a mystical experience—and vowed that despite his mother's opposition he would become a singer.

With Calhoun's encouragement, Hayes set out for Oberlin, but when he reached Nashville he realized he did not have enough money to continue the journey to Ohio. He enrolled instead at Fisk University, an all-black institution in Nashville, where he was placed in the preparatory division. Hayes studied at Fisk for four years and took singing lessons there; he supported himself by working as a servant. Suddenly, in 1910, he was dismissed from the school—apparently because he had begun singing for organizations off campus and had not received the required permission from school authorities to do so.

The dejected Hayes moved farther north, to Louisville, Kentucky, and became a waiter in a men's club. His voice again attracted attention, and he was asked to sing at various gatherings. Hayes had remained in touch with his singing teacher at Fisk, and in 1911 he was asked to join the university's famous performing group, the Fisk Jubilee Singers, in a concert appearance in Boston. Putting aside his bitterness, Hayes agreed. After the concert, he decided to stay in Boston, which became his home for the remainder of his life.

Hayes worked first as a hotel bellboy and then as a messenger at an insurance company while continuing his vocal studies with Arthur J. Hubbard, a teacher of some renown. When his brothers married, Hayes moved his mother to Boston. She lived with him there, and he supported her on his small wages. Their home was a tenement room, where they used packing boxes for furniture. Fanny Hayes was now supportive of her son's decision, and her encouragement, combined with Hubbard's, fueled Hayes's determination to be a great singer.

In 1917, with the help of Hubbard, Hayes rented Symphony Hall in Boston to give a recital—the first black musician ever to do so. His performance of Negro spirituals, lieder, and continental art songs was a notable success, and it launched his career. However, opportunities for black concert singers in the United States were limited, and Hayes knew that a climb to prominence would take time. After four years of local appearances, he had saved enough money to go abroad. In 1921 he gave several recitals in London, including a command performance for King George V and Queen Mary at Buckingham Palace. He then went on to appear in Paris, Vienna, and Prague, taking voice lessons in those cities.

Upon his return to the United States after a triumphal year in Europe, Hayes was hailed as a musical sensation. Singing a repertoire of spirituals, folk and art songs, and occasional operatic arias, he began what was to become a series of concert appearances throughout the United States and Europe during the next four decades. In addition to giving recitals, Hayes appeared with the Boston, Philadelphia, and Detroit symphonies, the New York Philharmonic, and leading orchestras in Paris, Amsterdam, Vienna, and Berlin. Many noted musicians of the twentieth century, including Ignace Paderewski, Sergei Rachmaninoff, Pablo Casals, Fritz Kreisler, and Nellie Melba, championed Hayes, who became the first black to be recognized as a serious musician on the American concert stage.

A deeply religious man throughout his life, Hayes believed that God had given him his voice for a purpose: to express the soul of his race. His success served as an example to younger black singers, and his encouragement of MARIAN ANDERSON, PAUL

ROBESON, and others helped launch their careers. Although some critics considered Hayes the equal of Lauritz Melchior, Giovanni Martinelli, and other renowned operatic tenors who were his contemporaries, his race deprived him of a career in opera. Black performers began to appear on the American operatic stage only after Anderson's debut with the Metropolitan Opera in 1955, and by then Hayes was in his late sixties.

Hayes refused to become embroiled in discussions about racism, even after a widely publicized incident in 1942 when he and his family were arrested in a shoe store in Rome, Georgia, after they sat in chairs reserved for whites. "I am not bitter," he said after his release. "I am only ashamed that this should happen in my native state. I love Georgia."

Hayes continued to perform in public until the early 1960s. To mark his seventy-fifth birthday in June 1962, he gave a recital at Carnegie Hall in New York City, and in a ceremony at city hall he was honored by Mayor Robert F. Wagner and a number of distinguished black performers, including Robeson, Anderson, and Leontyne Price.

Hayes was married to Helen A. Mann (the exact date of the marriage is unknown); they had one daughter, who later became a concert singer under the name Afrika Lambe. The family maintained a home in Brookline, Massachusetts, a Boston suburb, as well as a six-hundred-acre farm in Curryville, Georgia, which included his birthplace. One of Hayes's most valued possessions was the original phonograph from Chattanooga on which he heard operatic music for the first time. During his lifetime he received numerous awards, including the NAACP's Spingarn Medal and eight honorary degrees. Hayes died in Boston.

FURTHER READING

Brooks, Tim, and Richard K. Spottswood. *Lost Sounds: Blacks and the Birth of the Recording Industry, 1890–1919* (2004).

Hare, Maud Cuney. *Negro Musicians and Their Music* (1936).

Hayden, Robert C. *Singing for All People: Roland Hayes, A Biography* (1995).

Helm, Mackinley. *Angel Mo' and Her Son* (1942).

Stidger, William L. *The Human Side of Greatness* (1940).

Obituary: New York Times, 2 Jan. 1977.

ANN T. KEENE

HAYNES, Daniel

(6 June 1889–29 July 1954), actor, singer, and minister, was born in Atlanta, Georgia, the son of Charles Haynes, a bricklayer, and Mary ("Mollie") Leech, an office cleaner. Haynes was educated in the Atlanta public schools and graduated from the African Methodist Episcopal (AME) Church–affiliated Morris Brown College.

Haynes worked as a porter in Atlanta and as an itinerant preacher before securing a job in the records division at the Standard Life Insurance Company in Atlanta around 1915. Founded by Heman Edward Perry in 1913, Standard was one of the nation's few black life insurance companies, and Haynes gained valuable business experience working with one of the most active black entrepreneurs in America. While at Standard, he also met HARRY HERBERT PACE, the company's secretary-treasurer, with whom he would later work in New York. Haynes registered for the draft in 1917 and, according to one source, served in military intelligence during World War I.

In 1920 Haynes married Rosa B. Sims, also a graduate of Morris Brown College, and they moved to New York City, where he began working as a bookkeeper for the Pace and Handy Music Company. Harry H. Pace and W. C. HANDY, the company's founders, wrote and published sheet music, which they sold to white-owned record companies. When Pace split with Handy to found the Pace Phonograph Corporation and Black Swan Records, Haynes joined him as chief bookkeeper. Working with Pace placed Haynes in an environment in which he was able to meet some of the most influential musicians and composers of the day, including FLETCHER HENDERSON and WILLIAM GRANT STILL, as well as performers who would soon make their mark, such as ETHEL WATERS and ALBERTA HUNTER. His interaction with these great performers no doubt influenced him musically and aided him when he began his own performing career a few years later.

Black Swan Records ceased production in 1923, and little is known about Haynes's employment at this time. He may have worked as a part-time minister, having been licensed to preach in the AME Church in 1920. Some accounts indicate that he owned a small publishing business in Brooklyn, New York, in this period.

Haynes's performing career began in 1927, when friends in the theater enlisted him to serve as the

understudy to the famed actor CHARLES SIDNEY GILPIN in the Broadway production of *The Bottom of the Cup*. When Gilpin's illness prevented him from performing, Haynes assumed the lead role on opening night. Although the play was poorly reviewed, Haynes's performance was well received by critics. He went on later that year to play the lead role of a minister in *Earth* and appeared in the musical revue *Rang Tang*, which starred the vaudeville team of Flournoy Miller and Aubrey Lyles and featured the well-known stage and film actress EVELYN PREER. Haynes was also JULES BLEDSOE's understudy in the hit Ziegfeld production of *Show Boat* during its original run from 1927 to 1929, briefly assuming the lead in 1928.

Haynes achieved considerable fame when the white film director King Vidor cast him in the lead role of the Metro-Goldwyn-Mayer film *Hallelujah* (1929), which told the story of the rise and fall of a farmer-turned-revivalist preacher. The second all-black-cast film produced by a major Hollywood studio and Vidor's first sound film, *Hallelujah* became the focus of lively and heated discussion in the black press about the impact of film images of black religious life on African Americans' political and social opportunities. Haynes participated in these discussions, writing in the *New York Amsterdam News* about his sense of the film's realistic portrayal of black southern life and expressing gratitude to Vidor for providing a significant opportunity for black performers. Some African American commentators agreed with Haynes, but many insisted that the film's representation of black religion emphasized childish emotionalism. *Hallelujah*'s interpretation of African American religious practices, they argued, confirmed some white Americans' belief in the inherent and permanent backwardness of black people. Even as critics and audience members debated the film's political significance, most agreed that the performances, especially those of Haynes and his costar NINA MAE MCKINNEY, were strong and memorable.

Despite the positive reviews, it remained difficult for Haynes to find consistent work in Hollywood, where there were few parts for African American actors, and he returned to the stage in a number of capacities. His recording on Victor Records with the Dixie Jubilee Singers of Irving Berlin's "At the End of the Road" from *Hallelujah* led him to a brief career as a singer, including serving briefly as a featured singer with the HALL JOHNSON Choir, which specialized in singing African American spirituals. He returned to Broadway in 1930 when the white playwright and director Marc Connelly cast him in the parts of Adam and Hezdrel in his Pulitzer Prize–winning play *The Green Pastures*, a dramatization of stories from the Hebrew Bible set in an all-black context. The play was wildly successful, running on Broadway for more than a year and providing Haynes and the other cast members with steady work during its national and international tours beginning in 1931, and its return Broadway run in 1935. Haynes found small parts in a number of Hollywood films following his work in *The Green Pastures*, including in *Escape from Devil's Island* (1935), King Vidor's *So Red the Rose* (1935), Fritz Lang's *Fury* (1936), and *The Invisible Ray* (1936). He also appeared as Ferrovius in the Federal Theatre Project's production of George Bernard Shaw's *Androcles and the Lion*, which ran from 1938 to 1939.

Haynes retired from performing around 1939 and turned to a full-time career in the ministry. Ordained as an AME minister in 1941, he served as pastor of a number of churches in Brooklyn, Long Island, and Kingston, New York. He retired as pastor of St. Mark's AME Church in Kingston in 1952 and died of a heart attack in July of 1954.

Haynes's contributions as an actor intersect with his lifelong religious commitments. A compelling performer with a commanding presence, Haynes became one of the most significant dramatic interpreters of African American religious life in American theater and film in the 1920s and 1930s.

FURTHER READING

Ottley, Roi and William Weatherby, eds. *The Negro in New York: An Informal Social History, 1626–1940* (1967).

Weisenfeld, Judith. *Hollywood Be Thy Name: African American Religion in American Film, 1929–1949* (2007).

Obituary: New York Times, 30 July 1954.

JUDITH WEISENFELD

HAYNES, George Edmund

(11 May 1880–8 Jan. 1960), sociologist and social worker, was born in Pine Bluff, Arkansas, the son of Louis Haynes, an occasional laborer, and Mattie Sloan, a domestic servant. He was raised by devout, hardworking, but poorly educated parents.

His mother stressed that education and good character were paths to improvement. She moved with Haynes and his sister to Hot Springs, a city with better educational opportunities than Pine Bluff. Haynes attended Fisk University, completing his BA in 1903. His record at Fisk enabled him to go to Yale University, where he earned an MA in Sociology in 1904. He also won a scholarship to Yale's Divinity School but withdrew early in 1905 to help fund his sister's schooling.

In 1905 Haynes became secretary of the Colored Men's Department of the International (segregated) YMCA, traveling to African American colleges throughout the nation from 1905 to 1908. During this period he encountered Elizabeth Ross (Elizabeth Ross Haynes), a Fisk alumna and sociologist who later became the first secretary of Negro youth with the YWCA. Haynes married Ross in 1910; they had one son. Haynes studied for two summers at the University of Chicago, then left his YMCA work in 1908 to do graduate study in sociology at Columbia University and at its social work affiliate, the New York School of Philanthropy (later the Columbia University School of Social Work). In 1910 he became the first African American to graduate from this social work school, and two years later he became the first African American to earn a PhD at Columbia. His doctorate was in economics and his dissertation, *The Negro at Work in New York City* (1912), became his first book. It called for greater attention to urban blacks, whose population was continuing to grow.

While in New York Haynes worked with groups seeking to aid African Americans in cities. One group was the National League for Protection of Colored Women (NLPCW), which was established in 1906 by merging branches of the Association for the Protection of Colored Women that had been formed in 1905 in cities such as New York and Philadelphia. The league sought to protect African American women who migrated northward to cities from being exploited by unscrupulous recruiters. Another group with which Haynes worked was the Committee for Improving the Industrial Conditions of Negroes in New York (CIICNNY), which was also formed in 1906. This group sought to expand employment opportunities for African Americans and hired Haynes to do research through interviewing prospective employees.

Frances Kellor and Ruth Standish Baldwin, leaders in the NLPCW and the CIICNNY, shared Haynes's concern that many more black social workers needed college training and internships in agencies. Haynes hoped to have blacks work as equals with whites rather than having groups dominated by whites working on problems affecting African Americans. Along with Kellor and Baldwin, Haynes proposed that the CIICNNY expand its work to train and intern black social workers. When the CIICNNY declined, Haynes and Baldwin in 1910 led the effort to form a third group, the Committee on Urban Conditions among Negroes (CUCAN).

Overlapping leadership, membership, and programs led to a federation of all three groups in 1911 as the National League on Urban Conditions among Negroes, a title shortened in 1920 to the National Urban League. Haynes became its first executive secretary (1911–1917). The Urban League regards Haynes as its founder and considers its starting date 19 May 1910, when the CUCAN was formed. Haynes

George Edmund Haynes, social worker and sociologist, founder of the National Urban League. (University of Massachusetts, Amherst.)

was a moderate leader, more militant than BOOKER T. WASHINGTON but not as strident as W. E. B. DU BOIS.

As part of his overall career design, Haynes had moved to Fisk University in the fall of 1910 to teach economics and to set up a sociology department to train black social workers for internships in cities. He had hired EUGENE KINCKLE JONES in April 1911 as assistant secretary of CUCAN to direct day-to-day operations in New York. Haynes commuted to New York every six weeks and spent his summers there, but eventually Jones won over the board and staff, becoming coexecutive with Haynes in 1916 and becoming the executive secretary in 1917, with Haynes given a subordinate role. Urban League leaders increasingly deemed a full-time executive imperative, a need Haynes never met.

In a face-saving move, Haynes took a federal post in 1918, leaving first the Urban League then Fisk. His post, which he held until 1921, was the director of Negro Economics, a special assistant to the secretary of labor. His main task was to allay friction arising from blacks migrating to factory jobs in the North. His research in this position resulted in another book, *The Negro at Work during the World War* (1921).

From 1921 until he retired in 1946, Haynes worked for the Federal (later National) Council of Churches, heading the council's Race Relations Department. In 1923 he founded Race Relations Sunday, and in 1940 he initiated Interracial Brotherhood Month. His department fostered interracial conferences, clinics, and committees, and he published two more books, *The Trend of the Races* (1922) and *The Clinical Approach to Race Relations* (1946). In 1930 and again in 1947 Haynes conducted surveys in Africa on behalf of the YMCA, writing his final book, *Africa: Continent of the Future* (1950).

Haynes also wrote numerous articles and engaged in many civic activities. He organized and administered the Harmon Foundation Awards for black accomplishment from 1926 to 1931. He lobbied for antilynching laws and worked hard to save the SCOTTSBORO BOYS (nine black youths unjustly charged—and some sentenced to lengthy jail terms—in Alabama for an alleged rape), forming the American Scottsboro Committee (1934). He helped form and chaired the Joint Committee on National Recovery (1933–1935) to secure a fair share of New Deal programs for African Americans. Together with A. PHILIP RANDOLPH, he fought

from 1937 to 1940 to prevent communists from taking control of the National Negro Congress. Haynes served on a commission on the need for a state university in New York and on the board of the state university system (1948–1954) when it was set up.

During the 1950s Haynes was at the City College of New York, teaching courses on black history, interracial matters, and Africa in world affairs. After his first wife died in 1953, Haynes married Olyve Love Jeter in 1955; they had no children. He died in New York City.

FURTHER READING

Haynes's personal papers are in the George Edmund Haynes Collection at Yale University. Additional papers are in the Erastus Milo Cravath Library at Fisk University in Nashville, Tennessee. The National Urban League's Archives (covering 1910 to 1965) are in the Manuscripts Division of the Library of Congress. Haynes's work with the Race Relations Department of the National Council of Churches is documented in the council's archives in New York City.

Brooks, Lester, and Guichard Parris. *Blacks in the City: A History of the National Urban League* (1971).

Weiss, Nancy J. *The National Urban League, 1910–1940* (1974).

Obituary: New York Times, 10 Jan. 1960.

EDGAR ALLAN TOPPIN

HEDGEMAN, Anna Arnold

(5 July 1899–17 Jan. 1990), civil rights and women's rights activist and government administrator, was born Anna Arnold in Marshalltown, Iowa, to Marie Ellen Parker and William James Arnold II. The granddaughter of slaves, Arnold grew up in Anoka, Minnesota. Her parents, particularly her father, stressed the importance of education, religion, and discipline. She attended Hamline University in St. Paul, Minnesota, from 1918 to 1922. She majored in English and pursued her studies with a passion that marked the way she lived her life. In 1919 she attended a lecture given by W. E. B. DU BOIS, who had just returned from the Pan-African Conference held in Paris. This was her initial exposure to the African freedom struggles.

In the spring of 1922 Arnold became Hamline University's first black graduate. Shortly afterward she boarded a train for Holly Springs, Mississippi, and began her teaching career at Rust College. On

her trip to the South, she confronted the realities of the Jim Crow transportation system when she was forced to change trains halfway through the ride.

Rust College was a vibrant place, but its resources were stretched to the limit. During her two years in Holly Springs, Arnold began to grasp the devastating impact of racism. At the same time she learned about black history from Dr. J. Leonard Farmer, the dean of Rust College and the father of the future civil rights leader James Farmer. Frustrated by her inability to effect change, Arnold returned to the North in 1924, eager to work in a world she believed was more tolerant about race relations. But she quickly became disillusioned. Unable to secure a teaching position in a predominantly white school, Arnold realized that racism in the North was often more subtle, but just as devastating as it was in the South.

On the advice of a friend, Arnold sought a job with the YWCA and soon began work with the African American branch in Springfield, Ohio. But she became increasingly angry about the way racism divided resources along the color line. Searching for a community and a place to belong, she made her way to the Northeast, first working at the African American branch of the Jersey City YWCA and then settling in Harlem. She served as the Harlem YWCA's membership secretary and participated in the branch's stimulating cultural and educational programs. In 1933 she married Merritt Hedgeman, an interpreter and singer of black folk music and opera, and the couple made their home in New York City.

Ironically, the Depression enabled the relative newcomer to get a city administration job. Starting in 1934 she worked with the Emergency Relief Bureau (later the Department of Welfare), first as a supervisor and then as a consultant on racial problems. By the late 1930s Hedgeman had resigned from the Department of Welfare to assume the directorship of the African American branch of the Brooklyn YWCA. Yet, even while she held that position, she organized the Citizens' Coordinating Committee to advocate for city jobs for black workers. Through her efforts and leadership, black New Yorkers secured the first 150 provisional appointments the city had ever given the black community.

In 1941 Hedgeman helped A. PHILIP RANDOLPH with his first March on Washington effort. As World War II drew to a close, Randolph asked Hedgeman to be executive director of the National Council for a Permanent Fair Employment Practices Commission (FEPC). She spoke at rallies with other civil rights advocates and led strategy meetings on how to move legislation through Congress. Despite the pressure to maintain the FEPC, Congress eliminated the program.

Hedgeman's work with the FEPC however, had attracted national attention. Congressman WILLIAM DAWSON of Chicago brought her on board the National Citizens for the Re-Election of President Truman campaign. For her commitment to the Democratic Party, she received a high-level federal appointment as assistant director of the Federal Security Agency, which later became the Department of Health, Education, and Welfare.

In 1953 Hedgeman traveled to India at the request of Ambassador Chester Bowles. She spent three months there as part of a social work delegation, and she lectured, met with students, and studied. Shortly after her return from India, President Eisenhower took office, and Hedgeman, a Democratic appointee, left Washington. Settling back in New York City, she immediately became involved in Harlem politics. Hedgeman became the first African American in Mayor Robert F. Wagner Jr.'s cabinet in 1954. Her responsibilities included serving as the mayor's adviser and as a representative to the United Nations. In 1958 Hedgeman resigned from Wagner's administration and turned her energies to the private sector. She did not stay out of politics for long.

Local insurgents in the Bronx approached Hedgeman to run for the U.S. Congress in 1960. Although she was defeated in the primaries, she continued her activism locally and overseas. In July 1960 she flew to Ghana to deliver the keynote address for the First Conference of African Women and Women of African Descent. While there she met with the African leaders Kwame Nkrumah and Patrice Lumumba.

Hedgeman aggressively pursued civil rights, again working closely with A. Philip Randolph as a major architect of the 1963 March on Washington. The only woman on a nine-member organizing committee, she challenged the male leaders, insisting that women be recognized for their tremendous contributions to the movement and that at least one woman be put on the official program.

As the Civil Rights Bill of 1964 made its way through Congress, Hedgeman, then the assistant director of the Committee on Race Relations for the National Council of Churches, helped coordinate

the lobbying effort to get the stalled bill out of the Senate. Years of experience had taught her that the only hope of moving the president or Congress on race issues was through sustained public pressure.

In 1965 Hedgeman was asked to run for New York City Council president. She suffered a defeat but maintained her commitment to electoral politics. In 1968 she ran for office one last time, for the New York State Assembly. Her opponent, the incumbent Charles Rangel, beat her in the primaries. Even as she fought for civil rights and pursued elected office, Hedgeman worked for women's equality. She was among the National Organization for Women's earliest members and served on its board of directors.

Hedgeman, who published autobiographies in 1964 and 1977, received an honorary doctorate from Hamline University and numerous awards for her work on race relations. She died in Harlem Hospital in January 1990.

FURTHER READING

Hedgeman's papers are at the Schomburg Center for Research in Black Culture of the New York Public Library. The Schlesinger Library at Cambridge, Massachusetts, holds a transcript of an unpublished interview conducted in 1978 as part of the Black Women Oral History Project.

Hedgeman, Anna Arnold. *The Gift of Chaos: Decades of American Discontent* (1977).

Hedgeman, Anna Arnold. *The Trumpet Sounds: A Memoir of Negro Leadership* (1964).

Obituary: New York Times, 21 Jan. 1990.

JULIE GALLAGHER

HEGAMIN, Lucille

(29 Nov. 1894–1 Mar. 1970), blues singer, was born Lucille Nelson in Macon, Georgia, the daughter of John Nelson and Minnie Wallace. In her youth Hegamin sang in church, and she also sang ragtime tunes and popular ballads at theaters in Macon. At about age fifteen she joined Leonard Harper's touring company until it was stranded near Chicago. As the "Georgia Peach," Hegamin found steady work in that city from 1914 to 1917, presenting popular songs in nightclubs, cafés, and restaurants. Among her piano accompanists were Bill Hegamin, whom she married around 1914, Tony Jackson, and JELLY ROLL MORTON. She followed Morton, her husband, and many other entertainers to the West Coast,

performing in Los Angeles, San Francisco, and Seattle from 1918 to 1919.

Around November 1919 the Hegamins settled in New York City, where they performed in cabarets. Lucille gained further prominence through appearances in Happy Rhone's occasional all-star shows of dance and entertainment at the Manhattan Casino in Harlem on 30 April and 25 September 1920 and on 22 April 1921; at this third show she was billed as the Chicago Cyclone, perhaps owing to her vocal ability to fill a large casino in the era before microphones. Around November 1920 her recording career got under way with the pairing of "The Jazz Me Blues" and "Everybody's Blues." Hegamin was the second blues singer to record, after MAMIE SMITH. On the strength of the popularity of this disc, the Hegamins began a tour of Pennsylvania, West Virginia, and Ohio in May, now billed as Lucille Hegamin and her Blue Flame Syncopaters. In the course of this tour "Arkansas Blues," which she had recorded in February, was released. It became her biggest hit, with the Arto label's master eventually being leased by and issued on ten other 78-rpm labels

Hegamin held an engagement at the Shuffle Inn in Harlem from November 1921 to January 1922, and at the Manhattan Casino on 20 January she participated in a blues contest won by TRIXIE SMITH. From February through May Hegamin toured in the second of three companies presenting *Shuffle Along*, the pioneering African American musical comedy created by Flournoy E. Miller, Aubrey Lyles, NOBLE SISSLE, and EUBIE BLAKE. Smith was one of the stars, taking the position that the legendary FLORENCE MILLS held in company number one.

After the second company of *Shuffle Along* was disbanded in May, Hegamin began touring with her own Jazz Jubilee band, directed by the pianist J. Cyril Fullerton. With the demise of Arto records—despite her blues hits—Hegamin worked briefly for Paramount and then initiated a four-year association with the Cameo label, for which she recorded "Aggravatin' Papa" (Sept. 1922), "He May Be Your Man, But He Comes to See Me Sometimes" (Oct. 1922), "Some Early Morning" (June 1923), and "Rampart Street Blues" (Oct. 1923).

The marriage to Bill Hegamin ended in 1923. Lucille toured that fall with a musical comedy, *Creole Follies*, and also in a duo with Fullerton on the Keith circuit from December 1923 through 1924. In January 1925 she was at the Cotton Club in New York, broadcasting on WHN radio three times

weekly to the accompaniment of Andy Preer and his Cotton Club Syncopators. She resumed touring with Fullerton, working from February as a duo, from November 1925 to February 1926 with Fullerton leading a band, and then once again as a duo. Hegamin and singer ADELAIDE HALL were co-stars of *Lincoln Frolics* at Harlem's Lincoln Theater in March 1926. After further touring with Fullerton, Hegamin starred in shows at the Club Alabam in Philadelphia for four months in 1927; the accompanying band was led by George "Doc" Hyder. Later that year she appeared in the *Shufflin' Feet* revue at the Lincoln, and in 1928 she was at Harlem's Lafayette Theater in *The Midnight Steppers*.

Hegamin toured with Hyder in the late 1920s, and she sang with CLAUDE HOPKINS's Savoy Bohemians at the Lafayette for New Year's celebrations in 1930 and 1931. Her career ended at the Paradise Café in Atlantic City, where she appeared from 1933 to 1934. From 1934 into the 1950s she worked as a nurse. Details of a second marriage, to a Mr. Allen, are unknown. In August 1961, accompanied by the pianist WILLIE "THE LION" SMITH's band, Hegamin recorded four tracks on the album *Blues We Taught Your Mother*, and the next year she recorded the album *Basket of Blues*. Her last performance was at a benefit for Mamie Smith at the Celebrity Club in New York in 1964. She died in New York City, but despite her past fame and recent rediscovery, no obituary appeared in the *New York Times*.

Hegamin had a genuine feeling for the blues, but like her predecessor, Mamie Smith, she sang with a wholesomely full timbre and enunciated lyrics with clarity, sometimes throwing in exaggerated vaudevillian gestures as she did so. In contrast with the rough and unpretentious geniuses of the classic female blues style, MA RAINEY and BESSIE SMITH, Hegamin's sophisticated presentation fit reasonably well into the mainstream of American popular music. Thus it is not surprising that she would have been invited to record sooner than they, thereby establishing her position as a historical figure of note. Today Hegamin is largely forgotten and her recorded legacy unavailable, except to specialists in the areas of vaudeville and early blues.

FURTHER READING
Kunstadt, Len. "The Lucille Hegamin Story," *Record Research*, no. 39 (Nov. 1961); no. 40 (Jan. 1962); no. 41 (Feb. 1962); and no. 43 (May 1962).

Stewart-Baxter, Derrick. "Blues," *Jazz Journal* 20 (July 1967).
Stewart-Baxter, Derrick. "Blues: Lucille Hegamin, Part 2" (Aug. 1967).

Obituary: Jazz Journal 23 (June 1970).

BARRY KERNFELD

HENDERSON, Fletcher

(18 Dec. 1897–29 Dec. 1952), musician, was born Fletcher Hamilton Henderson Jr. in Cuthbert, Georgia, the son of Fletcher Hamilton Henderson Sr., a Latin and mathematics teacher, and Ozie Lena Chapman, a pianist. His middle-class family disapproved of jazz and blues, and Henderson studied piano with his classically trained mother. He graduated from Atlanta University in 1920 with a chemistry degree and then moved to New York City to pursue postgraduate studies. For a short time he was a laboratory assistant in a chemical firm, but with few opportunities for black chemists he became a part-time song demonstrator for the Pace-Handy Music Company. He subsequently worked as house pianist and recording manager for Black Swan Records, where his duties included accompanying ETHEL WATERS and BESSIE SMITH and arranging tours for Waters and the Black Swan Troubadours. He married Leora Meoux in 1924; they had no children.

Henderson eventually began to lead his own small groups in engagements at clubs and dances. He successfully auditioned for an opening at the Club Alabam on West 44th Street in late 1923, and the following summer the band took up residence at the Roseland Ballroom, which Henderson used as a base for the next decade. At first the group was little more than an ordinary dance band, playing watered-down blues and pop tunes. But Henderson also hired the best talent he could find, including COLEMAN HAWKINS on tenor saxophone and DON REDMAN as musical director. Redman's arrangements in particular had a profound and lasting influence on big band jazz. He separated reed and brass sections and played them off against each other. One section would play the melodic lead, for instance, and the other would answer during pauses, or else it would punctuate the playing with brief, rhythmic figures. In the group's recording of "Copenhagen" in late 1924, the music moved from one section or soloist to

another twenty-four times in three minutes. Still, the band at this stage played stiffly, with little jazz feeling.

Also in 1924 the group's style took another major step forward when Henderson hired LOUIS ARMSTRONG. Although Armstrong stayed with the band for only a short while, his lyrical style and propulsive sense of swing strongly influenced Henderson's men, who now began to play with more feeling and a more inventive sense of melody. During the next two years they broke through to become the first great big band in jazz history. Their recording of "Stampede" in May 1926 marks an early peak. Hawkins in particular was vastly improved over his initial recordings, playing with a powerful expressiveness and a rich, full-bodied sound. The trumpeter Rex Stewart contributed fiery solos, while Redman himself was writing fuller, better-integrated section passages. Recordings show the band continuing to improve over the next nine or ten months. Then in March 1927 Redman left to co-lead McKinney's Cotton Pickers. Henderson gradually lost interest in the band, his focus further blurred by an auto accident in the summer of 1928 in which he suffered head injuries. Between 1927 and 1930 the group made only a dozen or so recordings, mostly ponderous efforts that showed a steady deterioration from the advances of 1926 and early 1927.

Henderson's own weakness as a leader proved to be the last straw. In 1929 the band went to Philadelphia to rehearse for a musical review. The director, Vincent Youmans, brought in about twenty white musicians, mostly string players, to augment the band, and he suggested that an outside conductor also be hired. Henderson agreed, and the new conductor began to fire Henderson's players, giving their positions to white musicians. Henderson said nothing. Disillusioned, most of the musicians never worked for him again.

Henderson rebuilt the band, and by 1931 they were recording again. This time the group was more of a showcase for individual players, built on exchanges between the sections and the soloists. The young saxophonist Benny Carter contributed swinging, spare arrangements; Walter Johnson on drums and John Kirby on bass provided strong rhythmic support. Carter's composition, "Keep a Song in Your Soul," is a fine example of the band's playing from this period. In December 1932 the band recorded an arrangement of "King Porter

Stomp" that mightily swung, the solos seamlessly integrated with the ensembles. Hawkins's playing was masterful, and he dominated the band for the next two years before leaving for England. Henderson also had become his own arranger, turning to sparer arrangements than Redman's that created a light, unpretentious sound. His tunes were set in unusual keys, and his tempos more consistently swung. The band's 1934 recording of "Wrappin' It Up" perfectly illustrates this style, one which influenced the entire big band era. The piece opens with a call-and-response pattern; as the brass section states a fanfare, the saxophones respond, and the two sections engage in a brief exchange. In the first chorus the saxes state the main theme, and the brasses comment, joined at one point by the trumpets. The pattern continues through the arrangement, creating one of the early swing era masterpieces.

Unfortunately, by this time Henderson had lost much of his drive. He dissolved the group in 1934, and in 1935 he sold the arrangements for "Wrappin' It Up" and several other pieces to Benny Goodman, who used them to help fuel the swing craze of the later 1930s.

Henderson's last great band was a 1936 ensemble that included the trumpeter Roy Eldridge. Throughout the 1930s he also maintained a close relationship with his brother Horace W. Henderson, who often served as pianist and arranger for the band and later led an important group of his own. Henderson worked briefly as an arranger for Goodman in 1939, and he failed several times to establish new bands. In 1950 he wrote music for the short-lived New York show *The Jazz Train* and led the accompanying band. He settled in that same year at Cafe Society in New York with a sextet. He suffered a stroke in December and another in 1952, dying from a heart attack in New York City.

Henderson's influence on jazz and particularly on the development of big bands was pervasive and lasting. Although personally withdrawn and lacking leadership qualities, he was a superb judge of talent, an excellent pianist, and an outstanding musician. Through the musical innovations he introduced in his various groups he profoundly influenced the work of DUKE ELLINGTON, Goodman, Count Basie, and other big bands of the swing era, thereby laying an important foundation for an entire genre of jazz playing.

FURTHER READING

Henderson's personal papers are located at the Amistad Research Center at Tulane University.

Allen, W. C. *Hendersonia: The Music of Fletcher Henderson and His Musicians: A Bio-discography* (1973).

Schuller, Gunther. *Early Jazz: Its Roots and Musical Development* (1968).

Schuller, Gunther. *The Swing Era: The Development of Jazz, 1930–1945* (1989).

Shapiro, Nat, and Nat Hentoff, eds. *The Jazz Makers* (1957).

Obituary: New York Times, 31 Dec. 1952.

RONALD P. DUFOUR

HILL, Chippie

(15 Mar. 1905–7 May 1950), dancer and singer, was born Bertha Hill in Charleston, South Carolina, the daughter of John Hill and Ida Jones. From the age of nine she sang in church. The family moved to New York City sometime around 1918, and the following year Hill danced at Leroy's Club in Harlem in a show led by ETHEL WATERS. The owner of Leroy's nicknamed Hill "Chippie" because of her youth.

Hill toured as a singer and a dancer with the Rabbit Foot Minstrels in the early 1920s and as a featured blues singer on the Theater Owners' Booking Association circuit. In St. Louis her "wardrobe was stolen, and several nights later Chippie spotted the thief sitting in the front row. 'I knew her,' says Chippie, 'because she was wearing my best dress.' There was nothing for Chippie to do but leap off the stage in the middle of the show and attack the culprit. 'I tore that rag right off that bitch's back'" (Aurthur, 3).

Hill settled in Chicago in the mid-1920s. She participated in recording sessions with the cornetist LOUIS ARMSTRONG in November 1925 and February 1926, recording "Low Land Blues," "Trouble in Mind," and "Georgia Man." She performed at the Race Records Ball at the Chicago Coliseum in February 1926, and she also won a talent and recording contest at the coliseum. Hill commenced regular performances at the Plantation Café, where she worked with the cornetist KING OLIVER's band in August 1926, and at the Dreamland Café. In November 1926 Hill recorded "Pleadin' for the Blues," "Pratts [*sic*] City Blues," and "Lonesome Weary Blues" (again with Armstrong). Two years later she recorded "Weary Money Blues" and "Christmas Man Blues" with the pianist Thomas Andrew

Dorsey and the guitarist TAMPA RED as well as a new version of "Trouble in Mind." In 1929 she recorded "I Ain't Gonna Do It No More" and sang at Chicago's Elite No. 2 Club before touring with the pianist Lovie Austin. That year she married John Offett; they had seven children. Hill continued to work part-time at clubs around Chicago, including engagements at the Annex Café from 1934 to 1937, the Cabin Inn with the clarinetist Jimmie Noone in 1937, and the Club DeLisa from 1939 to 1940.

During the 1940s Hill left music to devote herself to her family, but early in 1946 the writer and promoter Rudi Blesh found her in Chicago and immediately recorded nine tracks, including versions of "Trouble in Mind," "Careless Love," "How Long Blues," and "Around the Clock Blues," all with Austin's band. Hill resumed working at the Club DeLisa from 1946 to 1947, and she participated in a jazz concert in Chicago before moving to New York, where she starred in Blesh's This Is Jazz concert at the Ziegfeld Theatre in June 1947 and on his weekly radio series *This Is Jazz* in July and August of that year. In late 1947 and early 1948 Hill appeared at the Village Vanguard in Greenwich Village, and she also sang at Jimmy Ryan's club in midtown.

In the spring of 1948 Hill worked with the trombonist KID ORY in a concert at Carnegie Hall, and she performed in Paris. She held engagements at New York's Central Plaza Club in 1949 and Riviera Club in 1949–1950, and she performed with the pianist Art Hodes's quintet at the Blue Note in Chicago in 1950, and again in New York at the Stuyvesant Casino in 1950. Hill's strong personality remained intact during these final years: "When she arrived in New York she slyly informed the press that she was forty-two. This year [1949] she is forty-one." Although already a grandmother, she could "outcurse and outdrink any truck driver you can dig up, and if you ever get up the nerve to ask her to dance, she'll jitterbug you into exhaustion" (Aurthur, 4). Hill died in a hit-and-run traffic accident in New York.

Like the better-known singers MA RAINEY and BESSIE SMITH, Hill emphasized a southern, African American, "down home" blues vocal style more than the mainstream mannerisms of vaudeville singing—although the latter may be heard in a song such as "Lonesome, All Alone and Blue," which she recorded with Armstrong in February 1926. Sliding blue notes abound in her work. She often moved out of her mid-range voice into a strained,

piercing shout-singing; and she sometimes muffled lyrics, as in her first recording, "Low Land Blues." Of the discs from her second career in the 1940s, Blesh writes that "in these she reveals . . . a rhythmic shouting more forceful than will be found on any of the known records of Ma and Bessie, and a clipped, hot phrasing that barely appears in her earlier work."

FURTHER READING

Aurthur, Bob. "Let the Good Times Roll: An Impression of Chippie Hill," *Playback* 3 (Feb. 1950).

Blesh, Rudi. *Shining Trumpets: A History of Jazz*, 2d ed. (1958).

Obituary: Melody Maker, 24 June 1950.

BARRY KERNFELD

HITE, Mattie

(ca. 1890–ca. 1935), blues singer and musician, was born in New York City around 1890. Very little is known about her family or upbringing except that she may have been a niece of Les Hite, a 1930s saxophone player and big band leader. Mattie Hite, who might have also been known by the alternative first name of Nellie, was a blues and cabaret singer who worked at various jazz clubs in New York and Chicago and sang on more than a dozen albums between 1915 and 1932.

Hite began singing in Chicago in 1915 at the Panama Café for twelve dollars a week with other blues singers such as ALBERTA HUNTER and Florence Mills. She returned to New York City in 1919 to work at Barron Wilkins's Café. For the next twelve years, Hite supported herself from performances at a host of New York City nightclubs, including Edmund's Cellar (1920), Leroy's (1920), the Lafayette Theatre (1928), the Lincoln Theatre (1928), and the Nest Club (1929). The height of her career coincided with Prohibition (1920–1933), which prompted the creation of a number of smaller, concealed nightclubs called "speakeasies," where alcohol was available and jazz performers were quite popular. An accomplished performer, Hite broke many barriers for African American women singers, as her songs became known for their emotional depth and overall quality. Although she performed live far more often than she recorded, her contribution to the Jazz Age—between the end of World War I and the onset of the Great Depression—was substantial, and she directly influenced the following generation of jazz singers. Widely esteemed as a blues singer, Hite was revered for her risqué words and exaggerated toughness in the barely integrated racial clubs and dance halls where the sad and reflective tone of the blues ruled the room. Hite's true skill was her full tone and warmth—her vocals invited a listener into a life of struggle and pain. However, she was not as financially successful as other singers such as BESSIE SMITH, ETHEL WATERS, Alberta Hunter, and MAMIE SMITH.

In late 1920s New York City Hite joined other singers in a number of revues that sometimes ran at Broadway and Off-Broadway venues for a few weeks at a time, including *Hot Feet* (1928), *Tip Top* (1928), *Chocolate Blondes* (1929), *Temple of Jazz* (1929), and *Desires of 1930* (1930). These revues might feature songs, sketches, and short dances, often based upon a comedic theme. Drawing in bigger crowds and more attention, Hite's following grew, which meant more opportunities to be recorded. Hite appeared on a handful of jazz recordings with piano accompaniment, including a 1920 album with Julian Motley (on the Victor label), a 1925 recording with FLETCHER HENDERSON (on the Pathe label), and one with Cliff Jackson (on Columbia) in 1930. She was listed on fewer than a dozen albums during her life, but reappeared on reissues and newer collections, such as the multivolume set *The Female Blues Singers*, (volume 9, on the Document label). One significant recording that helped Hite build her popularity was her 1924 version of "St. Joe's Infirmary," a blues tune that was later popularized by CAB CALLOWAY. Hite's emotional tone makes the listener feel the *blues* within the song. The song is a narrative ballad about a dead lover, and she croons the lyrics in a raspy and weary-sounding voice:

> Let her go
> Let her go
> God bless her . . .
> I may be killed on the ocean
> I may be killed by a cannonball
> but let me tell you, buddy
> That a woman was the cause of it all.

Hite's last documented performance was a 1932 revue at the Lafayette Theatre in New York City; after that, her whereabouts and the details of her life are largely unknown. In a 1960 article in *Jazz Review Magazine*, the author James Johnson called Hite "one of the greatest cabaret singers of all time" (Mar./Apr. 1960, 13).

FURTHER READING
Harris, Sheldon. *Blues Who's Who* (1979).

JAMES FARGO BALLIETT

HODGES, Johnny

(25 July 1907–11 May 1970), jazz musician, was born Cornelius Hodges in Cambridge, Massachusetts, the son of John Hodges and Katie Swan. The family moved to Boston when Cornelius was an infant, and he grew up in a rich musical environment. His neighbors included Harry Carney, the future baritone saxophonist for the DUKE ELLINGTON band, and both his mother and sister played piano. Katie Hodges taught him enough piano so that he could play at house hops, and throughout his career he often worked out musical ideas at the keyboard.

During his early teens Hodges began to play both soprano (curved) and alto saxophone. He met SID-NEY BECHET in 1920 when the soprano saxophonist came to Boston with a burlesque show, and Bechet and LOUIS ARMSTRONG through their recordings became Hodges's chief influences. He gained early experience playing in groups led by Bobby Sawyer and the pianist Walter Johnson, and he began to visit New York City on weekends, playing with the pianist Luckey Roberts's society band, with WILLIE "THE LION" SMITH at the Rhythm Club, and in various cutting contests. But his most important early experience was with Bechet, who adopted Hodges as his protégé and introduced him to the straight soprano saxophone. At Bechet's Club Pasha, Hodges played soprano duets with his mentor and often led the group when Bechet was late or absent.

From 1925 until 1928 Hodges spent time in both Boston and New York, playing with groups led by Lloyd Scott and CHICK WEBB. Duke Ellington's early group, the Washingtonians, spent summers in New England, and at times Hodges heard them in person. Ellington heard Hodges in both Boston and New York. Twice Ellington invited him to join the band, but Hodges felt he needed more experience. Finally, in 1928, on Webb's recommendation and after Otto Hardwick (Ellington's alto and soprano saxophonist) had been injured in an automobile accident, Hodges joined Ellington for a stay that, with only one interruption, lasted until his death.

Hodges immediately became a star attraction, and Ellington often turned to him for compositional and melodic ideas, contrasting his smooth tone with the "jungle" sounds of Joe "Tricky Sam" Nanton, BUBBER MILEY, and Cootie Williams. During the 1930s Hodges developed the sensuous, deeply lyrical sound that became his trademark, "a tone so beautiful," Ellington later wrote, "it sometimes brought tears to the eyes." His playing sounded like "poured honey" that could "melt the melody to smoldering." Hodges's deeply sensual sound is evident in such specialties as "Warm Valley" and "Passion Flower" and in the later Ellington compositions "Isfahan," "Come Sunday," "Star-Crossed Lovers," and Billy Strayhorn's masterpiece, "Blood Count." But Hodges's playing stayed rooted in the blues, clearly so on such pieces as "Jeep's Blues" and on the sextet album he recorded with Ellington in 1959, *Back to Back*. His solos never failed to convey a propulsive sense of swing. Pieces like "The Jeep Is Jumpin'," "Things Aint What They Used to Be," and "On the Sunny Side of the Street" are forever marked as swinging Hodges vehicles.

By 1940 Hodges had tired of the burden of playing lead and solos on both alto and soprano saxophones, and he decided to concentrate on the alto. He also began a long series of recordings with small groups drawn largely from Ellington's band. He recorded nine sextet sessions in 1938 and 1939 under the name of Johnny Hodges and His Orchestra, with Ellington on piano, and in 1947 he recorded with the Johnny Hodges All-Stars. In 1948, while Ellington was in Europe convalescing from surgery, Hodges, Strayhorn, the vocalist Al Hibbler, and five others enjoyed great success in a seven-week engagement at the Apollo Bar on 125th Street. Hodges also recorded with an octet in Paris in 1950.

By 1951 economic conditions had deteriorated for big bands. Even Ellington, one of the few leaders who held a band together without interruption, was forced to cut salaries. A dispirited Hodges and several others struck out on their own and Hodges signed a contract with the impresario Norman Granz for Verve Records. Immediately he had a huge recorded hit with "Castle Rock," a piece with a strong rhythm and blues feeling that featured the new group's manager, Al Sears, on tenor saxophone. The band enjoyed continued success; a summer 1954 session, *Used to Be Duke*, is particularly noteworthy. But Hodges disliked the responsibilities required of a bandleader and in 1955 he returned to Ellington.

Hodges continued to record with smaller groups, including a septet featuring Strayhorn on piano, for which he recorded, because of contractual reasons, under the pseudonym "Cue Porter," in 1958, an early

1959 sextet with Ellington, and 1959–1960 sessions with a ten-piece orchestra. In 1961 he toured Europe with an octet from the band while Ellington worked on the film *Paris Blues* (1961) in France. Hodges recorded one of his best albums, *Everybody Knows Johnny Hodges* in 1964, with both a big band and a smaller group. Ellington crafted the beautiful "Isfahan" movement of the *Far East Suite* with Hodges in mind. Although his health deteriorated during the 1960s, Hodges continued to play inspirationally. He died in New York City.

Although some found him personally brusque and aloof, in truth Hodges was painfully shy. In fact he often mediated disputes between band members. He was a dedicated family man. After a failed early marriage he married Edith Cue Fitzgerald, a dancer in the Cotton Club chorus, in 1957. The couple had two children. Never a good sight reader (Harry Carney and Barney Bigard often had to guide him through new orchestrations during rehearsals), Hodges possessed a powerful sense of swing, a fluid, graceful way of phrasing, and among the most softly beautiful sounds in jazz history.

FURTHER READING

Ellington, Duke. *Music Is My Mistress* (1973).
Tucker, Mark, ed. *The Duke Ellington Reader* (1993).

Obituary: New York Times, 12 May 1970.

DISCOGRAPHY

Dance, Stanley. *The Complete Johnny Hodges Sessions, 1951–1955* (Mosaic Records, 1989).

RONALD P. DUFOUR

HOLIDAY, Billie

(7 Apr. 1915–17 July 1959), vocalist and lyricist, was born Eleanora Fagan in Philadelphia, to a nineteen-year-old domestic worker, Sadie Fagan, and Clarence Holiday, a seventeen-year-old guitarist who would later gain fame as a member of the FLETCHER HENDERSON Orchestra.

Shortly after giving birth, Sadie Fagan returned to her home in Baltimore with her newborn daughter in tow. During her youth in this gritty, working-class port town, the young Holiday would encounter two things that influenced her for the duration of her life: the criminal justice system and music. By the time she entered Thomas E. Hays Elementary School, Holiday was the stepdaughter of Philip Gough, who had married her mother on 20 October 1920. A tomboy, the future singer enjoyed playing

stickball and softball with the boys in the neighborhood, and she loved the movies. These two forms of recreation, sports and film, helped to inspire the nickname by which she would become famous: Billie. Billie Dove was a popular film star of the day whom Holiday greatly admired. As a child, she began to sing popular blues songs around the house and in her neighborhood.

After her mother divorced Gough, Holiday was placed in the care of a neighbor while Sadie sought work elsewhere. Perhaps in an effort to protest her mother's absence, she began to skip school, and by January 1925 her truancy found her before the juvenile court. After finding Sadie Gough unfit as a mother, the judge sent Holiday to the House of the Good Shepherd for Colored Girls, a home run by Catholic nuns. While there Holiday was baptized. After a nine-month stay she was released in care of her mother, and the two moved into a small apartment about two blocks away from Sadie's new

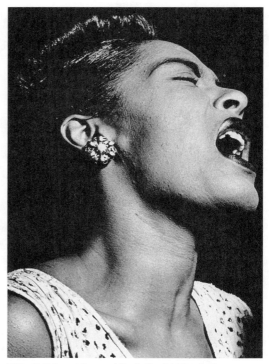

Billie Holiday, nicknamed "Lady Day" by Lester Young, recorded over three hundred songs, setting the standard for both jazz and American popular singing in general. (Library of Congress.)

business venture, a small eatery. Sadie spent long hours at work, and the young Holiday was often left alone. On Christmas Eve 1926 Sadie came home from work to find her neighbor, Wilbert Rich, having sex with her daughter. Rich was arrested and charged with rape; Billie was sent, once again, to the House of the Good Shepherd. Rich was indicted on six counts of rape, but only found guilty of one. He served three months in prison.

After she was released, Holiday never returned to school. Instead, she began to work in her mother's restaurant and in a local brothel. Her work at the brothel first involved only cleaning the white marble steps, running errands, and doing light cleaning in exchange for the opportunity to listen to the Victrola, but biographers agree that she eventually worked as a prostitute, a kind of "pretty baby" who also sang for the entertainment of the clientele. While at the brothel, she discovered the records of BESSIE SMITH and LOUIS ARMSTRONG, both of whom profoundly influenced her unique singing style. Other early influences were ETHEL WATERS and the Gregorian chant Holiday had heard at the House of the Good Shepherd.

In 1928 Holiday's mother moved to New York, settling in Harlem, and the following year she sent for her teenage daughter. By May 1929 both mother and daughter had been arrested for prostitution, caught in a raid on a Harlem brothel. Holiday spent one hundred days in the penitentiary workhouse on Welfare Island (formerly Blackwell's Island, now Roosevelt Island). Upon her release she determined never again to work as a maid or a prostitute. She began singing in small clubs in Brooklyn and later in Harlem, soon moving to the more renowned Harlem clubs like Small's Paradise. Beginning her apprenticeship and advanced musical education, Holiday spent every waking hour with other musicians. In 1933 she was discovered by the young producer and aspiring impresario John Hammond, who heard her at a Harlem club called Covan's. He immediately wrote about her for a London-based jazz publication, *Melody Maker*, and later produced her first record, "Your Mother's Son-in-Law" and "Riffin' the Scotch," with Benny Goodman. She was eighteen years old. The following year Holiday met the tenor saxophonist Lester Young, with whom she had an immediate affinity.

In 1934 Holiday made her film debut in a DUKE ELLINGTON short, *Symphony in Black*, in which she sang "Saddest Tale," a slow blues. Holiday is riveting

on film, but she made only one other, *New Orleans* (1947), with Louis Armstrong, playing a singing maid. Starting in 1935 Holiday recorded a number of sides with the gifted pianist Teddy Wilson. Some of the best of these featured Benny Goodman on clarinet, Roy Eldridge on trumpet, and Ben Webster (with whom Holiday had a brief and tumultuous affair) on saxophone. In the mid-1930s Joe Glaser, who managed Louis Armstrong, began to manage Holiday, and she began to get more work and greater exposure. He arranged for her to sing with the Fletcher Henderson Orchestra, one of the most popular big bands of the day. With the Henderson outfit, Holiday made a number of radio broadcasts, gaining exposure to a national audience. In the spring of 1937 she joined Buck Clayton and her good friend Lester Young, as well as the blues belter JIMMY RUSHING, in the Count Basie Orchestra; before long, she was on the road with the band. Basie gave her extraordinary freedom to stretch out musically and to cultivate her own style. She recorded for Columbia with members of the Basie outfit, especially Lester Young, but never with the entire orchestra. During this time, Lester Young gave Holiday the nickname "Lady Day," and she dubbed him "Prez." Life on the road was especially difficult for Holiday, as she faced firsthand the racism of the Jim Crow South. At one point she was encouraged by club owners to wear dark makeup so that Southern white audiences would not think she was a white woman singing with black musicians. By 1938 Holiday was no longer singing with the Basie Orchestra; she said she left because she was not paid enough.

When the white bandleader Artie Shaw heard that Holiday had left Basie, he offered her a job. She became one of the first black artists to join an all-white band. She traveled with Shaw throughout the country; although life on the road, with its constant confrontations with racial prejudice, proved to be more than Holiday wanted to handle. In New York, the owner of the Lincoln Hotel where she was performing with the Shaw band asked that Holiday take the service elevator. Although she had been thinking of leaving Shaw for some time, this proved to be the straw that broke the camel's back.

Fortunately John Hammond brought her an offer that would change the direction of her career and in so doing make an indelible mark on the history of popular music. With Hammond's assistance, Holiday opened at Café Society, a new nightclub in

Greenwich Village. Founded by Barney Josephson, the club not only presented racially mixed bands, but also had an integrated audience, making it unique in New York nightlife. It eventually became one of the favorite nightspots of bohemian intellectuals and political activists, as well as socialites looking for the thrill of something new.

During her tenure at Café Society, Holiday further shaped her style, both her singing and her visual presentation. A dramatic performer, she used each song as an opportunity to connect with her audience through a narrative that seemed almost personal. Here she began to sing the torch songs with which she would be identified throughout the rest of her career. She worked with smaller bands, including one led by Teddy Wilson. But most significantly, it was at Café Society that Holiday introduced "Strange Fruit," a song written by Abel Meeropol as a protest against the practice of lynching. She often closed her performances with dramatic renditions of this song, after which she would leave the stage and refuse to return for an encore, and included it in her repertoire throughout her career. When her record company, Columbia, refused to record it, she sought out the independent record producer Milt Gabler, who arranged for her to record the song with his label, Commodore Records. With "Strange Fruit," Holiday came to the attention of a whole new audience of artists, activists, and intellectuals. She also came to the attention of the FBI when she began to sing what was also considered a political song, "The Yanks Aren't Coming." The recording of "Strange Fruit" marked the second stage of Holiday's career. From 1945 to 1950 Gabler recorded Holiday classics such as "Don't Explain," "Lover Man," and "My Man" on Decca, while also recording more blues- and jazz-oriented fare like "Fine and Mellow" and "BillieBlues" for Commodore.

Holiday left Café Society to become the queen of Fifty-second Street, where the most important jazz clubs were located. During this time she was first arrested for possession of heroin, and in 1947 she was sent to the Federal Reformatory for Women at Alderson, West Virginia, where she served nine and a half months. It is said that she never sang a note while there. Upon her release Holiday was denied her cabaret card and thus was unable to perform in jazz clubs where liquor was sold. A number of significant jazz artists fell prey to this law and found their livelihood severely limited. Limited

in her club appearances, Holiday began singing in large halls. Shortly after her release from Alderson she appeared before a wildly enthusiastic audience at Carnegie Hall on 27 March 1948.

From the time of her first arrest in 1947 until her death in 1959, Holiday would be harassed and haunted by law enforcement for possession and use of narcotics. She sometimes beat the charges, but they inevitably took their toll on the sensitive singer. She was arrested in May 1947 in Philadelphia, in January 1949 in San Francisco, in February 1956, again in Philadelphia, and, even as she lay on her deathbed in New York in 1959, a guard was placed outside her hospital room.

In 1952 Holiday signed with Verve Records. She began working with Norman Granz, who had helped to ensure the financial and critical success of ELLA FITZGERALD and Frank Sinatra, and hoped to do the same for Holiday. Granz surrounded her with major jazz talent and recorded her in the small jam-session atmosphere in which she thrived, using such musicians as Oscar Peterson, Ray Brown, Ben Webster, Jimmy Rowles, Benny Carter, and Harry Edison. In recordings of these sessions, one can hear the grain of her voice, and at times her songs are like recitations and incantations. Holiday's choices are thoughtful and original, and, as always, she makes every note count.

The album *Lady in Satin*, recorded in 1958, is perhaps one of Holiday's most controversial recordings. Critics disagree in their appraisals; gone is the youthful Holiday of the early Columbia sides and the fully mature singer-actress of the torch days. In her place is a woman looking back on some of her earlier material, reinterpreting it through the lens of a life that had been difficult but full, an artist wholly committed to her form.

Holiday died in New York from heart, kidney, and liver ailments, along with lung blockage, the unfortunate but inevitable consequence of decades of substance abuse. She was forty-four years old. She had been married twice, once to Jimmy Monroe and then to Louis McKay. She had no children.

Holiday recorded more than three hundred songs and set the standard for jazz singing in particular and American popular singing in general. She paved the way for the sophisticated black songstresses who followed her, but who have rarely matched her level of artistry or originality. Billie Holiday is undoubtedly one of the most important artists of the twentieth century, and her singular

sound and distinctive approach to timing and phrasing, along with her iconographic life and image, have influenced not only other musicians, but poets, painters, novelists, and critical theorists.

FURTHER READING

Holiday, Billie, with William Dufty. *Lady Sings the Blues* (1956).

Clarke, Donald. *Wishing on the Moon: The Life and Times of Billie Holiday* (1995).

Gourse, Leslie, ed. *The Billie Holiday Companion: Seven Decades of Commentary* (1997).

Griffin, Farah Jasmine. *If You Can't Be Free, Be a Mystery: In Search of Billie Holiday* (2001).

Nicholson, Stuart. *Billie Holiday* (1995).

O'Meally, Robert. *Lady Day: The Many Faces of Billie Holiday* (1991).

Obituary: New York Times, 18 July 1959.

DISCOGRAPHY

Billie Holiday: The Complete Billie Holiday on Verve, 1945–1959 (PolyGram Records).

Billie Holiday: The Complete Commodore Recordings (GRP Records).

Billie Holiday: The Complete Decca Recordings (GRP Records).

Billie Holiday: The Legacy, (1933–1958), (Sony).

Lady Day: The Complete Billie Holiday on Columbia, 1933–1944 (Sony).

FARAH JASMINE GRIFFIN

HOLSTEIN, Casper

(1876–1944), philanthropist, activist, and numbers banker, was born in the Danish Virgin Islands. Holstein emigrated with his mother to the United States when he was nearly 12 years old. Little is known about his early childhood in the Virgin Islands. He attended high school in Brooklyn, New York, and enlisted in the U.S. Navy in 1898. He was stationed, for a time, on the islands of his birth. After completing his tour of duty he settled in Harlem in New York City. Holstein began working as a porter and bellhop at a Wall Street brokerage firm. As he swept floors and carried packages he also observed the intricacies of the stock market. He had ambitions that stretched far beyond his work as a porter.

Holstein had arrived in Harlem when the numbers game known as *Bolito* was a waning but still-popular recreational pastime for blacks in that neighborhood. This was an illegal gambling game in which players would place bets with "numbers banks." Players would bet by choosing a series of three numbers and giving them to number runners who would turn them over to the numbers bank. In winning bets, the numbers chosen by players matched those that were randomly selected through various systems by the numbers bank. Many players were suspicious of the randomness of the number selection and led to a lack of faith in number bankers and the numbers game itself. Holstein, like many other Harlemites, saw this pastime as a means of getting rich.

According to legend, Holstein, who had faithfully saved copies of daily newspapers, was reading the papers at work one day when he noticed the clearinghouse totals consisted of two sets of numbers that varied daily. Holstein suddenly had an idea that would forever change the numbers game. He devised a system in which the winning combination of numbers in a game would be chosen in a standardized way from the clearinghouse totals. In his system he would choose two numbers from the first set of numbers and one from the second to determine the winning number combination. Before Holstein revolutionized the numbers system, winning numbers were chosen randomly from racetrack totals or selected in drawings by the numbers bankers. After his epiphany, Holstein saved six months' worth of his meager wages; then he went into business as a numbers banker. Players were impressed with his system, since it guaranteed legitimate winning number combinations. In addition, players could check the winning numbers for themselves, free of dubious middlemen. With six-hundred-to-one odds for winners, Holstein quickly amassed a small fortune. Within a year, he owned three luxury apartment buildings in Harlem, a fleet of expensive cars, a Long Island home, thousands of acres of farmland in Virginia, and the infamous Turf Club, which also served as the headquarters of his numbers business.

With his growing wealth, Holstein became deeply involved in philanthropy and political activism in both Harlem and the Virgin Islands. He often wrote about what he considered to be the unjust situation in the U.S.-occupied Virgin Islands in the *Negro World*, a well-circulated publication of MARCUS GARVEY's Universal Negro Improvement Association (UNIA). The United States had purchased these islands in 1917 to build bases that would give U.S. military forces quick access to the Panama Canal. In 1925 he wrote an article for *Opportunity*

magazine, a publication of the Urban League, detailing and protesting the abusive treatment of Virgin Islanders at the hands of the U.S. Navy.

Although members of Harlem's elite generally looked down on Holstein because of how he made his money, he often attended events hosted by the very people who disdained him. In 1925 he attended the first Opportunity Awards dinner and soon became an important figure during the Harlem Renaissance: At this inaugural event he donated the money to make the 1926 Opportunity Awards possible.

Well known in Harlem circles for other philanthropic endeavors, Holstein was a Black Elk and contributed heavily to their lodges. He was one of the largest individual contributors to the Universal Negro Improvement Association, and he took impoverished children up the Hudson River for an annual summer retreat. He aided black colleges, building dormitories and financing scholarships. He also established a hurricane relief fund for the Virgin Islands and founded a museum. With the numbers racket growing in popularity—in part because of his system of picking winning numbers—Holstein was worth nearly a million dollars by 1926. Holstein's wealth and local fame, however, did not come without a high cost.

Although numbers bankers were not the brutally violent types found in downtown New York City among the Italian and Irish gangsters of the 1920s, the numbers business was no doubt a competitive and cutthroat industry. Holstein faced competition from numbers luminaries such as STEPHANIE ST. CLAIR, who ran a prosperous business prior to Holstein's entry into the numbers racket. Although St. Clair and Holstein were rivals, they did not interfere with each other's businesses.

By the late 1920s, however, the downtown mafia had become aware of the enormous profits being made by the Harlem bankers, and they began to threaten Holstein and others. As a result, the number of black bankers dropped dramatically in Harlem. Yet Holstein was steadfast and ignored these threats.

On 23 September 1928 Holstein left his Harlem apartment and walked toward his limousine waiting outside. He was immediately kidnapped by white gangsters and held for a $50,000 ransom. This case was highly publicized and put a spotlight on the numbers racket. It also exposed the country to the wealth of upper-class blacks in Harlem—a phenomenon that had been unknown to most people outside that neighborhood. Within a few days Holstein was left on a street corner beaten and bleeding. The events of the kidnapping remained murky. He never identified his abductors and denied that any ransom had been paid. Unable to sustain his numbers operation in the face of the mob's massive organization and use of gun violence, he quietly scaled down his business. Holstein eventually dropped out of the numbers game completely, as local, state, and federal investigations into the mob, their illegal businesses, and the numbers racket, gained intensity in the early 1930s.

Holstein was arrested in 1935 under a federal warrant from the Samuel Seabury Commission for illegal gambling and policy violations. He proclaimed his innocence and said his arrest was in direct connection to his political activism on behalf of the Virgin Islands. He spent nearly a year in prison and returned to Harlem penniless as the white mob took over the remainder of his numbers business. Holstein died in 1944.

At a time in America's history when African Americans had few legal pathways to wealth, Holstein built a business empire via illegal means. However, he used his wealth in many altruistic ways—mainly for the benefit of blacks in America and abroad.

FURTHER READING
Anderson, Jervis. *This Was Harlem: A Cultural Portrait, 1900–1950* (1982).
Lewis, David Levering. *When Harlem was in Vogue* (1997).
Schatzberg, Rufus. *Black Organized Crime in Harlem, 1920–1930* (1993).
Schatzberg, Rufus, and Robert J. Kelly. *African American Organized Crime: A Social History* (1997).
Wilson, Sondra K., and National Urban League. *Opportunity Reader: Stories, Poetry, and Essays from the Urban League's Opportunity Magazine* (1999).

H. ZAHRA CALDWELL

HOPKINS, Claude

(24 Aug. 1903–19 Feb. 1984), jazz bandleader and pianist, was born Claude Driskett Hopkins in Alexandria, Virginia, the son of Albert W. Hopkins and Gertrude D. (maiden name unknown), supervisors of a school for orphaned boys in Blue Plains, Virginia. Around 1913 the family moved

to Washington, D.C., where his father became postmaster at Howard University and his mother became matron of a Howard dormitory. After public schooling Hopkins enrolled at Howard, where he excelled in athletics and scholarship. Concentrating on music theory and classical piano while beginning preparations for medical study, he earned a BA in music. Despite his parents' preference he chose to become a musician, having already worked casually in nightclubs and theaters during his college years.

Hopkins had heard the Harlem stride piano style on piano rolls by JAMES P. JOHNSON and FATS WALLER, and like other distinguished jazzmen, including Waller himself, Hopkins learned Johnson's test piece, "Carolina Shout," by playing the roll slowly and imitating the fingering. In New York City he worked for a few months with the clarinetist Wilber Sweatman. The banjoist ELMER SNOWDEN reported that Hopkins was in his big band, replacing Bill Basie (Count Basie) as Snowden's pianist at New York's Bamville Club in 1925.

In the summer of 1925 Hopkins led a band in Atlantic City. When the job ended, he brought his five-piece band to the Smile Awhile Café in Asbury Park, New Jersey, where they won a job by outplaying Basie's group at an audition. Their performance at the café of a novelty version of "St. Louis Blues," featuring the trumpeter Henry Goodwin as a "preacher" and the other two wind players as the "sisters" of the congregation, secured the band a place in the *Revue Négre*. The revue traveled to Europe with JOSEPHINE BAKER as its star and the reed player SIDNEY BECHET added to Hopkins's instrumentalists. Hopkins had recently married Mabel (maiden name unknown), and she was taught to dance in the chorus so she could join the tour. Hopkins, an inveterate womanizer, had an undisguised affair with Baker while in transit to France. The *Revue Négre* debuted in Paris in October 1925 and toured in Belgium and Germany, finishing in Berlin in March 1926. Baker left for the *Folies Bergères* in Paris, and most of Hopkins's sidemen took other jobs. Struggling to fulfill commitments and keep a band together, Hopkins spent the next year performing in Europe. He and his wife returned to the United States in March 1927; they had one child.

In Washington, Hopkins formed a seven-piece band, including the trombonist Sandy Williams, the saxophonists Hilton Jefferson and Elmer Williams, and the guitarist Bernard Addison. The band returned to the Smile Awhile Café and tried to break into the New York scene but failed. Hopkins then worked on his own. He wrote for and led a band in another musical revue, *The Ginger Snaps of 1928*, which toured the Theater Owners' Booking Circuit (TOBA), a circuit of theaters presenting African American performers. He returned to Washington after the show failed.

Hopkins led a band at the Fulton Gardens in Brooklyn for the balance of 1928 and into 1929, and he recorded two titles with CLARENCE WILLIAMS's Blue Five on 20 September 1928. He then replaced the pianist Charlie Skeets at a dime-a-dance hall in Manhattan; the band included the clarinetist Edmond Hall. After taking over the band's leadership from Skeets, Hopkins secured a job in January 1930 at the Savoy Ballroom, where his understated approach to big-band jazz gave him a musical identity distinct from the typically extroverted bands that played at this venue. After the first night the Savoy manager Charlie Buchanan suggested a more hard-hitting approach; but Hopkins persisted, and as it turns out, the Savoy dancers loved his style. The band stayed there for most of 1930 and then moved to the more prestigious Roseland Ballroom.

Hopkins held residencies at Roseland from 1931 to April 1934 and broadcast nationally from the ballroom on the CBS radio network. In the spring of 1932 Hopkins began to take leaves from Roseland for extensive touring and for performances at Harlem theaters, including the Apollo. His band performed in the movies *Dance Team* (1931) and *Wayward* (1932). Hopkins wrote the band's theme song, "I Would Do Anything for You," featuring the trumpet playing and smooth-toned singing of Ovie Alston; this was their first recording, made on 24 May 1932. The same session featured the arranger Jimmy Mundy's "Mush Mouth." By 1933 Hopkins had hired a "freak" attraction, the singer Orlando Robeson, whose falsetto ballad singing was featured on "Trees," heard in the band's film short *Barber Shop Blues* (1933) and on record in 1935.

Hopkins's touring and Harlem theater engagements continued for a year after the band left Roseland, during which time he recorded "Three Little Words" and "Chasing All the Blues Away" (1934). In a move away from its focus on dance music, the band played for shows at the Cotton Club from March through December 1935 while also appearing in the movie short *Broadway Highlights*, filmed

at the Cotton Club. Hopkins's last movie short, *By Request*, dates from late that same year.

When his club residencies in New York ended Hopkins took his band on North American tours from 1936 to 1940. His sidemen during this period included the trumpeter Jabbo Smith (1936–1937) and the trombonist Vic Dickenson (1936–1939). Finally the band seems to have grown stale, and opportunities for work diminished. Hopkins disbanded in 1940 and declared bankruptcy a year later in 1941.

Hopkins had already written for other bands; ANDY KIRK's big band recorded his arrangement of "A Wednesday Night Hop" in 1937. In 1941 Hopkins's former arranger and trombonist, Fred Norman, procured some assignments for Hopkins as a commercial arranger, but he disliked this job and went to work at the Eastern Aircraft defense plant in New Jersey in 1942. In 1944 he formed a big band at the new Club Zanzibar in New York; he stayed there, directing and arranging, until 1947. He toured until 1949 as the leader of a small group, and he participated in USO tours, playing at veterans' hospitals in 1949 and 1950. He formed his own touring variety show, but this venue was unsuccessful.

After a period in Sheraton Hotel lounge bands Hopkins worked alongside the trumpeter Doc Cheatham and the trombonist Vic Dickenson in the pianist and promoter George Wein's band at Mahogany Hall in Boston (1951–1953). Hopkins worked with the trumpeter Henry "Red" Allen at the Metropole Cafe in New York until 1960. He spent the next six years working at the Nevele, a Catskill resort in Ellenville, New York, with the trumpeter Shorty Baker, a drummer, and a singer. Back in New York City he joined the Jazz Giants, a six-piece group featuring the cornetist Wild Bill Davison; they toured for three years and recorded an album in Toronto in 1968. In the 1970s Hopkins mainly led his own groups or performed as a soloist, but early in the decade he also worked with the trumpeter Roy Eldridge at Jimmy Ryan's Club in New York. In 1972 he recorded the unaccompanied stride piano albums *Crazy Fingers* and *Soliloquy*. From 1974 he made annual tours of European festivals. Hopkins's health started to fail while he was in Europe in 1979. He died in a nursing home in the Riverdale section of New York City.

Studio recordings by Hopkins's big band are routinely criticized as undistinguished, unoriginal, and unmemorable. The solo albums of 1972 are offered as his finest recorded legacy, presenting in high fidelity the prewar Harlem stride piano style. Without arguing with this general assessment, one might make an exception for "Three Little Words" from the session of 6 April 1934. Hopkins's rollicking stride piano solo, underpinned by soft saxophone chords, gives way to his heavily percussive accompaniment to the saxophones' smooth statement of the melody; from there the band moves into tight ensemble work. With these segments glued together by a wonderfully bouncy rhythm section, one can begin to understand why Hopkins's somewhat unusual blend of stride and swing and soft pop was such a favorite of the Savoy and Roseland dancers.

FURTHER READING
Bernhardt, Clyde E. B., and Sheldon Harris. *I Remember: Eighty Years of Black Entertainment, Big Bands, and the Blues* (1986).
Dance, Stanley. *The World of Swing* (1974).
Vaché, Warren W. *Crazy Fingers: Claude Hopkins' Life in Jazz* (1992).

Obituary: New York Times, 23 Feb. 1984.

DISCOGRAPHY
Fernett, Gene. *Swing Out: Great Negro Jazz Bands* (1970).
Selchow, Manfred. *Profoundly Blue: A Bio-Discographical Scrapbook on Edmond Hall* (1988).

BARRY KERNFELD

HORNE, Frank

(18 Aug. 1899–7 Sept. 1974) optometrist, educator, administrator, and poet, was born Frank Smith Horne in Brooklyn, New York, the son of Edwin Fletcher and Cora Calhoun Horne. He attended the College of the City of New York (now City College of the City University of New York), and after graduating from the Northern Illinois College of Ophthalmology and Otology (now Illinois College of Optometry) in 1922 or 1923, he went into private practice in Chicago and New York City. He also attended Columbia University and later received a master's degree from the University of Southern California (c. 1932). He was married twice, to Frankye Priestly in 1930 and to Mercedes Christopher Rector in 1950, ten years after his first wife's death.

In 1926 Horne was forced to leave his optometry practice and move to the South owing to poor health. He became a teacher and track coach at Fort Valley High and Industrial School (renamed Fort

Valley Normal and Industrial in 1932 and now Fort Valley State University) in Fort Valley, Georgia, and within a decade he had risen to the position of dean and acting president. After 1936 he held a number of governmental administrative positions and was a member of President Franklin Roosevelt's "black cabinet." He was assistant director of the Negro Affairs division of the National Youth Administration in Washington, D.C., from 1936 to 1938 and worked in various capacities for the U.S. Housing Authority, including in the Housing and Home Finance Agency and the Office of Race Relations in Washington and New York City, from 1938 to 1955. He also served as the executive director of the New York City Commission on Intergroup Relations from 1956 to 1962 and as a consultant for the New York City Housing Redevelopment Board on race relations from 1962 to 1974. He was a founding member of the National Committee against Discrimination in Housing in 1950.

As a poet Horne is best known for *Letters Found near a Suicide*. Submitted pseudonymously by "Xavier I," the eleven-poem composite won second prize in the poetry category of the Amy Spingarn Contest in Literature and Art sponsored by *Crisis* magazine in 1925. Beginning with "To All of You," the poems in the series address individuals who have played significant roles in the speaker's life. "To Jean," for instance, addressed to a romantic rival, begins:

When you poured your love
like molten flame
into the throbbing mould
of her pulsing veins
leaving her blood a river of fire
and her arteries channels of light,
I hated you.

In 1929 Horne published seven more poems in the series in *Crisis* as *More Letters Found near a Suicide*, and the expanded version was published in 1963 as the initial section of *Haverstraw*, his only volume of poetry. The title poem of the collection, also a composite, is subtitled "Lyrics for the halt" and concerns Horne's attempt, after a crippling illness, "to learn to walk again . . . all tensed and trembling."

Although *Letters Found near a Suicide* and other sporadically published poems, including "On Seeing Two Brown Boys in a Catholic Church" and "Nigger, a Chant for Children," form the basis of Horne's literary reputation, he also contributed fiction, essays, and numerous reviews to black-oriented periodicals. "The Man Who Wanted To Be Red," an allegory for children on the absurdity of race, was published in *Crisis* in 1928, and "I Am Initiated into the Negro Race," detailing his experiences with segregation upon his arrival in Georgia, appeared in *Opportunity* the same year. The Fort Valley High track team was the subject of "Running Fools: Athletics in a Colored School," published in *Crisis* in 1930; "To James," one of the poems in *More Letters Found near a Suicide*, is addressed to James Collins, the school's star sprinter. Horne's essay "Concerning White People," three vignettes framed by the ironic assertion "There is one thing that white people clearly understand . . . and that is the working of the Negro mind," won honorable mention in the *Opportunity* literary contest in 1934. "The Industrial School of the South," a two-part series published in *Opportunity* in 1935, is a testament to his emulation of BOOKER T. WASHINGTON's educational model, but later essays, including "Providing New Housing for Negroes" (1940) and "War Homes in Hampton Roads" (1942), both in *Opportunity*, and "Interracial Housing in the United States" (1958), in *Phylon*, signal Horne's increasing advocacy of a federal role in public housing.

A significant if minor figure in the Harlem Renaissance, Horne created a perhaps more lasting legacy in his tireless efforts as a public official to improve housing conditions for African Americans across the nation. In 1954 the composer Earl Kim adapted Horne's most famous work as *Letters Found near a Suicide* for baritone and piano.

FURTHER READING
Brown, Sterling. *Negro Poetry and Drama* (1937).
Primeau, Ronald. "Frank Horne and the Second-Echelon Poets of the Harlem Renaissance," in *The Harlem Renaissance Remembered,* ed. Arno Bontemps (1972).

Obituary: New York Times, 8 Sept. 1974.

HUGH DAVIS

HUGHES, Langston

(1 Feb. 1902?–22 May 1967), writer, was born James Langston Hughes in Joplin, Missouri, the son of James Nathaniel Hughes, a stenographer and bookkeeper, and Carrie Mercer Langston, a stenographer. Left behind by a frustrated father who, angered by racism, sought jobs in Cuba and Mexico, and also left often by a mother searching for employment, Hughes was raised primarily in

Lawrence, Kansas, by his maternal grandmother, Mary Langston. In 1915 he went to reside with his mother and stepfather, Homer Clark, in Lincoln, Illinois, later moving with them to Cleveland, Ohio.

Hughes spent the summers of 1919 and 1920 with his father in Mexico, writing his first great poem, "The Negro Speaks of Rivers," aboard a train on his second trip. By the time he entered Columbia University in September 1921, Hughes already had poems published in *Brownies' Book* and the *Crisis*. He left Columbia after one year, traveled as a dishwasher and cook's assistant on freighters to Africa and Holland and at Le Grand Duc in Paris, and later worked as a busboy in Washington, D.C. With financial help from the philanthropist Amy Spingarn, he entered Lincoln University in 1926 as an award-winning poet who had taken first place in an *Opportunity* contest and second and third places in a contest in the *Crisis* the year before. By the time he graduated in 1929, he had published two volumes of poetry, *The Weary Blues and Other Poems* (1926) and *Fine Clothes to the Jew* (1927), and had helped to launch the daring African American literary journal *Fire!!*. He had also completed a reading tour in the South with the writer and anthropologist ZORA NEALE HURSTON, had become friends with other leading lights of the Harlem Renaissance, and had interested white socialites, artists, and patrons in his work.

For developing his artistic and aesthetic sensibilities, however, Hughes credited those people he dubbed admiringly as the "low-down folks." He praised the lower classes for their pride and individuality, that "they accept what beauty is their own without question." Part of the beauty that attracted him most was their music, especially the blues, which Hughes had heard as a child in Kansas City, as a teen in nightclubs in Chicago, Harlem, and Washington, D.C., on his trips through the South, and even as a young man in Europe. To Hughes the blues were, as he wrote in "Songs Called the Blues" (1941), songs that came out of "black, beaten, but unbeatable throats." They were the sad songs of proud and wise people who, through the mixture of tears and laughter (often their response on hearing the lyrics) demonstrated a vivacity, wisdom, and determination. This inspired Hughes to attempt to capture the pulse and spirit of the blues tradition as a way of interpreting his people both to the rest of the world and to themselves. Hughes was galvanized by the music of his people, whether blues, jazz,

or religious. The music provided him with themes, motifs, images, symbols, languages, rhythms, and stanza forms he would use in his writing throughout his career. As early as 1926, he was trying to schedule blues music as part of his poetry readings; in 1958 he recorded his poetry to the accompaniment of jazz groups led by RED ALLEN and CHARLES MINGUS. At Hughes's funeral, a program of blues was performed.

At the beginning of his writing career, Hughes was encouraged by the writer and editor JESSIE FAUSET, W. E. B. DU BOIS, JAMES WELDON JOHNSON, one of the judges who awarded Hughes his first poetry prizes and later anthologized some of Hughes's work, and ALAIN LOCKE, whose 1925 issue of the *Survey Graphic*, later revised into the groundbreaking volume *The New Negro* (1925), included some of Hughes's work. Through both the intellectual leadership of the highbrows and the invigorating atmosphere provided by the "low-down" folks in Harlem, Hughes found himself encouraged and gaining in fame. Vachel Lindsay's praise in 1925 of poems left by his plate in the Wardman Park Hotel in Washington by a "busboy poet" precipitated a flurry of interest and brought Hughes a wider audience for his poetry. But it was the arts patron Carl Van Vechten who gave Hughes's career its biggest boost in the white world by taking Hughes's first book to Knopf and establishing contacts for Hughes that would serve him personally and professionally. Hughes repaid Van Vechten's assistance most directly with his support of and contributions to Van Vechten's novel *Nigger Heaven*; the two remained friends until Van Vechten's death in 1964.

At the end of her review of *The Weary Blues* in the *Crisis* in 1926, Fauset said of Hughes that "all life is his love and his work a brilliant, sensitive interpretation of its numerous facets." Not all reviews of Hughes's first book were so laudatory. Although the white press largely responded positively to Hughes's poetry, some black reviewers, seeking middle-class respectability from their "Talented Tenth" writers rather than Hughes's more realistic portrayal of the range of African American life, reacted negatively. They particularly opposed the blues and jazz poems of the opening section of the book In his review in *Opportunity* in February 1926, the poet COUNTÉE CULLEN characterized the book as "scornful in subject matter" with "too much emphasis here on strictly Negro themes." Hughes naturally identified with the black masses, but at the same time

he aligned himself with the modernist predilection for experimentation and frank treatment of themes previously banished from polite literature. Thus Hughes was both avant-gardist and traditionalist in his approach to his art. Surely he must have appreciated Locke's review in *Palms* in 1926, which stated that some of the lyrics "are such contributions to pure poetry that it makes little difference what substance of life and experience they are made of." Clearly, however, the substance of life and experience of which they were made also was paramount to Hughes. The lives and dreams of African Americans found intimate expression in Hughes's poems, such as the heritage-laden "The Negro Speaks of Rivers," "Mother to Son," with its doggedly determined narrator, "To Midnight Nan at Leroy's," with its evocation of Harlem nightclub life, and the longingly hopeful "Dream Variation." The volume was an auspicious beginning that established Hughes's ideological and artistic leanings and conflicts that recurred amplified in his later work.

The responses to *Fine Clothes to the Jew* were even more extreme. Hughes realized that the book was, as he told the *Chicago Defender*, "harder and more cynical." He braced himself nervously for the reviews, encouraged by positive responses from Amy and Arthur Spingarn and GEORGE SCHUYLER. Again many black critics believed that Hughes had presented a cheap, tawdry portrait, far from the respectable African American they longed to see in their literature. The "poet 'low-rate' of Harlem" the reviewer for the *Chicago Whip* dubbed him; "Sewer Dweller," sneered the headline of the *New York Amsterdam News* review; "piffling trash," pronounced the historian J. A. ROGERS in the *Pittsburgh Courier*. Attacks on the short-lived *Fire!!* and Van Vechten's *Nigger Heaven*, which Hughes supported and for which he wrote blues lyrics following a lawsuit against Van Vechten for copyright infringement, compounded Hughes's embattled aesthetic consciousness at this time. However, Hughes continued undeterred, in spite of the volume's failure to sell well. In winter 1927, Alain Locke introduced Hughes to "Godmother" Charlotte Mason, an elderly, wealthy widow with a newfound interest in African American authors, who became his benefactor, offering both financial support and opinions about his work. After reading and lecturing in the South in summer 1927, during which he met up with Hurston in Biloxi, Mississippi, Fauset in Tuskegee, Alabama, and BESSIE SMITH

in Macon, Georgia, Hughes returned to Harlem and the directive of Mason to write a novel, *Not without Laughter* (1930).

Initially Hughes and Mason got along well, but the artistic and social demands she made on him were at times stultifying, and even the stipend she provided placed him in uncomfortable surroundings that impeded his artistic progress. The social "upward mobility," the economic support for his mother and half brother Gwyn Clark, the free apartment, the patron-funded trip to Cuba—all were mixed blessings. After their relationship was ruptured in 1930, Hughes, hurt and angry, wrote about the situation in the poem "The Blues I'm Playing" (1934) and in the first volume of his autobiography, *The Big Sea* (1940). Winning the Harmon Foundation Prize in 1930 brought him welcome cash, and he occupied some of his time by collaborating with Hurston on the play *Mule Bone* and traveling to Haiti, but the break with Mason was both psychologically and physically trying for Hughes.

Hughes dedicated *Not without Laughter* to his friends and early patrons, the Spingarns; his *Dear Lovely Death* was privately printed by Amy Spingarn in 1931. At the same time he was losing Godmother, difficulties with Hurston concerning *Mule Bone* put a chasm between them and a distrust of Locke, who was vying for Godmother's favor, separated Hughes from him as well. Hughes avoided dealing with these personal difficulties by going first to Florida, then Cuba, and on to Haiti, where he met with the Haitian poet Jacques Roumain, who, inspired by Hughes, later wrote a poem titled "Langston Hughes" and received a letter of support from Hughes when he was sentenced to prison for alleged procommunist activity. Hughes, of course, had always identified with the masses, and he had a distinct influence on writers like Roumain and Nicolás Guillén, whom Hughes had inspired in 1929 to employ the rhythms of native Cuban music in his poetry. A 1931 reading tour partially sponsored by the Rosenwald Fund reintroduced Hughes to the rigid segregation and racism of the South, as did the much-publicized trial of the SCOTTSBORO BOYS. Hughes, the poet who initially had not been radical enough for the Marxist *New Masses* but who later published poems in that journal while at Lincoln, now began writing more controversial and directly political poems, such as "Christ in Alabama," which caused a furor that swelled his audience and increased sales of all his work.

In June 1932 he left for the Soviet Union with a group interested in making a film about race relations in America. Although the film, proposed by Soviet authorities and backed by the black communist JAMES W. FORD, was never made, Hughes's travels in the Soviet Union showed him the lack of racial prejudice he longed for and a peasant class that he sought out and admired. Both *The Dream Keeper* and *Popo and Fifina*, children's books, were released to acclaim while he was in Russia. After visits to Japan, where Hughes was both questioned and put under surveillance because he was a "revolutionary" just come from Moscow, and Hawaii, Hughes returned to the wealthy arts patron Noel Sullivan's home in Carmel, California, where he worked on the short-story collection *The Ways of White Folks* (1934), which was published shortly before his father died in Mexico.

Hughes's interest in drama, as shown by his collaboration on *Mule Bone*, finally bore fruit with the 1935 production of his play *Mulatto* at the Vanderbilt Theater on Broadway and the Gilpin Players' 1936 production of *Troubled Island*. He received financial support from a Guggenheim Fellowship in 1935 and worked in Spain as a correspondent for the *Baltimore Afro-American* in 1937. Following the death of his mother in 1938, Hughes founded the Harlem Suitcase Theatre that same year, the New Negro Theatre in Los Angeles in 1939, and the Skyloft Players in Harlem in 1942. During this period he had plays produced in Cleveland, New York, and Chicago, among them *Little Ham* (1936), *Soul Gone Home* (1937), *Don't You Want to Be Free?* (1938), *The Organizer* (with music by JAMES P. JOHNSON, 1939), and *The Sun Do Move* (1942), and he collaborated on a play with ARNA BONTEMPS, *When the Jack Hollers* (1936). His experience with Hollywood, writing the script for *Way Down South* (1939), was a bitter disappointment. Still, Hughes managed to establish his importance as an African American dramatist and continued to write plays and libretti for the rest of his career.

The year 1939 found Hughes back in Carmel working on his autobiography, *The Big Sea*, which dealt with his life up to 1931. Positive response to the work was overshadowed by fevered excitement over RICHARD WRIGHT's *Native Son*, but Hughes did receive a Rosenwald Fund Fellowship at a point when his repudiation of his poem "Goodbye Christ" had turned some of his leftist friends against him. The Rosenwald money allowed Hughes

to focus on writing rather than on financial matters. His blues-inflected *Shakespeare in Harlem* (1942) picked up where he had left off with *Fine Clothes to the Jew* in 1927 and provoked the same divided response as the earlier volume. Following an invitation to the writers' colony Yaddo, where he met Carson McCullers, Katherine Anne Porter, and Malcolm Cowley, he contacted the *Chicago Defender* about being a columnist and was hired. In 1943 Hughes created the beloved comic character Jesse B. Semple ("Simple"), the assertive and lively "lowdown" hero who appeared in many of his *Defender* columns over the next twenty years. Also in 1943 he published the prose poem *Freedom's Plow* (introduced with a reading by Paul Muni, with musical accompaniment by the Golden Gate Quartet and later performed publicly by Fredric March) and *Jim Crow's Last Stand*, a leftist, patchwork book of poetry.

In 1945 Hughes began to work on lyrics for Elmer Rice's *Street Scene*, with music by Kurt Weill, which opened to strong reviews in 1947. Hughes, however, opted to work as a visiting writer-in-residence at Atlanta University that year, seeing his book of lyric poems *Fields of Wonder* released to mixed reviews and the publication of his translation, with Mercer Cook, of Roumain's *Masters of the Dew*. Receiving a regular salary from Atlanta and one thousand dollars from a National Institute and American Academy of Arts and Letters Award in 1946, plus royalties from *Street Scene*, provided him more financial stability, thus leaving time for him to edit with Bontemps a reissue of James Weldon Johnson's *Book of American Negro Poetry*. He was also able to publish a translation (with Ben Frederic Carruthers) of Nicolás Guillén's *Cuba Libre* and prepare another collection of poetry, *One-Way Ticket* (1949). A return to jazz- and blues-saturated poetry, this volume contains Hughes's celebrated "Madam" poems and the song "Life Is Fine," trumpeting perseverance and optimism. When the opera *Troubled Island* opened in 1949, Hughes was busy trying to find a publisher for the second volume of his autobiography and a new volume of poems. The production of *The Barrier* (1950), an opera based on the play *Mulatto*, yielded little money, though the collection of Simple stories *Simple Speaks His Mind* (1950) sold thirty thousand copies and received general critical acclaim. Hughes was becoming better known, and translations of his work and critical essays were appearing.

Yet as success loomed, Hughes's masterful jazz-imbued *Montage of a Dream Deferred* (1951), a book-length poem in five sections depicting the rhythms of bop, boogie, and blues of the urban African American experience in the context of continued deferment of the promises of American democracy, was critically panned. However, his short-story collection *Laughing to Keep from Crying* (1952) fared better with critics. Prolific throughout his career in multiple genres, Hughes began work on a series of children's books for Franklin Watts, which released *The First Book of Negroes* (1952), *The First Book of Rhythms* (1954), *The First Book of Jazz* (1955), *The First Book of the West Indies* (1956), and *The First Book of Africa* (1960). He also published other historical nonfiction works, *Famous American Negroes* (1954), *Famous Negro Music Makers* (1955), *A Pictorial History of the Negro in America* (with Milton Meltzer, 1956), *Famous Negro Heroes of America* (1958), *Fight for Freedom: The Story of the NAACP* (1962), and *Black Magic: A Pictorial History of the Negro in American Entertainment* (with Meltzer, 1967). The quality and success of these books established Hughes's importance as a popular historian of African American life. The second volume of his autobiography, *I Wonder as I Wander* (1956), emphasized Hughes's determination to survive and prosper, undaunted by the adversity and suffering he had faced in his travels in this country and around the world.

Nevertheless, Hughes found himself increasingly under the siege of McCarthyism and was forced to appear in March 1953 before Joseph R. McCarthy's Senate subcommittee, not to defend his poetry but to repudiate some of his zealous leftist activities and work. Hughes's Simple stories continued to draw positive critical response and pleased his readers, although the Simple collections, *Simple Takes a Wife* (1953), *Simple Stakes a Claim* (1957), *The Best of Simple* (1961), and *Simple's Uncle Sam* (1965) did not sell well. The play *Simply Heavenly* began a reasonably successful run in 1957, landing on Broadway and on the London stage. That same year his translation of *Selected Poems of Gabriela Mistral* appeared, followed in 1958 by his selection and revision of his writings, *The Langston Hughes Reader*, and in 1959 by *Selected Poems of Langston Hughes* and his rousing play *Tambourines to Glory*, which he had converted into a novel of the same title in 1958.

Certainly by the 1960s Hughes was an elder statesman of his people and a literary celebrity, adding to his publications stagings of his dramas, recordings, television and radio shows, and appearances at conferences (in Uganda and Nigeria and at the National Poetry Festival in Washington, D.C., in 1962), jazz clubs, and festivals. He received honorary doctorates from Howard University in 1963 and Western Reserve University in 1964. The poetry was still flowing, with *Ask Your Mama* (1961) and *The Panther and the Lash* (1967) demonstrating that Hughes's satiric and humanitarian impulses were undiminished, as were his dramatic juices, evidenced by the critical success of the gospel play *Black Nativity* (1961). Always eager to help younger writers, he edited *New Negro Poets: USA* (1964).

Indeed, the final years of his life were filled with activity: the production of his play *The Prodigal Son* (1965), a two-month State Department tour of Europe lecturing on African American writers, work on *The Best Short Stories by Negro Writers* (1967), and trips to Paris (with the production of *Prodigal Son*) and to Africa (as a presidential appointee to the First World Festival of Negro Arts), along with readings and lectures, filled his days. In the midst of this frenetic life, Hughes was admitted to the hospital with abdominal pains, later found to be caused by a blocked bladder and an enlarged prostate. Despite a successful operation, his heart and kidneys began to fail, and Hughes died in New York City.

Langston Hughes praised the "low-down folks" in the essay "The Negro Artist and the Racial Mountain" (*Nation*, 23 June 1926) for furnishing "a wealth of colorful, distinctive material" and for maintaining "their individuality in the face of American standardizations." Hughes's own life and career might be viewed in the same light. The variety and quality of his achievements in various genres, always in the service of greater understanding and humanity, and his specific commitment to depicting and strengthening the African American heartbeat in America—and to helping others depict it as well—gave him a place of central importance in twentieth-century African American literature and American literature generally. Hughes sought to change the way people looked not only at African Americans and art but also at the world, and his modernistic vision was both experimental and traditional, cacophonous and mellifluous, rejecting of artificial middle-class values, and promoting emotional and intellectual freedom. He

demonstrated that African Americans could support themselves with their art both monetarily and spiritually. Hughes published more than forty books in a career that never lost touch with the concerns of sharecroppers and tenement dwellers as it provided inspiration for not only African American writers but for all working people.

FURTHER READING

Hughes's papers are in the James Weldon Johnson Memorial Collection, Beinecke Rare Book and Manuscript Library, Yale University.

Berry, Faith. *Langston Hughes: Before and Beyond Harlem* (1983).

The Langston Hughes Review (1982–present).

Mikolyzk, Thomas A., ed. *Langston Hughes: A Bio-Bibliography* (1990).

Nichols, Charles, ed. *Arna Bontemps–Langston Hughes Letters, 1925–1967* (1980).

Rampersad, Arnold. *The Life of Langston Hughes*, vol. 1 (1986) and vol. 2 (1988).

Tracy, Steven C. *Langston Hughes and the Blues* (1988).

Obituary: New York Times, 24 May 1967.

STEVEN C. TRACY

HUNTER, Alberta

(1 Apr. 1895–17 Oct. 1984), singer, was born in Memphis, Tennessee, the daughter of Charles Hunter, a sleeping-car porter, and Laura Peterson, a maid. Hunter attended public school until around age fifteen. Her singing career began after she went to Chicago with one of her teachers. Hunter stated at times that she was eleven or twelve years old when she tricked the teacher into allowing her to ride with her by train on a child's pass. However, other accounts suggest that she may have been in her mid-teens. Until she was able to support herself as a performer in Chicago's South Side clubs, she lived with a friend of her mother's.

Throughout her career, Hunter worked hard to keep her personal relationships out of the limelight. Her sudden marriage in 1919 to Willard Saxbe Townsend was most likely a cover for her lesbianism, although she claimed to love him. The marriage was never consummated, but Townsend did not apply for a divorce until 1923. Hunter's biographer, Frank Taylor, states that sexual abuse in her childhood may account for her abhorrence of any man who attempted to become intimate. Her close relationship with her mother probably

was her most enduring alliance. She is known to have had female traveling companions during her sojourns abroad, but there is scant written evidence of her openly acknowledging her homosexuality in the press, although language in her autobiography implicitly suggests her preference for women.

Hunter's first singing job was in a bordello. From there she moved to the small clubs that catered mainly to sporting men—black and white. In 1914 she was tutored by Tony Jackson, a prominent jazz pianist, who helped her to expand her repertoire and to compose her own songs.

The next move put her in the company of and competition with other aspiring young women such as MATTIE HITE, Cora Green, FLORENCE MILLS, and BRICKTOP SMITH. The Panama Club, owned by Isadore Levine and I. Shorr, was one of a number of white-owned clubs with white-only clientele that were gaining popularity in Chicago, New York, and a few other cities. Hunter claimed that her act was in the upstairs room where the music and the action were "kind of rough and ready." The barrelhouse upstairs contrasted with the ballads and fox-trot songs that Mills and others performed downstairs. In this setting Hunter developed as a blues singer for a cabaret crowd that was dramatically different from the audiences in black theaters and clubs. During the second decade of the twentieth century, she and the other women who performed in these surroundings shaped the blues into an insurgent song form that attracted an increasing number of white patrons: "The customers wouldn't stay downstairs. They'd go upstairs to hear us sing the blues. That's where I would stand and make up verses and sing as I go along." Hunter's appeal was based on her extraordinary gift for improvising lyrics to titillate and satisfy the white audience's appetite for ribald or humorous material. Other songwriters, recognizing her ability to promote a song by adding her unique melodic and textual twists, brought their new songs to her. This source of income added to her security as a performer and allowed her to support her mother, who had moved to Chicago.

Hunter moved from one small club to another from 1916 until 1920. She considered herself as having arrived when she got a contract at the Dreamland Café, where the fabulous King Oliver Band, with the young LOUIS ARMSTRONG, was playing. Her performances at the Dreamland garnered praise from the local black press, and by 1921 she was recording for the Black Swan label. Her first

release—" How Long, Sweet Daddy, How Long?" —established her as a blues singer of substantial quality. By the end of 1922 Hunter had already recorded fourteen blues and torch songs. The Black Swan numbers were recorded with the Dreamland orchestra or the FLETCHER HENDERSON Orchestra. The material was rather trite and reflected the label's hesitancy to record what it considered raw blues.

In mid-1922 Hunter switched to the Paramount label, for which she recorded her own creation, "Down-Hearted Blues," which was to become famous when BESSIE SMITH recorded it a year later for Columbia Records. She was called "The Idol of Dreamland" by Paramount Records when it advertised her releases in the *Chicago Defender*. She cut two sides with EUBIE BLAKE on piano around the same time, including "Jazzin' Baby Blues," a light fox-trot rather than a blues. In 1923, while still working for Paramount, she also recorded for Harmograph Records under the pseudonym May Alix. Hunter was listed as Alberta Prime, accompanied by DUKE ELLINGTON and Sonny Greer, on the Biltmore label by the end of 1924. On Gennett she assumed her sister's name, Josephine Beatty, accompanied by Armstrong and the Red Onion Jazz Babies. There is no question that Hunter is the artist on these numbers because her phrasing and expressiveness are evident. From 1921 until 1929 she recorded at least fifty-two songs under her name and various pseudonyms. Her accompanists included some of the finest jazz artists of that era: Armstrong, Henderson, Blake, Ellington, FATS WALLER, and Buster Bailey.

Hunter's career received a decided boost from the record advertisements that appeared in the black press. Unlike most of her blues singing peers, she seldom appeared in vaudeville. She was the darling of the cabaret set who enjoyed their blues in intimate club settings undisturbed by the lively crowds on the Theater Owners' Booking Association circuit. In 1923 she was the star of a touring musical revue, *How Come*, but she quit the company to return to New York after five months. Other shows in which she was featured were *Runnin' Wild* and *Struttin' Time*. In late 1924 she performed along with black artists such as NOBLE SISSLE, Blake, and Fletcher Henderson for a benefit sponsored by the NAACP in New York.

Hunter, augmented by two male dancers and a pianist, presented her new act, Syncopation DeLuxe, in February 1925. It opened at New York's Loewe's Theatre and moved to the Waldorf-Astoria in April. She had the only black act on the eighteen-act bill, according to the *Chicago Defender*. She toured the Orpheum circuit in the West and the Keith circuit in the East during that year and went back to New York in January 1926 to record her first release on the Okeh label. In June she and Samuel Bailey formed a duo, which toured on the Keith circuit.

Hunter's first European tour came at the end of 1927 and proved an overwhelming success with appearances at London's Hippodrome, Monte Carlo, and the Casino de Paris. She signed with the London cast in mid-1928 for Jerome Kern's *Show Boat*, in which she created the role of Queenie opposite PAUL ROBESON's Joe. The show remained in London at Drury Lane for nearly ten months, earning accolades for the two actor-singers. When *Show Boat* closed, Hunter toured the nightclub circuit in France, Denmark, and Germany.

On her return to New York in 1929, Hunter recorded on the Columbia label and formed another song-and-dance act with two young male dancers. Chicago continued to have its pull because of her early successes and her mother's presence, so she often moved between the two cities. New York, however, was where she recorded and performed regularly in clubs. She left again for Europe in 1933. That tour included Holland and a stint as a replacement for JOSEPHINE BAKER at the Casino de Paris. Londoners were particularly fond of Hunter's interpretation of ballads, and she did nightly broadcasts while there. Her first European film, *Radio Parade of 1935*, was produced in England. She was cast as a singing star in an episode depicting African dancers and drummers, but she had no speaking part.

Hunter frequently worked abroad during the 1930s. Her itinerary expanded to include the Middle East, Egypt, and Russia by the mid-1930s. Toward the end of the decade, however, the spread of fascism made Europe less receptive to black performers. She returned to Chicago in 1938, where she broadened her radio audience. She also tried serious drama with a role in *Mamba's Daughters*. From that point she performed mainly in small clubs in Chicago, Detroit, and the Great Lakes region. She made few recordings, and by the end of 1940 she was not to be recorded again on an American label for another forty years. By this time the music scene was dominated by the big swing bands, and opportunities were few for African American women to

record with the major white bands that garnered most of the recording contracts.

Ironically, World War II gave her another performing opportunity when she was attached to a USO unit. Her participation in efforts to entertain the troops ended with a command performance for General Dwight D. Eisenhower in June 1945. After the war Hunter officially retired from the stage and stayed home to care for her ailing mother. She earned a nursing certificate at an age when most women were retiring from the profession. Her habitual lying about her age and her youthful appearance fooled the authorities and enabled her to serve in that capacity until she was eighty-two.

Although she had declared that she would not return to the stage, Hunter was enticed to try the cabaret scene again in the fall of 1977 by the Greenwich Village club owner Barney Josephson. This appearance revived her singing career, but this time she concentrated on singing the blues for young patrons who were delighted by the octogenarian's naughty ad-libs. Energetic and bubbly with a wry sense of humor, Hunter embarked again on songwriting and recording with the assistance of Columbia Records producer John Hammond. Together, they produced her album *Amtrak Blues*, which included her compositions: the title song and revivals of the 1920s' "I Got a Mind to Ramble" and "I'm Having a Good Time." She also recorded her songs for the soundtrack of *Remember My Name* (1977) and an album of new and old blues, *The Glory of Alberta Hunter* (1981). Hunter appeared in clubs, on television talk shows and documentaries, in commercials, and at jazz festivals and concerts until her death in New York.

FURTHER READING

Harrison, Daphne Duval. *Black Pearls: Blues Queens of the 1920s* (1988).

Taylor, Frank C., with Gerald Cook. *Alberta Hunter: A Celebration in Blues* (1987).

Obituary: New York Times, 19 Oct. 1984.

DAPHNE DUVAL HARRISON

HURSTON, Zora Neale

(15 Jan. 1891–28 Jan. 1960), writer and anthropologist, was born Zora Lee Hurston in Notasulga, Alabama, the daughter of John Hurston, a Baptist minister and carpenter, and Lucy Ann Potts.

John Hurston's family were Alabama tenant farmers until he moved to Eatonville, Florida, the first African American town incorporated in the United States. He served three terms as its mayor and is said to have written Eatonville's ordinances. Zora Neale Hurston studied at its Hungerford School, where followers of BOOKER T. WASHINGTON taught both elementary academic skills and self-reliance. Growing up in an exclusively black community gave her a unique background that informed and inspired much of her later work.

Much of the chronological detail of Hurston's early life is obscured by the fact that she later claimed birth dates that varied from 1898 to 1903. Most often she cited 1901 as her birth year, but the census of 1900 lists a Zora L. Hurston, born in 1891, as the daughter of John and Lucy Hurston. According to Zora Neale Hurston's later accounts, she was nine years old when her mother died, and, when her

Zora Neale Hurston in the mid-1930s. Hurston published two important anthropological studies of African American and Caribbean folklore, as well as the well-known novel Their Eyes Were Watching God. *(Library of Congress.)*

father remarried, she left Eatonville to be "passed around the family like a bad penny." At fourteen, she reported, she joined a traveling Gilbert and Sullivan theater company as maid and wardrobe girl. After eighteen months on the road, she left the company in Baltimore, Maryland. There Hurston worked in menial positions and studied at Morgan Academy, the preparatory school operated by Morgan College.

After she graduated from Morgan Academy in 1918, Hurston moved to Washington, D.C. She worked in a variety of menial positions and was a part-time student at Howard University from 1919 to 1924. At Howard, Hurston studied with ALAIN LOCKE and Lorenzo Dow Turner, who encouraged her to write for publication. Accepted as a member of Stylus, the campus literary club, she published her first short story, "John Redding Goes to Sea," in its literary magazine, the *Stylus*, in May 1921. Three years later CHARLES S. JOHNSON's *Opportunity*, a major literary vehicle for writers of the Harlem Renaissance, published two of Hurston's stories, "Drenched in Light" and "Spunk." In these early stories she staked out a perspective characteristic of her later African American folktales. They celebrate the lives of ordinary black people who had little interaction with or sense of oppression by a white community.

In 1925, after winning an award for "Spunk," Hurston moved to New York City, where she joined other writers and artists of the Harlem Renaissance. As secretary and chauffeur to novelist Fannie Hurst, Hurston also gained access to contemporary white literary circles. In September 1925 she began studying at Barnard College on a scholarship. Nine months later Hurston, AARON DOUGLAS, LANGSTON HUGHES, and WALLACE THURMAN launched a short-lived, avant-garde magazine, *Fire!!*. Against the claim of older African American mentors, such as W. E. B. DU BOIS and Alain Locke, that a black writer was obliged to express a racial consciousness in the face of white hostility, they held that the creative artist's obligation was to give voice to the vitality of an African American culture that was more than simply a reaction to white oppression. Hurston's short story "Sweat" is the most important of her published essays and short stories in this period.

At Barnard, Hurston became a student of the noted anthropologist Franz Boas. "Papa Franz," as she called him, encouraged Hurston's interest in the folklore of her people. Her first field research took Hurston to Alabama to interview a former slave, Cudjo Lewis, for CARTER G. WOODSON's Association for the Study of Negro Life and History. Her article "Cudjo's Own Story of the Last African Slaves," which appeared in the *Journal of Negro History* (1927), was marred, however, by plagiarism from Emma Langdon Roache's *Historic Sketches of the Old South*. When Hurston received a BA from Barnard in 1928, she was the first African American known to have graduated from the institution.

In 1927 Hurston married Herbert Sheen, a medical student with whom she had begun a relationship in 1921 when they were both students at Howard University. Four months after their marriage, however, Hurston and Sheen parted company, and they were divorced in 1931.

Hurston's literary career illustrates the difficult struggle of an African American female writer for support and control of her work. From 1927 to 1932 Hurston's field research was sponsored by a wealthy white patron, Charlotte Louise Mason. With that support, Hurston made her most important anthropological forays into the South, revisiting Alabama and Florida, breaking new ground in Louisiana, and journeying to the Bahamas. Working in rural labor camps and as an apprentice to voodoo priests, she collected an anthropologist's treasure of folklore, children's games, prayers, sermons, songs, and voodoo rites. Yet the hand that sustained was also the hand that controlled. Mason insisted that Hurston sign a contract that acknowledged the white patron's ownership of and editorial control over the publication of Hurston's research.

In the spring of 1930, Hurston and Langston Hughes collaborated in writing a play, *Mule Bone*. Only its third act was published, but in 1931 Hughes and Hurston quarreled over its authorship. When she claimed that its material was hers, he accused her of trying to take full credit for the play. The two authors never resolved their differences in the matter, but it seems clear that Hurston's anthropological research supplied the material to which Hughes gave dramatic form.

By the mid-1930s Hurston had begun to reach her stride. Her first novel, *Jonah's Gourd Vine*, was published in 1934. Its protagonist, John Buddy "Jonah" Pearson, is a folk preacher whose sermons display Hurston's mastery of the idiom. Indeed, the folk material threatens to overshadow the novel's characters and plot. Like her other work, the novel

was also criticized for ignoring the effects of racial oppression in the South. In 1934, after a semester of teaching at Bethune-Cookman College in Daytona Beach, Florida, Hurston received a Rosenwald Fellowship and enrolled for graduate work in anthropology at Columbia University. Briefly in 1935–1936 she was employed as a drama coach by the Works Progress Administration (WPA) in New York. Hurston never completed a graduate degree, but she received Guggenheim field research fellowships for the 1935–1936 and 1936–1937 academic years. Her first major anthropological work, *Mules and Men*, appeared in 1935. It mined the rich lode of her research in southern African American folklore in the late 1920s and early 1930s. The Guggenheim fellowships took Hurston to Jamaica and Haiti to study Caribbean folk culture. Those studies produced her second major anthropological work, *Tell My Horse*, in 1938.

Now at the peak of her productive years, Hurston published her second major novel, *Their Eyes Were Watching God*, in 1937. Written in eight weeks, during which Hurston was recovering from a passionate romantic relationship, *Their Eyes Were Watching God* is the most successful of her novels artistically. Its heroine, Janie Starks, is a free-spirited woman who pursues her dream of emotional and spiritual fulfillment. Janie and her third husband, Tea Cake, like most of Hurston's folk subjects, enjoy their laughter and their sensuality even in their poverty. In her own life, however, Hurston was less successful in love. In 1939, after a year as an editor for the Federal Writers' Project in Florida and a year of teaching at North Carolina College in Durham, Hurston married Albert Price III, a WPA playground director who was at least fifteen years her junior. After eight months they filed for a divorce. There were attempts at a reconciliation, but the divorce became final in 1943.

Hurston's subsequent fiction was less successful artistically. *Moses, Man of the Mountain*, published in 1939, depicted the leader of the biblical exodus and lawgiver as a twentieth-century African American witch doctor. In 1942 Hurston published her autobiography, *Dust Tracks on the Road*. It was the most successful of her books commercially. As autobiography, however, it was an accurate portrait not of Hurston's life but of the persona she wanted the public to know: an ambitious, independent, even "outrageous" woman, with a zest

for life unhindered by racial barriers. Yet her life became increasingly difficult. Arrested on a morals charge involving a retarded sixteen-year-old boy, Hurston was eventually cleared of the accusations. The African American press gave graphic coverage to the sensational nature of the case, and the publicity had a devastating effect on her career. Hurston's efforts to win funding for a field trip for research in Central America were frustrated until she received an advance for a new novel. In 1947 Hurston left the United States for the British Honduras, where she did anthropological research in its black communities and completed *Seraph on the Suwanee*, her only novel whose characters are white. Published in 1948, *Seraph on the Suwanee*'s portrait of Arvay Henson Meserve as a woman entrapped in marriage might have found a more receptive audience two decades earlier or two decades later.

By 1950 Hurston's failure to find a steady source of support for her work forced her to take a position in Miami as a domestic worker. There was a stir of publicity when her employer found an article in the *Saturday Evening Post* written by her maid. During the 1940s and 1950s, however, Hurston's essays were more likely to appear in right-wing venues, such as the *American Legion Magazine* or *American Mercury*, rather than the mainstream press. By then her celebration of African American folk culture and her refusal to condemn the oppressive racial climate in which it was nurtured had allied Hurston with forces hostile to the civil rights movement. A 1950 article titled "Negro Votes Bought" seemed to oppose the enfranchisement of African Americans. Four years later, in a letter to the editor of a Florida newspaper, which was widely reprinted, Hurston attacked the U.S. Supreme Court's decision in *Brown v. Board of Education* on the grounds that it undervalued the capacity of African American institutions to educate African American people and of African American people to learn apart from a white presence.

Throughout the 1950s Hurston worked intermittently as a substitute teacher, a domestic worker, and a contributor to a local newspaper, but she was ill and without a steady income. She spent much of her time writing and revising a biography of Herod the Great, but both the subject and the language of the manuscript lacked the vitality of her earlier work. Even after a stroke in 1959, Hurston refused to ask her relatives for help. She died in the county

welfare home at Fort Pierce, Florida. After a public appeal for money to pay for her burial, Hurston was laid to rest in Fort Pierce's African American cemetery. In 1973 the writer Alice Walker placed a granite tombstone in the cemetery, somewhere near Hurston's unmarked grave.

FURTHER READING

Material from Hurston's early career is scattered in collections at the American Philosophical Society Library, the Amistad Research Center at Tulane University, Fisk University's Special Collections, Howard University's Moorland-Spingarn Research Center, the Library of Congress, and Yale University's Beinecke Library. The Zora Neale Hurston Collection at the University of Florida includes letters and manuscripts from her later years.

Davis, Arthur P. *From the Dark Tower: Afro-American Writers, 1900–1960* (1974).

Gates, Henry Louis, Jr., and K. A. Appiah, eds. *Zora Neale Hurston: Critical Perspectives Past and Present* (1993).

Hemenway, Robert E. *Zora Neale Hurston: A Literary Biography* (1977).

Newson, Adele S. *Zora Neale Hurston: A Reference Guide* (1987).

Sundquist, Eric J. *The Hammers of Creation: Folk Culture in Modern African American Fiction* (1992).

Turner, Darwin T. *In a Minor Chord: Three Afro-American Writers and Their Search for Identity* (1971).

Walker, Alice. "In Search of Zora Neale Hurston," *Ms.* (Mar. 1975), 74–79, 85–89.

Wall, Cheryl A. *Women of the Harlem Renaissance* (1995).

Obituary: *New York Times*, 5 Feb. 1960.

RALPH E. LUKER

JACKMAN, Harold

(1901–8 July 1961), teacher, model, dramatist, and collector of African American artifacts, was born in London to a West Indian mother and a British father, of whom little is known. It is believed that his mother was black and his father was white. Nor is it known when Jackman came to the United States, but he was raised in Harlem, New York, and graduated from DeWitt Clinton High School, where he befriended the poet COUNTÉE CULLEN. Jackman earned a BA degree from New York University in 1923 and an MA from Columbia University in 1927. For more than three decades he taught social studies in the New York Public Schools.

Aptly described as "the non-writer whom everyone adored," Jackman inspired tributes from those prominent Harlem Renaissance personalities with whom he socialized (Griffin, 494). Cullen, for example, dedicated an early version of his poem "Advice to Youth" (1925) to Jackman. In the same year, Winold Reiss's portrait of Jackman, titled *A College Lad,* was published on the back cover of an issue of *Survey Graphic,* whose subject matter was "Harlem: Mecca of the New Negro." Lewis incisively discusses the significance of the debonair "New Negro" and infers that Jackman, "one of Harlem's handsomer, more polished boulevardier bachelors" (Lewis, 115), appropriately exemplified this new identity. Bruce Kellner suggests, however, that Jackman was included in *Survey Graphic,* "less for his achievements than for his good looks" (Kellner, 189). Jackman worked as a model from the 1920s until the 1950s, most notably for Ophelia DeVore's Grace Del Marco (GDM) modeling agency. Thinly disguised characterizations of Jackman appeared in Carl Van Vechten's *Nigger Heaven* (1926) and WALLACE THURMAN's *Infants of Spring* (1932).

Jackman contributed significantly to the establishment and the promotion of African American theater. When, at the suggestion of Ernestine Rose, a librarian at the 135th Street branch, and W. E. B. DU BOIS, an ensemble of African American performers and playwrights established the Krigwa Players Little Negro Theater in 1926, Jackman was a founding member. He directed GEORGIA DOUGLAS JOHNSON's *Plumes* for the company's second season. Jackman helped establish the Harlem Experimental Theater Company in 1929 and was an active member of the American Theater Wing Stage Door Canteen in the 1930s and 1940s.

Jackman's friendship with Countée Cullen is of interest to scholars who study the influence of gay culture on the Harlem Renaissance because it exemplifies a typical combination of overt heterosexual and covert homosexual identities. During this period many gay African American men publicly socialized with women and privately associated with a network of gay men who shared a "positively defined same-sex interest" (Schwartz, 13). According to ARNA BONTEMPS, Jackman and Cullen were often referred to as the "David and Jonathan of the Harlem Twenties" because of their close friendship (Bontemps, 12). The homoerotic dimension of their friendship, however, was obscured by their obvious heterosexual behavior: Jackman frequently escorted single women to social events, and he was briefly married to Yolande Du Bois, the daughter of W. E. B. DU BOIS. Shortly after the wedding on 9 April 1928, Jackman accompanied Cullen on a trip to Europe without Yolande, an incident that scholars conjecture confirms Cullen's homosexual orientation and suggests an intimate physical relationship with Jackman. Jackman and Cullen remained friends until Cullen's death in 1947.

By the end of the 1920s Jackman began sending his African American memorabilia to Atlanta University; he later urged friends such as LANGSTON HUGHES, Owen Dodson, Dorothy Peterson, and Van Vechten to contribute to this collection. On Cullen's death Jackman requested that the collection be named the Countée Cullen Memorial Collection—the name it bore until it was renamed the Countée Cullen-Harold Jackman collection on the latter's death. Van Vechten and Jackman also gathered African American artifacts for the JAMES WELDON JOHNSON Memorial Collection at Yale, which includes Jackman's 1928–1930 correspondence with Cullen; for the Fisk University Library, and for the Schomburg Collection at the New York Public Library.

Jackman was associate editor of *New Challenge,* a literary magazine from 1935 to 1937 (Griffin, 495). He also worked as a contributing editor to and advisory editor of *Phylon,* a journal published by Atlanta University, from 1944 until his death in 1961. He was survived by his brother, Bertram, and his sister, Ivie Jackman, who instituted the Harold Jackman Memorial Committee, which continued

his commitment to conserving African American cultural artifacts.

Jackman contributed significantly to African American culture through his support of African American literature and art. His obituary in the *New York Times* paid tribute to his more than thirty years' service to the New York Public Schools, to his art patronage, and to his membership in social organizations such as the NAACP, the National Urban League Guild, the American Society on African Culture, and the Ira Aldridge Society.

FURTHER READING

The Harold Jackman Papers are in the Beinecke Rare Book and Manuscript Library, Yale University, New Haven, CT. Further materials on Jackman can be found in the Claude McKay Papers (Beinecke) and the Countée Cullen Papers, Amistad Research Center, Tulane University, New Orleans, Louisiana.

Bontemps, Arna. "The Awakening: A Memoir," in *The Harlem Renaissance Remembered: Essays Edited with a Memoir*" (1972).

Griffin, Barbara L. J. "Harold Jackman: The Joker in the Harlem Renaissance Deck," *CLA Journal* (June 2003).

Hawkswood, William G. *One of the Children: Gay Black Men in Harlem* (1996).

Kellner, Bruce. *The Harlem Renaissance: A Historical Dictionary for the Era* (1984).

Lewis, David Levering. *When Harlem Was in Vogue* (1981).

Schwarz, A. B. Christa. *Gay Voices of the Harlem Renaissance* (2003).

Obituary: New York Times, 10 July 1961.

DENNIS GOUWS

JESSYE, Eva Alberta

(20 Jan. 1895–21 Feb. 1992), choral conductor, composer, and actress, was born in Coffeyville, Kansas, to Albert Jesey, a chicken picker, and Julia (Buckner) Jesey. Eva changed the spelling of her surname to Jessye in the 1920s. Jessye later said that she received her life's directive in a speech she heard delivered by BOOKER T. WASHINGTON, wherein he declared: "I hope the time will never come when we neglect and scorn the songs of our fathers" (*Atlanta Constitution*, 6 Feb. 1978). That time never came for Eva Jessye, who dedicated herself to preserving the folk repertoire and performance practices of African Americans. Having ancestors born into slavery, she

was uniquely exposed to their songs, with their inherent drama, during her youth.

Eva's mother struggled to purchase for her daughter the first black-owned piano in Coffeyville, which she learned to play by ear. A piano teacher was acquired when she demonstrated talent for composing, singing, and playing. Eva organized a girls' quartet and performed with it at the large Odd Fellows Hall. This was not a small feat for a twelve-year-old.

The next year Eva enrolled in Quindaro State School for the Colored (now Western University) in Quindaro, Kansas, for her high school years. While there she was inspired to become a musician by the touring conductor and composer WILL MARION COOK, for whom she copied orchestral scores. In 1914 she graduated with honors, and received her BA and teaching certification from Oklahoma's Langston University four years later. An elementary-school teaching career ensued in the Oklahoma towns of Muskogee, Haskell, and Taft; thereafter she formed the first choir at Morgan College in Baltimore, Maryland, and subsequently taught at Claflin College in Orangeburg, South Carolina. She also became a music critic for the *Baltimore Afro-American* newspaper and was invited to direct the local Dixie Jubilee Singers. In time this group would become the Eva Jessye Choir.

This ensemble relocated to New York during the Harlem Renaissance of the 1920s, and Eva Jessye came of age as a choral conductor who promoted the Negro spiritual and folksong tradition. Further study was encouraged and directed by Will Marion Cook and the theorist Percy Goetschius. Her reputation advanced through the medium of radio on the Major Bowes Capitol Family Radio Hour, and both the CBS and NBC Artist Series. Later, in May 1942, Jessye worked with the famed conductor Leopold Stokowski for a performance of WILLIAM GRANT STILL's "And They Lynched Him on a Tree."

In 1929 she became the choral director of Metro-Goldwyn-Mayer's *Hallelujah,* the first talking motion picture with an all-black cast. Five years later she was the choral director for Virgil Thomson and Gertrude Stein's opera *Four Saints in Three Acts.* This production pioneered in showcasing blacks in an opera unrelated to black life.

Jessye's most noteworthy legacy resulted from George Gershwin's invitation to be the choral director of his folk opera *Porgy and Bess* in 1935. Her skills in choral and vocal solo training brought more

authenticity to the production. She was the keeper of that flame for countless national and international performances for the next thirty-five years. In 1963 the Eva Jessye Choir became the official choral group for the March on Washington.

Jessye's extensive conducting career sometimes featured larger forms of her spiritual arrangements and original works, including *The Life of Christ in Negro Spirituals* (1931) and *The Chronicle of Job* (written in 1936 and premiered at Clark College in 1978). Her folk oratorio *Paradise Lost and Regained,* from Milton's epic, was written in 1934 and premiered on NBC Radio late in 1936; a staged version was first performed at the Washington Cathedral to critical acclaim in 1972. Her dramatic flair as an actress can also be seen in such films as *Cotton Comes to Harlem* (1970) in which she appeared briefly, *Black Like Me* (1964), and *The Slaves* (1969).

Eva Jessye received numerous awards and honors during her almost century-long life, including honorary doctorates from the University of Michigan, Eastern Michigan University, and Wilberforce University. She was also named among the six most outstanding women in the history of Kansas in 1980 by the local Wichita, Kansas, chapter of Women in Communications, Inc. Her photograph was included in Brian Lanker's historic collection *I Dream a World: Portraits of Black Women Who Changed America* (1989). Eva Jessye was one of the first black women in America to earn an international reputation as a choral director and blazed the trail for many men and women to follow.

FURTHER READING

Information on Jessye can be found in the Eva Jessye Collection at the University of Michigan, Ann Arbor, and in the Eva Jessye Collection at Pittsburg State University, Kansas.

Black, Donald Fisher. "The Life and Work of Eva Jessye and Her Contributions to American Music," PhD diss., University of Michigan, Ann Arbor (1986).

Smith, Helen C. "Eva Jessye: Earth Mother Incarnate," *Atlanta Constitution,* 6 Feb. 1978.

Southern, Eileen. *Biographical Dictionary of Afro-American and African Musicians* (1982).

Wilson, Doris Louis Jones. "Eva Jessye: Afro-American Choral Director," EdD diss., Washington University, St. Louis (1989).

MARVA GRIFFIN CARTER

JOHNSON, Charles Spurgeon

(24 July 1893–27 Oct. 1956), sociologist and college president, was born in Bristol, Virginia, the eldest of six children of Charles Henry Johnson, a Baptist minister, and Winifred Branch. Because there was not a high school for blacks in Bristol, he moved to Richmond and attended the Wayland Academy. In 1913 Johnson entered college at Virginia Union in Richmond, and graduated in only three years. While at college, Johnson volunteered with the Richmond Welfare Association, and one incident there had a profound impact on his future career. During the holiday season, while delivering baskets to needy people, he came across a young woman lying on a pile of rags, groaning in labor. Although none of the doctors in the area would help the young woman, Johnson persuaded a midwife to deliver the baby. He then tried to locate a home for the young woman, but those he approached shut the door in his face. Some families rejected the young woman because she was black and others because, in their eyes, she had sinned. Edwin Embree, Johnson's longtime friend, once noted that Johnson could not get the image of the young woman out of his mind and could not "cease pondering the anger of people at human catastrophe while they calmly accept conditions that caused it" (*Thirteen against the Odds* [1944], 214).

In 1916 Johnson moved north to pursue a PhD at the University of Chicago, which at that time employed some of the world's most prominent sociologists. It was there that he would meet his lifetime mentor, Robert E. Park. As a result of this relationship, many of Johnson's writings and approaches to race relations bear the mark of the eminent Chicago researcher. Johnson interrupted his studies to enlist in the military in 1918, but upon returning to Chicago a year later, he found himself in the middle of one of the most horrific race riots in U.S. history.

This incident sparked Johnson's involvement with the Chicago Race Relations Commission; as associate executive secretary for that body, he was largely responsible for the writing of *The Negro in Chicago: A Study of Race Relations and a Race Riot* (1922). With this publication Johnson spearheaded a tradition of social science research that described changes in race relations as cycles of tension and resolution, largely caused by outside forces. Although partly based on the work of Park, Johnson's version of this sociological model envisioned

a wider role for human intervention; in particular, he believed that government could influence this process. Johnson's work with the Chicago Race Relations Commission also introduced him to Julius Rosenwald, the Sears and Roebuck tycoon and creator of the Julius Rosenwald Fund (which assisted with the establishment of black schools in the South and provided scholarships to talented black intellectuals).

Johnson married Marie Antoinette Burgette on 6 November 1920. Johnson moved with his wife to New York City, where he became the director of research and investigations for the National Urban League. During this period he also edited the league's journal, *Opportunity*, and published short stories and poems by several prominent Harlem Renaissance authors, including LANGSTON HUGHES, COUNTÉE CULLEN, AARON DOUGLAS, and ZORA NEALE HURSTON. Johnson also used his well-established connections to white philanthropists to secure financial support for black literature and art. In his view, promoting culture was a way of combating racism.

The sociologist Blyden Jackson, Johnson's colleague while he was attending Fisk University in Nashville, Tennessee, credits him with helping to "ease the transformation of more than one neophyte in the arts, like a Zora Neale Hurston, from a nonentity into a luminary of the Renaissance" (*Southern Review* 25.4 [1990]: 753). Indeed, both Jackson and ALAIN LOCKE point to a 1924 dinner Johnson hosted in New York as one of the most important contributions to the Renaissance. With more than three hundred people from both the white and black worlds in attendance (including Locke, JAMES WELDON JOHNSON, William Baldwin III, JESSIE FAUSET, Countée Cullen, Albert Barnes, and W. E. B. DU BOIS), the event helped many black poets, artists, and writers find mainstream publishers and venues for their endeavors. For Johnson, events like this dinner were part of a carefully planned effort to improve opportunities for African Americans in the 1920s in ways that had not been possible during the nadir of race relations before World War I.

Near the close of the Renaissance in 1928, Charles Johnson returned south to Nashville to chair the department of social sciences at Fisk University. Supported by a grant from the Laura Spelman Rockefeller Memorial, the department was set up with the idea that Johnson would be its leader.

Armed with solid connections and ample funding, he brought many important individuals to the Fisk campus, including STERLING BROWN, James Weldon Johnson, Horace Mann Bond, Robert E. Park, E. FRANKLIN FRAZIER, ARNA BONTEMPS, and Aaron Douglas. Along with his colleagues in the social sciences, Johnson published widely. It was during this time that he produced some of his best known works, such as *Shadow of the Plantation* (1934), *Growing Up in the Black Belt* (1938), and *Patterns of Negro Segregation* (1942). Johnson also created an internationally renowned race relations institute at Fisk, which brought together leaders, scholars, and ordinary citizens from throughout the United States and the world to discuss race relations in an integrated setting. Despite suffering extensive criticism locally, especially from the segregationist *Nashville Banner*, the institute and Johnson's leadership drew great prominence to Fisk and to Johnson as an individual.

In 1946, at time when Fisk was experiencing a leadership crisis, its board of trustees considered selecting the first black candidate to lead the institution. Given his international stature and administrative skills, Johnson seemed like the most obvious candidate, but several of the alumni, including Fisk's most prominent graduate, Du Bois, spoke out vehemently against his selection. Johnson's close ties to philanthropy, including the Whitney, Ford, and Rosenwald foundations, made him suspect in their minds. For this group, the foundations were forever tainted by their previous efforts to promote an industrial curriculum at black colleges. Despite this opposition, the financial needs of Fisk prevailed over ideology, and Johnson was inaugurated president in 1947; the board of trustees had recognized Johnson's success in advancing and improving Fisk's race relations institutes through his fund-raising efforts and believed that he might similarly ensure progress for the university as a whole.

In his role as president, Johnson created the Basic College Early Entry Program. Although Johnson was a proponent of integration, he doubted that it would occur quickly and thus was inspired to initiate a program to nurture young black minds within the black college setting. The Basic College offered students a cohesive learning environment in which they benefited from the knowledge and experience of literary, artistic, and political figures that Johnson invited to campus in the years before his death in 1956. The program produced such

figures as the Pulitzer Prize–winning author David Levering Lewis; Hazel O'Leary, energy secretary during the administration of President Bill Clinton; and Spelman College president Johnnetta Cole.

In addition to his university-related service, Johnson served as a trustee for the Julius Rosenwald Fund from 1933 to 1948, working specifically as the codirector of the fund's race-relations program. From 1944 to 1950 he acted as the director of the race-relations division of the American Missionary Association. Concurrently with his foundation work, Johnson conducted research for the federal government and worked as a cultural ambassador. As a member of the New Deal's Committee on Farm Tenancy, Johnson supported President Franklin Roosevelt's efforts to end poverty and racism in the rural South. After World War II, under the direction of President Harry Truman, Johnson was one of ten U.S. delegates for the first United Nations Educational, Scientific, and Cultural Organization (UNESCO) conference in Paris. And he assisted President Dwight Eisenhower by serving on the Board of Foreign Scholarships under the Fulbright-Hays Act.

Johnson spent a lifetime cultivating black scholarship, creativity, and leadership and used research and culture as tools to fight racism. As he grew older, however, the pressure generated by his many obligations began to take its toll: his migraine headaches worsened, and he developed a heart condition. On 27 October 1956, on the way to a board meeting in New York, Johnson died of a heart attack on the train platform in Louisville, Kentucky, at age sixty-three.

Although Johnson's professional training and early practical experience in race relations were in the urban North, he chose to address race relations in the South, thereby differentiating himself from Du Bois and other black intellectuals. He was not a radical, but rather a diplomat who, through his collaborations, realized many of the ideas of thinkers more radical than he.

FURTHER READING

Charles S. Johnson's personal and professional papers are located in the Special Collections at Fisk University, Nashville, Tennessee.

Gasman, Marybeth. "W. E. B. Du Bois and Charles S. Johnson: Opposing Views on Philanthropic Support for Black Higher Education," *History of Education Quarterly* 42.4 (Winter 2002).

Gilpin, Patrick J., and Marybeth Gasman. *Charles S. Johnson: Leadership behind the Veil in the Age of Jim Crow* (2003).

Robbins, Richard. *Sidelines Activist: Charles S. Johnson and the Struggle for Civil Rights* (1996).

Obituary: New York Times, 28 Oct. 1956.

MARYBETH GASMAN

JOHNSON, Ellsworth "Bumpy"

(1906–1968), Harlem gangster, was born Ellsworth Raymond Johnson in Charleston, South Carolina. He acquired the nickname "Bumpy" as a boy when his parents discovered a small marble-sized bump on the back of his head. This bump was simply an accident of birth, but it would provide Ellsworth with the nickname by which he would be known throughout his life. Little is known of Johnson's parents or childhood; however, by the age of fifteen he had moved to Brooklyn, New York, to live with an aunt. He finished high school and at sixteen he moved to Harlem to live on his own. He was soon involved in a life of petty crime. By sixteen he could already be described as a stickup gunman and a second-story burglar.

At the age of seventeen, Johnson was sent to a reformatory in Elmira, New York. This stay would serve as the beginning of nearly half a lifetime spent behind bars. Johnson used his time in prison to engage in cultural pursuits. He became an avid reader, a writer of poetry and prose, as well as a master chess player.

His life in Harlem in the 1920s and 1930s exposed Johnson to many famous and infamous personalities. Around the age of twenty he went to work for BILL "BOJANGLES" ROBINSON, one of the most famous African American dancers and actors of the day. Johnson worked as a bodyguard for Robinson, and performed other duties. On the street Johnson became a well-respected hustler. Always immaculately groomed and dressed, to the underworld he was known as an honest and generous man with a fiery temper. Despite his intelligence and cunning, his regular stays in prison continued.

Upon his release from a prison stay in 1932, he was recruited by STEPHANIE ST. CLAIR, known in the Harlem underworld as Madame Queen. Madam Queen was one of the most powerful bankers for the illegal lottery, called the "policy racket" or "the numbers." Until then, Johnson had been engaged in other types of crime, such as enforcement, but

the policy racket had slowly become the dominant and most profitable form of criminal enterprise in Harlem. Things were about to change. In the late 1920s members of the organized Italian and Irish mobs, including Dutch Schultz's, became gradually aware of the large profits being made by uptown Harlem bankers. By the early 1930s the black bankers in Harlem were under constant siege by the Bronx-based and downtown mobs, which were attempting to take over the lucrative business. This collection of ambitious and heartless mobsters, who were normally at war with one another, combined forces and engaged black middlemen to violently persuade Harlem bankers and numbers runners to join their organization. This alliance of mobsters would be known as "the Combination" (Lawrenson, 175). The "membership" in the group, of course, was limited those who "agreed" to turn over of 90 percent of their profits and hard-won territory to the downtown whites. In exchange the Combination would spare the lives of the kings and queens of Harlem policy. Neither Madame Queen nor Johnson viewed this as a fair trade.

Acting on behalf of Madame Queen, Johnson brazenly fought the Combination and their black henchmen until the early 1930s. White mobsters were unaccustomed to resistance uptown and were surprised by the fierceness of the response. In one of the bloodiest gang wars in Harlem's history, Johnson was successful in turning back the mob and returning the policy racket to black Harlem. As a result of this legendary fight Johnson became a folk hero to most black Harlemites. There were those, however, who viewed him as a reckless and dangerous criminal. Some saw him as the cause of unwarranted bloodshed on the streets of Harlem. In any case, his victory would be short-lived, as black bankers and gangsters lacked the political and economic clout of the mobsters who composed the Combination. The mob retook control of the policy racket in Harlem by 1935. Sensing defeat, Johnson urged Madame Queen to cooperate with the mob. She did so, and he went on to become the highest-ranking black in the Combination. Ironically, Johnson was put in charge of the enforcement of the white mob's policy in Harlem, the very presence he had fought against before he became involved with the Combination.

Johnson went on to become the most important black middleman for the mob in the period from 1940 to 1968. Despite his relationship to the mob he remained a well-respected member of the community. He would often be seen saving a poor family from eviction or supplying neighborhood children with Christmas presents. He donated to charities and was generous with his earnings. During this time period Johnson continued to serve intermittent, short terms in jail. In the early 1950s he was indicted for allegedly selling narcotics to undercover federal agents. He claimed that it was a setup. Proof of this is lost to history. However, after taking his case to the U.S. Court of Appeals, and losing, he was sent to prison in 1954. Because selling narcotics was a federal crime, Johnson was sent to Alcatraz to serve out the majority of his nine-year sentence. This would be his final prison term. He was released in 1963, and much of Harlem welcomed him back with open arms. Johnson never lost his rebellious spirit. In 1965 he staged a sit-in a police station because of what he deemed continuous surveillance and harassment (of himself). He was charged with refusing to leave a police station, but he was later acquitted. In 1967 Johnson was once again indicted on a federal narcotics charge, but he died of a heart attack in July 1968 at a well-known Harlem restaurant while out on a fifty-thousand-dollar bond.

Many have stated that the 1971-movie icon *Shaft*, an inner-city Robin Hood of sorts, was based on the real-life Johnson (Johnson, 118). Johnson has become a folk hero in the black community and in 1980 he was played by John Amos in the mini-series *Alcatraz: The Whole Shocking Story*. He was also played by Laurence Fishburne in both the *Cotton Club* (1984) and, more recently, *Hoodlum* (1997). Gangster, pimp, poet, and philanthropist are only a few of the words that were used to describe Johnson throughout his life. He was an unconventional hero at a time when the avenues to black success were few and exceedingly difficult to navigate. Within these constraints he cut his own extraordinary path.

FURTHER READING
Johnson, John H. *Fact Not Fiction in Harlem* (1980).
Lawrenson, Helen. *Stranger at the Party: A Memoir* (1975).
Schatzberg, Rufus. *African-American Organized Crime: A Social History* (1996).

H. ZAHRA CALDWELL

JOHNSON, Georgia Douglas

(10 Sept. 1886?–14 May 1966), poet and dramatist, was born Georgia Blanche Douglas Camp in

Atlanta, Georgia, the daughter of George Camp and Laura Jackson, a maid. Her birth date has traditionally been recorded as 10 September 1886, but recent biographies—based on obituary notices and school sources—alternatively list her year of birth as 1880 or 1877. Georgia's paternal grandfather was a wealthy Englishman, her maternal grandmother was a Native American, and her maternal grandfather was an African American. Her early years were spent in Rome, Georgia, and she graduated from Atlanta University's Normal School in 1893. In 1902–1903 she continued her schooling at the Oberlin Conservatory of Music, where she studied piano, violin, harmony, and voice. Her interest in music was reflected in her literary work.

She taught school in Marietta, Georgia, and later became an assistant principal in Atlanta. In September 1903 she married Henry Lincoln "Link" Johnson, an Atlanta lawyer and Georgia delegate at large to the Republican National Convention since 1896. They had two children. In 1910 the family moved to Washington, D.C., and in 1912 Link was appointed

Georgia Douglas Johnson, poet, playwright, and teacher who hosted a salon at her home in Washington, D.C., where writers such as Jean Toomer, Langston Hughes, Angelina Grimké, and Alice Dunbar-Nelson gathered. (Moorland-Spingarn.)

recorder of deeds by President William Howard Taft.

Johnson's first poems, "Omnipresence" and "Beautiful Eyes," were published in the Atlanta-based *Voice of the Negro* in June 1905. After the move to Washington, W. E. B. DU BOIS selected three of her poems, "Gossamer," "Fame," and "My Little One," for *Crisis* (1916). Her first book of poetry was *The Heart of a Woman and Other Poems* (1918). Characteristic of Johnson's verse, it contained short, introspective lyrics written in traditional forms. The book was criticized in some quarters because it did not contain enough "racially conscious" poems.

Perhaps in response to such criticism, Johnson's next book, *Bronze: A Book of Verse* (1922), was much concerned with issues of race as well as gender. In his foreword, Du Bois noted somewhat condescendingly that Johnson's "word is simple, sometimes trite, but it is sincere and true." ALICE DUNBAR-NELSON, in her review in the *Messenger* (May 1923), called *Bronze* "a contribution to the poetry of America as well as to the race, that is well worth while."

In 1925 Link Johnson died. In appreciation of his services to the Republican Party, Georgia Johnson was appointed commissioner of conciliation in the Department of Labor by President Calvin Coolidge. Often beleaguered by professional, financial, and family pressures, Johnson lamented the lack of time to pursue her writing. She said, "If I might ask of some fairy godmother special favors, one would sure be for a clearing space, elbow room in which to think and write and live beyond the reach of the Wolf's fingers" (*Opportunity*, July 1927).

Despite these demands, in 1928 Johnson published *An Autumn Love Cycle*. The book contained what may be her most famous poem, "I Want to Die While You Love Me," later set to music by Johnson and sung by HENRY T. BURLEIGH. The poems of this book, like much of Johnson's verse, were in the "genteel" tradition of "raceless" literature advocated by fellow African American writers like WILLIAM STANLEY BRAITHWAITE and COUNTÉE CULLEN. However, when reread from a feminist perspective, the book contains some of Johnson's best work.

In addition to her poetry, Johnson wrote more than thirty one-act plays. Only about a dozen have survived, and few have been produced. The focus of her plays, more than her poetry, was on racial issues. Plays such as *Blue Blood* (1926), *Safe* (c. 1930), and *Blue-Eyed Black Boy* (c. 1930) discuss such subjects as lynching and miscegenation. *Frederick Douglass*

(1935) and *William and Ellen Craft* (1935) treat of black heroes. Johnson's folk drama *Plumes*, which deals with the plight of a mother who must decide on spending her fifty dollars either on a dubious operation or on a splendid funeral for her daughter, won first prize in a 1927 *Opportunity* competition. *A Sunday Morning in the South* (c. 1925) concerns an innocent African American man who is lynched for the rape of a white woman. The use of hymns ironically adds to the chilling horror that unfolds throughout the work. Johnson submitted several plays to the Federal Theatre Project, but all were rejected by the readers, some of whom undoubtedly felt uncomfortable with her themes.

The need for money became an increasing burden in Johnson's life. She applied for many awards but was invariably rejected. Still, her poems were published in scores of periodicals, and she wrote a column of practical advice called "Homely Philosophy," which was carried in many newspapers from 1926 to 1932. She also published several short stories under the pseudonym Paul Tremaine.

Over the years, Johnson became increasingly important as a literary hostess. She called her house at 1461 S Street in northwest Washington "Half-Way House" because "I'm half-way between everybody and everything and I bring them together." Johnson's home was a popular haven for such writers as JESSIE FAUSET, LANGSTON HUGHES, Cullen, and JEAN TOOMER.

Johnson published her final book of poetry, *Share My World*, in 1962. This slim volume contained many previously published poems. The work was reflective, generally optimistic, and displayed her belief in the common bond of humanity. In 1965 Johnson was awarded an honorary doctorate of literature degree from Atlanta University. She died in Washington, D.C.

During her long life Johnson was frequently praised. JAMES WELDON JOHNSON said that "[s]he was the first colored woman after Frances Harper to gain general recognition as a poet." Du Bois described her as being "the leading colored woman in poetry and one of our leading poets." Only late in the twentieth century did she begin to receive more critical attention, and several of her surviving plays were published for the first time.

FURTHER READING

Manuscript material is scattered in various locations, including the Schomburg Center for Research in

Black Culture (New York Public Library), the Moorland-Spingarn Research Center at Howard University, the Federal Theatre Project Research Division at George Mason University, and the Robert W. Woodruff Library at Clark Atlanta University.

Fletcher, Winona. "Gloria Douglas Johnson," in Trudier Harris, ed. *Afro-American Writers from the Harlem Renaissance to 1940* (1987).

Hull, Gloria T. *Color, Sex, and Poetry: Three Women Writers of the Harlem Renaissance* (1987).

Randolph, Ruth Elizabeth. *Harlem Renaissance and Beyond: Literary Biographies of 100 Black Women Writers, 1900–1945* (1990).

Shockley, Ann Allen. *Afro-American Women Writers 1746–1933* (1988).

LOUIS J. PARASCANDOLA

JOHNSON, Hall

(12 Mar. 1888–30 Apr. 1970), composer, arranger, and choral conductor, was born Francis Hall Johnson in Athens, Georgia, the son of William Decker Johnson, an African Methodist Episcopal (AME) minister, and Alice (maiden name unknown). Music was an important part of Hall Johnson's childhood. He heard his grandmother and other former slaves as they sang the old spirituals in his father's Methodist church. This grounding in the original performance of Negro spirituals was to represent a significant influence on his later life. Johnson, exhibiting an early interest in music, received solfeggio lessons from his father and piano lessons from an older sister. As a teenager he developed an interest in the violin and taught himself to play.

Johnson was educated in the South at the Knox Institute, at Atlanta University, and at Allen University in Columbia, South Carolina, where his father was president. Frustrated by his inability to find a violin instructor in the segregated South, Johnson left his southern roots and went to the Hahn School of Music in Philadelphia, where he could study his instrument. In 1910 he transferred to the University of Pennsylvania, where he received a bachelor of music degree in Composition and won the Simon Haessler Prize for outstanding composition.

Johnson married Polly Copening in 1914, and the young couple settled in New York City, where Johnson opened a violin studio. He taught during the day and freelanced at night in various dance and theater orchestras, playing violin or viola. He played

with WILL MARION COOK's Southern Syncopated Orchestra in 1918 and with Vernon Castle's Orchestra in NOBLE SISSLE and EUBIE BLAKE's 1921 Negro musical *Shuffle Along*. In 1923 he organized the Negro String Quartet, which included the violinists Arthur Boyd and Felix Weir, the cellist MARION CUMBO, and himself as violist.

From 1923 to 1924 Johnson did graduate study at the New York Institute of Musical Arts (later combined with the Juilliard School of Music). He studied music theory, violin, and composition with his favorite teacher, Percy W. Goetschius. During his three-year stint as a pit musician for *Shuffle Along*, Johnson became disenchanted with the manner in which a quartet sang spirituals. The barbershop treatment of Negro spirituals seemed a mockery of the rich choral style sung by former-slaves during his childhood. In an article for *The Crisis* (November 1966), Charles Hobson wrote about Johnson's feelings toward the spiritual and quoted him as saying, "It is serious music and should be performed seriously in the spirit of its original conception" (483).

This experience served as a catalyst for Johnson's true contribution to America's musical history. Johnson became a man with a mission. He resolved to forsake his instrumental career and devote his life to the preservation of an authentic performance style for Negro spirituals. Though his musical background was strictly instrumental, he decided to organize a choir that would realize his dream. In September 1925 he organized the Hall Johnson Choir—one of the first professional African American choirs to earn international acclaim. The choir was started with only eight members, but by the time of its debut in February 1926, its size had increased to twenty members because Johnson realized he needed more singers to achieve the traditional stylistic effect.

Johnson achieved worldwide fame for his arrangements of spirituals and for his original spirituals. During his career he composed and arranged over forty choral selections and twenty solo spirituals—all with authentic African American dialect and accurate rhythmic patterns. He arranged and directed music for Marc Connelly's production of *Green Pastures* (featuring the Hall Johnson Choir), which premiered on Broadway in 1930. Johnson received the 1931 Harmon Award for his role in the tremendous success of this Pulitzer Prize–winning musical.

In 1933 Johnson's own *Run, Little Chillun*, a Negro folk drama, was produced on Broadway for a run of 126 performances. He wrote both the lyrics and the music (twenty-five spirituals) for this successful production, which was his first dramatic attempt.

Johnson took his choir to Hollywood in 1936 to film *Green Pastures*. He made Hollywood his base over the next eight years as he wrote musical scores and conducted choirs for nine films. They included *Dimples* with Shirley Temple; *Lost Horizons*, which won two Academy Awards; *Swanee River* with Al Jolson; and *Cabin in the Sky* with Lena Horne, ETHEL WATERS, LOUIS ARMSTRONG, and DUKE ELLINGTON. He also organized a two-hundred-voice Festival Negro Chorus in Los Angeles whose performances provided scholarships for talented students. While in Los Angeles, Johnson's *Run, Little Chillun* was staged as a WPA Negro Theatre Project. Its Broadway success was matched in Los Angeles and later in San Francisco as the show played to many enthusiastic audiences.

Johnson returned to New York in 1943 for a revival of *Run, Little Chillun*. His *Son of Man*, an Easter cantata (never published), was performed by the three-hundred-voice Festival Negro Chorus at the New York City Center in April 1946. It was presented again at Carnegie Hall on Good Friday of 1948. Johnson inaugurated an annual concert series titled New Artists to give visibility to young African American performers such as Kermit Moore, a cellist, and Robert McFerrin, a baritone singer.

In 1951 the Hall Johnson Choir was selected by the U.S. State Department to represent the nation at the International Festival of Fine Arts in Berlin. The choir won international acclaim as it toured Germany and other European countries. After the European tour Johnson alternated his career between Los Angeles and New York. A stroke in 1962 slowed his pace, but he soon recovered and resumed an active schedule of composing, teaching, and conducting. During that same year he was presented a citation by New York mayor Robert F. Wagner for thirty-five years of significant contributions to the world of music.

In 1965 Johnson was asked by MARIAN ANDERSON to arrange some solo spirituals for an RCA album she was doing. He also collaborated with Anderson and the Metropolitan Opera orchestra in arranging music for a concert production. He was honored again in March 1970 by Mayor John

Lindsay, who presented him with New York's most prestigious citation, the George Frederic Handel Award.

Just over a month later Johnson died of smoke inhalation from a fire in his New York apartment. Anderson, in a *New York Times* (1 May 1970) tribute, wrote, "Hall Johnson's music was a gift of inestimable value that brought to all people a greater understanding of the depth of the Negro spiritual." His outstanding legacy to the world lives on in his collections of spirituals that were published, in the few recordings that are still extant, and in his memoirs, which are at Rowan University (formerly Glassboro State College) in Glassboro, New Jersey.

FURTHER READING

Hall Johnson's papers are at Rowan University, Glassboro, New Jersey.

Floyd, Samuel A. *Black Music in the Harlem Renaissance* (1990).

Johnson, Francis Hall. "Notes on the Negro Spiritual," in *Readings in Black American Music*, ed. Eileen Southern (1983).

Lovell, John. *Black Song: The Forge and the Flame* (1972).

Roach, Hildred. *Black American Music: Past and Present* (1985).

Obituaries: New York Times and *New York Post*, 1 May 1970; *Jet* (21 May 1970).

MARY FRANCES EARLY

JOHNSON, Jack

(31 Mar. 1878–10 June 1946), world boxing champion, was born Arthur John Johnson in Galveston, Texas, the eldest son of Henry Johnson, a janitor and former slave, and Tiny (maiden name unknown). Johnson landed in many schoolyard fights, usually returning home beaten, bruised, and crying unless his sister came to his defense. Only when his mother, the more dominant of his parents, threatened him with a worse whipping did he begin to fight back. After attending public school for six years, he assisted his invalid father and then drifted from one job to another, working as a horse trainer, a baker, and a dockworker, usually near Galveston, although his autobiography lists more exotic, far-flung locations. That memoir contains serial exaggerations and embellishments, many of which are repeated in the Tony- and Pulitzer Prize–winning

stage play (1969) and later movie (1970), *The Great White Hope.*

Johnson also participated in "battle royals," in which he and eight or more black youths, often blindfolded, fought each other. The last youth standing won only a few coins. Such fights, staged for the amusement of whites, were intended to strip young African Americans of self-respect; for Johnson, however, they instilled a strong sense of grievance against a white power structure that tried to confine him. These bouts also led him into the realm of professional boxing. After several fights in Texas and Chicago, most of which he won, Johnson was matched in Galveston in 1901 against Joe Choynski, a veteran heavyweight from the golden era of Jewish American boxing. Although Choynski was much slower than his nimble-footed challenger, he knocked the black fighter to the canvas with a right cross. Johnson remained there after a count of ten, at which point five Texas Rangers climbed into the ring to arrest both boxers under a state law

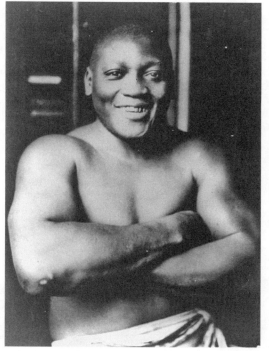

Jack Johnson, the first African American world heavy-weight boxing champion, 31 March 1915. (Library of Congress/George Grantham Bain Collection.)

that prohibited prizefighting. The two men shared a cell for three weeks, during which time Johnson learned much about the art of boxing from his fellow prisoner. After his release, Johnson fought several bouts, mostly against black opponents, and in 1903 he defeated "Denver" Ed Martin on points to win the black heavyweight title.

The conventions of boxing did not prohibit fights across the color line, but following the lead of John L. Sullivan in 1885, all world heavyweight champions had refused to defend their title against blacks. Johnson was determined to end that restriction. Between 1905 and 1908 he defeated several white former champions with ease, approaching those bouts with an uncharacteristic savagery. A Philadelphia newspaper reported in 1905 that Johnson, at six feet two inches and two hundred pounds, rendered Jack Monroe a "mass of palpitating gelatine" (Roberts, 43). Against black opponents Johnson emphasized speed, defensive counterpunching, and showmanship. However, he quickly tired of defeating black no-hopers and white has-beens, and in late 1906 he hired an ambitious white manager, Sam Fitzpatrick. With Fitzpatrick's backing, Johnson toured Britain and Australia in 1907, defeating several fighters and enhancing his reputation as a world heavyweight contender. The next year he followed the reigning champion Tommy Burns to England and Australia, trying to goad him into a contest. Burns initially tried to avoid Johnson but was willing to abandon the principle of Jim Crow pugilism if the price was right. Thirty-five thousand dollars win, lose, or draw proved to be the right price.

On 26 December 1908 in Sydney, Australia, Johnson defeated Burns with a fourteen-round knockout to become the first-ever black world heavyweight champion. In each round he taunted the short, hard-punching Canadian, calling him "white as the flag of surrender," and inflicted a series of punishing right-hand uppercuts. Even the novelist and white supremacist Jack London reported from the ringside that it had been a contest between a grown man and a naughty child. "The Fight!—There was no fight!" London famously wrote (Ashe, 34).

White commentators took up London's call for the undefeated former champion Jim Jeffries to come out of retirement to restore the title to its rightful Anglo-Saxon provenance. After lengthy negotiations, Johnson faced Jeffries in what was billed as the "fight of the century" in Reno, Nevada, on 4 July 1910. Global interest was such that the fighters would share $100,000 in movie rights, ushering in a new era in boxing. Again, Johnson dominated the contest. His merciless uppercuts and jabs exposed the once-invincible Jeffries for what he now was: an overweight, aging alfalfa farmer. The fight ended, mercifully for Jeffries, with a fifteenth-round knockdown. Johnson became the undisputed world champion and $110,000 richer, and Jeffries earned $90,000 for his considerable pains.

The full significance of the fight became clear the next morning, when newspapers reported a national wave of violence in which thirteen African Americans died and hundreds were injured. In some cases blacks had fired guns and attacked whites, but most of the clashes involved whites exacting revenge for Johnson's victory. The violence reflected the rancorous, indeed rancid, atmosphere of the early twentieth-century nadir in race relations, a time of white-on-black race riots and hundreds of lynchings of African Americans. In that respect, Johnson was merely a catalyst for preexisting white fears, though he took great pleasure in stoking and provoking those anxieties. He dressed flamboyantly, drank heavily, drove cars recklessly, taunted white boxers and spectators, and—most incendiary of all—flaunted a series of white lovers. In 1911 he married Etta Terry Duryea, a white woman. One year later, ostracized by her white friends and humiliated by beatings and what one biographer has called Johnson's "heroic infidelity," Duryea committed suicide, shooting herself in a room above his Chicago nightclub, the Café de Champion (Roberts, 140).

Like many famous and wealthy men, Johnson acted as though his money and celebrity placed him above the law. However, the world champion's skin color also attracted the attention of policemen, who arrested him for a string of offenses, usually involving reckless driving but most often for petty transgressions. After being arrested for having Chicago license plates while driving in New York, Johnson complained, "Next thing somebody'll arrest me for bein' a brunette in a blond town" (Roberts, 126).

The champion's arrest in October 1912 was much more serious. He was charged under the Mann Act, a 1910 federal law that prohibited the transportation of women across state or national borders "for the purpose of prostitution, debauchery or for any other immoral purpose." The Bureau of Investigation, forerunner of the FBI, charged that Johnson

had abducted Lucille Cameron, a white woman who had worked as his secretary, as part of an interstate prostitution ring. The vigor with which the federal authorities pursued their case against Johnson was in inverse proportion to the evidence they gathered. Cameron refused to testify and married Johnson in 1912 or 1913, but that did not deter the bureau, which found another white mistress, Belle Schreiber, to testify against him. The authors of the Mann Act had never intended to prosecute consensual sexual relations between an unmarried couple. Johnson's relationship with Schreiber may have been many things—tawdry, abusive, and maybe even "debauched" and "immoral" to some—but it did not violate the letter or the spirit of the law. Regardless of its flimsy evidence, the bureau pursued the case and secured a conviction in May 1913, when twelve white male jurors found Johnson guilty and a judge sentenced him to one year in prison. Released on bond, he fled to Europe.

Johnson defended his world title three times in Paris and proved even more successful in maintaining his reputation as the world's most notorious carouser. Financial problems and the onset of World War I encouraged Johnson to sail for Central America, and in April 1915 he arrived in Havana, Cuba, to defend his title against Jess Willard. The 250-pound white Kansan absorbed heavy punishment in the early rounds but remained standing; in the twenty-sixth round he knocked out the champion. White commentators celebrated what they saw as the return of the natural racial order. Johnson, for his part, claimed—indeed, he swore to God and to his mother—that he had been promised fifty thousand dollars to throw the fight. If so, he never received that payoff. Newsreel of the fight suggests a more prosaic explanation: the fitter, harder-hitting Willard had defeated the aging, poorly prepared Johnson.

After four years in Spain and Mexico, boxing, bullfighting, and squandering his fortune, Johnson surrendered to American authorities, serving one year in the federal penitentiary in Leavenworth, Kansas. Three years after his release in 1921, he divorced Lucille Cameron and married Irene Pineau. He briefly opened a nightclub, the Club De Lux, in Harlem in 1920, but money problems forced him to sell it to the New York gangster Owney Madden, who reopened it as the Cotton Club in 1923. After that, Johnson continued to box and perform in vaudeville shows, though the distinction between these activities became increasingly fine. In 1946 he lost control of his car near Raleigh, North Carolina, and died from his injuries.

Jack Johnson's life and legacy go far beyond the boxing ring. He was not only one of the greatest fighters ever but also a symbol of modernity, a movie-age celebrity who was at once renowned and reviled in his native land and beyond. He embodied the greatest fears of early twentieth-century whites; namely, that a hypersexualized "black beast" threatened the purity of white womanhood. For African Americans, Johnson presented more of a problem. Leaders like BOOKER T. WASHINGTON urged him to display more humility, fearing that the boxer's exuberant racial transgressions reflected badly on his race and might lead to even more violence against blacks. Yet for many blacks, Jack Johnson was a hero, a defiant forerunner of the assertive "New Negro" who emerged in the 1920s.

FURTHER READING

Johnson, Jack. *Jack Johnson—In the Ring—and Out* (1927); reprinted as *Jack Johnson Is a Dandy* (1969).

Ashe, Arthur R., Jr. *A Hard Road to Glory: A History of the African–American Athlete, 1619–1918* (1988).

Roberts, Randy. *Papa Jack: Jack Johnson and the Era of White Hopes* (1983).

Sammons, Jeffrey T. *Beyond the Ring: The Role of Boxing in American Society* (1988).

Obituary: New York Times, 11 June 1946.

STEVEN J. NIVEN

JOHNSON, James P.

(1 Feb. 1894–17 Nov. 1955), jazz and popular pianist, composer, and songwriter, was born James Price Johnson in New Brunswick, New Jersey, the son of William H. Johnson, a store helper and mechanic, and Josephine Harrison, a maid. Johnson's mother sang in a Methodist church choir and was a self-taught pianist. Johnson later cited popular songs and African American ring-shout dances at home and local brass bands in the streets as early influences. When his mother's piano was sold to help pay for their move to Jersey City in 1902, Johnson turned to singing, dancing, and playing the guitar, but he played piano whenever possible. In 1908 the family moved to Manhattan, at which point he enrolled at P.S. 69, and in 1911 the family moved uptown.

Johnson got his first job as a pianist in Far Rockaway, New York, in the summer of 1912. He so

enjoyed the work that he decided not to return to school, and in the fall he got other engagements in Jersey City and then in Manhattan. He studied the European piano tradition with Bruto Giannini from about 1913 to 1916 while also absorbing the skills of the finest ragtime pianists, among whom he singled out Abba Labba (Richard McLean), Luckey Roberts, and—in the summer of 1914—EUBIE BLAKE, who recalled that Johnson was able to play "Troublesome Ivories" perfectly after he had heard it only twice. Johnson was also composing rags that helped him win a piano contest in Egg Harbor, New Jersey, and he may have already developed a version of "Carolina Shout." He had certain advantages over his rivals, as he recalled in an interview with Tom Davin:

> I was born with absolute pitch. . . . I played rags very accurately and brilliantly. . . . I did . . . glissandos in sixths and double tremolos. These would run other ticklers out of the place at cutting sessions. They wouldn't play after me. . . . To develop clear touch and the feel of the piano, I'd put a bed sheet over the keyboard and play difficult pieces through it. . . . I was considered one of the best in New York—if not the best.

In the fall of 1914, while performing in Newark with the singer and dancer Lillie Mae Wright, Johnson met WILLIE "THE LION" SMITH. Both Johnson and Smith were formidable pianists and shared the belief that entertainers must be elegantly attired and have a dramatic stage presence. They became best friends; their personalities were complementary, Johnson as deferential as Smith was outspoken. That same year Johnson formed a songwriting and publishing partnership with William Farrell, who taught him to write music. Johnson began touring and writing for shows and dances.

From 1916 to 1927 Johnson made piano rolls, initially documenting many of his own ragtime compositions. He punched an as-yet-unperfected "Carolina Shout" for a roll issued in February 1918. Johnson married Wright in 1917; later they had two children and adopted a third, but initially Wright continued her career as an entertainer. In 1918 they toured in the *Smart Set Revue*. While performing regularly at a nightclub in Toledo, Ohio, Johnson studied composition at the local conservatory of music. He returned to New York late in 1919. Further piano rolls included a polished version of "Carolina Shout," issued in May 1921, and in September and October he made definitive early recordings in the stride piano style: "The Harlem Strut," "Keep Off the Grass," and, again, "Carolina Shout."

Stride piano has often been described as an orchestral style, and indeed, in contrast to boogie-woogie blues piano playing, it requires a fabulous conceptual independence; the individual player must play as though he were an orchestra, the left hand differentiating bass and mid-range lines while the right supplies melodic lines. Nevertheless, the overriding characteristic of Johnson's playing was his percussive attack. For all his harmonic subtlety and melodic invention, and for all his aspirations to become an arty orchestral composer, he was at his finest when he attacked the piano as if it were a drum set. By comparison with classic ragtime piano, Johnson's stride playing on these early recordings was vigorously faster and far more abrasive melodically; open to improvisation, his playing leaned rhythmically toward the uneven and propulsive feeling that later came to be called "swing." Denser and purposefully irregular, the left-hand patterns would "stride" between wide intervals in the piano's bass range; chords in the middle range were more dissonant harmonically, especially when Johnson "crushed" adjacent notes.

"Carolina Shout" became the test piece for aspiring pianists in the stride style. Those who copied it included Smith, DUKE ELLINGTON, Cliff Jackson, Joe Turner, CLAUDE HOPKINS, and FATS WALLER, who became Johnson's student after learning "Carolina Shout" from the piano roll. Smith and Waller subsequently were Johnson's closest colleagues and rivals as pianists at the rent parties that Harlem featured through the 1920s. By many accounts Johnson won the majority of these informal contests on the strength of his originality and keyboard technique, but surviving recordings give the honors to Waller.

Toward the end of 1922 Johnson became the musical director for the revue *Plantation Days*, a little-known touring show that took him to England from March to June 1923. In the summer he and lyricist CECIL MACK wrote the hit revue *Runnin' Wild*, which ran for more than five years on tour and on Broadway. *Runnin' Wild* presented Johnson's "Old Fashioned Love" and "Charleston," the latter perhaps the defining song of America in the 1920s.

In 1926 Johnson wrote "If I Could Be with You (One Hour Tonight)" with lyricist Henry Creamer; it became a hit song in 1930. From late 1927 into 1928 Johnson collaborated with Fats Waller, the lyricists ANDY RAZAF and Creamer, and others in the creation of the revue *Keep Shufflin'*, for which Johnson coauthored the song "'Sippi," directed the pit orchestra, and served as intermission pianist in duets with Waller. With Razaf in 1930 Johnson wrote "A Porter's Love Song to a Chambermaid" for the *Kitchen Mechanic's Revue* at Smalls' Paradise in Harlem.

During this period Johnson recorded regularly in jazz bands and as a soloist. His solo work yielded interpretations of his compositions "Riffs" (1929), "You've Got to Be Modernistic" (1930), and "Jingles" (1930), all carrying his playing to a new level of frenetically syncopated zaniness. He also accompanied recordings by singers as diverse as ETHEL WATERS ("Guess Who's in Town," 1928) and BESSIE SMITH. In "Preachin' the Blues" and "Backwater Blues" from his first session with Smith in 1927, Johnson somewhat toned down his busy pianistic style to conform to the musical aesthetics of the blues. In "Backwater Blues" he discarded the jagged and fast-changing oompahs of stride playing in favor of a loping, repeated boogie-woogie bass pattern. Johnson is the pianist on the soundtrack and on screen in Bessie Smith's movie *St. Louis Blues*, made in late June 1929.

Johnson also sought to create an African American version of European classical music, which proved to be the least successful of his many endeavors. Like most popular and jazz musicians of his era, he was a miniaturist whose great talent lay in the subtle manipulation of nuances of surface detail, not in the construction of grand architectural schemes characteristic of European classical masterpieces. *Yamekraw: Negro Rhapsody*, composed in 1927, was performed at Carnegie Hall for a 1928 concert organized by W. C. HANDY, but Johnson's commitment as music director of *Keep Shufflin'* prevented him from participating. Portions of the rhapsody were recorded and in 1930 were made into a movie short, again without Johnson's participation.

Although careless living and hard drinking began to catch up with him in the 1930s, Johnson continued working. Unfortunately, like JELLY ROLL MORTON, Johnson was so rigidly tied to early jazz and popular styles that he could not adapt when the swing era arrived, and many of his efforts were

unpopular. Johnson wrote for musical revues as the genre grew stale, and he composed largely forgotten pieces whose titles used words testifying to his European classical aspirations: "symphony," "concerto," "ballet," "opera." Many scores have been lost.

With the revival of interest in traditional jazz that began in the late 1930s, Johnson was sought out once again. He figured prominently in the Spirituals to Swing concerts that John Hammond produced and recorded at Carnegie Hall in December 1938 and December 1939. He also recorded in a trio with the clarinetist Pee Wee Russell and the drummer Zutty Singleton in 1938; for the trumpeter Frankie Newton's mixed swing and Dixieland group in January 1939; and with his own group, including the trumpeter Henry "Red" Allen and the trombonist J. C. Higginbotham, in March. In a few titles from these sessions, and particularly in "Blueberry Rhyme," recorded in June, Johnson plays with a lyricism and introspection quite different from his norm. In 1940 he led a band briefly, but in August he suffered the first of eight strokes.

Johnson's return to activity began in 1942, when the Brooklyn Civic Orchestra gave a concert of his "serious" works. He resumed playing in 1943, initially as a member of the trumpeter Wild Bill Davison's band in Boston and New York and then as a freelance bandleader and pianist. After Waller's death in December 1943, Johnson joined the guitarist Eddie Condon at New York Town Hall to perform Waller's tunes and his own music in a series of concerts extending into 1944. From August 1944 he engaged in stride piano contests with Willie "the Lion" Smith at the Pied Piper in Greenwich Village, but in December Johnson suffered a stroke, ending this now-legendary association.

Johnson recorded prolifically during the period 1942–1944, and discs such as "Arkansaw Blues," "Carolina Balmoral," and "Mule Walk—Stomp" (all from late 1943) give no indication that the stroke affected his playing. He also recorded as a bandleader and as a sideman, including beautifully melodic performances on Waller's song "Squeeze Me" and the slow blues "Too Many Times," both from the trumpeter Yank Lawson's session of December 1943.

In 1945 Johnson performed with LOUIS ARMSTRONG, and he heard performances of his concert works at Carnegie Hall and Town Hall. He worked occasionally the next year but became chronically ill. In 1947 he became a regular on Rudi Blesh's radio

show *This Is Jazz*, which was broadcast nationally and recorded. Johnson held assorted freelance jobs, including participation in Friday night jam sessions at Stuyvesant Casino and Central Plaza in downtown Manhattan from June 1948 to February 1949. Johnson suffered a massive stroke in 1951. Paralyzed, he survived financially on songwriting royalties. He died in New York City.

Apart from his tremendously important contributions to American stage and song of the 1920s—in particular, *Runnin' Wild* and "Charleston"—Johnson's significance lies in his stature as the creator of a jazz piano style, stride, and as one of the greatest practitioners and composers in that style. During his lifetime, Johnson's stride piano style was further developed along original and highly personalized paths by Waller, Art Tatum, and Thelonious Monk, and it made its way into the jazz mainstream in, for example, numerous moments of stride playing that the pianists and bandleaders DUKE ELLINGTON and Count Basie introduced into their performances.

FURTHER READING

Brown, Scott E., and Robert Hilbert. *James P. Johnson: A Case of Mistaken Identity* (1986).

Hasse, John, ed. *Ragtime: Its History, Composers, and Music* (1985).

Schuller, Gunther. *Early Jazz: Its Roots and Musical Development* (1968).

Smith, Willie "the Lion," and George Hoefer. *Music on My Mind* (1964; repr. 1975).

Obituaries: *New York Times*, 18 Nov. 1955; *Down Beat*, 28 Dec. 1955.

DISCOGRAPHY

Kappler, Frank. Liner notes in the Time-Life boxed LP set *Giants of Jazz: James P. Johnson* (1981).

BARRY KERNFELD

JOHNSON, James Weldon

(17 June 1871–26 June 1938), civil rights leader, poet, and novelist, was born in Jacksonville, Florida, the son of James Johnson, a resort hotel headwaiter, and Helen Dillet, a schoolteacher. He grew up in a secure, middle-class home in an era, Johnson recalled in *Along This Way* (1933), when "Jacksonville was known far and wide as a good town for Negroes" because of the jobs provided by its winter resorts. After completing the eighth grade at Stanton Grammar School, the only school open to African Americans in his hometown, Johnson attended the preparatory school and then the college division of Atlanta University, where he developed skills as a writer and a public speaker. Following his graduation in 1894 Johnson returned to his hometown and became principal of Stanton School.

School teaching, however, did not satisfy his ambitions. While continuing as principal Johnson started a short-lived newspaper and then read law in a local attorney's office well enough to pass the exam for admission to the Florida state bar. He also continued to write poetry, a practice he had started in college. In early 1900 he and his brother JOHN ROSAMOND JOHNSON collaborated on "Lift Every Voice and Sing," an anthem commemorating Abraham Lincoln's birthday. African American groups around the country found the song inspirational, and within fifteen years it had acquired a subtitle: "The Negro National Anthem."

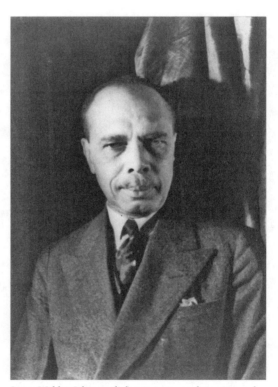

James Weldon Johnson, diplomat, poet, novelist, critic, and composer, 3 December 1932. (Library of Congress/Carl Van Vechten, photographer.)

"Lift Every Voice and Sing" was not the only song on which the brothers collaborated. In 1899 the two spent the summer in New York City, where they sold their first popular song, "Louisiana Lize." In 1902 they left Jacksonville to join Bob Cole, a young songwriter they had met early on in New York, in the quickly successful Broadway songwriting team of Cole and Johnson Brothers. Over the next few years Johnson was largely responsible for the lyrics of such hit songs as "Nobody's Lookin' but de Owl and de Moon" (1901), "Under the Bamboo Tree" (1902), and "Congo Love Song" (1903).

In 1906 Johnson's life took another turn when, through the influence of BOOKER T. WASHINGTON, Theodore Roosevelt appointed him U.S. consul to Puerto Cabello, Venezuela. In 1909 he moved to a more significant post as consul in Corinto, Nicaragua. A year later he returned to the United States for a brief stay in New York City, where he married Grace Nail, a member of a well-established African American family. They did not have children. In 1912 revolution broke out in Nicaragua. Johnson's role in aiding U.S. Marines in defeating the rebels drew high praise from Washington. He left the Consular Service in 1913; there would be, he felt, little opportunity for an African American in the newly elected Democratic administration of Woodrow Wilson.

Johnson maintained his literary efforts during this period. Several of his poems (including "Fifty Years," commemorating the anniversary of the Emancipation Proclamation) appeared in nationally circulated publications. In 1912 he published *The Autobiography of an Ex-Colored Man*, a novel whose central character, unlike Johnson, was light enough to "pass" as a white man; the book explores the young man's struggles to find his place in American society. Johnson returned to New York City in 1914, and he soon began a weekly column on current affairs for the *New York Age*, a widely distributed African American newspaper.

In 1917 Johnson joined the staff of the NAACP. He worked as field secretary, largely responsible for establishing local branches throughout the South and for increasing overall membership from 10,000 to 44,000 by the end of 1918. In 1920 Johnson became the NAACP's first African American secretary (its chief operating officer), a position he held throughout the 1920s.

Johnson was deeply committed to exposing the injustice and brutality imposed on African Americans throughout the United States, especially in the Jim Crow South. He labored with considerable success to put the NAACP on secure financial ground. He spent much time in Washington unsuccessfully lobbying to have Congress pass the Dyer Anti-Lynching Bill, legislation that would have made lynching a federal crime. Finally, Johnson was a key figure in making the NAACP a clearinghouse for civil rights court cases; he collaborated closely with such noted attorneys as Moorfield Storey, Louis Marshall, and Arthur Garfield Hayes in a series of cases defending African American civil rights and attacking the legal structure of segregation. In all these efforts he worked closely with WALTER WHITE, whom he brought into the NAACP as his assistant and who succeeded him as secretary, and W. E. B. DU BOIS, the editor of *The Crisis*, the NAACP monthly journal.

Johnson was probably better known in the 1920s for his literary efforts than for his leadership of the NAACP. He played an active role, as an author and as a supporter of young talent, in what has come to be called the Harlem Renaissance. Johnson urged writers and other artists to draw on everyday life in African American communities for their creative inspiration. He played the role of a father figure to a number of young writers, including CLAUDE MCKAY and LANGSTON HUGHES, whose often blunt prose and poetry drew condemnation from more genteel critics.

His own work during this period included a widely praised anthology, *The Book of American Negro Poetry* (1922), a volume that helped to give an identity to the "New Negro" movement. His continued interest in the African American musical tradition found expression in two collections of spirituals that he and Rosamond brought out: *The Book of American Negro Spirituals* in 1925 and *The Second Book of American Negro Spirituals* in 1926. A year later Johnson published his poetic interpretation of African American religion in *God's Trombones: Seven Negro Sermons in Verse*, a theme he first developed in "O Black and Unknown Bards" (1908). The year 1927 also saw the reissuing of *The Autobiography of an Ex-Colored Man*. Finally, Johnson published *Black Manhattan* (1930), the first history of African Americans in New York City.

In 1931 Johnson stepped down as secretary of the NAACP (though he remained on the association's board of directors) to become a professor at Fisk University. For the remainder of his life he spent

the winter and spring terms in Nashville teaching creative writing and classes in American and African American literature. The rest of the year the Johnsons largely spent in New York City. He remained active as a writer, publishing *Along This Way*, his autobiography, in 1933 and *Negro Americans, What Now?*, a work of social criticism, a year later. Johnson's unexpected death was the result of an automobile accident near Wiscasset, Maine.

Johnson took deserved pride in his accomplishments across a wide variety of careers: teacher, Broadway lyricist, poet, diplomat, novelist, and civil rights leader. Though he suffered most of the indignities forced on African Americans during the Jim Crow era, Johnson retained his sense of self-worth; he proclaimed forcefully in *Negro Americans, What Now?* that "My inner life is mine, and I shall defend and maintain its integrity against all the powers of hell." The defense of his "inner life" did not mean withdrawal, but active engagement. Thus Johnson was a key figure, perhaps the key figure, in making the NAACP a truly national organization capable of mounting the attack that eventually led to the dismantling of the system of segregation by law.

Maintaining his "inner life" also led Johnson to write both prose and poetry that has endured over the decades. "Lift Every Voice and Sing," written a century ago, can still be heard at African American gatherings, and the title phrase appears on the U.S. postage stamp issued in 1988 to honor Johnson. *The Autobiography of an Ex-Colored Man* has remained in print since its reissue in the 1920s, and it holds a significant place in the history of African American fiction. *Along This Way*, also still in print after more than sixty years, is acknowledged as a classic American autobiography. Finally, *God's Trombones*, Johnson's celebration of the creativity found in African American religion, has been adapted for the stage several times, most notably by Vinnette Carroll (as *Trumpets of the Lord*) in 1963.

FURTHER READING

The bulk of Johnson's papers are held at the Beinecke Library, Yale University.

Johnson, James Weldon. *Along This Way: The Autobiography of James Weldon Johnson*, introd. Sondra K. Wilson (2002).

Fleming, Robert E. *James Weldon Johnson* (1987).

Levy, Eugene. *James Weldon Johnson: Black Leader, Black Voice* (1973).

Price, Kenneth M., and Lawrence J. Oliver, eds. *Critical Essays on James Weldon Johnson* (1997).

Wilson, Sondra K., ed. *In Search of Democracy: The NAACP Writings of James Weldon Johnson, Walter White, and Roy Wilkins, 1920–1977* (1999).

Wilson, Sondra K., ed. *The Selected Writings of James Weldon Johnson*, 2 vols. (1995).

EUGENE LEVY

JOHNSON, John Rosamond

(11 Aug. 1873–11 Nov. 1954), composer, performer, and anthologist, was born in Jacksonville, Florida, to Helen Dillet, the first black public schoolteacher in Florida, and James Johnson, the headwaiter at a local restaurant. He and his younger brother, JAMES WELDON JOHNSON, were raised in a cultured and economically secure home, a rarity for African Americans in the South in this era. Their mother read Dickens novels to them every night before bed, and they received music lessons from an early age. Indeed, John began playing the piano as a toddler. He went on to attend Atlanta University in Georgia, and his brother followed eight years later.

When Johnson graduated in 1899 from the New England Conservatory in Boston, where he had studied classical music, he realized that he wanted to explore the realm of musical comedy. He became a vocalist with Oriental America, an African American opera company whose productions differed from the pejorative, stereotypical representations of African Americans present in most theater at the time, often described as "coon" songs. Johnson retuned to Jacksonville to teach music lessons and assume the position of musical director in the public schools. He and his brother, who would become a prominent social activist, novelist, and diplomat, then left for New York to attempt to have their comic opera, *Toloso*, produced; this work satirized the sense of American imperialism after the Spanish-American War. While *Toloso* was never performed on Broadway, the Johnsons did meet a number of prominent people in the musical and theatrical industry in the process of trying to have their work brought to the stage.

Indeed, it was then that they met BOB COLE. The three men went on to collaborate as Cole and Johnson Brothers and created hundreds of popular songs, most notably "Under the Bamboo Tree" (1902) and "Congo Love Song" (1903). The team's first collaboration was "Louisiana Lize," a love song

written in a new lyrical fashion, for which they earned fifty dollars. This song and the ones to follow marked a shift away from the burlesque and minstrel styles. Some of their songs (which featured titles like "I'll Love You, Honey, When the Money's Gone, but I'll Not Be with You" and "Ain't Dat Scan'lous") became best-sellers and were featured in numerous Broadway productions. The Johnson brothers' most famous collaboration, "Lift Every Voice and Sing," was created in 1900 to mark the anniversary of Abraham Lincoln's birthday. James wrote the lyrics and Rosamond wrote the music. The NAACP adopted it as the organization's official song, and it soon became known as "The Negro National Anthem."

Rosamond Johnson often set poetry to music, particularly the poetry of PAUL LAURENCE DUNBAR. The Johnsons also created musical comedies such as *The Shoo Fly Regiment* in 1906 and *The Red Moon* in 1908. Johnson also composed "The Belle of Bridgeport" (1900), "Humpty Dumpty" (1904), and "In Newport" (1904). He then collaborated with BERT WILLIAMS in "Mr. Load of Koal" and soon found that the musical collaborations created by Cole and Johnson Brothers were being sung by such popular entertainers as Lillian Russell and George Primrose. Johnson studied with Samuel Coleridge-Taylor in London in the early 1900s, and when he toured Europe in the 1910s, he became one of the first African Americans to conduct a white orchestra when he directed the revue *Hello Paris*. He then returned to the United States to perform in vaudeville productions with Cole.

After Cole's death in 1911, Johnson became the musical director of the Hammerstein Opera House in London. Upon his return to the United States in 1914, he and his wife started a music school known as the Music School Settlement for Colored People. He had married Nora Ethel Floyd, one of his former piano students in Jacksonville, in 1913 in London. They had two children. Johnson toured across the country, singing spirituals with Taylor Gordon and covering the vaudeville circuit in the early 1920s. The Johnson brothers also edited collections of spirituals (*The Book of American Negro Spirituals* in 1925 and *The Second Book of American Negro Spirituals* in 1926). He performed on stage in the role of Lawrence Frasier in *Porgy and Bess* in 1935 and in *Mamba's Daughter* in 1939 and served as the musical director of *Emperor Jones*, starring PAUL ROBESON, in 1933, and *Cabin in the Sky* in 1935. Johnson spent

the 1930s and 1940s as a music arranger and editor at a few publishing houses in New York and published hundreds of songs. He died at the age of eighty-one in New York City.

Johnson was an influential composer and performer who had a deep impact on the music and theater of New York from the beginning to the middle of the twentieth century. He and his brother will forever be remembered for giving the world "Lift Every Voice and Sing," but he should also be remembered as a prolific songwriter, singer, and anthologist. As talented as he was innovative, Johnson established new directions in both music and theater featuring African Americans, moving away from minstrelsy and toward productions that reflected his passion for musical comedy and his classical training in opera.

FURTHER READING

Johnson's papers are part of the Irving S. Gilmore Music Library at Yale University, a collection of music, correspondence, and photographs that resides across the street from the archive of his brother, James.

Floyd, Samuel A., Jr., ed. *International Dictionary of Black Composers* (1999).

Johnson, James Weldon. *Along This Way* (1933).

Perry, Frank, Jr. "John Rosamond Johnson," in *Afro-American Vocal Music: A Select Guide to Fifteen Composers* (1991).

Woll, Allen. "The End of the Coon Song: Bob Cole and the Johnson Brothers," in *Black Musical Theatre: From Coontown to Dreamgirls* (1989).

JENNIFER WOOD

JOHNSON, Mordecai Wyatt

(12 Jan. 1890–10 Sept. 1976), university president and clergyman, was born in Paris, Henry County, Tennessee, the son of the Reverend Wyatt Johnson, a stationary engine operator in a mill, and Caroline Freeman. Johnson received his grammar school education in Paris, but in 1903 he enrolled in the Academy of the Roger Williams University in Nashville, Tennessee. The school burned in 1905, so Johnson finished the semester at the Howe Institute in Memphis. In the fall of that year, he moved to Atlanta to finish high school in the preparatory department of Atlanta Baptist College (renamed Morehouse College in 1913). There he completed a bachelor's degree in 1911. While at Atlanta Baptist, Johnson played varsity football and tennis, sang in

various groups, and began his long career as a public speaker on the debating team.

After graduating, Johnson became an English instructor at his alma mater. For the 1912–1913 school year he taught economics and history and served as acting dean of the college. During the summers he earned a second bachelor's degree in the social sciences from the University of Chicago (1913). Johnson decided that he wanted to be a minister and enrolled in Rochester Theological Seminary. In seminary he was greatly influenced by Walter Rauschenbusch's theory of the Social Gospel, in which Christianity was responsible for economic and social change. While studying at Rochester he was a student pastor at the Second Baptist Church in Mumford, New York. He was granted a bachelor's of divinity degree in 1921 with a thesis titled "The Rise of the Knights Templars."

In December 1916 Johnson married Anna Ethelyn Gardner of Augusta, Georgia; they had five children. That year Johnson worked as a student secretary of the Young Men's Christian Association (YMCA). He traveled for one year in the Southwest, studying predominantly black schools and colleges. This effort resulted in the formation of the Southwestern Annual Student Conference.

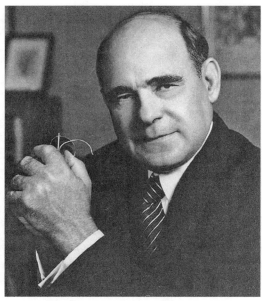

Mordecai Wyatt Johnson, the first African American president of Howard University. (Schomburg Center.)

Johnson was ordained in 1916 and received an assignment in 1917 to be the pastor of the First Baptist Church in Charleston, West Virginia. In his nine years in West Virginia, Johnson was responsible for organizing the Commercial Cooperative Society, the Rochdale Cooperative Cash Grocery, and the Charleston branch of the National Association for the Advancement of Colored People (NAACP). Under his leadership, the membership of the local branch of the NAACP increased to one thousand in nine years. He also became active in the Negro Baptist Convention. By the time he left in 1926, Johnson was well known as a community activist and speaker. In 1921 he took a year of absence while he studied at Harvard. The following year Johnson received a master's degree in Sacred Theology and gave the commencement address on postwar racism, titled "The Faith of the American Negro."

On 30 June 1926 Johnson was elected the thirteenth president of Howard University in Washington, D.C. Howard was chartered in 1867 out of the Freedmen's Bureau and was originally intended to be a theological seminary for African Americans and a normal school. By 1917 Howard and Fisk University were considered the only traditionally black schools offering a college-level education. When Johnson assumed the presidency of Howard on 1 September 1926, he had a broad vision for improvements to the university.

Johnson was the first African American to hold the presidency of Howard and came to office at a time when all other presidents of traditionally black colleges were white. Further, Howard was currently undergoing a time of controversy: Johnson's predecessor had been asked to resign, and the administration and the faculty sharply disagreed on a number of issues. Johnson sought to elevate the position of the professors by raising their salaries and providing tenure and security. During his tenure he brought in professors with national reputations and a large number of African Americans with PhDs.

Johnson's priorities for improvements were explained in his Twenty-Year Plan, which called for educational and physical development. In 1926 the only two accredited schools at Howard were dentistry and liberal arts. During his years at Howard, Johnson doubled the number of faculty members, doubled the library resources, tripled the amount of laboratory equipment, and constructed twenty new buildings. Under Johnson, all of the schools and colleges became fully accredited. In addition,

the university enrollment increased by 250 percent, and the budget grew from $700,000 to $8 million.

Johnson's most important contribution to Howard was fund-raising. He was not only successful at securing private donations and grants, but he also persuaded Congress to amend the charter of the university to provide annual appropriations on 13 December 1928. Between 1946 and 1960, Howard received an average of more than $1 million annually. This added funding gave Howard an advantage over similar schools. For his work in gaining Howard annual federal funds, Johnson received the Spingarn Medal for Public Service in 1929. (The Spingarn Medal is the highest award given by the NAACP.)

Johnson retired in June 1960 and became president emeritus. Howard had been remade in his thirty-four-year tenure. The school had students from more than ninety countries. The professional schools in particular were impressive. Howard's medical school was producing half of the nation's African American doctors, and the law school was in the vanguard of civil rights, providing 96 percent of the African American lawyers.

After leaving Howard, Johnson served on the District of Columbia's Board of Education in 1962. In his three-year tenure, he was a vocal critic of the disparity between funding of predominantly white schools and black schools in the district. Johnson was also a member of several charitable organizations. He was on the National Council of the United Negro College Fund; vice chairman of the National Council for the Prevention of War; director of the American Youth Committee; a member of the Advisory Council for the National Youth Administration; a member of the National Advisory Council on Education; a member of the National Religion and Labor Board; and director of the National Conference of Christians and Jews. In addition, he was a strong advocate for nations under colonial control by countries such as Great Britain and France, and he was a member of the advisory council for the Virgin Islands. He was an early proponent of India's independence from Great Britain and often spoke on the topic. In one such lecture, he spoke at Martin Luther King Jr.'s seminary, Crozer Theological Seminary in Philadelphia.

In 1969 Johnson's wife died. In April 1970 he married Alice Clinton Taylor King; they had no children. Howard University honored Johnson in 1973 by naming the administration building after him. His service was also recognized internationally: Ethiopia, Haiti, Liberia, and Panama all gave him awards for his achievements. Johnson died in Washington, D.C.

Johnson has been recognized for his excellent administrative skills and as "one of the great platform orators of his day." His involvement in civil rights and religious causes gained him notice. His organization and development of Howard University was remarkable. Johnson insisted on a quality faculty, high-caliber students, adequate funding, and sufficient facilities and laboratory equipment. These factors put Howard on a path for success. Johnson's contributions to Howard and his other causes have assured his legacy of improved educational opportunities for all.

FURTHER READING
Johnson's papers concerning Howard University are in the Moorland-Spingarn Research Center at Howard.
Logan, Rayford W. *Howard University: The First Hundred Years, 1867–1967* (1969).
McKinney, Richard I. *Mordecai—The Man and His Message: The Story of Mordecai Wyatt Johnson* (1998).
Winston, Michael R., ed. *Education for Freedom* (1976).
Obituaries: New York Times and *Washington Post*, 11 Sept. 1976.

SARA GRAVES WHEELER

JOHNSON, Sargent Claude

(7 Oct. 1887–10 Oct. 1967), artist, was born in Boston, Massachusetts, the son of Anderson Johnson and Lizzie Jackson. When Johnson was ten years old, his father died of an unknown cause. Because his mother suffered from tuberculosis, the children were sent to relatives. Johnson lived with his maternal uncle, Sherman William Jackson, and his wife, the sculptor May Howard Jackson, for several years in Washington, D.C. Then he and his siblings stayed briefly with their maternal grandparents in Alexandria, Virginia. When their mother died in 1902, the girls went to a Catholic school in Pennsylvania and the boys went to a Sisters of Charity orphanage in Worcester, Massachusetts. Johnson attended public school and worked in the Sisters of Charity Hospital. He began painting as an adolescent while recovering from a long illness. After Johnson studied

singing briefly at a music school in Boston, he lived with relatives in Chicago. Despite his tragic childhood, Johnson was a cheerful man. His friend, the painter Clay Spohn, described him as "perennially happy, joyous, exuberant in living."

In the early 1910s Johnson moved to San Francisco, where he married Pearl Lawson in 1915; they had one child before they separated in 1936. Lawson was hospitalized for mental illness in 1947 and remained at the Stockton State Hospital until her death in 1964. Johnson worked as a fitter for Schlusser Brothers from 1917 until about 1920, as a photographic retouch artist for Willard E. Worden in 1920, and as a framer for Valdespino Framers from about 1921 until 1931.

Johnson began studying drawing and painting at the A. W. Best School of Art, and then he studied at the California School of Fine Arts (1919 to 1923 and again from 1940 to 1942) under the sculptors Robert Stackpole and Beniamino Bufano. Johnson won first prize for his work there in 1921 and 1922. Much later, he studied metal sculpture with Claire Falkenstein. Upon leaving school, Johnson made his primary living as a framer. From 1925 to 1933 Johnson worked in wood, ceramics, oils, watercolors, and graphics in a backyard studio in Berkeley. In 1928 he won the Harmon Foundation's Otto Kahn Prize for *Sammy*, a terra-cotta head. Two years later he won the foundation's bronze award for fine arts, and in 1933 he received the Robert C. Ogden Prize for the most outstanding combination of materials for *Pearl*, a porcelain bust of his daughter, and two drawings, *Mother and Child* and *Defiant*. Johnson also exhibited several pieces with the foundation's traveling exhibitions, and thousands saw them in the Oakland Municipal Art Gallery in 1931 and 1933. Already recognized in the San Francisco Bay Area, Johnson was the only Californian in these national shows. *Chester* (1931), a terra-cotta portrait head of an African American boy resting his cheek in his right hand, was purchased by the German minister to Italy.

In 1935 the Harmon Foundation presented Johnson in a three-man exhibition at the Delphic Studios in New York. Included was a lacquered, redwood, polychrome sculpture of a woman, *Forever Free*. Incised on the skirt of her tubular body are two children playing under their mother's protective care. Covered with several coats of gesso and fine linen and highlighted in black and white paint, this is Johnson's best-known piece. "It is the pure American Negro I am concerned with," he said, "aiming to show the natural beauty and dignity . . . in that characteristic hair, bearing and manner; and I wish to show that beauty not so much to the White man as to the Negro himself" (*San Francisco Chronicle*, 6 Oct. 1935). Johnson, whose mother was of Cherokee and black ancestry, identified himself as African American. Among his memorable sculptures of the 1930s is a series of stylized bronze and copper heads and masks on art deco-like wooden bases. The stoic faces borrow certain qualities from West African, pre-Columbian (Maya and Aztec), and cubist art.

In the mid-1930s Johnson was employed by the Federal Art Project of the Works Progress Administration as artist, senior sculptor, assistant supervisor, assistant state supervisor, and unit supervisor. He produced several large-scale works, including an enormous carved redwood organ screen for the California School for the Blind (1937), semiabstract carvings of marine life in green Vermont slate, and a tile mural for San Francisco's Maritime Museum at Aquatic Park (c. 1938). He also completed statues at the Golden Gate International Exposition in San Francisco: two Inca—one a rich man, the other an intellectual—seated on llamas for the South American front of the Court of Pacifica and three works symbolizing industry, home life, and agriculture for the Alameda-Contra Costa County Fair Building (1939). In 1939 he also created a series of six animals in green and gray cast terrazzo for a child care center playground in San Francisco.

Johnson had been elected to the San Francisco Art Association in May 1932 and to its council board in 1934. He served on the organization's annual juries (1936, 1938, 1940, 1942, 1947 and 1948) and received awards from the group in 1925 (for *Pearl*), in 1931 (for *Chester*, a terra-cotta head), in 1935 (for *Forever Free*), and in 1938 (for *Black and White*, a lithograph). At the same time, local museums acquired Johnson's work; in the mid-1930s the San Francisco Museum of Art received the collection of the local philanthropist Albert M. Bender, which included several of Johnson's pieces (such as *Forever Free*), and in 1939 the San Diego Fine Arts Gallery purchased *Esther*, a terra-cotta head. Various museums and collectors purchased a number of the 150 copies of the lithograph *Singing Saint* in 1940. The semiabstract work of two women, one playing a guitar, was widely reproduced in the 1940s.

Johnson's long friendship with Bufano, his principal mentor, ended because of a long and acrimonious competition between the men for a contract to produce a work of art for the San Francisco Art Commission in 1940. Johnson's best-known large-scale decorative work is a tremendous cast-stone frieze, which covers the entire retaining wall across the back of the George Washington High School athletic field in San Francisco (1942). It depicts young men and women diving, rowing, wrestling, and playing football, basketball, baseball, and tennis.

Travel provided Johnson with much artistic inspiration. An unknown benefactor and two Abraham Rosenberg scholarships (1944 and 1949) helped finance numerous trips between 1945 and 1965 to Mexico, where he visited renowned archeological sites and studied ancient art and Chelula polychrome pottery. Working with black clay found outside Oaxaca in the manner of Zapotec Indians and Mexicans, he produced many small, hollow forms, including a representation of a do-nothing politician (a type that annoyed Johnson during the Depression). Johnson's anonymous patron also sponsored a seven-month trip to Japan in 1958. There Johnson visited Shinto shrines and studied Japanese art. An avid reader and guitarist, Johnson also taught art to several private students in his studio over several years and offered classes for the Junior Workshop program of the San Francisco Housing Authority and Mills College in 1947.

From 1947 to 1967 Johnson produced about one hundred abstract, surrealist, and impressionist porcelain enamel panels and plates on steel, a technique that he learned at the Paine-Mahoney Company, which produced enameled signs on steel plates. The company invited Johnson to create aesthetic porcelain plates on steel in his spare time. He shaped the metal in his studio or at the Architectural Porcelain Company, exploring religious, multiracial, antiwar, and mother-and-child themes. Johnson produced several commissions in this medium, including a semiabstract mural of pots and pans for Nathan Dohrmann & Company, a crockery and glass shop (1948), and a decorative map of Richmond, California, for its city hall chambers (1949). In 1949 the Paine-Mahoney Company hired Johnson to complete the details of a commission of an enamel mural for Harold's Club in Reno, Nevada. Reportedly the largest mural in the United States ever created by that method, it is 38 feet high and 78 feet long and depicts wagon-train pioneers crossing the Sierras. Johnson finished a similar mural—25 feet long by 50 feet high—for the West Club Casino in Las Vegas.

Johnson also continued large-scale works in other media. The Matson Navigation Company of Honolulu commissioned two works for pleasure ships: a large mahogany panel depicting Hawaiian leaders and warriors for SS *Lurline* (1948), and two ceramic tile walls for SS *Monterey* (1956). Two years after Johnson moved to San Francisco in 1948, he began to bring color back to his sculpture, affirming his earlier artistic statement:

> The slogan for the Negro artist should be "Go south, young man!" Too many Negro artists go to Europe and come back imitators of Cézanne, Matisse or Picasso, and this attitude is not only a weakness of the artists, but of their racial public. In all artistic circles I hear too much talking and too much theorizing. All their theories do not help me any, and I have but one technical hobby to ride: I am interested in applying color to sculpture as the Egyptian, Greek, and other ancient people did.
> (*San Francisco Chronicle*, 6 Oct. 1935)

In the late 1950s and 1960s the sculptor produced polychrome wood pieces with universal themes influenced by Asian, northwest Native American, and ancient Egyptian and Greek art. He also executed works in diorite rock, cast bronze, and forged enameled forms, and he collaborated with the ceramist John Magnani on glazes and clay bodies. During the 1960s Johnson also worked for the Flax Framing and Art Supply Company. Johnson died in San Francisco. Although somewhat isolated as one of the few African American artists consistently active in California from the 1920s through the 1960s, Johnson was nationally known for his stylistic pluralism, versatility, and daring innovation.

FURTHER READING

The whereabouts of Johnson's papers are not known.
The Archives of American Art has a thirty-three-page transcription of an oral history interview from 1964.

Bearden, Romare, and Harry Henderson. *A History of African-American Artists from 1792 to the Present* (1993).

Montgomery, Evangeline J. *Sargent Johnson: Retrospective* (1971).

"Sargent Johnson," *International Review of African American Art* 6, no. 2 (1984).

Obituary: *Oakland Tribune*, 12 Oct. 1967.

THERESA LEININGER-MILLER

JOHNSON, William H.

(18 Mar. 1901–13 Apr. 1970), artist, was born William Henry Johnson in Florence, South Carolina, the first of five children of Henry Johnson and Alice Smoot. From the moment of William's birth, neighbors speculated whether this light-skinned, wavy-haired child was the offspring of Henry Johnson, a dark-skinned laborer, and his wife, a woman with dark mahogany skin who worked as a domestic in the home of a prominent white family.

As a child, Johnson attended Wilson School, an all-black elementary school, where he exhibited an early interest in sketching. A teacher encouraged his talent by giving him supplies, and Johnson thought of becoming a cartoonist. However, as a youth he devoted most of his time to supplementing the meager family income as a pinsetter at a bowling alley, shoveling coal, and working at a laundry. Realizing that his opportunities for professional and artistic development were severely limited in a small, segregated southern town, Johnson boarded a train for New York City in 1918.

Upon his arrival in New York, Johnson lived on 128th Street in Harlem with his uncle, Willie Smoot. He found menial work in hotels and restaurants until the fall of 1921, when his drawings earned him a place at the National Academy of Design (NAD). Johnson excelled in his early studies and won a prize in a student competition for one of his drawings. During his second year Johnson fell under the influence of Charles Hawthorne, a new instructor at the NAD, who fundamentally altered Johnson's perspective on art.

Hawthorne urged his students to seek inspiration from their subjects, to experiment with form, and to abandon the more subdued conservative palette in favor of vivid color and bold expression. During the summers from 1924 to 1926 Johnson studied with Hawthorne at the Cape Cod School of Art, doing odd jobs around the school to earn his tuition. He was usually the only black student in these settings, and he had a reputation for being reticent, even aloof, preferring to let his work speak for him. Hawthorne recognized Johnson's exceptional talent and encouraged him to go to Europe, cautioning him that in America "there is bound to be prejudice against your race" (Powell, 37).

It is widely believed that Johnson was denied the NAD's most coveted award, the Pulitzer Traveling Scholarship, in 1926 because of class and race prejudice. Hawthorne and others were so incensed by this apparent act of discrimination that they privately raised the funds to support Johnson's study in France. Shortly after arriving in Paris, Johnson met the most renowned black painter of his generation, HENRY OSSAWA TANNER, who had long since made Paris his home. Johnson's European work from 1926 to 1932 focuses on the challenges of capturing landscapes and pastoral vistas rather than on human subjects. These paintings show an admiration for Paul Cézanne and the expressionist Chaim Soutine. Johnson often described what he was trying to express in his paintings as "primitivism." The art historian Richard Powell explains that Johnson's concept of primitivism "was not based on black culture itself, but rather on emotional and psychological interpretations of that culture" (Powell, 75).

In 1928 Johnson moved to Cagnes-sur-Mer in southern France. There he met the German expressionist sculptor Christoph Voll; Voll's wife, Erna; and her sister, Holcha Krake, a ceramic and textile artist. Together this group traveled to Corsica, France, Germany, Luxembourg, and Belgium, visiting museums and sharing their work.

Anxious to find an audience for his growing body of work and hoping to live on the proceeds of his art, Johnson returned to America in 1929 and entered six of his pieces in the William E. Harmon Foundation competition. He won the Gold Medal, which came with a four-hundred-dollar cash award, and four of his paintings were selected for an exhibit, where they received favorable reviews. Johnson returned for a brief visit to Florence, South Carolina, where the local YMCA arranged a one-day show featuring more than one hundred paintings by their up-and-coming native son. On his return trip to New York City, Johnson stopped in Washington, D.C., where he stayed at the home of ALAIN LOCKE, a leading spokesperson for the Negro arts movement during the Harlem Renaissance. Locke became a mentor to Johnson, finding buyers for some of his paintings and introducing him to luminaries in the art and literary world.

In May of 1930 Johnson returned to Europe, married Holcha in June, and settled in the small Danish

fishing village of Kerteminde. Many of Johnson's Scandinavian paintings, such as *Lanskab fra Kerteminde* (c. 1930–1932, National Museum of American Art [NMAA]) and *Sun Setting, Denmark* (c. 1930, NMAA), use vibrant color, thick paint, and strong brushwork reminiscent of the work of Vincent van Gogh. By the age of thirty Johnson had tried a variety of aesthetic approaches, from Postimpressionism to European Expressionism, yet, in his words, he had not found the "the real me." As he put it, "Europe is so very superficial. Modern European art strives to be primitive, but it is too complicated" (Powell, 69). Like Pablo Picasso and Paul Gauguin, who had incorporated African and Tahitian imagery into their work to great acclaim, Johnson planned a trip to North Africa for the spring of 1932. There, as he put it, "I might be the first at the same time primitive and cultivated painter the world has ever seen" (Turner and Dailey, 24).

Johnson and Holcha spent three months in Tunisia. They traveled to Kairouan, where Johnson painted a series of watercolors depicting the bustling markets, the towering minarets, and the majestic mosque. When they returned to Denmark at the end of the summer, his paintings and her ceramics appeared in several local exhibitions, but Johnson sent the majority of his new work to the Harmon Foundation in New York, expecting that it would be exhibited and sold. The foundation managed to sell only two of Johnson's paintings in six years, owing both to its lack of effort and the contracting art market during the Depression. By the late 1930s the scourge of Nazi propaganda was spreading across Europe; Christoph Voll's work was discredited by the Nazis as "degenerate art," resulting in Voll's being fired from his teaching position in Germany. In November 1938, with these ominous clouds on the horizon, Johnson and Holcha sailed for New York.

Back in America, the Works Progress Administration had created the Federal Art Project (FAP). In May 1939 Johnson was hired by the FAP and assigned to teach art at the Harlem Community Art Center. Two important developments emerged from this experience: Johnson again became part of the Black Arts Movement, surrounded by contemporaries like JACOB LAWRENCE and Gwendolyn Knight, and African Americans reappeared as the primary subject of his paintings.

During this period Johnson's paintings began to take on an Egyptian-like flatness, as can be seen in *Jitterbug (I)* (c. 1940–1941, NMAA), where the figures are animated on the canvas by bold colors and kinetic gestures. In addition, much of Johnson's American oeuvre contains explicit political messages, readily seen in *Chain Gang* (c. 1939, NMAA) and *Moon over Harlem* (c. 1943–1944, NMAA), which depicts acts of police brutality against blacks; and his Fighters for Freedom series, which pays homage to such significant figures as Frederick Douglass, Harriet Tubman, and Nat Turner.

Following Holcha's death from cancer in 1944, religious themes appear in Johnson's work with greater frequency, though his interest in spiritual subject matter was already well established. Johnson's own physical and mental state began to deteriorate rapidly after 1945. In 1946 he returned to Denmark, hoping to find the peace and happiness of an earlier time. However, Johnson's behavior became increasingly erratic and confused, and he lived briefly as a vagrant on the streets of Copenhagen until it was determined that he suffered from an advanced case of syphilis-induced paresis. Johnson's European relatives sent him back to America, where he spent the rest of his life as an inmate at Central Islip State Hospital on Long Island. Johnson never painted again, and he died in 1970, oblivious to the growing critical acclaim of his work.

FURTHER READING

The papers of William H. Johnson are in two collections: William H. Johnson Papers, Archives of American Art, Smithsonian Institution, Washington, D.C., and William H. Johnson Papers, Smithsonian Institution Archives, Washington, D.C.

Breeskin, Adelyn D. *William H. Johnson* (1971).

Powell, Richard J. *Homecoming: The Art and Life of William H. Johnson* (1991).

Turner, Steve, and Victoria Dailey. *William H. Johnson: Truth Be Told* (1998).

SHOLOMO B. LEVY

JONES, Eugene Kinckle

(30 July 1885–11 Jan. 1954), social welfare reformer, was the son of Joseph Endom Jones and Rosa Daniel Kinckle, a fairly comfortable and prominent middle-class black couple in Richmond, Virginia. Both his parents were college-educated. Jones grew to maturity at a period in American history when the federal government turned its back on providing full citizenship rights to African Americans.

Although the Civil War had ended slavery and the Fourteenth and Fifteenth amendments to the U.S. Constitution had guaranteed blacks equal rights, state governments in the South began to erode those rights following the end of Reconstruction in 1877.

Jones grew up in Richmond at a time of racial polarization, and he watched as African American men and women struggled to hold on to the gains that some had acquired during Reconstruction. Like others in W. E. B. DU BOIS's "Talented Tenth," he saw education as the best means of improving his own life and of helping others, and he graduated from Richmond's Virginia Union University in 1905. He then moved to Ithaca, New York, to attend Cornell University, where, in 1906, he was a founding member of the nation's first black Greek-lettered fraternity, Alpha Phi Alpha. He later helped found two other chapters at Howard University and at his alma mater, Virginia Union. He graduated from Cornell with a master's degree in 1908 and taught high school in Louisville, Kentucky, until 1911. In 1909 he married Blanche Ruby Watson, with whom he went on to have two children.

In 1911 Jones began working as the first field secretary for the National Urban League (NUL), a social service agency for blacks that had been founded in New York City in 1910. By the 1920s he had superimposed the philosophy and organization of Alpha Phi Alpha upon the league, which was by that time dealing with the problems of poverty, poor housing, ill health, and crime that emerged during the first great black migration from the rural South to the urban North. He worked diligently to establish as many local branches as possible, believing that the concept of local branches would further the NUL's national agenda. Jones also placed key individuals in the directorships of local branches, which enabled him to be informed at all times of the conditions in black urban areas. In addition, he established fellowship programs to ensure that a larger pool of African American social workers would be available to tackle the problems that rural migrants faced in the burgeoning inner cities of the North. In 1923, along with the NUL's research director, the sociologist CHARLES S. JOHNSON, Jones helped launch *Opportunity*, a journal that addressed the problems faced by urban blacks but which also provided an outlet for a new generation of African American writers and artists, including Aaron Douglas and LANGSTON HUGHES.

In 1915 Jones and a group of other black social reformers founded the Social Work Club to address the concerns of African American social workers. This organization was short-lived, for by 1921 black social workers had become actively involved with the American Association of Social Workers. In 1925 the National Conference of Social Work elected Jones treasurer, making him the first African American on its executive board. Jones went on to serve the organization until 1933, by which time he had risen to the position of vice president of the National Conference of Social Work (NCSW). This post put him in a position of importance within the national structure of the social work profession. During Jones's tenure as an executive officer of the NCSW, he worked with other black social workers to make white reformers aware—often for the first time—of the urban problems particular to African Americans.

In 1933 Jones became one of the leading black figures in Washington, D.C., when he took a position with the Department of Commerce as an adviser on Negro Affairs. Perhaps no single person matched Jones's efforts in delivering to African American communities the opportunities that became available to them through the federal government's newly initiated relief programs. While in Washington, he also served as the voice of the black community through the NUL and its local branches. In so doing, Jones came to personify the NUL in the 1930s, while he served along with MARY MCLEOD BETHUNE, Robert Weaver, and William Henry Hastie as part of President Franklin Roosevelt's so-called black cabinet.

By the time of Jones's retirement in 1940, the NUL had become a relatively conservative organization. A younger generation was rising to prominence, and many African Americans were no longer willing to wait as patiently for justice and their full citizenship rights as Jones and his contemporaries had been willing to do. However, Jones's handpicked successor, LESTER B. GRANGER, continued in the more conservative style of leadership embraced by Jones. The NUL therefore did not engage in the direct methods of the modern civil rights movement until 1960, when WHITNEY YOUNG was appointed executive secretary. Jones died in New York after a short illness in January 1954.

Like other middle-class blacks, Jones felt a strong sense of responsibility for uplifting less fortunate members of his race. In that regard, his social

views conformed with other turn-of-the-century African American social reformers, such as Du Bois, CARTER G. WOODSON, JAMES WELDON JOHNSON, IDA B. WELLS-BARNETT, and Mary Church Terrell. The accomplishments of these progressive-era reformers have historically been ignored compared with those of their white counterparts, such as the settlement house leader Jane Addams. Scholars have recently begun to acknowledge, however, that African American middle-class activists like Jones led the early twentieth-century social reform movement in black America, even though the middle-class ethos of these reformers did not exactly mirror that of the larger white society. Above all, Jones's tenure as executive secretary of the NUL showcases the achievements of early black social reformers. He also helped make the league an African American, and an American, institution.

FURTHER READING
Information on Jones can be found in the National Urban League Archives in the Manuscript Division of the Library of Congress, Washington, D.C.

Carlton-LaNey, Iris B., ed. *African American Leadership: An Empowerment Tradition in Social Welfare History* (2001).

Weiss, Nancy J. *The National Urban League, 1910–1940* (1974).

Wesley, Charles H. *The History of Alpha Phi Alpha: A Development in Negro College Life* (1929).

FELIX L. ARMFIELD

JONES, Laurence Clifton

(21 Nov. 1884–18 July 1975), educator, was born in St. Joseph, Missouri, the oldest of four children and the only son of John Q. Jones, a hotel porter and barbershop owner, and Lydia Foster Jones, a seamstress and parlor room hostess. Laurence learned the value of hard work in his youth as he shined shoes, sold newspapers, and raised chickens. In 1898 he moved to Marshalltown, Iowa, where he worked for room and board at a hotel. In 1903 Jones became the first African American to graduate from Marshalltown High School. Local whites encouraged him to attend the University of Iowa (then the State University of Iowa) in Iowa City. Influenced by the ideas of BOOKER T. WASHINGTON, Jones decided to help educate poor blacks in the South when he graduated from the University of Iowa in 1907 with a bachelor of philosophy degree.

Jones joined the Utica Institute in Utica, Mississippi, that same year, and while visiting impoverished Rankin County during a Christmas vacation, he discovered that the blacks there had talked for years about establishing a school but never had possessed the needed funds. He offered his services to the county and, in 1909, with three illiterate students and a stump for a desk, he began to teach. He named his new school Piney Woods Country Life School.

While many local blacks and whites were initially skeptical of Jones, he soon received help from Edward Taylor and John Webster. Taylor, a former slave, gave Jones an old sheep shed, forty acres of land, and fifty dollars. Webster, a white businessman, gave Jones lumber and building tools. Students could supply food, materials, or labor in lieu of tuition. Later, white business leaders who accepted the idea of giving African American youth practical agricultural training offered support, and blacks from surrounding communities began to attend and provide resources. Piney Woods Country Life School was co-educational and offered reading, writing, arithmetic, agriculture, home economics, and industrial labor training. A devout Christian, Jones emphasized hard work, public service, and good character—attributes that would lead students to self reliance and personal advancement. Regardless of Jones's sincerity and drive, his school faced chronic financial problems. Like other entrepreneurial black educators, Jones looked to sympathetic northerners, especially acquaintances in Iowa, for donations. He began making speaking tours, especially to churches, soliciting aid.

In 1912 Jones married Grace Morris Allen of Burlington, Iowa, who joined in teaching and fundraising activities for the school, which received a charter from the state of Mississippi in 1913. By then Piney Woods had become a boarding school with several teachers and focused primarily on manual training and farming. Jones promoted diversified farming to students and community members alike. He hosted farm conferences and brought noted northern agriculturalists to speak, such as Asa Turner, president of the Iowa Corn Growers Association. His efforts were further enhanced when Iowa friends purchased eight hundred acres for the school to use for farm projects. Led by his wife, Grace, the school also offered free home extension service. Also in 1913 the Joneses contracted to go on the Chautauqua speaking circuit.

During World War I, Jones took charge of the Thrift Stamp Campaign, a government savings program using stamps instead of war bonds, among blacks, and he worked for Armenian Relief. In 1917 Piney Woods School served as a summer normal school for African American teachers, and the next year teacher training became a regular feature of the institution. Jones was named to the state committee to establish accreditation standards for black high schools.

Grace Allen Jones organized the Cotton Blossom Singers in 1921 and, performing traditional black spirituals, they raised funds for the school as they traveled across the country and ultimately had their own radio program, which lasted until the 1970s. Grace, who accomplished much for the school as well as being noted for her efforts to improve health care, sanitation, and welfare in Mississippi, died in 1928. She left Laurence with two sons, and although he never remarried, Jones later adopted a daughter.

Mississippi did not offer any schooling for blind African American children, so Jones assumed that responsibility at Piney Woods School from 1929 until 1950, when the Mississippi School for the Blind was opened in Jackson. In 1931 he added a junior college, which continued at the school until the 1960s. Jones established a semiprofessional baseball team to play exhibition games, hoping the team would stimulate contributions to the school, and in 1939 he created the Sweethearts of Rhythm, an all-girl jazz band that performed widely into the 1940s.

By the 1950s the reputation of Piney Woods Country Life School was such that the U. S. State Department cited it as an example of American democracy and education. However, the biggest boost for Jones and the school came in 1954 when the television show *This Is Your Life* profiled Jones, and host Ralph Edwards enjoined viewers to send a dollar each to help the school. Within a few weeks $776,000 was raised. The next year Jones was designated "Mississippi's First Citizen" by Governor Hugh White. In 1974 Jones stepped down as the head of Piney Woods Country Life School. By then he had received awards and honorary degrees as well as having had much written about him and Piney Woods Country Life School. He also authored several books himself, including *Up through Difficulties* (1910), *Piney Woods and Its Story* (1923), *Spirit of Piney Woods* (1931), and *Bottom Rail* (1935). Jones died in 1975, ending a life inseparable from Piney

Woods Country Life School. Hard work, dedication, faith, and an adroit understanding of how an African American educator could succeed in the racist South created a heroic story and left a remarkable legacy. Jones assumed statewide leadership in civic and educational service, and in 1981 he became the first African American admitted to Mississippi's Hall of Fame.

FURTHER READING

Archival collections containing significant papers relating to Jones are the Piney Woods Country Life School Records at the Mississippi Department of History and Archives; Piney Wood Country Life School Archives at Piney Wood Country Life School; Laurence C. Jones Alumni Vertical File, University of Iowa; and Grace Morris Jones Papers, Iowa Women's Archives, University of Iowa. Much additional information on Jones and the Piney Woods Country Life School can be found in issues of the *Pine Torch*, the school newsletter that Jones began printing in 1911.

Apgar, Dorothy, ed. *The Continuing History of Marshall County Iowa* (1997).

Cooper, Arnold. *Between Struggle and Hope: Four Black Educators in the South, 1894–1915* (1989).

Day, Beth. *The Little Professor of Piney Woods: The Story of Professor Laurence Jones* (1955).

Harrison, Alferdteen. *Piney Woods School: An Oral History* (1982).

Martin, Lee. "Piney Woods Country Life School: An Educational Experience of African Americans," 1998 Proceedings of the Adult Education Research Conference. Available at http://www.edst.educ. ubc.ca/aerc/1998/98martin.htm

Purcell, Leslie Harper. *Miracle in Mississippi: Laurence C. Jones of Piney Woods* (1956).

THOMAS BURNELL COLBERT

JONES, Loïs Mailou

(3 Nov. 1905–9 June 1998), artist and teacher, was born in Boston, Massachusetts, the second of two children of Carolyn Dorinda Adams, a beautician, and Thomas Vreeland Jones, a building superintendent. Jones's father became a lawyer at age forty, and she credited him with inspiring her by example: "Much of my drive surely comes from my father— wanting to be someone, to have an ambition" (Benjamin, 4). While majoring in art at the High School of Practical Arts, Jones spent afternoons in a drawing program at Boston's Museum of Fine Arts.

On weekends she apprenticed with Grace Ripley, a prominent designer of theatrical masks and costumes. From 1923 to 1927 she studied design at the School of the Museum of Fine Arts and became one of the school's first African American graduates. Upon graduation, Jones, who had earned a teaching certificate from the Boston Normal Art School, received a one-year scholarship to the Designers Art School of Boston, where she studied with the internationally known textile designer Ludwig Frank. The following summer, while attending Harvard University, she designed textiles for companies in Boston and New York. She soon learned, however, that designers toiled in anonymity, and so, seeking recognition for her creations, she decided to pursue a career as a fine artist.

Jones's family spent summers on Martha's Vineyard, the beauty of which inspired her to paint as a child and where her first solo exhibitions, at ages seventeen and twenty-three, were held. A retreat for generations of African American intellectuals, Martha's Vineyard exposed the young artist to career encouragement from the sculptor META WARRICK FULLER, the composer HARRY BURLEIGH, and Jonas Lie, the president of the National Academy of Design. When she applied for a teaching job at the Museum of Fine Arts, administrators patronizingly told her to "go South and help your people." Jones did go to the South in 1928, but at the behest of Charlotte Hawkins Brown, who offered her a position developing an art department at the Palmer Memorial Institute, an African American school in North Carolina. Two years later Jones was recruited by Howard University and remained on the faculty until her retirement in 1977.

For forty-seven years she taught design and watercolor (which was considered more appropriate to her gender than oil painting) to generations of students, including ELIZABETH CATLETT. "I loved my students," Jones told the *Washington Post* when she was asked about teaching. "Also it gave me a certain prestige, a certain dignity. And it saved me from being trampled upon by the outside" (1 Mar. 1978). Jones emphasized craftsmanship and encouraged each student's choice of medium and mode of expression. As a former student, Akili Ron Anderson, recalled, "Loïs Jones would punish you like a parent . . . but when you met her standards, when you progressed, she loved you like your mother" (*Washington Post*, 26 Dec. 1995).

Jones remained committed to her own work and education, and she received a BA in Art Education magna cum laude from Howard University in 1945. In the 1930s she was a regular exhibitor at the Harmon Foundation, and from 1936 to 1965 she illustrated books and periodicals, including *African Heroes and Heroines* (1938) and the *Journal of Negro History*, for her friend CARTER G. WOODSON. After receiving a scholarship to study in Paris in 1937, Jones took a studio overlooking the Eiffel Tower, enrolled at the Académie Julien, and switched her focus from design and illustration to painting. France also precipitated a shift in her attitude. Feeling self-confident and liberated for the first time, she adopted the plein air method of painting, taking her large canvases outdoors onto the streets of Paris and the hills of the French countryside. With the African American expatriate artist ALBERT SMITH and the French painter Emile Bernard as mentors, she produced more than forty paintings in just nine months. Jones's streetscapes, still lifes, portraits, and landscapes, typified by *Rue St. Michel* (1938) and *Les Pommes Vertes* (1938), illustrate a sophisticated interpretation of Impressionist and Postimpressionist style and sensibility.

African art and culture were all the rage during Jones's visit to Paris. Sketching African masks on display in Parisian galleries prepared her for what would become her best-known work, *Les Fétiches* (1938), a Cubist-inspired painting of African masks that foreshadowed Jones's embrace of African themes and styles in her later work. In 1990, when the National Museum of American Art in Washington, D.C., acquired *Les Fétiches*, Jones responded: "I am very pleased but it is long overdue. . . . I can't help but think this is an honor that is 45 years late" (*Washington Post*, 7 Oct. 1994).

Even while the Robert Vose Gallery in Boston exhibited her Parisian paintings shortly after her return to the United States, Jones longed for the racial tolerance she had experienced in France. When she met ALAIN LOCKE upon her return to Howard, he challenged her to concentrate on African American subjects. And so began what Jones later called her Locke period. Throughout the 1940s and early 1950s she continued to paint in a semi-Impressionist style but increasingly depicted African American subjects, as in the character studies *Jennie* (1943), a portrait of a black girl cleaning fish; *Mob Victim* (1944), a study of a man about to be lynched; and *The Pink Tablecloth* (1944).

Jones began exhibiting more extensively, primarily in African American venues such as the Chicago Negro Exposition of 1940 and the black-owned Barnett Aden Gallery, although traditionally white venues also included her work. On occasion, Jones masked her race by entering competitions by mail or by sending her white friend Céline Tabary to deliver her work. Such was the case in 1941 when her painting *Indian Shops, Gay Head* (1940) won the Corcoran Gallery's Robert Wood Bliss Award. It was several years before the Corcoran knew that the painting was the product of a black artist.

In 1953 Jones married Louis Vergniaud Pierre-Noel, a Haitian artist she had met at Columbia University summer school in 1934. The couple, who had no children, maintained homes in Washington, Martha's Vineyard, and Port-au-Prince, Haiti, until Pierre-Noel's death in 1982. Shortly after their wedding Jones taught briefly at Haiti's Centre d'Art and the Foyer des Arts Plastiques. Haiti proved to be the next great influence on Jones's work. "Going to Haiti changed my art, changed my feelings, changed me" (*Callaloo*, Spring 1989). Character studies and renderings of the picturesque elements of island life soon gave way to more expressive works that fused abstraction and decorative elements with naturalism. Drawing on the palette and the diverse religious life and culture of Haiti, Jones incorporated voodoo gods, abstract decorative patterns, bright colors, and African elements into her paintings. Throughout the 1950s and 1960s she used strong color and flat, abstract shapes in a diverse range of works, including *Bazar du Quai* (1961), *VeVe Voodou III* (1963), and *Paris Rooftops* (1965).

In 1970–1971 Jones took a sabbatical from Howard and traveled through eleven countries in Africa, interviewing artists, photographing their work, and lecturing on African American artists. Jones, who had spent the previous summer interviewing contemporary Haitian artists, used these materials to complete her documentary project "The Black Visual Arts." The bold, graphic beauty of African textiles, leatherwork, and masks resonated with her early fabric designs and provided a new vocabulary for her work, which now included collage as well as painting and watercolor. Once again, Jones visited museums and sketched African masks and fetishes, items increasingly significant in pieces like *Moon Masque* (1971) and *Guli Mask* (1972). Throughout the 1970s and 1980s, inspired by Haiti and Africa and by the Black Arts Movement in the United States, Jones's work centered on African themes and styles.

Jones, who finally returned to Boston's Museum of Fine Arts in 1973 for a retrospective exhibition, had more than fifty solo shows. She received numerous awards and honorary degrees, including citations from the Haitian government in 1955 and from U.S. president Jimmy Carter in 1980. In 1988 Jones's artistic life came full circle when she opened the Loïs Mailou Jones Studio Gallery in Edgartown, Massachusetts, on Martha's Vineyard. At age eighty-four Jones assessed the key influences on her work: "So now . . . in the sixtieth year of my career, I can look back on my work and be inspired by France, Haiti, Africa, the Black experience, and Martha's Vineyard (where it all began) and admit There is no end to creative expression" (*Callaloo*, Spring 1989). Loïs Mailou Jones died at age ninety-two at her home in Washington, D.C.

FURTHER READING

Jones, Loïs Mailou. *Loïs Mailou Jones: Peintures 1937–1951* (1952).

Benjamin, Tritobia Hayes. *The Life and Art of Loïs Mailou Jones* (1994).

Howard University Gallery of Art. *Loïs Mailou Jones Retrospective Exhibition: Forty Years of Painting, 1932–72* (1972).

National Center of Afro-American Artists and Museum of Fine Arts, Boston. *Reflective Moments: Loïs Mailou Jones Retrospective, 1930–1972* (1973).

Obituaries: Journal of Blacks in Higher Education (Summer 1998); *Washington Post*, 12 June 1998.

LISA E. RIVO

JONES, Madame Sissieretta Joyner

(5 Jan. 1869–24 June 1933), classical prima donna and musical comedy performer, was born Matilda Sissieretta Joyner in Portsmouth, Virginia, less than four years after the abolition of slavery. Jones was the only surviving child of Jeremiah Malachi Joyner, a former slave and pastor of the Afro-Methodist Church in Portsmouth, and Henrietta B. Joyner, a singer in the church choir. Thus, she was exposed to music during her formative years. When she was six years old her family moved to Rhode Island, where Jones began singing in the church choir, which her father directed. Her school classmates were mesmerized by her sweet, melodic, soprano voice and nicknamed her "Sissy."

She began studying voice as a teenager at the prestigious Providence Academy of Music with Ada, Baroness Lacombe, an Italian prima donna. Not long afterward, in 1883, when she was only fourteen, Sissieretta met and married David Richard Jones, a newspaperman who also served as her manager during her early years on stage. She also received more vocal training at both the New England Conservatory and the Boston Conservatory. After her first concert performance with the Academy of Music on 8 May 1888, the *New York Age* reported that Jones's "voice is sweet, sympathetic and clear, and her enunciation a positive charm. She was recalled after each number" (*Black Perspective in Music*, 192). In an attempt to make her more palatable to white audiences, David Jones, who was himself of a mixed-race background, took his wife to Europe to have her skin lightened and to have some of her features altered.

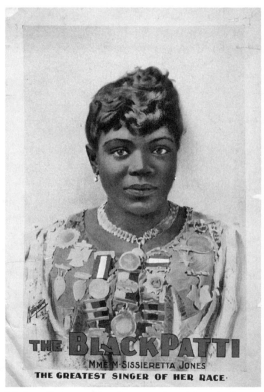

Madame Sissieretta Joyner Jones was barred from singing at the Metropolitan Opera in New York because of her race. Instead she became the star of her own musical comedy troupe. (Library of Congress.)

Jones made her New York City debut in a private concert at the Wallack Theatre on 1 August 1888. She was already being compared to the Italian prima donna Adelina Patti, who was adored by audiences throughout the world. As a result, Jones was dubbed "Black Patti." She wanted her own identity but was forced to accept the nickname, which remained with her throughout her more-than-thirty-year career (Daughtry, 133).

In the early 1890s discussions ensued about possible appearances by Jones at the New York City Metropolitan Opera. She wanted very much to sing in a full-length opera at the Met. In the meantime, in 1891, she set out on a tour of the West Indies, where she was honored with numerous medals for her dynamic voice. After she returned to the United States, Jones appeared at Madison Square Garden in New York City in what was billed as an "African Jubilee Spectacle and Cakewalk." Thousands listened to Jones, who was fluent in both Italian and French, sing selections from grand operas like Meyerbeer's *Robert le Diable* as well as her popular signature piece, "Swanee River." By 1892 she had already appeared at the White House three times as well as before European royalty. After performances at the Pittsburgh Exposition in 1893 and 1894, Jones became the highest paid black performer of her day.

Jones emerged as a celebrity and wanted to control her career. However, when she made this groundbreaking attempt in 1892, her manager, Major Pond, took her to court. There the judge ruled that she was ungrateful because she failed to appreciate how Pond was largely responsible for her accomplishments on the concert stage.

In New York City, Jones joined the famed Czech composer Antonin Dvorak and his students from the National Conservatory of Music for a benefit concert in 1894. A *New York Herald* reporter said of the January concert, "Mme. Jones was an enormous success with the audience. To those who heard her for the first time she came in the light of a revelation, singing high C's with as little apparent effort as her namesake, the white Patti" (*Black Perspective in Music*, 199). Both the white and the black press continued to laud her as the "greatest singer of her race." Nevertheless, the opportunity to sing at the Metropolitan Opera was still denied to Jones because of her race. These restrictions inspired her to leave the concert stage behind.

At the turn of the century, black musical comedies, which were first called "coon shows," drew

huge crowds into the theaters. Black female performers entered musical theater around 1885. During the height of popularity for musical comedies, managers were in control and dictated what performers would do. The managers Rudolph Voelckel and John J. Nolan, who are often credited along with David Jones for luring "Black Patti" to musical theater, planned to make the former concert stage prima donna the star of her own musical black touring company.

On 26 September 1896 Black Patti's Troubadours made their debut in a mini-musical called *At Jolly Coon-ey Island: A Merry Musical Farce*, cowritten by BOB COLE and William Johnson. *At Jolly Coon-ey Island* contained almost no plot. Rather, it was a revue that included classical music, vaudeville, burlesque, and skits performed by an enormous group of fifty dancers, singers, tumblers, and comedians. Black Patti's Troubadours were unique. Unlike other black companies, the Troubadours omitted the cakewalk, a popular, high-stepping dance, from their finale. Instead, an operatic kaleidoscope featuring Black Patti concluded the show. The Troubadours placed the spotlight on Black Patti, who stylishly appeared in tiaras, long satin gowns, and white gloves to perform selections from the operatic composers Balfe, Verdi, Wagner, and Gounod.

Black Patti's Troubadours, billed as the "greatest colored show on earth," was based in New York City but toured throughout the United States and abroad. Advertisements claimed the group traveled thousands of miles in the United States in a train car called "Black Patti, America's Finest Show Car." Jones was the central attraction in productions like *A Ragtime Frolic at Rasbury Park* (1899–1900) and *A Darktown Frolic at the Rialto* (1900–1901). Although it is unclear how much of Jones's actual earnings went to Voelckel and Nolan, two years after the establishment of Black Patti's Troubadours, the *Colored American* reported that Jones commanded a salary of five hundred dollars per week. However, her husband was allegedly a gambler. His gambling, drinking, and misuse of their money led to the couple's divorce in 1899.

By 1900 Black Patti's Troubadours was solidly recognized as one of the most popular companies on the American stage. It helped to launch the careers of women like Ida Forsyne, Aida Overton Walker, and Stella Wiley. Many black performers who began their careers with Black Patti went on to experience success on their own. One might argue that their association with Jones, a highly respected, even revered performer, contributed to their later success.

As America's tastes began to change, the Troubadours adopted the name Black Patti Musical Comedy Company. Blacks began to view black musical comedies as negative depictions of their race, while whites began to turn their attention to other forms of entertainment. Some of the troupe's later productions were set in an African jungle. Jones played the queen in a 1907 production called *Trip to Africa*. She was included in the action of the comedy in a skit called "In the Jungles" for the first time in 1911. From 1914 to 1915 the operatic kaleidoscope no longer appeared in the Troubadours' program.

Jones made her final performance at New York City's Lafayette Theatre in 1915. As the mother of two adopted sons, she moved back to Providence, Rhode Island, where she also cared for her ailing mother. When Jones became ill and fell into obscurity, she was forced to rely on assistance from the National Association for the Advancement of Colored People (NAACP). Sissieretta Jones died on 24 June 1933 at Rhode Island Hospital. She remains one of the most celebrated black performers of the late nineteenth and early twentieth centuries.

FURTHER READING

A press scrapbook on Jones is housed in the Moorland-Spingarn Collection, Howard University, Washington, D.C.

Black Perspective in Music 4, no. 2 (July 1976).

Daughtry, Willia Estelle. "Sissieretta Jones: A Study of the Negro's Contribution to Nineteenth Century American Concert and Theatrical Life," PhD diss., Syracuse University (1968).

Henricksen, Henry. "Madame Sissieretta Jones," *Record Research*, no. 165–166 (Aug. 1979).

Woll, Allen. *Black Musical Theatre: From Coontown to Dreamgirls* (1989).

MARTA J. EFFINGER-CRICHLOW

JOPLIN, Scott

(24 Nov. 1868?–1 Apr. 1917), ragtime composer and pianist, was born in or near Texarkana, Texas, one of six children of Giles Joplin, reportedly a former slave from North Carolina, and Florence Givens, a freewoman from Kentucky. Many aspects of Joplin's early life are shrouded in mystery. At a crucial time

in his youth, Joplin's father left the family, and his mother was forced to raise him as a single parent. She made arrangements for her son to receive piano lessons in exchange for her domestic services, and he was allowed to practice piano where she worked. A precocious child whose talent was noticed by the time he was seven years old, Joplin had undoubtedly inherited talent from his parents, as Giles had played violin and Florence sang and played the banjo. His own experimentations at the piano and his basic music training with local teachers contributed to his advancement. Joplin attended Orr Elementary School in Texarkana and then traveled to Sedalia, Missouri, perhaps residing with relatives while studying at Lincoln High School.

Joplin built an early reputation as a pianist and gained fame as a composer of piano ragtime during the Gay Nineties, plying his trade concurrently with composers such as WILL MARION COOK and HARRY BURLEIGH. Joplin was essential in the articulation of a distinctly American style of music. Minstrelsy was still in vogue when Joplin was a teenager performing in vaudeville shows with the Texas Medley Quartette, a group he founded with his brothers. Joplin reportedly arrived in St. Louis by 1885, landing a job as a pianist at John Turpin's Silver Dollar Saloon. In 1894 he was hired at Tom Turpin's Rosebud Cafe. As musicians flocked to the Chicago Columbian

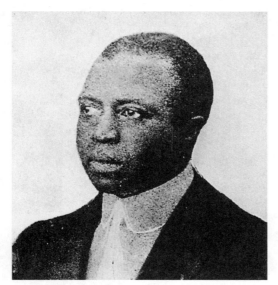

Scott Joplin, the "King of Ragtime," c. 1911. (Schomburg Center.)

Exposition in 1893, Joplin was among them, playing at nightspots close to the fair. Afterward he returned to Sedalia, the "Cradle of Ragtime," accompanied by the pianist Otis Saunders.

Although he was playing piano in various cities, Joplin still found time to blow the cornet in Sedalia's Queen City Band. In 1895 he continued playing with the Quartette and toured as far as Syracuse, New York, where some businessmen were sufficiently impressed with his talents to publish his first vocal songs. Additionally, Joplin was hired as a pianist at Sedalia's famous Maple Leaf Club. He also taught piano, banjo, and mandolin, claiming among his students the pianists Arthur Marshall, Scott Hayden, and Sanford B. Campbell. By 1896 Joplin had settled in Sedalia and matriculated at the George Smith College for Negroes. With the confidence and ambition fostered by this formal training, he approached the Fuller-Smith and Carl Hoffman Companies, which published some of his piano rags. It was also in Sedalia that he met John Stark, who became his friend and the publisher of Joplin's celebrated "Maple Leaf Rag" (1899).

In 1900 Joplin began a three-year relationship with Belle Hayden, which produced a child who soon died. He then married Freddie Alexander in 1904, but her death that same year sent him wandering about for at least a year, returning at times to Sedalia and St. Louis. In 1905 he went to Chicago, and by 1907 he had followed John Stark to New York and married Lottie Stokes, who remained with him until his death. In the years after the turn of the century, the piano replaced the violin in popularity. Playing ragtime on the parlor piano became "all the rage" in both the United States and Europe. Although there were ragtime bands and ragtime songs, classic rag soon became defined as an instrumental form, especially for the piano. Many Joplin rags consist of a left-hand part that jumps registers in eighth note rhythms set against tricky syncopated sixteenths in the right hand. Joplin was both prolific and successful in writing rags for the piano, and he came to be billed as "the King of Ragtime."

Ragtime or rag—from "ragged time"—is a genre that blends elements from marches, jigs, quadrilles, and bamboulas with blues, spirituals, minstrel ballads, and "coon songs." ("Coon songs" were highly stereotyped comic songs, popular from the 1880s to the 1920s, written in a pseudo-dialect purporting to record African American vernacular speech.) Ragtime is an infectious and stimulating music,

usually in 2/4 meter, with a marchlike sway and a proud, sharp, in-your-face joviality. Its defining rhythm, based on the African bamboula dance pattern, renamed "cakewalk" in America, is a three-note figuration of sixteenth-eighth-sixteenth notes, which is also heard in earlier spirituals, such as "I Got a Home in-a That Kingdom" and "Ain-a That Good News!"

A predecessor of jazz, ragtime was correlated with the "African jig" because of its foot stamps, shuffles, and shouts, "where hands clap out intricate and varying rhythmic patterns . . . and the foot is not marking straight time, but what Negroes call 'stop time,' or what the books call 'syncopation'" (JAMES WELDON JOHNSON, *The Book of American Spirituals* [1925], 31). Joplin alludes to these influences in his "Stoptime Rag," where the word "stamp" is marked on every quarter beat. Joplin admonished pianists to play ragtime slowly, even though his tempo for "Stoptime" is marked "Fast or slow." Campbell most revealingly wrote that rag was played variously in "march time, fast ragtime, slow, and the ragtime blues style" (Fisk University, Special Collections).

Vera Brodsky Lawrence's *Complete Works of Scott Joplin* lists forty-five rags, waltzes, marches, and other piano pieces that Joplin composed himself. In addition, he collaborated on a number of rags, including "Swipesy" with Arthur Marshall, "Sunflower Slow Drag," "Something Doing," "Felicity Rag," "Kismet Rag" with Scott Hayden, and "Heliotrope Bouquet" with Louis Chauvin. There are also various unpublished pieces and some that were stolen, lost, sold, or destroyed.

The most popular of Joplin's works, and one that brought continuous acclaim, is undoubtedly the "Maple Leaf Rag." No matter the studied care of "Gladiolus Rag" or the majesty of "Magnetic Rag," with its blue-note features, and no matter the catchiness of "The Entertainer," "Maple Leaf" beckons more. Over and above its engaging melodies and syncopations, the technical challenges alone are more than enough to induce an ambitious pianist to tackle "Maple Leaf." Whatever its ingredients, "Maple Leaf Rag" garnered a respect for ragtime that has lasted for decades. Numerous musicians have recorded it, and it has been arranged for instruments from guitar to oboe and for band and orchestra.

Joplin also composed small and large vocal forms, both original and arranged. A few of his nonsyncopated songs are related to the Tin Pan Alley types of the day, and at least two are influenced by "coon songs." He choreographed dance steps and wrote words for the "Ragtime Dance Song," and in a few cases he either wrote lyrics or arranged music for others. Joplin composed two operas, the first of which is lost. The second, *Treemonisha*, whose libretto Joplin also wrote, is an ambitious work containing twenty-seven numbers and requiring three sopranos, three tenors, one high baritone, four basses, and a chorus. Set "on a plantation somewhere in the State of Arkansas, Northeast of the Town of Texarkana and three or four miles from the Red River," the opera presents education as the key to success.

Throughout Joplin's preface to *Treemonisha*, one cannot help but note the parallelism of dates and geographic locations in the opera to those of his own past. The preface tells the tale of a young baby who was found under a tree, adopted, and named "Treemonisha" by Ned and Monisha. At age seven she is educated by a white family in return for Monisha's domestic services. The opera opens with eighteen-year-old Treemonisha touting the value of education and campaigning against two conjurers who earn their livelihoods promoting superstition. After various episodes with kidnappers, wasps, bears, and cotton pickers, who sing the brilliant "Aunt Dinah Has Blowed de Horn," Treemonisha is successful and joins the finale, singing "Marching Onward" to the tune of the "Real Slow Drag."

Compositionally, syncopated music is used in *Treemonisha* only when the plot calls for it, with the musical themes and harmonies employing "crossover" alternations between classical and popular styles. However, Joplin's intentions seem to have leaned more toward the classical. The basic harmonies are decorated with his favored diminished seventh chords and secondary dominants. Altered chords, chromatics, modulations, themes with mode changes, special effects to depict confusion, and even an example of seven key changes in "The Bag of Luck" all point toward Joplin's training and musical aspirations.

Joplin accompanied the first performance of *Treemonisha* on the piano. When he sought sponsors, and when he asked Stark to publish the opera, he was refused. Tackling these jobs himself proved to be his undoing. As a result of stress and illness, Joplin lost his mental balance in early 1917 and was admitted to the New York State Hospital.

A diagnosis signed by Dr. Philip Smith states that Joplin succumbed to "dementia paralytica—cerebral form about 9:10 o'clock p.m.," that the duration of the mental illness was one year and six months, and that the "contributory causes were Syphilis [of an] unknown duration" (Bureau of Records, New York City).

Campbell wrote that Joplin's funeral carriage bore names of his rag hits. Sadly, only the *New York Age* and a notice by John Stark carried his obituary. High society from New York to Paris had strutted the cakewalk accompanied by his rags since the late 1890s, but now he was forgotten. Perhaps World War I diverted people's attention away from the exuberance of raggedy rags and thus from Joplin. He received accolades for his piano rags, but his most difficult vocal music was not appreciated in his lifetime. Sixty years after his death he began to receive numerous honors, including the National Music Award, a Pulitzer Prize in 1976, and a U.S. postage stamp in 1983.

Several articles in the *Washington Post* and the *New York Times* inspired a revival of Joplin's music in the 1970s. Various films, especially *The Sting* (1973), and television productions have highlighted his work, and concerts and recordings by the finest of musicians have taken the music to new heights. Additionally, there have been several productions of *Treemonisha*. To be sure, rags were written before Joplin's *Original Rags* was published in 1899, but he must be credited with defining the classic concept and construction of ragtime and with rendering dignity and respectability to the style.

FURTHER READING

Selected repositories of music and other materials are at the New York Public Library; the Library of Congress, Washington, D.C.; the Fisk University Library, Nashville, Tennessee; the Center for Black Music Research, Chicago, Illinois; Indiana University Library, Terre Haute; and the Scott Joplin International Ragtime Foundation, Sedalia, Missouri.

Berlin, Edward A. *King of Ragtime: Scott Joplin and His Era* (1994).

Jasen, David, and Trebor J. Tichenor. *Rags and Ragtime: A Musical History* (1989).

Lawrence, Vera Brodsky. *The Complete Works of Scott Joplin* (1981).

Preston, Katherine. *Scott Joplin: Composer* (1988).

Obituary: New York Age, 5 Apr. 1917.

DISCOGRAPHY

Joplin, Scott. *Classic Ragtime from Rare Piano Rolls* (1989).

Rifkin, Joshua. *Scott Joplin: Piano Rags* (1987).

Zimmerman, Richard. *Complete Works of Scott Joplin* (1993).

HILDRED ROACH

JULIAN, Hubert F.

(20 Sept. 1897–19 Feb. 1983), aviator, was born Hubert Fauntleroy Julian in Port-of-Spain, Trinidad, the son of Henry Julian, a cocoa plantation manager, and Silvina "Lily" Hilaire Julian. He was educated at the Eastern Boys' School, an excellent private school in Port-of-Spain. In 1909 he saw his first airplane; minutes later, he witnessed its pilot's fatal crash. Nevertheless, Julian was instilled with a passion for both the exotic and the mechanical aspects of aviation. In 1912 his parents, who wanted their only child to be a doctor, sent him to England for further education. When World War I broke out, he went to Canada and attended high school in Montreal. Late in the war he took flying lessons with the Canadian ace Billy Bishop. Julian earned his Canadian pilot's license at the age of nineteen and thus became one of the earliest black aviators. In 1921 he was awarded Canadian and American patents for an airplane safety device he called a *parachuttagravepreresistra*. Although it was never produced commercially, the invention operated on principles that later propelled helicopters and deployed the parachute system that returned space capsules to earth. When activated by the pilot of a plane in distress, a parachutelike umbrella would blow open and lower the disabled plane to the ground by a system of rotating blades.

In July 1921 Julian settled in Harlem, already cultivating the flamboyant elegance that would be his lifelong hallmark. He became active in MARCUS GARVEY's Universal Negro Improvement Association and an officer in its paramilitary unit. Under Garvey's influence, Julian became absorbed in African history, an interest that later led to an active role in the history of Ethiopia. He broke into the African American aviation scene as a parachutist, appearing at an August 1922 air show on Long Island headlined by the African American aviator BESSIE COLEMAN. Two highly publicized parachute jumps over Manhattan in 1923 inspired a New York journalist to dub him "the Black Eagle," a

sobriquet that delighted Julian and that he retained for the rest of his life.

Invitations to lecture and perform air stunts poured in. Although many of Julian's exploits were greeted with skepticism and charges of self-promotion, he maintained that his activities were all intended to demonstrate that African Americans were as capable of extraordinary achievement as anyone else. Early in 1924 he announced plans for a solo flight from New York to Liberia and Ethiopia. On 4 July 1924 his overhauled World War I–era hydroplane *Ethiopia I* lifted off from the Harlem River. Within minutes a pontoon broke off. The plane plummeted two thousand feet into Flushing Bay. A solo transatlantic crossing would not be achieved until Charles Lindbergh's successful flight in 1927.

Over the next five years, Julian barnstormed all over the United States. In 1927 he married Essie Marie Gittens, a childhood friend from Port-of-Spain. She remained Julian's "constant advisor and companion" until her death in 1975; one daughter survived her (*New York Amsterdam News*, 11 Jan. 1975, A3). Julian subsequently married Doreen Thompson, with whom he had a son.

In 1930 Julian was recruited by the prince regent of Ethiopia, Ras Tafari Makonnen, to train the nascent Ethiopian air force. Soon after his arrival in Ethiopia, Julian's aerobatic prowess so impressed the prince regent that he awarded him Ethiopian citizenship and an air force colonelcy. The Ethiopian cadets and their entire air power—two German-made monoplanes and a British Gypsy Moth recently given to the future emperor—were to perform at the prince regent's November 1930 coronation as Emperor Haile Selassie I. During an air show rehearsal, Julian took up the untried Gypsy Moth. The engine failed, and the prized plane crashed. Whether or not the plane had been sabotaged, the Imperial Air Force had only two planes remaining; Julian was asked to leave the country.

On 30 July 1931 Julian received a U.S. Department of Commerce private pilot's license. On 6 December 1931 he took part in the Los Angeles air show, organized by the African American aviator William Powell, headlined "the Black Eagle and the Five Blackbirds." For the first time, six African American pilots appeared together. Throughout the early 1930s, Julian flew in capacities as varied as barnstormer, rum runner, and private

pilot for the evangelist FATHER DIVINE. When the Italo-Ethiopian war became imminent in 1935, Julian returned to Ethiopia as a volunteer. He briefly commanded the air force, but a violent dispute with the Chicago aviator John C. Robinson led to Robinson's appointment as air force commander in Julian's stead.

After the Italians overran Ethiopia in 1936, Julian publicly disavowed the Ethiopian cause—for which he was reviled in America. He traveled to Italy, ostensibly to offer his services to Benito Mussolini. He later wrote that his intent in fact was to assassinate Il Duce but that his loyalties became known and their meeting never took place. During the summer of 1939 he was the war correspondent for the *New York Amsterdam News* in France. Back in New York, Julian announced that he would prove that African Americans were as capable in the film industry as, he claimed, he had proved them to be in aviation. He assisted in producing two OSCAR MICHEAUX films, *Lying Lips* (1939) and *The Notorious Elinor Lee* (1940).

In Europe the war was escalating. In 1940 Julian served briefly with a Finnish air regiment, then publicly challenged Reichsmarschall Hermann Goering to an air duel over the English Channel to defend the honor of the black race, which Adolf Hitler and Goering had defamed. The challenge was not accepted. Volunteering to join the Royal Canadian Air Force, Julian found he could no longer pass the flying test. In July 1942 he enlisted in the U.S. Army as an alien infantryman and became an American citizen on 28 September 1942. In May 1943 he was honorably discharged at the age of forty-five. After the war he parlayed his international contacts into global businesses, founding first a short-lived air freight charter, Black Eagle Airlines. In 1949 Black Eagle Enterprises, Ltd., was registered as a munitions dealer with the U.S. Department of State. Over the next two decades, Julian supplied arms and materiel to clients in developing nations and diplomatic crisis spots around the globe.

A resident of the Bronx, New York, since the 1950s, Julian died there in the Veterans Administration Hospital. Although for fifty years he carried the honorific "Colonel" from his Ethiopian days, he was buried in Calverton National Cemetery, Long Island, courtesy of his service as a private in the U.S. infantry.

FURTHER READING

Julian, Hubert F., with John Bulloch. *Black Eagle* (1964).

Chamberlin, Clarence D. *Record Flights* (1928).

Nugent, John Peer. *The Black Eagle* (1971).

Powell, William A. *Black Wings* (1934; reprinted as *Black Aviator*, 1994).

Scott, William R. *The Sons of Sheba's Race: African Americans and the Italo-Ethiopian War, 1935–1941* (1993).

CAROLINE M. FANNIN

LARSEN, Nella

(13 Apr. 1891–30 Mar. 1964), novelist, was born Nellie Walker in Chicago, Illinois, the daughter of Peter Walker, a cook, and Mary Hanson. She was born to a Danish immigrant mother and a "colored" father, according to her birth certificate. On 14 July 1890 Peter Walker and Mary Hanson applied for a marriage license in Chicago, but there is no record that the marriage ever took place. Larsen told her publisher, Alfred A. Knopf, that her father was "a Negro from the Virgin Islands, formerly the Danish West Indies" and that he died when she was two, but none of this has been proven conclusively.

Larsen was prone to invent and embellish her past. Mary Hanson Walker married a Danish man, Peter Larson, on 7 February 1894, after the couple had had a daughter. Peter Larson eventually moved

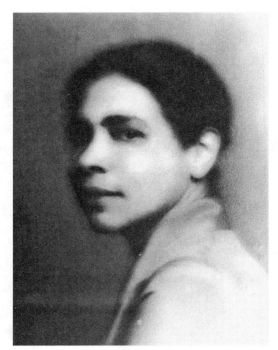

Nella Larsen is best known for her novels that explore the complexity of being mixed race in America. (Library of Congress.)

the family from the multiracial world of State Street to a white Chicago suburb, changed the spelling of his name to Larsen, and sent Nellie away to the South. In the 1910 census Mary Larsen denied the existence of Nellie, stating that she had given birth to only one child. The family rejection and the resulting cultural dualism over her racial heritage that Larsen experienced in her youth were to be reflected in her later fiction.

Nellie Larson entered the Coleman School in Chicago at age nine, then the Wendell Phillips Junior High School in 1905, where her name was recorded as Nellye Larson. In 1907 she was sent by Peter Larsen to complete high school at the Normal School of Fisk University in Nashville, Tennessee, where she took the spelling "Larsen" and began to use "Nella" as her given name. Larsen claimed to have spent the years 1909 to 1912 in Denmark with her mother's relatives and to have audited courses at the University of Copenhagen, but there is no record of her ever having done so. Her biographer, Thadious M. Davis, says, "The next four years (1908–1912) are a mystery, . . . and no conclusive traces of her for these years have surfaced" (67).

In 1912 Larsen enrolled in a three-year nurses' training course at New York City's Lincoln Hospital, one of few nursing programs for African Americans in the country. After graduating in 1915, she worked a year at the John A. Andrew Hospital and Nurse Training School in Tuskegee, Alabama. Unhappy at Tuskegee, Larsen returned to New York and worked briefly as a staff member of the city Department of Health. In May 1919 she married Dr. Elmer Imes, a prominent black physicist; the marriage ended in divorce in 1933.

Larsen left nursing in 1921 to become a librarian, beginning work with the New York Public Library in January 1922. Because of her husband's social position, Larsen was able to ascend in the heights of the Harlem social circle, and it is there she met WALTER WHITE, the NAACP leader and novelist, and Carl Van Vechten, the photographer and author of *Nigger Heaven* (1926). White and Van Vechten encouraged her to write, and in January 1926 Larsen quit her job in order to write full-time. She had already begun working on her first novel, *Quicksand*, perhaps during a period of convalescence, and it was published in 1928. Earlier in the 1920s she had published two children's stories in the *Brownies' Book* as Nella Larsen Imes and then two pulp-fiction stories for *Young's Magazine* under the

pseudonym Allen Semi. *Quicksand* won the Harmon Foundation's Bronze Medal for literature and established Larsen as one of the prominent writers of the Harlem Renaissance. After her second novel, *Passing*, was published in 1929, she applied for and became the first black woman to receive a Guggenheim Foundation Fellowship. Larsen used the award to travel to Spain in 1930 and to work on her third book, which was never published. After a year and a half in Spain and France, Larsen returned to New York.

Two shocks appear to have ended Larsen's literary career. In 1930 she was accused of plagiarizing her short story "Sanctuary," published that year in *Forum*, when a reader pointed out its likeness to Sheila Kaye-Smith's "Mrs. Adis," a story that had appeared in *Century* magazine in 1922. The editors of *Forum* pursued the charge and exonerated Larsen, but biographers and scholars have concluded that Larsen never recovered from the attack, however unfounded. The second shock was Larsen's discovery of her husband's infidelity early in 1930, although she refrained from seeking a divorce until 1933. Imes supported Larsen with alimony payments until his death in 1941, at which time Larsen returned to her first career, nursing, in New York City. She was a supervisor at Gouverneur Hospital from 1944 to 1961, and then worked at Metropolitan Hospital from 1961 to 1964 to avoid retirement. Since her death in New York City, Larsen's novels, considered "lost" until the 1970s, have been reprinted and reexamined. While she had always been included in the few histories of black American literature, her reputation was eclipsed in the era of naturalism and protest-writing (1930–1970), to be recovered along with the reputations of ZORA NEALE HURSTON and other African American women writers during the rise of the feminist movement in the 1970s.

Larsen's literary reputation rests on the achievement of her two novels of the late 1920s. In *Quicksand* she created an autobiographical protagonist, Helga Crane, the illegitimate daughter of a Danish immigrant mother and a black father who was a gambler and deserted the mother. Crane hates white society, from which she feels excluded by her black skin; she also despises the black bourgeoisie, partly because she is not from one of its families and partly for its racial hypocrisy about the color line and its puritanical moral and aesthetic code. After two years of living in Denmark, Helga returns to America to fall into "quicksand" by marrying an uneducated, animalistic black preacher who takes her to a rural southern town and keeps her pregnant until she is on the edge of death from exhaustion.

In *Passing* Larsen wrote a complicated psychological version of a favorite theme in African American literature. Clare Kendry has hidden her black blood from the white racist she has married. The novel ends with Clare's sudden death as she either plunges or is pushed out of a window by Irene, her best friend, just at the husband's surprise entrance. "What happened next, Irene Redfield never afterwards allowed herself to remember. Never clearly. One moment Clare had been there, a vital glowing thing, like a flame of red and gold. The next she was gone" (271).

Larsen's stature as a novelist continues to grow. She portrays black women convincingly and without the simplification of stereotype. Larsen fully realized the complexity of being of mixed race in America and was able to render her cultural dualism artistically.

FURTHER READING

Larsen's personal papers and books vanished from her apartment at her death, so neither a manuscript archive nor a collection of her private papers exists.

Carby, Hazel. *Reconstructing Womanhood: The Emergence of the Afro-American Woman Novelist* (1987).

Davis, Thadious M. *Nella Larsen, Novelist of the Harlem Renaissance: A Woman's Life Unveiled* (1994).

Larson, Charles. *Invisible Darkness: Jean Toomer and Nella Larsen* (1993).

Tucker, Adia C. *Tragic Mulattoes, Tragic Myths* (2001).

ANN RAYSON

LAWRENCE, Jacob Armstead

(7 Sept. 1917–9 June 2000), artist and teacher, was born in Atlantic City, New Jersey, to migrant parents. His father, Jacob Lawrence, a railroad cook, was from South Carolina, and his mother, Rose Lee Armstead, hailed from Virginia. In 1919 the family moved to Pennsylvania, where Jacob's sister, Geraldine, was born. Five years later Jacob's brother, William, was born, and his parents separated.

Jacob moved with his mother, sister, and brother to a Manhattan apartment on West 143d Street in 1930. Upon his arrival in Harlem, the teenage Lawrence began taking neighborhood art classes. His favorite teacher was the painter CHARLES

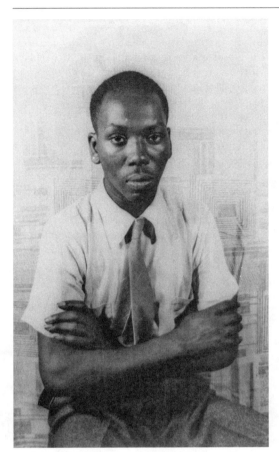

Jacob Armstead Lawrence on 31 July 1941. (Library of Congress. Photograph by Carl Van Vechten.)

ALSTON, who taught at the Harlem Art Workshop. This workshop, sponsored by the Works Progress Administration, was first housed in the central Harlem branch of the New York Public Library before relocating to Alston's studio at 306 West 141st Street. Many community cultural workers had studios in this spacious building. Affectionately called "306," Alston's studio in particular was a vital gathering place for creative people. Lawrence met ALAIN LOCKE, AARON DOUGLAS, LANGSTON HUGHES, CLAUDE MCKAY, RICHARD WRIGHT, and RALPH ELLISON at his mentor's lively studio.

In 1935, at age eighteen, Lawrence started painting scenes of Harlem using poster paint and brown paper. Initially chosen for their accessibility and low cost, these humble materials would remain central to the artist's work. The next year Lawrence began what would become his ritual of doing background research for his art projects at the 135th Street branch of the New York Public Library (now the Schomburg Center for Research in Black Culture). Inspired after seeing W. E. B. DU BOIS's play *Haiti* at Harlem's Lafayette Theatre in 1936, he began researching the Haitian Revolution (1791–1804). This eye-opening research culminated in a powerful series of forty-one paintings titled *The Life of Toussaint L'Ouverture*. Completed in 1938, this series dramatically visualized the life of the formerly enslaved man who led the Haitian struggle for independence from France and the creation of the world's first black republic. These paintings also signaled paths the artist would continue to explore in his work, namely, figurative expressionism, history painting, sequential narration, and prose captions. Moreover, the ambitious cycle revealed Lawrence's deep interest in heroism and struggles for freedom.

In September 1938 AUGUSTA SAVAGE, the sculptor and influential director of the Harlem Community Art Center, helped Lawrence gain work as an easel painter on the Works Progress Administration's Federal Art Project. During his eighteen months as a government-employed artist, Lawrence probably produced about thirty-six paintings. In addition, he worked on two more dramatic biographies of freedom fighters. In 1939 he completed *The Life of Frederick Douglass* series. Based on the famous abolitionist's autobiography, the thirty-two painted panels—each accompanied by text—chart the heroic transformation of the escaped slave into a fiery orator and an uncompromising activist. The following year Lawrence completed *The Life of Harriet Tubman* series. Composed of thirty-one panels, this epic visual and textual narrative features the courageous female conductor of the Underground Railroad. Both series were exhibited at the Library of Congress in 1940 in commemoration of the seventy-fifth anniversary of the Thirteenth Amendment to the U.S. Constitution.

In 1941, at age twenty-four, Lawrence completed his signature narrative series, *The Migration of the Negro*, a group of sixty tempera paintings illustrating the mass movement of African Americans from the rural South to the urban North. This historical cycle was done in a modern visual style with its emphasis on strong lines, simplified forms, geometric shapes, flat planes, bold colors and recurrent motifs. Gwendolyn Knight, a Barbados-born and Harlem-based artist, helped Lawrence complete the project by assisting with the preparation of the sixty hardboard panels and the accompanying prose

captions. The creative couple married in New York on 24 July 1941, shortly after completing this pivotal work. Lawrence's *Migration* series brought him wide public recognition and critical acclaim. Twenty-six of the panels were reproduced in *Fortune* magazine in November 1941. Simultaneously, New York's prestigious Downtown Gallery exhibited the cycle, and, soon after the show opened, Edith Halpert, the gallery's owner, asked Lawrence to join her roster of prominent American artists, which included Ben Shahn, Stuart Davis, and Charles Sheeler. Lawrence accepted Halpert's offer, making him the first artist of African descent to be represented by a downtown gallery. A few months later the Museum of Modern Art (MoMA) purchased half the *Migration* series, and the Phillips Collection in Washington, D.C., bought the other half, marking the first acquisition of works by an African American artist at either institution. In October 1942 MOMA organized a two-year, fifteen-venue national tour of the acclaimed series.

During World War II, Lawrence served in the U.S. Coast Guard, where he continued to paint. In 1944 a group of his paintings based on life at sea was exhibited at MoMA. The following year, while he was still on active duty, Lawrence successfully applied for a Guggenheim Fellowship to begin work on a series devoted to the crisis of war. The fourteen somber panels that make up his *War* series were first shown at the New Jersey State Museum in 1947, and *Time* magazine touted the series as "by far his best work yet" (*Time* 50 [22 Dec. 1947], 61).

Lawrence began his distinguished career as a teacher in 1946 when the former Bauhaus artist Josef Albers invited him to teach the summer session at Black Mountain College in North Carolina. Until his retirement in 1983 Lawrence was a highly sought-after teacher. He taught at numerous schools, including the Skowhegan School of Painting and Sculpture in Maine, Brandeis University in Massachusetts, Pratt Institute, the Art Students League, and the New School for Social Research in New York City. From 1970 to 1983 Lawrence was a full professor of art at the University of Washington in Seattle.

Lawrence's first retrospective began in 1960. Organized by the Brooklyn Museum of Art, the show traveled to sixteen sites across the country. The artist had two other traveling career retrospectives during his lifetime: one organized by the Whitney Museum of American Art in 1974, and another organized by the Seattle Art Museum in 1986.

During the civil rights movement, Lawrence visually captured the challenges of the freedom struggle of blacks in works such as *Two Rebels* (1963). His first venture into limited-edition printmaking, *Two Rebels* dramatized the struggle between black protesters and white policemen through lithography. Over the next three decades the artist would also experiment with other printmaking techniques, such as drypoint, etching, and silkscreen.

In 1962 Lawrence traveled to Nigeria, where he lectured on the influence of traditional West African sculpture on modernist art and exhibited his work in Lagos and Ibadan. Two years later the artist and his wife returned to Nigeria for eight months, to experience life in West Africa and to create work based on their stay.

After working primarily as a painter and a printmaker, Lawrence expanded his range in the late 1970s by also making murals. He received his first mural commission in 1979 when he was hired to create a work for Seattle's Kingdome stadium. He created a ten-panel work titled *Games*. Made of porcelain enamel on steel, the 9½-foot × 7½-foot mural features powerful athletes surrounded by adoring fans. This mural, which was relocated to the Washington State Convention Center in 2000, was followed by others at Howard University (1980, 1984), the University of Washington (1984), the Orlando International Airport (1988), the Joseph Addabbo Federal Building in Queens (1988), and the Harold Washington Library Center in Chicago (1991). The artist's final mural, a 72-foot-long mosaic commissioned by New York City's Metropolitan Transit Authority, was posthumously unveiled in the Times Square subway station in 2001.

When Jacob Lawrence died at home in Seattle at age eighty-two, he was exploring a theme that had captured his imagination at the beginning of his sixty-five-year artistic career. Lawrence was still painting pictures of laborers, their movements and constructions, and their tools. A collection of hand tools—hammers, chisels, planes, rulers, brushes, and a Pullman porter's bed wrench—graced his studio and inspired his work. Concerning his prized collection, the artist explained: "For me, tools became extensions of hands, and movement. Tools are like sculptures. You look at old paintings and you see in them the same tools we use today. Tools are eternal. And I also enjoy the illusion when I paint them: you know, making something that is about making something" (Kimmelman, 210–211).

Jacob Lawrence's lifelong interest in representing work and workers befits a man who left behind a monumental body of work—approximately seven hundred paintings, one hundred prints, eight murals, and hundreds of drawings, studies, and sketches. One of the most widely admired African American artists, he was passionately committed to employing his own expressive tools to creatively visualize historical struggles and modern American life.

FURTHER READING

Jacob Lawrence's papers are housed in the Archives of American Art, Smithsonian Institution, Washington, D.C.

Kimmelman, Michael. *Portraits: Talking with Artists at the Met, the Modern, the Louvre, and Elsewhere* (1998).

Nesbett, Peter T., with an essay by Patricia Hills. *Jacob Lawrence: The Complete Prints (1963–2000): A Catalogue Raisonné* (2001).

Nesbett, Peter T., and Michelle DuBois. *Jacob Lawrence: Paintings, Drawings, and Murals (1935–1999): A Catalogue Raisonné* (2000).

Nesbett, Peter T., and Michelle DuBois, eds. *Over the Line: The Art and Life of Jacob Lawrence* (2001).

Turner, Elizabeth Hutton, ed. *Jacob Lawrence: The Migration Series* (1993).

Wheat, Ellen Harkins. *Jacob Lawrence: American Painter* (1986).

Wheat, Ellen Harkins. *Jacob Lawrence: The Frederick Douglass and Harriet Tubman Series of 1938–40* (1991).

Obituary: *New York Times*, 10 June 2000.

LISA GAIL COLLINS

LEAD BELLY

(15 Jan. 1888–6 Dec. 1949), folk singer and composer, was born Huddie Ledbetter on the Jeter plantation near Caddo Lake, north of Shreveport, Louisiana, the only surviving son of John Wesley Ledbetter and Sally Pugh, farmers who were reasonably well-to-do. Young Huddie (or "Hudy," as the 1910 census records list him) grew up in a large rural black community centered around the Louisiana-Texas-Arkansas junction, and he would later play at rural dances where, in his own words, "there would be no white man around for twenty miles." Though he was exposed to the newer African American music forms like the blues, he also absorbed many of the older fiddle tunes, play-party tunes, church songs, field hollers, badman ballads, and even old vaudeville songs of the culture. His uncle taught him a song that later became his signature tune, "Goodnight, Irene." Though Ledbetter's first instrument was a "windjammer" (a small accordion), by 1903 he had acquired a guitar and was plying his trade at local dances.

In 1904, when he turned sixteen, Ledbetter made his way to the notorious red-light district of nearby Shreveport; there he was exposed to early jazz and ragtime, as well as blues, and learned how to adapt the left-hand rhythm of the piano players to his own guitar style. He also acquired a venereal disease that eventually drove him back home for treatment. In 1908 he married Aletha Henderson, with whom he had no children, and the pair moved just east of Dallas, where they worked in the fields and prowled the streets of Dallas. Two important things happened to Ledbetter here: he heard and bought his first twelve-string guitar (the instrument that he would make famous), and he met the man who later became one of the best-known exponents of the "country blues," Blind Lemon Jefferson. Though Jefferson was actually Ledbetter's junior by some five years, he had gained considerable experience as a musician, and he taught Ledbetter much about the blues and about how an itinerant musician in these early days could make a living. The pair were fixtures around Dallas's rough-and-tumble Deep Ellum district until about 1915.

Returning to Harrison County, Texas, Ledbetter then began a series of altercations with the law that would change his life and almost destroy his performing career. It started in 1915, when he was convicted on an assault charge and sent to the local chain gang. He soon escaped, however, and fled to Bowie County under the alias of Walter Boyd. There he lived peacefully until 1917, when he was accused of killing a cousin and wound up at the Sugarland Prison farm in south Texas. There he gained a reputation as a singer and a hard worker, and it was at Sugarland that a prison chaplain gave him the nickname "Lead Belly." (Though subsequent sources have listed the singer's nickname as one word, "Leadbelly," all original documents give "Lead Belly.") At Sugarland he also learned songs like "The Midnight Special" and began to create his own songs about local characters and events. When the Texas governor Pat Neff visited the prison on an inspection tour, Lead Belly composed a song to the governor pleading for his release; impressed by

the singer's skill, Neff did indeed give him a pardon, signing the papers on 16 January 1925. For the next five years Lead Belly lived and worked around Shreveport, until 1930, when he was again convicted for assault—this time for knifing a "prominent" white citizen. The result was a six-to-ten-year term in Angola, then arguably the worst prison in America.

In 1933, while in Angola, Lead Belly encountered folk-song collector John Lomax, who had been traveling throughout southern prisons collecting folk songs from inmates for the Library of Congress. Lead Belly sang several of his choice songs for the recording machine, including "The Western Cowboy" and "Goodnight, Irene." Lomax was impressed and a year later returned to gather more songs; this time Lead Belly decided to try his pardon-song technique again and recorded a plea to the Louisiana governor, O. K. Allen. The following year Lead Belly was in fact released, and though he always assumed the song had done the trick, prison records show Lead Belly was scheduled for release anyway because of overcrowding.

Lead Belly immediately sought out Lomax and took a job as his driver and bodyguard. For the last months of 1934, he traveled with Lomax as he made the rounds of southern prisons. During this time he learned a lot about folk music and added dozens of new songs to his own considerable repertoire.

In December 1934 Lomax presented his singer to the national meeting of the Modern Language Association in Philadelphia—Lead Belly's first real public appearance—and then took him to New York City in January 1935. His first appearances there generated a sensational round of stories in the press and on newsreels and set the stage for a series of concerts and interviews. One of these was a well-publicized marriage to a childhood sweetheart, Martha Promise (it is not known how or when his first marriage ended); another was a record contract with the American Record Company. Lomax himself continued to make records at a house in Westport, Connecticut, a series of recordings that was donated to the Library of Congress and that formed the foundation for the book by John Lomax and Alan Lomax, *Negro Folk Songs as Sung by Lead Belly* (1936). For three months money and offers poured in, but complex tensions stemming in part from Lomax's attempts to mold Lead Belly's repertoire in a way that fit the classic folk music image of the day led to an estrangement between Lomax and

Lead Belly, and before long the singer returned to Shreveport.

A year later Lead Belly and his wife returned to New York City to try to make it on their own. He found his audience not in the young African American fans of CAB CALLOWAY and DUKE ELLINGTON (who considered his music old-fashioned), but in the young white social activists of various political and labor movements. He felt strongly about issues concerning civil rights and produced songs on a number of topics, the best of which were "The Bourgeois Blues" and "We're in the Same Boat, Brother." Lead Belly soon had his own radio show in New York, which led to an invitation to Hollywood to try his hand at films. He tried out for a role in *Green Pastures* and was considered for a planned film with Bing Crosby about Lomax. The late 1940s saw a series of excellent commercial recordings for Capitol, as well as for the independent Folkways label in New York. His apartment became a headquarters for young aspiring folk singers coming to New York, including a young Woody Guthrie. Martha Promise's niece Tiny began managing Lead Belly's affairs, and his career was on the upswing when, in 1949, he became ill with amyotrophic lateral sclerosis (ALS, or Lou Gehrig disease). It progressed rapidly, and in December Lead Belly died in Bellevue Hospital in New York City. His body was returned to Mooringsport, Louisiana, for burial. Ironically, a few months later, his song "Goodnight, Irene" was recorded by the Weavers, a group of his folk-singing friends, and became one of the biggest record hits of the decade.

Lead Belly was one of the first performers to introduce African American traditional music to mainstream American culture in the 1930s and 1940s and was responsible for the popularity and survival of many of the nation's best-loved songs.

FURTHER READING
Lomax, John, and Alan Lomax. *Negro Folk Songs as Sung by Lead Belly* (1936).
Wolfe, Charles K., and Kip Lornell. *The Life and Legend of Leadbelly* (1992).

DISCOGRAPHY
Numerous CDs feature reissues of both the singer's commercial and Library of Congress recordings, notably *Lead Belly: The Library of Congress Recordings* (Rounder 1044–46).

CHARLES K. WOLFE

LEE, Canada

(3 May 1907–9 May 1952), actor, bandleader, and boxer, was born Leonard Lionel Cornelius Canegata in New York City, the son of James Cornelius Canegata, a clerk, and Lydia Whaley. Lee's father came from a wealthy and politically prominent family in St. Croix, Virgin Islands, whose ancestors had adopted a Danish surname. Lee's grandfather owned a fleet of merchant ships; the family also raced horses. James Canegata shipped out as a cabin boy at eighteen, settled in Manhattan, married, and worked for National Fuel and Gas for thirty-one years. Lee grew up in the San Juan Hill section of Manhattan's West Sixties and attended P.S. 5 in Harlem. An indifferent student, he devoted more energy to fisticuffs than to schoolwork. Lee studied violin from age seven with the composer J. ROSA-MOND JOHNSON, and at age eleven he was favorably reviewed at a student concert in Aeolian Hall; his parents hoped he would become a concert violinist.

Lee relished risk and excitement and, like his father, ran away from home, heading for the Saratoga racetracks at fourteen. He worked for two years as a stable hand until a "gyp" (a poor owner

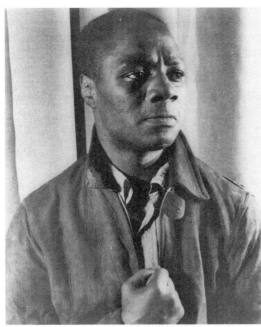

Canada Lee performing in a production of Native Son, 7 April 1941. (Library of Congress.)

who paid his jockeys from winnings only) gave him a chance to race. Lee's unremarkable career as a jockey at the New York tracks (Belmont, Aqueduct, Jamaica) and on a Canadian circuit based in Montreal lasted a further two years, until he grew too tall and too heavy to ride.

Returning penniless to New York, Lee encountered a school friend who had become a professional boxer and whom Lee remembered beating regularly in street fights. With his usual decisiveness, Lee turned to boxing. Within two years, under the training of Willie Powell at the Salem Crescent Athletic Club (in the basement of a Methodist church near his parents' house), Lee had won metropolitan, intercity, state, and national lightweight junior championships. In 1925 he turned professional, managed by Jim Buckley. Lee married his first wife, Juanita Waller, in 1926; their son, the actor Carl Vincent (Canegata) Lee, was born in 1928.

When the veteran fight announcer Joe Humphries introduced boxer Lee Canegata as "Canada Lee," Lee acquired the name he would use for the rest of his life. In an eight-year career as a welterweight, Lee fought some two hundred professional bouts, losing only twenty-five. He never won a championship but defeated champions Lou Brouillard, Vince Dundee, and Tommy Freeman in ineligible "over-the-weight" matches shortly before or after they won their crowns. Finally, in a 1931 Madison Square Garden bout intended as a preliminary to a championship bout with Jim McLarnin, Andi Di Vodi landed a blow that left Lee blind in his right eye, which was soon replaced with glass (boxing also left Lee with a broken nose and slightly cauliflow-ered ears). Always prodigally generous with money, Lee earned more than eighty thousand dollars as a boxer and saved none of it.

Lee returned to music, leading his own big band as violinist and singer (he also played piano). He toured domestically and once filled in for DUKE ELLINGTON at Harlem's famed Cotton Club. In 1933 or 1934 Lee ran a small Harlem nightclub, the Jitter-bug, for about six months, at a loss. (Lee later owned the Chicken Coop, a popular Harlem restaurant he ran from 1941 to 1943, where he fed innumerable prizefighters for free.) Broke again in 1934, in the depth of the Great Depression, and too proud to accept Home Relief but reluctant to take an ordinary job, Lee finally went to the Harlem YMCA employ-ment office. Instead of waiting in line, however, he slipped into the Y's Little Theatre to watch the

director FRANK WILSON's auditions for the "Negro unit" of the Public Works of Art Project theater division. Presuming Lee was an actor, Wilson had him audition; Lee found himself with the role of Nathan in Wilson's *Brother Mose* and a new career.

Lee soon succeeded Rex Ingram in the lead role of Blacksnake in a Theater Union revival of Paul Peters's *Stevedore*, which ran for a year at Chicago's Civic Rep. When the Negro unit became part of the Works Progress Administration Federal Theatre Project in 1935, Lee returned to New York as Banquo in Orson Welles's all-black *Macbeth*, a role that won critical notice and confirmed his new vocation. Lee's other Federal Theatre roles included parts in Lewis Stiles Gannett's *Sweet Land* and Kenyon Nicholson's *Sailor, Beware* (1935); Yank in an ill-conceived 1937 revival of Eugene O'Neill's four one-act sea plays; Henri Christophe, Haiti's nineteenth-century liberator and king, in W. E. B. DU BOIS's 1938 *Haiti*, again following Ingram; an Irish reporter in Ben Hecht and Charles MacArthur's *The Front Page* (1938); and Victor Mason in Theodore Ward's *Big White Fog* (1940). Lee also appeared in *Brown Sugar*, directed by George Abbott in 1937, and bowed on Broadway as Drayton in the 1938 hit by DuBose Heyward, *Mamba's Daughters*, starring the singer ETHEL WATERS. Despite the varying critical success of these largely popular productions, Lee was consistently singled out for notice by reviewers.

Lee also worked extensively in radio in the early 1940s. Harlem's WMCA built a 1944 series, *New World a' Coming* ("vivid programs of Negro life" based on the ROI OTTLEY best-seller), around Lee and made him the voice of the JOHN KIRBY Orchestra. He was featured in WNEW's *The Canada Lee Show*, narrated a series for CBS, and acted in many radio plays for NBC.

The role of Bigger Thomas in the stage adaptation of RICHARD WRIGHT's *Native Son*, directed by Welles in 1941, propelled Lee to stardom; overnight he was acclaimed one of the nation's greatest actors. After a 114-show run and extensive New York–area touring, the play returned to Broadway in 1942–1943 at popular prices. In 1942 Lee also took lead roles in a bill of two mystical Pirandellian one-acts by William Saroyan, *Talking to You* (in which he played a prizefighter) and *Across the Board on Tomorrow Morning*. Lee and his wife were divorced in 1942 after a long separation; Lee continued to raise his son alone.

Lee turned down many stereotypical film parts before accepting the role of Joe, an assistant steward, in Alfred Hitchcock's *Lifeboat* (shot in 1943; released in 1944). Lee insisted on rewriting all his dialogue to eliminate its obsequious Hollywood "Negro dialect." While *Lifeboat* was in postproduction, Lee returned to New York to produce and star in the controversial *South Pacific*, a didactic melodrama directed by Lee Strasberg that allegorized problems of racial integration in the American military (no relation to the famed Rodgers and Hammerstein musical).

As producer and board member of the American Negro Theater, Lee moved Phillip Yordan's *Anna Lucasta* from Harlem to Broadway for 957 performances in 1944 and triumphed in a role far smaller than his star status warranted. Lee won generally good notices also as Caliban, opposite the ballerina Vera Zorina as Ariel, in Margaret Webster's innovative 1944–1945 *The Tempest* and again as the villainous Daniel de Bosola in the director Paul Czinner's 1946 production of John Webster's *The Duchess of Malfi*, said to be the English-speaking world's first "whiteface" role. Lee was also the first African American to produce a straight play on Broadway when he starred in Maxine Wood's 1946 *On Whitman Avenue*, about a black family hounded out of a white neighborhood. The crudely written racial melodrama was a critical flop but a great popular success in New York and on its national tour.

In 1947 Lee costarred opposite John Garfield as the end-of-the-line champ Ben Chaplin in *Body and Soul*, considered the greatest of the classic boxing films (Lee had previously appeared in 1939's *Keep Punching*). To Lee this role represented "the first time the movies have handled an American Negro like any other human being." Lee often said that boxing remained his greatest love. He denied any interest in the sport's brutal aspect and described boxing as an alloy of music, poetry, dance, and psychology, saying he had "approached fighting from an aesthetic angle." Lee believed boxing had taught him balance, fluidity, and rhythm and given him stage presence. He was praised throughout his career for his physical grace and power, command of stage space, imagination, and directness.

Though Lee often told interviewers he had not suffered from discrimination, every aspect of his career was politicized and viewed through the lens of American race relations. He was seen, and saw

himself, as a pioneering black actor dedicated to demolishing racial stereotypes. Throughout his professional life an outspoken and eloquent defender of social justice, Lee lent his name and his gift for public speaking to such progressive causes as a 1946 American Veterans Committee rally to banish Jim Crow from the theater and numerous campaigns against fascism, racism, and anti-Semitism. As early as 1941 Lee took pains to distance himself publicly from any group with communist affiliations; nonetheless, he was blacklisted, the target of an orchestrated smear campaign in the press, and virtually unable to work in radio, television, or film after 1945. (Stefan Kanfer writes in *A Journal of the Plague Years* [1973] that Lee had been banned from forty radio and television shows by 1952.) The stress Lee endured left him with life-threatening hypertension; he never fully recovered his health.

Lee starred in a production of *Othello* in the summer of 1948 but was unable to secure funding for a Broadway run despite positive notices during the tryout tour, and in 1949 he unsuccessfully attempted to open a school, the Canada Lee Workshop for actors—two of this period's many unfulfilled projects. Lee's last role on Broadway was as George in Dorothy Heyward's 1948 *Set My People Free*. Although Lee was never indicted by the House Un-American Activities Committee (HUAC), an FBI document introduced in evidence at the 1949 trial of Judith Coplon (a government worker indicted for spying) accused him of being a "fellow traveler." Nearly eighteen thousand dollars in debt, Lee appealed to the variety-show host Ed Sullivan in a letter, declaring himself "no more a Communist than an Eskimo." In a press conference called to clear his name, Lee analyzed the racist motive behind HUAC's attack on black leaders, declaring, "Call me Communist and you call all Negroes Communists."

Lee made only two more films, both outside Hollywood. He was powerful in a custom-written role as a Harlem policeman in Louis de Rochemont's controversial *Lost Boundaries* (1949), based on the true story of a light-skinned black doctor and his family who passed for white in a small New Hampshire community. The novelist Alan Paton, impressed with Lee's performance in that film, insisted he be cast as Stephen Kumalo in the film version of Paton's *Cry, the Beloved Country* (1951), the first film ever made about apartheid, shot in Natal, South Africa, in 1950.

Lee married Frances Pollack, his companion of several years, while in London for retakes of *Cry* in 1951. While there, Lee required two operations to reduce his blood pressure. Retakes were further delayed when Lee had to return to New York after his father's death of a heart attack (the same disease that had killed Lee's mother in 1945), though Lee was too ill to attend the funeral. He traveled in Europe briefly to plan several film projects. He was supposed to return to Italy to begin shooting a film of *Othello* in 1951, but he was not permitted to renew his passport. *Cry* was being shown to capacity houses across the United States when Lee died of uremia in his Manhattan home in 1952 at age forty-five. Lee's memorial service at the Henry Street Settlement House was attended by the poet LANGSTON HUGHES, among other black leaders, and included a public denunciation of apartheid.

FURTHER READING

The Manuscripts/Archives and Rare Books Division of the New York Public Library's Schomburg Center for Research in Black Culture possesses collections of production stills from several of Lee's plays and films and all of Lee's personal and professional papers, donated by his widow, including scripts, speeches, correspondence, and photographs. The Schomburg also holds the complete records (1952–1954) of the Canada Lee Foundation, set up after his death to aid talented young African Americans in theater.

Smith, Mona Z. *Becoming Something: The Story of Canada Lee* (2004).

Obituary: New York Times, 10 May 1952.

CHRISTOPHER CAINES

LOCKE, Alain Leroy

(13 Sept. 1885–9 June 1954), philosopher and literary critic, was born in Philadelphia, Pennsylvania, the son of Pliny Ishmael Locke, a lawyer, and Mary Hawkins, a teacher and member of the Felix Adler Ethical Society. Locke graduated from Central High School and the Philadelphia School of Pedagogy in Philadelphia in 1904. That same year he published his first editorial, "Moral Training in Elementary Schools," in the *Teacher*, and entered undergraduate school at Harvard University. He studied at Harvard under such scholars as Josiah Royce, George H. Palmer, Ralph B. Perry, and Hugo Münsterberg before graduating in 1907 and becoming the

first African American Rhodes scholar, at Hertford College, Oxford. While in Europe, he also attended lectures at the University of Berlin (1910–1911) and studied the works of Franz Brentano, Alexius Meinong, and C. F. von Ehrenfels. Locke associated with other Rhodes scholars, including Horace M. Kallen, author of the concept of cultural pluralism; H. E. Alaily, president of the Egyptian Society of England; Pa Ka Isaka Seme, a black South African law student and eventual founder of the African National Congress of South Africa; and Har Dayal from India—each concerned with national liberation in their respective homelands. The formative years of Locke's education and early career were the years just proceeding and during World War I—years of nationalist uprising and wars between the world's major nation-states. Locke joined the Howard University faculty in 1912, to eventually form the most prestigious department of philosophy at a historically African American university.

In the summer of 1915 Locke began a lecture series sponsored by the Social Science Club of the National Association for the Advancement of Colored People, titled "Race Contacts and Interracial Relations: A Study of the Theory and Practice of Race." Locke argued against social Darwinism, which held that distinct races exist and are biologically determined to express peculiar cultural traits. Locke believed that races were socially constructed and that cultures are the manifestation of stressed values, values always subject to transvaluation and revaluation. Locke introduced a new way of thinking about social entities by conceiving of race as a socially formed category, which, despite its foundation in social history, substantively affected material reality.

Locke received his doctorate in Philosophy from Harvard in 1918 and shortly thereafter wrote "The Role of the Talented Tenth," which supported W. E. B. DU BOIS's idea that the upward mobility of approximately one-tenth of a population is crucial for the improvement of the whole population. Locke also became interested in the Baha'i faith, finding particularly attractive its emphasis on racial harmony and the interrelatedness of all religious faiths. Locke attended the 1921 Inter-Racial Amity conference on 19–21 May in Washington, D.C., and as late as 1932 published short editorials in the *Baha'i World*. Although he did not formally join the Baha'i faith, he remained respectful of its practices.

Locke went on to help initiate the Harlem Renaissance, a period of significant cultural contributions by African Americans. The years 1924–1925 were a major turning point in Locke's life. He edited a special edition of the magazine *Survey* titled the *Survey Graphic*, on the district of Harlem in New York City. The editor of *Survey* was Paul U. Kellogg, and the associate editor was Jane Addams. That edition became the source for his seminal work reflecting the nature of valuation and the classicism of African American culture, *The New Negro: An Interpretation of Negro Life*, published in 1925. *The New Negro* included a collage of art by Winold Reiss and AARON DOUGLAS and representations of African artifacts, articles by J. A. ROGERS, E. FRANKLIN FRAZIER, CHARLES S. JOHNSON, Melville J. Herskovits, and Du Bois, poetry by COUNTÉE CULLEN, LANGSTON HUGHES, ARNA BONTEMPS, and ANGELINA WELD GRIMKé, spirituals, and bibliographies. *The New Negro* was intended as a work "by" rather than "about" African Americans, a text exuding pride, historical continuity, and a new spirit of self-respect not because a metamorphosis had occurred in the psychology of African Americans, "but because the Old Negro had long become more of a myth than a man." *The New Negro* embodied Locke's definition of essential features of African American culture, themes such as the importance of self-respect in the face of social denigration; ethnic pride; overcoming racial stereotypes and idioms, such as call-and-response in the spirituals or discord and beats in jazz; and the importance that cultural hybridity, traditions, and revaluations play in shaping cross-cultural relationships. Locke promoted those features of African American folk culture that he believed could be universalized and thus become classical idioms, functioning, for Locke, as cultural ambassadors encouraging cross-cultural and racial respect. As debates over how to characterize American and African American cultural traits in literature became less a source of intellectual conflict, Locke's interests moved on to issues in education.

In 1936 Locke began work on a book series, the Bronze Booklets on the History, Problems, and Cultural Contributions of the Negro, under the auspices of the Associates in Negro Folk Education. Eight booklets were published in the series, which became a standard reference for the teaching of African American history. In one of his frequent

book reviews of African American literature for *Opportunity: A Journal of Negro Life*, Locke supported the controversial novel by RICHARD WRIGHT, *Native Son*, in 1941. The novel was controversial because Wright did not portray the lead character, Bigger Thomas, as a peace-loving, passive, and victimized African American, but as a critic of liberals and radicals. Locke's support for Wright's novel represented his belief that race divided America.

Locke published his first extensive article on his philosophy in 1935, "Values and Imperatives," in *American Philosophy: Today and Tomorrow*, edited by Horace M. Kallen and Sidney Hook. Locke argued that values are inherently unstable, always subject to transvaluation and transposition. Locke contended that "All philosophies, it seems to me, are in ultimate derivation philosophies of life and not of abstract, disembodied 'objective' reality; products of time, place, and situation, and thus systems of timed history rather than timeless eternity" (313). Rather than believe that science is an adequate model for reasoning about social reality, Locke presented the view that knowledge is a function of experience and the categories of logic, science, math, and social science are heuristic value fields or distinctions.

Locke published his landmark work on education, "The Need for a New Organon in Education," in *Findings of the First Annual Conference on Adult Education and the Negro* (1938), based on a lecture before the American Association for Adult Education, the Extension Department of Hampton Institute, and the Associates in Negro Folk Education, in Hampton, Virginia, on 20–22 October 1938. Locke proposed the concept of critical relativism (the view that there are no absolutely true propositions, but that we can have standards and criteria for critical evaluations). Locke warned against believing that all relevant knowledge can be acquired through application of formal logic and argued for the need to apply functional methods of reasoning and the importance of value judgments in considering defensible beliefs. Locke actively promoted adult education, working with the American Association of Adult Education in Washington, D.C., from 1948 to 1952.

In 1942 Locke edited, along with Bernard J. Stern, *When Peoples Meet: A Study of Race and Culture*. This anthology used a concept of ethnicity to account for both ethnic and racial contacts. Locke's approach continued his view that racial identities were socially created and were not based on substantive biological categories.

In 1944 Locke became a founding conference member of the Conference on Science, Philosophy and Religion, which published its annual proceedings of debates on the relationship of these areas of thought. He promoted the idea that cultural pluralism was an analogue for why one knowledge field was an insufficient reasoning model for sure knowledge, in other words that different cultures and civilizations supported laudable values just as different disciplines could sustain different spheres of knowledge. For Locke, there was no reason to believe in a unified theory of knowledge—a theory that would tell us about the nature of all forms of knowledge. Rather, a plurality of fields of knowledge and cultural values was a preferable perspective on Locke's account.

Locke was a controversial figure. His aesthetic views contrasted with those of the Black Aesthetic Movement of the 1970s. He was satirized in novels, criticized by ZORA NEALE HURSTON as an elitist interested in controlling the definition of African American culture, reproached for failing to acknowledge the largest Pan-African movement of the 1920s, the MARCUS GARVEY–led Universal Negro Improvement Association, and denounced for placing too great a value on African American literature as a text representing a unique cultural texture.

Locke died in New York City. He lived a controversial life because his ideas of values, race, and culture often challenged popular ideas. His concept of pragmatism was critical of, and different from, the dominant forms represented by William James and John Dewey. Locke's effort to shape the Harlem Renaissance and define the "New Negro" went against those who believed folk culture should not be changed, and his advocacy of value-oriented education within the adult education movement was viewed as a new orientation. Locke's philosophy, promoted by the Alain L. Locke Society, remains a source of controversy and debate.

FURTHER READING

Locke's papers are in the Alain L. Locke Archives, Howard University, Washington, D.C.

Harris, Leonard. *The Philosophy of Alain Locke: Harlem Renaissance and Beyond* (1989).

Harris, Leonard, ed. *The Critical Pragmatism of Alain Locke* (1999).

Holmes, Eugene C. "Alain L. Locke—Philosopher, Critic, Spokesman," *Journal of Philosophy* 54 (Feb. 1957): 113–118.

Linneman, Russell J. *Alain Locke: Reflections on a Modern Renaissance Man* (1982).

Stafford, Douglas K. "Alain Locke: The Child, the Man, and the People," *Journal of Negro Education*, (Winter, 1961): 25–34.

Stewart, Jeffrey C., ed. *The Critical Temper of Alain Locke: A Selection of His Essays on Art and Culture* (1983).

Washington, Johnny. *Alain Locke and His Philosophy: A Quest for Cultural Pluralism* (1986).

LEONARD HARRIS

LUNCEFORD, Jimmie

(6 June 1902–12 July 1947), jazz and popular bandleader, was born James Melvin Lunceford in Fulton, Missouri, the son of a choirmaster. His parents' names are unknown. Before Jimmie enrolled in high school, his family moved to Denver, Colorado, where he studied reed instruments, flute, guitar, and trombone under Wilberforce James Whiteman, the father of Paul Whiteman.

Lunceford first worked professionally in the society dance orchestra of the violinist GEORGE MORRISON, with whom he traveled to New York City in 1922 for performances at the Carlton Terrace and for recordings. Soon afterward he entered Fisk University in Nashville, Tennessee, where he excelled at basketball, football, and track while earning a bachelordegree in Music Education (c. 1926). During summer vacations he worked with Deacon Johnson's band in New York, and early in 1926 he was regularly with the band of the banjoist ELMER SNOWDEN at the Bamville Club in Harlem, playing saxophone and trombone alongside the pianist COUNT BASIE and the trumpeter BUBBER MILEY.

After taking some graduate courses at the City College of New York, Lunceford went to Memphis, Tennessee, in fall 1926 to teach physical education and music at Manassa High School; in Memphis he organized a jazz band that included the bassist Moses Allen and the drummer Jimmy Crawford. During the summers of 1928 and 1929 they played in Lakeside, Ohio, and during the 1929 season the band included the alto saxophonist and singer Willie Smith, the pianist Ed Wilcox, the trombonist and singer Henry Wells (all three having been Fisk students), along with Allen and Crawford.

Wilcox also recalled summer engagements at Belmar, New Jersey, and the following year at Asbury Park, New Jersey, the years unspecified. In Memphis the group played professionally at the Hotel Men's Improvement Club Dance Hall and the Silver Slipper nightclub, broadcasting on WREC from the Silver Slipper.

Lunceford finally abandoned education for entertainment. Around 1929 or 1930 the band suffered through an early winter in Cleveland, Ohio, struggling for work. They found a job in Cincinnati, Ohio, and in June 1930 recorded as the Chickasaw Syncopators. After touring in 1931, Lunceford made Buffalo, New York, the group's home base for about three years. In 1932 two additional Fisk alumni joined, the trumpeter Paul Webster and the baritone saxophonist Earl Carruthers. In summer 1933 the band performed at the Caroga Lake resort in upstate New York, and that year Lunceford hired the trumpeter Tommy Stevenson and the man who became his finest soloist, the tenor saxophonist Joe Thomas.

Up to this point the group had been structured as a cooperative held among Smith, Wilcox, and Lunceford, but when Harold F. Oxley took over management of the band in 1933, questions of business reverted to Lunceford and Oxley alone. By mid-decade the two men had expanded their domain with Lunceford Artists, Inc., managing other orchestras as well as their own.

The arranger, trumpeter, and singer Sy Oliver joined the band in Buffalo, shortly before an engagement at the Lafayette Theatre in Harlem in September 1933. The performance was a disaster, this being the first time that Lunceford's men had played for a choreographed show rather than for dancing, but they survived the experience, toured New England, and returned to New York to record their first well-received recordings, "White Heat" and "Jazznocracy," and more significantly, to follow CAB CALLOWAY's big band as the resident group at the Cotton Club. By January 1934 the trumpeter and singer Eddie Thompkins (often misspelled Tompkins) joined; he was another of Lunceford's men who doubled as a glee club singer in the band.

Lunceford's men broadcast nightly from the Cotton Club for roughly half a year. The band then embarked on years of regular national touring—as well as a Scandinavian tour in February 1937—while recording prolifically. Three titles associated with

DUKE ELLINGTON, including Smith's arrangements of "Sophisticated Lady" and "Mood Indigo," show off the virtuosity of the saxophone section and show the band's strong independence from Ellington's conception (other bands of that era having found it quite difficult to perform Ellington's music in an original manner). For this same session of September 1934 Lunceford himself made a rare contribution, his zany and technically demanding composition "Stratosphere." In general his musical involvement was directed toward inspiration and organization rather than the nuts and bolts of playing and writing.

Later sessions exemplify the band's bouncy dance music, including Oliver's arrangements of his own composition "Stomp It Off," Wilcox's arrangement of "Rhythm Is Our Business" (1934), and Oliver's versions of the popular songs "Four or Five Times," "My Blue Heaven" (1935), and "Organ Grinder's Swing" (1936). The band may be seen in action in the film short *Jimmie Lunceford and His Dance Orchestra* (1936).

The arranger, trombonist, and guitarist Eddie Durham had joined in 1935 and contributed scores to the band, but without making the impact that he earlier had with Bennie Moten and later had with Basie. In the fall of 1937 the trombonist Trummy Young replaced Durham, and the alto saxophonist Ted Buckner joined; both men are featured on "Margie" (1938). Further hits by Oliver included his compositions and arrangements of "For Dancers Only" (1937) and "Le Jazz Hot" (1939), as well as his arrangement of "'Tain't What You Do (It's the Way That You Do It)" (1939). In 1937 Lunceford married Crystal Tally.

In 1939 Snooky Young replaced Thompkins, and late that year Lunceford was featured with Smith on "Uptown Blues." In mid-1939 the trumpeter Gerald Wilson and the arranger Billy Moore collectively took Oliver's place, and Moore soon gave Lunceford a hit record with his version of "What's Your Story, Morning Glory?" (1940). In its last great moment, Lunceford's orchestra was featured in the movie *Blues in the Night* (1941), the movie's title track providing a hit song for Lunceford and others, including Woody Herman, Jo Stafford with Tommy Dorsey, and HOT LIPS PAGE with Artie Shaw.

By 1940 Lunceford's men were discontented. Crawford claimed that Oxley doled out insufficient salaries. Moore complained that Lunceford routinely appropriated royalty rights for his arrangers' scores, and that Lunceford and Oxley paid the band as little as possible:

> He was an inspiring leader, from a distance, and he did mould his men into a most effective orchestra; he kept the men on their toes and maintained a fine public image. But he failed to reward the musicians who were mostly responsible for his huge success. . . . Meanwhile Lunceford bought himself a Lincoln Continental, and then his own plane, which he piloted.
>
> (Feather, 170, 172)

Considering these and other remembrances, the writer Albert McCarthy speculated that "no musicians of any other major band of the swing era seem to have received such parsimonious salaries as those who worked with Lunceford." Snooky Young, Moses Allen, Smith, and Wilson quit in 1942, and Crawford and Trummy Young quit in 1943. The band continued for several years, but the spark was gone. While signing autographs at a music store in Seaside, Oregon, Lunceford collapsed and soon died of a heart attack. Wilcox and Thomas, and then Wilcox alone, kept the group going for nearly three years before it finally split up permanently.

Lunceford's big band may be rated a notch below the greatest ensembles of the swing era, owing to the absence of highly original improvisers or a consistently original approach to arrangement (Oliver's best scores excepted). The group excelled in its delivery of a relaxed swing beat for dancing, in its presentation of novelty vocal trios (usually sung by Wells, Smith, and Oliver) that became very popular with college students (especially "My Blue Heaven"), and, above all, in its showmanship. The writer George T. Simon reports that among twenty-eight bands playing fifteen-minute sets at the Manhattan Center on 18 November 1940—including the bands of Benny Goodman, Glenn Miller, Count Basie, Les Brown, and Guy Lombardo—Lunceford's band was the only one given such an overwhelming reception that they played beyond their allotted time. They owed this success to their superior antics:

> The trumpets would throw their horns in the air together; the saxes would almost charge off the stage; . . . the trombones would slip their slides toward the skies; and . . . the musicians would be kidding and shouting at one another, projecting an aura of irresistible exuberance.
>
> (Simon, 329)

FURTHER READING
Some Lunceford items are in the Sy Oliver Collection at the New York Public Library for the Performing Arts, Lincoln Center.

Dance, Stanley. *The World of Swing* (1974).

Feather, Leonard. *The Jazz Years: Earwitness to an Era* (1986).

Garrod, Charles. *Jimmie Lunceford and His Orchestra* (1990).

Hoefer, George. "Hot Box: Jimmie Lunceford," *Down Beat* (24 Sept. 1964).

Schuller, Gunther. *The Swing Era: The Development of Jazz, 1930–1945* (1989).

Simon, George T. *The Big Bands* (1974).

Obituary: New York Times, 14 July 1947.

BARRY KERNFELD

MABLEY, Moms

(19 Mar. 1894?–23 May 1975), comedian, was born Loretta Mary Aiken in Brevard, North Carolina, the daughter of Jim Aiken, a businessman and grocer. Her mother's name is not known. Details of her early life are sketchy at best, but she maintained in interviews she had black, Irish, and Cherokee ancestry. Her birth date is often given as sometime in 1897. Her grandmother, a former slave, advised her at age thirteen "to leave home if I wanted to make something of myself." However, she may have been unhappy over an arranged marriage with an older man. Mabley stated in a 4 October 1974 *Washington Post* interview, "I did get engaged two or three times, but they always wanted a free sample." Her formative years were spent in the Anacostia section of Washington, D.C., and in Cleveland, Ohio, where she later maintained a home. She had a child out of wedlock when she was sixteen. In an interview she explained she came from a religious family and had the baby because "I didn't believe in destroying children." Mabley recalled that the idea to go on the stage came to her when she prayed and had a vision. But in a 1974 interview she said she went into show business "because I was very pretty and didn't want to become a prostitute." Another time she explained, "I didn't know I was a comic till I got on the stage."

In 1908 she joined a Pittsburgh-based minstrel show by claiming to be sixteen; she earned $12.50 a week and sometimes performed in blackface. By 1910 she was working in black theatrical revues, such as *Look Who's Here* (1920), which briefly played on Broadway. She became engaged to a Canadian named Jack Mabley. Though they never married, she explained she took his name because "he took a lot off me and that was the least I could do."

In 1921 Mabley was working the chitlin circuit, as black entertainers referred to the black-owned and black-managed clubs and theaters in the segregated South. There, she recalled, she introduced a version of the persona that made her famous, the weary older woman on the make for a younger man. The dance duo Butterbeans and Suzie (JODIE EDWARDS and Susan Edwards) caught her act and

hired her, polishing her routines and introducing her to the Theater Owners' Booking Association, or TOBA—black artists said the initials stood for "Tough on Black Asses." She shared bills with PIGMEAT MARKHAM, Tim "Kingfish" Moore, and BILL "BOJANGLES" ROBINSON.

In the late 1920s, when Mabley struggled to find work in New York, the black comedian Bonnie Bell Drew (Mabley named her daughter in her honor) became mentor to Mabley, teaching her comedy monologues. Soon Mabley was working Harlem clubs such as the Savoy Ballroom and the Cotton Club and Atlantic City's Club Harlem. She appeared on shows with BESSIE SMITH and CAB CALLOWAY (with whom she had an affair), LOUIS ARMSTRONG, and the COUNT BASIE, DUKE ELLINGTON, and Benny Goodman orchestras. During the Depression, when many clubs closed, she worked church socials and urban movie houses, such as Washington's Howard and Chicago's Monogram and Regal theaters, where she later returned as a headliner.

Mabley had bit parts in early talkies made in the late 1920s in New York. She played a madam in *The Emperor Jones* (1931), based on the Eugene O'Neill play and starring PAUL ROBESON. In 1931 Mabley collaborated on and appeared in the short-lived Broadway production *Fast and Furious: A Colored Revue in 37 Scenes* with the flamboyant Harlem Renaissance writer ZORA NEALE HURSTON. In the late 1920s she appeared in a featured role on Broadway in *Blackbirds*. She played Quince in *Swinging the Dream* (also featuring Butterfly McQueen) in 1939, a jazz adaptation of *A Midsummer Night's Dream*. Other films include *Killer Diller* (1947), opposite Nat King Cole and Butterfly McQueen; *Boardinghouse Blues* (1948), in which she played a role much like her stage character; and *Amazing Grace* (1974), in which McQueen and STEPIN FETCHIT had cameos. It was drubbed by critics but did well at the box office.

The most popular Mabley character was the cantankerous but lovable toothless woman with bulging eyes and raspy voice who wore a garish smock or rumpled clothes, argyle socks, and slippers. Though she maintained, "I do the double entendre . . . and never did anything you haven't heard on the streets," the nature of her material, more often than not off-color, was such that, in spite of the brilliance of her comic timing and gift of ad-libbing, she was denied the route comics such as Flip Wilson, Dick Gregory, and Bill Cosby took into fine supper clubs

and Las Vegas. A younger brother, Eddie Parton, wrote comedy situations for her, but most of her material was absorbed from listening to her world. Offstage Mabley was an avid reader and an attractive woman who wore furs, chic clothes, and owned a Rolls-Royce, albeit an inveterate smoker, a card shark, and a whiz at checkers.

In 1940 she broke the gender barrier and became the first female comic to appear at Harlem's Apollo Theater, where her act, which included song and dance, played fifteen sold-out weeks. Mabley was mentor to a young Pearl Bailey and befriended by LANGSTON HUGHES, who wrote a friend that he occasionally helped Mabley financially. Legend has her acquiring the nickname "Moms" because of her mothering instincts toward performers.

Her first album, *Moms Mabley, the Funniest Woman in the World* (1960), sold in excess of a million copies. In 1966 she was signed by Mercury Records. She made more than twenty-five comedy records, many capturing her live performances; others, called "party records," had laugh tracks. She said black and white comics stole her material, then forgot her when they became famous.

Television was late to discover Mabley. Thanks to her fan Harry Belafonte, she made her TV debut in a breakthrough comedy he produced with an integrated cast, *A Time for Laughter* (1967), as the maid to a pretentious black suburban couple. Merv Griffin invited her on his show, and appearances followed with Mike Douglas and variety programs starring Flip Wilson, Bill Cosby, and the Smothers Brothers. Mabley had been known mainly to black audiences. Of this late acceptance, she mused: "It's too bad it took so long. Now that I've got some money, I have to use it all for doctor bills." Mabley was not always career savvy. She passed up an appearance on CBS's top-rated *Ed Sullivan Show*, saying: "Mr. Sullivan didn't want to give me but four minutes. Honey, it takes Moms four minutes just to get on the stage."

Because of her influence with African Americans, Mabley was seriously courted by politicians such as ADAM CLAYTON POWELL JR., whom she called "my minister." She did not aggressively support the 1960s civil rights movement, and she expressed outrage at the riots in Harlem. She was invited to the White House by presidents John F. Kennedy and Lyndon Johnson. Of the latter event, she told a (fictional) joke about admonishing Johnson to "get something colored up in the air quick" (a black astronaut). She said: "I happen to spy him [and] said, 'Hey, Lyndon! Lyndon, son! Lyndon. Come here, boy!'" She brought the house down merely by the gall in her delivery. Mabley maintained she corresponded with and met Eleanor Roosevelt to "talk about young men."

Various articles, which say nothing of a first husband—if there was one—note that Mabley had been separated from her second husband, Ernest Scherer, for twenty years when he died in 1974. The comedian had three daughters and adopted a son, who became a psychiatrist.

Late in her career, Mabley played Carnegie Hall on a bill with the singer Nancy Wilson and the jazz great Cannonball Adderley, the famed Copacabana, and even Washington's Kennedy Center (August 1972).

During the filming of her last movie, Mabley suffered a heart attack, and production was delayed for her to undergo surgery for a pacemaker. Her condition weakened on tours to publicize the film, and for six months she was confined to her home in Hartsdale, in New York's Westchester County. She died at White Plains Hospital. Her funeral at Harlem's Abyssinian Baptist Church drew thousands of fans.

FURTHER READING

The Schomburg Center for Research in Black Culture of the New York Public Library and the New York Public Library for the Performing Arts maintain research files on Mabley.

Bogle, Donald. *Brown Sugar: Eighty Years of America's Black Female Superstars* (1980).

Sochen, June. *Women's Comic Visions* (1991).

Watkins, Mel. *On the Real Side, Laughing, Lying, and Signifying: The Underground Tradition of African American Humor That Transformed American Culture, from Slavery to Richard Pryor* (1994).

Williams, Elsie A. *The Humor of Jackie "Moms" Mabley: An African American Comedic Tradition* (1995).

Obituary: New York Times, 25 May 1975.

ELLIS NASSOUR

MACK, Cecil

(6 Nov. 1883–1 Aug. 1944), songwriter, was born Richard C. McPherson in Norfolk, Virginia. Nothing is known of his parents or his early life. He studied at the Norfolk Mission College and at Lincoln University in Pennsylvania and set his sights on the

study of medicine at the University of Pennsylvania. At first music was merely an avocation, but he gradually found his musical interests crowding out his medical ones; he began serious music studies in New York with the eminent Melville Charlton, the organist at some of New York's leading churches and synagogues for several decades. His activities during the years around 1900 were manifold, evincing a considerable degree of energy. In addition to his musical activities he was an enthusiastic member of the New York Guard, rising to the rank of lieutenant. He was also later active in the African American entertainment brotherhood known as the Frogs, together with the other leading lights of the theatrical and musical scene in which he traveled.

Beginning his musical career as a songwriter at the age of seventeen, in the years 1901–1906 Mack became a crucial member of a consortium of composers supplying material to the stage acts and recordings of BERT WILLIAMS and GEORGE WALKER, the leading African American stage team of their generation. Among the songs that Mack collaborated on during this period were "Junie," "All In, Down and Out," "Good Morning, Carrie," and "He's a Cousin of Mine." Williams or Walker or both recorded all of them for Victor or Columbia during these years, and the last two were among the biggest hits of the ragtime song genre.

Mack generally wrote only the lyrics for these songs. His collaborators on the music included such leading lights of the African American entertainment scene as CHRIS SMITH and Euday Bowman, as well as the white Tin Pan Alley composer Silvio Hein. Mack also worked with WILL MARION COOK, the eminent classically trained African American musician, during these years. Among their joint efforts were "The Little Gypsy Maid" (1902) and the songs "Brown Skin Baby Mine" and "Molly Green" for the seminal 1903 musical *In Dahomey*. In later years they also combined their energies in a more entrepreneurial direction.

In 1905 Mack founded the Gotham Music Publishing Company. There had been a few other attempts to start such a venture, but none of them had been successful. Gotham merged with a rival firm, Attucks Music, releasing sheet music from the Williams and Walker shows as well as other material by Mack, by Will Marion Cook, and by other major talents of the burgeoning African American music scene. Among the music that Mack composed during these years was "That Minor Strain" in 1910 with

FORD DABNEY. His greatest song of this period was "That's Why They Call Me (Shine)," a clever comic song that became a standard and was recorded and performed steadily until at least the 1940s.

A second phase of career success for Mack occurred when the show *Runnin' Wild* took to the stage in 1923, which starred ADELAIDE HALL. Among the songs in this show were "Old Fashioned Love," "Ginger Brown," "Love Bug," "Snow Time," and "Open Your Heart." The music was by the Harlem stride piano giant JAMES P. JOHNSON. The great hit to emerge from this show was "Charleston," which became the ubiquitous dance for flappers and college boys through much of the 1920s. Though the lyrics for this infectious piece were negligible, Mack shared in some of the reflected glory of Johnson's extraordinary inspiration in penning the music.

Mack joined the American Society of Composers, Authors, and Publishers (ASCAP) in 1925, making him one of the first African Americans welcomed into the organization, which monitors performances of music to protect members' copyrights. He founded a vocal organization known as Cecil Mack's Southland Singers, and he later founded the Cecil Mack Choir, which performed in the Lew Leslie production *Rhapsody in Black* (1931). He arranged spirituals for use in this show and also wrote some lyrics for music by others. During the Depression, Mack was less active, although he did contribute the libretto for the Works Progress Administration (WPA)-funded project *Swing It* in 1937. He died in New York. His widow, Gertrude Curtis McPherson, was reputedly the first African American woman dentist licensed to practice in New York City.

FURTHER READING
Jasen, David A., and Gene Jones. *Spreadin' Rhythm Around* (1998).
Morgan, Thomas L., and William Barlow. *From Cakewalks to Concert Halls* (1992).

Obituaries: New York Times, 2 Aug. 1944; *Variety*, 9 Aug. 1944.

ELLIOTT S. HURWITT

MARKHAM, Dewey "Pigmeat"

(18 Apr. 1904–13 Dec. 1981), comedian and actor, was born in Durham, North Carolina, to unknown parents. As a comedian, his career spanned the eras of

minstrel shows, vaudeville, radio, motion pictures, and television.

As a young man Markham began performing in tent shows and minstrel shows. By 1917 he was gaining attention as a comedian on the Chitlin' Circuit, the nickname for the network of theaters and nightclubs in African American neighborhoods, with such performers as BESSIE SMITH and GERTRUDE "MA" RAINEY. The origin of his famous nickname is uncertain, although the phrase "Pigmeat" was commonly used as a sexual metaphor in blues songs of the early 1900s. It is known that he was performing under the name Pigmeat by the 1920s.

According to the music historian Bill Dahl, Markham originated his most famous character, Judge Pigmeat, during the late 1920s while performing at the Alhambra Theater in Harlem. This judge was known for entering his courtroom shouting "Here Come de Judge," mangling the English language, and giving ridiculously unfair sentences to people who appeared in his court. While some may have felt this routine was a stereotype of the supposed incompetence of African Americans, most black audiences enjoyed Markham's antics for decades before he became known to white Americans. In the liner notes to Markham's *The Crap Shootin' Rev*, Dahl suggests that Markham based this character on the outlandish racism African Americans often faced in court, particularly from judges in the southern United States at that time. This routine may also have its origins in an earlier routine by the pioneering black comedian BERT WILLIAMS. In his 1919 recording "Twenty Years," which appears on the 2001 Archeophone Records CD *Bert Williams, The Middle Years 1910–1919*, Williams's character Judge Grimes sentences a man who slipped on a banana peel to "twenty years for unlawful speeding" among other outrageous punishments. A casual comparison of this recording to one of Markham's Judge Pigmeat routines indicates that Williams's Judge Grimes was a likely precursor to Judge Pigmeat.

Another aspect of Williams's comedy used by Markham was the practice of performing in blackface minstrel makeup. This was a standard practice among black comedians in the late 1800s and early 1900s as a result of the influence of the white minstrel tradition. Although this trend appeared to be on the wane among African American comics by the time of Williams's death in 1922, many black comedians continued to perform in this fashion onstage well into the 1940s. On the 1993 Home Box Office documentary *Mo' Funny: Black Comedy in America*, Markham's contemporary Timmie Rogers recalled that he convinced Markham to discontinue wearing blackface makeup onstage when he asked Markham if he would wear such a costume on the radio.

In the 1940s Markham also became a pioneer in another fashion. He was among the first black comedians to have a major supporting role in a regular mainstream radio program, playing Alamo the Cook on the Andrews Sisters' radio show. The success of this role led to Markham being billed with the double moniker Pigmeat "Alamo" Markham for his appearances in all-black comedies produced for segregated theaters such as *House-Rent Party* (1946), where he teamed with fellow comic John "Rastus"

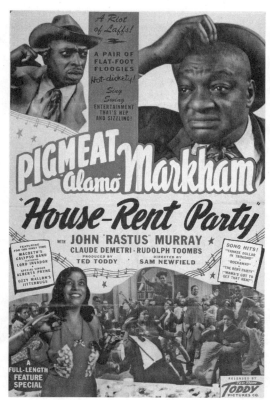

Pigmeat Markham. The 1946 motion picture poster for House-Rent Party featured head-and-shoulders portraits of Pigmeat "Alamo" Markham (right) and John "Rastus" Murray, with stills from the film and a half-length portrait of Alberta Pryne. (Library of Congress.)

Murray, and *Junction 88* (1947). By 1955 he had made occasional appearances on the popular *Ed Sullivan Show* on television.

Despite this modest success, Markham was not a household name in black or white America and was overshadowed by other African American comics such as Dick Gregory and Redd Foxx who had more success in mainstream media. This started to change in 1961 when Chess Records began producing albums of his comedy routines given at inner-city theaters and nightclubs such as the Regal in Chicago and the Apollo in Harlem. Some of these albums included *The Trial* (1961), *Anything Goes with Pigmeat Markham* (1962), *Pigmeat at the Party* (1961), and *The World's Greatest Clown* (1965). Portions of the latter were recorded at the Apollo on 21 February 1965 while at the same time human rights activist Malcolm X was assassinated only a few miles away.

These albums are among the best examples of Markham's legacy as a comedian. They consist largely of ensemble routines typically featuring Markham with Chuck Thompson, who portrayed an intellectual character who recoiled at Markham's onstage antics, fellow comedian "Baby" Seals, and actress Edna Mae Harris, who usually appeared as a femme fatale. The routines were laced with sexual innuendo and double entendre that was considered risqué at the time, but avoided the explicit references and profanity of later comedians. One such routine from *The Trial* featured Markham as Judge Pigmeat hearing the case of a man arrested for indecent exposure. Upon learning that the defendant is the father of nine children, Judge Pigmeat dismisses the case because "This man hasn't had time to put his pants on!"

These recordings made Markham a popular figure in black households, and many African American children of that era would recite his comedy routines in schools and playgrounds in the same manner that a later generation would with rap music. Some of Markham's skits were done in rhyme, and routines such as "I Got the Number" from *Anything Goes with Pigmeat* (where Markham and Thompson rhymed about playing the "numbers game") and "Here Come de Judge" were precursors to rap music, as the first generation of rappers were among those who enjoyed Markham's records in the 1960s and 1970s. The popular rap group Arrested Development sampled "I Got the Number" for their song "Ease My Mind" in the 1990s.

Markham's televised performances as Judge Pigmeat on the 1967 television special *A Time for Laughter: Negro Humor in America*, and a year later on *Rowan and Martin's Laugh-In* finally brought him mainstream celebrity status. In 1969 this success led to a book, *Here Come the Judge!*, co-written with Bill Levinson, filled with Markham's amusing commentary on the political situations of that era. Unfortunately, this success came late in Markham's life when health problems curtailed his career through the 1970s. Younger comedians such as Richard Pryor in the 1990 television special *A Party for Pryor* would cite him as an influence. Markham's death from a stroke on 13 December 1981 showed that he was not forgotten as tributes aired in sources as diverse as *Jet* magazine and the popular syndicated television program *Entertainment Tonight*. He left behind a wife, Bernice, a daughter, Cathy, and a son, Dewey Markham Jr.

FURTHER READING

Markham, Pigmeat, and Levinson, Bill. *Here Comes the Judge!* (1969).

Dahl, Bill. Liner notes to *Pigmeat Markham, The Crap Shootin' Rev* (1970).

Obituary: Jet (17 Jan. 1982).

DAMON L. FORDHAM

MATHEUS, John Frederick

(10 Sept. 1887–21 Feb. 1983), writer, educator, and scholar, was born in Keyser, West Virginia, the eldest son of John William Matheus, a bank messenger and part-time tannery worker, and Mary Susan Brown Matheus. As a young boy he moved with his family to Steubenville, Ohio, where he developed a great love for literature and reading. As a teenager he read the poets Edgar Allan Poe, Henry Wadsworth Longfellow, and Heinrich Heine and was inspired to write his own verse, some of which was published in two local newspapers. At the age of fifteen he also demonstrated his talent for writing prose by winning a prize for the best history of Ohio in a contest offered by the Woman's Club of Steubenville. He crowned these early achievements by graduating with honors from Steubenville High School in 1905. The following year he began studying at Western Reserve University and in 1910 earned an AB (cum laude), with a concentration in Latin, Greek, German, and Romance Languages.

That same year Matheus and his wife, Maude Roberts, whom he married in 1909 (they never had children), moved to Tallahassee, Florida, where he was professor of Latin and modern foreign languages at Florida Agricultural and Mechanical College. The South offered Matheus new opportunities and experiences, but not all were positive: "I had heard about prejudice but I didn't get my first taste of it until I visited Tallahassee in 1911" (Morris, 6). Undeterred, Matheus stayed there until 1920, but then left to attend Columbia University, where in 1921 he received a master's degree in romance languages and a diploma as a teacher of French. He furthered his education by attending classes at the Sorbonne in Paris in 1925 and doing a summer term at the University of Chicago in 1927.

Matheus was hired to head the Department of Romance Language and Literature at West Virginia Colored Institute (later West Virginia State College) in 1922, a position he occupied until 1953. Early in his stint there he resumed his creative writing in earnest and began submitting short stories, poems, plays, and essays to black literary periodicals. One of his short stories, "Fog," garnered national attention when it won first place in 1925 in a contest conducted by the magazine *Opportunity*. This story, arguably his best-known work, is about a racially diverse group of passengers aboard a trolley car that is involved in an accident on a fog-covered bridge. The passengers' near-death experience unites them and enables them, if only momentarily, to put aside their differences and see one another in a clearer light.

Although Matheus continued to produce a significant number of literary works between 1925 and 1935, his banner year was 1926, during which he won six awards in contests sponsored by *Opportunity*: a first place for his personal experience essay "Sand," a second place for his play 'Cruiter, and two honorable mentions for his poetry and two for his short stories. In a *Crisis* magazine contest that same year, he won first prize for his short story "Swamp Moccasin." By then Matheus was acquiring a reputation abroad, and his work reached more international readers when "Swamp Moccasin" and "Fog" were translated into German and French, respectively.

In 1928 Matheus accompanied Clarence Cameron White, a respected composer and music director at West Virginia State College, to Haiti to collect material on native music, folklore, and literature.

The result was Matheus's play *Tambour* (1929), for which White supplied incidental music. Matheus also penned the libretto for White's opera, *Ouanga* (1931), which would have its premiere performance in South Bend, Indiana, in 1949.

In 1930 Matheus was traveling again, this time to Africa to investigate charges of forced labor in Liberia. He served as secretary to Dr. CHARLES S. JOHNSON, American member of the International Commission of Inquiry to Liberia, which was sponsored by President Hoover, the U.S. Department of State, and the League of Nations.

After 1935 Matheus occasionally published a poem or short story, but increasingly he turned his attention to scholarly writing and service in academic associations. Among the latter, he served as treasurer of the College Language Association (1943–1975); as president of the West Virginia Chapter of the American Association of Teachers of French (1949–1950); and as president of the West Virginia Chapter of the Modern Language Teachers' Association (1952–1953). The Tau Chapter of Kappa Alpha Psi Fraternity recognized his service by awarding him its 1951 Annual Achievement Award.

Teaching also remained important to Matheus, so when offered the opportunity to use his pedagogical skills in Haiti, he seized it. From 1945 to 1946 was director of the teaching of English in the national schools of Haiti, under the Inter-American Education Foundation. While there he broadcast weekly English lessons and prepared a broadcast on American music. To reward his efforts, the Haitian government decorated him an Officier de l'Ordre Nationale ("Officer of the National Order").

Even after retiring from West Virginia State College in 1953, Matheus still wanted to teach. He came out of retirement to teach at six institutions: Maryland State College, 1953–1954; Dillard University, 1954–1957; Atlanta University System, 1957–1959; Texas Southern University, 1959–1961; Hampton Institute, 1961–1962; and Kentucky State College, 1962.

In 1965 his beloved wife, Maude Roberts, died. He married Ellen Turner Gordon in 1973 (the couple had no children.) That same year he acted as a consultant for Caribbean literature of French expression for a pre-conference workshop offered by the American Council of the Teaching of Foreign Languages. One year later he privately published a collection of his short stories.

In 1980, at the age of ninety-three, Matheus still had not slowed. He was assiduously working on his autobiography (which remains unpublished). Commenting to an interviewer at the time, he said, "I don't know how much longer I have, but as long as I have a life, I want to be working" (Morris, 6).

Matheus died a few years later in Tallahassee, Florida. With his death, the world lost not only a gifted writer but also a respected scholar, teacher, and a man who worked tirelessly for the betterment of himself and others.

FURTHER READING

Some of John Frederick Matheus's papers are housed in the Archives of Drain-Jordan Library, West Virginia State University, Institute, West Virginia; and in Special Collections at Florida A&M University, Tallahassee, Florida.

Morris, Gene. "John F. Matheus—A Man for Many Seasons," *Famuan* (29 Oct. 1980).

Obituary: Charleston (West Virginia) Daily Mail, 22 Feb. 1983.

LARRY SEAN KINDER

McCLENDON, Rose

(27 Aug. 1884–12 July 1936), actress, was born Rosalie Virginia Scott in Greenville, South Carolina, the daughter of Sandy Scott and Tena Jenkins. Around 1890 the family moved to New York City, where her parents worked for a wealthy family as a coachman and a housekeeper, respectively. An avid reader, McClendon and her brother and sister were educated at Public School No. 40 in Manhattan. Although she admitted to having no inclinations for the stage at this time, as a child she participated in plays at Sunday school and later performed in and directed plays at St. Mark's African Methodist Episcopal (AME) Church. In 1904 she married Henry Pruden McClendon, a licensed chiropractor and Pullman porter for the Pennsylvania Railroad. The couple had no children, and McClendon was content as a housewife for a number of years while also active in the community and at St. Mark's.

In 1916 McClendon received a scholarship to attend the American Academy of Dramatic Art at Carnegie Hall, studying acting under Frank Sargent and others. Three years later McClendon made her professional theatrical debut at the Davenport Theatre in New York during the 1919–1920 season, appearing in John Galsworthy's *Justice* with the

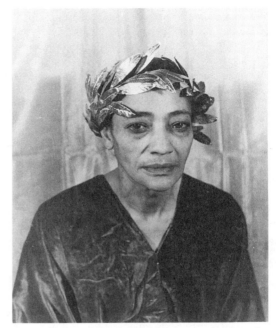

Rose McClendon, distinguished actor, director, organizer of the Negro People's Theatre, and head of the sixteen "Negro Units" of the Federal Theatre Project during the Depression, photographed as Medea in 1935. (Library of Congress/Carl Van Vechten.)

Bramhall Players. For the next fifteen years McClendon appeared in almost every important drama about black life that was produced in New York, which earned her the title of the "Negro race's first lady."

McClendon gained some critical attention in a touring production of *Roseanne* (1924), which starred CHARLES GILPIN, but it was the small role of Octavie in Laurence Stallings's and Frank Harling's *Deep River* that first brought McClendon critical success and the acknowledgment of her peers. The play opened on 21 September 1926 in Philadelphia, Pennsylvania, and on 4 October moved to New York City. As Octavie, McClendon entered and walked slowly down a grand staircase and exited through a garden—all without saying a word. Of her performance, critic John Anderson of the *New York Evening Post* said McClendon created "out of a few wisps of material an unforgettable picture" (5 Oct. 1926). In Philadelphia, the director Arthur Hopkins convinced Ethel Barrymore to "watch Rose McClendon come down those stairs," and

Barrymore later referred to McClendon's performance as "one of the memorable, immortal moments in the theatre" (*Journal of Negro History*, Jan. 1937).

On 30 December 1926 McClendon appeared as Goldie McAllister in Paul Green's Pulitzer Prize–winning play *In Abraham's Bosom* for the Provincetown Players at the Provincetown Theater, which also starred ABBIE MITCHELL and JULES BLEDSOE. The play was a success and ran for 277 performances. A revival was staged after the Pulitzer was awarded. In 1928 McClendon played Serena in Dorothy and DuBose Heyward's *Porgy*. The play had an extended run of 217 performances in New York, after which McClendon toured with the show across the country and abroad. McClendon was called "the perfect Aristocrat of Catfish Row" and won critical acclaim for her role. In 1931 she played Big Sue in Paul Green's *House of Connelly*, the first production of the Group Theatre. The production, which opened 23 February 1931, starred Franchot Tone and Morris Carnovsky and was sponsored in part by the Theatre Guild. *House of Connelly* was an immediate success and became an important part of the Group Theatre's contribution to American theater. In 1932 McClendon took the role of Mammy in *Never No More*, and for the 1933 season she played various roles in the radio series JOHN HENRY, Black River Giant.

In 1935 McClendon played Cora in LANGSTON HUGHES's *Mulatto*, which premiered at the Vanderbilt Theatre in New York on 24 October. *The Oxford Companion to American Theatre* asserts that the play itself was inferior but succeeded on the strength of McClendon's performance. Doris Abramson expressed a similar sentiment and praised McClendon, saying, "This great Negro actress brought power and dignity to the role" (Abramson, 79). The New York critics agreed. Brooks Atkinson called her "an artist with a sensitive personality and a bell-like voice. It is always a privilege to see her adding fineness of perception to the parts she takes" (*New York Times*, 25 Oct. 1935). The show ran 373 performances, a record for a play by a black author. However, ill health forced McClendon to leave the cast a few months after the opening. She died of pneumonia a year later in New York City.

Beyond her own acting, McClendon was deeply concerned with the state of the black theater art, and she used her influence to promote it during what became known as the Harlem Renaissance.

She directed productions for the Harlem Experimental Theatre, founded in 1928, and helped found in 1935 the Negro People's Theatre, which through McClendon's guidance became incorporated into the Federal Theatre Project's Black Unit in Harlem. McClendon also served on the advisory board of the Theatre Union, a nonprofit producing company founded in 1932 to produce socially significant plays at popular prices. She saw the theater as an important medium for depicting a true picture of African American life. She hoped the Federal Theatre Project support would produce quality black actors and writers.

As one of the great actresses of her time, McClendon became a strong symbol for black theater at a time when African Americans were just gaining their theatrical voice; indeed, when McClendon first appeared on the stage, blacks were not yet allowed into theater audiences. In the year after her death, the Rose McClendon Players were organized by Dick Campbell in memory of her vision for the black theater. While the company faltered after the Second World War, it launched the careers of numerous artists who would make their mark in the postwar American theater—her vision fulfilled.

FURTHER READING

McClendon's scrapbook and clippings are in the Schomburg Center for Research in Black Culture of the New York Public Library.

Abramson, Doris. *Negro Playwrights* (1969).

Bond, Frederick. *The Negro and the Drama* (1940).

Isaacs, Edith J. R. *The Negro in the American Theatre* (1947).

Obituaries: New York Times, 14 July 1936; *Afro-American* and *New York Amsterdam News*, 18 July 1936; *Journal of Negro History* (Jan. 1937).

MELISSA VICKERY-BAREFORD

McGUIRE, George Alexander

(26 Mar. 1866–10 Nov. 1934), bishop and founder of the African Orthodox Church, was born in Sweets, Antigua, British West Indies, the son of Edward Henry McGuire and Mary Elizabeth (maiden name unknown). He graduated from the Antigua branch of Mico College for Teachers in 1886. Baptized in his father's Anglican church, he was educated in the Moravian tradition of his mother, graduating in 1888 from the Moravian seminary at Nisky, St. Thomas,

in the Danish West Indies. Thereafter he pastored a Moravian congregation at Frederiksted, St. Croix. He married Ada Roberts in 1892; they had one daughter.

McGuire immigrated to the United States in 1894. The following year he was confirmed in the Protestant Episcopal Church. He studied for the Episcopal ministry under a fellow West Indian, Henry L. Phillips of Philadelphia, Pennsylvania. McGuire found himself in a church that desired to minister to African Americans but was generally unwilling to accept any blacks as equal to whites. McGuire's talent and Phillips's mentorship allowed him to advance swiftly through the offices open to him. Ordained deacon in 1896 and priest the next year, he pastored a succession of black congregations, including St. Andrew's, Cincinnati (1897–1899); St. Philip's, Richmond (1899–1901); and St. Thomas's, Philadelphia (1901–1904).

In 1905 McGuire accepted the appointment of Bishop William Montgomery Brown as archdeacon for colored work in the Diocese of Arkansas. This was the highest position open to a black man serving the church within the United States. The denomination's national General Convention, however, was considering two proposals for allowing blacks to serve as domestic bishops: the first would place black bishops in charge of all-black missionary districts independent of local dioceses; and the second would allow dioceses to elect suffragan bishops who would work under the supervision of the diocesan bishop. Soon after McGuire's arrival, Brown proposed a third plan: black Episcopalians should be separated into an independent denomination. In 1906 McGuire seems to have preferred the missionary plan; later, under his own initiative, he attempted to enact Brown's plan.

Racial conflicts in the Arkansas diocese led McGuire to accept an invitation to return to the North in 1909 to pastor St. Bartholomew's, a young congregation of West Indians in Cambridge, Massachusetts. Under McGuire's leadership the church grew dramatically, but again he was frustrated by the racism of the Episcopal Church, evident in the diocese's refusal to grant the congregation voting rights. In 1911 he moved to New York to become field secretary of the American Church Institute for Negroes. Two years later he accepted a call to serve as rector of St. Paul's Church, Falmouth, in his native Antigua.

While in the Islands McGuire encountered the ideas of racial independence and nationalism advocated by MARCUS GARVEY. These resonated with McGuire's experience of whites' inability to treat blacks as equals within the church. He returned to New York in 1919 to support Garvey's newly formed Universal Negro Improvement Association (UNIA) and African Communities League. McGuire soon established his own congregation, the Church of the Good Shepherd, which affiliated briefly with the Reformed Episcopal Church but soon united with a few other congregations to form the Independent Episcopal Church.

In August 1920 the first International Convention of the Negro Peoples of the World elected McGuire chaplain-general of the UNIA and "titular Archbishop of Ethiopia." McGuire strengthened the work of local UNIA chaplains and, according to the UNIA's *Negro World*, sought to create a church "big enough for all Negroes to enter, retaining their own worship" (2 Apr. 1921). McGuire linked Christianity and racial independence in *The Universal Negro Catechism* (1921) and *The Universal Negro Ritual* (1921), which he composed for the UNIA. The catechism taught that if one "had to think or speak of the color of God" it should be described "as black since we are created in His image and likeness." The infant baptism rite charged the baptized to "fight manfully . . . for the freedom of his race, and the redemption of Africa unto his life's end."

The formality of the rituals did not appeal to many Protestant supporters of the UNIA, nor did McGuire's ordination of a UNIA leader as a presbyter of the church. Within a year the *Negro World* was at pains to stress, "We favor all churches, but adopt none as a UNIA Church' (16 July 1921). Although Garvey desired to unite blacks into "a great Christian confraternity," he did not want the church and hierarchy that McGuire sought to create. After a brief period of estrangement, McGuire resumed a prominent role in the UNIA, presiding over the movement's "canonization" of Jesus as the "Black Man of Sorrows" in 1924.

Unable to establish a church linked to the UNIA, McGuire sought to provide an independent black church for Anglo-Catholics. Elected bishop of the Independent Episcopal Church in September 1921, he insisted that the church be renamed the African Orthodox Church (AOC) to emphasize its racial leadership. He maintained that his new church was "neither schismatic nor heretical," but a legitimate

national or racial "branch" of the one Holy Catholic Church.

When trying to form a church linked to the UNIA, McGuire had been willing to forgo apostolic succession, but he believed this was essential to authenticate the claims of the AOC. Refused consecration by Episcopal, Catholic, and Russian Orthodox bishops, he finally received it from Joseph René Vilatte of the Old Catholic Church of America. Having an autonomous church headed by a black bishop in apostolic succession was a great source of pride for McGuire and his followers, but the questionable authenticity of Vilatte's consecrations haunted their relations with other churches.

McGuire crafted a liturgy for his church based largely on the Book of Common Prayer and Anglo-Catholic practices, but also incorporating a few elements from Eastern Orthodoxy. The liturgy included prayers for the race and the redemption of Africa, though less pronounced than those in *The Universal Negro Ritual*. McGuire also founded Endich Theological Seminary in 1923 and edited the church's monthly *Negro Churchman* from 1923 to 1931. By the mid-1920s church membership numbered twelve thousand, with congregations in the northeastern United States, Nova Scotia, and the Caribbean. In 1927 McGuire was raised to the rank of patriarch and expanded the church to South Africa by receiving a few congregations and consecrating their leader, Daniel William Alexander, as bishop. McGuire died in New York City as head of a slowly expanding church.

McGuire broke new ground in extending the autonomy enjoyed by many black Protestants to black Anglo-Catholics. He was among the most important religious leaders in Garvey's movement and a talented member of the corps of West Indian clergy serving the Episcopal Church in the United States. The churches led by Alexander in Africa proved to be an enduring and significant presence on that continent. Yet in the United States the AOC became a small, though enduring, community of less than six thousand people. As a black church leader who boasted of a claim to apostolic succession that few recognized, McGuire remained a marginal figure in both the church and predominantly Protestant black America.

FURTHER READING

McGuire, George Alexander. *The Universal Negro Catechism* (1921).

McGuire, George Alexander. *The Universal Negro Ritual* (1921).

Burkett, Randall K. *Black Redemption: Churchmen Speak for the Garvey Movement* (1978).

Burkett, Randall K. *Garveyism as a Religious Movement: The Institutionalization of Black Civil Religion* (1978).

Farajajé-Jones, Elias. *In Search of Zion: The Spiritual Significance of Africa in Black Religious Movements* (1990).

Lewis, Harold T. *Yet with a Steady Beat: The African American Struggle for Recognition in the Episcopal Church* (1996).

DAVID R. BAINS

McKAY, Claude

(15 Sept. 1890–22 May 1948), poet, novelist, and journalist, was born Festus Claudius McKay in Sunny Ville, Clarendon Parish, Jamaica, the son of Thomas Francis McKay and Hannah Ann Elizabeth Edwards, farmers. The youngest of eleven children, McKay was sent at an early age to live with his oldest brother, a schoolteacher, so that he could be given the best education available. An avid reader, McKay began to write poetry at the age of ten. In 1906 he decided to enter a trade school, but when the school was destroyed by an earthquake he became apprenticed to a carriage- and cabinet-maker; a brief period in the constabulary followed. In 1907 McKay came to the attention of Walter Jekyll, an English gentleman residing in Jamaica who became his mentor, encouraging him to write dialect verse. Jekyll later set some of McKay's verse to music. By the time he immigrated to the United States in 1912, McKay had established himself as a poet, publishing two volumes of dialect verse, *Songs of Jamaica* (1912) and *Constab Ballads* (1912).

Having heard favorable reports of the work of BOOKER T. WASHINGTON, McKay enrolled at Tuskegee Institute in Alabama with the intention of studying agronomy; it was here that he first encountered the harsh realities of American racism, which would form the basis for much of his subsequent writing. He soon left Tuskegee for Kansas State College in Manhattan, Kansas. In 1914 a financial gift from Jekyll enabled him to move to New York, where he invested in a restaurant and married his childhood sweetheart, Eulalie Imelda Lewars. Neither venture lasted a year, and Lewars returned to Jamaica to give birth to their daughter. McKay

was forced to take a series of menial jobs. He was finally able to publish two poems, "Invocation" and "The Harlem Dancer," under a pseudonym in 1917. McKay's talent as a lyric poet earned him recognition, particularly from Frank Harris, editor of *Pearson's* magazine, and Max Eastman, editor of the *Liberator*, a socialist journal; both became instrumental in McKay's early career.

As a socialist, McKay eventually became an editor at the *Liberator*, in addition to writing various articles for a number of left-wing publications. During the period of racial violence against blacks known as the Red Summer of 1919, McKay wrote one of his best-known poems, the sonnet "If We Must Die," an anthem of resistance later quoted by Winston Churchill during World War II. "Baptism," "The White House," and "The Lynching," all sonnets, also exemplify some of McKay's finest protest poetry. The generation of poets who formed the core of the Harlem Renaissance, including LANGSTON HUGHES and COUNTÉE CULLEN, identified McKay as a leading inspirational force, even though he did not write modern verse. His innovation lay in the directness with which he spoke of racial issues and his choice of the working class, rather than the middle class, as his focus.

McKay resided in England from 1919 through 1921, then returned to the United States. While in England, he was employed by the British socialist journal *Workers' Dreadnought*, and published a book of verse, *Spring in New Hampshire*, which was released in an expanded version in the United States in 1922. The same year, *Harlem Shadows*, perhaps his most significant poetry collection, appeared. McKay then began a twelve-year sojourn through Europe, the Soviet Union, and Africa, a period marked by poverty and illness. While in the Soviet Union he compiled his journalistic essays into a book, *The Negroes in America*, which was not published in the United States until 1979. For a time he was buoyed by the success of his first published novel, *Home to Harlem* (1928), which was critically acclaimed but engendered controversy for its frank portrayal of the underside of Harlem life.

His next novel, *Banjo: A Story without a Plot* (1929), followed the exploits of an expatriate African American musician in Marseille, a locale McKay knew well. This novel and McKay's presence in France influenced Léopold Sédar Senghor, Aimé Césaire, and other pioneers of the Negritude literary movement that took hold in French West Africa

and the West Indies. *Banjo* did not sell well. Neither did *Gingertown* (1932), a short story collection, or *Banana Bottom* (1933). Often identified as McKay's finest novel, *Banana Bottom* tells the story of Bita Plant, who returns to Jamaica after being educated in England and struggles to form an identity that reconciles the aesthetic values imposed upon her with her appreciation for her native roots.

McKay had moved to Morocco in 1930, but his financial situation forced him to return to the United States in 1934. He gained acceptance to the Federal Writers' Project in 1936 and completed his autobiography, *A Long Way from Home*, in 1937. Although no longer sympathetic toward communism, he remained a socialist, publishing essays and articles in the *Nation*, the *New Leader*, and the *New York Amsterdam News*. In 1940 McKay produced a nonfiction work, *Harlem: Negro Metropolis*, which gained little attention but has remained an important historical source. Never able to regain the stature he had achieved during the 1920s, McKay blamed his chronic financial difficulties on his race and his failure to obtain academic credentials and associations.

McKay never returned to the homeland he left in 1912. He became a U.S. citizen in 1940. High blood pressure and heart disease led to a steady physical decline, and in a move that surprised his friends, McKay abandoned his lifelong agnosticism and embraced Catholicism. In 1944 he left New York for Chicago, where he worked for the Catholic Youth Organization. He eventually succumbed to congestive heart failure in Chicago. His second autobiography, *My Green Hills of Jamaica*, was published posthumously in 1979.

Assessments of McKay's lasting influence vary. To McKay's contemporaries, such as JAMES WELDON JOHNSON, "Claude McKay's poetry was one of the great forces in bringing about what is often called the 'Negro Literary Renaissance.'" While his novels and autobiographies have found an increasing audience in recent years, modern critics appear to concur with ARTHUR P. DAVIS that McKay's greatest literary contributions are found among his early sonnets and lyrics. McKay ended *A Long Way from Home* with this assessment of himself: "I have nothing to give but my singing. All my life I have been a troubadour wanderer, nourishing myself mainly on the poetry of existence. And all I offer here is the distilled poetry of my experience."

FURTHER READING

The bulk of McKay's papers is located in the James Weldon Johnson Collection at Yale University.

Bronz, Stephen H. *Roots of Negro Racial Consciousness: The 1920s, Three Harlem Renaissance Authors* (1964).

Cooper, Wayne F. *Claude McKay: Rebel Sojourner in the Harlem Renaissance, a Biography* (1987).

Cooper, Wayne F., ed. *The Passion of Claude McKay* (1973).

Gayle, Addison. *Claude McKay: The Black Poet at War* (1972).

Giles, James R. *Claude McKay* (1976).

Tillary, Tyrone. *Claude McKay: A Black Poet's Struggle for Identity* (1992).

Obituary: New York Times, 24 May 1948.

FREDA SCOTT GILES

McKINNEY, Nina Mae

(12 June 1912?–3 May 1967), actress, singer, and dancer, was born Nannie Mayme McKinney in Lancaster, South Carolina. Her father Hal McKinney was a postal worker; not much is known about her mother, Georgia Crawford McKinney. McKinney's early life is also a mystery, including her birth year, which has been listed as both 1912 and 1913. When McKinney was a child, her parents moved to New York, and she was raised by either her grandmother or a great aunt in South Carolina. Other sources suggest that she was raised in Philadelphia.

McKinney's parents sent for her when she was twelve or thirteen years old. She fell in love with New York and immediately began looking for venues in which to express her natural showmanship. At the age of seventeen, she won a part in the chorus of the musical revue *Blackbirds of 1928*. During this time she took on the stage name "Nina Mae McKinney."

After the film director King Vidor saw her perform in *Blackbirds*, he cast her in the leading role of Chick for the first all-black musical, *Hallelujah*, produced by MGM studios. The role proved important for African American women in film because it was the first time a black woman appeared in a leading role and was portrayed as a beautiful seductress rather than as an asexual mammy. It unfortunately also helped support the stereotypes of the overly sexual African American woman.

Historians also differ concerning Vidor's choice of McKinney for the role. In her essay on McKinney in *Notable Black American Women*, Nagueyalti Warren writes that actress "Honey" Brown was Vidor's original choice for the role he chose McKinney to replace her (Warren, 707). Donald Bogle in *Toms, Coons, Mulattoes, Mammies & Bucks* states Vidor's first choice was singer and dancer ETHEL WATERS (Bogle, 31). In fact, both sources are correct: Waters was Vidor's first choice, however, he next considered Brown, another actress from *Blackbirds of 1928*. After seeing McKinney's *Blackbirds'* performance, Vidor had both Brown and McKinney go through a round of auditions resulting in McKinney winning the historic role.

Hallelujah, set in the rural South, showcased every conceivable stereotype of African Americans under the guise of revealing true African American folk culture. Featuring songs written by Irving Berlin and W. C. HANDY and performed by the Dixie Jubilee Choir, the story focused on a southern Christian family whose older son, played by DANIEL L. HAYNES, loses his way in the arms of a beautiful, seductive cabaret singer but ultimately repents of his sins and finds redemption.

Before Lena Horne, Fredi Washington, and Dorothy Dandridge, there was McKinney. Young, beautiful, and light-skinned, McKinney physically fit the "mulatto" stereotype. Her performance in *Hallelujah* included singing Berlin's "Swanee Shuffle" and Handy's "St. Louis Blues." McKinney was a self-taught dancer and singer, and her hands-on-hips-swinging dance that accompanied her rendition of "Swanee Shuffle" became a show business legend. She received such rave reviews that MGM signed her to a five-year contract.

Throughout that contract McKinney had only minor roles in two movies: *Safe in Hell* (1931) and *Reckless* (1935). Actually McKinney did not appear in the latter; instead, her voice was dubbed in for a song "sung" by Jean Harlow (considered to be one of many white actresses who imitated McKinney's movements and gestures). Although Hollywood was not comfortable promoting an African American woman as a leading lady, McKinney continued to act in non-Hollywood and independently produced black films such as *Gang Smashers* (1938), with Mantan Moreland, *The Devil's Daughter* (1939), and *Straight to Heaven* (1939) among others. Even so she never achieved the stardom she deserved.

Using her triple threat skills as an actress-dancer-singer, McKinney worked in Europe, where she

found her talents to be more appreciated than in the States. Labeled the "Black Garbo," McKinney toured cabarets and clubs in Paris, London, Greece, Dublin, and Budapest with her accompanist Garland Wilson. While in England, she met and co-starred with PAUL ROBESON in *Sanders of the River* (1935). Some of her other films include *Pie, Pie Blackbird* (1932), with ragtime pianist and composer EUBIE BLAKE, *Dark Waters* (1944), *Night Train to Memphis* (1946), and *Danger Street* (1947).

In 1940 McKinney married jazz musician Jimmy Monroe and went on a national tour with her own jazz band. It was not until 1949 that McKinney appeared in her second major film, Elia Kazan's *Pinky*, about a light-skinned African American woman who has been passing as white. In the historic and controversial movie McKinney had a supporting role as a hardened, razor-carrying woman who threatens the lead character. Fame still eluded her, and she returned to live and work in Greece, where she was known as the "Queen of the Night."

During her film, stage, and musical career, McKinney appeared in more than twenty productions. Considered by fans and scholars to be Hollywood's first black goddess, McKinney returned to the United States in the 1960s. She died of a heart attack, virtually unknown, in New York City. In 1978 her legacy was revived, however, when she was inducted into the Black Filmmakers Hall of Fame.

FURTHER READING

Bogle, Donald. *Toms, Coons, Mulattoes, Mammies & Bucks: An Interpretive History of Blacks in American Films* (1991).

Chilton, John. *Who's Who of Jazz: Storyville to Swing Street* (1979).

Warren, Nagueyalti. "Nina McKinney," *Notable Black American Women*, ed. Jessie Carney Smith (1992).

JONETTE O'KELLEY MILLER

MICHEAUX, Oscar

(2 Jan. 1884–1 Apr. 1951), filmmaker, writer, and entrepreneur, was born on a farm near Metropolis, Illinois, the fifth of eleven children of the former slaves Calvin Swan Micheaux and Belle Willingham. After leaving home at age sixteen and working in several southern Illinois towns, he moved to Chicago and opened a shoe-shine stand in a white barbershop. Contacts he made there led to a job as a Pullman porter. Train porters were assigned

to passengers for the length of their travel, and Micheaux took full advantage of the opportunity to mingle with wealthy whites and watch while they conducted business.

Micheaux fell in love with the Northwest and Great Plains while working the Chicago-to-Portland run, and in 1905 he used his savings to purchase land in southern South Dakota, on the newly opened Rosebud Sioux Indian reservation. By age twenty-five he had amassed five hundred acres and began publishing articles in the *Chicago Defender* with titles like "Colored Americans Too Slow to Take Advantage of Great Land Opportunities Given Free by the Government," urging African Americans to follow in his footsteps and take up homesteading. Micheaux's homespun "Go west, young black man" philosophy combined elements of Frederick Jackson Turner's "frontier thesis," principles of American exceptionalism and individualism, and BOOKER T. WASHINGTON's belief in racial

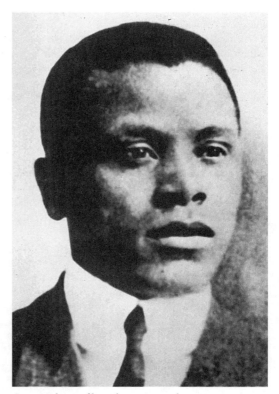

Oscar Micheaux, filmmaker, writer, and entrepreneur, in an undated photograph. (AP Images.)

uplift through self-reliance, "brains, property, and character." His confidence in the curative power of the western frontier and the successful pioneer formed the foundation of Micheaux's future efforts and attitudes.

In 1910 Micheaux married Orlean McCracken, the daughter of a Chicago minister who became the model for the villainous clergyman later depicted in Micheaux's films. Unhappy with pioneer life, she left the marriage within a year. Micheaux's bad luck continued with foreclosures of his land in 1912, 1913, and 1914. Looking for a new source of income, he wrote *The Conquest: The Story of a Negro Pioneer*, a thinly veiled autobiographical novel about the experiences of Oscar Devereaux, a lone African American homesteader in South Dakota. Micheaux, who had begun marketing the book even before its completion in 1913, sold copies door-to-door throughout the Great Plains and South. Sales were good, and he formed his own company, the Western Book Supply Company, through which he published and distributed two more semiautobiographical novels: *The Forged Note: A Romance of the Darker Races* (1915) and *The Homesteader* (1917).

In 1918 the Lincoln Motion Pictures Company, which had been established three years earlier by the African American brothers Nobel and George Johnson, approached Micheaux about filming *The Homesteader*. After the brothers refused to let him direct the picture, Micheaux decided to make the film himself. He renamed his business the Micheaux Book and Film Company and raised fifteen thousand dollars by convincing small investors of the market potential for black films. *The Homesteader* (1919), an eight-reel silent film melodrama of love, murder, suicide, and passing, was the longest African American feature film produced by that date. Micheaux used photos of himself and ad copy that spoke directly to issues of race, "Every Race man and woman should cast aside their skepticism regarding the Negro's ability as a motion picture star, and go." His second film, *Within Our Gates* (1920), included a graphic scene of the lynching of an African American sharecropper, prompting consternation from both blacks and whites. He followed with *The Brute* (1920), starring the black boxer Sam Langford, and the controversial film *The Symbol of the Unconquered* (1920), featuring a hero who strikes oil in the West and fights the Ku Klux Klan.

Micheaux produced an average of two pictures a year throughout the 1920s, including *The Gunsaulus Mystery* (1921), a reworking of the events surrounding the 1913 lynching of the Jewish Atlantan Leo Frank; *The Virgin of the Seminole* (1922), whose young black protagonist becomes a Canadian Mountie and successful ranchero; and *Deceit* (1923), the story of a black filmmaker, Alfred DuBois, who clashes with censors. Micheaux gave PAUL ROBESON his first screen role in *Body and Soul* (1925) and became the first black filmmaker to use African American source material with *The House behind the Cedars* (1924), based on Charles W. Chesnutt's 1900 novel of the same name. The filmmaker also adapted several plays by the African American sailor Henry Francis Downing as well as the 1922 novel *Birthright* by the white southerner T. S. Stribling.

With more than twenty films in distribution, Micheaux filed for bankruptcy in 1928. Undeterred, he reemerged a year later as Micheaux Pictures, this time with backing from whites. By 1931, when he released *The Exile*, the first all-sound film made by an African American filmmaker, most black moviemakers were closing up shop. The advent of sound and Hollywood's foray into black-cast films were severely challenging the commercial viability of race movies. Micheaux responded by recycling material and themes and by remaking a half dozen of his silent films into "talkies." With a nod to Hollywood, he produced the musicals *The Darktown Revue* (1931) and *Swing!* (1938), and he introduced musical sequences and nightclub settings into his melodramas, suspense films, and gangster movies.

Micheaux suspended film production during World War II and returned to writing. Of the four novels he published in quick succession, *The Wind from Nowhere* (1944), proved the most successful, and he used the proceeds to make America's last race film, *The Betrayal* (1948). Although it was promoted as the "Greatest Negro photoplay of all time," audiences' apathy and poor critical reception doomed the picture and, with it, the last vestiges of race films.

While only thirteen of his films survive, Micheaux produced at least thirty-eight and perhaps as many as fifty films, making him the most prolific African American filmmaker. Working on the margins of a new medium, he told stories from a black perspective, populated by black characters. Micheaux, who entered the film business with little education and no contacts, succeeded by sheer entrepreneurial skill, creative vision, and salesmanship. He parlayed door-to-door sales into

a grassroots promotional machine that both max-imized the opportunities offered by established urban movie theaters catering to black audiences and introduced distribution and exhibition routes into underserved areas. Sweeping into town in a chauffeur-driven car, wearing a long fur coat and a wide-brimmed hat, Micheaux created a mystique around himself and a hunger for his films. He made extensive use of the African American press and built a following for his stars, in part through a star system modeled after white Hollywood, promoting LORENZO TUCKER as the "black Valentino," Slick Chester as the "colored Cagney," and Bee Freeman as the "sepia Mae West."

Courting controversy, Micheaux introduced into his films such explosive subjects as rape, church corruption, racial violence, and miscegena-tion. Protests were customary, and censor boards routinely rejected or severely edited the films. In a typical ruling, Virginia's censor board rejected *Son of Satan* (1924), claiming: "It touches unpleasantly on miscegenation. Furthermore, many of its scenes and sub-titles will prove irritating if not hurtful alike to quadroons, octoroons, half-breeds and those of pure African descent. . . . there is the intermingling of the two races which would prove offensive to Southern ideas . . . [and the riot scenes] smack far too much of realism and race hatred" (Bowser, *Oscar Micheaux and His Circle*, 252). Micheaux turned protestations into promotion, advertising "banned" films and "uncensored" versions and aggressively selling his films' racial themes, which he often tied to current events of significance to African Amer-icans. Advertisements for *The Homesteader* called the film "a powerful drama . . . into which has been deftly woven the most subtle of all Amer-ica's problems—THE RACE QUESTION," while ads for *The Dungeon* (1922) linked the film to the fed-eral antilynching bill, known as the Dyer Bill. Sev-eral years later, promotion for *The House behind the Cedars* remarked on its parallel to the 1925 Leonard "Kip" Rhinelander case, in which a man sued for annulment after discovering that his wife was black.

Limited resources necessarily compromised qual-ity, and the production values of Micheaux's films were poor. Crews were often hired by the day, with multiple camera operators working on the same film. Mixing professionals with amateurs was common. Action was generally filmed in one take, without benefit of rehearsal, and limited to one set, filmed on borrowed locations. To meet hurried production schedules, Micheaux edited his films based on the footage available, some-times reediting, retitling, and rereleasing exist-ing films. As Thomas Cripps explains, "It was as though [PAUL LAURENCE] DUNBAR or LANGSTON HUGHES published their first drafts without ben-efit of editing, their flair and genius muffled in casual first strikes" (183). A few contemporary schol-ars have disagreed, arguing instead that Micheaux was a maverick aesthetic stylist who intentionally eschewed what is now called Classic Hollywood Style.

Criticisms of Micheaux and his films from African Americans in general and the black press in particular began in the 1920s and became increas-ingly common by the 1930s. These voices decried what they perceived as Micheaux's preference for light-skinned actors, his "negative" depictions of African Americans, and the poor quality of his productions. Threats of protest and boycott often hung over the release of his films. A black critic voiced the concern of many when he took the film-maker to task for his "intraracial color fetishism" where "all the noble characters are high yellow; all the ignoble ones are black" (*New York Ams-terdam News*, 1930). Occasionally, censure came from outside the black community. Upon the release of *God's Stepchildren* (1938), the Young Com-munist League charged that the film "slandered Negroes, holding them up to ridicule" and set "light-skinned Negroes against their darker brothers" (Cripps, 342).

Micheaux died in 1951 in Charlotte, North Car-olina, while on a promotional tour. He was sur-vived by his wife of twenty-five years, Alice B. Russell, an actress who had appeared in and pro-duced a number of his films. Despite, and perhaps owing to, the fact that audiences continue to argue about Micheaux's depictions of African Americans and African American life, his work remains pow-erfully relevant. An alternative to popular media images of African Americans, Micheaux's films offered unusually complex, sophisticated, and var-ied representations.

FURTHER READING
Bowser, Pearl, Jane Gaines, and Charles Musser, eds. *Oscar Micheaux and His Circle: African American Filmmaking and Race Cinema of the Silent Era* (2001).

Bowser, Pearl, and Louis Spence. *Writing Himself into History: Oscar Micheaux, His Silent Films, and His Audiences* (2000).

Cripps, Thomas. *Slow Fade to Black: The Negro in American Film, 1900–1942* (1977, 1993).

<div align="right">LISA E. RIVO</div>

MILES, Lizzie

(31 Mar. 1895–17 Mar. 1963), blues singer, was born Elizabeth Mary Landreaux Miles in New Orleans, Louisiana, the daughter of J. C. Miles, whose occupation is unknown. Her mother was a singer, whose name is unknown (Landreaux, presumably). Lizzie's stepbrothers were the trumpeter Herb Morand, who at some point during the 1920s played in New York in a band accompanying Lizzie, and the drummer Maurice Morand. Lizzie first sang in church at age five. She also sang in school before dropping out to perform at parties and dances. From 1909 to 1911 she sang with the cornetist KING OLIVER, the trombonist KID ORY, the trumpeter Bunk Johnson, and the violinist Armand John Piron at numerous venues in New Orleans. Around this time she married; no other details are known. Her second marriage was to August Pajaud; again, details are unknown.

Miles toured southern theaters as a member of the Benbow Stock Company. She rode elephants and other animals while traveling with the Jones Brothers and Wilson Circus, which billed her as "Queen Elleezzee," and the Cole Brothers Circus. She then toured with the Alabama Minstrels and the Rabbit Foot Minstrels. She sang with the pianist Manuel Manetta in New Orleans in 1917, and around this time she began working as a song plugger for the composer and publisher CLARENCE WILLIAMS. The sequence of these activities is unclear, as are reports of a serious illness, perhaps a heart attack, in 1918 or 1919, when she was with the pianist George Thomas's band at the Pythian Temple Roof Garden in New Orleans. Evidently Miles had to stop singing for some time.

In 1921 Miles was in Chicago, where she continued to promote Williams's songs. She sang with Oliver at the Dreamland Ballroom, as well as in bands led by Freddie Keppard, Carroll Dickerson, Wilbur Sweatman, Charlie Elgar, and Glover Compton. Late that year she moved to New York City, where in February 1922 she made her first recordings, "Muscle Shoals Blues" and "She Walked Right Up and Took My Man Away." While in New York she recorded regularly into 1923; she sang with Piron's orchestra at the Cotton Club that same year, and in 1924 she sang with Sam Wooding's orchestra at the Nest Club. She performed in Paris at the nightclub Chez Mitchell, where she was billed as *La rose noire*, and she toured Europe into 1925, at which time she returned to New Orleans to perform with the New Orleans Creole Jazz Band.

While singing in New York clubs from 1926 to 1931, Miles resumed recording. Her work included a session accompanied by Oliver's trio in 1928, "I Hate a Man like You" and "Don't Tell Me Nothin' 'bout My Man" with the pianist JELLY ROLL MORTON late in 1929, and "My Man o'War" and "Electrician Blues" with the pianist Harry Brooks early in 1930. Early in the 1930s she appeared in two little-known films, *The Stardust Ring* and *Tick Tack Toe*, but from 1931 she was mainly inactive, initially because of a serious lung illness and then because of her determination to stick to a religious resolution that if she recovered from her illness—she did—she would cease touring in stage shows.

In 1935 Miles resumed regular nightclub work, performing with the drummer Paul Barbarin at the Strollers Club in New York. She sang with FATS WALLER in New York in 1938 and then began working in Chicago, where the following year she recorded "Stranger Blues" and "Twenty Grand Blues." Miles performed in Chicago until 1942 and then left music for the remainder of the decade.

Ending her retirement in 1950, Miles performed with the band of the clarinetist George Lewis at the Hangover Club in San Francisco from 1953 to 1954; at the Blue Note Club in Chicago in 1954; with the band of the trumpeter Bob Scobey in the San Francisco Bay Area, the Los Angeles area, and Las Vegas from 1955 to 1957; with the band of the clarinetist Joe Darensbourg in San Francisco in 1958; and at the Monterey Jazz Festivals of 1958 and 1959. She also worked regularly in New Orleans, including residencies at the Parisian Room and with the band of the drummer Freddie Kohlman at the Mardi Gras Lounge (both perhaps before the engagement in San Francisco, although the chronology is unclear), as well as in 1958 with Barbarin on a riverboat.

During the final segment of her career Miles recorded two titles at a session with the trumpeter Sharkey Bonano in 1952, several tracks on the album *George Lewis Live at the Hangover Club* (1953–1954), and her own albums *Moans and Blues, Hot Songs My Mother Taught Me* (both c. 1954), *Torchy*

Lullabies My Mother Sang Me (c. 1955), and *Music from Bourbon Street*, with Scobey's band (1956). She also appeared on Paul Gregory's network television show and in 1957 sang on a Voice of America broadcast.

Miles retired to New Orleans in 1959 and became active with the Sisters of Holy Family Chapel and Jesuit Church. She died in New Orleans.

Miles sang in English, in Louisiana Creole patois (known as "gombo French"), and in a Creole that is closer to Parisian French. Like other classic female blues and vaudeville singers, Miles often performed sexy lyrics replete with double entendres of the sort popularized during the latter half of the 1920s. Miles occasionally pushed what was, in her lifetime, the boundary of propriety, passing from the risqué into obscenity, but compared to many twenty-first century lyrics, hers are not shocking.

A characteristically cynical Darensbourg remembered Miles thus:

> She was a typical New Orleans broad, just as evil as hell. What's that song? *Go to church all day Sunday and barrel-house all day Monday.* That was Lizzie. She was supposed to be a great church broad, went to church almost every day, yet she had a young-assed pimp on the side, taking all her money. (151)

Interviewer Berta Wood painted a much brighter portrait, recalling Miles's "zest and seemingly boundless energy" and that she was "a virtuoso conversationalist." Wood continued:

> She skims, dips, wheels about, breaks up with laughter and darts off again with such rapidity that it would take an ambidextrous shorthand writer to come out about even with her. . . . Her incredible mental agility and powerful spirit are the natural manifestations of a woman who does her own thinking.

FURTHER READING

Dahl, Linda. *Stormy Weather: The Music and Lives of a Century of Jazzwomen* (1984).

Darensbourg, Joe. *Telling It Like It Is*, ed. Peter Vacher (1987).

Stewart-Baxter, Derrick. *Ma Rainey and the Classic Blues Singers* (1970).

Wood, Berta. "Lizzie Miles from New Orleans," *Jazz Journal* (June 1957).

BARRY KERNFELD

MILEY, Bubber

(3 Apr. 1903–20 May 1932), jazz trumpeter and composer, was born James Wesley Miley in Aiken, South Carolina, the son of Valentine Miley, an amateur guitarist. Nothing is known of his mother, but his three sisters sang professionally as the South Carolina Trio. In 1909 the family moved to the San Juan Hill section of Manhattan, where at age fourteen Miley began studying trombone and cornet in school.

In 1918 he enlisted in the navy and after eighteen months of duty started playing locally with the Carolina Five and in Harlem with the pianist Willie Gant. In late 1921 Miley replaced Johnny Dunn, then New York's leading trumpeter, in the vaudevillian blues singer MAMIE SMITH's Jazz Hounds and did much traveling and some recording with her popular act. At this time Miley was playing in the stiff, ragtime-based style common to early New York jazzmen. While on tour with Smith in mid-1922 he heard the cornetist KING OLIVER's Creole Jazz Band at the Lincoln Gardens in Chicago. Deeply impressed with both the rhythmic drive of authentic New Orleans jazz and Oliver's use of blues inflections and the "wa-wa" plunger mute, Miley quickly began to incorporate these elements into his own playing.

In December 1922 he left the Jazz Hounds and played at O'Connor's in Harlem and Reisenweber's in Manhattan before going on tour with *The Sunny South* revue. Following his childhood friend, the trombonist Charlie Irvis, in September 1923 Miley joined ELMER SNOWDEN's Washingtonians at the Hollywood Club in Times Square, but the following February Snowden was ousted from the band, and its leadership was turned over to the group's pianist, DUKE ELLINGTON. In spring 1924 Ellington added the New Orleans clarinetist and soprano saxist SIDNEY BECHET to the band. However, because of his temperamental nature, frequent lateness, and ongoing friction with Miley and Irvis, Bechet was fired in the late summer, but he had wielded a powerful stylistic influence on both Miley and Ellington during his brief stay. In addition to their gigs at the Hollywood Club—remodeled and reopened as the Club Kentucky or, more popularly, the Kentucky Club—the Washingtonians also played in Harlem and at venues throughout New England.

Between 1923 and 1928 Miley also freelanced as an accompanist on many blues record dates, as well as recording with the Kansas City Five, the

Texas Blues Destroyers, and CLARENCE WILLIAMS. Although few of the singers or other musicians involved in the earlier New York sessions were experienced in southern blues expression, by 1924 Miley had already succeeded in adapting Oliver's blues inflections, plunger mute facility, and rhythmic swing to the staccato attack and double-timed triplets that were his legacy from Dunn. By this time he had also contributed an element of his own to this synthesis, the pronounced guttural rasp known as "growling," a timbral effect that quickly distinguished him from his colleagues. Miley first recorded with the Washingtonians in November 1924 and again in June 1926, but the results are, with the exception of a fairly competent solo on "Animal Crackers," largely unimpressive, primarily because of Ellingtonown band style, one still rooted in the rigid, unswinging, bouncy syncopations of white dance bands. Ellington did, however, continue to assimilate the lessons learned from Bechet's earlier example, and he recognized Miley as his most promising jazz soloist and a valuable source of melodic ideas and orchestral color.

After November 1926 the band's musical identity started to develop at a fairly rapid pace, largely because of Miley but also because of some important changes and additions in personnel. The trombonist Joe "Tricky Sam" Nanton, a ready student of Miley's plunger-muted growling, had replaced Irvis in late June, while the addition in mid-1927 of the alto and baritone saxophonist Harry Carney and the bassist Wellman Braud and in 1928 of the clarinetist Barney Bigard and the alto saxophonist JOHNNY HODGES provided the final touches to Ellington's first stylistically integrated orchestra. Especially important was the presence of the New Orleanians Bigard and Braud, for their grounding in blues and swinging rhythm set off the necessary sparks missing from the previous lineups, while Hodges, already a confirmed disciple of Bechet's, lent a grandeur and majesty to the band's sound.

Through the combination of these unique soloists, Miley's guiding hand, and the fortuitous circumstance of the band's employment, which necessitated a steady flow of "primitivistic" music, the Ellington "jungle style" was born. Growling brass, wailing clarinets, ominously moaning saxophones, dissonant blues sonorities, and "savage" tom-tom rhythms were the basic ingredients of the style, but rather than being mere formulaic effects, they provided a colorful foundation for the melodic ideas of both Miley and the other soloists. As a major voice in shaping this revolutionary orchestral timbre, Miley was responsible either in part or in whole for the composition of "East St. Louis Toodle-Oo," "Black and Tan Fantasy," "Creole Love Call," "The Blues I Love to Sing," "Blue Bubbles," "Goin' to Town," "Doin' the Voom Voom," and perhaps several more as well. Miley's horn is prominent throughout most of Ellington's recordings through January 1929 and can also be heard in stylistically definitive solos in "Immigration Blues," "New Orleans Low-Down," "Song of the Cotton Field," "Red Hot Band," "Take It Easy," "Jubilee Stomp," "Got Everything but You," "Yellow Dog Blues," and "The Mooche."

The Ellington band played at the Kentucky Club and other venues for more than four years before entering the Cotton Club in December 1927, where they continued to present a Harlem Renaissance view of African mystique for their wealthy, all-white clientele. Like many of the sidemen, Miley was a heavy drinker, but even in this carefree, hedonistic company he stood out for his lack of professional responsibility. Like Bechet before him, he often showed up late for work, and on two occasions in 1927 he failed to appear at all for scheduled record dates. Worst of all, he was frequently absent when important club owners and bookers came to hear the band, a behavior that so tried the patience of Ellington and his manager, Irving Mills, that in January 1929 Miley was fired. His replacement was Cootie Williams, a highly flexible disciple of LOUIS ARMSTRONG who soon learned the now-essential growl technique directly from Nanton.

Miley freelanced for a while in New York and in May 1929 went to Paris with NOBLE SISSLE, in whose orchestra he narrowly escaped another encounter with the bellicose Bechet by virtue of Bechet's incarceration some months before. After two weeks with Sissle, Miley returned to New York, where he worked with Zutty Singleton's band at the Lafayette Theatre and with Allie Ross at Connie's Inn. In January 1930 the society bandleader Leo Reisman hired Miley as a featured "hot" soloist for both records and theater performances, but for the theater performances Miley was required to play behind a screen or in the guise of a special act so as not to outrage the public with the sight of a racially mixed orchestra. In 1931, though, he was asked to play onstage while accompanying the dancer Roger Pryor Dodge in Billy Rose's *Sweet and Low*.

The records that Miley made in 1930 do not always present him in ideal settings, but his solos on King Oliver's "St. James Infirmary" and JELLY ROLL MORTON's "Little Lawrence" and "Pontchatrain" from January and March 1930 are undoubtedly among his best. Apart from his work with Ellington, perhaps the most notable session of Miley's career was with Bix Beiderbecke, Joe Venuti, and Bud Freeman on a Hoagy Carmichael date in May. He also appeared on several sides with Reisman between January 1930 and June 1931, of which "What Is This Thing Called Love?" "Puttin' On the Ritz," "Happy Feet," and "Take It from Me" warrant attention. However, the six titles from his own Mileage Makers dates between May and September yield only "I Lost My Gal from Memphis," "Without You, Emaline," and "Chinnin' and Chattin' with May" as performances worth hearing. With Irving Mills's backing, in late 1931 Miley formed his own band for a *Harlem Scandals* revue at the Lincoln Theatre in Philadelphia and the Lafayette Theatre in Harlem. But he became ill during the Philadelphia run and was feeling even worse on returning home. In January 1932 he was diagnosed with tuberculosis and, weighing only seventy-six pounds, was admitted to Bellevue Hospital and then transferred to Welfare Island (later Roosevelt Island) in New York City, where he died.

Although he possessed neither the soaring passion, creativity, swing, or emotional depth of Louis Armstrong, nor the lyrical beauty, harmonic adventurousness, or stylistic self-reliance of Bix Beiderbecke, Miley nevertheless emerged as one of the three most influential trumpeters of the 1920s. As the first to develop and master a style almost wholly based on plunger-muted growl effects, his influence, both direct and indirect, can be heard in the playing of such other trumpet stylists as Sidney De Paris, Rex Stewart, Bobby Stark, Ed Allen, Henry Goodwin, Cootie Williams, RAY NANCE, HOT LIPS PAGE, and Max Kaminsky, as well as all of the trombonists who based their plunger growl techniques on what Tricky Sam Nanton had learned from Miley.

FURTHER READING

Charters, Samuel B., and Leonard Kunstadt. *Jazz: A History of the New York Scene* (1962).
Dance, Stanley. *The World of Duke Ellington* (1970).
Schuller, Gunther. *Early Jazz: Its Roots and Musical Development* (1968).

Tucker, Mark. *Ellington: The Early Years* (1991).
Tucker, Mark, ed. *The Duke Ellington Reader* (1993).

DISCOGRAPHY
Rust, Brian. *Jazz Records, 1897–1942*, 4th ed. (1978).

JACK SOHMER

MILLER, Kelly

(18 July 1863–29 Dec. 1939), educator and essayist, was born in Winnsboro, South Carolina, the son of Kelly Miller, a free black who served in the Confederate army, and Elizabeth Roberts, a slave. The sixth of ten children, Miller received his early education in one of the local primary schools established during Reconstruction and later attended the Fairfield Institute in Winnsboro from 1878 to 1880. Awarded a scholarship to Howard University, he completed the preparatory department's three-year curriculum in Latin, Greek, and mathematics in two years (1880–1882), then attended the college department at Howard University from 1882 to 1886.

After his graduation from Howard, Miller studied advanced mathematics (1886–1887) with Captain Edgar Frisby, an English mathematician at the U.S. Naval Observatory. Frisby's chief at the observatory, Simon Newcomb, who was also a professor of mathematics at Johns Hopkins University, recommended Miller for admission. The first black student admitted to Johns Hopkins, Miller studied mathematics, physics, and astronomy there from 1887 to 1889 but did not graduate because he ran out of funds. After teaching mathematics briefly at the M Street High School in Washington, D.C. (1889–1890), he was appointed to the faculty of Howard University in 1890. Five years later Miller added sociology to Howard's curriculum because he thought that the new discipline was important for developing objective analyses of the racial system in the United States. From 1895 to 1907 Miller was professor of mathematics and sociology, but he taught sociology exclusively after that, serving from 1915 to 1925 as head of the new sociology department. In 1894 Miller had married Annie May Butler, a teacher at the Baltimore Normal School; the couple had five children.

Noted for his brilliant mind, Miller rapidly became a major figure in the life of Howard University. In 1907 he was appointed dean of the College of Arts and Sciences. During his twelve-year deanship, the college grew dramatically, as the old classical curriculum was modernized and new courses in

the natural sciences and the social sciences were added. Miller's recruiting tours through the South and Mid-Atlantic states were so successful that the enrollment increased from seventy-five undergraduates in 1907 to 243 undergraduates in 1911.

Although Miller was a leader at Howard for most of his tenure there, his national importance derived from his intellectual leadership during the conflict between the "accommodationism" of BOOKER T. WASHINGTON and the "radicalism" of the nascent civil rights movement led by W. E. B. DU BOIS. Critical of Washington's famous Cotton States Exposition Address (1895) in 1896, Miller later praised Washington's emphasis on self-help and initiative. Miller remained an opponent of the exaggerated claims made on behalf of industrial education and became one of the most effective advocates of higher education for black Americans when it was attacked as inappropriate for a people whose social role was increasingly limited by statute and custom to agriculture, some skilled trades, unskilled labor, and domestic service.

In the *Educational Review, Dial, Education,* the *Journal of Social Science,* and other leading journals, Miller argued that blacks required wise leadership in the difficult political and social circumstances following the defeat of Reconstruction, and only higher education could provide such leaders. Moreover, the race required physicians, lawyers, clergymen, teachers, and other professionals whose existence was dependent on higher education. Excluded from most white colleges, black Americans would have to secure higher education in their own institutions, Miller argued, and some of them, like Howard, Fisk, and Atlanta universities, would emphasize liberal education and the professions rather than the trades and manual arts (industrial education) stressed at Hampton and Tuskegee institutes. In the debate between the advocates of collegiate and industrial education, Miller maintained that the whole matter was one of "ratio and proportion," not "fundamental controversy." Recognized as one of the most influential black educators in the nation because of his extensive writing and his leadership at Howard, Miller was sought out by both camps in the controversy but was trusted by neither because of his refusal to dogmatically support either of the rival systems.

Miller's reputation as a "philosopher of the race question" was based on his brilliant articles, published anonymously at first, on "radicals" and "conservatives" in the *Boston Transcript* (18 and 19 Sept. 1903). With some alterations, these articles later became the lead essay in his book *Race Adjustment* (1908). Miller's essays insisted on the right of black Americans to protest against the injustices that had multiplied with the rise of the white supremacy movement in the South, as the Du Bois "radicals" did, but he also advocated racial solidarity, thrift, and institution building as emphasized by the followers of Washington. Characteristically, Miller had two reputations as a public policy analyst, first as a compromiser between black radicals and conservatives, and second as a race spokesman during the prolonged crisis of disenfranchisement and the denial of civil rights by white supremacists and their elected representatives in Congress. *The Disgrace of Democracy: An Open Letter to President Woodrow Wilson,* a pamphlet published in August 1917, was Miller's most popular effort. Responding to recent race riots in Memphis and East St. Louis, Miller argued that a "democracy of race or class is no democracy at all." Writing to Wilson, he said: "It is but hollow mockery of the Negro when he is beaten and bruised in all parts of the nation and flees to the national government for asylum, to be denied relief on the basis of doubtful jurisdiction. The black man asks for protection and is given a theory of government." More than 250,000 copies of the pamphlet were sold, and military authorities banned it at army posts.

Although Miller was best known as a controversialist, he also made important but frequently overlooked contributions to the discipline of sociology. His earliest contribution was his analysis of Frederick L. Hoffman's *Race Traits and Tendencies of the American Negro,* published by the American Economic Association in 1896. Hoffman attempted to demonstrate that the social disorganization of black Americans (weak community institutions and family structure) was caused by an alleged genetic inferiority and that their correspondingly high mortality rate would result in their disappearance as an element of the American population. Miller's refutation of Hoffman's claims, *A Review of Hoffman's "Race Traits and Tendencies of the American Negro,"* published by the American Negro Academy in 1897, was based on a technical analysis of census data.

Perhaps Miller's most lasting contribution to scholarship was his pioneering advocacy of the systematic study of black people. In 1901 he proposed to the Howard board of trustees that the university

financially support the publications of the American Negro Academy, whose goals were to promote literature, science, art, higher education, and scholarly works by blacks, and to defend them against "vicious assaults." Although the board declined, it permitted the academy to meet on the campus. Convinced that Howard should use its prestige and location in Washington to become a national center for black studies, Miller planned a "Negro-Americana Museum and Library." In 1914 he persuaded Jesse E. Moorland, a Howard alumnus and Young Men's Christian Association official, to donate to Howard his large private library on blacks in Africa and in the United States as the foundation for the proposed center. This became the Moorland Foundation (reorganized in 1973 as the Moorland-Spingarn Research Center), a research library, archives, and museum that has been vital to the emergence of sound scholarship in this field.

The years after World War I were difficult ones for Miller. J. Stanley Durkee, the last of Howard's white presidents, was appointed in 1918 and set out to curtail the baronial power of the deans by building a new central administration. Miller, a conspicuously powerful dean, was demoted in 1919 to dean of a new junior college, which was later abolished in 1925. A leader in the movement to have a black president of Howard, Miller was a perennial favorite of the alumni but was never selected. Although Miller's influence at Howard declined significantly by the late 1920s through his retirement in 1934, his stature as a commentator on race relations and politics remained high. He had become alarmed by the vast social changes stimulated by World War I and was seen as increasingly conservative. He opposed the widespread abandonment of farming by black Americans and warned that the mass migration to cities would be socially and culturally destructive. At a time when many younger blacks regarded labor unions as progressive forces, Miller was skeptical of them, citing their history of persistent racial discrimination. He remained an old-fashioned American patriot despite the nation's many disappointing failures to extend democracy to black Americans. As a weekly columnist in the black press, Miller published his views in more than one hundred newspapers. By 1923 it was estimated that his columns reached a half million readers. Miller died at his home on the campus of Howard University.

FURTHER READING

A limited collection of Miller's papers, including an incomplete autobiography and a scrapbook, is at the Moorland-Spingarn Research Center at Howard University.

Eisenberg, Bernard. "The Negro Leader as a Marginal Man," *Journal of Negro History* 45 (July 1960).

Holmes, D. O. W. "Kelly Miller," *Phylon* (Second Quarter, 1945).

Meier, August. "The Racial and Educational Philosophy of Kelly Miller, 1895–1915," *Journal of Negro Education* (July 1960).

Obituary: Woodson, Carter G., *Journal of Negro History* (Jan. 1940).

MICHAEL R. WINSTON

MILLER, May

(26 Jan. 1899–8 Feb. 1995, poet, playwright, and teacher was born May Miller in Washington, D.C., the daughter of Annie May Butler and KELLY MILLER, the dean of the College of Arts and Sciences at Howard University. Little is known about the background of Miller's mother, but her father was popular among black intellectuals. The Miller home on the campus was often visited by such luminaries as the writer PAUL LAURENCE DUNBAR, who once lived with the family; BOOKER T. WASHINGTON, the founder of the Tuskegee Institute; and the writer and activist W. E. B. DU BOIS, a cofounder of the National Association for the Advancement of Colored People. Miller lived in a community of college-educated blacks who worked as artists and musicians. Following the opening of the Howard Theatre in 1910, the neighborhood of Seventh and T was filled with restaurants, row houses, nightclubs, and after-hours social clubs.

Miller's father encouraged her writing career by teaching her poetry. He often quoted bits of poetry to his children, leaving them to wonder if the lines were real or something he made up on his own. Presumably, the family's large collection of books also influenced young Miller. The collection included, among others, *Oak and Ivy*, Dunbar's first volume of poetry. She began writing on her own and her first poem was published in the *Washington Post* when she was fourteen and her first play, *Pandora's Box*, was published in 1914. Miller graduated from the M Street School, a predecessor to Paul Laurence Dunbar High School, where the prominent black dramatist Mary Burrill and the poet and

playwright ANGELINA WELD GRIMKÉ were among her teachers. She studied drama at Howard, where she directed, acted, and produced plays. In 1920 Miller graduated first in her class and earned the Howard University Drama Award for her play, *Within the Shadows.*

The Harlem Renaissance, a period during which black literature and art flourished in this community, was at its peak in the 1920s. Miller often traveled between Harlem and Washington, meeting poets like LANGSTON HUGHES and COUNTÉE CULLEN at literary gatherings. In 1925 her play *The Bog Guide* was published, followed by *Scratches* in 1929, *Stragglers in the Dust*, and *Nails and Thorns* in 1933. *The Bog Guide* and a later play, *The Cuss'd Thing*, both won prizes in the Opportunity Contest. She managed to balance her writing with her work at Baltimore's Frederick Douglass High School, where she taught English, speech, and drama. At one point in Baltimore, Miller became acquainted with the young ZORA NEALE HURSTON, whom she encouraged to attend Howard University. In 1935 four of Miller's plays were published in the anthology *Negro History in Thirteen Plays*, which she edited with Willis Richardson. It included her plays *Harriet Tubman* and *Sojourner Truth*. Miller also did postgraduate study in literature at American University and Columbia University. She was a lecturer and poet in residence at Monmouth College in Monmouth, Illinois, in 1963, the University of Wisconsin-Milwaukee in 1972, and the Phillips Exeter Academy in Exeter, New Hampshire, from 1973 to 1976. She married John "Bud" Sullivan in 1940 and added Sullivan to her name.

Heart ailments caused Miller to retire from teaching in 1945, which left her more time to write poetry. She published several volumes of verse, including *Into the Clearing* (1959), *Poems* (1962), *Lyrics of Three Women: Katie Lyle, Maude Rubin and May Miller* (1964), and *Not that Far* (1973). In the 1960s Miller became an arts coordinator for the Washington, D.C., public schools and served on the Folger Library advisory committee. Meanwhile, the modern civil rights movement was well under way. The NAACP and the Student Nonviolent Coordinating Committee (SNCC) staged sit-ins and protests at establishments that refused to serve blacks. Miller purposely kept her distance from the racial upheaval in the country and was criticized for not being more outspoken on the issue of civil rights by other writers at the time.

Miller continued to live around Washington, often reading her poems at community gatherings and telling stories about growing up in the city. She never shied away from public appearances, and in 1976 she read her poetry at the inauguration of President Jimmy Carter. She often appeared on panel discussions and was mentioned in at least one documentary, *7th and T*, which aired in May 1987, to talk about her old neighborhood, which began a downward spiral after the 1968 riots.

A resurgence of interest in Miller's work took place in the late 1980s. Miller published more of her poetry in *The Ransomed Wait* (1983), which addressed the 1963 Birmingham bombing in a poem called "Blazing Accusation." She wrote: "Beyond allotted time and self, the four of them will go down red gullies of guilt and alleys of dark memories through snagging fields of scarecrows and up an unforgetting hill to blazon accusation of an age." In 1986 she received an award from the Institute for the Preservation and Study of African American Writing. Her last work, *Collected Poems of May Miller*, was published in 1989. Miller died from pneumonia at her home in Washington, D.C., in 1995; her husband had died in 1982. Her work never gained her celebrity status, but Miller did not seem to be bothered by that fact. She once said, "If out of silence I can fill that silence with a word that will conjure up an image, then I have succeeded."

FURTHER READING
Koolish, Lynda. "Miller, May," in *The Concise Oxford Companion to African American Literature*, eds. William L. Andrews, Frances Smith Foster, and Trudier Harris (2001).

Obituary: Washington Post, 10 Feb. 1995.

SHANTEÉ WOODARDS

MILLS, Florence

(25 Jan. 1895–1 Nov. 1927), entertainer, was born Florence Winfree in Washington, D.C., the daughter of John Winfree, a carpenter, and Nellie Simons, who did laundry. Educated locally, by age five Mills was winning contests in cakewalking and buck dancing. Her first professional engagement came as Baby Florence Mills in the second company (1902) of the BERT WILLIAMS–GEORGE WILLIAM WALKER *Sons of Ham*, singing a song she had learned from its originator, Aida Overton Walker, titled "Miss

Hannah from Savannah," the tale of a high-class African American who had come north.

Mills served a lengthy apprenticeship before becoming an "overnight" sensation in *The Plantation Revue* in 1922. After several years in vaudeville with the Bonita Company as a "pick" (i.e., a pickaninny), she and her sisters, Olivia and Maude, became the vaudeville Mills Sisters. When this act broke up, Mills joined others until 1914, when she began to sing in Chicago nightclubs. The jazzman Mezz Mezzrow recalled her "grace and . . . dignified, relaxed attitude. Florence, petite and demure, just stood at ease and sang like a humming bird" (*Really the Blues*, 22).

At the Panama Club Mills formed the singing Panama Trio with Ada Smith—later known as BRICKTOP, a favorite of American expatriates in Paris—and Cora Green; the trio toured the Pantages vaudeville circuit, where in 1916 Mills joined the Tennessee Ten. After four seasons with the group as the female singer-dancer in a trio with U. S. "SLOW KID" THOMPSON and Fredi Johnson, Mills married Thompson. The year of their marriage is not firmly established, and they had no children. (She may have had an earlier marriage, in 1912, to James Randolph.)

Mills and Thompson were recruited into *Shuffle Along*, the 1921 black musical comedy by NOBLE SISSLE and EUBIE BLAKE that began a decade-long Broadway vogue for shows featuring African American performers. *Shuffle Along* lured predominantly white audiences farther "uptown" than before to the Sixty-third Street Theatre and ran for a year and a half before enjoying a two-year road tour.

Shuffle Along coincided with the general post–World War I upsurge in theatrical, musical, and literary achievement by African Americans that became known as the Harlem Renaissance. Even the poet CLAUDE MCKAY, who characterized Harlem as "the glorified servant quarters of a vast estate" in *Harlem: Negro Metropolis*, expressed the hope that *Shuffle Along* might help black performers break through the "screen of sneering bigotry" to express their authentic "warmth, color and laughter."

Replacing *Shuffle Along*'s original female star, Gertrude Saunders, Mills soon stopped the show singing "I'm Craving for That Kind of Love" with her particular blend of ethereality and sensuality. Shortly her picture appeared on the sheet music of the show's hit, "I'm Just Wild about Harry." The white entrepreneur Lew Leslie hired Mills to star in his 1922 black revue at the Plantation Club at Fiftieth and Broadway. Adding a few acts, he then moved the entire show into the Forty-eighth Street Theatre.

Sometimes dressed in feathers and sometimes in male evening clothes, Mills created a sensation, particularly by her spontaneous dancing. She said: "I just go crazy when the music starts, and I like to give the audience all it craves. I make up the dances to the songs beforehand, but then something happens like one of the orchestra talking to me and I answer back and watch the audience." The musical historian Allen Woll quoted an uncredited critic: "In that season not to have seen and heard Florence Mills was to be quite out of the know on Broadway" (*Black Musical Theatre from "Coontown" to "Dreamgirls,"* 96).

Leslie took the Plantation Revue to London in 1923 as the second (and most effective) half of an Anglo-American revue, *From Dover Street to Dixie*; Mills sang "I'm a Little Blackbird Looking for a Bluebird," a poignant piece that wrung audiences dry. The impresario Charles B. Cochran wrote of the tension on its opening night, partly due to the recent failure of another black American revue. Upon Mills's appearance, he told his companion: "She owns the house—no audience in the world can resist that. . . . [She] controlled the emotions of the audience as only a true artist can . . . there was a heart-throb in her bird-like voice . . . her thin, lithe arms and legs were animated with a dancing delirium. It was all natural art" (*Secrets of a Showman*, 97–98).

After further European touring with *Dixie*, Leslie brought an enhanced version, built around Mills, to the Shubert Organization's Broadhurst Theatre in the heart of Times Square as *Dixie to Broadway*, and Mills was also added to the *Greenwich Village Follies of 1923*. JAMES WELDON JOHNSON wrote in *Black Manhattan* that *Dixie to Broadway* "broke away entirely from the established tradition of Negro musical comedies" in starring one woman. Writing in the *New York World* (23 Nov. 1924), Lester Walton said that "the long cherished dream . . . to see a colored musical comedy successfully playing in the very heart of Broadway" had become a reality. *Dixie to Broadway*, like other African American shows of the era, however, was produced by whites, who made most of the money. Still, Mills was quoted as saying that attitudes toward "colored people" were gradually changing; she saw a great future for "high browns."

After *Dixie to Broadway*, Mills settled in Harlem amid leaders of the Renaissance such as Johnson, LANGSTON HUGHES, COUNTÉE CULLEN, ZORA NEALE HURSTON, JEAN TOOMER, WALTER WHITE, and the actor CHARLES GILPIN. In 1925 Mills turned down an offer to star in a revue at the Folies Bergère in Paris; after ETHEL WATERS also declined, JOSEPHINE BAKER took the job and became famous. The artist Miguel Covarrubias caricatured Mills, and in 1926 the classical composer WILLIAM GRANT STILL wrote a jazz piece for her. Likewise, the choreographer Buddy Bradley wrote that the prima ballerina Alicia Markova reminded him of Mills. The theater historian Loften Mitchell wrote that in the Harlem of the 1920s her name "was on the lips of everyone in the community. People sat in parlors, on stoops, or stood in hallways, trying to find words that might describe her" (*Black Drama*, 78).

Leslie's next show, *Blackbirds*, named for Mills's trademark song, was built around Mills. After six weeks early in 1926 at the Alhambra Theater in Harlem, it opened in Paris, where it ran for six months, moved to London, and continued until August 1927. With slick bobbed hair and soft eyes, she was, Cochran wrote, the only performer he had ever seen who could count on an ovation upon entry and before doing a number. The Prince of Wales confessed to seeing *Blackbirds* twenty-two times. In London there were Florence Mills dolls, and the most fashionable shade for clothing was the "Florence Mills shade." The black British jazz musician Spike Hughes, however, questioned her authenticity: whites who thought she epitomized "Negroes" also thought the for-whites-only shows at the Cotton Club in Harlem were authentic. Comparing her unfavorably with BESSIE SMITH, who sang mainly for black audiences, Hughes said he could not tell from her singing whether she was black or white, British or American.

Mills returned to New York in late September 1927, and huge crowds turned out in Harlem to greet her. The 14 October 1927 edition of the *Inter State Tatler* called on her "to give the people the one great gift within her power . . . a national, or if you please, a race drama. . . . Miss Mills can do more than anyone else to satisfy the latent, unexpressed hunger for race drama."

Mills was twice operated on for appendicitis in late October 1927 and died in New York City of peritonitis and paralyticileus resulting from the appendicitis. Tributes came from London, where the composer Constant Lambert wrote an "Elegiac Blues" for her, and Paris, where, according to the *New York Times* correspondent, she was lauded as greatest of all. More than 75,000 mourners viewed her body before her funeral, which was attended by 5,000 people in a church meant for 2,000, while thousands waited outside. The jazz composer ANDY RAZAF contributed a poem beginning "All the World is Lonely / For a Little Blackbird" and ending "Sadness rules the hour / Left us only in tears." A chorus of 500 sang to the accompaniment of a 200-piece orchestra. An estimated 150,000 watched the funeral procession. Johnson wrote: "An airplane . . . released a flock of blackbirds. . . . They fluttered overhead a few seconds and then flew away" (*Black Manhattan*, 201).

FURTHER READING
Materials concerning Florence Mills are at the Billy Rose Theatre Collection of the New York Public Library for the Performing Arts, Lincoln Center.
Clarke, John Henrik, ed. *Harlem USA* (1964).
Lewis, David Levering. *When Harlem Was in Vogue* (1997).
Sampson, Henry T. *Black in Blackface: A Source Book on Early Black Musical Shows* (1980).
Shapiro, Nat, and Nat Hentoff. *Hear Me Talkin' to Ya* (1955).

Obituary: New York Times, 2 Nov. 1927.

JAMES ROSS MOORE

MITCHELL, Abbie

(25 Sept. 1884–16 Mar. 1960), singer, actress, and teacher, was born in New York City to an African American mother and German Jewish father. Her mother died during childbirth, and Mitchell moved to Baltimore, Maryland, with her maternal aunts, Alice and Josephine, and maternal grandmother. She attended St. Elizabeth's Convent, moving back to New York with her aunt Josephine when she was twelve to study music, a musical education that continued throughout her young adulthood. Her coaches included HARRY BURLEIGH, Emilia Serrano, and Jean de Retzke.

Mitchell began her fifty-year career in the theater in 1898, singing in *Clorindy, or the Origin of the Cakewalk*, composed by WILL MARION COOK and with lyrics by PAUL LAURENCE DUNBAR. This production marked the beginning of Mitchell's lifelong

professional and personal relationship with Cook, whom she married in 1900 (Carter, 55). The couple had two children, Marion Abigail and Will Mercer, who became an ambassador and Howard University professor. The couple divorced in 1908, and according to the *New York Age*, Mitchell then married William Phillips, a Chicago Railroad employee, in 1910. According to the Chicago *Bee*, she married Leslie Tompkins, an art student, in 1926. Mitchell's unpublished memoir, however, mentions neither of these men, and her obituary identifies her as the "widow" of Cook, who died in 1944.

In addition to Cook, Mitchell collaborated with BERT WILLIAMS, GEORGE WALKER and Aida Overton Walker, J. ROSAMOND JOHNSON, ROBERT COLE, SISSIERETTA JONES ("Black Patti"), and other notable entertainers in concert tours (with Black Patti's Troubadours and the Nashville, later Memphis, Students) and musical comedies such as *Jes Lak White Folks* and *The Policy Players* (1899), *The Casino Girl* and *Sons of Ham* (1900), *Uncle Eph's Christmas* and *The Cannibal King* (1901), *Wild Rose* (1902), *In Dahomey* (1903), *The Southerners* (1904), *Abyssinia* and *My Friend from Georgia* (1906), *The Man from 'Bam* (1907), *Bandana Land* and *Panama* (1908), *The Red Moon* (1909), *The Traitor* (1913), *Darkydom* (1915), *Darktown Follies* (1916), and *Harlem Rounders* (1925). In these works, which played in New York City, Chicago, various European capitals, and other venues, Mitchell scored personal triumphs with her renditions of musical numbers like "Brown Skin Baby Mine," "Mandy Lou," and "Red, Red Rose." She was equally admired for her classical repertoire, which featured German lieder, Puccini, Gounod, and Verdi. She was the first black woman to do a single vaudeville turn at New York's Majestic Theater, in May 1910.

In 1914 Mitchell made her nonmusical debut in *The Gentleman Burglar* at the Howard Theatre in Washington, D.C. From 1916 to 1929 she became one of the leading performers, in musical and nonmusical works, of the famed Lafayette Players in Harlem. Her Lafayette credits include *Within the Law*, *Madame X*, *A Fool There Was*, *Madame Sherry*, *45 Minutes from Broadway*, *Faust*, *The Eternal Magdalene*, *Resurrection*, *Paid in Full*, *Charlie's Aunt*, *Damaged Goods*, *The Great Divide*, and *The Chocolate Soldier*. In the early 1920s Mitchell also toured the United States and Europe as a concert singer, including another collaboration with Cook as singer and bookwriter for the concert series

Negro Nuances. From 1924 to 1927 she appeared as a prima donna at the Club Alabam' in midtown Manhattan, singing semi-classics and popular ballads.

In 1926 Mitchell broke into the New York theater mainstream with her appearance in the Pulitzer Prize–winning *In Abraham's Bosom*, also featuring ROSE MCCLENDON. Mitchell developed a rewarding professional relationship with the director Jasper Deeter, later appearing regularly at his Hedgerow Theatre in Pennsylvania. In 1927 Mitchell appeared on Broadway in *Coquette* (with Helen Hayes), *House of Shadows*, and a revival of *In Abraham's Bosom*. From 1929 to 1931 she was featured as the "Studebaker Songbird" on the Studebaker Radio show. As an established dramatic and musical star Mitchell coached the aspiring performers Etta Moten, ADELAIDE HALL, FREDI WASHINGTON, and Butterfly McQueen, and from 1931 to 1934 she was head of the voice department of Tuskegee Institute. Also in 1934 she returned to the stage as Binnie in the Theatre Union's *Stevedore* (replacing GEORGETTE HARVEY), appearing later in *Cavalleria Rusticana* with Todd Duncan. In 1935 Mitchell created the role of Clara in George Gershwin's opera *Porgy and Bess*. In 1938 she became one of several outstanding actresses to star as Cora in LANGSTON HUGHES's *Mulatto*. From 1939 until 1940 Mitchell appeared with Tallulah Bankhead in *The Little Foxes*. In the summer of 1943 Mitchell was a guest artist and teacher at Atlanta University.

In Broadway productions like *Coquette* and *The Little Foxes*, Mitchell played servants, usually darkening her naturally light complexion to do so. Despite the recognition she received for imbuing such limiting roles with dignity and strength, Mitchell remained frustrated by the lack of opportunities afforded black actresses, and so throughout the 1940s she tried to create more meaningful roles for herself, organizing the Abbie Mitchell Players and presenting her own one-woman show, *HARRIET TUBMAN*, in 1944. In 1943 Mitchell directed and starred in a revival of *The Eternal Magdalene* for the Ira Aldridge Players and performed Granny in *White Dresses* for the Harlem Boys' Club. In 1943 and 1944 Mitchell directed Allan R. Kenward's *Cry Havoc*, a drama of heroic nurses on Bataan, first for her own company, then for the Frederick Douglass Players. In 1945 Mitchell performed in *Arsenic and Old Lace* at the McKinley Square Theater, a production that included the young Ruby Dee as Elaine

and Avon Long as Mortimer. The following year she returned to Broadway as Cora in *On Whitman Avenue*, a play exploring race relations and produced by CANADA LEE. In 1947 Mitchell performed the role of Lina in *The Skull beneath the Skin* at the Westport Country Playhouse.

In addition to her stage work and concert appearances Mitchell appeared in at least five films, all by black film companies: *Uncle Remus' First Visit to New York* (1914), *The Scapegoat* (1917), *Eyes of Youth* (1920), *A Night in Dixie* (1926), and *Junction 88* (1947). She was also active in the Negro Actors Guild from 1937 until the 1950s, serving as executive secretary in 1946.

Battling failing health and fading vision Mitchell continued to teach at her studio in Harlem throughout the 1950s. According to the actress Rosetta Lenoire, Mitchell was widely recognized as the "grande dame of drama," and everyone sought her coaching. (Tanner, 126). At Mitchell's memorial service in 1960 the era's leading black performers, including EUBIE BLAKE, Helen Dowdy, and Leigh Whipper, honored the "Great Lady of the Negro Theater" by singing the songs that made her famous.

FURTHER READING

Correspondence and unpublished memoirs by Mitchell and Will Marion Cook can be found in the Mercer Cook Papers, Moorland-Spingarn Collection, Howard University. Clippings files on Mitchell as well as individual productions in which she appeared can be found in the Billy Rose Theatre Collection, New York Library of the Performing Arts and the Negro Actors Guild file, Actors' clipping files, and Black Theatre Scrapbook, Schomburg Center for Research in Black Culture, New York Public Library.

Carter, Marva Griffin. "The Life and Music of Will Marion Cook," PhD diss., University of Illinois (1988).

Fletcher, Tom. *The Tom Fletcher Story: One Hundred Years of the Negro in Show Business* (1954).

Isaacs, Edith J. R. *The Negro in the American Theatre* (1947).

Sampson, Henry T. *The Ghost Walks: A Chronological History of Blacks in Show Business, 1865–1910* (1988).

Tanner, Jo A. *Dusky Maidens: The Odyssey of the Early Black Dramatic Actress* (1993).

Thompson, Mary Francesca. "The Lafayette Players: 1915–1932," PhD diss., University of Michigan (1972).

Obituaries: New York Times, 20 Mar. 1960; *New York Amsterdam News*, 26 Mar. 1960.

CHERYL BLACK

MOORE, Frederick Randolph

(16 June 1857–1 Mar. 1943), journalist and politician, was born in Prince William County, Virginia, the son of Eugene Moore and Evelina Diggs, whose occupations are unknown. Having left Virginia in early childhood, Fred Moore grew up in Washington, D.C., where he attended public schools and sold newspapers to help support himself and his family. At age eighteen he began work as a messenger for the U.S. Treasury Department, and a few years later he was the personal messenger for the secretary of the treasury. He worked under six successive secretaries and traveled to Europe in 1887 with Secretary Daniel Manning. Also in 1887 Moore resigned from the Treasury Department and moved to New York City, where he became a clerk at the Western National Bank, which later merged with the National Bank of Commerce; he held the position of clerk for eighteen years.

Moore began his career as a journalist in New York City as general manager and then editor and publisher in 1904 of the *Colored American Magazine*. Originating in Boston in 1900, the magazine changed under Moore's editorship from a mainly literary magazine into one that stressed black economic advancement. Moore's purchase of the magazine and its removal to New York were aided by the secret financial support of the influential black educator BOOKER T. WASHINGTON. Washington wanted a publication that promoted his philosophy of black economic development, and he supported editors who accepted his conservative position on black political and civil rights. Washington also wanted to silence opponents like W. E. B. DU BOIS and WILLIAM MONROE TROTTER, who condemned him repeatedly for emphasizing vocational training rather than challenging lynching, disenfranchisement, and Jim Crow legislation. Moore shared Washington's belief in cultivating economic development in the black community as a means for gaining political equality. Black unity was key to Moore's political and economic philosophy. He believed that African Americans should own their own homes and businesses in their communities. Black success in this endeavor, Moore thought, would mean political and economic equality.

Consequently, as editor of the *Colored American Magazine*, Moore explained that the new focus of the periodical was to illustrate "the successes of our people as a whole and as individuals." In this way the editor hoped that the magazine would reach "the masses of the people," not merely "those who are highly educated and cultured." The *Colored American Magazine* became a didactic tool that encouraged African Americans to become entrepreneurs and, equally important, to patronize black businesses. The majority of black Americans needed, Moore argued, "information of the doings of the members of the race rather [than] the writing of dreamers or theorists." Yet Moore did not ignore political issues. He consistently published articles and wrote editorials that condemned disenfranchisement and lynching. At the same time, Washington's public policy of accommodationism and gradualism regarding southern black political and legal rights was promoted through articles by Washington and pro-Washington writers. Tuskegee Institute, Washington's agricultural and vocational training school in Alabama, received extensive coverage. Most important, there were no longer any attacks on Washington in the *Colored American Magazine*, as there had been before Moore became editor.

In 1907 Moore again advanced through Washington's clandestine maneuvering and financial support by becoming editor and publisher of the *New York Age*. Published under various names and editors this weekly newspaper had become the most prominent black paper in the country under the editorship of T. Thomas Fortune. Fortune supported Washington's goals but not his accommodationist strategy or his loyalty to the Republican Party. Under Moore's editorship the *Age* became a much more partisan paper. However, even though he was a devoted Republican, Moore did not endorse Washington or Republican Party policies completely; in fact, he challenged them on the editorial pages of the *Age*, condemning Republican quiescence on lynching and disenfranchisement and criticizing white southern political inequities and brutality.

Moore redirected the *Age* toward his own interest in black business development, and he highlighted such activities. Numerous articles featured the successes of black businessmen and businesswomen, stressing not only their achievements but also a work ethic of industry, frugality, and sobriety.

Moreover, Moore almost entirely ignored black radicals like Du Bois, Trotter, and MARCUS GARVEY. And as he had done with the *Colored American Magazine*, which died under new editorship in 1909, Moore added special features and increased the circulation of the *Age* to about twenty-seven thousand in 1937.

After Washington's death in 1915 Moore was more outspoken in his support for southern black migration and political protest, two activities that Washington had decried. After a trip to the South Moore in 1917 urged southern blacks to agitate for fair treatment: "Now is the time for the Negroes of the South to speak out for their rights—not offensively but frankly." He began publishing speeches by liberals like ADAM CLAYTON POWELL SR., who called in 1917 for blacks to take advantage of the nation's need for manpower and wage a "bloodless war" for constitutional rights. By 1924 the *Age* focused extensively on Harlem, where Moore had moved, and it revealed his concern for social issues, including medical services for Harlem residents. In the 1920s and 1930s the *Age* supported boycotts of white Harlem merchants who refused to employ blacks in their stores, and advocated city government investment in the rehabilitation of substandard housing for the poor. Moore's last contributions to the *Age* were during the early years of U.S. involvement in World War II when he supported A. PHILIP RANDOLPH's March on Washington movement, which demanded fair employment practices in the defense industry. Still, Moore's firm belief in black economic development and black patronage of black business remained a prominent theme in the newspaper.

Moore's career in journalism coexisted with the development of his own business interests. Consistent with his philosophy of racial solidarity and black economic development, in 1893 he helped establish the Afro-American Investment and Building Company, which bought New Jersey and New York property and sold it to blacks at reasonable interest rates. By late 1904 Moore was owner of the Moore Publishing and Printing Company, which published both the *Colored American Magazine* and the *New York Age*. Moore noted with pride that the company was owned by blacks and "that all of the mechanical work of construction connected with publishing the magazine has been done by members of the race exclusively." Also in 1904 he was organizer and in the following year

he was general secretary of the National Negro Business League, an organization that Washington created to promote black business. Moore was secretary and treasurer in 1904 of an investment company, the Afro-American Realty Company, which purchased Harlem property to sell or rent to New York City blacks in need of decent housing. Although the company failed in 1908, Afro-American Realty played a significant role in creating a predominantly black Harlem community.

Moore was also a politician and community activist. Always a faithful Republican, he began his political career as district captain in his Brooklyn community. In 1904 he was appointed deputy collector of internal revenue but resigned within a few months to become an organizer of the National Negro Business League. Moore also acted as a delegate or alternate delegate to several Republican National Conventions and served on the National Negro Republican Committee from 1908 to 1920. Although he quit after three months and did not actually leave the United States, Moore was appointed minister of Liberia by President William Howard Taft in 1912. After moving to Harlem, Moore was elected to the New York City Board of Aldermen for the Nineteenth District in 1927, replacing a white incumbent. He was reelected to this position in 1929.

Moore's community activism is illustrated by the fact that until his death at age eighty-five he was president of the Parent Teacher Association of the local public school in his neighborhood. More important, Moore helped found the National Urban League in 1911. The Urban League grew out of several northern interracial urban service organizations established to help the great wave of black migrants from the South. Moore had served on the board of several of these groups and was founder and chairman of the New York Association for the Protection of Colored Women in 1905, an organization created to protect southern black women migrants from labor exploitation in the North. He was also active in the National League for the Protection of Colored Women, founded the following year.

Moore married Ida Lawrence, a native of Washington, D.C., in 1879. The Moores had eighteen children, six of whom lived to adulthood. Actively involved with the *Age* until 1942, Moore died in New York City.

FURTHER READING

Detweiler, Frederick. *The Negro Press in the United States* (1922; repr. 1968).

Meier, August. "Booker T. Washington and the Negro Press: With Special Reference to the *Colored American Magazine*," *Journal of Negro History* 38 (Jan. 1953).

Thornbrough, Emma L. "More Light on Booker T. Washington and the New York *Age*," *Journal of Negro History* 43 (Jan. 1958).

Wolseley, Roland. *The Black Press, U.S.A.* (1971).

RITA ROBERTS

MOORE, Richard Benjamin

(9 Aug. 1893–18 Aug. 1978), activist, communist, and Pan-Africanist, was born in Hastings, Christ Church, Barbados, the son of Josephine Thorn Moore and Richard Henry Moore, a building contractor. Moore's mother died when he was three, and his father married Elizabeth McLean. In 1902 Moore's father died and Moore lived with his stepmother while attending middle school. After graduating in 1905 he became an office clerk, a job he would hold at different firms until he emigrated. During this period he also converted to an evangelical Christian group led by a white American preacher.

In 1908 two of his elder sisters immigrated to New York City, and on 4 July 1909 Moore and his stepmother followed. Moore briefly secured an office assistant job at a Manhattan advertising firm until an infatuation with a white coworker caused a scandal and forced him to leave his job. He then found employment with a silk company, first as an elevator operator and later as head of the stock department. He would remain employed for this firm until 1923.

Like many Caribbean immigrants, Moore encountered racism in his new American home that was quite different from his experiences in Barbados. When he applied to take secretarial classes at a Midtown YMCA he was denied entrance. When he attempted to attend services hosted by the sister organization of the church he had joined in Barbados, he was again denied because of his race. At this time Moore was searching for answers and companionship. He helped formed a tennis club in 1911, eventually becoming its president and helping to establish the first tennis court in Harlem. Moore also became a partner in a Harlem printing

company. At the same time he read widely about American history and racism, perhaps most importantly in the *Life and Times of FREDERICK DOUGLASS* (1881). Moore would eventually become an expert on Douglass, whose tenacity and dedication to black liberation he greatly admired.

Moore was greatly influenced by HUBERT H. HARRISON, one of the most eloquent Socialist speakers of the time, and one of the first black Socialists to attempt to analyze American race relations from a Socialist perspective. In 1918 Moore joined the 21st Assembly District Branch of the Socialist Party (SP). In some ways this was a strange decision, since the Socialist Party had been unable— or unwilling—to address the relationship between the systematic oppression of black people and capitalism in the United States. Even more left-wing Socialists tended to ignore the "Negro Question" altogether, reducing the oppression of black people to simply general economic oppression. However, despite the blind spot of the national SP, the Harlem Socialists had attracted an impressive cadre of black supporters, including A. PHILIP RANDOLPH and CHANDLER OWEN (who co-edited the *Messenger*), W. A. DOMINGO, Grace Campbell, Otto Huiswoud, and others. This amorphous group would form a core of black radicalism during the late teens and twenties, helping to contribute to the "New Negro" movement and, subsequently, the early black cadre of the Communist Party. Soon after joining the SP, Moore established himself as a capable Socialist orator.

The Harlem Socialists, who tended to remain aloof from the downtown SP headquarters, actively campaigned for votes in the 1918 and 1920 elections, and some, like Grace Campbell, stood for office themselves (as an immigrant, Moore was ineligible to vote or run for office). Largely because of this effort, the SP received some 25 percent of the black vote in the 1918 election. In March 1920 Moore, along with the former Garveyite W. A. Domingo, launched the *Emancipator*, an important black radical voice.

In November 1919 CYRIL V. BRIGGS, another Caribbean migrant and editor of the radical *Crusader*, launched a radical black nationalist organization, the African Blood Brotherhood (ABB), of which Moore and other black Socialists were early members. Amid the rising tide of racist attacks in the aftermath of the war, the ABB emphasized pan-Africanism, black nationalism, and sympathy

to anti-colonial liberation movements, including, vaguely, the Bolsheviks. During this period Moore married Kathleen James, a Jamaican immigrant, on 24 June 1919; they had a daughter, Joyce Webster, in August 1920.

In the aftermath of the Bolshevik Revolution left-wing Socialists established the American Communist movement. Like their Socialist parents, the early Communists all but ignored black Americans; nonetheless, the Bolshevik Revolution, in its opposition to Great Russian chauvinism and colonialism, was tremendously popular among black socialists, especially those from the British colonies in the Caribbean. By the early 1920s the New York ABB had joined the Communist Party. Some time after this—the exact date is unclear—Moore himself joined the Communist Party.

Moore helped organize the "Negro Sanhedrin Conference," a meeting in February 1924 of several black organizations. In 1925 he became a leader of the American Negro Labor Congress (ANLC) and in 1927 he replaced Lovett Fort-Whiteman as the national organizer and general secretary. In 1926 Moore was hired by the Party as a full-time functionary, which he remained until the 1940s. In 1927 Moore represented the ANLC (and, oddly, the New York branch of Garvey's organization) at the International Congress Against Colonial Oppression and Imperialism in Brussels, Belgium, and later toured France. The most successful result of the ANLC under Moore's watch, however, was the Harlem Tenants League, which was organized in early 1928 to protest poor conditions and high rents. Out of this work two important black leaders, GEORGE PADMORE and JAMES FORD, joined the party. During this time Moore was a regular spokesman for the party and ran for national and state office three times. During one of these campaigns he was arrested by the police. This political activity also took a toll on Moore's personal life; he separated from his wife, who died in 1946 of cancer.

In 1930 the Communist Party dissolved the ANLC and replaced it with the League of Struggle for Negro Rights, with Moore as general secretary and LANGSTON HUGHES as president. Moore's biggest role as a communist leader came in the 1930s when he became the vice president of the International Labor Defense (ILD). In 1931 Moore served as the "defense attorney" in the "trial" of August Yokinen, a Finnish American communist who was accused of white chauvinism. More importantly,

later that year, Moore organized the ILD's protest campaign in defense of the SCOTTSBORO BOYS, nine black youths who were falsely accused of raping two white women in Alabama. This case highlighted the "legal lynching" that Jim Crow "justice" meant in the American South, and it earned the party respect as a militant fighter for black rights. Moore toured the country and wrote a pamphlet entitled *Mr. President: Free the Scottsboro Boys* (1934).

In the mid-1930s Moore had a falling-out with Ford and in 1934 resigned as head of the LSNR. He became the Boston representative of the ILD until 1936. In 1937 he returned to New York and increasingly immersed himself in black history, especially the life of Frederick Douglass. In the early 1940s he attempted to publish, for the first time in forty years, *The Life and Times of Frederick Douglass.* His relations with the Communist Party became more attenuated, and in 1942 the party expelled Moore for, among other things, supposed softness on black nationalism. After his expulsion Moore threw himself into studying black history and collecting and trading black art and literature. With partners, he opened the Frederick Douglass Book Center in Harlem (which remained open until 1968). In September 1950 he married Lodie Briggs, one of his partners and another expelled Communist. He lectured widely on black history and politics until 1976.

Moore organized the Committee to Tell the Truth About the Name "Negro," which advocated for using the term "Afro American" instead. In 1960 he published a small book, *The Name "Negro"— Its Origin and Evil Use.* Moore also maintained an interest in the Caribbean. During the Second World War, unlike the first, Moore and other former ABBers supported the British; nonetheless, Moore advocated self-determination for the British colonies in the Caribbean. In 1941 he founded the West Indian National Emergency Committee, and in 1942 the West Indian National Council. At the founding of the United Nations after the war he also advocated Caribbean independence.

Moore continued lecturing and collecting books for the next several decades. He also renewed his connections to Barbados. In November 1966 the Barbadian government invited Moore, his wife, and other expatriates to witness the turnover from Britain. He sold his immense library of 15,000 volumes, the product of a lifetime of collecting, to the University of the West Indies in Barbados. In the late 1970s Moore's health suffered, and he fell ill to cancer. He died in Barbados and was buried there.

FURTHER READING

Moore's papers are deposited at the Schomburg Center, New York Public Library.

James, Winston. *Holding Aloft the Banner of Ethiopia: Caribbean Radicalism in Early Twentieth Century America* (1998).

Naison, Mark. *Communists in Harlem During the Depression* (1984).

Solomon, Mark. *The Cry Was Unity: Communists and African Americans, 1917–1936* (1998).

Turner, W. Burghardt, and Joyce Moore Turner, eds. *Richard B. Moore, Caribbean Militant in Harlem: Collected Writings 1920–1972* (1988).

Obituary: *Amsterdam News,* 23 Sept. 1978.

J. A. ZUMOFF

MORTON, Jelly Roll

(20 Oct. 1890–10 July 1941), was born Ferdinand Lamothe (sometimes mistakenly given as Le Menthe) in New Orleans, the son of Edward Lamothe, who disappeared soon after his son was born, and Louise Monette, who was not legally married to his father. Monette then married William Mouton, who changed his name to Morton, and they had two daughters. There is some confusion over Morton's birth date, because he claimed that he was born in 1885. However, scholars have discovered church records that reveal the 1890 date. Gary Giddins, a jazz scholar and historian, speculates that one reason Morton gave 1885 as his birth date was that had he been born in 1890, he would have been only twelve years old in 1902, the year he claimed to have invented jazz.

Morton was a Creole of color, a member of the New Orleans black community rooted in French, Caribbean, and African culture that flourished when Louisiana was a French colony in the eighteenth century. Creoles of color were generally Catholic, spoke French, and often considered themselves the elite of the black community. Many were well educated, and music was an essential part of their recreational life. When Morton was born, New Orleans was a musical bouillabaisse, filled with the sounds and rhythms of street bands, Italian opera, French quadrilles, Latin tangos, military music, ragtime, popular music, the blues, and the "hot" music from the night spots. Morton recalled that as a child

he set out to "whip the word and conquer all [musical] instruments" (Lomax, 4). Even in his childhood his musical abilities were evident. By the time he was fifteen, Morton said he was considered "one of the best junior pianists in the city."

While still a teenager, Morton was offered a job playing the piano in the red-light district of New Orleans. When he told his grandmother what he was doing, Morton said she banished him from the family, telling him: "A musician is nothing but a bum and a scalawag. I don't want you around your sisters. I reckon you better move." Morton began to play in the "high class" bordellos in the tenderloin district. He became one of the kings of the piano, second only to Tony Jackson, who was considered the greatest piano player of his time. Morton claimed that before he invented jazz, most musicians played the blues or ragtime. "Ragtime," he said, "is a certain kind of syncopation . . . but jazz is a style that can be applied to any kind of tune. Jazz music came from New Orleans" (Lomax, 67).

Morton's music was shaped, in part, by the world of racial segregation. Segregation and disfranchisement had been relatively fluid and flexible in New Orleans in the decades following Reconstruction. By the 1890s, however, Louisiana—like the rest of the South—legalized segregation. In June 1892 Homer Plessy, a Creole of color from New Orleans, challenged Louisiana's law segregating public transportation. In 1896 the U.S. Supreme Court established the doctrine of "separate but equal," sanctioning segregation. Two years later the court unanimously approved laws designed to reduce black voting. In New Orleans, as in the rest of the South, blacks were not even allowed in the same houses with white prostitutes. Thus, Morton was required to sit behind a screen in the bordello where he worked to prevent him from looking at the white prostitutes when they danced for their customers. Morton said he got around the restriction by cutting a slit in the screen.

For Morton, music provided an escape from the world of Jim Crow, and it allowed him both creative freedom and the freedom to travel. By the end of the first decade of the twentieth century, he was touring the South. During this period he wrote some of his classic songs, including "Alabama Bound" and "King Porter Stomp." He performed with various vaudeville companies and minstrel shows as a musician, actor, and comic entertainer, and he worked as a gambler, pimp, and pool hustler when things were slow. Because of his association with prostitutes, he got a reputation as a lady's man and was given the nickname "Jelly Roll," a slang term for the female or male genitalia and for sexual intercourse.

Morton moved about from St. Louis and Chicago to New York and Kansas City, until he landed on the West Coast in 1917. After World War I, Chicago became the capital of "hot music." Many of New Orleans's greatest jazz musicians performed there, including LOUIS ARMSTRONG, KING OLIVER, and Johnny St. Cyr. Southern musicians had joined the massive migration of hundreds of thousands of blacks fleeing the Jim Crow South in search of a better way of life in the North. Jazz quickly crossed the northern color line as young whites flocked to listen, dance, and play the new music.

Jelly Roll Morton arrived in Chicago in 1923, at the height of his musical powers. He quickly became one of the biggest names in jazz, playing dance halls and clubs throughout the Midwest for both black and white audiences. He teamed up with the Melrose brothers, white music entrepreneurs who negotiated his record and sheet music contracts (and who allegedly skimmed much of the profits for themselves, as did many other white producers of black music). Morton put together the Red Hot Peppers, a recording band composed of top New Orleans musicians, including KID ORY, Barney Bigard, Johnny Dodds, Johnny St. Cyr, and Baby Dodds, to record songs like "Black Bottom Stomp," "Sidewalk Blues," and "Turtle Twist." Alan Lomax, a music and folk historian, considered Morton's sessions with the Peppers, "the best recorded performances in jazz" of the period

By the end of the 1920s Morton's career was booming. Money was rolling in, and everybody loved his music. He flashed diamonds wherever he went—on his watch, belt buckle, and tie clip—and he even sported a diamond tooth. Morton owned more than a hundred suits and dozens of pairs of shoes. His business cards read "Jelly Roll Morton—Inventor of Jazz." His critics called him a braggart and a fabricator, but Morton may not have been too far off the mark. For if he did not invent jazz, he was certainly one of its founding fathers and one of its greatest piano players, composers, and arrangers. As Giddins notes, Morton "did prove to be . . . the catalyst who transfigured ragtime and minstrelsy into a new music that adroitly weighed the respective claims of the composer and the improviser—in a

word—jazz" (Giddins, 70). Morton's style suitably impressed his fellow performer Mabel Bertrand, whom he met in 1927 and married the following year.

Morton's bragging earned him enemies among his fellow musicians as well as among whites who controlled his bookings and money. In the 1930s Morton's career all but disappeared. A new generation of musicians had emerged, and swing developed as a new form of jazz. Big bands like those led by DUKE ELLINGTON, FATS WALLER, FLETCHER HENDERSON, and Benny Goodman were all the rage. Younger musicians considered Morton a dinosaur, even while others continued to play his music with great success. For a while Morton played at the Red Apple in New York, a second-rate club in Harlem.

Morton left New York in 1935 and wound up at the Jungle Inn, an obscure club in Washington, D.C., tending bar and playing the piano. Down and out and in poor health, Morton seemed at the end of the line. But his glory days were not over. Young people started to come to hear him play music and talk about the glamorous days of New Orleans jazz. When he heard that W. C. HANDY had been introduced as the creator of jazz on a radio show, Morton exploded. He wrote an angry public letter stating that it was he, not Handy, who created jazz. The article made headlines and put Morton back in the limelight.

In 1938 Alan Lomax, a musicologist at the Archive of Folk Song at the Library of Congress, invited Morton to record his music for the Library of Congress. The session became not only a classic recording of Morton's jazz but also a unique historical portrait of the era. Mixing fact and legend, myth and reality, Morton narrated the musical life of New Orleans at the turn of the century. He played many of the songs he had written, some with ribald or frankly sexual lyrics. He brought the golden age of New Orleans to life again, resurrecting many of its legendary figures, from the trumpeter Buddy Bolden and the pianist Tony Jackson to the blues singer Mamie Desdoumes and the rebel Robert Charles, whose legendary shootout with the police had made him a hero in the black community.

If the Library of Congress sessions secured Morton's fame for posterity, his financial condition was still anything but secure. In straitened circumstances and seriously ill, he tried desperately to collect back royalties from his publishers. Morton had attempted to join ASCAP, the musicians union, in 1934, because the union had the authority to collect some of the royalties due Morton. But ASCAP was slow to admit blacks as members, and it was not until 1939 that Morton was accepted. The union, however, did little to secure him his royalties.

In 1939 Morton's career had a brief resurgence. He recorded with SIDNEY BECHET for Victor Records and played many of his old songs. He continued to write music, most of which was not discovered until after his death. Ill and dying, his playing days over, Morton moved to Los Angeles in 1940. Too sick to perform or record, he remained confined to his bed until his death.

FURTHER READING

Giddins, Gary. *Visions of Jazz: The First Century* (1998).

Lomax, Alan. *Mr. Jelly Roll: The Fortunes of Jelly Roll Morton, New Orleans Creole and "Inventor of Jazz,"* with a new afterword by Lawrence Gushee (2001).

Reich, Howard, and William Gaines. *Jelly's Blues: The Life, Music, and Redemption of Jelly Roll Morton* (2003).

Obituary: Down Beat (1 Aug. 1941).

DISCOGRAPHY

Jelly Roll Morton: Jazz King of New Orleans (RCA/Bluebird 2002).

Jelly Roll Morton: The Library of Congress Recordings (Charly 1990).

Jelly Roll Morton: Pioneer of Jazz, 1923–1939 (Jazz Records 2003).

RICHARD WORMSER

MOTLEY, Archibald J., Jr.

(7 Oct. 1891–16 Jan. 1981), painter, was born in New Orleans, Louisiana, to Archibald John Motley Sr., a Pullman railway porter, and Mary F. Huff Motley, a schoolteacher. In 1892 the Motleys joined an early wave of African Americans by moving north and resettling in Chicago, Illinois, where they took their place among the city's middle class. During his early years, Motley attended area public schools, and the teachers there praised his artistic talents. After graduating from high school in 1914, he began his studies at the School of the Art Institute of Chicago. By the time he graduated with a bachelor's degree in Painting in 1918, he was well versed in the practices

and philosophies manifested in the long tradition of Western artistic production.

The year after he graduated from the Art Institute was not an easy time for Motley. In 1919 he lost a job as a commercial designer to a less-qualified, white applicant. That same year, race riots broke out on Chicago's South Side. Though the neighborhood had been largely white when the Motleys settled there in the 1890s, following World War I large numbers of African Americans from the rural South moved to the city during a period known as the Great Migration, changing the makeup of the South Side. Though his style told of his formal training, his subject matter shifted away from that of the canonical Western paintings he studied while at the School of the Art Institute of Chicago.

In 1919 Motley began producing the portraits of African Americans that would initiate a new and more mature phase in his work. Painting portraits allowed Motley to combine his academic training with his goal of changing the way blacks were portrayed in most popular art. Through his work, Motley sought to move past black stereotypes in paintings, which often showed blacks in subservient or domestic roles, by representing a broader range of subjects from the African American community.

The first of Motley's paintings to be professionally exhibited was *Portrait of My Mother* (1919), which was shown to great acclaim at the Art Institute of Chicago's Annual Exhibition in 1921. The portrait shows his mother seated and facing the viewer, her eyes looking straight ahead. The warm, monochromatic palette of deep browns relieved only by a white collar and a large, red-jeweled pendant bring a sense of richness to this depiction of an attractive, prosperous woman. *Self Portrait* (1920) and *Portrait of the Artist's Father (Portrait of My Father)* (c. 1921) followed *Portrait of My Mother*. In 1924 Motley created his best-known painting from a series of family portraits. *Mending Socks* was a portrait of his paternal grandmother. As he did in the majority of his portraits, Motley placed his subject in a domestic setting surrounded by symbolic objects. In this case, Emily Motley sat with her attention focused downward on the sock she was holding in her lap. Above her was a crucifix and, to her side, was a table laden with books and sewing paraphernalia. Above the table there hung a portrait of a white woman. Motley based this portrait-within-a-portrait on an actual painting his grandmother had of the woman who had owned her as a slave.

During the early 1920s that Motley produced his family portraits, he also created portraits of women of mixed race. Following the same general pattern as in his family portraits, Motley depicted these women seated and surrounded by objects rife with symbolism. Motley made his interest in the women's ancestry explicit by titling their portraits using Creole terms for racial identity. The series included *Mulatress with Figurine and Dutch Seascape* (1920), *Octoroon* (1922), and *The Octoroon Girl* (1925). In these graceful portraits of fashionable women, Motley explored how viewers saw different types of blackness. The brief titles immediately alerted viewers to think about the categorizations created by society to describe race. Motley's use of Creole terms in the titles of these portraits harks back to his own family's Creole background and mixed-race ancestry. The light-skinned, middle-class Motley believed in a pseudo-scientific approach to racial identity, which correlated ancestry (and its outward signifier, skin color) and social class.

The success of these portraits enabled Motley to begin exhibiting both locally and nationally. By 14 February 1924 he felt financially secure enough to marry his longtime love, Edith Granzo, who was white.

In 1927 Motley had his first solo show in New York City. Following the success of this exhibition, Motley traveled through the South, visiting relatives and painting portraits and landscapes reflecting rural life. In 1929 Motley won a Guggenheim Foundation fellowship, which allowed Motley and his wife to spend the year in Paris. Motley used his year well, studying art at the Louvre, painting, and observing race relations in Europe. Perhaps his best known work, *Blues*, comes from this period. A closely cropped scene set inside a crowded club, *Blues* was packed with images of jazz musicians and energetic dancers. As in his earlier works, Motley wanted to explore the variety inherent in the black experience. Genre paintings such as these presented viewers with scenes from everyday life, and in *Blues* Motley gave the viewer access to jazz culture and the world of urban blacks.

By painting genre scenes, "Motley believed that he could alter negative attitudes toward black culture, thereby creating a market for depictions of the everyday experience of African Americans" (Mooney, 60). During his stay in Paris, Motley

produced several paintings related to daily lives of black people, including *Senegalese Boy* (1929) and the nighttime scene *Jockey Club* (1929). Though he continued painting occasional portraits throughout his career, a definite shift occurred in Motley's artistic philosophy in Paris, and upon his return to Chicago he remained focused on creating genre scenes.

In 1933 the Public Works of Art Project, part of the Federal Art Project in Illinois and the Treasury Relief Art Project hired Motley as part of a program designed to bolster the economy and the national mood during the Depression. In this same year Motley's only son was born. For the next several years, Motley painted scenes of American life for public buildings around Illinois. At the same time, he continued painting and exhibiting his own work, using Chicago's black neighborhoods as the source of his subject matter. In the years after World War I, Chicago's African American population had soared, as poor Southern blacks moved north in a massive population shift known as the Great Migration. Chicago's growing and changing black community provided the inspiration for Motley's interior scenes such as *The Liar* (1936) and street scenes such as *Getting Religion* (1948).

The year 1948 marked the end of Motley's most productive and creative years. His wife died in December of that year. Throughout their marriage Edith had worked outside the home to help support the family. Following her death, Motley took a full-time job creating hand-painted shower curtains. He continued his painting outside of work, teaching, and exhibiting sporadically for the next several decades. In 1980 Motley received an honorary doctorate from the School of the Art Institute of Chicago and attended a White House reception honoring black artists.

FURTHER READING

Mooney, Amy M. *Archibald J. Motley Jr.* (2004).
Robinson, Jontyle Theresa, and Wendy Greenhouse. *The Art of Archibald J. Motley, Jr.* (1992).

ANGELA R. SIDMAN

MOTON, Robert Russa

(26 Aug. 1867–31 May 1940), educator and race leader, was born in Amelia County, Virginia, to Booker Moton, a field-hand supervisor, and Emily Brown, a domestic servant. Moton enjoyed a relatively pleasant childhood on the Samuel Vaughn plantation in Prince Edward County, where his parents moved to obtain work. At the age of thirteen, Moton went to Surry County, Virginia, where he worked as a laborer in a lumber camp. Seeking a formal education, Moton enrolled at Hampton Institute in 1885, where he remained until his junior year, when he withdrew to work and study law. After earning a license to practice law in Virginia, Moton resumed his education at Hampton in 1889, completed his senior year, and was appointed assistant commandant for the cadet corps of male students in 1890, becoming commandant in 1891 with the rank of major. Over the next twenty-five years Moton remained an ardent proponent of the institute's pedagogy, which stressed the acquisition of industrial skills and the cultivation of values centered on hygiene, grooming, and proper deportment, a combination thought by some to be the key to African American success in the years following Reconstruction.

Moton steeped himself in this educational ideology and emerged as a campus leader at Hampton Institute during the same period that his fellow Hampton alumnus BOOKER T. WASHINGTON stepped into the national spotlight as the principal of Tuskegee Institute and the heir apparent to Frederick Douglass. As Washington continued to expand his political role and extend his influence, he increasingly sought out bright representatives and promising leaders in the black community to join his movement, establishing a network that some derisively described as "the Tuskegee Machine." The unassuming and genteel Moton was soon pulled into Washington's orbit.

Beginning in 1908 Moton traveled with Washington on major speaking tours, during which Washington would often use Moton as an example of the potential of the "full-blooded" black man of "pure African stock," and he encouraged Moton to lead choirs or audiences in the singing of African American spirituals. The musical role aside, Moton's dark skin and statuesque presence enabled Washington to make the point that excellence resides in every segment of the African American population, not only among those of mixed parentage. Because of his frequent appearances with Washington, Moton soon became recognized as a close associate and confidant. Moton's first wife, Elizabeth Hunt Harris, had died within a year of their marriage in 1905, and he and Jennie Dee Booth were married in 1908; they had five children.

Moton worked diligently in 1910 to effect a rapprochement between the Washington camp and the more strident leaders, white and black, of the newly founded National Association for the Advancement of Colored People. He had tried, unsuccessfully, as early as 1905 in the New York Conference to reconcile with Washington the so-called radicals led by the scholar W. E. B. DU BOIS, whom Washington himself had tried to draw to his side years before. With Washington's death in 1915, Moton led the field of his most likely successors, and aided by Theodore Roosevelt, a Tuskegee trustee, he became the second principal of Tuskegee Institute.

As the principal of Tuskegee, Moton continued the policies of his mentor and amassed an impressive record of achievement. Having previously served as an adviser to the presidents William Howard Taft and Woodrow Wilson, Moton maintained amicable relations with the White House under subsequent administrations, from Warren G. Harding to Franklin D. Roosevelt. During World War I, Moton was a leader in the campaign to have an all-black officers training camp established at Des Moines, Iowa. He persuaded the Wilson administration to appoint EMMETT JAY SCOTT as "special adviser on Negro Affairs" to Secretary of War Newton D. Baker, and after the war Moton traveled to France in 1919 as an emissary to black troops. He boosted their morale, but in the eyes of some, his pleas for patience and his aversion to agitation lowered the expectation that African American military participation in the war would translate into an abatement of racism on the home front.

In the early years of his tenure at Tuskegee, Moton experienced acute criticism from his rivals for failing to be more assertive in the fight for African American civil rights. It is likely that Moton's choice of tactics was not motivated by a lack of courage, but rather stemmed from his belief that, given the racial climate of the early twentieth century, economic development and self-help would produce more tangible results for his constituents than any amount of protest. To that end, in 1919 he assumed the chairmanship of the National League on Urban Conditions among Negroes, a predecessor to the National Urban League. In 1921 Moton was elected president of the National Negro Business League, a powerful organization of black entrepreneurs loyal to Washington.

In 1922 Moton was invited to speak for his race at the unveiling of the Lincoln Memorial. The speech he submitted was uncharacteristically bold and forthright, paraphrasing Lincoln and offering a rare indictment of American racism: "No more can the nation endure half privileged and half repressed; half educated and half uneducated; half protected and half unprotected; . . . half free and half yet in bondage" (Fairclough, 411). Taft ordered all such critical statements excised from Moton's speech. Those sentiments would not find expression at the Lincoln Memorial until Martin Luther King Jr. gave voice to them on that very spot forty-one years later.

Moton is credited with making Tuskegee Institute a college when, in 1925, the catalog announced a course of study leading to a BS in both Agriculture and Education. In his twenty years as principal of Tuskegee, Moton increased the institute's endowment from $2.3 million to $7.7 million. Drawing on his experiences as an educator in the Deep South, Moton attempted to provide insightful leadership as chairman of President Herbert Hoover's commission on educational problems in Haiti; had his recommendations been heeded more often, Haiti's schools would have been greatly improved. Moton went on to found the Negro Organization Society of Virginia, and dedicate himself to the improvement of the health of African Americans by, among other things, helping Booker T. Washington establish a national Negro Health Day.

In 1923 he secured the building of a Veterans Administration Hospital in Tuskegee, in part by donating three hundred acres of Tuskegee's campus to guarantee the project. Eventually, the facility came to comprise some forty-five buildings, making it one of the largest hospitals in the state and an important training ground for black doctors and nurses. Tragically, in 1931, shortly before Moton's retirement in 1935, the U.S. Public Health Service began a clandestine medical experiment at the hospital on 399 black men in the late stages of syphilis. Most of these men were illiterate sharecroppers from the poorest parts of Alabama, and neither they nor their wives were told what they were suffering from; rather they were told they were being treated for "bad blood," a folk term for a variety of ailments. In fact, the course of the disease in these men was merely being observed; effective treatment was withheld, even after penicillin became available in the 1940s.

This "experiment" continued until it was exposed in the *Washington Evening Star* in 1972, and though

the survivors and their families were awarded $9 million in a class-action suit, it was not until May 1997 that a formal apology came from the government, when President Bill Clinton acknowledged: "What was done cannot be undone. But we can end the silence. We can stop turning our heads away. We can look you in the eye and finally say on behalf of the American people, what the United States government did was shameful, and I am sorry" (*Jet,* 2 June 1997, 6). Although it is unlikely that Moton had any knowledge of this experiment, and while Tuskegee was not directly involved, the reputation of the institute and those affiliated with it during those years was markedly damaged; in partial reparation President Clinton announced a grant for establishing the Tuskegee University National Center for Bioethics in Research and Health Care.

In 1920 Moton published his autobiography, *Finding a Way Out,* followed in 1928 by a political treatise, *What the Negro Thinks,* which was intended to bring attention to the ideas, issues, and problems affecting African Americans. He broadened his leadership activities in both white and black communities, serving as the chair of the Colored Advisory Commission to the American National Red Cross on the Mississippi Floods Disaster and as chair of the Campaign Committee Commission on Interracial Cooperation (1930), which was led by John Hope, president of Morehouse College and Atlanta University. Moton also became the president of Tuskegee Institute Savings Bank.

Among the many accolades he received were honorary degrees from Harvard University and Howard University, as well as the prestigious Harmon Award and Spingarn Medal from the NAACP. In 1935 Moton's son-in-law, Frederick D. Patterson, succeeded him as the third president of the institute and largely continued the traditions that Washington and Moton had so firmly established. Moton's legacy is best appreciated for the role he played in establishing a strong foundation for historically black colleges during a time when Tuskegee was the flagship of black educational institutions. Although his politics may seem tepid compared with the stance of later generations of black leaders, many of those firebrands received their education from institutions like Tuskegee.

FURTHER READING
The main body of Moton's papers can be found at the Hampton University Archives, Collis

P. Huntington Memorial Library; the Robert Russa Moton Papers, Hollis Burke Frissell Library, Tuskegee University; and the Moton Family Papers, Library of Congress, Washington, D.C.

Moton, Robert Russa. *Finding a Way Out* (1920).
Fairclough, Adam. "Civil Rights and the Lincoln Memorial: The Censored Speeches of Robert R. Moton (1922) and John Lewis (1963)," *Journal of Negro History* 82.4 (Autumn, 1997).
Hughes, William Hardin, ed. *Robert Russa Moton of Hampton and Tuskegee* (1956).
Jones, James H. *Bad Blood: The Tuskegee Syphilis Experiment* (1993).

Obituary: New York Times, 1 June 1940.

MACEO CRENSHAW DAILEY JR.

MURPHY, Carl

(17 Jan. 1889–25 Feb. 1967), journalist, editor, publisher, and civil rights leader, was born in Baltimore, Maryland, to John Henry Murphy Sr. and Martha Elizabeth Murphy. John Murphy Sr., a former slave and Civil War veteran, is best known as the owner and publisher of the Baltimore *Afro American* newspaper. His mother, Martha Elizabeth Murphy, was one of the founders of Baltimore's first "Colored" YWCA and served as its president for fifteen years. She was also active in a number of religious and civic organizations. Carl grew up under the limitations of de jure segregation. Although African Americans in Maryland possessed the right to vote, racial customs and legal barriers determined where they would live, the schools they attended, and often their life occupations. Murphy's circumstances were mitigated by his father's successful career as a newspaper owner. In 1907 he graduated from Baltimore's Colored High School (later Frederick Douglass High School) and then went to Howard University, where he completed his undergraduate degree in German in 1911.

Initially deciding on a path quite different from his father's, Murphy attended Harvard University, receiving a master's degree in German in 1913. During the following year he studied at the University of Jena in Berlin, returning to the United States shortly after the start of World War I. Murphy embarked on a career as a professor and head of the German department at his alma mater, Howard University, where he stayed until 1918. In addition to his professorial duties, Murphy joined the family business as an associate editor of the newspaper in 1916. While

teaching he met his future wife, a student at Howard named Vashti Turley, one of the founding members of the Delta Sigma Theta sorority. After her graduation in 1914, they married in 1916; the couple eventually had five daughters.

In 1918 Murphy left Howard University to work with the *Afro American* full time, and on the death of his father in 1922, Murphy became the driving force and dominant voice of the newspaper. As president and publisher, he assumed an important role in the black community as the leader of one of the most visible and well-functioning activist institutions in the civil rights struggle, whose influence equaled traditional organizations such as the Baltimore NAACP, established in 1914, and the Baltimore Urban League, founded in 1924. Under his guidance, the *Afro American* became even more confrontational in the fight to end racial discrimination. In addition to its civil rights work, during Murphy's forty-five year reign, from 1922 until 1967, the paper also grew as a financial institution. Along with the Baltimore edition, the company published weeklies in New Jersey, Philadelphia, Richmond, and Washington, D.C., as well as a national edition.

Along with covering national and international news, the newspaper served as a partner in Baltimore's black community, not only as an employer but also by publicizing and participating in events like the annual "Business Men's Exhibit." The newspaper also played an active role in social aspects of community life, creating a Clean Block Campaign in 1935, and holding forums on economic, social, and political issues. It supported its readers by highlighting local accomplishments, academic, and athletic achievements, as well as cultural, artistic, and political endeavors. The newspaper repeatedly encouraged citizens to get involved in the political and social life of their community through initiating its own voter registration drives, cooking schools, and education classes. The *Afro American* also included weekly reports of the social activities of local clubs and fraternal organizations along with notices of the births, deaths, and marriages of prominent local socialites.

Under Murphy's leadership the Afro American Company, which included the newspaper and several related businesses, promoted entrepreneurial growth in the black community, including purchasing stock as an investment in a short-lived department store located in Northwest Baltimore, on Pennsylvania Avenue, the central shopping local

in the black community. Most importantly, the *Afro* reporters stood as representatives of the community, engaging in investigative journalism that put them on the front lines. Taking their cues from their employer, journalists like Ralph Matthews and Clarence Mitchell Jr. adopted an active role in challenging elected officials, local law enforcement, and business owners on issues of racial discrimination. And in the absence of an active NAACP in the early 1930s Murphy directed his reporters to give special attention to the City-Wide Young People's Forum, led by the dynamic youth leader Juanita Jackson.

Carl Murphy, as president and editor of one of the largest black newspapers in the country, commanded local and national attention. It was not uncommon for Murphy to initiate conversations with elected officials and civil rights leaders and for them to seek him out for advice on appointments. The *Afro American* featured stories by national African Americans leaders like KELLY MILLER, JOEL A. ROGERS, and Nannie Helen Burroughs, and Murphy was in regular conversation with NAACP leaders like Robert Bagnall, Charles H. Houston, and WALTER WHITE, along with Maryland's top elected officials. In anticipation of the civil rights campaigns of the 1930s, Murphy and the *Afro American* launched several major investigative campaigns in areas such as unequal teachers' salaries, the barring of black students from the University of Maryland, and the discriminatory practices of department stores. During the 1930s and 1940s Murphy and the *Afro American* advocated for the hiring of blacks on the police force and in the fire department, black representation on the city, county, and state boards of education, and on the boards of state institutions with black residents, the inclusions of blacks in labor unions, equal salaries for black teachers, and a state-supported university and an agricultural college for African Americans. In 1935 the newspaper devoted substantial attention to the *Murray v. University of Maryland* case and the legal efforts of Thurgood Marshall to desegregate the state law school, going so far as to take the unusual step of publishing portions of the court transcripts.

As one of the leading figures in black Baltimore, Murphy was crucial in the reformation of the local branch of the NAACP in 1935. Although he declined the position of president for himself, he staunchly supported his Colored High School classmate, Lillie M. Jackson, throughout her tenure as head of the Baltimore NAACP. Murphy provided Jackson

with editorial support and news coverage, served as a member of her executive board and chair of the Legal Redress Committee, and he generously contributed to the branch's campaigns. As partners in the struggle for racial justice, Jackson's ability to mobilize the community was buttressed by Murphy's ability to command the attention of the state's political apparatus. Unlike his compatriot, Roscoe Dunjee, the publisher of Oklahoma's *Black Dispatch* who served as president of the state conference of NAACP branches, Murphy seemed to prefer a supportive rather than leading role in civil rights organizations. His part, however, was no less crucial to developing a civil rights movement in Baltimore and throughout Maryland.

In 1944 the *Afro American* newspaper published *This Is Our War*, a collection of essays written by black reporters, including Murphy's own daughter, Elizabeth Murphy Philips, the first African American female international war correspondent. In the 1950s Murphy was active in the campaign to desegregate public education, wrote directly to the attorney general to integrate the Maryland National Guard, and continued to press for the dismantling of both customary and legal Jim Crow in the state. Along with his work with the Baltimore branch of the NAACP, Murphy was a longtime member of the board of directors of the national NAACP, and served as chairman of the Board of Trustees of Morgan College. In the 1950s Murphy received a number of awards honoring his work as both a newspaperman and a civil rights leader. In 1953 he was elected president of the National Newspaper Publishers Association and in 1954 he received the American Teamwork Award from the National Urban League, which celebrated the civil rights work of the press. Finally, in 1955 he received the NAACP's most prestigious award, the Spingarn Medal, which honors individuals for exemplary service in the struggle for racial equality.

By the time of his death in 1967, most of the barriers to integration in Maryland had been removed. African Americans could attend integrated schools from the elementary to the postsecondary levels, utilize any public accommodations, try on clothes at any department store, and sit at any lunch counter. Although the Fair Housing Act had yet to be passed, the *Afro American* newspaper, along with local civil rights activists, continued the struggle for housing and jobs. In his forty-five years at the helm of the *Afro American*, Murphy used the pages of the newspaper, in conjunction with his personal influence, to press for an end to racial injustice.

FURTHER READING
The papers of the *Afro American* newspaper are housed at Moreland-Spingarn Archives at Howard University.
Farrar, Hayward. *The Baltimore Afro-American, 1892–1950* (1998).
Rollo, Vera. *The Black Experience in Maryland* (1980).

Obituaries: New York Times, 26 Feb. 1967; *Baltimore Afro American*, 28 Feb. 1967.

PRUDENCE CUMBERBATCH

MUSE, Clarence E.

(7 Oct. 1889–13 Oct. 1979), actor, producer, and writer of plays and films, was born in Baltimore, Maryland, the son of Alexander Muse and Mary Sales. He was educated at Dickinson College in Carlisle, Pennsylvania, where he became interested in music and participated in choral groups; although he graduated with a bachelor's degree in International Law in 1911, he immediately embarked on a musical and theatrical career. In 1907 he married Frieda Belle Moore; the marriage was apparently dissolved soon after the birth of their son in 1910.

Muse sang with a hotel employees' quartet in Palm Beach, Florida, for one season. In 1912 he helped organize the Freeman-Harper-Muse Stock Company at the Globe Theater in Jacksonville, in partnership with comedian George Freeman and choreographer Leonard Harper. The company toured in *Stranded in Africa* in 1912, starring Muse in the role of King Gazu.

By 1914 Muse was married to and performed in vaudeville on the East Coast with Ophelia (maiden name unknown), billed as the team of Muse and Muse. They had two children before their marriage ended. They settled in Harlem, New York, where they established the Muse and Pugh Stock Company (in partnership with another vaudevillian) at the Franklin Theatre. They soon moved their company to the Crescent Theatre, where they produced several plays during their brief residence, including *Another Man's Wife*, starring the two Muses. The company moved again to a better venue, the Lincoln Theatre, where it merged with the Lincoln Players, a newly formed stock company already in residence. In mid-1916 the group joined the Lafayette Players,

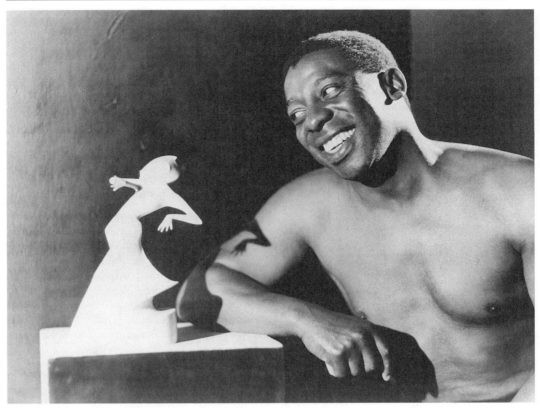

Clarence Muse, in a half-length portrait, with porcelain statue. (Library of Congress.)

who were just beginning to establish a name for themselves at the Lafayette Theatre.

Muse soon became the leading dramatic actor of the Lafayette Players. For the next six years he was featured in a variety of plays, such as *The Master Mind*, *A Servant in the House*, and *Dr. Jekyll and Mr. Hyde*; in the last he played in whiteface makeup, creating a sensation. The Muses' last performance together was in 1922.

In 1920 Muse became one of the founding directors of the Delsarte Film Corporation in New York City, a black independent film company, for which he wrote, produced, and starred in several films (1920–1921), including *Toussaint L'Ouverture* and *The Sport of Gods*, based on a story by PAUL LAURENCE DUNBAR. He was supported in these films by members of the Lafayette Players.

After this film venture Muse moved to Chicago, where he became associated with the Royal Gardens Theatre, owned by an African American

businessman. There he produced and directed shows such as *Hoola Boola* (1922), *Rambling Around* (1923), *The Charleston Dandies* (1926, 1927), *The Chicago Plantation Revue* (1927), and *Miss Bandana* (1927). These shows toured the South on the newly organized black Theater Owners' Booking Association (TOBA) circuit. He also directed and supervised the production of the opera *Thais*, which was performed in Chicago and St. Louis with a cast of nearly two hundred singers and actors.

In 1929 Muse went to Hollywood, at the invitation of the Fox Film Corporation, to portray the ninety-year-old leading character, Uncle Napus, in an all-black musical of plantation life, *Hearts in Dixie* (1929), under a twelve-month contract at a reported salary of $1,250 per week. Muse remained in Hollywood for the rest of his career. He became the protégé of white director Frank Capra, who used him in several films; the most notable was *Broadway Bill* (1934), a horse-racing film in which Muse

played the black companion and alter ego of Warner Baxter, the white star, while observing the distance in rank and station that the color barriers of the time required. Although Muse played a subservient domestic in this and most of his other Hollywood films, he managed to maintain a dignity in his carriage and manner that was unusual for black house servants in these early films. Capra treated him with great sensitivity and respect, and when he remade *Broadway Bill* with Bing Crosby, as *Riding High* (1950), Muse reprised his original role.

Other notable films that Muse made in his fifty-year stay in Hollywood were *Huckleberry Finn* (as Jim, 1931); *The Count of Monte Cristo* (as a deaf-mute, 1934); *So Red the Rose* (as Cato, a rebellious slave, 1935); *Show Boat* (1936); *Spirit of Youth* (1937); *Way Down South*, for which he cowrote the story, screenplay, and songs with LANGSTON HUGHES and played the part of Uncle Caton (1939); *Broken Strings*, an independent black film in which he starred as a concert violinist, his finest screen role (1940); *Porgy and Bess* (1959); *Buck and the Preacher* (1972); *The World's Greatest Athlete* (1973); *Car Wash* (1976); and *The Black Stallion*, his last film (1979).

While making films, Muse also starred in *Porgy* and in a new production of *Dr. Jekyll and Mr. Hyde* presented by the Lafayette Players, who were transplanted to the Lincoln Theatre in Los Angeles after they left New York in 1928. He also directed the WPA's Federal Theatre production of HALL JOHNSON's *Run, Little Chillun*, presented in Los Angeles and Hollywood in 1938–1939. He is credited as cowriter of a number of songs, including "When It's Sleepy Time Down South."

At some point Muse married Willabella Marchbanks, with whom he had one child before they divorced in 1949. His final marriage, in 1954, was to Irene Claire Kellman.

Muse was elected to the Black Filmmakers Hall of Fame in 1973. He died on his ranch in Perris, California, a week after his ninetieth birthday.

FURTHER READING

Documents relating to Muse are in the Schomburg Center for Research in Black Culture at the New York Public Library. Muse's publications include *Way Down South* (1932), written with David Arlen, and *The Dilemma of the Negro Actor* (1934).

Bogle, Donald. *Blacks in American Films and Television: An Illustrated Encyclopedia* (1988).

Leab, Daniel J. *From Sambo to Superspade: The Black Experience in Motion Pictures* (1988).

Peterson, Bernard L., Jr. *A Century of Musicals in Black and White: An Encyclopedia of Musical Stage Works by, about, or Involving Black Americans* (1993).

BERNARD L. PETERSON

NAIL, John E.

(22 Aug. 1883–6 Mar. 1947), real estate entrepreneur, was born in New London, Connecticut, the son of John Bennett Nail, a businessman, and Elizabeth (maiden name unknown). Nail was raised in New York City and graduated from a New York City public high school. His father was the role model on which he based his own business career. The elder Nail was an entrepreneur who prospered from the growth of Harlem and its inflated real estate market. He was one of several blacks who prior to the turn of the century recognized the potential of Harlem's housing market. The younger Nail, known to friends and family as Jack, worked for a time in his father's business, where he first entered into the real estate profession in the 1900s. After a brief stint as a self-employed real estate agent in his own Bronx office, Nail accepted employment with PHILIP A. PAYTON JR., whose Afro-American Realty Company was one of the most successful black-owned real estate firms in New York at the time.

Payton, a real estate trailblazer like Nail's father, had also seized the opportunity to invest in the Harlem real estate market. Between 1890 and 1914 southern blacks flooded into New York City in pursuit of social and economic betterment. Many gravitated to Harlem, where a sizable black settlement had taken shape as a result of earlier migration. By 1910 there were 91,709 blacks living in New York City, 60,534 of whom were born in the South. This mass migration of blacks placed an unforeseen pressure on the city. Racial antagonism and violence intensified, as did social and residential segregation. Areas formerly open to blacks became restricted, and blacks found themselves relegated to an increasingly crowded Harlem. Nail saw his opportunity in this evolving situation. Following Payton's example he educated himself on the intricacies of New York City's segregated housing market. In 1907, when Payton's company suffered financial setbacks (it went bankrupt in 1908), Nail and a colleague, Henry C. Parker, resigned their sales positions and founded the real estate firm of Nail & Parker, Inc. In 1910 Nail married Grace Fairfax; they had no children.

Nail was the moving force in Nail & Parker. He served as president, and Parker served as secretary-treasurer. From modest beginnings the firm, with the implementation of an aggressive advertising campaign, developed into a full-service company that offered mortgages to blacks, collected rents, and bought, sold, managed, and appraised properties. Nail recognized the need for black property ownership as a way to counter the discriminatory real estate practices of white lending institutions and white landlords. He urged blacks to invest in Harlem property to secure the future of the black community there. The firm engineered a significant coup when it successfully broke the deeply entrenched unwritten covenant that maintained that certain Harlem blocks were to remain white; blacks could neither own nor rent property in these areas. Furthermore, the covenant established restrictions in an attempt to prevent black real estate agents from controlling the Harlem housing market. It was a difficult battle, but ultimately Nail & Parker were victorious in their efforts to dismantle the system.

In 1911 Nail & Parker, Inc., negotiated a million-dollar deal. Working as agents for St. Philip's Episcopal Church, of which Nail was a member, the real estate firm figured prominently in the transaction in which the church purchased several properties in Harlem for $1,070,000. The annual rents collected on these investments amounted to twenty-five thousand dollars. The church, the real estate agents, and the black community all benefited from this transaction. Nail & Parker aggressively pursued other Harlem properties not only to increase the company's revenues but also to provide housing and stability for the community. The firm also sold a property for two hundred thousand dollars to MADAME C. J. WALKER, who had amassed a fortune developing hair-care products. In 1929 the firm was granted management responsibilities of the largest and finest apartment building in Harlem, which was owned by the Metropolitan Life Insurance Company. As their client list expanded and their transactions multiplied, Parker and Nail established respectable reputations both for themselves and for their business. Nail in particular earned respect from members of the white and black communities alike, and he emerged as an authority on property condemnation. Even the city of New York sought his expertise.

Despite Nail's status, black tenants claimed that he was an exploitive landlord who overcharged his tenants. The threat of a mass exodus from Harlem during the 1920s and early 1930s in response to exceedingly high prices for rentals was quelled when the company reluctantly reduced some rents. In his own defense Nail cited the high prices for rentals elsewhere in the city. Nail's philosophy reflected that of BOOKER T. WASHINGTON, who emphasized the importance of establishing an economic foundation on which blacks could build a stronger and more stable community and compete more directly with the white power structure.

Although Nail & Parker temporarily weathered the Depression, the firm collapsed in 1933, at which time Parker and Nail took forty-five shares of the company apiece, and the remaining ten shares went to Isador D. Brokow, their silent white partner. Parker and Nail parted ways, and that same year Nail established a new real estate venture, the John E. Nail Company, Inc., with Nail as president and David B. Peskin, a white real estate agent, as secretary and treasurer. The firm was active in several large real estate transactions, including as broker in a deal whereby the St. Philip's Church leased to Louis B. Lipman ten six-story apartment houses for an aggregate rental price of $1 million.

Nail's reputation earned him a place as the first black member of the Real Estate Board of New York, and he became the only black member of the Housing Committee of New York; he was also a member of the Harlem Board of Commerce. News of Nail's accomplishments extended beyond New York's boundaries; he acted as consultant for President Herbert Hoover's Committee on Housing during the Depression.

Nail's interests were not confined to housing. He and an influential coterie, among them ROBERT ABBOTT, publisher of the *Chicago Defender*, and HARRY PACE, a respected entrepreneur, engineered a campaign to discredit the race leader MARCUS GARVEY. Garvey's rise to prominence threatened their elite group, and they accused Garvey and his black nationalism philosophy of inciting hatred between the races. Nail and a self-styled Committee of Eight had nurtured a careful relationship with the white community, and they believed that Garvey's rhetoric undermined their efforts to stabilize race relations. The battle between Garvey, who charged his attackers with being "Uncle Tom Negroes," and the members of the committee

represented a broader split between an elite group of blacks and the masses of lower-income blacks who supported Garvey's celebration of African culture and his philosophy of self-help. Ironically, the two opposing factions shared a belief in the importance of economic development.

Nail's deep commitment to the black community is reflected in his role in the development of the Colored Merchants' Association (CMA), created to advance race solidarity and economic stability. Unfortunately the first Harlem CMA cooperative, established in 1930, failed to attract black consumers, who complained of high prices during a time when people were just trying to survive. Nail was also concerned with the overall plight of urban blacks and for a time held the position of vice president of the New York Urban League. He was chair of the Finance Committee of the 135th Street Branch of the YMCA, which was located in the heart of Harlem, and was involved with the NAACP. Nail died in New York City.

FURTHER READING
Ingham, John N., and Lynne B. Feldman.
 African-American Business Leaders: A Biographical Dictionary (1994).
Osofsky, Gilbert. *Harlem, the Making of a Ghetto: Negro New York, 1890–1930* (1966).

LYNNE B. FELDMAN

NANCE, Ethel Ray

(13 Apr. 1899–19 July 1992), secretary and administrative assistant, civil rights worker, researcher, and writer, was born Ethel Ray in Duluth, Minnesota, the youngest of four children of a racially mixed couple, William Henry Ray, a black man from North Carolina, and Inga Nordquist, a Swedish immigrant. Inga and William met and married in Minneapolis in the 1880s, settling in segregated Duluth in 1889 in an immigrant neighborhood. In a city with less than two hundred African American residents, the Rays faced hostility from their white neighbors, prompting resistance from the defiant and proud William Henry Ray, who kept his hunting rifle loaded for self-defense. William fortified Ethel and her siblings against racism with stark tales of racial oppression and heroic resistance he had witnessed in Raleigh, where his parents and their neighbors took up guns to protect northern teachers who had come South to educate blacks after the Civil War. The family's isolation generated Ethel's

childhood desire to leave Duluth, yearnings that were later intensified by stories of the excitement of big cities and tales of college life relayed by students from Howard, Fisk, and other historically black universities, who worked at Minnesota resorts during summer vacations.

Ethel was educated in public schools in Duluth, graduating from high school in June 1917, having mastered secretarial skills rarely possessed in the black world at that time. That training later made her an invaluable resource to a long line of grateful executives that would include W.E.B. DU BOIS and CHARLES S. JOHNSON. She also received a parallel education in racial politics from her autodidact father who had his own library and subscribed to the *Messenger,* the *Guardian,* and *The Crisis.* Nance often read aloud the articles on racial struggle and uplift. Rounding out her youthful education in racial reality, in 1919 Nance was taken on an intensive four-month trip by her father. With his birth city, Raleigh, as the ultimate destination, the two made stops in Chicago, Philadelphia, Detroit, New York, and other major cities, where Nance was introduced to leading personalities in the African American world, including WILLIAM MONROE TROTTER and A. PHILIP RANDOLPH. In the South, she bore witness to the harsh segregation governing the lives of their southern relatives.

Financially unable to attend college, Nance began work in 1918, eventually landing a stenographer's position after a frustrating job quest prolonged by racial discrimination in Duluth. This first post came only when massive forest fires in northern Minnesota in 1918 created a high demand for workers. The Minnesota Forest Fires Relief Commission hired Nance first in Duluth, and then later in nearby Moose Lake, itself rampant with discrimination. The brutal and highly publicized lynching of three African American men near the family residence in Duluth in 1920 brought her back home. A personal and community turning point, this atrocity not only gave Ethel new awareness of the dangers of her hometown but it also galvanized Duluth's small black community and paved the way for the city's first NAACP branch, organized by Nance's ever-vigilant father.

Nance's participation in what would become a lifetime commitment to the NAACP and to W.E.B. Du Bois began in 1921 when she introduced Du Bois to members of the fledgling branch. Following Du Bois's visit, she ardently embraced his call to work for the passage of the Dyer antilynching bill. Her lobbying of Minnesotans so impressed WALTER WHITE that he wrote her a personal letter of thanks and praise. This political work gave her some insight into the legislative process and resulted in a move to St. Paul, where, in what would be a stream of "racial firsts," Nance broke the secretarial color bar in the state legislature, becoming its first African American stenographer. Publicized in the local and national press, Nance's boundary-breaking activity brought letters of praise from women's and civil rights organizations and job offers from across the country. She accepted a position with the Kansas City Urban League, where she met Charles S. Johnson, editor of *Opportunity* magazine and director of research for the New York Urban League. Moving in the spring of 1924 to become Johnson's secretary and editorial assistant, Nance eagerly joined the ranks of other "New Negro" women seeking meaning and adventure in New York.

Nance's stay in New York was both brief and brilliant, and was the high point of her long career. Lasting under two years, the intense New York sojourn took place during the critical cultural coming-of-age period for black America and for the generation that gave birth to the Harlem Renaissance. New York provided the opportunity for Nance's stellar administrative and organizational skills to flourish. In addition to serving as Johnson's secretary, she sought new talent in college publications, helped edit *Opportunity,* and undertook research projects. She helped organize the first *Opportunity Awards Dinner* held in 1925 and participated in the ensuing compilation of *Survey Graphics's* groundbreaking "Negro" number, which gave birth to *The New Negro.* An extension of the *Opportunity* office, "Dream Haven," the apartment she shared at 580 St. Nicholas with Regina Anderson Andrews, nurtured members of the younger generation, including LANGSTON HUGHES, COUNTÉE CULLEN, ZORA NEALE HURSTON, AARON DOUGLASS, and other "New Negroes," who wined, dined, and discoursed with Carl Van Vechten and other members of the older generation. W. E. B. Du Bois regarded her as a valuable liaison to the younger generation and deeply regretted Nance's reluctant return to Duluth in 1926 to attend her ailing mother.

From 1926 until a short but exciting position at the founding of the United Nations in San Francisco in 1945, Nance worked in various positions, none of which fully utilized her talents and ambitions.

Outside the office she enjoyed a fulfilling life. She sponsored literary discussions (using books lists from Du Bois), participated in civil rights organizations, and followed national and international currents in letters with Du Bois and others. Nance took another brief secretarial position in the state legislature in St. Paul in 1926, leaving to become associate head resident at the Phyllis Wheatley Settlement House in Minneapolis (1926–1928). Not heeding her father's advice that she run for political office, she became Minneapolis's first policewoman of color, working from 1928 to 1932; then became secretary to the Commissioner of Education in St. Paul from 1937 to 1940. In 1929 she married Leroy Williams and between 1932 and 1934 gave birth to their two sons, Thatcher and Glenn Ray. From 1940 to 1943 she was an administrative assistant at Hampton Institute, moving to Seattle, Washington, in 1943 to be with her second husband, Clarence Nance. Spending four exhilarating months in San Francisco in 1945, she was Du Bois's assistant when he became NAACP special consultant during the founding meeting of the United Nations. Nance was invigorated by her contact with delegates from all over the world and regarded this four-month assignment as the second high point in her career.

From 1945 to 1953, Nance was an administrative assistant in the NAACP's San Francisco office, helping the organization establish its West Coast regional site, while finding time to do research, act as sales agent, and provide other assistance to Du Bois. In 1953 she once again accepted a position with Charles S. Johnson, when he became the first black president of Fisk University. Her return to San Francisco in 1954 was marked by intense volunteer activities in civil rights and women's organizations, while employed in secretarial positions at the Veterans Administration, from 1954 to 1956; the San Francisco school district, 1956 to 1964; and the U.S. Post Office, from 1964 to 1969. Helping to found the San Francisco Historical and Cultural Society in 1959, Nance was delighted to serve as program director and research assistant from 1970 to 1977. As renewed interest in the Harlem Renaissance emerged, she enjoyed sharing her reflections with scholars while working on Du Bois's memoirs; she would remain in contact with him up to his death in 1963. In the early 1970s she assisted Regina Andrews in compiling "A Chronology of African Americans in New York," which, while unpublished during their lives, served as source for the Schomburg's successful millennium exhibition and book *The Black New Yorkers: The Schomburg Illustrated Chronology* (2000). At the age of seventy-eight in 1977 she received her BA from the University of San Francisco, becoming its oldest graduate. Upon Nance's death in 1992 the San Francisco Board of Supervisors adjourned in honor of her distinguished service to the community.

FURTHER READING
Two oral histories that Nance undertook in the 1970s contain source material for her life and work. The one completed by Ann Shockley is part of the Black Oral History Collection at Fisk University and is accessible online at http://www.fisk.edu. Part of the Black Minnesotan's project sponsored by the Minnesota Historical Society, David Vassar Taylor's interview, which includes Nance's reaction to the Duluth lynchings, is available at www.collection.mnhs. The Bancroft Special Collections Library at the University of California, Berkeley, holds 170 letters between Nance and W.E.B. Du Bois.
Lewis, David Levering. *When Harlem Was in Vogue* (1979).
Lewis, David Levering. *W. E. B. Du Bois: The Fight for Equality and the American Century* (2000).
Smith, Jesse Carney, ed. *Notable Black American Women* (1992).
Wintz, Cary. *Encyclopedia of the Harlem Renaissance* (2005).

Obituary: San Francisco Examiner, 19 July 1992.

ONITA ESTES-HICKS

NEWSOME, Mary Effie Lee

(18 Jan. 1885–12 May 1979), author, editor, and illustrator, was born Mary Effie Lee in Philadelphia, Pennsylvania, one of five children of Mary Elizabeth Lee and Benjamin Franklin Lee, Wilberforce University professor and president, bishop of the African Methodist Episcopal (AME) Church, and chief editor of its official publication, *Christian Recorder*. Newsome learned to appreciate literature at an early age from her parents. She loved the nature stories she heard from her mother, who also taught her children how to draw pictures of birds, insects, and flowers. Her well-read father also shared an appreciation for art and literature and encouraged Newsome's artistic and literary expression. When she moved to Waco, Texas, at

the age of seven, when her father was elected an AME bishop, Newsome continued to explore nature through verse and sketches and attempted to publish her work. Four years later her family established its permanent home in Xenia, Ohio. At age sixteen she began her extensive training in the liberal and fine arts, first at Wilberforce University (1901–1904), where both her parents were educated, and later at Oberlin College (1904–1905); the Philadelphia Academy of Fine Art (1907–1908); and the University of Pennsylvania (1911–1914).

Mary Effie Lee first began publishing in 1915 in *Crisis*, where more than one hundred of her poems were printed over the next nineteen years. She found another publishing outlet when *Crisis* editor W. E. B. DU BOIS established a magazine in 1920 devoted to African American children, ages six to sixteen, called the *Brownies' Book*. The monthly publication was meant to "make colored children realize that being 'colored' is a normal, beautiful thing" and "to make them familiar with the history and achievements of the Negro race" (*Crisis*, Oct. 1919). Newsome saw eleven of her poems in the *Brownies' Book*, which lasted only two years.

In 1920 Mary Effie Lee changed her name to Effie Lee Newsome after marrying the African Methodist Episcopal Church Reverend Henry Nesby Newsome, who taught at Wilberforce. They moved to Birmingham, Alabama, where her husband was assigned an AME congregation. Newsome organized the Boys of Birmingham Club and became an elementary school teacher and children's librarian. She and her husband soon moved back to Wilberforce, where she took a job as a librarian at Central State College.

In 1924 Du Bois transferred his effort in the *Brownies' Book* to a column in *Crisis*, recruiting Newsome to edit and write "The Little Page," which featured poems, illustrations, and short prose writing. Newsome produced nature poetry, drawings, nonsense verse, and parables relating to African American youth facing racial discrimination. These prose pieces aimed to instill pride in black youth by emphasizing the history of Africa and its descendants.

Newsome also appeared in other major publications such as *Opportunity*, from 1925 to 1927, and *Phylon*, another journal edited by Du Bois, from 1940 until 1944. Though she published nonfiction and short stories, Newsome's reputation rests mostly on her poetry. In 1940 she published her only book, a collection of poems. *Gladiola Garden: Poems of Outdoors and Indoors for Second Graders* is a testimony to her devotion to the wonders of nature. Mary Hastings Bradley, in the foreword, described Newsome's book as possessing charm and significance beyond what children would value. "The spirit of kindness, of gentle insight, and of quiet understanding underlies even the gayest of her fantasies." Newsome dedicated the book to her sister for "keeping the garden of hope alive," revealing her own optimism, which Bradley claims captures the attitude of their time. The editors of the *Negro History Bulletin* (Feb. 1947) depicted her encouraging spirit well when they said that Newsome's "aim is not only to help children to appreciate the good and the beautiful but to express themselves accordingly."

Newsome received some critical notice for her adult poems, especially "Morning Light: The Dew-Drier." The poem is perhaps Newsome's most enduring legacy, anthologized in COUNTÉE CULLEN's *Caroling Dusk* (1927); ARNA BONTEMPS's *American Negro Poetry* (1963); LANGSTON HUGHES's and Bontemps's *Poetry of the Negro: 1746–1970* (1970); and Arnold Adoff's *Poetry of Black America* (1973). Published in 1918 in *Crisis*, "Morning Light" describes the role of "dew-driers," African boys who bushwhacked paths for white explorers and safari hunters. Leading the way, these boys absorbed the wet grasses and faced serious dangers, a role Newsome foretells for black people in the era following the World War I: "May not his race, even as the Dew Boy leads / Bear onward the world to a time / When tolerance, forbearance, / Such as reigned in the heart of ONE / Whose heart was gold / Shall shape the world for that fresh dawning / After the dews of blood?"

Newsome's "Morning Light" contributed to the early momentum of the Harlem Renaissance, which began at the end of World War I, by bringing attention to the value of African American heritage. Her work also reflected the spirit of the Harlem Renaissance through the African and African American images that she drew to accompany her poems. However, she was not known for the social and political activism associated with the Harlem Renaissance. Instead, Newsome was appreciated for her mastery of "the difficult art of writing verses for children that keep a sense of literary values and do not offend by too much of a juvenile air" (230), as she is described in *The Negro Genius* (1937).

Venetria K. Patton and Maureen Honey's effort to redress the historical emphasis on male writers from the Harlem Renaissance included several of Newsome's poems in *Double-Take: A Revisionist Harlem Renaissance Anthology* (2001) on the strength of her writings for children. Her reputation as a gifted children's writer also lives on among early childhood educators. Rudine Sims Bishop, who wrote the introduction to *Wonders: The Best Children's Poems of Effie Lee Newsome* (1999), applauded Newsome for her timeless gift of capturing the way a child views the world. Newsome stopped publishing in 1944. She retired from her work as a librarian at Wilberforce University in 1963 and lived in Wilberforce until her death.

FURTHER READING

The only surviving paper of Effie Lee Newsome is a biographical sketch that she wrote for Arna Bontemps, kept in the Harold Jackman Collection, Atlanta University Center Library, Atlanta, Georgia.

MacCann, Donnarae. "Effie Lee Newsome: African American Poet of the 1920s," *Children's Literature Association Quarterly* 13 (1988): 60–65.

Rollins, Charlemae Hill. *Famous American Negro Poets* (1965).

CALEB A. CORKERY

NICHOLAS, Fayard, and Harold Nicholas

(28 Oct. 1914–24 Jan. 2006) and (27 Mar. 1921–3 Jul. 2000), dancers and performers who together made up the Nicholas Brothers dance duo, were born Fayard Antonio Nicholas, in Mobile, Alabama, and Harold Lloyd Nicholas, in Winston-Salem, North Carolina, to Ulysses Nicholas, a jazz drummer, and Viola Harden, a jazz pianist. In 1926 the Nicholas family moved to Philadelphia, Pennsylvania, where Ulysses and Viola led a pit orchestra. Fayard and Harold performed in Philadelphia vaudeville theaters and radio stations from 1929 to 1931 as part of the Nicholas Kids (a sister, Dorothy Nicholas, was briefly in the act). In 1932 the Nicholas Brothers appeared with EUBIE BLAKE and NINA MAE MCKINNEY in the short film *Pie, Pie, Blackbird*. That same year the Nicholas Brothers debuted at the Cotton Club, where they were so well received that they became known as "The Show Stoppers." Also, because they were children, they were allowed to mingle with the white audience after the show.

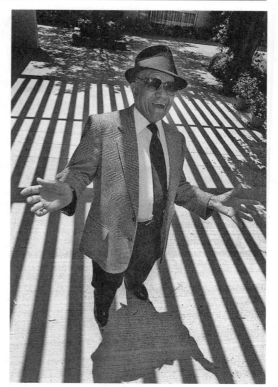

Fayard Nicholas strikes a pose at his residence in Woodland Hills, California, 28 June 1999. In their prime, Fayard and his brother, Harold, performed as a song-and-dance team on Broadway, in Las Vegas, and in the movies. (AP Images.)

In 1933 Harold appeared with PAUL ROBESON in *The Emperor Jones*, and in the following year the Nicholas Brothers appeared together in their first feature-length Hollywood film, *Kid Millions*. In the 1930s the Nicholas Brothers performed in films such as *The Big Broadcast of 1936* (1935), *The Black Network* (1936), and *Calling All Stars* (1937). They made their Broadway debut in *The Ziegfeld Follies of 1936*, appeared in the West End of London in Lew Leslie's *Blackbirds of 1936*, and were invited by George Balanchine to perform their own number in Rodger and Hart's *Babes in Arms* (1937). Their song, "All Dark People Is Light on Their Feet," is commonly dropped from revivals of the play. Their acrobatic, full-bodied tap style contributed to their reputation as two of the premiere "flash" or "specialty" dancers of their time; their signature moves included jumping into a split and then rising upright without using their hands.

In 1940 the Nicholas Brothers began a series of six films for Twentieth Century–Fox that contain their most notable performances: *Down Argentine Way* (1940), *Tin Pan Alley* (1940), *Sun Valley Serenade* (1941), *The Great American Broadcast* (1941), *Orchestra Wives* (1942), *Stormy Weather* (1943), and *Take It or Leave It* (1944). In these films, their collaboration with the choreographer Nick Castle (born Nicholas John Casaccio) led to some spectacular innovations. In *Orchestra Wives* (1942), Harold takes two vertical steps up a wall and then executes a backward flip into a split. In *Stormy Weather* (1943, starring Lena Horne and BILL ROBINSON), they appear with CAB CALLOWAY and his orchestra in "Jumpin' Jive," a routine in which the Nicholas Brothers keep the rhythm with their feet while leaping and dancing over and on top of the orchestra (they dance on round pedestals made to look like the tops of drums). The end of the routine features a sequence in which Harold and Fayard descend a flight of stairs by leap-frogging over each other and landing into splits. Fred Astaire called "Jumpin' Jive" the greatest musical number he ever saw on film. The brothers later remarked that they performed the number in one take and that they had not rehearsed it beforehand.

Despite the virtuosity of the Nicholas Brothers, racial segregation limited their film roles. Most of their numbers were short and not integrated into the plots of the films so that the sequences could easily be removed when the films were exhibited for white audiences in the South. Moreover, as the brothers aged they could no longer be seen as precocious children devoid of sexuality. In most of their films they had no scenes or dialogue with the female leads; the only woman with whom they danced on film was Dorothy Dandridge, who later married Harold Nicholas, in the "Chattanooga Choo Choo" number in *Sun Valley Serenade* (1941). The Nicholas Brothers did not dance with a white star on film until they performed with Gene Kelly in their last Hollywood film, *The Pirate* (1948).

Disillusioned by racial tension in the United States, in the 1950s Harold elected to stay in France following a European tour with his brother. "The way we were treated there was a revelation," he said (Tom Vallance, "Obituary: Harold Nicholas," *Independent* [London] 5 July 2000). Based in Paris, Harold appeared with JOSEPHINE BAKER at the Olympia, and also toured European and North African nightclubs. While in Europe, Harold made

Harold Nicholas looks up after performing the song "Blue Skies" during a tribute to Fred Astaire, 5 December 1999, at the Getty Center in Los Angeles. (AP Images.)

occasional films both with and without Fayard, including *Botta e Risposta* (Italy, 1949) and *L'Empire de la Nuit* (France, 1963). In 1964 Harold and Fayard reunited for three *Hollywood Palace* television specials and other cabaret performances. In subsequent years Harold often performed as a singer. Other films in which Harold appeared include the SIDNEY POITIER comedy *Uptown Saturday Night* (1974), the Nick Castle film *Tap* (1989), and Robert Townsend's *The Five Heartbeats* (1991).

In 1970 Fayard appeared in a dramatic role in the William Wyler film *The Liberation of L. B. Jones.* By 1975 he was suffering from severe arthritis in both hips; in 1985 he underwent hip replacement surgery. During this period, though he occasionally performed as a soloist and with Harold, Fayard devoted more time to teaching and choreography. In 1989 Fayard received a Tony Award as one of four co-choreographers for the Broadway musical *Black and Blue.* In 1991 both Nicholas Brothers received Kennedy Center Honors. In 1992

the Nicholas Brothers were the subject of a documentary feature directed by Chris Boulder, *Nicholas Brothers: We Sing and We Dance.*

Fayard's first marriage, to Geraldine Pate, which produced two sons, ended in divorce in 1955. He was married a second time to Lee Barton. He was married a third time, to Barbara January, in 1967, and a fourth time, in 2000, to Katherine Hopkins. Harold married the actress Dorothy Dandridge in 1942. Their daughter, Harolyn, born in 1943 with severe brain damage, was eventually institutionalized. Nicholas and Dandridge divorced in 1949. His second marriage, to Elyanne Patronne, with whom he had a son, Melih, also ended in divorce. He was married a third time to Rigmor Newman.

In the Broadway musical *Bring in 'Da Noise, Bring in 'Da Funk* (1996), George C. Wolfe and Savion Glover (who appeared with Harold in *Tap*) satirized the Nicholas Brothers as "Grin and Flash," smiling Uncle Toms who sacrificed their heritage for financial gain. Fayard's response: "He was say-ing the studios used us. . . . Why bring us down? We are the ones who made it possible for them to be where they are today" (Caroline Palmer, "Amazing Feet: The Nicholas Brothers," *City Pages* [Minneapolis/St. Paul] 18 Aug. 1999).

Fayard Nicholas died in 2006 in Los Angeles. The cause was pneumonia and other complications of a stroke he suffered in November 2005. Harold died in 2000 in New York City, from heart failure following surgery at New York Hospital.

FURTHER READING
Frank, Rusty E. *Tap!: The Greatest Tap Dance Stars and Their Stories, 1900–1955* (1990).
Hill, Constance Valis. *Brotherhood in Rhythm: The Jazz Tap Dancing of the Nicholas Brothers* (2000).

Obituaries: New York Times, 26 Jan. 2006 (Fayard Nicholas); *New York Times*, 4 Jul. 2000 (Harold Nicholas).

MATTHEW SEWELL

OLIVER, King

(11 May 1885–8 Apr. 1938), cornetist and bandleader, was born Joseph Oliver in or near New Orleans, Louisiana, the son of Jessie Jones, a cook; his father's identity is unknown. After completing elementary school, Oliver probably had a variety of menial jobs, and he worked as a yardman for a well-to-do clothing merchant. He appears to have begun playing cornet relatively late, perhaps around 1905. For the next ten years he played in a variety of brass bands and large and small dance bands, coming to prominence about 1915. Between 1916 and 1918 Oliver was the cornetist of trombonist EDWARD "KID" ORY's orchestra, which was one of the most highly regarded African American dance orchestras in New Orleans. Early in 1919 Oliver moved to Chicago and soon became one of the most sought-after bandleaders in the cabarets of the South Side black entertainment district.

In early 1921 Oliver accepted an engagement in a taxi-dance hall on Market Street in San Francisco, and he also played in Oakland with his old friend Ory and perhaps in local vaudeville as well. After a stop in Los Angeles, he returned to Chicago in June 1922, beginning a two-year engagement at the Lincoln Gardens. After a few weeks, Oliver sent to New Orleans for his young protégé LOUIS ARMSTRONG, who had been Oliver's regular substitute in the Ory band some five years earlier. With two cornets (Oliver and Armstrong), the trombonist Honore Dutrey, the clarinetist Johnny Dodds, the string bassist William Manuel Johnson, the drummer Warren "Baby" Dodds, and the pianist Lillian Hardin (LIL ARMSTRONG), King Oliver's Creole Jazz Band made a series of recordings for the Gennett, Okeh, Columbia, and Paramount labels (some thirty-seven issued titles), which are regarded as supreme achievements of early recorded jazz. (Other musicians substitute for the regulars on a few of these recordings.) There is ample evidence that a great many musicians, black and white, made special and repeated efforts to hear the band perform live.

By early 1925 Oliver was leading a larger and more up-to-date orchestra with entirely new personnel. This group was the house band at the flashy Plantation Cafe (also on the South Side) and as the Dixie Syncopators made a series of successful recordings for the Vocalion label. Oliver took his band to the East Coast in May 1927, but after little more than a month, it dispersed. For the next four years Oliver lived in New York City, touring occasionally and making records for the Victor Company at the head of a variety of ad hoc orchestras; these are widely considered inferior to his earlier work.

His popularity waning and his playing suffering because of his chronic gum disease, Oliver spent an unprosperous six years between 1931 and 1937 incessantly touring the Midwest and the upper South. Savannah, Georgia, became his headquarters for the last year of his life; he stopped playing in September 1937 and supported himself subsequently by a variety of odd jobs. He died in Savannah of a cerebral hemorrhage; he was buried in Woodlawn Cemetery in New York City. The Reverend ADAM CLAYTON POWELL JR. officiated, and Louis Armstrong performed at the funeral service. He was survived by his wife, Stella (maiden name unknown), and two daughters.

Oliver is the most widely and favorably recorded of the earliest generation of New Orleans ragtime/jazz cornetists, most influential perhaps in his use of straight and plunger mutes; aspects of Louis Armstrong's style clearly derive from Oliver. Oliver's best-known contributions as a soloist are his three choruses on "Dipper Mouth Blues," copied hundreds of times by a wide variety of instrumentalists on recordings made during the next twenty years. His major achievement, however, remains the highly expressive and rhythmically driving style of his band as recorded in 1923–1924. While the band owed its distinctiveness and energy, like all early New Orleans jazz, to the idiosyncratic musical talents of the individual musicians, its greatness was undoubtedly the result of Oliver's painstaking rehearsals and tonal concept.

FURTHER READING
Gushee, Lawrence. "Oliver, 'King,'" in New Grove Dictionary of Jazz, ed. Barry Kernfeld (1988).
Wright, Laurie. "King" Oliver (1987).

Obituary: Chicago Defender, 16 Apr. 1938.

LAWRENCE GUSHEE

ORY, Kid

(25 Dec. 1890?–23 Jan. 1973), jazz trombonist, bandleader, and composer, was born Edward Ory in La Place, Louisiana, of Creole French, Spanish, African American, and Native American heritage. His father was a landowner; the names and other details of his parents are unknown. Ory first spoke French. The family made weekend visits to New Orleans, thirty miles away, where Ory had many opportunities to hear musicians. He built several instruments before acquiring a banjo at age ten, shortly before his mother died.

His father having become an invalid, Ory took over the support of his younger sisters and then, after the younger ones went to live with relatives, an older sister. He apprenticed as a bricklayer, caught and sold crawfish, and worked as a water boy for field hands. At age thirteen he began performing in public with his own band. He started to play trombone—first a valved instrument and then a slide trombone—at around age fourteen. Not long afterward the legendary cornetist Buddy Bolden asked Ory to join his band, but Ory was too young to accept the offer.

Ory fulfilled a promise to his parents that he would take care of the older sister until he was twenty-one, and on that birthday (c. 1911) he moved to New Orleans. He married Elizabeth "Dort" (maiden name unknown) in 1911; they had no children. From about 1912 to 1919 he led what was widely regarded as the best band in New Orleans. His sidemen included Mutt Carey on trumpet, KING OLIVER or LOUIS ARMSTRONG on cornet, Johnny Dodds, SIDNEY BECHET, Big Eye Louis Nelson, or Jimmie Noone on clarinet, and Ed Garland on string bass.

Having asked his wife if she would rather live in Chicago or California, Ory went west in October 1919. Carey and Garland joined his new band, which worked mainly in Los Angeles and San Francisco as Kid Ory's Brownskinned Babies and Kid Ory's Original Creole Jazz Band, the latter also known as the Sunshine Orchestra. In Los Angeles in June 1922, as Spikes' Seven Pods of Pepper, this group recorded "Ory's Creole Trombone" and "Society Blues." Ory's trombone solo is crude and unswinging, but the performances nonetheless have historical significance as some of the first instrumentals made by an African American jazz band.

Around late October 1925 Ory traveled to Chicago to record with Armstrong and to join Oliver at the Plantation Cafe. He initially worked as an alto saxophonist until trombonist George Filhe finished out his six-week notice to Oliver. Over the next two years he was involved in many of the greatest early jazz sessions. With Armstrong, Ory recorded his own composition "Muskrat Ramble" (1926), which was titled "Muskat Ramble" on original issues by the producer and publisher Walter Melrose, who thought "muskrat" offensive. "Muskrat Ramble" became a staple of the traditional jazz repertory. Ory also recorded "Drop That Sack" (1926) with Louis Armstrong and his wife, the pianist Lil Armstrong, who led the session; with the pianist JELLY ROLL MORTON's Red Hot Peppers, "Dead Man Blues," "Doctor Jazz," and "Smokehouse Blues" (all 1926); with the New Orleans Wanderers, "Perdido Street Blues" and "Gate Mouth" (also 1926); with Louis Armstrong, "Potato Head Blues," "S.O.L. Blues," and an updated rendition of "Ory's Creole Trombone" (all 1927); and with Oliver's Dixie Syncopators, "Every Tub" (1927).

Ory started on Oliver's tour to New York City in May 1927, but he returned to Chicago by early June. He joined Dave Peyton's orchestra and then transferred to Clarence Black's group at the Savoy Ballroom, at which point he composed "Savoy Blues," recorded with Armstrong in December. Ory left Black in 1928 to become a member of the Chicago Vagabonds at the Sunset Cafe. He remained into 1929. He returned to Los Angeles in 1930. His last job was with Leon René's band in the show "Lucky Day" in San Francisco in the early 1930s.

Leaving music, Ory sorted mail at the Santa Fe Railroad post office, ran a chicken ranch in Los Angeles, worked as a cook, and served as a custodian at the city morgue. He resumed playing in 1942 as a member of the clarinetist Barney Bigard's group in Los Angeles. Bigard categorically denied a fairly unimportant but nonetheless oft-told story, that Ory initially played string bass in the group, but the clarinetist Joe Darensbourg remembered that Ory played bass pretty well.

In any event, Ory was soon back on trombone. He gave concerts with the cornetist Bunk Johnson in San Francisco in 1943. In February 1944 he broadcast on Orson Welles's show as a member of a cooperative seven-piece traditional jazz group that included Carey, Noone, Garland, and the drummer Zutty Singleton. Welles's show was a great success, and the group returned weekly for many months. Noone died in April, and Bigard

was among several new band members. The band became Ory's, and he recorded under his name, with the clarinetist Omer Simeon for Bigard on "Get Out of Here" and "Blues for Jimmie" (both 1944) and Darnell Howard taking Simeon's place for "Maryland, My Maryland," "Down Home Rag," and "Maple Leaf Rag" (all 1945). These discs are among the central recordings of the New Orleans jazz revival.

Ory's band held extended runs at the Jade Room on Hollywood Boulevard in Hollywood, beginning in April 1945, and at the Beverly Cavern in Los Angeles from 1949 to 1953. Among his sidemen were Howard, Darensbourg or Bigard, and the drummer Minor Hall. In rather bitter remembrances of Ory, Bigard reported that he helped the trombonist secure royalties for "Muskat Ramble." Ory received eight thousand dollars immediately, followed by quarterly checks for several hundred dollars. Bigard said that Ory bought a house and changed for the worse, leaving his wife in an underhanded manner, remarrying, and treating his sidemen badly. Ory married Barbara (maiden name unknown) around 1952; they had one daughter.

Ory recorded the album *Kid Ory's Creole Jazz Band, 1954*, and from 1954 to 1961 ran his own club, On the Levee, in San Francisco. He also had a role in the movie *The Benny Goodman Story* (1955), and he toured Europe in 1956 and England in 1959. In July 1961 he moved back to Los Angeles and resumed bandleading at the Beverly Cavern. From 1964 onward he reduced his activities to performances on the riverboat at Disneyland, and in 1966 he retired to Hawaii. Ory suffered a serious bout of pneumonia in 1969. Four years later he died in Honolulu, Hawaii.

The writer Martin Williams supplied a remembrance: "Ory was stiff or standoffish with everyone, but if you had a pretty girl with you, a kind of Creole graciousness would come out. . . . He was always a frugal man, you know. He always saved money and lived well. And he usually did his own business management and booking. Ory has the mentality of a French peasant, with all the charm that that implies, and all the shrewdness and stinginess and caginess too."

In the mid-1920s Ory was a shaky, awkward, coarse soloist by comparison with his frequent companions Armstrong and Dodds, but he excelled in collective improvisations, offering definitive examples of the raucous, sliding technique known as "tailgate trombone" within the New Orleans jazz style. He played the instrument open and muted, mainly using a cup mute. During his second career, he sometimes sang; his manner was entertaining but utterly unremarkable, save for the occasional use of Creole patois rather than English. While retaining his formidable ensemble skills, he became a smoother trombone soloist, and he expanded his collection of mutes to achieve a variety of timbres.

FURTHER READING
Charters, Samuel Barclay, IV. *Jazz: New Orleans, 1885–1963: An Index to the Negro Musicians of New Orleans* (1963; rev. ed. 1983).
Williams, Martin T. *Jazz Masters of New Orleans* (1967; repr. 1979).
Obituary: New York Times, 24 Jan 1973.

BARRY KERNFELD

OTTLEY, Roi

(2 Aug. 1906–1 Oct. 1960), journalist, was born Vincent Lushington Ottley in New York City, the son of Jerome Peter Ottley, a real estate broker in Harlem, and Beatrice Brisbane. His parents were both immigrants from the West Indies. Ottley grew up in Harlem in the 1920s. As a young person, Ottley witnessed the great expansion of black participation in cultural and intellectual activities as well as in politics and entertainment. He watched the parades held by the black nationalist MARCUS GARVEY and his supporters in the Universal Negro Improvement Association. He also attended the largest black church in the United States, the Abyssinian Baptist Church in Harlem, where ADAM CLAYTON POWELL SR. was the minister.

Ottley attended public schools in New York City; a city sprinting championship in 1926 won him a track scholarship to St. Bonaventure College in Olean, New York. He began his career in journalism at St. Bonaventure, drawing cartoons and illustrations for the student newspaper. In 1928 he studied journalism at the University of Michigan. Although he never earned an undergraduate degree, Ottley briefly studied law at St. John's Law School in Brooklyn and writing at Columbia University, City College of New York, and New York University.

Ottley sought employment as a newspaper writer during the Great Depression. In 1932 he began writing for the *Amsterdam News*, a black newspaper published in New York City. At the same time he worked for the New York Welfare Department and

in the Abyssinian Baptist Church relief program providing free meals. He was fired from his job as editor of the sports and theater pages of the *Amsterdam News* in 1937, ostensibly for his support of a new labor union, the New York Newspaper Guild. Ottley then began working for the Federal Writers' Project, a Works Progress Administration program under the New Deal. The program provided work for unemployed writers during the Great Depression. Ottley became one of the supervisors of a project that researched and wrote a history of the experience of black people in New York. The result of this project, *The Negro in New York*, edited by Ottley and William J. Weatherby, was not published until 1967, after Ottley's death, by the New York Public Library from the Federal Writers' Project research collection that had been deposited by Ottley in the Schomburg Collection.

Ottley used the material from the Federal Writers' Project as the basis for his first book, *"New World A-Coming": Inside Black America* (1943). This history of black people in New York City covers the period from the first appearance of eleven black slaves in 1626 to a discussion of African American opinion concerning America's entrance into World War II. The book was published in the middle of World War II, as race riots erupted in Detroit and Harlem and black Americans demanded that the United States practice democracy at home by ending racial discrimination. More than a history, the book attempted to explain the condition of black people in contemporary society and to explain their demands as well. Ottley warned that the black American's "rumblings for equality in every phase of American life will reverberate into a mighty roar in the days to come. For the Negro feels that the day for talking quietly has passed" (344). *"New World A-Coming"* won the Life in America Prize, the Ainsworth Award, and the Peabody Award.

After the Federal Writers' Project ended in 1940, Ottley began freelance writing for several periodicals and newspapers. During World War II he was a war correspondent in Europe and North Africa for the New York newspaper *PM*, for *Liberty* magazine, and for the *Pittsburgh Courier*. When he returned to New York after the war, he continued freelance writing, contributing articles to African American publications, including the *Negro Digest*, *Jet*, and *Ebony*.

In 1948 Ottley's second book, *Black Odyssey*, a history of African Americans in the United States, was published. Both *Black Odyssey* and *"New World A-Coming"* were noteworthy because they attempted to present the experiences of black people from their own perspective using original documents and interviews. In *Black Odyssey* Ottley presented the position that the United States must extend full civil rights to all of its citizens. His history stressed the international implications of American racial discrimination in the post–World War II climate, in which the United States sought to maintain its position as a model for democracy around the world. A third book, *No Green Pastures* (1951), based on Ottley's experience as a war correspondent, was primarily a record of his observations and feelings as he traveled in Europe, Egypt, and Israel from 1944 through 1946. The thesis of *No Green Pastures* was that black Americans should not delude themselves into thinking that they would find less racial discrimination in Europe.

In 1950 Ottley moved to Chicago and began writing for the black weekly newspaper the *Chicago Defender*. After his previous marriages, to Mildred M. Peyton and to Gladys Tarr, had ended in divorce, Ottley in 1951 married Alice Dungey, a librarian at the *Defender*; the couple had one child. In 1953 he began writing regular bylined articles for the *Chicago Tribune* on issues that concerned African Americans. During this period Ottley also hosted a radio interview program. In 1955 he published *The Lonely Warrior*, his biography of ROBERT S. ABBOTT, the founder of the *Chicago Defender*, whom Ottley described as one of the greatest influences on African American thought in his position as the founding editor of one of the nation's most widely read black newspapers.

At the time of his death in Chicago, Ottley had nearly finished his first book of fiction about an interracial marriage, *White Marble Lady*. His wife edited and published the book in 1965.

FURTHER READING
Material collected during the Federal Writers' Project under Ottley's supervision is in the Schomburg Collection at the New York Public Library in Harlem.
"Ottley Sees New World A'Coming," *New York Post*, 7 Apr. 1944.

Obituaries: *Amsterdam News*, *New York Times*, and *Chicago Tribune*, 2 Oct. 1960; *Chicago Defender*, 8 Oct. 1960.

JENIFER W. GILBERT

OWEN, Chandler

(5 Apr. 1889–2 Nov. 1967), journalist and politician, was born in Warrenton, North Carolina; his parents' names and occupations are unknown. He graduated in 1913 from Virginia Union University in Richmond, a school that taught its students to think of themselves as men, not as black men or as former slaves. Migrating to the North, where he lived for the remainder of his life, Owen enrolled in Columbia University and the New York School of Philanthropy, receiving one of the National Urban League's first social work fellowships. In 1915 he met another southern transplant, A. PHILIP RANDOLPH, with whom he formed a lifelong friendship. The pair studied sociology and Marx, listened to street corner orators, and joined the Socialist Party, working for Morris Hillquit's campaign for mayor of New York City in 1917. Concerned about the exploitation of black workers, Owen and Randolph opened a short-lived employment agency and edited a newsletter for hotel workers, which was the predecessor for their later Marxist-oriented monthly magazine, the *Messenger*, which they edited from 1917 to 1928.

World War I and the postwar red scare propelled Owen into the most significant years of his life. During this period he had his most significant influence on black affairs and was at his most influential in attracting white attention to black issues. He and Randolph believed that capitalists had caused the war and that the working masses of all nations, including African Americans, were being sacrificed for purposes that would bring them no benefit. They admired the Russian Revolution and therefore exempted Russia from censure. The first issue of the *Messenger* in 1917 expressed these themes and the view, shared by many blacks, that World War I was a "white man's war." Subsequent articles argued that blacks could hardly be expected to support a war to "make the world safe for democracy" when they suffered lynching and discrimination. An article in the July 1918 *Messenger* entitled "Pro Germanism among Negroes" prompted the Post Office Department to cancel the magazine's second-class mailing permit, and for the remainder of the war Owen and Randolph printed their most radical essays in pamphlet form. Both men declared themselves conscientious objectors. Randolph escaped military service because he was married, but Owen was inducted in late 1918 and served to the end of the war.

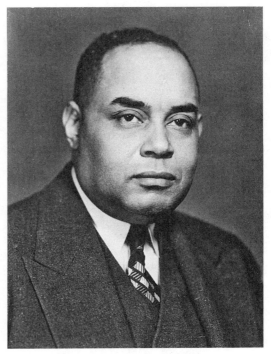

Chandler Owen, coeditor of the socialist magazine The Messenger *and, later, Republican Party activist. (Library of Congress.)*

The Department of Justice and army intelligence watched Owen and Randolph closely. They were charged with treason in the summer of 1918 for allegedly impeding the war effort, but the judge dismissed the charges, refusing to believe the two young African Americans were capable of writing the socialist and antiwar essays offered as evidence. During the rest of the war and throughout the red scare, the Justice Department's Bureau of Investigation (later renamed the Federal Bureau of Investigation) monitored Owen and Randolph's activities and writings, burglarized their offices, and unsuccessfully sought their prosecution. J. Edgar Hoover, head of the Justice Department's antiradical campaign, charged that Owen and Randolph's *Messenger* was "the most dangerous Negro magazine" and the worst example of black radicalism. Hoover and other guardians of the racial status quo objected particularly to its admiration for Russian Bolshevism, enthusiasm for the Industrial Workers of the World, legitimization of armed self-defense against lynchers and rioters, and demand for social

equality between the races. Hoover hoped to prosecute Owen and Randolph in 1919, using the wartime Espionage Act, but was thwarted when federal attorneys argued that a jury was unlikely to convict them.

Surveillance of Owen and Randolph by infiltrators and the bureau's first black agents continued into the 1920s. The pair coined the term "New Crowd Negroes" to describe their own generation, which rejected not only the racial accommodationism once promoted by BOOKER T. WASHINGTON but also the leadership of W. E. B. DU BOIS, whom they considered to be insufficiently militant. They continued to promote the Socialist Party, Owen running unsuccessfully for the New York State Assembly in 1920. The post office refused to restore the magazine's second-class rate until 1921, when the *Messenger* resumed full publication, devoting much of its energy to the campaign against the West Indian Pan-Africanist MARCUS GARVEY. Owen and Randolph were completely opposed to Garvey's rejection of a future in the United States for blacks; they believed that integration and full civil rights should be the goals for all American blacks. In January 1923 Owen wrote a controversial public letter to Attorney General Harry M. Daugherty, signed by seven other prominent blacks, urging the government to speed up its prosecution of Garvey, charging him with worsening race relations and encouraging violence against his opponents.

After the red scare of 1919 and 1920 Owen became disillusioned with socialism, moved to Chicago in 1923, and for a time was managing editor of the *Chicago Bee*, a black newspaper that supported Randolph's efforts to organize a Pullman porter's union. Changing his political course, Owen joined the Republican Party and ran unsuccessfully for the House of Representatives in 1928. For the rest of his life he worked in journalism and public relations, for a number of years writing a column for the *Chicago Daily News*. During World War II Owen wrote a patriotic government pamphlet, *Negroes and the War* (1942), 5 million copies of which were distributed to civilians and soldiers. He wrote speeches for the presidential candidates Wendell Willkie and Thomas Dewey and campaigned for Dwight Eisenhower in 1952. Owen's long-standing Republicanism was only interrupted in 1964, when he felt he could not support Barry Goldwater and instead backed Lyndon Johnson. He died in Chicago.

FURTHER READING
Kornweibel, Theodore, Jr. *No Crystal Stair: Black Life and the Messenger, 1917–1928* (1975).

THEODORE KORNWEIBEL

PACE, Harry Herbert

(6 Jan. 1884–26 July 1943), entrepreneur, was born in Covington, Georgia, the son of Charles Pace, a blacksmith, and Nancy Francis. Pace's father died when he was an infant, but Pace was nonetheless able to secure a good education. He finished elementary school in Covington by the time he was twelve, and seven years later he graduated as valedictorian of his class at Atlanta University.

Pace learned the trade of printer's devil as a youth and worked in the Atlanta University printing office. After graduation he took a job in a new firm established by a group of prominent blacks in Atlanta. Pace served as foreman and shop manager, but the venture was unsuccessful and soon closed. In 1904 Pace became an instructor at the Haines Institute in Augusta, Georgia, where he remained for only a year before W. E. B. DU BOIS, who had been one of his teachers at Atlanta University, persuaded Pace to join him in launching the *Moon Illustrated Weekly*, a magazine for blacks to be published in Memphis, Tennessee. Du Bois was editor of the journal, which commenced publication in December 1905, and Pace was its manager. Although the venture was relatively short-lived, it was one of the earliest efforts at a weekly magazine for blacks and provided Pace with a favorable introduction to the rising African American business community of Memphis.

When the *Moon* folded in July 1906 Pace was offered a position as professor of Latin and Greek at Lincoln University in Jefferson City, Missouri, where he remained for a year. In 1907 Robert R. Church Sr., president of Solvent Savings Bank in Memphis, asked the young man to join the bank as cashier. Pace proved himself an excellent businessman. Within four years he had increased the bank's assets from fifty thousand dollars to six hundred thousand dollars, turning it into an exceedingly profitable venture.

In 1912 Heman Perry, the owner of Standard Life Insurance Company of Atlanta, offered Pace the position of secretary of the firm, which was just being organized. Perry and Pace made Herculean efforts for the company, and in 1913 Standard Life became the first black insurance company organized solely for the purpose of selling ordinary life insurance and the third black insurance company to achieve legal reserve status. Standard Life grew rapidly over its first ten years. Pace installed rigorous business systems at Standard, but these exacting regulations did not suit the entrepreneurial personality of Perry, causing the two men to clash often over Perry's cavalier attitude. Nonetheless Pace managed to work with Perry until the summer of 1917, when petty friction while Pace was on his honeymoon with Ethlynde Bibb, with whom he had two children, finally exploded into a confrontation that ended with Pace leaving Standard Life.

Pace headed for New York City, where in 1918 he joined W. C. HANDY, the great composer and compiler of the blues, in establishing Pace and Handy Music, a sheet-music publishing company. The two had worked with each other since 1907 in Memphis, where Pace had often written lyrics to accompany music written by Handy. Pace and Handy Music was a dynamic and successful business in New York for a number of years. Pace, who served as its first president, stayed with the company until 1921. Handy continued to run the company as Handy Brothers Music Company until the 1950s.

Pace and Handy's greatest success was with "St. Louis Blues," written earlier by Handy, which became a huge hit. But Pace was frustrated. White-owned record companies would buy their songs and then record them using white artists. In March 1921 Pace started his own record firm, Black Swan Records—the first record firm in the United States to be owned by blacks. Pace did not have an easy time getting the firm established because white-owned companies set up obstacles, preventing him for a time, for instance, from purchasing a record-pressing plant. Ultimately, however, he set up recording studios and a pressing laboratory, and he obtained other supplies necessary to produce records. The future for Black Swan Records seemed bright in 1922–1923, but the advent of radio as a popular, and much cheaper, means of transmitting music destroyed the prospects of the company and threatened to send even white record firms into bankruptcy. As a result Pace decided to sell his firm to Paramount Records in 1925. Although many of Pace's artists, such as ETHEL WATERS, continued to be recorded, much of the authenticity of the firm's earlier black music was lost. Most importantly,

blacks were largely shut out of the management side of the record business.

In 1925 Pace moved back into the insurance industry, participating in the organization of Northeastern Life Insurance Company in Newark, New Jersey, and serving as its president. Although the firm struggled in its first few years, Pace operated it fairly successfully until 1929, when he began talking with Truman K. Gibson Sr. about the possibility of merging Northeastern with Supreme Life and Casualty of Columbus, Ohio. Supreme Life had large holdings of industrial insurance, with salesmen trained to sell it, while Pace's Northeastern had an excellent investment portfolio and first-rate management. Neither firm, however, had been profitable in 1928, so they began seeking another company that had larger cash reserves. They merged with Liberty Life Insurance of Chicago, one of the largest and most successful black companies in the country. The new firm, called Supreme Liberty Life Insurance, had combined capital of $400,000, insurance in force of $25 million, total assets of more than $1.4 million, and 1,090 employees. Pace was named president and chief executive officer of the new company.

The early years of Supreme Liberty Life were ones of struggle. Just after the merger in 1929, the devastating Great Depression struck. The situation for Supreme Liberty was more desperate than it was for many insurance firms because the company relied more heavily on the ordinary life insurance market. These policies were expensive, so poor blacks, who suffered greatly from the Depression, were more likely to allow the policies to lapse. To deal with these crushing problems Pace focused the firm more on the industrial insurance market. This was successful, and Supreme Liberty became increasingly profitable in the late 1930s. This recovery was based largely on a system called "mass production" in which largely untrained agents were sent out to write as many policies as they could without requiring any financial settlement at the time of signing. After the policy had been processed and issued the agent would then try to get the client to sign it, stressing the small weekly premiums to be paid. This technique allowed a rapid expansion of Supreme Liberty's industrial holdings, even if the expansion was itself quite expensive. Supreme Liberty's lapse rate was the highest among black firms, and the expense of collecting premiums on policies in force was also high. Although this did little to enhance the reputation of Supreme Liberty, the total insurance in force increased from $16.6 million in 1930 to $83.1 million by 1944.

After the American entrance into World War II, with black employment and wages rising rapidly, Supreme Liberty began to sell the more profitable ordinary life insurance. But this new era was faced by Gibson after Pace's death in Chicago. Pace was a member of the National Negro Insurance Association, serving as its president in 1928–1929. Partially because of this position he became an influential writer on insurance issues among blacks and wrote a number of articles for the African American insurance industry that appeared in major African American publications.

Pace was the founder or cofounder of an impressive number of important African American companies, at times introducing blacks into industries where they previously had no standing. He networked with most of the prominent African Americans of the time to the extent that he operated at the very apex of the status and power pyramids in the black communities of Memphis, Atlanta, New York City, and Chicago at various points in his life.

FURTHER READING

At least two letters from Pace to BOOKER T. WASHINGTON are in the Booker T. Washington Papers at the Library of Congress. A number of letters between Pace and ROBERT L. VANN concerning Black Swan Records are in the Percival L. Prattis Collection at the Moorland-Spingarn Research Center at Howard University.

Partington, Paul G. "The *Moon Illustrated Weekly*—the Precursor of *The Crisis*," *Journal of Negro History* (July 1963).

Puth, Robert C. "Supreme Life: The History of a Negro Life Insurance Company," *Business History Review* (Spring 1969).

Obituaries: Chicago Defender and *Amsterdam News*, 31 July 1943.

JOHN N. INGHAM

PADMORE, George

(1903?–23 Sept. 1959), writer and Pan-Africanist, was born Malcolm Ivan Meredith Nurse in Arouca, Trinidad, the son of James Hubert Alfonso Nurse, a teacher, and Anna Susanna Symister of Antigua. In Port-of-Spain he attended Tranquillity School and St. Mary's College of the Immaculate Conception

before graduating from Pamphylian High School in 1918. As a reporter of shipping news for the *Weekly Guardian*, he saw in the arrogant treatment the white editor meted out to a black assistant editor the future that lay in store for him. In 1924 he traveled to the United States with the declared intention of studying medicine. His wife, Julia Semper, joined him later, leaving behind their daughter, Blyden.

In the United States, Nurse evolved quickly into a political leader. While a student at Fisk University in Nashville, Tennessee, he wrote to Nnamdi ("Ben") Azikiwe, a Nigerian studying at Storer College in West Virginia, proposing an organization of "foreign Negro students in American colleges and universities. . . . to foster racial consciousness and a spirit of nationalism aiming at the protection of the sovereignty of Liberia" (Azikiwe, 138). Although the organization did not apparently materialize, later, when both Nurse and Azikiwe had moved on to Howard University Law School in Washington, D.C., Nurse organized a demonstration against the British ambassador, who was visiting the campus, and Azikiwe participated. A personal network of African liberationists was taking shape, and already Nurse was playing a key role in creating it.

By 1928 Nurse had associated himself with the Workers (Communist) Party and had taken the political name George Padmore. Dividing his life between Washington, D.C., and New York City, Padmore gave speeches at Communist gatherings, wrote for the *Daily Worker*, and in Harlem worked alongside his fellow West Indians CYRIL BRIGGS and RICHARD B. MOORE at the *Negro Champion*, a paper published by the American Negro Labor Congress.

In 1929, before Padmore had completed any American degrees, he attended a League Against Imperialism conference in Frankfurt, Germany. Just a few months later, leaving his wife behind in the United States, Padmore traveled to Moscow. However, upon his return he was barred from reentering the country by American authorities, and would never return.

Recognizing Padmore's talent as a writer, speaker, and organizer, the Communist International named him head of the International Trade Union Committee of Negro Workers. He moved in high circles in Moscow and traveled in Africa and Europe to recruit potential leaders for conferences or study in the Soviet Union. He wrote for the ITUC-NW's magazine, the *Negro Worker*, and became its editor with the October-November 1931 issue. Several Harlem writers contributed to the magazine, among them Cyril Briggs and LANGSTON HUGHES. Via sailors leaving Hamburg, Germany, his headquarters, Padmore sent copies of the *Negro Worker* to ports around the world. Considered seditious by colonial governments, the magazine was sometimes banned and its copies confiscated. Then in February 1933, not long before the Reichstag fire, the Nazis arrested Padmore and closed the *Negro Worker* office. After a brief time in prison, Padmore was deported to England. He published three more issues of the *Negro Worker*, using Copenhagen, Denmark, as a publishing address. But the Soviet Union was no longer eager to anger Britain and France, which were potential allies against Germany and major targets of the *Negro Worker*'s anti-imperialist rhetoric. Padmore learned in August 1933 that the ITUC-NW was being shut down. He resigned from his positions there and was subsequently expelled from the Communist International in 1934.

Relocating to Paris, Padmore wrote an exposé of life in the British African colonies, *How Britain Rules Africa*. He had difficulty finding a publisher, but Wishart Books, a press in London, brought the book out in 1936. By that time Padmore had moved to London. There he reconnected with his boyhood friend C. L. R. James, who had become a Trotskyist writer and agitator. An organization that James had started in order to oppose Italian aggression against Ethiopia evolved in 1937 into a new organization, the International African Service Bureau, of which Padmore became chair. Other IASB leaders included men Padmore had known in his Communist International days, Kenya's Jomo Kenyatta and Sierra Leone's I. T. A. Wallace Johnson. Operating with meager resources and observed by British intelligence, the IASB published pamphlets and short-lived periodicals that were sometimes seized in the African colonies.

Still a staunch socialist despite his break with the Communists, Padmore became a regular contributor to the British Independent Labour Party publication, the *New Leader*. He often recycled his *New Leader* articles in *The Crisis*, the NAACP's magazine in the United States. A new publisher on the British scene, Secker & Warburg, published books by several leading members of the Padmore circle, including Padmore's *Africa and World Peace* (1937).

For twenty-two years Padmore would use London as a base for a far-flung political operation dedicated to ending the British Empire. He lived on a low income earned by his writing and the secretarial work of Dorothy Pizer, the Englishwoman who became known as his wife (although he was never divorced from Julia). Their flat became a crossroads for African nationalists visiting or studying in London. When the South African Peter Abrahams arrived in London after the beginning of World War II, he found Padmore pounding out dispatches on a worn office typewriter. The copies he mailed to little magazines and newspapers around the world bore the request: "Please pass on to other periodicals" (Abrahams, 38). Running his one-man press service, Padmore sent articles to newspapers and magazines in Africa, the United States, the Caribbean, and Asia.

During the war, Padmore wrote a short book, *The White Man's Duty: An Analysis of the Colonial Question in the Light of the Atlantic Charter* (1942), with Nancy Cunard, the editor of an anthology, *Negro (1934)*, to which Padmore had contributed. In collaboration with Dorothy Pizer, he also wrote another book, *How Russia Transformed Her Colonial Empire*, but wartime publishing difficulties delayed its appearance until 1946. At the end of the war, Padmore organized the Fifth Pan-African Congress, held at Manchester in 1945. Presided over by W. E. B DU BOIS, the conference ushered in the postwar anti-imperialist movement. After the conference, one of the organizers, Kwame Nkrumah, returned to the Gold Coast (now Ghana) to build the independence movement there, while Kenyatta, another political colleague, returned to Kenya, where he eventually became prime minister and then president. To provide ammunition for this more vigorous postwar effort to end the empire in Africa, Padmore wrote *Africa: Britain's Third Empire* (1949), which was banned in several colonies.

As Nkrumah's star rose in the Gold Coast, Padmore increasingly focused his efforts on that West African country. He traveled there in 1951, ostensibly to write about political developments for the African American press, but touring the country as Nkrumah's guest, he spoke to sizable audiences. Returning to London to write *The Gold Coast Revolution: The Struggle of an African People from Slavery to Freedom* (1953), he encouraged his American friend RICHARD WRIGHT, another writer

disillusioned with Stalinism, to write his own book about the Gold Coast, and Wright produced *Black Power: A Record of Reactions in a Land of Pathos* (1954). Meanwhile, Padmore acted as Nkrumah's representative in London, meeting with European companies to discuss contracts to build housing, conferring with sympathetic members of Parliament, and writing front-page articles for the *Accra Evening News* (renamed the *Ghana Evening News* in 1953). In his most influential book, *Pan-Africanism or Communism?: The Coming Struggle for Africa*, published in 1956, Padmore presented a united, socialist Africa as an alternative to communism. In his foreword to the book, Wright called Padmore "the greatest living authority on the fervent nationalist movements sweeping Black Africa today" (11). That same year Peter Abrahams, a former London ally, pilloried Padmore in a roman à clef, *A Wreath for Udomo* (1956), as a theorist out of touch with African reality.

After Ghana's independence in 1957, Padmore accepted Nkrumah's invitation to move to Accra, Ghana, as an adviser on African affairs. He accompanied Nkrumah on state visits to other countries and organized the 1958 All African Peoples' Conference in Accra. But resentment by others in the Nkrumah government made his position uncomfortable, and a year after he came, he told Nkrumah he wanted to leave. Nkrumah persuaded him to stay, but just a few months later Padmore died at a London hospital of a hemorrhage precipitated by cirrhosis of the liver. His ashes were taken to Ghana for burial at Christiansborg Castle. On Ghana Radio, Nkrumah predicted that "one day the whole of Africa will surely be free and united and when the final tale is told the significance of George Padmore's work will be revealed" (Hooker, 140).

FURTHER READING

Correspondence to, from, and about Padmore is scattered across collections on several continents, for example in the papers of RICHARD WRIGHT, Beinecke Library, Yale; ST. CLAIR DRAKE and Cyril Ollivierre, Schomburg Center for Research in Black Culture, New York Public Library; Nancy Cunard, University of Texas, Austin; Kwame Nkrumah, Moorland-Spingarn Research Center, Howard University; C. L. R. James, University of West Indies, St. Augustine; and Daniel Guerin, University of Paris-Nanterre, France.

Abrahams, Peter. *The Black Experience in the 20th Century: An Autobiography and Meditation* (2001).

Adi, Hakim, and Marika Sherwood. *The 1945 Manchester Pan-African Congress Revisited* (1995).

Azikiwe, Nnamdi. *My Odyssey: An Autobiography* (1970).

Hooker, James R. *Black Revolutionary: George Padmore's Path from Communism to Pan-Africanism* (1967).

Makonnen, Ras. *Pan-Africanism from Within; As Recorded and Edited by Kenneth King* (1973).

CAROL POLSGROVE

PAGE, Hot Lips

(27 Jan. 1908–5 Nov. 1954), jazz trumpeter and singer, was born Oran Thaddeus Page in Dallas, Texas. His parents' names are unknown. His father, who worked in the moving business, died in 1916. His mother taught school and gave Page his first music lessons. He played piano, clarinet, and saxophone before taking up trumpet when he was twelve.

Page played in adolescent bands locally before touring in carnival and minstrel shows during the summer after he turned fifteen. At some point he toured on the Theater Owners' Booking Association circuit, accompanying the blues singers BESSIE SMITH and IDA COX. By one account Page attended high school in Corsicana, Texas, but dropped out to work in a Texas oil field; by another, he organized bands while attending a college in Texas. Accompanying the blues singer MA RAINEY, he went on tour to New York for performances at the Lincoln Theater in Harlem.

By the late 1920s Page had become one of the first trumpeters to make a career of patterning his playing and singing after LOUIS ARMSTRONG. From early 1928 to 1930 he was a member of the bassist Walter Page's southwestern band, the Blue Devils, with whom he recorded solos on "Blue Devil Blues" and "Squabblin'" in November 1929. Along with other musicians from the Blue Devils, Page had transferred into the Kansas City–based big band of Bennie Moten by October 1930, when he made his first recordings under Moten, including "That Too, Do." Page was unquestionably the finest soloist in Moten's band, as heard for example on "The Blue Room" and "Milenberg Joys," from a magnificent recording session of December 1932 that the group made in the midst of an otherwise disastrous trip east.

As work for Moten declined in 1933, Page found work with Moten's former pianist COUNT BASIE, playing in Basie's Cherry Blossom Orchestra in Little Rock, Arkansas, and in the Southwest from 1933 into 1934. The group gradually dissolved. Page returned to Kansas City in 1934. After Moten's death in April 1935, Page formed a quintet that included the tenor saxophonist Herschel Evans and the pianist Pete Johnson. He also worked as a freelancer with Basie's new band, of which he became a member while they were at the Reno Club in Kansas City in 1936. At this now legendary venue, Page participated in broadcasts on WXBY that led to Basie's discovery and subsequent fame. In what has been deemed one of the worst career moves in the history of jazz, Page excluded himself from this success in the summer of 1936 when he was persuaded by Armstrong's manager, Joe Glaser, to leave Basie and to work instead as a soloist. Page led an assortment of bands in New York from 1937 on, but often he just participated in jam sessions for lack of steady work. Many have speculated that Glaser made this move to undermine Page, thus protecting Armstrong from one of his most direct competitors.

Before organizing his own band in New York, Page joined the trumpeter Louis Metcalf's big band in the autumn of 1936 for performances at the Renaissance Casino in Manhattan and the Bedford Ballroom in Brooklyn. Page's first big band performed in August 1937 at Small's Paradise in Harlem and in May 1938 at the Plantation Club, a whites-only venue, but it broke up a month later. He then formed a group at the Brick Club, which became in effect a venue for out-of-work musicians, playing for whatever they could take in at the door; this did not last, either.

Page recorded "Skull Duggery" as a leader in 1938, participated in the Spirituals to Swing concert at Carnegie Hall on 23 December, and in June 1939 recorded "Cherry Red" with the pianist Pete Johnson and His Boogie Woogie Boys, featuring the singer BIG JOE TURNER. Later that year he led another band at Kelly's Stable and the Golden Gate Ballroom in New York. In January 1940 he recorded "Gone with the Gin." He toured as the featured soloist with the tenor saxophonist Bud Freeman's big band in July 1940, joined the clarinetist Joe Marsala in October, and then formed another short-lived big band for a stand at the West End Theater

Club in November, in which month he recorded "Piney Brown Blues" with Turner and "Lafayette" and "South" under his own name.

Page returned to Kelly's Stable as the leader of a septet from May 1941 into the summer. He then joined the clarinetist Artie Shaw's big band in August 1941 and soon made a hit with his singing and trumpeting on "Blues in the Night" and "St. James Infirmary." Like others of his era, including the singer BILLIE HOLIDAY and the trumpeter Roy Eldridge, Page suffered from racist taunts as the African American star in a white band. In any event, the association was short-lived, as Shaw broke up the band in January 1942 to enlist in the navy.

Page once again led an unsuccessful big band. Writer Greg Murphy reports, "The pattern of Lips' life now reflected the increasing frustration with big bands that seemed accident prone, compensated by large intakes of alcohol and throwing himself into the jam session without restraint." From the summer of 1943, he usually led small groups, while forming big bands for special occasions. His playing and singing are featured on "Uncle Sam Blues," made with Eddie Condon (March 1944), and "I Keep Rollin' On" (June 1944), the latter session as a leader also including one of his finest instrumentals, "Pagin' Mr. Page." He participated in several of Condon's weekly concerts at Town Hall in New York in May and June 1944. At year's end he recorded "The Sheik of Araby" under his own name.

Page performed with DON REDMAN at the Apollo Theater in the summer of 1945, and that July he recorded under the pseudonym Papa Snow White with the reed player SIDNEY BECHET. In the spring of 1946 he accompanied ETHEL WATERS in New York. That year Page's first wife died; her name and details of the marriage are unknown.

This period of Page's career was recalled by the record store owner and producer Milt Gabler, who ran a swing-style session at Jimmy Ryan's on Fifty-second Street in competition with a concurrent bebop session: "There was only one musician who played both jams: Hot Lips Page. He would play one set in our place and run across the street and play theirs."

Page continued to lead a small band. Between March and August 1949 he performed occasionally on Condon's television program *Floor Show*, and early in May he went to Paris to participate in the first Festival International de Jazz. That same year Page and the singer Pearl Bailey recorded

a hit record, pairing together "The Hucklebuck" and "Baby, It's Cold Outside" (1949), but its success did much more for her career than for his. Page married Elizabeth (maiden name unknown) around 1950. Whether his son was from the first or second marriage is unknown.

Page worked mainly as a freelance soloist during the 1950s. He toured Europe from July to October 1951 and again in the summer of 1952, and he held a residency at the downtown location of Café Society in New York from May to June 1953. By this time his health was failing. He suffered a heart attack late in 1953 and another in October 1954, shortly before his death in New York City.

Perhaps Page's most devoted fan was jazz writer Dan Morgenstern, who well captured his essential qualities:

> Lips Page was one of the most powerful trumpeters in jazz history. When he wanted to, he could make walls shake. But he could also play softly and tenderly, and everywhere in between. His tone was broad and brilliant, with a wide but pleasing vibrato. He was a master of the growl and of the plunger mute—only trombonist Tricky Sam [Joe] Nanton could approximate the depth of feeling evoked by Page on a minor blues. . . . Yet he could also make swinging, stinging sounds with a Harmon mute, or make a romantic ballad bloom the way an Armstrong or a COLEMAN HAWKINS can.

As a singer, Page excelled at the blues. According to Morgenstern, "He had a marvelous sense of humor. . . . He could also be savage and scathing. . . . And in the wee hours of the morning, when most of the blowing was done, Page could sit and sing the blues, happy and sad at once, making up new verses or remembering some good old ones, in a way that no witness will ever forget" (*Music '65*, 84).

FURTHER READING

Chilton, John. *Who's Who of Jazz: Storyville to Swing Street*, 4th ed. (1985).

Russell, Ross. *Jazz Style in Kansas City and the Southwest* (1971).

Schuller, Gunther. *Early Jazz: Its Roots and Musical Development* (1968).

Obituary: New York Times, 7 Nov. 1954.

BARRY KERNFELD

PATTERSON, William L.

(27 Aug. 1891–5 Mar. 1980), writer, attorney, and leader of the American Communist Party, was born William Lorenzo Patterson in San Francisco, California, the son of James Edward Patterson, a ship's cook and dentist, and Mary Galt, a domestic. After his father left the family to become a missionary as a Seventh-day Adventist, his mother worked to support the family. Failure to pay the rent resulted in numerous evictions, but Patterson managed to attend Tamalpais High School in California by working first as a newsboy and later as a racetrack hand. He graduated from high school in 1911 and studied at the University of California, Berkeley, to be a mining engineer, but he had to drop out because he could not afford tuition. No scholarships were available, and he objected to Berkeley's compulsory military training. Later Patterson refused to participate in World War I because he felt that it was being fought for a democratic tradition that did not extend to blacks. He was arrested and held for five days in Oakland for declaring the conflict a "white man's war."

Patterson decided to study law in 1915. He took jobs as a night clerk and elevator operator to attend the Hastings College of Law at the University of California in San Francisco. While there he joined radical political activists in protesting discrimination against blacks. He graduated in 1919, but when he failed to be admitted to the California bar, he suspected that this failure was the result of his political activism. In the same year he was chairman of the National Association for the Advancement of Colored People (NAACP) branch in Oakland.

Patterson then took a job as cook on the SS *Barracuda*, which was headed for England. In London he introduced himself to the editor and publisher of the *Daily Herald*, Robert Lansbury, who was also a leading figure of the British Labour Party. Lansbury published an article written by Patterson on "the Negro's problem" in the United States. After a short-lived plan to settle in Liberia, Patterson moved to New York City and in 1923 opened a law firm in Harlem, Dyett, Hall, and Patterson, with two friends. In 1924 he was admitted to the New York bar. Patterson married Minnie Summer, a fashion designer and dressmaker, in 1926; they had no children and divorced within two years.

Patterson was appalled in 1926 by the legal treatment of the Italian immigrant anarchists Nicola Sacco and Bartolomeo Vanzetti, accused of murder

and executed in 1927 despite questionable evidence and international protest. Patterson was arrested in Boston during a protest as part of the Sacco-Vanzetti Freedom Delegation. Upton Sinclair, in his semifictional account of the Sacco-Vanzetti case in his novel *Boston* (1928), describes "William Patterson, a Negro lawyer from New York, running the greatest risk of any of [the protesters], with his black face not to be disguised" (682). Communist friends helped persuade Patterson that black oppression was caused by class exploitation as well as racism. Patterson left his law practice in 1927 to enroll in the Communist Party Workers School. Along with LANGSTON HUGHES, Patterson was one of the first black men attracted to the American Communist Party. His efforts resulted in a fifty-year career as a leader in the party and as an activist for human rights.

The American Communist Party sent Patterson to the Soviet Union to attend the University of Toiling People of the Far East, in Moscow. Patterson's experiences in the Soviet Union persuaded him that socialism precluded the need for prejudice based on race, class, or religious creed. He joined the International Organization to Help Workers in Moscow. While in Moscow in 1928, Patterson married Vera Gorohovskaya; they had two children and amicably divorced in 1930 when Patterson returned to the United States.

In New York City Patterson became a Communist organizer, teacher, and public speaker. As a lawyer he defended blacks who he felt were wrongly accused or not given a fair trial. In 1931 he accepted the position of national secretary of the International Labor Defense. His first assignment was to defend the SCOTTSBORO BOYS, nine black youths aged thirteen to nineteen who had been charged in Scottsdale, Alabama, again on questionable evidence, with allegedly raping and assaulting two white women on a freight train. Eight of the boys were sentenced to death, despite the revelation that Alabama state police had obstructed justice. In 1930 Patterson participated in the World Conference against Racism and Anti-Semitism in Paris. The same year he helped plan the First International Negro Workers Congress. In 1932 he was elected to the party's Central Committee and was chosen as its Communist candidate for mayor of New York City, the year that Democrat John O'Brien won.

Patterson firmly believed that journalists and historians obscured the truth about blacks, black

history, and blacks' contributions to the development of the United States, and he believed that Americans needed to be educated about how the negative effects of racism reached beyond blacks to whites—ideas that he addressed in his many writings. He was associate editor of the *Daily Record* in Chicago from 1938 to 1940, and he contributed articles to the *Daily World, Daily Worker, Worker, New Times, African Communist, New World Review, Negro Worker,* and *Marxist Review*.

Patterson was an active leader of other communist organizations, such as the International Labor Defense, for which he served as the national executive secretary from 1931 to 1949. He held the same position for the Civil Rights Congress (CRC) in 1949. In 1950 he was prosecuted by the federal government and sentenced to three months in prison for failure to turn over to the Internal Revenue Service the Civil Rights Congress's list of contributors. The sentence was reversed on appeal. Patterson engaged in a number of political and legal battles in which he protested what he termed genocide, the unconstitutional treatment of blacks. As a member of the Civil Rights Congress, Patterson aided in the legal appeals for Willie McGee, veteran and father of four, wrongly accused of rape by a white woman in Laurel, Mississippi, and the Martinsville Seven, seven men also charged with raping a white woman. All eight victims were forced to confess to the crimes, convicted by an all-white jury, and in 1951 executed despite CRC appeals to the state and federal supreme courts.

The climactic moment of Patterson's career came in 1951 when he joined the actor and activist PAUL ROBESON, whom he had met in Harlem in 1920, and presented to the United Nations his petition *We Charge Genocide: The Crime of Government against the Negro People*, accusing the U.S. government of committing acts of genocide, which include killing or harming mentally or physically with the intent to destroy in part or in whole. The petition was signed by many notable figures, including the activist and writer W. E. B. DU BOIS, and was resubmitted in 1970 with the signatures of Ossie Davis, actor and civil rights activist; Ralph Abernathy, leader of the Southern Christian Leadership Conference after Martin Luther King Jr.'s death; Shirley Chisholm, U.S. representative of the Twelfth Congressional District in New York; and Huey Newton, cofounder with Bobby Seale of the Black Panther Party.

Patterson had married Louise Thompson in 1940; they had one child. In 1971 he received the Lenin Anniversary Medal from the Union of Soviet Socialist Republics. The Academy of Arts of the German Democratic Republic in 1978 bestowed on him the honor of the Paul Robeson Memorial Medal. Patterson died in the Bronx, New York.

FURTHER READING

Patterson, William L. *The Man Who Cried Genocide* (1971).

Patterson, William L. *We Charge Genocide: The Crime of Government against the Negro People* (1951; repr. 1970, 2001).

Howe, Irving. *The American Communist Party: A Critical History, 1919–1957* (1957).

Ottanelli, Fraser. *The Communist Party of the United States: From the Depression to World War II* (1991).

Obituary: New York Times, 7 Mar. 1980.

BARBARA L. CICCARELLI

PAYTON, Philip A., Jr.

(27 Feb. 1876–29 Aug. 1917), Harlem real estate agent, was born in Westfield, Massachusetts, the son of Philip Payton Sr., a barber and tea merchant, and Anna Marie Rynes. Payton's father was a graduate of Wayland Seminary in Washington, D.C., and his shop was an important gathering place for Westfield's small black community. The younger Payton went to public schools in Westfield and in 1899 obtained a degree from Livingston College in Salisbury, North Carolina. Payton married Maggie (maiden name unknown) that same year and relocated to New York City, where he held odd jobs, including department store attendant and barber. As a janitor to a real estate firm, Payton became intrigued with real estate and decided to go into business for himself.

Payton's entrance into the real estate field was well timed. In 1900 New York was a mecca for black migrants from the South. Decent-paying jobs were more plentiful, and the racial climate was more tolerant. Migrants, however, found that the housing market in Harlem was closed to them, as it was in most of the city. Many middle-class blacks felt intense frustration about their lack of access to decent housing. White real estate agents and landlords refused to sell or rent to blacks and confined them to a dilapidated stretch of Manhattan between

Thirty-seventh and Fifty-eighth streets and other rundown areas.

Overspeculation in Harlem in the 1890s and early 1900s created an unusual opportunity for blacks to gain access to decent housing in other sections of the city. In the late nineteenth century Harlem became a fashionable neighborhood for successful New Yorkers. White landowners bought up property and built high-grade apartments with the expectation that the area would prosper. However, real estate developers were overconfident about the area's future and drove up land prices out of proportion to their actual value. When the housing market collapsed in 1904–1905, many owners had difficulty locating white tenants willing to pay the high rents the owners had to charge to meet their financial obligations. Payton, along with other black and white real estate agents, exploited this collapse in values and opened large areas of Harlem to black tenants.

Earlier, in 1900, Payton and a partner had opened an office on West Thirty-second Street specializing in managing "colored" tenements. For a while Payton struggled; his partner quit, and he was evicted from his offices more than once. Payton received his first break when owners of an apartment building on 134th Street could not find new tenants. They turned the building over to Payton to rent to blacks. He was successful and between 1900 and 1907 expanded his operation to become a wealthy, nationally recognized black business leader.

Payton's success was based on his audacity as a businessman, his skill as a promoter, and his reputation as an advocate of black-owned businesses in New York and elsewhere. He formed a limited partnership with a group of ten black businessmen and specialized in five-year leases on white-owned property rented to blacks. After 1904 Payton's creation, the Afro-American Realty Company, proceeded to attract new investors and tenants through extensive advertising in local and national black newspapers and on billboards, trains, and in subway stations. Payton also attracted attention by successfully confronting white realty companies that opposed his business strategy. He was aided by strong relationships with a small group of white real estate agents and bankers who tacitly supported his efforts.

Payton's activities in promoting black-owned enterprises in New York and in other urban centers included becoming a manager of the National Negro Business League, and in 1905 he organized a local black defense society to protest police brutality. Payton was also closely allied with prominent black leaders such as FREDERICK R. MOORE, the editor of the *New York Age*, and associates of BOOKER T. WASHINGTON such as CHARLES W. ANDERSON and EMMETT JAY SCOTT. While Payton counted Washington himself among his network of associates, their relationship was often troubled by philosophical differences and Payton's reluctance to fully endorse Washington's efforts to expand his influence in New York City. Payton drew together a group of black real estate agents and other businessmen, including John M. Royall, JOHN E. NAIL, and Henry C. Parker, who adopted Payton's methods to advance black expansion in Harlem even after Payton's own fortunes began to decline in 1907–1908.

After a series of organizational shake-ups, Afro-American Realty Company stockholders began to question Payton's high-risk speculating policies as well as his autocratic management style. In 1906 the stockholders sued Payton on the grounds that he ran the company without any input from the board of directors and was therefore responsible for any losses the company might accrue. Because the company claimed that it owned property free and clear when actually all of it was heavily mortgaged, the courts found the company guilty of misrepresentation (although Payton himself was cleared). Banking on his friends and his reputation, Payton kept the company afloat for another two years. However, the bad press created by the lawsuit and Payton's own speculations made obtaining credit increasingly difficult, and by 1908 the company had failed. Payton remained personally active in Harlem properties. In the summer of 1917 he obtained six apartment buildings on West 141st Street valued at $1.5 million, the biggest deal of his career. In late August, however, he became ill and died at his summer home in Allenhurst, New Jersey.

Philip A. Payton Jr. was a prominent black real estate entrepreneur who helped open the housing market in the Harlem section of New York City to blacks in the early twentieth century. He provided quality housing to black New Yorkers of all classes, became an influential business leader, an associate of national black leaders, and a symbol to black entrepreneurs and home seekers who referred to him as the "Father of Colored Harlem."

FURTHER READING

Many important documents relating to Payton can be found in the Booker T. Washington Papers at the Library of Congress and at the New York City Hall of Records.

Dailey, Maceo. "Booker T. Washington and the Afro-American Realty Company," *Review of Black Political Economy* (Winter 1978): 184–201.

Ingham, John, and Lynne B. Feldman. *African American Business Leaders* (1994).

Johnson, James Weldon. *Black Manhattan* (1930).

Osofsky, Gilbert. *Harlem: The Making of a Ghetto* (1971, 1996).

Richardson, Clement. *National Cyclopedia of the Colored Race* (1919).

JARED N. DAY

PIERCE, Billy

(14 June 1890–11 Apr. 1933), choreographer, dance studio owner, and journalist, was born William Joseph Pierce in Purcellville, Virginia, the only child of Dennis Pierce and Nellie Shorter, who spent their childhoods enslaved and later became truck farmers. After attending the public schools in Loudoun County, Virginia, Pierce attended two colleges, Storer College in Harpers Ferry, West Virginia, and Howard University in Washington, D.C. During World War I he served with the Eighth Illinois Regiment in the United States Army.

Pierce was a journalist, an often overlooked aspect of his life and work. He was a reporter and editor for the *Chicago Defender*, the (Washington, D.C.) *Dispatcher*, and the *Washington Eagle*, adding to the stature of these newspapers in the area of arts coverage. But Pierce's heart belonged to show business. He made his dancing debut in the early 1920s at the Pekin Theater in Chicago. During this time Pierce worked as a vaudeville dancer, a trombonist, a ticket-taker in a minstrel show, and the banjo player in Dr. Diamond Dick's Kickapoo Indian Medicine Show on what was commonly called the "TOBA" (Tough on Black Actors) circuit before heading to New York City.

Shortly after arriving in New York, Pierce realized his dream of owning a dance studio. He rented a fourteen-by-sixteen-foot room in a building on Forty-sixth Street where he worked as an elevator operator. There was no shortage of dance studios on Broadway, but Pierce's reputation grew, and he was able to expand the Billy Pierce Dance Studio to two whole floors in the same building and devote himself full-time to choreography. Established performers and would-be dancers from all over the country sought classes at his studio.

During the Harlem Renaissance theater critics began to acknowledge the influence of African American dance in Broadway shows and revues. Buddy Bradley, a behind-the-scenes choreographer for many productions, taught Broadway stars at the Billy Pierce Dance Studio. The space provided inspiration to artists working outside of the performing arts as well. BEAUFORD DELANEY, for example, launched his painting career with a series of Degas-like sketches and portraits created there.

Pierce was noted for creating original routines, and he encouraged whole-body dancing. He perfected the "exchanging steps" and "milking applause" routines. He taught Norma Tarria, who "took the show" in *Show Boat*; wrote the "Sugar Foot Strut" for *Rio Rita*; and conceived "Moaning Low," the signature number by the famed dance team of Cliff Webb and Libby Holman. He was also a pioneer in the movement to send African American artists abroad, where their chances of achieving fame were greater than in the United States. In 1924 he trained and sent Tea for Two, the first African American group of dancing girls, to the Moulin Rouge in Paris.

In July 1927 Pierce staged the dances for *Half a Widow*, a musical. That same year he married Nona Stovall. They became the parents of two children, Billy Jr., born in 1928, and Denise, born in 1930. In 1930 Pierce spent eleven months working in Europe with the directors and producers Charles Cochran, Joseph Stern, and Max Reinhardt. He staged productions in London, Moscow, Rome, and Paris. Although rarely credited on theater programs, he was mentioned in newspaper articles, and autographed photographs of stars acknowledging his work covered the walls of his studio. He received full credit for the Broadway show *Walk a Little Faster*, which was staged in 1932.

Throughout his life Pierce retained a deep interest in civil rights. In 1931 he was active in rallying support among New Yorkers for the defense of the SCOTTSBORO BOYS, a group of young men who had been falsely accused of rape in Alabama. He was a founder and lifelong member of the Dennis Pierce Lodge No. 795, Northern Virginia Council, Order of Elks, which was named in honor of his father. A year before his death Pierce followed in his father's footsteps and was elected to the board of directors of the

Loudoun County Emancipation Association, Inc., in Purcellville, Virginia.

Pierce's career was cut short by his untimely death due to complications from mastoiditis. After funeral services in New York City and Washington, D.C., Pierce, hailed as the master of dance, the maker of Broadway stars, and choreographer extraordinaire, was returned to his native Virginia for burial.

FURTHER READING

Carter, Elmer A. "He Smashed the Color Line: A Sketch of Billy Pierce," *Opportunity: The Journal of Negro History* 8:5 (May 1930).

Cohen-Stratyner, Barbara N., ed. "Billy Pierce," in *Biographical Dictionary of Dance* (1982).

Hamilton, Kendra Y. *The Essence of a People II: African Americans Who Made Their World Anew in Loudoun County, Virginia, and Beyond* (2002).

Yenser, Thomas, ed. *Who's Who in Colored America* (1933).

Obituaries: New York Times, 12 Apr. 1933; *Washington Tribune*, 21 Apr. 1933.

ELAINE E. THOMPSON

POPEL, Esther

(16 July 1896–28 Jan. 1958), poet, was born in Harrisburg, Pennsylvania, where her family had lived since 1826 when her paternal grandfather had been taken there by his free-born parents. Popel was of mixed heritage (African American, Native American, and German) on her paternal side. Little is known of her maternal side. Popel attended Central High School in Harrisburg and then commuted to Dickinson College in Carlisle, Pennsylvania. She was, according to Dickinson College Archives, a day student and the first African American woman to attend the school, where she graduated Phi Beta Kappa after majoring in modern languages. The description accompanying her yearbook picture (*The Microcosm* [1919]) is indicative of her life at the college: "We see her but we seldom hear her. . . . [Y]et her recitations and marks prove her to be a scholar and we feel sure that she will make good practical use of her vast knowledge and ability."

Racism prevented Popel from making full use of this knowledge at her first job, the War Risk Insurance Department. She was, however, able to use her language skills successfully as a teacher. For more than thirty-nine years she taught French and Spanish (she also knew German and Latin) at junior high schools in Baltimore and Washington, D.C. In addition to teaching, she wrote six plays (seemingly lost) for junior high school students and published a collection of her students' works from Francis Junior High in *The Franthology: A Collection of Verse* (1949).

Popel was married in 1925 to William A. Shaw, an African American, who died in 1946. The couple had one child. Shortly after her marriage, Popel moved to Washington, D.C., where she became a member of the Lincoln Memorial Congregational Temple. She gave talks to women's clubs, often speaking on race relations, several of which were published in *The Journal of the National Association of College Women*. One series of addresses given at the Women's Club in Lawrenceville, New Jersey, was published by the Women's Press of the YMCA as *Personal Adventures in Race Relations* (1946). These talks, leavened with a cautious optimism, present a poignant picture, of "[t]he unlovely story of race relations in the United States" (3).

Though little remembered today, Popel published several poems in *The Crisis* and *Opportunity* between 1925 and 1934 as well as a privately printed collection, *A Forest Pool* (1934). In addition, Popel was active in GEORGIA DOUGLAS JOHNSON's famous Saturday Night reading groups in Washington. Her lack of recognition today may be because of the perceived raceless nature of her poetry, which was in the genteel tradition. However, as recent feminist critics have demonstrated, the poetry of these pioneering women often contained a thinly disguised subversive element. Popel's poetry seems conventional, with themes frequently about nature, death, and lost love, yet these commonplace subjects often masked a deeper agenda.

Her nature poems link nature with the condition of women. Such a view of nature as a nurturing figure, one that protects women from the everyday oppression in their lives from men and white women, is typical in women's poetry of the time (Honey, 8). In "Theft" (*Opportunity*, Apr. 1925), the moon is personified as an old woman in search of her children. The blinding white snow mocks the misery of the woman. "Popel's central figure is ambiguous in that she evokes pity, modifying the image of the moon as dangerous. At the same time, she represents weakness, debility, and devastating loss" (Honey, 11).

Popel's poetry reveals conflicting views of death. One of her finest poems about death is an elegy,

likely to the poet's mother, "Reach Down, Sweet Grass," in which the speaker hopes that the beauty of spring will provide comfort to the deceased. In "October Prayer," death is seen as a suitor, in some ways reminiscent of Emily Dickinson's "Because I could not Stop for Death." But here, death is not like the courteous caller in Dickinson's poem: Death will strip off her clothes and she will "stand / Before him, proud and naked, / Unashamed, uncaring."

Lost love and unfulfilled desires are recurrent in Popel's poetry. In "A Forest Pool," reminiscent of Georgia Douglas Johnson's "Heart of a Woman," we are told: "A woman's heart, / A forest pool / Are one!" Though seemingly calm, in reality, it contains just beneath the surface " . . . hidden things / Imprisoned in its dark and secret depths." Sexual frustration burns in "Storage," where the fancy linen, left unused, rots. This sexual tension is further reflected in "The Pilferer," where Time with "a pass-key" boldly opens "the strong box / Hidden in my heart."

Popel also wrote several poems with a highly political message, most notably the chilling "Flag Salute" (*The Crisis* [Aug. 1934]) and "Blasphemy—American Style" (*Opportunity* [Dec. 1934]) both based on actual lynchings. In the former poem, the pledge of allegiance is intertwined with the report of a lynching. In the latter poem, a mob lynches a black man, mocking him for praying as he is about to be killed. These poems, like the talks she gave on race relations, indicate that Popel had a clear commitment to social justice.

Popel's writings accurately reflect the hopes and ambitions of many middle class African American women of the 1920s and 1930s. Although she is a minor poet, her best work, including "Flag Salute," "Blasphemy—American Style," "Reach Down, Sweet Grass," "A Forest Pool," "October Prayer," and "Storage," resonates in a voice still worth hearing.

FURTHER READING
Material on Esther Popel is held in the Dickinson College Archives, Carlisle, Pennsylvania.
Honey, Maureen, ed. and intro. *Shadowed Dreams: Women's Poetry of the Harlem Renaissance* (1989).
Roses, Lorraine Elena, and Ruth Elizabeth Randolph. *Harlem Renaissance and Beyond: Literary Biographies of 100 Black Women Writers 1900–1945* (1990).

LOUIS J. PARASCANDOLA

PORTER, James Amos

(22 Dec. 1905–28 Feb. 1970), painter, art historian, and writer, was born in Baltimore, Maryland, the son of John Porter, a Methodist minister, and Lydia Peck, a schoolteacher. The youngest of seven siblings, he attended the public schools in Baltimore and Washington, D.C., and graduated cum laude from Howard University in 1927 with a bachelor of science in Art. That same year Howard appointed him instructor in art in the School of Applied Sciences. In December 1929 he married Dorothy Louise Burnett of Montclair, New Jersey; they had one daughter.

In 1929 Porter studied at the Art Students League of New York under Dimitri Romanovsky and George Bridgeman. In August 1935 he received the *certificat de présence* from the Institut d'Art et Archéologie, University of Paris, and in 1937 he received a master of arts in Art History from New York University, Fine Arts Graduate Center.

Porter first exhibited with the Harmon Foundation in 1928 and in 1933 was awarded the ARTHUR SCHOMBURG Portrait Prize during the Harmon Foundation Exhibition of Negro Artists for his painting *Woman Holding a Jug* (Fisk University, Carl Van Vechten Collection). Other early exhibitions in which he participated included the Thirty-second Annual Exhibition of the Washington Water Color Club (Gallery Room, National Gallery of Art, Smithsonian Institution, Washington, D.C., 1928), Exhibition of Paintings and Sculpture of American Negro Artists at the National Gallery of Art (Smithsonian Institution, 1929), Exhibition of Paintings and Drawings by James A. Porter and Block Prints by JAMES LESESNE WELLS (Young Women's Christian Association, Montclair, New Jersey, 1930), and Exhibition of Paintings by American Negro Artists at the United States National Museum (Smithsonian Institution, 1930). His first one-man show was Exhibition of Paintings and Drawings by James A. Porter (Howard University Gallery of Art, 1930).

Porter began writing about art in the late 1920s. One of his earliest articles, "Versatile Interests of the Early Negro Artist," appeared in *Art in America* in 1931. One of his most important and still-discussed articles, "Four Problems in the History of Negro Art," published in the *Journal of Negro History* in 1942, mentions numerous artists and analyzes the following four problems: documenting and locating the earliest art by blacks—or the reality of handicrafts and fine arts by blacks before 1820; discovering

when racial subject matter takes vital hold on the black artist—or the black artist's relation to the mainstream of American society; investigating the decline of productivity among black artists between 1870 and 1890 (a process that coincided with the end of an era, especially of neoclassicism and portraiture), concentrating on the period of Reconstruction; and determining the role of visual artists in the New Negro movement of 1900–1920, the period of self-expression for the African American.

Porter's classic book, *Modern Negro Art* (1943), has proved to be one of the most informative sources on the productivity of the African American artist in the United States since the eighteenth century. Its placement of African American artists in the context of modern art history was both novel and profound. "For some, *Modern Negro Art* was considered presumptuous and certainly premature. But Porter's bold and perceptive scholarship helped those who subsequently focused their attention on African American expression in the visual arts to see the wealth of work that had been produced in the United States for over two centuries" (*James A. Porter Inaugural Colloquium on African American Art*, brochure, 31 Mar. 1990, Howard University).

First reprinted in 1963 for use as a standard reference work on black art in America, the book was reprinted again in 1992 and is considered by many to be the fundamental book on black art history. As Lowery S. Sims of the Metropolitan Museum of Art has noted in the 1992 edition, *Modern Negro Art* "is still an indispensable reference work fifty years after its initial publication"; and, in the view of the art historian Richard J. Powell, it "continues to provide today's scholars with early source information, core bibliographic material, and other essential research tools for African American art history" (*Modern Negro Art* [1992]).

Porter also wrote about many artists, including HENRY OSSAWA TANNER, Robert S. Duncanson, Malvin Gray Johnson, and LAURA WHEELER WARING. His other writings included monographs, book reviews, introductions to books, including Charles White's *Dignity of Images* and LOÏS MAILOU JONES's *Peintures, 1937–1951*, introductions and forewords to exhibition catalogs, and newspaper and periodical articles.

In 1953 Porter was appointed head of the department of art and director of the Gallery of Art at Howard University. This dual position enabled him to organize exhibitions featuring artists of many races from many countries who previously had not been recognized. He is credited with enlarging the permanent art collection of Howard University and strengthening the art department's collection of works by black artists as well as its art curriculum. Porter's leadership led the Kress Foundation to include Howard among the roughly two dozen American universities selected in 1961 to receive the Kress Study Collection of Renaissance paintings and sculpture as a stimulus to the study of art history.

In 1955 Porter received the Achievement in Art Award from the Pyramid Club of Philadelphia, Pennsylvania, and also was appointed a fellow of the Belgium-American Art Seminar studying Flemish and Dutch art of the sixteenth to eighteenth centuries. In 1961 he was a delegate at the UNESCO Conference on Africa, held in Boston, and he served as a member of the Arts Council of Washington, D.C. (1961–1963), and as a member of the conference Symposium on Art and Public Education (1962). In August 1962 he was a delegate-member of the International Congress on African Art and Culture, sponsored by the Rhodes National Gallery, in Salisbury, Southern Rhodesia.

In 1963–1964, having been awarded a Washington *Evening Star* faculty-research grant to gather materials for a projected book on West African art and architecture, Porter took a sabbatical leave to West Africa, including Nigeria and Egypt. From September 1963 to July 1964 he collected various pieces of African art throughout West Africa and Egypt and participated in a USIA exhibition. Also in this period he lectured on African and African American art for the radio broadcast *Voice of America*. In August 1964 he traveled to Brazil in search of documentation of the African influence on and contribution to Brazilian colonial and modern art and to Latin American art and culture. Porter thought a worldview was needed to explore the transcontinental, historical, and cultural perspectives of blacks, and he wanted the quantitative and qualitative factors examined that affected the African's experience outside Africa. Only through comparative research of this kind, Porter argued, would it become possible to relate and reconstruct the dissimilar experiences and cultural expression of the transplanted African. Upon returning to the United States in the fall with twenty-five of his own paintings that he had completed while in Lagos, Nigeria Porter said that he hoped "my paintings reflect the enthusiasm and the understanding [and] admiration which I have

felt for Africa and the Africans, even though, admittedly the most skillful expatriate artist may utterly fail to capture those ineffable traits in the African people which we believe are made visible to us in their arts" ("Professor Porter Paints in Nigeria," *Howard University Magazine* 7, no. 4 [July 1965]: 12–16).

In March 1965 Porter and twenty-six other teachers in the United States were named "America's most outstanding men of the arts." They received the first National Gallery of Art Medals and Honoraria for Distinguished Achievement in Art Education, which were presented at a White House ceremony by First Lady Lady Bird Johnson. These medals were specially designed as part of a day-long celebration commemorating the twenty-fifth anniversary of the founding of the National Gallery of Art.

Since Porter's death in Washington, D.C., his legacy has been honored in various ways. The James A. Porter Gallery of African American Art was dedicated at the Howard University Gallery of Art on 4 December 1970. Aesthetic Dynamics organized in Wilmington, Delaware, Afro-American Images (1971), an exhibition dedicated, according to the catalog, to "a man ahead of his time. Unique in the sense that he was totally involved in the creative expression which characterizes the Black life-style in African, Latin American and African American art as an historian and was an accomplished practicing artist as well." In March 1990 the department of art at Howard University organized the James A. Porter Inaugural Colloquium on African American Art. This annual event seeks to continue Porter's efforts to bring previously invisible artists to the attention of the American mainstream and to define and assess the enduring artistic values that are meaningful for African Americans. In *James A. Porter, Artist and Art Historian: The Memory of the Legacy*, the catalog for a retrospective exhibition held at the Howard University Gallery of Art in 1992–1993, ROMARE BEARDEN wrote that, because of Porter's efforts, college art programs, in particular art programs in traditionally black colleges, are no longer considered secondary to the other disciplines.

FURTHER READING

Porter's papers are in the Dorothy Porter Wesley Archives, Wesport Foundation and Gallery, Washington, D.C.

Bearden, Romare. *A History of African-American Artists from 1792 to the Present* (1993).

Davis, Donald F. "James Porter of Howard: Artist, Writer," *Journal of Negro History* 70 (1985): 89–91.

Powell, Richard. *Black Art: A Cultural History* (2003)

Obituaries: Evening Star (Washington, D.C.), 3–4 Mar. 1970; *International Herald Tribune*, 5 Mar. 1970; *Washington Post*, 14 Mar. 1970; *Jet* (19 Mar. 1970); *Art Journal* 29 (1970).

CONSTANCE PORTER UZELAC

POSTON, Ted

(4 July 1906–11 Jan. 1974), journalist, was born Theodore Roosevelt Augustus Major Poston, in Hopkinsville, Kentucky, the youngest of eight children of Ephraim Poston and Mollie Cox, who were both teachers. In the short stories later collected in *The Dark Side of Hopkinsville* (1991), Poston provided a folksy, sometimes fictionalized account of his small-town southern childhood. Poston's father, for example, was elevated in one story to the position of dean of male students at the Kentucky State Industrial College for Negroes in Frankfort, when he was, in fact, an instructor in that school's preparatory department. Yet the stories accurately reflected the importance of education and intellectual debate in the Poston household. Ted's older siblings also pursued careers in writing and journalism. In 1918 his brothers Robert and Ulysses helped their father establish a newspaper, the *Hopkinsville Contender*, which gave Ted his first experience in journalism. Ted's elder brothers later moved to Detroit, Michigan, where they worked on MARCUS GARVEY's newspaper, the *Negro World*. Poston wrote short stories about his childhood because he believed that "someone should put down the not-always-depressing experiences of a segregated society like the one I grew up in" (*Dark Side*, xv). His stories celebrated the simplicity of rural life, of lazy summer afternoons spent fishing and poaching. They also highlighted the importance of the black church and of extended family networks in helping African American children not only to survive in an unequal society but also to flourish.

Yet for all of the Postons' relative wealth and security—they were one of the few black families in Hopkinsville to own their own home—Poston's childhood was not without its indignities and suffering. As his short story "The Revolt of the Evil

Faeries" makes clear, he deeply resented the prejudice within his own community against dark-skinned blacks like himself. During his late childhood years Poston also mourned the loss of several close family members in quick succession: his brother Ephraim Jr. in 1914, his mother three years later, his sister Roberta in 1919, and his brother Robert—who had married the sculptor AUGUSTA SAVAGE—who died of pneumonia in 1924, on his return from a Garveyite mission to Liberia.

Despite these tragedies, Poston graduated from high school in 1924 and set off—on foot—for Nashville, where he enrolled in the Tennessee Agricultural and Industrial Normal College (later Tennessee State University). He supported himself by working a series of laboring jobs, including stints as a tobacco stemmer and as a Pullman porter, and he graduated with a degree in English and Journalism in 1928. He then moved to New York City to work with his brother Ulysses, who had established the *Contender* as a Democratic Party news sheet in that city and who was working on the New York governor Al Smith's 1928 presidential campaign. Poston soon joined A. PHILIP RANDOLPH's efforts to unionize black railroad workers, and he began penning a column about Harlem for the *Pittsburgh Courier*. In 1931, under the byline T. R. Poston, he launched his full-time journalistic career as a reporter for the New York *Amsterdam News*, the city's leading African American newspaper.

Poston quickly became one of the leading lights of the Harlem intelligentsia. He began lifelong friendships with the poet LANGSTON HUGHES and the NAACP political strategist Henry Lee Moon, whom he accompanied in 1932 on a trip to the Soviet Union to make a movie about American racism. After two months, however, the Soviet leader Joseph Stalin cancelled the movie—in which Poston was to play a lynching victim—so as not to offend the United States, which was then close to reopening diplomatic ties with the Soviet Union. Closer to home, Poston earned plaudits for his sympathetic coverage of the trials of the SCOTTSBORO BOYS, who were accused of raping two white women in Alabama, and of the tribulations of their Communist Party defenders in the 1930s. He also, in 1935, helped lead efforts to unionize the *Amsterdam News*, for which he was rewarded with the sack. That year he married Miriam Rivers, a young and glamorous Harlemite, whom he had met during the *Amsterdam News* strike; they divorced in 1940. All three of Poston's marriages were childless.

Following a spell with the Federal Writers' Project, Poston joined the *New York Post* in 1936, where he adopted the new byline Ted Poston. Though he was not the first black writer for a major white-owned daily, over the span of three decades he became the best-known African American in the ranks of the nation's journalists. In addition to his journalistic efforts for the *Post*, Poston began to publish some of his short stories in the *New Republic*, among other outlets. His fame was aided not only by his journalistic skill but also by his continuing interest in politics. Along with Moon, Robert Weaver, and MARY MCLEOD BETHUNE, he became a member of President Roosevelt's "Black Cabinet" in the New Deal years of the 1930s and 1940s. Such contacts undoubtedly helped provide Poston with the connections needed for his exclusive and well-regarded interviews with white political leaders such as Huey Long, Louisiana's populist and controversial governor, and Wendell Wilkie, the Republican presidential candidate in 1940. During World War II Poston worked at the Negro News Desk of the Office of War Information and later in the White House, where he helped to monitor the often tense racial situation of the war years. While in Washington in December 1941, he married Marie Byrd Tancil, an ambitious young socialite and assistant on Weaver's staff. They divorced in 1956.

Poston returned full-time to the *New York Post* in 1945. Over the next two decades he emerged as one of the leading commentators on the civil rights movement. During those years the *Post* earned a reputation as one of the most racially liberal northern newspapers, in large part because of Poston's pioneering role in translating the hopes and fears of southern African Americans to a white northern audience. In several of his finest pieces, Poston's role as a black northern journalist covering racial tensions in the South became part of the story. His 1949 series on the "Little Scottsboro" trial of three black youths accused of raping a white woman in Tavares, Florida, for example, resulted in a lynch mob chasing Poston down a deserted Florida road. The series earned Poston the George Polk Journalism Award and a nomination for the Pulitzer Prize for journalism. Poston's biographer Kathleen Hauke has suggested that he might have also become the first African American to win the Pulitzer, but his nomination was sabotaged by some of his colleagues

on the *Post*. Among other stories, Poston covered the career of the first black baseball star in the major leagues, the Brooklyn Dodgers' Jackie Robinson, the *Brown v. Board of Education* school desegregation decision, the Montgomery bus boycott, and the Little Rock school integration crisis. While covering the opening of the integrated Little Rock schools in 1959, Poston and Carl Rowan were shot at by a carload of whites while standing outside the home of Daisy Bates, a fellow journalist and a mentor to the nine black students who faced white violence as they integrated the schools.

Poston covered many of the great victories of the civil rights movement in the 1960s; one memorable piece he wrote in 1966 was about an Alabama man named Jeff Hamilton, who cast his first-ever ballot that year at the age of seventy-seven. Poston was by then widely regarded as the "dean of black journalists," but his relationship with the *New York Post* had become increasingly fraught. Management at the *Post* began to view his journalistic style as dated and began to look for new reporters who they believed might better capture the new black nationalist phase of the civil rights movement. Poston, in return, criticized management for failing to understand the complexity of its African American readership and believed that the paper's reputation in the African American community had been tarnished. By the late 1960s Poston was drinking and smoking heavily, and his drinking, especially, began to interfere with his once tireless workload. Sent to cover the assassination of Martin Luther King Jr. in Memphis in 1968, Poston got drunk—a not altogether unnatural reaction to a senseless killing and the seeming end of a civil rights dream—and missed his deadline with the *Post*.

Poston's family life was also troubled. He had married Ersa Hines Clinton, a personnel manager, in 1957, but the couple barely saw each other because of their hectic work schedules. They separated sometime before Poston's retirement from the *Post* in 1972, the same year that the city of New York awarded Poston its distinguished service medal. In retirement Poston was unable to muster the energy to complete his planned collection of short stories, *The Dark Side of Hopkinsville*, though they were published posthumously.

Ted Poston often said that his three loves were writing, whiskey, and women. But his three marriages were tempestuous, and he spent his final years alone. His love of whiskey—and of tobacco, another homegrown Kentucky vice—undoubtedly hastened his physical demise and his relatively early death at age sixty-seven in Brooklyn. But his writing, especially his trailblazing civil rights reportage for the *New York Post*, is a fitting legacy. Poston created for the *Post*'s primarily white urban readership an understanding of the nature of the apartheid system that flourished within its own nation and of the need for racial change in both the South and the North.

FURTHER READING

Poston, Ted. *The Dark Side of Hopkinsville: Stories by Ted Poston*, ed. Kathleen A. Hauke (1991).

Poston, Ted. *A First Draft of History*, ed. Kathleen A. Hauke (2000).

Hauke, Kathleen A. *Ted Poston: Pioneer American Journalist* (1998).

Reporting Civil Rights: Part One, American Journalism 1941–1963, comp. Clayborne Carson, David J. Garrow, Bill Kovach, and Carol Polsgrove (2003).

Obituary: New York Times, 12 Jan. 1974.

STEVEN J. NIVEN

POWELL, Adam Clayton, Jr.

(29 Nov. 1908–4 Apr. 1972), minister and congressman, was born in New Haven, Connecticut, the son of the Reverend ADAM CLAYTON POWELL SR. and Mattie Fletcher Shaffer. The family moved to New York City in 1909 after the senior Powell became minister of the Abyssinian Baptist Church, then located at Fortieth Street between Seventh and Eighth avenues. In 1923, at the elder Powell's urging, the church and the family joined the surge of black migration uptown to Harlem, with the church moving to 138th Street between Seventh and Lenox avenues.

Adam Powell Jr. earned an AB at Colgate University in 1930 and an AM in Religious Education at Columbia University in 1932. So light-skinned that he could pass for white, and did so for a time at Colgate, he came to identify himself as black, and, although from a comfortable background, he advocated the rights of workers.

Powell's rise to power, and his adoption of various leadership roles in civil rights, dated from the 1930s. His power base throughout his career was the Abyssinian Baptist Church, where his father ministered to his flock's social and economic as well as spiritual needs. There, during the Great Depression, young Powell directed a soup kitchen and

Adam Clayton Powell Jr., congressman from Harlem, minister, and lifelong warrior for civil rights. (Library of Congress.)

relief operation that supplied thousands of destitute Harlemites with food and clothing. In 1930 he became the church's business manager and director of its community center. In 1937 he succeeded his father as pastor. He married the Cotton Club dancer Isabel Washington in 1933 and adopted her son from a previous marriage.

Beginning in 1936 Powell published a column, "The Soap Box," in the black weekly *Amsterdam News*. Active in a campaign for equal employment opportunities for black residents of Harlem, his first major social campaign involved efforts to improve blacks' employment opportunities and working conditions at Harlem Hospital. By the mid-1930s, "Don't buy where you can't work" became a slogan in Harlem, as it already had become in Chicago and some other cities. Powell became a leader of organized picketing of offending stores. By 1938 he led the Greater New York Coordinating Committee for Employment, which pushed successfully in the next few years for jobs for blacks not only in stores but also with the electric and telephone companies, as workers at the 1939 New York World's Fair, as drivers and mechanics on city buses, and as faculty at the city's colleges.

During World War II Powell continued proselytizing from old platforms, and he found new ones. He preached at Abyssinian Baptist, which had the largest Protestant congregation in the United States; led the militant Harlem People's Committee; published the *People's Voice*, a Harlem weekly; and wrote *Marching Blacks: An Interpretive History of the Rise of the Black Common Man* (1945). Divorcing his first wife, he married the pianist and singer Hazel Scott in 1945, and they had a son. Powell's prominence in Harlem resulted in his election in 1941 to the New York City Council, where he continued to hone his combination of political and protest skills. From this political base he ran for Congress in 1944 when a new congressional district was formed for Harlem. Winning, he became New York City's first black congressman; WILLIAM L. DAWSON of Chicago was the only other African American then in Congress.

For many years an often lonely voice in Congress, Powell called for a permanent Fair Employment Practices Commission, an end to the poll tax in federal elections, and an end to racial segregation in the military. Finding that House rules banned him because of his race from such facilities as dining rooms, steam baths and barbershops, he nonetheless proceeded to make use of all such facilities, and he insisted that his staff follow his lead. He brought an end to the exclusion of black journalists from the press gallery in the House of Representatives. As early as the 1940s he was characteristically offering what became known as the "Powell Amendment" to spending legislation. The proviso, supported by the National Association for the Advancement of Colored People, would have banned federal funds from any project that supported racial segregation, and though it failed to pass, it made him known as "Mr. Civil Rights."

A New Deal Democrat, Powell nonetheless maintained political independence, whether from his father or from the Democratic Party's leadership. Charting his own way, though his father remained a Republican, Powell campaigned in 1932 for the Democratic presidential nominee Franklin D. Roosevelt. In 1944 he ran for Congress as the nominee of the Republican and American Labor parties as well as the Democratic Party. In 1956 he broke with the Democrats over the party's temporizing stance on civil rights issues to support Dwight

Eisenhower's reelection campaign. Throughout his years in Congress he saw his main mission as thwarting the southern wing of his own party in Congress. He demonstrated no patience with liberal Democrats who trimmed sails or pulled punches when civil rights legislation was at stake.

One of Powell's chief roles, often behind the scenes, was to monitor the behavior of organized labor and the federal government on the racial front. He believed apprenticeship programs in the labor market should be open to blacks, progressive legislation should be enacted, and no federal agency should practice or foster racial segregation or discrimination. During the 1960s he tried to ensure that blacks would hold leadership positions in the Peace Corps, the Poverty Corps, and federal regulatory agencies. Ambassadorships, cabinet positions, and the Supreme Court, he urged, should have black representation. His relations with the Eisenhower administration enabled him to arrange in 1954 for the Ethiopian emperor Haile Selassie, while on a visit to the United States, to visit Abyssinian Baptist Church. There the emperor presented Powell with a large gold medallion, which he proudly wore on a chain around his neck for the rest of his life.

Powell divorced his second wife and married Yvette Flores in 1960, and they had a son. As a result of the seniority system in Congress, Powell's peak in power came in the 1960s, the years of the New Frontier and the Great Society. For three terms, from 1961 to 1967, he chaired the House Committee on Education and Labor. From his committee came such landmark legislation as the 1961 Minimum Wage Bill, the Vocational Education Act, the Manpower Development and Training Act, various antipoverty bills, and the Elementary and Secondary Education Act. When the National Defense Education Act of 1958, with its promotion of education in science, mathematics, and foreign languages, came up for renewal in 1964, Powell steered through an expansion of coverage to the humanities and social sciences. And when the Civil Rights Act of 1964 became law, Title VI, which authorized all federal agencies to withhold aid from institutions that practiced racial segregation or discrimination, embodied the "Powell Amendment." His time had come; he pushed ahead to challenge school segregation in the North.

Powell's fall from power came at the height of his national prominence. Always flamboyant and controversial, he displayed moral behavior anything but ascetic, spent tax dollars merrily on pleasure trips, and often missed important votes in Congress. In a television interview in March 1960 Powell referred to a Harlem widow, Esther James, as a "bag woman," someone who collected graft for corrupt police. She sued and won. Powell refused to apologize or pay, or even respond to subpoenas to appear in court to explain his failure to comply. After he was cited for contempt of court in November 1966, a Select Committee of the House investigated Powell's affairs, partly because of the James case and partly because of an alleged misuse of public funds. Powell remained convinced that the real purpose was a racist attempt to silence a key proponent of civil rights. In March 1967 the Select Committee recommended Powell's public censure and his loss of seniority. The full House went farther and voted to exclude Powell from the Ninetieth Congress. In a special election to fill the vacant seat, Powell trounced his opponents. Then, after a successful fund-raising effort, he paid James her award. An agreement was worked out that ended the threat of jail for contempt of court so—after spending much of 1967 in an idyllic exile on Bimini—he could return to New York whenever he wished. In January 1969 the House voted to seat him in the Ninety-first Congress, though it stripped him of his seniority and fined him for misuse of payroll and travel funds. Later that year, in *Powell v. McCormack*, the Supreme Court ruled against the House's exclusion of him in 1967.

After being out of Congress from 1967 to 1969, Powell retrieved his seat. But he was no longer committee chairman, and his power had evaporated. Worse, in 1969 Powell was hospitalized with cancer. Weakened physically and politically he nonetheless entered the Democratic primary in 1970 but was narrowly defeated by State Assemblyman Charles Rangel. Powell's time in Congress was over. He wrote an autobiography and retired in 1971 from Abyssinian Baptist.

Powell liked one characterization of him as "arrogant, but with style." His legacy is a mixed one, for his personal presumptions clouded his political accomplishments. Yet during the 1940s and 1950s he ranked with A. PHILIP RANDOLPH among the great leaders of African Americans. He proved a resourceful and effective leader in America's largest city from the 1930s through World War II. From the mid-1940s through the mid-1960s he combined his political position as a congressman

with a commitment to progressive politics that far outstripped his few black congressional predecessors of the 1930s or his few black colleagues of the 1940s and 1950s. In the 1960s he had greater power to get things done, but he was also less irreplaceable, for American politics had begun to catch up with his positions on matters of race and class. He died in Miami, Florida.

FURTHER READING

No large collection of Powell papers exists, but scattered materials by or about him are at the Schomburg Center for Research in Black Culture of the New York Public Library and the Lyndon B. Johnson Presidential Library in Austin, Texas.

Powell, Adam Clayton, Jr. *Adam by Adam: The Autobiography of Adam Clayton Powell Jr.* (1971).

Hamilton, Charles V. *Adam Clayton Powell Jr.: The Political Biography of an American Dilemma* (1991).

Haygood, Wil. *King of the Cats: The Life and Times of Adam Clayton Powell Jr.* (1993).

Reeves, Andrée E. *Congressional Committee Chairmen: Three Who Made an Evolution* (1993).

Obituaries: *New York Times* and *Washington Post*, 5 Apr. 1972.

PETER WALLENSTEIN

POWELL, Adam Clayton, Sr.

(5 May 1865–12 June 1953), pastor, was born in Martins Mill, Virginia, the son of a German planter he knew only as "Powell" and a woman of African American and Indian heritage named Sally. Powell's father was killed during the Civil War before his son's birth, and shortly before Powell was born his recently freed mother moved into the cabin of the tenant farmer Anthony Dunn, a former slave of Powell's father. His family migrated to West Virginia in 1875 to work on a farm and the next year settled at Paint Creek. There Powell attended school for two years, which, combined with one year of schooling at Martins Mill, constituted his entire formal primary education. Powell later described his eight years in West Virginia as "a mental and moral disaster" (13). Often involved in fights, he was forced to leave the state in 1884 to avoid being lynched or murdered because of his role in the shooting of an influential white resident of Paint Creek while Powell was guarding a melon patch.

Powell then took a job at the W. P. Rend coal mines in Rendville, Ohio. Most months he lost all his pay gambling. In 1885 a revival swept through Rendville, shutting down the coal mine and all the town's businesses for a week. Along with many residents of the community, Powell was "born again" and then attended the Rendville Academy, supporting himself by working as a school janitor. Inspired by reading about the lives of Frederick Douglass and other prominent black leaders, Powell decided to prepare for a career in law and politics, with the hope of someday serving in Congress.

Powell moved to Washington, D.C., in 1887 to attend Howard University School of Law. When both his inadequate academic preparation and his lack of funds prevented him from studying at the university, Powell took a job at Howard House, a hotel in Washington. While reading the Bible, he "was seized with an unquenchable desire to preach" (Powell, 20) and in 1888 began classes in both the academic and theological departments of Wayland Seminary (later Virginia Union University) in Washington, graduating from both programs in 1892. In 1889 Powell married Mattie Fletcher Shaffer, whom he had met while living in West Virginia. They had a daughter and a son.

After short pastorates in Baptist congregations in St. Paul and Philadelphia, Pennsylvania, in 1893 Powell became the minister of the Immanuel Baptist Church of New Haven, Connecticut. During his fifteen-year tenure in New Haven, his congregation grew from 135 to 600 members, and the church building was remodeled for $10,000. Powell participated in interdenominational and interracial endeavors to improve the quality of life in New Haven. For some of these years he earned more money by lecturing on racial issues and holding evangelistic services throughout the country than he did by serving his church. According to one of his contemporaries, the key to Powell's successful ministry in New Haven was his winsome personality, his eloquent, enthusiastic preaching, his continuous quest to broaden his knowledge, and his passion for serving others. To become a more effective minister, Powell attended classes at Yale Divinity School in 1895–1996. He also served as a delegate to the World's Christian Endeavor Convention in 1900.

In 1908 Powell accepted a call to pastor the century-old Abyssinian Baptist Church in New York City, then located in the neighborhood surrounding West Fortieth Street between Seventh and Eighth avenues, one of the city's most notorious red-light districts. Shortly after his arrival he led a

successful campaign to close down houses of prostitution in the area around his church. A talented organizer, an inspiring orator, and a shrewd publicist, Powell during a twenty-nine-year ministry built the Abyssinian Baptist Church, composed primarily of middle-class New Yorkers, into the largest black congregation in the world. After threatening to resign to become a full-time evangelist, Powell convinced the congregation to move uptown to a new facility on 138th Street in Harlem that was dedicated in 1923. Because the area between 125th and 145th streets was becoming heavily populated with African Americans, the church gained tremendous potential for both growth and ministry by moving there.

In its new location the congregation became a center during the 1920s and 1930s for programs designed to help community residents. Like many other institutional churches in major American cities, the Abyssinian Baptist Church sponsored a wide array of religious, educational, and social programs, including a free food kitchen, job counseling, a home for the aged, and a clothing ministry. When Powell retired in 1937, the membership of the church had grown to more than 10,000 (from 1,600 in 1908), and its budget had increased to $135,000 (from $6,000 in 1908). Its staff numbered three ministers and nineteen other paid workers. Powell claimed that his church hosted the nation's largest adult education school, which held classes in physical education, English, political science, dressmaking, nursing, typewriting, and many other subjects, and a large teacher training school (operated in conjunction with Columbia University). He also insisted that under his leadership the congregation had made great strides toward achieving its four main objectives: providing a model church for African Americans, teaching blacks the value of punctuality, helping to improve race relations, and working to promote social justice. These accomplishments brought many visitors from around the world to Harlem to study the church's programs.

While serving his church, Powell conducted evangelistic crusades throughout the country and became active in politics. A captivating and persuasive speaker, he inspired thousands of blacks in Baltimore, Indianapolis, Toronto, Los Angeles, and dozens of other cities to repent of their sins, profess their faith in Christ, and join local congregations. In 1937 he delivered one of the main addresses, "The Negro's Enrichment of the Church Today," at the Northern Baptist Convention's annual meeting in Philadelphia. Deeply involved in Republican politics in New York, Powell was chosen in 1932 by the Republican State Committee to represent the state in the electoral college. Like many other blacks, he shifted his allegiance to Franklin Roosevelt in 1936 but thereafter primarily supported the American Labor Party (ALP). Organized by key labor leaders in 1936, the ALP had strong ties with labor unions and supported candidates, Democratic or Republican, who endorsed liberal social legislation.

As one of the most prominent black clergymen in the United States, Powell had a significant influence on black attitudes and strategies toward racism and discrimination. He was a founder of the Urban League in 1910 and served on the first board of directors of the National Association for the Advancement of Colored People and as a vice president of the organization. Powell was influenced by the ideas of both w. e. b. du bois and booker t. washington. While he held leadership positions in several black protest organizations, he generally favored a conciliatory approach to white-black relations and the philosophy of self-help advocated by Washington. He wrote in his autobiography that in his lectures to whites during the past twenty-five years he had asked only for one right for his race—"the right of equal opportunity with all other American people" (Powell, 180). This included, he argued, the same educational opportunities, equal pay for equal work, and equivalent living conditions, but it did not include the "pernicious doctrine" of social equality or integration. He praised whites for their support of black colleges, churches, and social agencies, denounced racial prejudice among both blacks and whites, and insisted that in the United States the destiny of the races was "inextricably intertwisted." Each had a contribution to make to the other. While blacks needed whites' "courage, initiative, punctuality, business acumen and aggressiveness," whites needed blacks' "meekness, love, forgiving spirit, and emotional religion" (Powell, 187).

Although Powell was an advocate of the premillennial view that held that the world would grow worse and worse until Christ's Second Coming, he worked energetically to reform social conditions. During his ministry Powell trumpeted many of the themes proclaimed by fundamentalists during the 1920s and 1930s: that a new birth experience was paramount, that Christ's Second Coming was imminent, and that Christians should seek to develop

a deep spirituality and abstain from alcohol. He was also a political conservative and supported the Republican Party's commitment to limited government. However, he recognized that people's social environments formed them, and he strove to help blacks find jobs, gain education, improve their living conditions, and advance socially. When Powell retired from the active ministry, three thousand friends and admirers jammed his church to honor him. One speaker attributed Powell's great success to five factors: his executive ability, vision, courage, honesty, and faith in God. Powell was replaced as the senior minister of the Abyssinian Baptist Church by his son, ADAM CLAYTON POWELL JR., who during the 1940s used the congregation as a base to launch a campaign that made him the first African American from New York to be elected to Congress.

After his retirement, the elder Powell continued to lecture and preach throughout the nation, wrote five books, and took an active part in community affairs. *Against the Tide* (1938) told the story of his life, ministry, and philosophy. In *Riots and Ruins* (1945) he analyzed the causes and effects of the Harlem riots of 1943 and suggested ways to improve race relations. During this racial conflict Powell co-chaired the citywide Citizens' Committee on Harlem that sought to discover and remedy the conditions that provoked the riots. Powell's first wife died in 1945, and in 1946 he married Inez Means Cottrell, a nurse. He died in New York City.

FURTHER READING

The Schomburg Center for Research in Black Culture in New York City contains several accounts of Powell's work with the Abyssinian Baptist Church.

Powell, A. Clayton. *Against the Tide* (1938; repr. 1980).

Hickey, Neil, and Ed Edwin. *Adam Clayton Powell and the Politics of Race* (1965).

Obituaries: *New York Times*, 13 June and 17 June 1953; *Amsterdam News*, 20 June 1953.

GARY SCOTT SMITH

PREER, Evelyn

(16 July 1896–17 Nov. 1932), actress and singer, was born Evelyn Jarvis in Vicksburg, Mississippi, to Blanche and Frank Jarvis. While Preer was still a young child, her father passed away, and she and her mother migrated north to Chicago. There she completed grammar school and high school, and she eventually persuaded her strict Pentecostal mother to allow her to pursue an acting career. Initially Preer's opportunities were limited to performing with minor traveling musical and minstrel shows. However, while still in her early twenties she met the pioneering African American filmmaker OSCAR MICHEAUX and began her film career in his 1919 film *The Homesteader.*

Preer would owe the lion's share of her exposure in cinema to Micheaux, who featured her in a number of his subsequent films, including *Within Our Gates* (1920), *The Brute* (1920), *The Gunsaulus Mystery* (1921), *Deceit* (1923), *Birthright* (1924), *The Devil's Disciple* (1925), and *The Conjure Woman* (1926). Her role in *Within Our Gates* is particularly noteworthy because of the film's reputation among film scholars as having been Micheaux's "answer" to the racist history presented in D. W. Griffith's 1915 blockbuster *The Birth of a Nation.* Micheaux sought to unveil the brutal southern tradition of white-on-black violence ignored in Griffith's film by explicitly portraying a white mob's lynching of a helpless African American family. *Within Our Gates* also depicted Preer's character, Sylvia Landry, as the victim of an attempted rape by a white man who is discovered to be her biological father.

Preer's prominence in so many of Micheaux's films draws attention to the important history of "race movies," films made by independent African American directors like Micheaux during the silent era, when Hollywood studios were disinclined to produce movies targeting black audiences. Preer became acquainted with many race movie actors through her membership in the Harlem-based Lafayette Players, a professional black stock acting company founded by Anita Bush in 1915. The company's members regularly appeared both in stage dramas and in the screen works of race filmmakers. Many accomplished black actors and actresses got their training and professional experience through their association with the Lafayette Players. Preer first joined the Players in 1920, as the troupe was enjoying a run at Chicago's Lincoln Theater. Among their members was the actor Edward Thompson, the son of the black composer DeKoven Thompson and who would himself appear in race films like Micheaux's *The Spider's Web* (1927). Preer and Thompson acted together in a number of the Lafayette Players' 1920s stage productions. The pair fell in love and was married during a Players tour in 1924, just outside of Nashville, Tennessee.

Preer was also an accomplished singer and recorded a number of jazz tunes over her lifetime. She performed and recorded with the jazz legend DUKE ELLINGTON songs such as "If You Can't Hold the Man You Love," and "Baby Won't You Please Come Home." Sometimes appearing in her singing career as Evelyn Thompson, Preer also performed with accomplished entertainers like ETHEL WATERS and Josh White. Her singing landed her roles in stage musicals like *Rang Tang* (1927), as well as a lead role in her first sound film, *Georgia Rose* (1930), a race musical produced by Aristo Films.

Preer was, however, an actress first and foremost. In addition to her appearances in race films, Preer acted in small roles in Hollywood productions. She appeared as a prisoner in the 1931 Paramount film *Ladies of the Big House*, which starred Sylvia Sidney. In the following year Preer was cast in another Paramount film, *Blonde Venus* (1932), starring Marlene Dietrich. Also appearing with her in this film were Hattie McDaniel and her fellow Lafayette Player CLARENCE MUSE. Paramount distributed a series of comedy shorts produced by the Christie Film Company, and some of these, like *The Framing of the Shrew* (1929) and *Oft in the Silly Night* (1929) also featured Preer. For some of the Christie Company roles, Preer's light skin was darkened with makeup, illustrating the endurance of the minstrel idiom and, moreover, the deep anxiety around the representation of race in Hollywood during this era. Such "blackface" appearances in mainstream comedies provided an odd visual counterpoint to Preer's appearances in uplift-oriented race movies with predominantly light-skinned black casts, many of whom could "pass" for white.

Indeed, for African American actresses like Preer, color was a highly significant and highly complex indicator of their prospects on screen in the early decades of American cinema. Darker-skinned actresses like Hattie McDaniel and LOUISE BEAVERS worked fairly steadily in Hollywood films, but they appeared overwhelmingly in predictable comic or tragic maid roles. Among whites and blacks, they would become associated with the stereotyping of the black image. Lighter-skinned actresses like Preer, NINA MAE MCKINNEY, and FREDI WASHINGTON (who was also darkened with makeup for Hollywood films) had a more difficult time getting Hollywood roles, presumably because their light skin signified "beauty" and suggested sexuality, concepts that white audiences were often uncomfortable perceiving with respect to black characters. They also threatened to upset the simple visual opposition of race as black and white that Hollywood studios relied upon for their audiences' comfort and recognition.

Preer's professional endeavors generally met with substantial acclaim, with critics both black and white giving her performances high marks. The *Pittsburgh Courier* reporter Floyd Calvin treated her in a 1927 article entitled "Evelyn Preer Ranks First as Stage and Movie Star." Citing the variety of Preer's accomplishments, Calvin called her "a pioneer in the cinema world for colored actresses" (Thompson, 29). Though Preer and her husband, Edward Thompson, enjoyed considerable professional success, their personal dreams of beginning a family were more difficult. In the years after they married, they were told by a number of doctors that Preer would never be able to bear children. Thus it was with great joy and satisfaction that in April 1932, the couple announced the birth of their daughter, Edeve (Sister Francesca) Thompson.

Tragically, the family's joy was short-lived. Preer grew ill after delivering the child, and she died of double pneumonia only seven months after Edeve was born. Her Los Angeles funeral was lavish, attended by throngs of her fans and fellow actors. Preer was movingly eulogized by Clarence Muse, who honored the quality of her work as an actress, concluding that "the world has been uplifted" (Thompson, 32). Her obituary in the Hollywood trade magazine *Variety* proclaimed that she was "considered the foremost dramatic actress of the colored race."

FURTHER READING

Cripps, Thomas. *Slow Fade to Black: The Negro in American Film, 1900–1942* (1977).

Musser, Charles, et al. "An Oscar Micheaux Filmography: From the Silents through His Transition to Sound, 1919–1931," in *Oscar Micheaux and His Circle: African-American Filmmaking and Race Cinema of the Silent Era*, eds. Pearl Bowser, Jane Gaines, and Charles Musser (2001).

Thompson, Sister Francesca. "From Shadows 'n Shufflin' to Spotlights and Cinema: The Lafayette Players, 1915–1932," in *Oscar Micheaux and His Circle: African-American Filmmaking and Race Cinema of the Silent Era*, eds. Pearl Bowser, Jane Gaines, and Charles Musser (2001).

Obituary: Variety (22 Nov. 1932).

MIRIAM J. PETTY

PRICE, Florence B.

(9 Apr. 1887–3 June 1953), composer and instrumentalist, was born Florence Beatrice Smith in Little Rock, Arkansas, the daughter of James H. Smith, a dentist, and Florence Gulliver. Besides working as a dentist, her father was also an amateur novelist, painter, and inventor. Her mother, who had been an elementary school teacher in Indianapolis, had been trained in music and provided her daughter's earliest musical instruction. Price attended the black schools of Little Rock, where she was a classmate of WILLIAM GRANT STILL, who would later become the leading black American composer of the twentieth century.

Price graduated high school at the age of fourteen and enrolled in the New England Conservatory of Music in Boston. Whereas racial tensions were increasing in Little Rock, the climate at the conservatory was favorable to black students, and George W. Chadwick, the director of the school and a composer of note, had a considerable interest in black musical materials. In 1906 Price graduated with a degree in Piano Pedagogy and Organ Performance. She then returned to Arkansas and taught at the Cotton Plant-Arkadelphia Academy for a year and then at Shorter College in North Little Rock for the next three years.

In 1910 Price began a promising academic career at Clark University in Atlanta as head of the music department, but she left the post in 1912 to marry Thomas J. Price, a rising Little Rock attorney; they had three children. While raising the children, Price taught music privately and composed, twice submitting prize-winning works to *Opportunity* magazine's Holstein competition.

Increasing racial tensions in Little Rock, climaxed by a lynching in a black middle-class neighborhood, led the Price family to move to Chicago in 1927. There Price continued her composition studies at a number of schools, among them the Chicago Musical College, the American Conservatory of Music, and the University of Chicago. She also continued to give organ and piano performances and instruction and to compose. By 1928 her works were being published by G. Schirmer and the McKinley Company, and her pieces for beginning piano students were in great demand.

During the 1930s Price's reputation as a composer and performer grew rapidly in the Chicago area. In 1932 she was awarded the first-place prize in the Wanamaker competition for her Symphony

Florence B. Price was one of the first African American women composers to achieve widespread recognition. (Moorland-Spingarn Research Center.)

in E Minor, having won three other Wanamaker awards that year, plus an honorable mention the year before. In addition, one of her composition students, Margaret Bonds, also received a prize in 1932.

At Chicago's Century of Progress Exposition in 1933, Price's Symphony in E Minor was performed by Frederick A. Stock, leading the Chicago Symphony Orchestra. Later her symphonic compositions were played by orchestras in Detroit, Pittsburgh, and New York. In 1934 she appeared as a piano soloist with the Chicago Women's Symphony, playing her own Concerto in F Minor.

Price remained an active organist in Chicago, and her organ compositions were published by Lorenz, Summy, and Galaxy. She also continued to publish piano pieces and began to add choral works, spiritual arrangements, and songs to her catalog. Several well-known black concert singers performed Price's songs, notably MARIAN ANDERSON, who was especially fond of "My Soul's Been Anchored in the Lord" and a setting of LANGSTON HUGHES's poem "Songs to a Dark Virgin." In later years her songs were her best-known compositions

and were included in anthologies such as *Art Songs by Black American Composers* (1977) and *Art Songs by American Women Composers* (1994).

After her husband's death in the early 1940s, Price continued her active career as a teacher, performer, and composer for another decade. She wrote the Second Violin Concerto in 1952 and the Suite of Negro Dances in 1953, which was performed on a television Pops concert by Chicago Symphony members. She died in Chicago. In 1964 a Chicago elementary school was named in her honor.

For many years Florence Price was primarily known as the first black woman to compose a work performed by a major symphony orchestra. A full appreciation of her work was hampered during this period by the fact that many of her compositions remained unpublished. In addition, a number of the larger works had been lost. Until the early 1970s Price was almost unknown outside of Chicago, but with the increasing emphasis on women's and multicultural studies, she has begun to receive recognition as one of the major African American women composers. Price's compositional style combines black folk idioms with late nineteenth-century emphasis on lyricism and chromatically altered tonality. During the avantgarde 1950s and 1960s her music fell out of fashion, but then attracted more interest in the neo-Romantic climate of the following decades. Her songs and spiritual arrangements came to be particularly favored by performers for the compelling rhythmic, melodic, and harmonic aspects of her text setting.

FURTHER READING

Price's papers are held by the University of Arkansas at Fayetteville.

Jackson, Barbara Garvey. "Florence Price, Composer," *The Black Perspective in Music* 5 (Spring 1977).

Walker-Hill, Helen. *From Spirituals to Symphonies: African-American Women Composers and Their Music* (2002).

RUTH C. FRIEDBERG

RAINEY, Ma

(26 Apr. 1886–22 Dec. 1939), vaudeville artiste and "Mother of the Blues," was born Gertrude Pridgett in Columbus, Georgia, the daughter of Ella Allen, an employee of the Georgia Central Railroad, and Thomas Pridgett, whose occupation is unknown. Around 1900, at the age of fourteen, Pridgett made her debut in the *Bunch of Blackberries* revue at the Springer Opera House in Columbus, one of the biggest theaters in Georgia and a venue that had been graced by, among others, Lillie Langtry and Oscar Wilde. Within two years she was a regular in minstrel tent shows—troupes of singers, acrobats, dancers, and novelty acts—which traveled throughout the South. At one show in Missouri in 1902 she heard a new musical form, "the blues," and incorporated it into her act. Although she did not discover or name the blues, as legend would later have it, Gertrude Pridgett was undeniably one of the pioneers of the three-line stanza, twelve-bar style now known as the "classic blues."

In 1904 the seventeen-year-old Gertrude married William Rainey, a comedian, dancer, and minstrel-show veteran. "Ma" and "Pa" Rainey soon became a fixture on the southern tent-show circuit, and they achieved their greatest success in 1914–1916 as Rainey and Rainey, Assassinators of the Blues, part of the touring Tolliver's Circus and Musical Extravaganza. Their adopted son, Danny, "the world's greatest juvenile stepper," also worked with the show.

The summer tent shows took the Raineys throughout the South, where Ma was popular among both white and black audiences. Winters brought Ma, billed as Madame Gertrude Rainey, to New Orleans, where she performed with several pioneering jazz and blues musicians, including SIDNEY BECHET and KING OLIVER. Around 1914 Ma took a young blues singer from Chattanooga, Tennessee, BESSIE SMITH, under her wing—legend erroneously had it that she kidnapped her—and the two collaborated and remained friends over the next two decades. During these tent-show years, Rainey honed a flamboyant stage persona, making her entrance in a bejeweled, floor-length gown and a necklace made of twenty-dollar gold pieces. The blues composer Thomas A. Dorsey recalled that Rainey had the audience in the palm of her hand even before she began to sing, while LANGSTON HUGHES noted that only a testifying Holiness church could match the enthusiasm of a Ma Rainey concert.

Rainey's voice was earthy and powerful, a rural Georgian contralto with a distinctive moan and lisp. One blues singer also suggested that Rainey held a dime under her tongue to prevent a stutter. Far from hindering her performance, these imperfections made Rainey's vocal style even more appealing to an audience that shared her down-to-earth philosophy, captured in "Down in the Basement":

Grand Opera and parlor junk
I'll tell the world it's all bunk
That's the kind of stuff I shun
Let's get dirty and have some fun.

Rainey often sang of pain and love lost or betrayed, but her songs—and her life—also celebrated the bawdy and unabashed pleasures of the flesh. Rainey joked with her audiences that she preferred her men "young and tender" (Barlow, 159), but in songs such as "Lawd Send Me a Man Blues," the preference matters less than the pleasure: "Send me a Zulu, a voodoo, any old man, / I'm not that particular, boys, I'll take what I can."

By World War I, Ma Rainey's star had eclipsed that of Pa's. (They separated in the late teens, and Pa died soon after.) In 1923 Rainey began a recording career with Chicago's Paramount Records, which brought her down-home country blues to a national audience. Over the next five years, she recorded more than a hundred songs with many of the leading instrumentalists of the day, including Lovie Austin, COLEMAN HAWKINS, and Thomas A. Dorsey, who also led Rainey's touring band. In 1924 a young LOUIS ARMSTRONG played cornet on her most famous release, "See See Rider." Though already a blues standard, Rainey's rendition was the first and, bluesologists contend, the definitive recording of the song.

Her success as a recording artist and the general popularity of the "race records" industry led to a string of headlining tours with the Theater Owners' Booking Association (TOBA). Black performers often called the organization "Tough on Black Asses" because of its low wages and grueling schedule, but Rainey's sense of fairness

Ma Rainey in the touring show The Rabbit Foot Minstrels. Known as the "Mother of the Blues," she toured regularly in the South and Midwest. (AP Images.)

may have assuaged any complaints from the touring entourage of singers, dancers, and comedians. Unlike many TOBA headliners, Rainey never skipped town without paying her fellow performers. As a teenager, Lionel Hampton, who knew Rainey through his bootlegger uncle in Chicago, "used to dream of joining Ma Rainey's band because she treated her musicians so wonderfully and always bought them an instrument" (Lieb, 26). Rainey's TOBA shows were even more popular than her tent shows had been, and her audience spread to midwestern cities, whose black populations had swelled during the Great Migration. The shift from tents to theaters also provided new outlets for Rainey's showmanship. She now made an even grander entrance, stepping out of the doors of a huge Victrola onto the stage, wearing her trademark spangles and sequins.

Contemporaries often contrasted Rainey's even-handed temperament with Bessie Smith's hard-drinking, fiery temper, but Rainey was not unacquainted with the wrong side of the law. Her love of jewelry once led to an arrest onstage in Cleveland, Ohio, when police from Nashville, Tennessee, arrested her for possession of stolen goods. Rainey denied knowing that the items were hot, but was detained in Nashville for a week and forced to return the jewelry. More notoriously, Rainey spent a night in jail in Chicago in 1925, when neighbors called the police to complain about a loud and drunken party that she was holding with a group of women. When the police discovered the women in various states of undress, they arrested Rainey for "running an indecent party." Her friend Bessie Smith bailed her out the next day.

That incident and several biographies of Smith have highlighted Rainey's open bisexuality and the possibility of a lesbian relationship between the two women. To be sure, Ma Rainey's life and songs rejected the prevailing puritan orthodoxy when it came to sexuality. In "Sissy Blues," written by Tom Dorsey, she bemoans the loss of her man to his male lover: "My man's got a sissy, his name is Miss Kate, / He shook that thing like jelly on a plate." Most famously, in "Prove It on Me Blues," Rainey declares, "Went out last night with a crowd of my friends, / They must've been women, 'cause I don't like no men." Ma's bold assertion of her preference for women alternated with a coy but knowing wink to the taboo of that choice: " 'Cause they say I do it, ain't nobody caught me, / Sure got to

prove it on me." Paramount's advertisement for the record was somewhat less coy, depicting a hefty Ma Rainey in waistcoat, men's jacket, shirt, tie, and fedora—though still wearing a skirt—towering over two slim, femininely dressed young women while a policeman looks on.

The sexual politics of the lyrics was just one aspect of the song, however. Paramount appeared just as keen to highlight that it was "recorded by the latest electric method," all the better to hear Rainey's vocals and the "bang-up accompaniment by the Tub Jug Washboard Band." Indeed, the company saw no problem in promoting some of its most popular gospel spirituals on the same advertisement. Like Ma Rainey herself, the race records industry of the 1920s may have been less squeamish about open declarations of homosexuality than many media giants in the late twentieth century.

Paramount ended Rainey's recording contract in 1928, shortly after the release of "Prove It on Me Blues," but not because of any controversy regarding the record itself. The company argued that Rainey's "down home material had gone out of fashion," though that did not deter the label from signing male country blues performers who accepted lower fees. Ma returned to the southern tent-show circuit with TOBA, but by the early 1930s the Great Depression and the rival attractions of radio and the movies had destroyed the mass audience for the old-time country blues and black vaudeville at which Rainey excelled. Undeterred, though as much through necessity as choice, Rainey returned to her southern roots, touring the oilfield towns of East Texas with the Donald MacGregor Carnival. Gone were the gold necklaces, the touring bus, and the grand entrance out of a huge Victrola. Now MacGregor, formerly the "Scottish Giant" in the Ringling Brothers' circus, stood outside Rainey's tent and barked his introduction of the "Black Nightingale" inside. Rainey's performances were as entertaining as ever, but the uncertainty and poor wages of the tent-show circuit may have somewhat diminished her trademark good humor and generosity. A young guitarist who toured with her in those years, Aaron "T-Bone" Walker, described Rainey as "mean as hell, but she sang nice blues and never cursed *me* out" (Lieb, 46–47).

The death of her sister Malissa in 1935 brought Ma Rainey back to Columbus to look after her mother. At some time before that Rainey had separated from her second husband, whose name is not

known. Although she no longer performed, Rainey opened two theaters in Rome, Georgia, where she died of heart disease in December 1939, at age fifty-three. The obituary in Rainey's local newspaper noted that she was a housekeeper but failed to mention her musical career. In the 1980s, however, both the Blues Foundation Hall of Fame and the Rock and Roll Hall of Fame recognized Ma Rainey's significance as a consummate performer and as a pioneer of the classic blues.

FURTHER READING

Barlow, William. *"Looking Up at Down": The Emergence of Blues Culture* (1989).

Carby, Hazel. "It Jus' Be's Dat Way Sometime: The Sexual Politics of Women's Blues," in *The Jazz Cadence of American Culture*, ed. Robert G. O'Meally (1998).

Davis, Angela Y. *Blues Legacies and Black Feminism: Gertrude "Ma" Rainey, Bessie Smith, and Billie Holiday* (1998).

Lieb, Sandra. *Mother of the Blues: A Study of Ma Rainey* (1981).

DISCOGRAPHY

Complete Recorded Works in Chronological Order, 1923–1927 (vols. 1–4, Document Records DOCD 5581–5584).

Complete Recorded Works: 1928 Sessions (Document Records DOCD 5156).

STEVEN J. NIVEN

A. Phillip Randolph at a meeting between civil rights leaders and Lyndon B. Johnson in the Oval Office, Washington, D.C., 11 August 1965. (LBJ Presidential Library/Yoichi R. Okamoto, photographer.)

RANDOLPH, A. Philip

(15 Apr. 1889–16 May 1979), labor organizer, editor, and activist, was born Asa Philip Randolph in Crescent City, Florida, to Elizabeth Robinson and James Randolph, an African Methodist Episcopal (AME) Church preacher. In 1891 the Randolphs moved to Jacksonville, where James had been offered the pastorship of a small church. Both Asa Philip and his older brother, James Jr., were talented students who graduated from Cookman Institute (later Bethune-Cookman College), the first high school for African Americans in Florida.

Randolph left Florida in 1911, moving to New York to pursue a career as an actor. Between 1912 and 1917 he attended City College, where he was first exposed to the ideas of Karl Marx and political radicalism. He joined the Socialist Party in 1916, attracted to the party's economic analysis of black exploitation in America. Randolph, along with W. E. B. DU BOIS, HUBERT HENRY HARRISON,

and CHANDLER OWEN, was one of the pioneer black members of the Socialist Party—then led by Eugene Debs. Like a number of his peers, Randolph did not subscribe to a belief in a "special" racialized oppression of blacks that existed independent of class. Rather, he argued at this point that socialism would essentially "answer" the "Negro question." His faith in the socialist solution can be seen in the title of an essay he wrote on racial violence, "Lynching: Capitalism Its Cause; Socialism Its Cure" (*Messenger*, Sept. 1921).

In 1916 Randolph and Owen began working to organize the black labor force, founding the short-lived United Brotherhood of Elevator and Switchboard Operators union. Shortly thereafter, they coedited the *Hotel Messenger*, the journal of the Headwaiters and Sidewaiters Society. After being fired by the organization, they created the *Messenger* in 1917—with crucial financial

support from Lucille Randolph, a beauty salon owner whom Randolph had married in 1914. The couple had no children. Lucille Randolph's success as an entrepreneur was a consistent source of stability—despite the fact that her husband's reputation as a radical scared away some of her clientele. Billing itself as "The Only Radical Negro Magazine," the boldly iconoclastic *Messenger* quickly became one of the benchmark publications of the incipient New Negro movement. A single issue contained the views of Abram Harris, KELLY MILLER, GEORGE SCHUYLER, ALICE DUNBAR-NELSON, COUNTÉE CULLEN, EMMETT JAY SCOTT, and CHARLES S. JOHNSON.

In the context of the postwar Red Scare, however, Randolph's leftist politics brought him to the attention of federal authorities determined to root out radicals, anarchists, and communists but who showed little regard for civil liberties. With the *Messenger* dubbed "the most dangerous of all Negro publications" by the Bureau of Investigation (later the FBI), Randolph and Owen were arrested under the Espionage Act in 1918 but were eventually acquitted of all charges.

When the Socialist Party split in 1919 over the issue of affiliation with the newly created socialist state in Russia, Randolph and Owen remained in the Socialist Party faction. The left wing of the party broke away, eventually coalescing into the Communist Party USA (CPUSA). Randolph's ties to the Socialist Party remained firm, and he ran as the party's candidate for New York State comptroller in 1920 and as its candidate for secretary of state in 1921. Initial relations with the black CPUSA members were warm, with the Communists Lovett Fort-Whiteman and W. A. DOMINGO writing for the *Messenger*. By the late 1920s, however, Randolph had become involved in the sometime fractious politics of the black left in the New Negro era.

In the early 1920s Randolph worked for the "Garvey Must Go" campaigns directed by an adhoc collection of black leaders opposed to the charismatic—and often belligerent—black nationalist MARCUS GARVEY. Randolph and Garvey had shared a common mentor in the socialist intellectual Hubert Harrison. Randolph claimed, in fact, to have introduced Garvey to the tradition of Harlem street-corner oratory. Randolph's opposition to Garvey appears to have been rooted in his perspective that Garvey's Universal Negro Improvement Association ignored the "class struggle nature of the Negro problem," as well as in his belief that Garvey was untrustworthy.

At the same time that W. A. Domingo charged that the *Messenger's* attacks on Marcus Garvey had metastasized into a general anti-Caribbean bias, the magazine began devoting much less attention to radical politics in general and Russia specifically. Randolph's embryonic anticommunism was partially responsible for this shift, but the *Messenger* had also attempted to broaden its base by appealing to more upwardly mobile black strivers.

With the *Messenger* in editorial and financial decline, Randolph accepted a position as the head of the newly established Brotherhood of Sleeping Car Porters (BSCP) and spearheaded a joint drive for recognition of the union by the American Federation of Labor (AFL) and the Pullman Company. Randolph led the organization to affiliation with the AFL in 1928—a significant accomplishment in the face of the racial discrimination practiced by many of its sibling unions in the AFL. Randolph's decision to cancel a planned BSCP strike in 1928, however, resulted in a significant loss of confidence in the union and opened him up to criticism from the Communist Party, among others.

The Communist Party–affiliated American Negro Labor Congress, created in 1925, became increasingly critical of Randolph and the BSCP by the end of the decade. At the same time, Randolph's thinking and writing took a strong and persistent anticommunist turn. In the 1930s the economic upheaval of the Great Depression and the controversial treatment of the wrongfully imprisoned SCOTTSBORO BOYS brought Communists an unprecedented degree of recognition and status within black America. The era's radicalism found expression in 1935 in the creation of the National Negro Congress (NNC)—an umbrella organization with liberal, radical, and moderate black elements. Randolph was selected as the organization's first president in 1936. Given his standing as a radical socialist, labor organizer, and civil rights advocate, Randolph was one of the few prominent African Americans with ties to many of the diverse constituencies that made up the NNC.

Global politics shaped the organization from the outset. The NNC had been founded in the midst of the "Popular Front" era and, in many ways, had been facilitated by the shared concern of communists, liberals, socialists, and moderates about the spread of fascism across Europe and the lack of

civil rights for blacks in America. However, the Hitler-Stalin Pact of 1939 effectively ended the Popular Front, and tensions within the NNC increased. Randolph resigned in 1940, charging that Communist influence had undercut the NNC's autonomy and saying famously that "it was hard enough being black without also being red" (press release, 4 May 1940, in NAACP papers, A-444).

World War II brought Randolph a new set of challenges. With America on the verge of war in 1941, he organized the March on Washington movement, an attempt to bring ten thousand African Americans to Washington to protest discrimination in defense industries. President Franklin Roosevelt, recognizing the possible impact upon morale and public relations and the significance of the black vote in the 1932 and 1936 presidential elections, issued Executive Order 8806, which forbade discrimination in defense industries and created the Fair Employment Practices Commission. In response, the proposed march was cancelled. Randolph, however, remained at the head of the organization until 1946.

In 1948 Randolph, along with Bayard Rustin, with whom he would work closely in later years, organized the League for Nonviolent Civil Disobedience against Military Segregation. The organization's efforts led to a meeting with President Harry S. Truman in which Randolph predicted that black Americans would not fight any more wars in a Jim Crow army. As with the planned March on Washington, the 1948 efforts influenced Truman's decision to desegregate the military with Executive Order 9981.

During the 1950s Randolph became more closely aligned with mainstream civil rights organizations like the NAACP—organizations that he had fiercely criticized earlier in his career. He also became more outspokenly anticommunist, traveling internationally with the Socialist Norman Thomas to point out the shortcomings of Soviet communism. He was elected to the executive council of the newly united AFL-CIO in 1955. The high-water mark of his influence, however, had passed. Randolph did not exert as much influence with the union president George Meany as he had with the AFL president William Green, whom he had known since the BSCP's affiliation in 1928. In 1959 Randolph assumed the presidency of the Negro American Labor Council (NALC). That same year, Randolph's address on the subject of racism within the

AFL-CIO elicited a stern rebuke from Meany. Wedged between the radical younger members of the NALC and his contentious relationship with Meany, Randolph resigned his position in 1964.

Randolph reemerged in the 1960s in connection with the modern civil rights movement; in 1962 Rustin and the seventy-two-year-old Randolph proposed a march on Washington to Martin Luther King Jr. and the NAACP's Roy Wilkins. Randolph was the first speaker to address the two hundred thousand marchers at the Lincoln Memorial on 28 August 1963, stating that "we are not a pressure group, an organization or a group of organizations, we are the advance guard for a massive moral revolution for jobs and freedom." The march was a decisive factor in the passage of the Civil Rights Act of 1964.

Randolph presided over the creation of the A. Philip Randolph Institute in 1964 and spearheaded the organization's efforts to extend a guaranteed income to all citizens of the United States. His anticommunist views led him to support the war in Vietnam—a stance that put him at odds with his onetime ally Martin Luther King, among others. He distrusted the evolving radicalism that characterized the decade, stating that Black Power had overtones of black racism. His public support for the United Federation of Teachers in the Ocean Hill–Brownsville conflict of 1968, in which black community organizations attempted to minimize the authority of the largely white teachers' union, further alienated Randolph from the younger generation of Black Power advocates.

By the time of his death in Manhattan in 1979 Randolph had become an icon in the struggle for black equality in the twentieth century. More than any other figure, A. Philip Randolph was responsible for articulating the concerns of black labor—particularly in the context of the civil rights movement. His organizing abilities and strategic acumen were key to the desegregation of defense contracting and the signal legislative achievement of the civil rights era: passage of the Civil Rights Act of 1964.

FURTHER READING

A. Philip Randolph's papers are housed in the Library of Congress. Microfilm versions are available at other institutions, including the Schomburg Center for Research in Black Culture of the New York Public Library.

Anderson, Jervis. *A. Philip Randolph* (1972).

Kornweibel, Theodore. *No Crystal Stair: Black Life and the "Messenger", 1917–1928* (1975).

Marable, Manning. "A. Philip Randolph, An Assessment," in *From the Grassroots* (1980).

Pfeffer, Paula. *A. Philip Randolph: Pioneer of the Civil Rights Movement* (1990).

Obituary: New York Times, 17 May 1979.

WILLIAM J. COBB

RANDOLPH, Amanda

(2 Sept. 1902–24 Aug. 1967), actress, singer, and comedian, was born in Louisville, Kentucky. Many sources confuse Amanda Randolph with her sister Lillian Randolph, also an entertainer but ten years her junior. In radio and onstage they stood in for each other, which makes a precise accounting of her career as a performer nearly impossible.

Randolph's father was a Methodist minister and the family moved frequently. After his death in 1920, Randolph settled in New York and began a career as a performer in the NOBLE SISSLE and EUBIE BLAKE productions of *Shuffle Along* (1921) and *The Chocolate Dandies* (1924). From 1925 to about 1927 Randolph performed at the Alhambra Theatre in New York City, in the All-Colored Musical Burlesque vaudeville review called *Lucky Sambo*. She then spent a year in London with the Harry Clifford Scott and Eddie Peter Whaley variety act. A talented, earthy-voiced singer, in 1932 she teamed with Catherine Handy as the Dixie Nightingales. That same year she appeared on a variety bill at New York's Capitol Theatre in a solo act as the character Venus Geetch.

As the Depression took its toll on the entertainment industry, Randolph left show business for a time and, with her husband, ran an after-hours eatery called The Clam Shop. Using the moniker Mandy Randolph, she made recordings of "In the Groove: Fox Trot" (1936), "Rainbow on the River: Fox Trot" (1936), "Cryin' Blues," (1936), and "I'm Gonna Jazz My Way Right Straight thru Paradise" (1937). Billed as Amanda Randolph and her Orchestra, she also made recordings for Bluebird Records.

Randolph's career includes numerous radio credits. She performed in an unknown number of episodes of the CBS radio programs, including *Young Dr. Malone* (1939–1960), *Big Sister* (1936–1941), *The Romance of Helen Trent* (1933–1960), and *Aunt Jenny's Real Life Stories* (1937–1956). Later she was cast in the part of Lily on the program *Abie's Irish Rose* (1942–1944); she was Ellen on the show *Kitty Foyle* (1946–1947); and on Ethel Barrymore's 1945 program *Miss Hattie*, Randolph reprised her role as the comic character, Venus Geetch. In 1937 she was heard singing the song "Tain't Right, Tain't Wrong" on LOUIS ARMSTRONG's radio show. She also performed with PAUL ROBESON and Eddie Green on the WABD program *All God's Chillun* (1940), and appeared in costume as the character Aunt Jemima on the audience-participation show *Lady Be Seated*. The CBS radio show *Aunt Jemima* ran from 1929 to 1945, and beginning in 1943, Randolph played the lead part at various times. She is perhaps best remembered for her performances on two particular radio programs: *Amos 'n Andy* (1926–1955), where she and her sister Lillian played the part of the character Sapphire Stevens; and *The Beulah Show. Beulah* ran from 1945 to 1954, and Amanda and her sister Lillian played the lead from 1950 to 1954.

During the 1940s Randolph appeared in Broadway stage plays. In 1940 she was cast as Cleota, "a comic servant girl," in the James Thurber comedy *The Male Animal*. In 1942 she was cast as the servant, Tinny, in the John Patrick play *The Willow and I*. Also in 1942, she appeared at the Ritz Theatre in the black-cast musical revue *Harlem Cavalcade*.

Randolph's extensive career in motion pictures includes appearances in full-length productions, soundies, and two-reelers, in both mainstream Hollywood films and race movies (black-cast films produced for black audiences). *Swing* (1938), *Lying Lips* (1939), and *The Notorious Elinor Lee* (1941) were produced by the pioneering filmmaker OSCAR MICHEAUX. In Hollywood pictures she was often uncredited or typecast as an unnamed household servant. Her credits included *At the Circus* (1939), *The Iron Mistress* (1952), *She's Working Her Way through College* (1952), *Bomba and the Jungle Girl* (1952), *Mister Scoutmaster* (1953), *A Man Called Peter* (1955), *Heller in Pink Tights* (1960), and *The Last Challenge* (1967). Of particular note, however, is her role as the character Gladys in the Twentieth Century–Fox production of *No Way Out* (1950). This film, which explored the Negro problem in America, is one of a cycle of Hollywood pictures released during the postwar era that portrayed the country's racial divide.

In 1948 Randolph began her long association with the new medium of television, appearing in the Dumont Network comedy *The Laytons* (1948). She also briefly had her own show, *Amanda* (1948); she was described in the *New York Times* as an "actress, singer, and genial back-fence philosopher." Randolph was the first African American woman to host her own daytime television show. Though *Amanda* lasted for only a few episodes, Randolph became associated with another show that remained on television for more than a decade, *Make Room for Daddy* (ABC from 1953 to 1957, and CBS from 1957 to 1964). Randolph appeared as the family housekeeper from 1955 to 1964.

Among other television appearances, Randolph earned the part of Grace on an episode of *Perry Mason*, appeared on the *Matinee Theatre* production of *The Serpent's Tooth* (1957) and on the police drama *The New Breed* (1961); she played Marian in the 1967 teleplay *Do Not Go Gentle into That Good Night*. Most notably, however, Randolph appeared on two of the most polarizing and contentious programs ever to air on television, *Amos 'n Andy* and *The Beulah Show*.

Amos 'n Andy, which originated on radio in 1926, featured the comic exploits of two black men: Andy, the dull-witted president of the Fresh Air Cab Company, and his friend and associate, the level-headed Amos. On radio, the lead roles were played by white actors who used so-called black vernacular and dialect. When the radio program transitioned to television, both Amanda Randolph and her sister Lillian, both of the radio cast, earned parts on the television show, with Amanda playing the role of character Mama. *Amos 'n Andy* was first broadcast on CBS television in June 1951 and lasted two years before the program was canceled in the midst of a firestorm of contention and debate. Postwar African Americans, bolstered by recent civil rights gains, looked to television as a medium that would be free of the old racial stereotypes promulgated on film and other forms of popular culture. Many considered the characters of *Amos 'n Andy* to be offensive.

Beulah was the black maid on the highly popular radio show, *Fibber McGee and Molly* (1945–1953). In early episodes, the part of Beulah was played by a white, male actor, Marlin Hurt. *The Beulah Show* (1945–1953), a spin-off of *Fibber McGee*, with Hattie McDaniel as Beulah, debuted in CBS radio 1945. A television sitcom was developed from the radio program, which debuted on ABC in 1950. Amanda Randolph followed ETHEL WATERS, Hattie McDaniel, and LOUISE BEAVERS as the fourth actress to play the part of Beulah. In its brief run the program was criticized for its inclusion of black "types." Actors in the male roles complained of being forced to act "Tomish," and the NAACP leveled complaints and threatened to begin a boycott of the show's sponsors. The show was canceled in 1953.

Multitalented and versatile, Amanda Randolph enjoyed a lengthy and successful career in show business as a performer, vaudevillian, singer, and radio, film, and television pioneer. She died of a stroke at Santa Teresita Hospital in Duarte, California, leaving behind her sister, Lillian; a son, Joseph; and a daughter, Evelyn.

FURTHER READING

Atkinson, Brooks. "The Play: James Thurber and Elliott Nugent's 'The Male Animal' Begins a New Theatre Year." *New York Times*, 10 Jan. 1940.

Ely, Melvin Patrick. *The Adventure of Amos 'n' Andy: A Social History of an American Phenomenon*, 2d ed. (2001).

MacDonald, J. Fred. *Blacks and White TV: Afro-Americans in Television since 1948* (1993).

Terrace, Vincent. *Radio Programs, 1924–1984: A Catalogue of Over 1800 Shows* (1999).

Obituaries: New York Times, 25 Aug. 1967; *Variety*, 30 Aug. 1967.

PAMALA S. DEANE

RAZAF, Andy

(15 Dec. 1895–3 Feb. 1973), song lyricist, was born Andreamentania Paul Razafkeriefo in Washington, D.C., the son of Henry Razafkeriefo, a military officer and nephew of the queen of Madagascar, and Jennie Maria Waller. His grandfather was John Louis Waller, a U.S. consul to Madagascar whose arrest in Tamatave and subsequent imprisonment in Marseilles, France, touched off an 1895 upheaval in Madagascar that resulted in his father's death there and his mother's flight home to the United States, where she gave birth. From the spring of 1896, when John Waller returned from prison, the young Razafkeriefo followed in the trail of his grandfather's ultimately unsuccessful political and entrepreneurial activities in Baltimore, Kansas City, Cuba (for two years), Manhattan (from 1900), and Yonkers (from 1905). By 1911—after his grandfather's

death in 1907 and his mother's short-lived second marriage, which brought the family to Passaic, New Jersey—he and his mother had settled in Manhattan.

Razafkeriefo dropped out of high school at the age of sixteen to work as an elevator operator, a telephone operator, a butler, a cleaner, and a custodian while endeavoring to break into the world of popular song. He had a few insignificant successes, and early on, in 1913, someone made the pragmatic suggestion that he shorten his name to Andrea Razaf. This in turn became Andy Razaf, although he did not adopt that name systematically until the mid-1920s.

Razaf married Annabelle Miller in 1915, but he was an incorrigible womanizer, and the relationship never blossomed; the couple had no children. Following World War I he developed a reputation in the African American press as a poet protesting racism, and he wrote poetry for many years. Temporarily abandoning his lyric-writing ambition, Razaf pitched in Cleveland's semiprofessional baseball league while working as a porter there in 1920, only to move back to New York City the following year with the prospect of participating in the new craze for blues and jazz. There he met FATS WALLER (no relation to John Waller). Razaf's biographer Barry Singer argues that Razaf wrote lyrics to Waller's tune "Squeeze Me" in 1923 or 1925, and that somehow Clarence Williams appropriated Razaf's credit, such appropriations being commonplace in American popular song at that time. If true, then "Squeeze Me" is by far the most important product of Razaf's first dozen years of professional songwriting.

In 1924 Razaf initiated a modest complementary career, singing on radio broadcasts under Williams's direction and, as "Anthony," forming a song-and-dance duo with Doc Straine at the Club Alabam, where FLETCHER HENDERSON's big band was based. Razaf contributed to and toured with the revue *Desires* from October 1926 through early 1927, wrote with Waller late in 1927 for the Broadway revue *Keep Shufflin'*, and collaborated with the songwriter J. C. Johnson for the revue *Brown Skin Models*, with which he toured in 1928. Having achieved modest hits with lyrics to Johnson's songs "My Special Friend," "When," and "Louisiana" (1926–1928), Razaf wrote both words and melody for the delightfully clever, humorous, and risqué song "My Handy Man" (1928).

Razaf's greatest work began in February 1929 in collaboration with Waller and songwriter Harvey Brooks (whose precise contribution is unknown) for the show *Hot Feet*, which was modified and renamed *Connie's Hot Chocolates* in June. The show ran at both Connie's Inn in Harlem and at the Hudson Theater downtown. "Ain't Misbehavin'" displays Razaf's characteristic talent for expressing an innocently suggestive outlook. By contrast, "(What Did I Do to Be So) Black and Blue?" presented separately by the singers EDITH WILSON and LOUIS ARMSTRONG in different portions of the show, is unusual and was the first significant African American protest in American popular song.

Later that same year Razaf wrote "S'posin'" with another regular collaborator, the English-born songwriter Paul Denniker; "Gee, Baby, Ain't I Good to You?" with DON REDMAN; and "Honeysuckle Rose" with Waller, this last for a new revue at Connie's Inn, *Load of Coal*. In 1930 Razaf wrote "A Porter's Love Song to a Chambermaid" with James P. Johnson for the *Kitchen Mechanic's Revue* at Smalls' Paradise in Harlem, and "Memories of You" and "My Handy Man Ain't Handy No More" with EUBIE BLAKE for Lew Leslie's *Blackbirds of 1930*. *Blackbirds* starred MINTO CATO, with whom Razaf was living, although he was still married to Annabelle. "Keepin' Out of Mischief Now," written with Waller, was a hit in 1932. From that year into the 1940s Razaf wrote for new musical comedies at Connie's Inn (which closed in 1933), at the Grand Terrace in Chicago, at the Cotton Club in Cleveland, and at the Ubangi Club (on the site of Connie's Inn), but the content of these shows grew excessively predictable and their success diminished accordingly. Nonetheless, Razaf wrote lyrics for "Christopher Columbus," "Big Chief de Sota" (two marvelously silly songs), and "Stompin' at the Savoy," all from 1936, and "The Joint Is Jumpin'" (1937). Despite all this he was in continuous financial difficulty, as unscrupulous managers, producers, and publishers, both white and African American, took advantage of him, denying him opportunities and appropriating portions of his composing royalties. No doubt racist structures contributed to this situation, particularly in his exclusion from a new and lucrative forum for lyricists, Hollywood movie musicals; however, Razaf himself exacerbated the situation time and again by shortsightedly bartering away future royalties for modest fixed fees.

Finally divorced, he married Jean Blackwell in 1939, and they settled in Englewood, New Jersey. Amid his continuing financial problems and extramarital affairs during the 1940s, and in the absence of new professional success, the relationship ended. On obtaining a second divorce he married Dorothy Carpenter in 1948 and moved to Los Angeles. Neither marriage produced children. Despite all of his naive dealings Razaf still received enough royalties as a member of ASCAP (American Society of Publishers, Authors, and Composers) to survive. In 1951 a spinal attack of tertiary syphilis made him a paraplegic. Dorothy supervised his care until, at decade's end, her infidelity led to his third divorce. In January 1963 he was reunited with Alice Wilson, whom he had renamed Alicia when at age fourteen she met him in Chicago in 1934. They married the next month, and she cared for him in his final years. He died in North Hollywood, California.

In the decade 1928–1937 Razaf was one of the most important lyricists in American popular song. His ability to create at a moment's notice a polished verse, perfectly matched to a given melody, was legendary. And however brilliantly spontaneous his method may have been, the results epitomize popular song of the swing era, in which sentiments of joy, nostalgia, politeness, and yearning toy with sensuality.

FURTHER READING

Brackney, R. L. "The Musical Legacy of Andy Razaf," *Jazz Report* 8, no. 5 (1974).

Singer, Barry. *Black and Blue: The Life and Lyrics of Andy Razaf* (1992).

Obituaries: New York Times and *Los Angeles Times*, 4 Feb. 1973.

BARRY KERNFELD

RECTOR, Eddie

(25 Dec. late 1890s–1962), dancer, was born in Orange, New Jersey, and moved to Philadelphia about age seven. His parents' names are unknown. He never studied dance but began performing while still a child, performing behind Mayme Remington, a former French burlesque dancer turned headliner, as one of her "picks" or "pickaninnies," a racial caricature of black children Common in vaudeville and popular culture.

Rector first acquired a reputation in the stage show *The Darktown Follies* (1915). Though he joined as a chorus boy, he devised his own act in which he did a military-style tap routine—soon imitated by many others—which the producers promptly incorporated into the show. After the show closed, Rector remained in New York City, partnering with another chorus boy from *The Darktown Follies* named Toots Davis. For the remainder of the 1910s and into the 1920s Rector was one of the best of the tap-dance acts in the revues that traveled on the TOBA circuit—a circuit that was for black performers approximately what vaudeville houses were for whites, providing work for a number of black entertainers before dying out during the Depression. Though the acronym "TOBA" stood for Theatre Owners' Booking Association, performers preferred "Tough on Black Asses" because of the pitiful pay scale. A typical TOBA show started rehearsing in April, spent all summer on the road, and returned to New York City in the fall. When in New York City, Rector liked to hang out at the Hoofer's Club, next door to the Lafayette Theatre.

When he was finally able to give up the TOBA circuit, Rector appeared in such shows as *Liza* (1922) and *Dixie to Broadway* (1924). He sometimes performed with his wife Grace or his brother Harry. In 1928 Rector replaced BILL ROBINSON in Lew Leslie's *Blackbirds of 1928* when that show went on tour. By then a Broadway star, Robinson had refused to travel with the show because of the low pay. Leslie asked Rector to copy Robinson's signature stair dance, provoking a short-lived feud between the two dancers when Rector acquiesced.

The tap dancing of just a few years earlier had been done in two-to-a-bar time in a straight-up, flashy style known as buck-and-wing dancing. Rector was one of those who smoothed out this style, adding more complex rhythms and steps even as he made the dancing seem more effortless. He used the entire stage while performing, gliding across it as if he were on skates. He invented several varieties of traveling time steps for that purpose, the most famous of which was the Bambalina. He "helped perfect a new style of tap dancing (perhaps derived from the white minstrel star George Primrose) in which he traveled across the stage with superb grace and elegance, a style that transcended the stereotypes of the strutting or shuffling 'darky' and culminated in the suave 'class acts' of the 1930s and later" (Stearns and Stearns, 127). Rector was

a profound influence on many younger dancers, including Buddy Bradley, Pete Nugent, and Steve Condos.

Rector's signature step was the sand dance, which he claimed to have originated. A sand dancer does not use tap shoes but instead disperses sand on the floor and produces the rhythmical effect from rubbing and sliding the sand around with his feet. Rector also claimed to have originated the practice of tap dancing on a drum while performing with DUKE ELLINGTON at the Cotton Club in Harlem.

Unfortunately, Rector never appeared in a good enough musical to make him a real star and was fated to appear in mediocre shows like *Hot Rhythm* (1930). The last big show in which he appeared during his prime was the flop *Yeah Man* (1932), which closed after four performances. Soon thereafter, for circumstances that remain unclear, Rector was confined to a mental institution for several years. After his recovery and release he teamed up with Ralph Cooper in the late 1940s and early 1950s. Though he had lost much of his fire as a performer, Rector stole the show doing the sand dance in a brief attempt to revive the musical *Shuffle Along* in 1952. In October 1954 he performed in an evening of "nostalgia" at the soon-to-be-closed Savoy Ballroom. By 1960 Rector was working as a night watchman at a theater. Though saddled with calluses, fallen arches, and a frail-looking body, he was still looking for a break in the dance world. He died in New York City.

Eddie Rector was one of the greatest of the soft-shoe artists and a key figure in the transformation of tap dancing from its early buck-and-wing style into a graceful and elegant stagecraft.

FURTHER READING

Frank, Rusty E. *Tap! The Greatest Tap Dance Stars and Their Stories, 1900–1955* (1990).
Stearns, Marshall, and Jean Stearns. *Jazz Dance: The Story of American Vernacular Dance* (1968; rpt. 1994).

ROBERT P. CREASE

REDDING, J. Saunders

(13 Oct. 1906–2 Mar. 1988), African American educator, historian, and literary critic, was born Jay Saunders Redding in Wilmington, Delaware, the son of Lewis Alfred Redding, a schoolteacher, and Mary Ann Holmes. As graduates of Howard University, Redding's parents maintained a modest middle-class environment for their children; his father was secretary of the local Wilmington branch of the NAACP. Redding graduated from high school in 1923 and entered Lincoln University in Pennsylvania that year, with no discernible career ambitions. In 1924 he transferred to Brown University, where he received his bachelor's degree in 1928.

After graduation Redding became an instructor at Morehouse College in Atlanta, where in 1929 he married Esther Elizabeth James. The Reddings had two children. Redding felt that his liberal political beliefs, which his conservative colleagues believed were "too radical," were a major factor in the Morehouse College administration's decision to fire him in 1931. Redding returned to Brown University for graduate study and received a master's degree in 1932. He then went to Columbia University as a graduate fellow for two years, and he was an adjunct English instructor at Louisville Municipal College in Louisville, Kentucky, in 1934. From 1936 to 1938 Redding taught English at Southern University in Baton Rouge and then joined the faculty at Elizabeth City State Teachers' College in North Carolina, where he remained from 1938 until 1943 as chairman of the English department. During this period, Redding completed his first book, *To Make a Poet Black* (1939), one of the earliest works of literary criticism on African American literature.

The publication of *To Make a Poet Black* enabled him in 1939 to earn a fellowship that was funded by the Rockefeller Foundation. Redding used this fellowship to travel throughout the American South to prepare his partly autobiographical work, *No Day of Triumph*, written in 1942. *No Day of Triumph* chronicled the daily lives and aspirations of working-class African American southerners and became a critical success. In this book Redding observed that his life affirmed the importance of integrity, courage, freedom, and hope that African Americans traditionally cherished. In *No Day of Triumph* he wrote that "I set out in nearly hopeless desperation to find out, both as a Negro and as an American, certain values and validities that would hold for me as a man . . . to find among my people those validities that proclaimed them and me as men . . . the highest common denominator of mankind."

Redding joined the faculty at Hampton Institute in Hampton, Virginia, as a professor of English and creative writing in 1943; that same year he received a Guggenheim Fellowship. The National Urban League honored Redding in 1945 for outstanding

achievement. Moreover, during that same year Redding became the first African American to hold a full professorship at Brown University when the university invited him to be a visiting professor of English. In 1950 Redding published his only novel, *Stranger and Alone*, which reflected his experiences as a professor in historic all-black colleges.

Redding remained best known for his monographs that document African American contributions to American history, such as *They Came in Chains: Americans from Africa* (1950), *The Lonesome Road: The Story of the Negro's Part in America* (1958), and *The Negro* (1967). These books utilized biographical vignettes and primary sources to document African American history and investigate the historical context of American race relations. Redding's fifth book, *On Being Negro in America* (1951), examined psychological dilemmas of racism in American society, while his 1954 work, *An American in India*, described his observations on Indian nationalism and anti-imperialism during a U.S. State Department–sponsored trip. In 1959 Redding received another Guggenheim Fellowship, which allowed him to continue his lecture tours. During a six-month West African lecture tour in 1963, Redding became a close friend of the Nigerian writer Wole Soyinka, who went on to receive a Nobel Prize in Literature in 1986.

In 1964 Redding became a fellow in humanities at Duke University. The following year Redding returned to Hampton Institute, and in 1966 he was the director of research and publication at the National Endowment for the Humanities in Washington, D.C. By 1969 Redding had assumed a professorship in American history and civilization at George Washington University while remaining a special consultant for the National Endowment for the Humanities. With Arthur P. Davis, he edited *Cavalcade*, an anthology of African American literature, from 1960 to 1970 at Howard University. In 1970 Redding received the Ernest I. White Professorship of American Studies and Humane Letters at Cornell University. A program of fellowships for students of color at Cornell University was established in his honor in 1986. When he retired in 1975 from Cornell University, Redding continued his writing and scholarly activities.

As a liberal Democrat, Redding worked with other progressive African American intellectuals to discuss solutions for confronting racism in American society. During the 1970s he became a member of the Haverford Group, an informal gathering of notable African American scholars who met to investigate methods to dissuade American youth from racial separatism. This group consisted of the psychologist Kenneth B. Clark, the historian John Hope Franklin, former secretary of Housing and Urban Development Robert Weaver, and federal judge William Hastie. Along with fellow colleagues of the Haverford Group, Redding worked with the Joint Center for Political Studies to devise political strategies for interracial cooperation.

After Redding's death at his home in Ithaca, New York, the 4 March 1988 obituary in the *Ithaca Journal* described him as the dean of African American scholars whose works influenced younger African American intellectuals, such as Henry Louis Gates, literary critic and director of Harvard University's African American Studies. The *New York Times* 5 March 1988 notice of Redding's death recalled that he was regarded as the first African American to teach at an Ivy League institution. And in an obituary in the 10 March 1988 edition of the *Cornell Chronicle*, Cornell University president Frank H. T. Rhodes commented, "J. Saunders Redding represented the essence of human dignity who often stood alone between the two worlds of white and black, contributing to an understanding of the human condition that transcends race and culture."

FURTHER READING
Redding's personal manuscripts are in the John Hay Library at Brown University.
Redding, J. Saunders. *Troubled in the Mind* (1991).
Berry, Faith, ed. *A Scholar's Conscience: Selected Writings of J. Saunders Redding, 1942–1977* (1992).
Davis, Arthur P., ed. *From the Dark Tower: Afro-American Writers, 1900 to 1960* (1974).
Emanuel, James, and Theodore Gross, eds. *Dark Symphony: Negro Literature in America* (1968).
Wagner, Jean. *Black Poets of the United States: From Paul Laurence Dunbar to Langston Hughes* (1973).

KIMBERLY WELCH

REDMAN, Don

(29 July 1900–30 Nov. 1964), composer, arranger, and alto saxophonist, was born Donald Matthew Redman in Piedmont, West Virginia, to parents whose names are unknown. What is known, however, is that Redman came from a musical family and was a child prodigy. He learned to play several instruments as a youngster, and he wrote

arrangements for a visiting road band while still in his teens; he even backed up the group with his own band on occasion.

Redman graduated from Storer College in Harpers Ferry, West Virginia, at age twenty with a music degree. He worked professionally for about a year around Piedmont, then joined Billy Paige's Broadway Syncopators in Pittsburgh; he played clarinet and saxophones and wrote arrangements for the popular group. The Syncopators were invited to play in New York City in 1923, but the band broke up soon after its arrival. Redman himself, though, got a call for a recording date, and at the session he met FLETCHER HENDERSON, who led the pick-up group hired to back up the singer FLORENCE MILLS. Henderson immediately recognized Redman's talent and hired him for several more sessions, eventually asking him to join his own new orchestra. Over the next several years Redman played saxes, clarinet, and other instruments with the Henderson group, but his biggest influence lay in his revolutionary approach to arranging.

At first the Henderson band's tunes consisted mostly of unimaginative stock arrangements. Gradually, Redman completely rewrote the group's book. His August 1923 arrangement of "Dicty Blues" shows that he had already begun to employ improvised ensembles and a variety of section combinations; he separated reeds and brass, pitting the sections against each other. One would play the melodic lead, for instance, and the other would answer during pauses or punctuate the playing with brief, rhythmic figures. The band's recording of "Copenhagen" at the end of 1924 marked a significant step forward in this style, as the music moved from one section or soloist to another twenty-four times in three minutes.

Redman was undoubtedly influenced, in part at least, by the brief presence of LOUIS ARMSTRONG in the band. Armstrong was still close to the New Orleans collective style of improvisation and thus served as a bridge between it and "the newer solo-and-section style" that Redman pioneered. "Copenhagen" also employed unusual instrumental combinations, contrasting, for instance, brass with clarinet trios. By the end of 1926 Redman had also moved beyond the rhythmic stiffness that characterized even such an advanced piece as "Copenhagen," and in compositions like "Stampede," recorded in May of that year, he was writing fuller, better integrated section passages and eliciting a powerful emotional

expressiveness and a richer, full-bodied sound from the band.

Redman left Henderson in March 1927 to become music director of McKinney's Cotton Pickers, a rather nondescript group that he elevated to the level of competent jazz playing. He toured and recorded extensively with the band, which became popular enough to pack Sebastian's Cotton Club in Hollywood nightly during a seven-week engagement in 1930. During this time he also played with Louis Armstrong in Chicago and with Carroll Dickerson's band, and he recorded with Armstrong (1928) and COLEMAN HAWKINS (1929).

In 1931 Redman left McKinney to form his own group; that same year he composed and recorded what some regard as his greatest composition, "Chant of the Weed," with its unusual, almost atonal harmonies. Don Redman and His Orchestra broadcast regularly over the radio and recorded often during the early 1930s for Brunswick Victor and other labels. Redman also used two vocalists—Harlan Lattimore and Chick Bullock—and employed the tap dancing and singing OF BILL ROBINSON with particular effectiveness on a piece called "Doin' the New Low Down." However, the band was not particularly successful in musical terms, and Redman gradually decreased his activity.

Redman had two recording dates in 1934, followed by two and a half years of silence. By the time his orchestra reemerged, Benny Goodman and COUNT BASIE had forever changed the parameters of big band swing. Redman's group performed and recorded sporadically during the late 1930s, disbanding permanently in 1940. He did take Jay Mcshann's band out under his own name a couple of times in 1942 and led another group at the Club Zanzibar on Broadway in New York City.

During the 1940s Redman composed and wrote arrangements for radio and other big bands. He opened an office on Broadway and produced arrangements for bandleaders like Fred Waring, Paul Whiteman, Harry James, Jimmy Dorsey, JIMMIE LUNCEFORD, and Basie. In 1946 he toured Europe with a group that included Tyree Glenn, DON BYAS, and the young pianist Billy Taylor.

In 1951 Redman became musical director for the singer Pearl Bailey, a job he held for over a decade. He made a few disappointing jazz recordings at the end of the decade, including an unsuccessful reunion with Coleman Hawkins. In the early 1960s he did freelance work for CBS and for

transcription and record companies while continuing his position with Bailey. He played little during his last years, writing several extended works that have never been publicly performed. Redman had one daughter with his wife, Gladys Henderson. He died in New York City.

Redman was the first master of jazz orchestration. He came up with the idea of dividing jazz bands into sections, and among later bandleaders only Basie and DUKE ELLINGTON surpassed his innovations. A gentle, kindly man whom musicians truly loved, Redman was cursed by an erratic career and self-defeating professional moves. But as unpredictable as his life was, and as uneven as even the greatest of his arrangements could be, he stands alone as the forerunner of modern jazz arranging.

FURTHER READING

Schuller, Gunther. *Early Jazz: Its Roots and Musical Development* (1968).

Schuller, Gunther. *The Swing Era: The Development of Jazz, 1930–1945* (1989).

Tirro, Frank. *Jazz: A History* (1993).

Obituary: New York Times, 2 Dec. 1964.

DISCOGRAPHY

Harrison, Max. *The Essential Jazz Records*, vol. 1: *Ragtime to Swing* (1984).

Allen, W. C. *Hendersonia: The Music of Fletcher Henderson and His Musicians, a Bio-Discography* (1973).

RONALD P. DUFOUR

RICHARDSON, Willis

(5 Nov. 1889–17 Nov. 1977), playwright, was born in Wilmington, North Carolina, the only child of Willis Wilder, a laborer, and Agnes Ann Harper. In 1898, when Richardson was nine years old, a white mob burned down the newspaper offices of a Wilmington newspaperman named Alexander Manly and precipitated a coup d'état in North Carolina's largest city, which resulted in the deaths of at least sixteen blacks. Many African Americans left Wilmington in the months that followed, among them Richardson and his family, who moved to Washington, D.C., because of the riots and the threats made on his father's life. Richardson would live in Washington until his death in 1977.

After completing elementary school, Richardson attended the M Street School (later Dunbar High

School) from 1906 until 1910. At the school, Richardson had contact with people who would later be important in his development as a dramatist. CARTER G. WOODSON, founder of *Negro History Week* and a history teacher at the school from 1909 to 1918, later hired Richardson to edit two anthologies of African American plays. Mary P. Burrill, an English teacher and playwright, encouraged Richardson in his writing and was instrumental in having Richardson's first play read and evaluated by ALAIN LOCKE. Another M Street English teacher, ANGELINA WELD GRIMKÉ, whose own play, *Rachel*, would give Richardson the initial impetus for his career as a dramatist, reviewed Richardson's poems before he began writing plays.

In 1911, unable to afford college tuition, Richardson began working as a "skilled helper" in the wetting division of the Bureau of Engraving and Printing. In 1912 he met Mary Ellen Jones. After the couple married in 1914, Richardson converted to Roman Catholicism, his bride's religion, and by 1921 they had three daughters.

First drawn to writing poetry, Richardson enrolled in a correspondence course, entitled Poetry and Versification, in 1915. In March of 1916, however, after seeing Grimké's play *Rachel* (1916), he switched his focus from poetry to drama. Grimké and other African American playwrights of that decade and the next used racial conflict as the theme of their plays. Richardson soon developed strong opinions about African American drama, and in the fall of 1919, three years after seeing *Rachel*, Richardson's essay "The Hope of a Negro Drama," his first of six essays on the theater, was published in *Crisis* magazine. In the essay Richardson criticized plays written by African Americans, citing *Rachel* as an example, for "showing the manner in which Negroes are treated by white people in the United States." Richardson advocated that African American playwrights should focus on problems within the black community, not on racial tensions. In this manner, Richardson's plays differed from most of the nearly 400 plays written by African Americans by 1930 (many of which were never produced).

Through his publications with *Crisis*, Richardson met W. E. B. DU BOIS who, in December 1920, arranged for publication of Richardson's first play for children, *The King's Dilemma*, in *The Brownies' Book*, a magazine for African American children that Du Bois had helped found. Over the next year Richardson wrote three more one-act children's

plays for the publication: *The Gypsy's Finger-Ring* (March 1921), *The Children's Treasure* (June 1921), and *The Dragon's Tooth* (Oct. 1921). *The Deacon's Awakening*, his first play for general audiences, was published in *Crisis* in November 1920 and first produced on in January 1921 at a union hall in St. Paul, Minnesota.

Edward Christopher Williams was another early champion of Richardson's work. In 1916, Williams, then a librarian at Howard University, read Richardson's play *The Idle Head* and declared it "the best play he had seen written by a member of our race." After reading several of Richardson's other plays, Williams suggested that the playwright show his work to his former M Street teacher Mary Burrill, who arranged a reading of the play by the Howard University Players for Alain Locke and Montgomery Gregory.

Because of the scarcity of African American plays, Locke and Gregory were enthusiastic about Richardson's submission. In a December 1922 letter, Gregory wrote to Richardson: "The sun is just beginning to shine on Negro art and I am encouraged to believe that this year will see even finer things." Aside from student productions, *Mortgaged* was the first play written by an African American to be staged at the university. Over the next several years, Richardson's plays *The House of Sham, Compromise*, and *The Chip Woman's Fortune* were also produced at Howard University.

Du Bois arranged for *The Chip Woman's Fortune* to be produced by the Ethiopian Art Theater, a theater group in Chicago. The play opened in Chicago in January 1923 and began a two-week run at the Howard Theater in April of the same year. In May 1923, the Frazee Theater in New York presented it on a triple bill with Shakespeare's *The Comedy of Errors* and Oscar Wilde's *Salome*. This would be the first time an African American play would be produced on Broadway.

In 1925, Richardson won first place for *The Broken Banjo* in the Krigwa Literary Contest, which was sponsored by *Crisis*. Eugene O'Neill, a judge of the drama entries, remarked that he was "glad the judges all agree on *The Broken Banjo*" and that "Richardson should certainly continue working in his field" (O'Neill, 17–18). The following year Richardson was awarded first place for his play *The Bootblack Lover*.

During the 1920s, through his contacts at Howard University, Richardson began joining other artists and writers at the "Saturday Nighters," an informal group that met at the home of Washington, D.C., poet and playwright GEORGIA DOUGLAS JOHNSON. Richardson was involved with the group from its formation in 1926 until it disbanded ten years later.

After the appearance of several of his plays and essays in the magazines *Crisis, Opportunity*, and *The Messenger* and through his involvement with the drama department at Howard University, African American schools and little-theater groups throughout the country sought his one-act plays. For example, in 1925, the Gilpin Players, a black little-theater group in Cleveland, produced Richardson's play *Compromise*, the group's first production by an African American playwright. Rowena Jelliffe, the group's founder, remarked in an interview shortly before her death in 1992 that "Richardson's play was the first bright spot on the Karamu stage" (Interview with the author, 1 Feb. 1992). Among the most popular of his plays were *Compromise, Mortgaged*, and *The Broken Banjo*. In addition, Locke included *Flight of the Natives* in his anthology *Plays of Negro Life* (1927).

In 1929 Carter G. Woodson contacted Richardson about gathering African American plays and preparing them for two anthologies. Published in 1930, *Plays and Pageants from the Life of the Negro*, the first collection of plays by African Americans, included Richardson's introduction and four of his plays. In response to requests for materials on African American history, *Negro History in Thirteen Plays* (1935), the second collection, included five plays by Richardson. Both anthologies were published by Associated Publishers, an African American publishing firm in Washington, D.C., for which Woodson was editor.

On retiring from the Bureau in 1954, Richardson again attempted to get his work before the public. He compiled and published the children's plays he had written over thirty years earlier for *The Brownies' Book* and added new plays. Published in 1955 by Associated Publishers, the collection was titled *The King's Dilemma*.

Near the end of his life, Richardson began falling down frequently and at times was unable to stand; he was diagnosed with Padgett's disease, a progressive deterioration of the bone. He died on 7 November 1977. Two weeks after his death, Richardson was recognized as an Outstanding Pioneer in black theater by AUDELCO, the Audience Development

Committee, a New York City organization promoting black theater.

FURTHER READING

Gray, Christine Rauchfuss. *Willis Richardson: Forgotten Pioneer of African-American Drama* (1999).

O'Neill, Eugene. Letter in "Comments on the Negro Actor." *The Messenger* 7 (1925).

Sanders, Leslie Catherine. *The Development of Black Theater in America: From Shadows to Selves* (1988).

CHRISTINE RAUCHFUSS GRAY

ROBESON, Paul

(9 Apr. 1898–23 Jan. 1976), actor, singer, and civil rights activist, was born Paul Leroy Robeson in Princeton, New Jersey, the son of William Drew Robeson, a Protestant minister, and Maria Louisa Bustill, a schoolteacher. Robeson's mother died when he was six years old, and he grew up under the influence of a perfectionist father, a former runaway slave who fought in the Union army. During his senior year at the Somerville, New Jersey, high school, he achieved the highest score in a statewide scholarship examination to attend Rutgers College (later Rutgers University). The lone black at Rutgers as a freshman in 1915 and only the third African American to attend the institution, Robeson was an outstanding student and athlete. A varsity debater, he won class prizes for oratory all four years, was elected to Phi Beta Kappa as a junior, was one of four seniors chosen for membership in the Cap and Skull honorary society, and was named class valedictorian. The six-foot three-inch, 215-pound Robeson earned twelve varsity letters in four sports (baseball, basketball, football, and track) and was twice named football All-America (1917 and 1918). According to the former Yale coach Walter Camp, "There never has been a more serviceable end, both in attack and defense, than Robeson." Despite his popularity with fellow students, a series of social slights and racial incidents in football brought to the fore long-standing concerns about race. Robeson's senior thesis predicted the eventual use of the Fourteenth Amendment to advance civil rights, and his commencement address boldly combined the accommodationist philosophy of BOOKER T. WASHINGTON with the more militant views of W. E. B. DU BOIS.

Robeson received the BA degree in 1919 and moved to Harlem preparatory to entering the

Paul Robeson as Othello, Theatre Guild Production, Broadway, 1943–1944. (Library of Congress/Farm Security Administration—Office of War Information Photograph Collection.)

Columbia University Law School in 1920. He helped finance his legal education by playing professional football for three seasons (1920–1922) with the Akron Pros and the Milwaukee Badgers. In 1921 he married Eslanda "Essie" Cardozo Goode (Eslanda Cardozo Goode Robeson) a member of a prominent Washington, D.C., black family, who worked as a laboratory pathologist at Columbia's medical school; they had one child. Recognizing Robeson's lack of enthusiasm for the law and football, his wife urged him to take up acting. After playing the lead in a Harlem YMCA production of *Simon the Cyrenian* in 1920, he appeared in several other local productions and became acquainted with the Provincetown Players, a Greenwich Village theatrical group that included Eugene O'Neill. He debuted professionally in a short-run Broadway play, *Taboo*, in 1922. Robeson, meanwhile, finished his legal studies, received the LLB degree in February 1923, and joined a New York City law firm headed by a Rutgers

alumnus. But discouraged by discrimination within the firm and the legal profession generally, he quit a few months later, before taking the bar exam, to pursue an acting career.

Robeson launched his stage career in 1924 in the lead roles in two O'Neill plays, *The Emperor Jones* and *All God's Chillun Got Wings*, the latter a daring drama about interracial marriage. He achieved a spectacular triumph in London in 1930 when he not only became one of the first black actors to play Othello but also rendered the finest portrayal of the character yet seen. Robeson was also an accomplished singer, and at his wife's urging he performed at Carnegie Hall in 1925. The first soloist to devote an entire concert to Negro spirituals, Robeson both enthralled the sold-out audience and boosted the popularity of the musical genre. Robeson steadfastly refused to sing operatic and classical music, preferring to emphasize Negro spirituals and international folk songs. In time his rich basso-baritone voice was familiar to millions through national and international concert tours, radio performances, and more than three hundred recordings. He combined singing and acting in several musicals and was best known for his rendition of "Ol' Man River" in *Show Boat* (London, 1928; New York, 1932; Los Angeles, 1940). Robeson also appeared in eleven motion pictures, including film versions of *The Emperor Jones* (1933) and *Show Boat* (1936) and Hollywood extravaganzas such as *King Solomon's Mines* (1937). Robeson chafed at the stereotyping and racial slights suffered by blacks in the movie industry and demanded positive leading roles; he was most proud of his work in *Song of Freedom* (1936) and *The Proud Valley* (1940). Robeson's legacy, as actor-director Sidney Poitier noted, was profound: "Before him, no black man or woman had been portrayed in American movies as anything but a racist stereotype" (quoted in *Current Biography* [1976], 345–46).

Robeson's political ideas took shape after George Bernard Shaw introduced him to socialism in 1928. To escape American racism, he lived during most of the 1930s in Europe, returning to the United States only for movie and concert appearances. Impressed by the absence of racial and class discrimination in the Soviet Union during a concert tour in 1934, Robeson subsequently spent extended periods in Moscow, learned Russian, and enrolled his son in Soviet schools. He became politically active in opposing fascism, imperialism, and racism. He gave benefit performances in England for refugees from fascist countries, associated with British left-wing political groups, became acquainted with key figures in the West African Political Union, including Jomo Kenyatta and Kwame Nkrumah, and in 1938 traveled to Spain to support the republican troops engaged in the civil war against Francisco Franco's fascists.

When forced by the outbreak of World War II to return to the United States in 1939, Robeson was as well known as a critic of American racism and champion of the Soviet Union as an entertainer. He protested the segregation of organized baseball, appeared frequently at union and labor meetings, delivered antiracist lectures during concerts, joined the Pan-Africanist Council on African Affairs, and quit Hollywood because "the industry is not prepared to permit me to portray the life or express the living interests, hopes, and aspirations of the struggling people from whom I come." Robeson's political activism drew criticism but did not hurt his career, primarily because of the U.S.-Soviet military alliance. Indeed, he enjoyed his greatest hour as a performer in October 1943 when he became the first black actor to play Othello in the United States. Following a then record-setting 296 performances for a Shakespearean drama on Broadway, the company undertook a nationwide tour and Robeson received the Donaldson Award as the best actor of the year. In 1945 the National Association for the Advancement of Colored People (NAACP) awarded him the prestigious Spingarn Medal.

However, when Robeson continued to use the Soviet Union as a hammer to pound against racism in the United States, he suffered the fate of other political leftists during the anticommunist hysteria of the cold war. In 1946 he denied under oath to a California state legislative committee that he was a member of the Communist Party but thereafter refused as a matter of conscience and constitutional right to comment on his political beliefs or affiliation. Instead, he continued to speak out against American racism and to praise the Soviet "experiment in socialism," associated openly with Marxist organizations, and, as a founder and chairman of the Progressive Party, campaigned for Henry Wallace in the 1948 presidential election. While addressing the World Peace Congress in Paris in 1949, he said, "It is unthinkable that American Negroes could go to war on behalf of those who have oppressed us for generations against a country

[the Soviet Union] which in one generation has raised our people to the full dignity of mankind." He was immediately denounced by the black and white press, repudiated by most black civil rights organizations, and attacked by government agencies and congressional committees. The U.S. House of Representatives Committee on Un-American Activities labeled him a "Communist" and a "Communist sympathizer" and enlisted Jackie Robinson, who in 1947 had integrated organized baseball, to "give the lie" to Robeson's statement. He was hounded by the Federal Bureau of Investigation, and in 1950 the State Department took away his passport, refusing to issue a new one until he signed a noncommunist oath and pledged not to give political speeches abroad. He refused, and his persistent use of the Fifth Amendment during House and Senate hearings and the Soviet Union's awarding him the International Stalin Peace Prize in 1952 only exacerbated the public's perception of him as a subversive. Outraged Rutgers alumni demanded that his name be excised from the school's athletic records and that the honorary master of arts degree awarded to him in 1930 be rescinded. He was blacklisted as an entertainer, and his recordings were removed from stores. His income fell from more than $100,000 in 1947 to $6,000 in 1952. Unable to travel abroad to earn money, Robeson was forced to sell his estate, The Beeches, in Enfield, Connecticut.

By the late 1950s the burgeoning civil rights movement along with the lessening of cold war paranoia and the demise of McCarthyism led to a rehabilitation of Robeson's reputation, particularly among African Americans. Critical was *Here I Stand* (1958), a brief autobiography as manifesto in which Robeson reaffirmed his admiration for the Soviet Union and in which he stated, "I am not and never have been involved in any international conspiracy." He also declared his "belief in the principles of scientific Socialism" as the basis for a society "economically, socially, culturally, and ethically superior to a system based upon production for private profit." Although essentially a recitation of the stands he had taken all along, as the first sentence of the foreword—"I am a Negro"—made clear, the book was primarily a declaration of allegiance to the black community. Here Robeson presaged the Black Power politics of the 1960s by rejecting gradualism in civil rights, insisting that "the Negro people's movement must be led by Negroes," and advocating change through the "mass action" of "aroused and militant" black masses. He performed several concerts, recorded an album, and after being reissued a passport in 1958 (following a Supreme Court decision in a related case that confirmed his contention that the right to travel was independent of political views), left for Europe to revitalize his career.

But fifteen years of persistent harassment and political attacks had taken its toll, destroying not only his career but also his health and, ultimately, his sanity. Despite a tumultuous welcome, his sojourn in the Soviet Union was bleak. He was frequently hospitalized for exhaustion and a circulatory ailment as well as emotional instability. He attempted suicide; excessive drug and electric shock therapy likely caused permanent brain damage. He returned to the United States in 1963 and went into seclusion. His wife's death in 1965 ended their long marriage of convenience. Robeson's numerous infidelities had led to several separations, but Essie Goode Robeson, who obtained a PhD in Anthropology and wrote *African Journey* (1945), resignedly managed his career in exchange for economic and social status. Robeson then moved to Philadelphia, Pennsylvania, where he lived with a sister. Virtually an invalid and suffering from acute depression, he refused interviews and was seen only by family and close friends. Too ill to attend the 75th Birthday Salute to Paul Robeson staged at Carnegie Hall in April 1973 by leaders in the entertainment and civil rights fields, he sent a recorded message: "I want you to know that I am still the same Paul, dedicated as ever to the worldwide cause of humanity for freedom, peace and brotherhood." Three years later he died in Philadelphia.

Paul Robeson is an American tragedy. He was an enormously talented black man whose imposing personality and uncompromising political ideals were more than a racist and anticommunist United States could appreciate or tolerate. One of the major performing artists of the twentieth century, his achievements as a stage actor, movie star, and singer are individually outstanding but collectively astounding. He was easily the most influential black entertainer of his day. Because he spent so much time abroad, Robeson never established close political associations in black America and thus served the African American community more as a symbol of black consciousness and pride than as a spokesperson. A victim of character assassination during the cold war, Robeson—unlike many black (and white) entertainers who maintained silence

to protect or advance their careers—courageously combined art and politics. If he was politically naive and oblivious to the realities of Stalinist Russia, he astutely connected American racism and the international oppression of colored peoples. And Robeson proved to be ahead of his time in rejecting both the black nationalism of separation and repatriation as well as the assimilationism of the NAACP in favor of a cultural pluralism in which ethnic integrity was maintained amid international solidarity. For all his achievements, Robeson's pro-Soviet stance continues to preclude just recognition. He remains the only two-time All-American not in the College Football Hall of Fame.

FURTHER READING

By far the largest and most important collection of manuscript materials pertaining to Paul Robeson's life and career is the Robeson Family Archives, featuring the writings of his wife, in the Moorland-Spingarn Research Center, Howard University, Washington, D.C.

Robeson, Paul. *Here I Stand* (1958).

Davis, Lenwood G., comp. *A Paul Robeson Research Guide: A Selected Annotated Bibliography* (1982).

Duberman, Martin Bauml. *Paul Robeson* (1988).

Foner, Philip S., ed. *Paul Robeson Speaks: Writings, Speeches, Interviews, 1918–1974* (1978).

Gilliam, Dorothy Butler. *Paul Robeson: All-American* (1976).

Robeson, Eslanda Cardozo. *Paul Robeson, Negro* (1930).

Robeson, Paul, Jr. *The Undiscovered Paul Robeson: An Artist's Journey, 1898–1939* (2001).

Seton, Marie. *Paul Robeson* (1958).

Obituaries: New York Times, 24 Jan. 1976; *New York Amsterdam News,* 31 Jan. 1976.

LARRY R. GERLACH

ROBINSON, Bill

(25 May 1878–25 Nov. 1949), tap dancer, known as "Bojangles," was born Luther Robinson in Richmond, Virginia, the son of Maxwell Robinson, a machinist, and Maria (maiden name unknown), a choir director. After both parents died in an accident around 1885, Luther and his brother William lived with their grandmother, Bedilia Robinson, a former slave who sought salvation through faith and disavowed dancing of any kind in her house. Too old and infirm to care for the boys, she entrusted them to a local judge, John Crutchfield.

Robinson appropriated his brother's name, calling himself Bill, and took to the streets to earn nickels and dimes by dancing and scat-singing. In Richmond he got the nickname "Bojangles," from "jangler," meaning contentious, and he invented the famous phrase "everything's copasetic," meaning everything's tip-top or first-rate. Robinson ran away to Washington, D.C., picking up odd jobs dancing in beer gardens around town. He got his first professional break in 1892 as a pickaninny in the chorus line of Whallen and Martel's *South before the War,* a touring show that featured Mayme Remington, a former French burlesque dancer who became a top headliner in the 1890s. Shortly after arriving in New York in 1900, Robinson challenged the *In Old Kentucky* star dancer Harry Swinton to a Friday night buck-and-wing dance contest and won. With a gold medal and the valuable publicity attendant on winning, he was quickly targeted as the man to challenge.

Robinson worked wherever and whenever he could, and with a variety of partners, including Theodore Miller, Lula Brown, and Johnny Juniper. Bound by the "two-colored" rule in vaudeville, which restricted blacks to performing in pairs, he teamed with George W. Cooper from 1902 to 1914. They played the classiest tours in white vaudeville, the Keith and Orpheum circuits, without the blackface makeup expected of African American performers at the time. They also toured London with great success. Robinson married Lena Chase in 1907, although touring and professional activities kept them apart and forced them to separate around 1915 and divorce in 1922.

Robinson was a staunch professional, adamant about punctuality and a perfectionist with his routines. He was also known to anger quickly, gamble, and carry a gold-plated revolver. After an assault charge in 1908 that split up his act with Cooper, Robinson decided to launch his solo career and became one of the few blacks to perform as a soloist on the Keith circuit. He was a headliner at New York's Palace Theatre, the undisputed crown jewel of vaudeville theaters. At one point in his career, he made $6,500 a week in vaudeville and was billed as the "World's Greatest Tap Dancer." Being billed as a champion dancer meant winning dance competitions of the toughest kind to stay on top. Contests were audited by a panel of judges who sat under the stage, in the wings, and in the house, judging the dancer on the tempo and execution of

steps. Robinson was challenged to dozens of contests and won, and according to tap dance lore competed against dancers such as James Barton, Will Mahoney, Jack Donahue, Fred Astaire, and Ray Bolger. Robinson's stair dance, first performed in 1918, was distinguished by its showmanship and sound, each step emitting a different pitch and rhythm. Onstage his open face, twinkling eyes, and infectious smile were irresistible, as was his tapping, which was delicate and clear. Buck or time steps were inserted with skating steps or crossover steps on the balls of the feet that looked like a jig, all while he chatted and joked with the audience. Robinson danced in split clog shoes, ordinary shoes with a wooden half-sole and raised wooden heel. The wooden sole was attached from the toe to the ball of the foot and left loose, which allowed for greater flexibility and tonality.

In 1922 Robinson married Fannie Clay, who became his business manager, secretary, and partner in efforts to fight the barriers of racial prejudice. He was a founding member of the Negro Actors Guild of America. Hailed as the "Dark Cloud of Joy" on the Orpheum circuit, Robinson performed in vaudeville from 1914 to 1927 without a single season's layoff. Yet Broadway fame did not come until he was fifty years old, with the all-black revue *Blackbirds of 1928*, in which he sang and danced "Doin' the New Low Down." Success was instantaneous, and he was saluted as the greatest of all dancers by at least seven New York newspapers. Broadway shows that followed included *Brown Buddies* (1930), *Blackbirds of 1933*, *All in Fun* (1940), and *Memphis Bound* (1945). The opening of *The Hot Mikado* (1939) marked Robinson's sixty-first birthday, and he celebrated by dancing down Broadway, from Sixty-first Street to the Broadhurst Theatre at Forty-fourth Street.

In the 1930s Robinson also performed in Hollywood films, a venue that had hitherto restricted African American performers. His first film, *Dixiana* (1930), had a predominantly white cast, but *Harlem Is Heaven* (1933) was one of the first all-black films ever made. Other films included *Hooray for Love* (1935), *In Old Kentucky* (1935), *The Big Broadcast of 1937* (1935), *One Mile from Heaven* (1937), *By an Old Southern River* (1941), and *Let's Shuffle* (1941). The well-known all-black film *Stormy Weather* (1943) featured Robinson, Lena Horne, CAB CALLOWAY, and Katherine Dunham and her dance troupe. Robinson and Shirley Temple teamed

up in *The Little Colonel* (1935), *The Littlest Rebel* (1935), *Just around the Corner* (1938), and *Rebecca of Sunnybrook Farm* (1938), in which he taught the child superstar to tap dance.

In 1936 Robinson opened the downtown Cotton Club in New York (south of the more famous uptown Harlem Cotton Club) and introduced a new dance, the Suzi-Q; he was later featured in several Cotton Club shows. Claiming to have taught tap dancing to Eleanor Powell, FLORENCE MILLS, FAYARD AND HAROLD NICHOLAS, and Astaire, Robinson profoundly influenced the next generation of dancers at the Hoofers Club in Harlem, where he also gambled and shot pool. Throughout his lifetime, he was a member of many clubs and civic organizations and an honorary member of police departments in cities across the United States. Robinson was named "Mayor of Harlem" in 1933. His participation in benefits is legendary, and it is estimated that he gave away well over $1 million in loans and charities. During his long career he never refused to play a benefit, regardless of race, creed, or color of those who were to profit by his performance. In 1943 he divorced Fannie Clay and married the young dancer Elaine Plaines.

"To his own people," Marshall Stearns wrote in *Jazz Dance*, "Robinson became a modern John Henry, who instead of driving steel, laid down iron taps." Although he was uneducated, Robinson was accepted in high places that were previously beyond the reach of most African Americans. He commanded the respect due to a gifted artist and became the most famous tap dancer of the twentieth century. Robinson's exacting yet light footwork was said to have brought tap "up on its toes" from an earlier flat-footed shuffling style. Although he invented few new steps, he presented those he used with technical ease and a sparkling personality, turning relatively simple tap dancing into an exciting art.

When Robinson died in New York City, newspapers claimed that almost one hundred thousand people witnessed the passing of the funeral procession, a testament to the esteem in which he was held by members of his community. The founding of the Copasetics, a fraternity of male tap dancers formed the year Robinson died, ensured that his excellence would not be forgotten.

FURTHER READING
Fletcher, Tom. *One Hundred Years of the Negro in Show Business* (1954).

Frank, Rusty. *Tap!: The Greatest Tap Dance Stars and Their Stories, 1900–1955* (1990).

Haskins, Jim, and N. R. Mitgang. *Mr. Bojangles: The Biography of Bill Robinson* (1999).

Stearns, Marshall, and Jean Stearns. *Jazz Dance: The Story of American Vernacular Dance* (1968).

CONSTANCE VALIS HILL

ROGERS, Joel Augustus

(6 Sept. 1880–26 Mar. 1966), writer, historian, novelist, photo-anthropologist, and journalist, was born in Negril, Jamaica, to Samuel Rogers and Emily Johnstone. As a child growing up in Jamaica, the British ruling class told Rogers that "black people were inherently inferior and that their sole reason for being was to be servants to white people and the lighter colored-mulattoes" (Rogers, *World's Great Men*, 1). Rogers, a light-skinned black Jamaican, found it very hard to believe such sentiments. Before emigrating to the United States, Rogers served in the British army with the Royal Garrison Artillery at Port Royal, but he was discharged because of a heart murmur.

Shortly after arriving in New York on 23 July 1906, Rogers first experienced American racial discrimination at a small restaurant in Times Square, something he would never forget. He stayed briefly in New York, Boston, and Canada before relocating to Chicago on 4 July 1908. In 1909 he enrolled in the Chicago Art Institute, where he studied commercial art and worked as a Pullman porter during the summers from 1909 to 1919. Rogers tried to enroll at the University of Chicago to take a sociology course, but was denied entry because he did not possess a high school diploma. The irony of Rogers's being denied entry to this prestigious institution is that the distinguished Chicago professors Zonia Baber and George B. Foster were using Rogers's self-published race novel *From "Superman" to Man* (1917) in their classes. In fact, after learning of Rogers's rejection, Foster invited Rogers to lecture in one of his classes.

While living in Chicago, Rogers officially became a naturalized U.S. citizen on 21 February 1918. In 1921 he relocated to Harlem, where he met and befriended HUBERT HARRISON, the Caribbean black radical, and his lifetime friend GEORGE SCHUYLER, a journalist and novelist. During the late 1920s and various times afterward throughout the rest of his life, New York and later Paris became the two places where Rogers lived while he conducted research at important libraries, art galleries, museums, and cathedrals in America, Europe, and Africa. Although Rogers never received an academic degree, he was respected for his historical and anthropological scholarship in France. In 1930 he was elected to membership in the Paris Society of Anthropology, the oldest anthropological society in the world. During that same year Rogers also gave a paper on "Race Mixing" at the International Congress of Anthropology, which was attended by President Paul Doumer of the French Third Republic. To Rogers's surprise his paper was later published in several French newspapers and in the London *Times*. Rogers was also a member of the American Geographical Society (1945), the Academy of Political Science, the American Association for the Advancement of Science, and the Association Populaire des Amis des Musées of France.

Rogers is mostly known for his writings about history and race, but he is rarely given credit for being an exceptional journalist. He contributed many columns and articles to various African American, Caribbean, and European newspapers and periodicals. His first job as a newspaper reporter was with the *Chicago Enterprise*, which was supported by the controversial mayor William Hale Thompson during the 1910s. When Rogers relocated to New York in 1921, he became a newspaper columnist and reporter for the *Pittsburgh Courier* and the *Amsterdam News* (New York City), and he wrote many essays and commentaries for the *Messenger* magazine during the 1920s. Rogers worked for the *Pittsburgh Courier* from 1921 to 1966. His weekly comic column "Your History," which began in 1934, became a medium for popularizing African and African diaspora history to the masses of African Americans throughout the United States. Not only did Rogers use the "Your History" column to disseminate history, but he also used it to popularize prominent contemporary people of African descent. In 1962 the column's name was changed to "Facts about the Negro." In addition to this column, Rogers also wrote social commentaries in columns entitled "Rogers Says" and "History Shows."

During the 1920s, while traveling overseas, Rogers did observational international journalism in Africa and Europe for the *Pittsburgh Courier* and *New York Amsterdam News*. While living in Paris during the late 1920s, Rogers wrote a short-lived column entitled the "Paris Pepper Pot," which covered

race relations in France and how African Americans fared in Paris compared to America. The "Paris Pepper Pot" was also syndicated in the *Amsterdam News* and the *Chicago Defender*. In 1930 Rogers attended the coronation of emperor Haile Selassie (Ras Tafari) of Ethiopia, yet his most rewarding international journalistic opportunity came when the *Pittsburgh Courier* sent him to Ethiopia in 1935 to cover the Italo-Ethiopia War (1935–1936). Rogers was the only African American journalist sent to Ethiopia during the conflict; he reported firsthand and secondary accounts of the war, and did a rare exclusive interview with Emperor Haile Selassie.

After leaving Ethiopia in 1936, Rogers traveled to Geneva to attend the League of Nations hearings on the Ethiopian war, and he reported through the *Pittsburgh Courier* what the league's Committee of Thirteen proposed to do about the conflict. Within a week Rogers traveled to London and lectured before Sir Percy Vincent, the Lord mayor of London, and other British dignitaries about the crisis confronting Ethiopia. After settling back in New York, Rogers became a major contributor and advisor for the WPA's *Negroes of New York* (1936–1941). As a historian and journalist, Rogers received one of his biggest compliments from the journalist and social critic H. L. Mencken, who paid Rogers five hundred dollars to publish "The Negro in Europe" in the *American Mercury* (May 1930), and in 1945 Mencken wrote Rogers to commend his book *Sex and Race*.

Although Rogers wrote on a variety of issues concerning people of African descent, he is best remembered for his African diasporic biographical sketches about people of African descent, and his writings about miscegenation between blacks and whites from antiquity to the modern era. The amount of archival research Rogers did during his lifetime is remarkable considering the handicaps of not having a research assistant while traveling throughout Europe, Africa, and America. In Europe, Rogers was able to do extensive archival research that many other black and white Americans could not do because he had mastered several languages, including French, German, Portuguese, and Spanish. Furthermore, without philanthropic or institutional support, Rogers self-published his own works that challenged the conventional racist scholarship about people of African descent. His major works include *Sex and Race*, Volumes I–III (1941–1944), *World's Great Men of Color* Volumes

I–II (1946–1947), *Nature Knows No Color Line* (1952), and *Africa's Gift to America* (1961).

At the end of his life Rogers was working on a two projects; the first was a book entitled *Color Mania*, which he addressed mainly to white Americans. Rogers intended to write about the historical aversion and phobia of black skin color in America. Since Rogers was a secular humanist he envisioned a world where people of all different ethnic backgrounds could coexist and appreciate what people of African descent had contributed to humanity from antiquity to the modern era. Shortly before Rogers passed away he suffered a stroke while visiting friends and doing research in Washington, D.C. Rogers had spent the entire day at the National Gallery and the Smithsonian Institute, and had planned on going to the Library of Congress. Ten years before the appearance of Ivan Van Sertima's controversial *They Came Before Columbus* (1976), Rogers had started research on his second project about Africans making contact with the Olmecs in Mexico during the pre-Columbian era. Unfortunately, Rogers never published *Color Mania*, nor did he have the chance to finish his latest research. He died at St. Clare's Hospital in New York.

FURTHER READING

Rogers, J. A. *World's Great Men of Color*. Vol. 1 (1972).

Asukile, Thabiti. "J. A. Rogers: The Scholarship of an Organic Intellectual," in *The Black Scholar*. Vol. 36, Nos. 2–3 (2006).

Asukile, Thabiti. "My Name is J. A. Rogers: The Making of a Black Intellectual (1880–1936)." PhD dissertation, University of California, Berkeley (2007).

Rogers, Helga. *100 Amazing facts about the Negro with Complete Proof: A short cut to the world history of the Negro by J.A. Rogers: as well as additional information by the author and a biographical sketch by Helga Rogers* (1934, 1995).

Turner, W. Burghardt. "J. A. Rogers: Portrait of an Afro-American Historian," in *The Black Scholar*. Vol. 6, No. 5 (1975).

THABITI ASUKILE

RUSHING, Jimmy

(26 Aug. 1903–8 June 1972), singer and composer, was born James Andrew Rushing in Oklahoma City, the son of musical parents who ran a family luncheonette business. In addition to his mother and brother, who were singers, his father played

trumpet well enough to be in the Oklahoma City Knights of Pythias Marching Band. A relative, Wesley Manning, resident pianist in a "gaming house," taught young Jimmy the basics of piano playing. The youngster even managed to pick up enough violin technique to claim that instrument as well. In fact, he first thought of singing more as a hobby than as a profession. After finishing Douglas High School in Oklahoma City in 1921, Rushing attended Wilberforce University in southwestern Ohio for two years, where he participated in the school's outstanding choral program. In addition to his native intelligence and sophistication, he was a thoughtful and trained musician, one of the few professional band or cabaret singers of his era who could read music fluently.

Rushing was blessed with a remarkably accurate ear and a uniquely focused voice, a sound that could cut through a tangled band texture yet still project a pathos ideally suited for the blues. His vocal range was exceptionally wide (two octaves), and within that baritone-plus-tenor territory he exercised precise control. For this reason alone it is a pity that what one hears in many of his recorded performances, especially with bands, is limited to the high end of his tenor range. (For instance the 1938 recording with the COUNT BASIE band of "Sent for You Yesterday" winds through a narrow band of only about six notes.)

While only twenty, Rushing was singing professionally in California (on occasion to the accompaniment of JELLY ROLL MORTON), at the Jump Steady Club and at the Quality Club on Los Angeles's legendary South Central Avenue. But he returned to his hometown in 1925 to help his family run the luncheonette service for over a year. His next professional engagement was a tour with the Billy King Review, followed by brief stints with the traveling bands of Jay McShann and Andy Kirk.

The bassist Walter Page led the band for the King show. Rushing's association with him led to appearances for two years with the Blue Devils band, also led by Page. It was during this tenure that he first met and played with the pianist Basie who would play a dominant role in his career. When Basie and Page abandoned the Blue Devils to join the Bennie Moten band in Kansas City in 1929, Rushing went with them. He recalled frequently how the Moten band provided a new and exciting musical experience for him because of its unique rhythmic vitality, a quality he described as

sounding "like a train a-comin'." His affiliation with that ensemble lasted until just after Moten's death in 1935. (Buster Moten kept the band working for a brief time following his brother's sudden death.)

The big turn toward success in Rushing's career began when he joined the new Basie Band in Kansas City. Consisting of no more than seven to eight pieces when it began its inaugural run at the Reno Club in 1935, the Basie group so prospered during its first two years that Basie could add personnel to bring the band into conformity with the norm that was developing in the country. A recording session for the band in 1937 ("One O'Clock Jump") lists thirteen players, including Basie. Rushing was featured singer with Basie until 1948 and even after that appeared frequently with the band as a guest singer until 1950, and sporadically even into the 1960s. He was one of the few real blues artists who occupied a headliner-vocalist role in the band world of the 1930s and 1940s, most organizations opting for straight ballad and/or "novelty" singers of a more pop-commercial persuasion. Rushing had begun his own professional life singing music of more pop-ballad orientation. He nonetheless claimed his first and greatest influences to have been BESSIE SMITH and MAMIE SMITH, dating back to their appearance at a theater in Oklahoma City in 1923.

Rushing's identity is dominated by his long association with the Basie Band, although after 1950 he enjoyed the success of an established solo entertainer. For two years he fronted, as singer, his own small band in the Savoy Ballroom in Harlem. Following that he made solo appearances throughout the United States and Canada, sometimes accompanying himself, at other times accompanied by a pianist or small instrumental group. European tours presented a new and especially lucrative performance source for American jazz artists following World War II, and Rushing made three. He first toured as a solo act, then as featured singer with the Benny Goodman band for the Brussels World's Fair in 1958, and as featured singer with a band led by the trumpeter Buck Clayton in 1959.

Rushing was a popular participant at the jazz festivals in this country—mostly summer outdoor affairs that took root during the late 1950s—until ill health forced him into virtual retirement during the final year of his life. His later tours with groups covered a broad array of jazz styles. They included one with Harry James, another with the Benny Goodman Sextet, and in 1964 a tour to Japan and Australia

with Eddie Condon. Back in New York in 1965 he filled an extended contract at the Half-Note, returning there during the early 1970s on a permanent weekends-only schedule, this capped by one brief string of performances in Toronto during early 1971. He died in New York, never having married.

This ebullient rotund figure, an original Mr. Five-by-Five, was one of the great blues singers of the first half of this century. With such artists as Bessie Smith, Joe Williams, Jack Teagarden, BILLIE HOLIDAY, and later Ray Charles, he brought that genre into the mainstream of jazz, to become a national commodity cutting across the race lines that had confined it until the Great Depression.

FURTHER READING
Schuller, Gunther. *The Swing Era* (1989).
Williams, Martin. *Jazz Heritage* (1985).

WILLIAM THOMSON

SAVAGE, Augusta

(29 Feb. 1892–26 Mar. 1962) sculptor, educator, and advocate for black artists, was born Augusta Christine Fells in Green Cove Springs, Florida, the seventh of fourteen children of Edward Fells, a laborer and Methodist minister, and Cornelia Murphy. As a child, Savage routinely skipped school, preferring to model small figurines at local clay pits, much to the consternation of her religious father, who, as she recalled in a 1935 interview, "almost whipped the art out of me" (Bearden, 168). At age fifteen, Augusta married John T. Moore, and a year later a daughter, Irene Connie Moore, was born; John Moore died several years later. In 1915 the Fells family moved to West Palm Beach, where Savage taught clay modeling at her high school. She later spent a year at Tallahassee Normal School (now Florida A&M). At some point after 1915 she married a carpenter named James Savage. The couple had no children and divorced in the early 1920s.

Encouraged by sales of her small sculptures at local events, Savage left her daughter in the care of her parents and moved to New York City in 1921. With the help of the sculptor Solon Borglum, she was granted admission to Cooper Union, a tuition-free art school, where she completed the four-year program in only three years. Savage augmented her studies with self-directed reading in African art at the Harlem branch of the New York Public Library. When the librarian Sadie Peterson (later SADIE DELANEY) persuaded the library to commission a bust of W. E. B. DU BOIS, Savage's life as a working artist began. Several commissions followed, including a bust of MARCUS GARVEY, who sat for the young artist on Sunday mornings in her Harlem apartment. It was through Garvey that Savage met her third husband, Robert L. Poston. The couple married in October 1923; five months later, however, she was again widowed.

In 1922 Savage applied to a summer art school program for American women at the palace of Fontainebleau outside Paris. The seven white American artists who constituted the selection committee, however, yielded to complaints from two Alabama women who refused to travel with a "colored girl" and rejected her application. When Savage exposed the committee's racism, becoming the first black artist to challenge the white art establishment openly, the story was reported in both the African American and the white press. Making her case directly to the public, Savage reasoned: "Democracy is a strange thing. My brother was good enough to be accepted in one of the regiments that saw service in France during the war, but it seems his sister is not good enough to be a guest of the country for which he fought" (New York World, 20 May 1923). Despite her protestations, the committee's decision was not reversed and while Savage's outspoken position brought her respect as a civil rights leader, she also won a reputation within the art world as a troublemaker. "No one knows how many times she was excluded from exhibits, galleries, and museums because of this confrontation," speculated ROMARE BEARDEN (170).

Economic limitations denied Savage a second opportunity to study abroad when, in 1925, through the efforts of W. E. B. Du Bois, the Italian-American Society offered her a scholarship to the Royal Academy of Fine Arts in Rome. Savage, who was working at menial jobs to support herself and her parents, was forced to turn down the scholarship when she was unable to raise enough money for living expenses. Her economic and familial burden increased—by 1928 she had eight relatives living in her three-room apartment—and Savage remained in Harlem, studying when she could and exhibiting wherever possible.

A lifesize bronze bust of an adolescent boy, *Gamin* (1929), revived Savage's dream of studying abroad. The sculpture, which *Opportunity* magazine put on its first cover in June 1929, delighted audiences and helped Savage secure two consecutive Julius Rosenwald Fund fellowships for study in Paris. While in Paris, she studied at the Académie de la Grand Chaumière and with the award-winning sculptors Felix Benneteau-Desgrois and Charles Despiau. She exhibited at the key Parisian salons and enjoyed the company of an expatriate social circle that included CLAUDE MCKAY, HENRY OSSAWA TANNER, COUNTÉE CULLEN, and Elizabeth Prophet.

Upon her return to New York in 1932 Savage exhibited at the Anderson Galleries, the Argent Gallery, and the Harmon Foundation and received commissions for busts of JAMES WELDON JOHNSON, W. C. HANDY, and others. But by 1932 much

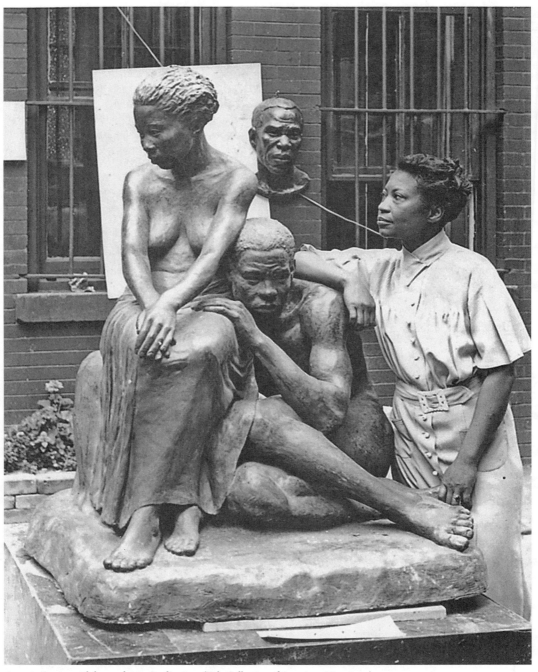

Augusta Savage with her sculpture Realization. (Yale Collection of American Literature.)

had changed. The Depression was taking its toll on institutions and innovations that had flourished in Harlem in the previous decade. Private funding for the arts was drying up, and by 1933 even the Harmon Foundation had suspended giving monetary awards. Savage recognized the effect of these shifts on her own endeavors and on the artistic community more generally. Convinced that her work might not be economically viable, she focused on generating her own creative opportunities, on teaching, and on supporting other African American artists.

Savage had long been unhappy with exhibition and patronage systems that gave white bureaucrats power over opportunities extended to African American artists, and after the Fontainebleau controversy, she had the skills to confront institutional racism and garner public support. Through the establishment of a series of influential art institutions and exhibitions, Savage became an aggressive spokesperson for nurturing black talent, for bringing art into the community, and for including black artists in mainstream arenas. In 1932 she opened the Savage School of Arts, which became the largest program of free art classes in New York. A demanding and devoted teacher, Savage was a powerful influence on her students, who included JACOB LAWRENCE, Norman Lewis, WILLIAM ARTIS, and Ernest Crichlow. The psychologist Kenneth B. Clark, also a former Savage student, recounts her unique and open approach: "Once I was doing this nude and was having trouble with the breasts. . . . Augusta came along and said, 'Kenneth, you're having trouble with that breast.' I said, 'Yes I am.' And she simply opened her blouse and showed me her breast" (Bearden, 173).

Harlem's leading intellectuals often met at Savage's studio, and in 1933 she and AARON DOUGLAS cofounded the Vanguard, a salon-style group that met weekly to discuss progressive causes and cultural issues. Two years later Savage and CHARLES ALSTON established the Harlem Artists Guild, which lobbied for funding for African American artists. In 1936 Savage was appointed an assistant supervisor for the Federal Arts Project (FAP), a division of the Works Progress Administration (WPA), employing thousands of artists. Savage convinced WPA administrators of the existence of nearly two hundred active African American artists and demanded that they be given assignments and supervisory positions through WPA programs. Within a year she became the first director of the Harlem Community Art Center, the FAP's most successful community center. More than three thousand students and ten thousand visitors were drawn to the Center during its first year. Under Savage's direction, an interracial staff of artists, including Douglas, Alston, WILLIAM H. JOHNSON, PALMER HAYDEN, and SELMA BURKE, taught workshops in a variety of mediums.

Savage took a break from administration in 1938, after she received a commission to create a monumental statue reflecting "the American Negro's contribution to music, especially to song" for the 1939 New York World's Fair. One of only four women given a commission and one of only two black artists represented at the fair, she produced a harp-shaped sixteen-foot sculpture of a stylized African American choir supported by a monumental arm. Even though the sculpture, inspired by James Weldon Johnson and JOHN ROSAMOND JOHNSON's song "Lift Every Voice and Sing," was one of the fair's most popular and most publicized attractions, it was destroyed at the close of the fair when Savage was unable to pay for the piece to be cast.

Savage had intended to return to the Harlem Community Art Center, but her opponents at the WPA effectively pushed her out, and she officially resigned in April 1939. "In the end Savage was left a famous but poor, unemployed black artist," lamented Bearden (177). At age forty-seven, never having received a one-woman show or a museum exhibition, Savage organized a retrospective of her work at Argent Galleries. Frustrated by poor reviews, she returned to arts administration and in June 1939 opened the Salon of Contemporary Negro Art in Harlem, the nation's first gallery devoted to the exhibition and sale of work by African American artists. Although more than five hundred people came to see the work of such artists as Richmond Barthé, BEAUFORD DELANEY, JAMES LESESNE WELLS, LOÏS MAILOU JONES, and META WARRICK FULLER, poor sales and lack of resources forced the gallery to close a few months after its opening. The next year Savage attempted to jumpstart her sculptural career with a nine-city tour of her work to conclude at the American Negro Exposition in Chicago in July 1940. But while the popular response to her work was positive, she sold very few pieces, and when she could not cover the shipping costs to New York, many of her works were abandoned or destroyed.

Savage continued to teach but increasingly isolated herself from her contemporaries. In the early 1940s she moved to an old chicken farm in Saugerties, New York, where she remained until 1961, when failing health necessitated a move to her daughter's house in the Bronx. Augusta Savage died of cancer in 1962. Unfortunately, few of her sculptures remain; for a 1988 exhibition at the Schomburg Center, only nineteen small pieces could be located.

FURTHER READING

Bearden, Romare, and Harry Henderson. *A History of African-American Artists: From 1792 to the Present* (1993).

King-Hammond, Leslie, Tritobia Hayes Benjamin, and the Afro-American Historical and Cultural Museum. *Three Generations of African American Women Sculptors* (1996).

Schomburg Center for Research in Black Culture. *Augusta Savage and the Art Schools of Harlem* (1988).

LISA E. RIVO

SCHOMBURG, Arthur Alfonso

(24 Jan. 1874–10 June 1938), historian, bibliophile, and curator, was born Arturo Alfonso Schomburg in San Juan, Puerto Rico, the son of Mary Joseph, an unwed midwife or laundress who had been born free in 1837 on St. Croix, Virgin Islands. His father's name is unknown, though Schomburg recorded that he was born in 1839, the son of a German émigré merchant.

Details of Schomburg's education are also sparse. He may have attended the College of St. Thomas, a secondary school, but there is no documentation. Schomburg knew French, and his writings in Spanish are both grammatically correct and eloquent. His lack of formal education ate away at him all his life, and it was surely one of the spurs to his untiring search for information and his efforts to make the results widely known. As a child he belonged to a club of young people who studied history, and also learned about Puerto Rican history and nationalism from the island's cigar makers.

Schomburg moved to New York City on 17 April 1891. He lived among tobacco workers and participated in their meetings, fund-raising, and publication activities. The Cuban and Puerto Rican independence movements of that time inspired his youthful activism and scholarly bent, and the Cuban Revolutionary Party's newspaper, *Patria*, published

Arthur Alfonso Schomburg's personal library formed the core of the New York Public Library's Schomburg Center for Research in Black Culture. (Library of Congress.)

his first article, a description of Las Dos Antillas, a political club he had cofounded earlier that year. Still a teenager, Schomburg worked as an elevator operator, bellhop, printer, and porter, and also taught Spanish in the night school where he learned English. Schomburg, an exceptionally social and fraternal man, joined a Masonic lodge, El Sol de Cuba No. 38, founded by Cuban and Puerto Rican exiles in 1881. English-speaking blacks were encouraged to join, and Schomburg translated the proceedings into English. He began acquiring and organizing the lodge's papers, books, correspondence, and photographs, and was elected master in 1911. The lodge, by then mostly black, changed its name to Prince Hall, after the first black Mason in the United States.

This name change was emblematic of Schomburg's realization that his future was in America. The Spanish-American War of 1898, which

put Cuba, Puerto Rico, and the Philippines under the control of the United States, effectively ended the revolutionary efforts of the exiles. Family ties also strengthened Schomburg's commitment to his adopted land. In 1895 he married Elizabeth Hatcher, an African American from Staunton, Virginia, but she died in 1900 having borne three children. His second marriage, to Elizabeth Morrow Taylor of Williamsburg, North Carolina, lasted from 1902 until 1909, when she died, leaving two children. Visits to his five children, who were being raised by maternal relatives, exposed the New Yorker to the full-blown racism of the Jim Crow South.

Schomburg worked as a clerk and messenger for Pryor, Mellis, and Harris, a law firm, from 1901 to 1906. On 1 February 1906 he took a job with the Bankers Trust Company on Wall Street, where he remained for twenty-three years. He rose from messenger to supervisor of the bank's foreign mailing section, where his knowledge of French and Spanish, his exceptional memory, and his attention to detail were valuable qualities.

But Schomburg's real work was not on Wall Street; it was wherever he found others equally impassioned to prove that black people did indeed have an international history of accomplishment that stretched past slavery days to Africa. In April 1911 Schomburg was one of five founders of the Negro Society for Historical Research. The society aimed "to show that the Negro race has a history that antedates that of the proud Anglo-Saxon race"; they planned "to collect useful historical data relating to the Negro race, books written by or about Negroes, rare pictures of prominent men and women . . . letters . . . African curios of native manufacture" (Sinnette, 43). It acquired members in Europe, the Americas, the Caribbean, and Africa, including the vice president of Liberia, James Dossen, Edward Blyden of Sierra Leone, and Mojola Agbebe of Nigeria—which must have gratified Schomburg, a Pan-Africanist.

Schomburg, activist and expansive in outlook, generously made available to those in his wide network his private library, acquired with a limited budget. He had already begun to carry out the society's mission of collecting historical documents. At about this time he married his third wife. By 1916 their household was filled with three young children and Schomburg's growing library.

The American Negro Academy, founded in Washington, D.C., in 1897 and limited to forty members, elected Schomburg to membership in 1914. Schomburg became the academy's fifth president (1920–1929). The group held annual conventions, encouraged publication of scholarly works, and urged members to acquire books and manuscripts by and about people of African descent. At the 1915 convention, Schomburg's paper, "The Economic Contribution by the Negro to America," brought to the academy's attention the theme that had always engaged him: that people of African origin, wherever they were in the world, had made significant but unrecognized contributions in all fields to white society. Schomburg's research, writings, and talks about Haitians and blacks of European, Central, and South American birth broadened the perspective of the academy's members.

In 1918 Schomburg was elected grand secretary of the Prince Hall Grand Lodge of the State of New York, a position that required frequent travel and attention to many organizational activities, including planning a new temple. He was still able to mount a weeklong exhibition at the Carleton Street YMCA in Brooklyn. On view were rare books, manuscripts, engravings, paintings, and sculpture, as well as African art. Only one earlier exhibition, in New York in 1909, had displayed African art as art, not as ethnographic curiosities.

By 1925 Schomburg had formed a library of nearly 4,000 books and pamphlets and about 1,000 manuscripts and prints, which he wished to make widely available to inspire Negro youth. With a grant of $10,000 from the Carnegie Corporation in 1926, the New York Public Library purchased the collection and housed it in its 135th Street Library. Among its rarest items were Benjamin Banneker's almanacs (1792–1796) and manuscripts by PAUL LAURENCE DUNBAR and Toussaint-Louverture.

The library also became a gathering place for the writers and artists of the Harlem Renaissance. Schomburg's most influential essay, "The Negro Digs Up His Past," appeared in one of the preeminent texts of that movement, ALAIN LOCKE's The New Negro (1925), and was often reprinted. His essay called for rigorous historical research, not "a pathetically over-corrective, ridiculously over-laudatory . . . apologetics turned into biography." Though he urged that "history must restore what

slavery took away," half a century passed before his collection was recognized as a treasure house and received funding for renovation and new construction.

After the sale of his collection, Schomburg began to spend more time at the 135th Street Library. When he retired from Bankers Trust at the end of 1929, he planned to devote his time to research and to travel to Spain again. Even before his retirement, however, CHARLES S. JOHNSON, chairman of the social science department of Fisk University in Nashville, Tennessee, invited him to build Fisk's Negro Collection. From November 1930 until the end of 1931 Schomburg was the curator of that collection, acquiring 4,524 books out of a total of 4,630. The Fisk librarian Louis Shores wrote that Schomburg's "bibliographic memory was spectacular." Schomburg returned to New York in 1932 to accept his final position as curator in charge of his own collection, serving until his death six years later.

Money was short because of the Great Depression, but Schomburg managed to add outstanding items to the New York collection, including the long-sought *Ad Catholicum* of Juan Latino (1573) and a folio of engravings by Patrick Henry Reason, a nineteenth-century black artist. The marble-and-bronze sculpture of Ira Aldridge as Othello, which often serves as the graphic symbol of the Schomburg Center, was bought in 1934, with assistance from a fellow bibliophile, Arthur B. Spingarn. Donations from authors, artists, and Schomburg's many friends further enriched the collection, as did purchases paid for by Schomburg himself.

The acquisition of Schomburg's collection by the New York Public Library vindicated his forty-year search for the evidence of black history. He was gratified that it would be freely available to all. A teenage immigrant without influential family, formal education, or ample funds, consigned to a segregated world, he nevertheless amassed a collection of inestimable value. Schomburg was "a man who built his own monument," said one eulogist. From his core of five thousand items, the Schomburg Center for Research in Black Culture would grow to 5 million items and become the world's most important repository in the field. Schomburg's name is also commemorated in a street in San Juan, Puerto Rico, an elementary school in the Bronx, and a housing complex in Harlem.

FURTHER READING

A large collection of Schomburg's papers is at the Schomburg Center for Research in Black Culture of the New York Public Library, along with extensive clipping files about him.

Gubert, Betty Kaplan, and Richard Newman. *Nine Decades of Scholarship: A Bibliography of the Writings 1892–1983 of the Staff of the Schomburg Center for Research in Black Culture* (1986).

Sinnette, Elinor Des Verney. *Arthur Alfonso Schomburg: Black Bibliophile and Collector* (1989).

Obituary: New York Times, 11 June 1983.

BETTY KAPLAN GUBERT

SCHUYLER, George Samuel

(25 Feb. 1895–31 Aug. 1977) journalist, was born in Providence, Rhode Island, to George Francis Schuyler and Eliza Jane Fischer, both cooks. He was raised in Syracuse, New York, and often remarked that his family had never lived in the South and had never been slaves. That did not mean that they had not suffered discrimination, however, for as Schuyler wrote in his 1966 autobiography: "A black person learns very early that his color is a disadvantage in a world of white folks. This being an unalterable circumstance, one also learns to make the best of it" (Schuyler, 1).

For Schuyler, that early exposure to racism came on his first day at school, when he registered three firsts: he was called "nigger," fought the Italian American boy who used the slur, and received a bloody nose for his pains. After that experience, his mother told him to always fight back when called names, and she also taught him about the achievements of Frederick Douglass, Harriet Tubman, and other great African Americans. From then on, Schuyler later recalled, he never felt inferior to whites, even though he saw no person of color in any position of authority until he was fourteen and witnessed black soldiers on exercise in Syracuse.

Perhaps because of the childhood school incident and because he saw few prospects for young black men in his hometown, Schuyler left school at seventeen and joined the army. He served for seven years in the Twenty-fifth U.S. Infantry, a predominantly black regiment famed for its Buffalo Soldiers, who had been recruited for "pacification" campaigns against Indians in the post–Civil War American West. Stationed at first in Seattle, Washington, Schuyler found the Pacific Northwest

to be little different from upstate New York in terms of racial discrimination. Schuyler's next posting, in Hawaii, proved much more congenial to him, in part because of the camaraderie among African American recruits and the seemingly endless opportunities in Honolulu for "rum and roistering" (Schuyler, 71). But he also loved the breathtaking landscape of Hawaii and initially planned to stay in Honolulu at the end of his service in 1915.

Finding few opportunities in civilian life, he reenlisted in his former regiment and began his first efforts at journalism, writing satirical pieces for the *Service*, a weekly magazine for soldiers in Hawaii. When the United States entered World War I, he received a commission and, according to his autobiography, served at Camp Dix, New Jersey, and Camp Meade, Maryland. Schuyler's memoir does not mention, however, that he went AWOL for three months in 1918 after he had visited Philadelphia, Pennsylvania, in uniform and was denied service by a Greek bootblack. He later surrendered to military authorities in San Diego and was sentenced to five years in prison on Governors Island in New York; in his autobiography, he claims to have worked at that prison as a clerk.

After serving only nine months in jail, Schuyler was released for good behavior and worked a series of low-paying laboring jobs in Syracuse, where he joined the Socialist Party in 1921. He then moved to New York, where he drew upon his experiences in a Bowery flophouse in "Hobohemia," a satirical essay that he wrote in 1923 for the *Messenger*, a socialist newspaper founded by A. PHILIP RANDOLPH. That same year, Schuyler joined the *Messenger*'s editorial staff and wrote a monthly column, "Shafts and Darts: A Page of Calumny and Satire," which aimed to "slur, lampoon, damn, and occasionally praise anybody or anything in the known universe" (Peplow, 22). Although he also targeted white hypocrisy and racism, Schuyler most effectively skewered what he saw as the cant and hypocrisy of African American leaders, notably MARCUS GARVEY.

As he no doubt intended, Schuyler's satirical barbs provoked outrage among his targets, especially his fellow African American intellectuals. In "The Negro-Art Hokum," which appeared in the *Nation* in 1926, Schuyler declared that there is no distinct, unified African American aesthetic separate from an American aesthetic. More controversially, he summarized that view by

stating that "the Aframerican is merely a lamp-blacked Anglo-Saxon" (Leak, 14). The essay provoked a bitter response among Harlem Renaissance artists—notably LANGSTON HUGHES—who were at that time exalting the unique achievements of black American culture. Schuyler's combative essays proved good copy, however, and by the late 1920s he was the most widely read black journalist in America. In addition to a regular opinion column in the *Pittsburgh Courier*, his essays appeared in national publications such as the *American Mercury*, a periodical founded by the gadfly journalist H. L. Mencken, who greatly influenced Schuyler's iconoclastic style. Schuyler's prodigious journalistic output coincided with his marriage in 1928 to Josephine Cogdell, a white Texas heiress, artist, and former model. The union produced a daughter, Philippa Duke Schuyler, a child prodigy who, at the age of thirteen, performed her own composition, "Manhattan Nocturne," with the New York Philharmonic.

The 1930s marked the peak of Schuyler's influence as a cultural critic. *Black No More* (1931), the first black science fiction novel, reversed traditional American race roles by means of a whitening agent that made Americans of African descent a shade lighter than whites of European descent. In the process, Schuyler lampoons W. E. B. DU BOIS as Dr. Shakespeare Agamemnon Beard—a portrayal Du Bois greatly enjoyed—and introduces a black nationalist character, Santop Licorice, a thinly veiled Garvey, who was less forgiving of Schuyler's acerbic wit. Du Bois joined Garvey, however, in criticizing *Slaves Today* (1931). This satire was drawn from Schuyler's experiences in Liberia in the early 1930s, when he had written a series of articles—published in the *Courier* and syndicated to several other newspapers—criticizing the African republic for its corrupt government and toleration of slavery.

Despite his frequent criticisms of Garvey, Schuyler wrote two black nationalist pulp science fiction serials under the pseudonym of Samuel I. Brooks for the *Pittsburgh Courier* in the late 1930s. Schuyler's adoption of a nationalist alter ego and his criticisms of "Brooks's" serials as "hokum and hack work" appear paradoxical. The literary scholar Henry Louis Gates Jr. suggests, however, that Schuyler/Brooks purposively adopted the dual role in an intellectual playing out of Du Bois's metaphor of black double-consciousness.

Around the same time, Schuyler's political philosophy also changed; George Schuyler, radical and socialist, metamorphosed into George Schuyler, reactionary and conservative. One factor may have been what Schuyler saw as the exploitation of the SCOTTSBORO BOYS' case by the Communist Party in the late 1930s, but the bulk of his writings before the McCarthy era place him firmly on the progressive left. Indeed, from 1934 to 1944 he served as business manager of the NAACP and worked closely with his protégé, ELLA BAKER, in promoting workers' and consumers' cooperatives. Both before and during World War II, Schuyler used his columns in the *Pittsburgh Courier* to attack the hypocrisy of blacks fighting against fascism abroad while suffering Jim Crow at home.

After World War II, Schuyler's conservatism became unambiguous. His anticommunism and opposition to the Soviet Union may not have been unique among black intellectuals at that time, but his strident defense of Senator Joseph McCarthy certainly was. Likewise, most African Americans would have agreed with Schuyler's contention in "The Negro Question without Propaganda" (1950) that lynching had declined since 1900, but few, especially in the South, could take seriously his claim that force was rarely used to keep blacks from the polls. Indeed, as the civil rights movement made impressive legal and political victories in the 1950s and 1960s, Schuyler moved farther and farther to the right, not only criticizing Malcolm X as a latter-day Garvey, but also attacking Martin Luther King Jr. as a communist stooge. When black newspapers refused to publish his essay discrediting King's 1964 Nobel Prize, Schuyler published the piece in the rabidly conservative *Manchester (N.H.) Union Leader*. In the 1960s and 1970s Schuyler also contributed several articles to *American Opinion*, the journal of the John Birch Society, an organization so profoundly right wing that it regarded President Dwight Eisenhower as a communist sympathizer.

Schuyler died in relative obscurity in New York City. Most commentators noted his political journey from left to right, but the historian JOHN HENRIK CLARKE was probably more accurate in noting Schuyler's consistency as a rebel. Clark recalled that he "used to tell people that George got up in the morning, waited to see which way the world was turning, then struck out in the opposite direction" (*New York Times*, 7 Sept. 1977).

FURTHER READING

Schuyler's papers are housed at the Schomburg Center for Research in Black Culture of the New York Public Library

Schuyler, George S. *Black and Conservative* (1966).

Gates, Henry Louis, Jr. "A Fragmented Man: George Schuyler and the Claims of Race," *New York Times Book Review*, 20 Sept. 1992.

Leak, Jeffery B. *Rac[e]ing to the Right: Selected Essays of George Schuyler* (2001).

Peplow, Michael W. *George S. Schuyler* (1980).

Obituary: New York Times, 7 Sept. 1977.

STEVEN J. NIVEN

SCOTT, Emmett Jay

(13 Feb. 1873–12 Dec. 1957), educator and publicist, was born in Houston, Texas, the son of Horace Lacy Scott, a civil servant, and Emma Kyle. Scott attended Wiley College in Marshall, Texas, for three years but left college in 1890 for a career in journalism. Starting as a janitor and messenger for a white daily newspaper, the *Houston Post*, he worked his way up to reporter. In 1894 he became associate editor of a new black newspaper in Houston, the *Texas Freeman*. Soon he was named editor and built this newspaper into a leading voice in black journalism in its region. Initially, he tied his fortune to the state's preeminent black politician, Norris Cuney, and was his secretary for a while.

When Cuney retired, Scott turned to BOOKER T. WASHINGTON, the founder of the Tuskegee Institute in Alabama. Scott greatly admired Washington, praising his 1895 "Atlanta Compromise" speech. Two years later he invited Washington to speak in Houston. Scott handled the publicity and promotion so well that Washington hired him as his private secretary. When Scott moved to Tuskegee on 10 September 1897, he brought with him his wife, Eleonora Juanita Baker, the daughter of a newspaper editor. They had been married in April 1897 and eventually had five children.

From 1897 until Washington's death in November 1915, Scott was his closest adviser and friend. The two worked together so smoothly that determining which man authored a particular letter can be a challenge. As his top aide, Scott ran Tuskegee when Washington was away. Washington acknowledged that Scott made "himself invaluable not only to me personally, but to the institution" (Washington, *The Story of My Life and Work* [1901]). Scott developed

and operated the "Tuskegee Machine," an elaborate apparatus by which Booker T. Washington controlled, influenced, and manipulated African American leaders, press, and institutions. He also worked closely with Washington in founding the National Negro Business League in 1900. Washington was president of the league, but Scott, as secretary from 1900 to 1922, actually ran it. The two coauthored *Tuskegee and Its People* (1905).

Scott served on the three-man American Commission to Liberia in 1909, the report of which led to an American protectorate over Liberia. In 1912 Tuskegee Institute's board made Scott the secretary of the school. When Washington died in 1915, Scott was a leading candidate to succeed him, but Robert Russa Moton of Hampton was chosen instead. Scott remained as secretary. He and Lyman Beecher Stowe coauthored a highly laudatory biography, titled *Booker T. Washington*, published in 1916. That year, Scott and others in the Tuskegean camp reconciled with Washington's rival and National Association for the Advancement of Colored People (NAACP) founder W. E. B. DU BOIS, at the Amenia Conference on Long Island, New York.

The entrance of the United States into World War I gave Scott a chance to leave Tuskegee and end any rivalry with Moton. He became special assistant to the secretary of war and was in charge of affairs relating to African Americans. While in this post he wrote *Scott's Official History of the American Negro in the World War* (1919). He also wrote *Negro Migration during the War* (1920), under the auspices of the Carnegie Endowment for International Peace. Scott stayed in Washington after the war, becoming a top administrator at Howard University. From 1919 to 1932 he was the university's secretary-treasurer and business manager. He was the top black official until Howard's first black president, MORDECAI JOHNSON, was appointed in 1926. The two clashed, and Scott was relegated to the position of secretary of the university but remained at Howard until he retired in 1938.

Meanwhile, he was active in business and politics. Among his business ventures in the African American community were banking, insurance, and real estate. In politics he was a staunch Republican. He served on an advisory committee for the 1924 Republican National Convention, specializing in black affairs, and he was the assistant publicity director of the Republican National Committee from 1939 to 1942. In 1941 Scott went to work at the Sun Shipbuilding Company of Chester, Pennsylvania, at the request of the Republican Party. The company president, John Pew, was a major funder of the party. Pew's company was nonunion. With Scott's help the company established Yard No. 4, staffed by African Americans supervised by Scott. When the war ended in 1945, Scott's yard was dismantled, and Scott retired to Washington. From time to time, he did public relations work. He died in Washington, D.C.

FURTHER READING

Scott's personal papers are in the Morris A. Soper Library of Morgan State University, Baltimore. His letters and other materials are also found among the Booker T. Washington Papers in the Library of Congress.

Harlan, Louis. *Booker T. Washington: The Making of a Black Leader, 1856–1901* (1972).

Harlan, Louis. *Booker T. Washington: The Wizard of Tuskegee, 1901–1915* (1983).

Logan, Rayford W. *Howard University* (1969).

Meier, August. *Negro Thought in America, 1880–1915* (1963).

Obituaries: Atlanta Daily World and *Washington Post*, 13 Dec. 1957; *Washington Afro-American* and *New York Times*, 14 Dec. 1957; *Afro-American* (national edition), 21 Dec. 1957.

EDGAR ALLAN TOPPIN

SCOTTSBORO BOYS

Olen Montgomery (1914–?), Clarence Norris (12 July 1912–23 Jan. 1989), Haywood Patterson (1913–24 Aug. 1952), Ozie Powell (1915–?), Willie Roberson (4 July 1916–c. 1959), Charlie Weems (1911–?), Eugene Williams (1918–?), Andrew "Andy" Wright, (1912–?), and Leroy "Roy" Wright (1918–1959), became an international cause célèbre after they were accused of raping two white women on a Southern Railroad freight train traveling on 25 March 1931 through northern Alabama en route to Memphis, Tennessee. Like many Depression-era Americans, the nine young men and the two women had been riding the rails in search of work. Shortly after their train crossed into Alabama, a white male hobo stepped on the hand of Haywood Patterson, who had been hanging on to one of the freight carriages. A scuffle ensued in which Patterson and his friends forced the white hobo and his colleagues off the train, after

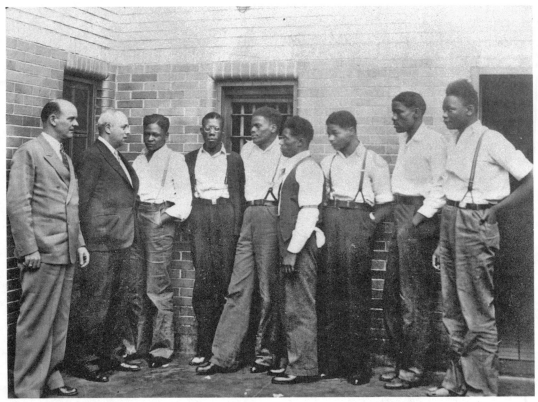

Scottsboro Boys. Left to right are Deputy Sheriff Charles McComb, attorney Samueal Leibowitz, and the defendants Roy Wright, Olen Montgomery, Ozie Powell, Willie Roberson, Eugene Williams, Charlie Weems, and Andy Wright. The youths, along with Clarence Norris and Haywood Patterson, were charged with an attack on two white women on 25 March 1931. (AP Images.)

which the whites reported the assault to a station-master, who in turn informed the sheriff of Jackson County, Alabama. The sheriff deputized a posse of heavily armed white men, who stopped the train at the small town of Paint Rock and rounded up every black male on the train. The nine youths were then tied together, loaded on a truck, and driven to jail in Scottsboro, the Jackson County seat.

When the prisoners arrived at the jail, they found that the two women, Ruby Bates and Victoria Price, had told the authorities that twelve African Americans armed with pistols and knives had raped them. Price later identified six of the nine jailed teenagers as her assailants, prompting a prison guard to declare—though he provided no evidence—that the three others must have raped Bates. A presumption of the black youths' guilt led hundreds of angry whites to surround the jail in the hope of lynching

the accused, but their plans were thwarted when the governor of Alabama ordered the National Guard to protect the Scottsboro jail.

However, the state of Alabama showed less interest in the defendants' broader procedural rights, assigning them two ineffective attorneys—one drunk and the other elderly—who defended their clients with little skill and even less enthusiasm. The lawyers failed to probe inconsistencies in the women's testimony, including a physician's report that contradicted Price's claim of a brutal gang rape. They also ignored the fact that Willie Roberson, suffering from syphilis, could barely walk and certainly could not jump from one railroad car to another as claimed; his condition—which had left him with sores on his genitals—would also have made intercourse extremely painful. The defense was also compromised when Roy Wright, Haywood

Patterson, and Clarence Norris testified that they had seen some of the others rape the two women, though it later emerged that these accusations had been coerced by prison guards. Roy Wright told a *New York Times* reporter in 1933 that the guards "whipped me and it seemed like they was going to kill me. All the time they kept saying, 'Now will you tell?' and finally it seemed like I couldn't stand no more and I said yes. Then I went back into the courtroom and they put me up on the chair in front of the judge and began asking a lot of questions, and I said I had seen Charlie Weems and Clarence Norris with the white girls" (quoted in Goodman, 97).

After a trial lasting only three days, the all-white, all-male jury found the teenagers guilty and recommended that eight of them be sentenced to death in the electric chair on 10 July 1931. The prosecution had requested that Roy Wright, who was only twelve or thirteen, should receive a life sentence, but because seven of the jurors held out for the death penalty for him, too, the judge declared a mistrial in his case.

The Scottsboro Boys were hardly the first black victims of injustice in southern courts, but their youth and the paucity of evidence against them provoked an immediate uproar. Four of the teenagers were from Chattanooga, Tennessee, and had been traveling to Memphis in search of work hauling logs on the Mississippi. Roy Wright and his nineteen-year-old brother, Andy, had been raised by their mother, Ada, after their father died when Andy was twelve. His father's death had forced Andy, who had shown promise in grade school, to find work as a truck driver, though at the time of his arrest he was unemployed. Roy worked in a grocery store. Eugene Williams, thirteen years old, had been a dishwasher in a Chattanooga cafe. Haywood Patterson was the fourth of nine surviving children born to sharecroppers in Elberton, Georgia. In March 1931 he was eighteen and had spent the previous four years riding the rails of the South and Midwest in search of work. Patterson could barely read and write, having left school after the third grade, but he "knew the train schedules, when the freights left and where they arrived [and] could light a butt in the wind on top of a moving boxcar" (quoted in Goodman, 93).

The five other Scottsboro defendants did not know the four Chattanooga teenagers before boarding the train to Memphis; they also did not all know each other. At nineteen or twenty, Charles

Weems was the oldest of the nine youths arrested. His mother had died when he was only four, and six of his seven siblings had also died. Clarence Norris was the second of eleven children born to a former slave and his wife in Warm Springs, Georgia. He had attended school up to the second grade, and at age seven he joined his sharecropping parents in the cotton fields, where he did "everything a grown man could do . . . or my daddy would whup me good" (Norris, 28). By the time he was a teenager, beatings from his father had become more frequent, and Norris left home, working a series of laboring jobs before seeking his luck on the rails.

Ozie Powell had also been born in rural Georgia and, like Norris, could barely read and write. Sixteen at the time of his arrest, he had been living in Atlanta for three years, working in sawmills and lumber camps. Seventeen-year-old Olen Montgomery was from Monroe, Georgia, and had attended school through the fifth grade. His vision was extremely poor because of cataracts, and he was traveling to Memphis to buy new glasses when he was arrested. Montgomery, like Powell, had not participated in the fight on the freight train. Nor had Willie Roberson, who was born in Columbus, Georgia. His father abandoned the family a few weeks after Willie's birth, and his mother died two years later, leaving him in the care of his grandmother until she, too, died around 1930. At the time of his arrest, Roberson, who was illiterate and had a severe speech defect, was traveling to Memphis to get treatment for syphilis and gonorrhea. These diseases had left him crippled, but his cane, like Olen Montgomery's glasses, was confiscated after his arrest.

The nation's leading civil rights organization, the NAACP, might have been expected to take on the Scottsboro Boys' case, but its executive secretary, WALTER WHITE, was initially reluctant to get involved in a controversial rape case in the Deep South. The American Communist Party had no such qualms and quickly convinced the Scottsboro Boys and their parents that their best hope of overturning their convictions lay with its legal arm, the International Labor Defense (ILD). When the U.S. Supreme Court overturned the boys' convictions in *Powell v. Alabama* (1932) and ordered a retrial in March 1933, the ILD's Joseph Brodsky and the famed criminal attorney Samuel Leibowitz—who was not a Communist—took up their case.

The Communist Party's involvement in the case helped dramatize the Scottsboro case throughout

the nation. On May Day of 1931, demonstrations by 300,000 workers in more than 100 American cities demanded the Scottsboro Boys' release. In addition to communist and socialist agitation, a wide range of black and white church leaders, liberal politicians, including New York City's mayor, Fiorello LaGuardia, and thousands of ordinary men and women voiced their criticism of the Alabama courts. Although W. E. B. DU BOIS was suspicious of the ILD's and the Communists' motives in supporting the Scottsboro Boys, most African Americans agreed with the Oklahoma journalist Roscoe Dunjee, who asked: "What does it matter whether God, the devil, or Communists save those helpless black boys?" (quoted in Goodman, 69). Both COUNTÉE CULLEN and LANGSTON HUGHES wrote poems demanding justice for the Scottsboro Boys.

International support for the Scottsboro Boys was perhaps even more dramatic. A series of European demonstrations, at which Roy and Andy Wright's mother, Ada, was a prominent speaker, also began that summer. More than 150,000 people attended one rally in Berlin in 1932, while other, occasionally violent, protests were staged in Geneva, Paris, and Glasgow. Thousands of Canadian, African, South American, and Chinese supporters of the Scottsboro Boys also sent petitions and letters to the governor of Alabama and to the White House, demanding the boys' release.

International pressure was one thing, but getting justice for black men accused of raping white women in Alabama was quite another. While they waited for a retrial, the Scottsboro Boys remained on death row in appalling conditions; from their cells they could hear the screams of inmates being electrocuted. In all, Clarence Norris recalled, he saw fifteen men walk through the notorious green door to the death chamber. Only one of them was white.

In the first retrial, which involved only Haywood Patterson, Leibowitz exposed the weaknesses of the prosecution's original case. He called the physician who had treated Price and Bates to testify that he had found no bleeding or vaginal damage. A white male witness also testified that he and another white man had had sexual intercourse with Price and Bates on the evening before the two women boarded the train at Huntsville, Alabama, which, Leibowitz argued, explained the nonmotile semen found inside the women's vaginas. Most dramatically, Ruby Bates now testified that there had been no rapes and that she and Price had concocted the original charges out of a fear that they would be arrested for vagrancy. Regardless of that evidence, the jury again found Patterson guilty—after deliberating for only five minutes—and again sentenced him to death. However, the presiding judge, James Horton, agreed with Leibowitz that the evidence indicated Patterson's and the other boys' innocence and ordered a retrial.

That retrial in November 1933 proved even more farcical than the first trial. The presiding judge, William Callahan, all but instructed the jury to convict Patterson. They did so. Patterson later recalled that the judge could not get him to the chair fast enough. He added: "When Callahan sentenced me to death for the third time, I noticed he left out the Lord. He didn't even want the Lord to have any mercy on me" (Patterson, 50). One week later Clarence Norris was also convicted and sentenced to death.

Throughout 1934 the ILD petitioned the Alabama courts for a retrial and publicized the inhumane conditions and the physical and mental abuse the Scottsboro Boys received in jail. The Alabama authorities denied those petitions, but in January 1935 the U.S. Supreme Court allowed a review of the convictions of Norris and Patterson. That April, in what proved to be a landmark case, *Norris v. Alabama*, the Supreme Court reversed both convictions on the ground that African Americans had been excluded from the pool of jurors selected to try the case. In the long term the ruling can be seen as one of the first steps in a series of Supreme Court decisions assuring blacks equal protection rights, leading to the 1954 *Brown v. Board of Education* decision that declared racial segregation unconstitutional. In the short term *Norris v. Alabama* required only that African Americans be included in the pool of potential jurors; it did not guarantee equal black representation on actual juries. This became readily apparent in November 1935, when an Alabama grand jury, with only one black member, issued new indictments that again charged the nine Scottsboro defendants with rape.

The indictments prompted the ILD to make common cause with other civil rights groups, including the NAACP, in a broad-based Scottsboro Defense Committee (SDC) for the next trial in January 1936. Patterson was again convicted—again by an all-white jury—and sentenced to seventy-five years in prison. The following day, however, when Norris, Roy Wright, and Powell were being driven

back to Birmingham jail, they got into an argument with their escorts, Sheriff Sandlin and his deputy. The deputy struck Powell about the head; Powell responded by slashing the deputy's throat with a knife that he had concealed. Sheriff Sandlin then shot Powell in the head at close range. The doctors who removed the bullet from his brain gave him a 50 percent chance of surviving; Powell did survive, but he suffered from severe brain damage for the rest of his life.

That incident and a series of appeals by the SDC delayed the trials of the other prisoners until the summer of 1937. Clarence Norris was again found guilty and again received the death sentence, though the governor of Alabama later commuted that sentence to life imprisonment. Andy Wright and Charlie Weems were also found guilty and received prison sentences of ninety-nine and seventy-five years, respectively. Ozie Powell, the only Scottsboro Boy to plead guilty—to a lesser charge of assault—was sentenced to twenty years. The SDC reached a compromise with the Alabama authorities to drop all charges against Roy Wright and Eugene Williams, the youngest of the Scottsboro Boys, and against Olen Montgomery and Willie Roberson, who had not been in the boxcar when the alleged rape took place.

Upon their release, Wright, Williams, Montgomery, and Roberson traveled to New York, where they were mobbed by crowds and appeared briefly in a vaudeville show at Harlem's famed Apollo Theater. Williams and Montgomery had both dreamed of music careers while in prison, and the latter had even composed a song, "Lonesome Jailhouse Blues," but neither found lasting success as musicians. Williams left to live with relatives in St. Louis, Missouri, apparently with plans to attend Western Baptist Seminary, and was not heard of again. Along with Roy Wright, Montgomery embarked on a publicity tour to raise funds for the release of the remaining Scottsboro Boys and spent the next few years traveling between New York, Atlanta, and Detroit in search of work. A heavy drinker, Montgomery was arrested several times for public disorder and probably returned to Georgia in 1960.

Roy Wright at first adapted well to his newfound freedom. Sponsored by the entertainer BILL "BOJANGLES" ROBINSON, he enrolled in a vocational school and later served in the army, married, and then joined the merchant marine. While on leave from the army in 1959, however, he shot and killed his wife, believing that she had been unfaithful, and then committed suicide. Willie Roberson remained in New York City, settling in Brooklyn, where he found regular employment, though he was arrested once—wrongfully, he claimed—for disorderly conduct. He died sometime around 1959, following an asthma attack.

The release of four of the boys signaled the end of one part of the Scottsboro saga. By the late 1930s American and international opinion had begun to focus on the impending world war, and even the black press devoted less attention to the case. The SDC and the ILD persisted in their efforts to gain the release of the five others, but the Alabama authorities proved equally determined that their sentences should stand. Andy Wright, Weems, and Norris were assigned to a new prison, Kilby, where they worked twelve-hour shifts at a cotton mill and were beaten systematically by their guards. On one occasion a guard stabbed Weems, though he had intended to stab Wright. Norris had a finger severed in a work accident and received several whippings and beatings.

In August 1943 Weems was paroled and found a job in an Atlanta laundry. Little is known about him after that, other than that he married and that his eyesight continued to suffer from a tear-gas attack by prison guards, who had found him reading a communist publication in his cell. Wright and Norris were paroled in early 1944 on the condition that they labor at a lumberyard near Montgomery, Alabama. Forced to share a single bed in a tiny room, their living and working conditions were worse than at Kilby. They were nonetheless free to marry—Norris to Dora Lee of Montgomery and Wright to Ruby Belle of Mobile, Alabama. Both men left Montgomery in violation of their paroles in late 1944 but later returned to serve more time at Kilby prison.

Ozie Powell served his sentence at Atmore farm, a penitentiary that, like Parchman in Mississippi and Angola in Louisiana, was notorious for its brutal and inhumane treatment of prisoners. Little is known about Powell's experiences there, other than that he was beaten and that he continued to suffer from depression and paralysis on his right side, a consequence of the gunshot wounds he had suffered at the hands of Sheriff Sandlin. He was released from Atmore in 1946 and returned to Georgia.

Much more is known about Haywood Patterson's time at Atmore because of his memoir, *Scottsboro*

Boy (1950). In February 1941 a guard paid one of Patterson's friends a few dollars to kill him; he stabbed Patterson twenty times and punctured a lung, but the Scottsboro Boy survived. The certainty of violence and the uncertainty of when it might occur made Patterson keep faith only in himself and in the knife that was his constant companion. Like other men who survived Atmore, Patterson became a sexual predator; by giving a brutal beating to a "young wolf" who had made advances on his "gal-boy," he gave warning to his fellow prisoners that nobody would "make a girl" out of him.

After an escape attempt in 1943, the authorities sent Patterson to work in the cotton mill at Kilby prison. At first the violent reputation he had earned at Atmore served him well. The guards left him alone to run what he called his "store," selling cigarettes and other goods to fellow prisoners. He was not immune to unofficial beatings and official whippings from the guards, however, and he endured several spells in solitary confinement. In July 1948, believing that he would never be released, Patterson decided to "parole himself" by escaping from the Kilby farm, where he was working at the time, to his sister's home in Detroit, Michigan. There, at age thirty-six, he drank his first beer, but his freedom was short-lived.

He took a series of laboring jobs and began working on his autobiography with the writer Earl Conrad. Two weeks after the release of *Scottsboro Boy* in June 1950, the FBI arrested him in Detroit for escaping from Kilby; he was released on bail, and the governor of Michigan refused to extradite him to Alabama to serve his sentence. In December 1950 Patterson was charged with murder after he stabbed and killed a man in a barroom fight. Patterson claimed that he had acted in self-defense, but he was convicted in September 1951 of manslaughter and sentenced to six to fifteen years in the Michigan State penitentiary. He died in prison of cancer less than a year later.

In June 1950, nineteen years after being arrested in Paint Rock, Andy Wright was the last of the Scottsboro Boys to be released, and he moved to Connecticut. Like Montgomery, Powell, Weems, and Williams, it is not known when—or if—Andy Wright died. The failure of historians, journalists, and documentary filmmakers since the 1960s to find them suggests that, if they lived, they probably chose obscurity rather than having to relive the trauma of their years in prison and on death row.

That Clarence Norris titled his own memoir *The Last of the Scottsboro Boys* (1979) suggests that he believed the others had died. This autobiography detailed Norris's life after breaking parole in 1946. He moved first to his sister's home in Cleveland, Ohio, where he found a job shoveling coal in a furnace room and spent some of his first wages at a brothel. There he slept with a white woman to discover why the Alabama authorities had been enraged by even the idea of interracial sex. He discovered, however, that when it came to sex, there "ain't no difference" between white and black women (Norris, 208). He married again, worked a series of laboring jobs interspersed with bouts of unemployment, and moved to New York in 1953. There he was arrested several times, once for stabbing his girlfriend.

By 1960 Norris had settled down with Melba Sanders, his third wife, with whom he had two children, Adele and Deborah. He moved to Brooklyn, found a permanent job that he liked, as a vacuum sweeper in a warehouse, and in the early 1970s began working with the NAACP to get his parole violation expunged. After a lengthy battle, the state of Alabama eventually relented, and in October 1976 Governor George Wallace granted Norris an official pardon. Norris was later diagnosed with Alzheimer's disease and died in January 1989. None of the Scottsboro Boys or their families has ever received compensation for their wrongful arrests and imprisonment.

Some historians have depicted the campaign to free the Scottsboro Boys as a harbinger of the post–World War II civil rights movement that challenged and finally ended legal segregation and second-class citizenship for African Americans. Others have viewed the case as one of the first modern global campaigns for human rights, a forerunner of efforts to win the release of political prisoners from Andrei Sakharov to Nelson Mandela. Both assessments are true, but the Scottsboro Boys knew instinctively that the *reasons* for their imprisonment and inhumane treatment were brutally simple. As Olen Montgomery told a Tuskegee psychiatrist in 1937, "I'm just being held here because I'm a Nigger. That's why I'm in jail; not nothing I've done" (Goodman, 275).

FURTHER READING

Carter, Dan T. *Scottsboro* (1969, rev. ed., 1979).
Goodman, James. *Stories of Scottsboro* (1994).

Miller, James A., et al. "Mother Ada Wright and the International Campaign to Free the Scottsboro Boys, 1931–1934," *American Historical Review* (Apr. 2001).

Norris, Clarence. *The Last of the Scottsboro Boys* (1979).

Patterson, Haywood. *Scottsboro Boy* (1950).

STEVEN J. NIVEN

SISSLE, Noble

(10 July 1889–17 Dec. 1975), vocalist, lyricist, and orchestra leader, was born in Indianapolis, Indiana. His early interest in performance was influenced by his father, George Andrew, a Methodist Episcopal minister and organist, and by his schoolteacher mother, Martha Angeline, who stressed good diction. When he was seventeen the family moved to Cleveland, Ohio, and Sissle attended the integrated Central High School. Sissle had begun his professional life by joining Edward Thomas's all-male singing quartet in 1908, which toured a Midwest evangelical Chautauqua circuit. Upon graduating from high school, Sissle toured again, this time with Hann's Jubilee Singers. After brief enrollments at DePauw University and Butler University in Indiana, Sissle got his show business break when he was asked by the manager of the Severin Hotel to form a syncopated orchestra in the style of JAMES REESE EUROPE. Syncopated orchestras (also known as "society orchestras" and "symphony orchestras") played dance arrangements, restructured from the violin-based music of traditional dance orchestras, to feature mandolins, guitars, banjos, and saxophones. As the music historian Eileen Southern notes, the syncopated orchestra sound was not "genuine ragtime, but it was nevertheless a lusty, joyful music, full of zest" (347). Sissle's pioneering work with syncopated orchestras formed the basis for his important contributions to the newly developing sounds of American popular music, dance music, and musical theater.

In the spring of 1915 Sissle was offered a summer job as a vocalist and bandolin player for Joe Porter's Serenaders. He moved to Baltimore, where he met his first and most significant collaborating partner, EUBIE BLAKE, who had published his first piano rag at the age of fifteen and honed his craft by studying great ragtime pianists. When Blake met Sissle, he said: "You're a lyricist. I need a lyricist." Soon Sissle and Blake, with Eddie Nelson, wrote their first hit. "It's All Your Fault" was recorded by the

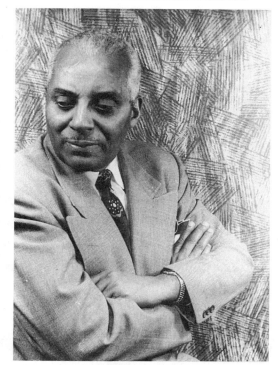

Noble Sissle, composer and co-creator of such celebrated American musicals as Shuffle Along. *(Library of Congress/Carl Van Vechten.)*

singer Sophie Tucker and netted the trio two hundred dollars. In the fall and winter of 1915–1916 Sissle played with Bob Young's sextet in Baltimore, Palm Beach, and other Florida venues After playing in E. F. Albee's Palm Beach Week show at the Palace Theatre, New York, Sissle took a letter of introduction from the white socialite Mary Brown Warburton to James Reese Europe. Europe invited Sissle to join his Clef Club Symphony Orchestra. Sissle persuaded Europe to find work for Blake, and Sissle himself had his own small orchestra gig in New Jersey.

When Sissle and Europe joined the army in 1917 upon the entry of the United States into World War I, the band they formed, the 369th U.S. Infantry Jazz Band, toured as the Hell Fighters. Their command performance in Paris, France, in 1918 electrified the crowd of thirty thousand. During their tour of duty, Europe and Sissle wrote songs together and sent them back to Blake (who, at thirty-five, was too old to enlist), who put them to music. Such songs

as "Too Much Mustard," "To Hell with Germany," "No Man's Land Will Soon Be Ours," and "What a Great, Great Day" clearly reflected the patriotic fervor of the period. With the end of the war, Sissle, Blake, and Europe began discussing a new musical. The tragic murder of Europe at the hands of a disgruntled band member in May 1919 cut short his participation in the musical genre. Sissle and Blake went on to become true songwriting partners in New York. The words of the hit song "Syncopation Rules the Nation" became a reality as they put the roar in the "Roaring Twenties."

Encouraged by Europe's former managers, Sissle and Blake reworked their material from the Clef Club shows and became the Dixie Duo on the Keith Orpheum vaudeville circuit. Blake banged out songs on an onstage upright piano, instead of a more traditional minstrel instrument such as the banjo or violin. However, the Dixie Duo's performances were greatly influenced by blackface minstrelsy. Sissle and Blake, and other African American duos such as BERT WILLIAMS AND GEORGE WILLIAM WALKER (billed as "Two Real Coons"), existed on the narrow band between blackface minstrelsy and vaudeville. The racist and sexist joke material of minstrelsy was still standard, as was the glorification of plantation life "befo' de War." Progress was made beyond the stereotype through the innovations of ragtime music and by adopting sophisticated dress. By playing ragtime music but not performing in blackface, Sissle and Blake further separated black popular entertainment from its artistic dependency on minstrelsy.

In 1920, after seeing Sissle and Blake perform at an NAACP benefit performance in Philadelphia, Pennsylvania, Aubrey Lyles and Flournoy E. Miller asked them to collaborate on a new musical. Miller and Lyles, a vaudeville comedy duo who had met while students at Fisk University in Nashville, were interested in developing one of their comedic routines, "The Mayor of Dixie" (c. 1918), into a musical comedy. Miller believed blacks could and should perform in white theaters, but only in musical comedy. From 1910 to 1917 all-black musical shows had begun to define Broadway as the place for black talent. However, after 1917 black theater had experienced, in the words of JAMES WELDON JOHNSON, a "term of exile."

By 1921 Sissle and Blake had completed their development work in black popular music and theater and were ready to introduce their sound to mixed audiences. They did so in two musical theater productions, *Shuffle Along* (1921) and *Chocolate Dandies* (1924, initially titled "In Bamville"), which moved black musical theater further from its roots in blackface minstrelsy and vaudeville.

Shuffle Along was actually a hodgepodge of material gleaned from the work of Miller and Lyles and the Dixie Duo of Sissle and Blake. But with the song "Love Will Find a Way," Sissle and Blake wrote the first romantic love song between two African Americans performed on Broadway. During the opening night performance in New York City, Miller, Lyles, and Sissle stood waiting by the stage door as Lottie Gee and Roger Matthews sang the song, ready to flee if the audience turned violent; they didn't, and the show was an overwhelming hit. Another landmark aspect of *Shuffle Along* is that the Sixty-third Street Theatre allowed blacks and whites to sit together in the orchestra seats. It also introduced the Broadway audience to a host of great African American performers, both during its New York run and its subsequent tour. In addition to Miller, Lyles, Sissle, and Blake, such notable performers as Gee, Gertrude Saunders, ADELAIDE HALL, JOSEPHINE BAKER, FLORENCE MILLS, and PAUL ROBESON were in the cast at various points. Orchestra members included WILLIAM GRANT STILL, the composer, as an oboist. But the great success of *Shuffle Along* also depended on prescribed conventions. Its creators were extremely anxious about introducing jazz music and dance to Broadway; Blake worried that "people would think it was a freak show." For example, the orchestra members had to memorize their parts, because, as Blake stated, white people were uncomfortable with seeing blacks read music. The creators of *Shuffle Along* had to strike a fine balance between the skill and professionalism integral to creating a great musical comedy, and the white audience's unease with the presentation of such a piece being written, composed, directed, and performed by blacks.

After the tremendous triumph of *Shuffle Along*, Miller, Lyles, Sissle, and Blake had difficulty deciding what to do next and opted to go their separate ways. Sissle and Blake wrote twelve songs for the musical *Elsie* (1923); they were jobbed in for the music only and had no influence on the production. They then worked on a new musical that became *Chocolate Dandies*. With a cast of 125, *Dandies* was an elaborate musical modeled on the revues of Florenz Ziegfeld and George White. Written by Sissle

and Lew Payton, with music by Sissle and Blake, *Dandies* was Sissle and Blake's attempt to build a musical from the ground up. Staged in the South, *Dandies'* Bamville is a town where all life is centered on a racetrack. It recognizes the performance legacy of blackface minstrelsy and also pokes fun at it, as in Sissle's lyrics for the most overtly minstrelsy-influenced number in the show, "Sons of Old Black Joe": "Though we're a dusky hue let us say to you / We're proud of our complexion." Sissle and Blake were able to create a musical comedy that was enjoyable but also mildly critical of musical theater's racist history. And their cast reflected, again, some of the greatest performers of their day, including Johnny Hudgins, Baker, VALAIDA SNOW, Gee, and Sissle, with Blake leading the band. In the end, *Chocolate Dandies* was not more economically successful for Sissle and Blake than *Shuffle Along*, but they considered it their greatest collaborating achievement.

After *Chocolate Dandies* closed in May 1925, with a loss of sixty thousand dollars, Sissle and Blake returned to vaudeville. A European tour soon followed, and the pair toured England, Scotland, and France billed as the "American Ambassadors of Syncopation." They were commissioned to write songs for Charles B. Cochran's (the Ziegfeld of England) revues. Sissle wanted to continue living in England, but Blake was unhappy with life there, so they returned to the United States, with Sissle resentful that he could no longer work for Cochran. In 1927 Sissle returned to Europe, where he toured France and England. With the encouragement of Cole Porter, he formed an orchestra for Edmond Sayag's Paris café Les Ambassadeurs, performing as the Ace of Syncopation. Sissle's band included many expatriate black musicians, including SIDNEY BECHET. In 1930 the Duke of Windsor played drums with Sissle's orchestra when it played for the British royal family in London. The orchestra took its first American tour in 1931, playing at the Park Central Hotel in New York and on a CBS nationwide radio broadcast. Meanwhile, Sissle and Blake reunited with Flournoy Miller to write *Shuffle Along of 1933*. The revision proved to be unpopular in the Depression-laden times, running for only fifteen performances in New York and touring briefly. Sissle returned to his orchestra in February of the same year, touring from 1933 through the late 1940s. Sissle also wrote and helped stage a pageant in Chicago, *O, Sing a New Song*, choreographed by the young Katherine Dunham. Lena Horne, Billy Banks, and Bechet all toured with Sissle at various points during this period. Sissle married his second wife Ethel in 1942 and became a father with the birth of Noble Jr. and Cynthia. (His first wife was Harriet Toye, whom he'd married on Christmas Day of 1919; their relationship had ended by 1926.) During World War II he toured a new version of *Shuffle Along* with the USO. After 1945 Sissle became increasingly involved in life away from the stage. He was a founder and the first president of the Negro Actors Guild and became the honorary mayor of Harlem in 1950. Both Sissle and Blake were involved with the Broadway production of *Shuffle Along 1952*. Developed as a star vehicle for Pearl Bailey (who dropped out of the production), *Shuffle Along 1952* was changed through "modernization" and was an artistic and box office failure, and Sissle himself was injured when he fell into the orchestra pit during a rehearsal. His last recording, *Eighty-six Years of Eubie Blake*, was recorded with Blake in 1968.

Sissle died in Tampa, Florida. With James Reese Europe and Eubie Blake, and in his own work as an orchestra leader, Sissle created the sounds of syncopated dance music, ragtime, and musical theater that defined American music in the first third of the twentieth century.

FURTHER READING

Kimball, Robert, and Bolcom Williams. *Reminiscing with Noble Sissle and Eubie Blake* (1973).

Krasner, David. *A Beautiful Pageant: African American Theatre, Drama, and Performance in the Harlem Renaissance, 1910–1927* (2002).

Southern, Eileen. *The Music of Black Americans: A History* (1997).

Obituary: New York Times, 18 Dec. 1975.

DISCOGRAPHY

The Eighty-six Years of Eubie Blake (1969).

James Reese Europe and the 369th U.S. Infantry "Hell Fighters" Band, Featuring Noble Sissle (1996).

Sissle and Blake's Shuffle Along. Selections (1976).

ANNEMARIE BEAN

SMITH, Albert Alexander

(17 Sept. 1896–3 Apr. 1940), painter, printmaker, and jazz musician, was born in New York City, the only child of immigrants from Bermuda Albert Renforth Smith, lifelong chauffeur to newspaper publisher Ralph Pulitzer, and Elizabeth A. Smith, a homemaker. After graduating from Public School

No. 70 in 1911, Smith attended the DeWitt Clinton High School for two years. He began studying art under Irene Weir in 1913 and was the first African American to receive a Wolfe scholarship at the Ethical Culture Art High School. In 1915 Smith became the first African American student at the National Academy of Design, where he studied painting under Douglas Volk, etching with William Auerbach-Levy, and mural painting with Kenyon Cox. There he won honorable mention and the Suydam Bronze Medal in his first- and second-year classes (1915, 1916), two prizes from the academy poster competition, and the Suydam Medal for charcoal work in a life-drawing class (1917). He also published an illustration, *The Fall of the Castle*, which depicted African Americans marching up a hill ready to dismantle a fortress labeled "Prejudice," in the National Association for the Advancement of Colored People magazine *The Crisis* in 1917.

When the United States entered World War I, Smith enlisted in the 807 Pioneer Band of the American Expeditionary Force and served overseas for two-and-a-half months. In 1919 he received an honorable discharge from the army and returned to the National Academy of Design, where he was awarded a John Armstrong Chaloner Paris Foundation first prize for painting from life, as well as a first prize in etching. In 1920 *The Crisis* published Smith's drawings, *The Reason* (depicting a Southern African American fleeing North, while a black man hangs from a tree in the background) and *They Have Ears But They Hear Not* (which showed a chained black man on trial before a Southern white judge and jurors wearing earphones). That year he also produced an etching called *Plantation Melodies*, which showed folks enjoying banjo, fiddle, guitar, and harmonica music in front of a cabin. *The Crisis* published the image and a column about the artist, and the print won a prize from the children's magazine *Brownies Book*.

Smith worked briefly as a chauffeur before expatriating to Europe in 1920. During his first two years abroad, he worked as a musician by night and an artist by day, producing mostly images of tourist spots in France. He exhibited these at the Salon of 1921 in Paris and at the New York Public Library in 1921 and 1922. His drawing *Plantation Melodies* was exhibited in 1922 at the Society of Independent Artists in New York and the Tanner Art League in Washington, D.C., where it earned a gold medal.

The drawing would also later be exhibited at the New York Public Library.

Smith spent the first half of 1922 in Italy. His art began to celebrate black achievements and racial uplift, as in his print of *René Maran*, the black French novelist who won the Prix Goncourt in 1921. He executed a series of portrait etchings of great black leaders, perhaps at the request of ARTHUR SCHOMBURG, librarian at the 135th Street branch of the New York Public Library. Smith sent Schomburg rare books and materials on black culture he found throughout Europe.

Also in 1922 Smith moved to Montmartre, the center of black expatriate life in Paris. He played the banjo at many of the nightclubs in this neighborhood where he would maintain residence for the rest of his life. During most of 1923 and 1924, Smith lived in Belgium, performing in Brussels and studying printmaking at the Académie des Beaux-Arts in Liège under François Maréchal. He also began to draw magnificent scenes of ancient Ethiopia, such as *Visions of Ethiopia* (1923) and *The Builders of the Temple* (1924), which appeared on covers of *The Crisis*.

Smith's prints of European tourist scenes were exhibited at the Brooklyn Society of Etchers from December 1924 to January 1925. Back in France, Smith continued drawing tourist scenes and themes of racial discrimination and racial uplift until 1926. During the following two years, Smith mostly drew anonymous Europeans, especially the Spanish and the French, after having traveled to Seville, Bilbao, and Madrid earlier that year.

In the late 1920s and early 1930s, Smith worked primarily in Paris, performing on radio and in the nightclubs La Coupole, Zelli's, and the Café de Paris. Only two of his etchings depicted the French cabaret atmosphere, *Montmartre, Paris* and *Bal Musette*, both from 1928. Smith honored the origins of the banjo in the *chera masingo* in the drawing *A Fantasy Ethiopia* (1928) and the Abyssianian ten-stringed harp, the *beganeh*, in an oil painting, *Ethiopian Music* (1928), which was published on the cover of *Opportunity* magazine. Around this time, the Harmon Foundation in New York embraced Smith's work, showing two dozen of his pieces between 1928 and 1933 and awarding him a bronze medal in 1929. That same year, his work was also shown at the Smithsonian Institution in Washington, D.C. More common in his work were caricature-like black banjo players in stock settings, such as *Do*

That Thing, Temptation, and *Dancing Time,* all from 1930.

After a short trip to Italy, Smith was rejected for a Guggenheim Fellowship in 1934, as he had been previously in 1929. While Smith's artistic productivity slowed in the mid-1930s, he exhibited every year at the American Artists Professional League in Paris from 1935 to 1938. In 1937 his interest in portraiture revived and he produced a watercolor series of great black historic leaders, including painter HENRY OSSAWA TANNER (also an expatriate in Paris) and novelist Victor Séjour, as well as black Cubans, Haitians, Ethiopians, Spanish, and Frenchmen. In 1939 Smith's work was included in the Contemporary Negro Art exhibition at the Baltimore Museum of Art, and he created a series of drawings with Arabian themes; however, these pieces were apparently lost. In 1940 Smith died suddenly of a brain clot in Haute-Savoie, France, at the age of forty-four. In his lifetime he produced more than 220 prints, drawings, and paintings, many which have been in the Library of Congress and the New York Public Library.

FURTHER READING

Allen, Cleveland G. "Our Young Artists," *Opportunity* (June 1923).

Leininger-Miller, Theresa. "Playing to American and European Audiences: Albert Alexander Smith Abroad, 1922–1940," *New Negro Artists in Paris: African American Painters and Sculptors in the City of Light, 1922–1934* (2001).

McGleughlin, Jean. "Albert Alexander Smith," *Opportunity* (July 1940).

Weintraub, Laurel. "Albert A. Smith's *Plantation Melodies*: The American South as Musical Heartland," *International Review of African American Art* (2003).

THERESA LEININGER-MILLER

SMITH, Bessie

(15 Apr. 1894?–26 Sept. 1937), blues recording artist and performer, was born in Chattanooga, Tennessee, the third of seven children, to William Smith and Laura (maiden name unknown). The exact date of Bessie's birth is unknown, partly because in the rural and poor place in which she was born the official records of African Americans were given little care. The abject poverty in which Bessie's family lived contributed to the death of her eldest brother, who died before Smith was born, and her father, a

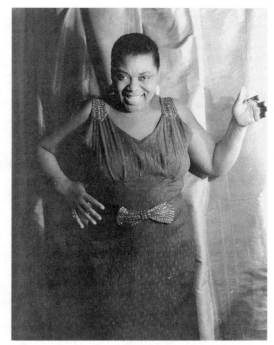

Bessie Smith, the jazz and blues singing great, photographed on 3 February 1936. (Library of Congress/Photographed by Carl Van Vechten.)

part-time Baptist preacher, who died shortly after her birth. By the time Bessie was eight or nine, her mother and a second brother had died. Viola, the oldest sister, raised the remaining brothers and sisters.

There are a number of gaps in the record of Smith's career, some of which have been filled by myth. There is evidence that she began singing when she was nine—performing in the streets of Chattanooga for nickels and dimes with her brother Andrew, who played the guitar. Her first professional opportunity came when her oldest surviving brother, Clarence, arranged an audition for a traveling show owned by Moses Stokes, which included, among others, MA RAINEY. Legend has it that Rainey kidnapped Smith, teaching her how to sing the blues while taking her throughout the South. Actually, Smith did not need Rainey's coaching, since she had a natural talent, with unparalleled vocal abilities and a remarkable gift for showmanship.

No one knows how long she stayed with Stokes's show, but there is evidence that Smith spent a long time performing at the 81 Theater in Atlanta, Georgia. Her shows there earned her only ten dollars a week, but her audiences were so taken by the power of her voice that they would throw money on the stage. Records show that she had begun touring with the Theater Owners' Booking Association and Pete Werley's Florida Blossoms troupe by 1918. Aside from singing, her performances for these shows included dancing in chorus lines and performing comedy routines. As Smith made her rounds in the southern circuits, she gathered increasing numbers of adoring fans and became known to producers like Frank Walker of Columbia Records, who hired her years later and supervised her 1923–1931 recording sessions.

Smith met and married Earl Love, a man about whom little is known, except for the fact that he came from a prominent black southern family and that he died shortly after his 1920 marriage to Smith. After his death, Smith moved to Philadelphia, Pennsylvania, where she met Jack Gee, a night watchman, whom she married in 1923 and with whom she adopted a child, Jack Gee Jr. Smith and Gee's marriage was passionate but tumultuous and they separated in 1929.

During the early 1920s Smith's career developed rapidly. She began performing at the Standard Theater in Philadelphia and Paradise Gardens in Atlantic City, and by 1923 she had recorded her first song, "Downhearted Blues," for Columbia Records. Though another blues singer had recently recorded and popularized the song, Smith's version sold seventy-eight thousand copies in less than six months. Following this success, Smith recorded seven more songs, this time with the piano accompaniment of FLETCHER HENDERSON. Smith then toured the South, where she was greeted as the star she was quickly becoming.

Like most blues singers of her time, Smith sang of love and sex and, in particular, of the challenges black men and women face in romantic relationships. But Smith was able to evoke the vigor of sex and the joy and sorrow of love in ways few others could match. Her slow tempos and deeply felt inflections enraptured her audiences, who remained largely African American. When she sang of love, she sang of love lost, often to infidelity and sometimes to death. But while she expressed the grief of such loss, she also projected the image of the loud-talking mama who would not take life passively. Smith drew easily on her own life to project this image. Her life with Gee was plagued by infidelity, though Gee was not the only guilty party; Smith was known for her affairs, some of them with women. No one knows when Smith began to have female lovers; some assume, without any actual evidence, that the first was Ma Rainey. By 1926 there was public knowledge of her relationship with a chorus girl from her troupe.

Smith sang her life story, and audiences and listeners felt that she was singing theirs. Her music did so well that it was said that people who did not have money to buy coal bought Bessie Smith records. By 1925 she had recorded nine more, with a young cornet player named LOUIS ARMSTRONG. By the end of her career, Smith had sold between 8 and 10 million records and recorded a total of 160 sides.

Yet Smith never forgot what she had left behind in the South. In her "Back Water Blues," she poetically evokes the sorrow of a people forced out of their homes by floods in the Louisiana backlands, while presenting a subtle statement of social protest. She also testified to the poverty that plagued African Americans in northern urban centers. In "Poor Man's Blues," which she wrote and which some consider her finest record, Smith eloquently exposes the "cruel irony of poverty in the land of riches" (Harrison, 70). Smith sang about the sickness and despair—often accompanied by alcoholism and drug addiction—that afflicted communities besieged by racism and inequality, and she sang of the rage that resulted from these ills. "Her blues could be funny and boisterous and gentle and angry and bleak, but underneath all of them ran the raw bitterness of being a human being who had to think twice about what toilet she could use" (Shapiro and Hentoff, 127).

Smith met the world with a bold toughness of spirit. She generally gave people—no matter their race or background—a tongue-lashing if they gave her trouble and sometimes she actually used physical force. She literally beat pianist CLARENCE WILLIAMS because he had been pocketing money that should have been hers. Her boldness, coupled with her immense talent, allowed Smith to earn as much as two thousand dollars per week. However, with artistic and monetary success came problems. Smith, who had always had a taste for alcohol, began to drink heavily when she became estranged from her husband. By the time she and Gee separated,

her drinking had begun to make her temperamental and unreliable as an artist. She turned from a "hard-working performer who ran her shows with military discipline into a mean drunk who thought nothing of breaking a contract or leaving a troupe stranded penniless in some godforsaken town" (Albertson, 111). She also squandered the money she made. While some of her profligacy with money was due to the fact that she was generous—Smith was a renowned for giving money to friends in need—much of it was also a result of her destructive behavior.

Her problematic behavior, the impact of the Depression, changes in musical tastes, and the negative effect of the advent of radio on the record industry conspired to bring about Smith's decline. By 1931 Columbia Records was forced to drop her, as the sales of her records had decreased dramatically. Smith attempted to revise her repertoire, and in 1929 she starred in a Broadway show and acted in the motion picture *St. Louis Blues* in order to save her career. But the efforts proved fruitless—while she could still pack shows, her record sales continued to drop. Yet the power of her art was still evident. "Nobody Knows You When You're Down and Out," which she recorded that same year, captures the sorrow of her own decline as it speaks to a larger truth.

Smith died in a car crash in Clarksdale, Mississippi, in 1937, still trying to regain her professional footing. According to popular myth, she died because a whites-only hospital refused to admit her. The truth is that Smith could have been taken sooner to the African American hospital where she died, but it is unlikely that she could have survived given the seriousness of her injuries. Known as the Empress of the Blues, Smith laid the foundation for all subsequent women's jazz and blues singing, influencing hundreds of musicians and singers, among them Louis Armstrong, BILLIE HOLIDAY, and Mahalia Jackson. Ironically, no one from the music industry attended her funeral. In contrast, the number of adoring fans attending was seven thousand strong, and she continues to be loved today.

FURTHER READING

Albertson, Chris. *Bessie* (1972).

Davis, Angela Y. *Blues Legacies and Black Feminism* (1998).

Harrison, Daphne D. *Black Pearls: Blues Queens of the 1920s* (1988).

Shapiro, Nat, and Nat Hentoff, *The Jazz Makers* (1957).

DISCOGRAPHY

The Bessie Smith Collection, (Columbia CK 44441).

Bessie Smith: Empress of the Blues (Charly Records CDCD 1030).

The Bessie Smith Story (vols. 1–4, Columbia CL 855–858).

GLENDA R. CARPIO

SMITH, Chris

(12 Oct. 1879–4 Oct. 1949), songwriter and vaudeville performer, was born Christopher Smith in Charleston, South Carolina, the son of Henry Mirtry, a shoemaker, and Clara Browne.

A baker by trade, Smith learned to play the piano and guitar by himself and showed much interest in and took part in local entertainment. He left Charleston with his friend Elmer Bowman to join a medicine show while they were "still in short pants," as he told Edward B. Marks. Smith and Bowman went to New York sometime in the 1890s and formed a vaudeville act billed as Smith Bowman. Smith began to publish songs in the late 1890s, and his "Good Morning Carrie!" (1901), written with Bowman, was his first major hit.

In the late 1890s and the 1900s Smith was an important member of the community of black entertainers in New York, home to a flowering of black theatricals, developments in the popular music publishing business, and the growing popularity of ragtime music. Smith was closely affiliated with Gotham-Attucks Music Co., one of the first black-owned publishing houses. Gotham-Attucks represented many songwriters and performers, including WILL MARION COOK, BERT WILLIAMS, CECIL MACK, Alex Rogers, William Tyers, JAMES REESE EUROPE, Tom Lemonier, TIM BRYMN, Henry S. Creamer, and FORD DABNEY. With Cecil Mack, the head of the firm, Smith formed a successful songwriting team, scoring hits such as "He's a Cousin of Mine" (1906). Smith was also a close associate of Bert Williams, supplying many songs throughout Williams's career. Several of Smith's songs were featured in the Williams and George Walker show *Bandanna Land* in 1908. During this period Smith's songs were also popularized by white stars such as May Irwin and Marie Cahill.

From early on, Smith was acquainted with the firm of Jos. W. Stern & Co., the major publisher of Smith's songs throughout most of his career.

Edward B. Marks, the cofounder of the firm, indicated in his autobiography that he had known Smith since 1895 and praised the longevity of Smith as a successful songwriter.

Many of Smith's works during the early period of his career were ragtime songs, a new genre of popular song introduced to the mainstream in the late 1890s. Ragtime songs were noted for their vigorous syncopation. This kind of song played an important role in the development of black musical comedies and in the prosperity of Jos. W. Stern and other Tin Pan Alley publishers in the 1900s. Smith's songs were also noted for their combination of rhythmic vitality, interesting, often unusual harmonies, and felicitous lyrics.

In the 1910s Smith was active in vaudeville, teaming with George Cooper and Billy B. Johnson. In 1913 Smith produced his most famous song, "Ballin' the Jack," whose popularity can be understood in the context of the modern dance movement of the early 1910s. This song is noted for Smith's use of ingenious harmonies and for James Burris's lyrics describing dance steps, and it was later revived on many occasions, including the 1942 motion picture *For Me and My Gal*, starring Judy Garland and Gene Kelly, and *On the Riviera* (1951), starring Danny Kaye.

In the early 1920s Smith was engaged in the realm of private entertainment as well as in songwriting. According to the trumpeter Rex Stewart, Smith belonged to the Clef Club cliques, which "were the aristocracy . . . the bigwigs who played Miami Beach, Piping Rock, Bar Harbor, and all the other posh resorts where society gathered to follow the sun." At this time Smith was associated with some important blues and jazz musicians of the day, such as PERRY BRADFORD, MAMIE SMITH, CLARENCE WILLIAMS, and W. C. HANDY. Smith also collaborated with the comedian Jimmy Durante.

Although Smith was a prolific songwriter until the mid-1920s, he did not become a member of the American Society of Composers, Authors, and Publishers (ASCAP) until 1931. In the 1930s and 1940s the number of Smith's new compositions declined, but he continued writing songs until his death in New York City. Little is known about his personal life. He was married and had at least two daughters, but other specifics are not known.

Smith is representative of the generation of black musicians who entered the entertainment field in New York around the turn of the century. They wrote songs in a distinctly black musical idiom and

led successful careers in both songwriting and performing. Most of his collaborators came from the same pool of black talent and included Elmer Bowman, Cecil Mack, Harry Brown, Billy B. Johnson, John Larkins, James Burris, Tim Brymn, and Henry Troy, many of whom provided lyrics to Smith's melodies.

Well-known works other than those mentioned above are "I Ain't Poor No More" (1899), "Shame on You" (1904), "All In, Down and Out" (1906), (1906), "Down among the Sugar Cane" (1908), "You're in the Right Church but the Wrong Pew" (1908), "There's a Big Cry Baby in the Moon" (1909), "Come after Breakfast" (1909), "Constantly" (1910), "Honky Tonky Monkey Rag" (1911), "Beans, Beans, Beans" (1912), "I've Got My Habits On" (1921), "Cake Walking Babies from Home" (1924), and "Of All the Wrongs You've Done to Me" (1924).

Another important aspect of Smith as a songwriter is his opposition to the use of the derogatory term *coon* in the popular songs of the late 1890s. According to TOM FLETCHER, a black entertainer and one of Smith's close associates, Smith's refusal to use the term in the song "Good Morning Carrie!" started the turn away from "coon songs" around the turn of the century.

FURTHER READING
Fletcher, Tom. *100 Years of the Negro in Show Business* (1984).
Marks, Edward B. *They All Sang: From Tony Pastor to Rudy Vallee* (1934).
Shim, Eunmi. *Chris Smith and the Ragtime Song* (1993).
Obituary: Amsterdam News, 8 Oct. 1949.

EUNMI SHIM

SMITH, Clara

(1894–2 Feb. 1935), blues and vaudeville singer, was born in Spartanburg, South Carolina. Nothing is known of her parents, including their names, or of her childhood. In about 1910 she began touring the South as a vaudeville performer. Probably in 1920 she joined the new Theater Owners' Booking Association circuit, in which context the guitarist Lonnie Johnson recalled working with Clara and MAMIE SMITH (no relation) in New Orleans. He said that Clara was "a lovely piano player and a lovely singer" (Oliver, 135).

In 1923 Smith came to New York and began singing in Harlem clubs and began a recording

career that stretched to 1932. She became the most frequently recorded classic blues singer after BESSIE SMITH (also no relation). Disks from 1923 include "I Never Miss the Sunshine," "Awful Moanin' Blues" (documenting her nickname, "Queen of the Moaners"), and "Kansas City Man Blues." In 1924 she recorded "Good Looking Papa Blues," "Mean Papa, Turn in Your Key," "Texas Moaner Blues," "Freight Train Blues," and "Death Letter Blues." That same year she opened the Clara Smith Theatrical Club in New York while resuming her extensive touring. Visits to the West Coast reportedly extended into 1925, and she performed in Nashville, Tennessee, although she also worked at a theater in Harlem and recorded regularly in New York that year. Cornetist LOUIS ARMSTRONG was among Smith's accompanists on "Nobody Knows the Way I Feel 'Dis Mornin'," "My John Blues," and "Shipwrecked Blues," a morbidly chilling account of drowning and one of the earliest examples of a twelve-bar blues consistently in a minor key. Further sessions from 1925 include "My Two-Timing Papa" and two uninspired duets with Bessie Smith. Later that year the two Columbia Records blues stars became drunk at a party and got into a fistfight, with Bessie severely beating Clara; this fight ended their friendship and their collaborations.

In 1926 Smith married Charles "Two-Side" Wesley, a manager in the Negro baseball leagues; no children are mentioned in biographies or in Smith's obituary. Her recordings from 1926 include "Whip It to a Jelly," "Salty Dog," "My Brand New Papa," and two gospel songs. She had her own *Clara Smith Revue* at the Lincoln Theatre in 1927, and she continued working in Harlem theater revues until 1931. She recorded "Jelly Look What You Done Done," "Gin Mill Blues," and "Got My Mind on That Thing" (all 1928); "It's Tight Like That" and "Papa I Don't Need You Now" (both 1929); and two vaudeville vocal duets with Lonnie Johnson, "You Had Too Much" and "Don't Wear It Out," these last two under the pseudonym Violet Green (1930).

Smith sang with Charlie Johnson's Paradise Band at the Harlem Opera House in 1931 and that year appeared in Philadelphia, Pennsylvania, in the African American cowboy show *Trouble on the Ranch*. She worked in Cleveland from around 1931 to 1932 before returning to New York, where she joined the drummer Paul Barbarin at the Strollers Club in about 1934. She also worked for six months at Orchestra Gardens in Detroit. Smith had just

returned to Detroit from further performances in Cleveland when she suffered heart trouble. Hospitalized for eleven days, she died of a heart attack. By the time of her death Smith was evidently separated from her husband, who could not be located.

Smith's singing straddled vaudeville and downhome blues styles. Her voice was slightly raspy. Moaning blue notes abounded, as for example in the session with Armstrong, but she enunciated lyrics clearly, using a southern African American pronunciation. In her first years of recording Smith favored lugubrious blues and vaudeville songs, but it may be obvious from titles listed above that she later followed a fashion for perky, risqué songs.

Smith was the subject of one of the finest contemporary descriptions of classic blues singing, written by Carl Van Vechten: "As she comes upon the stage through folds of electric blue hangings at the back, she is wrapped in a black evening cloak bordered with white fur. . . . Clara begins to sing:

All day long I'm worried;
All day long I'm blue;
I'm so awfully lonesome,
I don' know what to do;
So I ask yo', doctor,
See if yo' kin fin'
Somethin' in yo' satchel
To pacify my min'.
Doctor! Doctor!
(Her tones become poignantly pathetic; tears roll down her cheeks.)
Write me a prescription fo' duh Blues
Duh mean ole Blues.

. . . Her voice is powerful or melancholy, by turn. It tears the blood from one's heart" (105–108).

FURTHER READING

Bourgeois, Anna Stong. *Blueswomen: Profiles of 37 Early Performers with an Anthology of Lyrics, 1920–1945* (1996).

Oliver, Paul. *Conversation with the Blues* (1965).

Stewart-Baxter, Derrick. *Ma Rainey and the Classic Blues Singers* (1970).

Van Vechten, Carl. "Negro 'Blues' Singers: An Appreciation of Three Coloured Artists Who Excel in an Unusual and Native Medium," *Vanity Fair* (Mar. 1926).

Obituary: Chicago Defender, 9 Feb. 1935.

BARRY KERNFELD

SMITH, Mamie

(26 May 1883–30 Oct. 1946?), blues and vaudeville singer and film actress, was born Mamie Robinson in Cincinnati, Ohio. Nothing is known of her parents. At the age of ten she toured with a white act, the Four Dancing Mitchells. She danced in J. Homer Tutt and Salem Tutt-Whitney's The Smart Set Company in 1912 and then left the tour the next year to sing in Harlem clubs and theaters. Around this time she married William "Smitty" Smith, a singing waiter who died in 1928. At the Lincoln Theatre in 1918 she starred in Perry Bradford's musical revue *Made in Harlem*, in which she sang "Harlem Blues."

In 1920 Bradford persuaded a New York recording company, Okeh, to take a chance and record Smith, despite racist threats of a boycott. In February, Smith recorded Bradford's songs "That Thing Called Love" and "You Can't Keep a Good Man Down," accompanied by a white band; this disk was not immediately released because of an industry-wide patent dispute. In August, with a hastily organized African American band that came to be known as Smith's Jazz Hounds, Smith recorded "It's Right Here for You" and "Crazy Blues." The latter tune, a retitled version of "Harlem Blues," sold spectacularly well. Further female blues singers were sought after and recorded, and a new marketing category, "race records," was under way in the industry.

Bradford organized a touring Jazz Hounds band. Trumpeter Johnny Dunn and reed player Garvin Bushell were among Smith's accompanists in 1920. Trumpeter Bubber Miley replaced Dunn, perhaps early in 1921. Tenor saxophonist COLEMAN HAWKINS joined that summer, while Bradford placed Smith on the Theater Owners' Booking Association circuit and continued directing recording sessions. Immensely popular, Smith made huge earnings in royalties (reportedly nearly one hundred thousand dollars) and performance fees (often more than one thousand dollars per week), enabling her to purchase a lavishly furnished house on 130th Street. Dan Burley of the *Amsterdam News* reported, "There were servants, cars, and all the luxuries that would go with being the highest paid Negro star of that day" (24 Feb. 1940, 20). Smith bought a building on Saint Nicholas Place, which she later lost in the stock market crash, and another home in Jamaica, New York.

Because of Bradford's financial and touring disputes with Smith's second husband, Sam Gardner, and with her boyfriend and band manager, Ocey

(or Ocie) Wilson, Smith's contract was sold to a white manager, Maurice Fulchner, and Bradford left Okeh for the Columbia label to work with the singer EDITH WILSON. Later, Burley wrote, "Mister Bradford came to serve a summons on the blues queen on account of certain 'misunderstandings' having to do with his songs. Reports are that Mr. Bradford jumped roofs for a block and a half after Mamie got her gun" (9 Mar. 1940).

Late in 1922 Smith recorded "I Ain't Gonna Give Nobody None o' This Jelly-Roll" and "The Darktown Flappers' Ball." She continued to tour nationally with her Jazz Hounds. Hawkins remained with her until 1923, and in that year he may have worked alongside reed player SIDNEY BECHET with Smith at the Garden of Joy in New York. Featured in her own shows, Smith performed in theaters through the 1920s and into the 1930s. Among her recordings were "Goin' Crazy with the Blues," "What Have I Done?" (both from 1926), and "Jenny's Ball" (1931).

In 1929 Smith married a Mr. Goldberg (given name unknown), one of the brothers who managed and owned the Seven Eleven troupe in which she performed. No account of her marriage mentions children. She appeared in the film short *Jailhouse Blues* (1929) and costarred in *Fireworks of 1930*, a short-lived revue written and performed by FATS WALLER and JAMES P. JOHNSON. She worked with the band of the pianist and singer Fats Pichon from 1932 to 1934 and toured Europe around 1936, at which time she also led her Beale Street Boys at the Town Casino in New York. At some point in the 1930s Smith sang with Andy Kirk's big band.

Smith starred in a series of low-budget African American films: *Paradise in Harlem* (1940) with Lucky Millinder's big band, *Mystery in Swing* (1940), *Murder on Lenox Avenue* and *Sunday Sinners* (both 1941), and the soundie, a film short for video juke-boxes, *Because I Love You* (c. 1942), again with Millinder. Smith last sang in a concert at the Lido Ballroom in New York in August 1944. Confined to Harlem Hospital during a long illness, she died in New York.

Among classic female blues and vaudeville singers, Smith is celebrated more as a racial pioneer than as a great performer. Bushell recalled that "Mamie was a very fine-looking lady, had a nice personality, and was a bit higher cultured than a lot of the singers. She wasn't a low, gutbucket type of singer that they were wanting on records. . . . She usually had a husband who was a big bruiser, taking

all her money" (22). Derrick Stewart-Baxter wrote that "her voice lacked the richness of the truly great women artists who were to follow her into the recording studios. . . . Seldom was she really involved in what she was singing, and at times she lapsed into the sentimental. . . . There may appear to be an outward toughness, but occasionally the marshmallow at the roots comes to the surface" (10).

But Smith unquestionably had a special stage presence. The singer VICTORIA SPIVEY recalled seeing her for the first time:

> Miss Smith walked on that stage and I could not breathe for a minute. She threw those big sparkling eyes on us with that lovely smile showing those pearly teeth with a diamond the size of one of her teeth. Then I looked at her dress. Nothing but sequins and rhinestones, plus a velvet cape with fur on it. We all went wild. And then she sang—she tore the house apart. Between numbers while the band was playing she would make a complete change in about a minute, and was back in record time for her next selection. Her full voice filled the entire auditorium without the use of mikes like we use today. That was singing the blues! I was really inspired and kept plugging to become a singer.
> (quoted in Stewart-Baxter, 16)

This talent comes across reasonably well in Smith's late-career film roles, where she repeatedly steals the show, acting and singing in a manner that seems refreshingly natural and comfortable by comparison with and in spite of her consistently mediocre associates.

FURTHER READING

Burley, Dan. " 'Crazy Blues' and the Woman Who Sold 'Em," *Amsterdam News*, 17 Feb. 1940, continued as "The 'Crazy Blues,'" 24 Feb. 1940, 3 Mar. 1940, and 9 Mar. 1940.

Bushell, Garvin, and Mark Tucker. *Jazz from the Beginning* (1988).

Charters, Samuel B., and Leonard Kunstadt. *Jazz: A History of the New York Scene* (1962; rpt. 1981).

Chilton, John. *Who's Who of Jazz: Storyville to Swing Street*, 4th ed. (1985).

Placksin, Sally. *American Women in Jazz, 1900 to the Present: Their Words, Lives, and Music* (1982).

Stewart-Baxter, Derrick. *Ma Rainey and the Classic Blues Singers* (1970).

BARRY KERNFELD

SMITH, Trixie

(1895–21 Sept. 1943), blues and vaudeville singer, was born in Atlanta, Georgia. Nothing is known of her parents or of her childhood. Having studied at Selma University in Alabama, she went to New York City around 1915 to perform in clubs and theaters. She was at the New Standard Theater in Philadelphia in 1916, and she toured on the Theater Owners' Booking Association circuit, probably in 1920 and 1921.

While performing at Harlem's Lincoln Theatre and recording for the Black Swan label from 1921 to 1923, Smith furthered her fame by entering and winning a blues contest at the Manhattan Casino on 20 January 1922. Her recordings included "Trixie's Blues" (c. 1921; by some accounts she recorded it after winning the contest) and two titles accompanied by the cornetist LOUIS ARMSTRONG in 1925, "The World's Jazz Crazy and So Am I" and "Railroad Blues." In 1932 Smith appeared in the film *The Black King*. She continued working as a singer and actress in New York until 1933 and then in national tours until 1935. As the New Orleans jazz revival was just beginning to get under way she had an opportunity to record an outstanding session with the reed player SIDNEY BECHET's group in 1938, including "My Daddy Rocks Me." Smith made one further title, "No Good Man," with a jazz trio in 1939. She died in New York City.

Although little is known of Smith's life, she is remembered for her few recordings, which document her stature as one of the best classic blues and vaudeville singers. In her early work Smith's voice is high-pitched and penetrating. On some titles she seems uncomfortable singing blues. But "Railroad Blues" is dramatic and convincing, and it shows a fully idiomatic command of sliding blue notes. She articulates lyrics clearly yet retains some black English pronunciation. Thus her historical place among African American singers is midway between those who attempted to assimilate completely into the mainstream of American popular song, like ETHEL WATERS, and those who upheld rural southern traditions, like MA RAINEY—and whose pronunciation could verge on the indecipherable.

By the time of her 1938 recordings with Bechet, Smith's voice remained as penetrating as it did when it sounded more girlish, but it had acquired a full-bodied timbre. Whether this change reflects her physical maturity or whether it reflects a dozen or so

years of improvement in recording fidelity is hard to determine. It may be that better microphones captured what had been in her voice all along.

A far more significant development is represented by an excerpt from the lyrics of "My Daddy Rocks Me," the two-sided (six-minutes-long) 78-rpm record from the session with Bechet:

> My daddy rocks me, with one steady roll.
> There's no slippin' when he once takes hold.
> . . .
> I looked at the clock, and the clock struck ten.
> I said, "Gloooooooory, Aaaamen."
> He kept rockin' with one steady roll.
> . . .
> I looked at the clock, and the clock struck eleven.
> I said, "Now daddy, ain't we in heaven!"
> He kept rockin' with one steady roll.

Through her extroverted and heavy manner of delivering this irreverent blend of sex and religion, Smith claims her place in a path leading from the risqué African American cabaret singing of the 1920s to the soul music of the 1950s and 1960s.

FURTHER READING

Dixon, Robert M. W., and John Godrich. *Recording the Blues* (1970).

Harrison, Daphne Duval. *Black Pearls: Blues Queens of the 1920s* (1988).

Stewart-Baxter, Derrick. *Ma Rainey and the Classic Blues Singers* (1970).

BARRY KERNFELD

SMITH, Willie "the Lion"

(25 Nov. 1897–18 Apr. 1973), jazz pianist, was born William Henry Joseph Bonaparte Bertholoff in Goshen, New York, the son of Ida Oliver, a domestic worker, and Frank Bertholoff. In 1900 Ida expelled Frank from the household; he died the next year, and she married John Smith, who took the family to Newark, New Jersey, where he worked as a meat-wagon driver and later a mechanic. Willie attended Newark High School, where he excelled as an athlete.

Having begun to play the family's home organ by ear, Smith received lessons from his mother, a church pianist and organist. He worked for tips as a dancer but preferred piano and, after winning an upright piano in a contest, devoted himself to it, practicing pop songs and ragtime. From around

1911 he entertained in saloons in Newark. Although his music was informed by his background in the African American Baptist Church, Smith had been befriended by a Jewish family and had embraced Judaism, learning Hebrew as a child and becoming a bar mitzvah at age thirteen; later in life he served as a cantor at a synagogue in Harlem.

In the summers of 1915 and 1916 Smith worked in saloons in Atlantic City, New Jersey, initially as a replacement for EUBIE BLAKE. He also began to play professionally in New York City. The pianist Arthur Eck taught Smith to read music, and in exchange Smith improved Eck's improvisatory skills. At age nineteen Smith married Blanche Howard Merrill, a pianist (not the vaudeville songwriter of the same name); they separated after one year. Smith enlisted in the army in November 1916 and the following July was sent to France, where he played bass drum in Lieutenant TIM BRYMN's Regimental Band and where, by one account, his energy as a gunner earned him his nickname (Artie Shaw, however, attributed the nickname to the growls that Smith vocalized while playing piano). Late in 1919 Smith was discharged and returned to New York City. Reunited with his lifelong friend JAMES P. JOHNSON, whom he had met in 1914, and soon joined by their younger colleague FATS WALLER, he became a pioneer and a virtuoso in a new jazz style that came to be known as stride piano, a swinging and sometimes improvised offshoot of classic ragtime that features irregular patterns in which the left hand "strides" between the instrument's bass range and mid-range.

Smith performed at Leroy's in Harlem in 1919 and 1920. In August 1920 he organized and performed in the band that accompanied the singer MAMIE SMITH on the historic recording "Crazy Blues." Its success touched off a craze for "classic blues" (female African American blues and vaudeville singers with jazz bands), and it established a new marketing category that soon acquired the name "race records." As a member of the Holiday in Dixieland troupe, Smith performed in New York in April 1922 and then set out on a brief tour. In 1923, while working in Chicago, he heard some of the great New Orleans jazz musicians.

Back in Harlem by year's end, Smith performed at the Garden of Joy and then at the Capitol Palace, where future jazz soloists BUBBER MILEY and Jimmy Harrison sat in with the band. Many nights, after the Capitol Palace closed, he went to

the Rhythm Club, where the house band was led by SIDNEY BECHET and where emerging giants of jazz came to improvise. Smith took over the leadership and hired the soprano saxophonist JOHNNY HODGES when Bechet left in the spring of 1925. When the Rhythm Club moved, Smith stayed at the same location, now renamed the Hoofers' Club, and he changed the format from an open jam session to a tightly organized quartet that included the C-melody saxophonist Benny Carter. Smith played and acted in the drama *Four Walls* at the John Golden Theater on Fifty-eighth Street in New York City beginning in September 1927. When after 144 performances the show moved to Chicago, he, as usual, chose to stay in New York.

Throughout the mid- to late 1920s, Smith, Johnson, and Waller were in constant demand as solo pianists at rent parties in Harlem. Although the three friends were energetic to excess and lived wild lives, Smith, like Johnson (and unlike Waller), was nonetheless concerned with meticulous show-business mannerisms and a stylishly elegant and orderly presentation: a fine suit, a derby hat, and a cigar were fixtures of his appearance. He was intelligent, inquisitive, and opinionated, and (anticipating the 1960s) he was sensitive to good and bad "vibrations," which would determine his involvement in a given situation.

Smith spent about two years in the early 1930s at another Harlem club, Pods' and Jerry's (officially the Catagonia Club but known by the owners' nicknames). He discouraged sitting in, after the chaos of the Rhythm Club, but he made exceptions for talents like Bechet and the young Artie Shaw; Shaw played without pay for the experience of performing with Smith. At Pods' and Jerry's he met his future wife, then a married woman, Jennie Williams, also known as "Silvertop" or "Jane." Her maiden name, details of the marriage, and the number of their children, if any, are unknown.

Smith began working steadily for Joe Helbock on Fifty-second Street, and with the end of Prohibition in 1933, Helbock made the venue into a legitimate nightclub, the Onyx. Smith worked as intermission pianist at the nearby Famous Door from 1934 to 1935. During these years he recorded and broadcast with EVA TAYLOR in CLARENCE WILLIAMS's band. He may be heard as a soloist on "Somebody Stole My Gal" from a session on 3 October 1934 by a group of Williams's musicians recording under the name of the Alabama Jug Band. Also during this period Smith commenced formal studies with the pianist Hans Steinke, and he began to write pieces exhibiting an amalgam of jazz, blues, and European influences.

In 1935, with personnel drawn from Williams's circle, Smith made his first recordings as a leader, including his composition "Echo of Spring." After further sessions of his own in 1937, he agreed to a recording contract with the musically ponderous organist Milt Herth, an association he detested. In January 1938 he recorded two more compositions, "Passionette" and "Morning Air," in a duo with drummer O'Neil Spencer; these are firmly based in the irregularly leaping and swinging patterns of stride and thus exhibit Smith's usual approach to performance. For the Commodore label in January 1939 he made his most famous recordings: fourteen unaccompanied titles comprising popular songs and his own compositions, including "Concentratin'," "Fading Star," "Sneakaway," and "Finger Buster," as well as versions of some previously recorded pieces. The fourteen recordings summarize his twofold approach, alternately centered in the mainstream of the flamboyant stride piano tradition and exploring a sensitive twist on that tradition. In the best known of these, titled "Echoes of Spring" for the Commodore session (rather than "Echo of Spring"), his exuberant style is modified by a delicacy that hints at turn-of-the-century French piano impressionism and by a simple, repeated, loping accompanimental figure that perhaps owes more to boogie woogie piano than to the complexities of stride. The Tommy Dorsey and Artie Shaw orchestras performed arrangements of Smith's compositions in the 1940s, thereby bringing him a somewhat greater audience, although he was never famous outside the jazz world.

Smith worked in a trio with Bechet in the spring of 1939. In November, as members of the Haitian Orchestra, they recorded an odd session of arranged merengues, rhumbas, and Haitian melodies, notable for pioneering the concept of Caribbean jazz but not for the result. In 1940 he accompanied the blues singer Joe Turner, but unfortunately this pairing was a mismatch: Smith's musically florid and emotionally fluffy blues playing is temperamentally unsuited to Turner's raw style. In 1941 he recorded with Bechet's New Orleans Feetwarmers.

In the 1940s Smith worked at the Man About Town Club on Fifty-first Street and in dixieland

bands in Lower Manhattan, including the Pied Piper, where in 1944 he served as the pianist in the trumpeter Max Kaminsky's band while also engaging in legendary solo contests with the intermission pianist, his friend James Johnson. Smith also made regular trips to perform in Toronto. Hard living finally took its toll, and he ceased working temporarily. He returned to performing to tour Europe and North Africa from December 1949 through February 1950 and recorded for the Royal Jazz label in Paris. By this time he had arthritis in his fingers, and it slowly worsened over the years, but only the expert and cranky listener will find fault with these performances. His career continued unabated, and he recorded new versions of the Commodore solos for Royal Jazz in December 1950. Despite the strong compositional element in his own pieces, the recreations are substantially different from the originals of 1939. His dramatic, texturally thick, bent-for-hell readings of several of the popular songs, including "Stormy Weather," "Tea for Two," and "Between the Devil and the Deep Blue Sea," demonstrate the sort of playing that must have given the competition fits.

During the 1950s Smith worked regularly at the Central Plaza, and the film *Jazz Dance* captures him there in 1954. He hated the crass tastelessness of the music (the band was notorious for playing loudly and without regard for the sensitive aspects of musical taste), but he stayed at the Central Plaza until 1958. In the spring of that year he appeared in the third show ("Ragtime") of the television series "The Subject Is Jazz." Smith ceased performing in nightclubs and turned instead to colleges, country clubs, festivals, benefit concerts, and other less demanding work. He toured and recorded again in Europe in 1965 and 1966. In the spring of 1969 he was filmed playing in New York for the French documentary *L'Aventure du jazz* (1970). He died in New York City.

Smith was one of the most formidably talented stride pianists. Although not an innovator of the stature of Johnson, Waller, and ART TATUM, he was a central figure for a half century in the development and subsequent international dissemination of stride and related early jazz styles.

FURTHER READING

Smith, Willie "the Lion," with George Hoefer. *Music on My Mind* (1964; repr. 1975).

Obituary: New York Times, 19 Apr. 1973.

DISCOGRAPHY

Collison, John. "Willie 'the Lion' Smith." *Storyville*, nos. 132 (1 Dec. 1987), 133 (1 Mar. 1988), 134 (1 June 1988), 135 (1 Sept. 1988), 136 (1 Dec. 1988), 137 (1 Mar. 1989), 138 (1 June 1989).

BARRY KERNFELD

SNOW, Valaida

(2 June 1903–30 May 1956), jazz singer, lyricist, jazz trumpeter, band director, dancer, and actress, was born in Chattanooga, Tennessee, to Etta Snow, a Howard University–trained musician, and John Snow. Little is known about John Snow, but it is thought that he may have been white. Snow had at least two sisters, named Alvaida and Lavaida; she may have had other siblings as well. Snow began performing early in life but first achieved widespread recognition performing in Barron Wilkins's productions in New York in 1922. By 1924 she had appeared in a number of variety shows and musicals, including *Ramblin' Round* (1923), *Follow Me* (1923), and *In Bamville* (1924), the last by NOBLE SISSLE and EUBIE BLAKE. *In Bamville* was later renamed *Chocolate Dandies* and featured JOSEPHINE BAKER. In 1926 she traveled to London as the understudy for FLORENCE MILLS in *Blackbirds* (she would perform in *Blackbirds* again in London in 1929 and 1934). She soon traveled the world, playing locales such as Hong Kong, Rangoon, and Cairo. In Paris she performed with Maurice Chevalier, who became a close friend. In 1931 she was in a hit show on Broadway in New York, *Rhapsody in Black*, which starred ETHEL WATERS. Snow also directed the show's sixty-piece orchestra. In short, she was a multitalented and ubiquitous figure on the American and international musical theater scene in the 1920s and 1930s.

Snow was also an exceptional trumpet player. At a time when it was rare for women to play wind instruments, especially brass (something still rare today), Snow's playing was reportedly comparable to that of the greatest trumpet player alive at the time, LOUIS ARMSTRONG. Two prominent contemporary critics, Krin Gabbard and Will Friedwald, have slightly different takes on her approach to playing like Armstrong, with Gabbard claiming she developed a "distinctly Armstrongian style" and Friedwald claiming she "mimicked" Armstrong (Lusane, 168). At any rate, her Armstrong-like trumpet playing led to her nickname, "Little Louis."

Armstrong himself on one occasion had the chance to check out Snow's trumpet playing and other talents. In a 1928 performance in Chicago at the Sunset Café, Snow played the trumpet, sang, and then followed up with a specialty dance number, in which seven pairs of shoes were placed in a row at the front of the stage, and she did a dance in each pair for one chorus. The dances and shoes to match were: soft-shoe, adagio shoes, tap shoes, Dutch clogs, Chinese straw sandals, Turkish slippers, and the last pair, Russian boots. "When Louis Armstrong saw the show one night, he continued clapping after others had stopped and remarked, 'Boy I never saw anything that great'" (Reitz, 158).

In 1934 Snow married Ananais Berry, a dancer. Around this time she performed with Earl Hines in Chicago at the Grand Terrace. Also that year, she wrote a piece in the *Chicago Defender* opposing interracial relationships. In 1936 she toured with big band pioneer FLETCHER HENDERSON. Snow was apparently rather flashy, and there are reports (repeated by the pianist Bobby Short) of her wearing orchid-colored dresses and being driven around in an orchid-colored Mercedes-Benz with a chauffeur and pet monkey also dressed in orchid uniforms.

Snow also had a brief film career. She appeared in the French films *L'Alibi* (1936) and *Pièges* (1939), and the English film, *Take it From Me* (1937). Snow's career took an unfortunate turn around 1940. A miscalculation of the political situation in Europe led her to continue performing there (primarily in Denmark and Sweden) when many black American stars such as COLEMAN HAWKINS had returned home. In early 1941 Snow's work permit in Denmark was revoked, possibly due to involvement with narcotics. Shortly thereafter she was imprisoned in the Wester-Faengle internment camp in Copenhagen. According to the political scientist Clarence Lusane who described Snow's life, in an understatement, as "imperfectly known," this was "clearly not a 'concentration camp'" *per se*, as is often reported in accounts of Snow's life (Lusane, 169). According to Rosetta Reitz, Snow's elaborate wardrobe and $7,000 in travelers' checks were seized (Reitz, 159). Snow claimed to have suffered a beating during her imprisonment that left her with a head wound and permanent scar.

Snow managed to return to the United States, via Portugal, in late 1942. She was apparently emaciated and in very poor health. In 1943 she married her manager and caretaker Earle Edwards. It is not clear when or if she divorced Ananais Berry. Snow revived her career in the mid-1940s, performing with bands such as the Sunset Royal Orchestra and Buzz Adlam's. She also came into prominence again as a soloist. The *New York Times* published a report of her 1949 performance at Town Hall in Manhattan, noting that her performance included everything from "early American folk songs" to pieces by Howard Arlen, George Gershwin, and "a group of sacred songs by Schubert" (*New York Times*, 21 May 1949).

By 1950 Snow's career was flagging, but she was honored that year in a ceremony at the popular New York jazz club Small's Paradise, which also honored major figures such as W.C. HANDY, Billy Eckstine, ETHEL WATERS, CAB CALLOWAY, among others. In 1956 Snow suffered a stroke after a show at the Palace Theater in New York. She died three weeks later at Kings County Hospital in Brooklyn. Snow's life was fictionalized in Candace Allen's 2005 novel, *Valaida*.

FURTHER READING
Snow, Valaida. "I've Met No Color Ear," *Chicago Defender* (Oct. 1934).

Charles, Mario A. "The Age of a Jazzwoman: Valaida Snow, 1900–1956," *The Journal of Negro History* (1995).

Lusane, Clarence. *Hitler's Black Victims: The Historical Experiences of Afro-Germans, European Blacks, Africans, and African Americans in the Nazi Era* (2003).

Reitz, Rosetta. "Hot Snow: Valaida Snow (Queen of the Trumpet Sings and Swings)," *Black American Literature Forum* (1982).

PAUL DEVLIN

SNOWDEN, Elmer

(10 Sept. or 9 Oct. 1900–14 May 1973), banjo, guitar, and saxophone player, was born in Baltimore, Maryland. His parents' names are unknown and his exact birth date varies depending on the source. In 1915 he began his career in his hometown playing a New Orleans–derived jazz with EUBIE BLAKE and later with the pianist Gertie Wells, to whom he was married for several years during the early 1920s. By 1921 he had moved to nearby Washington, D.C., where he jobbed with Louis Thomas and CLAUDE HOPKINS and his own eight-piece group, which played alternately with DUKE ELLINGTON's trio. Snowden also appears to have played banjo

with Ellington's group earlier, from 1919 to 1920, but this is not reported conclusively. Snowden's Washington band included Sonny Greer on drums, Arthur Whetsol on trumpet, and Otto Hardwick on sax. The three would later be long-term members of the Ellington orchestra.

Bolstered by the belief that FATS WALLER was to join the group as featured artist, Snowden and band moved their operation to New York City in 1923. The Waller association proved to be a false start, but all ended happily in 1924 when Ellington joined the band on piano, replacing the no-show Waller. This began an arrangement wherein Snowden was nominal leader responsible for financial matters and managerial details, while Ellington was responsible for conducting rehearsals, planning music, and "setting moods," which probably meant just "counting off" the beat for each number, during performances. At this time the band's name was changed to the Washingtonians in recognition of their geographical past. Key members of the Snowden/Ellington group were BUBBER MILEY on trumpet (who replaced Whetsol), Charlie Irvis on trombone (soon to be replaced by Joe Nanton), Hardwick on reeds, Fred Guy on banjo and guitar, and Greer on drums. From 1923 until 1927 the band was nominally based in the Hollywood Club (renamed the Kentucky Club in 1924) at Forty-ninth and Broadway.

The Snowden/Ellington co-op connection reached an ignominious end in early 1927 when members of this talented group discovered that Snowden, as their business representative, had on occasion cut himself a disproportionate share of the collective proceeds. It was after Snowden's departure in December 1927 that Ellington enlarged the band, now called The Duke Ellington Orchestra, and began his historic appearances at the famed Cotton Club in Harlem.

Snowden was reported by his contemporaries to have been an exceptional banjo player, an instrument whose time in the jazz world had, alas, run out. He also possessed a keen nose for talent, and his New York network gave him entrée to some of the hottest jazz talent of the Prohibition era. During the late twenties and early thirties he led groups operating in Harlem and Greenwich Village through which passed names destined to play momentous roles in their art's history. At one time he could boast as many as five bands working under his imprimatur in the New York City area. In an

impressive succession his sidemen included Count Basie (whom he reputedly fired), Hopkins, JIMMIE LUNCEFORD, Chick Webb, Benny Carter, Fats Waller, Roy Eldridge, and Sid Catlett. Snowden and this array of jazz giants played dates at the "in" clubs: the City, the Hot Feet, the Bamville, the Nest, and Small's Paradise. At the Nest during the 1930s Snowden's group featured the cornetist Rex Stewart, who would later achieve artist status with the Ellington orchestra. During the band's tenure at Small's, in 1930–1931, its lineup included Catlett, Gus Aiken, Dicky Wells, Al Sears, and Hardwick. At this venue Eldridge, on trumpet, had replaced Stewart. The last-named roster was the band featured in a 1932 Warner Bros. film short, provocatively titled *Smash Your Baggage*.

Snowden's career as a performer and leader did not prosper on schedule. In addition to the gradual replacement of banjos by guitars in bands' rhythm sections, he encountered legal difficulties in the early 1930s with the New York City Musicians' Union. The circumstances were serious enough to lead to his expulsion from Local 802 of the American Federation of Musicians for eight years. This direct professional barrier added to the difficulties musicians commonly experience in their club-to-club, date-by-date existences, soured him on the performing life of New York. He thus moved to Philadelphia, Pennsylvania, in 1933 to teach banjo, mandolin, and reed instruments, maintaining only modest professional status as a part-time performer and leader. During the two decades of 1940 to 1960, after settling his union problems, he occasionally led small groups for limited engagements in clubs in Canada and the northeastern United States. These sorties were sandwiched between short runs in New York City at Jimmy Ryan's and the Metropole.

In 1963 Snowden moved once again, this time with high hopes for a new start, to Berkeley, California, replacing the steel strings on his old banjo with the gut of a guitar. He played the Monterey Jazz Festival that summer with an unlikely yet smashingly successful quartet consisting of old-timers Darnell Howard and Pops Foster and the young bebop drummer Tony Williams. That success behind him, he took a job at the Berkeley School of Music, teaching there for three years and playing night dates around the Bay Area with the trombonist Turk Murphy. Before returning for good to the East Coast he led his own groups at the Cabale in Berkeley and at the Coffee House in San Francisco. He

joined a European jazz tour in 1967, then returned to his adopted hometown of Philadelphia, where he died. His last big public performance took place at the fledgling Newport Jazz Festival in 1968.

Ralph Gleason tells a touching story about a kind of last roundup meeting between Snowden and Ellington in 1963 shortly after the Monterey Festival, where both had played but on different days. The meeting took place between sets in Ellington's dressing room in San Francisco's Basin Street West, many years after the two aging pros had last seen each other. Gleason says:

the two of them, Duke, the piano player who went on to the heights of show business success, and Snowden, the man who gave him his first job and had gone down steadily ever since, just radiated love and delight at seeing each other. For an hour they sat there, Duke on the cot and Snowden on the chair, and reminisced. "Remember the night . . . ?" "How did such and such go?" "What ever happened to . . . ?" It was a magic moment and I felt privileged to be present as they played the game of Remember When, each trying to catch the other out by bringing up an old nickname or the title of a song neither one of them had played for forty years.

FURTHER READING
Dance, Stanley. *The World of Swing* (1974, 2001).
Gleason, Ralph J. *Celebrating the Duke: And Louis, Bessie, Billie, Bird, Carmen, Miles, Dizzy and Other Heroes* (1995, 1975).
Ulanov, Barry. *Duke Ellington* (1946).

WILLIAM THOMSON

SPAULDING, Asa Timothy

(22 July 1902–5 Sept. 1990), businessman and civic leader, was born in Columbus County, North Carolina, to Armstead Spaulding and Annie Lowery (Bell) Spaulding, who together owned a farm and ran a general store. He was born into a family that had produced several prominent political and business leaders, including his great-uncle, Dr. Aaron McDuffie Moore, a founder of the North Carolina Mutual Life Insurance Company in Durham, and his second cousin, Charles Clinton Spaulding, who was the Mutual's general manager and later its president. Asa's mother was a descendant of Henry Berry Lowry, a leader of resistance to the Ku Klux Klan in the 1870s. His parents ensured that Asa learned business principles at an early age by making him plant and look after his own one-acre cotton patch.

It was his grandfather, however, a Sunday school superintendent for more than four decades, who instilled in the young boy a basic philosophy that guided him throughout his life—namely, that the solution to most problems can be found by reading the Bible.

Asa Spaulding showed a precocious aptitude for numbers and mathematics. When his grade-school classmates were still learning basic counting, he was practicing multiplication tables up to twenty. His reputation as the brightest student in Columbus County brought him to the attention of his uncle Aaron Moore, who in 1919 encouraged him to move to Durham—a move that another ambitious young man from Columbus County, C. C. Spaulding, had made exactly a quarter of a century earlier. Asa enrolled at Dr. James Shepard's National Religious Training School and Chautauqua for the Colored Race (now North Carolina Central University) in Durham and worked for the Mutual during his summer vacations. He graduated with several student awards in 1923 and returned home to his native Columbus County to serve as the principal and teacher in a rural school, just as his uncle Aaron Moore had done in the 1880s. Spaulding's intellectual curiosity and his desire to learn more about both mathematics and the business world encouraged him to take a take a leave of absence from teaching in 1924 while he studied at Howard University in Washington, D.C., and continued to work for the Mutual.

In 1927 Spaulding moved north, and with financial support from C. C. Spaulding he enrolled at New York University (NYU), where he studied mathematics. Spaulding's first experience of life outside the South proved bittersweet. He found intellectual stimulation and academic success at NYU and took some satisfaction in personally dispelling the myth of white intellectual superiority when several of his white colleagues approached him for help with their studies. "They are willing to admit their 'inferiority' for the time being. Isn't it strange," he wrote to his friend William Kennedy in 1927 (Weare, 165).

Spaulding also enjoyed living in Harlem during the peak of the Harlem Renaissance, and he regularly attended ADAM CLAYTON POWELL SR.'s Abyssinian Baptist Church. He did not, however, enjoy the daily journey of more than a hundred blocks from his shared room in Harlem to NYU in Greenwich Village, and he chafed at the lack of job

opportunities that he found in the city. Unlike in Durham, Spaulding's talents and connections mattered far less to employers in New York than did his race. With what he called at the time a "burning passion to be of loyal, upright service to my group," Spaulding determined that he should return to Durham and the Mutual after he finished his studies (Weare, 165).

After graduating magna cum laude from NYU in 1930, Spaulding moved first to the University of Michigan in Ann Arbor, where he graduated two years later as the first African American to receive a master's degree in Actuarial Mathematics, a relatively new discipline. Spaulding's experience in the Midwest was at best mixed. He found more explicit racial prejudice than in North Carolina or New York, as well as a far greater sense of racial isolation. Upon graduation Spaulding worked briefly for an actuarial consulting firm in Indianapolis before returning to North Carolina to put into practice at the Mutual the actuarial science that he had learned at NYU and Michigan. Shortly after arriving in Durham in June 1933, Spaulding married Elna Bridgeforth of Tuskegee, Alabama; the couple would have four children, Asa Jr., Patricia Ann, Aaron, and Kenneth.

A history of the North Carolina Mutual notes that "virtually every dimension of the business improved" after Spaulding's arrival at the height of the Great Depression (Weare, 163). At the same time that President Franklin Roosevelt was establishing the New Deal's innovative programs to regenerate the American economy, Spaulding brought to the Mutual the new insights of actuarial science to address the company's financial woes. Actuarial science combined statistics, business theory, and a little morality; its complex calculations and formulas punished policyholders considered a poor risk, such as the elderly and the sick, while rewarding younger and healthier policyholders.

By analyzing the Mutual's entire financial operations Spaulding discovered, for example, that the Mutual paid out a disproportionate number of claims to policyholders who had been insured for less than five years. He responded to this problem by increasing the benefits paid to claimants who died decades after taking out policies with the Mutual, while cutting benefits paid to claimants who died shortly after signing up for their policies. Spaulding also instructed the company to pay out only one-quarter of the policy value to beneficiaries

who died within a year of paying premiums. Over five years Spaulding promoted these new policies of risk selection in columns for the *Whetstone*, the Mutual's magazine, and in seminars for the company's hundreds of insurance agents. In 1938, at age thirty-five, he became the youngest officer on the Mutual's board, an appointment that reflected his skills at placing the company on a sound financial footing.

Asa Spaulding remained at the North Carolina Mutual during the prosperous era of World War II and the 1950s, steering it through the death of C. C. Spaulding in 1952 and assuming the presidency of the company seven years later. By then, under the guidance of Spaulding and his close friend William Kennedy, the company had expanded its operations to New Jersey and other northern and midwestern states, reflecting the population shift of its primarily African American base of policyholders. Trained to analyze risk and to predict future outcomes, Spaulding believed that the Supreme Court's 1954 *Brown v. Board of Education* decision signaled the potential death knell for companies such as the Mutual that depended on segregated markets. Spaulding's hopes for an integrated future must have been dampened somewhat by his defeat in a race for Durham County commissioner just weeks after the *Brown* ruling. Thanks to the get-out-the-vote efforts by the Durham Committee on Negro Affairs, Spaulding won 98 percent of the black vote, but he attracted almost no support from whites.

In the 1950s Spaulding began to take a strong interest in international relations. He served as an official representative of the U.S. government at a UNESCO conference in New Delhi, India, in 1956 and helped organize one of the first state visits by a postcolonial African leader to the United States in 1959 when Sekou Toure of Guinea visited North Carolina. Asked about his impression of the American South, Toure responded that he was most impressed by the size and ambitions of Negro institutions, especially the Mutual.

By the 1960s the federal government finally responded to black demands for integration and equality, and white insurance firms began to compete with the Mutual and other black companies for customers. Such competition further persuaded Spaulding to court white customers and to attract white tenants to share the Mutual's gleaming new offices, which were formally opened by

Vice President Hubert Humphrey in April 1966. This decision angered some black Durhamites who viewed the new Mutual as having betrayed its African American past. Shortly after Spaulding stepped down as president in 1971, the wisdom of his decision to seek new markets became apparent. That year the Mutual became the first black-owned company to reach one billion dollars in annual insurance business, primarily by securing lucrative group policies from white corporate clients such as IBM and General Motors. The company's profits were also boosted, however, by advertising campaigns that appealed to black pride and greatly increased the ranks of its African American policy-holders.

In 1971 Spaulding narrowly lost a race to become Durham's first African American mayor, and thereafter he focused primarily on business and community affairs. Since 1964 he had been a major shareholder in several large, historically white corporations, and in 1972 he became active in the Association for the Integration of Management (AIM), which lobbied to increase the presence of African Americans in corporate boardrooms. Spaulding and the research chemist Percy Julian were also prominent in the National Negro Business and Professional Committee, which helped raise money for the NAACP's Legal Defense Fund. Spaulding also formed his own consulting company and during more than seven decades in Durham remained an active member of the city's White Rock Baptist Church. He died in Durham at the age of eighty-eight.

FURTHER READING

The Asa Timothy Spaulding Papers are housed in the JOHN HOPE FRANKLIN Research Collection of African and African-American Documentation at Duke University in Durham, North Carolina. A smaller set of Asa Timothy Spaulding Papers, 1943–1974, can be found at the State of North Carolina Archives in Raleigh, North Carolina.

Kennedy, William J., Jr. *The North Carolina Mutual Story: A Symbol of Progress, 1898–1970* (1970).

Surface, Bill. "The World of the Wealthy Negro," *New York Times*, 23 July 1967.

Weare, Walter B. *Black Business in the New South: A Social History of the North Carolina Mutual Insurance Company* (1973).

Wise, Jim. *Durham: A Bull City Story* (2002).

STEVEN J. NIVEN

SPENCER, Anne

(6 Feb. 1882–27 July 1975), poet, librarian, and teacher, was born Annie Bethel Scales Bannister in Henry County, near Danville, Virginia, the daughter of Joel Cephus Bannister, a saloon owner and former slave, and Sarah Louise Scales. The only child of divorced parents, at the age of eleven Annie was sent to Virginia Seminary in Lynchburg, where she excelled in literature and languages. After graduating in 1899 she taught for two years, then in 1901 married fellow student Edward Spencer and lived the rest of her life in Lynchburg.

Outwardly it was a pleasant life that Spencer spent with her husband, a postal worker, and their three children in a comfortable house built in part by Edward. For twenty years (1925–1945) Anne Spencer was a librarian and part-time teacher of literature and language at the all-black Dunbar High School, named for the poet PAUL LAURENCE DUNBAR. The Spencers often entertained in their home well-known visitors to the city who, because of their race, were denied lodging in local hotels.

Their son Chauncey Spencer, who was born in 1906, remembered houseguests such as LANGSTON HUGHES, PAUL ROBESON, W. E. B. DU BOIS, GEORGE WASHINGTON CARVER, and Thurgood Marshall. Adjoining the house was "a beautiful garden tended by my mother," her son wrote. "As soon as mother, 'Miss Anne,' arrived home from her job as a librarian, she would head for the garden. . . . Either she was working with her flowers, which she cross-bred, or she'd be reading and writing in the garden house. This was my mother's world, the only world in which she felt comfortable" (Spencer, 42). The garden house, called "Edankraal," and the main house are maintained as historic sites.

A less tranquil side of Anne Spencer's life was her indignation toward racial and social injustice and her lifelong efforts to improve the lot of blacks. Her biographer, J. Lee Greene, records her successful campaign to replace the all-white faculty at a black high school with black teachers and "her outspoken opposition to tokenism when school integration came to Lynchburg" in the 1960s (85). Her letters to newspaper editors and city officials, as well as her refusal to patronize segregated city buses and streetcars, earned her grudging recognition as an uncompromising foe of Jim Crowism. "My mother was full of fire," her son recalled (Spencer, 17).

Anne Spencer had scribbled poems since school days, but her career as a poet began when she met

JAMES WELDON JOHNSON during his stay at the Spencer home in 1918 while he was helping to establish a local chapter of the National Association for the Advancement of Colored People. "He released my soul," she was to say (Greene, 78). Johnson recommended her to H. L. Mencken, and the two writers jointly sponsored the publication of her poem "Before the Feast of Shushan" in *Crisis: A Record of the Darker Races* (Feb. 1920). Based on the Book of Esther, the poem is a monologue by King Ahasuerus about his wife Vashti. Eleven Spencer poems were published between 1920 and 1931 in magazines such as *Crisis*, *Palms*, and *Opportunity*, which were associated with the Harlem Renaissance movement. Her poems have been frequently included in anthologies, beginning with Johnson's *The Book of American Negro Poetry* (1922, with five Spencer poems) and including *The Norton Anthology of Modern Poetry* (1973) and *Four Hundred Years of Virginia, An Anthology* (1985). Yet her poems published in her lifetime number less than thirty, and her biographer could account for only about fifty extant poems of the hundreds that Spencer remembered writing. Forty-two poems, including twenty-two previously unpublished, are printed in the appendix of the biography.

This slim surviving body of work has nonetheless established Anne Spencer as a significant American black poet of the twentieth century. Her themes are universal. She uses traditional forms: sonnets, epigrams in varied rhythm and rhyming schemes, and elegies such as "For Jim, Easter Eve," recalling Johnson. She published little poetry after his death in 1938. Most of Spencer's poems are short, with only "At the Carnival" (fifty lines) and "Before the Feast of Shushan" (forty-one lines) running much beyond twenty lines.

Spencer read widely and felt deeply. Her tribute to lost poets, "Dunbar," first published 1920, is in the voice of Paul Laurence Dunbar:

Ah, how poets sing and die!
Make one song and Heaven takes it;
Have one heart and Beauty breaks it;
Chatterton, Shelley, Keats and I–
Ah, how poets sing and die!

In its four rhyming quatrains and concluding couplet, "Life-long, Poor Browning Never Knew Virginia," published in 1927, sums up Browning's Italian exile, his pantheistic existence in nature after death, and his possible reunion with Elizabeth Barrett Browning. A touch of Gerard Manley Hopkins's sprung rhythm is in her description of a half-inch brown spider in "Po' Little Lib" (1977): "M O V E S thru the grass, O god / if it chance / For the drought driven air turns leaf into lance."

Greene indicates that "as a private poet, Anne Spencer did not see racial protest as her métier in poetry" (138). An exception is "White Things," with its two intricate rhyming stanzas about a lynching.

Anne Spencer loved gardens, books, freedom, and the life of the mind—and when she died in Lynchburg she left a slender golden legacy in her poems and in her restored garden.

FURTHER READING
Spencer's papers are in the archives at Alderman
 Library, University of Virginia.
Greene, J. Lee. *Time's Unfading Garden: Anne Spencer's
 Life and Poetry* (1977).
Spencer, Chauncey. *Who Is Chauncey Spencer?* (1976).

DORA JEAN ASHE

SPIVEY, Victoria

(15 Oct. 1906–3 Oct. 1976), blues singer, songwriter, and record label founder, was born Victoria Regina Spivey in Houston, Texas, the daughter of Grant Spivey, a straw boss on Texas wharfs and a string player, and Addie Smith, a nurse. She was one of eight children in a musical family. Her father and brothers were members of a local string band, and her three sisters, Addie "Sweet Peas," Elton "Za Zu," and Leona, also were singers. Spivey began playing piano at an early age and soon was performing with various local groups, including Henry "Lazy Daddy" Filmore's Blues-Jazz Band and L. C. Tolen's Band and Revue. There followed appearances in vaudeville houses and theaters throughout Texas, Missouri, and Michigan. As a teenager she played piano for silent movies at the Lincoln Theater in Houston.

In 1926 Spivey went to St. Louis with the goal of meeting Jesse Johnson, a recording talent scout. After hearing her audition, Johnson awarded Spivey a contract to record four tunes for the Okeh label. One of them, "Black Snake Blues," a Spivey original, established her as a blues singer. Within the first month the record sold 150,000 copies, leading to a New York City recording date. Six Victoria Spivey discs were released in 1926 alone. Over the course of her career she would record on several other labels,

including Victor, Vocalion, Decca, Bluesville, GHB, Folkways, and later in life, her own label, Spivey Records. Typical of Spivey's Texas singing style were off-tones, drops, moans, wails, and flat tones, which she used to great effect when performing. Often billed as "The Queen of the Blues" or as Queen Victoria Spivey, she collaborated, over the course of her career, with such stellar artists such as KING OLIVER, LOUIS ARMSTRONG, Lonnie Johnson, Porter Grainger, Red Allen, Eddie Durham, J. C. Higginbotham, Sidney De Paris, Lee Collins, Luis Russell, Albert Nicholas, Pops Foster, Zutty Singleton, Eddie Barefield, and Memphis Minnie.

Returning to St. Louis in 1927, Spivey worked as a staff writer for the St. Louis Publishing Company. That same year she appeared in the musical revue *Hit Bits from Africana* in New York City. In 1929 she made her film debut in the King Vidor film *Hallelujah*. She appeared in two other musical revues in those early years, *4-11-44* in New York City in 1930 and, on tour in Texas and Oklahoma, *Dallas Tan Town Topics* in 1933.

Spivey is believed to have had four husbands—among them, Reuben Floyd, whom she apparently married sometime around 1928 and with whom she remained until the early 1930s. However, her most significant marriage was to dancer Billy Adams, whom she married sometime around 1934 and with whom she had a long professional association until their relationship ended in 1951. Spivey and Adams performed in the highly successful Ole Olsen and Chic Johnson musical revue *Hellzapoppin* on Broadway in 1938–1939 and then on tour for an additional three and a half years. During the late 1930s and the 1940s Spivey and Adams worked the vaudeville circuit and appeared at various exclusive clubs, lounges, and theaters in Chicago, Cleveland, St. Louis, and New York City, including the Apollo Theater.

Spivey was comparatively inactive during the 1950s, but in the 1960s her musical career revived, and the decade was filled with various artistic endeavors. She toured widely, both in the United States and abroad, appearing at blues festivals, on radio and television, and on college campuses, and as a blues historian she contributed to *Record Research* magazine. Her most noteworthy accomplishment of the period, however, was the establishment of her own record company, Spivey Records, which reissued many of her own recordings, brought out of retirement other classic blues singers, in particular, LUCILLE HEGAMIN and ALBERTA HUNTER, and provided recording opportunities for a cadre of younger blues artists, with whom Spivey frequently shared recording sessions. Of the Spivey reissues, the most outstanding was *Victoria Spivey Recorded Legacy of the Blues* (1969), which features Spivey recordings made between 1927 and 1937 with the backing of trumpet greats such as King Oliver and Louis Armstrong.

Other highlights of Spivey's professional activity in the 1960s and 1970s included an appearance on "Lyrics and Legends" on New York television station WNET in 1963; at the American Folk-Blues Festival tour in England and Europe, also in 1963; at the Chicago Blues Festival in 1969; on the PBS show "Free Time" in 1971; and at the Philadelphia Folk Festival, broadcast on PBS in 1972. In the early 1970s she served as a blues adviser to the Conn Instrument Company of Chicago, and in 1975 she was featured in the BBC-TV documentary *The Devil's Music—A History of the Blues*.

A prolific songwriter (many of her songs were considered to be blues "tone poems"), Spivey contributed to the blues repertoire such titles as "Arkansas Road Blues," "Big Black Belt," "Blood Hound Blues," "Garter Snake Blues," "You're Going to Miss Me When I'm Gone," "No. 12, Let Me Roam," "Black Belt Blues," "Big Black Limousine," and "Organ Grinder Blues." According to one blues historian, "Spivey produced nearly 1500 songs, many of them never credited to her" (Placksin, 33). During her final years, she was able to both inform and clarify for blues aficionados and researchers. Her recall faculties were excellent and she had lived through the various eras and had heard and often performed with the legends. In 1970 Broadcast Music Incorporated (BMI) awarded Spivey a Commendation of Excellence "for long and outstanding contributions to the many worlds of music." She died at the Beekman-Downtown Hospital in New York City. According to her obituary in the *New York Times*, she was survived by two daughters.

FURTHER READING
Bourgeois, Anna Stong. *Blueswomen: Profiles of 37 Early Performers, 1920–1945* (1996).
Harrison, Daphne Duval. *Black Pearls: Blues Queens of the 1920s* (1988).
Placksin, Sally. *American Women in Jazz, 1900 to the Present: Their Words, Lives, and Music* (1982).

Stewart-Baxter, Derrick. *Ma Rainey and the Classic Blues Singers* (1970)

Obituary: New York Times, 7 Oct. 1976.

ANTOINETTE HANDY

ST. CLAIR, Stephanie ("Queenie")

(c. 1890–c. 1974), Harlem "policy queen" and advocate for immigrant and African American rights, was born in Martinique. She immigrated to New York via Marseilles, France. After settling in Harlem in 1913, she served as an advocate for renter's rights and fought to require police to have search warrants to enter a resident's home. She also became a passionate advocate for French-speaking immigrants in need of education and job opportunities. In 1922 St. Clair opened a successful "numbers" bank in Harlem.

According to the *Encyclopedia of African-American Culture and History*, the "numbers game" was a "pervasive form of gambling in African-American urban communities from around the turn of the century until the late 1970s" (Palmer, 2032). The numbers game—also referred to as "policy"—eventually folded in the 1970s with the advent of state lotteries and legal gambling. "Playing the numbers" initially involved placing a bet on the last three digits of the daily trade volume of the New York Stock Exchange. Later the winning numbers were taken from the winning horses at the racetrack. Number runners moved through the neighborhood on a daily basis, picking up bets written on small sheets of paper. At the end of the day there was a payout to those who chose a combination of the correct three-digit number.

St. Clair, who was nicknamed "Queenie" and "Madame St. Clair," built Harlem policy into a multimillion-dollar business, pumping a significant amount of money into the fragile economy. Her infamy began after she infiltrated the Forty Thieves, an extortion gang that dated back to the nineteenth century. As a result of her fierce reputation, St. Clair established herself as the leader of this once white-led organization. She invested nearly ten thousand dollars to open her own policy bank.

St. Clair charged nickels and dimes for residents to play the numbers. The affordability made the game immensely popular despite the dearth of wealth in the neighborhood. By the middle 1920s St. Clair's estimated worth was five hundred thousand dollars. She employed more than fifty runners

and ten comptrollers for her flourishing business. Surprisingly she achieved this during the Great Depression of the late 1920s and 1930s.

ELLSWORTH RAYMOND "BUMPY" JOHNSON was the most well known of St. Clair's protégés. His involvement in the numbers game in Harlem grew so legendary that his life has been documented and dramatized far more often than has St. Clair's. In Francis Ford Coppola's film *The Cotton Club* (1984), Novella Nelson portrayed St. Clair. The character does not figure as significantly into the plot and cinematic turf war battles as does Bumpy Johnson, played by Laurence Fishburne. Fishburne later reprised the role in the 1997 film *Hoodlum*. In this film St. Clair (played by Cicely Tyson) plays a much larger role in the narrative. However, Bumpy Johnson still serves as the primary focus.

Both St. Clair and Johnson shared a passion for the arts and attended opera and events at Carnegie Hall. In addition, both made countless anonymous donations to help the Harlem poor. St. Clair lived at 409 Edgecombe Avenue, the most prestigious address in Harlem's Sugar Hill district.

As the policy business continued to grow and succeed, white outsiders began to overtake both St. Clair and Johnson. St. Clair took out full-page newspaper advertisements to highlight the graft and corruption by the police force and city judges.

Dutch Schultz, of German Jewish descent, became a successful bootlegger in the 1920s and 1930s. After the end of Prohibition in 1933, Schultz sought a new source of income. He seized on Harlem policy with hopes to overtake St. Clair's coveted business. Between 1931 and 1935 Schultz engaged in a bloody turf war with St. Clair and Johnson. Schultz, also a feared gangster, had strong alliances with the police and Tammany Hall. St. Clair fought Schultz's pressure but was in and out of jail beginning in the 1930s. Schultz eventually died in a Newark, New Jersey, hospital from gunshot wounds inflicted by rival gangsters. Before his death, St. Clair sent him a telegram: "As ye sow, so shall you reap" (Cook, 170). She provided evidence that led to a series of convictions of Schultz's people after his death.

Many white-owned Harlem businesses refused to hire African Americans. SUFI ABDUL HAMID, an activist, labor organizer, and speaker, worked to secure rights for African American workers using aggressive tactics, such as storekeeper intimidation. His 1 August 1938 *New York Times* obituary

called him the "Harlem Hitler," referring to his anti-Semitic preaching against the Jewish shop owners in Harlem. To residents of Harlem, Hamid was a peerless advocate for their right to work.

In 1935 St. Clair married Hamid. However, they did not have a peaceful marriage, and it ended two years later. The 1938 *New York Times* obituary for Hamid referred to "Queenie" as Hamid's "'contract' wife." Although St. Clair did not kill Hamid, she ambushed and shot him on 8 January 1938. Hamid died in a plane crash later that year.

On 18 January 1938 St. Clair was arrested for shooting Hamid. Definitive information concerning St. Clair's prison release from the Bedford Correctional Women's Facility in Bedford Hills, New York, is not available. After finishing her time at the facility, she kept a low profile. Upon her sentencing, the white mafia slowly took over policy in Harlem until legalized gambling and state lotteries were established in the 1970s. St. Clair's time and place of death cannot be confirmed.

FURTHER READING

Cook, Fred J. "The Black Mafia Moves into the Numbers Racket," *New York Times*, 4 Apr. 1991.

Jones, Catherine Butler. "409 Edgecombe, Baseball, and Madame St. Clair," in *The Harlem Reader*, ed. Herb Boyd (2003).

Lawrenson, Helen. *Stranger at the Party: A Memoir* (1975).

Palmer, Colin A., ed. *Encyclopedia of African-American Culture and History: The Black Experience in the Americas*, 2d ed. (2006).

Watkins-Owens, Irma. *Blood Relations: Caribbean Immigrants and the Harlem Community, 1900–1930* (1996).

DONNY LEVIT

STILL, William Grant

(11 May 1895–3 Dec. 1978), composer, orchestrator, arranger, and musician, once called the "Dean of Afro-American Composers," was born in Woodville, Mississippi, the son of William Grant Still, a music teacher and bandmaster, and Carrie Lena Fambro, a schoolteacher. His father died during Still's infancy. Still and his mother moved to Little Rock, Arkansas, where she taught school and in 1909 or 1910 married Charles Shepperson, a railway postal clerk, who strongly supported his stepson's musical interests. Still graduated from high school

at sixteen, valedictorian of his class, and went to Wilberforce University.

Still's mother had wanted him to become a doctor, but music became his primary interest. He taught himself to play the oboe and clarinet, formed a string quartet in which he played violin, arranged music for his college band, and began composing; a concert of his music was presented at the school. In 1915, just a few months shy of graduation, Still dropped out of Wilberforce in order to become a professional musician, playing in various dance bands, including one led by W. C. HANDY, "the Father of the Blues." That year he married Grace Bundy, with whom he had four children. They divorced in the late 1920s.

A small legacy from his father which Still inherited on his twenty-first birthday, allowed him to resume his musical studies in 1917, this time at Oberlin College's conservatory. World War I interrupted Still's studies, and he spent it in the segregated U.S.

William Grant Still on 12 March 1949. (Library of Congress/Photographed by Carl Van Vechten.)

Navy as a mess attendant and as a violinist in an officers' mess. After being discharged in 1919, Still returned to the world of popular music. He had a strong commitment to serious music and received further formal training during a short stay in 1922 at the New England Conservatory. From 1923 to 1925 he studied, as a private scholarship pupil, with the noted French "ultra-modernist" composer Edgard Varèse, whose influence can be heard in the dissonant passages found in Still's early serious work.

Still managed to make his way both in the world of popular entertainment and as a serious composer. He worked successfully into the 1940s in the entertainment world as a musician, arranger, orchestrator, and conductor. As an arranger and orchestrator, he worked on a variety of Broadway shows, including the fifth edition of Earl Carroll's *Vanities*. He also worked with a wide variety of entertainers, including Paul Whiteman, Sophie Tucker, and Artie Shaw. Still arranged Shaw's "Frenesi," which became one of the best-selling "singles" of all time. He also conducted on the radio for all three networks and was active in early television.

Despite his many commercial activities, Still also produced more serious efforts. Initially these works, such as *From the Land of Dreams* (written in 1924 and first performed a year later) and *Darker America* (also written in 1924 and first performed two years later), were described by critics as being "decidedly in the ultra-modern idiom." He soon moved into a simpler harmonic milieu, often drawing on jazz themes, as in *From the Black Belt* (written in 1926 and first performed in 1927), a seven movement suite for orchestra.

Still's most successful and best-known work, *Afro-American Symphony* (completed in 1930 and first performed a year later), draws heavily on the blues idiom; Still said he wanted "to demonstrate how the blues, so often considered a lowly expression, could be elevated to the highest musical level." To some extent the symphony is "programmatic," since after its completion Still added verses by black poet PAUL LAURENCE DUNBAR that precede each movement. Still believed that his symphony was probably the first to make use of the banjo. The work was well received and has continued to be played in the United States and overseas.

Still was a prodigious worker. His oeuvre includes symphonies; folk suites; tone poems; works for band, organ, piano, and violin; and operas, most of which focus on racial themes. His first opera,

Blue Steel (completed in 1935), addresses the conflict between African voodooism and modern American values; its main protagonist is a black worker in Birmingham, Alabama. Still's first staged opera, *Troubled Island* (completed in 1938), which premiered at the New York City Opera in March 1949, centers around the character of Jean Jacques Dessalines, the first emperor of Haiti. The libretto, begun by the black poet Langston Hughes and completed by Verna Arvey, depicts the Haitian leader's stirring rise and tragic fall. Still married Arvey in 1939; the couple had two children. Arvey was to provide libretti for a number of Still's operas and choral works.

Among Still's other notable works are *And They Lynched Him on a Tree* (1940), a plea for brotherhood and tolerance presented by an orchestra, a white chorus, a black chorus, a narrator, and a soloist; *Festive Overture* (1944), a rousing piece based on "American themes"; *Lenox Avenue*, a ballet, with scenario by Arvey, commissioned by CBS and first performed on radio in 1937; *Highway 1, USA* (1962), a short opera, with libretto by Arvey, dealing with an incident in the life of an American family and set just off the highway in a gas station.

Still received many awards. Recognition had come relatively early to him—in 1928 the Harmon Foundation honored him with its second annual award, given to the person judged that year to have made the "most significant contribution to Negro culture in America." He won successive Guggenheim Fellowships in 1934 and 1935 and was awarded a Rosenwald Fellowship in 1939.

Still's early compositions were in an avant-garde idiom, but he soon turned to more conventional melodic and harmonic methods, in what he later described as "an attempt to elevate the folk idiom into symphonic form." This transition may have made his serious work more accessible, but for much of his career he sustained himself and his family by pursuing more commercially successful endeavors.

Still dismissed the black militants who criticized his serious music as "Eur-American music," insisting that his goal had been "to elevate Negro musical idioms to a position of dignity and effectiveness in the fields of symphonic and operatic music." And at a 1969 Indiana University seminar on black music he asserted, "I made this decision of my own free will. . . . I have stuck to this decision, and I've not been sorry."

During his lifetime Still broke many racial barriers. He was heralded as the first black man to have a major orchestral work played before an American audience, the first to conduct a major symphony orchestra (the Los Angeles Philharmonic) in an evening of his own compositions (at the Hollywood Bowl in 1936), and the first to conduct a major all-white orchestra in the deep South (the New Orleans Philharmonic in 1955 at Southern University). He is also credited with being the first black man to have an opera performed by a "significant" American company (the New York City Opera in 1949). He composed into his late seventies; the Fisk Jubilee Singers performed a piece by him at the Fisk University Centennial Celebration in 1971. He died in Los Angeles.

FURTHER READING
Arvey, Verna. *William Grant Still* (1939).
Haas, R. B., ed. *William Grant Still and the Fusion of Cultures in American Music* (1972; repr. 1995).
Smith, Catherine Parsons. *William Grant Still: A Study in Contradictions* (2000).
Still, Judith Anne, et al. *William Grant Still: A Bio-Bibliography* (1996).

DANIEL J. LEAB

SUL-TE-WAN, Madame

(12 Sept. 1873–1 Feb. 1959), actress, was born Nellie (last name unknown) in Louisville, Kentucky, to Cleo de Londa and Silas Crawford Wan, a native of Hawaii who died when his daughter was young. Nellie's mother was a washerwoman whose clients included several local actresses from whom Nellie caught the acting bug. Her first performing work was in an all-black novelty act at the Buckingham Theater and New Brunswick Saloon, a high-end vaudeville and burlesque theater owned by the brothers John and James Wallen, local Democratic political bosses who ran their businesses out of the back of the theater. Nellie and her mother moved to Cincinnati, Ohio, where, using the stage name Creole Nell, she found vaudeville work in Over-the-Rhine, Cincinnati's German-immigrant neighborhood that was home to many breweries and theaters, including vaudeville, burlesque, and legitimate venues. She also performed at Cincinnati's dime museum, one of a series of popular late-nineteenth- and early-twentieth-century establishments exhibiting exotic objects and specimens and offering live entertainment. Sul-te-Wan later joined the Three Black Cloaks Company and performed on the legitimate stage in a touring play starring Fanny Davenport during its Cincinnati engagement. Using the growing network of theaters catering to black audiences, she eventually organized and performed with her own vaudeville touring companies, The Black Four Hundred and the Rair Black Minstrels.

Around 1906 she married her fellow performer Onest Conley and five or six years later they moved to Arcadia, California, a suburb of Los Angeles. It is not known when she began using the professional name Madame Sul-te-Wan, but all her screen and radio credits use this name. Within two years of their arrival in California, Conley deserted his wife and their three sons, Otto, Onest, and James, aged seven years to three weeks old. With help from several African American aid organizations, Sul-te-Wan and her children moved to downtown Los Angeles while she worked at the Pier Theater in nearby Venice. When she heard that the filmmaker D. W. Griffith, who had also grown up in her hometown of Louisville, was casting African Americans for his current project, Sul-te-Wan personally convinced him to hire her on the movie, then filming under the title *The Clansman*. Released in 1915 as *The Birth of a Nation*, the resulting film was a significant flashpoint in both the history of cinema and in the African American experience, spurring the growth of the fledgling National Association for the Advancement of Colored People (NAACP) and the birth of race films. The impact of the events surrounding the film and her association with Griffith directly impacted Sul-te-Wan's subsequent film career.

Pioneering a new visual and narrative vocabulary, *The Birth of a Nation*, the longest and most expensive film that had yet been produced, was a milestone in film history, introducing crosscut editing, aerial shots, mobile camera takes, various rising effects, and the employment of new storytelling techniques that formed the basis of modern filmmaking. Based on Thomas Dixon's pro-South, pro-Ku Klux Klan novels *The Clansman* and *The Leopard*, the film was also maliciously antiblack, presenting devastating depictions of African Americans and a racist treatment of the historical events of the Civil War and Reconstruction, which it argued resulted in the subjugation of whites by malevolent blacks and "mulattos." Prior to the film's release, a committee consisting of members of the Los Angeles branch of the NAACP, the Ministers' Alliance,

and the Forum, filed a protest with the local Los Angeles censor board. When the censor board nevertheless passed the film, the NAACP registered a protest with the L.A. City Council arguing that the film made "an appeal to violence and outrage" by its efforts to "excuse the lynchings and other deeds of violence committed against the Negro and to make him in the public mind a hideous monster." Intervention by the National Board of Censorship's executive committee resulted in the first series of edits to the film. While *The Birth of a Nation* proved an enormous popular and financial success, over the next fifteen years, owing to protests and pressure from African American groups and their allies, the film was repeatedly banned or edited by local politicians, community groups, or theater owners across the country, further obfuscating the details of the film's original version.

In an interview with the African American journalist Delilah Beasley for her 1919 book, *The Negro Trailblazers of California*, Sul-te-Wan recalled that after her first day in front of the camera, Griffith, who launched the career of a number of stars, including Mary Pickford, Lillian and Dorothy Gish, and Mae Marsh, raised her pay from three dollars to five dollars a day and expanded her on-screen role, casting her "as a rich colored lady, finely gowned and owner of a Negro colony of educated colored citizens." In the film released nationally, however, the character Sul-te-Wan described is not in the film and all major African American parts are played by whites in blackface. Sul-te-Wan appears only as a bit player, her more substantial scenes having been cut either by Griffith or by censors. The extent of her original participation and contribution to the film is not known. After *The Birth of a Nation* Griffith put Sul-te-Wan on his company's payroll at five dollars day, making her one of the first African Americans under contract to a film studio. She also recalled that Griffith fired her when associates accused her of helping to organize protests against the film, but then he reinstated her after she hired the African American lawyer E. Burton Ceruti. Although some scholars have claimed that she remained employed by Griffith for the next seven years, the extent of her working relationship with the filmmaker remains unclear. Sul-te-Wan did appear in Griffith's next film, *Intolerance* (1916).

With limited work available to black performers, she continued to work in black vaudeville and occasionally on radio with L-KO. "I get bitter sometimes," she later confided to an interviewer, "because I don't work long enough to buy a handkerchief" (quoted in Cripps, 130). Sul-te-Wan managed, however, after her screen debut in *The Birth of a Nation*, to sustain a career as a film actor for forty-three years. Cast mostly as a bit player or extra and often uncredited for her performances, Sul-te-Wan portrayed mothers and grandmothers, slaves and midwives, and most often servants. Mammies, housekeepers, cooks, and maids were her bread and butter and like other black actors in Hollywood, she played African Americans, American Indians, "gypsies," "half-breeds," and "natives."

In the silent era she appeared in three films directed by Lloyd Ingraham, *Hoodoo Ann* (1916), *The Children Pay* (1916), and *The Lightning Rider* (1924), as well as *Stage Struck* (1917) starring Dorothy Gish, *Manslaughter* (1922) directed by Cecil B. DeMille, *Who's Your Father?* (1918), *The Narrow Street* (1925), and *Uncle Tom's Cabin* (1927). After the arrival of sound technologies Sul-te-Wan made the transition to "talkies" in small parts in *Sarah and Son* (1930) and *Queen Kelly* (1929), Erich von Stroheim's uncompleted big-budget feature film, which was never completed having been halted mid-production by producer and star Gloria Swanson.

In the 1930s and 1940s she worked alongside many of the era's biggest Hollywood stars, including Barbara Stanwyck in *Ladies They Talk About* (1933), Fay Wray in *King Kong* (1933) and *Black Moon* (1934), Melvyn Douglas in *The Toy Wife* (1938) and *Tell No Tales* (1939), Jane Wyman in *Torchy Plays with Dynamite* (1939), and Douglas Fairbanks Jr. in *Safari* (1940). She worked in B movies, including *Pagan Lady* (1931), *The Thoroughbred* (1930), *King of the Zombies* (1941), and *Revenge of the Zombies* (1943) and under the groundbreaking directors G. W. Pabst in *A Modern Hero* (1934) and Preston Sturges in *Sullivan's Travels* (1941). Although her work in these films was often limited to small roles, Sul-te-Wan turned in larger supporting performances as "Voodoo Sue" in *Heaven on Earth* (1931), "Hattie" in *In Old Chicago* (1937), "Lily" in *Kentucky* (1938), "Naomi" in *Maryland* (1940), and, most significantly, "Tituba" in *Maid of Salem* (1937).

In 1934 Sul-te-Wan played a cook in *Imitation of Life*, one of the only Hollywood films of the period to directly explore racial themes. The film starred Claudette Colbert and LOUISE BEAVERS,

with whom Sul-te-Wan had appeared in three previous films. She worked with most of early Hollywood's black actors, including Hattie McDaniel, Noble Johnson, Ben Carter, and George Reed, there is no record that she ever worked with OSCAR MICHEAUX, Noble and George Johnson of the Lincoln Motion Picture Company, or other black filmmakers producing race films, or films made specifically for black audiences. In 1954 Sul-te-Wan appeared as the grandmother of the title character played by Dorothy Dandridge in *Carmen Jones*, costarring Harry Belafonte, Pearl Bailey, and Diahann Carroll and directed by Preminger. Playing Dandridge's grandmother on-screen led to persistent misidentification of Sul-te-Wan as the real-life mother of Ruby Butler Dandridge, Dorothy Dandridge's mother.

Sul-te-Wan continued working even into her eighties, appearing in *Something of Value* (1957) starring Rock Hudson, *The Buccaneer* (1958) starring Yul Brenner, and *Tarzan and the Trappers* (1958). In 1957 her career came full circle, when she was cast in *Band of Angels* (1957), directed by Raoul Walsh, whom she had met forty-two years earlier when he played John Wilkes Booth in *The Birth of a Nation*.

Publicity photos show a pretty, slight woman, beautifully dressed and bejeweled. After her divorce from Conley, Sul-te-Wan was briefly married to William Holt, a man she described as a "German count." In 1943, at the age of seventy, she married Anon Ebenthur, a white interior decorator twenty-two years her junior.

Sul-te-Wan died in 1959 at the age of eighty-six. At the time of her death she was living at the Motion Picture Country Home in Woodland Hills, California, home to Hattie McDaniel until her death in 1952 and Billy Bitzer, the innovative cinematographer who shot *The Birth of a Nation*, who died in 1944.

FURTHER READING

Beasley, Delilah L. *The Negro Trailblazers of California* (1919, 1997).

Cripps, Thomas. *Slow Fade to Black: The Negro in American Film* (1977, 1993).

LISA E. RIVO

TANNER, Henry Ossawa

(21 June 1859–25 May 1937), painter and draughts-man, was born in Pittsburgh, Pennsylvania, the son of Benjamin Tucker Tanner, a bishop of the African Methodist Episcopal Church and editor of the *Christian Recorder*, and Sarah Miller. Tanner's parents were strong civil rights advocates; his middle name, Ossawa, was a tribute to the abolitionist John Brown of Osawatomie.

The Tanner family moved in 1868 to Philadelphia, where Henry saw an artist at work in Fairmont Park and "decided on the spot" to become one. His mother encouraged this ambition although his father apprenticed him in the flour business after he graduated valedictorian of the Roberts Vaux Consolidated School for Colored Students in 1877. The latter work proved too strenuous for Tanner, and he became ill. After a convalescence in the Adirondacks, near John Brown's farm, in 1879 he entered the Pennsylvania Academy of Fine Arts and studied under Thomas Eakins and Thomas Hovenden, his mentor. At the academy the illustrator Joseph Pennell and a group of his friends heaped racial abuse on Tanner, who would not be deterred from his goal, because the academy was "where I had every right to be."

Tanner's professional career began while he was still a student. He made his debut at the Pennsylvania Academy Annual Exhibition in 1880. During this period he specialized in seascape painting, such as *Hazy Morning at Narragansett* (c. 1880; Washington, D.C., private collection), while also rendering memories of his Adirondack sojourn as evinced by *Burnt Pines-Adirondacks* (c. 1880; Hampton University Museum). His tendency toward using overlapping shapes and diagonal lines to render recession into space was announced in these works and can be seen over the whole of Tanner's career. Also, the rich browns, blues, blue-greens, and mauves, with accents of bright red, in the palettes of these pictures remained constant in the artist's oeuvre.

During the mid-1880s Tanner decided to become an animal painter, because they were less numerous than marine painters. A superb example of this genre is *Lion Licking His Paw* (1886; Allentown Art Museum). His unlocated picture of an elk attacked

Henry Ossawa Tanner, painter. He studied with American master Thomas Eakins and then left behind the racism of his homeland in 1891 to settle in Paris, where he had a long and successful career. (Smithsonian Archive.)

by wolves, shown at the World's Industrial and Cotton Centennial Exhibition at New Orleans in 1884, prompted the Reverend William J. Simmons to conclude in his book *Men of Mark* (1887): "His pictures take high rank. . . . [Do not] think he is patronized . . . through the influence of his father, or because someone takes pity on him, trying to help a colored man to rise. No! It is merit" (185). In addition to easel paintings Tanner provided illustrations for the July 1882 issue of *Our Continent* and the 10 January 1888 issue of *Harper's Young People*.

In 1889 Tanner opened a photography studio in Atlanta, Georgia. After it failed, he taught drawing at Clark College in Atlanta, where he met Bishop and Mrs. Joseph Crane Hartzell, who arranged Tanner's first solo exhibition in Cincinnati in 1890 to help him raise funds for European study. Tanner set sail on 4 January 1891 for Rome, but after arriving in Paris, he decided to remain there and enrolled in the Académie Julian, where his teachers were Jean-Paul Laurens and Jean-Joseph Benjamin-Constant. Tanner was also influenced by the painter Arthur Fitzwilliam Tait, whose work Tanner had encountered while convalescing in the Adirondacks. He was affected by the works of the artists in the circle of Paul Gauguin at Brittany in the early 1890s and later by the art of Diego Velazquez and El Greco. Tanner did not, however, become an imitator of any of these artists' styles. Tanner made Paris

and Trépied, France, his permanent homes for the remainder of his life, although he visited the United States periodically.

Tanner returned to the United States in 1893 and delivered a paper on the achievements of black painters and sculptors at the Congress on Africa held at the World's Columbian Exposition. In his own work he was motivated at this time to concentrate on sober, sympathetic depictions of African American life to offset a history of one-sided comic representations. *The Banjo Lesson* (1893; Hampton University Museum), in which an older man instructs a young lad, is the first painting that can be ascribed to Tanner's new efforts. It was inspired by the poem "A Banjo Song," which PAUL LAURENCE DUNBAR included in his 1892 *Oak and Ivy* collection. Stylistically, Tanner's like for multiple and conflicting light sources sparkle in *Banjo Lesson* and became a characteristic of his manner. He unveiled it at the Paris Salon—the prestigious French annual juried exhibition. The *Banjo Lesson*'s theme of age instructing youth recurs in *The Thankful Poor* (1894; William H. and Camille O. Cosby Collection) and *The Young Sabot Maker* (1895; Washington, D.C., private collection), which conjures up images of Jesus in the carpentry shop of Joseph.

At the turn of the twentieth century Tanner was devoting himself almost exclusively to biblical scenes as a result of both his devout family background and economic opportunities provided by the subject. Tanner's art was also informed by his extensive travels to the Holy Land in 1897 and 1898–1899 and to North Africa in 1908 and 1912. Among his famous works depicting religious scenes are *Resurrection of Lazarus* (1896; Musée d'Orsay, Paris), which was bought by the French government; *Nicodemus Visiting Jesus* (1899; Pennsylvania Academy of the Fine Arts); *Mary* (1900; LaSalle University Art Museum); *Return of the Holy Women* (1904; Cedar Rapids Art Gallery); *Two Disciples at the Tomb* (1905–1906; Art Institute of Chicago); and *Christ at the Home of Lazarus* (c. 1912; unlocated). Almost all of Tanner's biblical themes are centered around ideas of birth and rebirth, both physically and spiritually. Devoted since childhood to equality for African Americans, Tanner chose these themes because they related to President Abraham Lincoln's Emancipation Proclamation, which promised freedom, or birth and rebirth, to black slaves. This approach was also consistent with

Tanner's desire to render sympathetic depictions of African Americans.

Although Tanner made a relatively small number of portraits over his career, those he did paint were of individuals involved with equality and other humane concerns. Notable are the James Whistler–inspired *Portrait of the Artist's Mother* (1897; Riverdale, N.Y., private collection); the formal portrayal of his early supporter and secretary of the Freedman's Air and Southern Education Society, *Joseph Crane Hartzell* (1902; Hampton University Museum); the distinguished civil rights leader Rabbi Stephen Samuel Wise (c. 1909; unlocated); and the illustrious educator BOOKER T. WASHINGTON (1917; State Historical Society of Iowa). Stylistically, Tanner's portraits follow the patterns of his subject pictures; however, they are characterized by a very shallow recession into space or a certain flatness. On the other hand, there is a continued consistency of the rich brown, blue, blue-green, and mauve palette spiked with bright reds, while multiple light sources abound. These stylistic characteristics are particularly notable in genre scenes based on Tanner's visits to North Africa, as can be seen in *Flight into Egypt: Palais de Justice, Tangier* (c. 1908; National Museum of American Art) and *Sunlight, Tangier* (c. 1912–1914; Milwaukee Art Museum).

Tanner's mature style, which began around 1914, is characterized stylistically by experiments with the thick build-up of enamel-like surfaces, as in one of his last paintings, *Return from the Crucifixion* (1936; Howard University Gallery of Art). During the early years of World War I, Tanner was so frustrated over the military situation that he was unable to create art. While his artistic production was in abeyance, Tanner was a major figure in the American Red Cross; he worked with convalescing soldiers while serving as assistant director of Farm and Garden Services. His artistic career was resumed on 11 November 1918, Armistice Day, when the American Expeditionary Force authorized Tanner's travel to make sketches of the war front. as represented in *Canteen at the Front* (1918; Washington, D.C., American Red Cross).

Tanner garnered ample recognition in the international art literature of his time from critics for periodicals such as *Revue de l'Art, Gazette des Beaux-Arts, International Studio, Fine Arts Journal,* and *Brush and Pencil.* One contemporary critic stated in 1911, "He makes his home continuously in Paris, where many claim that he is the greatest

artist that America has produced" (E. J. Campbell, "Henry O. Tanner's Biblical Pictures," *Fine Arts Journal* 25 [Mar. 1911]: 166). In the final years of his career Tanner's work depicted a preponderance of good-shepherd themes, with which he expressed a strong sense that Jesus watches over his flock and that together man and God overcome evil. Tanner exhibited frequently on both sides of the Atlantic, and several medals from the French Salon jury made him exempt from the jurying process, or *hors concours*, in 1906. He was awarded a gold medal at the 1915 Panama-Pacific Exposition and the prestigious French Cross of the Legion of Honor in 1923. Tanner was elected full academician of the National Academy of Design in 1927.

Tanner's personal life was interwoven with his professional career. In 1899 he married Jessie Macauley Olssen, a white woman from San Francisco who frequently served as his model. They had one child. His wife died in 1925.

Henry O. Tanner was extremely proud of his race but at times lamented the humiliation and sorrow that being black caused him. Moreover, he was sad that he could not live freely in America, the country he loved. It would be impossible to imagine the succeeding generation of African American artists who contributed to the Harlem Renaissance without the example of Tanner's single-minded pursuit of artistic success and his subsequent international recognition. Tanner died in Paris and was buried at Sceaux, Hauts-de-Seine. The U.S. Postal Service issued a commemorative stamp in his honor in 1973.

FURTHER READING

Tanner's papers are in the Archives of American Art, Smithsonian Institution. Valuable information is also included in the Alexander papers at the archives of the University of Pennsylvania.

Mathews, Marcia M. *Henry Ossawa Tanner: American Artist* (1969).

Mosby, Dewey F. *Across Continents and Cultures: The Art and Life of Henry Ossawa Tanner* (1995).

Mosby, Dewey F. *Henry Ossawa Tanner* (1991).

Obituary: New York Herald Tribune, 26 May 1937.

DEWEY FRANKLIN MOSBY

TAYLOR, Eva

(22 Jan. 1895–31 Oct. 1977), vaudeville singer, was born Irene Gibbons in St. Louis, Missouri, the daughter of Frank Gibbons and Julia Evans. Her father died when she was fifteen months old and her mother had difficulty providing for her, and so her career in show business began as a toddler, dancing and singing with Josephine Gassman and her Pickaninnies, a vaudeville act headed by a former opera singer. In this capacity she toured America annually and also visited Hawaii, Australia, and New Zealand from around 1904 to 1906, Europe in 1906, and Australia again from 1914 to 1915.

Gibbons met the songwriter and publisher CLARENCE WILLIAMS while performing in Chicago. Married in New York in 1921, they had three children; their daughter Joy, using the stage name Irene Williams, later became an actress and singer, touring in *Porgy and Bess*. Having grown too old for Gassman's act, Gibbons became a featured soloist in Harlem from 1921 to 1922 at the Lafayette Theater, where she took the stage name Eva Taylor. In 1922 she held a modest solo role in the pioneering African American musical comedy *Shuffle Along*. That same year she also toured with the variety show *Step on It*, appeared in the show *Queen o'Hearts* in New York City, and broadcast with Williams's trio on Vaughn De Leath's *Musical Program* on WEAF in New York City.

Later Taylor became a familiar voice on radio. She explained, "I specialized in ballads, not blues. That and my diction qualified me for the white radio and records market. No one could tell on a record or a broadcast whether I was coloured or white" (Napoleon, 30). She recorded sessions for Columbia with the Charleston Chasers, a white jazz studio group, in June and September 1929. This in turn led to recordings with the bandleader Ben Selvin and then to a staff job at radio station WEAF. The pianist WILLIE "THE LION" SMITH added that Taylor "was known as 'The Dixie Nightingale' and for several years performed on sustaining programs from nine to nine-fifteen every morning over radio station WOR in New York. She made three hundred and fifty dollars per week and turned every cent of it over to Brother Clarence." Among these broadcasts were *Major Bowes Capitol Family Show, The Morning Glories Show, The Rise of the Goldbergs, The Eveready Hour, The Atwater Kent Hour* (all from 1929); *The General Motors Show* (1931); *The Kraft Music Hall* (1933); *The Rye-Crisp Show* (1935); and finally *The Sheep and Goat Club*, in which she made a guest appearance in August 1940 and did so well that she took over the character of Sister Clorinda Billup.

From around 1942 Taylor focused on entertaining at local hospitals. Later she reduced her activities further, singing only occasionally. Williams died in 1965, and in 1967 Taylor visited England. Mary Rust, her English hostess in 1967, wrote, "Everyone that has met her has fallen under her spell. . . . When Eva walks in, it is like the sun coming out." Taylor sang with the Sweet Peruna Jazz Band in Copenhagen in 1974, at the Overseas Press Club in New York in 1974 and 1975, and in Copenhagen and Stockholm in 1975 and 1976. She died in Mineola, New York.

Taylor is best remembered for Williams's Blue Five recordings in sessions of December 1924 and January 1925 with the cornetist LOUIS ARMSTRONG and the reed player SIDNEY BECHET among the instrumentalists. Her vaudeville-style performances include "Mandy, Make Up Your Mind" and "Cake-Walking Babies from Home." She sang with a rich tone, a fast vibrato, a (sometimes overly) precise articulation of lyrics, and a good feeling for jazz rhythm.

FURTHER READING

Dixon, Robert M. W., and John Godrich. *Recording the Blues* (1970).

Harris, Sheldon. *Blues Who's Who: A Biographical Dictionary of Blues Singers* (1979).

Smith, Willie "the Lion," with George Hoefer. *Music on My Mind* (1964; repr. 1975).

BARRY KERNFELD

THOMAS, Edna Lewis

(1886–22 July 1974), actress, was born in Lawrenceville, Virginia, but grew up, from the age of one, in Boston. No information about her parents is available. At the age of sixteen she married Lloyd Thomas, the owner of a custom tailoring business. It is not known when the couple left Boston, but by 1918 they were living in Harlem, where Edna Thomas performed in a benefit performance for Rosamond Johnson's music school at the Lafayette Theatre. The elegant Thomas, who looked much younger than her thirty-two years, was pursued by the Lafayette manager Lester Walton to become a member of the stock company. Despite her husband's objections, Thomas finally succumbed, making her professional debut in Frank Wilson's *Confidence* at the Putnam Theatre in Brooklyn. Thomas quickly became a Lafayette favorite, appearing over the next several years in *Turn to the Right*, *The*

Two Orphans, *Nothing But the Truth*, *Are You a Mason?*, *Within the Law*, *The Cat and the Canary*, and *Rain*. In 1923 she replaced EVELYN PREER in the Ethiopian Art Theatre's *Salome*. She also appeared in the Ethiopian Art Theatre's *Comedy of Errors* and *The Gold Front Stores*. The critic Theophilus Lewis recalled Thomas's "delightful gold digger" as a "moment of glory" in the theater (Black Theatre Scrapbook).

In 1925 Thomas portrayed Celie in Eugene O'Neill's *The Dreamy Kid*, a curtain raiser to *The Emperor Jones* with PAUL ROBESON. In 1927 Thomas joined the cast of David Belasco's sensational *Lulu Belle*, for which the Boston-bred, light-complexioned Thomas had to "black up" and learn a southern dialect, which she accomplished by studying the dialect poems of PAUL LAURENCE DUNBAR. In 1928 Thomas performed *Why Women Cheat* and *In the Underworld* for the Alhambra Players. In the fall of that year Thomas replaced Marie Young as Clara in *Porgy*, traveling to London with the company. By this time Thomas was well established as one of the artistic and cultural leaders of the Harlem Renaissance, an intimate friend of LANGSTON HUGHES, A'LELIA WALKER, Carl Van Vechten, JAMES WELDON JOHNSON, Grace Nail Johnson, FREDI WASHINGTON, and Olivia Wyndham, who shared a home with Thomas and her husband.

In 1930 Thomas appeared as Dr. Bess on Carlton Moss's *Careless Love* radio program. In 1932 she was back on Broadway in *Ol' Man Satan*, playing Maggie (Mary Magdalene). The following year Thomas played Ella, a faithful, forgiving wife, opposite her friend Fredi Washington's temptress, Sulamai, in Hall Johnson's *Run Little Chillun*. Along with Washington, Thomas auditioned for the celebrated role of Peola, a black girl who passes for white, in the 1934 film *Imitation of Life*. Washington got the role, but the two friends shared the common dilemma of being black actors who did not look or sound black enough for unimaginative casting directors. As Thomas recalled, she was frequently dismissed as "too refined, too cultured, too white—when all the time every beat of my heart was Negro" (Thomas clippings file, Billy Rose Theatre Collection).

From 1934 to 1935 Thomas appeared in the Theatre Union's acclaimed and controversial *Stevedore*, a dramatization of labor and racial conflicts that Congress condemned as communist propaganda. The producers and performers of *Stevedore* were

interested in protesting racial and class injustices, and they gave benefit performances for the League of Struggle for Negro Rights, the Actors Fund, and the Scottsboro Defense Fund (aimed to help free the nine young men falsely accused of rape in Scottsboro, Alabama). In 1936 Thomas performed the role of Lady Macbeth in one of the era's most notable theatrical events, Orson Welles's *Macbeth* for the New York Negro Unit of the Federal Theatre Project (FTP). Set in Haiti and featuring an all-black cast, *Macbeth* was a sensation seen by more than one hundred thousand people, greatly admired by many, and discussed by everyone. Thomas was also generally applauded for her portrayal of Lavinia in the FTP's *Androcles and the Lion*.

In addition to performing, Thomas was an administrative assistant for the FTP, and in 1939 she was appointed acting head supervisor for all FTP Negro productions, replacing J. Augustus Smith in that capacity. After Congress dismantled the FTP in 1939, Thomas was instrumental in helping found a playwrights' company to carry on the momentum garnered by the Negro units of the FTP in fostering black artists. Thomas was on the board of directors of the Negro Playwrights Company, which produced Theodore Ward's *Big White Fog* in 1940 at the Lincoln Theatre. Thomas was also a founder and leader of the Negro Actors Guild, serving as a vice president from 1938 to 1939 and as acting executive secretary in 1941.

Thomas returned to Broadway in 1943 as Sukey, a runaway slave, in the long-running *Harriet*, with Helen Hayes. In 1945 Thomas took on another controversial role, as a southern woman desperate to protect her son in the antilynching drama *Strange Fruit*. From 1947 to 1950 Thomas portrayed the Mexican flower vendor in *A Streetcar Named Desire*, in the original Broadway production with Marlon Brando and Jessica Tandy, on tour with Anthony Quinn and Uta Hagen, and in the film version with Brando and Vivien Leigh. She also made guest appearances on television's *The Enforcer* and *Take a Giant Step*.

In the late 1960s Thomas lost the two people she loved most: her intimate friend Olivia died in 1967, and the following year Lloyd Thomas died. The three had lived together since at least the 1920s. Edna Thomas died in New York, of heart disease, six years later. In 1982 one of her FTP collaborators, the musician Leonard Paur, provided this assessment of her unique gifts: "There was about her a sense of quality and absolute total professionalism which permeated not only her performance, but affected the performance of everyone involved with her. She lifted her stage by reason of her own integrity and greatness" (Gill, 75).

FURTHER READING
A clippings file on Edna Thomas is available in the Billy Rose Theatre Collection, New York Library of the Performing Arts. Programs and clippings related to productions in which Thomas appeared may also be found in the Billy Rose Theatre Collection, as well as in the Black Theatre Scrapbook and Fredi Washington Papers, both at the Schomburg Center for Research in Black Culture, New York Public Library. Correspondence between Thomas and Carl Van Vechten, Grace Nail Johnson, and others is held in the James Weldon Johnson Collection, Yale Collection of American Literature, Beinecke Library.

Gill, Glenda E. *White Grease Paint on Black Performers: A Study of the Federal Theatre, 1935–39* (1988).

Obituaries: New York Times, 24 July 1974; *Variety*, 31 July 1974.

CHERYL BLACK

THOMPSON PATTERSON, Louise

(9 Sept. 1901–27 Aug. 1999), cultural and political radical, activist, and feminist, was born Louise Alone Toles in Chicago, the daughter of William Toles, a bartender, and Lula Brown Toles. In 1904 Louise's parents separated, and in the next ten years she lived throughout the Northwest with her mother and her stepfather, William Thompson. Often the only black child in town, Louise was the target of vicious racial insults. In an effort to maintain her self-respect she strove to excel in school. In 1919 she enrolled at the University of California at Berkeley. There she attended a lecture by W. E. B. DU BOIS, a founder of the National Association for the Advancement of Colored People. "For the first time in my life," she recalled, "I was proud to be black." Du Bois's talk prompted Thompson to dream of traveling to New York City and becoming involved in racial politics. In 1923, one of only a handful of black students, she graduated cum laude in economics.

With the encouragement of Du Bois, Thompson took a position in 1925 at a dilapidated black college in Pine Bluff, Arkansas, and in 1927 at the Hampton Institute. But her support for a student strike against the school's racially conservative administration cost Thompson her job. In 1928 she took a position as a social worker with the National Urban League in New York City. But she soon became disillusioned with the profession's paternalism. She also became immersed in the Harlem Renaissance, working as the secretary to ZORA NEALE HURSTON and LANGSTON HUGHES. Hughes remained a lifelong friend. In 1928 Thompson married the novelist Wallace Thurman, but they separated after less than six months.

With the onset of the Depression, Thompson gravitated toward the left. In 1931 she founded the Harlem branch of the Friends of the Soviet Union, and Harlem intellectuals congregated at her apartment to discuss Marxism and the Soviet Union. In 1932 she was asked to organize a group of African Americans to travel to the Soviet Union and make a film about racial conditions in the United States. Thompson pulled together twenty-two black artists and writers, including Langston Hughes. The film was canceled after they arrived, making international headlines. Yet Thompson was deeply impressed with the Soviet Union, viewing it as a striking model for building a society committed to social equality. "Because of what I had seen in the Soviet Union," she recalled, "I . . . was ready to make a change" (LTP Papers, 14 May 1987 interview, 22).

After she returned to Harlem, Thompson became widely known as "Madame Moscow" for her vocal support of the Soviet Union. Her critics included the African American journalist Henry Lee Moon, who had been one of the cast members for the film. She was also attracted to the Communist movement because of its efforts to free the SCOTTSBORO BOYS, nine black adolescents who had been falsely accused and sentenced to death for raping two white women in Alabama. In 1933 she organized a successful Scottsboro march in Washington, D.C., and joined the Communist Party; in 1934 she joined the International Workers Order (IWO), a Communist-affiliated fraternal organization. By the end of the decade Thompson was elected IWO national secretary. In 1937 she attended the Paris World Congress against Racism and Fascism and observed the Spanish Civil War. In 1938

she cofounded with Hughes the short-lived Harlem Suitcase Theater, which produced the wildly popular *Don't You Want To Be Free?*

In 1940 Thompson married the Communist leader WILLIAM PATTERSON, and they moved to Chicago. Three years later she gave birth to a daughter. In the late 1940s she and Patterson, along with Du Bois, Alpheaus Hunton Jr., and PAUL ROBESON, formed the Council of African Affairs, an organization dedicated to ending colonialism. By 1950 the Pattersons had returned to New York.

In 1951 Thompson Patterson, with the actor Beulah Richardson and the journalist Charlotta Bass, founded the Sojourners for Truth and Justice, an all-black women's progressive civil rights organization. The group issued a call for African American women to join in a demonstration "to call upon our government to prove its loyalty to its fifteen million Negro citizens" (LTP Papers, box 15, folder 26). The stifling anti-Communist political atmosphere of the era partially contributed to the Sojourners' demise.

Louise and William Patterson fell victim to McCarthyism during the early 1950s. On 6 April 1951 Thompson Patterson was called to testify in *People of New York v. International Workers Order*, a New York State court case, because of her involvement with the IWO, which had been deemed a "subversive" organization. She invoked the Fifth Amendment but was not jailed. William Patterson, however, was jailed and lost his passport because of his political activities. Thompson Patterson organized national campaigns to free him and for the return of his passport, as well as those of Du Bois and Robeson.

Although some African American activists broke their ties with the left, Thompson Patterson continued agitating for progressive causes. In the early 1960s she helped the noted historian Herbert Aptheker found the American Institute for Marxist Studies. In 1969 she returned to the Soviet Union, marveling at the tremendous changes that had taken place there. The Pattersons' New York apartment served as a place where many young black militants came to gain valuable political insight.

In the early 1970s Thompson Patterson headed the New York Committee to Free Angela Davis, the African American Communist who had been accused of involvement in the shooting death of a California judge in August 1970. After her husband's death in 1980, Thompson Patterson founded the William L. Patterson Foundation. In the late

1980s, with the assistance of the scholar Margaret Wilkerson, Thompson Patterson began writing her memoirs. She was discussed in numerous critically acclaimed studies of Du Bois, Hughes, the Harlem Renaissance, and the black left, and she appeared in several documentaries. She also received many awards. By the mid-1990s Thompson Patterson's health declined; consequently her memoir was never completed. It would have been a fascinating account of an extraordinary African American woman who took part in many of the most significant social, political, and cultural movements in the United States and abroad during the twentieth century.

FURTHER READING

The main body of Thompson Patterson's papers can be found at the Special Collections Department, Robert W. Woodruff Library, Emory University, Atlanta, Georgia. Information can also be found about her in the Matt N. and Evelyn Graves Crawford Papers, Special Collections, Emory University; the Langston Hughes Papers, Beinecke Rare Book and Manuscript Library, Yale University, New Haven, Connecticut; and in the Communist Party USA Files, Library of Congress, Washington, D.C. The Tamiment Library at New York University contains audiotapes of Thompson Paterson's lengthy 1981 interview with Ruth Prago, which was part of the Oral History of the American Left (OHAL) project.

Kelley, Robin. "The Left," in *Black Women in America: An Historical Encyclopedia*, ed. Darlene Clark Hine (1994).

Massiah, Louis. *Louise Alone Thompson Patterson* (2002).

Naison, Mark. *Communists in Harlem during the Depression* (1983; repr. 2005).

Wilkerson, Margaret. "Excavating Our History: The Importance of Biographies of Women of Color," *Black American Literature Forum* 24, no. 1 (Spring 1990): 73–84.

Obituary: Los Angeles Times, 19 Sept. 1997.

ERIK S. MCDUFFIE

THOMPSON, Ulysses "Slow Kid"

(28 Aug. 1888–17 Mar. 1990), dancer and comedian, was born in Prescott, Arkansas, the son of George Thompson, whose father, Aaron Thompson, was a local white doctor. Thompson's mother,

Hannah Pandora Driver, was six years older than his father and came from a large family that "populated that whole community," as Thompson would later recall (Helen Armstead-Johnson Collection). The four Driver brothers, including Thompson's maternal grandfather, owned their farms. Several of the Driver girls became schoolteachers in the area, and a Driver cousin of Thompson's was nominated for a bishopric in the 1960s.

Although his family was upwardly mobile, Thompson himself had only a rudimentary education; men in the family were expected to work as farmers and laborers. When Thompson was seven years of age, his mother died; after this tragic loss, life at home was not pleasant for Thompson. His father remarried repeatedly, and Thompson had numerous half brothers and sisters in addition to an older brother and sister by the same mother. After his mother's death, Thompson lived with a grandmother temporarily. He ran away from home sometime between the ages of twelve and fourteen; and over the next several years, he worked in a stave factory, a quarry, a mining camp, and a slaughterhouse. At sixteen years of age he served time on a chain gang in Mineola, Texas, after being caught riding atop a passenger train car. He was beaten while imprisoned, and after local whites burned his cell, he served the remainder of his sentence chained by his neck to a stake in a hayloft.

Around 1910 Thompson found work as a cook with the Mighty Hagg Circus, then he apprenticed in such troupes as the Gillie Medicine Show and Dr. Fuller's Louisiana Medicine Show. These were rough tent shows featuring "geeks" and "hootchie-cootchie" girls, and performers in this particular show-business environment endured disagreeable living conditions and danger at the hands of rowdy locals. Thompson worked his way up to a better class of shows, and around 1915 he joined the Ringling Brothers Circus. By the end of that year he had joined Ralph Dunbar's Tennessee Ten as their dance director. In this show he met a young soubrette named FLORENCE MILLS, hiring her as a replacement for a girl who had left the show.

Through the teens Thompson toured widely on the African American vaudeville circuit. By the end of the decade he began to work the white vaudeville circuit as well, with the B. F. Keith organization. He married for the first time during this phase of his career, but little is known of his first wife, a dancer named Letitha Blackburn.

Thompson served in France as a "musician third class" during World War I. He is not known to have played an instrument, and probably served as a drum major and entertainer with his regiment, as did NOBLE SISSLE and other performers in the war. By war's end Thompson was proficient in several forms of show dancing, including the cakewalk and minstrel dances, the buck and wing, and tap. He became best known for his specialty or "eccentric" dances. These ran the gamut from highly acrobatic "jumping" dances—a *New York Times* critic referred to him as "Jumpin' Jack" in 1921 ("Plantation Revue," 18 July 1822)—to a slow motion routine that earned him his lifelong nickname, "Slow Kid."

In 1920 Thompson joined the cast of a show called *Folly Town*, where he reencountered Mills, now an up-and-coming showgirl. Both joined the cast of the long-running musical *Shuffle Along*, with Mills replacing the star of the show, Gertrude Saunders. On the strength of their work in *Shuffle Along*, Mills and Thompson, now dancing partners, were hired by impresario Lew Leslie to perform in the floor show at his plantation restaurant. This show became so successful that Leslie moved it to Broadway as the *Plantation Revue* in 1922. In the same year, Thompson and Mills were married; it is not known what had become of Thompson's first wife.

Through the remainder of Mills's life, she and Thompson worked together, and he was frequently credited with putting her career ahead of his own. They traveled to England with *From Dover to Dixie* (a renamed version of the *Plantation Revue*) in 1923. In 1924 they were back in New York, in *From Dixie to Broadway*; 1925 found them again in London with Lew Leslie's *Blackbirds*, which also enjoyed a successful run in Paris. In 1927 the *Blackbirds* cast made a triumphant return to New York. However, Mills soon died of appendicitis, a tragedy which sent shock waves through the entertainment world. Her funeral was among the biggest New York had ever seen.

By 1930 Thompson's American career was waning, although he continued to work, playing the Howard Theatre in Washington, D.C., in 1929 and Harlem's Lafayette Theatre in 1931. He had never been a headliner during his joint career with Mills, taking a back seat to her and several other stars, including the dancer-comedian Johnny Hudgins; however, he had a stock of routines, songs, and jokes as well as dance numbers—some of these were his own creations, others were by such leading writers as Henry Creamer. In the wake of Mills's death, Thompson embarked on a series of tours in Europe, Asia, and the Pacific, now often as headliner. In 1933 he played the Garden Petits Champs in Constantinople (later Istanbul). On this same tour, he played Bucharest in Romania and Berlin in Germany, among other cities. In 1937 he was with George Sorlie's *Crispies and Crackers* tour of the South Pacific, including Hobart (in Tasmania), and stops throughout Australia. Two years later Thompson was with Teddy Weatherford's *Plantation Nights* show in Colombo, Ceylon (later Sri Lanka), and appeared at a Jewish Relief Charity Cocktail Dance in Bombay. Other Asian stops during this extended tour included Singapore, Manila, Surabaya, Penang, Rangoon, Saigon, and Shanghai.

Long after he ceased performing regularly, Thompson remained busy by attending to the Florence Mills estate. Initially there was a move to create a permanent memorial to her, and Thompson served as treasurer of the Florence Mills Theatrical Society from 1927 to 1929, but these efforts came to nothing. Thompson received a sizable payment from the Hollywood firm of Herzbrun & Chantry in 1943, granting them the right to develop a treatment of Mills's life and promising Thompson both an advisory role and the chance of an acting part in the piece. He also appears to have contributed to the Harlem portion of a guidebook to New York City and was paid a percentage by Grayson's Guides Company in 1950. In 1969 he was in contact with the playwright and theater historian Loften Mitchell about another attempt to create a musical about Mills's life.

In 1936 Thompson married his third wife, Dr. Sophronia Turner; she died two years later. In 1946 he married his fourth wife, Dr. Gertrude Curtis, the first African American female dentist in New York. Dr. Curtis died in 1973 at the age of ninety-three. Show business historians and chroniclers of African American culture sought Thompson out in his old age. Through the 1980s he also kept in touch with numerous correspondents, particularly show folk, in such far-flung locales as Australia. "Slow Kid" Thompson spent his last five years in a retirement home in Arkansas, where he was looked after by two nieces; he died there at the age of 101. As a veteran of World War I, Thompson was entitled to a veteran's burial and was interred at the Little Rock National Cemetery in Arkansas.

FURTHER READING

Thompson's papers are included, as are those of Florence Mills, in the Helen Armstead-Johnson Collection, Schomburg Center for Research in Black Culture, New York Public Library.

Obituary: Arkansas Gazette, 19 Mar. 1990.

ELLIOT HURWITT

THURMAN, Wallace

(16 Aug. 1902–21 Dec. 1934), Harlem Renaissance writer and editor, was born in Salt Lake City, Utah, the son of Oscar Thurman and Beulah Jackson. His father left the family while Wallace was young, and his mother remarried several times, possibly contributing to his lifelong feelings of insecurity. Thurman's lifetime struggle with ill health began as a child, and his fragile constitution and nervous disposition led him to become a voracious reader with literary aspirations. Thurman entered the University of Utah in 1919, but he quickly transferred to the University of Southern California, where he studied for entrance into medical school until 1923. After leaving college, Thurman worked in a post office to support himself while he wrote a column for a black newspaper and edited *Outlet* magazine. In the fall of 1925 Thurman journeyed to Harlem, where he worked for meals in various capacities for Theophilus Lewis, editor of *Looking Glass*, whose recommendation resulted in a position as managing editor for the *Messenger*. Thurman used his skills in the publishing industry to support his artistic endeavors, and he later moved to the white magazine *World Tomorrow* as circulation manager. Eventually he became editor in chief at the publishing firm of Macaulay Company.

Thurman's first priority, however, was always art, and his most noteworthy contribution to the Harlem Renaissance was his publication in 1926 of the short-lived magazine *Fire!!* Although *Fire!!* was shakily financed by contributions from its own editorial collective, its impact went beyond its meager circulation. Through the magazine, Thurman established himself as the galvanizing force behind the younger generation of Harlem Renaissance writers, such as ZORA NEALE HURSTON and LANGSTON HUGHES, who wished to be freed from what they perceived as the propagandistic motivations and thematic limitations advocated by older black critics such as W. E. B. DU BOIS and ALAIN LOCKE. These critics, as well as much of the black press, reacted negatively to the journal, claiming that its content was too lascivious and that the journal gloried in images of dissipated black working-class life instead of glorifying the respectable black middle classes. In the aftermath of the commercial failure of *Fire!!*, Thurman began another journal, *Harlem*, that was less controversial among critics and less confrontational with its readers. It specialized in short fiction and theater and book reviews and sought to provide its readers with a guide to Harlem's activities and attractions. This magazine also lasted one issue.

Despite his homosexuality Thurman married Louise Thompson in 1928, shortly before his 1929 theatrical success, *Harlem*. The couple had no children and later divorced. Cowritten with William Jourdan Rapp, *Harlem* dealt with the topic of southern transplants adjusting to life in the black urban metropolis. Based on Thurman's short story "Cordelia the Crude" in *Fire!!*, the play dealt with black urban realities such as male unemployment and it introduced white theatergoers to the Harlem rent parties and the numbers racket. It was to have been the first part of a trilogy, coauthored with Rapp, titled *Black Belt*. The second play in the trilogy, *Jeremiah the Magnificent*, dealt evenhandedly with the MARCUS GARVEY phenomenon, yet the play was never produced. The final play, *Black Cinderella*, explored intraracial prejudice but remained unfinished, possibly because the authors were discouraged by their inability to stage *Jeremiah the Magnificent* or to interest Hollywood in *Harlem*.

In 1929 Thurman published his first novel, *The Blacker the Berry*, to mixed reviews. The novel tells the story of Emma Lou Morgan, a dark-skinned black woman whose obsession with light skin (or internalized self-hatred) results repeatedly in personal misfortune. Thurman deftly investigated the many ironies of this situation, as middle-class Emma Lou's own prejudice against dark-skinned working-class blacks remains disconnected in her own mind from the unjust social snobbery that she encounters from the mulatto society whose social circle she covets. In 1932 Thurman published a satirical roman à clef, *The Infants of Spring*. This novel offered a somewhat grim prognosis for the lasting achievements of the Harlem Renaissance. Thurman portrayed the young black artists in the novel as hampered by the suffocating management of older black critics, the faddish attention of a white audience, and their own bloated egos. Thurman evinced concern for the fate of talented if untrained artists

within a racially charged milieu that simultaneously inflated their accomplishments while circumscribing their significance. He also explored the difficulties inherent in trying to negotiate the opposite demands of art as racial propaganda and art as transcending race. In that same year, Thurman also released a muckraking novel, *The Interne*, cowritten with Abraham L. Furman, about unethical medical practices and the pressures of a medical bureaucracy on a young intern at a hospital where Thurman, ironically, died several years later.

In 1934 Thurman went to Hollywood to write scripts for an independent production company for $250 a week. He wrote scripts for two films, one of which, *Tomorrow's Children*, a serious social problem film dealing with state-mandated sterilization, survives today. Ill health cut short his tinseltown sojourn, and he returned to Harlem later that same year. Although warned about taxing himself, Thurman collapsed at a party and was admitted to City Hospital on Welfare Island. He was diagnosed with tuberculosis and gradually weakened until his death. The death of Thurman and fellow Harlem Renaissance writer RUDOLPH FISHER within days of each other marked for many the symbolic end of the Harlem Renaissance.

FURTHER READING

The majority of Thurman's papers are in the James Weldon Johnson Collection at the Beinecke Library, Yale University. Smaller collections of his letters are in the Moorland-Spingarn Research Center at Howard University and the William Jourdan Rapp Collection at the University of Oregon Library.

Bontemps, Arna. "Portrait of Wallace Thurman," in *The Harlem Renaissance Remembered*, ed. Bontemps (1972).

Lewis, David Levering. *When Harlem Was in Vogue* (1981).

Obituary: New York Amsterdam News, 29 Dec. 1934.

MICHAEL MAIWALD

TOLSON, Melvin Beaunorus

(6 Feb. 1900–29 Aug. 1966), poet, teacher, and essayist, was born in Moberly, Missouri, the son of Alonzo Tolson, an itinerant Methodist minister, and Lera Ann Hurt, a seamstress. Some sources list his year of birth as 1898. Although his father's occupation required frequent moves to various towns in Missouri, Iowa, and Kansas, young Tolson's childhood was a happy one, relatively unscathed by the various forms of racial prejudice that many African Americans faced during the early twentieth century. After a brief stint at Fisk University following his graduation from high school in 1918, Tolson enrolled in 1919 at Lincoln University in Pennsylvania, where he earned a bachelor of arts degree in Journalism and Theology in 1923. In 1922 he married Ruth Southall, and together they raised four children. Tolson in 1931 entered a graduate program in comparative literature at Columbia University, though he was not overly concerned with the formal aspects of applying for the degree; it was not until 1940 that he was finally awarded the master of arts degree.

In 1923, fresh from college and only twenty-three years old, Tolson accepted a position as instructor of English and speech at a small African American college in Marshall, Texas, thus beginning a brilliant teaching career that he would maintain with dedication and energy for more than forty years. Tolson distinguished himself at Wiley College by coaching the debate team to a ten-year winning streak that included victories over champion teams from Oxford University and the University of Southern California. According to Robert M. Farnsworth, his experiences with the debate teams, which included circumventing the color line in racially divided towns throughout the South and the Midwest, often found their way into his creative and journalistic writings, particularly his columns written for the *Washington Tribune* during the 1930s and 1940s.

Tolson remained at Wiley until 1947, when he accepted a position as professor of English and drama at Langston University in the small African American town of Langston, Oklahoma. Although his years with the celebrated debate teams from Texas had passed, he soon established a solid reputation within the Langston community as a respected teacher and, in 1954, as the town's mayor, an office to which he was reelected three times. The capstone of Tolson's teaching career came in 1965, the year he had planned to retire from Langston University. At sixty-five years of age he accepted the Avalon Chair in Humanities at Tuskegee Institute, an appointment arranged by a former student of Tolson's who now chaired the English department at Tuskegee.

While his long teaching career provided stability and a consistent income for Tolson's family,

it was as a poet that Tolson made a significant contribution to American literature and history. Tolson had tinkered with poetry and painting as a child and had experimented with several literary genres in his early years at Wiley College, but his professional career as a poet began in earnest in the early 1930s with his work on a lengthy manuscript, "A Gallery of Harlem Portraits." Tolson was strongly influenced by Harlem Renaissance poets, including LANGSTON HUGHES, COUNTÉE CULLEN, and CLAUDE MCKAY, whose writings he had studied extensively while writing his master's thesis at Columbia. "A Gallery of Harlem Portraits" represents an early example of Tolson's conviction that the distinct cultural expressions of the African American community, particularly the blues, jazz, and gospel forms, provide a wealth of material from which the black poet can draw for inspiration.

Although his first book-length manuscript was praised in a 1938 *Current History* column by fellow writer V. F. Calverton, who lauded Tolson for "trying to do for the Negro what Edgar Lee Masters did for the middlewest white folk over two decades ago," "A Gallery of Harlem Portraits" was rejected by publishers (Farnsworth, 58). Determined to continue writing, however, Tolson gained national recognition with "Dark Symphony," a poem that blends a profound historical consciousness of the African American struggle against adversity with a defiant message aimed at oppressors throughout the world. "Dark Symphony" won first place in a national poetry contest in 1940 and was published in the *Atlantic Monthly* in 1941. Shortly after these initial successes, *Rendezvous with America*, another book-length collection of poems, was accepted by Dodd, Mead and Company. Published in 1944, *Rendezvous* reflected the complexity of the American experience in the context of World War II. While many of the poems allude to the ironies inherent in a racially divided nation that was fighting a war to rid the world of racial supremacy, the book as a whole is also a celebration of America's diversity: "America? / An international river with a legion of tributaries! / A magnificent cosmorama with myriad patterns and colors!" (*Rendezvous*, 5). Tolson's book elicited enthusiastic reviews and nearly unqualified praise from prominent African American writers such as RICHARD WRIGHT, who opined that "Tolson's poetic lines and images sing, affirm, reject, predict, and judge experience in America. . . . All history, from Genesis to Munich, is his domain"

(Farnsworth, 95). Following the success of *Rendezvous*, in 1947 Tolson was named "poet laureate of Liberia" at a ceremony in Washington, D.C., and shortly thereafter began work on a poem to celebrate the Liberian centennial. The result was *Libretto for the Republic of Liberia* (1953), a book-length ode that revealed Tolson's broad knowledge of modernist poetry and world history. Although *Libretto* garnered some strong reviews and elicited comparisons with the works of modernists such as Ezra Pound and T. S. Eliot, it was *Harlem Gallery: Book I: The Curator*, released by Twayne Publishers in 1965, that marked the pinnacle of Tolson's poetic career. Tolson envisioned *Harlem Gallery* as a multivolume epic exploring the full experience of African Americans throughout history, but his goal was never realized; he died a year later at a hospital in Dallas, Texas. Nevertheless, the first volume of *Harlem Gallery*, with its innovative use of language and its synthesis of modernist poetics and African American musical forms, ensured Tolson a place among the highest ranks of American literary masters. In the words of one reviewer, "The book is 'Gibraltarian' in content and apogean in scope. . . . He has taken the language of America and the idiom of the world to fashion a heroic declaration of, about and for Negroes in America" (Farnsworth, 277).

FURTHER READING
Tolson's papers are in the Library of Congress.
Berube, Michael. *Marginal Forces/Cultural Centers: Tolson, Pynchon, and the Politics of the Canon* (1992).
Farnsworth, Robert M. *Melvin B. Tolson, 1898–1966: Plain Talk and Poetic Prophecy* (1984).
Farnsworth, Robert, ed. *Caviar and Cabbage: Selected Columns by Melvin B. Tolson from the Washington Tribune, 1937–1944* (1982).
Farnsworth, Robert, ed. *A Gallery of Harlem Portraits* (1979).
Werner, Craig Hansen. *Playing the Changes: From Afro-Modernism to the Jazz Impulse* (1994).
Obituary: New York Times, 30 Aug. 1966.

CHRISTOPHER C. DE SANTIS

TOOMER, Jean

(26 Dec. 1894–30 Mar. 1967), writer and philosopher, was born Nathan Pinchback Toomer in Washington, D.C., the only child of Nathan Toomer, a

planter from North Carolina, and Nina Pinchback, the daughter of the Reconstruction-era senator P. B. S. Pinchback. Pinchback was biracial, and he could easily have passed for white. In fact, his sister urged him to do just that when she wrote, "I have nothing to do with negroes am *not* one of them. Take my advice *dear* brother and do the same" (Kerman and Eldridge, 19). Toomer's grandfather ignored that advice, went on to become, briefly, acting governor of Louisiana, and was elected to both the U.S. House of Representatives and the U.S. Senate, though he was denied entrance to both houses.

Toomer once said that it would be "libelous for anyone to refer to me as a colored man" (Rayford Logan, *Dictionary of American Negro Biography* [1982], 598), and he felt betrayed when ALAIN LOCKE included some of his writings in *The New Negro* (1925), a book showcasing emerging black artists of the Harlem Renaissance. Unraveling the paradox of his life and work goes to the heart of the problem of race in America: Who is black, what is black culture, and who has the power to make these decisions?

Abandoned by her husband in 1895, Nina took her son to live with her parents in their stately home in Washington, D.C. Pinchback did not want his grandson to keep either the name Nathan or the name Toomer because they belonged to his delinquent father; the family began calling him Eugene instead, after another relative. As an adult, Toomer chose the form Jean. He grew up in a neighborhood where most of the children were white, and he did not think of himself as being different until he was about nine years old, when he entered the Garnet School for colored children. Then, for the first time in his life, the pall of race separated him from those he thought were his natural associates. He did not apply himself or excel academically, though he maintained a sense of entitlement and superiority over his peers.

In 1906 Nina married Archibald Combes, an insurance salesman, and the family moved to New York, where they lived in predominantly white neighborhoods in Brooklyn and then in New Rochelle. However, when Toomer's mother died three years later, he returned to Washington to live with his grandparents, who had moved to a more modest residence in an integrated section of town. In 1910 Toomer enrolled at the M Street High School, which he described as "an aristocracy—such

as never existed before and perhaps never will exist again in America—mid-way between the white and negro worlds. For the first time I lived in a colored world" (Kerman and Eldridge, 47).

Toomer saw himself as a person who could travel freely in the black world, comprehend its meaning, and imbibe its melancholy beauty, but he never claimed that world as his own, and he resisted every attempt at being claimed by it. In fact, at every juncture at which he was given the chance to indicate his racial identity (on college applications, marriage licenses, and so on), he chose to identify himself as white. This was not merely a subconscious motivation; Toomer was quite aware of his chameleon-like ability to straddle the color line. He remarked that "viewed from the world of race distinctions, I take the color of whatever group I at the time am sojourning in" (Kerman and Eldridge, 96).

Toomer's early adult years were devoid of focus. Between 1914 and 1917 he enrolled at the University of Wisconsin, Massachusetts College of Agriculture, American College of Physical Training in Chicago, University of Chicago, New York University, and City College of New York. He attempted to join the military but was rejected because of poor eyesight. For a brief time he studied privately to become a musician. Between each fleeting ambition, Toomer worked a variety of jobs: drugstore clerk, assistant librarian, fitter in a New Jersey shipyard, and car salesman. Financially, Toomer relied on his grandfather's largesse and, later, on the generosity of various women in his life.

Although he did not thrive in formal academic settings, Toomer was a voracious reader. He delved into works on Eastern religion and politics and the writings of Walt Whitman, George Bernard Shaw, and Robert Frost. While living in Greenwich Village in 1918, Toomer began writing poetry and short stories in earnest. Waldo Frank, a close friend and mentor, nurtured his literary aspirations and encouraged him to refine his talent. Destitute and desperate to make a success of writing, Toomer returned to Washington, secluded himself in a room rented by his grandfather, and devoted himself to his new craft.

An auspicious break came in the fall of 1921, when Toomer learned from one of his grandfather's visitors that the all-black Sparta Agricultural and Industrial Institute in Georgia was in need of a temporary principal. Toomer secured the position and moved to the South, where he took in the sight of

blacks toiling in the soil, the sound of spirituals sung in black churches, and the drama of black life in the segregated South. This experience was artistically stimulating for Toomer; it contrasted sharply with his limited encounters with the Negro elite in Washington, and it supplied the inspiration and much of the content for his literary masterpiece.

Cane (1923) is a montage of self-contained vignettes interspersed with poetry. Each of its elements could stand alone (and several were published separately), but they fit together to form a harmonious testament to a segment of black life in the twilight between slavery and freedom. Toomer's female characters, in particular, are imbued with an aesthetic beauty and pathos that makes each of their stories compelling. This slim volume had a monumental impact, opening up new avenues of expression for Negro artists trying to find an authentic voice. It demonstrated that black folk culture could be rendered in powerful prose of a sort not often found in polemical novels and with an integrity that was lacking in the "happy darky" caricatures popular at the time. Similarly, its mosaic structure encouraged greater experimentation with form and presentation. LANGSTON HUGHES and ZORA NEALE HURSTON were so moved by *Cane* that they drove to Sparta as if they might find there a wellspring of creativity. Yet Toomer had written this gem and walked away. A gold rush followed, as other artists eagerly mined the black experience, which until then had not been fully appreciated as a fruitful source for serious works of literature, music, and art.

When *Cane* appeared in 1923 to moderate reviews and sales among the white reading public but to enthusiastic praise in Negro publications, such as the *Crisis* and *Opportunity*, Toomer realized that a place was being set for him at the table of black writers, whereas he had hoped to be accepted as a writer without reference to race. Toomer was disappointed that Waldo Frank, whom he had asked to write the book's introduction, referred to him as a "Negro," and Toomer bluntly refused to assist his publisher in any marketing strategy that featured him as a premier black talent. However, his choice of subject matter emphasized the very connection to blackness that he had hoped to avoid. Despite the prodding of those who yearned for more works like *Cane*, Toomer devoted the next four decades to writing material that explored universal rather than racial topics. For the rest of his life, he threw himself

into a world of mystics, spiritualists, and new age thinkers.

Toomer's spiritual journey ranged from Jungian psychology to Scientology. He consulted psychics, journeyed to India in search of enlightenment, and became a noted Quaker. Toomer was most captivated with the teachings of the Russian philosopher George Ivanovich Gurdjieff, who developed a system of beliefs and exercises by which one could achieve a higher consciousness he called "Unitism." In 1924 Toomer became an acolyte of this movement; he met the guru in New York and by 1929 had made several trips to France to study at Gurdjieff's Institute for Man's Harmonious Development. Back in the United States, Toomer became a teacher of Gurdjieffian metaphysics. In Harlem he attempted to recruit members of the black intelligentsia, such as AARON DOUGLAS, NELLA LARSEN, and ARNA BONTEMPS. While speaking at a Gurdjieff gathering in Chicago, Toomer met Margery Latimer, a wealthy white writer. The two were married in 1931. Margery died within the year while giving birth to Toomer's only child, Margery.

In addition to *Cane*, Toomer wrote three unpublished novels: "The Gallowerps" (1927), "Transatlantic" (1929), and "Caromb" (1932). None of these books features black protagonists, and they were all rejected by the publishers to whom they were sent. *Essentials* (1931), a collection of aphorisms, was privately printed. In 1934 Toomer married Marjorie Content, a photographer and the daughter of an affluent Wall Street executive. They settled in Doylestown County, Pennsylvania, where Toomer continued to write essays and fiction that embodied his philosophy. The closest Toomer ever came to writing about racial issues after *Cane* was in a discursive poem called "Blue Meridian," which appeared in *The New American Caravan* (1936). This poem articulates a fantastic vision of the amalgamation of different races into a new order of being represented by the "blue" man. Toomer's play *Balo* appeared in Alain Locke's *Plays of Negro Life* (1929), and some of his early essays and short stories were featured in *Dial*, the *Crisis*, *Broom*, and the *Little Review*.

After a series of geriatric illnesses, Toomer died in 1967 in a nursing home in Bucks County, Pennsylvania, at the age of seventy-seven and in virtual obscurity. In 1969 *Cane* was reissued and has become an indispensable work in the African American literary canon. Alice Walker wrote in her

review of *The Wayward and the Seeking* (1982), a collection of Toomer's previously unpublished work, that "*Cane* was for Toomer a double 'swan song.' He meant it to memorialize a culture he thought was dying, whose folk spirit he considered beautiful, but he was also saying goodbye to the 'Negro' he felt dying in himself. *Cane* then is a parting gift, and no less precious because of that. I think Jean Toomer would want us to keep its beauty, but let him go" (*New York Times Book Review*, 13 July 1980).

FURTHER READING

The main body of Toomer's papers is located at the Beinecke Rare Book and Manuscript Library, Yale University, New Haven, Connecticut.

Jones, Robert B., ed. *Critical Essays on Jean Toomer* (1994).

Kerman, Cynthia, and Richard Eldridge. *The Lives of Jean Toomer: A Hunger for Wholeness* (1987).

McKay, Nellie Y. *Jean Toomer, Artist: A Study of His Literary Life and Work, 1894–1936* (1984).

Turner, Darwin T., ed. *The Wayward and the Seeking: A Collection of Writings by Jean Toomer* (1982).

SHOLOMO B. LEVY

TROTTER, William Monroe

(7 Apr. 1872–7 Apr. 1934), newspaper publisher and civil rights activist, was born in Chillicothe, Ohio, the son of James Monroe Trotter, a politician who served as recorder of deeds under President Grover Cleveland, and former slave Virginia Isaacs. In addition to his political career, Trotter's father was an abolitionist, a veteran of the 55th Massachusetts regiment, and an authority on African American music. Raised among Boston's black elite and steeped in the abolitionist tradition, Trotter entered Harvard University and made history as the institution's first African American elected to Phi Beta Kappa. After graduating magna cum laude and earning his master's degree from Harvard, Trotter returned to Boston to learn the real estate business. He founded his own firm in 1899, the same year that he married Boston aristocrat Geraldine Pindell.

A turning point in Trotter's life occurred in 1901 when discrimination in his real estate business and worsening racial conditions throughout the country, and especially in the South, led to his increased militancy. In response to his frustration with segregation, disenfranchisement, and violence against blacks, Trotter founded the *Boston Guardian*, a crusading weekly newspaper. Cofounder George Forbes soon left the paper in Trotter's able hands. The *Guardian* was an overnight success that boasted a circulation of 2,500 by its first birthday. As editor and publisher, Trotter was articulate, fearless, and defiant. The *Guardian* reestablished the black press as a force in the struggle for civil rights.

Trotter's great crusade in the pages of his newspaper was a vendetta against BOOKER T. WASHINGTON. Trotter opposed Washington's complacent optimism in the face of increasingly intolerable racial conditions. He also disagreed with Washington's emphasis on manual and industrial training for blacks, with its accompanying denigration of the classical education. Trotter's opposition to Washington forced white America to acknowledge that all of black America did not adhere to Washington's conciliatory and accommodationist views. Trotter's frustration with Washington reached its boiling point in July 1903. When Washington came to Boston for a public appearance, Trotter and some thirty associates heckled the orator and asked him several embarrassing questions. A free-for-all erupted into what became known as the Boston Riot. Washington supporters then pursued the case to its conclusion, resulting in Trotter's being fined fifty dollars and imprisoned for a month. Trotter thereafter assumed the mantle of martyr.

Trotter has been credited with leading a resurgence of the protest tradition among African Americans of the early twentieth century. In 1905 he joined W. E. B. DU BOIS in founding the Niagara Movement, an early civil rights organization and precursor of the National Association for the Advancement of Colored People (NAACP). Trotter helped to push Du Bois away from research and into defiance as the avenue down which African Americans would secure equal rights. The tenacity and independence that served Trotter well as a journalist, however, hampered his work as a political leader. Personal quarrels with Du Bois created an estrangement between the two leaders. Chief among their disagreements was Trotter's insistence that a national civil rights organization had to be led and financed exclusively by African Americans. In 1908 Trotter founded the National Equal Rights League, an all-black organization that advocated militant efforts to secure racial equality. Although Trotter participated in the founding of the NAACP a year later, he would not accept the white leadership and

financial support underpinning the association. As the NAACP's influence swelled, the uncompromising Trotter became isolated on the left wing of black leadership.

One of Trotter's most fiery interchanges occurred at the White House. Trotter, a political independent, supported Woodrow Wilson for president in 1912. When Wilson approved increased segregation in federal office buildings, however, the new president lost Trotter's support. The radical black leader took a delegation to the White House in 1914 and engaged Wilson in a jaw-to-jaw argument. After nearly an hour, the president ordered the vitriolic Trotter out of his office.

Trotter moved the struggle for racial equality in the direction of mass mobilization. In 1915 he experimented with picket lines and demonstrations by orchestrating a nonviolent effort to ban D. W. Griffith's epic motion picture *Birth of a Nation*. Trotter's arrest did not prevent him from leading some one thousand marchers to the statehouse two days later, thereby creating one of the earliest protest marches by Americans of African descent.

In 1919 Trotter announced plans to attend the Versailles Peace Conference in an attempt to have a racial equality clause adopted in the treaty. When the U.S. government denied his request for a passport, the defiant Trotter secured a job as a ship's cook and sailed to France. Although his efforts at Versailles ultimately failed, they garnered worldwide publicity—and Wilson's wrath. Trotter continued to raise his voice through the *Guardian*, doing so only by sacrificing both his own and his wife's personal wealth to finance the newspaper.

After Geraldine Trotter died in the influenza epidemic of 1918, her husband grew ever more isolated. The economic downturn of the Depression proved too overwhelming for Trotter, and he lost his newspaper early in 1934. Trotter died later that year, apparently of suicide, when he plunged from the roof of a three-story building in Boston on his sixty-second birthday.

FURTHER READING

A small collection of Trotter's papers is at Boston University, and some Trotter correspondence is in the papers of W. E. B. Du Bois at the University of Massachusetts, Amherst.

Fox, Stephen R. *The Guardian of Boston: William Monroe Trotter* (1970).

RODGER STREITMATTER

TUCKER, Lorenzo

(28 June 1907–19 Aug. 1986), actor, was born in Philadelphia, Pennsylvania, the son of John Tucker, a laborer, and Virginia Lee. From early childhood, Lorenzo Tucker wanted to be in show business; as an adolescent he would write and stage back-porch shows, casting himself and his friends as performers. His mother, however, wanted him to be a doctor, but he deliberately quit Temple University in 1926 and left home for Atlantic City, New Jersey, where he met a chorus girl from one of the black nightclubs. Together they formed a ballroom dance specialty act, and by the end of 1926 they were performing on the black vaudeville circuit.

Tucker rose quickly through the ranks of black show business. Within a year he was touring with blues legend BESSIE SMITH, and in 1927 he was signed as a movie actor by black film pioneer OSCAR MICHEAUX. Tucker's good looks and urbanity made him a minor star of black stage and screen, and in the next few years he appeared in vaudeville shows, Broadway plays, and a dozen feature films made with black casts for African American audiences, known as "race movies." Micheaux, the most important and prolific of the race filmmakers, dubbed Tucker the "Colored Valentino" for the sake of publicity. Tucker appeared in at least eight Micheaux films, the earliest, *When Men Betray*, in 1928. Following appearances in two more Micheaux silent films, *Wages of Sin* (1929) and *Easy Street* (1930), Tucker starred in *Veiled Aristocrats*, Micheaux's 1932 sound remake of his 1925 silent film, *The House behind the Cedars*, based on CHARLES CHESNUTT's novel about passing.

But Tucker's fame was short-lived. The Great Depression, the advent of sound film, and other factors threatened the viability of race films, and by 1933 Tucker had quit show business, married Katherine Godfrey, and moved to Long Island, where he built himself a business as a carpenter and a house painter. The lure of show business was too strong, however, and Tucker returned to New York City and to acting, appearing in the Micheaux films *Harlem after Midnight* (1934), *Temptation* (1935), and *Underworld* (1937).

In 1942 he was drafted and spent the next three years in Europe, gaining the rank of sergeant in the 847th Army Air Corps Aviation Battalion. Though not a member of Special Services, Tucker nevertheless produced numerous stage shows for the 847th during the war. In many he served as the master of

ceremonies. Most of these shows were staged before integrated audiences.

After being discharged in 1946, Tucker returned to black show business and appeared in a few more black-cast films. By 1950, however, such films were no longer being made because Hollywood had begun integration, and he spent the next ten years acting in black theater companies touring the United States and Great Britain. In 1962 Tucker quit show business again, divorced, and married his second wife, Julia Garnett. That same year he was hired as the autopsy assistant to the chief medical examiner of New York City, Dr. Milton Helpern. In this capacity Tucker assisted in hundreds of autopsies, most notably that of Malcolm X in 1965.

Tucker retired in 1973, and after the death of his second wife, he married Mildred Childs. That marriage soon ended in divorce, and by 1977 he had relocated to Los Angeles, where he began to audition for movie roles. But the entertainment industry had passed him by; he spent his final years in Hollywood documenting black theater and film history in general and his own career in particular. During his life Tucker amassed over six hundred pounds of black film memorabilia, which, as the Lorenzo Tucker Collection, is now housed in New York at the Schomburg Center for Research in Black Culture. In 1983 he married his fourth wife, Paulina Segura. There were no children from any of his marriages. He died in Los Angeles.

FURTHER READING

Bowser, Pearl, Jane Gaines, and Charles Musser. *Oscar Micheaux and His Circle: African-American Filmmaking and Race Cinema of the Silent Era* (2001).

Grupenhoff, Richard. *The Black Valentino: The Stage and Screen Career of Lorenzo Tucker* (1988).

RICHARD GRUPENHOFF

TUCKER, Snake Hips

(1905–1937), dancer, was born Earl Tucker, probably in Maryland. The names and occupations of his parents are unknown, and little is known about his early life. What has been determined about his later career is owed to the efforts of jazz scholars Marshall Stearns and Jean Stearns. Tucker is said to have arrived in New York City as a child. By the mid-1920s he was dancing regularly at Connie's Inn, a Harlem nightclub that catered to whites. By that time Tucker had already begun to work out his signature dance style and had acquired the nickname "Snake Hips," the name of an old hip-grinding dance. He was also renowned for making women in the audience scream and swoon with his steamy, erotic movements, which were wholly original and utterly inimitable.

Erotic dances had been an element of dancing to jazz music from the beginning: the "Mooche" around the turn of the century, the "Grind," shimmy-and-shake dancing, and others. But Tucker's act was in a class by itself, and it took eroticism in dancing to a level that has never been surpassed. It was a pelvic-grinding performance of his own invention that always enthralled, no matter how many times it was seen. Tucker's routine has been described in detail by many, including Marshall and Jean Stearns, Mura Dehn, DUKE ELLINGTON, and LANGSTON HUGHES. He would dress in a silk blouse and tight black bell-bottom pants, with a tassel dangling from an ornate belt buckle. The first glimpse of his sharp and threatening appearance usually sufficed to quiet an audience. "Tucker had at the same time a disengaged and a menacing air, like a sleeping volcano," write the Stearns, who saw Tucker in action, "which seemed to give audiences the feeling that he was a cobra and they were mice." He would glide forward, rocking his hips in progressively greater motions, the tassel describing progressively greater circles, until his whole body was in motion. Tucker used his feet "merely for propulsion," wrote Hughes, "since his body did all the rest."

In the late 1920s Tucker began an association with Duke Ellington that would last the rest of his life. Ellington served as a kind of father figure and protector for Tucker, a brash, hot-tempered, and often violent partygoer and playboy who was usually armed with a razor. Ellington also found him a perfect stage accompaniment to his "jungle-style jazz," along with the usual shake-and-shimmy dancers. When Ellington opened at the Cotton Club on 4 December 1927, Tucker was a prominent part of the show, dancing to "East St. Louis Toodle-Oo." Later Ellington composed the "Snake Hips" dance, which he recorded in the summer of 1929, especially for Tucker; "Rockin' in Rhythm," too, was composed with Tucker in mind.

Tucker appeared in the musical *Blackbirds of 1928*, which opened at the Liberty Theatre on 9 May 1928 and which included BILL "BOJANGLES" ROBINSON. Critics described Tucker's performance

as everything from astounding to scandalous. The most remarkable extant footage of Tucker is found in the two-reel film *Crazy House* (1931; not to be confused with a 1943 film with the same name). The action takes place in an asylum, and at one point the camera pans over to discover Tucker, playing an inmate, doing his stunning trademark dance in a long segment. Tucker also appears briefly in *Symphony in Black: A Rhapsody of Negro Life* (1935), a one-reel short subject devoted to Ellington. Tucker is doubtless also in the background of a number of other short subjects of the era.

Tucker was one of the few truly erotic stage performers and one of the few African American dancers of the 1920s and 1930s to achieve a measure of success without doing tap. Many performers drew from Tucker, including Albert Minns, Clifton Webb, and Elvis Presley. The so-called dirty dancing moves of the 1990s were but distant echoes of Tucker's sensuous, erotic performances. Tucker eventually grew ill from "internal ailments" (syphilis) and died in New York. Duke Ellington paid his hospital bills.

FURTHER READING
Hughes, Langston. *Black Magic* (1967).
Stearns, Marshall, and Jean Stearns. *Jazz Dance* (1968; repr. 1994).

ROBERT P. CREASE

TURNER, Big Joe

(18 May 1911–24 Nov. 1985), jazz, blues, and early rock-and-roll singer, was born Joseph Vernon Turner Jr. in Kansas City, Missouri, the son of Joseph Turner Sr. and Georgie Harrington, of whom virtually nothing else is known. After his father died in a railroad accident when Joe was four years old, he and his sister were raised by their mother and maternal grandmother. Joe Turner, who grew up singing in church choirs and on street corners and whose large frame belied his young age, began performing in Kansas City nightclubs while in his teens. His deep, roaring voice quickly attracted notice and garnered him a regular spot at several clubs. While doubling as a bartender and singer at Kansas City's Sunset Cafe in the early 1930s, Turner met the boogie piano player Pete Johnson, with whom he would collaborate over the next thirty years, producing some of Turner's most renowned recordings. Their club performances soon attracted the attention of the talent

scout and record producer John Hammond, who in 1936 brought the pair to New York to perform and record.

In December 1938 Turner and Johnson played at Carnegie Hall in the "Spirituals to Swing" concert, sharing a bill with the blues and jazz luminaries Big Bill Broonzy, Sonny Terry, and Count Basie. This celebrated show helped launch a national boogie-woogie craze. With their burgeoning success Turner and Johnson secured steady work at Manhattan's Café Society, where they performed songs that remained in Turner's repertoire for the rest of his career. The rollicking "Roll 'Em Pete," which they recorded for the Vocalian label at the close of 1938, became one of Turner's signature tunes and featured Johnson's thundering piano accompaniment. In 1940 Turner moved to the Decca label, recording with Johnson "Piney Brown Blues" and, backed by WILLIE "THE LION" SMITH, the jazz-tinged "Careless Love." After 1941 Turner's association with Johnson began to wane, although the pair periodically worked together throughout the 1940s and 1950s.

During World War II Turner settled in Los Angeles, where he quickly became a fixture on the West Coast jazz and blues circuits. In 1945 he married Lou Willie Turner, who died in 1972. From 1945 to 1947 Turner recorded for National Records, releasing in 1947 "My Gal's a Jockey," his first popular radio hit. Also that year, under the pseudonym Big Vernon, he cut the salacious "Around the Clock" for the Stag label. By the end of the 1940s almost all of the major West Coast labels featured at least one Turner record, as he switched in rapid succession from National to Stag, Aladdin, RPM, Downbeat/Swing Time, MGM, Freedom, and Specialty, and finally to Imperial Records in 1950 where he teamed with a young FATS DOMINO on "Still in the Dark."

By the early 1950s Turner's career appeared to be on the decline; demand for him to perform and record decreased. In an effort to energize his career he moved back to New York in 1950. Filling in for Jimmy Risling as the front man for Count Basie's group, Turner drew wide praise and was offered a recording contract by the Atlantic Records heads Herb Abramson and Ahmet Ertegun. In April 1951 Turner initiated his Atlantic work with the mournful "Chains of Love," which catapulted him back on to the rhythm and blues charts. Thus began Turner's most prolific period, during which he released a

string of hits including "Sweet Sixteen," "Chill Is On," and "Don't You Cry." In 1953 he landed his first chart-topping hit, the stomping "Honey Hush." At the end of the year he went to Chicago, teaming up with the blues guitarist Elmore James on the risqué number "T.V. Mama."

The prolific Atlantic staff songwriter Jesse Stone penned the 1954 smash hit "Shake, Rattle, and Roll," a pioneering rock-and-roll song and Turner's second number 1 record. Turner's version offered a thinly veiled sexual metaphor. Sanitized versions of the song would prove even more popular—in part because radio stations were more willing to play them—when covered by white recording stars such as Bill Haley and the Comets and, later, Elvis Presley.

Now forty-three years old, Turner had become a bona fide star. His subsequent work, including "Flip, Flop, and Fly" and "Morning, Noon, and Night," all employed the same rhythmic formula as "Shake, Rattle, and Roll." In the mid-1950s he made several appearances on the television variety program *Showtime at the Apollo*, performing "Shake, Rattle, and Roll," and he also sang it in a Hollywood film of the same name. In 1956 he released "Corinna, Corinna," another hit record, and followed this with "Rock a While." As younger artists began to dominate the rock-and-roll charts, at Atlantic's behest Turner began recording more jazz-oriented material aimed at adult audiences. Critics later hailed his 1956 sessions in which he reunited with Pete Johnson, but at the time the public's interests had moved on, and Turner's career began to decline once more. In 1959 his association with Atlantic came to an end.

In the 1960s Turner made few recordings, despite a resurgence of public interest in seasoned jazz and blues performers—a revival that brought many of his contemporaries back into the spotlight. Turner, however, produced nothing that remotely approached a hit record. His only notable sessions were made in Mexico City in 1966, backed by his longtime admirers Bill Haley and the Comets. But these, too, failed to produce a hit, and Turner spent the decade in relative obscurity. By the early 1970s, though, his career picked up again, and he began recording for Norman Ganz's jazz label Pablo Records. These were essentially jam sessions, and the resulting records featured Turner's famous roaring vocals, accompanied by lengthy jazz solos.

By the 1980s Turner had suffered a stroke and contracted diabetes, yet he continued to record, singing on the 1983 compilation *Roomful of Blues*. He also performed in clubs around the country, frequently appearing on stage sitting in a chair, his enormous size and declining health forcing him to remain seated as his band played. Critics, though, claimed that Turner's voice still commanded the respect of fans, and he toured extensively until just before his death in November 1985. Pete Johnson sang at his funeral, and he, too, passed away the following spring.

Known as the Boss of the Blues, Big Joe Turner's reputation largely rests on his more accessible songs such as "Shake, Rattle, and Roll," yet his impeccable timing, confidant persona, and powerful voice could fill a concert hall and delight audiences. His ability to excel in a wide range of vocal styles, from soulful crooning to joyous shouting, remains his lasting legacy.

FURTHER READING

Belz, Carl. *The Story of Rock* (1969).

Guralnik, Peter. *Lost Highway: Journeys and Arrivals of American Musicians* (1979).

Tosches, Nick. *The Unsung Heroes of Rock n' Roll: The Birth of Rock in the Wild Years before Elvis* (1999).

DISCOGRAPHY

Boss of the Blues (Atlantic 8812).

Classic Hits, 1938–1952 (JSP B00008LJEG).

The Very Best of Big Joe Turner (Rhino 72968).

BRENTON E. RIFFEL

VANDERZEE, James Augustus Joseph

(29 June 1886–15 May 1983), photographer and entrepreneur, was born in Lenox, Massachusetts, the second of six children of John VanDerZee and Susan Elizabeth Egberts. Part of a working-class African American community that provided services to wealthy summer residents, the VanDerZees (sometimes written Van Der Zee or Van DerZee) and their large extended family operated a laundry and bakery and worked at local luxury hotels. James played the violin and piano and enjoyed a bucolic childhood riding bicycles, swimming, skiing, and ice fishing with his siblings and cousins. He received his first camera from a mail-order catalogue just before his fourteenth birthday and taught himself how to take and develop photographs using his family as subjects. He left school that same year and began work as a hotel waiter. In 1905 he and his brother Walter moved to New York City.

James was working as an elevator operator when he met a seamstress, Kate Brown. They married when Kate became pregnant, and a daughter, Rachel, was born in 1907. A year later a son, Emile, was born but died within a year. (Rachel died of peritonitis in 1927.) In addition to a series of service jobs, VanDerZee worked sporadically as a musician. In 1911 he landed his first photography-related job at a portrait studio located in the largest department store in Newark, New Jersey. Although he was hired as a darkroom assistant, he quickly advanced to photographer when patrons began asking for "the colored fellow." The following year VanDerZee's sister Jennie invited him to set up a small studio in the Toussaint Conservatory of Art, a school she had established in her Harlem brownstone. Convinced that he could make a living as a photographer, VanDerZee wanted to open his own studio, but Kate was opposed to the venture. This fundamental disagreement contributed to the couple's divorce in 1917.

VanDerZee found a better companion and collaborator in Gaynella Greenlee, a woman of German and Spanish descent who, after marrying VanDerZee in 1917, claimed to be a light-skinned African American. That same year the couple opened the Guarantee Photo Studio, later the GGG Photo Studio, on West 135th Street, next door to the Harlem branch of the New York Public Library. This was the first of four studio sites VanDerZee would rent over the next twenty-five years. With his inventive window displays and strong word of mouth within the burgeoning African American community, VanDerZee quickly established himself as Harlem's preeminent photographer.

By the early 1920s VanDerZee had developed a distinct style of portrait photography that emphasized narrative, mood, and the uniqueness of each image. Harlem's African American citizens—couples, families, co-workers, and even family pets—had their portraits taken by VanDerZee. With a nod to Victorian photographers, he employed a range of props, including fashionable clothes and exotic costumes, and elaborate backdrops (many of which he painted himself) featuring landscapes or architectural elements. Although they appear natural and effortless, VanDerZee's portraits were deliberately constructed compositions, with sitters posed in complex and artful arrangements. "I posed everyone according to their type and personality, and therefore almost every picture was different" (McGhee). VanDerZee made every sitter look and feel like a celebrity, even mimicking popular media images on occasion. In VanDerZee's photographs, sitters appear sophisticated, urbane, and self-aware, and Harlem emerges as a prosperous, healthy, and diverse community.

Another characteristic of VanDerZee's portrait work was his creative manipulation of prints and negatives, which included retouching, double printing, and hand painting images. In addition to improving sitters' imperfections, retouching and hand painting added dramatic and narrative details, like tinted roses or a wisp of smoke rising from an abandoned cigarette. VanDerZee often employed double printing—at times using as many as three or four negatives to make a print—to introduce theatrical storytelling elements into his portraits.

Such attention to detail was commercial as well as artistic. VanDerZee never forgot that photography was essentially a commercial venture and that making his patrons happy and his images one of a kind helped business. He regularly took on trade work, creating calendars and advertisements and, in later years, photographing autopsies for insurance companies and identification cards for taxi drivers. But portraits, of both the living and the dead, were

James VanDerZee's portrait "Wedding Day, Harlem, 1926." (Library of Congress.)

VanDerZee's bread and butter. Funerary photography, a practice begun in the nineteenth century and popular in some communities through the mid-twentieth century, was a major part of his business. VanDerZee's daily visits to funeral parlors culminated in his book *Harlem Book of the Dead* (1978). Harlemites of every background hired VanDerZee to document their weddings, baptisms, graduations, and businesses with portraits and on-site photographs. Organizations as diverse as the Monte Carlo Sporting Club, Les Modernes Bridge Club, the New York Black Yankees, the Renaissance Big Five basketball team, Madame C. J. Walker's Beauty Salon, the Dark Tower Literary Salon, and the Black Cross Nurses commissioned VanDerZee portraits. Today these photographs serve as an invaluable and unique visual record of African American life during Harlem's heyday.

In the 1920s and 1930s and into the 1940s VanDerZee photographed the African American leaders living and working in Harlem, including the entertainment and literary luminaries of the Harlem Renaissance BILL "Bojangles" ROBINSON, JELLY ROLL MORTON, and COUNTÉE CULLEN; the boxing legends JACK JOHNSON and Joe Louis; and the political, business, and religious leaders ADAM CLAYTON POWELL SR. and ADAM CLAYTON POWELL JR., A'LELIA WALKER, FATHER DIVINE, and Daddy Grace. In a move that anticipated the birth of photojournalism, VanDerZee took to documenting street life and events when he was hired by Marcus Garvey to create photographic public relations material for the Universal Negro Improvement Association (UNIA) in 1924. VanDerZee produced several thousand prints of UNIA parades, rallies, and the fourth international convention, including many of the most reproduced images of Garvey.

Unlike many of its competitors, VanDerZee's studio remained profitable throughout the Depression. After World War II, however, business steadily declined, the result of the popularity of portable cameras, changing aesthetic styles, and the broader financial decline of Harlem as middle-class blacks moved away from the area. In 1945 the VanDerZees purchased the house they had been renting on Lenox Avenue, but by 1948 they had taken out a second mortgage and by the mid-1960s were facing foreclosure. Fighting for his economic survival, VanDerZee worked primarily as a photographic restorer.

The reevaluation of VanDerZee's place in photographic history began with *Harlem on My Mind*, a groundbreaking and controversial 1969 exhibition at the Metropolitan Museum of Art. After being "discovered" by the photo researcher Reginald McGhee, VanDerZee became the single largest contributor to the exhibition, which drew seventy-seven thousand visitors in its first week. Unfortunately, the exhibition's success arrived too late to help the cash-strapped couple, and the VanDerZees were evicted from their Lenox Avenue house the day after the exhibition closed. Gaynella suffered a nervous breakdown as a result and remained an invalid until her death in 1976.

Hoping to resurrect his finances, VanDerZee established the James VanDerZee Institute in June 1969. With McGhee as project director, the institute published several monographs and organized nationwide exhibitions showcasing VanDerZee's photographs alongside work by young African American photographers. In the early 1970s VanDerZee became a minor celebrity, appearing on television, in film, and as the subject of numerous articles. Meanwhile, he found himself living in a tiny Harlem apartment and relying on his Social Security payments, having received little financial support from the VanDerZee Institute. Several benefactors helped VanDerZee in fund-raising and in his attempts to wrest control of his photographic collection from the VanDerZee Institute, which in 1977 moved to the Metropolitan Museum of Art.

In 1978 the majority of his photographic materials held by the Metropolitan was transferred to the Studio Museum in Harlem, and in 1981 VanDerZee, who had saved almost every negative he had ever made, sued the museum for ownership of fifty thousand prints and negatives. The dispute was finally settled a year after VanDerZee's death, when a New York court divided the collection between the VanDerZee estate, the VanDerZee Institute, and the Studio Museum.

In 1978 VanDerZee married Donna Mussenden, a gallery director thirty years his junior who physically and spiritually rejuvenated the ninety-two-year-old photographer. Encouraged by Mussenden, VanDerZee returned to portrait photography, and in the early 1980s photographed such prominent African Americans as Bill Cosby, Miles Davis, EUBIE BLAKE, Muhammad Ali, Ossie Davis, Ruby Dee, Jean-Michel Basquiat, and ROMARE BEARDEN.

James VanDerZee died in 1983, just shy of his ninety-seventh birthday, on the same day he received an honorary doctorate from Howard University. Although he was omitted from Beaumont Newhall's 1982 seminal volume *The History of Photography*, VanDerZee was honored in 2002 by the U.S. Postal Service with a postage stamp bearing his image.

VanDerZee's photographs chronicle African American life between the wars. His images of such landmarks as the Hotel Theresa and the Manhattan Temple Bible Club Lunchroom and of the ordinary drugstores, beauty salons, pool halls, synagogues, and churches of Harlem record the unprecedented migration of black Americans from the South to the North and from rural to urban living. His portraits offer a human-scale account of the New Negro and the Harlem Renaissance and of race pride and self-determination. Documenting the vitality and diversity of African American life, VanDerZee's photographs countered existing popular images of African Americans, which historically rendered black Americans invisible or degenerate. Here, instead, are images testifying to the artistic, commercial, and political richness of the African American community.

FURTHER READING

Haskins, James. *Van DerZee: The Picture Takin' Man* (1991).

McGhee, Reginald. *The World of James Van DerZee: A Visual Record of Black Americans* (1969).

Willis, Deborah. *VanDerZee: Photographer 1886–1983* (1993).

Obituary: New York Times, 16 May 1983.

LISA E. RIVO

VANN, Robert L.

(27 Aug. 1879–24 Oct. 1940), journalist, lawyer, and activist, was born Robert Lee Vann in Hertford County, North Carolina, the son of Lucy Peoples, who cooked for the Albert Vann family, and an unidentified father. His mother named him following a custom from slavery times, giving the last name of her employer to her children. The paternity of Vann, according to his major biographer Andrew L. Buni, is uncertain. It is thought that his father was Joseph Hall, a field worker, but there are no birth records to this effect. There is the possibility that his

father was white but not the Vann that his mother worked for.

Vann spent his childhood on the Vann and Askew farms. He entered the Waters Training School in Winston, North Carolina, at age sixteen. In 1901 he enrolled in Virginia Union University in Richmond. After two years Vann moved to Pittsburgh and entered Western University of Pennsylvania (later the University of Pittsburgh), where he was the only African American and wrote for the student newspaper, the *Courant*. Upon graduating in 1906, he entered Western's law school and subsequently passed the Pennsylvania bar examination in 1909. When he set up practice in 1910, Vann was one of only five black attorneys in Pittsburgh. Business was so scarce that he postponed his wedding to Jessie Matthews by one day in order to take a client to pay the preacher's fee. The marriage took place on 11 February 1910.

Vann soon found himself involved with a fledgling black newspaper, the *Pittsburgh Courier*; using his legal expertise, he had the paper incorporated and became its treasurer. In the fall of 1910 he became the *Courier*'s editor while continuing his law practice. Vann also became involved in Pittsburgh politics and was a leader in calling for civil rights laws and improvements in housing and municipal services. In 1917 he was named fourth assistant city solicitor as a result of his successful opposition to Pittsburgh's political machine in the mayoral election. Vann was also a member of the Committee of One Hundred, a group of black leaders who opposed the United States' entry into World War I.

The 1920s saw Vann making the *Pittsburgh Courier* profitable by focusing on important issues in the black community. He was a firm believer in the uplift ideology of BOOKER T. WASHINGTON and often lauded that black leader's movement in his paper. Though Vann tried several other business ventures without success, one of his most ambitious was a glossy photographic magazine on issues of interest to African Americans, the *Competitor*. Started in 1920, it ran only eighteen months. In the 1930s Vann went on to make the *Pittsburgh Courier* the largest and most popular black newspaper in the country by enlarging the sports section—the paper liked to take credit for "discovering" and promoting the boxer Joe Louis—and by sending a reporter to cover the Italian invasion of Ethiopia.

Robert L. Vann's political activity was on the rise through the 1930s. In a speech in Cleveland on 11

September 1933, as the Great Depression ravaged black America, Vann called upon African Americans to turn "their pictures of Lincoln to the wall" and vote for the Democratic Party. By 1936, as Vann had hoped, blacks did move to the Democratic column en masse and would remain there for the rest of the twentieth century. Vann served briefly in Washington, D.C., as a special adviser to the attorney general and on a Commerce Department advisory committee, but his effect on New Deal policies and the Black Cabinet was minimal, and he subsequently returned to Pittsburgh in 1935.

Vann served the remainder of his years fighting for civil rights, especially in the armed forces, and encouraging blacks to make their voting power "liquid" by supporting only those who would give them the fairest economic deal. Vann's health had always been precarious, and in 1940 he died in the Shadyside Hospital, Pittsburgh, after battling cancer.

FURTHER READING

Buni, Andrew L. *Robert L. Vann of the Pittsburgh Courier: Politics and Black Journalism* (1974).

CHARLES PETE T. BANNER-HALEY

WALKER, A'Lelia

(6 June 1885–17 Aug. 1931), heiress, businesswoman, patron of the arts, and Harlem Renaissance hostess, was born Lelia McWilliams in Vicksburg, Mississippi, the only child of Moses McWilliams and Sarah Breedlove McWilliams, who later was known as MADAM C. J. WALKER, the influential early-twentieth-century entrepreneur, philanthropist, and political activist. Almost nothing is known about Moses, who died around 1887. Although some sources say he was lynched, there is no credible documentation to support that claim. After his death, Lelia moved with her mother to St. Louis, where three of her Breedlove uncles worked as barbers.

The McWilliamses' transition to the unfamiliar, fast-paced city was made easier by the kindness of middle-class black women who were members of St. Paul African Methodist Episcopal Church, and whose participation in the National Association of Colored Women (NACW) made them sensitive to the needs of such newcomers. In March 1890, while Sarah worked as a washerwoman, Maggie Rector—the matron of the St. Louis Colored Orphans' Home and an NACW member—enrolled Lelia at Dessalines Elementary School. Despite her mother's best efforts to create a stable life in ragtime-era St. Louis, Lelia's school attendance was inconsistent—nearly perfect some years, but sporadic in others—depending upon the whims of Lelia's abusive and alcoholic stepfather, John Davis, whom her mother married in 1894 and from whom she separated around 1903. Although Sarah and Lelia were sometimes on the verge of homelessness, Sarah managed to save enough money from her wages as a laundress to send Lelia to Knoxville College in 1902. Around the same time, Sarah began to experiment with hair-care product formulas to address severe dandruff and other scalp ailments that were causing her to go bald.

During the summer of 1906, Lelia joined her mother and new stepfather, Charles Joseph Walker, in Denver, where her mother had established the Madam C. J. Walker Manufacturing Company. As one of the company's first employees, Walker learned beauty culture—a method of hairdressing and "cultivating" healthy scalps—and her mother's "hair growing" process, which promoted hygiene, frequent shampooing, and the application of a sulfur-based ointment to heal the scalp disease that was so rampant at the time. That fall, as Madam Walker and her husband traveled throughout the southern and eastern United States, Lelia assumed control of the mail-order and manufacturing operation in Denver. When her mother established a temporary headquarters and the first Lelia College of Beauty Culture in Pittsburgh in 1908, Walker moved east as one of the company's first traveling sales agents. In early 1910, after her mother opened a permanent facility in Indianapolis, Walker took over the management of the Pittsburgh beauty school and sales agents' supply station.

Although Walker never was adopted formally by her stepfather, she substituted his surname for her own in order to make clear her connection to the family business. When she married John Robinson in 1909, however, she became known as Lelia Walker Robinson. While visiting Indianapolis in 1911, Walker (who had no biological children) was introduced by her mother to 12-year-old Fairy Mae Bryant, whose hip-length hair made her an ideal model for Madam Walker's scalp treatment demonstrations. In October 1912—with the promise to Bryant's family that she would receive formal education and business training—Walker legally adopted her through the court system in Pittsburgh, where they lived at the time.

In 1913, as Harlem was emerging as the cultural, political, and social mecca of black America, Robinson persuaded her mother to establish a Walker Company branch office on 136th Street near Lenox Avenue. In an exquisite limestone and brick, Georgian-style townhouse designed by architect and Alpha Phi Alpha founder Vertner Woodson Tandy, Robinson oversaw the six-week Lelia College training course and managed the company's northeastern sales territory. During World War I, in line with her mother's support of black troops, she hosted fund-raisers at her Harlem townhouse and volunteered as an ambulance driver for parades and formal occasions honoring the soldiers in the Colored Women's Motor Corps.

Upon her mother's death on 25 May 1919, Robinson became president of the Walker Company, inheriting much of her mother's real estate,

including Villa Lewaro, the mansion in Irvington-on-Hudson, New York. Twelve days later on her 34th birthday, she married Dr. Wiley Wilson, a graduate of Howard University's Medical School. They divorced in 1925. Already a seasoned traveler—having visited Central America, the Caribbean, and Hawaii—Robinson crossed the Atlantic Ocean in November 1921 for a five-month excursion to Europe, Africa, and the Middle East. After attending the coronation of Pope Pius XI in Rome, she visited the Egyptian pyramids and Addis Ababa, Ethiopia, where she is said to have been the first American to have met Ethiopian Empress Waizeru Zauditu.

In 1922, for reasons that are not entirely clear, Lelia changed her name to A'Lelia. In May 1926, she married Dr. James Arthur Kennedy, a Chicago psychiatrist, who later was a physician at the Tuskegee, Alabama, Veterans Hospital. They divorced in 1931.

She is best remembered as the hostess of the Dark Tower, the salon on the top floor of her 136th Street townhouse that opened in October 1927 and served as a magnet for Harlem Renaissance writers, artists, actors, and musicians. Robinson's guest lists—for her Dark Tower soirees and the more intimate gatherings at her 80 Edgecombe Avenue pied-à-terre—were quite diverse, ranging from composer and pianist EUBIE BLAKE, author ZORA NEALE HURSTON, dancer FLORENCE MILLS, and actor PAUL ROBESON to downtown white writers Carl Van Vechten, Witter Bynner, Muriel Draper, and Max Ewing, and an array of African and European royalty. Sculptors AUGUSTA SAVAGE and RICHMOND BARTHÉ and photographer Berenice Abbott were among the artists for whom she modeled. Poet LANGSTON HUGHES, who was a frequent visitor, called her "the joy goddess of Harlem's 1920s" (Hughes, 245).

Walker, who had long suffered from hypertension, died of a stroke in a guest cottage in the resort community of Long Branch, New Jersey, after attending a friend's birthday celebration. Just as Walker's parties had been grand, so was her funeral, as more than eleven thousand people filed past her silver, orchid-filled casket. With Reverend ADAM CLAYTON POWELL SR. presiding, Daytona Normal and Industrial Institute founder MARY MCLEOD BETHUNE eulogized her friend's daughter. In most obituaries, Walker inevitably was compared to her mother. One black newspaper harshly called her "happy, hapless life" a "tragedy" because her personal achievements as an entrepreneur paled alongside those of her precedent-setting mother (*New York News and Harlem Home Journal,* 22 Aug. 1931). But Hughes mourned the loss, likening her death to "the end of the gay times of the New Negro era in Harlem" (Hughes, 247). Many have blamed Walker for the financial demise of the Walker Company, but severely declining sales during the first years of the Great Depression, the upkeep of Villa Lewaro, and the Walker trustees' decision to build a million-dollar Indianapolis headquarters in 1927 had more actual impact on the company's fiscal health than Walker's admittedly extravagant spending. (Nevertheless, the company survived until the mid-1980s.)

During her lifetime A'Lelia Walker Robinson had indeed lived in the shadow of her more accomplished mother, with whom she had a loving but complicated relationship. While she may have lacked her mother's fortitude and perseverance, she inherited her flair for dramatic promotion and her expansive vision. Whereas Madam Walker influenced the commerce and politics of her era, A'Lelia Walker set the tone for the social and cultural aura of hers, in many ways creating the role of black American heiress.

FURTHER READING

A'Lelia Walker's correspondence is housed at the Indiana Historical Society in Indianapolis. Additional letters, legal documents, photographs, clothing, and other items are in the private collection of A'Lelia Bundles, Walker's great-granddaughter, in Washington, D.C.

Bundles, A'Lelia. *On Her Own Ground: The Life and Times of Madam C. J. Walker* (2001).

Hughes, Langston. *The Big Sea* (1944).

Lewis, David Levering. *When Harlem Was in Vogue* (1981).

A'LELIA BUNDLES

WALKER, Madam C. J.

(23 Dec. 1867–25 May 1919), entrepreneur, philanthropist, and political activist, was born Sarah Breedlove in Delta (Madison Parish), Louisiana, the fifth of six children of Minerva to Anderson and Owen Breedlove Sr., sharecroppers and former slaves.

Orphaned at seven years old, she had almost no formal education during her early life. Around 1878—when racial violence was at its most virulent in her rural Louisiana parish—she moved

with her elder sister, Louvenia Breedlove Powell, across the Mississippi River to Vicksburg. At fourteen Sarah married Moses McWilliams, about whom almost nothing is known, to escape what she called the "cruelty" of her brother-in-law Jesse Powell. Around 1887 when the McWilliamses' daughter Lelia, later known as A'LELIA WALKER, was two years old, Moses died. Although some sources say he was lynched, there is no credible documentation to justify such a claim.

To support herself and her daughter, Sarah McWilliams moved to St. Louis, Missouri, where her three older brothers had become barbers after joining the Exodusters, a millenarian movement of black Louisianans and Mississippians who had fled to Missouri, Kansas, and Nebraska in 1879 and 1880. For most of the next decade and a half, McWilliams worked as a washerwoman, struggling to educate her daughter in the city's segregated public schools. In 1894 she married John Davis, but his drinking, abuse, and philandering led to their separation around 1903. Her saving grace during this period was membership at St. Paul African Methodist Episcopal Church, whose middle-class club women and community workers lived by the words, "Lifting As We Climb," the motto of the National Association of Colored Women (NACW), to which many of them belonged. Perhaps more than anyone, Jessie Batts Robinson—a teacher and wife of local newspaper publisher, C. K. Robinson—encouraged Sarah to seek more education as a way to better her life and helped her develop a vision of herself as something other than an illiterate laundress.

In 1903 as St. Louis prepared for the 1904 World's Fair, Davis supplemented her income by working as a sales agent for Annie Turnbo Pope Malone, whose newly created Poro Company manufactured hair-care products for black women. Like many women of her era, Davis already had experimented with home remedies and other commercially available ointments in an effort to cure baldness and scalp disease that were caused by poor hygiene, stress, inadequate nutrition, and damaging hair-care treatments.

With $1.50 in savings, the thirty-seven-year-old Davis moved in July 1905 to Denver, Colorado, where she joined her widowed sister-in-law and four nieces and worked briefly as a Poro agent selling Malone's "Wonderful Hair Grower." In January 1906 she married Charles Joseph Walker, a St. Louis newspaper agent and promoter who had followed

An advertisement for Madam C. J. Walker's line of cold creams and hair and complexion products, 17 January 1920. (Library of Congress.)

her from St. Louis to Denver. Adopting a custom practiced by many businesswomen of the era, she added the title "Madam" to her name, then began marketing a line of hair-care products as "Madam C. J. Walker." Despite Malone's later assertion that Walker had stolen her formula, Walker insisted that the ingredients for her own "hair grower" had been revealed to her in a dream by an African man. She also is said to have received assistance in developing her sulfur-based ointment—a centuries old cure for skin and scalp disease—from Denver pharmacist, E. L. Scholtz, for whom she worked as a cook during her first few months in Colorado.

The myth that Walker invented the "hot comb," a steel, hair-straightening implement, persists, but is not true. Heated metal styling tools seem first to have gained popularity in France in the early 1870s when Marcel Grateau introduced curling irons—and the Marcel Wave—to European women. Similar devices probably were developed independently in the United States. Acutely aware of the debate about whether black women should alter the appearance of their natural hair texture, Walker insisted that her ointments were conditioners, scalp treatments, and

grooming aids rather than hair straighteners. Nevertheless, she and her sales agents were responsible for popularizing the use of the hot comb in America. Even as large numbers of black women have adopted natural hairstyles since the black pride and black power movements of the 1960s, the majority still straighten their hair with chemicals or heat.

In September 1906 when Walker and her husband embarked upon an eighteen-month trip to promote her products and train new sales agents, the American hair-care and cosmetics industry was in its infancy. Settling briefly in Pittsburgh from 1908 to 1910, Walker opened her first Lelia College, where she trained "hair culturists" in the Walker System of hair care. In 1910 the Walkers moved to Indianapolis, then the nation's largest inland manufacturing center, to take advantage of its railways and highway system for their largely mail-order business. Walker quickly became involved in the city's civic activities, contributing $1,000 to the fund of a new black Young Men's Christian Association (YMCA) building. That gift, which was the largest such donation ever received from a black woman by the YMCA, launched Walker's reputation as a philanthropist and increased her visibility in the national black press.

In the midst of Walker's growing success, irreconcilable personal and business differences with her husband resulted in divorce in 1912, though she retained his name until her death. The next year her daughter A'Lelia persuaded Walker to purchase a Harlem townhouse on 136th Street near Lenox Avenue as a residence and East Coast business headquarters. In 1916 Walker joined A'Lelia in New York in order to become more directly involved in Harlem's burgeoning political and cultural activities and entrusted the day-to-day management of her Indianapolis manufacturing operation to her attorney, Freeman B. Ransom, and factory forewoman, Alice Kelly. From 1912 to 1918 Walker crisscrossed the United States, giving stereopticon slide lectures at black religious, business, fraternal, and civic gatherings. In 1913 she traveled to Jamaica, Cuba, Haiti, Costa Rica, and the Panama Canal Zone to cultivate the lucrative, untapped international market.

As an entrepreneur Walker stressed economic independence for women. "The girls and women of our race must not be afraid to take hold of business endeavor and . . . wring success out of a number of business opportunities that lie at their very doors," she told National Negro Business League

convention delegates in 1913 (Bundles, 152). By 1916 the Walker Company claimed 20,000 agents in the United States, Central America, and the Caribbean. "Walker," according to historian Davarian Baldwin, "marketed beauty culture as a way out of servitude for black women" (Baldwin, 71). Walker supported her agents by advertising in dozens of black newspapers throughout the United States. Among the earliest advertisers in W. E. B. DU BOIS's *The Crisis* and A. PHILIP RANDOLPH's *The Messenger,* she was credited by more than one publisher with helping to keep black newspapers afloat. In 1917, to foster cooperation among her agents and to protect them from competitors, Walker created the Madam C. J. Walker Hair Culturists Union of America, a national organization of sales agents and beauticians. That same year she organized the first federation of black hair-care and cosmetics manufacturers.

In July 1917 after the east St. Louis, Illinois riot left at least thirty-nine African Americans dead, Walker joined the planning committee of the Negro Silent Protest Parade, where ten thousand New Yorkers marched silently down Fifth Avenue to protest lynching and racial violence. Heartened by the show of solidarity, Walker, along with JAMES WELDON JOHNSON, realtor JOHN E. NAIL, and other Harlem leaders traveled to Washington, D.C., to present a petition to President Woodrow Wilson urging him to support legislation to make lynching a federal crime. Later that month at the first annual Walker Hair Culturists Union convention, Walker urged the delegates to "protest until the American sense of justice is so aroused that such affairs as the east St. Louis riot be forever impossible" (Bundles, 212).

When the United States entered World War I in the spring of 1917, Walker was among those, like Du Bois and Johnson, who, with reservations and caveats, encouraged African Americans to cooperate with the nation's war effort. In support of black soldiers, Walker visited several segregated training camps, urged her sales agents to spearhead local war-bond drives, and became a leader in the Circle for Negro War Relief.

At the official opening of Villa Lewaro, her Irvington-on-Hudson, New York, estate in August 1918, she honored EMMETT J. SCOTT, former private secretary to BOOKER T. WASHINGTON and special assistant to the Secretary of War in Charge of Negro Affairs. She thought of Villa Lewaro—designed by architect and Alpha Phi Alpha founder Vertner

Woodson Tandy, named by opera singer Enrico Caruso, and located near the home of industrialists Jay Gould and John D. Rockefeller—as a symbol to inspire other African Americans and as a venue to convene summits of race leaders.

Realizing that her wealth gave her visibility and credibility, Walker became increasingly outspoken on political issues. In early 1918 she was the keynote speaker at several National Association for the Advancement of Colored People (NAACP) fundraisers throughout the Midwest and East for the group's antilynching campaign. That summer she was honored at the NACW's convention in Denver for having made the largest individual monetary contribution to purchase and restore Cedar Hill, Frederick Douglass's Anacostia, Washington, D.C., home. After the end of World War I, she supported several efforts by African Americans to participate in the Versailles Peace Conference, including MARCUS GARVEY's International League of Darker Peoples. Although those initiatives were thwarted by the Wilson administration's denial of passports, Walker remained concerned about the rights of Africans and helped support Du Bois's first Pan-African Congress in Paris in 1919. Walker's plans for a Liberian industrial training school for girls never materialized.

During the spring of 1919 Walker's long battle with hypertension began to exact its final toll. On Easter Sunday while in St. Louis to introduce a new line of products, she became so ill in the home of her friend, Jessie Robinson, that she was rushed back to Villa Lewaro in a private train car. Upon arrival she directed her attorney to donate $5,000 to the NAACP's antilynching campaign. During the last month of her life, Walker revamped her will, bequeathing thousands of dollars to black schools, organizations, individuals, and institutions, including MARY MCLEOD BETHUNE's Daytona Normal and Industrial School for Girls, Lucy Laney's Haines Institute, CHARLOTTE HAWKINS BROWN's Palmer Memorial Institute, Washington's Tuskegee Institute, and numerous orphanages, retirement homes, YWCAs, and YMCAs in cities where she had lived. When Walker died at Villa Lewaro, she was widely considered as the wealthiest black woman in America and reputed to be among the first self-made American women millionaires. At the time of her death, Walker's estate was valued at $600,000 to $700,000, the equivalent of $6 million to $7 million in 2007 dollars. The estimated value of her

company, based on annual gross receipts in 1919, easily could have been set at $1.5 million. A'Lelia Walker, who later would become a central figure of the Harlem Renaissance of the 1920s, succeeded her mother as president of the Madam C. J. Walker Manufacturing Company.

Walker's significance lies as much in her innovative, and sometimes controversial, hair-care system as it does in her advocacy of black women's economic independence and her creation of business opportunities during a time when most working black women were employed as servants and sharecroppers. Her entrepreneurial strategies and organizational skills revolutionized what has become a multibillion-dollar international hair-care and cosmetics industry. She was a trailblazer of black philanthropy, using her wealth and influence to leverage social, political, and economic rights for women and African Americans. In 1998 Walker became the twenty-first African American to be featured in the U.S. Postal Service's Black Heritage Series. Her tangible legacy is best exemplified by two National Historic Landmarks—the Madam Walker Theatre Center, a cultural arts facility in Indianapolis, and Villa Lewaro, her Westchester County, New York, mansion—as well as by the many entrepreneurial awards that bear her name and the museum exhibits in which she is featured.

FURTHER READING
Madam Walker's papers are housed at the Indiana Historical Society in Indianapolis, Indiana. Additional documents, photographs, and memorabilia are part of the A'Lelia Bundles/ Madam Walker Family Collection in Washington, D.C. Other items are on view at the Madam Walker Theatre Center in Indianapolis.
Baldwin, Davarian. *Chicago's New Negroes: Modernity, the Great Migration, and Black Urban Life* (2007).
Bundles, A'Lelia. *On Her Own Ground: The Life and Times of Madam C. J. Walker* (2001).
Peiss, Kathy. *Hope in a Jar: The Making of America's Beauty Culture* (1998).
Rooks, Noliwe M. *Hair-Raising: Beauty Culture, and African American Women* (1996).

A'LELIA BUNDLES

WALKER, Margaret

(7 July 1915–30 Nov. 1998), poet and novelist, was born Margaret Abigail Walker in Birmingham, Alabama, the daughter of Sigismund Walker, a

Methodist minister and college professor, and Marion Dozier Walker, a music teacher. A studious and sensitive child, Walker was encouraged to write by her parents, who inspired in her a love of books and music. She was also fascinated by her grandmother's stories of slave life in rural Georgia, and she began writing daily, both prose and poetry, at the age of eleven. Her parents moved to Louisiana to accept teaching positions at New Orleans College (later Dillard University). Walker graduated from Gilbert Academy in 1930 and matriculated at New Orleans College, but, on the advice of the poet LANGSTON HUGHES, her parents decided to send her north to study. In 1932 Walker transferred from New Orleans College to Northwestern University in Evanston, Illinois, from which she received an AB degree in 1935. During her time at Northwestern, she met the African American activist and editor W. E. B. DU BOIS, whose magazine *The Crisis* carried her first published poem in May 1934.

After graduating, Walker worked for the Federal Writers' Project in Chicago under the Works Progress Administration (WPA) and came to know

Margaret Walker accepts the Mississippi Arts Commission's Lifetime Achievement Award in Jackson, Mississippi, 8 April 1992. (AP Images.)

such literary figures as RICHARD WRIGHT, with whom she collaborated closely as a member of the South Side Writers Group. She returned to school at the University of Iowa, where in 1937 she wrote the poem "For My People," which earned her national acclaim and became the title piece in a collection of twenty-six poems that were accepted as her master's thesis in creative writing in 1940. The next year she returned to the South to become an English instructor at Livingstone College in Salisbury, North Carolina. Her volume *For My People* appeared with an introduction by Stephen Vincent Benét. The collection won the Yale Series of Younger Poets Award, making Her the first African American to be so honored. In 1942–1943 she taught English at West Virginia State College in Institute. In 1943 she married Firnist James Alexander, an interior decorator; they had four children.

For My People contains three sections written in different styles but bound together by the theme of the southern black experience and the directness of their diction. The title poem in the first part is written in long, flowing lines of free verse that suggested Walt Whitman or Carl Sandburg to many reviewers and prompted Benét to describe the poem as containing "a controlled intensity of emotion and a language that . . . has something of the surge of biblical poetry" (Walker, 5). A second section is devoted to rhyming dialect ballads celebrating such traditional black characters as John Henry and Stagolee. Like blues songs, they draw on folk tradition and earned the critical comment that they reflected the influence of Langston Hughes or were, as Louis Untermeyer wrote, "like Paul Laurence Dunbar turned sour" (Walker, 371). The six sonnets that constitute the third section were praised for their formal skill but dismissed by some critics as lacking the intensity of the title poem. Although the critical response to the volume was mixed, the poem "For My People" placed Walker firmly in the tradition of social protest as an activist of unusual emotional depth and passion.

Walker returned to Livingstone for two years as a professor in 1945, and in 1949 she moved to Jackson, Mississippi, where she served as professor of English at Jackson State College until her retirement in 1979. During her tenure there she created and directed the Institute for the Study of the History, Life, and Culture of Black People and originated the Phillis Wheatley Poetry Festival. In 1965 she earned a PhD from the University of Iowa, and

the next year she published her only novel, *Jubilee*, which had been her doctoral dissertation. *Jubilee* is a realistic story of a slave family set before, during, and after the Civil War, based on the tales her grandmother had told her. It traces the life of the daughter of a white plantation owner and a slave, relating the oppression of her early life as a slave and the alienation of her postwar life cut off from the social structure she had known. Deeply researched over a period of thirty years, the novel was meticulous in its details of black folklore and culture and was generally well received, selling some three million copies in eleven languages during her lifetime. Some sources, however, criticized it for perpetuating the romantic myths of the nineteenth-century South from a black point of view and compared it to Margaret Mitchell's 1936 novel *Gone with the Wind*. In 1972 Walker defended her work vigorously, publishing *How I Wrote "Jubilee,"* a pamphlet describing its composition and the research that went into it. Alex Haley published his best-selling historical novel *Roots*, employing a similar oral style, in 1977; Walker in 1988 charged him with plagiarism. "There was nothing verbatim," she admitted, "but there were at least a hundred pages of out-standing similarities" (quoted in Milloy, 35). Although another writer did successfully charge Haley with plagiarism, Walker lost the case in court.

Three other collections of new poems—*Ballad of the Free* (1966), *Prophets for a New Day* (1970), and *October Journey* (1973)—appeared, all brief collections striking the same note of racial pride as her earlier volume, and in 1989 the University of Georgia Press published *This Is My Century: New and Collected Poems*. In 1974 she collaborated on *A Poetic Equation: Conversations between Nikki Giovanni and Margaret Walker*, discussing the experience of African American women poets. Her critical essays written between 1932 and 1992 were collected under the title *On Being Female, Black, and Free* in 1997. Her only effort at biography, *Richard Wright: Daemonic Genius*, appeared in 1987. Largely based on personal contact with her subject, it received a warm response in the literary community. Although long retired from teaching, Walker continued to be active as professor emerita, directing the institute she had founded in the 1960s. She died of breast cancer at her daughter's home in Chicago.

Despite her modest output, Margaret Walker made a substantial contribution to the literature of African American social protest, and the rolling cadences of "For My People" provide an enduring voice for her people.

FURTHER READING
Walker, Margaret. *For My People* (1942).
Barksdale, Richard K. "Margaret Walker: Folk Orature and Historical Prophecy," in *Black American Poets between Worlds, 1940–1960*, ed. R. Baxter Miller (1986).
Collier, Eugenia. "Fields Watered with Blood: Myth and Ritual in the Poetry of Margaret Walker," in *Black Women Writers (1950–1980): A Critical Evaluation*, ed. Mari Evans (1984).

DENNIS WEPMAN

WALLER, Fats

(12 May 1904–15 Dec. 1943), pianist, organist, singer, and composer, was born Thomas Wright Waller in New York City, the fourth of five surviving children of Edward Waller and Adeline (maiden name unknown). Edward was a Baptist lay minister, and one of young Thomas's earliest musical experiences was playing harmonium for his father's street-corner sermons. Thomas's mother was deeply involved in music as well, and the family acquired a piano around 1910. Although Waller had formal musical instruction during his formative years, he was largely self-taught and indulged in a lot of musical experimentation.

Thomas's development as a jazz pianist really began in 1920, when, upon the death of his mother, he moved in with the family of the pianist Russell Brooks and then with the Harlem stride piano master James Price Johnson. Like his pianist contemporaries, Waller had learned some aspects of ragtime and jazz style from studying the player piano rolls of masters such as Johnson. Now his instructional experience consisted of sitting at one piano while Johnson sat at another. Johnson's earliest impression of Waller was that he "played with fervor" but that "he didn't have any swing then" (Peck, 20). At the time, young Thomas was playing quite a bit of organ and had not developed the propulsive and difficult stride left hand required of the jazz piano style of the day. Long hours of practice, association with Johnson and other stride masters, and formal studies with the pianist Leopold Godowsky and the composer Carl Bohm at Juilliard honed Waller's skills.

By 1922 Waller had embarked on a busy career cutting piano rolls and playing theater organ at the Lincoln and Lafayette theaters. In that same year he made his debut solo recording for the Okeh label with "Muscle Shoals Blues" and "Birmingham Blues." He also began accompanying a number of vaudeville blues singers, including Sara Martin and ALBERTA HUNTER. In 1923, through an association with the New Orleans songwriter CLARENCE WILLIAMS, Waller launched his own songwriting career with the publication and recording of "Wild Cat Blues."

In the mid-1920s many of Waller's instrumental compositions were recorded by the prominent FLETCHER HENDERSON orchestra, including "Henderson Stomp," which featured a brief sixteen-bar solo by Waller as guest pianist that demonstrated his muscular technique and innovative ascending parallel tenths in his left hand. Henderson also recorded Waller's "Stealin' Apples" and an overblown parody of the Paul Whiteman Orchestra called "Whiteman Stomp." During this time Waller began his association with the lyricists Spencer Williams and ANDY RAZAF. With Razaf, Waller wrote his most enduring songs, those included in the musicals *Keep Shufflin'* (1928) and *Hot Chocolates* (1929). *Hot Chocolates*, which premiered at Connie's Inn in Harlem, moved to Broadway within a month. "Ain't Misbehavin'," a song from that show, was a signature vehicle for CAB CALLOWAY and was largely responsible for propelling the singing career of LOUIS ARMSTRONG.

Waller became a star entertainer in his own right. His large physical dimensions—which earned him the nickname "Fats"—his wit, and his extroverted personality made him a comic favorite to millions. While many fans and critics saw Waller as a mere buffoon, they failed to grasp the true genius of his humorous presentation. Often given uninspired hack songs to record, Waller transformed the material into successful performance vehicles that simultaneously offered veiled, biting commentary. Through his musical and comic ingenuity, he chided pompous, high-brow society in the song "Lounging at the Waldorf" and tainted the glib romantic sentiment of Billy Mayhew's "It's a Sin to Tell a Lie" by modifying the lyric to "If you break my heart, I'll break your jaw, and then I'll die." Much like the interlocutors of minstrelsy, he used pompous, complex word replacements, such as "your pedal extremities are colossal" in place of "your feet's too big." Waller was also able to diffuse overt racist expressions in songs like "Darktown Strutters' Ball" by referring to it as "Sepia Town."

Waller had a long-running relationship with Victor Records dating back to 1926 and had an exclusive contract with them by 1934. He recorded prolifically with his own ensembles, Fats Waller and His Rhythm, and costarred with and accompanied other artists. In addition to an exhausting and ultimately fatal road tour schedule, he had his own regular radio program on WOR in New York (1931) and WLW in Cincinnati (1932–1934). He made four "soundies," song-length music videos on film that were shown in nickelodeon arcades, and appeared in three full-length films, *King of Burlesque* (1935), *Hooray for Love* (1935), and *Stormy Weather* (1943), costarring Lena Horne, BILL "BOJANGLES" ROBINSON, Katherine Dunham, the NICHOLAS Brothers, and EDDIE "ROCHESTER" ANDERSON.

Fats Waller's ultimate contribution to music was as a pianist. Behind the comic exterior was an uncompromising and deeply gifted keyboard artist. His most sublime piano performances were recorded in a series beginning in 1929 that included "Handful of Keys," "Smashing Thirds," and "Numb Fumblin'." These pieces continued the two-fisted, swinging, and virtuoso solo style developed by James P. Johnson and others, but they also showcased Waller's own innovations, such as a graceful melodic sense and gliding walking tenths in the left hand that presaged modern swing. His influence can be heard in almost all the swing pianists who followed him, including Count Basie. Waller had a love and deep knowledge of classical music, especially Bach, and in 1928 he was the soloist premiering in JAMES P. JOHNSON's *Yamekraw*, a concert work for piano and orchestra performed at Carnegie Hall. In London in 1939 Waller ventured into longer compositional forms with his *London Suite*, which was orchestrated and recorded by the Ted Heath Orchestra in 1950. Waller continued to record jazz, blues, and popular songs on his beloved pipe organ and was the first prominent artist to showcase the new Hammond electric organ in the 1930s.

In 1943 Waller's overweight condition and indulgences in food, tobacco, and liquor, combined with the exhausting pace of his career and several personal crises, including an alimony liability to Edith Hatchett, his wife of 1920–1923, that dogged him all his adult life, finally caught up with him. On a train

returning to the East Coast from Hollywood after filming *Stormy Weather*, Waller died in his sleep somewhere around Kansas City. He was thirty-nine years old.

FURTHER READING

Hadlock, Richard. *Jazz Masters of the Twenties* (1965; repr. 1988).

Kirkeby, Ed. *Ain't Misbehavin': The Story of Fats Waller* (1966; repr. 1988).

Machlin, Paul S. *Stride: The Music of Fats Waller* (1985).

Peck, Seymour. "The Dean of Jazz Pianists," *PM*, 27 Apr. 1945: 20.

Shipton, Alyn. *Fats Waller: The Cheerful Little Earful* (2002).

Waller, Maurice, and Anthony Calabrese. *Fats Waller* (1977).

DISCOGRAPHY

Posnak, Paul, comp. *The Great Piano Solos 1929–1941* (1998).

"Thomas Wright 'Fats' Waller" in *Performances in Transcription 1927–1943*, comp. Paul S. Machlin, Music of the United States of America series, vol. 10 (2001).

DAVID JOYNER

WALROND, Eric

(1898–1966), journalist and short-story writer, was born in Georgetown, Guyana, to a Guyanese father and a Barbadian mother who disappointed her landowning father by marrying below her class. Walrond lived in English- and Spanish-speaking Barbados with his parents until 1906, when his father deserted the family and his mother returned to her father's settlement near Black Rock in Barbados. Walrond's mother took her son to Panama in 1910, in a futile attempt to find her husband, who she thought had gone there to find employment in the newly opened construction of the Panama Canal. Walrond and his mother remained in Panama, settling in Colón, where Walrond's education in Spanish, first in public schools and then from 1913 to 1916 with private tutors, supplemented his earlier British schooling in Barbados and would form the rich understanding of Spanish culture he would later bring to his short stories.

Walrond's first job was as a clerk for the Health Department of the Canal Commission at Cristobal. He began work at the region's most important newspaper, the *Panama Star and Herald* in 1916, where he filled the roles of general reporter, court reporter, and sportswriter at the paper. In 1918 Walrond emigrated to the United States, heading for New York City at the beginning of the explosively creative Harlem Renaissance. During the 1920s, Harlem became a national and international magnet for African Americans. The migration of southern blacks to the North continued, fueled by the increasing violence and narrowing opportunities in the South, and the lure of jobs, better education, and milder racism in the North. The next decade, which Walrond would spend in Harlem, would gain him recognition as one of the important writers of the Harlem Renaissance period.

Upon his arrival, Walrond intended to work at one of the many Harlem newspapers. When his attempts to find a position were unsuccessful, he decided to pursue his education. He studied for three years (1922 to 1924) at City College of New York and then from 1924 to 1926 he took creative writing courses at Columbia University. During these years, he worked odd jobs to support himself. Although his secretarial training helped him secure employment, his job searches brought him into contact with racism and discrimination on a scale he had not previously known in Panama and Barbados. These experiences would form the basis of much of his early writing. "On Being Black," his first story published in the United States, appeared in the *New Republic* in 1922, and it effectively re-creates the humiliations he experienced in his daily life in New York. It was in 1921 that Walrond reentered the world of journalism, when he became editor and co-owner of the black weekly the *Brooklyn and Long Island Informer*. His attraction to the vision of MARCUS GARVEY led him to leave that paper in 1923 to join Garvey's *Negro World* as associate editor. Walrond saw Garvey as the kind of political leader needed to combat the profound racism he had found in the United States.

Although he would become disaffected with Garvey, leaving him and the Universal Negro Improvement Association (UNIA) in 1925, during his three years with the UNIA Walrond wrote several articles on African American life for a number of periodicals and journals. He critiqued African American leaders BOOKER T. WASHINGTON, W. E. B. DU BOIS, and Garvey in "The New Negro Faces America" and examined migration in "The Negro Exodus from the South" (both in *Current History*, 1923). He explored Harlem

in "The Black City" (the *Messenger*, 1924) and considered Garvey's popular appeal in a 1925 article in the *Independent*, titled "Imperator Africanus, Marcus Garvey: Menace or Promise?" When National Urban League leader and editor CHARLES S. JOHNSON invited him to leave *Negro World* and join him at *Opportunity*, Walrond's focus would move from journalism to fiction. The Urban League's periodical had been started in 1923 to provide more of a focus on cultural life than the NAACP's *Crisis*. It would initiate the literary contests that would not only encourage young talent like LANGSTON HUGHES, COUNTÉE CULLEN, and CLAUDE MCKAY but would also bring to Harlem budding writers such as Helene Johnson, Dorothy West, and ZORA NEALE HURSTON.

Walrond had already written and published short stories before he joined *Opportunity* in 1925 as business manager. In 1923, for example, four short stories had found their way into print: "Miss Kenny's Marriage," in September's *The Smart Set*, and "On Being a Domestic," "The Stone Rebounds," and "Cynthia Goes to the Prom"—all in *Opportunity*, respectively in August, September, and November. These early stories show Walrond's experimentation with realistic style and urban settings. The stories written between 1924 and 1927 are much more impressionistic and often treat life in the Caribbean; these are the works for which Walrond is remembered. In 1925, ALAIN LOCKE included Walrond's short story "The Palm Porch" in his landmark publication *The New Negro*. In 1926, the publication of *Tropic Death*, Walrond's collection of ten short stories, earned Walrond recognition as a master short-story writer and a central place in the Harlem Renaissance. In these ten stories, all set in the American tropics, he creates a lush natural world into which the aims of colonialism intrude, leaving its inhabitants culturally disoriented. The style, full of imagery, reveals Walrond's modernist, avant-garde approach, reminiscent of JEAN TOOMER's *Cane* and the poetry of ANGELINA WELD GRIMKÉ. Prominent Harlem Renaissance leaders and editors W. E. B. Du Bois, CHARLES S. JOHNSON, JESSIE FAUSET, and Alain Locke celebrated Walrond's talent.

The information available on Walrond's life after he left Harlem in 1928 is quite sketchy. Following the success of *Tropic Death*, publishers Boni & Liveright gave him a contract for a book on the French involvement with the Panama Canal project.

He continued to work at *Opportunity* until 1927 but published little. In 1928, Walrond was awarded both a John Simon Guggenheim Memorial Foundation Award and a Zona Gale scholarship at the University of Wisconsin. He left the United States permanently in 1928, book contract in hand, to conduct research in the Caribbean. With an extension of the Guggenheim grant, Walrond traveled through Europe, working on his manuscript, tentatively titled "The Big Ditch." Walrond lived for a considerable time in France as part of the African American community in Paris until 1931, sharing a studio with poet Countée Cullen. While in Europe, Walrond published a number of shorter pieces—articles and short stories in both Spanish and French magazines as well as in *The Black Man*, a Garveyite magazine, in 1932. After he made a short visit to his parents in Brooklyn in 1931, Walrond returned to France, to a small village outside Avignon. He lived the rest of his life in France and England, generally disappearing from the public eye. His book on the Panama Canal would remain unfinished.

When Walrond died in 1966 in London, England, he left behind questions about his personal life. It is known that he was twice married and had three daughters, Jean, Dorothy, and Lucille, but details about the identities of his wives and about marriage and birth dates are unknown. Walrond survives in WALLACE THURMAN's satirical novel about the Harlem Renaissance, *Infants of the Spring*, as the character Cedric Williams, "one of three Negroes writing who actually had something to say, and also some concrete idea of style." Indeed, his short fiction combines an impressionistic style with a keen, critical journalistic eye to bring a lush, yet bleak, Caribbean environment to vivid life. Walrond's voice speaks to the wide reach of the New Negro Renaissance from its center in Harlem out into the world.

FURTHER READING
Lewis, David Levering. *When Harlem Was in Vogue* (1981).
Parascandola, Louis J., ed. *Winds Can Wake Up the Dead: An Eric Walrond Reader* (1998).

MARY ANNE BOELCSKEVY

WARING, Laura Wheeler

(16 May 1887–3 Feb. 1948), portrait artist, was born in Hartford, Connecticut, to Robert Foster Wheeler, a pastor, and Mary Freeman Wheeler, an artist.

While known for her landscapes and portraits, Waring is best remembered for her work in the Harmon Foundation exhibition Portraits of Outstanding Americans of Negro Origin, which toured the United States in 1944.

Five generations of Waring's family had attended college during an era when basic education for blacks, let alone a college education, was hard to get, particularly for girls and women. Waring graduated from Hartford Public High in 1906 and that same year entered the Pennsylvania Academy of the Fine Arts at Pennsylvania. She studied with painters Thomas Anschutz and William Merritt Chase, who also taught Georgia O'Keeffe. Black American artists studying with her included painters Lenwood Morris and Henry Jones and sculptors May Howard Jackson and META WARRICK FULLER.

Graduating with honors in 1914, Waring received a scholarship that allowed her to travel to Europe. She studied at the Académie de la Grande Chaumière in Paris. She returned to the States just before the outbreak of war in Europe to join the faculty of Pennsylvania's State Normal School, later renamed Cheyney State Teachers College. (She may have taught at Cheyney while at Pennsylvania Academy.) Here she met and married Walter E. Waring, who had been teaching at Lincoln University, in the late 1920s. She became director of the art department at Cheyney in 1925, a position she held for more than twenty years.

During visits to Europe, Waring met and befriended other artists, writers, and intellectuals of the African diaspora, such as HENRY OSSAWA TANNER and W. E. B. DU BOIS. Some of her friends and acquaintances sat for their portraits with Waring. Her art was displayed at the Harmon Foundation exhibition of works by "Negro artists" in 1927. Founded by the white real estate developer William E. Harmon, the Harmon Foundation's mission was to promote interracial cooperation and understanding. The foundation's executive director, Mary Beattie Brady, organized the exhibition Portraits of Outstanding Americans of Negro Origin in 1944. She commissioned Waring to work with the white artist Betsy Graves Reyneau on the series of notable black Americans, and the exhibition traveled nationally.

Waring's contributions included her portrait of Harlem Renaissance writer JESSIE FAUSET, whom she had met in Paris thirty years earlier and with whom she remained friends. Waring traveled to the farm of opera singer MARIAN ANDERSON to paint her portrait. Her other Harmon portraits were of Judge Raymond Alexander, lawyer Sadie Alexander, musician HARRY T. BURLEIGH, educator Du Bois, sociologist George T. Haynes, author and educator JAMES WELDON JOHNSON, and physician Dr. John P. Turner.

Waring was also a contributor and supporter of social change. Her work was frequently found in *The Crisis,* the official monthly publication of the NAACP, of which she was a member. Waring shared her skills and talent through education, particularly with black American students. Her dedication to education was honored when the Laura Wheeler Waring School was named in Philadelphia in 1956. After her death in 1948, her husband donated many of her papers to the Archives of American Art's Philadelphia Arts Documentation Project. A historical marker was erected at her home on North Forty-third Street in Philadelphia.

Waring's work reflected a traditional style gained through academic training: realistic and rendered with an impressionist attention to color, brush stroke, and detail. Her portraits had a dignified tone, creating an almost reverential attitude for her subjects. Du Bois, Anderson, Fauset, and more, were depicted formally, at their best, to demonstrate the best—the New Negro—an ideological identification of that time. This traditional presentation of a subject was augmented by details specific to the subject's life or to African American culture or history. The paintings emphasized the emotional response to the subject and his or her contributions to society. Similar to her contemporary, painter Tanner, she emphasized biblical motifs and symbols, gained from her childhood sitting in the pew of her father's church, while known for her more traditional and academic style. Her work was exhibited at the Galerie du Luxembourg, Paris; Howard University, Washington, D.C.; Brooklyn Museum, New York; and the Newark Museum, New Jersey.

FURTHER READING

Driskell, David D., and Tuliza K. Fleming. *Breaking Racial Barriers: African Americans in the Harmon Foundation Collection* (1997).

Laura Wheeler Waring: An Appreciational Study (1949).

Patton, Sharon F. *African-American Art* (1998).

Taha, Halima. *Collecting African American Art: Works on Paper and Canvas* (1998).

ROBIN JONES

WASHINGTON, Booker T.

(5 Apr. 1856?–14 Nov. 1915), educator and race leader, was born on the plantation of James Burroughs, near Hale's Ford in Franklin County, Virginia, the son of an unknown white father and Jane, a slave cook owned by Burroughs. Washington was never certain of the date of his birth and showed little interest in who his father might have been. His mother gave him his first and middle names, Booker Taliaferro; he took his last name in 1870 from his stepfather, Washington Ferguson, a slave whom his mother had married. In his autobiography *Up from Slavery* (1901), he recalled the poverty of his early years as a slave on Burroughs's plantation, but because emancipation came when he was around nine, he was spared the harsher experiences of the slave system. In 1865, at the end of the Civil War, his mother moved him, his half-sister, and his half-brother to Malden, West Virginia, where her husband had found work. Young Booker was put to work packing salt from a nearby mine and later did even harder work in a coal mine.

Two women were influential in Washington's early education. The first was his mother. He displayed an intense interest in learning to read; although illiterate herself, she bought her son a spelling book and encouraged him to learn. While working in the mines, Washington also began attending a local elementary school for black youths. The other female influence was Viola Ruffner, wife of General Lewis Ruffner, owner of the mines. Probably around the age of eleven, eager to escape the brutal mine work, he secured a position as Viola Ruffner's houseboy. She had a prickly personality, was a demanding taskmaster, and had driven off several other boys, but in the eighteen months he worked for her he came to absorb and appreciate her emphasis on the values of hard work, cleanliness, and thrift; thereby an unlikely bond of affection and respect developed between these two people from very different backgrounds. Early on, Ruffner spotted the ambition in young Washington: "He seemed peculiarly determined to emerge from his obscurity. He was ever restless, uneasy, as if knowing that contentment would mean inaction. 'Am I getting on?'—that was his principal question" (quoted in Gilson Willetts, "Slave Boy and Leader of His Race," *New Voice* 16 [24 June 1899]: 3).

In 1872, at age sixteen, Washington entered Hampton Normal and Agricultural Institute in Hampton, Virginia; it turned out to be one of the most important steps of his life. Having overheard two miners talking about the school for young blacks, he had determined to make his way there and set out on the five-hundred-mile trip with a small sum of money donated by family and friends, barely enough to take him partway by train. The rest of the monthlong journey was on foot or via an occasional passing wagon. He arrived with fifty cents in his pocket and asked to be admitted. Ordered to clean out a room, and sensing that this might be his entrance examination, he swept and dusted until the room was spotless and was soon a Hampton student. While there he worked as a custodian to help defray his expenses.

Hampton Institute, only four years old at the time, was a monument to its principal, General Samuel Chapman Armstrong, probably the single most influential person in Washington's life. Born of missionary parents in Hawaii, Armstrong had led black troops in the Civil War. Convinced that the future of the freedmen lay in practical and industrial education and the instilling of Christian virtues, Armstrong had founded Hampton under

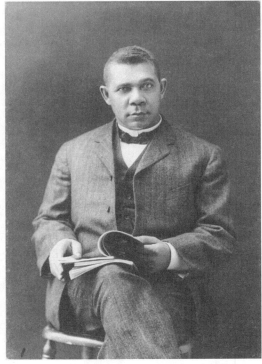

Booker T. Washington, c. 1903. (Library of Congress.)

the auspices of the American Missionary Association. In Booker Washington he found an extraordinarily apt and ambitious pupil. Washington not only learned agriculture, brickmasonry, and the standard academic subjects taught at Hampton, more importantly he absorbed the entire philosophy of character building and utilitarian education stressed by the handsome and charismatic Armstrong.

After graduating in 1875, Washington returned to Malden for three years to teach in a black school and to spread the Hampton philosophy. Several months spent at Wayland Seminary, a Baptist institution, in Washington, D.C., in 1878–1879 convinced the restless young Washington that he was not cut out for the ministry. In addition, his exposure to the poverty and degeneracy of lower-class urban life instilled in him a lifelong dislike of cities. This prejudice would later weaken to a degree his message to his fellow blacks to remain in the rural South, at a time when far greater job opportunities were to be found in the nation's burgeoning cities.

Somewhat adrift in the late 1870s, having rejected the ministry, law, and public school teaching as viable careers, Washington was invited back to Hampton in 1879 by General Armstrong to run the night school and later to supervise the dormitory for Indian boys, who had recently been admitted. As usual, his performance was exemplary. In the spring of 1881 Armstrong received a request from three education commissioners in Alabama to recommend a white principal for a new Negro normal school to be established in Tuskegee. He wrote a persuasive letter urging them to accept Washington instead. They agreed, and the young educator was soon on the way to what would be his life's work. On arriving in Alabama, he learned that the state legislature had appropriated two thousand dollars for salaries only. There was no land, no buildings, no campus.

Plunging into unremitting activity, Washington won over local whites in the community, began to recruit black students who were hungry for education, and held the first classes in a shanty. One of his mentors at Hampton was the school's treasurer, James F. B. Marshall, an elderly and kindly ex-general who now began coaching Washington in the arts of financial management and extracting money from wealthy white benefactors. With a two-hundred-dollar loan from Marshall, Washington purchased land outside of town for a permanent

campus. Student labor erected the initial buildings of Tuskegee Institute, and student farming supplied much of the foodstuff for the dormitory kitchen. Tuskegee would grow to two thousand acres and one hundred buildings, with a faculty of nearly two hundred and an endowment close to $2 million by the time of Washington's death.

In spite of Washington's national fame in years to come, Tuskegee never ceased to be his base of operations and the enterprise to which he devoted most of his time. Each morning began with a horseback ride to inspect the campus. He hired and fired faculty, admitted and expelled students, oversaw the smallest details of finances and purchasing, bought more land when he could, kept creditors at bay when he had to, and spent much time cultivating northern philanthropists for donations, at which he became extremely adept. Among the notable benefactors of Tuskegee were steel magnate Andrew Carnegie, oilman John D. Rockefeller, camera manufacturer George Eastman, and Julius Rosenwald, president of Sears, Roebuck, and Co.

In many respects Tuskegee was a "colony" of Hampton Institute, as Washington had imbibed General Armstrong's emphasis on industrial skills and character building. The vocational curriculum included some thirty-eight subjects, including printing, carpentry, cabinetmaking, and farming. Female students specialized in cooking, sewing, and other domestic skills. In addition to the standard academic subjects, from grammar and composition to history, mathematics, chemistry, and bookkeeping, strong emphasis was placed on personal hygiene and moral development and on daily chapel services. At the time of Washington's death the student body numbered more than fifteen hundred.

Unlike Hampton, however, Washington's faculty and administrative staff were all black, and many were graduates of Hampton and Fisk University. Notable among the staff were botanist and agricultural researcher GEORGE WASHINGTON CARVER and MONROE NATHAN WORK, the sociologist and bibliographer of black history and life who spent thirty-seven years at Tuskegee as head of the Records and Research Department. The highly capable Olivia Davidson, a graduate of Hampton and the Framingham State Normal School near Boston, arrived in 1881 to serve as principal of the female students and came as close as anyone to being Washington's co-superintendent. For the last eighteen years of his life, Washington's personal

private secretary, factotum, and alter ego was Emmett Jay Scott, an extraordinarily loyal, astute, and circumspect assistant who handled much of Washington's correspondence, supervised the Tuskegee office staff, and was privy to all of Washington's secret machinations at controlling black American politics.

Washington was married three times. His first wife, Fannie Smith [Washington], his sweetheart from Malden, gave birth to a child in 1883, the year after their marriage, but died prematurely the next year. In 1885 Washington married Olivia Davidson; they had two children. This too was a short marriage, for she had suffered from physical maladies for years and died in 1889. Four years later he married Margaret J. Murray (Margaret Murray Washington), a Fisk graduate who had replaced Davidson as lady principal. She remained Washington's wife for the rest of his life, helping to raise his three children and continuing to play a major role at Tuskegee.

As Tuskegee Institute grew, it branched out into other endeavors. The annual Tuskegee Negro Conferences, inaugurated in 1892, sought solutions for impoverished black farmers through crop diversity and education. The National Negro Business League, founded in 1900, gave encouragement to black enterprises and publicized their successes. Margaret Washington hosted women's conferences on campus. Washington established National Negro Health Week and called attention to minority health issues in addresses nationwide.

By the mid-1880s Washington was becoming a fixture on the nation's lecture circuit. This exposure both drew attention and dollars to Tuskegee and allowed the black educator to articulate his philosophy of racial advancement. In a notable 1884 address to the National Education Association in Madison, Wisconsin, Washington touted education for blacks—"brains, property, and character"—as the key to black advancement and acceptance by white southerners. "Separate but equal" railroad and other public facilities were acceptable to blacks, he argued, as long as they really were equal. This speech foreshadowed the accommodationist racial compromises he would preach for the rest of his life. During the 1880s and 1890s Washington went out of his way to soft-pedal racial insults and attacks on blacks (including himself) by whites. He courted southern white politicians who were racial moderates, arguing that black Americans had to exhibit

good citizenship, hard work, and elevated character in order to win the respect of the "better sort" of whites. Full political and social equality would result in all due time, he maintained.

The apogee of Washington's career as a spokesman for his race occurred at the opening of Atlanta's Cotton States and International Exposition in September 1895. This was one of a number of such fairs held to highlight the South's progress since the Civil War. Blacks had their own, albeit segregated, exhibit space at the exposition, and the Atlanta leaders of the affair invited Washington to give a ten-minute address. He spent much time honing the speech, sensing its symbolic importance, and was uncharacteristically nervous as 18 September approached.

Dubbed the "Atlanta Compromise," the speech was a masterpiece of tact and ambiguity intended to impress all members of the integrated audience—northern whites, southern whites, and blacks from the South. It had all been said before by Washington but never as succinctly and before such an important gathering. Though acceding realistically to the deplorable state of race relations in the United States at that time, Washington seemed to accept the existence of segregation for his people and urged them not to push for integrated facilities and other civil and political rights. "The wisest among my race understand that the agitation of questions of social equality is the extremest folly, and that progress in the enjoyment of all the privileges that will come to us must be the result of severe and constant struggle rather than of artificial forcing." He urged southern blacks to "cast down your bucket where you are"—stay in the South, gain education, and through hard work win the economic advancement that would also gain them the respect of their white neighbors. He reminded his white listeners that the blacks among them made up one-third of the South's population and that the fates of the two races were inextricably bound. The climax of the speech, which brought the audience to its feet in thunderous applause, was the memorable sentence: "In all things that are purely social we can be as separate as the fingers, yet one as the hand in all things essential to mutual progress."

The Atlanta Compromise speech unquestionably secured Washington's position as the leading spokesman for American blacks to the larger white community and particularly to the white power structure of American politics, and it was lavishly

praised by white leaders. Symbolically the torch of black leadership had also been passed to a younger generation, inasmuch as Frederick Douglass, the former slave turned abolitionist, orator, and journalist, who had been the most notable black American of his day, had died a few months before Washington spoke. Washington had tapped into the classic American myth that hard work, self-discipline, and economic independence would win for any citizen the respect of his neighbors. He conveniently ignored or chose to omit the fact that at the very time he spoke, American race relations were at their worst point since the end of the Civil War, with lynchings and other violence, grinding poverty, and legal and extralegal discrimination at the ballot box a fact of life for most American blacks. The U.S. Supreme Court's decision the very next year in *Plessy* V. Ferguson would place the fiction of "separate but equal" on segregated public facilities.

Yet the decade after 1895 was for Washington the most influential period of his life, if that influence is measured by his demand as a speaker and the power he wielded among white political leaders. In 1898 President William McKinley paid a visit to Tuskegee Institute. McKinley's successor, Theodore Roosevelt, had been a friend of Washington's for several years. The relationship between president and educator began on an inauspicious note when Roosevelt, one month after taking office in 1901, invited Washington to dinner at the White House. Although other blacks had visited the executive mansion on occasion since at least the time of Abraham Lincoln, the Roosevelt-Washington dinner set off a firestorm of outrage, especially in the southern white press. Washington was chagrined by the whole affair; Roosevelt made light of it to his southern friend but privately called it a "mistake" and never again invited minorities to the White House.

The dinner aside, the relationship between the two men was unusually close. Roosevelt regularly though privately consulted Washington on matters involving race and southern policies, and almost all of the minority political appointments Roosevelt made as president were first cleared with the Tuskegeean. Washington's relationship with Roosevelt's successor, William Howard Taft, was cooler, given Taft's greater reluctance than Roosevelt's to make significant black political appointments; but Washington scored an occasional minor victory with Taft, and it was one of the many ironies of his

career that while he urged ordinary blacks to eschew politics and humbly go about their daily work, he himself wielded more political power than any other black American of his day.

Washington's prolific writing also helped to spread his influence; moreover, much of the royalties from his books went into the coffers of Tuskegee. He wrote scores of articles and ten books, often with the help of ghost-writers. owing to his busy schedule. Among them were *The Future of the American Negro* (1899), a collection of his articles and speeches; *The Story of My Life and Work* (1900), the first of three autobiographies; *Up from Slavery* (1901), his most critically acclaimed autobiography, translated into some eighteen languages; *Working with the Hands* (1904); *The Negro in Business* and a biography of Frederick Douglass, both in 1907; *My Larger Education* (1911), the last of the trilogy about his own life; and *The Man Farthest Down* (1912), based on a European tour.

Washington's power involved not only close relationships with influential white political leaders and industrialists but also a secret network of contacts with journalists and various organizations. He schemed with white and black Alabamians to try to keep other black schools from locating near Tuskegee. He engineered political appointments for supporters in the black community as a way of solidifying his own power base. He planted spies in organizations unfriendly to him to report on their activities and at one time even used a detective agency briefly. Despite public denials, Washington owned partial interests in some minority newspapers. This allowed him to plant stories and to influence their news coverage and editorial stands in ways beneficial to himself. Beginning in the mid-1880s, and lasting for some twenty years, he maintained a clandestine relationship with T. Thomas Fortune, editor of the *New York Age*, the leading black newspaper of its day. He helped support the paper financially, was one of its stockholders, and quietly endorsed many of Fortune's militant stands for voting and other civil rights and against lynching. He also supported the Afro-American League, a civil rights organization founded by Fortune in 1887. Washington secretly provided financial and legal support for court challenges to all-white juries in Alabama, segregated transportation facilities, and disfranchisement of black voters. As black suffrage decreased nonetheless around the turn of the century, Washington struggled to keep a modicum of

black influence and patronage in the Republican Party in the South. From 1908 to 1911 he played a major, though covert, role in the successful effort to get the U.S. Supreme Court to overturn a harsh Alabama peonage law under which Alonzo Bailey, a black Alabama farmer, had been convicted.

It is clear, from research in Washington's massive correspondence, that he supported the full agenda of civil and political rights put forward by Fortune, the Afro-American League, and later the National Association for the Advancement of Colored People (NAACP). But he refused to go public with such efforts, fearing, probably rightly, that to reveal his involvement would undercut if not destroy his support from white politicians and philanthropists and perhaps threaten his beloved Tuskegee. Emmett Scott was one of very few blacks who knew the full range of Washington's secret activities; certainly no whites did.

After about 1900 Washington came under increasing criticism from black opponents who questioned his measured and nonaggressive responses to legalized segregation, loss of voting rights, and violence against blacks. His critics referred disrespectfully to his enormous influence as the Tuskegee Machine. Among the most vocal were WILLIAM MONROE TROTTER, the militant editor of the *Boston Guardian*, and noted sociologist W. E. B. DU BOIS. In his *The Souls of Black Folk* (1903) Du Bois launched a strong indictment of Washington's accommodationist philosophy toward the terrible racial climate of the time. Du Bois and others also questioned Washington's emphasis on vocational and industrial education, claiming that the black race needed college-educated professionals in its fight against discrimination and injustice.

A series of setbacks after the turn of the century illustrated how little effect Washington's moderation had had in ameliorating the nation's tense racial climate. The uproar over the 1901 dinner with President Roosevelt was a harbinger of worse things to come. In September 1906 five days of frenzied racial violence rocked Atlanta, the supposedly progressive capital of the New South. After the violence subsided, at least eleven citizens, ten black and one white, were dead, many other blacks were injured, and black areas of the city experienced destruction. Washington gave his usual muted response, urging Atlanta's blacks to exercise "self-control" and not compound the lawless white behavior with violence of their own. He was, however, instrumental

in bringing leaders of both races together after the riot to begin the healing process.

Also in 1906 occurred the notorious Brownsville affair. In August an undetermined group of people shot up an area of Brownsville, Texas, nearby Fort Brown, where black infantry soldiers were stationed. One white man was killed. The racial climate was already strained owing to previous attacks on soldiers by local residents. Townspeople assumed that the soldiers had done the shooting in retaliation for the previous attacks. All of the black soldiers vehemently denied their involvement, however, and there was no compelling evidence or proof whatsoever of their guilt. In spite of Washington's pleas not to do so, President Roosevelt dishonorably dismissed three companies of the black troops, creating an uproar among blacks and liberal whites.

Exasperated with Washington's low-key responses in the Atlanta and Brownsville cases, his old friend Fortune finally broke with him. More serious for Washington was the founding of the NAACP in 1909. Melvin J. Chisum, a northern confidant of Emmett Scott, had infiltrated Trotter's Boston Suffrage League and later the Niagara Movement, the forerunner of the NAACP, and reported the activities of both groups back to Tuskegee. Characteristically, Washington had a spy planted at the NAACP's founding meeting. Nonetheless, he was unable to prevent the creation of the NAACP, the membership of which included blacks, sympathetic white progressives, Jews, and even a few white southerners, or to influence its agenda, which included a broad-based call for a major assault on all fronts against racial injustice and white supremacy. Washington's old nemesis Du Bois became editor of the organization's monthly magazine, *The Crisis*. Although Washington privately supported many of the goals of the NAACP, his concern was its threat to his own power within the black community.

An ugly incident that took place in New York City on the evening of 19 March 1911 illustrates how little protection was then afforded to a black person, even one as eminent as Washington, under certain circumstances. While scanning the residents' directory in the vestibule of an apartment building in search of a friend, Washington was assaulted and repeatedly struck on the head by Henry Ulrich, a white resident of the apartment. Ulrich first claimed that Washington was a burglar; the second version of his story was that the black educator was looking through the keyhole of a white woman's apartment

and that he had made an improper advance toward Ulrich's wife. Washington charged him with assault, and the ensuing trial received much national publicity. Washington won considerable support from the black community, even from his critics. Ulrich's acquittal in the face of overwhelming evidence illustrated the difficulties that even a prominent black man could have with the American justice system in the early twentieth century.

Washington died of overwork and arteriosclerosis at Tuskegee, shortly after returning from New York City, where he had been hospitalized.

Assessments of Washington by his contemporaries and, later, by historians have been wide-ranging and contentious, revealing, if nothing else, his complexity and many-sidedness. In the 1960s his secret life emerged as scholars began to plumb the 1 million documents in his collected papers. They reveal a much more complex, manipulative, secretive, vain, and at times deceptive individual than the inspiring and benign image that Washington himself so assiduously cultivated in his own lifetime. Indeed, he likely enjoyed leading this "double life."

To most of his students and faculty at Tuskegee, and to millions of poor blacks nationwide, he was a self-made and beneficent, if stern, Moses leading them out of slavery and into the promised land. He tirelessly preached an upbeat, optimistic view of the future of his fellow blacks. "When persons ask me," he said once, "how, in the midst of what sometimes seem hopelessly discouraging conditions, I can have such faith in the future of my race in this country, I remind them of the wilderness through which and out of which a good Providence has already led us." When he also wrote that he would "permit no man, no matter what his color, to narrow and degrade my soul by making me hate him," he was undoubtedly sincere. His message to his fellow blacks that hard work, good citizenship, patient fortitude in the face of adversity, and love would ultimately conquer the hatred of the white man was appealing to the majority of whites of his time and foreshadowed the similar message of a later leader, Martin Luther King Jr.

Washington's hardscrabble "up from slavery" background made it difficult for him to communicate with his college-educated critics, such as Trotter and Du Bois. They in turn, from the comfort of their editorial offices in the North, were perhaps unable to fathom the pressures and constraints from the white community that southern educators like Washington had to deal with on a daily basis. Yet their point that the race needed lawyers and doctors as well as farmers and bricklayers was valid, and the growing crescendo of criticism against Washington on this issue made the last decade of his life probably his most difficult. The irony, of course, was that Washington was secretly supporting the campaign against legal segregation and racial violence and for full civil rights. But he was unwilling to reveal his covert role for fear that it would undercut his power base among blacks and sympathetic whites, and he was doubtlessly right.

Close analysis of Washington's autobiographies and speeches reveals a vagueness and subtlety to his message lost on most people of his time, whites and blacks alike. He never said that American minorities would forever forgo the right to vote, to gain a full education, or to enjoy the fruits of an integrated society. But he strategically chose not to force the issue in the face of the overwhelming white hostility that was the reality of American race relations in the late nineteenth and early twentieth centuries. In this sense, he did what he had to do to assure the survival of himself and the people for whom he spoke.

FURTHER READING

Most of Washington's papers are in the Library of Congress. A smaller but important collection is at Tuskegee University. The major published collection is *The Booker T. Washington Papers*, ed. Louis R. Harlan and Raymond W. Smock (14 vols., 1972–1989).

Harlan, Louis R. *Booker T. Washington: The Making of a Black Leader, 1856–1901* (1972).

Harlan, Louis R. *Booker T. Washington: The Wizard of Tuskegee, 1901–1915* (1983).

Hawkins, Hugh, ed. *Booker T. Washington and His Critics: The Problem of Negro Leadership* (1962).

Logan, Rayford W. *The Betrayal of the Negro* (1965).

Meier, August. *Negro Thought in America, 1880–1915: Racial Ideologies in the Age of Booker T. Washington* (1963).

Scott, Emmett J., and Lyman Beecher Stowe. *Booker T. Washington: Builder of a Civilization* (1916).

Obituary: New York Times, 15 Nov. 1915.

WILLIAM F. MUGLESTON

WASHINGTON, Fredi

(23 Dec. 1903–28 June 1994), dancer, actor, organizer, and activist, was born Fredericka Carolyn Washington in Savannah, Georgia. Washington was

best known for her Caucasian features (pale skin, straight hair, and green eyes) which helped her to secure the original role of Peola, the sullen and dissatisfied daughter who attempts to claim the benefits of white privilege while passing in the 1934 film *Imitation of Life*. One of Robert T. Washington and Harriet Walker Ward Washington's nine children, Fredericka's early life was unsettled by the sudden death of her mother.

After the death of their mother, both Washington and her younger sister, Isabel Washington, were sent away to St. Elizabeth's Convent in Cornwell Heights, Pennsylvania, to be educated. In 1919 Washington moved to Harlem, New York, to live with her grandmother and later dropped out of school. Her exposure to show business probably began when she went to work as a typist and secretary for HARRY H. PACE at Black Swan Phonograph Corporation, whose slogan was "The Only Genuine Colored Record. Others Are Only Passing for Colored" (Kellner, 39).

Washington seemed to easily find show business opportunities. Her first stage appearance, in the early 1920s, was as a dancer in the chorus of NOBLE SISSLE and EUBIE BLAKE's legendary musical comedy *Shuffle Along*, then playing in Manhattan's Club Alabam. In 1926 she assumed the stage name of Edith Warren when she got a lead role opposite PAUL ROBESON in the play *Black Boy*, by Jim Tully and Frank Dazey. She toured Europe with Al Moiret as half of the dance team called Fredi and Moiret. According to the author Donald Bogle, they traveled to Paris, Nice, Berlin, Dresden, and Hamburg, and "in London, she taught the latest dance craze, the Black Bottom, to the Prince of Wales" (Bogle, *Bright Boulevards*, 130). She returned to the United States in 1928 prepared to resume her acting career.

During the 1930s Washington became familiar to audiences as an actor. In 1930 she starred in the musical play *Sweet Chariot* with FRANK H. WILSON and the blues singer CLARA SMITH. The play's theme was suggestive of the United Negro Improvement Association (UNIA) and the philosophy of MARCUS GARVEY. The play considered what would happen if a Garvey-type character (Marius Harvey) was able to transport a group of African Americans from the United States to the continent of Africa. Washington appeared in another musical in 1931, *Singin' the Blues*, which again starred Frank Wilson; Washington's younger sister, Isabel, was also in the cast. Washington continued to build her stage experience with the musical *Run, Little Chillun* in 1933.

Washington's movie career began in 1929 with an appearance in DUKE ELLINGTON's short sound feature, *Black and Tan Fantasy*. According to Washington's sister Isabel, the blues singer ALBERTA HUNTER, and the musician Mercer Ellington (Duke's son), the love of Fredi Washington's life was Duke Ellington (Bogle, *Bright Boulevards*, 131–132). In July 1933, however, Washington married LAWRENCE BROWN (1907–1988), a trombonist in Ellington's orchestra, and announced her retirement from show business. Their marriage would end in divorce in 1948.

During the 1930s Washington was politically active and participated in a number of boycotts and pickets to persuade Harlem businesses to hire African Americans. The protests were usually organized by ADAM CLAYTON POWELL JR., Washington's brother-in-law (Isabel's husband). Powell's weekly paper, the *People's Voice*, included a column by Washington, which focused on theater happenings and the struggles of black actors. She was also one of the cofounders of the Negro Actors Guild and served as its first executive secretary in 1937; the guild was formed to help black performers battle discrimination in show business. Her activism extended to the Joint Actors Equity-Theater League Committee that examined the problem of hotel accommodations for African American actors.

Washington's postnuptial retirement was short-lived, for in 1933 she appeared with Paul Robeson in the film *Emperor Jones*. Her light skin led the film's producers to darken her face with makeup for fear that audiences might think that the couple was interracial, a Hollywood taboo at the time (Bogle, *Bright Boulevards*, 130). The same year she also appeared in *Drums in the Jungle*, which was filmed in Jamaica. Washington's most famous film role came in 1934 in *Imitation of Life*, based on a novel by Fannie Hurst; she starred opposite LOUISE BEAVERS and Claudette Colbert. Her performance as Peola made her a celebrity and convinced many moviegoers that Washington, like Peola, passed for white. Unfortunately, Washington never had another opportunity to act in a movie that offered such wide exposure. Nevertheless, she went on to make other films during the 1930s, including *Mills Blue Rhythm Band* (1934), *Ouanga* (1936), and *One Mile from Heaven* (1937) with BILL ROBINSON and

EDDIE ANDERSON. During the 1930s and 1940s she continued to work in theater, and some believe that her best work on Broadway was in *Mamba's Daughter* (1939), opposite ETHEL WATERS. In 1946 she performed on stage in *Lysistrata* with Etta Moten and a young Sidney Poitier; in 1948, *A Long Way from Home*; and in 1949, *How Long till Summer*. Her contribution to show business was honored in 1975 when she was inducted into the Black Filmmakers Hall of Fame.

Washington's political activism continued in the 1940s and 1950s through her work with the Cultural Division of the National Negro Congress and the Committee for the Negro in the Arts. Also, in 1952 Washington wed Hugh Anthony Bell, a prominent Connecticut dentist, and she retired—this time, permanently—from show business. Their marriage lasted until his death in 1970. Fredericka Carolyn Washington Brown Bell died of pneumonia in Stamford, Connecticut, after suffering a stroke.

FURTHER READING

Bogle, Donald. *Bright Boulevards, Bold Dreams: The Story of Black Hollywood* (2005).

Bogle, Donald. *Brown Sugar: Eighty Years of America's Black Female Superstars* (1980).

Kellner, Bruce, ed. *The Harlem Renaissance: A Historical Dictionary for the Era* (1987).

Newkirk, Pamela. *A Love No Less: More Than Two Centuries of African American Love Letters* (2003).

REGINA V. JONES

WATERS, Ethel

(31 Oct. 1896–1 Sept. 1977), singer and actress, was born in a slum section of Chester, Pennsylvania, as a result of the rape at knifepoint of her twelve-year-old mother, Louisa Tar Anderson, by her white father, John Wesley Waters. She was raised by her grandmother in Chester and Philadelphia. Completing only the sixth grade, Waters could not read or write well and was unable to express herself verbally without often resorting to violence. She grew up with prostitutes, procurers, and thieves and stole in order to eat. Having begun to sing at the age of five, Waters became known as "Baby Star." In 1909, at the age of thirteen, she married Merritt "Buddy" Purnsley, who was twenty-three. He beat her and humiliated her frequently. They separated by the time Waters was fourteen. The unhappiness of her early years is poignantly addressed in Waters's autobiography, where she writes, "I was never a child. I never felt I belonged. I was always an outsider. I was born out of wedlock" (Waters, 1).

Waters worked as a maid before she began entering singing competitions. In 1917 she made her professional debut at the Lincoln Theatre in Baltimore, Maryland, for nine dollars a week. Because of their dark skin, both Waters and JOSEPHINE BAKER were rejected for the 1921 Broadway production of *Shuffle Along*. While Baker finally worked her way into the chorus and clowned her way into acceptance, Waters became bitter.

She began singing in Edmonds's Cellar in Harlem. "It was a sure enough honky-tonk, occupying the cellar of a saloon. It was the social center of what was then, and still is, Negro Harlem's kitchen. Here a tall brown-skin girl, unmistakably the one guaranteed in the song to make a preacher lay his Bible down, used to sing and dance her own peculiar numbers" (Rudolph Fisher, quoted in Krasner, 72).

Waters also toured with the Theater Owners' Booking Association (TOBA), a booking agency for black performers, often referred to as "Tough on Black Actors." Performers often rehearsed without pay and got no money if a show closed on the road. Frequently, they were denied hot or cold running water and other amenities in their dressing rooms. More than once, Waters dressed under a staircase, without even a curtain for privacy. She endured many of the difficulties of segregated America as well as the abuse of some in management and the police. She was very poorly treated in a black wing of a hospital in Anniston, Alabama, after she sustained a leg injury in a car accident while on a TOBA tour. For much of the 1920s and all of the 1930s, Waters sang at popular nightspots and recorded. Leonard Feather observed, "It is curious that the obituaries described Waters as a blues singer, which during almost all of her career she was not. In fact, she had been the first prominent black singer on records who was not primarily associated with the blues. While BESSIE SMITH . . . [was at her peak], Waters was lending her gracious touch to pop songs of the day" (*Los Angeles Times*, 3 Sept. 1977).

Waters sang with FLETCHER HENDERSON's and DUKE ELLINGTON's bands at the Cotton Club, the Plantation Club, and many other elegant establishments. When Earl Dancer implored Waters to leave the "colored time" and try the white clubs, she made him her manager and toured the Keith-Orpheum vaudeville circuit. In her early years Waters was tall and lean; audiences and critics dubbed her

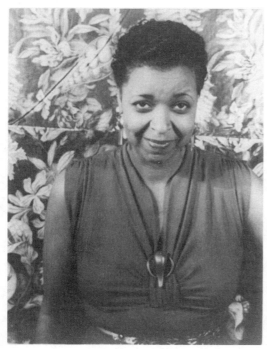

Ethel Waters, singer and actress, photographed between 1938 and 1948, probably in New York City. (Library of Congress/Gottlieb Collection.)

York Times, wrote of her performance: "Ethel Waters takes full control of the audience and the show whenever she appears. Her abandon to the ruddy tune of 'Heat Wave Hits New York,' her rowdy comedy . . . and her deep-toned song about a lynching give some notion of the broad range she can encompass in musical shows" (*New York Times*, 2 Oct. 1933).

Four years out of bankruptcy, Waters became the highest-paid woman on Broadway. In 1933 she lived royally, for a season, while many stood in soup lines. She had an apartment on Harlem's "Sugar Hill," a regal wardrobe, a large earring collection, a Lincoln Town Car with a chauffeur, servants for her ten-room apartment—and a man to occupy it, though in 1934 she divorced Matthews.

In 1939, as the Depression lifted and World War II approached, Waters became one of the first African American women to star in a dramatic role on Broadway, in Dorothy and DuBose Heyward's *Mamba's Daughters*. (ROSE MCCLENDON had starred in LANGSTON HUGHES's *Mulatto* on Broadway in 1935.) Waters played Hagar, an unlettered woman on a South Carolina plantation. On opening night, she took seventeen curtain calls. Brooks Atkinson printed a lukewarm review, and many of Waters's friends took out a full-page advertisement in the *New York Times*, strongly suggesting that he return to the theater and review the play more objectively. He did. Waters also appeared in an experimental television broadcast by NBC in 1939, *The Ethel Waters Show*, which was the first ever television show to star an African American.

Following the close of *Mamba's Daughters*, Waters worked with the United Service Organization (USO), entertaining military men of color all over the world. In 1940 she starred in Lynn Root's *Cabin in the Sky* in New York City. Katherine Dunham, whose dance troupe was part of the musical, took over as choreographer when George Balanchine was fired. In *Cabin in the Sky*, Waters played a God-fearing woman whose husband, Little Joe, gambles and enjoys the women. Hollywood made a film of *Cabin in the Sky* in 1943, again starring Waters as Petunia, with Lena Horne replacing Dunham as Sweet Georgia Brown, the other woman. The jealousy Waters displayed on both the stage and film sets became legendary. Waters's poor judgment, violent streak, and jealousy often eclipsed her talent. During the *Cabin* productions, she lived with Eddie Mallory, a handsome trumpeter who

"Sweet Mama Stringbean." By 1927 she had made her Broadway debut as Miss Calico in the revue *Africana*. Following the early death of FLORENCE MILLS, Waters performed in Lew Leslie's *Blackbirds* in 1927 and 1928. Also in 1928 she married Clyde Matthews, with whom she adopted a daughter, Algretta.

All her life Waters struggled financially, even when she made good money. Generous to a fault with her men and with considerable medical expenses, Waters declared bankruptcy in 1929, at the time of the great stock-market crash. That same year she appeared in a movie, *On with the Show*, wearing a bandana and carrying a large basket of cotton, and in *Rhapsody in Blue*, a revue at the Belasco Theatre in Washington, D.C. Several New York City theaters picked up the revue in 1930, and by 1931 Waters was a star.

Irving Berlin heard her sing "Stormy Weather" at the Cotton Club and cast her in the famous Broadway revue *As Thousands Cheer*, at the Music Box in 1933. Brooks Atkinson, critic for the New

developed an eye for other women. Nevertheless, she gave him a large portion of her savings, set him up in business, and helped sponsor his musical career.

Talley Beatty, a member of the Dunham dance company, observed that Waters removed Dunham from two dance numbers in *Cabin*, so that Waters herself could dance with the younger Archie Savage. Because Waters was better known than Dunham at the time, the producers bowed to her wishes. Waters's relationship with Mallory was in trouble, and she claimed Savage as her protégé, setting him up in her Los Angeles home, rent free, around 1943.

In 1944 Waters accused Savage of stealing ten thousand dollars in cash and thirty thousand dollars worth of jewelry, and he was convicted and sentenced to a year and a day in San Quentin Prison. Such a public display of revenge, coupled with publicity about her outbursts and language in the courtroom, did not help Waters's image in the media, which expected its female stars, at least, to show some propriety.

Waters claimed that, because of some anti-Semitic epithets she allegedly uttered on the set of *Cabin in the Sky*, she was unable to get employment for six years, except for an appearance on the *Amos 'n Andy* radio show on NBC. In 1949, however, her fortunes turned when she secured the part of Granny Dysey Johnson, in Darryl F. Zanuck's *Pinky*, a highly touted film about passing for white, starring the white actress Jeanne Crain as Pinky, a fair-complexioned black nurse who returns to Mississippi after passing in Boston. Though Granny was ostensibly another Mammy role, Waters, like Hattie McDaniel before her, gave a performance that went beyond stereotype. In 1949 Waters was nominated for an Academy Award for Best Supporting Actress for her portrayal of Granny.

In 1950 Waters took on the servant role of Berenice Sadie Browne in the stage production of Carson McCullers's *The Member of the Wedding* at New York City's Empire Theater, giving over 850 performances on the stage, followed by a road tour. The critical acclaim she received for that role, which she reprised in a film version in 1952, was the greatest of her career. In 1950 Waters began to play a maid on the *Beulah* television show. Dooley Wilson, who had portrayed Sam, the piano player, in the film *Casablanca* (1942), played her boyfriend. Television historian Donald Bogle notes that "Waters's

Beulah seemed a real person, trapped in an artificial world" (25). She did not use dialect, and came across as much sexier than larger, older women were supposed to on television. Nonetheless, Waters left the series after two years, because she no longer wanted a "white folks kitchen comedy role" (quoted in Bogle, 25).

Being typecast in Mammy roles and her constant financial troubles marred Waters's artistic success. In a letter to Floretta Howard, her secretary, Waters wrote on 8 December 1951: "It looks as if they [the IRS] are going to make me pay an extra $4,000. . . . They will take $625.00 weekly. . . . They still don't know what I have." After Dooley Wilson's death in 1953, *Beulah* was syndicated and withdrawn. Waters's career was all but over.

Waters sought solace in religion and in 1957 began touring with the Billy Graham Crusade, singing her signature song for this period in her life, "His Eye is on the Sparrow," which was also the title of her best-selling autobiography, which was first published in 1951. In 1959 Waters appeared in the film of William Faulkner's novel *The Sound and the Fury*, again playing a Mammy role, Dilsey. She was a favorite of President Richard Nixon and performed for him in the White House in 1971. Her tragic, though occasionally triumphant, life ended at age eighty, on 1 September 1977, in Chatsworth, California. She was a diabetic, suffered greatly from weight problems in her later years, and was living with friends, on Social Security, when she died.

FURTHER READING

Ethel Waters's letters to her secretary, Floretta Howard, are housed in the Performing Arts Section of the Library of Congress.

Waters, Ethel, with Charles Samuels. *His Eye Is on the Sparrow* (1951; repr. 1980).

Bogle, Donald. *Prime Time Blues: African Americans on Network Television* (2001).

Cherry, Randall. "Ethel Waters: The Voice of an Era" in *Temples for Tomorrow: Looking Back at the Harlem Renaissance*, eds. Geneviève Fabre and Michael Feith (2001).

Gill, Glenda E. *No Surrender! No Retreat! African American Pioneer Performers of Twentieth Century American Theater* (2000).

Krasner, David. *A Beautiful Pageant: African American Theatre, Drama and Performance in the Harlem Renaissance, 1910–1927* (2002).

Obituaries: *Chicago Tribune, New York Times, Washington Post,* and *New Orleans Picayune,* 2 Sept. 1977; *Los Angeles Times,* 2 and 3 Sept. 1977.

GLENDA E. GILL

WEBB, Chick

(10 Feb. 1909–16 June 1939), jazz drummer and bandleader, was born William Henry Webb in Baltimore, Maryland. The identity of his father is unknown. He was raised by his mother, Marie Jones, and his maternal grandfather, Clarence Jones, a porter in a shoe store. Webb was a hunchback and often lived in pain. According to an oft-repeated but probably apocryphal story, he was dropped on his back in infancy, and several vertebrae were crushed, but another oft-repeated and entirely plausible account attributed his condition to tuberculosis of the spine (then common in the inner city), which dwarfed his torso while leaving his limbs intact. Webb never grew above four feet one inch tall. He acquired the nickname Chick in boyhood as a reference to his small size.

Webb was interested in music from age three and seemed a natural drummer, banging on household objects. This activity helped strengthen him, but clearly the inner motivation was musical rather than therapeutic. To help support his family, he began working at age nine. Three years later, by selling newspapers, he had earned enough to buy a drum set. He performed locally on the street and then with dance bands, including jobs with the Jazzola Band on excursion boats on the Chesapeake Bay. In this setting he met guitarist and banjoist John Trueheart, who became a lifelong friend and musical colleague.

Webb and Trueheart moved to Harlem in 1924 or 1925 and joined the band of Edgar Dowell. Webb's bandleading commenced for five months in 1926 at the Black Bottom Club, where his group also included the trumpeter Bobby Stark, the saxophonist Johnny Hodges, and the pianist Don Kirkpatrick. For a job at the Paddock Club he added the tenor saxophonist Elmer Williams and a trombonist. Webb's group performed at the Savoy Ballroom for the first time in January 1927, and it expanded further in size for an engagement at Rose Danceland from December 1927.

The next few years were a period of struggle during which Webb remained loyal to his sidemen, suffering with them through the lack of steady work in an effort to keep the band together. Stark joined FLETCHER HENDERSON's band early in 1928, and Hodges joined DUKE ELLINGTON in May after a brief period with the pianist Luckey Foberts. In June 1928 Webb made his first recordings, "Dog Bottom" and "Jungle Mama," released under the name the Jungle Band, a studio name echoing Ellington's records, and indeed "Jungle Mama" could be passed off as Ellington's work. In 1929 Webb's band performed in the film short *After Seben.* He secured jobs at clubs and ballrooms such as the Strand Roof, Roseland, and the Cotton Club (July 1929). Late that year the saxophonist Benny Carter reached into the band's personnel, taking Trueheart and others temporarily to form a short-lived group.

After another stand at the Savoy, Webb was leading his band at Roseland in March 1931 when he engineered a celebrated trade: the trombonist Benny Morton and the alto saxophonist Russell Procope went to Henderson's orchestra in exchange for the superior musicians Jimmy Harrison and Carter. On 30 March they recorded Carter's song "Blues in My Heart" and Carter's arrangement of "Heebie Jeebies," on which the featured soloists include Williams, Kirkpatrick, and Harrison. But Harrison died from stomach cancer in July, and Carter left Webb in August to lead McKinney's Cotton Pickers, thus placing Henderson's seemingly disadvantageous trade in another light.

Late in 1932 Webb's big band embarked on a theater tour accompanying LOUIS ARMSTRONG in a revised version of the musical revue *Hot Chocolates.* The drummer reportedly was unusually attuned to the needs of the lindy-hopping dancers at the Savoy, where his group was resident from 1933 on, apart from theater shows and short tours. Late in 1933 the arranger and alto saxophonist Edgar Sampson joined Webb. When the big band began recording regularly in mid-1934, Sampson's contributions proved crucial in the achievement of a special sense of identity and creativity. Sampson brought in two compositions he had written for the cornetist Rex Stewart's short-lived big band in 1933, "Stomping at the Savoy" and "Don't Be That Way," and even though these pieces did not become anthems of the swing era until Benny Goodman recorded his versions later that decade, Webb's 1934 versions are superior for their rhythmic drive.

Sampson also arranged others of the group's best instrumental recordings, including "Blue Minor," "What a Shuffle," "Blue Lou" (all from 1934), and

"Go Harlem" (1936). Apart from the attractive ensemble work and catchy themes, these recordings feature a rhythm section—the pianists Joe Steele or Kirkpatrick, Trueheart, the bassists John Kirby or Bill Thomas, and Webb—that was probably the best in New York before Count Basie's orchestra came east. It also spotlighted soloists such as Stark (who rejoined in 1934), the trumpeter Taft Jordan, the trombonist Sandy Williams, and the tenor saxophonist Elmer Williams. The group's finest instrumentalist was Webb, who figures prominently on "Go Harlem" and on further studio recordings made after Sampson's departure—"Clap Hands! Here Comes Charley," "Squeeze Me," "Harlem Congo" (all from 1937), and "Liza" (1938)—although by the testimony of many who heard him live, these recordings give only a small taste of his drumming for the Savoy's dancers.

During this last period of recordings, Webb engaged in celebrated battles of the bands at the Savoy, and on 11 May 1937 he faced Benny Goodman. This legendary event broke attendance records at the club, and Webb was universally acclaimed the victor. His group came off far less well in a contest with Basie's big band on 16 January 1938, but nevertheless the audience voted slightly in Webb's favor, the dancers' loyalty to their drummer outweighing Basie's musical advantages. Not even loyalty was enough for Webb in March 1938, when his big band was reportedly trounced by Duke Ellington's in all respects except drumming.

By conflicting accounts, the singer ELLA FITZGERALD somehow came to Webb's attention after winning an amateur contest at the Apollo Theater in Harlem in 1934. In 1935 she joined his orchestra. Fitzgerald was an orphan, and Webb became her legal guardian; Fitzgerald moved into his home. Her singing gradually reshaped the band's stylistic orientation. This shift became dramatic in mid-1938 with the success of "A-Tisket, A-Tasket," in which she rendered the nursery rhyme as a swing tune. At some cost to fans of Webb's instrumental jazz, Fitzgerald's hit song brought Webb more exposure on radio, including weekly performances on the "Good Time Society" network show, and it attracted offers of residencies at prestigious locations such as the Park Central and the Paramount Theater in midtown Manhattan, and Levaggi's in Boston.

Just as Webb began to achieve the commercial success he had sought for the past dozen years, his health failed. Hospitalized after a hugely successful summer tour, he resumed playing in November 1938. He was hospitalized again in January 1939. In June, after one final effort, he entered Johns Hopkins Hospital in Baltimore, where he died after a major urological operation. Webb was beloved by many, and the published account of the usually irrepressibly cheerful Fitzgerald breaking down at Webb's public funeral is as moving today as it was in 1939. Webb was survived by his wife Sally; her maiden name and the date of their marriage are unknown. His orchestra continued under Fitzgerald's leadership until early 1942, when she disbanded it.

Webb's recordings document his unfailing sense of swing, explosive percussive force, and formidable technique. Such qualities are not at all unusual for a drummer. What set Webb apart was his ability to couple such extroverted playing to a keen and discreet musical sensitivity to questions of tuning, tone color, balance, and volume. From this sensitivity there resulted a handful of recorded examples of drum melodies in which he effortlessly combined the components of the drum set—assorted drums, cymbals, bells, and blocks—to create utterly original, kaleidoscopic sequences of percussion sounds. Insufficiently representative as these documents may be, Webb's recorded solos nonetheless argue that he deserves his reputation as the greatest jazz drummer of his era.

FURTHER READING

Charters, Samuel B., and Leonard Kunsttadt. *Jazz: A History of the New York Scene* (1962; repr. 1981).

Garrod, Charles. *Chick Webb and His Orchestra* (1993).

Korall, Burt. *Drummin' Men: The Heartbeat of Jazz: The Swing Years* (1990).

Schuller, Gunther. *The Swing Era: The Development of Jazz, 1930–1945* (1989).

BARRY KERNFELD

WELCH, Elisabeth

(27 Feb. 1904–15 July 2003), stage and screen actress and singer, was born Elisabeth Welsh in New York City, the daughter of a Scotch-Irish mother, Elisabeth (Kay) Welsh, and an African American father, John Wesley Welsh (she changed the spelling of her last name from "Welsh" to "Welch" in the late 1920s). Her parents met around the beginning of the twentieth century as domestic workers on the estate of a New Jersey millionaire. Elisabeth described her mother as "a defiant woman" who married her

father in spite of the prevailing legal and social prohibitions against interracial relationships in the United States. From the age of seven Welch sang in the choir of her neighborhood Episcopal church, St. Cyprian's, beginning a lifelong singing career that placed her in major stage productions and onto the silver screen. Her proclivity for music reflected her musical family; both parents sang, and John Welsh's brother played trombone. Elisabeth Welch and both of her brothers, Edward and John Jr., took piano lessons as children. John Welsh Jr. eventually studied piano in Berlin.

Welch attended Julia Richman High School, an all-girls school in Manhattan, where she made friends with an assortment of fellow students, including FREDI WASHINGTON. From her early days Welch cultivated the racially color-blind outlook that she maintained for much of her life. Her parents' unconventional relationship, the mixed neighborhood of San Juan Hill in which she grew up, and the panoply of racially diverse friends she collected in school all shaped her view of race as no boundary to the way she lived. Reflecting upon her childhood Welch wrote: "I never felt that I had to fight anything. My closest friends at school were a German and a Swede and they lived around the corner because it was a mixed neighborhood" (Bourne, *Elisabeth Welch*, 5).

Welch made her first show business appearances in the Broadway shows *Liza* (1922) and *Runnin' Wild*, both resulting from her membership in the St. Cyprian's choir. *Runnin' Wild* was a production of the celebrated black vaudeville duo Flournoy Miller and Aubrey Lyles. Welch appeared as Ruth Little, a notable role in which she performed the soon-to-be famous song "Charleston," which introduced the 1920s dance craze of the same name. Yet the success of Welch's first theatrical outings presaged a tragic change in the life of her family. In her late teens, when she first appeared onstage, Welch earned the support of her Episcopalian mother, who accepted the young woman's choice of a life in the entertainment business. Her Baptist father, however, hated his daughter's choice. According to Welch, her father "associated show business with low life and he thought I would become a whore, a streetwalker" (Bourne, *Soft Lights*, 8). Distraught and angry over what he felt was his only daughter's betrayal and his wife's collusion against him, John Welsh left his family and never returned. Though she mourned her father's abandonment, Welch grew more and

more enamored with performing and did so now all the more out of the necessity to help support her mother.

In the mid-1920s Elisabeth appeared in NOBLE SISSLE and EUBIE BLAKE's *Chocolate Dandies* with a cast that included JOSEPHINE BAKER. Following this, Welch performed as a chorus member in Lew Leslie's *Blackbirds of 1928*, a noteworthy production that included ADELAIDE HALL, BILL "BOJANGLES" ROBINSON, and Aida Ward. This appearance proved fateful for Welch, for the show's success in the United States initiated European interest, and in 1929 the entire company traveled to Paris for an extended engagement at the Moulin Rouge. This trip marked the beginning of Welch's life as an American expatriate, and her presence in Europe shaped her career significantly. Only a year before Welch had married the trumpeter Luke Smith Jr. in a bid for greater independence from her family. But Smith wanted Welch to give up show business, and she was unwilling to compromise her life on the stage. Her departure for Europe with *Blackbirds* ended the brief marriage. According to her biographer Stephen Bourne, Welch rarely spoke about this particular chapter in her life.

Welch's talent as a singer had always brought her applause, and throughout her show business career she performed in many popular and critically acclaimed stage musicals and revues. Her signature performances set the bar for a number of songs that became standards. Besides "Charleston," Welch performed Cole Porter's "Love for Sale" and "Solomon." In 1933 she introduced the British to Harold Arlen's hit "Stormy Weather" in a wildly popular London revue called *Dark Doings* fully ten years before Lena Horne popularized the song Stateside. Welch's London performances in *Dark Doings* and then later in that year in Porter's musical play *Nymph Errant* signified the beginning of her fifty-year sojourn in England. She remained there through World War II and beyond and did not appear on an American stage again until the 1980s, when her name, though fairly well known in Britain, was almost entirely forgotten in the United States.

Welch is perhaps best remembered for her British film roles with the African American actor, singer, and activist PAUL ROBESON: *Song of Freedom* (1936) and *Big Fella* (1937). Welch's roles in these films were fairly unconventional in the sense that they avoided the clichés of black women playing servants or prostitutes and were instead leading roles,

sharing with Robeson's characters romance, kindness, humor, tenderness, and intimacy. Moreover both films (especially *Song of Freedom*) feature the Robeson and Welch characters as part of egalitarian, interracial communities. Complex and human portrayals of black characters were largely unseen onscreen in the 1930s, and it is not surprising that both of these films came out of Europe instead of the United States.

Although she spent the bulk of her show business career in Europe, Welch returned to the United States toward the end of her life, appearing in musicals and revues that celebrated the tradition of musical theater that launched her career. These included *Black Broadway* in 1980 (featuring Bobby Short, Honi Coles, JOHN W. BUBBLES, and EDITH WILSON), a 1985 production staged in tribute to the composer Jerome Kern, and her own one-woman show *Time to Start Living*, which won an Off-Broadway Theater (OBIE) Award in 1986. Welch continued to perform and record regularly until her death in 2003. She died in Denville Hall, Middlesex, England, at the age of ninety-nine.

FURTHER READING

Bourne, Stephen. *Black in the British Frame: Black People in British Film and Television 1896–1996* (1998).

Bourne, Stephen. *Elisabeth Welch: Soft Lights and Sweet Music* (2005).

DISCOGRAPHY

Elizabeth Welch: Harlem in My Heart (Living Era CD CDAJA5376).

Elisabeth Welch: Soft Lights and Sweet Music (Pavillion Records: Flapper 7060PASTCD).

Miss Elisabeth Welch, 1933–1940 (World Records SH-328).

Paul Robeson and Elisabeth Welch: Songs from Their Films (Movie Star Series CD B000004C4R).

Obituaries: New York Times, 18 July 2003; *Variety*, 21–27 July 2003.

MIRIAM J. PETTY

WELLS, James Lesesne

(2 Nov. 1902–20 Jan. 1993), artist and educator, was born in Atlanta, Georgia, the oldest of three children of Frederick W. Wells, a Baptist minister, and Hortensia Ruth (Lesesne) Wells, a kindergarten teacher. The couple met while both were students at Wilberforce College in Ohio. When James was one year old, the family moved to the working-class town of Palatka, Florida, where Frederick Wells became pastor of the Mount Tabor Baptist Church. After Reverend Wells died, around 1912, Hortensia Wells opened a day-care center and a five-and-dime store, and James helped support his mother and two siblings by doing odd jobs. Wells's artistic skills were encouraged by his mother, and in 1914 he received a scholarship to the Florida Normal and Industrial Institute, a segregated Baptist high school in Jacksonville. As a teenager he won several awards for drawing and woodworking at the Florida State Fair. Wells deferred admission to Lincoln University in Pennsylvania, which had offered him a scholarship, in order to earn some money before beginning school. In 1919 he moved to Harlem where he lived with an aunt until 1922. Working as a porter on the Hudson River Day Line, he visited art museums and galleries in his spare time and, in 1920 he took evening classes with George Laurence Nelson at the National Academy of Design.

When Wells entered Lincoln University in 1922 he was disappointed to find that the school had no studio art program. After two years of study he returned to New York and the evening classes at the National Academy of Design, which he continued after enrolling in the undergraduate department of fine arts at Columbia University's Teachers College in the fall of 1924. That same year he received his first solo show, at the 135th Street branch of the New York Public Library. At Columbia, Wells was introduced to the graphic work of Albrecht Dürer and the German Expressionists, both profound influences on his work. Private pilgrimages to the Metropolitan Museum of Art and the Morgan Library, as well as visits to a groundbreaking exhibition of African sculpture at the Brooklyn Museum of Art in 1923, furthered his training. Wells took his first printmaking class in 1927, a year before graduating, and almost immediately he began selling illustrations to the growing number of magazines and journals of the period, especially Harlem's two major publications, *Crisis* and *Opportunity*. A variety of books and publications including the literary magazines *The Dial* (edited by poet Marianne Moore) and *The Golden Book*, and the political journals *The Survey*, *Annals of the American Academy of Political and Social Science*, and *New Masses*, also showcased Wells's graphic works. In 1929 Wells's flirty art deco prints with their Egyptian and African motifs were exhibited by the influential

art dealer J. B. Neumann at his New Art Circle gallery.

Later that same year Wells accepted a post at Howard University, in Washington, D.C., teaching art alongside James V. Herring and James A. Porter, the school's only other art instructors until LOIS MAILOU JONES joined the department the following year. Wells remained at Howard for the next thirty-nine years, founding the graphic arts program and teaching several generations of African American artists, including ELIZABETH CATLETT, Lou Stovall, and David Driskell. Upon his arrival in Washington, Wells moved into a house on R Street in the Logan Circle area, where his neighbors included the Grimké family, Alma Thomas, MARY MCLEOD BETHUNE, ALAIN LOCKE, and Mary Jane Patterson. Wells quickly became an integral member of Washington's thriving black community, contributing to a range of social, political, and creative pursuits.

After the publication of Alain Locke's anthology *The New Negro* in 1925, Wells heeded the author's call for black artists to focus on African and African American forms and themes. In Washington Wells became a close friend and collaborator of Locke's, who was now his colleague at Howard; he even illustrated later reprints of *The New Negro*. Almost immediately, Wells commenced a long affiliation with another Washington friend, CARTER G. WOODSON, for whom he illustrated books, including *The Negro Wage Earner* (1930) and *The Rural Negro* (1930), and the *Journal of Negro History* published under the auspices of Woodson's Association of the Study of Negro Life and History. He also illustrated books on black history, including Maurice Delafosse's *The Negroes of Africa: History and Culture* (1931), published by Woodson's company, The Associated Publishers. Other projects for which Wells contributed illustrations include the books of the Washington playwright WILLIS RICHARDSON and publications of the New Negro Alliance.

The graphic works, primarily wood block and linoleum-cut prints, that Wells produced for these publications during the early 1930s are characterized by their bold use of pattern and shape and their confident juxtaposition of negative and positive space, realized by intense areas of black and white. Enthusiastically indebted to both African and Egyptian art traditions, Wells often concentrated on African American subjects and themes, including the slave trade and contemporary black life. During his first

years in Washington, Wells was also painting, in a style influenced by Cézanne's handling of paint and perspective and the Fauves' use of hot colors. In 1931 he sold two oil paintings, *Flight into Egypt* and *Journey to Egypt*, the first to the Harmon Foundation, which also awarded him their gold medal, and the second to Duncan Phillips, founder of the Phillips Collection. By the early 1930s, Wells was showing regularly in Washington and New York.

In 1931 Wells spent the first of many summers in New York working towards his master's degree at Columbia University's Teachers College. In 1933 he married Ophelia Davidson, a high school teacher and the daughter of a prominent Washington lawyer, Shelby Davidson, and the sister of Eugene Davidson, president of the NAACP's Washington chapter. The couple had a son, James Lesesne Wells Jr., in 1941. The summer after their wedding, Wells was appointed director of the Harlem Art Workshop, a Works Progress Administration (WPA)–sponsored program offering free art classes to Harlem children, including young JACOB LAWRENCE, ROBERT BLACKBURN, and brothers Morgan and Marvin Smith, all of whom later became well-known artists. Located at the 135th Street branch of the New York Public Library (later the Schomburg Center for Research in Black Culture), the Workshop's faculty included CHARLES ALSTON, Henry Bannarn, and AUGUSTA SAVAGE, who went on to direct the Harlem Community Art Center. The WPA's support of printmaking through its workshops and exhibitions proved a great boon to the development of the graphic arts. Inexpensive to reproduce and distribute, prints played a key role in efforts to democratize both the creation and consumption of art, making it more accessible and affordable to the general public. These goals dovetailed with Wells's interests, and by the time he took another WPA position in the summer of 1935, teaching for the Civilian Conservation Corps in Renovo, Pennsylvania, Wells had turned exclusively to printmaking.

In 1936 Wells took a sabbatical from Howard, returning to Columbia University to complete his MA degree. During this year he also studied with the printmaker Frank A. Nankivell. Encouraged by the aesthetics, themes, and politics of Social Realism, Wells took up lithography, an even less expensive production medium, and shifted his focus to images of black workers and contemporary African Americans with works like *Negro Worker* (1938),

Asphalt Workers (1940), *Portuguese Girl* (1940), and *Flower Vendors, Georgetown* (1940). He continued to teach at Howard, spending occasional summers in Provincetown, Massachusetts. He took a second sabbatical in 1947, which he spent studying at the innovative printmaking studio Atelier 17 in New York City, and after which he introduced engravings to his oeuvre. In the 1950s and 1960s Wells turned to themes from the Old and New Testaments, some inspired by medieval and renaissance art. In the 1960s he began reintroducing color to his work, producing several paintings, including *Salome* (1963), *Ascension* (1963), and *Calvary* (1964). In 1968, after almost four decades of teaching and more than a decade of civil rights work (for which he experienced some hostility—in 1957 a burning cross was placed on his lawn), Wells retired from Howard. In the early 1970s he switched to color linoleum-cut prints, many of which depicted African subjects and places he first encountered on an extended trip to West Africa in 1969. Wells continued working until his death in 1993, in Washington, D.C., from congestive heart failure.

During his lifetime Wells was included in over seventy-five group exhibitions and had solo exhibitions at the Delphic Studios (1932), the Barnett-Aden Gallery (1950), the Smithsonian Institution (1948, 1961), Howard University Gallery of Art (1938, 1959, 1965), Spelman College (1966), the Smith Mason Gallery of Art (1969), and Fisk University (1972). Retrospectives of his work were organized by Howard University in 1977 and the Washington Project for the Arts in 1986, and remounted at the Studio Museum in Harlem two years later. Wells was the recipient of several honors, including the JAMES VANDERZEE Award given by the Afro-American History and Cultural Museum in Philadelphia (1977), a citation for lifelong contribution to American art from President Jimmy Carter (1980), and a Living Legend Award from the National Black Arts Festival (1991). In 1984, the mayor of Washington, D.C., Marion Barry, declared 15 February James L. Wells Day. Wells's work is held in the collection of many galleries and museums, including the Smithsonian, the Metropolitan Museum of Art, and the Howard University Gallery of Art, which boasts galleries named after two beloved teachers, Lois Mailou Jones and James Lesesne Wells.

FURTHER READING

Powell, Richard J., and the Washington Project for the Arts. *James Lesesne Wells: Sixty Years in Art* (1986).

Obituary: Washington Post, 23 Jan. 1993.

LISA E. RIVO

WESLEY, Charles Harris

(2 Dec. 1891–16 Aug. 1987), historian, educator, minister, and administrator, was born in Louisville, Kentucky, the only child of Matilda Harris and Charles Snowden Wesley. His father, who had attended Atlanta University and worked as a clerk in a funeral home, died when Charles Wesley was nine years old. Wesley grew up in his maternal grandparents' comfortable home, completed Louisville Central High School in two years, and entered the preparatory division of Fisk University in Nashville, Tennessee, at the age of fourteen. He later enrolled in Fisk's collegiate division, where he developed a strong interest in music. He joined the famous Fisk Jubilee Singers, which had been organized in 1867 to raise much-needed funds for the fledgling school, founded two years earlier by the American Missionary Association. The Jubilee Singers secured funds from national and international tours to construct the university's first permanent building, Jubilee Hall, in 1875. Wesley was a baritone and sang in the group with ROLAND HAYES, later a renowned tenor.

Wesley excelled in the classroom, on the athletic field, and in debate and drama. He ran track, played baseball and basketball, and was quarterback of the football team. He graduated in 1911 with honors in classics and was later initiated into Phi Beta Kappa when the honor society established a chapter at Fisk in 1953. At nineteen Wesley entered Yale University with a graduate fellowship and earned a master's degree with honors in History and Economics two years later, while waiting tables to support himself. He then became an instructor of history and modern languages at Howard University and traveled to Europe, where he studied French history and language. He completed a year of law school at Howard University in 1915 and that same year married Louise Johnson of Baltimore, Maryland, with whom he had two daughters, Louise and Charlotte. Wesley's daughter Louise died in 1950, and his wife passed away in 1973.

Wesley became a minister in the African Methodist Episcopal (AME) Church and was

presiding elder over all the AME churches in Washington, D.C., from 1918 to 1938. He later became a candidate for bishop but was not elected, as he refused to campaign for the position. Wesley, who had taught at Howard for seven years, took a sabbatical leave during the 1920–1921 academic year to pursue a doctoral degree in History at Harvard University, while returning regularly to Washington, D.C., to preach at several local AME churches. In 1925 he became the third African American to receive a PhD in History from Harvard, following W. E. B. DU BOIS and CARTER G. WOODSON.

Wesley rose through the ranks at Howard University, where he was promoted to professor, chaired the history department, and was director of the summer school, dean of the College of Liberal Arts, and dean of the graduate school. Together with other influential faculty, he helped persuade the board of trustees in 1926 to appoint Howard's first black president, MORDECAI JOHNSON. Wesley's first book, based on his dissertation, *Negro Labor in the United States, 1850–1925: A Study in American Economic History*, appeared in 1927. Carter G. Woodson, who reviewed the book in *The American Historical Review* in 1927, called it "the only scientific treatment of Negro labor in the United States." Wesley refuted biased accounts of black labor, which contended that African Americans were not capable of skilled labor and that they would not work after emancipation without coercion. He revealed early labor-organizing efforts among black Americans and their struggle for economic rights after Reconstruction. Wesley concluded that labor inequality during the early twentieth century resulted more from racial prejudice and discrimination against black workers than from any innate ability among whites. His work was the first comprehensive study of African Americans as laborers rather than as slaves.

Wesley published hundreds of articles and twelve books during his career. His book *The Collapse of the Confederacy*, published in 1937 by the Association for the Study of Negro Life and History, established him as an expert in the field of southern history. The study began as an essay written for a graduate course taught by Edward Channing at Harvard. In the expanded work, Wesley suggested a revisionist thesis that the South lost the Civil War because of internal social disintegration. He became the first black historian to receive a Guggenheim Fellowship in 1930, which he used in London to study slave emancipation within the British Empire. That work influenced his pioneering publications on the role of African Americans in the fight against slavery in the United States. He sought to demonstrate that African Americans made important contributions to the struggle for their freedom. This was at a time when many mainstream historians argued that African Americans were given their freedom without much effort on their part.

During his long career, Wesley wrote extensively about the history of black fraternal organizations. He explored the group life of African Americans and what they did for themselves more than what was done to them. He published the first edition of the history of Alpha Phi Alpha, the first black college fraternity, in 1929 and became its national historian in 1941. He served as the fraternity's general president from 1932 to 1940, the longest tenure of anyone in that office.

In addition to histories of black fraternal organizations, such as the Prince Hall Masons, the Improved Benevolent and Protective Order of Elks, and the Sigma Pi Phi fraternity, Wesley published *The History of the National Association of Colored Women's Clubs: A Legacy of Service*, when he was ninety-two years old. Wesley was concerned with revealing the group life of African Americans and their achievements not only within their own communities but also in the context of the broader American society. In examining how teachers of U.S. history treated African Americans, he noted that revisions had taken place in interpreting American history and stated in the journal *Social Education* in 1943 that "This need of revision is also clear in relation to the study of Negro life in the United States." He believed in a conscious effort to set the record straight and to revise the errors, omissions, and distortions about black life and culture from the African roots through slavery, Reconstruction, migration, and urbanization.

Wesley became president of Wilberforce University in 1942, an AME-affiliated school that the Methodist Episcopal Church founded in 1856 to educate African Americans from Ohio and nearby free states. The AME Church had purchased the school in 1863. He clashed with church trustees over administration of the school and was asked to resign in 1947. The state of Ohio had financially supported the Normal and Industrial Department within Wilberforce since 1887. When Wesley left Wilberforce, he presided over the separation of the

state-supported unit from the university and the establishment of Wilberforce State College, which, after an acrimonious court fight, became Central State University. Wesley served as president of Central State from 1947 to 1965, when he retired.

He was soon appointed executive director of the Association for the Study of Negro Life and History (ASNLH), which had been organized in 1915 by Carter G. Woodson, who had served as a mentor to him. Wesley had been president of ASNLH from 1950, after Woodson's death, to 1965, when he became executive director, a position that he held until 1972, when he again retired. During his tenure as executive director, he revised and republished many of Woodson's earlier works, such as *The Negro in Our History, Negro Makers of History*, and *The Story of the Negro Retold*. He also edited a ten-volume series, *The International Library of Negro Life and History*. Wesley again came out of retirement in 1974 to head the new Afro-American Historical and Cultural Museum in Philadelphia, Pennsylvania, until 1976. He married Dorothy B. Porter [Wesley], former head of the Moorland-Spingarn Research Center at Howard University, in 1979. Charles Harris Wesley, who at the time was known as the dean of black historians, died of pneumonia and cardiac arrest at Howard University Hospital.

FURTHER READING
Most of Charles Harris Wesley's papers are in the possession of his family. Some of his papers and publications are housed in the Archives of Dorothy Porter Wesley in Fort Lauderdale, Florida.

Conyers, James L., ed. *Charles H. Wesley: The Intellectual Tradition of a Black Historian* (1994).

Harris, Janette Hoston. "Charles Harris Wesley: Educator and Historian, 1891–1947," PhD diss., Howard University, 1975.

Meier, August, and Elliott Rudwick. *Black History and the Historical Profession, 1915–1980* (1986).

Obituary: Washington Post, 22 Aug. 1987.

ROBERT L. HARRIS JR.

WEST, Dorothy

(2 June 1907–16 Aug. 1998), writer and editor, was born in Boston, Massachusetts, the only child of Rachel Pease Benson of Camden, South Carolina, and Isaac Christopher West, an enterprising former slave from Virginia who was a generation his wife's senior. Nicknamed the "Black Banana King" before his prosperous wholesale fruit business failed during the Depression, Isaac West provided his gifted daughter with a privileged, bourgeois upbringing. Dorothy's formal education began at the age of two when she took private lessons from Bessie Trotter, sister of the *Boston Guardian* editor WILLIAM MONROE TROTTER. Young Dorothy grew up in a four-story house in Boston with a large extended family made up of her mother's numerous siblings and their children. Although Dorothy tested at the second-grade level at age four, Rachel West insisted that her precocious daughter enter first grade at Boston's Farragut School. Years later West recalled, "When I was a child of four or five, listening to the conversation of my mother and her sisters, I would sometimes intrude on their territory with a solemnly stated opinion that would jerk their heads in my direction, then send them into roars of uncontrollable laughter. . . . [T]he first adult who caught her breath would speak for them all and say 'That's no child. That's a sawed-off woman'" (West, *The Richer*). Dorothy finished her elementary education in the racist environment of the Martin School located in the city's heavily Irish Mission District, graduated from Girls' Latin School in 1923, and later took courses at Columbia University, where she studied creative writing.

Dorothy always thought of herself as a short-story writer and began her literary career at age seven when she said, "I wrote a story about a little Chinese girl, though . . . I'm sure I had never seen a Chinese girl in my life" (McDowell, 267). From about age ten into her early teens, she regularly won the weekly short-story contest sponsored by the *Boston Post*. The *Post* published her first story, "Promise and Fulfillment," when Dorothy was ten, and the paper's African American short-story editor, EUGENE GORDON, encouraged her to join the Saturday Evening Quill Club, a black writers group. In response to a story submission, *Cosmopolitan*'s editor Ray Long—convinced that the writer was a forty-year-old spinster who knew nothing about love—wrote the fourteen-year-old Dorothy a scathing letter asserting that his magazine "had one Fanny Hurst and so didn't need another" (McDowell, 268). Far from discouraging her, however, this rejection had the opposite effect on Dorothy.

In 1925, shortly before turning eighteen, West entered a short-story competition sponsored jointly

by *The Crisis* and *Opportunity*, the publications of the NAACP and the Urban League respectively. Her submission, "The Typewriter," tied for second place with ZORA NEALE HURSTON's "Muttsy" and was subsequently published in the July 1926 issue of *Opportunity*. West was then able to convince her family that she had the talent to launch a literary career in New York City alongside Harlem Renaissance stalwarts.

Almost immediately West's stories began to appear in print. "Hannah Byde," published in *The Messenger* (July 1926), was one of the earliest pieces of African American literature to use a jazz motif to explore the spiritual discord of urban life. Over the next few years she published "Prologue to a Life," "Funeral," and "An Unimportant Man." These early stories feature West's lifetime preoccupation with the ways in which children interact with and affect the adult world around them. They are suffused with West's characteristically ironic tone, inspired by Fyodor Dostoyevski, who, she said, "became my master, though I knew I would never write like him" (McDowell, 268). "Nine out of ten stories I write are real," West later said, of her keen observations of family, friends, and social milieus. "I change the situation, but they are something that really happened" (Dalsgard, 37).

When Hurston left New York, West and her cousin Helene Johnson, with financial help from West's father, took over her apartment. West continued to write short stories, although, for a variety of reasons, including the discontinuation of *Opportunity*'s writing contests in 1927, few were published, leaving the young writer dissatisfied with her literary prospects. In 1927 West and her new friend Wallace Thurman won minor roles in the stage production of *Porgy and Bess*, and her weekly earnings of seventeen and a half dollars helped keep her in New York during hard economic times. In June 1932 West sailed for the Soviet Union, along with twenty-two other African Americans including LANGSTON HUGHES, who had been commissioned to revise a movie script about black American life titled "Black and White." When the project fell through, West—and Hughes—remained in the Soviet Union for nearly a year, until word arrived that her father had died.

A more responsible, twenty-five-year-old West returned to New York in 1933, regretful that she had not lived up to her earlier artistic promise. Only "Funeral" and "The Black Dress" were published during the 1930s, although she produced the nonfiction pieces "Ghost Story," "Pluto," "Temple of Grace," and "Cocktail Party" while working for the Depression-era Federal Writer's Project, part of the Works Progress Administration.

In 1933, in an attempt to revitalize the Harlem Renaissance movement by providing an outlet for black authors, West founded *Challenge Magazine*, of which she published five issues. Under the pseudonym of Mary Christopher, West published her own work and that of Hughes, Hurston, ARNA BONTEMPS, CLAUDE MCKAY, COUNTÉE CULLEN, and Pauli Murray. The last issue appeared in June 1936, when RICHARD WRIGHT virtually took West's journal away from her. Wright wanted to shift the journal's focus toward a more socially conscious protest literature, a direction West found uncomfortable but against which she offered little resistance. As she explained later, unlike modern women, she was too passive, petite, and soft-spoken to stand up to Wright, his friends, and his lawyer, "who sent me a form to sign giving Wright the rights to something, I can't remember" (McDowell, 272). Moreover, she presumed Wright was acting as a pawn of communists. "I was never crazy about Richard Wright because he was too timid and afraid of white people. I guess it stemmed from his southern background" (McDowell, 272).

West's own dry spell came to an end on 29 September 1940, when the *New York Daily News* published "Jack in the Pot," a story that captured the economic and spiritual strife of the Depression. For the next twenty years she wrote two short stories per month for the *Daily News*, a job that kept her writing and able to pay her bills. In the mid-1940s West left New York and moved to Oak Bluffs, Massachusetts, on Martha's Vineyard, the summer playground of her youth. There she wrote her first novel, the semiautobiographical *The Living Is Easy* (1948). The novel, a family drama told through the eyes of young Judy Judson, includes West's examination of black middle-class social pretensions in Boston. The novel was generally well-received although, in a move that deeply affected West, *Ladies Home Journal* eventually decided against serializing the book, which it felt might offend southern readers. When the Feminist Press reprinted *The Living Is Easy* in 1982, West was introduced to a whole new generation.

In the late 1960s West began a new novel, "Where the Wild Grape Grows." Although she had financial support from a Mary Roberts Rinehart grant and a Harper and Row contract, she stopped work on the book, feeling that black revolutionary politics conflicted with her theme of miscegenation. Instead, she resigned herself to writing for the *Vineyard Gazette*, focusing on countering the impression that the only blacks on Martha's Vineyard were in work uniforms. At first her "Cottagers Corner" columns showcased prosperous and affluent black families and their prominent friends and visitors. Later, she began to write more broadly, about people, places, and island happenings, even contributing sketches to the *Gazette*'s bird column. Her last piece appeared on 13 August 1993, when she left the paper to devote herself full time to completing the novel *The Wedding*, incorporating much of the earlier "Where the Wild Grape Grows" into it.

In the early 1990s, after reading West's *Gazette* articles, Jacqueline Kennedy Onassis helped West secure a book contract for *The Wedding*. The novel, about the spiritual price of assimilation and miscegenation, was published in 1995 and became a best-seller, drawing yet another generation to the door of the woman who became known as the sole survivor of the Harlem Renaissance. West's book, which centers on the wedding preparations of Shelby Coles, ends with a child's death and without a wedding, though Doubleday sent out review copies of the novel with an ending Dorothy West had not written. When this was discovered in the fall of 1994, the Harvard professor of African American studies, Henry Louis Gates Jr., championed her cause, and Doubleday delayed publication until West's own final chapter could be included. Unfortunately, a number of reviewers had already published their assessments of the novel with the spurious ending. In 1998 Oprah Winfrey produced a television adaptation of the novel starring Halle Berry which transformed the story into a sentimental tale in which Shelby heads down the aisle with few racial concerns and which the critic John Leonard called "Soap Oprah."

West died at age ninety-one in 1998 in Boston. Her many short stories, two prominent novels, and nonfiction articles distinguish a literary career of eight decades that, in the final analysis, reflected the many expectations, failures, and achievements of its times.

FURTHER READING

West, Dorothy. *The Dorothy West Martha's Vineyard Stories: Essays and Reminiscences by Dorothy West in the Vineyard Gazette*, eds. James Roberts Saunders and Renae Nadine Shackelford (2001).

West, Dorothy. *The Richer, The Poorer: Stories, Sketches, and Reminscences* (1995).

Dalsgard, Katrine. "Alive and Well and Living on the Island of Martha's Vineyard: An Interview with Dorothy West, October 29, 1988," *Langston Hughes Review* 12 (Fall 1993).

Guinier, Genii. "Interview with Dorothy West (6 May 1978)" in *Black Women Oral History Project* (1991).

McDowell, Deborah E. "Conversations with Dorothy West," in *The Harlem Renaissance Re-examined*, ed. Victor Kramer (1987).

Obituary: New York Times, 19 Aug. 1998.

SALLYANN H. FERGUSON

WHITE, Walter Francis

(1 July 1893–21 Mar. 1955), civil rights leader, was born in Atlanta, Georgia, to George White, a mail carrier, and Madeline Harrison, a former schoolteacher. The fourth of seven children, White, whose parents had been born in slavery, grew up entrenched in black Atlanta's leading and most respected institutions: his family attended the prestigious First Congregational Church, and he received his secondary and collegiate education at Atlanta University, from which he graduated in 1916. (His siblings enjoyed similar religious training and educational opportunities.) With blond hair, blue eyes, and a light complexion, White was a "voluntary Negro," a person who could "pass" for white yet chose not to do so. His black racial identity was annealed by the Atlanta riot of September 1906. For three days white mobs rampaged through African American neighborhoods, destroying property and assaulting people; the thirteen-year-old White realized, as he put it in his autobiography, that he could never join a race that was infected with such toxic hatred.

Upon graduation from college, White became an executive with the Standard Life Insurance Company, one of the largest black-owned businesses of its day. Part of Atlanta's "New Negro" business elite, White was a founder of a real estate and investment company and looked forward to a successful business career. He also participated in civic affairs: in 1916 he was a founding member and secretary

of the Atlanta branch of the NAACP. The branch experienced rapid growth, largely because, in 1917, it stopped the school board from eliminating seventh grade in the black public schools. White was an energetic organizer and enthusiastic speaker, qualities that attracted the attention of NAACP field secretary JAMES WELDON JOHNSON. The association's board of directors, at Johnson's behest, invited White to join the national staff as assistant secretary. White accepted, and in January 1918 he moved to New York City.

During White's first eight years with the NAACP, his primary responsibility was to conduct undercover investigations of lynchings and racial violence, primarily in the South. Putting his complexion in service of the cause, he adopted a series of white male incognitos—among the cleverer ones were itinerant patent-medicine salesman, land speculator, and newspaper reporter intent on exposing the libelous tales being spread in the North about white southerners—and fooled mob members and lynching spectators into providing detailed accounts of the recent violence. Upon White returning to New York from his investigative trips, the NAACP would publicize his findings, and White eventually wrote several articles on the racial carnage of the post–World War I era that appeared in the *Nation*, the *New Republic*, the *New York Herald-Tribune*, and other prestigious journals of liberal opinion. By 1924 White had investigated forty-one lynchings and eight race riots. Among the most notorious of these was the 1918 lynching in Valdosta, Georgia, of Mary Turner, who was set ablaze. Turner was nine months pregnant, her womb was slashed open, and her fetus was crushed to death. White also investigated the bloody race riots that left hundreds of African Americans dead in Chicago and in Elaine, Arkansas, during the "red summer" of 1919, and the 1921 riot in Tulsa, Oklahoma, that resulted in the leveling of the black business district and entire residential neighborhoods. White's investigations also revealed that prominent and respected whites participated in racial violence; the mob that perpetrated a triple lynching in Aiken, South Carolina, in 1926, for example, included local officials and relatives of the governor.

White wrote of his undercover investigations in the July 1928 *American Mercury* and in *Rope and Faggot* (1929), a detailed study of the history of lynching and its place in American culture and politics that remains indispensable. His derring-do

in narrowly escaping detection and avoiding vigilante punishment was also rendered in verse in LANGSTON HUGHES's "Ballad of Walter White" (1941).

At the same time that he was exposing lynching, White also emerged as a leading light in the Harlem Renaissance. He authored two novels. *The Fire in the Flint* (1924) was the second novel to be published by a New Negro, appearing just after JESSIE FAUSET's *There Is Confusion*. Set in Georgia after World War I and based on White's acquaintance with his native state, *The Fire in the Flint* tells the story of the racial awakening of Kenneth Harper, who pays for his new consciousness when a white mob murders him. The novel was greeted with critical acclaim and was translated into French, German, Japanese, and Russian. His second work of fiction, *Flight* (1926), set in New Orleans, Atlanta, and New York, is both a work about the Great Migration of blacks to the North and story about "passing." *Flight*'s reviews were mixed. White's response to one of the negative reviews—by the African American poet FRANK HORNE, in *Opportunity* magazine—is instructive. He complained to the editor about being blindsided and parlayed his dissatisfaction into a debate over his book's merits that stretched over three issues. To White there was no such thing as bad publicity—in art or in politics. The salient point was to keep a topic—a book or a political cause—firmly in public view, which would eventually create interest and sympathy.

White's dynamism and energy was central to the New Negro movement. He was a prominent figure in Harlem's nightlife, chaperoning well-connected and sympathetic whites to clubs and dances. He helped to place the works of Langston Hughes, COUNTÉE CULLEN, and CLAUDE MCKAY with major publishers, and promoted the careers of the singer and actor PAUL ROBESON, the tenor ROLAND HAYES, and the contralto MARIAN ANDERSON.

When James Weldon Johnson retired from the NAACP in 1929, White, who had been looking to assume more responsibility, succeeded him. As the association's chief executive, White had a striking influence on the civil rights movement's agenda and methods. In 1930 he originated and orchestrated the victorious lobbying campaign to defeat President Hoover's nomination to the Supreme Court of John J. Parker, a North Carolina politician and jurist who had publicly stated his opposition to black suffrage and his hostility to organized labor. During the

next two election cycles, the NAACP worked with substantial success to defeat senators with significant black constituencies who had voted to confirm Parker. The NAACP became a recognized force in national politics.

During Franklin Roosevelt's New Deal and Harry Truman's Fair Deal, White raised both the NAACP's public profile and its influence on national politics. White's success owed much to his special knack for organizing the more enlightened of America's white elites to back the NAACP's programs. Over the decade of the 1930s, he won the support of the majority of the Senate and House of Representatives for a federal antilynching law; only southern senators' filibusters prevented its passage. His friendship with Eleanor Roosevelt likewise gave him unparalleled access to the White House. This proved invaluable when he conceived and organized Marian Anderson's Easter Sunday 1939 concert at the Lincoln Memorial, which was blessed by the president and had as honorary sponsors cabinet members, other New Deal officials, and Supreme Court justices. As NAACP secretary and head of the National Committee against Mob Violence, White convinced President Truman in 1946 to form a presidential civil rights commission, which the following year issued its groundbreaking antisegregationist report, *To Secure These Rights*. In 1947 he persuaded Truman to address the closing rally of the NAACP's annual meeting, held at the Washington Monument; it was the first time that a president had spoken at an association event.

As secretary, White oversaw the NAACP's legal work, which after 1934 included lawsuits seeking equal educational opportunities for African Americans. He was also instrumental in convincing the liberal philanthropists of the American Fund for Public Service to commit $100,000 to fund the endeavor, though only a portion was delivered before the fund became insolvent. After 1939 the day-to-day running of the legal campaign against desegregation rested with Charles Hamilton Houston and Thurgood Marshall's NAACP Legal Defense Fund, but White remained intimately involved in the details of the campaign, which culminated with the Supreme Court's 1954 *Brown v. Board of Education* ruling that declared the doctrine of "separate but equal" unconstitutional.

White had married Gladys Powell, a clerical worker in the NAACP national office, in 1922. They had two children, Jane and Walter Carl Darrow, and

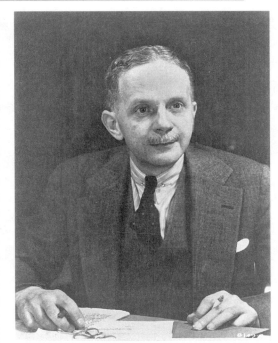

Walter Francis White, civil rights activist and NAACP leader, c. 1935. (Library of Congress.)

divorced in 1948. In 1949 he married Poppy Cannon, a white woman. This interracial union provoked a major controversy within both the NAACP and black America at large, and there was widespread sentiment that White should resign. In response, White, who was always an integrationist, claimed the right to marry whomever he wanted. He weathered the storm with the help of NAACP board member Eleanor Roosevelt, who threatened to resign should White be forced from office. Though White maintained the title of secretary, his powers were reduced, with Roy Wilkins taking over administrative duties. White continued to be the association's public spokesperson until his death on 21 March 1955. In declining health for several years, he suffered a fatal heart attack in his New York apartment.

Unlike other NAACP leaders such as W. E. B. DU BOIS and Charles Houston, Walter White was neither a great theoretician nor a master of legal theory. His lasting accomplishment lay in his ability to organize support for the NAACP agenda among persons of influence in and out of government and to persuade Americans of all races to support the cause of equal rights for African Americans.

FURTHER READING

The bulk of Walter White's papers are in the Papers of the National Association for the Advancement of Colored People, deposited at the Library of Congress in Washington, D.C., and the Walter Francis White/Poppy Cannon Papers, deposited at the Beinecke Rare Books and Manuscript Library, Yale University, New Haven, Connecticut.

White, Walter. *A Man Called White* (1948).

Cannon, Poppy. *A Gentle Knight: My Husband Walter White* (1956).

Janken, Kenneth Robert. *WHITE: The Biography of Walter White, Mr. NAACP* (2003).

Obituaries: New York Times, 22 Mar. 1955; *Washington Afro-American*, 26 Mar. 1955.

KENNETH R. JANKEN

WILLIAMS, Bert, and George Walker

(12 Nov. 1874–4 Mar. 1922) and (1873–6 Jan. 1911), stage entertainers, were born, respectively, Egbert Austin Williams in Nassau, the Bahamas, and George Williams Walker in Lawrence, Kansas. Williams was the son of Frederick Williams Jr., a waiter, and Julia Monceur. Walker was the son of "Nash" Walker, a policeman; his mother's name is unknown. Williams moved with his family to Riverside, California, in 1885 and attended Riverside High School. Walker began performing "darkey" material for traveling medicine shows during his boyhood and left Kansas with Dr. Waite's medicine show. In 1893 Williams and Walker met in San Francisco, where they first worked together in Martin and Selig's Minstrels.

To compete in the crowded field of mostly white blackface performers, "Walker and Williams," as they were originally known, subtitled their act "The Two Real Coons." Walker developed a fast-talking, city hustler persona, straight man to Williams's slow-witted, woeful bumbler. Williams, who was light-skinned, used blackface makeup on stage, noting that "it was not until I was able to see myself as another person that my sense of humor developed." An unlikely engagement in the unsuccessful Victor Herbert operetta *The Gold Bug* brought Williams and Walker to New York in 1896, but the duo won critical acclaim and rose quickly through the ranks of vaudeville, eventually playing Koster and Bial's famed New York theater. During this run they added a sensational cakewalk dance finale to the act, cinching popular success. Walker performed exceptionally graceful and complex dance variations, while Williams clowned through an inept parody of Walker's steps. Aida Overton [Walker], who later become a noteworthy dancer and choreographer in her own right, was hired as Walker's cakewalk partner in 1897 and became his wife in 1899. They had no children. The act brought the cakewalk to the height of its popularity, and Williams and Walker subsequently toured the eastern seaboard and performed a week at the Empire Theatre in London in April 1897.

Vaudeville typically used stereotyped ethnic characterizations as humor, and Williams and Walker developed a "coon" act without peer in the industry. For the 1898 season, the African American composer WILL MARION COOK and the noted poet PAUL LAURENCE DUNBAR created *Senegambian Carnival* for the duo, the first in a series of entertainments featuring African Americans that eventually played New York. *A Lucky Coon* (1898), *The Policy Players* (1899), and *Sons of Ham* (1900) were basically vaudeville acts connected by Williams and Walker's patter. In 1901 they began recording their ragtime stage hits for the Victor label. Their popularity spread, and the 18 February 1903 Broadway premiere of *In Dahomey* was considered the first fully realized musical comedy performed by an all-black company. In 1900 Williams had married Charlotte Louise Johnson; they had no children.

Williams and Walker led the *In Dahomey* cast of fifty as Shylock Homestead and Rareback Pinkerton, two confidence men out to defraud a party of would-be African colonizers. Its three acts included a number of dances, vocal choruses, specialty acts, and a grand cakewalk sequence. Critics cited Williams's performance of "I'm a Jonah Man," a hard-luck song by Alex Rogers, as a high point of the hit show. *In Dahomey* toured England and Scotland, with a command performance at Buckingham Palace arranged for the ninth birthday of King Edward VII's grandson David. The cakewalk became the rage of fashionable English society, and company members worked as private dance instructors both abroad and when they returned home.

Williams composed more than seventy songs in his lifetime. "Nobody," the most famous of these, was introduced to the popular stage in 1905:

When life seems full of clouds and rain, And I am filled with naught but pain, Who soothes my thumping, bumping brain? Nobody!

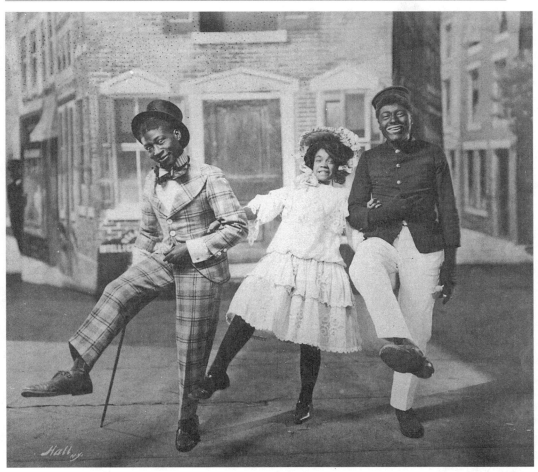

Bert Williams and George Walker performed in Will Marion Cook's musical In Dahomey on the lawn of Buckingham Palace in 1902. (Museum of London.)

The sense of pathos lurking behind Williams's plaintive delivery was not lost on his audience. Walker gained fame performing boastful, danceable struts, such as the 1906 "It's Hard to Find a King Like Me" and his signature song, "Bon Bon Buddie, the Chocolate Drop," introduced in 1907. During this period Williams and Walker signed their substantial music publishing rights with the black-owned Attucks Music Publishing Company.

Walker, who was more business-minded than Williams, controlled production details of the 1906 *Abyssinia* and the 1907 *Bandanna Land*. Walker demanded that these "all-Negro" productions play only in first-class theaters. His hard business tactics worked, and Williams and Walker played several theaters that had previously barred black performers. In 1908, at the height of their success, the duo were founding members of The Frogs, a charitable and social organization of black theatrical celebrities. Other members included composers Bob Cole and JOHN ROSAMOND JOHNSON, bandleader JAMES REESE EUROPE, and writer/directors Alex Rogers and Jesse Shipp.

During the tour of *Bandanna Land*, Walker succumbed to general paresis, an advanced stage of syphilis. He retired from the stage in February 1909. Aida Walker took over his songs and dances, and the book scenes were rewritten for Williams to play alone. Walker died in Islip, New York.

Williams continued doing blackface and attempted to produce the 1909 *Mr. Lode of Koal* without Walker. His attention to business details languished, and the show failed. Williams's performances, however, received significant critical praise, and he gained stature as "an artist of pantomime" and "a comic genius." In 1910 he joined Florenz Ziegfeld's *Follies*. He told the *New York Age* (1 Dec. 1910) that "the colored show business—that is colored musical shows—is at the low ebb just now. I reached the conclusion last spring that I could best represent my race by doing pioneer work. It was far better to have joined a large white show than to have starred in a colored show, considering conditions."

Williams was aware of the potential for racial backlash from his white audience and insisted on a contract clause stating that he would at no time appear on stage with any of the scantily clad women in the *Follies* chorus. His celebrity advanced, and he became the star attraction of the *Follies* for some eight seasons, leaving the show twice, in 1913 and 1918, to spend time with his family and to headline in vaudeville. His overwhelming success prompted educator BOOKER T. WASHINGTON to quip, "Bert Williams has done more for the race than I have. He has smiled his way into people's hearts. I have been obliged to fight my way."

An Actor's Equity strike troubled Ziegfeld's 1919 edition of the *Follies*, and Williams, who had never been asked or allowed to join the union because of his African ancestry, left the show. In 1920 he and Eddie Cantor headlined Rufus and George Lemaire's short-lived *Broadway Brevities*. In 1921 the Shuberts financed a musical, *Under the Bamboo Tree*, to star Williams with an otherwise all-white cast. The show opened in Cincinnati, Ohio, but in February 1922 Williams succumbed to pneumonia, complicated by heart problems, and died the next month in New York City.

Although Williams's stage career solidified the stereotype of the "shiftless darkey," his unique talent at pantomime and the hard work he put into it was indisputable. In his famous poker game sketch, filmed in the 1916 short *A Natural Born Gambler*, Williams enacted a four-handed imaginary game without benefit of props or partners. His cache of comic stories, popularized in his solo vaudeville and Ziegfeld *Follies* appearances, were drawn largely from African American folk humor, which Williams and Alex Rogers duly noted and collected for their shows. Williams collected an extensive library and wrote frequently for the black press and theatrical publications.

The commercial success of Williams and Walker proved that large audiences would pay to see black performers. Tall and light-skinned Williams, in blackface and ill-fitting tatters, contrasted perfectly with short, dark-skinned, dandyish Walker. Their cakewalks revived widespread interest in African American dance styles. Their successful business operations, responsible for a "$2,300 a week" payroll in 1908, encouraged black participation in mainstream show business. The *Chicago Defender* (11 Mar. 1922) called them "the greatest Negro team of actors who ever lived and the most popular pair of comedy stars America has produced."

FURTHER READING
Allen, Woll. *Black Musical Theatre—From Coontown to Dreamgirls* (1989).
Charters, Ann. *Nobody: The Story of Bert Williams* (1970).
Johnson, James Weldon. *Black Manhattan* (1930).
Rowland, Mabel. *Bert Williams: Son of Laughter* (1923).
Sampson, Henry T. *Blacks in Blackface: A Source Book on Early Black Musical Shows* (1980).
Smith, Eric Ledell. *Bert Williams: A Biography of the Pioneer Black Comedian* (1992).
Obituaries: New York Times, 8 Jan. 1911 (Walker) and 5 Mar. 1922 (Williams).

THOMAS F. DEFRANTZ

WILLIAMS, Clarence

(8 Oct. 1898 or 1893–6 Nov. 1965), blues and jazz musician, publisher, and music producer, was born in Plaquemine, Louisiana. The names and occupations of his parents are unknown. In 1906 his family moved to New Orleans. Williams's first instrument was the guitar, which he abandoned before he reached his teens to concentrate on the piano. Most of his learning was done by ear or by watching others, although he did receive eight lessons in the early 1910s, at the end of which he believed he knew all he needed to know about piano playing. At the age of twelve he left home to join Billy Kersands's traveling minstrel show as a pianist, master of ceremonies, dancer, and comedian. Williams spent most of his teenage years in the clubs of New Orleans's legendary Storyville district as a pianist and songwriter. During this time he met the pianist and composer JELLY ROLL MORTON, who played an

important role in transforming ragtime music into jazz and represented the main musical influence on Williams.

Williams's entrepreneurial skill and multifaceted musical talents exhibited themselves early in his life. About the year 1915 he founded his first publishing company, which lasted for two years, with the bandleader and songwriter Armand John Piron. Among the copyrights they handled were "Brownskin, Who You For" and Piron's oft-covered jazz classic "I Wish I Could Shimmy Like My Sister Kate." Williams formed his own jazz group that featured the jazz soloists Bunk Johnson, KING OLIVER, and SIDNEY BECHET, and they toured the South in the mid-1910s. At nineteen he served as a musical director for Salem Tutt Whitney's The Smart Set, a black touring company that produced musicals. He also toured briefly in 1917 with blues songwriter-entrepreneur W. C. HANDY.

At the end of World War I, Williams moved to Chicago and attempted to take advantage of the local activity surrounding jazz music by opening a music store and publishing company on State Street. Williams peddled his compositions door-to-door and on street corners from Texas to New York. He was one of the first African Americans to demonstrate his songs in five-and-dime stores, which were usually segregated. Despite extensive effort, the business failed. Not easily deterred, Williams relocated to New York City in 1919 and launched a publishing company that initiated his meteoric rise in the music business. That year Piron's "Sister Kate" marked its first significant commercial success. For the next two decades, dozens of hit songs in the blues, jazz, and vaudeville genres emanated from the company, and most of them were credited to Williams.

Being in New York City, home of the major record companies, represented a boon for Williams. Spurred on by the unprecedented sales of MAMIE SMITH's "Crazy Blues" (1920), the first popular vocal recording by an African American, these companies were starting to realize the previously untapped financial potential of a popular music market aimed at African Americans. Williams, with his combination of songwriting, publishing, band leading, and piano skills, proved invaluable in their efforts to exploit this market. By 1923 Williams became manager of the Race Artists' Section of Okeh Records and remained in that position for eight years. He directed sessions for his own groups and for others, sometimes playing piano or singing. He often selected the material to be performed, much of which was published under his company's banner. Perhaps Williams's most valuable skill to these companies was his ability to spot emerging and important artists. Many jazz legends made early recorded appearances on Williams's sessions long before they were famous, including Bechet, LOUIS ARMSTRONG, BUBBER MILEY, COLEMAN HAWKINS, and DON REDMAN.

Williams proved instrumental in the first recordings of BESSIE SMITH, the best-selling blues artist of the 1920s. Frank Walker, the head of Columbia Records' "race" music division, recalled seeing Smith perform in Alabama in 1917 and six years later had Williams find her so she could record for the company. Williams played piano and contributed two original songs to her first eight sides. One of them, "Baby Won't You Please Come Home" (1919), became a blues standard and one of Williams's most covered compositions. A bitter disagreement over a one-sided personal representation contract that Williams had Smith sign with him led to a divisive impasse between them, though they would be reunited in the recording studio in the late 1920s and early 1930s. In 1923 Smith's debut recording, "Down Hearted Blues," featured her joined only by Williams. His piano playing was not virtuosic, but he provided a bittersweet ambience that complemented the song and attractively lined the edges of Smith's vocal performance. It is no accident that a disproportionate amount of Smith's best sides are the relatively few times Williams was paired with her, including "Black Mountain Blues" (1930) and "Long Old Road" (1931).

Williams's talents as a simple but effective accompanist were regularly heard alongside the rich array of 1920s female vocal blues talent, including ETHEL WATERS, ALBERTA HUNTER, VICTORIA SPIVEY, and Sippie Wallace. However, the female vocalist most identified with Williams was EVA TAYLOR, whom he met as a result of his work as an accompanist. They married in 1921. Taylor's successful career endured longer than most black female vocalists of the period; she appeared on recordings and radio well into the 1930s. The biggest hits by the Williams bands of the 1920s (such as the Blue Five, Morocco Five, and Blue Seven) usually showcased Taylor's vocals on Williams's songs. Some examples are "Everybody Loves My Baby (But My Baby Don't Love Nobody but Me)," "Cake Walking

Babies from Home" (both from 1925 and featuring Armstrong), and the suggestive "Shake That Thing" (1926). Many of the mid-1920s Blue Five recordings are now considered early jazz classics, especially "Texas Moaner Blues" and "Mandy, Make Up Your Mind," two tracks from 1924 that document Armstrong and Bechet's definition of the jazz solo. Williams's skill at maintaining a relaxed and friendly atmosphere in the studio encouraged artists to perform at their highest level. "He could somehow manage to get the best out of them, and to this day hasn't received the credit he really deserves," marveled Walker in a 1950s interview (Shapiro and Hentoff, 239).

Throughout the late 1910s and the 1920s Williams contributed additional jazz and blues standards: "Royal Garden Blues" (1919), cowritten with the non-related Spencer Williams; "Tain't Nobody's Business if I Do" (1922); "Gulf Coast Blues" (1923); "West End Blues" (1928); and what may have been his most financially successful composition, "Squeeze Me," written with FATS WALLER in 1925. Some latter-day authors have accused Williams of claiming popular "unwritten" tunes of the day rather than composing his own and of taking credit for songs that he only helped promote. No conclusive evidence has been found on these charges, but such situations were not uncommon in the music business of Williams's era.

Williams was also part of an exclusive group of black artists (others included JAMES P. JOHNSON, WILLIE "THE LION" SMITH, and Waller) contracted to record piano rolls for the QRS Company in 1923. Beginning in 1926 Williams embarked on a moderately successful series of recordings that utilized novelty "washboard" instrumentation that musically and humorously straddled the line between the hillbilly and vaudeville genres. In 1927 Williams wrote the music for an unsuccessful Broadway production titled *Bottomland*.

After his position at Okeh ended, Williams concentrated on administering his publishing and continuing his songwriting. His appearances on recordings and his string of hit songs subsided during the 1930s. Throughout the 1930s and 1940s Williams acted as an agent for black recording artists, arranging recording sessions with major record labels. By 1941 he had ceased to record, and two years later he sold his publishing interests to the Decca Recording Company for a large sum. Afterward Williams enjoyed a wealthy and private semiretirement as the proprietor of a hobby shop in Harlem. He died in New York City.

Williams played a significant role in enlarging the scope of the commercial possibilities for black music, which led to the rise of the African American music market and the dominance of blues- and jazz-influenced music on American radio airwaves in the 1920s and 1930s. He was one of the first African Americans to wield real power in the music business as an entrepreneur, executive, and artist. Williams was one of the main progenitors of the recording and songwriting legacy of the opening decade of recorded jazz and blues—writing, cowriting, and recording many of the standards identified with the music for decades to come. Despite his many achievements, Williams told an interviewer in the 1960s that there was a significant amount of struggle involved as well. He called the blues a "mood" that represented a "carry-over from slavery—nothing but trouble in sight for everyone. There was no need to hitch your wagon to a star, because there weren't any stars. You got only what you fought for" (Patterson, 56).

FURTHER READING
Lord, Tom. *Clarence Williams* (1976).
Patterson, Lindsay, ed. *The Negro in Music and Art* (1967).
Shapiro, Nat, and Nat Hentoff, eds. *Hear Me Talkin' to Ya* (1955).

Obituary: New York Times, 9 Nov. 1965.

DISCOGRAPHY
Rust, Byron. *Jazz Records, 1897–1942*, 4th rev. ed. (1978).

HARVEY COHEN

WILLIAMS, Edward Christopher

(11 Feb. 1871–24 Dec. 1929), librarian, educator, and writer, was born in Cleveland, Ohio, the only child of Daniel P. Williams, from a prominent African American family in Ohio, and Mary Kilkary, a white woman born in Tipperary, County Cork, Ireland. Williams attended public schools, graduated from the Cleveland Central High School, and enrolled at Adelbert College of Western Reserve University (later Case Western Reserve University). Though fair enough to pass for white, Williams never hid his racial heritage, and despite the prevailing racism of the era he flourished in college. Acknowledged by his instructors and peers as an outstanding student

and athlete, Williams was elected to Phi Beta Kappa in his junior year and participated in a number of team sports, varsity baseball among them. He received his bachelor's degree in 1892 and was class valedictorian.

After graduation Williams was appointed first assistant librarian of Adelbert College, and in 1894 he became head librarian of Western Reserve's Hatch Library, where he remained until 1909. Williams achieved distinction during his tenure at Western Reserve in a number of ways. Beginning in 1896 he oversaw the library's move from its cramped location to a new structure, and he worked aggressively for a larger staff, increased holdings, and improved physical equipment. In 1899 Williams went on leave in order to attend the New York State Library School in Albany, finishing the bulk of the two-year course in one year. Williams is widely considered the first professionally trained African American librarian. Upon his return to Ohio, Williams resumed working as a librarian and educator. In addition to his library duties he taught various courses on library science and tutored students in foreign languages.

In 1902 Williams married Ethel Chesnutt, daughter of CHARLES WADDELL CHESNUTT, the writer, and a graduate of Smith College. They had one son, Charles, who went on to become a lawyer in Washington, D.C. Williams became a charter member of the Ohio Library Association, acting as its secretary in 1904, and he chaired the association's constitution committee and college section. Williams also served as second vice president of the New York State Library Association in 1904.

A new chapter of Williams's life began in 1909, when he resigned from the library, moved his family to Washington, D.C., and became principal of M Street High School (later the Paul Laurence Dunbar High School), an institution renowned for academic excellence. In that same year he joined the Mu-So-Lit Club, a cultural men's group, and in 1916 he helped organize a drama committee for the local chapter of the NAACP.

Williams served as principal until 1916, at which time he resumed his role as a librarian by accepting a position at Howard University. Tireless as ever, Williams assumed multiple roles, becoming librarian, director of the library training class, professor of bibliography, and an instructor of foreign languages and literature. As head librarian Williams worked for years to improve every aspect of the library, which he felt lacked adequate space, equipment, books, and staff for an institution of Howard's stature. As an instructor and administrator he provided sound, firm leadership in the development and teaching of library science courses at the university. He also offered a wide variety of courses in French, German, and Italian language and literature, and his course on Dante was the first of its kind to be offered at a historically black college. Williams also served as director of both student organizations and the library committee, edited the Howard University *Record*, and during a number of his summer vacations he worked in Harlem at the 135th Street branch of the New York Public Library.

Already an accomplished educator and librarian, Williams began to blossom as a writer, becoming an integral figure of Washington's cultural life. He was instrumental in founding a locally influential literary society, helped nurture the talents of poets such as GEORGIA DOUGLAS JOHNSON and Carrie Clifford, and was in contact with a number of emergent literary figures, including JEAN TOOMER, ZORA NEALE HURSTON, Mary Burrill, and ANGELINA GRIMKÉ. His book club, which often discussed African American literature, met on Wednesday nights at the Carnegie Library. An important mentor and organizer during an era of intense creativity, Williams also wrote three plays that were performed at Howard: *The Exile* (1924), a two-act drama set in fifteenth-century Florence during the power struggle between the Salviati and Medici families; *The Chasm* (1926), cowritten with WILLIS RICHARDSON; and *The Sheriff's Children* (n.d.), an adaptation of Chesnutt's short story of the same name. In addition Williams wrote at least two unpublished short stories, "The Colonel" and "The Incomparable Dolly," both of which feature socially conservative men who fall in love with younger modern women. Williams was, moreover, known by his contemporaries as the author of a number of unsigned essays and poems, and he perhaps published in A. PHILIP RANDOLPH and CHANDLER OWEN's little magazine, the *Messenger*, under the pseudonym "Bertuccio Dantino."

Williams's most important literary work, however, is his novel, *When Washington Was in Vogue*, which is most likely the first African American epistolary novel. Published serially and anonymously in the *Messenger* in 1925–1926 under the title *The Letters of Davy Carr: A True Story of Colored Vanity Fair*, the novel did not appear in book form and under

Williams's name until 2004. *When Washington Was in Vogue* consists of a series of letters written by the fictional Captain Davy Carr, a World War I veteran on a visit to Washington to research the slave trade, to his friend and former comrade-in-arms, Bob Fletcher, who is living in Harlem. Davy describes the mores and foibles of Washington's black social elite and, as the novel progresses, he falls in love with his landlady's daughter, Caroline, a vivacious, younger flapper.

Awarded a Julius Rosenwald Fellowship, Williams left Howard in 1929 in order to pursue further education in library science at Columbia University. He traveled to New York but soon fell ill and returned to Washington, where he died at age fifty-eight.

FURTHER READING

Some archival material concerning Edward Christopher Williams can be found in the Founders Library, Howard University.

Josey, E. J. "Edward Christopher Williams: Librarian's Librarian," *Negro History Bulletin* 33 (Mar. 1970).

Porter, Dorothy. "Edward Christopher Williams," In *Dictionary of American Biography*, eds. Rayford W. Logan and Michael R. Winston (1994).

ADAM MCKIBLE

WILSON, Edith Goodall

(6 Sept. 1896–30 Mar. 1981), blues and popular singer, was born Edith Goodall in Louisville, Kentucky, the daughter of Hundley Goodall, a schoolteacher, and Susan Jones, a housekeeper. She grew up in a mixed middle-class and working-class black neighborhood of small, neat cottages. Like many African Americans, she began singing in the church and at community social clubs. She completed her elementary education but by the time she was fourteen had dropped out of school. Her first taste of performing in an adult venue came in the White City Park talent shows in Louisville.

Eventually, Edith teamed with the pianist Danny Wilson and his sister, Lena Wilson, a blues singer. The trio performed in Kentucky and Ohio and later Chicago, where jazz was making inroads. Edith married the pianist around 1919. Danny Wilson had had some musical training, which enabled him to teach his wife how to use her voice. He also encouraged her to sing a variety of ballads, light classics, and blues. After performing in small clubs around Chicago for two years, the trio moved to Washington, D.C., in 1921. Their musical exposure in the nation's capital and in clubs around Atlantic City, New Jersey, helped prepare them for the much tougher competition of New York City.

Wilson was appearing in the musical revue at Town Hall, *Put and Take*, when Columbia Records signed her in September 1921 as the label's first blues singer. Johnny Dunn's Original Jazz Hounds, with Danny Wilson on piano, backed her on the first release, "Nervous Blues," by Perry Bradford. From 1921 until 1925 Wilson recorded thirty-one vocals, most of them blues, but a few of them humorous novelties such as "He May Be Your Man (But He Comes to See Me Sometime)." This song was among the most popular with Wilson's audiences during blues festivals in the 1970s. Wilson's voice, a light, plaintive soprano, was more refined—some jazz critics termed it "citified"—than those of most blues singers. This was partly the result of the training she received from her husband, who advised her to continue expanding her repertoire. In all, she made about forty recordings during the 1920s.

Wilson's stage career received a boost when she toured briefly on the TOBA (Theater Owners' Booking Association) circuit to promote her recordings. A fine comedian, she was offered roles in shows that featured both comedy and singing. She appeared in Lew Leslie's first major venture in producing black shows at Manhattan's Plantation Room in 1922. Noted for her blues and for songs featuring double entendres, she also sang at the Cotton Club in Harlem.

Wilson's first trip abroad was with Leslie's *Dover Street to Dixie*, which starred FLORENCE MILLS and played London's Pavilion in 1923. A theatrical version of the revue, *Dixie to Broadway*, opened at New York's Broadhurst Theater in 1924, then toured until early 1925. Wilson and Doc Straine were partners from 1924 until 1926, with Wilson singing the blues as part of their comedy routine. They traveled on the Keith theatrical circuit and, according to press reports, were highly popular. They also recorded two comedy songs about a bossy woman. That personality often became a Wilson feature in her later Broadway shows. Subsequent revues in which she traveled abroad included *Chocolate Kiddies* and two more Leslie shows, *Blackbirds, 1926* and *Blackbirds of 1934*. Wilson was a quick study with languages. Her fluency enabled her to perform blues and popular songs in French and German as well as the languages of other countries where she appeared.

Wilson's versatility kept her in demand in revues in the United States and overseas throughout the 1920s and 1930s. Her vocal style easily adjusted to the changing tastes and big-band arrangements of the swing years. During the 1930s she was featured on occasion with orchestras led by CAB CALLOWAY, JIMMIE LUNCEFORD, Lucky Millinder, NOBLE SISSLE, and Sam Wooding. Later, in 1945, she worked with LOUIS ARMSTRONG in *Memphis Bound*, but the Broadway show, excepting her own performance, received poor notices.

At the end of the 1930s Wilson moved to Los Angeles and began a new phase of her career with a nonsinging role in the film *I'm Still Alive* (1940). She appeared in other movies, her most important part coming in the classic *To Have and Have Not* (1944) that starred Humphrey Bogart and Lauren Bacall. During the mid-1940s Wilson toured on the major Burt Levy and Orpheum circuits and served with the USO.

Wilson, who had been widowed in 1928, married her second husband, Millard Wilson, in 1949. Eventually, they moved to Chicago and remained together until her death.

Wilson's career took a social and political twist when she was signed by the Quaker Oats Company to be the radio voice of its Aunt Jemima character for pancake mix commercials. The opportunity resulted from her portrayal of the Kingfish's wife on the "Amos 'n' Andy" radio show. In her Aunt Jemima role she toured on behalf of many charitable projects. Notwithstanding her charitable activities, however, black civil rights leaders and influential activists criticized her for what they saw as the exploitation of her talents to promote minstrel show stereotypes. She refused to give in to the pressure, insisting that her work was for good causes for which she was not being given proper credit. Wilson was dropped from the role in 1965, and eventually Quaker Oats bowed to criticism and retired the Aunt Jemima character.

Nearly seventy, Wilson resumed her singing career, performing regularly at clubs in the Chicago area. She appeared on local television shows and recorded an exemplary album for the Delmark label in 1976. At eighty, she was singing with the verve and sophistication that were hallmarks of her younger years. She performed in local and national blues and jazz festivals, including the 1980 Newport Jazz Festival, and made her final appearance on Broadway in a 1980 show, *Blacks on Broadway*, produced by Bobby Short. She died in Chicago, having remained a highly regarded performer to the end.

FURTHER READING
Harrison, Daphne. *Black Pearls: Blues Queens of the 1920s* (1988).

DISCOGRAPHY
Godrich, John, and Robert M. W. Dixon, comp. *Blues and Gospel Records, 1902–1942* (1969).

DAPHNE DUVAL HARRISON

WILSON, Ellis

(30 Apr. 1899–7 Jan. 1977), painter, was born in Mayfield, Kentucky, one of seven children of Frank Wilson, a second-generation barber, and Minnie Wilson, a founding member of the local Second Christian Church. Frank Wilson was an amateur artist, and two of his paintings proudly hung in the Wilson home. Ellis later credited his parents with encouraging his educational and artistic pursuits. The Wilsons lived in The Bottom, the largest of several African American sections of Mayfield, a small town in the heart of western Kentucky's tobacco-growing region. After graduation from the Mayfield Colored Grade School, Ellis studied for two years at the Kentucky Normal and Industrial Institute (later Kentucky State University), an all-black school in Frankfort. In 1919 he transferred to the School of the Art Institute of Chicago, where he won several student prizes and studied with the school's first African American instructor, WILLIAM MCK-NIGHT FARROW, among others. Following graduation in 1923 Wilson remained in Chicago, working as a commercial artist and in several service jobs, including at the YMCA cafeteria.

In 1928 Wilson moved from Chicago to Harlem, New York. Although he sold a few illustrations, including one that graced that cover of *Crisis* magazine in March 1929, he was primarily a painter of still lifes and urban street scenes. Throughout his life Wilson did not support himself through sales of his art; rather he worked as a handyman and at other jobs. After three years in Harlem Wilson moved to West 18th Street in Greenwich Village, where he produced work that depicted black life. His reserved temperament, however, kept him from direct participation in black politics. Wilson was not the only African American artist to move downtown; PALMER HAYDEN, BEAUFORD DELANEY and Joseph Delaney, and RICHMOND BARTHE

lived nearby. In 1931 Wilson began several years of weekend study with the painter Xavier J. Barile and took free evening classes at the Mechanics' Institute. Throughout the 1930s his paintings were included in exhibitions of work by African American artists, including the Harmon Foundation shows in 1930 and 1933, AUGUSTA SAVAGE's Salon of Contemporary Negro Art in 1934, and the American Negro Exposition in Chicago in 1939. Wilson joined the newly established Harlem Artists Guild in 1935, and along with many other African American artists, including AARON DOUGLAS, Dox Thrash, CHARLES ALSTON, Jacob Lawrence, and Ernest Crichlow, Wilson worked for the Works Progress Administration (WPA) Federal Arts Program. From 1935 through 1939 he was assigned to a mapping division that produced detailed maps and dioramas of New York City's five boroughs. During World War II, from 1940 to 1944, he worked in a New Jersey aircraft engine factory. While not at work on the floor of the plant he produced sketches and paintings of black factory workers.

In 1939 Wilson began applying annually to the Simon Guggenheim Memorial Foundation for a fellowship award. "Practically all of my life I have been painting under difficult conditions," he wrote in his first application, echoing the experience of many African American artists of the period; "Lack of money and time, especially time, have prevented me from painting as much and as often as I have wanted to. . . . I am most interested in painting the Negro. Unfortunately, this type of painting hasn't a large following at present." Wilson argued in his 1940 application, "I want to continue to paint the Negro! There is such a wide, rich field of unexplored material to work from. Although I have been painting the Negro for a number of years, I feel I have only begun to go beneath the surface." When he finally won a fellowship in 1944 (renewed the following year), he used the award money to travel through the American South, where he sketched black fishermen, lumberjacks, fieldworkers, mothers with children, the open markets in Charleston, South Carolina, and African Americans from the Sea Islands. The resulting paintings, influenced in part by the social realism movement, offer little in the way of specific locales or identifiable portraits; rather they evoke African American life in the rural South through emotion, color, and texture.

Kentucky welcomed Wilson home with a 1947 exhibition at the Mayfield public library and a solo exhibition the following year at the Speed Museum in Louisville. Wilson found champions in Justus and Senta Bier, art critics for Louisville's *Courier Journal*, who published several complimentary articles about him, including a 1950 Sunday magazine story with color reproductions of his work. In 1952 a painting, later lost, depicting an African American fisherwoman won Wilson a $3,000 prize from the Terry Art Institute in Miami. He used this prize to finance the first of several trips to Haiti, after which his painting style, while still representational, employed bolder colors—pinks, purples, sea blues—and more geometric and elongated figures. These Haitian-inspired paintings earned reviews in both *Art News* and *Art Digest* in 1954 and an exhibition in 1960 at the New York Contemporary Arts Gallery. The next exhibition of Wilson's work came eleven years later in a joint retrospective curated by David Driskell entitled *Paintings by Ellis Wilson, Ceramics and Sculpture by* WILLIAM E. ARTIS.

Wilson was by all accounts a shy and private man. He preferred sketching on site and painting alone in his studio. His intimate, often small paintings of African American and Haitian subjects engaged in the details of daily life were generally painted in oil on wood or board. Because he was a lesser-known artist and had no heirs, historians have been challenged in documenting his oeuvre. Though he rarely dated or titled his work it appears that Wilson produced nearly three hundred paintings in his lifetime. Upon his death in New York, Wilson was buried in an unmarked pauper's grave.

Interest in Wilson was rekindled in the 1980s after one of the artist's best paintings, "Funeral Procession" (c. 1950s), was featured as a key story element on the *Cosby Show* (see Bill Cosby). In a 1985 episode from the television show's second season, Claire Huxtable learns that a painting by her "great uncle Ellis" is up for auction at Sotheby's. After buying the painting for $11,000 (in real life Wilson never sold a painting for more than $300), the painting hung above the fictional Huxtable family's fireplace, appearing in the background of every episode. The original "Funeral Procession" is located in the Aaron Douglas Collection at the Amistad Research Center. Wilson's paintings are held by several important collections, including the Howard University Gallery of Art, the Studio Museum in Harlem, and the National Museum of American Art.

FURTHER READING
Murray State University. *The Art of Ellis Wilson* (2000).

LISA E. RIVO

WILSON, Frank H.

(4 May 1886–16 Feb. 1956), actor and playwright, was born Frank Henry Wilson in New York City. Little is known about his family and early life, although it is known that he attended the American Academy of Dramatic Arts. Wilson supported himself with a job as a postman while also pursuing his acting and writing career.

Wilson began his career in vaudeville, spending twelve years as a baritone singer, but his true calling was the stage, where he worked as a playwright and as an actor. Wilson's career as a playwright began in 1914, when he wrote one-act plays for the Lincoln and Lafayette theaters in Harlem. During these early years of the century, African American leaders organized a push for recognition of African American arts as a road to civil rights. Wilson's career as playwright and actor was set in the midst of early debates over the form and definition of African American theater. That debate proceeded on two very different levels. The first concerned what might be called the cultural question: what kind of theater constituted art? Clearly, the successful musical comedies and variety shows that filled Broadway stages were not high art. A second level of debate concerned the social role of art: what were the proper aims of art? In this, African American leadership was divided. W. E. B. DU BOIS argued that art must always be propaganda, while ALAIN LOCKE argued that aesthetics must be the guide to African American arts and letters. Wilson's work followed Du Bois's challenge for playwrights to deal honestly with African American life.

Beginning in 1925 the two major African American periodicals of the time, the NAACP's *Crisis* and the National Urban League's *Opportunity*, sponsored competitions among writers and artists. Wilson's one-act play *Sugar Cain* won the 1925 *Opportunity* prize. On 6 February 1928 Wilson's play *Meek Mose*, about an African American preacher who believes that "the meek shall inherit the earth," opened on Broadway, while Wilson was acting the title role in Dubose Heyward's play *Porgy*. Although *Meek Mose* would be produced again in 1934 by the Federal Theatre's Negro Drama Unit of New York

under the title *Brother Mose*, Wilson's play was considered a failure. His *The Wall Between* (1929) was scheduled for Broadway but was cancelled when the Depression hit.

Wilson found greater success in his acting career. He had had his first triumph in 1926 in Paul Green's Pulitzer Prize–winning play, *In Abraham's Bosom*. When the play's lead, Jules Bledsoe, failed to appear, Wilson exchanged his small part for the leading role. His performance, which *New York Times* critic Brooks Atkinson called "almost letter perfect" and "swift, direct and extraordinarily moving" (20 Feb. 1926, sec. 7), earned him the role permanently. His performance as Porgy in 1927 earned him recognition as one of the best African American actors of the time, among the ranks of CHARLES GILPIN and PAUL ROBESON. His subsequent successes included *Sweet Chariot* (1930), *We the People* (1931), the musical play *Singin' the Blues* (1931), Frederick Schlick's prison drama *Bloodstream* (1932), and *They Shall Not Die* (1934), a play by John Wexley based on the SCOTTSBORO BOYS case.

While the majority of Wilson's success came on the stage, he acted in films as well, and he appeared in a variety of Hollywood productions and "race" films, films made by either African American or mixed-race production companies for black audiences. Wilson's debut was in the film version of *The Emperor Jones* (1933), with Paul Robeson in the title role. Next he portrayed Moses in the film adaptation of the popular Broadway play *The Green Pastures* (1936), co-starring with Rex Ingram, EDDIE "ROCHESTER" ANDERSON, and Edna Mae Harris. Wilson also performed in sound-era race films, including *Paradise in Harlem* (1939), which he co-scripted. Other screenwriting credits included *Murder on Lenox Avenue* (1941), one of the last "black gangster" movies. Wilson also performed for radio, and played the role of Jackson Papaloi on *Young Dr. Malone*, a soap opera that ran from 1939 to 1960.

Shortly before his death, Wilson appeared on television in the role of Henry in *Floodtide*, the first episode of *The Elgin Hour*, a series of live dramas sponsored by the Elgin Watch Company. Frank Wilson died in Queens, New York, at the age of sixty-nine. Although his plays are not included in anthologies of African American drama such as Alain Locke's 1927 *Plays of Negro Life* or James V. Hatch's 1974 *Black Theater*, Wilson's plays remain important examples of African American theater

during a time when African American aesthetics were being defined.

FURTHER READING

Bogle, Donald. *Toms, Coons, Mulattoes, Mammies, & Bucks: An Interpretive History of Blacks in American Films* (2001).

Cripps, Thomas. *Slow Fade to Black: The Negro in American Film, 1900–1942* (1993).

Wilson, Sondra Kathryn, ed. *The Opportunity Reader* (1999).

MARY ANNE BOELCSKEVY

WINFIELD, Hemsley

(20 Apr. 1907–15 Jan. 1934), actor and dancer, was born in Yonkers, New York, the son of Osbourne Winfield, a civil engineer, and Jeraldine (maiden name unknown but perhaps Hemsley), an actress and playwright. Educated at public schools, Winfield showed an early interest in theater, perhaps prompted by his mother's involvement. In 1924 he received his first role in a major production, Eugene O'Neill's *All God's Chillun Got Wings*, performed by the Provincetown Players and starring a rising PAUL ROBESON. Winfield acted in other productions in the 1920s but soon turned to producing and directing. In April 1927 he put on his own play, *On*. The play was not critically received, but its production is indicative of the growing little theater movement of the early twentieth century, during which community and small theaters attracted larger audiences and offered greater and more varied opportunities to aspiring actors, writers, and directors. Winfield continued in this arena in 1928 and 1929, directing different versions of the popular *Salome*—once even playing the role of Salome when his female lead failed to show up—and collaborating with his mother in a production called *Wade in de Water* in 1929. Around this same time he began taking dance lessons, and this led him to shift his attention from theater to dance.

On 6 March 1931 Winfield's newly formed dance company, the Bronze Ballet Plastique, performed at the Saunders Trade School in Yonkers in a benefit for the Colored Citizens Unemployment and Relief Committee. This was Winfield's first collaboration with African American dancer Edna Guy, who had received much of her training from Ruth St. Denis, one of the founders of concert dance in America. Guy and Winfield went on to create the New Negro Art Theatre Dance Group, which placed itself by name and mission in the artistic resurgence now known as the Harlem Renaissance.

It was within this highly creative and receptive environment that, on 29 April 1931, Winfield and Guy performed what they called the "First Negro Dance Recital in America." Playing to an overflowing audience in the theater at the top of the Chanin Building on Forty-second Street, the innovative duo hoped to initiate a new tradition in African American dance separate from the swing and jitterbugging that characterized Harlem's dance halls. Concert dance provided a new means of expression, one that was more profound than the entertaining theatrics of social dancing for which African Americans were thought to be naturally talented. Winfield and Guy sought to place African Americans within the emerging artistic movement of modern dance, which was then dominated by the austere and serious works of Martha Graham and Doris Humphrey. The influential *New York Times* dance critic John Martin, recognizing the value of their purpose, described the performance as the "outstanding novelty of the dance season." In a further exploration of Winfield's group, Martin called Winfield's choreography "crude" but supported his effort to establish an African American tradition in concert dance that neither mimicked European traditions nor restricted itself to what short-sighted whites delimited as "Negro art" (*New York Times*, 14 Feb. 1932).

Throughout 1931 and 1932 Winfield and Guy performed this program of the New Negro Art Theatre Dance Group in settings around New York City. In December 1932 they were included in a large benefit for the Dancers Club, a newly founded organization to aid struggling dancers, at the Mecca Temple, where they performed alongside the famous dancers Ruth St. Denis, Charles Weidman, and Fred Astaire. Soon after, Winfield received the opportunity to choreograph the opera *The Emperor Jones* at the Metropolitan Opera in New York. Dancing the role of the Witch Doctor, Winfield became the first African American to perform at the Metropolitan. His choreography and performance received praise for depicting authentic sounds and movement of the African jungle. He was thus fast accomplishing the establishment of a concert dance tradition for African Americans.

In October 1933 Winfield and noted African American sculptor AUGUSTA SAVAGE led a discussion on the topic "What Shall the Negro Dance

About?" at a forum sponsored by the Workers Dance League, an organization associated with the Communist Party, held at the YWCA in Harlem on 138th Street. Fittingly, the forum recognized the social as well as artistic implications of African Americans' producing their own art and also considered the political relevance of such actions. There is no evidence that Winfield was a member of the Communist Party, but he was keenly aware of the injustices facing African Americans, and he used modern dance to promote new and broader perspectives of African Americans and their capabilities. Unfortunately for the movement he initiated, Winfield's artistic responses to the question "What Shall the Negro Dance About?" were cut short; soon after the forum, he died of pneumonia in New York City, at the tragically young age of twenty-six.

Despite his premature death, Winfield had made startling progress. Others who had been inspired by him, in particular Edna Guy, took up his mission of creating an African American concert dance tradition, and by the late 1930s African Americans, led by the dancer-choreographers Katherine Dunham and Pearl Primus, were making significant contributions to concert dance.

FURTHER READING

Emery, Lynne Fauley. *Black Dance from 1619 to Today*, rev. ed. (1988).

Long, Richard. *The Black Tradition in American Dance* (1989).

Thorpe, Edward. *Black Dance* (1990).

Obituaries: New York Amsterdam News, 17 Jan. 1934; *New York Times*, 16 Jan. 1934.

JULIA L. FOULKES

WOODRUFF, Hale Aspacio

(26 Aug. 1900–26 Sept. 1980), artist and teacher, was born in Cairo, Illinois, the only child of Augusta (Bell) Woodruff, a domestic worker, and George Woodruff, who died when his son was quite young. After his father's death, Woodruff and his mother moved to east Nashville, Tennessee. Art instruction was not available in his segregated public school, so Woodruff drew on his own, mostly copying from books, and later as a cartoonist for his high school newspaper.

After graduating from high school in 1918, Woodruff moved to Indianapolis, Illinois, where he held several menial jobs while living at the YMCA. From 1920 to 1922 he studied landscape painting with William Forsyth at the Herron School of Art, while drawing weekly cartoons for the local African American newspaper, *The Indianapolis Ledger*. After a short stint in Chicago, where he studied briefly at the School of the Art Institute of Chicago, he returned to Indianapolis. By the mid-1920s he had experienced some success as a working artist, exhibiting at a few local galleries, the Herron Art Museum, and the YMCA's annual Indiana artists' exhibition. In 1924 he won third prize in *Crisis* magazine's Amy Spingarn Prize contest, bringing him to the attention of NAACP leaders W. E. B. DU BOIS and WALTER WHITE. The following year he became the membership director of the Senate Avenue YMCA, the country's largest African American YMCA branch, through which he met and was inspired by the many African American political and cultural leaders who came to speak.

When his painting *The Old Women* won a bronze award from the Harmon Foundation in 1926, Woodruff's dream of studying painting abroad took shape. In September 1927 he left for Paris, funded by one hundred dollars in prize money and financial support from local patrons. PALMER HAYDEN, a fellow African American painter, helped situate Woodruff in Paris, where he enrolled in two small art schools, the Académies Scandinave and Moderne. Over the next year and a half he wrote tourist features, essentially dispatches to his hometown paper, often accompanied by his own drawings, for *The Indianapolis Star*. In the winter of 1928, Woodruff made a pilgrimage to see HENRY OSSAWA TANNER in Normandy, a visit that had a lasting and profound effect on the young artist. In 1929 Woodruff moved to Cagnes-sur-Mer, a village in the south of France where African American painter WILLIAM H. JOHNSON had lived several years earlier.

Through his visits to Parisian galleries and shops Woodruff had been introduced to African art, then in vogue with collectors and modern artists. While this exposure proved pivotal to his later work, the watercolors and paintings Woodruff produced in France were primarily influenced by the Postimpressionists and early modernists, especially Picasso, Braque, and Cézanne. In 1930 he had a few small exhibitions in Paris. More importantly, however, his works, including the paintings *Old Farmhouse in Beauce Valley* (c. 1927), *Old Woman Peeling Apples* (1929), and

The Card Players (1930), were being exhibited in the United States in the Harmon Foundation annual shows and had piqued the interest of American collectors.

Having run out of money, Woodruff left France in the fall of 1931, accepting John Hope's offer of a teaching post at Atlanta University. As the school's first and only art instructor, Woodruff taught students from its affiliate colleges, Spelman and Morehouse, the university's Laboratory High School, Oglethorpe elementary school, summer school workshops, and People's College. Over the next fifteen years Woodruff built an art curriculum that included innovative interdisciplinary arts courses, and he recruited sculptor Nancy Elizabeth Prophet and other art faculty. He also secured crucial financial and material gifts to the art department. He launched an annual student exhibition and brought traveling exhibitions to the campus, offering students—and faculty—opportunities to view historical and contemporary art unavailable to them in Atlanta's segregated facilities.

Within a few years Atlanta University had become a center for young black artists. Woodruff endowed students with self-confidence, encouraging them to exhibit and take risks with their work, especially by working from their own experience and backgrounds. He organized his students into a "Painter's Guild," explaining to *Time* magazine in 1942, "We are interested in the South as a field, as a territory: its particular rundown landscapes, its social and economic problems, and [its] Negro people." Woodruff's students, including Wilmer Jennings, Frederick Flemister, Eugene Grigsby, Hayward Oubre, and Lawrence A. Jones, many of whom depicted African American figures, became known as the Atlanta School.

Woodruff's influence on black artists was felt beyond his own classroom. In 1942 he initiated, and continued to jury, an annual exhibition of African American artists at Atlanta University. Within three years the Atlanta Annuals had become the chief national outlet for black artists to exhibit, sell, and win prize money for their work. By 1970, the last year of the Annuals, more than nine hundred black artists had been exhibited and the university had amassed one of the nation's largest collections of African American art.

Influenced by social realism, American regionalism, and the Mexican muralists, Woodruff's own work began to shift in style and subject within several years of his return from France. From the early 1930s until after World War II, Woodruff depicted the distinctly American landscape of the segregated American South in paintings like *Big Wind in Georgia* (c. 1933), *Picking Cotton* (c.1936), and *Cigarette Smoker* (n.d). He joined African American artists CHARLES ALSTON, Charles White, Dox Thrash, ROBERT BLACKBURN, and ELIZABETH CATLETT in adopting the democratizing medium of printmaking, producing linoleum and woodblock prints, such as *Returning Home, Old Church and Sunday Promenade,* and *Relics,* that offered an unsentimental view of life and poverty in black southern communities. In 1935 he contributed two haunting linocuts, *Giddap* and *By Parties Unknown,* to an art exhibition on lynching sponsored by NAACP.

In the summer of 1934 Woodruff apprenticed himself to Mexican artist Diego Rivera in Mexico City, an experience that deeply affected both his teaching and painting. Woodruff's first murals, *The Negro in Modern American Life, Literature, Music, Agriculture, Rural Life, and Art* (1934), and two panels for the Atlanta School of Social Work in 1935, were sponsored by the Works Progress Administration (WPA). Woodruff's next major mural, commissioned by Talladega College, was a series of three six-by-ten-foot panels depicting the 1839 slave mutiny led by CINQUE aboard the *Amistad,* the 1840 trial of the slaves who participated, and their triumphant return to Sierra Leone in 1842. Completed in 1939 but begun more than a year earlier, the work was the result of nine months of painting preceded by months of intensive historical research, including trips to New Haven, Connecticut, the site of the trial, to view the letters, documents, and drawings of *Amistad* participants. The paintings' bright colors, sculptural figures, and focus on dramatic gesture show Woodruff's debt to the Mexican muralists. The commission also included a second set of four murals celebrating the founding of Talladega College and the newly completed Slavery Library on campus. After the success of the *Amistad* murals, Woodruff received other mural commissions, including the recently rediscovered panels *Effects of Bad Housing* and *Effects of Good Housing,* completed in 1942.

Woodruff had married Theresa Ada Baker, a teacher from Topeka, Kansas, in 1934, and the

couple had a son, Roy, the following year. When Woodruff received a Rosenwald Fund Fellowship in 1943 (renewed in 1944), the family moved to New York, where for the first time in twelve years Woodruff devoted himself solely to painting. He returned briefly to Atlanta for the fall term of 1945, before joining the faculty of the Department of Art Education at New York University the following semester, a position he held until retiring in 1968. In 1948 Woodruff and Charles Alston collaborated on a two-part mural celebrating the contributions of African Americans to California, commissioned for the lobby of a new one-million-dollar Los Angeles headquarters of Golden State Mutual Life Insurance Company, one of the West's largest black-owned businesses.

Woodruff's move to New York in the early 1940s coincided with seismic shifts in the history of painting brought about by artists like Jackson Pollock, Willem de Kooning, Franz Kline, and Helen Frankenthaler, who were forging a new, purely abstract, non-representational style. Just when Woodruff began experimenting with abstraction is difficult to pinpoint because he often left his works undated. His works from the late1940s, however, show an increased interest in abstraction and patterning and illustrate a more hearty, gestural use of paint. By the 1950s, in works like *Carnival* (1950) and *Europa and the Bull* (1958), he was producing abstracted landscapes in muted tones of blues, greens, burgundy, and mustard yellow.

Just as he had amended the vocabulary of the social realists and American regionalists, Woodruff offered a unique brand of abstraction, steeped in an African American context. Like the abstract expressionists' preoccupation with mythology and psychology, Woodruff also turned to signs and symbols drawn from the waking and subconscious mind. In Woodruff's case, however, the subject was the African American collective experience. Years before the Black Arts Movement and Africobra, he was investigating themes of black pride and Afrocentrism, folding African elements into paintings like *Afro Emblems* (1950), *Ancestral Memory* (1966), and especially the *Celestial Gates* (1953) series. His project, however, was more complex than introducing African motifs and forms; he was questioning the slippery boundary between celebrating—and appropriating—African art, and by extension, Africa.

In 1950 Woodruff returned to Atlanta University to work on a mural project he had proposed more than a decade before. Woodruff came to view the resulting *Art of the Negro* cycle as the most significant work of his career. While representational and highly narrative, the six eleven-foot murals employed the themes and style he would explore further in his abstract works. The mural begins with a panel called *Native Forms*, which is a survey of the traditional arts of Africa, including cave painting, sculpture, and masks. The second panel, *Interchange*, shows the exchange of ideas between ancient Africa and the West, and was followed, in panel three (*Dissipation*), by the destruction and looting of African artifacts during colonialization, exemplified by the British burning of Benin in 1897. The fourth panel illustrates *Parallels* in the arts of Africa, Oceana, and the native peoples of the Americas, while panel five, called *Influences*, references the sculpture of Henry Moore and the paintings of Amadeo Modigliani, along with other examples of modern art's debt to African art. The final panel, *Muses,* features seventeen black artists from ancient Africa to contemporary America.

In 1963, hoping to further the goals of the civil rights movement, Woodruff and ROMARE BEARDEN established Spiral, a weekly discussion group of ten to sixteen African American artists that included Alston, Norman Lewis, Richard Mayhew, Ernest Crichlow, and Emma Amos. While the group disbanded in 1966, it laid the groundwork for the Black Arts Movement groups of the late 1960s and 1970s. In the mid-1960s he served as chair of visual arts committee for the United States exhibition at the First World Festival of Negro Arts in Dakar, Senegal, and as the U.S. representative on two State Department–sponsored trips to Africa. In 1967 Woodruff received solo exhibitions at New York University, the Museum of Fine Arts in Boston, the San Diego Art Museum, and the Los Angeles County Museum of Art. A year before his death in 1980, a major retrospective of his work was held at the Studio Museum in Harlem.

FURTHER READING

Reynolds, Gary A. and Beryl J. Wright. *Against the Odds: African-American Artists and the Harmon Foundation* (1989).

Studio Museum in Harlem. *Hale Woodruff: 50 Years of His Art* (1979).

LISA E. RIVO

WOODSON, Carter Godwin

(19 Dec. 1875–3 Apr. 1950), historian, was born in New Canton, Virginia, the son of James Henry Woodson, a sharecropper, and Anne Eliza Riddle. Woodson, the "Father of Negro History," was the first and only American born of former slaves to earn a PhD in History. His grandfather and father, who were skilled carpenters, were forced into share-cropping after the Civil War. The family eventually purchased land and eked out a meager living in the late 1870s and 1880s.

Woodson's parents instilled in him high moral-ity and strong character through religious teachings and a thirst for education. One of nine children, Woodson purportedly was his mother's favorite, and was sheltered. As a small child he worked on the family farm, and as a teenager he worked as an agricultural day laborer. In the late 1880s the Woodsons moved to Fayette County, West Virginia, where his father worked in railroad construction, and where he himself found work as a coal miner. In 1895, at the age of twenty, he enrolled in Frederick Douglass High School where, possibly because he was an older student and felt the need to catch up, Woodson completed four years of course work in two years and graduated in 1897. Desiring additional education, Woodson enrolled in Berea College in Kentucky, which had been founded by abolitionists in the 1850s for the education of ex-slaves. Although he briefly attended Lincoln University in Pennsyl-vania, Woodson graduated from Berea in 1903, just a year before Kentucky passed the "Day Law," pro-hibiting interracial education. After college Wood-son taught at Frederick Douglass High School in West Virginia. Believing in the uplifting power of education, and desiring the opportunity to travel to another country to observe and experience the cul-ture firsthand, he decided to accept a teaching post in the Philippines, teaching at all grade levels, and remained there from 1903 to 1907.

Woodson's worldview and ideas about how edu-cation could transform society, improve race rela-tions, and benefit the lower classes were shaped by his experiences as a college student and as a teacher. Woodson took correspondence courses through the University of Chicago because he was determined to obtain additional education. He was enrolled at the University of Chicago in 1907 as a full-time stu-dent and earned a bachelor's degree and a master's degree in European History, submitting a thesis on French diplomatic policy toward Germany in the eighteenth century. Woodson then attended Har-vard University on scholarships, matriculating in 1909 and studying with Edward Channing, Albert Bushnell Hart, and Frederick Jackson Turner. In 1912 Woodson earned his PhD in History, com-pleting a dissertation on the events leading to the creation of the state of West Virginia after the Civil War broke out. Unfortunately, he never published the dissertation. He taught at the Armstrong and Dunbar/M Street high schools in Washington from 1909 to 1919, and then moved on to Howard Univer-sity, where he served as dean of arts and sciences, professor of history, and head of the graduate pro-gram in history in 1919–1920. From 1920 to 1922 he taught at the West Virginia Collegiate Institute. In 1922 he returned to Washington to direct the Asso-ciation for the Study of Negro Life and History full time.

Woodson began the work that sustained him for the rest of his career, and for which he is best known, when he founded the association in Chicago in the summer of 1915. Woodson had always been inter-ested in African American history and believed that education in the subject at all levels of the curricu-lum could inculcate racial pride and foster better race relations. Under the auspices of the association, Woodson founded the *Journal of Negro History*, which began publication in 1915, and established Associated Publishers in 1921, to publish works in black history. He launched the annual celebration of Negro History Week in February 1926 and had achieved a distinguished publishing career as a scholar of African American history by 1937, when he began publishing the *Negro History Bulletin*.

The *Journal of Negro History*, which Woodson edited until his death, served as the centerpiece of his research program, not only providing black scholars with a medium in which to publish their research but also serving as an outlet for the pub-lication of articles written by white scholars when their interpretations of such subjects as slavery and black culture differed from those of mainstream historians. Woodson formulated an editorial policy that was inclusive. Topically, the *Journal* provided coverage in various aspects of the black experi-ence: slavery, the slave trade, black culture, the fam-ily, religion, and antislavery and abolitionism, and included biographical articles on prominent African Americans. Chronologically, articles covered the sixteenth through the twentieth centuries. Scholars, as well as interested amateurs, published important

historical articles in the *Journal*, and Woodson kept a balance between professional and nonspecialist contributors.

Woodson began celebration of Negro History Week to increase awareness of and interest in black history among both blacks and whites. He chose the second week of February to commemorate the birthdays of Frederick Douglass and Abraham Lincoln. Each year he sent promotional brochures and pamphlets to state boards of education, elementary and secondary schools, colleges, women's clubs, black newspapers and periodicals, and white scholarly journals suggesting ways to celebrate. The association also produced bibliographies, photographs, books, pamphlets, and other promotional literature to assist the black community in the commemoration. Negro History Week celebrations often included parades of costumed characters depicting the lives of famous blacks, breakfasts, banquets, lectures, poetry readings, speeches, exhibits, and other special presentations. During Woodson's lifetime the celebration reached every state and several foreign countries.

Among the major objectives of Woodson's research and the programs he sponsored through the Association for the Study of Afro-American Life and History (the name was changed in the 1970s to reflect the changing times) was to counteract the racism promoted in works published by white scholars. With several young black assistants— Rayford W. Logan, CHARLES HARRIS WESLEY, Lorenzo J. Greene, and A. A. Taylor—Woodson pioneered in writing the social history of black Americans, using new sources and methods, such as census data, slave testimony, and oral history. These scholars moved away from interpreting blacks solely as victims of white oppression and racism toward a view of them as major actors in American history. Recognizing Woodson's major achievements, the NAACP presented him its highest honor, the Spingarn Medal, in June 1926. At the award ceremony, John Haynes Holmes, the minister and interracial activist, cited Woodson's tireless labors to promote the truth about Negro history.

During the 1920s Woodson funded the research and outreach programs of the association with substantial grants from white foundations such as the Carnegie Foundation, the General Education Board, and the Laura Spellman Rockefeller Foundation. Wealthy whites, such as Julius Rosenwald, also made contributions. White philanthropists cut Woodson's funding in the early 1930s, however, after he refused to affiliate the association with a black college. During and after the Depression, Woodson depended on the black community as his sole source of support.

Woodson began his career as a publishing scholar in the field of African American history in 1915 with the publication of *The Education of the Negro Prior to 1861*. By 1947, when the ninth edition of his textbook *The Negro in Our History* (1922) appeared, Woodson had published four monographs, five textbooks, five edited collections of source materials, and thirteen articles, as well as five collaborative sociological studies. Among Woodson's major works are *A Century of Negro Migration* (1918), *A History of the Negro Church* (1921), *The Mis-Education of the Negro* (1933), and *The African Background Outlined* (1936). Covering a wide range of topics, he relied on an interdisciplinary method, combining anthropology, archaeology, sociology, and history.

Among the first scholars to investigate slavery from the slaves' point of view, Woodson studied it comparatively at institutions in the United States and Latin America. His work prefigured the concerns of later scholars of slavery by several decades, as he examined slaves' resistance to bondage, the internal slave trade and the breakup of slave families, miscegenation, and blacks' achievements despite the adversity of slavery.

Woodson focused mainly on slavery in the antebellum period, examining the relationships between owners and slaves and the impact of slavery upon the organization of land, labor, agriculture, industry, education, religion, politics, and culture. Woodson also noted the African cultural influences on African American culture. In *The Negro Wage Earner* (1930) and *The Negro Professional Man and the Community* (1934) Woodson described class and occupational stratification within the black community. Using a sample of twenty-five thousand doctors, dentists, nurses, lawyers, writers, and journalists, he examined income, education, family background, marital status, religious affiliation, club and professional memberships, and the literary tastes of black professionals. He hoped that his work on Africa would "invite attention to the vastness of Africa and the complex problems of conflicting cultures."

Woodson also pioneered in the study of black religious history. A Baptist who attended church

regularly, he was drawn to an examination of black religion because the church functioned as an educational, political, and social institution in the black community and served as the foundation for the rise of an independent black culture. Black churches, he noted, established kindergartens, women's clubs, training schools, and burial and fraternal societies, from which independent black businesses developed. As meeting places for kin and neighbors, black churches strengthened the political and economic base of the black community and promoted racial solidarity. Woodson believed that the "impetus for the uplift of the race must come from its ministry," and he predicted that black ministers would have a central role in the modern civil rights movement.

Woodson never married or had children, and he died at his Washington home; he had directed the association until his death. For thirty-five years he had dedicated his life to the exploration and study of the African American past. Woodson made an immeasurable and enduring contribution to the advancement of the study of black history through his own scholarship and the programs he launched through the Association for the Study of Negro Life and History.

FURTHER READING

Two small collections of Woodson's papers exist at the Library of Congress Manuscript Division and the Moorland-Spingarn Research Center at Howard University.

Goggin, Jacqueline. *Carter G. Woodson: A Life in Black History* (1993).

Meier, August, and Elliott Rudwick. *Black History and the Historical Profession, 1915–1980* (1986).

JACQUELINE GOGGIN

WORK, John Wesley, III

(15 June 1901–17 May 1967), composer and educator, was born in Tullahoma, Tennessee, the son of John Wesley Work Jr., an educator who became president of Roger Williams College, and Agnes Haynes, a contralto and soloist who assisted her husband in training and leading the Fisk Singers. Work was born into a musical family. His grandfather John Wesley Work Sr., a former Kentucky slave, directed a Nashville church choir whose members included some of the original Fisk Jubilee Singers. His uncle Frederick Jerome Work collected and arranged folk

songs, and his brother Julian Work became a well-known composer. In 1898 Work's father accepted a teaching position at Fisk University and moved the family to Nashville. The younger Work, who began composing while in high school, matriculated at Fisk, where he earned an AB in History in 1923 but pursued formal music study in theory and voice.

After graduating from Fisk, Work studied voice at New York's Institute of Musical Art (now Juilliard) from 1923 to 1924 and afterward studied at Columbia University. When his father died in 1925, Work brought his mother and three younger siblings to live with him in New York while he completed his studies. On 19 September 1928 he married Edith Carr McFall, who had been his classmate at Fisk. They had two sons.

Fisk's new president, Thomas E. Jones, sought to revive the spirituals tradition, and Work's mother returned to Nashville to train new singers. In February 1927, during Work's final semester at Columbia, his mother suffered a fatal stroke while on tour in St. Louis. Work returned to Fisk with his wife and assumed his mother's duties. Working toward his Columbia degree during the summers, he completed his master's thesis in 1930, later published as *American Negro Songs and Spirituals* (1940). This landmark collection became a valuable source for researchers and musicians. Work was awarded a Rosenwald Fellowship in both 1931 and 1932, which allowed him to take a leave of absence from Fisk and study composition at Yale University, where he earned a BMus, a conservatory degree, in 1933. Returning to Fisk, Work taught theory and composition. In 1946 he became director of the Jubilee Singers, and in 1950 he was named chairman of Fisk's Music Department. He conducted the Jubilee Singers until 1957.

Work's Yale mentor George Herzog encouraged him to continue his research. Work's students served as important sources of information as he collected and transcribed songs he learned from them. He also taught them that folk music could be valuable in their work as schoolteachers. He was one of the first African American scholars to apply ethnomusicology in his research and to use a portable recorder in the field. He not only collected songs but also studied the music's cultural context. He moved beyond earlier collectors' single-minded focus on spirituals and other sacred songs by studying blues, work songs, and instrumental music. Work used a portable phonograph

disc recorder during fieldwork in rural Alabama in 1938, and in 1939 and 1940 he recorded local singers in the Nashville area. He presented his findings in Fisk's annual Robinson Music Lecture Series in a lecture titled "Negro Folk Music." He published his previous fieldwork on Alabama African American folk music collected during the summer of 1938 as a part of the 1941 *Musical Quarterly* article "Plantation Meistersinger."

A tragic fire on 23 April 1940 in Natchez precipitated Work's most important study. Reading of the event in the newspaper, he realized that the tragedy should be commemorated in song. When Work and the sociologist CHARLES S. JOHNSON first suggested the project idea, the university president was hesitant to endorse it, suggesting that Work and his team of African Americans partner with white researchers from the Library of Congress. To win the president's approval, Work partnered with the Library of Congress's Alan Lomax, who undertook fieldwork with the sociologist Lewis Wade Jones, assisted by Johnson.

Work and Lomax disagreed on many issues, including the research site and the project's focus, as Lomax took control of the project and its content. Nonetheless, Work successfully concentrated their efforts on the Delta region in what became known as the Fisk University–Library of Congress Coahoma County Study, focusing on Clarksdale, Mississippi, as an important blues center. Although relegated mostly to transcribing recordings made by Lomax and his assistants during two field trips in 1941 and in 1942, Work made the first field recordings of the bluesmen Muddy Waters and Son House. The interracial team finally concluded its research in mid-1942, and Work prepared his manuscript for publication in 1943. Lost for many years, it was finally located and published in 2005 as *Lost Delta Found: Rediscovering the Fisk University–Library of Congress Coahoma County Study, 1941–1942*.

As a formally trained musician, Work composed vocal music and arrangements of spirituals for most of his life. During his most prolific period, from 1946 to 1956, he composed more than fifty works for orchestra, chamber music, solo instruments, chorus, voice, and keyboard instruments. He completed his organ suite *From the Deep South* in 1936. In 1941 he composed the cantata *The Singers* (based on a poem by Henry W. Longfellow), which won first prize in the Fellowship of American Composers competition in 1946, when it premiered at the organization's convention in Detroit. His instrumental works seldom employ the folk song form. Among his best known are the orchestral suite *Yenvalou* (1946) and the piano piece *Sassafras* (1946). *Yenvalou*, inspired by a three-month trip to Haiti, is based on Haitian musical themes. His *Golgotha Is a Mountain* (1949) is based on ARNA BONTEMPS's poem of the same name.

Work's piano pieces *Scuppernong* (1951) and *Appalachia* (1954) date from this period. His *My Lord, What a Morning* was performed by choirs from Germany, Sweden, Great Britain, South America, France, Yugoslavia, Japan, Canada, and the United States as part of the 1956 Festival of Music and Art. It was also performed at the United Nations and in New York's Philharmonic Hall. In 1957, after a twelve-week European tour, Work's health weakened, and he stepped down as chair and director at Fisk to concentrate on composing, teaching, and research. Work remained at Fisk and became professor emeritus in 1966, although he continued to teach part-time. During his long career he received several honors, including an award from the National Association of Negro Musicians in 1947 and an honorary doctorate from Fisk in 1963. A member of the American Society of Composers, Authors, and Publishers (ASCAP) and other organizations, he composed more than one hundred works before his death in Nashville at age sixty-six.

FURTHER READING
Work, John W., Lewis Wade Jones, and Samuel C. Adams Jr. *Lost Delta Found: Rediscovering the Fisk University–Library of Congress Coahoma County Study, 1941–1942* (2005).

GAYLE MURCHISON

WORK, Monroe Nathan

(15 Aug. 1866–2 May 1945), sociologist, was born in rural Iredell County, North Carolina, the son of Alexander Work and Eliza Hobbs, former slaves and farmers. His family migrated to Cairo, Illinois, in 1866 and in 1876 to Kansas, where they homesteaded, and Work remained to help on the farm until he was twenty-three. He then started secondary school and by 1903 had received his MA in Sociology from the University of Chicago. That year he accepted a teaching job at Georgia State Industrial College in Savannah.

Living in the deep South for the first time, Work became concerned about the plight of African

Americans, who constituted a majority of Savannah's population. In 1905 he answered a call from W. E. B. DU BOIS to attend the conference that established the Niagara Movement, a militant black rights group that opposed BOOKER T. WASHINGTON's accommodationist approach to black advancement. While continuing to participate in the Niagara Movement, Work founded the Savannah Men's Sunday Club. It combined the functions of a lyceum, lobbying group, and civic club, engaging in such activities as petitioning the city government, opening a reading room, organizing youth activities, and conducting a health education campaign among lower-class African Americans. Quickly accepted into the city's black elite, he married Florence E. Henderson in 1904. Their marriage lasted until his death, but no children survived infancy.

In 1908 Work was offered a position at Washington's Tuskegee Institute in Macon County, Alabama. As an ally of Du Bois, Work found it difficult to accept the position, but he did. By 1908 he had begun to doubt the efficacy of protest. A streetcar boycott had not halted legalized segregation in Savannah, and the Niagara Movement had failed to expand. Work had begun to see another way to use his talents on behalf of black advancement. He was not a dynamic speaker or a natural leader, but a quiet scholar and researcher. He believed that prejudice was rooted in ignorance, and this suggested reliance on education rather than protest. In a 1932 interview Work declared that while still a student, "I dedicated my life to the gathering of information, the compiling of exact knowledge concerning the Negro." Disillusioned about the power of protest, Work believed that the resources and audience available at Tuskegee would allow him to make his skills useful: "It was the center of things relating to the Negro," he noted.

Although Washington had hired Work primarily as a record keeper and researcher for his own articles and speeches, Work used every opportunity to expand the functions of his Department of Records and Research. In 1908 he began compiling a day-to-day record of the African American experience. His sources included newspaper clippings, pamphlets, reports, and replies to his own letters of inquiry. All were organized by category and date, providing the data for the *Negro Yearbook* and the Tuskegee Lynching Report, both of which began in 1912. Each year he distributed the Tuskegee Lynching Report to southern newspapers and leaders to publicize the extent and injustice of lynch law. Under his editorship, nine editions of the *Negro Yearbook* provided information on discrimination and black progress to educators, researchers, and newspaper editorialists. In 1928 Work supplied another valuable research tool with the publication of *A Bibliography of the Negro in Africa and America*. It was the first extensive, classified bibliography of its kind.

Work did not spend all his time compiling data for others; he was also a teacher, department head, crusader, and researcher. He published over seventy articles and pamphlets. His research usually highlighted either the achievements of Africans and African Americans or the obstacles to black progress. Earlier than most black scholars, Work wrote in a positive manner about African history and culture. In a 1916 article for the *Journal of Negro History*, he declared that "Negroes should not despise the rock from which they were hewn." Work also investigated African American folktales and their African roots. Even before the Harlem Renaissance, Work celebrated the distinctiveness of African American culture. His meticulous scholarship was widely recognized in the academic community. In 1900 he became the first African American to publish an article in the *American Journal of Sociology*; the article dealt with black crime in Chicago and pointed to the lack of social services for African Americans. In 1929 he presented a paper at the American Historical Association annual meeting.

Although Work eschewed protest when he left the Niagara Movement and went to Tuskegee, he remained a quiet crusader for change. Early in his career Work developed a special interest in black health issues. In Savannah he started health education programs through the churches. He encouraged Booker T. Washington to establish National Negro Health Week in 1914. Work organized the week for seventeen years before it was taken over by the United States Public Health Service. He was also deeply concerned with the problem of lynching, and he became active in a southern-based movement to eradicate the evil. Work's estrangement from Du Bois made cooperation with the National Association for the Advancement of Colored People's antilynching campaign difficult, but Work found allies in the Atlanta-based Commission on Interracial Cooperation and the Association of Southern

Women for the Prevention of Lynching. The latter groups sought to change the South through education, while the NAACP sought change through legislation. Through his contacts in the antilynching campaign, Work became actively involved in numerous interracial groups in the South.

Monroe Work overestimated the power of education to eliminate prejudice, but his numerous articles and his quiet, dignified presence in biracial professional organizations and reform groups undoubtedly helped to dispel some of the southern white stereotypes of African Americans. He accepted the constraints required to work in the deep South in order to use his abilities to change it. After his death, in Tuskegee, two of his protégés established the Tuskegee Civic Association, which brought majority rule and desegregation to Macon County. Monroe Work was one of the lesser-known figures who tilled the soil from which the civil rights movement sprouted in the 1950s and 1960s.

FURTHER READING

A small collection of Work's personal papers is kept in the Tuskegee University Archives in Alabama, and a 1932 interview by Lewis A. Jones and other biographical materials can be found among the Jessie P. Guzman papers also at Tuskegee.

McMurry, Linda O. *Recorder of the Black Experience: A Biography of Monroe Nathan Work* (1985).

LINDA O. MCMURRY

WRIGHT, Louis Tompkins

(22 July 1891–8 Oct. 1952), surgeon, hospital administrator, and civil rights leader, was born in La Grange, Georgia, the son of Ceah Ketcham Wright, a physician and clergyman, and Lula Tompkins. After his father's death in 1895, his mother married William Fletcher Penn, a physician who was the first African American to graduate from Yale University Medical School. Raised and educated in Atlanta, Wright received his elementary, secondary, and college education at Clark University in Atlanta, graduating in 1911 as valedictorian of his class. His stepfather was one of the guiding influences that led to his choice of medicine as a career.

Wright graduated from Harvard Medical School, cum laude and fourth in his class, in 1915. While in medical school he exhibited his willingness to take a strong stand against racial injustice when he successfully opposed a hospital policy that would have barred him (but not his white classmates) from the practicum in delivering babies (obstetrics) at Boston-Lying-In Hospital. Despite an early record of publications, because of restrictions based on race, Wright completed an internship during 1915–1916 at Freedmen's Hospital, the teaching hospital at the Howard University School of Medicine in Washington, D.C., one of only three black hospitals with approved internship programs at that time.

While he was an intern at Freedmen's, Wright rejected a claim in the medical literature that the Schick test for diptheria could not be used on African Americans because of their heavy skin pigmentation. A study he conducted proved the validity of the usefulness of this test on dark-skinned people and was the basis of his second published paper, "The Schick Test, with Especial Reference to the Negro" (*Journal of Infectious Diseases* 21 [1917]: 265–268). Wright returned to Atlanta in July 1916 to practice medicine. In Atlanta he launched his civil rights career as a founding member of the Atlanta branch of the NAACP, serving as its first treasurer (1916–1917).

With the onset of World War I, Wright applied for a military commission and became a first lieutenant in the U.S. Army Medical Corps. A month before going overseas in June 1918, he married Corrine M. Cooke in New York City. They had two daughters, both of whom became physicians: Jane Cooke Wright and Barbara Penn Wright.

While Wright was in France, his unit was gassed with phosgene, causing him permanent lung damage. Because his injury (for which he received a Purple Heart) imposed physical limitations, he served out the rest of the war in charge of the surgical wards at three field hospitals. As a medical officer he introduced the intradermal method for smallpox vaccination ("Intradermal Vaccination against Smallpox," *Journal of the American Medical Association* 71 [1918]: 654–657), which was officially adopted by the U.S. Army.

In 1919, when Wright settled in Harlem to start a general medical practice, Harlem Hospital, a municipal facility with a 90 percent black patient population, had no African American doctors or nurses on staff. With an assignment effective 1 January 1920 as a clinical assistant (the lowest rank) in the Out-Patient Department, he became the first African American to be appointed to the staff of a New York City hospital. His steadfast and successful efforts during the 1920s working with hospital administrators and with city officials led gradually to

appointments for other African Americans as interns and attending physicians. His push for greater opportunities for African American professionals at Harlem Hospital culminated in a reorganization mandated in 1930 by William Schroeder, commissioner of the Department of Hospitals for the City of New York. The result was the first genuine effort to racially integrate the entire medical staff of a major U.S. hospital. By then Wright had risen to the position of visiting surgeon, and in October 1934 he became the second African American to be admitted to the American College of Surgeons (established in 1913). In 1938 he was appointed to a one-year term as the hospital's director of surgery. In 1929 he had achieved yet another breakthrough, as the first African American to be appointed as a police surgeon through the city's competitive civil service examination. He retained the position until his death.

In 1935 Wright was elected chairman of the national board of directors of the NAACP, a position he held until 1952. As a civil rights leader he opposed the establishment of hospitals exclusively for black people, and in the 1940s he argued for national health care insurance; he also challenged discriminatory policies and practices of the powerful American Medical Association. In a published open letter (dated 28 Jan. 1931) in response to an offer from the Julius Rosenwald Fund to build a hospital for blacks in New York City, Wright wrote: "A segregated hospital makes the white person feel superior and the black person feel inferior. It sets the black person apart from all other citizens as being a different kind of citizen and a different kind of medical student and physician, which you know and we know is not the case. What the Negro physician needs is equal opportunity for training and practice—no more, no less."

Treating common injuries in the surgical wards of Harlem Hospital led Wright to develop, in 1936, a device for handling fractured and dislocated neck vertebrae. In addition to this neck brace, he also designed a special metal plate to treat certain fractures of the femur. He became an expert on bone injuries and in 1937 was asked to write the chapter on head injuries for Charles Scudder's monumental textbook *The Treatment of Fractures* (1938), this being the first contribution by an African American to a major authoritative medical text.

Wright became ill with tuberculosis in 1939 and for nearly three years was confined to Biggs Memorial Hospital in Ithaca, New York. In 1939, while hospitalized, he was elected a diplomate of the American Board of Surgery. The year before, *Life* magazine had recognized him as the "most eminent Negro doctor" in the United States. In 1940 he was awarded the NAACP's prestigious Spingarn Medal for his achievements and contributions to American medicine.

In 1942, after returning to Harlem Hospital, Wright was appointed director of surgery, a position he held until his death. In 1945 he established a certified four-year residency program in surgery, a first for a black hospital. In 1948 he led a team of resident doctors in the first clinical trials of the antibiotic aureomycin with human beings. This pioneering testing at Harlem Hospital and subsequently at other hospitals paved the way for the approval of this drug and eventually other antibiotics by the U.S. Food and Drug Administration. In 1948 he established and became director of the Harlem Hospital Cancer Research Foundation, funded by the U.S. Public Health Service. Perhaps his crowning achievement was his election, that year, as president of the hospital's medical board.

Over the course of his long career at Harlem Hospital, Wright welded together into a harmonious whole the various white and black groups within the hospital. He recognized and confronted directly the problems faced by other ethnic professionals, particularly Jewish and Italian American physicians, so that shortly before his death, at the dedication of the hospital's Louis T. Wright Library, he said, "Harlem Hospital represents to my mind the finest example of democracy at work in the field of medicine."

Wright died in New York City. His presence at Harlem Hospital and on the national civil rights scene, and his voice and actions in public and private health forums and debates, had significant consequences for American medicine in three areas: it led to a rapport between black and white doctors that generated scientific and clinical research yielding important contributions in several areas of medicine; it dispensed with myths regarding black physicians that excluded them from any hospital staff on grounds other than those related to individual competence and character; and it led to the admittance of qualified physicians who were African American into local and national medical and scientific societies.

FURTHER READING

Wright published eighty-nine scientific articles in leading medical journals: thirty-five on antibiotics, fourteen in the field of cancer, six on bone trauma, and others on various surgical procedures on the colon and the repair of gunshot wounds.

Cobb, William Montague. "Louis Tompkins Wright, 1891–1952," *Journal of the National Medical Association* 45 (Mar. 1953): 130–148.

de L'Maynard, Aubre. *Surgeons to the Poor: The Harlem Hospital Story* (1978).

Obituary: New York Times, 9 Oct. 1952.

ROBERT C. HAYDEN

WRIGHT, Richard

(4 Sept. 1908–28 Nov. 1960), author, was born Richard Nathaniel Wright in a log cabin in the backwoods of Adams County, Mississippi. He was the eldest of the two sons of Nathaniel Wright, an illiterate sharecropper, and Ella Wilson, a semiliterate schoolteacher. Since the boll weevil had ravaged the local cotton industry, the family moved to Memphis, Tennessee, and shortly afterward, Nathaniel Wright abandoned them.

Ella Wright eked out a living by working as a servant in white households, but after a severe stroke in 1918, she was never able to work again. She and the boys went to live with her parents, Richard and Margaret Wilson, in Jackson, Mississippi. Wright's autobiographical narrative *Black Boy* (1945) gives a vivid picture of those difficult years in his grandparents' house. There were constant arguments and violent beatings. The family resources were stretched to the limits, and his grandmother, the family matriarch, bitterly resented Richard's independent spirit. She was a devout Seventh-day Adventist who believed that all books other than the Scriptures were "Devil's Work," and pressured Wright to be "saved" by the church. Wright remained an atheist all his life.

After a year at the Negro Seventh-day Adventist School in Jackson, Wright attended the Jim Hill Primary School and, in eighth grade, the Smith Robertson Elementary School. For the first time, he came into contact with the striving black middle class, whose models were people like W. E. B. DU BOIS and BOOKER T. WASHINGTON. He blossomed and soon proved an outstanding student. In 1925 Wright was the school valedictorian. That same

year, he had a short story published in the *Southern Register*, a local African American weekly. A black high school opened in Jackson for the first time that year, but Wright could not buy books or clothes from the money he earned from odd jobs after school. In November 1925 he left behind the hostile atmosphere in his grandmother's house and took the train to Memphis to seek full-time work.

His job opportunities were severely curtailed by the color of his skin. The best he could find was work as a messenger in an optical company. One day, in the local newspaper, he came across the name H. L. Mencken. It would prove a turning point. As a black man, Wright was not able to borrow books from the public library, but he persuaded an Irish coworker to lend him his card, and he went to the library, pretending to be picking up books for this white man. He took out two books by Mencken. Wright was excited to discover that the iconoclastic Baltimore journalist and literary critic used words like a weapon. He realized he wanted nothing more than to do the same. With Mencken's *A Book of Prefaces* as his guide, Wright began to read voraciously. He was painfully aware that his formal education extended only to the eighth grade, and that famous writers, as well as their subject matter, were invariably white.

Wright left the segregated South in November 1927. For the next ten years he lived in Chicago. He was one of 12 million black people who made that journey from the rural South to the industrial North during the Great Migration of 1916–1928, and he would describe it as the most traumatic journey of his entire life. His narrative *Twelve Million Black Voices* (1941), accompanied by WPA photographs, movingly conveys the two different worlds.

Wright soon landed a job as an unskilled laborer, sorting mail on the night shift at the Chicago Post Office—the best-paying job in town for a black man. Wright brought his mother, brother, and aunt to live with him in Chicago. During the Depression, however, Wright took whatever work he could find, while also pursuing his reading and writing with extraordinary determination.

In the fall of 1933 a white friend from the post office told him about the John Reed Club, a national organization of "proletarian artists and writers" founded by the Communist Party. Wright went along and met other aspiring artists and writers— mostly sons of Jewish immigrants. Stimulated by

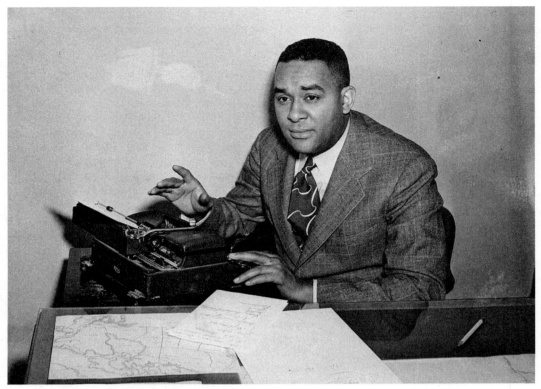

Richard Wright in New York City, 27 March 1945. (AP Images.)

this environment, he began to write poems, several of which were published in Communist magazines. His poem "I Have Seen Black Hands" was printed in the national weekly *The New Masses* in June 1934.

Early in 1934 Wright was pressured to join the Communist Party. Since it consciously fought racism and was one of the few places in the United States where blacks and whites mixed on an equal footing, Wright decided to do so, but from the beginning there were conflicts. He disliked being told what to do, and in his spare time, his writing was far more important to him than party work. Nevertheless, the party provided crucial support to Wright, both as an artist and as a bulwark against racism in America. He did not leave it until 1944, when he became an outspoken anti-Communist. He was disgusted that the Communist Party put civil rights issues on hold during World War II, at a time when blacks were expected to fight in segregated armed forces, and as he explained in his famous essay, "I Tried To Be a Communist," published in the *Atlantic Monthly* in August and September 1944, while the party claimed to be democratic, it actually took its orders from Moscow.

The Works Progress Administration (WPA) was established by President Franklin Roosevelt in May 1935, with the Federal Writers Project as one of its offshoots. Wright, who by now had published two short stories and thirteen poems, was signed on to the Illinois Writers Project as a supervisor. He could hardly believe his luck. This was a thirty-hour-a-week job, and the U.S. government was paying him to write. In his spare time Wright wrote a volume of short stories, *Uncle Tom's Children* (1938), and a novel, *Lawd Today!* (1963).

Wright was influenced by Marxism and the Chicago School of Sociology, which related neurotic behavior and crime to environment, and both were important influences on the South Side group of black writers that Wright organized in 1936. Other members who became well-known writers were

Frank Marshall Davis, MARGARET WALKER, and THEODORE (TED) WARD.

In May 1937 Wright moved to New York City. He became a friend and mentor to RALPH ELLISON, encouraged the young James Baldwin, and championed Chester Himes and Gwendolyn Brooks. Wright was briefly the Harlem correspondent for the Communist Party newspaper *The Daily Worker*, before he was transferred to the New York Writers Project. In February 1938 his writing career took off when he won a national competition of WPA writers for his collection of short stories *Uncle Tom's Children*, which portrayed the barbarism of black life and lynching in the Jim Crow South. Harper and Brothers published the book, which won Wright national recognition.

In 1939 a Guggenheim Fellowship allowed Wright to work full-time on his novel *Native Son* (1940). With its negative depiction of black ghetto life and its hint of interracial sex, the novel was controversial at the time and would remain so for decades to come. Promoted by the Book-of-the-Month Club, though the judges insisted on deleting nearly all allusions to interracial sexual attraction, the book sold a quarter of a million copies. Wright became the first best-selling African American writer. In 1941 the play *Native Son*, written by Wright and Paul Green and directed by Orson Welles, opened on Broadway to rave reviews. In 1945 Wright's autobiographical narrative *Black Boy*, again promoted by the Book-of-the-Month Club, sold an incredible half million copies. The original manuscript, entitled *American Hunger*, referring to the spiritual hunger of oppressed American blacks, portrayed Wright's formative years up to the beginning of the war, focusing on his experience of racism in both the deep South and in the North. The Book-of-the-Month Club insisted that he cut the second half, with its depiction of racism in the North and Wright's experiences in the Communist Party. Similarly, the judges disliked the unpatriotic title, and finally Wright changed it to *Black Boy*. The original manuscript was finally published posthumously in 1977 under its original title.

After a brief marriage to Dhimah Meidman in 1939, Wright married Ellen Poplowitz in March 1941, and their daughter Julia was born in 1942. His marriage to a white woman and the taunts that followed them when they walked together around New York and when Ellen went out with Julia reinforced Wright's desire to leave the country. He desperately

wanted to expand his horizons and see the world. Encouraged by Gertrude Stein, who lived in Paris and whose work he greatly admired, Wright and his family left for Paris in May 1946. Their second daughter, Rachel, was born in Paris on 17 January 1949.

Wright was thirty-eight and in his prime when he left for Europe, but that ship voyage across the Atlantic marked a dramatic downturn in his career. For the next fourteen years he continued to write prolifically, both fiction and nonfiction. In Europe his work was celebrated by the famous existentialists Jean-Paul Sartre and Simone de Beauvoir. He was interviewed frequently and his work was widely translated. He was regarded as an important American writer and public intellectual. But in the United States he was largely ignored. Even today, few Americans have heard of the titles he wrote after he left the United States—*The Outsider* (1953), *Savage Holiday* (1954), *Black Power* (1954), *The Color Curtain* (1956), *Pagan Spain* (1957), *White Man, Listen!* (1957), *The Long Dream* (1958), *Eight Men* (1961), and *Haiku: This Other World* (1998). Wright's exile writing had the same power, the same emotional persuasiveness. His nonfiction—a mixture of travel essay, memoir, biographical sketch, and political commentary—was in many ways ahead of its time. But in the highly conservative atmosphere of the McCarthyist 1950s, hard-hitting critiques of American racism and Western imperialism—and protest literature, in general—were no longer in vogue.

Wright's world opened up considerably after he left the United States. In 1949–1950 he spent almost a year in Argentina, where he played Bigger Thomas in the movie *Native Son*. (The film, made in an adverse political climate, with the forty-year-old Wright badly miscast as an eighteen-year old, was a financial flop.) In 1953 he visited the Gold Coast, a trip he chronicled in *Black Power*. In 1955 he attended the Bandung Conference in Indonesia, an experience he recalled in *The Color Curtain*. He spent time exploring life in Franco's Spain for the book *Pagan Spain* (1957), and he gave lectures that were collected in *White Man, Listen!* (1957).

American critics often refer to Wright's last fourteen years as his "exile" years. The term is hardly appropriate, however, since Wright's entire body of work prior to his departure for France was a passionate portrayal of what it was like to live as an exile in his native land. The prevalent view, even today, is that living abroad was bad for his writing,

that it cut him off from the reality of contemporary America, from his roots, and from the anger that fueled his writing. Others claim that Wright did not lose his power in the 1950s. What changed were the historical circumstances in which he was writing.

Wright died in Paris at the age of fifty-two. His death certificate gives a heart attack as the cause, but the circumstances of his premature death have always aroused suspicion, especially as it is known that the U.S. State Department watched him closely, throughout the 1950s. As someone who ceaselessly criticized American racism from his prominent vantage point as a black intellectual in Europe, Wright was something of a threat to the 1950s propaganda war.

Richard Wright was the first African American writer to enter mainstream American literature. A watershed figure in African American literature, he pushed back the horizons for black writers, expanding their possible subject matter. At the beginning of the twenty-first century, Wright's writing continued to provoke passionate responses, from deep admiration to vehement hostility. He is an *uncomfortable* writer. He challenges, he tells painful truths, he is a disturber of the peace. He was never interested in pleasing readers. Wright wanted his words to be weapons.

FURTHER READING

Fabre, Michel. *The Unfinished Quest of Richard Wright* (1973).

Kinnamon, Keneth, and Michel Fabre, eds. *Conversations with Richard Wright* (1993).

Rowley, Hazel. *Richard Wright: The Life and Times* (2001).

Walker, Margaret. *Richard Wright: Daemonic Genius* (1988).

Webb, Constance. *Richard Wright: A Biography* (1968).

Obituary: New York Times, 30 Nov. 1960.

HAZEL ROWLEY

DIRECTORY OF CONTRIBUTORS

AMALIA K. AMAKI
 Artis, William Ellisworth
FELIX L. ARMFIELD
 Jones, Eugene Kinckle
DORA JEAN ASHE
 Spencer, Anne
THABITI ASUKILE
 Rogers, Joel Augustus
LOUIS E. AULD
 Cox, Ida
REID BADGER
 Europe, James Reese
DAVID R. BAINS
 McGuire, George Alexander
JAMES FARGO BALLIETT
 Hite, Mattie
CHARLES "PETE" BANNER-HALEY
 Vann, Robert L.
SHARON L. BARNES
 Gilbert, Mercedes
ANNEMARIE BEAN
 Sissle, Noble
CHERYL BLACK
 Cooke, Marvel Jackson; Harvey, Georgette Mickey;
 Mitchell, Abbie; Thomas, Edna Lewis
MARY ANNE BOELCSKEVY
 Alston, Charles Henry; Bowman, Laura; Brown,
 Ada; Edmonds, S. Randolph; Fauset, Arthur Huff;
 Harleston, Edwin Augustus; Walrond, Eric; Wilson,
 Frank H.
LISA BRATTON
 Anderson, Charles Alfred (Chief)
CHRISTINE BROWN
 Carter, Elmer Anderson
A'LELIA BUNDLES
 Walker, A'Lelia; Walker, Madam C. J.
KEVIN JAMES BYRNE
 Dudley, Sherman H.
CHRISTOPHER CAINES
 Lee, Canada
H. ZAHRA CALDWELL
 Holstein, Casper; Johnson, Ellsworth (Bumpy)
DAVID A. CANTON
 Bruce, John Edward
CHARLES W. CAREY
 Dunbar, Paul Laurence
RICHARD CARLIN
 Handy, W. C.

GLENDA CARPIO
 Smith, Bessie
MARVA GRIFFIN CARTER
 Cumbo, Marion; Fletcher, Tom; Jessye,
 Eva Alberta
FAYE A. CHADWELL
 Carter, Eunice Hunton
BARBARA L. CICCARELLI
 Patterson, William L.
WILLIAM J. COBB
 Randolph, A. Philip
HARVEY COHEN
 Williams, Clarence
THOMAS COLBERT
 Jones, Laurence Clifton
FLORENCE M. COLEMAN
 Burch, Charles Eaton
JAMES LINCOLN COLLIER
 Ellington, Duke
LISA COLLINS
 Lawrence, Jacob Armstead
CALEB A. CORKERY
 Newsome, Mary Effie Lee
IDE CORLEY-CARMODY
 Duse, Mohammed Ali
ROBERT P. CREASE
 Rector, Eddie; Tucker, Snake Hips
PRUDENCE CUMBERBATCH
 Murphy, Carl
MACEO C. DAILEY
 Moton, Robert Russa
KAREN C. DALTON
 Baker, Josephine
HUGH DAVIS
 Gordon, Emmanuel Taylor; Horne, Frank
JARED N. DAY
 Payton, Philip A., Jr.
DOMINIQUE-RENE DE LERMA
 Bledsoe, Jules
CHRISTOPHER C. DE SANTIS
 Tolson, Melvin Beaunorus
PAMALA S. DEANE
 Gilpin, Charles Sidney; Randolph, Amanda
THOMAS F. DEFRANTZ
 Williams, Bert, and George Walker
PAUL DEVLIN
 Dean, Lillian Harris "Pig Foot Mary" Edwards,
 Jodie "Butterbeans"; Snow, Valaida

GEORGE H. DOUGLAS
Anderson, Eddie "Rochester"

ANNE K. DRISCOLL
Bentley, Gladys

RONALD DUFOUR
Coleman, Bill; Hawkins, Coleman; Henderson,
Fletcher; Hodges, Johnny; Redman, Don

PEG DUTHIE
Cullen, Frederick Ashbury

MARY FRANCES EARLY
Johnson, Hall

ALICE KNOX EATON
Dunbar-Nelson, Alice

MARTA EFFINGER-CRICHLOW
Jones, Madame Sissieretta Joyner

WILLIAM G. ELLIOTT
Blake, Eubie

ONITA ESTES-HICKS
Anderson, Regina; Nance, Ethel Ray

CAROLINE M. FANNIN
Julian, Hubert F.

ANTOINETTE BROUSSARD FARMER
Anderson, Marian; Freeman, Harry Lawrence;
Spivey, Victoria

LYNNE B. FELDMAN
Nail, John E.

SALLYANN H. FERGUSON
West, Dorothy

ROBERT E. FLEMING
Bontemps, Arna Wendell

DAMON L. FORDHAM
Markham, Dewey (Pigmeat)

JULIA L. FOULKES
Dafora, Asadata; Winfield, Hemsley

LISA D. FREIMAN
Delaney, Beauford

RUTH C. FRIEDBERG
Price, Florence B.

LINDA K. FULLER
Beavers, Louise

JULIE GALLAGHER
Hedgeman, Anna Arnold

SHENNETTE GARRETT
Calloway, Blanche Dorothea Jones

MARYBETH GASMAN
Johnson, Charles Spurgeon

LARRY R. GERLACH
Robeson, Paul

PAULA GIDDINGS
Wells-Barnett, Ida Bell

JENIFER W. GILBERT
Ottley, Roi

FREDA SCOTT GILES
McKay, Claude; Bubbles, John

GLENDA GILL
Waters, Ethel

JACQUELINE GOGGIN
Woodson, Carter Godwin

DENNIS GOUWS
Dill, Augustus Granville; Jackman, Harold

NATHAN L. GRANT
Bush-Banks, Olivia Ward

CHRISTINE GRAY
Richardson, Willis

PAMELA LEE GRAY
Campbell, Elmer Simms; Farrow, William McNight

ROBERT M. GREENBERG
Hayden, Robert Earl

FARAH JASMINE GRIFFIN
Holiday, Billie

MARY JEAN GROSS
Braithwaite, William Stanley Beaumont

RICHARD GRUPENHOFF
Tucker, Lorenzo

BETTY KAPLAN GUBERT
Schomburg, Arthur Alfonso

LAWRENCE GUSHEE
Oliver, King

DONNA HALPER
Gordon, Eugene

RENEE HANSON
Hathaway, Isaac Scott

RICHARD HARMON
Delany, Bessie, and Sadie Delany

ROBERT L. HARRIS
Barnett, Claude Albert; Wesley, Charles Harris

LEONARD HARRIS
Locke, Alain Leroy

DAPHNE DUVAL HARRISON
Hunter, Alberta; Wilson, Edith Goodall

JIM HASKINS
Bricktop

JAMES V. HATCH
Anderson, Garland

ROBERT C. HAYDEN
Wright, Louis Tompkins

CONSTANCE VALLIS HILL
Bates, Peg Leg; Robinson, Bill

DARLENE CLARK HINE
Bethune, Mary McLeod

ROBERT HINTON
Delany, Hubert T.

CAMARA DIA HOLLOWAY
Allen, James Latimer

THOMAS C. HOLT
Du Bois, W. E. B.

ELLIOTT HURWITT
Brooks, Shelton; Brymn, Tim; Cooke, Charles "Doc"; Cato, Minto; Dabney, Ford; Mack, Cecil; Thompson, Ulysses "Slow Kid"

AIDA AHMED HUSSEN
Cuney-Hare, Maud

LENA HYUN
Blackburn, Robert Hamilton

JOHN N. INGHAM
Pace, Harry Herbert

E. RENEE INGRAM
Bruce, Roscoe Conkling, Sr.

JEFF IOVANNONE
Gumby, Levi Sandy Alexander

ERIC R. JACKSON
Frazier, E. Franklin

KENNETH R. JANKEN
White, Walter Francis

CLIFTON H. JOHNSON
Cullen, Countee

GWENDOLYN S. JONES
Delany, Clarissa Scott

REGINA V. JONES
Washington, Fredi

ROBIN JONES
Burke, Selma Hortense; Waring, Laura Wheeler

DAVID JOYNER
Waller, Fats

ANN T. KEENE
Hayes, Roland

ALLISON KELLAR-LENHARDT
Barnett, Etta Moten; Blanks, Birleanna

BARRY KERNFELD
Bernhardt, Clyde; Bradford, Perry; Hegamin, Lucille; Hall, Adelaide; Hill, Chippie; Hopkins, Claude; Johnson, James P.; Ory, Kid; Lunceford, Jimmie; Miles, Lizzie; Page, Hot Lips; Razaf, Andy; Taylor, Eva; Smith, Willie "The Lion"; Smith, Clara; Smith, Mamie; Smith, Trixie; Webb, Chick

SEAN KINDER
Matheus, John Frederick

AMY H. KIRSCHKE
Douglas, Aaron

THEODORE KORNWEIBEL
Owen, Chandler

DAVID KRASNER
Cook, Will Marion

DANIEL J. LEAB
Still, William Grant

THERESA LEININGER-MILLER
Barthé, Richmond; Bennett, Gwendolyn; Hayden, Palmer; Johnson, Sargent Claude; Prophet, Elizabeth; Smith, Albert Alexander

DONALD LEVIT
St. Clair, Stephanie "Queenie"

ALAN LEVY
Burleigh, Henry Thacker; Dett, R. Nathaniel

EUGENE LEVY
Johnson, James Weldon

SHOLOMO BEN LEVY
Father Divine; Ford, Arnold Josiah; Johnson, William H.; Toomer, Jean

RALPH E. LUKER
Hurston, Zora Neale

MICHAEL MAIWALD
Fisher, Rudolph; Thurman, Wallace

JULIAN MASON
Chesnutt, Charles Waddell

ERIK S. MCDUFFIE
Thompson Patterson, Louise

ROBYN MCGEE
Calvin, Floyd (Joseph)

CHRISTINE G. MCKAY
Harrington, Oliver W.

ADAM D. MCKIBLE
Williams, Edward Christopher

LINDA O. MCMURRY
Carver, George Washington; Work, Monroe Nathan

KRISTIE MILLER
De Priest, Oscar Stanton

MICHAEL MIZELL-NELSON
Christian, Marcus Bruce

JAMES ROSS MOORE
Mills, Florence

DEWEY FRANKLIN MOSBY
Tanner, Henry Ossawa

AMBER MOULTON-WISEMAN
Briggs, Cyril Valentine

WILLIAM F. MUGLESTON
Garvey, Marcus; Washington, Booker T.

PETER MUIR
Davenport, Charles Edward (Cow-Cow)

GAYLE MURCHISON
Work, John Wesley, III

ELLIS NASSOUR
Mabley, Moms

STEVEN J. NIVEN
Calloway, Cab; Poston, Ted; Scottsboro Boys; Rainey, Ma; Schuyler, George Samuel; Spaulding, Asa Timothy

W. FARRELL O'GORMAN
Cotter, Joseph Seamon, Sr.

JONETTE O'KELLEY MILLER
McKinney, Nina Mae

SUSAN GUSHEE O'MALLEY
Baker, Ella

SANDRA OPDYCKE
Ford, James William

LOUIS PARASCANDOLA
Johnson, Georgia Douglas; Popel, Esther

JEFFREY B. PERRY
Harrison, Hubert Henry

BERNARD L. PETERSON
Muse, Clarence E.

MIRIAM J. PETTY
Fetchit, Stepin; Preer, Evelyn; Welch, Elizabeth

MARTHA PITTS
Bibb, Joseph Dandridge

CAROL C. POLSGROVE
Padmore, George

ARNOLD RAMPERSAD
Ellison, Ralph Waldo

SUSAN J. RAYL
Cooper, Tarzan

ANN RAYSON
Larsen, Nella

SHANA L. REDMOND
Brown, Lawrence Benjamin

ALTHEA E. RHODES
Bonner, Marita Odette

BRENTON E. RIFFEL
Turner, Big Joe

LISA RIVO
Brown, Hallie Quinn; Catlett, Elizabeth; Fuller, Meta Warrick; Jones, Lois Mailou; Micheaux, Oscar; Savage, Augusta; Sul-Te-Wan, Madame; VanDerZee, James Augustus Joseph; Woodruff, Hale Aspacio; Wells, James Lesesne; Wilson, Ellis

HILDRED ROACH
Joplin, Scott

RITA ROBERTS
Moore, Frederick Randolph

HAZEL ROWLEY
Wright, Richard

CHRIS RUIZ-VELASCO
Griggs, Sutton E.

THADDEUS RUSSELL
Hamid, Sufi Abdul

ELIZABETH RUSSEY
Dawson, William Levi [ii]

ROGER A. SCHUPPERT
Brawley, Benjamin

LAINE A. SCOTT
Grimke, Angelina Weld

MATTHEW SEWELL
Nicholas, Fayard and Harold Nicholas

EUNMI SHIM
Smith, Chris

ANGELA SIDMAN
Motley, Archibald J., Jr.

BEVERLY L. SKINNER
Davis, Arthur Paul

ERIC LEDELL SMITH
Brown, E. C. (Edward Cooper); Evanti, Lillian Evans; Gibson, John Trusty

ERIN A. SMITH
Fauset, Jessie Redmon

GARY SCOTT SMITH
Powell, Adam Clayton, Sr.

JACK SOHMER
Armstrong, Lil; Miley, Bubber

ROBERT STEPTO
Brown, Sterling Allen

RODGER STREITMATTER
Trotter, William Monroe

ELAINE E. THOMPSON
Pierce, Billy

WILLIAM THOMSON
Rushing, Jimmy; Snowden, Elmer

FRANK TIRRO
Armstrong, Louis

EDGAR ALLAN TOPPIN
Haynes, George Edmund; Scott, Emmett Jay

STEVEN C. TRACY
Hughes, Langston

CONSTANCE PORTER UZELAC
Coleman, Bessie; Porter, James Amos

J. E. VACHA
Hall, Juanita

MELISSA VICKERY-BAREFORD
McClendon, Rose

PETER WALLENSTEIN
Powell, Adam Clayton, Jr.

MICHAEL SALIM WASHINGTON
Bechet, Sidney

YOLANDA L. WATSON
Du Bois, Nina Yolande

ELEANOR F. WEDGE
Bearden, Romare

GEORGE P. WEICK
Attaway, William Alexander

JUDITH WEISENFELD
Haynes, Daniel

KIMBERLY WELCH
Redding, J. Saunders

DENNIS WEPMAN
Walker, Margaret

SARA GRAVES WHEELER
Johnson, Mordecai Wyatt

CHRISTOPHER WILLIAMS
Clarke, John Henrik

LATICIA ANN MARIE WILLIS
Granger, Lester Blackwell

CLINT C. WILSON
Abbott, Robert Sengstacke

MICHAEL R. WINSTON
Miller, Kelly

CHARLES K. WOLFE
Lead Belly

JENNIFER WOOD
Johnson, John Rosamond

SHANTEE WOODARDS
Miller, May

RICHARD WORMSER
Morton, Jelly Roll

JACOB ZUMOFF
Domingo, Wilfred Adolphus; Moore,
Richard Benjamin

INDEX

Page numbers in **boldface** refer to main entries.

Abatino, Giuseppe "Pepito", 29
Abbot, Lynne, 180–81
Abbott, George, 234, 461
Abbott, Robert Sengstacke, **1–2**, 31, 118–19, 374, 384
Abernathy, Ralph, 394
Abraham Lincoln (Drinkwater), 221
Abrahams, Peter, 390
Abramson, Doris, 340
Adams, Barbara Eleanor, 117
Adams, Billy, 469
Addams, Jane, 36
Adderley, Cannonball, 334
Adelbert College, 536–37
"Adventures of My Scrapbooks, The" (Gumby), 231
AFL-CIO, 416
Afram House Inc., 97
African Academy of Arts and Research, 143
African-American Art (Wright), 5
African Blood Brotherhood for African Liberation and Redemption (ABB), 72, 160, 361–62
African Suite (Bledsoe), 59
African Times and Orient Review (ATOR), 177, 215
African Woman (Barthé), 38
African Youth (Artis), 22
Afro-American Federation of Labor, 236
Afro-American League (AAL), 83, 513–14
Afro-American Realty Company, 360, 395
Afro-American Symphony (Still), 472
Agriculture Department, U.S., 32, 106
Aida (Verdi), 12, 58–59, 110
"Ain't Misbehavin'," 19–20, 419, 506
Alabamians, 98–99
Albertson, Chris, 455
Aldridge, Ira, 10, 79, 440
Alex, Joe, 28–29
Alexander, Daniel William, 342
Alexander, Raymond, 509
Alexander, Sadie, 509
Alfred University, 21–22
Ali, Muhammad, 200, 496
Allen, Gracie, 180
Allen, Henry "Red," 17, 247, 271, 273, 296, 469
Allen, James Latimer, **2–4**
Allen, Moses, 330–31
Allen University, 77
All God's Chillun Got Wings (O'Neill), 9, 427

Allied Arts Centre, 139
All Negro Hour, The, 126–27
Along This Way (Johnson), 297, 299
Alpha Phi Alpha, 526
"Also Ran Blues, The," 219
Alston, Charles Henry, 2–5, **4–5**, 40, 53, 151, 321, 437, 524, 540, 544–45
Amaki, Amalia K., 23
Amanda, 418
Amateur Night at the Apollo (Cooper), 139
Amazing Grace, 333
America (Fauset and Bright), 196
American Academy in Rome, 186
American Dilemma, An (Myrdal), 81
American Federation of Labor (AFL), 415–16
American Journal (Hayden), 251–52
American Labor Party (ALP), 406
American Negro Academy, 166, 353, 439
"American Negro Folk Literature" (Fauset), 195
American Negro Labor Congress (ANLC), 361
American Negro Songs and Spirituals (Work), 548
American Negro Theatre (ANT), 14
American Society of Composers, Authors, and Publishers (ASCAP), 56, 74, 124, 145, 183, 203, 335, 364, 420, 456, 549
Amistad murals (Woodruff), 544
Amos, Emma, 545
Amos 'n' Andy, 417–18
Amsterdam News, 29, 46, 71–72, 125, 123–29, 240, 255, 274, 317, 343, 347, 383–84, 401, 403, 431, 458, 462
Amtrak Blues, 279
Anderson, Agnes Campbell, 90
Anderson, Akili Ron, 310
Anderson, Charles Alfred "Chief," **5–7**
Anderson, Charles W., 395
Anderson, Doris Garland, 9
Anderson, Eddie "Rochester," **7–8**, 88, 506, 517, 541
Anderson, Garland, **8–10**
Anderson, Ivie, 183
Anderson, Marian, **10–13**, 59, 80, 125, 138, 157, 180, 190, 253–54, 291–92, 409, 509, 530–31
Anderson, Regina, **13–15**, 375
And They Lynched Him on a Tree (Still), 472
Angelou, Maya, 118
Angle of Ascent (Hayden), 251–52
"Animal Crackers," 350

Anna Lucasta (Yordan), 65, 326

Antar of Araby (Cuney-Hare), 139–40

Anti-Caste, 35

Anything Goes with Pigmeat Markham, 337

Apollo Theater, 130, 202, 334, 337

Appeal to the World, An (Du Bois), 168

Appearances (Anderson), 8–9

Arch, The, 134

Arican Orthodox Church (AOC), 340–42

Aristocats, The, 133

"Arkansas Blues," 259

Arlen, Harold, 136

Armfield, Felix L., 308

Armstrong, Lil, 15–20, **15–17,** 381–82

Armstrong, Louis, 8, 15–21, **17–21,** 45, 66, 73, 96,
 98–99, 110, 121–22, 132, 151, 181, 184–85, 219, 247,
 261–62, 264, 266, 277, 291, 296, 333, 350–51, 363,
 381–83, 391–92, 411, 417, 419, 423, 454–55, 457,
 459, 463, 469, 479, 506, 520, 535–36, 539

Armstrong, Samuel Chapman, 510–11

Arrested Development, 337

Arsenic and Old Lace (Kesselring), 357–58

Art Institute of Chicago, School of the Art Institute of
 Chicago, 37–38, 192–93, 364–66

Artis, William Ellisworth, **21–23,** 53, 437, 540

ARTnews, 54

Art of the Negro (Woodruff), 545

Arts Quarterly, 179

Art Students League, 53, 101

Arvey, Verna, 472

Ashe, Arthur R., Jr., 293

Ashe, Dora Jean, 468

Aspects of Negro Life (Douglas), 162

Associated Negro Press (ANP), 31–33, 175, 220

Associated Publishers Representatives, 32

Association for the Integration of Management
 (AIM), 467

Association for the Study of African American Life and
 History, 50, 83, 280, 527, 547–48

Association of Southern Women for the Prevention of
 Lynching, 550–51

Astaire, Fred, 89, 379, 430

As Thousands Cheer, 518

Asukile, Thabiti, 432

Athenaeum, 68

"A-Tisket, A-Tasket," 521

At Jolly Coon-ey Island, 313

Atkinson, Brooks, 234, 340, 518, 541

"Atlanta Compromise" (Washington), 130, 166, 352,
 442, 512–13

Atlanta Constitution, 1–2

Atlanta riots, 514, 529

Atlanta University, 5, 21–22, 51, 68, 158, 166, 168, 209,
 238–39, 251, 275, 283, 352, 357, 387, 544–45

Atlantic Monthly, 112–13, 166, 200–201

Atlantic Records, 492–93

Attaway, William Alexander, **23–24**

"At the End of the Road," 255

Auld, Louis E., 131

"Aunt Hagar's Children Blues," 87

Aunt Jemima, 417

Aunt Sara's Wooden God (Gilbert), 220

"Aunt Viney's Sketches" (Bush-Banks), 94

Aurienoth Club, 206

Aurthur, Bob, 262

Austin, J. C., 235

Austin, Lovie, 131, 262, 411

Autobiography of an Ex-Colored Man, The (Johnson),
 298–99

Autumn Love Cycle, An (Johnson), 289

Averty, Jean-Cristophe, 57

Avery Institute, 238

Avon, 102

Awakening of Hezekiah Jones, The (Bruce), 83

Azikiwe, Nnamdi "Ben," 389

"Baby Won't You Please Come Home," 535

Bach, Johann Sebastian, 249

"Backwater Blues," 296, 454

Badger, Reid, 190

Bad Man (Edmonds), 179

Bailey, Al, 204

Bailey, Buster, 16, 66, 278

Bailey, Pearl, 42, 99–100, 235, 334, 392, 423–24, 451, 475

Bains, David R., 342

Baker, Ella, **25–27,** 442

Baker, Josephine, **27–31,** 38, 45, 56, 218, 231, 233, 270,
 278, 356, 379, 450, 462, 517, 522

Baldwin, Davarian, 502

Baldwin, James, 53, 118, 136, 151–52, 555

Baldwin, Ruth Standish, 256

Bal jeunesse (Hayden), 250

"Ballad for Americans," 80

Ballad of a Brown Girl, The (Cullen), 135

Ballad of John Henry (Hayden), 250

Ballad of Remembrance, A (Hayden), 251–52

"Ballad of Walter White" (Hughes), 530

Balliett, James Fargo, 264

"Ballin' the Jack," 456

Ballo in Maschera, Un (Verdi), 12

Baltimore Afro-American, 40, 46, 368–70

Bamville, 28

Banana Bottom (McKay), 343
Bandanna Land, 533
Banjo (McKay), 343
Banjo Lesson, The (Tanner), 477
"Banjo Song, A" (Dunbar), 477
Bankers Trust Company, 439–40
Banneker, Benjamin, 439
Banner-Haley, Charles Pete T., 498
Baquet, George, 44
Barbarin, Paul, 348, 457
Barkroot Carnival, 144
Barlow, William, 411
Barnes, Mae, 58
Barnes, Sharon L., 220
Barnet, Will, 53–54
Barnett, Claude Albert, 31–34, **31–33**
Barnett, Etta Moten, 32–34, **33–34**
Barnett, Ferdinand L., 36
Barnett, Ida B. Wells, 1, 13, **34–37,** 308
Barrett, Wilson, 176
Barron's Exclusive Club, 182
Barry, Marion, 525
Barrymore, Ethel, 339–40, 417
Barthé, Richmond, 21, **37–39,** 437, 500, 539–40
Basic College Early Entry Program, 286–87
Basie, Count, 99, 185, 261, 266, 270, 297, 330–31, 333, 391, 423–24, 433, 464, 492, 506, 521
Basquiat, Jean-Michel, 496
Bass, Charlotta, 481
Batanga (Dafora), 143
Bates, Ad, 40
Bates, Daisy, 402
Bates, Peg Leg, **39–40**
Bates, Ruby, 444–46
Battle, Samuel J., 137
"Baxter's Procrustes" (Chesnutt), 113
Bean, Annemarie, 451
Bearden, Bessye, 240–41
Bearden, Romare, 4, 21, **40–42,** 47, 53, 91, 240, 400, 435–37, 496, 545
Beasley, Delilah, 474
Beatty, Talley, 519
Beavers, Louise, **42–43,** 408, 418, 474–75, 516
Bechet, Sidney, 17, 19, 28, **43–46,** 86, 182, 264, 270, 349–50, 364, 382, 392, 411, 451, 458–61, 479, 535–36
"Before the Feast of Shushan" (Spencer), 468
Beiderbecke, Bix, 351
Belafonte, Harry, 14, 24, 30–31, 334, 475
Belasco, David, 479
Belle of 14th Street, The, 88
Bellow, Saul, 187

Benét, Stephen Vincent, 504
Benjamin, Tritobia Hayes, 309
Bennett, Gwendolyn, 4, **46–47,** 53, 155, 162
Benny, Jack, 7–8
Bentley, Gladys, **47–48**
Berlin, Irving, 73–74, 110, 344, 518
Berman, Sam, 102
Bernhardt, Clyde, **48–50**
Berry, Chu, 16, 99
Berry, Halle, 529
"Beso, El" (Grimké), 229
Best, Willie, 199
Bethune, Mary McLeod, **50–51,** 92, 104, 156, 307, 401, 500, 503, 524
Bethune-Cookman College, 50, 414
Betrayal, The, 346
Beulah, 43, 417–18, 519
"Beware Lest He Awakes" (Grimké), 229
Bibb, Joseph Dandridge, **51–52**
Bier, Justus and Senta, 540
Bigard, Barney, 183–84, 265, 350, 363, 382–83
Big Fella, 522–23
Big Mama (Burke), 92
Big Sea, The (Hughes), 275
Bill Haley and the Comets, 493
Binga, Jesse, 118–19
Birth of a Nation, The, 407, 473–75, 490
Birth of the Spirituals (Barthé), 38
Birthright (Stribling), 197
Bishop, Rudine Sims, 378
"Black, Brown, and Beige" (Ellington), 183
Black, Cheryl, 126, 246, 358, 480
"Black and Tan Fantasy" (Ellington), 183–84
Black Arts Movement, 15, 108–9, 187, 306, 311, 329, 545
Blackbirds, 56, 88, 110, 233, 344, 356, 419–20, 430, 483, 491–92, 522
Black Bourgeoisie (Frazier), 209–10
Black Boy (Wright), 553, 555
Blackburn, Robert Hamilton, **52–55,** 251, 524, 544
Black Cabinet, 51, 272, 307, 401, 498, 531
Black Devils, 86
Black Eagle Enterprises, Ltd., 317
Blacker the Berry, The (Thurman), 162, 484
Black Gods of the Metropolis (Fauset), 196
Black History (Douglas and Harleston), 239
Black History (television documentary), 200
black Jews, 205–7
Black Manhattan (Johnson), 150, 189, 298, 355–56
Black No More (Schuyler), 441
Black Odyssey (Ottley), 384
Blackouts, 39

Black Panthers, 109, 394

Black Patti's Troubadours, 313

Black Politician, The, 171

Black Power (movement), 187, 200, 428, 416

Black Power (Wright), 555

Black Reconstruction in America (Du Bois), 168

Black Revue, 45

Blacks in Blackface (Sampson), 218

"Black Snake Blues," 468

Black Star Line, 217

Black Swan Phonograph Corporation, 387, 516

Black Thunder (Bontemps), 62–63

"Black Visual Arts, The" (Jones), 311

Black Wings (Powell), 120

Blake, Eubie, 28, **55–57,** 74, 76, 96, 110, 138, 189–90,
 245, 259, 278, 291, 295, 345, 355, 358, 378, 417, 419,
 449–51, 462–63, 496, 500, 516, 522

Blanks, Birleanna, **57–58**

Blanton, Jimmy, 184

"Blazing Accusation" (Miller), 354

Bledsoe, Jules, **58–59,** 255, 340

Blesh, Rudi, 262–63, 296–97

Block, The (Bearden), 41

Blonde Venus, 408

Blood on the Forge (Attaway), 23

Blood Red Record, The (Bruce), 83

"Blueberry Rhyme," 296

"Blue Meridian" (Toomer), 488

Blues (Handy), 237–38

Blues (Motley), 365

Blues Brothers, The, 100

Blues for Rampart Street, 131

Blue Steel (Still), 472

Blyden, Edward, 439

B'nai Abraham Progressive Corporation, 206

Boardinghouse Blues, 333

Boas, Franz, 280

Body and Soul (films), 220, 326, 346

"Body and Soul" (song), 248

Boelcskevy, Mary Anne, 5, 65, 75, 180, 196, 240, 508, 542

Bogle, Donald, 42–43, 75, 344, 516, 519

Bolden, Buddy, 17, 364, 382

Bombshell, 42–43

Bond, Horace Mann, 286

Bond, Julian, 26–27

Bondage (Bledsoe), 59

Bonds, Margaret, 135, 409

Bone, Robert A., 23

Bonner, Marita Odette, **59–61**

Bontemps, Arna Wendell, 23, **61–63,** 102, 136, 275, 283,
 286, 328, 377, 488, 528, 549

Book of American Negro Poetry, The (Johnson), 298

Book of American Negro Spirituals (Johnson), 79

Book of Prefaces, A (Mencken), 553

Boothbay Harbor (Hayden), 250

Bootsie (Harrington), 240–42

"Borden Case, The" (Gordon), 225

Born to Be (Gordon), 223

Boston (Sinclair), 393

Boston Guardian, 489–90

Boston Museum of Fine Arts, Boston School of the
 Museum of Fine Arts, 238–39, 309–11

Boston Post, 224–25, 527

Boston Riot, 489

Boston Transcript, 229

Boswell Sisters, 202

Bottom of the Cup, The, 255

Bouillon, Jo, 30

Bourne, Stephen, 522

Bowman, Elmer, 455

Bowman, Laura, **63–65**

Bowser, Pearl, 347

Boykin, Cloyd, 250

"Boy Who Painted Christ Black, The" (Clarke), 116

Braden, Carl, 27

Bradford, Perry, **65–66,** 86, 456, 458, 538

Bradley, Buddy, 356, 396, 421

Bradley, Mary Hastings, 377

Bradshaw, Tiny, 202

Brady, Mary Beattie, 509

Braithwaite, William Stanley Beaumont, 46, **67–68,**
 197, 289

Branson, Lloyd, 151

Bratton, Lisa M., 7

Braud, Wellman, 350

Brawley, Benjamin, **68–69,** 211

Brawley, Edward McKnight, 68–69

Bricktop, **70–71,** 277, 355

Briggs, Cyril Valentine, **71–73,** 160, 361, 389

Bright, Nellie Rathbone, 196

Bring in 'Da Noise, Bring in 'Da Funk, 380

British Anti-lynching Committee, 36

Broadway, 9, 19, 28, 32–34, 39, 55–57, 64–65, 87,
 99–100, 122, 136, 138, 182, 204, 218, 220, 223–24,
 234–35, 245, 255, 263, 276, 291, 298–300, 326–27,
 333, 355, 357–58, 378–80, 396–97, 417, 419–20,
 425–27, 430, 450–51, 455, 462, 464, 469, 472, 479–80,
 483, 490, 506, 517–18, 522, 532, 536, 538, 541, 555

Broadway Bill, 371–72

Broadway Rastus, 218

Brodsky, Joseph, 445

Broken Banjo, The (Richardson), 425

"Bronx Slave Market" (Cooke), 126
Bronze (Johnson), 289
Brooklyn Eagle, 134
Brooks, Gwendolyn, 555
Brooks, Shelton, **73–74,** 142
Broonzy, Big Bill, 492
Brotherhood of Sleeping Car Porters (BSCP), 415–16
Browder, Earl, 208
Brown, Ada, **74–75**
Brown, Anne, 180
Brown, Charlotte Hawkins, 214, 310, 503
Brown, Christine G., 104
Brown, E. C. (Edward Cooper), **75–76,** 218
Brown, Hallie Quinn, **76–79**
Brown, Lawrence, 516
Brown, Lawrence Benjamin, **79–80**
Brown, Lloyd Louis, 80
Brown, Ray, 203
Brown, Ruth, 97
Brown, Sterling Allen, **80–82,** 146, 155, 286
Brown and Stevens Bank, 75–76
Brown Buddies, 74
Brownies' Book, 159, 196, 273, 319–20, 377, 424–25, 452
Browning, Robert, 468
Brown Savings Bank, 75
Brownsville affair, 514
Brown v. Board of Education, 281, 402, 446, 466, 531
Bruce, Blanche Kelso, 84
Bruce, John Edward, **82–84,** 177, 243
Bruce, Josephine Beall Willson, 84
Bruce, Roscoe Conkling, Sr., **84–86**
Brussels World's Fair, 5
Brymn, Tim, **86–87,** 210, 455–56, 460
Bubbles, John, **87–89,** 141, 523
Buck and Bubbles, 87–88
Buckner, Ted, 331
Bullard, Eugéne, 70
Bumbry, Grace, 191
Bunche, Ralph, 168
Bundles, A'Lelia, 500, 502–3
Burch, Charles Eaton, **89–91**
Bureau of Labor, U.S., 166
Burke, Selma Hortense, 21, **91–92,** 251, 437
Burleigh, Henry Thacker, 12, **92–93,** 289, 310, 314, 356, 509
Burley, Dan, 458
Burns, George, 180
Burns, Tommy, 293
Burrill, Mary P., 353–54, 424–25, 537
Burris, James, 456
Burroughs, Nannie Helen, 369

Burton, Richard, 71
Bush, Anita, 58
Bush-Banks, Olivia Ward, **93–95**
Butcher, Philip, 67–68
Butterbeans and Susie, 180–81, 333
Byas, Don, 248, 423
"Bye Bye Blues," 99
Byrne, Kevin, 172

Cabin in the Sky (film), 8, 88
Cabin in the Sky (play), 8, 518–19
Cable, George Washington, 113
Café Society, 266–67
Caines, Christopher, 327
Caldwell, H. Zahra, 269, 288
Caleb, the Degenerate (Cotter), 130
Calhoun, W. Arthur, 253
California Eagle, 72
Callahan, John F., 188
Callahan, William, 446
Calloway, Blanche Dorothea Jones, 96–98, **96–97**
Calloway, Cab, 73, 96–101, **97–100,** 263, 324, 330, 333, 379, 430, 463, 506, 539
Calverton, V. F., 486
Calvin, Floyd (Joseph), **100–101,** 408
Calvin's News Service, 100–101
Calypso Song Book (Attaway), 24
Cameron, Lucille, 294
Camp, Walter, 426
Campbell, E. J., 478
Campbell, Elmer Simms, **101–2**
Cane (Toomer), 67, 488–89
Cantarow, Ellen, 25, 27
Canton, David Alvin, 84
Capra, Frank, 371–72
Carey, Charles W., Jr., 174
Carey, Mutt, 382
"Carioca, The," 33
Carlin, Richard, 238
Carmen Jones, 475
Carmichael, Stokely, 217
Carnegie Hall, 11, 13, 138, 147, 183, 205, 296, 427–28, 492
Carney, Harry, 45, 264–65, 350
"Carolina Shout," 295
Caroling Dusk (Cullen), 134, 155, 162, 230
Carpio, Glenda R., 455
Carr, Dora, 144
Carr, Ian, 121
Carroll, Diahann, 154, 235, 475
Carroll, Vinnette, 299

Carson, Eddie, 27–28
Carter, Benny, 121, 248, 261, 267, 461, 464, 520
Carter, Elmer Anderson, **103–4**
Carter, Eunice Hunton, **104–5**
Carter, Jimmy, 92, 311, 354, 525
Carter, Marva Griffin, 138, 205, 285, 357
Caruso, Enrico, 223, 253
Carver, George Washington, 38, 62, **105–7,** 164, 246, 467, 511
Casino de Paris, 29
Castle, Nick, 379
Castle, Vernon and Irene, 141, 189
"Castle Rock," 264
Castles in the Air (Castle), 189
Catlett, Big Sid, 20, 248, 464
Catlett, Elizabeth, **107–9,** 310, 524, 544
Cato, Minto, **109–11,** 419
Cavalcade (Davis and Redding), 146
CBS, 200, 417–18
Central Plaza, 462
Century, 320
Century Association, 187
Chadwell, Faye A., 105
Chadwick, George W., 409
Challenge Magazine, 23, 528
Chapin, James, 143
Charles, Ray, 434
Charles, Robert, 364
"Charleston," 295, 297, 335, 522
"Chattanooga Shoe Shine Boy," 132
Chauvin, Louis, 315
Cheatham, Doc, 271
Cheatham, Wallace, 12
Chenault, Lawrence, 172
Chesnutt, Charles Waddell, 94, **111–15,** 130, 175, 227, 346, 490, 537
Chester (Johnson), 303
Chester, Roscoe, 116
Chicago Academy of Fine Arts, 192
Chicago Art League, 192
Chicago Bee, 52, 386
Chicago Defender, 1–2, 31, 45, 52, 110, 118, 126–27, 192, 198–99, 225, 240, 274–75, 278, 345, 384, 396, 432, 463, 534
Chicago Race Relations Commission, 285–86
Chicago riots, 36–37, 285–86, 530
Chicago Tribune, 384
Chicago Whip, 2, 52, 235, 274
Chico and the Man, 133
Chinaberry Tree, The (Fauset), 197
Chip Woman's Fortune, The (Richardson), 64, 425

Chisholm, Shirley, 394
Chisum, Melvin J., 514
Chocolate Dandies, The, 28, 56, 450–51
Chocolate Kiddies, 233
Choynski, Joe, 292–93
Christian, Charlie, 131, 185
Christian, Marcus Bruce, **115–16**
"Christ in Alabama" (Hughes), 274
Chronology of African-Americans in New York, 1621–1966, A (Anderson and Nance), 15
Church, Robert R., Sr., 387
Ciccarelli, Barbara L., 394
City College of New York, 142
"City of Refuge, The" (Fisher), 200
Civic Club, 14
Civil Rights Acts, 34, 258–59, 404, 416
Civil Rights Congress (CRC), 394
Civil War, 55, 76, 82, 111–13, 164–65, 175, 179, 199, 307, 351, 368, 374, 405, 426, 440, 473, 505, 510, 512–13, 526, 546
Clapham, George, 45
Clark, Ed, 152
Clark, Kenneth B., 422, 437
Clarke, John Henrik, **116–18,** 442
Clayton, Buck, 266, 433
Clef Club, Clef Club Orchestra, 86–87, 123, 141, 188–89, 205, 456
Cleveland, Grover, 489
Cleveland Museum of Art, 109
Cleveland Symphony Orchestra, 210
Clifford, Carrie, 537
Climbing Jacobs Ladder (Anderson), 13–14
Clinton, Bill, 100, 287, 368
Clorindy, the Origin of the Cakewalk, 122–23, 356–57
"Close Ranks" (Du Bois), 167
"Closing Door, The" (Grimké), 229
Cobb, William J., 417
Cochran, Charles B., 355–56, 451
Cohen, Harvey, 536
Colbert, Thomas Burnell, 309
Cole, Cozy, 99
Cole, Johnnetta, 155, 287
Cole, Nat "King," 121, 333
Cole, Robert, 122, 298–300, 313, 357, 533
Coleman, Bessie, **118–20,** 316
Coleman, Bill, **120–22**
Coleman, Florence M., 91
Coles, Honi, 523
Collapse of the Confederacy, The (Wesley), 526
Collier, James Lincoln, 185
Collins, Lisa Gail, 323

Colonel's Dream, The (Chesnutt), 111, 113–14
Color (Cullen), 134–35
Color and Democracy (Du Bois), 168
Color Curtain, The (Wright), 555
Colored Actors' Union (CAU), 171–72
Colored American, 94, 313, 358–59
Colored American Review, 71
Colored Grand Army Man, A (Harleston), 239
Colored Merchants' Association (CMA), 374
Colored Players Film Corporation, 172
Colored Socialist Club (CSC), 243
"Colored Soldiers, The" (Dunbar), 173
Coltrane, John, 44–45, 184, 249
Columbia Records, 454–55, 535
Columbia University, 4–5, 13–14, 145–46, 153–54, 200, 231, 256, 426, 523–24, 548
Combination, 288
Comedy (Fauset), 197
Comet, 177
Commission on Interracial Cooperation, 107, 550–51
Committee for Improving the Industrial Conditions of Negroes in New York (CIICNNY), 256
Committee of Eight, 374
Committee on Equality of Treatment and Opportunity in the Armed Services, 226
Committee on Urban Conditions among Negroes (CUCAN), 256–57
Commodore, 461–62
communism, Communist Party, 72, 107, 110–11, 116, 125–26, 156–57, 160, 164, 167–69, 186, 207–8, 225, 236, 241–42, 245, 274–76, 327, 343, 347, 360–62, 385–86, 389, 393–94, 401, 415–16, 427–28, 445–47, 479, 481, 528, 543, 553–55
Complete Works of Scott Joplin (Lawrence), 315
"Composer of Fourteen Operas, A" (Brawley), 211
Composition 16 (Delaney), 152
Compromise (Richardson), 425
Compton, Glover, 45
"Concentration of Energy" (Bruce), 83
"Concerning White People" (Horne), 272
Condon, Eddie, 19, 392
Congress, U.S., 47–48, 72, 108, 111, 149, 169, 190, 225, 244–45, 258–59, 276, 298, 302, 327, 352, 386, 394, 403–5, 407, 428, 479–80, 487, 531
Congressional Organic Act, 85
Congress of Racial Equality (CORE), 97
Conjure-Man Dies, The (Fisher), 201
Conjure Woman, The (Chesnutt), 112, 114
Connelly, Marc, 7, 220, 255, 291, 541
Connie's Hot Chocolates, 419
Connie's Inn, 109, 419

Conquest, The (Micheaux), 346
Conroy, Jack, 62
"Conservation of the Races, The" (Du Bois), 166
Conservator, 36
Constitution Hall, 11–12
"Contribution of the Individual, The" (Davis), 146
Cook, Fred J., 470
Cook, Will Marion, 44–45, 86, **122–23,** 138, 171, 173–74, 189, 204, 223, 284, 291, 314 335, 356–57, 455, 532–33
Cooke, Charles "Doc," **123–25,** 147
Cooke, Marvel Jackson, **125–26,** 241
Coolidge, Calvin, 9, 50, 217, 289
Coonskin, 133
Cooper, George W., 429
Cooper, Jack Leroy, **126–27**
Cooper, Ralph, 199
Cooper, Tarzan, **128–29**
Copa City, 30
Copeland, Charles Townsend, 60
"Copenhagen," 260–61, 423
Copland, Aaron, 11
Copper Sun (Cullen), 134
Coppola, Francis Ford, 470
Corkery, Caleb A., 378
Corley, Íde, 178
Cornell University, 117
"Corner Store" (Bonner), 60
Corrothers, James David, 94
Cortor, Eldzier, 53
Cosby, Bill, 30–31, 200, 333–34, 496, 540
Cosmopolitan Little Symphony, 138
Cotter, Joseph Seamon, Sr., **129–30**
Cotton Club (nightclub), 99, 101, 109, 183, 259–60, 270–71, 330, 350, 378, 430
Cotton Club, The (film), 470
Cotton States and International Exposition, 130, 352, 512
"Cotton Tail," 184–85
Council on African Affairs, 156, 168–69, 481
Covarrubias, Miguel, 28
"Cow Cow Blues," 144
Cox, Ida, 96, **130–31,** 391
Cox, Lenore, 4
Crap Shootin' Rev, The, 336
Crawford, Jimmy, 330–31
"Crazy Blues," 66, 458, 460, 535
Crazy House, 492
Creamer, Harry, 56, 296
Crease, Robert P., 421, 492
Creative Graphic Workshop, 53–54

Creole Belles, 245

Creole Bronze Revue, 109

Creole Jazz Band, 15–16, 18

"Creole Love Call," 183

Crescent Concerts Company, 180

Crichlow, Ernest, 53, 437, 540, 545

Crigwa (Krigwa) Players, 14

Cripps, Thomas, 347, 474

Crisis, 3, 14, 46, 60–61, 81, 100–101, 125, 134, 139, 146, 155–59, 161, 163, 167–68, 171, 176, 179, 192, 195–97, 201, 213, 224, 239, 272–73, 289, 291, 298, 338, 375, 377, 389, 397–98, 424–25, 452, 468, 488, 502, 504, 508–9, 514, 523, 528, 539, 541, 543

Crosby, Bing, 99

Cross, James, 181

Crothers, Helen Sullivan, 132

Crothers, Scatman, **131–33**

Crown Savings Bank, 75

Crucifixion, The (Fuller), 214

Crummell, Alexander, 83

Crump, Jesse "Tiny," 130–31

Crusader, 72, 361

Cry, the Beloved Country, 327

Cry Havoc (Kenward), 357

"Cudjo's Own Story of the Last African Slaves" (Hurston), 280

Cullen, Countée, 2–3, 14, 46–47, 53, 61–62, 81, 94, 133–37, **133–36,** 146, 155–56, 162, 196, 230–31, 250, 273, 283, 286, 289–90, 328, 343, 354, 356, 375, 377, 415, 435, 446, 486, 496, 508, 528, 530

Cullen, Deborah, 54

Cullen, Frederick Ashbury, 134, **136–38**

Cultural and Scientific Conference for World Peace, 169

Cumberbatch, Prudence, 370

Cumbo, Marion, **138,** 291

Cuney, Norris Wright, 138–39, 442

Cuney-Hare, Maud, **138–40,** 211

Currie, Kathleen, 126

Cuties (Campbell), 102

Dabney, Ford, 86, **141–42,** 189, 335, 455

Dabney, Wendell P., 141

Daddy Grace, 195, 496

Dafora, Asadata, **142–43**

Dahl, Bill, 336

Dailey, Maceo Crenshaw, Jr., 368

Dailey, Victoria, 306

Daily Compass, 126

Dalsgard, Katrine, 528

Dalton, Karen C. C., 31

Dancer, Earl, 517

Dandridge, Dorothy, 344, 379–80, 475

Darensbourg, Joe, 348–49, 382–83

Dark Doings, 522

Dark Side of Hopkinsville, The (Poston), 400, 402

"Dark Symphony" (Tolson), 486

Darktown Entertainers, 63

Darktown Follies, The, 420

Darktown Scandals, 130

"Darktown Strutters' Ball, The," 73, 142

Darkwater (Du Bois), 167

Daugherty, Harry M., 386

Daughters of the American Revolution, 12, 157

Daughtry, Willia Estelle, 312

Davenport, Charles Edward "Cow Cow," **144–45**

Davidson, Olivia, 511

Davidson, Shelby, 524

Davies, Bob, 144

Davin, Tom, 295

Davis, Angela, 27, 37, 108–9, 126, 481

Davis, Arthur Paul, 81, **145–46,** 343

Davis, Benjamin Jefferson, Jr., 240–41

Davis, Benjamin O., 6

Davis, Daniel Webster, 94

Davis, Frank Marshall, 555

Davis, Hugh, 224, 272

Davis, Miles, 496

Davis, Ossie, 394, 496

Davis, Sulky, 132

Davis, Thadious M., 319

Dawson, Mary Cardwell, 191

Dawson, William L., 258, 403

Dawson, William Levi, **147–48,** 185

Day, Jared N., 396

"Daybreak Express," 183

Dean, Lillian Harris "Pig Foot Mary," **149–50**

Deane, Pamala S., 222, 418

"Death Letter Blues," 131

Decca Records, 16–17

Dee, Ruby, 154, 357–58, 496

Deep River (Harling and Stalling), 58–59, 339–40

Deeter, Jasper, 357

Defoe, Daniel, 89–91

De Forest, Lee, 56

DeFrantz, Thomas F., 534

de Gaulle, Charles, 30

Delaney, Beauford, **151–52,** 250–51, 396, 437, 539–40

Delaney, Joseph, 250–51, 539–40

Delany, Bessie, **152–54**

Delany, Clarissa Scott, **154–56**

Delany, Hubert T., 155–57, **156–57**

Delany, Sadie, **152–54,** 435

De Lerma, Dominique-René, 59
Delibes, Léo, 190
Delsarte Film Corporation, 371
De Paris, Sidney, 351, 469
DePreist, James, 10–11
De Priest, Oscar Stanton, 36, **148–49**
de Rochemont, Louis, 327
De Santis, Christopher C., 486
Dett, R. Nathaniel, **157–58**
Devine, Loretta, 150
Devlin, Paul, 150, 181, 463
Dewey, Thomas E., 104, 191, 386
Dewitt Clinton High School, 2–4, 53, 134
Dickenson, Vic, 271
Dickerson, Carroll, 16, 98, 348, 423
Dickinson, Emily, 398
Dickinson College, 397
Dike, Alice Miller, 250
Dill, Augustus Granville, **158–59**
Dillard University, 115, 179, 226
"Dipper Mouth Blues," 381
Disgrace of Democracy, The (Miller), 352
Dismond, Binga, 102
Dixie Duo, 55, 450
Dixie to Broadway, 355–56, 538
Dobbs, Mattiwilda, 191
Dodds, Johnny, 16–19, 363, 381–83
Dodds, Warren "Baby," 18, 363, 381
Dodge, William C., 104
Domingo, Wilfred Adolphus, **159–60,** 361, 415
Domino, Fats, 492
Dorsey, Thomas Andrew, 262, 411–13
Dostoyevski, Fyodor, 528
Double-Take (Patton and Honey), 378
Douglas, Aaron, 3–4, 14–15, 47, **161–62,** 195, 239, 280,
 286, 307, 321, 328, 375, 437, 488, 540
Douglas, Alta Sawyer, 161
Douglas, George H., 8
Douglas, Louis, 28
Douglas, Robert, 128
Douglass, Frederick, 1, 35–36, 53, 62, 78, 94, 112, 129,
 164, 173, 188, 246, 289–90, 306, 321, 354, 361–62,
 366, 368, 405, 440, 503, 513, 546–47
Douglas Specialty Company, 31
Dove, The (Bearden), 41
Down Beat, 20
"Down-Hearted Blues," 278, 454, 535
Downing, Henry Francis, 346
"Down in the Basement," 411
Dr. Beans from Boston, 171
Dream Haven, 14–15, 375
Dreamland Ballroom, 15–16, 19, 124, 277

Drew, Bonnie Bell, 333
Driftwood (Bush-Banks), 94
Drinkwater, John, 221
Driscoll, Anne K., 48
Driskell, David, 524, 540
Dr. Jekyll and Mr. Hyde, 371–72
Drums at Dusk (Bontemps), 62
Drums of Voodoo, 64
Duberman, Martin Bauml, 47
Du Bois, Shirley Lola Graham, 58–59, **162–64,** 169
Du Bois, W. E. B., 3, 13–15, 59, 61, 83–84, 94, 113, 115,
 125, 129–30, 135, 137, 139, 155–59, 161, 163–70,
 164–70, 176–77, 188, 196–97, 209, 212–13, 217, 224,
 227, 238–39, 243–44, 257, 273, 280, 283, 286,
 289–90, 307–8, 321, 326, 328, 352–53, 358, 367,
 375–77, 386–87, 390, 394, 406, 414, 424–26, 435,
 441, 443, 446, 467, 480–82, 484, 489, 502–4, 507–9,
 514–15, 526, 531, 541, 543, 550, 553
Du Bois, Yolande, 283
du Closel, Madame, 152
Ducongé, Peter, 70
Dudley, Sherman Houston, 86, **170–72,** 188
"Dudley and His Mule," 171
Dudley Circuit, 171–72
Dufour, Ronald P., 122, 249, 262, 265, 423–24
Duke, Doris, 71
"Dunbar" (Spencer), 468
Dunbar, Paul Laurence, 69, 77, 81, 89, 94, 118, 123,
 129–30, 139, 172–75, **172–74,** 193, 227, 246, 300,
 347, 353, 356, 371, 439, 467–68, 472, 477, 479, 504,
 532
Dunbar Amusement Commpany, 76
Dunbar Apartments, 85
Dunbar Building, 101
Dunbar-Nelson, Alice, 155, **174–76,** 289, 415
Dunbar Speaker and Entertainer, The
 (Dunbar-Nelson), 175
Dunbar Theatre, 76, 218–19
Duncanson, Robert S., 399
Dungeon, The, 347
Dunham, Katherine, 99, 143, 430, 451, 506,
 518–19, 543
Dunjee, Roscoe, 370, 446
Dunn, Johnny, 349–50
Durham, Eddie, 331, 469
Durkee, J. Stanley, 353
Duse, Mohammed Ali, **176–78,** 215
Dusk of Dawn (Du Bois), 159, 168
Duster, Alfreda M., 34
Dust Tracks on the Road (Hurston), 282
Duthie, Peg, 138

Dutrey, Honore, 18, 381
Dvořák, Antonín, 92–93, 122, 147, 312

Eakins, Thomas, 476
Early, Gerald, 134
Early, Mary Frances, 292
Early Jazz (Schuller), 19
East St. Louis Massacre, 36, 502
"East St. Louis Toodle-Oo," 183
Eaton, Alice Knox, 176
Ebony, 52, 104, 176
"Ebony Flute, The" (Bennett), 46
Ebony Harvest, 146
"Echoes of Harlem" (Ellington), 184–85
"Echoes of Spring," 461
Eckstine, Billy, 463
"Economic Contribution by the Negro to America, The"
 (Schom-burg), 439
Edmonds, S. Randolph, **179–80**
Edmonds's Cellar, 517
Ed Sullivan Show, 39, 334
Edwards, Jodie "Butterbeans," 16, **180–81,** 333
Edwards, Susie Hawthorne, 180–81, 333
Effinger-Crichlow, Marta J., 313
"Eight Weeks in Dixie" (Calvin), 100
Eighty-six Years of Eubie Blake, The, 57
Eisenhower, Dwight D., 11, 32, 52, 226, 258, 279, 287,
 386, 404, 442
Elaine riots, 36, 530
Eldridge, Richard, 487
Eldridge, Roy, 131, 248, 261, 266, 271, 392, 464
Eliot, T. S., 70, 185–86
Ellington, Duke, 88, 99, 101, 121–22, 150–51, **181–85,**
 190, 203–4, 219, 233, 248, 261, 264–66, 278, 291, 295,
 297, 324–25, 331, 333, 349–50, 364, 408, 421, 424,
 463–65, 491–92, 516–17, 520–21
Elliott, William G., 57
Ellison, Ralph Waldo, 23, 40, 150, **185–88,** 321, 555
Elsie, 450
Emancipation Proclamation, 175, 213–14, 298, 477
Emancipator, 160, 361
Embree, Edwin, 285
Emperor Jones, The (film), 516
Emperor Jones, The (Gruenberg), 542
Emperor Jones, The (O'Neill), 143, 221–22, 300,
 333, 427
Encyclopedia Africana (Du Bois), 164, 169–70
Engel, Carl, 158
Ere Roosevelt Came (Duse), 177
Esquire, 102
Estes-Hicks, Onita, 15, 376

Ethiopia (country), 205–7, 316–17, 404, 432, 452, 500
"Ethiopia" (song), 205
Ethiopia Awakening (Fuller), 213
Eubie!, 57
"Eugenics for the Negro" (Carter), 103
Europe, James Reese, 44, 55, 86–87, 141–42, **188–90,**
 205, 449–51, 455, 533
Eva Jessye Choir, 33, 284–85
Evans, Henry, 190
Evans, Howie, 128–29
Evanti, Lillian Evans, **190–91**
Evanti Chorale, 191
Everybody Knows Johnny Hodges, 265
"Everybody's Blues," 259
Exile, The (film), 346
Exile, The (Williams), 537
Exit an Illusion (Bonner), 60
Exonian, 84–85
Extortion (Anderson), 9
"Ezekiel Saw de Wheel," 148

Faderman, Lillian, 48
Fairclough, Adam, 367
Falkenstein, Claire, 22
Fall of the Castle, The (Smith), 452
Fannin, Caroline M., 318
Farmer, James, 258
Farnsworth, Robert M., 485–86
Farrakhan, Louis, 217
Farrow, William McKnight, **192–93,** 539
Fast and Furious, 33, 333
Fast Sooner Hound, The (Bontemps and Conroy), 62
Father Divine, 193–96, **193–95,** 317, 496
Father of the Blues (Handy), 238
Fatou, 29
Faubus, Orval, 20
Faulkner, William, 158
Fauset, Arthur Huff, 194–96, **195–96**
Fauset, Crystal Bird, 196
Fauset, Jessie Redmon, 61, 125, 155, 159, 195–98,
 196–98, 273–74, 286, 290, 508–9, 530
Fayer, Steve, 27
Feather, Leonard, 331, 517
Federal Aviation Administration, 120
Feldman, Lynne B., 374
Ferguson, SallyAnn H., 529
Fetchit, Stepin, 58, 181, **198–200,** 333
Fétiche et Fleurs (Hayden), 250
Fétiches, Les (Jones), 310
Fibber McGee and Molly, 418
Fields, W. C., 199

Fifteen Infantry Regiment "Hellfighters" Jazz Band, 188–89, 449

Fine Clothes to the Jew (Hughes), 273–75

Fire!!, 46, 195, 273–74, 280, 484

Fire in the Flint, The (White), 530

Fireworks of 1930, 458

First International Convention of Negro Peoples of the World, 205

Fishburne, Laurence, 150, 288, 470

Fisher, Rudolph, **200–201,** 485, 517

Fisk Jubilee Singers, 525, 548

Fisk University, 15, 62, 81, 162, 165, 207, 209, 239, 251, 253, 256–57, 283, 286–87, 298–99, 301, 315, 319, 330, 352, 376, 389, 398, 440, 450, 473, 511–12, 525, 548–49

Fisk University-Library of Congress Coahoma County Study, 549

Fitzgerald, Ella, **201–4,** 267, 521

Fitzgerald, F. Scott, 70

Fitzpatrick, Sam, 293

FitzSimmons, H. T., 147

Flanner, Janet, 28–29

Fleming, Robert E., 63

Fletcher, Tom, **204–5,** 245, 456

Flight (White), 530

Flower, Desmond, 45

Flower Drum Song, 235

Flying Down to Rio, 33

"Flying Home" (Ellison), 186

Flynn, Joyce, 60–61

"Fog" (Matheus), 338

Foley, Jodie, 224

Folies-Bergére, 29

Folklore from Nova Scotia (Fauset), 195

Folk Musicians (Bearden), 40

Folks from Dixie (Dunbar), 173

Follies, 29, 534

Fool, The (Pollack), 8

Ford, Arnold Josiah, **205–7**

Ford, Henry, 107

Ford, James William, **207–8,** 275, 361–62

Ford, John, 199–200

Ford, Mignon Innis, 206

Fordham, Damon L., 337

"Forest Pool, A" (Popel), 398

Forever Free (Johnson), 303

"Forever Thine" (Dawson), 147

For Freedom (Fauset), 196

Forman, James, 27

"For My People" (Walker), 504–5

Forsythe, Albert E., 6

Fortune, John Nelson, 96–98

Fortune, T. Thomas, 35, 82, 165, 359, 513–15

Fort-Whiteman, Lovett, 361, 415

Forty Thieves, 470

Forum, 320

Fosdick, Marion L., 21–22

Foster, George B., 431

Foster, George "Pops," 18, 464, 469

Foster, William Z., 208

Foulkes, Julia L., 143, 543

"Four Problems in the History of Negro Art" (Porter), 398–99

Four Saints in Three Acts (Thomson and Stein), 284

Four Walls (Abbott), 461

Fox Studio, 198–99

Foxx, Redd, 24, 181, 337

Frank, Waldo, 487–88

Franklin, John Hope, 422

Frazier, E. Franklin, 153, 156, **208–10,** 286, 328

Freedmen's Bureau, 111

Freedom, 242

Freedomways, 163–64

Freeman, Harry Lawrence, **210–11**

Freeman, John, 82

Free Speech and Headlight, 35

Freiman, Lisa D., 152

"Frenesi," 472

Friedberg, Ruth C., 410

Friedwald, Will, 462

Frogs, 335, 533

From Dover Street to Dixie, 74, 355, 483, 538

From "Superman" to Man (Rogers), 431

Frost, Robert, 68

Frye Street and Environs (Bonner), 61

Fuller, Linda K., 43

Fuller, Meta Warrick, **212–14,** 310, 437, 509

Fuller, Solomon, 212

Fullerton, J. Cyril, 259–60

"Funeral Procession" (Wilson), 540

Furman, Abraham L., 485

Futher Definitions, 248

Gabbard, Krin, 462

Gabler, Milt, 267, 392

Gaines, E. L., 205

Gale, Zona, 197

Gallagher, Julie, 259

"Gallery of Harlem Portraits, A" (Tolson), 486

Games (Lawrence), 322

Gamin (Savage), 435

Gans, Joe, 55

García Lorca, Federico, 40

Garland, Will, 63

Garnet, Henry Highland, 179

Garrett, Shennette, 97

Garvey, Amy Ashwood, 167, 215

Garvey, Amy Jacques, 167, 215

Garvey, Marcus, 36, 52, 72, 83–84, 118, 159–60, 167,
 177–78, 195, 205–6, **215–18,** 243–44, 268, 316, 329,
 341–42, 359, 361, 374, 383, 386, 400–401, 415, 435,
 441–42, 484, 496, 503, 507–8, 516

Gasman, Marybeth, 287

Gates, Henry Louis, Jr., 140, 441, 529

Gayle, James E., 180

Gee, Jack, 454–55

Gee, Lottie, 450–51

Gentlemen Unafraid, 110

Gerlach, Larry R., 429

Gershwin, George, 32–34, 73, 88–89, 99, 143, 180,
 189–90, 203, 245, 284, 300, 357, 463

Ghana, 117, 164, 169–70, 217, 258, 390

"Ghost of a Chance, A," 99

Giblins, Dolores, 45

Gibson, John Trusty, 76, **218–19**

Gibson, Truman K., Sr., 388

Giddings, Paula J., 37

Giddins, Gary, 21, 362–64

"Gift of Laughter, The" (Fauset), 196

Gilbert, Jenifer W., 384

Gilbert, L. Wolfe, 87

Gilbert, Mercedes, **219–20**

Giles, Freda Scott, 89, 344

Gill, Glenda E., 480, 520

Gillespie, Dizzy, 99, 132, 184, 203, 248

Gilpin, Charles Sidney, **220–22,** 255, 339, 356, 541

Ginger Snaps of 1928, The, 270

Gingrich, Arnold, 102

Girl in a Red Dress (Alston), 4

Girls' School, 43

Give Us Each Day (Dunbar-Nelson), 176

Gladiola Garden (Newsome), 377

Glaser, Joe, 20, 266, 391

Gleason, Ralph, 465

Gloster, Hugh Morris, 227

Glover, Danny, 155

Glover, Savion, 380

God Sends Sunday (Bontemps), 61

God's Stepchildren, 347

God's Trombones (Johnson), 298–99

Goering, Hermann, 317

Goggin, Jacqueline, 548

Going to the Territory (Ellison), 187

Gold Diggers, 33

"Golden Afternoon in Germany, A" (Delany), 155

Goldfield Hotel, 55

"Goldie" (Grimké), 229

Goldwater, Barry, 386

Golgotha Is a Mountain (Work), 549

Gone with the Wind, 125

Gonsalves, Paul, 184

"Goodbye Christ" (Hughes), 275

Goodman, Benny, 261, 266, 433–34, 520–21

Goodman, James, 445–46, 448

Goodness of St. Rocque and Other Stories, The
 (Dunbar-Nelson), 174

"Goodnight, Irene," 323–24

Good Shepherd (Fuller), 214

"Goophered Grapevine, The" (Chesnutt), 112

Gordon, Emmanuel Taylor, **222–24**

Gordon, Eugene F., **224–25,** 527

Gordon, June, 225

Gordon, Rose Beatris, 224

Gotham-Attucks Music Co., 455

Gouws, Dennis, 159, 284

Graham, Ed, 101

Granger, Lester Blackwell, **225–27,** 307

Grant, Nathan L., 95

Granz, Norman, 203, 267

"Grave in the Corner, The" (Grimké), 229

Gray, Christine Rauchfuss, 426

Gray, Pamela Lee, 102, 193

Great Depression, 23, 43, 48, 52–53, 56, 61, 91, 94, 99,
 116, 128, 140, 145, 149, 151, 153–54, 162, 167–68,
 172, 185, 192, 194–95, 202, 206, 217, 219, 225, 231,
 236, 258, 263, 304, 306, 325, 333, 335, 339, 366, 374,
 383, 388, 402–3, 413, 415, 417, 434, 437, 440, 443,
 451, 455, 466, 481, 490, 496, 498, 500, 518, 527–28,
 541, 547, 553

Great Migration, 23, 51, 75, 116, 180, 201, 249, 321,
 365–66, 413, 507, 530, 553

Great White Hope, The, 292

Green, Eddie, 417

Green, Paul, 340, 541, 555

Green, William, 416

Greenberg, Robert M., 252

Greene, J. Lee, 467–68

Greene, Lorenzo J., 547

Green Pastures, The (Connelly), 7, 220, 255, 291, 541

Green Pastures, The (film), 7, 541

Greer, Sonny, 182, 278, 464

Gregory, Dick, 333–34, 337

Gregory, George, 4–5

Gregory, Thomas Montgomery, 14, 425

Griffin, Barbara L. J., 283
Griffin, Farah Jasmine, 268
Griffith, D. W., 407, 473–74, 490
Griggs, Sutton E., **227–28**
Grimké, Angelina Weld, 155, **228–30,** 289, 328, 354,
 424, 508, 537
Grimké, Archibald Henry, 228
Grimké, Charlotte L. Forten, 229
Grimké, Francis James, 85
Gross, Dalton and MaryJean, 68
Group Theatre, 340
"Growlin' Dan," 97
Grupenhoff, Richard, 491
Gubert, Betty Kaplan, 440
Guide to Racial Greatness, The (Griggs), 227
Gumby, Levi Sandy Alexander, **230–32**
Gunsaulus Mystery, The, 346
Gurdjieff, George Ivanovich, 488
Gushee, Lawrence, 381
Guy, Edna, 542–43

Hager, Fred, 65
Haile Selassie, Emperor of Ethiopia, 206, 317, 404, 432
Haiti (Du Bois), 321, 326
Hales, Douglas, 140
Haley, Alex, 505
Hall, Adelaide, 56, **233–34,** 260, 335, 357, 450, 522
Hall, Edmond, 270
Hall, Juanita, 64, **234–35**
Hallelujah, 7, 255, 344
Hall Johnson Choir, 291
Halper, Donna L., 127, 225
Halpert, Edith, 322
Hamid, Sufi Abdul, **235–37,** 470–71
Hamilton, Jeff, 402
Hammerstein, Oscar, II, 80, 234–35, 326
Hammond, John, 131, 266–67, 279, 296, 492
Hampton, Henry, 26–27
Hampton, Lionel, 45, 131, 413
Hampton, Pete, 63
Hampton Institute, 1, 145–46, 157–58, 197, 352, 366,
 421–22, 510–11
"Hands, The" (Bonner), 60
Handy, Antoinette, 13, 211, 470
Handy, W. C., 73–74, 86–87, 110, 124, 189, 191, 218,
 237–38, 254, 296, 344, 364, 387, 435, 456, 463,
 471, 535
"Hannah Byde" (West), 528
Hansberry, Lorraine, 118
Hansberry, William Leo, 117
Hanson, Renée R., 247

"Happy Hollow" (Dunbar), 174
Harder, Charles M., 21–22
Harding, Warren G., 78–79, 175, 222, 367
Hardwick, Otto "Toby," 182, 464
Harlem (journal), 484
Harlem (Thurman and Rapp), 484
Harlem: Negro Metropolis (McKay), 343, 355
Harlem Academy, 61
"Harlem Air Shaft," 184
Harlem Artists Guild, 4, 53
Harlem Art Workshop, 3, 53, 321
Harlem Blues and Jazz Band, 49
Harlem Book of the Dead (VanDerZee), 496
Harlem Community Art Center (HCAC), 3, 53, 91, 437
Harlem Experimental Theatre, 14
Harlem Gallery, Book I (Tolson), 486
Harlem Globetrotters, 133
Harlem History Club, 117
Harlem Hospital, 4, 551–52
Harlem Music Center, 110
Harlem on My Mind, 15, 496
Harlem Renaissance (Huggins), 4–5, 15
Harlem riots, 156, 407
Harlem Writers Guild, 118
Harleston, Edwin Augustus, **238–40**
Harleston, Elise Forrest, 239
Harling, Frank, 58–59, 339–40
Harmond, Richard, 154
Harmon Foundation, 3, 21–22, 37–38, 53, 114, 134, 192,
 257, 306, 452, 509, 524
Harper, Frances, 290
Harper, Michael S., 82
Harper & Blanks, 57
Harper's Weekly, 173
Harrigan, Nedda, 9
Harrington, Oliver W., **240–42**
Harris, Abram, 415
Harris, Barry, 249
Harris, Leonard, 330
Harris, Robert L., Jr., 33, 527
Harrison, Beatrice, 79
Harrison, Benjamin, 190
Harrison, Daphne Duval, 131, 279, 454, 539
Harrison, Hubert Henry, 160, **242–44,** 361, 414–15, 431
Harrison, Jimmy, 520
Harrison, Richard B., 9
Hart, Albert Bushnell, 165–66
Harvard University, 158–59, 165, 186, 238, 327–28,
 489, 526
Harvey, Georgette Mickey, **245–46,** 357
HARYOU-ACT, 117

Haskins, Jim, 71, 132

Hastie, William Henry, 51, 307, 422

Hatch, James V., 10

Hathaway, Isaac Scott, **246–47**

Hauke, Kathleen, 401–2

Haverford Group, 422

Haverstraw (Horne), 272

Having Our Say (Delany, Delany, and Hearth), 153–54

Hawkins, Coleman, 18–19, 45, 73, 121, 131, 184, **247–49,** 260, 392, 411, 423, 458, 463, 535

Hawthorne, Charles, 305

Hayden, Palmer, 162, 240, **249–51,** 437, 539–40, 543

Hayden, Robert C., 553

Hayden, Robert Earl, **251–52**

Hayden, Scott, 314–15

Hayes, Roland, 59, 79, 138, 159, 161, **252–54,** 525, 530

Haynes, Daniel, 222, **254–55,** 344

Haynes, Elizabeth Ross, 256

Haynes, George Edmund, **255–57**

Head (Artis), 22

Head of a Girl (Artis), 21

Hearth, Amy Hill, 153–54

Heart of a Woman and Other Poems, The (Johnson), 289

Hearts in Dixie, 198, 371

Hedgeman, Anna Arnold, **257–59**

Hegamin, Lucille, **259–60,** 469

He Is Arisen (Bearden), 40

Helbock, Joe, 461

Helfond, Riva, 53

"Hello Dolly," 20

"He May Be Your Man (But He Comes to See Me Sometime)," 538

Henderson, Fletcher, 16, 18–19, 58, 73–74, 121, 131, 190, 247, 254, 260–63, **260–62,** 265–66, 278, 364, 419, 423, 454, 463, 506, 517, 520

Henderson, Horace W., 49, 121, 261

Hentoff, Nat, 454, 536

"Here Come de Judge," 336–37

"Here Comes the Hot Tamale Man," 124

Here I Stand (Robeson), 428

Herman, Mordecai, 206

Herndon, Angelo, 116

Herzog, George, 548

Heyward, DuBose and Dorothy, 245, 326, 340, 518, 541

Heywood, Donald, 45

Hibbler, Al, 264

Hickerson, John, 193–94

Hicks, Bert, 233

Higginbotham, J. C., 16, 121, 131, 296, 469

Highlander Folk School, 27

Highway 1, USA (Still), 472

Hill, Abram, 245

Hill, Chippie, **262–63**

Hill, Constance Valis, 40, 431

Hill, Teddy, 121

Himes, Chester, 242, 555

Hindered Hand, The (Griggs), 227

Hine, Darlene Clark, 51

Hines, Earl "Fatha," 19, 463

Hinton, Robert, 157

Hipsher, Edward Ellsworth, 210

His Honor the Barber, 171

Hitchcock, Alfred, 326

Hite, Les, 263

Hite, Mattie, **263–64,** 277

Hitler, Adolf, 208

Hobson, Charles, 291

Hodges, Johnny, 45, 183–84, **264–65,** 350, 461, 520

Hoffman, Frederick L., 352

Hogan, Ernest, 122, 188, 210, 245

Holiday, Billie, 202, **265–68,** 392, 434, 455

Holloway, Camara Dia, 4

Holmes, John Haynes, 547

Holstein, Casper, **268–69**

Holt, Thomas C., 170

Homespun Heroines and Other Women of Distinction (Brown), 79

Homesteader, The, 346–47

Home to Harlem (McKay), 61

Honey, Maureen, 378, 397

Hong Kong Phooey, 133

Hoodlum, 150

Hooker, James R., 390

Hooks, Bell, 37

Hoover, Herbert, 2, 50, 148, 338, 367, 374, 530

Hoover, J. Edgar, 385–86

Hoover, Lou, 149

Hope, Bob, 133

Hope, John, 21, 168, 368, 544

"Hope of a Negro Drama, The" (Richardson), 424

Hopkins, Arthur, 339–40

Hopkins, Claude, 28, 49, 260, **269–71,** 295, 463–64

Hopkins, Gerard Manley, 468

Horizon, 166

Horne, Frank, **271–72,** 530

Horne, Lena, 30–31, 88, 99, 291, 344, 379, 430, 451, 506, 518, 522

Horton, James, 446

Hosmer, Frank, 165

Hot Chocolates, 19, 506

Hotel Messenger, 414

Hot Five, 16, 19

Hot Seven, 16, 19

Houghton Mifflin, 112–14

House, Son, 549

House behind the Cedars, The (Chesnutt), 112–14, 346

House behind the Cedars, The (film), 346–47

House of Connelly (Green), 340

House-Rent Party, 336–37

House Un-American Activities Committee (HUAC), 47–48, 72, 108, 111, 225, 327, 428

Houston, Charles Hamilton, 369, 531

Houston riots, 36

Hovenden, Thomas, 476

Howard, Floretta, 519

Howard's American Magazine, 83

Howard University, 3, 6, 11, 14, 46, 51, 53, 69, 81–82, 89, 91, 107, 145–46, 154, 156–57, 190, 200, 209–10, 270, 280, 301–2, 310–11, 322, 328, 351–54, 368–69, 389, 398–400, 425, 443, 524–27, 537–38

How Britain Rules Africa (Padmore), 389

How Come (Heywood), 45

Howells, William Dean, 112–13, 173

"How John Boscoe Outsung the Devil" (Davis), 146

"How Long, Sweet Daddy, How Long?," 278

"How You Gonna' Keep 'Em Down on the Farm," 142

Hubbard, Arthur J., 253

Huggins, Nathan Irvin, 4–5, 14–15, 196

Hughes, Langston, 3, 14, 23, 47, 61–62, 80, 82, 94, 102, 115, 125, 134, 146, 155–56, 162, 174, 176, 185–86, 195–96, 220, 230–31, 234, 242, **272–77,** 280, 283, 289–90, 298, 307, 327–28, 334, 340, 343, 347, 354, 356–57, 361, 372, 375, 377, 389, 393, 401, 411, 441, 446, 467, 472, 479, 481–82, 484, 486, 488, 491, 500, 504, 508, 518, 528, 530

Hughes, Spike, 356

Huiswoud, Otto, 361

Humphrey, Hubert, 467

Hunt, Richard, 38

Hunter, Alberta, 16–17, 254, 263, **277–79,** 469, 506, 516, 535

Hunter College, 117–18

Hunton, Addie Waites, 104

Hunton, William Alphaeus, Jr., 104, 481

Hurok, Sol, 10–11

Hurston, Zora Neale, 14, 61, 81, 100, 116, 195, 273–75, **279–82,** 286, 320, 329, 333, 354, 356, 375, 481, 484, 488, 500, 508, 528, 537

Hurwitt, Elliott S., 74, 87, 111, 125, 142, 335, 484

Hussen, Aida Ahmed, 140

Hyder, George "Doc," 260

Hyun, Lena, 55

"I Am Initiated into the Negro Race" (Horne), 272

"I Am the Scat Man," 132

"I Can't Give You Anything but Love," 20

Ida B. Wells Club, 36–37

Idle Head, The (Richardson), 425

"If I Could Be with You (One Hour Tonight)," 296

"If We Must Die" (McKay), 343

"I Go to Whittier School" (Davis), 145

"I Got Rhythm," 121, 184

"I Got the Number," 337

"I have a dream" (King), 30

"I Have a Rendezvous with Life" (Cullen), 134

"I Have Seen Black Hands" (Wright), 554

"I'm a Jonah Man," 532

Imes, Elmer, 319–20

Imitation of Life, 43, 474–75, 479, 516

"I'm Just Wild about Harry," 55, 57

Imperium in Imperio (Griggs), 227

In Abraham's Bosom (Green), 340, 541

In Dahomey, 63, 86, 122–23, 532–33

Indian Shops, Gay Head (Jones), 311

"Indian Trails" (Bush-Banks), 94

Industrial School for Colored Girls, 175

"Industrial School of the South, The" (Horne), 272

Industrial Workers of the World (IWW), 243

Infants of the Spring (Thurman), 484–85, 508

Ingham, John N., 388

Ingraham, Lloyd, 474

Ingram, E. Renée, 86

In Old Kentucky (film), 198

In Old Kentucky (minstrel show), 55

Intercollegiate Liberal League, 159

"Interim" (Delany), 155

Interior Department, U.S., 51

International African Service Bureau (IASB), 389

International Colored Unity League (ICUL), 244

International Labor Defense (ILD), 361–62, 393–94, 445–47

International Trade Union Committee of Negro Workers (ITUC-NW), 389

International Workers Order (IWO), 481

Interne, The (Thurman and Furman), 435

In the Bottoms Suite (Dett), 158

In the Land of the Pharaohs (Duse), 177

Invisible Man (Ellison), 150, 186–88

Iovannone, J. James, 232

Iowa State University, 106

Irvis, Charlie, 349

Isaacs, Edith J. R., 221

Isaac Watts (Davis), 146

"Isfahan," 264–65

"I Tried To Be a Communist" (Wright), 554

"It's All Your Fault," 55

"I've Got the Blue Ridge Blues," 123

"I've Got the Blues but I'm Too Blamed Mean to Cry," 86

"I Want a Hot Dog for my Roll," 181

"I Want to Die While You Love Me" (Johnson), 289

"I Want to Shimmie," 73

"I Wish I Could Shimmy Like My Sister Kate," 535

I Wonder as I Wander (Hughes), 276

I Wonder Where My Easy Rider's Gone," 73

"I Would Do Anything for You," 270

Jack Benny Show, 7–8

"Jack in the Pot" (West), 528

Jackman, Harold, 3, **283–84**

Jackson, Blyden, 286

Jackson, Eric R., 210

Jackson, Janet, 100

Jackson, Jay, 127

Jackson, Lillie M., 369–70

Jackson, Mahalia, 455

Jackson, Tony, 363–64

"J'ai deux amours," 29

James, C. L. R., 389

James, Daniel "Chappie," 6

James, Elmore, 493

James, Esther, 404

James, William, 165

Janitor Who Paints, The (Hayden), 250

Janken, Kenneth R., 532

Jazz at the Philharmonic (JATP), 203

Jazz Cleopatra (Rose), 30

Jazz Dance (Stearns and Stearns), 430

Jazz Hounds, 458

"Jazz Me Blues, The," 259

Jazzmen (Ramsey and Smith), 49

Jazz Review Magazine, 263

Jeannette, Gertrude, 14

Jeb (Ardrey), 64–65

Jefferson, Blind Lemon, 323

Jeffries, Jim, 293

Jekyll, Walter, 342

Jenkins, Clarence "Fats," 128

Jennie (Jones), 310

Jeremiah the Magnificent (Thurman and Rapp), 484

Jessye, Eva Alberta, 33, 138, **284–85**

Jitterbug (I) (Johnson), 306

Jive Gray (Harrington), 241

John Brown (Du Bois), 166

John Henry, 250, 340, 430, 504

Johns Hopkins University, 351

Johnson, Budd, 248

Johnson, Bunk, 44, 348, 382, 535

Johnson, Charles Spurgeon, 3, 14, 46, 103, 135, 155, 224, 280, **285–87,** 307, 328, 338, 375–76, 415, 440, 508, 549

Johnson, Clifton H., 136

Johnson, Ellsworth "Bumpy" , **287–88,** 470

Johnson, George, 475

Johnson, Georgia Douglas, 60, 85, 94, 155, 176, 230, 283, **288–90,** 397–98, 425, 537

Johnson, Hall, 3, 138, 234, 255, **290–92,** 372, 479

Johnson, Helene V., 231, 508

Johnson, Holcha Krake, 305–6

Johnson, Jack, 70, 200, **292–94,** 496

Johnson, James, 263

Johnson, James P., 55, 57, 66, 131, 270, 275, **294–97,** 335, 458, 460–62, 505–6, 536

Johnson, James Weldon, 3, 9, 46, 61–62, 67, 72, 79, 81, 114, 122, 150, 153, 155, 161–62, 174–76, 189, 211, 222, 239, 273, 275, 283, 286, 290, 297–300, **297–99,** 308, 315, 343, 355–56, 435, 450, 468, 479, 502, 509, 530

Johnson, J. C., 419

Johnson, Jesse, 468

Johnson, John H., 288

Johnson, John Rosamond, 188–89, 211, 218, 223, 297–300, **299–300,** 325, 357, 437, 479, 533

Johnson, Lonnie, 456, 469

Johnson, Lyndon B., 334, 386, 414

Johnson, Mordecai Wyatt, **300–302,** 443, 526

Johnson, Pete, 391, 492–93

Johnson, Sargent Claude, **302–5**

Johnson, William H., 212, **305–6,** 437, 543

Joint Committee on the Negro Child Study, 155

Jolson, Al, 9, 123

Jonah's Gourd Vine (Hurston), 280–81

Jones, David, 312–13

Jones, Eugene Kinckle, 257, **306–8**

Jones, Grace Allen, 308–9

Jones, Gwendolyn S., 156

Jones, Henry "Broadway," 55–56

Jones, Laurence Clifton, **308–9**

Jones, Lewis Wade, 549

Jones, Loïs Mailou, 107, 212, **309–11,** 399, 437, 524

Jones, Madame Sissieretta Joyner, **311–13,** 357

Jones, Regina V., 517

Jones, Robin, 92, 509

Joplin, Scott, 55, **313–16**

Jordan, Louis, 66

Joseph, "One-Leg Willie," 55

Jos. W. Stern & Co., 455–56

Journal of Negro History, 546–47, 550
Joy, Leatrice, 42
Joyce, Joyce Ann, 146
Joyner, David, 507
Joyner, Mathilda, 190
Jubilee (Walker), 505
Judge Priest, 199
Julian, Hubert F., **316–18**
Julian, Percy, 467
Julius Rosenwald Fund, 286–87
"Just a Crazy Song," 97
Justice Department, U.S., 164, 385
Just Women (Bruce), 85

Kanfer, Stefan, 327
Kashmir Chemical Company, 31
Kay, Ulysses Simpson, 138
Kaye-Smith, Sheila, 320
Kazan, Elia, 345
Keating, Liam, 121
Keats, John, 67, 135
Keene, Ann T., 254
"Keep a Song in Your Soul," 261
Keep Shufflin', 296
Keith, B. F., 109
Kellar, Allison, 34, 58
Kellner, Bruce, 74, 283, 516
Kellor, Frances, 256
Kelly's Stable, 248
Kennedy, John F., 11, 334
Kennedy, William, 465–66
Kentucky Club, 182, 349–50
Kenward, Allan R., 357
Kenya, 217, 389–90
Kenyatta, Jomo, 217, 389–90
Keppard, Freddie, 15–17, 44, 124, 348
Kerman, Cynthia, 487
Kern, Jerome, 58, 80, 110, 278
Kernfeld, Barry, 50, 66, 234, 260, 263, 271, 297, 332, 349,
 383, 392, 420, 457, 459–60, 462, 479, 521
Kersands, Billy, 171, 534
Khrushchev, Nikita, 169
"Kicking the Gong Around," 99
Kim, Earl, 272
Kimmelman, Michael, 322
Kinder, Larry Sean, 339
King, Billy, 57–58
King, Martin Luther, Jr., 5, 25–27, 30, 34, 157, 214, 302,
 367, 394, 402, 416, 442, 515
King Features Syndicate, 102
"King Porter Stomp," 261

Kinnon, Joy Bennett, 34
Kirby, John, 121, 261, 326, 521
Kirk, Andy, 96, 121, 271, 433, 458
Kirkpatrick, Don, 520–21
Kirkpatrick, Sidney, 63–64
Kirschke, Amy Helene, 161–62
Kittredge, George Lyman, 80
Knight, Gwendolyn, 21, 53, 306, 321–22
Kobre, Sidney, 205–6
Koch, Frederick H., 179
"Ko-Ko," 184–85
Kootz, Samuel, 40
Korean War, 169
Kornweibel, Theodore, 386
Koslow, Philip J., 91
Kowalski, Piotr, 22
Kranz, Rachel, 91
Krasner, David, 123, 517
Kritz, Marjorie, 120
Krokodil, 242
Ku Klux Klan, 217, 473
Kykunkor (Dafora), 142–43

Lace Petticoat, The, 220
Ladies of the Big House, 42–43, 408
Lady from Philadelphia, The, 11
Lady in Satin, 267
Lafayette Players, 58, 63–64, 76, 218–19, 221, 357, 407–8
Lafayette Theatre, 57–58, 74, 76, 263, 330, 479
LaGuardia, Fiorello, 156–57, 236, 446
Lakmé (Delibes), 190
Lambert, Constant, 356
Lament for a Bullfighter (Bearden), 40
Land of Cotton, The (Edmonds), 179
Land of Cotton and Other Plays, The (Edmonds), 180
Laney, Lucy, 503
Langford, Sam, 346
Lansbury, Robert, 393
Lapchick, Joe, 128
Larsen, Nella, 3, 61, 197, **319–20,** 488
"Lawd Send Me a Man Blues," 411
Lawrence, Jacob Armstead, 3–4, 21, 40 53, 91, 306,
 320–23, 437, 524, 540
Lawrence, Vera Brodsky, 315
Lawrenson, Helen, 288
Lawson, James, 26
Leab, Daniel J., 473
Lead Belly, **323–24**
League for Nonviolent Civil Disobedience against
 Military Segregation, 416
Leak, Jeffery B., 441

"Leaves from an Active Life" (Duse), 177
Ledbetter, Martha Promise, 324
Lee, Canada, **325–27**, 358
Lee, Everett Astor, 138
Lee, Ulysses Grant, 81, 146
"Legacy of the Ancestral Arts, The" (Locke), 213
Lehman, Herbert, 103
Leibowitz, Samuel, 444–46
Leininger-Miller, Theresa, 39, 47, 251, 305, 453
Lemon, Meadowlark, 133
Lenoire, Rosetta, 358
Leonard, John, 529
LeRoy, Hal, 39
Leslie, Lew, 56, 74, 88, 110, 355–56, 419–20, 483,
 522, 538
Let Me Breathe Thunder (Attaway), 23
Letters Found near a Suicide (Horne), 272
Levison, Stanley, 25
Levit, Donny, 471
Levy, Alan, 93, 158
Levy, Eugene, 299
Levy, Sholomo B., 195, 207, 306, 489
Lewis, Cudjo, 280
Lewis, David Levering, 36, 283, 287
Lewis, George, 348–49
Lewis, Norman, 3
Lewis, Theophilus, 479
Lhote, André, 54
Liberator, 343
Liberia, 443, 486, 503
Liberty League, 243–44
Library of Congress, 364, 549
Libretto for the Republic of Liberia (Tolson), 486
Lieb, Sandra, 413
Life, 151, 552
Life and Times of Frederick Douglass, The (Moore),
 361–62
Life of Frederick Douglass, The (Lawrence), 321
Life of Harriet Tubman, The (Lawrence), 321
Life of Toussaint L'Ouverture, The (Lawrence), 321
"Lift Every Voice and Sing" (Johnson and Johnson),
 297–300
Lincoln, Abraham, 38, 94, 167, 221, 238–39, 297, 300,
 477, 498, 513, 547
Lincoln Center for the Performing Arts, 150
Lincoln Memorial, 12, 30, 125, 157, 367, 416, 531
Lincoln Players, 370–72
Lincoln Portrait (Copland), 11
Lindsay, John, 292
Lindsay, Vachel, 273
Linton, William, 52

Listen Chicago, 127
Little Buck, 39
Little Rock school integration crisis, 402
Living Is Easy, The (West), 528
Living Way, 34–35
Locke, Alain Leroy, 3, 14, 53, 117, 134, 143, 146, 155,
 160–62, 179, 192, 195, 213, 231, 240, 250, 273–74,
 280, 286, 305, 310, 321, **327–30**, 424–25, 439, 484,
 487–88, 508, 524, 541–42
Logan, Rayford W., 487, 547
Lomax, Alan, 324, 363–64, 549
Lomax, John, 324
London, Jack, 293
London Suite (Waller), 506
Lonely Warrior, The (Ottley), 384
"Lonesome, All Alone and Blue," 262
Long Way from Home, A (McKay), 343
Los Angeles Times, 517
Lost Boundaries (de Rochemont), 327
Lost Delta Found (Work, Jones, and Adams), 549
Louis, Joe, 496–497
Louisiana, 64
"Louisiana Lize," 299–300
Louisiana Weekly, 115–16
"Love Will Find a Way," 450
"Low Land Blues," 262–63
L. S. Alexander Gumby Collection of Negroiana,
 The, 231
Lucky Sambo, 58
Luker, Ralph E., 282
Lulu Belle (MacArthur and Sheldon), 9, 479
Lunceford, Jimmie, 132, **330–32**, 423, 464, 539
Lusane, Clarence, 462–63
Lyceum movement, 77
Lyles, Aubrey, 55, 70, 74, 142, 221, 450
"Lynching of Jube Benson, The" (Dunbar), 174
Lyrics of Life and Love (Braithwaite), 68
Lyrics of Lowly Life (Dunbar), 173
Lyrics of Sunshine and Shadow (Dunbar), 172

Mabley, Moms, 24, 181, **333–34**
Macbeth (Shakespeare), 326, 480
MacGregor, Donald, 413
Mack, Cecil, 86, 123, 141, 295, **334–35**, 455–56
Madam C. J. Walker Manufacturing Company,
 499–500, 502–3
Madden, Martin B., 148–49
Made in Harlem, 65
Magic and Medicine (Alston), 4–5
Magpie, 2, 4, 53, 134
Mahara's Minstrels, 237

"Main Stem," 184
Maiwald, Michael, 201, 485
Ma Johnson's Harlem Rooming House (Gilbert), 220
Majors and Minors (Dunbar), 173
Make Room for Daddy, 418
"Making of Harlem, The" (Johnson), 150
Malcolm X, 109, 117–18, 150, 217, 337, 442, 491
"Malicious Lies Magnifying the Truth" (Gordon), 223
Mallory, Eddie, 518–19
Malone, Annie Turnbo Pope, 501
Malraux, André, 185–86
"Mama Don't Allow," 144
Mamba's Daughters (Heyward and Heyward), 245, 326, 518
Managers and Performers Association (M&P), 218–19
Manley, Norman, 38, 160
Manly, Alexander, 424
Mann, Kenneth Eugene, 149
Manning, Wesley, 433
Manual Training and Industrial School for Colored Youth, 226
Man Who Built the Stone Castle, The (Gordon), 224
"Man Who Wanted To Be Red, The" (Horne), 272
"Maple Leaf Rag," 314–15
Mara (Grimké), 229
Marable, Fate, 18
Marches on Washington, 30, 170, 226, 258, 285, 359, 416
Marian Anderson, 13
Markham, Dewey "Pigmeat," 333, **335–37**
Marks, Edward B., 455–56
Marrow of Tradition, The (Chesnutt), 113–14
Marsh, Mattie, 238
Marshall, Arthur, 314–15
Marshall, James F. B., 511
Marshall, Thurgood, 15, 369, 467, 531
Martin, John, 142, 542
Martin, Mary, 235
Martyr, The (Freeman), 210–11
Mary Turner (Fuller), 213
Masaai (Barthé), 38
"Mask, The" (Delany), 155
Mason, "Godmother" Charlotte, 195, 274
Mason, Julian, 115
Masterpieces of Negro Eloquence (Dunbar-Nelson), 175
Masters, Edgar Lee, 486
Matheus, John Frederick, **337–39**
Matthew, W. A., 206–7
Matthews, James Newton, 173
Matthews, Roger, 450
Mayhew, Richard, 545
Mayor of Dixie, The (Miller and Lyles), 221

McCarthy, Albert, 331
McClendon, Rose, 3, 219, **339–40,** 357, 518
McComb, Charles, 444
McCullers, Carson, 519
McDaniel, Hattie, 43, 408, 418, 475, 519
McDowell, Deborah E., 527–28
McDuffie, Erik S., 482
McGee, Robyn, 101
McGhee, Reginald, 494–96
McGuire, George Alexander, 205, **340–42**
McKay, Christine G., 242
McKay, Claude, 3, 23, 61, 92, 162, 174, 196, 231, 250, 298, 321, **342–44,** 355, 435, 486, 508, 528, 530
McKendrick, Gilbert "Little Mike," 45
McKible, Adam, 538
McKinley, William, 230, 513
McKinney, Nina Mae, 255, **344–45,** 378, 408
McKinney's Cotton Pickers, 423
McMahon, Audrey, 21
McMurry, Linda O., 107, 551
McQueen, Butterfly, 245, 333, 357
McShann, Jay, 49, 423, 433
Meany, George, 416
Meek Mose (Wilson), 64, 541
Meet Me at the Fair, 132
Melrose Brothers, 19
Member of the Wedding, The (McCullers), 519
Memories of Calvary (Bush-Banks), 94
"Memories of You," 56, 110
"Memphis Blues, The," 237
Memphis Minnie, 469
Memphis Students, 204
Mencken, H. L., 432, 441, 468, 553
Mending Socks (Motley), 365
Men of Mark (Simmons), 476
Mercer, Johnny, 136
Mercer, Mabel, 70–71
Message of the Trees, The (Cuney-Hare), 139
Messenger, The, 3, 100, 160, 179, 289, 361, 375, 385–86, 414–15, 425, 431, 441, 484, 502, 508, 528, 537–38
Metropolitan Museum of Art, 15, 496
Metropolitan Opera, 12–13, 59, 190, 312
Mezzrow, Mezz, 355
Micheaux, Oscar, 64, 76, 220, 317, **345–48,** 407, 417, 475, 490
Michigan, University of, 251
Middle Passage, 123
Midnight at the Crossroads (Hayden), 249
"Midnight Special, The," 323
Midsummer Night in Harlem (Hayden) 250
Migration of the Negro, The (Lawrence), 321–22

Miles, Lizzie, **348–49**

Miley, Bubber, 182–83, 233, 264, 330, **349–51,** 458, 460, 464, 535

Miller, Flournoy E., 55, 70, 74, 142, 259, 450–51

Miller, Irvin C., 221

Miller, Jonette O'Kelley, 345

Miller, Kelly, 85, **351–53,** 369, 415

Miller, Kristie, 149

Miller, May, **353–54**

Millinder, Lucky, 121, 458, 539

Mills, Florence, 56, 74, 96, 222, 233, 259, 263, 277, **354–56,** 423, 430, 450, 462, 482–83, 500, 518, 538

Mills, Harry and Herbert, 202

Mills, Irving, 182, 350–51

Mine Eyes Have Seen the Glory (Dunbar-Nelson), 175

Mingus, Charles, 273

"Minnie the Moocher," 97–100

"Miss Hannah from Savannah," 354–55

Miss Hattie, 417

Mississippi Freedom Democratic Party (MFDP), 27

"Miss Otis Regrets," 70

Mitchell, Abbie, 45, 122–23, 204, 340, **356–58**

Mitchell, Arthur W., 149

Mitchell, Loften, 356

Mizell-Nelson, Michael, 116

Mob Victim (Jones), 310

Modern Negro Art (Porter), 399

Mo' Funny, 336

Monet, Claude, 151

Monk, Thelonious, 248, 297

Monroe, Harriet, 68

Montage of a Dream Deferred (Hughes), 276

Montgomery, Olen, 443–45, 447–48

Montgomery bus boycott, 402

"Mood Indigo," 183, 185

Moon, 166, 387

Moon, Henry Lee, 240, 401, 481

Mooney, Amy M., 365

Moon over Harlem (Johnson), 306

Moore, Aaron McDuffie, 465

Moore, Billy, 331

Moore, Frederick Randolph, **358–60,** 395

Moore, James Ross, 356

Moore, Richard Benjamin, 117, 160, **360–62,** 389

Moore Publishing and Printing Company, 359

Moorland, Jesse E., 353

Moorland-Spingarn Research Center, 353

More Blues and Jazz from Harlem, 49

Morehouse College, 68–69, 209, 421

More Letters Found near a Suicide (Horne), 272

"More than a hamburger" (Baker), 26–27

Morgan Players, 179

Morgan State College, 179

Morgenstern, Dan, 249, 392

"Morning Light" (Newsome), 377

Morris, Gene, 338–39

Morris, Samuel, 193

Morrison, George, 330

Morrison, Toni, 61

Mortgaged (Richardson), 425

Morton, Benny, 520

Morton, Jelly Roll, 17, 66, 124, 131, 259, 296, 348, 351, **362–64,** 382, 433, 496, 534–35

Mosby, Dewey Franklin, 478

Moscow Daily News, 225

Moses, Lucia Lynn, 172

Moses, Man of the Mountain (Hurston), 281

Moses, Robert P., 27

Moten, Bennie, 74, 331, 391, 433

Mother and Child (Burke), 92

Mother and Child (Catlett), 107

Motley, Archibald J., Jr., **364–66**

Motley, Edith Granzo, 365–66

Moton, Robert Russa, **366–68,** 443

Moulton-Wiseman, Amber, 73

Mr. Lode of Koal, 534

"Mrs. Adis" (Kaye-Smith), 320

Muddy Waters, 549

Mugleston, William F., 218, 515

Muhammad, Wallace Fard, 177

Muir, Peter, 145

Mulatto (Hughes), 220, 340

Mule Bone (Hughes and Hurston), 274–75, 280

Mules and Men (Hurston), 281

Mundy, Jimmy, 270

Murchison, Gayle, 549

Murphy, Carl, **368–70**

Murphy, Greg, 392

Murphy, John Henry, Sr., 368

Murray, Albert L., 99, 187

Murray, John "Rastus," 336–37

Murray, Pauli, 528

Murrow, Edward R., 11

Muse, Clarence E., **370–72,** 408

Musée d'Art Moderne, 152

Museum of Modern Art (MoMA), 4–5, 322

Musical America, 11

"Muskrat Ramble," 382–83

Mussolini, Benito, 317

"My Blue Heaven," 331

"My Daddy Rocks Me," 460

"My Forgotten Man," 33
My Life in New Orleans (Armstrong), 17
My Lord, What a Morning (Work), 549
"My Own Man Blues," 144
Myrdal, Gunnar, 81
My Soul's High Song (Early), 134

Nail, John E., **373–74**, 395, 502
Nance, Ethel Ray, 14–15, **374–76**
Nance, Ray, 351
Nanton, Joe "Tricky Sam," 183, 264, 350–51, 392, 464
Nassour, Ellis, 334
National Academy of Design (NAD), 305, 452
National Association for the Advancement of Colored
 People (NAACP), 12, 25, 36, 50, 61, 72, 79, 97, 101,
 106, 113–14, 125, 130, 133, 136–37, 139, 149,
 156–57, 159, 163, 166–68, 192, 196, 208, 213, 217,
 222, 229, 239, 241–44, 254, 278, 284, 298–302, 313,
 319, 328, 353–54, 367–70, 374–76, 389, 393, 401,
 403, 406, 416, 418, 421, 427, 429, 442–46, 448, 450,
 452, 467–68, 473–74, 480, 489–90, 503, 508–9, 514,
 524, 528, 530–31, 537, 541, 543–44, 547, 550–52
National Association of Colored Women (NACW), 35,
 50, 78, 499, 501, 503
National Association of Negro Musicians, 111
National Basketball League (NBL), 128
National Conference of Negro Artists, 108
National Conference of Social Work (NCSW), 307
National Council for a Permanent Fair Employment
 Practices Commission (FEPC), 258
National Council of Negro Women (NCNW),
 50–51, 104
National Equal Rights League, 36
National Feature Service, 32
National League for Protection of Colored Women
 (NLPCW), 256
National Negro Business League, 75, 443
National Negro Congress (NNC), 415–16
National Negro Health Week, 550
National Negro Opera Company (NNOC), 110, 191
National News, 240
National Urban League (NUL), 3, 15, 50, 61, 97, 103,
 105, 137, 155, 161, 186, 208, 224–26, 239, 244,
 256–57, 269, 284, 286, 307–8, 360, 367, 370, 385, 406,
 421–22, 481, 508, 528, 541
National Youth Administration (NYA), 50–51
Nation of Islam, 177, 200
Native Son (film), 555
Native Son (Wright), 23, 325–26, 329
Nat Turner (Edmonds), 180
Natural Born Gambler, A, 534

Nebraska, University of, 161
"Need for a New Organon in Education The"
 (Locke), 329
Neff, Pat, 323–24
Negro Actors Guild of America, 74–75, 516
Negro American Labor Council (NALC), 416
Negro Americans, What Now? (Johnson), 299
"Negro and Socialism, The" (Harrison), 243
"Negro-Art Hokum, The" (Schuyler), 441
"Negro Artist and the Racial Mountain, The"
 (Hughes), 276
Negro at Work during the World War, The
 (Haynes), 257
Negro at Work in New York City, The (Haynes), 256
Negro Caravan, The (Brown, Lee, and Davis), 81, 146
"Negro Child and the Story Book, The" (Cotter), 130
"Negro Digs Up His Past, The" (Schomburg), 117,
 439–40
Negroes and the War (Owen), 386
Negroes of Farmville, Virginia, The (Du Bois), 166
Negro Factories Corporation, 217
Negro Family in Chicago, The (Frazier), 209
Negro Family in the United States, The (Frazier), 209
Negro Fellowship League, 36
Negro Folk Songs (Brown), 79
Negro Folk Songs as Sung by Lead Belly (Lomax and
 Lomax), 324
Negro Folk Symphony (Dawson), 147
Negro Genius, The (Brawley), 69
Negro History Bulletin, 149, 377
Negro History in Thirteen Plays (Richardson), 425
Negro History Week, 546–47
"Negro in American Literature, The" (Braithwaite), 67
Negro in Chicago, The, 285–86
Negro Industrial and Clerical Alliance, 236
"Negro in Europe, The" (Rogers), 432
Negro in New York, The (Ottley and Weatherby), 384
Negro in Virginia, The (Brown), 81
Negro Labor in the United States, 1850–1925
 (Wesley), 526
Negro Looks Ahead, The (Barthé), 38
Negro Musicians and Their Music (Cuney-Hare),
 140, 211
Negro Nuances, 45
Negro People's Theatre, 339–40
Negro Press Association, 35
Negro Quarterly, 186
"Negro Question without Propaganda, The"
 (Schuyler), 442
Negro Silent Protest Parade, 502
Negro Society for Historical Research (NSHR), 83, 439

"Negro Speaks of Rivers, The" (Hughes), 273
Negro String Quartet, 138
Negro Tales (Cotter), 130
Negro Trailblazers of California, The (Beasley), 474
"Negro Votes Bought" (Hurston), 281
Negro Woman, The (Catlett), 107–8
Negro Worker, 389, 394
Negro World, 83, 159, 177, 215, 244, 268, 341, 400, 507–8
Negro Yearbook, 550
Nelson, "Big Eye" Louis, 44
Nelson, Eddie, 449
Nelson, Robert, 176
New Age, 177
New Amsterdam Theater, 141
New Cavalcade, The (Davis and Joyce), 146
New Deal, 4, 50–51, 287, 384, 401, 403, 466, 498, 531
New Leader, 389
Newman, Charles W., 230–31
Newman, Mark, 127
New Masses, 274
New Negro (magazine), 244
New Negro, New Negro movement, 3, 33, 47, 72, 81, 138, 146, 159–60, 179, 192–93, 243–44, 283, 294, 298, 329, 361, 375, 399, 415, 497, 500, 509, 529–30
New Negro, The (Locke), 117, 146, 160, 162, 195, 273, 328, 439, 487, 524
New Negro Art Theatre Dance Group, 542
"New Negro in Literature, The" (Brown), 81
New Negro Renaissance, The (Davis and Peplow), 146
New Orleans, 266
New Orleans, University of, 116
New Orleans Feetwarmers, 45
Newsome, Mary Effie Lee, **376–78**
"Newspaperman's Blues," 124
New Standard Theater, 218–19
New Survey of English Literature, A (Brawley), 69
New Thought ideology, 193
Newton, Frankie, 296
Newton, Huey, 394
"New World A-Coming" (Ottley), 384
New York Age, 1, 35, 46, 225, 298, 312, 316, 357, 359, 395, 513, 534
New York Association for the Protection of Colored Women, 360
New York City Opera, 472–73
New York Daily News, 528
New Yorker, 28–29
New York Freeman, 82
New York Herald, 312
New York Post, 157, 401–2

New York Public Library, 4, 13–15, 53, 117, 124, 136, 159, 162, 193, 201, 244, 283, 319, 321, 384, 435, 438–40, 452–53, 494, 523–24
New York Renaissance "Rens," 128
New York Syncopated Orchestra, 123, 204
New York Telegraph, 151
New York Times, 13, 37, 65, 78, 82, 92, 100, 109, 131, 142,145, 147, 154, 159, 168, 202, 211, 220–22, 234, 260, 284, 292, 316, 340, 356, 418, 422, 442, 445, 463, 469–71, 482, 489, 518, 541–42
New York University, 40, 465–66
New York World, 355, 435
New York World's Fair, 37–38, 403, 437
New York World Telegram, 220
New York Zoological Society, 143
Niagara Movement, 139, 166, 550
Nicholas, Albert, 469
Nicholas, Fayard, 89, **378–80,** 430, 506
Nicholas, Harold, **378–80,** 430, 506
Nigeria, 322
Nigger Heaven (Van Vechten), 61, 273–74
Nigger Lover (Anderson), 9
Night-blooming Cereus, The (Hayden), 251–52
Nile, Blair, 48
Nine Plays by Black Women (Wilkerson), 60
Niven, Steven J., 100, 294, 402, 414, 442, 449, 467
Nixon, Richard, 52, 519
Nkrumah, Kwame, 164, 169, 217, 258, 390
Noble Savage, 187
"Nobody," 532
"Nobody Knows You When You're Down and Out," 455
No Day of Triumph (Redding), 421
No Green Pastures (Ottley), 384
Nolan, John J., 313
Noone, Jimmie, 124–25, 382–83
Norman, Jessye, 13
Norris, Clarence, 443–48
Norris v. Alabama, 446
Norris Wright Cuney (Cuney-Hare), 139–40
North Carolina Mutual Life Insurance Company, 465–67
Northeastern Life Insurance Company, 388
North Pole Theater, 218
Notable Black American Women (Smith), 344
"Nothing New" (Bonner), 60
Notorious Elinor Lee, The, 64
Not without Laughter (Hughes), 274
Nous quatre á Paris (Hayden), 250
No Way Out, 417

Nugent, Richard Bruce, 2, 231
Nuit est une Sorciére, La (Bechet), 45
numbers game, 268–69, 470–71

Oak and Ivy (Dunbar), 173
Oberlin College, 163, 179
Ocean Hill-Brownsville conflict, 416
"October Prayer" (Popel), 398
Ode to America (Bledsoe), 59
Of Mice and Men (Steinbeck), 23
O'Gorman, W. Farrell, 130
Okeh Records, 47, 65–66, 74, 86–87, 124, 535–36
Old Man Pete (Edmonds), 180
Old Servant, The (Harleston), 240
O'Leary, Hazel, 287
Oliver, King, 15–18, 49, 182, 262, 277, 348–51, 363, 381–82,**381,** 411, 469, 535
Oliver, Paul, 456
Oliver, Sy, 121, 330–31
"Ol' Man River," 427
O'Malley, Susan Gushee, 25, 27
On (Winfield), 542
"On Alexander Gumby" (Nugent), 231
"On Being Black" (Walrond), 507
"On Being Young-A Woman-and Colored" (Bonner), 60
"One Hour," 247
100 Years of the Negro in Show Business (Fletcher), 204
O'Neill, Eugene, 9, 143, 221–22, 300, 326, 333, 425–27
One-Way Ticket (Hughes), 275
One Way to Heaven (Cullen), 135
On These I Stand (Cullen), 136
On Whitman Avenue (Wood), 326, 358
Opdycke, Sandra, 208
Open-Letter Club, 113
Opportunity, 3–4, 46, 60–61, 81, 100, 103, 115, 134–35, 146, 155, 161, 176, 179, 195, 197, 201, 224, 226, 239, 268–69, 272–73, 280, 286, 289–90, 307, 338, 375, 377, 397–98, 409, 425, 435, 452, 468, 488, 508, 523, 528, 530, 541
Original Celtics, 128
Original Poems (Bush-Banks), 93–94
Ormes-Dudley, Alberta, 171
"Ornithology," 203
Ory, Kid, 18–19, 262, 348, 363, 381–83, **382–83**
Oshkosh All-Stars, 128
Othello (Shakespeare), 327, 426–27
Ottley, Roi, 29, 150, 235, 240, 326, **383–84**
Ouida (Harleston), 239

Outline for the Study of the Poetry of American Negroes (Brown), 81
Overshadowed (Griggs), 227
Over the Top, 57
Owen, Chandler, 100, 160, 361, **385–86,** 414–15, 537
Oxley, Harold F., 330–31

Pace, Harry Herbert, 254, 374, **387–88,** 516
Padmore, George, 167, 361, **388–91**
Pagan Spain (Wright), 555
Page, Hot Lips, 131, 185, 331, 351, **391–92**
Page, Walter, 391, 433
Page, Walter Hines, 113
Paine-Mahoney Company, 304
Palace Theatre, 429
Palmer, Colin A., 470
Palms, 134, 155
Pan-Africanism or Communism? (Padmore), 390
Panama Club, 277
Paradise Lost and Regained (Jessye), 285
Paramount, 413
Parascandola, Louis J., 290, 398
Paris, Nancy, 205
"Paris Blues," 184
Park, Robert E., 285–86
Parker, Charlie, 185, 203
Parker, Henry C., 373–74
Parker, John J., 530–31
Parker, John W., 69
Parks, Gordon, 102, 192
Parks, Rosa, 92
Passing (Larsen), 320
Passion of Christ (Bearden), 40
"Pathology of Race Prejudice, The" (Frazier), 209
Paton, Alan, 327
Patria, 438
Patterson, Frederick D., 368
Patterson, Haywood, 443–48
Patterson, Lindsay, 536
Patterson, Mary Jane, 524
Patterson, Russell, 102
Patterson, William L., **393–94,** 481
Patti, Adelina, 312
Patton, Charley, 237
Patton, Venetria K., 378
Paur, Leonard, 480
Payne, Daniel Alexander, 77
Payton, Philip A., Jr., 373, **394–96**
Payton Apartments, 76
Peace Halting the Ruthlessness of War (Fuller), 213
Peace Information Center, 169

Peace Mission movement, 193–95

Pearl (Johnson), 303

Peck, Seymour, 505

Pellegrinelli, Lara, 204

Pennsylvania, University of, 165, 195

Pennsylvania Academy of Fine Arts, 476

"People of Color in Louisiana" (Dunbar-Nelson), 175

People of New York v. International Workers Order, 481

People's Grocery, 35

People's Voice, 125–26, 241, 516

Peplow, Michael W., 146, 441

Perez, Manuel, 44

Perlina, Hilda, 58

Perry, Heman, 387

Perry, Jeffrey B., 244

Personals (Bontemps), 63

Peters, Paul, 245, 326, 479–80

Peterson, Bernard L., 372

Peterson, Oscar, 267

"Petite fleur," 45

Petty, Miriam J., 200, 408, 523

Peyton, Dave, 382

Peyton, William T., 129

Philadelphia College of Art, 212

Philadelphia Negro, The (Du Bois), 165–66, 209

Philadelphia Tribune, 75

Philips, Elizabeth Murphy, 370

Phillips, Henry L., 341

Phoenix, The, 101

Phylon, 69, 81, 146, 168, 179, 272, 377

Pickens, William, 244

Picou, Alphonse, 44

Pierce, Billy, **396–97**

Pierce, Dennis, 396–97

"Pilferer, The" (Popel), 398

Pilot, 53

Pinchback, P. B. S., 487

Piney Woods Country Life School, 308–9

Pinky, 345, 519

Pipes of Pan (Bennett), 46

Pippin, Horace, 91

Piron, Armand John, 87, 348, 535

Pitts, Martha, 52

Pittsburgh Courier, 52, 96, 100–101, 175, 192, 224, 241–42, 274, 384, 401, 408, 431–32, 441–42, 497

Pizer, Dorothy, 390

Placksin, Sally, 469

Plantation Club, 28

Plantation Days, 96–98

"Plantation Meistersinger" (Work), 549

Plantation Melodies (Smith), 452

Plantation Revue, 74, 483

Plays and Pageants from the Life of the Negro (Richardson), 425

Plessy v. Ferguson, 106, 363, 513

Plum Bun (Fauset), 197

Plumes (Johnson), 290

Plumes in the Dust (Treadwell), 64

Pods' and Jerry's, 461

Poetry Journal, 68

Pointing the Way (Griggs), 227

Poiret, Paul, 29

Poitier, Sidney, 7, 14, 34, 42, 379, 427, 517

"Po' Little Lib" (Spencer), 468

Pollack, Channing, 8

Polsgrove, Carol, 391

Pond, James Burton, 173

"Poor Man's Blues," 454

Pope, Alexander, 222

Popel, Esther, **397–98**

Popo and Fifina (Bontemps and Hughes), 62, 102

Porgy (Heyward and Heyward), 340, 541

Porgy and Bess (Gershwin), 32–34, 88–89, 99, 180, 245, 284, 300, 357

Porter, Cole, 70, 522

Porter, James Amos, 53, 107, 240, 250, **398–400**

"Porto Rico," 86

Portrait of My Mother (Motley), 365

"Possible Triad on Black Notes, A" (Bonner), 60

Poston, Ted, 157, 240, **400–402**

Powell, Adam Clayton, Jr., 4, 125, 156, 241, 334, 381, **402-5,** 407, 496, 516

Powell, Adam Clayton, Sr., 94, 137, 359, 383, 402, **405–7,** 465–66, 496, 500

Powell, Ozie, 443–48

Powell, Richard J., 4, 305–6, 399

Powell, William J., 120

Powell v. Alabama, 445

Preer, Evelyn, 255, **407–8,** 479

Prevalence of Ritual, The (Bearden), 41

Price, Florence B., **409–10**

Price, Leontyne, 13, 89, 110, 191, 254

Price, Sammy, 131

Price, Victoria, 444–46

Primus, Pearl, 143, 543

Prince Hall, 438–39

Printmaking Workshop (PMW), 54

Procope, Russell, 520

Prodigal Son, The (Hughes), 276

Progressive American, 82

Projections (Bearden), 41

Prophet, Nancy Elizabeth, 435, 544
Prosser, Gabriel, 62
"Prove It on Me Blues," 413
Provincetown Players, Provincetown Playhouse, 8–9, 221–22
Pryne, Alberta, 336
Pryor, Richard, 337
Psalms, 206
Public Broadcasting Service (PBS), 13
Purple Flower, The (Bonner), 60
Put and Take, 87

Quaker Oats Company, 539
Quality Amusement Company, 76
"Quatrains" (Bennett), 46
Queen Kelly, 474
Quicksand (Larsen), 319–20
Quiet One (Artis), 22
Quilting Time (Bearden), 41

Rabbit Foot Minstrels, The, 412
Race Adjustment (Miller), 352
Race and Culture Contacts in the Modern World (Frazier), 210
"Race Contacts and Interracial Relations" (Locke), 328
"Race Mixing" (Rogers), 431
Race Traits and Tendencies of the American Negro (Hoffman), 352
Rachel (Grimké), 228–29, 424
Radcliffe College, 59–60
Radical Lecture Forum, 243
Radio Parade of 1935, 278
"Ragtime Dance Song," 315
Rainbow Tribe, 30
Rainey, Ma, 19, 47, 73, 75, 120, 180, 260, 262–63, 336, 391, **411–14,** 453–54, 459
Raisin' Cain, 130
Rampersad, Arnold, 188
Randolph, Amanda, 58, **417–18**
Randolph, A. Philip, 37, 94, 100, 156, 160, 207, 243, 257–58, 359, 361, 375, 385–86, 401, 404, **414–17,** 441, 502, 537
Randolph, Lillian, 417–18
Randolph, Ruth E., 219–20
Rangel, Charles, 259, 404
Rang Tang, 142, 255
Rapp, William Jourdan, 484
Ray, William Henry, 374–76
Rayl, Susan J., 129
Rayson, Ann, 320
Razaf, Andy, 56, 65, 110, 296, 356, **418–20,** 506

Razzberry Salad (Harrington), 240
"Reach Down, Sweet Grass" (Popel), 398
Reagan, Caroline Dudley, 28
Reagan, Ronald, 42, 187
Realization (Savage), 436
Reason, Patrick Henry, 440
Reason, The (Smith), 452
Reason Why the Colored American Is Not in the World's Columbian Exposition, The (Barnett et al.), 35–36
Rebellion in Rhyme (Clarke), 117
Reconstruction, 307, 351–52, 399, 473, 487, 526
Rector, Eddie, **420–21**
Red, Tampa, 262
Reddie, Milton, 56
Redding, J. Saunders, 146, **421–22**
Red Hot Peppers, 363
Redman, Don, 18–19, 260–61, 392, 419, **422–24,** 535
Redmond, Shana L., 80
Red Moon, 211
Reeve, Carl, 225
Reid, Joan, 45
Reinhardt, Django, 121
Reisman, Leo, 350–51
Reiss, Winold, 161
Reitz, Rosetta, 463
Render, Sylvia Lyons, 114
Rendezvous with America (Tolson), 486
Review of Hoffman's "Race Traits and Tendencies of the American Negro," A (Miller), 352
"Revolt of the Evil Faeries, The" (Poston), 400–401
Revue Négre, La, 28, 270
Reynolds, Gary A., 38
Rhapsody in Blue, 518
Rhinelander, Leonard "Kip," 347
Rhodes, Althea E., 61
Rhodes, Frank H. T., 422
Rhone, Happy, 259
Rhyming, A (Cotter), 129
Rice, Elmer, 275
Richardson, William Howard, 139
Richardson, Willis, 64, 140, **424–26,** 526, 537
Riddick, William, 79
Ridley, Ethel, 66
Riffel, Brenton E., 493
Ringling, John, 223
Rivera, Diego, 544
Rivo, Lisa E., 79, 109, 214, 311, 348, 438, 475, 497, 525, 541, 545
Roach, Hal, 199
Roach, Hildred, 316

Roach, Max, 121, 248
Robbins, Richard, 125
Roberson, Willie, 443–45, 447
Roberts, Luckey, 55, 57, 264, 295, 520
Roberts, Randy, 293
Roberts, Rita, 360
Robeson, Eslanda Cardozo Goode, 80, 426–28
Robeson, Paul, 3–4, 9, 30–31, 38, 56, 59, 80, 94, 100, 125,
 143, 156, 164, 168, 180, 198, 219–20, 222, 231, 242,
 254, 278, 300, 333, 345–46, 378, 394, 417, **426–29,**
 450, 467, 479, 481, 500, 516, 522–23, 530, 541–42
Robinson, Bill, 39, 49, 74–75, 99, 233, 287, 333, 379, 420,
 423, **429–31,** 447, 491, 496, 506, 516–17, 522
Robinson, Edwin Arlington, 68
Robinson, Jackie, 43, 402, 428
Robinson, John C., 317
Robinson, Sugar Ray, 137
Rockefeller, Nelson A., 103
"Rockin' in Rhythm," 183
Rodgers, Richard, 234–35, 326
Rodin, Auguste, 212
Rogers, Joel Augustus, 3, 117, 244, 274, 328, 369, **431–32**
Rogers, Timmie, 336
Rogers, Will, 199
Rohan, Nanette, 40–41
Roko Gallery, 152
"Role of the Talented Tenth, The" (Locke), 328
Rollins, Bryant, 98–99
Rollins, Sonny, 249
Roosevelt, Eleanor, 6, 32, 51, 59, 91, 143, 168, 190,
 334, 531
Roosevelt, Franklin D., 6, 32–33, 51, 59, 91, 106,
 148, 246, 272, 287, 307, 367, 401, 403, 406, 416,
 466, 531, 554
Roosevelt, Theodore, 13, 106, 298, 367, 513–14
Roots (Haley), 505
Roots (miniseries), 133
Rose, Billy, 124
Rose, Ernestine, 14, 283
Rose, Phyllis, 30
Roseanne (Stephensen), 222
Rose Danceland, 520
Roseland Ballroom, 16, 18, 270–71
Roses, Lorraine E., 219–20
Ross, Allie, 142
Rossiter, Will, 73
Roumain, Jacques, 274–75
Rowan, Carl, 402
Rowfant Club, 113
Rowley, Hazel, 556
Ruffin, Josephine St. Pierre, 78, 139

Ruffner, Viola, 510
Rufus Rastus, 210
Ruiz-Velasco, Chris, 228
Run, Little Chillun (Johnson), 291
"Running Fools" (Horne), 272
Runnin' Wild, 28, 295, 297, 335, 522
Rushing, Jimmy, 185, 266, **432–34**
Russell, Luis, 19, 49, 121, 469
Russell, Thaddeus, 237
Russey, Elizabeth A., 148
Rust, Mary, 479
Rust College, 257–58
Rustin, Bayard, 25, 416
Rutgers University, 426–28

Sacco-Vanzetti case, 393
"Sacred Concerts" (Ellington), 184
Sad-Faced Boy (Bontemps), 62
Sagar, Lester W., 9
Saint-Gaudens, Augustus, 212
Salem Methodist Episcopal Church, 137
Sammy (Johnson), 303
Sampson, Edgar, 520–21
Sampson, Henry T., 218
"Sanctuary" (Larsen), 320
Satchmo (Giddins), 21
Saturday Evening Quill, 224
Saturday Nighters Club, 155, 425
Savage, Archie, 519
Savage, Augusta, 3–4, 21, 46, 53, 91, 214, 321, 401,
 435–38, 500, 524, 540, 542–43
Savannah Echo, 1
Savannah Men's Sunday Club, 550
Savoy, The (Bearden), 41
Savoy Ballroom, 98–99, 121, 270–71, 520–21
Saxon, Lyle, 37, 115
"Schick Test, with Especial Reference to the Negro, The"
 (Wright), 551
Schomburg, Arthur Alfonso, 3, 14, 83, 85, 117, 243, 398,
 438–40, 452
Schomburg Center for Research in Black Culture, 3–4,
 438, 440
Schreiber, Belle, 294
Schuller, Gunther, 19, 248
Schultz, Dutch, 470
Schuppert, Roger A., 69
Schuyler, George Samuel, 25, 100, 274, 415, 431, **440–42**
Schuyler, Philippa Duke, 180, 441
Schwartzman, Marvin, 41
Schwarz, A. B. Christa, 283
Scott, Cecil, 49, 121

Scott, Emmett Jay, 154, 156, 367, 395, 415, **442–43**, 502, 512, 514
Scott, Hazel, 403
Scott, James Sylvester, 74
Scott, Laine A., 230
Scott, Lloyd, 121
Scottsboro Boys, 62, 116, 137, 149, 245, 257, 274, 362, 393, 396, 401, 415, 442–49, **443–49**, 480–81, 541
Scudder, Charles, 552
Seale, Bobby, 394
Search for Missing Persons, 127
Sears, Richard W., 31
Secret Sorrow (Fuller), 212
"See See Rider," 411
Séjour, Victor, 453
Selected Gems of Poetry, Comedy, and Drama (Gilbert), 220
Selected Poems (Braithwaite), 68
Self-Portrait (Delaney), 152
Senegambian Carnival, 532
"Sent for You Yesterday," 433
Sequel to "The Pied Piper of Hamelin," and Other Poems (Cotter), 130
Seraph on the Suwanee (Hurston), 281
Sewell, Matthew, 380
Sex and Race (Rogers), 432
Shades and Shadows (Edmonds), 180
Shadow and Act (Ellison), 187–88
"Shadows of the Slave Tradition" (Carter), 103
"Shake, Rattle, and Roll," 493
Shakespeare, William, 10, 38, 80, 326–27, 426–27, 480
Shakespeare in Harlem (Hughes), 275
Shapiro, Bruce, 126
Shapiro, Nat, 454, 536
Share My World (Johnson), 290
Shaw, Artie, 266, 392, 460–61, 472
She Done Him Wrong, 42–43
Sheftell, Joe, 109
Shelton, Aggie, 55
Shepard, James, 465
Shim, Eunmi, 456
"Shine," 88
Shining, The, 133
Short, Bobby, 463, 523, 539
Short Biographical Sketches of Eminent Negro Men and Women in Europe and the United States (Bruce), 83
Show Boat (film), 198
Show Boat (musical), 58–59, 80, 110, 255, 278, 427
Shuffle Along, 28, 55–57, 74, 76, 96, 138, 233, 259, 291, 355, 449–51, 483
Sibelius, Jean, 11

Sidman, Angela R., 366
Silos, Jill, 133
Silverstein, Joseph, 126–27
Silver Streak, 133
Simeon, Omer, 383
Simmons, William J., 476
Simon, George T., 331
Simple Speaks His Mind (Hughes), 275
Simpson, Wallis, 70–71
Sims, Lowery S., 399
Sinbad, 123
Sinclair, Upton, 393
Singer, Barry, 419
Singers, The (Work), 549
Singleton, Zutty, 17, 296, 350, 382, 469
Sinnette, Elinor Des Verney, 439
Sissle, Noble, 28, 44–45, 55–57, 66, 74, 76, 96, 138, 189–90, 245, 259, 278, 291, 350, 355, 417, **449–51,** 462, 482, 516, 522, 539
Sissle and Blake's Snappy Songs, 56
"Sissy Blues," 413
Six Plays for Negro Theatre (Edmonds), 180
Sketches of the Deep South (Cooke), 124
Skinner, Beverly Lanier, 146
Slaves Today (Schuyler), 441
Smart Set, 86, 171, 180
Smile Awhile Café, 270
Smith, Albert Alexander, 310, **451–53**
Smith, Alfred E., 2
Smith, Bessie, 19, 47, 75, 120, 130, 218–19, 237, 260, 262–63, 265, 274, 278, 296, 333, 335, 356, 391, 411, 413, 433–34, **453–55,** 457, 490, 517, 535
Smith, Bill, 88
Smith, Chris, 73, 86–87, 335, **455–56**
Smith, Clara, **456–57,** 516
Smith, "Cricket," 141–42
Smith, Eric Ledell, 76, 191, 219
Smith, Erin A., 198
Smith, Gary Scott, 407
Smith, Ivy, 144–45
Smith, Jabbo, 271
Smith, Lewis, 194
Smith, Mamie, 45, 65–66, 76, 120, 202, 247, 259–60, 263, 349, 433, 456, 458–60, **458–59,** 535
Smith, Morgan and Marvin, 524
Smith, Trixie, 259, **459–60**
Smith, Willie, 330–31
Smith, Willie "the Lion," 55, 205, 260, 264, 295–96, **460–62,** 478, 492, 536
Snipes, Wesley, 118
Snow, Valaida, 73, 96–97, 451, **462–63**

Snowden, Elmer, 182, 270, 330, 349, **463–65**

Social Education, 526

Social History of the American Negro, A (Brawley), 69

"Socialism and the Negro" (Harrison), 243

Socialist Party (SP), 160, 243, 361, 385, 414–15, 441

Society Orchestra, 189

Sohmer, Jack, 17, 351

Sojourners for Truth and Justice, 481

"Solace" (Delany), 155

Solitude (Sibelius), 11

Solvent Savings Bank, 387

"Some Notable Colored Men" (Calvin), 101

"Some of These Days," 73

Song of Freedom, 522–23

"Songs Called the Blues" (Hughes), 273

Son of Ingagi, 64

Son of Man (Johnson), 291

Son of Satan, 347

Sons of Ham, 354–55

"Sons of Old Black Joe," 451

"Son's Return, A" (Brown), 82

Souls of Black Folk, The (Du Bois), 166, 168, 188

South before the War, 429

Southern, Eileen, 211, 449

Southern Christian Leadership Conference (SCLC), 25–27

Southern Conference Education Fund (SCEF), 27

Southern Consolidated Circuit (SCC), 171

Southern Horrors (Barnett), 35

Southern Road (Brown), 81

Southerns, The, 63

Southern Syncopated Orchestra, 44

Southern Tailor Shop, 45

Southern Workman, 211

South Pacific (melodrama), 326

South Pacific (musical), 234–35

Southside Community Art Center, 192

Soyinka, Wole, 422

Spanish-American War, 438–39

Sparta Agricultural and Industrial Institute, 487–88

Spaulding, Asa Timothy, **465–67**

Spaulding, Charles Clinton, 465–66

Spelman College, 22–23

Spencer, Anne, **467–68**

Spencer, Chauncey, 467

Speyer, Darthea, 152

Spingarn, Amy and Arthur, 274

Spingarn, Joel, 114

Spiral Group, 5, 41, 545

Spirit of Emancipation (Fuller), 213

Spivey, Victoria, 459, **468–70,** 535

Spivey Records, 469

Spohn, Clay, 303

Springer Opera House, 411

Springfield riot, 36

"Spunk" (Hurston), 280

"Squeeze Me," 419

Stagolee, 504

Stalin, Joseph, 169, 208, 401

Stalling, Laurence, 58–59, 339–40

"Stampede, The," 247, 261

Standard Life Insurance Company, 254, 387

Stark, Bobby, 520–21

Stark, John, 314–15

State Department, U.S., 11, 20, 108, 148, 191, 206, 276, 291, 309, 338, 422, 428, 545, 556

St. Clair, Stephanie ("Queenie"), 236, 269, 287–88, **470–71**

St. Cyr, Johnny, 18–19, 363

Stearns, Marshall and Jean, 65, 420, 430, 491

Steiffel, Sam, 96

Stein, Gertrude, 284, 555

Steinbeck, John, 23

Stephensen, Nan Bagby, 222

Step on It, 74

Stepto, Robert, 82

Stern, Bernard J., 329

Stevedore (Peters), 245, 326, 479–80

Stevens, Andrew, Jr., 75–76

Stewart, Rex, 121, 184, 261, 351, 456, 464, 520

Stewart-Baxter, Derrick, 49, 459

Still, William Grant, 138, 254, 284, 356, 409, 450, **471–73**

"St. Joe's Infirmary," 263

"St. Louis Blues, The," 237, 270, 387

St. Louis Woman (Bontemps and Cullen), 62

St. Louis Woman (musical), 136

St. Louis World's Fair, 501

Stomping the Blues (Murray), 99

Stone, Louis Collins, 2

"Stop! Rest a While," 87

"Stoptime Rag," 315

"Storage" (Popel), 398

Stormy Weather (film), 75, 99, 379

"Stormy Weather" (song), 522

Story, Rosalyn, 10

Story of My Life and Work, The (Washington), 442

Stowe, Harriet Beecher, 59, 204, 234

Straine, Doc, 538

Strange Brother (Nile), 48

"Strange Fruit," 267

"Stratosphere," 331

Stratton, William G., 52

Strayhorn, Billy, 184, 264
Streetcar Named Desire, A (Williams), 480
Street Scene, 275
Streitmatter, Rodger, 490
Stribling, T. S., 197
Stricklin, Joyce Occomy, 60–61
Stringbeans and Sweetie Mae, 180–81
"Strivings of the Negro People, The" (Du Bois), 166
Struttin' Time, 74
Student Nonviolent Coordinating Committee (SNCC), 26–27, 354
Studio Museum, 108, 496
"Study of the Negro Problem, The" (Du Bois), 166, 169–70
Sul-Te-Wan, Madame, **473–75**
"Summer Tragedy, A" (Bontemps), 61
Sunday Morning in the South, A (Johnson), 290
Sunset Club, 98
Sun Shines Bright, The, 199–200
Sun Shipbuilding Company, 443
"Suppression of the African Slave Trade to the United States of America, The" (Du Bois), 165
Supreme Court, U.S., 34, 281, 363, 404, 428, 445–46, 466, 513–14, 530–31
Supreme Liberty Life Insurance, 388
Survey, 328
Survey Graphic, 283
"Survey of the Life and Poetry of Paul Laurence Dunbar, A" (Burch), 89
"Survival of Africanisms in Modern Music" (Du Bois), 163
"Swamp Moccasin" (Matheus), 338
"Sweat" (Hurston), 280
Sweatman, Wilbur, 348
Sweet Chariot, 516
Sweet River (Abbott), 234
"Swing Along," 123
Swinging the Dream, 333
Swing It, 56
Swinton, Harry, 429
Symbol of the Unconquered, The, 346
"Sympathy" (Dunbar), 174
Symphony in Black, 266
Symphony in E Minor (Price), 409
Symphony of the New World, 138
Syncopation DeLuxe, 278
Syracuse University, 22

Taft, William Howard, 145, 289, 360, 367, 513
"Take the 'A' Train," 184
Talladega College, 68

Taller de Grafica Popular (TGP), 108
Tanner, Benjamin Tucker, 476
Tanner, Henry Ossawa, 37, 162, 212, 240, 305, 399, 435, 453, **476–78,** 509, 543
Tanner, Jo A., 358
Tattler, 172
Tatum, Art, 233, 247, 297, 462
Taylor, A. A., 547
Taylor, Edward, 308
Taylor, Elizabeth, 71
Taylor, Eva, 45, 461, **478–79,** 535–36
Taylor, Jeanette, 65
Teagarden, Jack, 19–20
Temple, Shirley, 430
Temple of Tranquility, 236
Tempo Club, 141
Terrell, Mary Eliza Church, 85, 176, 308
Terry, Sonny, 492
Texas Freeman, 442
"Texas Shout," 144
Thaïs (Massenet), 371
"(That's Why They Call Me) Shine," 141, 335
"That Thing Called Love," 65
Theard, Sam, 144
Theater Owners' Booking Association (TOBA), 88, 130, 144, 171–72, 181, 218–19, 270, 333, 411–13, 420, 517
"Theft" (Popel), 397
Their Eyes Were Watching God (Hurston), 279, 281
"There Is a Balm in Gilead," 148
There Is Confusion (Fauset), 197
They Have Ears But They Hear Not (Smith), 452
This Is Our War, 370
This Is Show Business, 39
This Is Your Life, 309
Thomas, Alma, 524
Thomas, Edna Lewis, 3, **479–80**
Thomas, Joe, 16, 330–31
Thomas, Lloyd, 479–80
Thompson, Chuck, 337
Thompson, Edward, 407
Thompson, Elaine E., 397
Thompson, Francesca, 408
Thompson, Ulysses "Slow Kid", 355, **482–84**
Thompson, William Hale, 148–49
Thompson Patterson, Louise, 3, **480–82,** 484
Thomson, Virgil, 284
Thomson, William, 434, 465
Thrash, Dox, 540, 544
Three Dixie Songbirds, 58
306, 4, 321

369th U.S. Infantry "Hell Fighters" Jazz Band, 188–89, 449

Thurman, Wallace, 100, 146, 162, 195, 231, 280, 283, 481, **484–85**, 508, 528

Tilley, John L., 25

Time, 12, 20, 322, 544

Time for Laughter, A, 334

"Tin Can" (Bonner), 60

Tirro, Frank, 21

"To Clarissa Scott Delany" (Grimké), 155

"To James" (Horne), 272

"To Jean" (Horne), 272

Toloso (Johnson and Johnson), 299

Tolson, Melvin Beaunorus, **485–86**

To Make a Poet Black (Redding), 421

Toms, Coons, Mulattoes, Mammies, & Bucks (Bogle), 75, 344

Tom-Tom (Du Bois), 58–59, 163

Toomer, Jean, 14, 61, 67, 81, 155, 196, 289–90, 356, **486–89,** 508, 537

"Toot Toot, Dixie Bound in the Morning," 87

Toppin, Edgar Allan, 257, 443

Toscanini, Arturo, 11

Tough Winter, A, 199

Toure, Sekou, 466

Toussaint-Louverture, 37–38, 62, 321, 371, 439

"To Usward" (Bennett), 46

Town Hall, 10–11, 20, 110, 296

Townsend, Robert, 379

Tracy, Steven C., 277

Trade Union Educational League (TUEL), 207–8

Trade Union Unity League (TUUL), 207–8

Train Whistle Blues (Bearden), 41

Traviata, La (Verdi), 191

Treasury Department, U.S., 358

Treat It Gentle (Bechet), 45

Treatment of Fractures, The (Scudder), 552

Tree, Sir Herbert Beerbohm, 176–77

Treemonisha (Joplin), 315

Trent, Jo, 142

Trial, The, 337

Trip to Africa, 313

Trip to Coontown, A, 122

Trotter, William Monroe, 36, 166, 358, 375, **489–90,** 514, 527

Troubled Island (Still), 472

Trovatore, Il (Verdi), 110

Trueheart, John, 520–21

"Truly I Do," 132

Truman, Harry S., 32, 57, 168–69, 226, 246, 258, 287, 416, 531

Truth, Sojourner, 108, 196, 354

Tubman, Harriet, 85, 108, 118, 306, 321, 354, 357, 440

Tucker, Lorenzo, 347, **490–91**

Tucker, Snake Hips, **491–92**

Tucker, Sophie, 73

Tucker, Vernitta Brothers, 164

Tulsa riots, 530

Turner, Big Joe, 391, 461, **492–93**

Turner, Frederick Jackson, 345–46

Turner, Lorenzo Dow, 280

Turner, Mary, 213, 530

Turner, Nat, 180, 306

Turner, Steve, 306

Turpin, Tom, 314

Tuskegee Airmen, 5–7, 241

Tuskegee Lynching Report, 550

Tuskegee University, 6–7, 22, 31–32, 77, 84–85, 106–7, 147–48, 154–55, 166, 185, 187, 197, 246, 342, 352–53, 357, 359, 366–68, 442–43, 485, 503, 511–15, 550–51

Twelve Million Black Voices (Wright), 553

"Twenty Years," 336

Two Rebels (Lawrence), 322

Tyers, William, 189, 455

Tyler, Marion Gant, 56–57

"Typewriter, The" (West), 528

Tyson, Cicely, 470

Ubangi Club, 48–49

Ulrich, Henry, 514–15

Uncalled The (Dunbar), 173

Uncle Tom's Cabin (Stowe), 59, 204, 234

Uncle Tom's Children (Wright), 554–55

Uncommon Sense (Anderson), 9

Underground Railroad, 76

Unfettered (Griggs), 227

United Nations, 11, 32, 104, 168, 258, 375–76, 394

United Nations Educational, Scientific, and Cultural Organization (UNESCO), 15, 287, 466

Universal Limited Art Editions (ULAE), 54

Universal Negro Improvement Association (UNIA), 36, 72, 83, 159, 177, 205–6, 215–17, 244, 268–69, 316, 329, 341–42, 383, 415, 496, 507, 516

Untermeyer, Louis, 504

Up from Slavery (Washington), 215, 510, 513

Used to Be Duke, 264

Utopian House, 4

Uzelac, Constance Porter, 120, 400

Vacha, J. E., 235

Valentine, Samuel, 205–6

"Values and Imperatives" (Locke), 329

VanDerZee, James Augustus Joseph, 206, **494–97,** 525

Vann, Robert L, **497–98**

Van Vechten, Carl, 3, 47–48, 61, 143, 202, 223, 273–74, 283, 319, 375, 398, 479, 500

Varése, Edgard, 472

Variety, 30, 88, 234–35, 408

Verdi, Giuseppe, 12, 58–59, 110, 191

Versailles Peace Conference, 36, 490

Vickery-Bareford, Melissa, 340

Victoria Spivey Recorded Legacy of the Blues, 469

Victor Records, 506

Vidor, King, 255, 344

Vilatte, Joseph René, 342

Villa Lewaro, 500, 502–3

Vineyard Gazette, 529

"Viney's Free Papers" (Dunbar), 94

Violets and Other Tales (Dunbar-Nelson), 174

Virginia Seminary and College, 80–81

Virgin of the Seminole, The, 346

Voelckel, Rudolph, 313

Voice of the Negro, 93–94, 243–44

Voll, Christoph, 305–6

von Stroheim, Erich, 474

Voodoo (Freeman), 211

Vytlacil, Vaclav, 53

Wagner, Richard, 210

Wagner, Robert F., Jr., 157, 254, 258, 291

Walcott, Derek, 41

Walker, Aaron "T-Bone," 132, 413

Walker, Aida Overton, 218, 313, 354–55, 357, 532–33

Walker, A'Lelia, 3, 479, 496, 499–503, **499–500**

Walker, Alice, 37, 61, 282, 488–89

Walker, Frank, 454, 535–36

Walker, George, 86, 122–23, 221, 335, 354–55, 357, 450, 455, **532–34**

Walker, Madam C. J., 373, 496, 499–503, **500–503**

Walker, Margaret, 23, **503–5,** 555

Walker, Wyatt Tee, 26–27

"Walking the Dog," 73

Wallace, Sippie, 45, 535

Wallenstein, Peter, 154, 405

Waller, Fats, 19, 49, 75, 99–100, 110, 121, 124, 219, 233, 270, 278, 295–96, 348, 364, 419, 458, 460–62, 464, **505–7,** 536

Waller, John Louis, 418–19

Walls of Jericho, The (Fisher), 201

Walrond, Eric, 14, 250, **507–8**

Walters, Alexander, 83

Walton, Lester, 355

War (Lawrence), 322

Ward, Theodore "Ted," 555

War Department, U.S., 51, 125

Warfield, William, 89

Waring, Laura Wheeler, 240, 399, **508–9**

Warren, Nagueyalti, 344

Washington, Booker T., 6, 9, 31, 38, 62, 75, 77, 83–84, 106, 113–14, 118, 129–30, 145, 147 154, 156, 163–64, 166–67, 215–17, 227, 243, 246, 257, 272, 279, 284, 294, 298, 308, 342, 345–46, 352–53, 358–59, 366–67, 374, 386, 395, 406, 426, 442–43, 477, 489, 497, 502–3, 507, **510–15,** 534, 550, 553

Washington, Fannie Smith, 512

Washington, Ford Lee "Buck," 87–88

Washington, Fredi, 74–75, 125, 245, 344, 357, 408, 479, **515- 17,** 522

Washington, Harold, 120

Washington, Margaret Murray, 512

Washington, Mary Parks, 22–23

Washington, Salim, 46

Washington Bears, 128

Washington Post, 85, 221, 310, 316, 335, 353

Waters, Ethel, 8, 14, 43, 47, 66, 73, 88, 151, 219, 245, 254, 260, 262–63, 265, 291, 296, 326, 344, 356, 387, 392, 408, 418, 459, 462–63, **517–20,** 535

Watkins, Mel, 181

Watkins, Perry, 245

Watson, James S., 156

Watts, Jill, 193

Way Down South, 372

Wayward and the Seeking, The (Toomer), 489

Weare, Walter B., 465–66

Weary Blues and Other Poems, The (Hughes), 273–74

"Weather Bird," 19

Weatherby, William J., 384

Weaver, Robert, 51, 307, 401

Weavers, 324

Webb, Chick, 202–3, 264, 464, **520–51**

Webster, Ben, 96, 121, 184, 248, 266–67

Webster, John, 308

We Charge Genocide, 394

Wedding, The (West), 529

"Wedding Day, Harlem, 1926" (VanDerZee), 495

Wedge, Eleanor F., 42

Weems, Charlie, 443–45, 447–48

Weick, George P., 24

Weill, Kurt, 275

Wein, George, 88

Weisbrot, Robert, 193

Weisenfeld, Judith, 255

Welch, Elisabeth, **521–23**

Welch, Kimberly, 422

Welles, Orson, 326, 382, 480, 555

Wellesley College, 155–56

Wells, Dicky, 121, 464

Wells, Henry, 330–31

Wells, James, 34

Wells, James Lesesne, 107, 398, 437, **523–25**

Wepman, Dennis, 505

Wesley, Charles Harris, **525–27,** 547

Wesley, Dorothy B. Porter, 527

West, Dorothy, 100, 224, 231, 508, **527–29**

"West End Blues," 19

Western Association of Writers, 172–73

Western Reserve University, 536–37

"We Wear the Mask" (Dunbar), 174

We Who Die & Other Poems (Dismond), 102

"(What Did I Do to Be So) Black and Blue?," 419

What the Negro Thinks (Moton), 368

Wheatley, Phillis, 108, 164, 376, 504

Wheatstraw, Peetie, 17

Wheeler, Sara Graves, 302

"When I Was in Knee Pants" (Davis), 145

When Peoples Meet (Locke and Stern), 329

When Washington Was in Vogue (Williams), 537–38

Whetsol, Arthur, 182, 464

White, Charles, 107–8, 192, 399, 544

White, Clarence Cameron, 338

White, Hugh, 309

White, Josh, 408

White, Walter Francis, 15, 136, 168, 197, 241–42, 298, 319, 356, 369, 375, 445, **529–32,** 543

White Man, Listen! (Wright), 555

White Marble Lady (Ottley), 384

Whitman Sisters, 49, 109, 218

Whitney Studio Gallery, 151

Whittier Elementary School, 145

Wife of His Youth and Other Stories of the Color Line, The (Chesnutt), 112

Wilberforce University, 13, 76–79, 89, 114, 165–66, 210, 376–78, 526–27

Wilcox, Ed, 330–31

Wiley College, 485–86

Wilkerson, Margaret, 60

Wilkins, Roy, 125, 416, 531

Willard, Frances, 36

Willard, Jess, 294

Willetts, Gilson, 510

Williams, Bert, 86, 122–23, 188, 221, 300, 335–36, 354–55, 357, 450, 455, **532–34**

Williams, Christopher, 118

Williams, Clarence, 19, 45, 66, 87, 144, 270, 348, 350, 419, 454, 456, 461, 478–79, 506, **534–36**

Williams, Cootie, 183–84, 264, 350

Williams, Edward Christopher, 425, **536–38**

Williams, Elmer, 520–21

Williams, Eugene, 443–45, 447–48

Williams, Joe, 434

Williams, Martin, 383

Williams, Mary Lou, 121

Williams, Tennessee, 480

Williams, Tony, 464

Williams, Wilburn, Jr., 252

Williams College, 80

"Willie the Weeper," 124

Willis, Laticia Ann Marie, 227

Willkie, Wendell, 386

Wills, William D., 120

Wilson, Clint C., 2

Wilson, Danny, 538

Wilson, Dooley, 519

Wilson, Edith Goodall, 66, 419, 458, 523, **538–39**

Wilson, Ellis, 250–51, **539–41**

Wilson, Flip, 24, 333–34

Wilson, Frank H., 64, 326, 516, **541–42**

Wilson, Gerald, 331

Wilson, John, 131

Wilson, Teddy, 121, 266–67

Wilson, Woodrow, 71–72, 86, 154, 244, 298, 352, 367, 490, 502

Winfield, Hemsley, **542–43**

Winfrey, Oprah, 529

Winston, Michael R., 353

Winter Garden Theater, 28

Within Our Gates, 346, 407

Wodrow, Robert, 90

Wolfe, Charles K., 324

Wolfe, George C., 380

Woll, Allen, 355

Woman and the Blues, A, 235

Woman with a Kerchief (Artis), 22

Women's Review of Books, 154

Wonders (Newsome), 378

Wood, Berta, 349

Wood, Grant, 107

Wood, Jennifer, 300

Wood, Maxine, 326

Woodards, Shanteé, 354

Wooding, Sam, 348, 539

Woodruff, Hale Aspacio, 5, 147, 192, 212, 250, **543–45**

Woodson, Carter Godwin, 83, 116, 280, 308, 310, 424–25, 524, 526–27, **546–48**

Woodville Times, 1

Woollcott, Alexander, 221

Words in the Mourning Time (Hayden), 251–52

Work, John Wesley, Jr., 548

Work, John Wesley, III, **548–49**

Work, Monroe Nathan, 511, **549–51**

Works of Alice Dunbar-Nelson, The (Dunbar-Nelson), 175–76

Works Progress Administration (WPA), 3–4, 21, 23, 25, 53–54, 56, 62, 91, 94, 117, 143, 151, 162, 192, 234–35, 250–51, 281, 291, 303, 321, 326, 335, 372, 384, 432, 437, 504, 524, 528, 540, 544, 553–55

World and Africa, The (Du Bois), 168

World News Service, 32

World Peace Congress, 427–28

World's Columbian Exposition, 35, 78, 173, 314, 477

World War I, 1–2, 36, 46, 55, 70–74, 83, 86–87, 93, 118, 130, 141, 150, 160, 167, 175, 188–89, 207, 215, 226, 230, 243, 249, 251, 254, 263, 286, 294, 309, 316–17, 328, 353, 355, 363, 365–68, 377, 385, 393, 396, 411, 419, 435, 441, 443, 449–50, 452, 471–72, 477, 483, 497, 499, 502–3, 509, 530, 535, 551

World War II, 3, 5, 20–21, 29–30, 32, 40, 51, 56–57, 59, 65, 70–71, 80, 92, 99, 102, 110, 115, 117, 123, 128, 154, 160, 163, 165, 168, 186, 196, 207, 233, 241–42, 258, 279, 287, 317, 322, 340, 343, 346, 359, 362, 384, 386, 388, 390, 401, 403–4, 416, 427, 433, 442–43, 447–48, 451, 466, 486, 490, 492, 496, 518, 522, 540, 544, 554–55

Wormser, Richard, 364

"Wrappin' It Up," 261

Wretched, The (Fuller), 212

Wright, Andrew "Andy," 443–48

Wright, Beryl J., 5, 38

Wright, Leroy "Roy," 443–47

Wright, Louis Tompkins, **551–53**

Wright, P. T., 170

Wright, Richard, 23, 53, 61, 185–86, 2c2, 275, 321, 325–26, 329, 390, 486, 504–5, 528, **553–56**

WSBC, 126–27

Wyandank Pharaoh v. Jane Ann Benson et al., 94

Yaddo, 152

Yale University, 241

Yamekraw (Johnson), 296, 506

Yeats, William Butler, 251

"Yellow Dog Blues," 73

Yenvalou (Work), 549

Yerby, Frank, 23

Yergan, Max, 156, 168

"Yesterdays," 249

Yordan, Philip, 65, 326

"You Ain't Talking to Me," 73

"You Can't Keep a Good Man Down," 65

You Can't Pet a Possum (Bontemps), €2

"You'll Have to Swing It," 203

Youmans, Vincent, 261

Young, Lester, 121, 185, 247, 265–66

Young, Snooky, 331

Young, Trummy, 331

Young, Whitney, 307

"Young Blood Hungers, The" (Bonner), 60

Young Men's Christian Association (YMCA), 3, 104, 107, 129, 150, 162, 256–57, 3c5, 325–26, 374, 439, 502–3, 543

Young's Magazine, 319–20

"Young Warrior, The" (Burleigh), 93

Young Women's Christian Association (YWCA), 27, 104–5, 155, 258, 301, 368, 397–98, 503

Zanuck, Darryl F., 519

Zenobia, 199

Ziegfeld, Florenz, 450–51, 534

Zombie (Webb), 33

Zuluki (Freeman), 210

Zumoff, J. A., 160, 362

Zunguru (Dafora), 143